PRICE GUIDE TO ANTIQUE AND CLASSIC CAMERAS
Seventh Edition
1990-1991

Edited by James M. McKeown
and Joan C. McKeown

Seventh Edition on press. Published October 16, 1989

European Distributors:
Hove Foto Books
Hove, East Sussex, U.K.

German Distrubutor:
Stubing, Kellner & Schick
Osnabrucker Str. 79
4800 Bielefeld 1
WEST GERMANY

Library of Congress Catalog Card Number: 87-654177

ISBN 0-931838-13-4 (PAPER)
ISBN 0-931838-14-2 (CLOTH)

EDITORS
James M. McKeown
Joan C. McKeown

ASSISTANT EDITOR
LeeAnne Byers

**HISTORICAL AND
TECHNICAL CONSULTANTS**
Roger Adams
Ron Anger
John Baird
Bob Barlow
William P. Carroll
Don Chatterton
Peter Dechert
Dr. Arthur Evans
Stein Falchenberg
Jean-Paul Francesch
Adam Geschwind
Leo Hilkhuijsen
Matthew Isenberg
Robert Johnson
Alan Kattelle
KEH Camera Brokers
Mike Kessler
Mead Kibbey
Dr. Rudolf Kingslake
George Kirkman
Helmut Kummer
Eaton S. Lothrop, Jr.
Steve Lyons
Thurman F. Naylor
Richard Paine
Harry Poster
Michael Pritchard
Jack & Debbie Quigley
Cynthia A. Repinski
Robert Rotoloni
Dr. Burton Rubin
Richard Sanford
Jerry Smith
Bob Sperling
Frank Storey
Jim Stewart
Thomas A. Surovek
Jay Tepper
Helge Thelander
Paul-Henry van Hasbroeck
Allen Weiner

PRODUCTION ASSISTANT
Jeremy Byers

OTHER CONTRIBUTORS
Dennis Allaman
Greg Bedore
Sig Bloom
Peter Boots
Robert Byers
Bob Campbell
Barney Copeland
John Courtis
John S. Craig
Ray D'Addario
Alton H. Donor
RoBerta Etter
Ken Hough
Leon Jacobson
Wesley Jost
Mike Kudla
Cliff Latford
Mike McCabe
Tom McKeown
Tim McNally
W. S. Morley
Parker Pen Co.
Pilecki's Camera Exchange
Roger Reinke
Bill Savage
Harry Smith
Vintage Cameras Ltd.
Gene Vogel
Gerry Vogel
Marge Vogel
Fred Waterman
Gene Whitman
Dick Whitstone
Duane Williams
British Journal Photographic
 Almanac

ON THE COVER

FRONT COVER - Daguerreotype Camera
 (American Chamfered box style)
Stereo Graphic 35mm
Micro 110 Panda
Kunik Petie (gold)
Rochester Optical Co. Pony Premo No. 2
Flex-O-Cord (Kojima)
Teddy Camera Model A

BACK COVER - *Blair Kamaret*
Vidmar Vidax
Regula Citalux 300
Yashica Rapide
Reflex Beauty (Taiyodo)
ITT Fashionflash
QRS Kamra
French magazine box (unidentified)
Agfa-Ansco No. 1A Readyset Royal
Cinescopie
Kodak Petite from Ensemble
Kodak Centennial Truck
Franklin Magazine 8
Minolta-16
Fallowfield Popular Ferrotype Camera
E.K.C. Brownie Flash 20
Photake (Chicago Camera Co.)

DEDICATION

*To Nicéphore, Louis,
and William Henry,
who began collecting cameras
150 years ago.*

McKeown's Law:

The price of
an antique camera
is entirely dependent
upon the moods
of the buyer and seller
at the time of
the transaction.

CONTENTS

ACKNOWLEDGEMENTS

This book has grown tremendously since we began researching camera prices in 1969. Not only have we increased the number of cameras by an average of nearly 1,000 per edition, but we have also increased the amount and accuracy of the information on each. Obviously this has not been the work of a single individual. This current edition has benefitted greatly from the knowledge and research of many authorities in specialized areas of the camera collecting field. The depth of information in these specialty areas would not have been possible without their generous sharing, for while the job of editing this guide requires a broad interest in the field, this wide interest is necessarily shallow overall.

Without detracting from previous contributors, we usually give first billing to those who have made the greatest, latest, or most significant contribution to the current edition. Sharing the spotlight for this edition are three people: Stein Falchenberg, Tom Surovek, and Adam Geschwind.

Mr. Stein Falchenberg took a great deal of time to locate and correct many small errors and omissions that would have gone unnoticed by a less scrutinous eye. Fortunately he found a large enough percentage of good in this book that he felt it was worth correcting. Mr. Falchenberg's knowledge spans national borders and decades of production. His particular interest is the history of the SLR, on which he is writing a book. He welcomes correspondence form serious collectors and researchers on that subject at 11 Shelton St.; London WC2H 9JN; England. FAX 01-379-0981.

Tom Surovek and *Adam Geschwind* cooperated across the globe to recreate the Miranda section of this guide. For the first time, we are listing and illustrating most models, along with their distinguishing characteristics and a bit of Miranda history. Not only have they contributed heavily to this guide, but they are actively promoting correspondence among Miranda collectors. They welcome correspondence. Adam Geschwind; 5/16 Miller Street; Bondi Sydney NSW; Australia 2026. Tom Surovek; Box 2001; Hammond, IN 46323 USA. A new society of Miranda collectors is forming. Contact Mr. Surovek for details.

Mr. Leo Hilkhuijsen send a great deal of information on Agfa camera models, which allowed us to add details throughout that section.

There is a young but growing section on ACCESSORIES, virtually all of which was contributed by *Fred Waterman*, a camera collector since 1972. His current interests center around novel cameras with unusual devices or appearance, and the accessories of photography such as meters, exposure guides, darkroom equipment, etc. He welcomes correspondence from collectors with similar interests and is actively seeking to expand his collection of accessories. Write to him at: 1704 Valencia Dr.; Rockford, IL 61l08.

The basis for the movie camera section was information supplied by *Wes Lambert* on the early 35mm and professional cameras. A large amount of additional material was provided by *Alan Kattelle*. Alan provided information and photos for many unusual cameras and virtually all of the projectors included in this edition. Cine enthusiasts are welcomed to contact Alan at: 50 Old County Rd.; Hudson, MA 01749. Also see his ad on page 819. Wes Lambert may be reached at 1568 Dapple Ave., Camarillo, CA 93010. Don't forget to ask them about the newsletter *Sixteen Frames* which is always interesting and informative, or the *Movie Machine Society* which invites you to join.

The section on Minolta is primarily the work of *Jack & Debbie Quigley* of Quigley Photographic Services. They provided dates and technical information as well as photographs for nearly every Minolta model up to about 1965. The Quigleys are well known authorities on Minolta. Debbie runs the mail order end of their

business, teaches photography, and works full time as a representative for Minolta copiers. Jack does commercial photography, camera repair and custom crafting.

The Zeiss-Ikon section is the work of *Mead Kibbey*. Mead is widely recognized as one of the world's leading authorities on Zeiss-Ikon. Recent price statistics are from our database.

Peter Dechert is responsible for the Canon section. Dr. Dechert is well known as a leading authority in the field of Canon rangefinder cameras, and author of the book *Canon Rangefinder Cameras* published by Hove Foto Books. He is also working with *Historical Camera Publications* on a series of monographs on Japanese cameras. For further information, see page 823.

Bob Rotoloni, who literally wrote the book on Nikon, was the major contributor for that section. His book called *Nikon Rangefinder Cameras* is published by Hove Foto Books. Bob also heads up the Nikon Historical Society. For details, see page 824.

Paul-Henry van Hasbroeck contributed historical information and photographs for the Leica section. Paul-Henry is the author of several books on Leica cameras, including *Leica: A History Illustrating Every Model and Accessory*.

Art Evans supplied information for the Franke & Heidecke (Rollei) section. His book, *Collectors Guide to Rollei Cameras*, is published by Centennial Photo Service.

Dick Paine was kind enough to let us use material from his book, *Graflex, The All American Cameras*. Further help in the Graflex area was provided by *Roger Adams*, who is currently working on a book on the subject.

Jim Stewart provided help in several areas, of which the Alpa section is only the most obvious. Many other details and bits of information provided by Mr. Stewart are scattered throughout the book, in areas including 35mm and subminiature cameras. He may be contacted at 201-361-0114.

Bill Carroll made numerous additions throughout the guide. His particular interests are early shutters, small format rollfilm cameras, mechanically complex cameras (built-in motor drives or other unusual features), camera look-alikes (flasks, compacts, etc.), and non-photo-electric exposure determining devices. Contact him at 8500 La Entrada, Whittier, CA 90605, (213)-693-8421.

Mike Kessler is particularly interested in unusual 1880-1890's disguised or detective cameras and Simon Wing cameras. He may be reached at 25749 Anchor Circle, San Juan Capistrano, CA 92675, (714)-661-3320.

George Kirkman provided information on many early stereo cameras. He will field questions on (or buy) stereo cameras (1900-1940) and would appreciate hearing from you at: P.O. Box 24468, Los Angeles, CA 90024, (213)-208-6148.

The Western Photographic Collectors Association volunteered to respond to any questions on collectible cameras. If they don't have the answers, they will find someone who does. Write: WPCA, P.O. Box 4294, Whittier, CA 90607. Please include a self-addressed, stamped envelope.

In addition to the historian/collectors, we are indebted to another group of friends who are the market specialists. These are primarily dealers or very active collectors who review the price data from a viewpoint based on extensive experience in the general market or specialized areas thereof. While the majority of the prices in this book are derived from our database of worldwide sales records, it is of critical importance that these figures be reviewed for possible errors. We communicate regularly with many of the top dealers and collectors in the field to constantly verify our statistics.

Jay Tepper has always been willing to help in this area. Jay and his wife Bobby publish a monthly list and regularly purchase large numbers of cameras worldwide to maintain their extensive inventory. He may be contacted at 313 N. Quaker Lane, West Hartford, CT 06119 U.S.A. Tel: 203-233-2851.

Don Chatterton is a specialist in the Leica field, and we greatly appreciate his help with the nuances of Leica pricing. He actively buys and sells Leica cameras. See his display advertisement in the back of this book or call 805-682-3540.

Bob Barlow helped eliminate some of the confusion among the various Contax-type cameras made in post-war East Germany. Bob specializes in East German Contax cameras, and welcomes the exchange of information and/or equipment. Contact him at P.O. Box 76, Livingston, NJ 07039.

Greg Bedore gave strong support to our pricing data on Zeiss cameras by sharing hundreds of recent purchase prices from his own collecting.

Ron Anger contributed to the Ernemann section from the market and historical viewpoints.

Subminiature camera collecting has its specialists who were also very cooperative, including *Bob Johnson, Don Sellers, Jim Stewart, and Jay Tepper.*

Allen Weiner was called upon for his respected opinion on relatively unusual cameras for which there are always inadequate sales figures to make a good average. Allen & Hilary Weiner are well established and respected dealers who are always interested in buying entire collections or fine individual items. They may be contacted at 80 Central Park West, New York City 10023. Tel: 212-787-8357.

Thurman F. (Jack) Naylor of Cameras & Images International Inc. has always been generous in sharing his knowledge in both the historical and pricing areas. Certainly one of the world's leading collectors, Jack keeps abreast of the latest price trends on significant cameras, and has also been thoroughly cooperative in providing needed information on many of the rare items from his collection.

Camera manufacturers are in business to sell cameras, not to provide historical information to those of us who live with one foot in the past. In spite of the sometimes cold push toward productivity so prevalent in today's world, there are a few camera manufacturers who took time from their schedules to provide us with information and/or photographs. Included are *Agfa-Gevaert, Eastman Kodak Co., Ernst Leitz GmbH, Victor Hasselblad Aktiebolag, VEB Pentacon, Robot Foto & Electronic GmbH, Rollei-Werk, Ehrenreich Photo Optical Industries, and Durst S.A.* We would like to thank them for the help they have provided.

Numerous other people and organizations have helped, and unfortunately they can not all be detailed here. Even the list of contributors at the front of the book is not nearly complete. This book has become a depository for useful information, and we are often approached by collectors at camera shows who fill in bits and pieces of information gleaned from new purchases and discoveries. We receive many letters and postcards with contributions of historical, technical, or pricing information. All of this is greatly appreciated. While we have tried to list the major contributors, I am sure that there are omissions, and I would like to thank especially those whose contributions are going temporarily without recognition.

INTRODUCTION

The first edition of *Price Guide to Antique & Classic Still Cameras* was published in 1974, shortly after the camera collecting hobby came out of the closet. Since that time, this guide has been the single most complete and accurate reference guide to cameras in the entire field. The first edition included 1000 cameras. This Seventh Edition now includes over seven times that number. Not only has it been expanded to include more camera models, but we have made every effort to expand the information given for the individual cameras, providing dates and historical information wherever possible. We have also added over 500 new photographs for this edition to make a total of 2500 cameras illustrated. Each new edition of this guide has made significant improvements over the last, and with your support we hope to continue this tradition. In addition to reporting on the cameras which are routine merchandise for dealers, we try to ferret out the cameras that are not listed in any of the standard reference works. In this edition, you will find over 1500 cameras that do not appear in any other reference book. We hope you enjoy them.

WHERE ARE PRICES GOING? In order to understand the current and future prices of collectible cameras, it helps to know some of the history. The general trends of prices showed ascending patterns through 1981 and a leveling off about 1982-83 with some items beginning to drop. In 1983 and 1984, camera prices dropped considerably, especially in reference to the American Dollar, which is our basis. Partially this was due to the general softening of the market and of course a good portion of the loss was due to the rapid rise in the value of the dollar compared to other currencies. The rate of decline slowed in 1985, and by 1986 had stabilized and some items had begun to recover. By late 1986 and early 1987, the relative strength of British, German, and Japanese currencies against the Dollar had strengthened the market, since shopping for classic cameras in the U.S. was a little like shopping in a discount store. Prices in the U.S. began to firm up for many of the better collectibles. From 1987 through 1989, we have seen sharply rising prices in specific areas. The Japanese had been influencing prices upward for several years with the strength of the Yen. We now have an increasingly competitive environment among the collectors in Tokyo, which carries over to the buyers and brokers in the USA, Europe, & elsewhere. Prices have escalated at rates that even dealers have trouble believing. The wild increase in Leica prices has slowed, but only to be replaced by a similar infatuation with Canon and Nikon rangefinder cameras. Leica copies, once a poor man's substitute, have become in many cases more valuable than the real Leicas they imitated.

The general trend in collecting is toward the high quality, sophisticated cameras of postwar period (1945-1970's). Because Japan played an increasingly dominant role in camera production during this period, and since they are buying these cameras back by the thousands, it has become an active and lucrative market segment. The lure of profit has created a new breed of dealers and middlemen for the inflationary Japanese market. However, there are isolated individuals and groups who continue to discover beautiful wood, brass, and leather antique cameras. As the value of most of these older cameras is relatively stable, one might suspect that these collectors have a fondness for cameras that is not directly related to cash. Early, rare, historically important cameras are seen less often, but so too are collectors and dealers who recognize them. One dealer told me of a customer who walked in to a camera show with a Simplex, an early 35mm camera by Multi-Speed Shutter Co. Fortunately, one dealer in the room had heard of it and thought it might have some value. A dealer took a chance on it and took it in trade for something new and shiny. Smart move!

Collectors have become increasingly aware of condition. A camera which is not cosmetically clean and attractive becomes difficult to sell. A few cameras escape this scrutiny if they are extremely rare, but ordinary "merchandise" had better be clean, and preferably working as well.

When camera collecting was experiencing a boom in the late 1970's, speculators began buying heavily and indiscriminately, which fanned the flames of inflation and drove prices to the breaking point. A major slump followed in 1982-83. Many speculators left the field, and new collectors joined our ranks. It is quite likely that the inflated market in Japan will reach a peak and level off, or even drop. However, the Japanese collectors have been more careful of condition than were the speculators of the 1970's, so it is not as likely that their investments will lose much value. If the spiral stops quickly, it will be heavily stocked dealers who will suffer.

Apart from the Japanese market, there are other segments which are also rising at present. Tropical cameras are beginning to rise again after a few years of hesitiation. European plate cameras with brown leather are being recognized as more valuable than the more common black ones. Any color other than black demands a premium. Box cameras (except ordinary black ones) are finally getting off the ground. Colored box cameras, those with art-deco designs, unusually shaped plastic ones, etc. have been picked up by the demand/supply ratio. Europe is a bit ahead of the USA in this regard. Some art-deco cameras have brought considerably better prices in the art market than in the traditional camera collectors circles.

ADVICE TO NEW COLLECTORS
Our advice to collectors would depend entirely on your motives for collecting. If you are concerned with collecting as an investment, you should concentrate on the more rare and unusual camera models, which will naturally require more capital and expertise. If you are collecting primarily for the enjoyment of it, you should follow the dictates of your interest and budget. Many of the lower-priced cameras offer an inexpensive hobby, and often this is a good place to start. Most collectors start out with a general interest which often becomes more defined and specialized as they continue in collecting. If you are dealing in cameras to make a profit, you must maintain close contact with the market. Find your own niche and remain within your area of expertise. By following the market closely, you can make a profit from its ordinary fluctuations, and by knowing your customers' interests.

All prices in this edition have been updated. They are as current as possible, and data has been weighted toward the most recent figures. However, we have also retained the stabilizing influence of the last 10 year price record of each camera to prevent the "overshooting" which can occur in a less researched effort. Our prices tend to follow the long-term trends more accurately in the same way that a viscous-damped compass maintains a smooth heading.

The information and data in this edition is based on hundreds of thousands of verifiable sales, trades, offers, and auction bids. It is a reference work – a research report. The prices do not tell you what I think the camera is worth, but they tell you what a lot of former owners and present owners thought it was worth at the moment of truth. That is the essence of "McKeown's Law" which states: **"The price of an antique camera is entirely dependent upon the moods of the buyer and seller at the time of the transaction."**

Several corollaries have been added to this general philosophy of collecting.
1. "If you pass up the chance to buy a camera you really want, you will never have that chance again."
2. "If you buy a camera because you know you will never have the chance again, a better example of the same camera will be offered to you a week later for a much lower price."
3. "The intrinsic value of an antique or classic camera is directly proportional to the owner's certainty that someone else wants it." -*Dan Adams*

These observations should always be taken into account when applying McKeown's Law.

INSTRUCTIONS FOR USE OF THIS GUIDE

All cameras are listed by manufacturer, and manufacturers are listed in alphabetical order. A few cameras are listed by model name if we were not sure of the manufacturer. Generally, we have listed the cameras under each manufacturer in alphabetical order, but occasionally we have grouped them by type, size, or date of introduction or other sequence appropriate to the situation.

Photos usually appear immediately above the boldface heading which describes that camera. For layout reasons, this is not always possible. At times, when the text continues to another column, the photograph appears in the middle of the paragraph which describes it. When the photo does not fit with the text, it is captioned in italic typeface, and a note at the end of the text gives the location of the photo. When a photo of one camera is placed at the end of a column where it splits the text of another camera, we have tried to set it apart visually with a simple bold line. Following these standards allows the normal boldface heading to double as a caption for most photos, thus saving a great deal of space. Captioning all 2500 photos would require an additional 56 pages!

We have used different type faces to make the guide easier to follow. The pattern is as follows:

MANUFACTURER NAME (all caps)
Historical notes or comments on the manufacturer.
Camera Name - Description of camera and current value data. *Special notes regarding camera or price.*

CAMERA NAME - If the camera model name is in all caps, it is a separate listing, not related to the previous manufacturer. We use this style usually when the manufacturer is unknown.

At first glance, this style of layout may not be visually appealing from an "artistic" sense, but it has been carefully planned to conserve space, yet be easy to follow. Our computer could automatically add a box outline around each photo, but that would add 75 pages to this book. Similarly, if we drew little boxes around the columns of type, we could improve the appearance, but at a cost of an additional 130 pages. Our readers are serious collectors and dealers who want the maximum information in the smallest possible space. We hope you like our "little" 832 page book. If we took the easy and pretty approach to layout, this monster would be about 1100 pages. That's 35% thicker, heavier, and more expensive. So please, if you find fault with our "Plain Jane" style, consider that substance rates higher on our scale of values.

CONDITION OF CAMERAS
Two recent trends in describing condition should be noted. The first is a rather alarming number of people who consistently describe the condition while looking through rose-colored glasses. One dealer, speaking of his printed ads, recently said to me: "If I don't put it down as Excellent, I can't sell it." Personally, I disagree with that policy and attitude. In the short term, he may sell a few overrated cameras, but eventually will lose his entire business. I once bought by mail from another dealer a camera which was described as "excellent". It was not only less than excellent, but had parts missing. That was my first and last mail transaction with that dealer. I know of many other people who have had the same type of experience with the same dealer. In order to maintain any stability in the collecting field, we would recommend that buyers insist on a return privilege for any items purchased unseen by mail or phone. Any reputable dealer will allow this, but some individuals may not. If you find a dealer or collector who consistently exaggerates condition, we would recommend that you confront him with the problem or perhaps stop dealing with him. There are various sets of standards in use, but none that should allow a dented, scratched or non-functioning camera to be described as "excellent".

The second trend in describing condition is a reaction against the earlier system of misleading word descriptions in which a camera described as "good" really means

it is "poor" and a camera described as "very good" is really only "fair". The more recent approach is to separately describe the cosmetic and functional attributes of the camera. We feel strongly that the field should adopt a universally accepted standard which would allow for this flexibility. A camera in mint cosmetic condition, but not functioning may be perfectly acceptable to a collector who will put it on the shelf. On the other hand, a user may not care much about the appearance as long as it works. We strongly support such a system, and recommend that it be implemented on a world-wide scale with the cooperation of pricing guides, collector publications and societies, auction houses and dealers.

In an effort to establish an international standard for describing condition, we proposed the following scale. We have purposely used a combination of a number and a letter to avoid any confusion with other grading systems already in use. Condition of a camera should be given as a single digit followed by a letter. The number represents cosmetic condition and the letter gives functional condition. This system has been adopted by the Photographic Collectors Club of Great Britain.

GRADE---COSMETIC CONDITION
0 - New merchandise, never sold. In original box, with warranties.
1 - AS NEW. Never used. Same as new, but not warrantied with box or original packaging.
2 - No signs of wear. If it had a box, you wouldn't be able to tell it from new.
3 - Very minimal signs of wear.
4 - Signs of light use, but not misuse. No other cosmetic damage.
5 - Complete, but showing signs of normal use or age.
6 - Complete, but showing signs of heavy use. Well used.
7 - Restorable. Some refinshing neccessary. Minor parts may be broken or missing.
8 - Restorable. Refinishing required. May be missing some parts.
9 - For parts only, or major restoration if a rare camera.

GRADE---FUNCTIONAL CONDITION
A - AS NEW. Everything in perfect working order, with factory and/or warranty.
B - AS NEW. Everything in perfect working order, but not warrantied by factory. Seller fully guaranties functioning.
C - Everything working. Recently professionally cleaned, lubed, overhauled and fully guaranteed.
D - Everything working. Recently professionally cleaned, or overhauled, but no longer under warranty.
E - Everything working. Major functions have recently been professionally tested.
F - Not recently cleaned, lubed, or overhauled. Fully functioning, but accuracy of shutter or meter not guaranteed.
G - Fully fuctioning. Shutter speeds and/or meter probably not accurate. Needs adjusting or cleaning only.
H - Usable but not fully. Shutter may stick on slow speeds. Meter may not work.
J - NOT USABLE without repair or cleaning. Shutter, meter, film advance may be stuck, jammed, or broken.
K - Probably not repairable.

In this system, an average camera would be rated as 5F. A camera rated as 3G would mean cosmetically showing minimal signs of wear, but with questionable accuracy of meter or shutter. Thus a very specific description of condition fits in a small amount of space, and eliminates the problems which have been associated with word or letter descriptions which do not allow distinctions between cosmetic and functional condition. To be even more specific, users may wish to expand the cosmetic grade by using a second digit. Thus "56B" would mean cosmetic condition somewhere between grade 5 and 6, guaranteed to be functioning properly. Since we proposed this system, *Camera Shopper* magazine and some dealers have adopted similar systems, but with the numerical values reversed so that 10 is the top grade. If buying any camera without inspecting it, be sure you know what grading system is in use.

Generally speaking, condition will affect prices as follows. However, these are only approximations. Condition affects price differently on various types and ages of cameras. Suggested allowances below are given as percentages of the listed price.

Sometimes collectors are more lenient in applying these standards to older and more rare cameras, and more strict in applying them to newer or more common models. This is somewhat self-defeating. If you describe a camera as "very good condition considering its age", you are adding a personal judgement that old cameras should be judged by a different set of standards. Even though most cameras of that age may show some signs of age, the fact that it is old does nothing to improve its condition.

COMPARISON WITH OTHER GRADING SYSTEMS:

The following table compares the Cosmetic portion of the condition grading system with some of the common word or letter descriptions currently in use. These comparisons are approximate and are provided only to help users move to the new system more easily. The last column in the table shows in general terms how condition will affect prices. However, these are only approximations. Condition affects price differently on various types and ages of cameras. The suggested allowances below are given as percentages of the listed price.

McKeown	SA	Cornwall	Percent of listed price
0	N	-	150-200%
1	LN	-	130-150%
2	M	A	120-140%
3	M-	AB	115-130%
4	E+	B	110-120%
5	E	C	95-115%
6	VG	CD	80-110%
7	G	D	55-85%
8	F	E	30-60%
9	P	-	10-30%

Any missing or loose parts should be specifically noted. Use of a (-) after a condition number or letter means that it meets the standard except for minor condition AS DESCRIBED in adjoining comment. Use of a (+) means it exceeds this condition standard, but doesn't qualify for next higher rating.

INTERPRETATION OF PRICE FIGURES:

All price figures are in United States Dollars. Prices apply to cameras in condition range 5 to 6 according to the standards previously set forth. This is the most common condition in which cameras are found and collected, and makes the most useful standard. To determine the value of a particular camera, the user of this guide should consider any variation from this condition when assessing it and vary his value estimate accordingly.

The lower priced items in this guide and on the market tend to be slightly over-priced, simply because the cost and bother of advertising, selling, and shipping an $5.00 item is not much different from the same costs and efforts to sell an item valued for hundreds or thousands of dollars. The middle priced items show the most accurate prices. They are the most commonly traded; they are in large supply, and thus the market is very stable. The higher priced cameras of any particular style, brand, or age tend to be the most volatile, because there is both limited supply and limited demand.

DON'T EXPECT TO GET "BOOK PRICE" FROM A DEALER

If you have one or two cameras for sale and expect to get top book price for them from a dealer, you would do well to consider the situation from the dealer's viewpoint. In order to resell your camera, he has to repair it, guarantee it, pay table rent at shows, print and mail a list, and defend his price to buyers who want to pay no more than the low book price. After your camera goes unsold for a few months and shows a bit more wear from prospective buyers handling it, he wholesales it to another dealer for half price in trade for something else to sell. After your camera passes through the hands of 4 or 5 dealers, eventually it finds that one elusive buyer who pays the "top price". The less valuable and more common your camera is, the more you have to learn from this example. If you indeed have an extremely rare or valuable camera, do not worry. The dealers will literally fight over it. This is a very competitive field.

PRICES OF CAMERAS IN JAPAN AND EUROPE

In some cases we have made price distinctions for the same camera in different markets such as USA, Europe, England, Germany, Japan, etc. Obviously there will be differences on other cameras where we have not made such notations. First of all, it should be made clear that the base price of most cameras is that at which it can generally be purchased by a buyer in the USA. For this reason, some inexpensive box cameras from Germany or England carry a book price that is occasionally higher than the same camera would bring in its home country. This applies generally to simple cameras which were not exported to the USA but which were fairly common at home. However, since most cameras were imported into the USA, they can generally be found there for as low a price as anywhere in the world, so the price difference for inexpensive cameras is normally negligible and has not been noted in this guide except for particular models where a difference of more than shipping cost seems to be consistently encountered. Prices for many quality Japanese cameras are higher in Europe than in the USA. This is due to the fact that more of these cameras were originally imported into the USA. With a smaller supply in Europe, competition among collectors is greater.

PRICES ARE HIGHER IN JAPAN FOR MANY CAMERAS.

Japanese collectors have been scouring the world for high quality cameras in fine condition. The financial strength of Japan as a nation has only been equalled by the enthusiasm of its camera collectors. As the dollar gained strength against the Yen in late summer of 1989, some U.S. dealers noted a slowing of sales to SOME regular Japanese customers, but there were still plenty standing in line to take their places. No good merchandise stays long on a dealer's table. The volume of cameras moving to Japan and the prices paid for them are mind-boggling. It is impossible to put realistic "top" prices on any camera which has competitive buyers in Japan. However, since most of us do not live on the Ginza, we are not likely to get "Tokyo prices" in Sheffield, Stuttgart, or Schenectady. We have noted a few of the Tokyo prices for reference. They often run double or triple the prices prevalent in the rest of the world. However, this is a very speculative and inflated market. The easiest and safest way to reach it is through a professional buyer or dealer. We have several who advertise in the back of this guide.

HOW OUR PRICES ARE DETERMINED

We monitor and analyze prices from many varied sources worldwide, including traders publications, dealers lists, public auctions, and trade shows. Our database includes hundreds of thousands of transactions for each new edition, plus the accumulated base from previous editions. While our formulas are proprietary, a few words may indicate why our statistics do not always reflect your own observations. You read a trader publication regularly and Camera X generally seems to be advertised at $275 to $325. Your keen mind stores this for recall. Our computer does also. There is a good chance that the SAME ITEM has appeared for sale several times. Thus a price at which an item **does not sell** appears in print more often than a realistic price. In the case of the real Camera X, one dealer started offering it at $450. After over a year of advertising, the same camera was still being offered for $250 when we went to press. Many other confirmed sales worldwide tell us that Camera X regularly **sells** for $125-175. Eventually, the dealer whose ads you have been reading may sell his overpriced camera to a buyer who has become accustomed to seeing it advertised at $300 and thinks it a bargain when it appears for $250. Our computer has a long memory which tracks individual cameras offered by dealers until they sell. "Unsold" prices are not data except as evidence of a price ceiling.

Our prices represent the normal range for the largest share of the cameras sold. While a Leica Luxus may find one buyer in Japan for $25,000 nobody could argue that as an average or reasonable price. Our prices are based on extensive research, not guesswork. We are not dealers in cameras, because we view that to be a conflict of interest.

CUSTOMIZE YOUR GUIDE:

You will notice that the index section can be easily found by the black at the edge of the page. If there is a particular manufacturer which you reference often, we suggest marking that section as follows. Open the book on each side of the section

to be marked, then use a PERMANENT, WATERPROOF marking pen to rub along the EDGE of the pages to be marked. You may mark several manufacturers or sections by making your edge marks in different places or by the use of different colors.

EXCHANGE RATES

The prices in this guide represent prices in the U.S.A. market. There are definite variations from these figures in the foreign markets. Some cameras are more common in one country than another. Collectors' interests are different in various parts of the world, and "trends" or "fads" affect different markets at different times. However, none of the world's markets are closed to outside influence, and the fluctuations have a tendency to level off on a world wide scale. A higher price in one country will tend to draw more cameras to that area and the world price rises until that demand eventually becomes satisfied, usually between the earlier norm and the "fad" high. Keeping this general background in mind, the following chart will prove useful to people dealing across national boundaries. The following figures are for the U.S. Dollar values of the indicated currencies as of September 24, 1989. Multiplying these factors* times the U.S. Dollar price gives the value in the foreign currencies.

CURRENCY	EXCHANGE RATE	MULTIPLCATION FACTOR *
Australian $.7745	1.2911
Canadian $.8460	1.1821
British £	1.5832	.6316
French Franc	.1523	6.5645
German DM	.5161	1.9375
Japanese Yen	.006908	144.75
Netherlands Fl	.4559	2.1935

FOR FURTHER INFORMATION:

We receive many inquiries and requests for further information, far more than we can possibly answer. We do not give opinions or appraisals on items not included in this book. We realize that many cameras are not included in this book, and caution you that omission does not indicate rarity. We have excluded at least 30,000 cameras for various reasons to keep this book to a reasonable size and price. Some of the excluded cameras include: most cameras produced since the 1960's, which are generally more usable than collectible; most 126 and 110 cameras which were produced in such large numbers that they are common and inexpensive; and many early cameras which rarely are seen for sale. We have selected about 7,000 cameras which are representative of the field of camera collecting, and for which we can determine typical selling prices.

Requests for further information will be considered only if a self-addressed, stamped envelope is enclosed with the inquiry. There is often a delay of several months in answering such inquiries due to our backlog of mail.

SAVE 20% ON EVERY NEW BOOK WE PUBLISH

We can't control the cost of paper and printing, but we can hold down your cost for the next edition of this book. Each time we go to press, we need cash to buy over 10 tons of paper, not to mention all the associated supplies and services. By ordering your book a month in advance, you help us tremendously. Not only does it help us with our printing costs, but it gives us time to get your mailing label and package ready so we can ship your book within hours of the time it leaves the bindery. In return for your early order, we give you a 20% discount. Where else can you get a 20% per **month** return on your investment? But we can't offer you this special price if we don't know who you are. We promise to offer you a discount plus **first day shipping** if you will just send your name and address on a postcard or letter to:

Centennial Photo
Pre-Pub Club
Rt. 3 Box 1125
Grantsburg, WI 54840 U.S.A.

ACCURAFLEX - c1950's. TLR, 2¼x2¼" on 120 rollfilm. Accur Anastigmat f3.5/80mm lens. Accurapid 1-300,B,ST sync shutter. Semi-automatic film transport. Original price was $60 in 1957. Current value: $40-60.

ACMA (Australasian Camera Manufacturers - Australia)

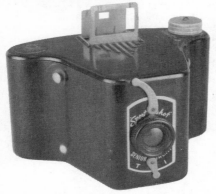

Sportshot Senior Twenty - Bakelite box camera, trapezoidal shape, for either 620 or 120 film. Made in green, brown, maroon, grey, and black. Folding frame finder on top. Green: $40+. Other colors: $15-25.

ACRO - c1940. Brown bakelite minicam for 16 exposures on 127 rollfilm. Identical to Photo Master. $10-15.

ACRO SCIENTIFIC PRODUCTS CO. (Chicago)

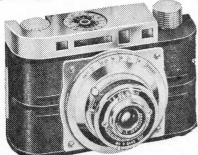

Acro Model R - Black plastic and metal camera for 16 exp. on 127 rollfilm. Built-in rangefinder & extinction meter. Styled similar to the Detrola. Wollensak f3.5 lens in Alphax shutter. $25-40.

Acro Model V - Heavy black bakelite body for 16 exp. on 127 film. Metal back & telescoping front. Simple model without RF. Rigid optical finder. Similar to Detrola

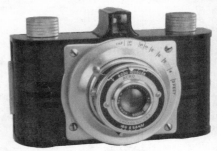

Acro Model V

cameras. Helical focus; knob advance. Acro Anastigmat f4.5/2" in Acro 25-200, B,T shutter. $15-25.

ADAMS & CO. (London) *Adams made many important cameras not listed in this guide. In most cases, they were the most expensive of their kind, only sold direct, and all relatively uncommon. In compiling this guide, we view our job as reporting prices, not setting them, so the only examples listed are items for which we have recent sales data.*

Aidex - c1928. Folding single-lens reflex camera, made in sizes for 2½x3½" or 3¼x4¼" plates. Self-capping FP shutter T,B, 3-1000. Ross Xpres f3.5 lens. $300-350.

Challenge - c1892. Mahogany tailboard-style camera in all the common sizes. With Dallmeyer landscape lens. $400-500.

Club - c1890's-1930's. Folding mahogany field camera for 6½x8½". Ross Symmetrical with wheel stops or Rapid Rectilinear with iris diaphragm are typical lenses. $200-300.

De Luxe - c1898. A deluxe variation of the earlier Adams Hand Camera for 3¼x4¼" plates. Spanish mahogany with sealskin covering. Double extension bellows with rack and pinion focusing. $350-500.

Hand Camera - c1891-96. Leather covered hand camera with detachable 12-plate magazine. 3¼x4¼" or 4x5" size. Rising, shifting front, double swing back. Ross Rapid Symmetrical f8 lens, Iris T,I

shutter. Rare. $350-500.

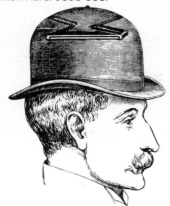

Hat Detective Camera - c1892-96. The camera fits into a bowler-style hat. ¼-plate is secured in a strut folding mechanism inside the hat. Bayonet mount f11 Rapid Rectilinear lens and T,I between-the-lens shutter are in the crown of the hat. Advertised as a "secret Camera that defies detection". Made from Jekeli & Horner's patent of the Chapeau Photographique; Adams had sole rights in Great Britain. Hat had to be removed from the head to be used. Extremely rare. No known sales. Would command a very high price, easily over $10,000.

Ideal - c1892-95. Magazine box camera for 12 plates, 3¼x4¼". Falling-plate mechanism. Rapid Rectilinear f8/5½". Shutter 1-100. $75-100.

Idento - c1905. Folding camera with side panels supporting the lensboard, similar to the Shew Xit. Ross Homocentric or Zeiss Protar f6.3/5" lens. Between-the-lens ½-100, T shutter. Leather covered. Made in 5 sizes 2½x3½" to ½-plate. $200-300.

Minex - c1910-1950's. Deluxe single lens reflex cameras similar to the Graflex, made in various sizes. $150-200.

Minex Tropical - c1930's. 2½x3½, 3¼x4¼, 4x5, 4¾x6½" sizes. Beautifully constructed and finished teakwood SLR with brass binding. One unusually fine and complete matching outfit, with 9 dark slides, FPA, RFH, tropical Adams lenshood, etc. in exceptional condition brought $10,000 at auction in January 1988. More typical price for camera and plateholders would be $3000-4000.

Minex Tropical Stereoscopic Reflex - A stereo version of the Tropical Minex, with brown leather bellows & focusing hood. With Ross Xpres f4.5 lenses, one of these in near mint condition sold at auction in mid-1982 for $8600.

Royal - c1890's. Compact folding field camera made in half-plate and full-plate sizes. Very similar to the Club, but a less expensive and somewhat heavier model. $75-125.

Verto - c1930. Double extension folding camera for 3¼x4¼" plates. Ross Combinable lens, shutter 1-200,TB. Focusing scale is engraved for single or combined lenses. $275-325.

Vesta - Folding bed and strut cameras. Ross Xpres f4.5 lens. Several versions:
Focal Plane Vesta - c1912. For 9x12cm plates. $200-300.
Vesta Model A - For 9x12cm plates. Basic model without FP shutter. $70-100.
Rollfilm Vesta - c1930's. Takes 6.5x9cm plates and 6x9cm on 120 rollfilm. Compound 1-200,T,B shutter. $200-275.

Videx - 1903-1910. SLR. For the less common 4¼x6½" size: $150-250. Usually found in the 3¼x4¼" size. $125-175.

Yale No. 1, No. 2 - c1895. Detective magazine camera for 12 plates 3¼x4¼". Adams Patent Shutter ½-100. Focus by

internal bellows. No. 1 has Rapid Rectilinear f8 lens, No. 2 has Cooke f6.5/5" lens. $150-200.

Yale Stereo Detective No. 5 - c1902 Leather covered body. Zeiss 7½" lenses. Internal bellows with rack focusing. Leather plate changing bag. $450-550.

ADAMS & WESTLAKE CO. (Chicago)

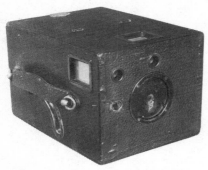

Adlake Regular - c1897. Manual plate changing box camera. Looks like a magazine camera but is not. Holds 12 steel plateholders inside the top door compartment behind the plane of focus. Holders are manually inserted into a slot at the focal plane and the top door closed. A lever on the side (under handle) opens the front of the plateholder to prepare it for exposure. Made in 3¼x4¼" & 4x5" sizes. $40-60.

Adlake Special - c1897. Same as Adlake Regular, but with aluminum plateholders rather than steel. Made only in 4x5" size. $45-65.

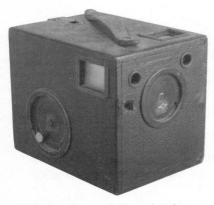

Adlake Repeater - Falling-plate box camera, made in 3¼x4¼" and 4x5" sizes. Side crank advances 12 plates in succession. Fixed focus lens. $40-50.

ADINA - Folding 6x9cm rollfilm camera. f6.3/105mm Rodenstock Trinar lens in Adina or Compur shutter. $15-20.

ADOX KAMERAWERK (Wiesbaden)
Adox, Adox II, Adox III - c1936-1950. 35mm cameras with extensible front. Made by Wirgin, styled like the Wirgin Edinex. $25-35.

Adox 35 - c1955. 35mm viewfinder camera. Body style is similar to the DeJur D-1, but top housing is dissimilar. Film advance knob, not lever. Kataplast f2.8/45mm in Prontor-S. $75-100.

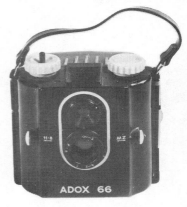

Adox 66 - c1950. Bakelite box camera for 6x6cm on 120. $18-23.

Adox 300 - c1958. The first German 35mm camera with interchangeable magazine backs. Large film advance & shutter cocking lever concentric with lens. BIM. Synchro-Compur to 500. Steinheil Cassar or Schneider Xenar f2.8/45mm lens. Originally supplied with 3 magazines in 1957. $150-165.

Adrette - c1939. 35mm camera with extensible front. Identical to the Wirgin Edinex. Front focus Steinheil Cassar f3.5/50mm, Schneider Radionar f2.9/50mm, or Xenon f2/50mm lens in Prontor, Prontor II, or Compur shutter. $75-95.

Adrette II - c1939. Same as the Adrette, but with helical focus. Prontor II, Compur, or Compur Rapid shutter. $50-75.

Blitz - c1950. Bakelite box camera for 6x6cm on 120 film. f6.3/75mm lens. Styled like the Adox 66. $15-25.

Golf - c1950's. 6x6cm folding camera. Adoxar or Cassar f6.3 lens. Vario or Pronto shutter. Rangefinder model: $30-40. Simple model without rangefinder: $20-30.

Golf IA Rapid - c1963-65. Simple, boxy 35mm camera for rapid cassettes. Adoxon f2.8/45mm in Prontor to 125. $5-8.

Golf IIA - c1964. Similar, but with built-in selenium meter above lens. Prontor-Matic shutter to 125. $8-12.

Golf IIIA - c1960's. Radionar L f2.8/45mm in Prontor 500LK. Coupled light meter. $5-10.

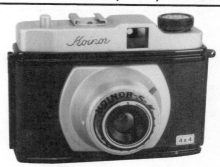

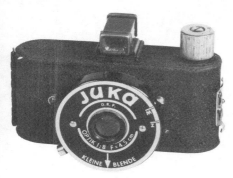

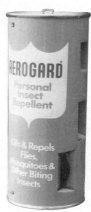

A.D.Y.C. Koinor 4x4

Juka - c1950. A postwar version of the Junka-Werke "Junka" camera for 3x4cm on special rollfilm. Achromat f8/45mm lens. Single speed shutter. $50-75.

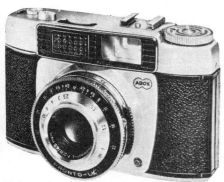

AEROGARD CAN CAMERA - c1987. Camera is the standard 250ml can shape originated by the Coke can camera for 110 cartridge film. This one advertises Aerogard Personal Insect Repellent, which we assume must come in a spray can. The only example of this camera that we have seen came from Australia. $25-35.

AFIOM (Italy)
Kristall - c1955. Leica copy. Elionar f3.5/5cm lens. $225-275.

Polomat - c1962. Rigid body 35mm camera with BIM. f2.8 lens. Pronto LK shutter 15-250. $10-15.

Sport - c1950. Folding dual-format rollfilm cameras for 6x9 or 4.5x6cm on 120 film. Steinheil Cassar f6.3 or Radionar f4.5. Vario shutter. Optical or folding viewfinder models. Common. $20-35.

A.D.Y.C. (Argentina)
Koinor 4x4 - Simple fixed-focus stamped metal camera for 120 film. Body release. Sync. $20-25. *Illustrated top of next column.*

Wega II, IIa - c1950. Leica copies which accept Leica screw-mount lenses. CRF. Synchronized FP shutter to 1000. Trixar f3.5/50mm. $225-275.

AGFA

AGFA KAMERAWERKE (Munich)

*Established in 1867. "Aktien Gesellschaft für
Analin-Fabrikation" was formed in 1873.
AGFA is an abbreviation from the original
name. Agfa purchased Rietzschel's factory
(Munich) in 1925, from which time the
Rietzschel name was no longer used on cameras
and the first "Agfa" cameras were produced.
Agfa's USA operations joined forces with Ansco
in 1928 to form Agfa-Ansco, which eventually
became GAF. Agfa also continued in the
production of cameras and films in the Munich,
Leverkusen, and Wolfen factories, in operation
before WWII and resuming production in the
summer of 1945. (The Wolfen factory now
operates under the name ORWO for ORiginal
WOlfen.) In 1952, Agfa founded "Agfa AG für
Photofabrikation" in Leverkusen and "Agfa
Kamerawerk AG" in Munich. These merged in
1957 to become Agfa AG, which soon acquired
Perutz Photowerke, Leonar-Werke, Mimosa,
and others before merging with Gevaert of
Belgium in 1964.*

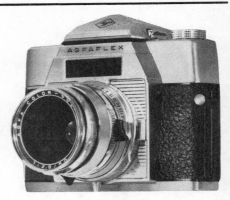

Agfaflex IV

Available interchangeable lenses: Ambion
f3.4/35mm, or Telinear f3.4/90mm, f4/
135mm, and f4.5/180mm: $30-50.

Ambi-Silette - c1957-1961. 35mm RF.
Solinar f2.8/50mm, Synchro-Compur to 500.
Interchangeable lenses available include
Ambion f4/35mm, Telinear f4/90mm and
f4/130mm. With normal lens: $40-70.
Extra lenses: $30-50.

Ambiflex - c1959. Models I-III. SLR
cameras with coupled meters. Prontor
Reflex 1-300 shutter. Identical to the
following Agfaflex models: Ambiflex I =
Agfaflex III; Ambiflex II = Agfaflex IV;
Ambiflex III = Agfaflex V. $60-85.

Automatic 66 - c1956. Horizontally styled
folding camera for 6x6cm on 120. CRF.
Fully automatic metering with manual over-
ride. Color Solinar f3.5/75mm in Prontor
SL shutter. Helical focusing. $375-600.

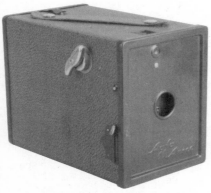

No. 2 Agfa-Ansco Box Model E in green

Agfa-Ansco Box - Simple cardboard box
cameras with colored exterior covering and
metal front and back. Made in No. 2 and
2A sizes in various colors. $20-30.

Agfaflex - c1959. 35mm SLR cameras with
built-in meter. Prontor Reflex 1-300 shutter.
Model I - Non-interchangeable Color
Apotar f2.8/50mm lens. Interchangeable
waist-level finder. $50-65.
Model II - Similar, but with interchangeable
pentaprism. $50-65.
Model III - Interchangeable Color Solinar
f2.8/50mm lens. Interchangeable waist-
level finder. Coupled meter. $50-75.
Model IV - Similar to the Model III, but
with interchangeable pentaprism. $60-100.
(Illustrated top of next column.)
Model V - Interchangeable Color Solagon
f2/55mm lens. Interchangeable pentaprism.
$60-85.

Billette - c1930-33. Folding rollfilm camera,
like the Billy II, but with better lens and
Compur shutter. $25-40.

Billy - *A series of folding rollfilm cameras produced from 1928-1960.*
Billy - c1928-31. Folding rollfilm camera with square ends. Igetar f8.8 lens in Automat shutter 1/25-100. Exported to the USA and England under the name Speedex. $25-35.

Billy O - c1932-38. Vertical folding rollfilm camera for 4x6.5cm on A-8 (127) film. Igestar f5.6/75mm in Pronto or Solinar f3.9/75mm in Compur. $225-250.

Billy I, prewar - c1931-33. Same basic camera as the original Billy, but the lens in now called Igestar. Exported to the USA and England as the No. 1 Speedex. Brown leather. $30-50.

Billy I, postwar - c1950-57. Re-styled folding rollfilm camera. Agnar f6.3 lens in synched shutter. Two versions: c1950 has eye-level frame finder on right side of body (probably using pre-war bodies). Vario 1/25-200,B. c1952 has optical eye-level finder on right side of body. Pronto 1/25-200,B. $15-25.

Billy I Luxus - c1931. Igestar f8.8/100 in Billy Automat 25-100 shutter. $75-125.

Billy II - c1931-33. Folding rollfilm camera with rounded body ends and other minor differences from the Billy I. Igestar f7.7 lens. Sold in the USA and England as the No. 2 Speedex. $15-25.

Billy III - c1932-34. Similar to Billy II, but improved strut design. Igestar f5.6 in Pronto, or Oppar or Solinar f4.5 in Compur. $20-30.

Billy-Clack - c1934-42. Strut-type folding 120 rollfilm, similar in appearance to the Jiffy Kodak cameras. Two sizes: one for 16 exp. 4.5x6cm; the other for 6x9cm. Exported to USA and England as Speedex Clack. USA: $20-25. Europe: $10-20.

Billy Compur - c1934-42. Like the Billy, but with Compur shutter and f4.5 or f3.9 Solinar or f4.5 Apotar. Sold in England and USA under the names Speedex 2¼x3¼" or Speedex Compur. $25-40.

Billy Optima - c1932-40. 7.5x10.5cm. Solinar f4.5/120mm, Compur 1-250. $50-75.

AGFA (cont.)

Billy Record, prewar - c1933-42. Folding rollfilm camera with ribbed leatherette covering. Available with Igestar f8.8, f7.7, f6.3 lens in Automat shutter 1/25-100, or with Apotar f4.5 in Prontor II 1-150 shutter. Sold in England and the USA as the Speedex Record. $15-20.

Billy Record, postwar - c1950. Folding rollfilm camera with Apotar f4.5 in Prontor-S 1-300 shutter. Eye-level frame finder on right side of body; probably made from pre-war bodies. $15-20.

Billy Record I - c1950-52. Self-erecting folding rollfilm camera. Optical eye-level finder and accessory shoe on right side of body. No waist-level finder. Radionar or Agnar f4.5/105mm lens in Pronto 1/25-200,B shutter. Exported to the USA and England as the Ventura 69. $15-20.

Billy Record II - c1950-52. Similar to the Billy Record I, but better lens and shutter. Apotar f4.5 in Prontor-S 1-250,B or Solinar f4.5 in Compur-Rapid 1-400,B. Exported as the Ventura 69 Deluxe. $15-20.

Agfa Box I (54)

Box camera - c1930's-1950's. Misc. sizes, styles including B-2, D, 45, 50, and 54. Basically, these are leatherette covered metal or cardboard box cameras with simple lens and shutter. *See also Agfa-Ansco Box, Box 24, Box 44, and Box-Spezial all under the Agfa heading.* $10-15. *Earlier models in prime condition bring a bit more.*

Box 24 - c1932. Box camera similar to the Schul-Prämie but in black. $20-30.

Box 44 - c1932-40. Leatherette covering on cardboard body and metal front plate. 6x9cm on 120 film. For some reason, these are selling in the $15-25 range.

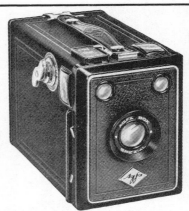

Box-Spezial - c1930-33. Box camera for 6x9cm on B-2 (120) rollfilm. Simple lens and shutter with a 3-point distance scale for "portrait", "group" or "distance" settings. Agfa diamond trademark on the front. $5-10.

Cadet A-8 - c1937. Made by Agfa-Ansco in the USA. Simple box camera for 4x6.5cm on A-8 (127) rollfilm. $5-10.

Cadet B-2 - c1939. Made by Agfa-Ansco in Binghamton, New York. After 1943, sold under the Ansco Cadet name. Metal and cardboard box camera. $1-5.

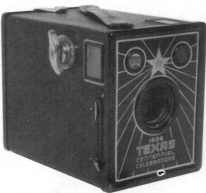

Cadet B-2 Texas Centennial - c1936. Special comemmorative version of the B-2 Cadet box camera made for the hundredth anniversary of the state of Texas. Single star above the lens for the "Lone Star" state. Very uncommon. $125-175.

Cadet D-6 - c1935-41. Like the Cadet B-2, but 2½x4¼" on D-6 (116) rollfilm. $1-5.

Captain - 6x9cm folding camera made by Agfa-Ansco in USA. Captain lens in Agfa T,I shutter. $10-20. *(Illust. top of next page.)*

24

Chief - c1940. Metal eye-level box camera. Similar to the Pioneer, but with zone focus and built-in finder. $4-8.

Clack - c1954-59. Metal eye-level box camera with reptile-grained covering. Takes 6x9cm on 120 film. Common. $1-5.

Click I - c1958-65. Simple plastic eye-level box camera, 6x6cm on 120 film. Meniscus lens. Single speed shutter. Common. $1-5.

Click II - c1959-65. Similar to Click I, but zone-focusing f8.8 Achromat. Common. $3-6.

Agfa-Ansco Captain

in a round front panel. Color Apotar f2.8/45mm in Prontor 1-500. $75-100.

Folding Rollfilm cameras - Common models for 116 and 120 films. $8-12.

Iso Rapid I, IF, IC - c1965-70's. Compact cameras resembling the 126 cartridge type, but for Rapid 35mm cassettes. I has hot shoe. IF has AG-1 flash. IC has flashcube socket. $1-5.

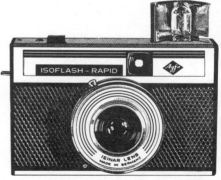

Clipper PD-16 - c1938. Metal bodied camera with extensible rectangular front section. Takes 16 exp. on 616 film. Single speed shutter & meniscus lens. Made by Agfa-Ansco in U.S.A. $1-5.

Clipper Special - c1939. Like the Clipper, but with f6.3 Anastigmat and 25-100 shutter. Optical finder. $4-7.

Colorflex I, II - c1959. 35mm SLR cameras. (Sold as Agfaflex I and II in the U.S.A.) $60-90.

Flexilette - c1960. 35mm TLR. Unusual design has viewing lens above taking lens

Isoflash Rapid - c1965. Similar to Iso Rapid IF. Isoflash Rapid C uses flashcubes. $1-5.

Isola - c1955. Simple eye-level camera for 6x6cm on 120 film. Telescoping front. Agnar f6.3 lens in Singlo shutter. $5-10.

Isola I - c1957-59. Similar, but with Meniscus lens in single speed shutter. "Agfa Isola I" on shutter face. $5-10.

Isola II - c1956-59. 2¼x2¼". Agnar f6.3/75mm, Singlo 2 shutter B,30,100. $5-10.

Isolar - c1926-35. 9x12cm folding plate camera. Solinear f4.5/135mm. Dial Compur to 200. DEB. GGB. Metal body. $40-50.

Isolar Luxus - Deluxe version of above with brown bellows and brown leather covering. Unusual. $150-200.

Isolette - *A series of horizontal folding rollfilm cameras for 6x6cm & 4.5x6cm on 120 film.*

Isolette, original - 1938-49. Originally introduced as the Isorette, the name was changed during 1938. Top housing is black plastic, instead of chrome like on all the later models. Igestar f6.3 in Vario or Pronto, Apotar f4.5 in Prontor II or Compur, or Solinar f4.5 in Compur Rapid. $15-25.

Isolette I - c1952-1957. f4.5 Agnar in Vario or Pronto. $12-18.

Isolette II - c1948-1954. f4.5 Agnar, Apotar or Solinar in Vario, Pronto, Prontor-S, Prontor-SV, Compur Rapid, Synchro-Compur. $10-18.

Isolette III - c1952. Non-coupled RF. f4.5

Apotar in Prontor SV, f4.5 Solinar Synchro-Compur, or f3.5 or f4.5 Solinar in Prontor SV or Synchro-Compur. $30-45.

Isolette V - c1950-53. Similar to Isolette I. Agnar f4.5/85mm in Vario or Pronto. $10-20.

Isolette L - 1957-1960. Last model in the Isolette series. Uncoupled BIM. Color Apotar f4.5/85mm in Pronto. $55-70.

- Super Isolette - c1954-57. Folding camera for 6x6cm on 120 film. Coupled rangefinder. Solinar f3.5/75mm. Synchro-Compur MXV shutter to 500. Not often seen. $150-200.

Isoly - c1960-67. Inexpensive eye-level cameras for 16 exposures 4x4cm on 120 film. Models include:
Isoly (I) - Achromat f8 in B,30-100 shutter. $5-10.
Isoly IIa - Color-Agnar f5.6. $6-10.
Isoly III - Apotar f3.9. $8-12.
Isoly IIIa - Apotar f3.5. $10-15.

Isoly-Mat - c1961. Like Isoly, but with built-in automatic meter with selenium cell below lens. Color Agnar f5.6/55mm. $5-15.

Isorette - c1938. Horizontally styled folding-bed camera for 6x6cm on 120 film. Models include: Igestar f6.3/85mm in Vario or Pronto; Apotar f4.5 in Prontor II or Compur; Solinar f4.5 in Compur Rapid. This camera continued as the Isolette. $20-30.

Karat - *A long-lived series of cameras for 24x36mm exp. on 35mm film in Karat-cassettes, the original design which eventually led to the international standard "Rapid Cassette" system. The pre-WWII models, officially named by their lens aperture, all have the same body style with tapered ends and with the viewfinder protruding from the slightly rounded top.*
Karat 6.3 - 1938-1940. Igestar f6.3 in Automat shutter. $25-40.

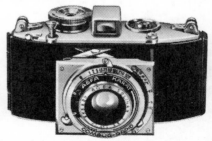

Karat 3.5 - 1938-1940. Solinar f3.5 in Compur or Compur Rapid shutter. $30-40.
Karat 4.5 - 1939-50. Oppar f4.5 in Pronto shutter. $15-25.
Karat 2.8 - 1941. This model has the body style of the postwar models, being almost

identical to the Karat 12 except for the lack of an accessory shoe. Xenar f2.8 in Compur shutter. Probably not many were made because of the war. $50-75.

Karat - *Postwar models have a new body style with beveled ends and viewfinder incorporated with rangefinder in the top housing.*
Karat 12 - 1948-50. Solinar f3.5 or Xenar f2.8 in Compur-Rapid shutter (1948). Apotar f3.5 in Prontor-S (1948-1950). $45-55.
Karat 36 - (also called Karomat 36) 1949-1952. Xenar f2.8 in Compur Rapid or Xenon f2 in Synchro-Compur (1949). Xenon or Heligon f2 in Synchro-Compur (1950). Solinar or Soligon f2.8 in Synchro-Compur (1952). With f2: $50-70. With f2.8: $45-55.
Karat IV - 1950-1956. Identifiable by the equally sized and spaced finder windows on the front. Solinar f2.8 (1950). Solagon f2 or Apotar f3.5 (1955-1956). Prontor SV or SVS. With f2 lens: $80-130. Others: $50-70.

Karomat - c1951. Also called Karat 36. f2.8 Xenar or f2 Xenon in Compur Rapid. $50-65.

Major - Folding bed camera for 6x9cm exposures on 120 film. Made in the U.S.A. by Agfa-Ansco. $10-15.

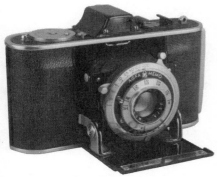

Memo (full frame) - c1939. Horizontally styled folding bed camera for 24x36mm exposures on 35mm Agfa Rapid cassettes. Rapid advance lever on back. Made by Agfa-Ansco in the U.S.A. Agfa Memar f3.5, 4.5, or 5.6 lens. $25-40.

Memo (half-frame) - Similar to the above, this single-frame (18x24mm) model was added in 1940. $35-50.

Moto-Rapid C - 1965. Spring-motor driven camera for 24x24mm on Agfa-Rapid 35mm cassette film. Color Isomar f8 in Parator shutter. $15-25.

Motor-Kamera - c1951. Unusual 35mm camera for remote control use. Agfa Color

Telinear f3.4/90mm. Large electric motor built on to front of camera and externally coupled to the advance knob. (A rather clumsy arrangement when compared with modern mass-marketed autowinders.) $300-400.

Nitor - 1927-30. 6x9cm on plates, pack, or rollfilm. Helostar f6.3/Pronto or Linear f4.5/Compur to 250. $25-40.

Opal Luxus - c1925-26. Folding bed camera for 6.5x9cm plates. Double extension brown bellows. Brown leather covering. Rietzschel Solinear f4.5/105mm in Compur. $225-250.

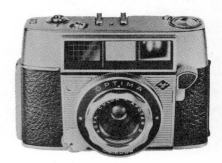

Optima - A series of 35mm cameras. Original model 1959-1963 has left-hand shutter release, Color Apotar f3.9 in Compur. Claimed to be the first fully automatic camera in the world. Model I 1960-1964 has Color Agnar f2.8/45mm in Prontorlux. Right-hand release. Mod. IA c1962 has an advance lever on top and removable back. Model II 1960-1964. IIS 1961-1966 is like the II but with CRF. Model III (1960) has meter and IIIS (1960) includes meter & CRF. Prices range from $15-25 for the simpler models to $35-45 for a nice IIIS.

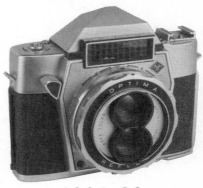

Agfa Optima Reflex

27

Optima Parat - c1960. Metered half-frame 35mm camera. Color Solinar f2.8/30mm in Compur to 500. $30-60.

Optima Rapid 125C - c1967. Simple camera for 16 exposures 24x24mm with Agfa-Rapid cassettes. Fully automatic exposures controlled by selenium meter. Apotar f2.8/35mm in Paratic shutter. $3-7.

Optima Reflex - c1963-66. 35mm TLR, eye-level pentaprism, meter, matched Color Apotar f2.8/45mm lenses. An unusual design, and not commonly found. $125-175. *(Illustrated bottom of previous page.)*

Paramat - c1963. Like the Parat but with meter. $20-30.

Parat, Parat I - c1963. Half-frame, 18x24mm. Color Apotar f2.8/30mm. $15-25.

PD-16 - *This was Agfa's number for the same size rollfilm as Kodak 116. Several of the Agfa cameras use this number in their names, but they are listed by their key word (Clipper, Plenax, etc.)*

Pioneer - c1940. Metal & plastic eye-level box camera with tapered ends made in both PD-16 and PB-20 sizes. Made in the USA by Agfa-Ansco. After 1943, sold as "Ansco" Pioneer. Very common. $2-5.

Plate cameras - 6x9cm with f4.5/105 and 9x12cm with f4.5/135mm Solinar or Double Anastigmat lenses. Compur shutter. $20-40.

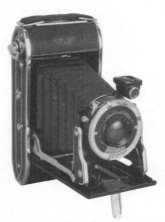

Plenax - c1935. Folding rollfilm cameras made by Agfa-Ansco in the U.S.A. Models PD-16 & PB-20. Antar, Tripar, or Hypar lens. $8-12.

Preis-Box - c1932. Box camera which originally sold for 4 marks. Meniscus lens, simple shutter. $7-12. *(Illustrated top of next column.)*

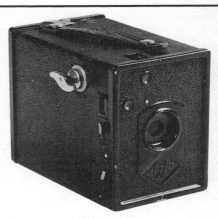

Agfa Preis-Box

Record I - c1952-54. Folding-bed rollfilm camera with self-erecting front. This is a continuation of the Billy Record I camera. Accesory shoe mounted on top of the chrome housing that integrates the viewfinder and knobs. Agnar f6.3 or f4.5 in Pronto. $15-25.

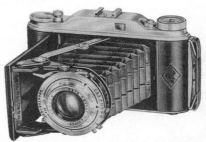

Record II - c1952-57. Similar to the Record I. Agnar or Apotar f4.5 in Pronto; Apotar f4.5 in Prontor S or SV. $15-25.

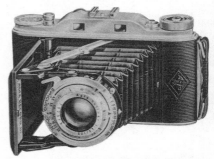

Record III - c1952-55. Similar to the Record II, but with CRF. Apotar f4.5 in Prontor SV or Solinar f4.5 in Synchro-Compur. $35-65.

Schul-Prämie Box - c1932. Originally given out in Germany as a school premium to the best in the class, which accounts for the inscribed title. A blue metal and plastic box for 6x9cm rollfilm. $40-60.

Selecta - c1960. 35mm rangefinder camera, automatic metering. Color Apotar f2.8/45mm. Prontor-Matic P shutter. $15-20.

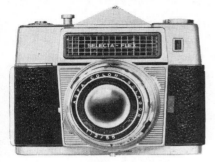

Selecta-Flex - c1963. Pentaprism 35mm SLR. Interchangeable f2.8 Solinar or f2 Solagon. $50-75.

Selecta-M - c1962-65. Fully automatic motor camera for 24x36mm. Shutter regulated by BIM. Solinar f2.8/45mm in Compur 30-500. $100-160.

Shurflash, Shurshot - Made in USA by Agfa-Ansco. Common box cameras. $4-8.

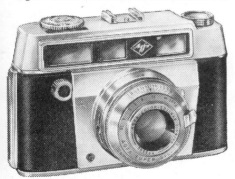

Silette - A series of 35mm cameras introduced in 1954 and ranging from the simple viewfinder model to the metered rangefinder models. Common.
Silette (I) - $10-15.
Silette II - $10-15.
Silette L - $15-25.
Silette LK - $20-30.
Silette SL - $20-30.
Silette SLE - $20-25.
Super Silette - $25-35.
Super Silette L - $30-40.
Super Silette LK - $30-45.

Silette Rapid - c1965. Similar to the normal Silette but for rapid cassettes. All have Color Agnar f2.8/45mm lens.
Silette Rapid I - Prontor 30-125. $5-9.
Silette Rapid F - Parator 30-250. $5-9.
Silette Rapid L - Prontor 30-250 shutter. Uncoupled exposure meter. $10-20.

Solina - c1960-62. Simple 35mm camera with large viewfinder window centered above the lens. Color-Apotar f3.5/45mm, Pronto 1/25-200,B. Lever advance. $20-30.

--Super Solina - c1960-62. 35mm CRF. Color-Apotar f2.8/45mm in Prontor SVS 1-500,B. $10-25.

Solinette, Solinette II - c1952. Folding 35mm cameras. Solinar or Apotar f3.5/50 lens in Prontor-SVS or Synchro-Compur. $30-40.

--Super Solinette - c1953-1957. Similar but with CRF. $35-55.

Speedex 0 - c1935-38. Vertical style vest pocket folding bed camera taking 4x6.5cm on 127 film. Solinar f3.9 lens in Compur. Leather covered with chrome and enamel side panels. This is the export version of the Billy 0. $45-65.

Speedex No. 1 - c1928-33. Export version of the Billy I. Square cornered body. $25-35.

Speedex No. 2 - c1928-33. Export version of the Billy II. Rounded body ends. $15-25.

Speedex B2 6x6cm - c1940. Horizontally styled rollfilm camera made in USA. f4.5 Anastigmat in ½-250 shutter. $12-18.

Speedex Compur - c1933-36. Self-erecting folding rollfilm camera, sometimes referred to as the Speedex 2¼x3¼". f4.5 Anastigmat in Compur. This was the export version of the Billy Compur. $25-30.
(Illustrated top of next page.)

Agfa Speedex Compur

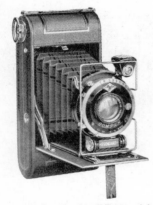

Agfa Standard, rollfilm model

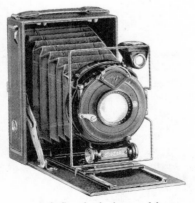

Agfa Standard, plate model

Speedex Jr. - c1940. Similar to the Speedex B2, but with fixed-focus lens in T&I shutter. $5-10.

Standard - c1927-31. *A series of folding cameras in various models for rollfilm or plates.*
--plate models - For 6.5x9cm or 9x12cm plates. Various f4.5 or f6.3 lenses in Automat or Compur shutter. $20-40. *(Illustrated in previous column.)*

--deluxe plate models - Brown leather covering, brown bellows. Original price was only about 10% higher than standard plate model. Current collectors pay $125-175.

--rollfilm models - Made in 6x9cm and 6.5x11cm sizes. Various lenses/shutters. $15-35. *(Illustrated in previous column.)*

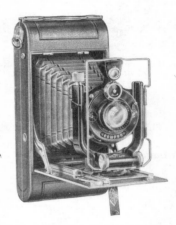

Superior - 1930-32. A deluxe folding camera for 8x14cm "postcard size" photos. Reddish-brown leather, brown bellows. Trilinear f6.3 or Solinear f4.5 in Compur. $150-200.

Synchro-Box - c1951. Metal box camera for 6x9cm on 120 film. Plastic covering and art-deco front. $5-10.

Synchro-Box (Made in India) - c1950. Unusual variant of Synchro Box; made by New India Industries Ltd, Baroda, India. Very rare. Only one recorded sale in 1985 for about $150.

Trolita - c1938-40. Folding bed, self-erecting rollfilm camera for 6x9cm or 6x6cm on 120 film. Made of "Trolit" plastic (similar to bakelite). Leather bellows. Apotar f4.5/105mm. Prontor II shutter. $125-150.

Trolix - c1937. Nicely styled 2¼x3¼" box camera made of "Trolit" plastic, similar to

amateur market to concentrate on military & industrial aerial cameras.

Agiflash - c1954-1958. Streamlined, leatherette covered black bakelite camera for 8 exp, 4x6.5cm on 127 film. Socket on top next to VF for #5 flashbulb. Removable bakelite plug marked "Flash" covers socket when not in use. $10-15.

bakelite. Usually found cracked at $25-30. Perfect condition: $40-60.

Ventura 66 - c1950. Among the first postwar products of Agfa Camerawerk. Horizontal style folding camera for 6x6cm on 120. Export version of the Isolette V. Agnar f4.5 in synchronized Vario to 200. $15-20.

Ventura 66 Deluxe - c1950. Similar to the regular 66, but with Apotar f4.5 in Prontor-S or Solinar f4.5 in Compur-Rapid. Double exposure prevention. Export version of the Isolette II. $15-20.

Ventura 69 - c1950. Vertically styled folding rollfilm camera for 6x9cm on 120 film. Export versio of the Billy Record I. Agnar f4.5 or f6.3 in Vario or Prontor-S. $15-20.

Ventura 69 Deluxe - c1950. Vertical folding rollfilm camera, similar to the Ventura 69, but with double exposure prevention. Solinar f4.5 in Compur. Export version of the Billy Record II. $15-25.

View cameras - Various models in 3¼x4¼ to 5x7 inch sizes. As collectible cameras, these do not create as much interest as they do for studio use. Collector value $40-75 with shutter and lens. If the camera has full movements, it is a usable item for commercial photographers and will fetch $100-250 without lens or shutter.

Viking - c1940. Folding cameras for 120 or 116 rollfilms. f6.3 or 7.7 lens. $10-20.

AGILUX LTD. (Croydon, England)
A subsidiary of Aeronautical & General Instruments, Ltd., from which the AGI names originate. Founded in 1936 to make military cameras. Added amateur cameras from about 1954-65, but subsequently withdrew from the

Agiflash 35 - Simple boxy grey plastic 35mm, identical to the Ilford Sprite 35. Fixed focus f8 lens. Single speed shutter. Double exposure prevention. $10-15.

Agiflash 44 - c1959-64. Black plastic camera for 127 film. Aluminum top housing with optical eye-level finder and recessed socket for flashbulbs. Body made of two-tone grey plastic after 1960. $8-12.

Agiflex - c1947. Agilux originally made a handheld aerial camera called ARL for the Royal Navy during WWII. It had no reflex viewing, but was based on the body design of the Reflex Korelle. The postwar civilian models included reflex viewing and were named Agiflex. FP shutter 25-500. No. 1: $50-75. No. 2: $75-125. No. 3: $125-175.

Agifold (rangefinder model) - c1955. 6x6cm folding camera. Built-in uncoupled rangefinder and extinction meter. Agilux anastigmat f4.5/75mm. $30-40.

Agima - c1960. Interchangeable lens 35mm CRF. Finder has 35mm, 45mm, and 90mm frames. Normal lens is four-element Anastigmat f2.8/45mm. Unusual single stroke combined shutter release and advance lever around right side of lens.

AGILUX (cont.) - AIRES

Uncommon in U.S., but not difficult to find in England. $70-90.

Agimatic - c1956. Rigid body 35mm with uncoupled RF and BIM. Agilux f2.8/45mm in Agimatic 1-300,B. $30-45.

Auto Flash Super 44 - c1959-64. Two-tone grey plastic camera for 4x4cm on 127 film. Automatic exposure; selenium meter adjusts aperture. Single speed shutter. Fixed focus. $10-15.

Colt 44 - c1961-65. Inexpensive grey plastic camera for 127 film. Not synchronized. Also made for Ilford and sold as the Sprite. $4-8.

AHI - Japanese novelty subminiature of the Hit type. $15-20.

AIGLON - c1934. French subminiature. All metal, nickel-plated body with removable single-speed shutter attached to the lens cone. Special rollfilm records 8 exposures with meniscus lens. $150-200.

Air King Camera Radio

Aires 35-III

AIR KING PRODUCTS CO. INC. (Brooklyn, NY)
Air King Camera Radio - The perfect marriage of a brown or red reptile-skin covered tube radio and concealed novelty camera for 828 film. Europe: $250-350. USA: $150-175. *(Illustrated in previous column.)*

AIRES CAMERA IND. CO. LTD. (Tokyo)
Aires 35-III - c1957-58. 35mm RF camera. f1.9/45mm in Seikosha MX. Single stroke lever advance. Bright frame finder. $25-35. *(Illustrated bottom of previous column.)*

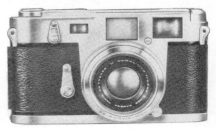

Aires 35-IIIC - c1958-59. Improved version of III & IIIL, incorporating coupled LVS system, self-timer, and automatic parallax correction. Strongly resembles the Leica M3 from a distance. It was designed to accept Aires or Leica M3 cassettes. $30-45.

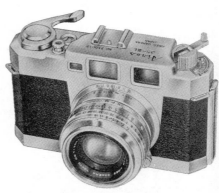

Aires 35-IIIL - c1957-59. Similar to III, but with LVS shutter 1-500. Rewind knob has crank. $30-40.

Aires 35-V - c1959-62. BIM, interchangeable bayonet mount lenses, fast f1.5 normal lens. Also available were f3.5/100mm and f3.2/35mm. With three lenses $100-150. With normal lens only $50-75.

Aires Automat - c1954. TLR for 6x6cm on 120 rollfilm. Nikkor, Zuiko, or Coral f3.5/75mm lens in Seikosha-Rapid 1-500. $75-100.

Airesflex - c1953-55. 6x6cm TLR. Coral f3.5/75mm in Seikosha-Rapid shutter to 500. $60-90.

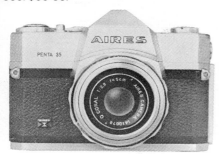

Penta 35 - c1960. Low-priced 35mm SLR. Non-changeable Q Coral f2.8/50mm lens accepts supplementary telephoto & wide angle lenses. Seikosha SLV 1-500. $50-80.

Penta 35 LM - c1961. Similar to Penta 35, but with f2 lens and BIM. $50-80.

Viceroy - Copy of Super Ikonta for 6x6cm or 4.5x6cm on 120. CRF. Coral f3.5/75mm in Seikosha shutter. Scarce. $300-350.

Viscount - c1962. Low-price 35mm RF camera. Even with its fast f1.9 lens, it sold new for under $40. $20-30.

AIVAS (A. Aivas, Paris)
Beginner's Camera - c1910. ¼-plate tailboard camera. Mahogany body, blue or grey cloth bellows. Brass barrel lens, gravity guillotine shutter. $130-180.

AKTIEBOLAGET SVENSKA KAMERAFABRIKEN
Svenska Magazine Camera - Black leathered wood body for 8x10.5cm plates. Lens with 4 stops. $25-35.

ALIBERT (Charles Alibert, Paris)
Kauffer Photo-Sac a Main - c1895.

Folding plate camera disguised as a handbag. Several models were made. One is styled like a square-cornered case which hinges from the middle and a strut-supported front extends. A similar model uses the strut-supported front but in a smartly styled handbag with a split front door hinged at the top and bottom. The other variation has the handbag shape but uses the bottom door as a bed to support the lens standard. Designed by Bernard Kauffer of Paris. Estimated: $2500-3500.

ALLIED CAMERA SUPPLY CO. (New York, NY)

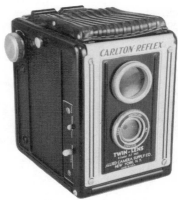

Carlton Reflex - c1950. Black bakelite TLR-style box camera, identical to the Spartus Ful-Vue. Faceplate sports Allied name, but "Utility Mfg. Co." is molded inside the back. $5-10.

ALSAPHOT (France)

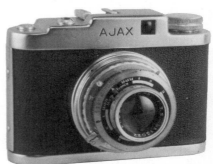

Ajax - Metal-bodied camera with leatherette covering and telescoping tube front. Takes 12 exp. on 120 film. Front element focusing Alsar f3.5 in Alsaphot 1-300 shutter. $20-30.

Cady - Stamped metal telescoping-front camera similar to the Ajax & d'Assas. 6x6cm

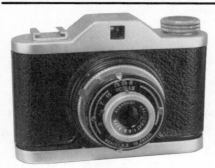

on 120. Focusing Alsaphot Anastigmat f6.3 lens in B,25,75 shutter. $15-20.

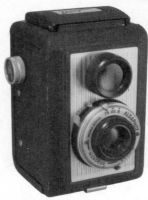

Dauphin, Dauphin II - Pseudo-TLR, 2¼x2¼". $15-30.

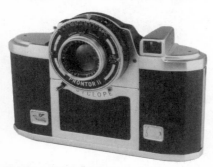

Cyclope - Unusually styled camera for 6x9cm on 120 film. Depth of camera is minimized by using two mirrors to fold the light path. Film travels across front of camera. Small sliding door on front covers red exposure-counting window. The f3.5 version is quite rare and brings somewhat more than the also rare f4.5 model. $600-800.

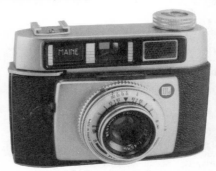

Maine - c1960's. Metal-bodied 35mm cameras with leatherette covering, all with Berthiot f2.8/45mm lens.
Model I: Basic knob-advance model.
Model IIc: Collimated viewfinder; lever advance. Model IIIa: Built-in meter for automatic exposures. $15-20.

ALTHEIMER & BAER INC.
Photo-Craft - Black bakelite minicam, 3x4cm on 127 rollfilm. $5-10.

ALTISSA KAMERAWERK (B. Altmann, Dresden) *Same firm as E. Hofert of Dresden, eventually becoming Eho-Altissa. See Eho-Altissa.*

ALVIX - Prewar folding 6x9cm rollfilm camera from Germany. Trino Anastigmat f4.5/105mm in Pronto. $25-35.

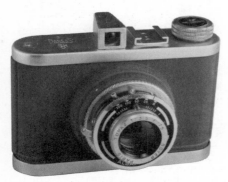

D'Assas - Stamped metal camera with telescoping front. Grey crinkle-painted front; black leatherette covered back. 6x6cm on 120. Boyer Topaz f3.5/75mm in B,25-200 shutter. $20-30.

AMCO - Japanese paper "Yen" box camera for single exposures on sheetfilm in paper holders. The Amco is larger than most cameras of this type, taking 4.5x6.5cm exposures. It is covered in brown & tan rather than the normal black. An unusual item for a collection of novelty cameras. $30-40.

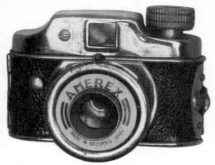

AMEREX - Early Japanese 16mm Hit type subminiature. One of very few marked "Made in Occupied Japan". $25-30.

AMERICAN ADVERTISING & RESEARCH CORP. (Chicago)

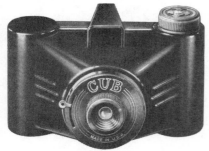

Cub - c1940. Small plastic camera for 28x40mm exposures on 828 film. All plastic construction, similar to the Scenex. Simple lens/shutter. Toothpaste premium. (Original cost was 15 cents and a Pepsodent box.) Common but cute. $10-15.

AMERICAN CAMERA CO. (London)

Demon Detective Camera - Small metal

camera for single round exposures on dry plates. Originally introduced in 1889 for 2¼ inch diameter photos on 2¼x2¼ inch plates (later called No. 1 size). A larger model (No. 2 Size) for 3¾ inch plates was introduced in 1890. Funnel-shaped front with flat, rectangular back. The striking design of the back stamping (by W. Phillips of Birmingham) makes the back view more interesting than the front view of these cameras. $1000-1500.

AMERICAN CAMERA MFG. CO. (Northboro, Mass. USA) *This company was founded in 1895 by Thomas Blair, who had previously founded the Blair Tourograph & Dry Plate Co. in 1881 (later changed to Blair Camera Co.). He still held partial interest in the Blair Camera Co. until 1898, but internal difficulties had prompted him to leave the Blair organization about 1892. The American Camera Mfg. Co. was in business for only a short time, since Thomas Blair sold out to George Eastman about 1897. The company was moved to Rochester about 1899 and continued to operate under the American Camera Mfg. Co. name at least through 1904, even though owned by Kodak. By 1908, the catalogs showed it as the American Camera Division of Eastman Kodak Co. If all of this seems confusing, remember also not to confuse this with the American Optical Co., which is a completely different company.*

BUCK Cameras

Buckeye Cameras:
No. 2 Buckeye - c1899-1908? Box camera for 4x5" exposures. Similar to the Blair Hawk-eye box cameras. $40-60.

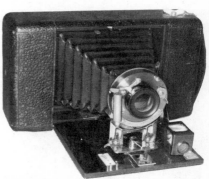

No. 3 Buckeye - c1895. Folding rollfilm camera. Maroon leather bellows. f8 lens. $40-60.

No. 8 Folding Buckeye - c1904. 4x5" rollfilm camera. Rollholder lifts up to focus on ground glass. $250-350.

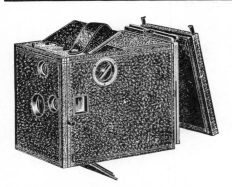

Buckeye Special - c1897. Like the No. 2 Buckeye, but for rollfilm or glass plates. $75-100.

No. 1 Tourist Buckeye - c1895. Folding rollfilm cameras in sizes for 3½x3½" or 3¼x4½" exposures. Maroon bellows, wooden lens standard. $125-150.

Long Focus Poco - c1904. 4x5". Folding camera with maroon leather bellows. $75-100.

AMERICAN FAR EAST TRADING CO.

Santa Claus Camera - c1980. Novelty camera for 126 film. Santa Claus face forms the front of the camera. $10-15.

AMERICAN MINUTE PHOTO CO. (Chicago)
American Sleeve Machine - A street camera for tintypes, similar to the more common models by the Chicago Ferrotype Co. $75-150.

AMERICAN OPTICAL CO. (New York)
Acquired the John Stock Co. (including the C.C. Harrison Co.) in 1866 and was then bought out by Scovill Mfg. Co. in 1867.
Flammang's Patent Revolving Back Camera - c1886. Tailboard style view camera, with patent revolving and tilting back. Tapered bellows, rising front. Mahogany body with brass fittings. Usually found in 5x7" and 6½x8½" sizes. $150-200.

Henry Clay Camera - c1892. 5x7 inch folding plate camera. A well-made hand camera with many desirable features, such as double shift and swing front, fine focusing, etc. Somewhat uncommon and quite distinctive. With original Wale shutter: $450-650.

John Stock Wet Plate Camera - c1866. Tailboard style studio camera for wet collodion plates. Examples we have seen

ranged from 4x5" to 8x10" sizes. Square back allows vertical or horizontal format. Side-hinged ground glass viewing screen swings out of the way to insert plateholder. Drip trough protects bed from chemicals. Brass plateholder retaining springs stamped "John Stock Patented May 31, 1864" and "Assigned to Am. Optical Co." "Am. Optical Co. Manufacturer, NY" stamped at rear corners of bed. $400-800.

Plate camera, 5x8 inch - horizontal format. Complete with lens, back, holder. $125-175.

Wet Plate Camera, 4-tube - c1866. Tailboard-style studio camera of heavy construction. Takes 4 exposures 2x2" each. $800-1200.

AMERICAN RAND CORP.
Photo Binocular 110 - c1980. A pair of 4x30mm binoculars with a built-in camera with 80mm telephoto lens for 110 cartridge film. Made by Sedic Ltd. Also sold as Tele-Spot 110 by J. Gerber Co. Ltd., Japan. $40-60.

AMERICAN RAYLO CORP. (New York)

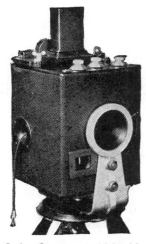

Raylo Color Camera - c1925. Magazine-loading color separation camera for 4.5x8cm plates. Automatic clockwork mechanism apportions the time through each color filter in the correct ratio to produce three negatives of even scale. Rare. $1500-2000.

AMERICAN SAFETY RAZOR CORP. (New York)
ASR Fotodisc - c1950. A small cast metal camera with eye-level finder. A film disc in a special holder fastens by bayonet mount to the back of the camera. Takes 8

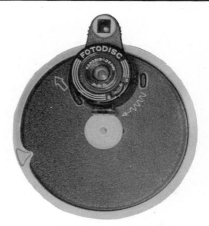

exposures 22x24mm on a film disc. $400-500.

AMICA INTERNATIONAL (Japan)

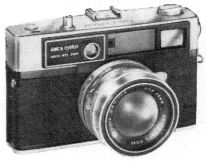

Eyelux - c1966. 35mm RF. f1.8/45mm lens in Citizen MVE shutter. $25-35.

ANNY - Plastic 120 rollfilm camera of the "Diana" type. $1-5.

ANSCHÜTZ (Ottomar Anschütz, Berlin)
Rollda - c1900-05. Double extension folding rollfilm camera for 8x10.5cm. Anschütz Aplanat f7.2/135mm in B&L Unicum shutter 1-100. $50-60.

ANSCO (Binghamton NY USA) *Formed by the merger of the E.& H.T. Anthony Co. and Scovill & Adams in 1902. The name was shortened to Ansco in 1907. A merger with the American interests in the German firm of Agfa in 1928 formed Agfa-Ansco. In 1939, Agfa-Ansco changed its name to General Aniline & Film Corporation, but still used the Agfa-Ansco name in advertising until 1943 when the Agfa name was dropped. The Ansco Division of General Aniline kept its name as the main banner of the company until the company name was officially shortened to GAF in 1967. More recently, GAF*

withdrew from the consumer photographic market but the Ansco name continues as part of Haking International. See also Agfa, Anthony, Scovill.

Admiral - Black plastic twin lens box camera, 2¼x2¼". $1-5.

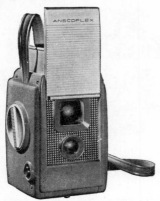

Anscoflex, Anscoflex II - c1954. All metal 6x6cm reflex-style camera. Gray & silver color. Front door slides up and opens finder hood. Model II has closeup lens and yellow filter built in and controlled by knobs on the front. Less common in Europe: $25-40. USA: $10-15.

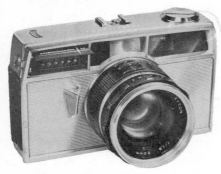

Anscomark M

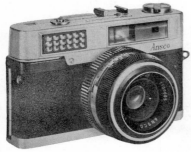

Anscoset

Anscomark M - c1960-1963. 35mm RF camera. Interchangeable bayonet mount Xyton f1.9/50mm or f2.8/50 Xytar lens. Viewfinder has frames for 100mm & 35mm lenses. Coupled meter. With 3 lenses: $60-100. With normal lens only: $25-35. *(Illustrated previous column.)*

Anscoset - c1960. 35mm RF. BIM with match-needle operation, f2.8/45mm Rokkor. Made by Minolta for Ansco. $25-30. *(Illustrated bottom of previous column.)*

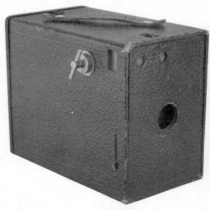

Arrow - c1925. Cardboard box camera with leatherette exterior. Removable metal back; wooden interior section. "The Arrow" on strap, no other identification. Styled like an oversized Ansco Dollar Camera, but with two finders. Uncommon. $10-15.

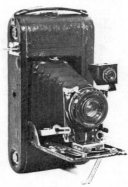

Automatic No. 1A - c1925. Folding rollfilm camera for 6 exp. 2½x4¼ inches in six seconds. Required a new film "No. 6A Automatic" since the regular 6A film only allowed 5 exposures. Spring-wound automatic film advance. Designed and patented in 1915 by Carl Bornmann, who had also designed the 1888 Antique Oak Detective Camera for Scovill & Adams and

was still designing for the company, now 38 years later. Anastigmat f6.3 lens. Original price about $75. $100-150.

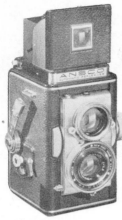

Automatic Reflex - High quality TLR introduced in 1947 at the healthy list price of $262.50. This original model did not cock the shutter with the film advance, and was lacking flash sync. The improved model (sometimes called Model II, although not marked as such) has a sync post in the lower corner of the front plate, and features automatic shutter cocking. By 1950, the list price had dropped to $165. Ansco Anastigmat f3.5/83mm lens; f3.2/83mm viewing lens. Shutter to 400. Ground glass focusing screen and optical eye-level finder. $125-175.

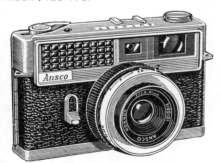

Autoset - c1961. 35mm RF. Similar to the Anscoset, but fully automatic shutter speed control rather than match-needle. $20-30.

Box cameras - Colors other than black: $15-25. Black models: $3-6.

Buster Brown Box Cameras:
No. O Buster Brown - c1923. 4x6.5cm on 127 rollfilm. $5-10.
No. 2 Buster Brown - c1906-23. 6x9cm on 120 (4A) film. $5-10.

No. 2A Buster Brown - c1910-24. 2½x4¼" on 118 film. $8-15.
No. 2C Buster Brown - c1917-23. 2⅞x4⅞". $8-15.
No. 3 Buster Brown - c1906. 3¼x4¼". $8-12.
No. 3A Buster Brown - c1914-16. 3¼x5½". $15-25.

Buster Brown Special, Nos. O, 2, 2A - c1923. Box cameras with red covering and lacquered brass trim. $15-25.

Buster Brown Folding Cameras:
No. 1 Folding Buster Brown, Model B - c1910. $10-15.
No. 2 Folding Buster Brown, Model B - c1914-17. $13-18
No. 2A Folding Buster Brown - c1910's. $10-15.
No. 3 Folding Buster Brown - c1914. $12-18.
No. 3A Folding Buster Brown - c1910's. Postcard size. Deltax or Actus sh. $12-18.

Buster Brown Junior - Folding camera for 116 roll. $10-15.

Cadet cameras:
Cadet B2 and D-6 box cameras - c1947. Basic rectangular box cameras. $1-5.
Cadet (I) - c1959. Black plastic camera with metal faceplate. $1-5.
Cadet Flash - c1960. Similar to the Cadet 4x4cm, but with large built-in flash on top. $3-7.
Cadet II, Cadet III - c1965. Horizontally styled gray plastic cameras with aluminum faceplate for 127 film. Originally came in hard plastic carrying case. $3-7.
Cadet Reflex - c1960. Reflex brillant finder version of the Cadet. 4x4cm on 127 film. $4-8.

Century of Progress - Cardboard box camera with art-deco style World's Fair design on metal front. Made for the 1933 World's Fair at Chicago. $50-75.

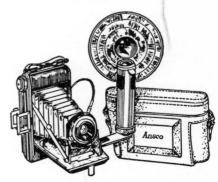

Ansco Commander

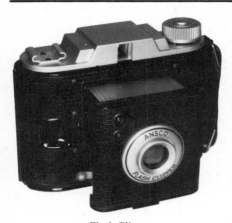

Flash Clipper

Clipper, Color Clipper, Flash Clipper, Clipper Special - 1940's-1950's. A series of metal cameras with rectangular extensible front. $3-7.

Commander - Mid-1950's folding rollfilm camera. Agnar f6.3 zone focusing lens in Vario sync shutter. $15-20. *(Illustrated bottom of previous page.)*

Craftsman - c1950. A construction kit to build your own 6x9cm box camera. The camera kit was pre-tested by Ansco for several months before the decision was made to market it. Over 100 grammar school children participated in the tests. Current value of an original unused kit with assembly instructions $40-50. Assembled Craftsman $4-8.

Dollar Box Camera - c1910-1928. A small 4x3½x2½" box camera for 127 film. Available in black or green. No strap. Some are identified "Ansco Dollar Camera"

on the front. The same camera in red and with a strap was sold as the Kiddie Camera c1926-29. $15-25.

Flash Champion - Metal-bodied camera with rectangular extensible front. Similar to the Clipper cameras. $1-5.

Folding Ansco cameras: *(There is a certain amount of confusion over the correct name for some of these cameras, since Ansco catalogs called them by different names even within the same catalog. For example, the No. 4 Folding Pocket Ansco is the same as the No. 4 Ansco Model B, or the No. 4 Folding Ansco.)*
No. 1 Folding Ansco - c1924-28. Folding bed camera for 6x9cm. Anastigmat f7.5 in Ilex General shutter 1/5-100. $10-15.
No. 1 Special Folding Ansco - c1924-28. $10-15.
No. 1A Folding Ansco - c1915-26. For 116 film. Anastigmat f7.5 in Ilex. $10-15.
No. 3 Folding Ansco - c1914-28. For 118 film. $12-18.

No. 3A Folding Ansco - c1914-32. Common post-card size. Lenses: Wollensak, RR, Ansco Anast. Shutters: Ilex, Deltax, Bionic, Speedex. $10-20.

No. 4 Folding Ansco - c1905. Models C & D. 3¼x4¼ on 118 film. Horizontal format. Mahogany drop bed. Wollensak lens, Cyko Auto shutter. Nickel trim. $15-25.
No. 5 Folding Ansco - c1907. Wollensak lens. Cyko Automatic shutter. Black bellows. $15-25.

No. 6 Folding Ansco - c1907. Models C & D. 3¼x4¼. Wollensak f4 lens. Red leather bellows. For roll or cut film. $20-30.
No. 7 Folding Ansco - (Anthony & Scovill Co.) Postcard sized rollfilm camera. Last patent date 1894. Red bellows, brass barrel Wollensak lens. $20-30.
No. 9 Ansco, Model B - c1906. Horizontal folding rollfilm camera, 3¼x5½". Leather covered cherry wood body, red bellows. Cyko shutter in brass housing. $20-35. Later models had black bellows, nickeled shutter and will bring about $20-35.
No. 10 Ansco - pat. Jan. 1907. Folding camera for 3½x5" on 122 film. (Model A has removable ground glass back. Ansco Automatic shutter.) $20-30.

Goodwin cameras *Named in honor of the Rev. Hannibal Goodwin. Dr. Goodwin invented the flexible transparent rollfilm which has become the standard of the photographic industry. His 1887 patent application took over 11 years to process, by which time his idea was already in widespread use. The Goodwin Film & Camera Co., Inc. was the Premium and Special Sales Division of Ansco Photo Products Inc.*
No. 1 Goodwin Jr. - c1925. Folding camera. Strut-supported front pulls straight out. $15-25.
No. 1A Folding Goodwin - c1930. Folding bed rollfilm camera for 116 film. Says "Goodwin Film & Camera Co." on the shutter face. $10-15.
No. 2, 2A, 3 Goodwin - c1930. Box cameras. $5-10.

Junior *A series of folding rollfilm cameras, beginning with the Model A about 1910. At first horizontally styled, the later models switched to the vertical styling.*
Ansco Junior (Models A & B) - c1906-

1913. Horizontal style folding camera. 2½x4¼" exposures. RR lens. $15-25.
No. 1 Ansco Junior - c1924-32. 2¼x3¼" on 120 rollfilm. Vertical style. Originally available with Achromatic, Rectilinear, or Modico Anastigmat lens in Actus or Bionic shutter. Later versions had other options. $10-15.
No. 1A Ansco Junior - c1916-32. Like the No. 1, but 2½x4¼ on 116 film. $10-15.
No. 2C Ansco Junior - c1917-23. 2⅞x4⅞" on 130 film, otherwise like the No. 1 above. $15-25.
No. 3 Ansco Junior - c1923. 3¼x4¼ on 118 film. Introduced somewhat later than the other sizes. $10-18.
No. 3A Ansco Junior - c1916-31. 3¼x5½" on 122 film, otherwise like the No. 1 above. $15-25.

Juniorette No. 1 - c1923. Folding rollfilm camera for 6x9cm. Nearly identical to the No. 1 Ansco Junior and No. 1 Folding Ansco, but with lower-priced f8 Single Achromatic lens in Deltax shutter. $8-12.

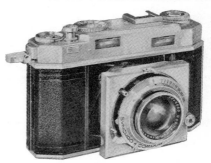

Karomat - c1951-56. 35mm strut-folding rangefinder camera, identical to the Agfa Karat 36. Early models have hinged knob on advance lever, and a depth of field calculator on top. Beginning about 1953, the advance lever has a fixed knob, and there is no longer a depth calculator.

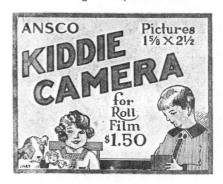

Box flap from Ansco Kiddie Camera

41

ANSCO (cont.)

Originally with Heligon or Xenon in Compur-Rapid. Later with Schneider Xenar f2.8 or Xenon f2.0 in Synchro-Compur. $35-50.

Kiddie Camera - c1926-29. Listed in the catalogs along with the Dollar Camera, with shared description and photo. It is the same cardboard box camera, but with red covering and a strap. $10-15.

Lancer - c1959. Streamlined cast metal camera made for Ansco by Bilora. Identical in style to the Bilora Bella 44. Simple f8 lens in 2-speed shutter. Takes 12 exposures 4x4cm on 127 film. $10-15.

Lancer LG - c1962. Identical, but with uncoupled meter attached to the front. $15-25.

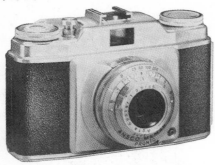

Memar - c1954-58. Basic 35mm camera. Same as the Agfa Silette. Apotar f3.5/45mm in Pronto. $10-20.

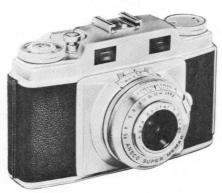

Super Memar - c1956-59. Similar to the Memar, but with CRF and f3.5 Apotar in Prontor SVS. Also sold as the Agfa Super Silette. $20-35.

Super Memar LVS - c1957-59. CRF, Synchro-Compur LVS shutter, f2 Solagon lens. Same as Agfa Super Silette. $25-35.

Memo cameras *The Memo cameras have presented a problem to some collectors who advertise one for sale and do not indicate which model they are selling. Ansco sold several different cameras which were simply called "Memo" with no further designation. In recent years, serious collectors and dealers have tried to identify them further by using the year of introduction along with the name.*

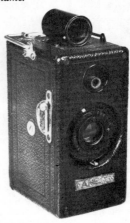

Memo (1927 type) - Half-frame 35mm camera. Wooden vertical box body with leather covering. Tubular optical finder on top. Makes 50 exposures 18x23mm on 35mm film in special cassettes which were originally made of wood. Wollensak Cine-Velostigmat or Ilex Cinemat 40mm f6.3 lens. Sliding button on back for film advance, automatic exposure counter. Some models focus, others are fixed focus. A shutter release guard was added to later models. Although these sell for about 50% more in Europe, they are fairly common in the USA. $50-75.

Memo (Boy Scout model) - The "Official Boy Scout Memo Camera" has a wooden body painted olive-drab color and has a special nameplate with the official insignia, and comes in a matching olive-drab case. Much less common than the normal models. Camera only: $150-200. With case: $200-250.

Memo (Wood finished) - The earliest variation of the 1927 type Memo, this had varnished wood and brass trim rather than leather covering. Less common than the others of the series. (Original ads in December 1926 and January 1927 illustrate this wood model.) $200-250.

Memo (1940 type) - see AGFA Memo.

Memo Automatic - c1963. Single frame (18x24mm) camera for standard 35mm

cartridges. Features spring-motor film advance. Made by Ricoh for Ansco, and identical to the Ricoh Auto Half. Also continued as the Memo II under the Ansco and GAF labels. $25-35.

Memo II - see Memo Automatic, above.

Memory Kit - c1923. A specially packaged outfit including a folding camera in a fitted polished wood box with 4 rolls of film. A metal plate on the box is suitable for engraving. Came with No. 1 Ansco Junior, No. 1 Folding Ansco, or No. 1 Readyset Royal. Complete with camera and original boxes of film: $60-90. Camera and presentation box only: $40-60.

Panda - c1939-50. Small black plastic camera with white trim for 6x6cm exposures. Ansco's answer to Kodak's Baby Brownie cameras. $3-7.

Photo Vanity - A small Ansco box camera concealed in one end of a case. May be operated from the exterior with the case closed. The case also contains art-deco designed lipstick, powder, rouge & comb,

and a mirror in the lid. Apparently the vanity case was made by Q.L.G. Co. and fitted with an Ansco camera, so only the camera itself is actually on Ansco product. $600-900.

Pioneer - c1947-1953. Plastic eye-level cameras in the PB-20 and PD-16 sizes. Formerly called Agfa Pioneer. Common. $1-5.

Readyflash - Low-priced plastic eye-level camera for 6x9cm on 620 film. Sold new in 1953 for $14 with a flash, 6 bulbs, gadget bag & film. $2-6.

Readyset (No.1, 1A, Eagle, Special, etc.) - 1920's. Folding cameras. $10-15.

Readyset Royal, Nos. 1, 1A - c1925-32. Folding cameras with special leather coverings, usually brown, including pigskin & ostrich skin. These are not rare, and although they are seen advertised for sale at higher prices, they are generally available for $20-30. Somewhat higher in Europe.

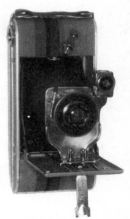

Readyset Traveler - c1931. Folding cameras in #1 & 1A sizes (for 120 & 116 film). These are covered in canvas with colored stripes and have a matching canvas case. $20-30.

Rediflex - c1950. Plastic twin lens box camera, 6x6cm on 620 film. $2-7.

Regent - c1953. Identical to the Agfa Solinette II. Horizontally styled folding bed 35mm camera. Apotar f3.5 in Prontor-SV to 300. $15-25.

--Super Regent - intro. 1954. The Ansco equivalent of the Agfa Super Solinette. CRF. Solinar f3.5 lens in Synchro-Compur shutter. $35-50.

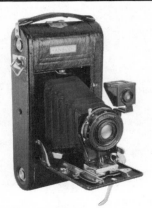

Semi-Automatic Ansco - c1924. Folding rollfilm camera. A lever on the rear of the drop bed actuates a spring-wound advance system. There are two distinct variations. One has the advance lever on the operator's right while the other has the advance lever on the left. It differs from the Automatic model which further couples the winding mechanism to the shutter release. Ansco Anastigmat f7.5/130mm in Ilex shutter. $100-150.

Shur-Flash - c1953. Basic box camera with flash attachment. $1-5.

Shur-Shot - c1948. A basic box camera with vertically striped aluminum front. Perhaps the most common of the Ansco box cameras. $1-5.

Shur-Shot Jr. - c1948. Basic box camera with metal faceplate. 2¼x3¼" on 120 film. $5-10.

Speedex *See the listing of Speedex cameras under Agfa. Essentially the same cameras were marketed under both the Agfa and Ansco names.*

Speedex 1A - c1916. Folding camera for 116 film. Anastigmat f6.3 in Ilex Universal shutter. $12-20.

Speedex 45 - c1946-50. Horizontal folding rollfilm camera, similar to the Isolette V from the same years. Apotar or Agnar f4.5 lens. $10-20.

Speedex Special R - c1953. Horizontally styled folding camera for 6x6cm on 120 film. Made in Germany; similar to Agfa Isolette III. Uncoupled rangefinder. Apotar f4.5/85 in Prontor-S or SVS. Original price $55. $30-40.

Super Speedex - c1953-58. Folding camera for 6x6 on 120. Similar to the Speedex Special R, but rangefinder is coupled. Solinar f3.5/75mm in Synchro-Compur 1-500. Sold for $120 in 1953. $75-125.

Titan - c1949. Horizontal folding rollfilm camera for 2¼x2¼" on 120. Ansco Anastigmat f4.5/90mm, ½-400,TB shutter. Advertised as "Agfa's finest folding camera." $20-45.

Vest Pocket Ansco: *While we tend to think that all vest pocket cameras are for 4x6.5cm exposures on 127 film, Ansco called its No. 1 and No. 2 models "Vest Pocket" even though they were larger cameras.*

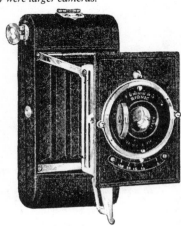

Vest Pocket No. O - c1916-23. For 4x6.5cm exposures on 127 film. Ansco Anastigmat f6.3 or Modico Anastigmat f7.5. Strut-supported front pulls straight out. $20-35.

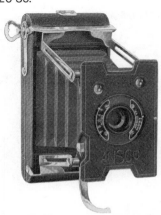

Vest Pocket No. 1 - c1915-19. Folding camera for 6x9cm. Strut-supported front. Patents to 1912. Actus shutter. $15-25.

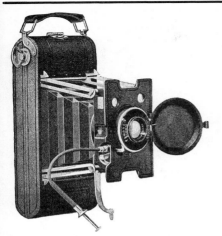

Ansco Anastigmat f5 or f6.3, or Modico Anastigmat f7.5 in Acme Speedex shutter. $25-40.

Ansco View - View cameras are difficult to price as collectibles because their main value lies in their usability. Any usable view camera with tilts and swings generally exceeds the price collectors would pay. Shutter & lens are even more important in estimating the value, since a good lens has more value than the camera itself. Collectible value, with older type lens & shutter $50-100. Usable value with full movements, not including lens $75-125.

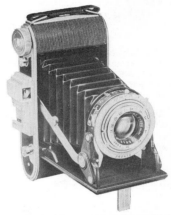

Vest Pocket No. 2 - c1915-24. Similar to the No. 1 and also for 6x9cm on 120 film. The unusual feature of this camera is the hinged lens cover. Ansco Anastigmat or f7.5 Modico Anast. Bionic or Gammax shutter. $20-30.

Vest Pocket Model A - Designed with a folding bed, unlike the other vest pocket models above. B&L Zeiss Tessar lens. Ansco shutter. $20-30.

Vest Pocket Junior - c1919. Folding bed camera, 6x9cm on 4A (120) film. $12-20.

Vest Pocket Readyset - Folding bed style camera for 4x6.5cm exposures on 127 film. Pastel enameled in various colors including blue, red, and green (1925-29): $30-50. Black leather covered models (1925-31): $20-35.

Viking - c1946-56. Self-erecting folding bed camera for 6x9cm on 120 film. Agnar f6.3 in Vario or f4.5 in Pronto shutter to 200. Same as the Billy Record I. $15-20.

Viking Readyset - c1952-59. Self-erecting folding camera for 2¼x3¼" on 120. Fixed focus Isomat lens. Folding frame finder. $10-15.

ANTHONY *The oldest American manufacturer of cameras and photographic supplies. Begun by Edward Anthony in 1842 as E.Anthony. Edward's brother Henry joined him in 1852, and in 1862 the firm's name was changed to E. & H.T. Anthony & Co. In 1902, they merged with the Scovill & Adams Co. to form Anthony & Scovill, and five years later the name was shortened to Ansco, a contracted form of the two names. At the same time, they moved from their original location on Broadway to Binghamton, N.Y. (See also Agfa, Ansco, Scovill.)*

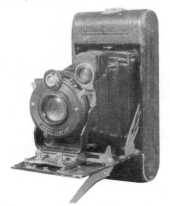

Vest Pocket Speedex No. 3 - c1916-20. Folding bed rollfilm camera for 6x9cm on 4A (120) film. Tessar f4.5, Goerz-Celor f4.8,

Ascot - c1899. Folding plate cameras. *Note: The plate & hand camera division of E.& H.T. Anthony Camera Co., which made the Ascot Cameras, merged with several other companies in 1899 to become the Rochester Optical & Camera Co. Ascot cameras are quite uncommon, since they were made for such a short time.*

ANTHONY (cont.)

Ascot Cycle No. 1 - 4x5" size. Orig. price $8 in 1899. $60-90.
Ascot Folding No. 25 - 4x5". $60-90.
Ascot Folding No. 29 - 4x5" size. Original price $15 in 1899. $60-90.

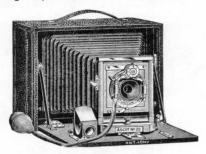

Ascot Folding No. 30 - The big brother of the above cameras, this one takes 5x7" plates. Like the others, it has a side door for loading and storage of plate holders. $60-100.

Box cameras:
- c1903-1906. Leather covered box for 3¼x4¼" on rollfilm. $30-40.
- Focusing model for 4x5" exposures on plates or with rollholder. $40-60.

Buckeye - c1896. Box cameras for 12 exp. on daylight-loading rollfilm sold by Anthony. (Some models equipped for either plates or rollfilm.) Made in 3¼x4¼" & 4x5" sizes. These were probably by American Camera Mfg. Co. with Anthony acting as a sales agent. These cameras were the competition for the Boston Bullseye and the Eastman Bullet cameras of the day. $40-60.

Champion - c1890. A series of mahogany field cameras, in sizes from 4x5" to 8x10". Folding bed with hook-shaped "patent clamps" to hold it rigid. Rising front, swing back. Originally supplied with cone-shaped brass barrel single achromatic lens, case, holder, and tripod. $150-200.

Clifton - c1901. A series of view cameras with a great variety of movements including double-swing back and front, rising &

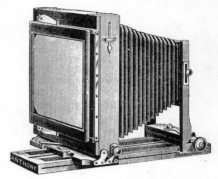

shifting front, reversible back, front & rear rack focus. Made in 6 sizes from 5x7" to 14x17". $125-200.

Climax Detective - A rather large wooden box "detective" camera from the late 1880's for 4x5" plates. It was called a detective camera because it didn't look like the large tripod-mounted bellows style view cameras which were the order of the day. It could be operated hand-held, and all the shutter controls could be operated without opening the box. A removable rear storage compartment holds five double plateholders. Available in polished wood or leather covered models. Earlier high asking prices have given way to realistic $800-900 asking prices in 1988.

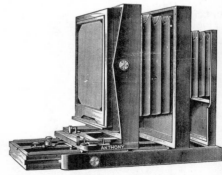

Climax Portrait Camera - c1888. A large studio view camera, usually found in the 11x14" size, but made up to 25x30". Two sets of bellows allow long extension with telescoping bed. With brass barrel lens $200-300.

Compact Camera - c1890's. A compact folding field camera based on English designs of the time. The lensboard folds flat against the bed using its center tilt axis. A rotating tripod top is built into the bed. The lens must be removed to fold the

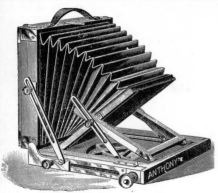

camera, and unfortunately many cameras of this style have become separated from their original lenses. Made in sizes from 5x7" to 8x10". $125-175.

Daylight Enlarging Camera - c1888. A view camera & enlarger for plates to 11½x11½". Masking back for enlarging. Rotating back & bellows. Without lens $150-175.

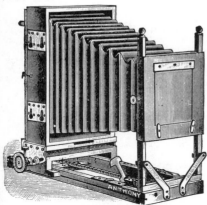

Fairy Camera - c1888. A lightweight folding view camera. Similar in design to the more common Novelette camera, it featured a revolving back & bellows combination for horizontal or vertical orientation. It also offered rack & pinion focusing while the Novelette employed a sliding back with a fine-focus screw. The Fairy camera has a walnut body with nickel plated fittings. Made in 6 sizes from 4x5" to 8x10". $200-275.

Gem Box - c1877. A series of cameras for making multiple "gem" tintypes by using from 4 to 12 lenses on Anthony's Universal Portrait & Ferrotype Camera. Camera sizes from 3¼x4¼" to 6½x8½". Quite rare. We would recommend consultation with several reputable dealers or advanced collectors,

since these would interest only a small group of collectors in the estimated price range of $1500-3000.

Klondike - c1898. Fixed focus box camera for 3¼x4¼" plates. Adjustable shutter speeds & diaphragm. $50-75.

Lilliput Detective Camera - c1889. A detective camera shaped like a miniature satchel. Takes 2½x2½" plates in double plateholders. A rare item. $3000-3500.

Normandie - According to the Anthony 1891 catalog, this was the "lightest, most compact, and easily adjustable, reversible back camera in the market." The spring-loaded ground glass back was a relatively new feature at that time. Made in sizes from 4x5" to 14x17". Current value with original lens $125-250.

Novel - A family of view cameras from the 1880's with a rotating back & bellows combination. Although 4x5" & 5x7" sizes were made, by 1888 the Novel cameras were made only in sizes 8x10" and larger. The smaller sizes were replaced by the Novelette. With brass barrel lens $125-175. *(Illustrated on next page.)*

Novelette, Duplex Novelette - c1885. View cameras. Similar in design to the Novel, with the rotating back & bellows unit. The Duplex Novelette carried this idea

one step further by allowing the bellows to be easily released from the lensboard. This permitted the user to convert from a 5x8" to an 8x10" back in seconds. Made in all standard sizes from 4x5" to 11x14" in basic, single swing, and double swing models ranging from $12 to $54. Current value with lens $200-250.

Anthony Novel

Novelette Stereo - Essentially the same camera, but fitted with twin lenses to make stereo views to enchant the pre-TV generation. $350-500.

PDQ - c1890. A detective box camera for

4x5" plates or films. Original price $20. Currently $500-700.

Satchel Detective Camera - Consists of a Climax Detective camera in a special covering designed to look like a satchel with a shoulder strap. The bottom of the satchel is completely open to allow access to the camera's controls. This outfit was called the "Climax Detective Satchel Camera" in the 1893 catalog, although earlier catalogs used the "Satchel Detective Camera" name. This is an extremely rare camera, and obviously the price would be negotiable. One sold at auction a few years ago in the range of $15,000-$20,000.

Schmid's Patent Detective Camera - The first hand-held instantaneous camera produced in America. Although two years

earlier the Englishman, Thomas Bolas, produced and patented two hand-made prototype cameras which were hand-held with viewfinders, but these were never commercially produced. Therefore the world's first "commercially produced" hand-held camera was the Schmid. Patented January 2, 1883 by Wm. Schmid, Brooklyn, NY. The earliest model for 3¼x4¼" plates featured a rigid one-piece carrying handle formed from a brass rod. The second model featured a folding handle. Later models had the focusing scale on the right side, and leather covering was optional. The 1891 catalog offers 6 sizes from 3¼x4¼" to 8x10", sizes above 4x5" on special order only. $3000-4000.

Stereo Solograph - c1901. Well-crafted lightweight folding-bed stereo camera for 4½x6½" plates. Mahogany body with morocco leather covering. Polished wood interior. Red Russian leather bellows. Rack & pinion focus. $325-375.

Victor, 5x8" - c1891-93. Mahogany folding view camera. Brass lens in B&L shutter. $125-150.

View cameras - Anthony made a variety of view cameras, most of which can be identified with a certain amount of research. However, it is relatively safe to say that most do not fall into the category of useful equipment today, and therefore can be classified strictly as collectible cameras. While some of the earlier models stir more interest, the later, more common types can generally be found in very good condition, with an original vintage lens, for $125-225.

APM (Amalgamated Photographic Manufacturers Ltd., London) *APM was formed in 1921 and brought together seven British photogrpahic companies: A. Kershaw and Son Ltd, Kershaw Optical Co., Marion and Co. Ltd, Marion and Foulgar Ltd, Paget Prize Plate Co. Ltd, Rajar Ltd, and Rotary Photographic Co. Ltd. APM aimed to bring together the resources of these companies which included both equipment manufacturers and producers of sensitised materials. The "APeM" tradename was adopted for many of its products.*

The amalgamation was never a commercial success despite the wide range of its products and on February 1, 1929 APM divided. The sensitised materials manufacturers of Marion and Co., Paget, and Rajar formed Apem Ltd. and based themselves in the Watford factory of Paget. Apem was taken over and absorbed into Ilford Ltd c1932. The remaining companies all concerned with equipment production (except Rotary which undertook printing) remained as APM until c1930 when they regrouped as Soho Ltd.

APM produced a wide range of cameras which tended towards the lower end of the market, although by 1928 studio cameras featured heavily alongside a vast number of accessories. Their cameras included the Apem press camera, Soho Reflex made by Kershaws and the Rajar No. 6 camera (1929). The Rajar is noteworthy because it was one of the first all plastic-bodied cameras and was distributed through premium schemes.

Box cameras - c1920's. Leather covered wooden box camera, 2¼x3¼" and 2¼x4¼" sizes. Three stops; single speed. $10-15.

Focal Plane Camera, plate model - Strut folding 9x12cm plate camera with focal plane shutter. Kershaw Anastigmat f4.5/5½" lens. $30-50.

Rajar No. 6 - Folding camera with 4 cross-swing struts. Body and front plate made of bakelite. Its 1929 introduction makes it one of the earliest bakelite rollfilm cameras. $15-20.

Reflex - Inexpensive single lens reflex camera, 2¼x3¼" and 3¼x4¼" sizes, made by Thornton-Pickard, also associated with Apem. Cooke Apem Anastigmat f4.5. $45-75.

APOLLO - c1951-54. Horizontal folding camera for 16 exposures 4.5x6cm on 120 film. Westar Anastigmat f3.5 lens. $25-35.

APPARATE & KAMERABAU (Friedrichshafen, Germany)
Akarelle - c1954. Unusually designed 35mm with two side-by-side finder windows. Lever wind. Various interchangeable lenses f2 to f3.5. Prontor shutter. $35-50.

Akarette - c1949. Similar to Akarelle.

Model 0 is basic black enameled model with Radionar f3.5 lens. **Model I** has chrome faceplate, self-timer, and film reminder in advance knob. **Model II** has metal parts chromed, is leather covered, has strap lugs, and one of the following lenses: Radionar f3.5, Xenar f3.5, 2.8, or f2. $30-45.

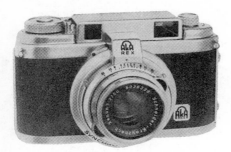

Akarex (Models I & III) - c1953. 35mm rangefinder camera. Rangefinder and lens are interchangeable as a unit. Normal lens: Isco Westar f3.5/45mm. Also available: Schneider Xenon f2/50mm, Tele-Xenar f3.5/90, and Xenagon f3.5/35mm. Camera with 3 lenses: $125-175. Camera with f2 lens only: $50-75. With f3.5 lens: $40-45.

Arette - 35mm cameras of the late 1950's. Model A is basic. Model IA early models c1957 are basic. Later variation c1959 has bright frame. Model IB has meter. Model IC has CRF. Model ID has meter & rangefinder. $15-35.

Arette Automatic S - c1959. Built-in automatic meter. Color-Westanar f2.8/45mm in Prontormat. $25-35.

APPLETON & CO. (Bradford, England) Criterion - c1900. Half-plate mahogany field camera. Voigtländer lens with wheel stops. Thornton-Pickard shutter. $60-90.

ARCOFLEX - Japanese novelty camera of the "Hit" type. Not a reflex camera as the name would imply. A rather uncommon name. $15-25.

ARGUS, INC. (Ann Arbor, Michigan & Chicago, Illinois.) *Originally founded as International Research Corp., Ann Arbor, Michigan. The name was changed to "Argus, Inc." in 1944, the new name coming from their popular Argus cameras. We are listing the Argus cameras basically in alphabetical order, but with the "A" and "C" series chronological. Therefore the "B" and "FA" fall as variations within the "A" series, where they belong in reality despite their model letter.*

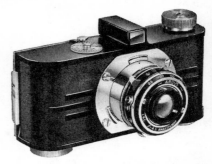

A - 1936-41. 35mm cartridge camera with bakelite body. Argus Anastigmat f4.5/50mm in collapsible mount. Early models have fixed pressure plate, sprockets on one side of film. Later models have floating pressure plate and sprockets on both sides. Originally advertised in the following color combinations: Black/chrome, gray/gunmetal, ivory/gold, and brown/gold. In actuality, the "gunmetal" may be chrome and the "gold" is definitely brass. Gold: $100-150. Gray or Olive drab: $25-40. Black: $10-20.

A (126 cartridge) - To avoid confusion with the original Argus A above: This is a recent 2-tone gray plastic camera for 126 "Instamatic" film. $1-5.

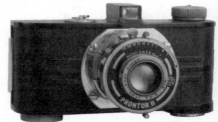

B - 1937. Body same as A, but with fast Argus Anastigmat f2.9 lens in Prontor II shutter with self-timer. Reportedly only 1,000 made. $30-50.

AF - 1937-38. Same as A, but lens mount focuses to 15". $15-25.

A2 (A2B) - 1939-50. Similar to the A, but with extinction meter. Two position focus.

Coated lens after July 1946. $12-18.

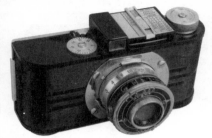

A2F - 1939-41. Like A2 with extinction meter but also close focus to 15". $15-25.

AA (Argoflash) - 1940-42. Synchronized for flash, otherwise similar to the "A". However, it has a simpler f6.3 lens and T&I shutter. $20-30.

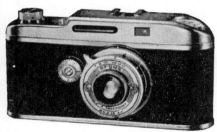

A3 - 1940-42. A streamlined version of the A series, with fully rounded body ends and a chrome top housing incorporating an extinction meter. Exposure counter on front. Body shutter release. $20-30.

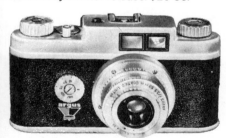

21 (Markfinder) - 1947-52. Reincarnation of the A3 body style, with interchangeable lenses and a bright-frame finder. Cintar f3.5/50mm coated lens. $20-25.

FA - 1950-51. The last of the "A" series with the original body style. Large flash socket added to the left end of the body. Argus Anastigmat f4.5/50mm. Two position focus. 25-150,B,T. $20-30.

A4 - 1953-56. Body style completely different from the earlier "A" cameras. Boxy black plastic body with aluminum faceplate. Cintar f3.5/44mm, sync. $8-12.

Argoflex *There are a number of Argoflex twin-lens cameras, none of which cause any great excitement among collectors.*

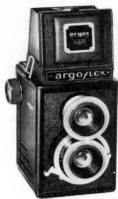

Argoflex E - 1940-48. Focusing f4.5/75mm Varex Anastigmat; shutter b-200. $20-30.
Argoflex EM - 1948. Also called Argoflex II. Metal body. $20-30.
Argoflex EF - 1948-51. Flash model. $20-30.

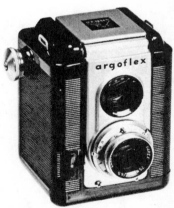

Argoflex 40 - 1950-54. Beginning with this model, the lenses are no longer externally coupled, and the viewing lens does not focus. $15-25.
Argoflex Seventy-five - 1949-58. Black plastic body. Fixed focus. $5-10. Slightly higher in Europe.
Argus 75 - 1958-64. Brown plastic body. Continuation of the Argoflex Seventy-five with minor cosmetic changes. $5-10. Slightly higher in Europe.
Argus Super Seventy-five - 1954-58. Focusing Lumar f8/65mm coated lens, otherwise like Argoflex Seventy-five. $10-15.

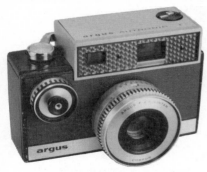

Autronic I, Autronic 35, Autronic C3 -
1960-62. Although the camera bore several
designations during its short life, it was
really just one model. Similar in appearance
to the C33, but incorporating a meter for
automatic exposure with manual override.
Cintar f3.5/50mm. Synch shutter 30-500,
B. $15-25. (Often found with inoperative
meter for about half as much.)

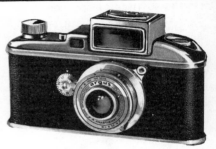

CC (Colorcamera) - 1941-42. Streamlined
camera based on the A3 body, but with
uncoupled selenium meter instead of
extinction type. $35-50.

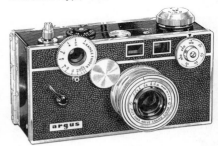

Argus C3

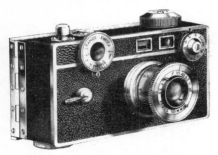

C - 1938-39. The original brick-shaped
camera with a non-coupled rangefinder.
With olive drab body: $50-75. With speed
range select switch: $75-100. Without
speed range select switch, as in C2: 20-35.

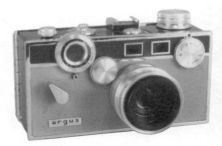

Argus C3 Matchmatic

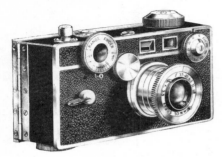

C2 - 1938-42. Like the "C", but the
rangefinder is coupled. Introduced just after
the model C in 1938. An early "brick".
$15-25. Slightly higher in Europe.

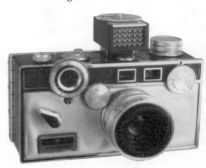

Argus Golden Shield

C3 - 1939-66. The most common "brick". A solid, durable, and well-liked camera, like the C2, but with internal synch. Common. Somewhat higher in Europe. $10-15. *(Illustrated on previous page.)*

C3 Matchmatic - 1958-66. Basically a face-lifted C3 in two-tone finish. Designed for use with a non-coupled clip-on selenium meter. Must be complete with meter to be valued as a collectible. Somewhat higher in Europe. $10-20. *(Illustrated on previous page.)*

Golden Shield (Matchmatic C-3) - Special exterior trim enhances an otherwise normal Matchmatic C-3. Bright embossed metal front and small "Golden Shield by Argus" nameplate. With meter: $15-25. *(Illustrated on previous page.)*

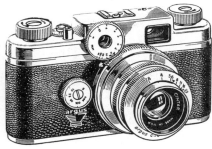

C4 - 1951-57. Similar to the Model 21 Markfinder of 1947, but with coupled range-finder rather than bright frame viewfinder. Cintar f2.8/50mm. $25-35. *Some C4 cameras were adapted to take interchangeable lenses. These use a different mounting flange from the C44. Available lenses included Enna Lithagon 35mm, 45mm, and 100mm. This modification was done by dealers representing Geiss America and Enna-Werk. Wide angle or tele lens: $30-40.*

C4R - 1958. Like the C4, but with rapid film advance lever. $30-45.

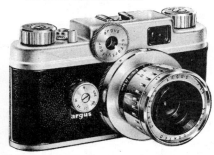

C44 - 1956-57. Similar to the C4 series, but interchangeable lens mount. Three-lens outfit: $50-85. With Cintagon f2.8/50mm normal lens: $35-50.

C44R - 1958-62. Like the C44 but with rapid advance lever. Three-lens outfit: $60-90. With normal lens: $35-50.

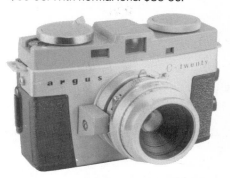

C20 - 1956-58. Replaced the A4, using the same basic body style but incorporating a rangefinder. Brown plastic body. $15-20.

C33 - 1959-61. A new design incorporating features of the C3 and C4 series in a boxy body even less appealing than the famous brick. It did have a combined view/range-finder and interchangeable lenses, and accepted an accessory coupled meter. Shutter cocking is coupled to the film advance lever. With normal lens: $15-25. Extra lenses $15-25.

Camro 28 - Same camera as the Minca 28, but with a different name. $20-25.

Delco 828 - Same camera as the Minca 28, but with a different name. $20-25.

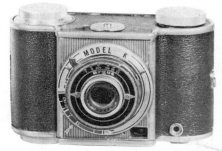

K - 1939-40. One of the more desirable Argus cameras, the Model K is assumed to be a simplified version of the legendary Model D (a spring-motor autowind camera announced in 1939 but apparently never marketed). The Model K retained the same body style without the autowind feature. It did include a COUPLED extinction meter for its $19.50 original price. $175-200.

Lady Carefree - Cheap 126 cartridge camera made for Argus by Balda-Werke in

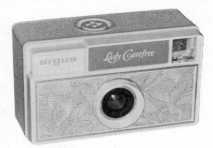

Germany. Tan with brown covering or white with cream brocade covering. $1-5.

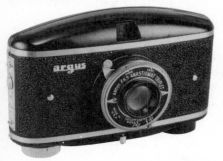

Model M - 1939-40. Streamlined bakelite camera for 828 film. Argus anastigmat f6.3 lens in a collapsible mount. For 8 exp. 24x36mm or 16 exp. 19x24mm. $40-60.

Minca 28 - (also called Model 19) 1947-1948. A post-war version of the streamlined bakelite Model M camera. Lunar f9.7 lens. (Also sold under the names "Camro 28" and "Delco 828".) $20-25.

Argus SLR - c1962-66. 35mm SLR made by Mamiya for Argus. Mamiya-Sekor f1.7/58mm, bayonet mount. FP shutter 1-1000,B. $40-60.

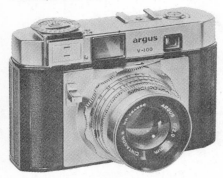

V-100 - 1958-59. Rangefinder camera

made in Germany for Argus. BIM. f2/45mm Cintagon II or f2.8/50mm Cintar II in Synchro-Compur. $20-30.

ARNOLD, KARL (Marienberg) *Producer of KARMA cameras, an abbreviation of KArl ARnold, MArienberg.*

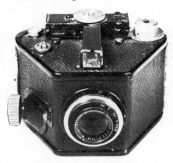

Karma - 6x6cm rollfilm camera for 120 film. Trapezoid-shaped body with black leather. Eye-level telescopic finder and uncoupled rangefinder. Meyer Trioplan f3.5/75mm lens, helix focus. Focal plane shutter 25-500, T. $400-500.

Karma-Flex 6x6cm - Rare model resembling the Karma camera with a reflex finder perched on top almost as if an afterthought. Focal plane shutter to 500. Victar f3.5/75mm in helical focusing mount. This is much less common than the 4x4cm models. $900-1000.

Karma-Flex 4x4 Model I - c1932-36. Typical Karma body style, but twin-lens-reflex, with two small closely spaced lenses on front. 4x4cm on 127 film. Fixed focus f9 lens in M,Z shutter. Rare. $500-750.

Karma-Flex 4x4 Model 2 - c1932-37. SLR for 4x4cm on 127 film. Ludwig Vidar f4.5/60mm or Laack Ragolyt f4.5/60mm.

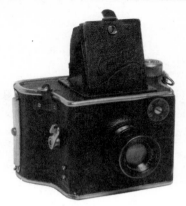

Guillotine shutter 25-100. Black leather covered metal body. $275-325.

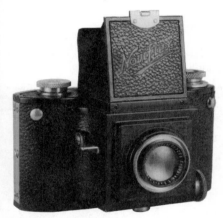

Noviflex - c1935. One source attributes this camera to Arnold, but we have no evidence to confirm or deny that assumption. Can any of our readers help? German SLR, 6x6cm on 120 film, the first of this style, beating the better known Reflex Korelle to the market. Schneider Radionar f2.9/75mm or Victar f3.5/75mm lens. FP shutter 1/20-1/1000. Uncommon. $175-250.

ARROW - Novelty camera of "Hit" type for 14x14mm on 16mm paper-backed rollfilm. Japanese made: $15-20. Later Hong Kong version: $10-15.

ARROW - Plastic 120 rollfilm camera of the Diana type. $1-5.

ARS OPTICAL CO. LTD.
Acon 35 - c1956-1958. Japanese 35mm RF cameras. f3.5/45mm Vita lens. Models I, II, & IIL. $20-30.

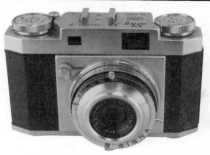

Sky 35 Model II - Same as the Acon 35 except for the unusual name. Vita Anastigmat f3.5/45mm. Signa B,10-200 shutter. $30-40.

ASAHI KOGAKU (Tokyo) *Founded in 1919, the Asahi Optical Co. began making projector lenses in the 1920's and camera lenses in 1931. During the war, Asahi production was strictly military. Their claim to fame is the introduction of the first Japanese 35mm SLR, the Asahiflex I of 1951. The Asahiflex line became the Pentax line which remains among the major cameras of today.*

Asahiflex Cameras *The early Asahiflex cameras made from 1951-1957 are considerably different from the later Pentax models. Aside from the fact that they are boldly marked "Asahiflex" on the front, there are several other features which distinguish them. The reflex viewing is waist-level only, and there is a separate eye-level finder. The lens mount is a screw-thread, but not the standard 42mm size.*

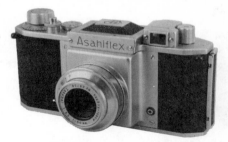

Asahiflex I - 1952. FP shutter 25-500. Single X-synch post on front for FP bulbs. No slow speed dial or patch. Takumar f3.5/50mm normal lens. The first Japanese 35mm SLR. Uncommon. $200-400.

Asahiflex Ia - 1953. Similar to model I, but F and X synch posts on front. $150-200.

Asahiflex IIB - 1954. Instant-return mirror. (*We previously stated that it was the world's first instant-return-mirror, but have been advised that the Duflex of 1947 and Vanneck of 1890 both preclude that possibility.*) Takumar f2.4/58mm

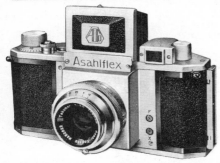

or f3.5/50mm. Early model without slow speed dial or patch: $175-225. Later version, c1955, with slow speed patch: $150-200.

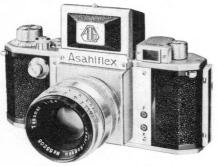

Asahiflex IIA - 1955. Like IIB, but with slow speed dial added to front. Also sold in USA by Sears as Tower 22. $100-150.

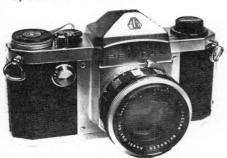

Pentax (original) - 1957. In a completely new design from the earlier Asahiflex cameras, the Pentax incorporated an eye-level pentaprism, interchangeable Takumar f2/55mm lens with standard 42mm threaded lens mount, rapid advance lever, crank rewind, etc. $100-150.

Pentax H-1 - c1962-66. 35mm SLR. Like the Pentax S, but has interchangeable Takumar f2/55mm. $70-100.

Pentax H1a - c1963-71. 35mm SLR. Like the Pentax S, but has interchangeable Auto Takumar f2/50mm. With normal lens: $60-75. Body: $35-45.

Pentax H-2 - c1959-66. 35mm SLR. Like Pentax S, but semi-automatic diaphragm. With normal lens: $70-100.

Pentax H-3 - c1962-64. 35mm SLR. Like Pentax K, but the two shutter speed dials were combined into one. With lens: $70-95.

Pentax H3v - c1963-71. 35mm SLR. Like the Pentax H-3, but has interchangeable Super-Takumar f1.8/55mm and self-timer. With lens: $60-90.

Pentax K - 1958. Automatic diaphragm stop-down to pre-selected aperture. Interchangeable Auto-Takumar f1.8/55mm lens, shutter to 1000. Central microprism grid added to finder. Also sold as Tower 29 in USA. With lens: $140-170. Body: $100-125.

Pentax S - 1957. Identical to the original Pentax, but with arithmetic progression of shutter speeds, 1,2,4,8,15,30,60,125,250, 500 and interchangeable Takumar f1.8/ 55mm lens. Black rewind knob. $50-75.

Pentax Spotmatic - c1964. First Pentax with through-the-lens exposure metering. Named "Spotmatic" because prototype had spot meter, but production versions have averaging meter. Super Takumar f1.8/ 55mm. FP shutter B,1-1000. $90-120.

ASAHI OPTICAL WORKS

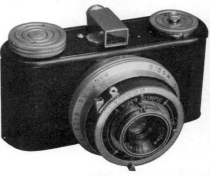

Super Olympic Model D - 1936. Japan's first 35mm camera. Body style similar to Korelle model K. The major difference is that the Korelle was a half-frame and the Super Olympic is full-frame 24x36mm. Uses Contax spools. Ukas f4.5/50mm. $60-80.

ASANUMA TRADING CO.
Kansha-go Field Camera - c1925. Teak and brass field camera for 8x10.5cm plates. With lens: $150-250.

ASIA AMERICAN INDUSTRIES LTD. (Tokyo)

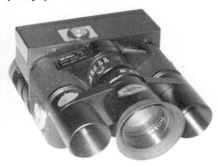

Orinox Binocular Camera, Model AAI-720 - c1978. Camera for 110 film built into binoculars. $75-100.

ASIANA - Plastic 120 novelty camera of the Diana type. $1-5.

ASTRA - Japanese novelty subminiature of the Hit type. $15-20.

ASTROPIC - Japanese novelty subminiature of the Hit type. $12-18.

ATAK (Czechoslovakia)

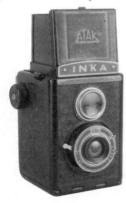

Inka - Bakelite TLR-style box camera, similar to the Voigtländer Brillant. Fixed focus. B,25,75 shutter. $20-30.

ATKINSON, J.J. (Liverpool, England)
Stereo camera - c1900. For 9x18cm. Mahogany body, brass trim, lilac leather bellows. Beck Rectilinear 5" lenses in T-P Stereo shutter 1/30-1/90 sec. One sale in late 1988. $700.

Tailboard camera - ¼-plate size. Mahogany construction with brass landscape lens. $150-200.

Wet-plate Field Camera - c1870? For 12x16.5cm wet plates. Fine wood with brass trim. Square black bellows. Brass barrel lens with revolving stops. $250-350.

ATLAS-RAND
Mark IV - 126 cartridge camera with electronic flash. Made by Keystone. $4-8.

ATOM OPTICAL WORKS (Japan)
Atom-Six-I - c1951. Folding camera for 6x6cm on 120 rollfilm. Eye-level and waist-level finders. Seriter Anastigmat f3.5/75mm, Atom shutter B,1-200. $50-80.

Atom-Six-II - c1952. Similar, but dual-format for 6x6cm or 4.5x6cm on 120. Separate finder for each size. f3.5/75mm Atom Anastigmat. N.K.S. shutter B,1-200. $50-80.

ATOMS (St. Etienne, France)
The ATOMS name is an acronym for "Association de Techniciens en Optique et Mecanique Scientifique", a company founded in 1946 to build twin-lens reflex cameras.

Aiglon - A series of TLR style cameras in which the finder lens is fixed focus, and the objective focuses by turning the front element. Various lenses in Atos I or II shutters. $30-40.

Aiglon Reflex - c1950. A better quality model with coupled Angenieux, Berthiot or Roussel f4.5 lenses. $35-45.

Atoflex - The best of ATOMS' TLR cameras with externally gear-coupled lenses. Angenieux f4.5 or f3.5 objective. Shutter 10-300. $40-50.

ATTACHE CASE CAMERA 007 - c1960's. Sophisticated toy from Japan. A James Bond style attache case with a spy camera, radio, telescope, and decoder. $75-125.

AURORA PRODUCTS CORP.
Ready Ranger Tele-photo Camera Gun - c1974. A thoroughly modern collectible with some interesting features. The actual camera is a "Snapshooter" slip-on camera for 126 cartridges, which is little more than a lens and winding knob. The most interesting

part is an outlandish telephoto attachment, shaped like a giant blue bazooka with a folding stock. In new condition with the original box: $20-40. Camera & tele lens only: $10-20.

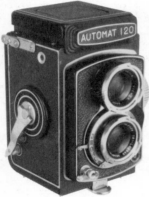

Automat 120

Tom Thumb Camera Radio

AUTOMAT 120 - Japanese TLR. Tri-Lausar lens in Rectus shutter. Crank film advance. $40-60. *(Illustrated in previous column.)*

AUTOMATIC RADIO MFG. CO. (Boston) Tom Thumb Camera Radio - c1948. A great combination of a 4-tube portable radio and a plastic reflex novelty camera, all in a wooden body with gray and red exterior. Identical in appearance to the "Cameradio" of Universal Radio Mfg. Co. Sells in Europe for double the USA price of $95-125. *(Illustrated bottom of previous column.)*

B & R Manufacturing Co. (NY)

Photoette #115 - Small metal box camera with cardboard back. Covered with leather-pattern black fabric. 4.5x6cm on 127 film. Not common. $20-30.

B & W Manufacturing Co. (Toronto, Canada)
Press King - c1948-50. 4x5" press camera, similar to the Crown Graphic. Lightweight metal body, double extenion bellows, drop-bed, revolving spring back. $125-160.

BABETTE - Hong Kong novelty camera for 127 film. Also sold with the "Bazooka" name as a chewing gum premium. Various colors. $2-6.

BABY CAMERA - Small novelty "Yen" camera, available in both folding style and box type. Paper covered wood with ground glass back. Takes single sheets of film in

paper holders for 3x4.5cm negatives.
Folding style: $20-30. Box style: $15-25.

BABY FINAZZI - c1950. Made in Baden, Switzerland. Box camera for 6x9cm on 120 rollfilm. Red leatherette, red lacquered metal parts. $30-50.

BABY FLEX - c1950. Japanese subminiature TLR for 13x14mm exp. on 17.5mm paper-backed rollfilm. Sanko f3.5/20mm lens in Peace Model II shutter 1/25, 1/150. A rare subminiature. $400-600.

Baco Press Club

**BACO ACCESSORIES CO.
(Hollywood, CA)
Baco Press Club, Model B** - c1950. Heavy, rigid-bodied cast metal press camera for 2¼x3¼" film holders. $50-65. *(Illustrated bottom of previous column.)*

**BAIRD (A.H. Baird, Edinburgh Scotland)
Single lens stereo camera** - Tailboard style camera with sliding lensboard to allow either single or stereo exposures. Mahogany with brass fittings. Roller-blind shutter. $450-500.

Tropical Field Camera 5x7" - Brass bound field camera of light wood. Square-cornered bellows. $250-350.

BALDA-WERK (Max Baldeweg, Dresden) *After WWII, the Dresden factory remained, eventually becoming a part of the VEB Pentacon. The post-war cameras listed here are from Balda-Bünde in West Germany.*

AMC 67 Instant Load - c1967. A very basic camera for 126 cartridges. Normally we would not devote much space or time to this type of camera, but for those who collect special edition and premium cameras, this apparently was made for use by American Motors Co. as a sales promotion. $5-10.

Baldafix - Folding camera for 6x9cm on rollfilm. Enar f4.5/105 in Prontor. $20-30

Baldak-Box - c1938. $10-15.

Baldalette - c1950. Folding 35mm. Schneider Radionar f2.9/50. Compur Rapid or Pronto shutter. $35-50.

Baldalux - c1952. Folding camera for 6x9cm or 4.5x6cm on 120 film. Radionar f4.5 lens in Prontor SV shutter with body release and DEP. Eye level and reflex finders. $25-40.

Baldamatic I - c1959. 35mm rangefinder camera with non-changeable f2.8/45mm Xenar in Synchro-Compur. Bright frame finder with auto parallax correction. Match-needle metering. $40-60.

BALDA (cont.)

Baldamatic II - c1960. $40-60.

Baldamatic III - c1960. Similar, but interchangeable lenses. $75-100. (extra lenses additional).

Baldax 6x6 - c1935. Folding camera for 6x6cm on 120 film. Trioplan f2.9/75mm in Compur or Compur-Rapid. Newton finder with manual parallax adjustment. $30-40.

Baldax V.P. - c1930's. Compact folding camera for 16 exp. 4.5x6cm on 120 film. Available in a large variety of lens/shutter combinations, f2.8-f4.5. $30-40.

Baldaxette Model I - c1936. For 16 exp. 4.5x6 cm on 120 film. f2.9/75 Hugo Meyer Trioplan or f2.8/80 Zeiss Tessar. Rimset Compur or Compur Rapid shutter with self-timer. $60-80.
Model II - For 12 exp. 6x6cm on 120. CRF. $75-125.

Baldessa - c1957. Basic 35mm with bright frame finder. No meter or rangefinder. Baldanar, Westanar, or Color Isconar f2.8/45mm, non-interchangeable. Vario or Prontor SVS. $10-20.

Baldessa Ia - Baldanar f2.8/45mm in Prontor SVS shutter. $25-40.

Baldessa Ib - c1958. 35mm, BIM, CRF, bright frame finder. f2.8 Isco lens. $25-40.

Baldessamat F, RF - c1963-66. 35mm with Baldanar f2.8/45mm lens in Prontor-Lux-B 1/30-500 sync shutter. The "RF" has built-in rangefinder. $20-30.

Baldi - c1930's. For 16 exp. 3x4cm on 127. f2.9 or 3.5/50mm Trioplan. $40-65. *(Illustrated top of next column.)*

Baldina - c1930's. Folding 35, similar to the early folding Retina Cameras. Common combinations include: f3.5/50 Baldanar, f2/45 Xenon, f2.9/50 Xenar. Prontor-S or Compur Rapid shutter. $30-45.

Balda Baldi

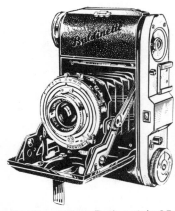

Baldinette - c1951. Retina-style 35mm. Various shutter/lens combinations. $30-50.

Baldini - c1950. Retina-style folding 35mm camera, similar to the Baldinette. $20-40.

Baldix - c1952. Self-erecting folding camera, 6x6cm on 120. Baltar f2.9/75mm or Ennagon f3.5 in Prontor SV. $25-45.

Baldixette - c1950's. 6x6cm rollfilm camera with telescoping front. Baldar f9/72mm in B,M shutter. $10-15.

Doppel-Box - c1933. Metal box camera with leather covering. Dual format, 6x9cm or 4.5x6cm on 120 film. Two brilliant finders and folding frame finder. Universal Doppel f11 lens. Z,M shutter. Built-in portrait lens. $4-8.

Erkania - c1938. Box camera, 6x9cm on 120. Juwella Anastigmat f6.3/105. $15-25.

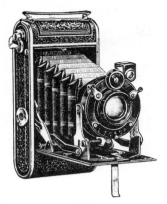

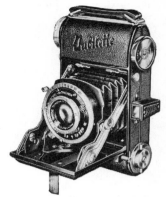

Fixfocus - c1938. Self-erecting dual-format folding bed camera for 6x9cm or 4.5x6cm on 120 film. Normally with Trioplan f4.5/105mm in Pronto. $15-20.

Front-Box - c1936. Metal box with leatherette covering. Nicely styled front with chrome edges shield under lens. Germany: $10-15. USA: $15-25.

Gloria - c1934. Folding camera for 6x9cm or 4.5x6cm on 120 film. Folding eye-level finder and small reflex finder. Trioplan f3.8 in Compur. $20-35.

Glorina - c1936. Folding 6x9cm rollfilm camera. Various shutter/lens combinations including Trioplan f3.8/105mm in Compur S, 1-250. Waist-level and folding optical finders. $30-45.

Jubilette - c1938 (the 30th anniversary of Balda-Werk, thus the name). Folding 35mm similar to Baldina. f2.9/50mm Baltar or Trioplan. Compur shutter. $20-40.

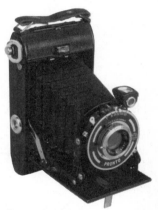

Juwella - c1939. 6x9cm folding rollfilm camera. f6.3 or f4.5 Juwella Anast. Prontor T,B, 25-125, self-timer. $25-35.

Mickey Rollbox - Small box cameras for 4x6.5cm exposures on 127 film. Original advertising featured the Disney characters, but the cameras are rather simple. Several variations: Model I: Meniscus lens. Model II: Double lens. Two-zone focusing. Built-in close-up lens. Cable release socket. Two tripod bushes. $30-50.

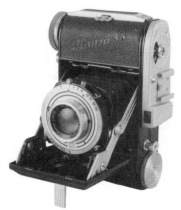

Hansa 35 - c1948-50. Folding 35mm camera styled like Retina. Also sold under other names such as Central 35, etc. Westar f3.5/50mm in Prontor-S 1-300, B. $30-40.

Piccochic - c1932. Vest-pocket camera for 16 exp. 3x4cm on 127 film. Normal lens: Ludwig Vidar f4.5/50mm. Also available: f3.5 Trioplan, f2.9 Vidonar, f2.9 Schneider Xenar, f3.5 Elmar. Compur, Prontor, or Ibsor shutters. New prices ranged from $12.50 to $37.50. With Elmar: $125-175. With other lenses: $35-60. *(Illustrated top of next page.)*

Balda Piccochic

Pierrette - c1934. Unusual folding 4x6.5cm rollfilm camera with leather covered "barndoor" front doors and strut-supported front. Trioplan f3.5/75 in Compur 1-300 or Pronto 25-100. Folding optical finder. Uncommon. $150-200.

Pinette - c1930. 3x4cm. Trioplan f2.9/50mm in Compur. $75-95.

Poka - c1929-38. Metal box camera for 6x9cm exp. on 120 rollfilm. Meniscus lens, simple shutter. $15-30.

Pontina - c1938. Self-erecting rollfilm camera for 6x9cm on 120. Trioplan f3.8/105mm; Trioplan, Trinar, or Radionar f4.5; Tessar f4.5 or f3.8. Prontor or Compur shutter. $25-40.

Primula - 1930's. Box camera for 6x9cm. Similar to Rollbox. $10-15.

Rigona - c1936-42. Folding camera for 16 exp. 3x4cm on 127 film. Similar to the Baldi.

Normal lenses: f4.5 Vidanar, f2.9 Schneider Radionar, f2.9 Meyer Trioplan. Prontor shutter. $50-75.

Rollbox 120 - c1934. All metal 6x9cm box. Unusual variant with brown covering: $35-50. Normal models, common in Germany: $8-12.

Springbox - c1934. Uncommon strutfolding vest-pocket camera for two formats on 127 film. Takes 4x6.5cm or 3x4cm on 127 film. Doppel-Objectiv f11. $30-45.

Super Baldax - c1954-57. Folding rollfilm camera with CRF. 6x6cm on 120 film. Schneider Radionar f2.9/80mm in Prontor SV 1-300,B; Balda Baltar f2.9 in Prontor SVS 1-300, B; or Enna Ennit f2.8/80 in Synchro Compur 1-500,B. $60-90.

Super Baldina (bellows style) - c1937-1940. Folding "Retina-style" 35mm with CRF. Trioplan f2.9, Tessar f2.8, Xenon f2. Compur or Compur Rapid. $45-70.

Super Baldina (telescoping front) - c1955. 35mm cameras, with or without RF. $40-50.

Super Baldinette - c1951. CRF, f2 lens. Also sold as Hapo 35 by Porst. $45-65. *(Illustrated top of next page.)*

Balda Super Baldinette

Super Pontura - c1938. Folding camera, for 8 exp. 6x9cm on 120 film, adaptable for 16 exp. 4x6cm. CRF, automatic parallax compensation. f3.8 or 4.5 Meyer Trioplan. Compur Rapid to 400. Uncommon. $200-300.

BALLIN RABE (Germany)
Folding plate camera - 9x12cm. DEB. RB. Meyer Aristostigmat f6.8/135mm in Compound. $35-50.

BAN - c1953. Small Japanese camera for 28x28mm on Bolta-size film. f2.8/40mm Sunny Anastigmat. Uncommon. $75-125.

BANIER - Plastic Diana-type novelty camera. $2-6.

BANNER - Diana-type camera. $2-6.

BAOCA BC-9 - c1985. Novelty 35mm camera from Taiwan. Small pseudo-prism. Retractable lens shade. $1-5.

BARCO - c1954. Japanese novelty subminiature of the Hit type. Simple fixed-focus lens, single-speed shutter. Unique construction- front half is cast aluminum. Shutter housing appears to be copper, not brass. In colors. $25-35.

BARON CAMERA WORKS
Baron Six - c1953. Horizontally styled self-erecting camera for 6x6cm and 4.5x6cm images on 120 film. Ciskol Anastigmat f3.5/80mm in N.K.S. shutter B,1-200. $45-60.

BARTHELEMY
Stereo Magazine Camera - c1905. Leather-covered wooden box camera for stereo exposures on 45x107mm plates. Changing mechanism for 12 plates. Guillotine shutter. $250-300.

BAUCHET (France)

Mosquito I - c1962. Plastic camera with rectangular telescoping front. Made by Fex for the Bauchet firm. Similar to the Ultra Fex. No sync or accessory shoe. $15-20.

Mosquito II - c1962. Like the Mosquito I, but with accessory shoe and flash sync. $15-20.

BAUDINET INTERNATIONAL
Pixie Slip-On - Lens & shutter assembly which snaps onto a 126 film cartridge to form a camera. $1-3.

BAUER - folding camera for 8 exposures 6x9cm or 16 exposures 4x6cm on 620 rollfilm. Schneider Radionar f4.5/105. Vario sync. shutter. $15-25.

BAZIN & LEROY (Paris)
Le Stereocycle - c1898. Jumelle-styled stereo camera for 12 plates 6x13cm. Ross Rapid Rectilinear lenses. Guillotine shutter. $250-300.

BEAR PHOTO CO. (California)

Beck Cornex Model A

Bear Photo Special - Simple metal box camera for 6x9cm. Made by Ansco for the Bear Photo Co. Decorative front plate with outline of bear. $25-35.

BEAURLINE INDUSTRIES INC.
(St. Paul, Minnesota)

Frena - c1897. Detective box magazine cameras for special sheetfilms. Three sizes: 2⅝x3½, 3¼x4¼, 4x5". More common and half as expensive in England. $100-150.

Frena Presentation Model - c1897. Deluxe version of the Frena, in the same sizes. Covered with brown calves leather. Polished brass fittings. $1200-1500.

Imp - A disposable mail-in camera, factory loaded. Plastic body covered with bright red or yellow paper. Camera is self-addressed to the processing lab. $10-15.

Pro - c1954. Disposable mail-in 35mm plastic camera, factory loaded with 12 exposure Ansco film. $10-15.

BECK (R & J Beck, Ltd., London)
Cornex Model A - c1903. Drop-plate magazine box camera. Wood body with leatherette covering. Quarter-plate size. Single Achromatic f11 lens. Shutter: T, 10, 20, 40, 80. Automatic exposure counter. $40-50. *(Illustrated top of next column.)*

Bedfordflex

Hill's Cloud Camera - c1923. Flat, square mahogany body with extreme wide angle lens. Designed by Robin Hill to photograph the entire sky on a 3¼x4¼" plate. An entire hemisphere was reduced to a 2½" circular image. One failed to reach its estimate of $3700 in a July of 1988 auction.

Zambex - c1911. Leathered mahogany folding camera for 3¼x4¼" cut film in Zambex Skeleton (not plate). Nickel trim. Various shutters/lenses. Rare. $300-400.

BEDFORDFLEX - Twin lens novelty camera for 4x4cm on 127 film. $5-10. *(Illustrated bottom of previous page.)*

BEICA - Japanese "Hit" type novelty camera. $10-15.

BEIER (Kamera-Fabrik Woldemar Beier, Freital, Germany) *Several major reference books have misspelled the name of this company. In an effort to keep the incorrect spellings from proliferating, we would like to affirm that the first name is spelled with an "o" and that the last name is NOT "Bayer".*

*Beier-Flex with rare
Rodenstock Imagon 12cm lens*

Beier-Flex - c1938. 2¼x2¼" SLR, similar to the Reflex-Korelle. First model has FP shutter 1/25 to 500. Second model has 2 sec to 500. Xenar f3.5/75mm lens. A fine example of the first model sold at a German auction in April 1988 for $880. Data for the second model indicates $200-250.

Beiermatic - c1961. Trioplan f3.5/45mm in Juniormatic Auto shutter. BIM. $15-20.

Beira (bed-type) - c1936? Horizontally-styled 35mm camera, self-erecting front. No rangefinder, but top housing looks as though it were designed to include one. Trioplan f2.9/50mm lens in Compur (with Balda faceplate). Helical focusing. Only one recorded sale, at auction in 1986 for $95.

Beira (strut-type) - c1930. 35mm camera with pop-out front supported by scissor-struts. Dialytar f2.7/50mm. Originally for non-standard film and without rangefinder. Later modified for standard 35mm film and unusual prismatic telescopic rangefinder added. This was called Model II in German advertising, but not in U.S.A. ads. Compur or Compur Rapid. Rangefinder model: $250-350. Without RF: $125-175.

Beirax - c1930's. Folding 6x9cm rollfilm camera. E. Ludwig Victar f4.5/105. Prontor or Vario shutter. $15-20.

Beirette (folding type) - ca. late 1930's compact, horizontal style folding 35mm. Cast metal body, leather bellows. Rodenstock Trinar lens: f2.9, 3.5, or 3.9 in Compur or Compur Rapid shutter. $100-175.

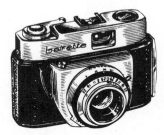

Beirette (rigid type) - c1966-on. Low cost East German 35mm cameras, various models, which were sold new as late as 1981 for $24. Used value $10-20.

Beirette K - c1960's. From VEB Beier, a version of the Beirette for Rapid cassettes. Meritar f2.9/45, Model II shutter. $10-15.

Beirette VSN - c1960's. Inexpensive 35mm. Meritar f2.8/45 in Priomat 3-speed shutter with weather symbols. $10-15.

Edith II - c1925-33. Folding plate camera with leather covered aluminum body. Made in sizes for 6.5x9cm or 9x12cm plates. Various lens/shutter combinations, with Fotar f6.3/105mm in Vario. $25-45.

Folding sheet film cameras - 3¼x4¼" or 9x12cm size. Rodenstock Trinar Anast. f4.5 or Betar f4.5 in Compur shutter. $25-35.

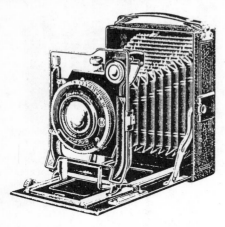

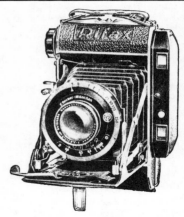

Beier Rifax, Rangefinder model

BELCA-WERK (Dresden)

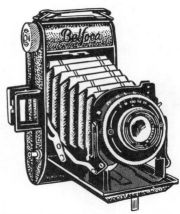

Lotte II - c1925-37. Leather covered aluminum folding plate camera. 6.5x9cm and 9x12cm sizes. DEB. Rack and pinion focus. Various shutters/lenses. $25-45.

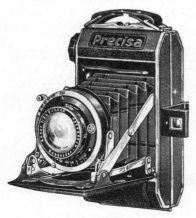

Precisa - c1937. Folding camera for 6x6cm on 120. 75mm lenses range from f2.9 to f4.5. AGC, Compur, or Compur Rapid shutter. $25-45.

Rifax - 6x9cm rollfilm. Rodenstock Trinar f3.8/105. Prontor II, 1-150. $30-50.

Rifax (Rangefinder model) - c1937. Vertical style folding-bed camera for 6x6cm or 4.5x6cm on 120 film. CRF. $60-100. *(Illustrated top of next column.)*

Voran - c1937-41. Self-erecting camera for 6x9cm and 4.5x6cm on 120 rollfilm. Various shutters and lenses. $25-45.

Belfoca - c1952. Folding camera for 8 exp. 6x9cm on 120. Some models are dual format, taking 6x9cm and with 6x6cm or 4.5x6cm. Folding frame finder. Prontor shutter, f4.5 Ludwig Meritar lens. $15-25.

Belfoca II - c1954. Similar to Belfoca, but with finder incorporated in top housing. Bonotar f4.5/105mm in Junior or Tempor shutter. $15-25.

Belmira - c1950s. Rangefinder 35mm. VF window at end of top housing. Rapid wind lever on back. Trioplan f2.9 or Tessar f2.8 in Cludor or Vebur shutter. Also exists under the Welta name. $15-20.

Belplasca - c1955. Stereo 24x30mm on 35mm film. Tessar f3.5/37.5 lenses. Shutter 1-200, sync. Very common in Germany, less common in USA. Popular among stereo

enthusiasts. In excellent working condition: $385-500.

Beltica - c1951. Folding 35mm. Ludwig Meritar f2.9/50 or Zeiss Tessar f2.8/50. Ovus or Cludor shutter. $15-25.

BELCO - Small black-enameled cast metal camera for 36x36mm exposures on 127 film. Extinction meter. $35-50.

BELL-14 - c1960. Novelty 16mm subminiature camera styled like a 35mm. Simple fixed-focus lens, single-speed shutter. $15-25.

BELL & HOWELL (Chicago)
Dial 35 - Half-frame 35mm. Auto wind. Same as Canon Dial 35, but sold under B&H label. With unique molded plastic case: $45-65.

Electric Eye 127 - (originally announced in late 1958 under the name "Infallible".) A heavy all-metal box camera with an automatic diaphragm and a large eye-level optical finder. Normally with silver enamel and black leatherette, but also with black enamel and grey covering. 4x4cm on 127 film. $20-25. *Twice that amount in Europe.*

Foton - c1948. 35mm spring-motor driven, 6 frames per sec. CRF. Original price of $700 (subsequently reduced to $500) made it a marketing failure and it was discontinued in 1950. Asking prices up to $600. Known sales with Amotal f2.2/50mm normal lens: $375-450.
Accessory lenses for Foton:
Cooke 4" - $175-250.
Cooke 12" - $300-450.
Accessory viewfinder - $40-75.

Stereo Colorist I - c1954-60. Stereo camera for 35mm film. f3.5 Rodenstock Trinar lenses. Made in Germany for Bell & Howell. $75-100.

Stereo Colorist II - c1957-61. Similar, but with rangefinder. $100-120.

Stereo Vivid - c1954-60. Leather covered cast aluminum body. Combined rangefinder-viewfinder with spirit level. Steinheil Trinar Anastigmats f3.5/35mm, focus to 2½'.

Shutter 1/10-1/100, MFX sync, with front squeeze release. Common. $120-145.

BELL CAMERA CO. (Grinnell, Iowa)
Bell's Straight-Working Panorama Camera - c1908. Panoramic camera in which neither the film nor lens swings, pivots, or moves, which justified the cumbersome name. This camera is basically an extra-wide folding camera for 5 exp. 3¼x11½" on rollfilm. On some models, knobs on top of camera allow user to change format in mid-roll to 3¼x5½" postcard size, 10 exposures per roll. Scarce. $400-550.

BELL INTERNATIONAL CORP.

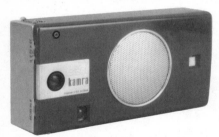

Bell Kamra Model KTC-62 - c1959. Combination 16mm cassette camera & shirt-pocket sized transistor radio. Identical to the Kowa Ramera, but not often found under this name. $100-125.

BELLCRAFT CREATIONS
Can-Tex - Plastic novelty camera, "Cardinal" type, for 16 exp on 127. $3-6.

BELLIENI (H. Bellieni & Fils, Nancy, France)

Jumelle - Trapezoidal, leather covered wood camera with magazine back for 9x12cm plates. Zeiss Protar f8/136mm or Goerz Doppel Anast. $200-300.

Stereo Jumelle - c1894. 6x13cm or 9x18cm stereo plate cameras, magazines backs. Some versions could also take panoramic exposures. Goerz or Zeiss lenses in aluminum barrel with brass diaphragm ring. 6 speed shutter. $150-300.

BENCINI (Milan, Italy) *Originally founded in 1937 as I.C.A.F., then C.M.F., and finally Bencini.*

Comet II

Comet S

Animatic 600 - c1955. Cassette camera for 126 film. $1-5.

Comet, Comet II, Comet S - c1948. A series of cast aluminum cameras for 4x4cm & 3x4cm on 127 film. Model II has telescoping front and focusing lens. $10-20. *(Comet II and Comet S illustrated bottom of previous page.)*

Comet 3, III - c1953. Unusual 3x4cm rollfilm camera styled vertically like a movie camera. Shutter B, 50. Model 3 is fixed focus, Model III has helical focus. $30-60.

Comet NK 135 - Simple cast metal and plastic 35mm camera. Color Bluestar 50mm f2.8 in 3-blade shutter with release button on front of body. $20-40.

Cometa - c1959. Cast aluminum camera for 4x4cm on 127 film. Integral accessory shoe cast into bottom. Aplanatic f8/55mm. Shutter B,50,100. $10-15.

Eno - Inexpensive 6x9cm rollfilm camera. $15-25.

Gabri - c1938. Metal box camera for 4x6cm on rollfilm. (Made by C.M.F. before it became Bencini.) f11/75mm lens in B,30 shutter. $15-25.

Koroll - c1951. Cast aluminum camera for 6x6cm on 120 film. Telescoping front. f11/150mm Achromatic. Shutter B,50. $10-20.

Koroll 24 - c1953. 16 exposures on 120 film. Achromatic lens, shutter B,50. $15-25.

Koroll S - c1953. Cast aluminum camera for 12 exposures on 120 film, or 16 exp. with insertable masks. Extensible front. f11 focusing lens. Sector shutter, B, 50. $10-20.

Rolet - Compact 3x4cm rollfilm camera with telescoping front. Shutter will not release unless front is extended and locked. Planetar f11/75mm lens. $20-25.

BENETFINK (London)
Lightning Detective Camera - c1895. ¼-plate. Ilex string-cock shutter. $75-100.

Lightning Hand Camera - c1903. Falling-plate magazine camera for 12 plates 3¼x4¼". $50-75.

Speedy Detective Camera - Falling plate box camera with unusual 10-plate changing mechanism & counter. Guillotine

shutter attached to inner side of hinged front. $75-100.

BENSON DRY PLATE & CAMERA CO.

Victor - Street Camera with cloth sleeve, tank, and tripod. Three-way internal film carrier holds tintypes or direct positive paper in 2½x3½", 1¾x2½" sizes or photo buttons. Below the film plane is a two-compartment storage drawer. Wollensak RR lens, two-speed shutter, helical focusing mount. $100-150.

BENTLEY BX-3 - c1986. Novelty 35mm from Taiwan, styled to strongly resemble a 35mm SLR camera, and with metal weight added inside the plastic body to enhance the illusion of quality. $1-5.

BENTZIN (Curt Bentzin, Görlitz, Germany) *(Succeeded by VEB Primar, Görlitz)* **Folding Focal Plane Camera** - c1902-1930's in different improved versions. Strut-type folding camera with focal plane shutter to 1000. Made in various sizes, 6x9cm to ½-plate. A typical example in 9x12cm size would have Tessar f6.3/150mm. $75-125.

Planovista - c1930. Twin-lens folding camera (NOT a reflex). A "taking" camera

topped by a second "viewing" or "finder" camera. Separate lens and bellows for each half. For 8 exp. 4x6.5cm on 127 film. Meyer Trioplan f3.5/75mm in Pronto shutter, 25-100, T,B. Top lens tilts down for automatic parallax correction. Recent sales: $500-650. *(The Planovista was made by Bentzin to be marketed by the Planovista Seeing Camera Co. Ltd. of London. The design is that of the Primarette, but with a new name.)*

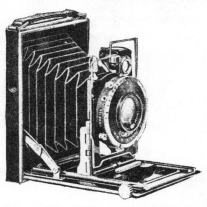

Primar (Plan Primar) - c1938. 6.5x9cm folding plate/sheetfilm camera, double extension. Meyer Trioplan f3.8 or Zeiss Tessar f4.5. Rimset Compur. $70-90.

Primar Reflex - early 1900's through 1950's. Many variations of size and equipment. Typical prices for 6.5x9 or 9x12cm with Tessar f4.5 lens: $150-250.

Primar Klapp Reflex - c1911-1920's. 9x12 cm folding reflex. Meyer Trioplan or Tessar f3.5/210mm. Focal plane shutter 1-300, T, B. $125-200.

BENTZIN (cont.) - BERMPOHL

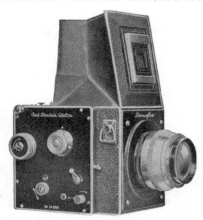

Primarette - c1933-37. Compact twin-lens folding camera as described above under "Planovista". Tessar f2.8 lens. $500-750.

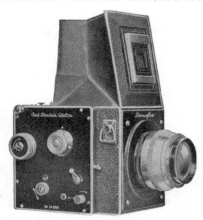

Primarflex (Primar Reflex) - c1936. An early 6x6cm SLR which pre-dates the Hasselblad by over 10 years. f3.5/105 Tessar. FP shutter. Uses rollfilm or single glass plates. (Primar Reflex name appears to have been used after WWII for the same camera which was formerly called Primarflex.) Working: $175-250. With inoperative shutter: $130-160.

Primarflex II - c1951. Similar to the Primarflex, but with interchangeable finder hood and optional pentaprism. Also sold under the name "Astraflex II". Both this and the earlier model tend to have shutter problems. Working: $100-150. Defective: $65-95. *(Illustrated bottom of next column.)*

Rechteck Primar (stereo model) - c1912-1920's. Called "Primar Folding Hand Camera" in English language catalogues. Folding-bed camera with double extension

bellows. Leather covered wooden body. Made in 9x12cm and 10x15cm sizes. Tessar f4.5 lenses in Stereo Compur shutter. $300-500.

Stereo-Fokal Primar - c1923-29. Strut-type focal plane camera for stereo exposures on 6x13cm plates. Tessar f4.5/ 120mm lenses. $200-300.

Stereo Reflex - c1920's. 6x13cm stereo reflex. GGB. FP shutter 20-1000. Roja Detective Aplanat f6. $400-450.

Stereo Reflex Primar - c1918-30. Reflex-style stereo camera for 6x13cm plates. Focal plane shutter to 1000. Tessar f4.5/ 120mm lenses. $250-450.

BENTZIN (Richard Bentzin, Germany) Landschaftskamera - c1890. Huge 30x40cm folding tailboard wooden camera with brass trim. Double extension blue/grey square bellows with red corners. With Goerz Doppel Anast. Ser. III No. 5 f4.6/270mm lens, one sold at auction in 9/87 for $210.

BERA - *There is no such camera name, but the word "Vega" in Cyrillic letters somewhat resembles "Bera" in Roman script. See Maschpriborintorg Vega.*

BERMPOHL & CO. K.G. (Berlin, Germany) *Two distinctive designs in color-separation cameras were produced by Bermpohl. Miethe's Three-color camera took succesive exposures on a shifting plate. Bermpohl's Naturfarbenkamera (natural color camera) used beam-splitting mirrors to expose three plates at the same time.*
Bermpohl's Naturfarbenkamera - A beautifully constructed teakwood beam-splitting tri-color camera made in 9x12cm, 13x18cm (5x7"), and 18x24cm sizes. These rarely appear on the market, and are of

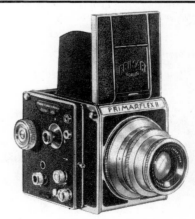

Bentzin Primarflex II

71

interest to a limited number of collectors. Sales in the early 1980's were $1800-2200, but recent auction sales have been as low as $1100. Current estimate: $1100-1700.

Bildmeister Studio Camera - c1950. Wooden 9x12cm monorail view. Brown square bellows. Since it is a very usable camera, it's price without lens: $250-375.

Miethe/Bermpohl Camera - c1903. Folding bed camera of polished mahogany with brass trim. Wine red bellows. Tall sliding back allows for three successive exposures through blue, green, and red filters. Goerz Doppel-Anastigmat f4.6/180mm or Goerz Dogmar f4.5/190mm lens. $1800-2500. Companion viewer, a 3-tiered wooden box with tilting base sells for about $1500.

BERNARD PRODUCTS CO.

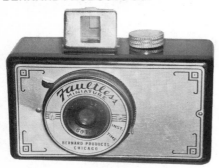

Faultless Miniature - c1947. Boxy bakelite minicam for 3x4cm on 127 film. Metal art-deco faceplate. $5-10.

BERNER (W.Heinz Berner, Erfurt, Germany)
Field camera, 13x18cm - c1895-1900. Wooden view camera with brass trim. Double extension tailboard. Tapered green bellows with wine red corners. Brass barrel lens with rollerblind shutter. $150-200.

BERNING (Otto Berning & Co., Düsseldorf, Germany) *Currently known as Robot Foto & Electronic GmbH & Co. K.G., the*

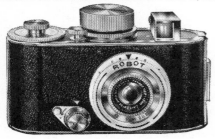

Berning Robot I

company was founded in 1933 and its first camera presented at the 1934 Leipzig Spring Fair.

Robot I - c1934. For 1x1" exp. on 35mm film. Spring motor automatic film advance. Zeiss Tessar f2.8/32.5mm lens. Rotating shutter 2-500. The Robot I requires special supply and take-up cassettes which open automatically inside the camera, and close when the camera is opened. Includes built-in lever-actuated green filter. Serial numbers below 30,000 with no letter prefix. $150-200. *(Illustrated bottom of previous column.)*

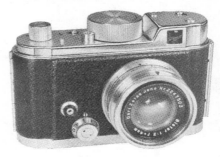

Robot II - c1939-1950. Improved model of Robot I. Built-in flash synchronizer, but no filter. Enlarged finder housing includes right-angle finder. Various lenses f1.9, f2.8, f3.8, in 37.5 or 40mm focal lengths. Serial number has "B" prefix. $115-145.

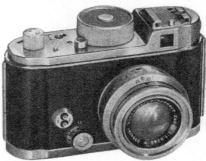

Robot IIa - c1951-53. Similar to II, but takes standard 35mm or special Robot cartridges. Has accessory shoe. Double flash contacts on front. Available with tall double spring. "C" serial numbers. $100-140.

Robot Junior - c1955-58. Similar to IIa, but without right-angle viewing. Schneider Radionar f3.5/38mm. "J" serial prefix. $100-140.

Robot Luftwaffe Model - 1940-45. Most commonly found with 75mm lens. Note the tall winding grip. "F" serial prefix. Not uncommon, but often overpriced by hopeful sellers. Some counterfeits have been made

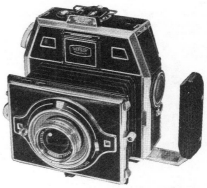

from civilian models. With Tele-Xenar lens: $200-300. With Biotar: $175-225.

Robot Recorder 24 - With Tele-Xenar f4/75mm: $200-250.

Robot Royal 24, III - c1954. Newer style but still 24x24mm exposures. 24 has "G" serial prefix; III has "H" prefix. $250-350.

Robot Royal 36 - c1956. 24x36mm full-frame, rather than the 24x24mm of the other models. "Z" serial prefix. $200-250.

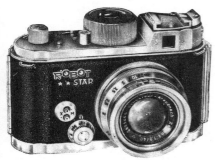

Robot Star - c1952-59. f1.9 Xenon. MX sync. "D" serial prefix. $175-250.

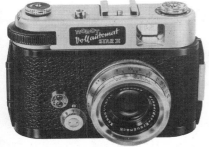

Robot Star II - c1960. New body style.

"L" serial prefix. $100-150.

Robot Star 50 - $165-215.

BERTRAM (Ernst & Wilhelm Bertram, Munich, Germany)

Bertram-Kamera - c1954-56. Press-type camera for 2¼x3¼" exposures. Unusual design for a press camera, with no bed. CRF. Parallax compensation. Tilt and swing back. Rack & pinion focus. Lenses are bayonet-mounted, rather than using interchangeable lensboards as did most contemporary press cameras, and the viewfinder automatically matches the lens in use. Lenses include Schneider Angulon f6.7/65mm wide angle, Xenar f3.5/75mm, Xenar f3.5/105mm normal, and Tele-Xenar f5.5/180mm. Synchro-Compur 1-400 shutter. With normal, WA, and tele lenses: $500-800. With normal lens only: $300-350.

BERTSCH (Adolphe Bertsch, Paris)
Chambre Automatique - c1860. A small brass box camera with fixed-focus brass barrel lens, and a permanently attached wooden plateholder designed for 2½x2½" wet plates. The camera case also housed the equipment and chemicals to prepare and develop plates in the field, while an outer case served as a darkroom. A museum-quality collectible. Estimated value $5000. Stereo version (c1864) would likely bring $6000-7000.

BESTA - Bakelite minicam for 3x4cm on 127 rollfilm. $3-7.

BIAL & FREUND (Breslau, Germany)
Field Camera, 13x18cm - c1900. Walnut wood with brass trim. Tapered green double extension bellows with leather corners. Brass lens with waterhouse stops. $225-250.

Plate Camera, 9x12cm. - c1890. f8 Anastoskop Meniscus lens. $75-125.

Magazine Camera - c1900-05. Falling-plate type box camera for 12 plates, 9x12cm. Guillotine shutter. Two stops. $75-100.

BIANCHI (Alfred Bianchi, Florence Italy)
Tropical Stereo Camera - Folding-bed style camera with polished walnut body, brass trim. $550-650.

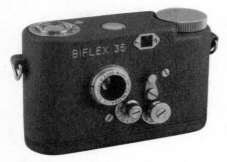

BIFLEX 35 - An unusual Swiss submini-ature for 11x11mm exposures in staggered vertical pairs on 35mm wide rollfilm. Meyer Görlitz Trioplan f2.8/20mm. Shutter 10-250. Quite rare. $600-900.

BILLCLIFF (England)
Studio Camera - c1880. Fine wood body, triple extension track. 9x14cm or ¼-plate size. Black square bellows. Brass lens. Two auction sales in 1988 at $140 and $890.

BILORA (Kürbi & Niggeloh)
Bella (4x6.5 cm) - Cast aluminum eye-level camera for 8 exposures, 4x6.5cm on 127 film. All black enamel or blue-grey combination. $10-20.

Bella 35 - c1959. Simple cast aluminum camera for standard 35mm film. Trinar f2.8/45mm in Pronto. $10-20.

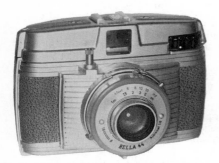

Bella 44 - c1958. Cast metal camera for 4x4cm exp. on 127 film. Styled like a 35mm camera. $8-12.

Bella 46 - c1959. Similar to the previous Bella cameras, but for 4x6cm on 127 film. Grey covering. $8-16.

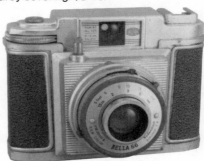

Bella 66 - c1956. Aluminum body. 6x6cm exposures on 120 film. Grey leatherette covering. $10-15.

Bella D - c1957. For 4x6cm on 127 film. Achromat f8. Shutter 50,100. $10-15.

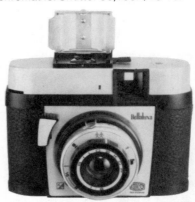

Bellaluxa 4/4 - Rigid bodied camera for 4x4cm on 127. Hinged flash reflector on top. Lever advance with double exposure prevention. Zone focus Biloskop f8. $12-18.

Bellina 127 - Compact camera for 4x4cm on 127. Rectangular collapsible front. Introduced ca. 1964, but still being sold as late as 1980 for $18 new. $10-15.

Blitz Box - c1948-58. Basic metal box camera with flash sync. Two speed shutter. Front lens focus. $15-20.

Blitz Boy - c1950's. Red-brown plastic eye-level camera with flash shoe. Gold trim. $25-35.

Bonita 66 - c1953. Twin-lens box camera covered with imitation reptile skin. Meniscus f9 lens. $20-25. *(Illustrated top of next page.)*

Box Cameras - c1950's. Simple lenses and shutters, some with sync. $5-10.

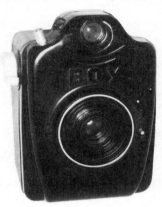

Bilora Bonita 66

Boy - c1950. Small round-cornered bakelite box camera. Brown with gold trim: $30-40. Black: $15-20.

Cariphot - Name variation of Bilora box. Uncommon. $15-20.

Quelle Box - c1950's. Flash sync. $15-20.

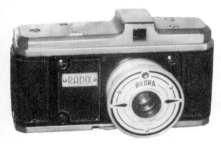

BINOCA PICTURE BINOCULAR - Japan. c1950. 16mm subminiature built into 2.5x opera glasses. Bicon f4.5/40mm fixed focus. Shutter B,25-100. Formerly sold higher, but is now settling in at $400-500 for white model. Red or blue somewhat higher.

Radix - c1947-51. Small 35mm camera for 24x24mm on rapid cassettes. Biloxar f5.6/38mm lens. Simple model has rotary B&I shutter. Better model has f3.5 lens, 5 shutter speeds, plus accessory shoe. A camera in its case in unique original decorative metal box sold for $100 on the strength of the box. The camera itself is common. $20-30.

Stahl Box - c1950. Name variation of Bilora box. $10-15.

Standard Box - c1950's. Exactly as its name implies. It looks like all the rest of Bilora's many metal box cameras. With or without sync for those who object to too much standardization. $10-15.

BING (Germany)
Fita - c1931-36. Simple folding-bed 5x8cm rollfilm camera. Meniscus f11/105mm. M,Z shutter. $20-35.

Birmingham Criterion

BIOFLEX - c1965. Hong Kong. 6x6cm TLR-style plastic novelty camera. Two-speed shutter. Not to be confused with the all-metal Bioflex made by Tokiwa Seiki in Japan. $10-20.

BIRDSEYE CAMERA CORP. (New York, NY)
Birdseye Flash Camera - c1954. Plastic eye-level box camera similar to the Herbert-George Co. Savoy. $5-10.

BIRMINGHAM PHOTOGRAPHIC CO. LTD. (London)
Criterion - c1897. Simple little box camera for 1/16-plates (4x5cm). Uncommon. $75-100. *(Illustrated bottom of previous page.)*

BISCHOFF (V. Bischoff, Munich)

Detective camera - c1890. Box camera for 9x12cm plates. Polished wood body. Aplanat lens, iris diaphragm. Two-speed shutter. $600-800.

BITTNER (L.O. Bittner, Munich)
Roka Luxus - c1923. Folding rollfilm camera with brown bellows and brown lizard-skin covering. Trinar f6.3/105mm in Pronto. Radial focus. Rare. $125-150.

BLAIR CAMERA CO. *Thomas H. Blair applied for a patent in 1878 for a unique camera which included its own miniature dark-tent for in-camera processing of wet collodion plates. This camera, called the Tourograph, was built for him by the American Optical Division of Scovill Mfg. Co. In 1879, Blair incorporated as "Blair Tourograph Co." in Connecticut. In 1881, he moved to Boston and reincorporated as the Blair Tourograph & Dry Plate Co. (shortened to Blair Camera Co. in 1886). In 1890, Blair absorbed the Boston Camera Co., manufacturer of the Hawkeye cameras. In 1899, Eastman Kodak Co. bought Blair Camera Co., moving it to Rochester, N.Y. Beginning in 1908, it was no longer operated independently, but as the Blair Camera Division of Eastman Kodak Co.*

Baby Hawk-Eye - 1896-1898. A small 7 ounce box camera similar to Kodak's Pocket Kodak cameras. Takes 12 exp.

2x2½" on daylight-loading rollfilm. Much less common than the comparable Kodak cameras. $150-175.

Century Hawk-Eye - 1895-96. A leather covered wooden folding plate camera, 6½x8½". Nearly identical to the Folding Hawk-Eye cameras of the same vintage, but the opening for plate holders is at the side instead of at the top. $250-300.

Columbus - Box camera similar to the '95 Hawk-Eye Box, but with integrated rollfilm system and not for plates. $300-375.

Combination Camera - c1882. A 4x5" view camera with an accessory back in the shape of a truncated pyramid which allows it to use 5x7" plates. $250-350.

No. 3 Combination Hawk-Eye Model 1 - 1904-05. Replaced the No. 3 Focusing Weno Hawk-Eye. This camera is nearly identical to the better known Screen Focus Kodak Camera of the same year. The rollfilm back hinges up for focusing on the ground glass. $225-275.

English Compact Reversible Back Camera - c1888-98. Very compact view camera, made in 7 sizes from 3¼x4¼" to

Blair Focusing Weno Hawk-Eye No. 4

10x12". Sunken tripod head in bed of camera. Mahogany body, brass trim. Double extension. $150-275.

Focusing Weno Hawk-Eye No. 4 - 1902-1903. (Advertised as the "Focussing Weno Film Camera" in England). Allowed use of No. 103 rollfilm or 4x5" plates, and groundglass could be used with either. Rollfilm holder pulls out from the top like a drawer. This design was probably the inspiration for the Screen Focus Kodak and Combination Hawk-Eye cameras which appeared in 1904. Double extension red bellows. Wood interior. B&L RR lens. Blair/B&L pneumatic shutter. $325-375.
(Illustrated bottom of previous page.)

Folding '95 Hawk-Eye - c1895-1898. A 4x5 folding plate camera, basically a cube when closed. Similar to the No. 4 Folding Kodak Camera of the same period. Top back door for loading plate holders. Could also use roll holder. $225-275.

Folding Hawk-Eye 5x7 - c1892. Again, a cube-shaped camera when closed. Black lacquered wood with brass trim. Top back door accepts plate holders or Eastman Roll Holder. Model No.1 has built-in shutter. Model No.2 has exterior shutter and more movements. $275-350.

No. 3 Folding Hawk-Eye, Model 3 - 1905-1907. Horizontal format folding rollfilm

camera for 3¼x4¼" negatives. Wood interior. Maroon bellows. B&L RR lens. $35-50.

No. 4 Folding Hawk-Eye, Models 3 & 4 - 1905-13. Horizontal format folding rollfilm camera for 4x5" exp. Red double-extension bellows. Rapid Symmetrical lens. Hawk-Eye pneumatic shutter. Nickel trim. Wood focus rails. $30-50.

No. 4 Folding Weno Hawk-Eye - 1902. Horizontal style folding camera. Polished mahogany interior, leather exterior. Meniscus, R.R., or Plastigmat lens in B&L automatic shutter. $30-50.

Hawk-Eye Camera (Also called Hawk-Eye Detective Camera or Detective & Combination Camera) - 1893-98. Originally made by Boston Camera Co., then continued by Blair. A large polished light wood box camera with brass fittings. Internal bellows focus. No leather covering. Takes 4x5" plates.
--First Blair version - Self-capping shutter cocked by a knob. Just below the knob on the side is a hole through which tension strengths of 1, 2, and 3 can be read. The distance scale window has become a small slit. Time release button on the front, instant release on top. $150-200.

--Improved model - Separate releases on top for time and instant. Distance scale is on the focusing knob on top. $125-175.

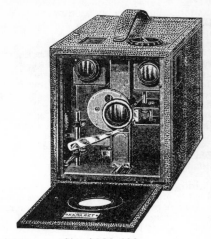

Hawk-Eye Camera (Leather Covered) - 1893-98. Box camera for 4x5" plates in plate holders. Top back door hinges forward to change holders. Leather covered wood construction. Essentially the same as the Hawk-Eye camera above except for the leather covering. $100-150.

'95 Hawk-Eye Box - c1895. Box camera for plates, or will accept Blair rollholder. $300-350.

plates or cut film. $300-400.
- 5x7 size - Relatively rare, valued up to $650.

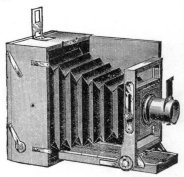

Hawk-Eye Junior - 1895-1900. Box for 3½x3½" on rollfilm or plates. $40-65.

L Lens.
R R Film Rolls.
F F Focal Plane.

Kamaret - intro. 1891. This large box camera (5½x6½x8¾") was advertised as being "one-third smaller than any other camera of equal capacity" because it was the first American box camera to move the film spools to the front of the camera. Made to take 100 exposures 4x5" on rollfilm. Other features included double exposure prevention, automatic film counter, and an attachment for using

Lucidograph - c1885-86. A folding plate camera with all wood body. Front door hinges to side, bed drops, and standard pulls out on geared track. Tapered black bellows. Brass-barrel single achromatic lens with rotating disc stops. Made in several sizes: No. 1 for 3¼x4¼, No. 2 for 4¼x5½, No. 3 for 5x8". 5x8" model also has sliding front. These are not found often. $650-750.

Petite Kamarette - c1892. Small box camera, like the Kamaret but in a "petite" size for 3½" round exposures. $400-500.

Reversible Back Camera - c1895. 6½x8½". With Darlot lens: $200-250.
- Improved Reversible Back Camera - c1890's. 5x7" size. $175-250.

Stereo Hawk-Eye - 1904-07. RR lenses in B&L pneumatic shutter. Single extension wine-red bellows. Leather covered wood body. $250-300.

Stereo Weno (1902-03) - Leather covered, wood bodied stereo rollfilm cameras for 3½x3½" exp. Blair Hawk-Eye models 1 & 2 are from 1904-06. Later models by EKC/Blair 1907-16. Maroon bellows, simple B&L stereo shutter in brass housing. $225-300.

Tourist Hawk-Eye - 1898-1904. Folding rollfilm camera. 3½x3½" or 4x5" size. Plain-looking wooden standard conceals lens and shutter. $120-140. (With optional accessory plate attachment add $50.)

Tourist Hawk-Eye Special - 1898-1901. Horizontally styled folding camera for 4x5" exposures on rollfilm (or plates with accessory back.) Unicum shutter. $100-140.

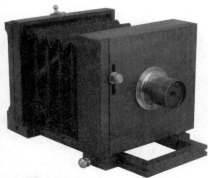

View cameras:
4x5", 5x7" or 5x8" field type - with lens. $125-225.
6½x8½" - with lens. $175-225.
11x14" - $200-300.

No. 2 Weno Hawk-Eye - 1904-1915. Box camera for 3½x3½" on 101 rollfilm. Similar to the "Bulls-Eye" series of the Boston Camera Co. $18-25.

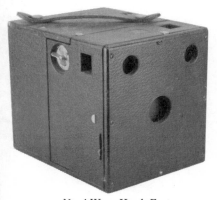

No. 4 Weno Hawk-Eye

No. 3 Weno Hawk-Eye - c1904. 3¼x4¼" box. $18-25.

No. 4 Weno Hawk-Eye - 1904-15. 4x5". Large box camera. Single speed shutter. Two finders. $18-25. *(Illustrated bottom of previous column.)*

No. 6 Weno Hawk-Eye - 1906-07. Box for 3¼x5½" on 125 film. $18-25.

No. 7 Weno Hawk-Eye - 1908-1915. Box camera for 3¼x5½" on 122 rollfilm. Most commonly found model of the Weno Hawk-Eyes. $18-25.

BLAND & CO. (England) *Manufacturers of a variety of cameras for wet collodion plates. Bland & Co. cameras should be individually evaluated. We have seen examples sold at prices ranging from $395 to $3000. The large stereo, sliding-box, and collapsible types are obviously of much greater value than the more common view cameras.*

BLOCH (Edmund & Leon Bloch, Paris, France) *Leon was the manufacturer, while Edmund was the designer.*

Photo-Bouquin Stereoscopique - c1904. Stereo camera disguised as a book with the two objectives and the finder lens in the spine. For 45x107mm stereo plates. The camera is operated with the book cover open, and operating instructions in French are on the "first page". $3000-4000.

Photo Cravate - c1890. An unusual camera designed to be concealed in a necktie with the lens masquerading as a tie-pin. The body of the camera is a flat metal box with rounded ends. Six 23x23mm glass plates are advanced on a roller-chain controlled by an exterior knob. The shutter is released by a concealed bulb release. Estimated current value: $3000-6000.

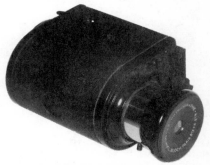

Physio-Pocket - c1904-1907. Camera disguised as a monocular, with deceptive right-angle viewer in eyepiece. f6.3 Krauss Tessar lens is concealed behind a small

round hole in the side. This monocular camera was later sold as the Physiographe. This basic design was later used in the Nettel Argus, Zeiss Ergo, etc. $800-1000.

Physiographe (monocular) - *see description and price under Physio-Pocket above.*

Physiographe (binocular) - A "binocular" version of the Physio-Pocket. The second side is actually a plate changing magazine for 12 plates, 4.5x6cm. $700-1000.

Physiographe Stereo - (Also sold in England as "Watson's Stereo Binocular".) Patented in 1896 and sold until the 1920's, the Physiographe Stereo camera resembles a pair of binoculars (slightly larger than the regular Physiographe). Incorporating the deceptive angle viewfinder in one eyepiece, the other is used as a handle to slide out the plate magazine which is hidden in the second half. Takes 45x107mm plates. Current value: $1000-1500. *Note: the first two models of the Stereo Physiographe used 5x12cm plates, with the earliest model using a leather bag for plate changing rather than the magazine. These early models would naturally be more valuable.*

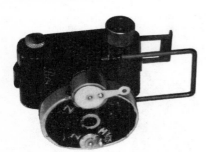

BOBBY - Cast metal subminiature, similar to the Aiglon, but with black enamel finish. $100-150.

BOCHOD (VOSKHOD) - c1970. Cyrillic letters look like "BOCHOD", while Roman-lettered models read "Voskhod", the Russian word for "sunrise". Unusual vertically styled 35mm camera. BIM. Lomo T-48 f2.8/45mm lens. Shutter to 1/250. $65-100. *(Illustrated bottom of next column.)*

BOLLES & SMITH (L.M. Bolles & W.G. Smith, Cooperstown, NY)
Patent Camera Box - c1857. An unusual sliding-box style camera for in-camera processing of single 4¼x6½" wet collodion plates. With this camera, the photographer could sensitize, expose, and develop wet plates entirely within the camera. Patented in 1857, this pre-dates the famous (and less complicated) Dubroni camera. It is also more rare. $4000-6000.

BOLSEY CORP. OF AMERICA (New York) *See also Pignons for Alpa cameras which were designed by Jacques Bolsey before his move to the United States. Cameras designed in the U.S.A. by Bolsey were manufactured by the Obex Corporation of America, Long Island, NY and distributed by Bolsey. After June 1, 1956, all distribution was also taken over by Obex.*

Bolsey B - c1947-56. Compact 35mm with CRF. f3.2/44mm Anastigmat in helical mount. Shutter to 200, T, B. $20-25. Often found with inoperative shutter for $5-10.

Bolsey B (red) - *Both the B and B2 have been offered for sale with red leather covering for*

BOCHOD (VOSKHOD)

about $125 each. In each case these were represented as being original.

Wollensak Anastigmat f3.2 lens. If working $15-22.

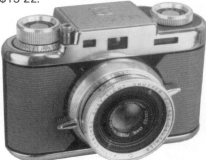

Bolsey B2 - c1949-1956. Similar to the B, but with double exposure prevention and sync shutter. $15-25.

Air Force model - Identical to the B2, except for the top plate which, in typical government language says "Camera, Ground, 35mm" and "Property USAF". $75-100.

Bolsey B3 - 1956. Similar to the 1955 Jubilee, but without the Set-O-Matic system. $20-30.

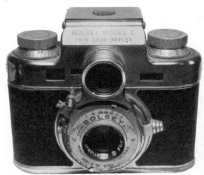

Army model, PH324A - An olive-drab and black version made for the U.S. Army Signal Corps. $75-100.

Bolsey C - c1950-1956. 35mm TLR, CRF. f3.2/44mm Wollensak Anast. Wollensak shutter, 10-200, B,T, synch. $60-75.

Bolsey C22 - c1953. Similar to C, but with Set-O-Matic. $60-75.

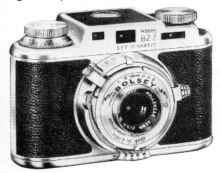

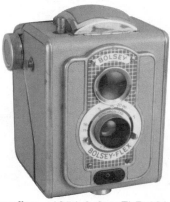

Bolsey B22 - c1953. Set-O-Matic.

Bolseyflex - c1954. 6x6cm TLR, 120 film. f7.7/80mm lens. Made in Germany by Ising for Bolsey. The earlier model has a smaller

finder hood and "Bolsey-Flex" is hyphenated. The later model has a larger finder hood which covers the shutter release, and "Bolseyflex" is not hyphenated. The same camera models were also sold by Sears under the Tower name. $15-25.

Explorer - c1955. f2.8 lens. Rapid wind. $20-30.

Explorer "Treasure Chest" outfit - In special display box with flash, case, instructions, guarantee, etc. $45-60.

Jubilee - c1955-56. 35mm camera with coupled rangefinder. Steinheil f2.8/45mm. Gauthier leaf shutter 10-200, B. $30-40.

La Belle Pal - c1952. A simplified and

restyled 35mm camera without a rangefinder. Manual front-element focusing. Wollensak f4.5/44mm anastigmat in Wollensak Synchro-Matic shutter. Originally was to be called Bolsey Model A, but apparently it was only marketed by La Belle as the Pal. Scarce. Formerly sold in excess of $200. Currently: $50-75.

Bolsey 8 - 1956. Still or motion picture camera. Shutter speed variable from 1/50-1/600. Stainless steel body, size of cigarette pack. $100-150.

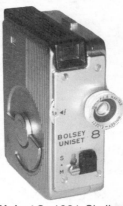

Bolsey Uniset 8 - 1961. Similar to Bolsey 8 but without variable shutter speeds. Rare. $175-275.

Bolsey Reflex - Original model, c1938. Mfd. by Pignons SA, Balaigues, Switzerland. This camera is identical to the Alpa I, both cameras being developed by Jacques Bolsey shortly before he moved to the United States. 35mm SLR. 24x36mm format. Interchangeable lens. Focal plane shutter 25-1000. Focus with ground glass or split-image RF.
-Model A - c1942. Bolca Anastigmat f2.8/ 50mm. $800-1200.

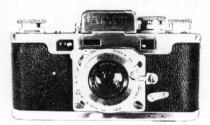

-Model G - c1946. Angenieux f2.9/50mm. $150-250.
-Model H - c1946. Angenieux f1.8/50mm. $200-300.

BOLTA-WERK (later called Photavit-Werk GmbH. Nürnberg, Germany)

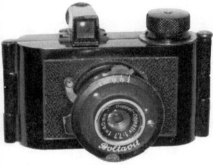

Boltavit - c1936. A small cast metal camera for 25x25mm exp. on rollfilm. Black enameled body or bright chrome plated. Both versions have black leather front panel. Doppel Objectiv f7.7 or Corygon Anastigmat f4.5/40mm lens. $85-135.

Photavit (Bolta-size) - c1937. Body design like the Boltavit, and uses Bolta-size rollfilm. All black body or chrome with black leather front panel. $60-90.

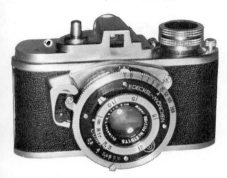

Photavit (35mm) - c1938. Models I, II, III, IV, V. Compact 35mm cameras for

24x24mm exposures on standard 35mm film, but in special cartridges. Film advances from one cartridge to the other. No rewinding needed: the old supply cartridge becomes the new take-up cartridge. Wide variety of shutter & lens combinations. Standard model I, 1938, is black enameled with leather covering. Deluxe model I and all later models are chrome plated with leather covering. $60-80.

Photavit (828) - Post-war version, styled like the chrome and leather 35mm model, but for 828 rollfilm. $60-80.

BOOTS (Nottingham, England) *Boots is a large drugstore chain with branches all over Britain. Cameras were made with their name by Houghton among others. In later years, German, Japanese, & other cameras were also imported and sold under the Boots name. Obviously, Boots cameras are more plentiful in Britain than elsewhere.*

Boots Comet 404-X - Basic 126 cartridge camera made in Italy by Bencini for Boots. $4-8.

Boots Field Camera - 3¼x4¼", brass and mahogany. Planomat lens in roller-blind shutter. $350-400.

Boots Special - c1911. Lightweight compact folding field camera. Mahogany

with brass fittings. Beck Rapid Symmetrical f8 lens. Thornton-Pickard rollerblind shutter. $60-85.

BOREUX (Armand Boreux, Basel, Switzerland)

Nanna 1 - intro. 1909. Folding stereo for 45x107mm plates. Streamlined body with rounded edges and corners. Clamshell-opening front with struts to support lensboard. Suter Anastigmat f6.8/62mm lenses. 3-speed guillotine shutter. Folding frame finder. Unusual design. $300-450.

BORSUM CAMERA CO. (Newark, N.J.)

The Reflex cameras sold by Borsum were apparently the same as those manufactured and sold by the Reflex Camera Co. of Yonkers and later Newark. The two companies share a complex history. Lenses on the cameras vary. Borsum listed no specific lenses in their catalog, stating that any make of lens would be fitted at no charge.
5x7 Reflex - patents 1896-97. c1906. Very early American SLR. Measures 15x11x8½" when closed. FP shutter. $300-350.

5x7 New Model Reflex - c1906. Large box with internal bellows focus. Small front door hinges down to uncover lens. Identical to the 5x7 Reflex of the Reflex Camera Co. $300-350.

BOSTON CAMERA CO. (Boston, Mass.)

Founded in 1884 by Samuel Turner, who later invented numbered paper-backed rollfilm. Boston Camera Co. began marketing the Hawk-Eye detective camera in 1888. In 1890, it was purchased by Blair Camera Co., which continued to market improved versions of the Hawk-Eye cameras. About 1892, Turner left the Blair Co. and started a new company named "Boston Camera Manufacturing Co." which made "Bulls-Eye" cameras. Thus there are two separate "Boston" companies, both founded by Samuel Turner. The first made "Hawk-Eye" cameras and the second made "Bulls-Eye" cameras. It was this second company which held the rights to Turner's numbered rollfilm. George Eastman purchased the company in 1895 to secure those rights.

Hawk-Eye "Detective" box cameras - c1888-1890 as a "Boston" camera, but

continued by Blair after 1890. Large wooden box camera for 4x5" plates. Rotating brass knob at rear focuses camera by means of internal bellows. Certain features distinguish it from the later Blair models: Wire tensioning device on the side; small shutter cocking lever in a curved front depression; top front shutter release; distance scale window on side near center. All wood box model: $200-275. Leather covered model: $150-200.

BOSTON CAMERA MFG. CO. *(see historical note above under Boston Camera Co.)*

Bull's-Eye box cameras - intro c1892. Simple, wooden, leather-covered box cameras for rollfilm. Very similar to the later Blair and Kodak Bull's-Eye cameras, but easily identified by the "D"-shaped red window. Historically important as the first cameras to use numbered paper-backed rollfilm and red windows. $75-125.

BOUMSELL (Paris)

Azur - c1950. A series of folding rollfilm

cameras for 6x9cm on 120 film. $15-25.

Box Metal - c1950. Basic metal box camera for 6x9cm on 120 film. Imitation leather covered. $8-15.

Longchamp - c1950. Simple bakelite reflex-style camera for 3x4cm on 127 film. Similar to Clix-O-Flex. $10-20.

Photo-Magic - c1950. Small bakelite eye-level camera similar to the MIOM. Black or wine-colored. Takes 4x6.5cm photos on 127 film. $15-25.

BOWER (Saul Bower Inc., New York City)
Bower 35 - c1952-1958. Basic 35mm viewfinder camera. Steinheil Cassar f2.8 or Meritar 45mm lens. Prontor-S or SV shutter. $20-25.

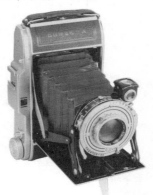

Bower-X Model II

Bower-X - c1951-1958. Folding camera for 620 rollfilm. Models I, II, and 63: $12-18. Colored models: $40-60.

BOX CAMERAS - *The simplest, most common type of camera. Box cameras have been made by most camera manufacturers, and of most common materials from paper to plastic to metal. Many models are listed in this guide under the manufacturer, but to save you the trouble of looking, common boxes usually sell for Five Dollars or less, including sales tax, postage, and green stamps. They can make a fascinating collection without straining the average budget.*

BRACK & CO. (Munich)
Field camera 18x24cm - square cloth bellows (black with red corners) extend backwards. A fine wood and brass camera. With appropriate lens: $175-225.

BRADAC (Bratri Bradacove [Bradac Brothers], Hovorcovice, Czechoslovakia)
The Bradac Brothers began production in the 1930's with the Kamarad I ca. 1936 and the Kamarad II about 1937. At the beginning of 1936, they closed their factory and part of the production was taken over by Optikotechna in Prague. The cameras were renamed Flexette (formerly Kamarad II) and Autoflex (would have been Kamarad IIa). Autoflex does exist with Bradac Prague markings, however. See Optikotechna for the continuation of these cameras.
Kamarad (I) - c1936. TLR for 6x6cm on 120 film. Ludwig Dresden Bellar f3.9/75mm lenses. Prontor II shutter. This was the first camera in the line which became Flexette, Autoflex, Optiflex, etc. from Optikotechna. $75-125.

Kamarad MII - c1937. Same as (I), but with Trioplan f2.9/75mm in Compur 1-250. $75-125.

BRAUN (Carl Braun, Nürnberg, Germany)
Gloria - c1953-60. Eye-level camera for 6x6cm on 120 film. Styled like an oversized 35mm RF camera. Uncoupled rangefinder. Telescoping front. Praxar f2.9/75mm in Pronto 25-200 or Prontor SVS 1-300. $25-40.

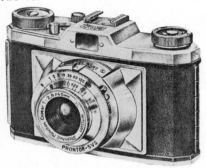

Gloriette - c1954. Non-RF 35mm camera 24x36mm. f2.8/45mm Steinheil Cassar. Prontor SVS shutter. $15-25.

Imperial 6x6 (eye-level) - c1953. Eye-level camera for 6x6cm on 120 film. Bellows with internal struts. Branar f8/75mm. Shutter B,25,75. Built-in extinction meter. $15-25.

Imperial Box 6x6 (twin lens) - c1951. Twin-lens reflex style box cameras. Model S has single speed shutter, fixed focus lens. Model V has synchronized M,Z shutter, 2 stops. $15-30.

Imperial Box 6x9 - c1951. Standard rectangular box cameras. Model S has simple lens, Z,M shutter. Model V has two stops, synchronized Z,M shutter. $15-25.

Nimco - c1960. Export and department store version of the Imperial 6x6 Box. Rare with this name. $20-25.

Norca - c1953. 6x9cm folding rollfilm camera with cast aluminum body. Praxar f8 lens. Shutter 25,75. $15-20.

Pax - c1950. Compact metal camera with square extensible front. For 6x6cm on 120 film. Identical to the Paxina I. $10-20. *(Illustrated top of next column.)*

Paxette I - c1950's. Compact 35mm. Various models. Looks like a rangefinder camera, but actually houses an extinction meter in the second window. $25-40.

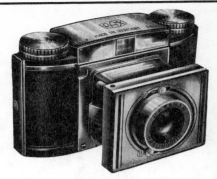

Braun Pax

Paxette IIM - c1953. 35mm camera with uncoupled rangefinder and interchangeable prime lenses. Normal lenses include Cassarit, Staeble-Kata, or Ultralit f2.8/45mm. Interchangeable front elements include: Staeble-Choro f3.5/38mm and Staeble-Telon f5.6/85mm. Body covering in various colors including brown, red, green, grey. $25-40.

Paxette Automatic Super III - c1958. Interchangeable f2.8/50 Color Ennit lens. BIM. $25-40.

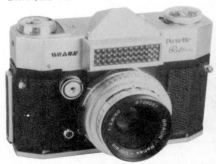

Braun Paxette Reflex Automatic

Paxette Electromatic - c1960-62. 35mm with built-in meter. Model I has fixed focus f5.6, single speed shutter: $8-12. Model II has focusing f2.8, shutter 1/30-300: $10-20. Model Ia has interchangeable f2.8/40mm lens, mounted in front of shutter: $25-35.

Paxette Reflex Automatic - SLR with built-in meter. Braun-Reflex-Ultralit f2.8/50mm in Synchro-Compur 1-500 cross-coupled to diaphragm. $50-75. *(Illustrated bottom of previous column.)*

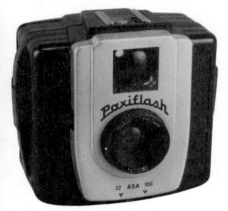

Paxiflash - c1961. Plastic eye-level box camera for 4x4cm on 127 film. Grey body: $20-30. Black body: $10-20.

Paxina I - c1952. Metal camera with square telescoping front. Paxanar f7.7/75mm lens. Shutter built into front has 30, 100, T. $8-12.

Paxina II - 6x6cm rollfilm camera. Round telescoping front. f3.5/75 Staebler Kataplast lens in Vario shutter. $10-15.

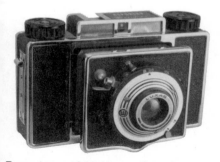

Reporter - c1953. Unusually styled eye-level 6x6cm camera. Extinction meter; extensible front with bellows supported by spring-loaded internal struts. Body is rather sophisticated for the simple 2-speed shutter and Luxar f8 lens. $15-25.

Super Colorette - c1957. 35mm RF cameras.
I - CRF, f2.8, rapid advance. $20-25.
Ib - Meter, 4-element lens. $25-30.
II - Interchangeable lenses. $30-35.
IIb - Like II, but with meter. $35-40.

Super Paxette - 35mm RF cameras, various models including I, IB, IIB, IIBL. Interchangeable lenses include: Xenar f2.8/50mm and Enna Color Ennit. Prontor shutter. $30-60.

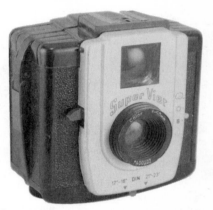

Super Vier - c1965. Inexpensive black plastic camera with hot shoe for flash. As the name implies, it takes 4x4cm negatives on 127 film. Also sold as Paxiflash. Color 50mm lens. Unusual. $15-22.

BRIN'S PATENT CAMERA - London, c1891. A miniature detective camera hidden in an opera glass. Takes 25mm circular plates. f3.5/30 lens, simple front shutter. Very rare. $3000-4500. Replica recently made. $850.

BRIOIS (A. Briois, Paris)
Thompson's Revolver Camera - intro. 1862. Designed by Thompson. Brass pistol-shaped camera with scope, wooden pistol grip, but no barrel. Takes four 23mm dia. exposures in rapid succession on a 7.5cm circular wet-plate. Ground glass focusing through the scope which is above the cylindrical plate chamber. Petzval f2/40mm lens, single speed rotary behind-the-lens shutter. The lens is raised, sighted through to focus, then dropped into place in front of the plate, automatically releasing the shutter. The circular plate was then rotated a ¼ turn and was ready for the next exp. Rare. Estimated value about $15,000.

BRITISH FERROTYPE CO. (Blackpool, England)
Telephot Button Camera - c1911. Like the Talbot Errtee Button Tintype Camera.

1" dia. ferrotype dry plates. Rapid Rectilinear, between-the-lens shutter. $500-900.

BROOKLYN CAMERA CO. (Brooklyn, NY)
Brooklyn Camera - c1885. ¼-plate (3¼x4¼") collapsible-bellows view camera with non-folding bed. $150-200.

BROWNELL (Frank Brownell, Rochester, NY)
Stereo Camera - c1885. A square bellows dry-plate camera for stereo exposures. Historically significant, because Frank Brownell made very few cameras which sold under his own name. He made the first Kodak cameras for the Eastman Dry Plate & Film Co., and was later a Plant Manager for EKC. Rare. No recent sales.

BRÜCKNER (Rabenau, Germany)
Field camera - c1900-10. Tailboard style cameras in various sizes including 9x12cm, 13x18cm, and 18x24cm. Fine wood body, brass trim, square black bellows. $125-175.

Schüler-Apparat (Student camera) - c1905-10. Tailboard camera for 9x12cm plates. Mahogany with brass trim. Voigtländer Collinear III f7.7 lens. String-set shutter built into wooden front. $150-200.

Union Model III - c1920-30. Highly polished mahogany body with much brass trim. Square grey double extension bellows with black corners. Brass-bound Busch Rapid Aplanat f7.5/260 in roller-blind shutter. $400-450.

BRUMBERGER 35 - c1960. 35mm RF camera designed to look like a Nikon S2. Non-changeable f2.8 or f3.5/45mm coated lens in leaf shutter to 300. Made by Neoca for Brumberger. $35-50.

BRUNS (Christian Bruns, Munich)

Detective camera - c1893. An unusual wooden box detective camera for plates. The unique design incorporates an auxiliary bellows with ground glass which mounts piggy-back on top of the camera. The camera lens slides up to double as a lens for this full-size ground glass viewer. Two sizes: 12x16.5cm sold at auction 10/88 for $4500. 9x12cm size: $3000-3500.

BUDDIE 2A - Basic box camera for 2½x4¼"on 116 film. We hope one of our well-versed readers will be able to help us determine the manufacturer of this one. Metal, wood, cardboard construction, with leatherette covering. The only identification is "2A-BUDDIE" on strap. $8-12.

BUESS (Lausanne)

Multiprint - A special camera for 24 small exp. on a 13x18cm plate which shifts from lower right to upper left by means of a crank on the back. Corygon f3.5/105mm lens, rotating shutter 1-100. Reflex finder. *(Only 25 of these cameras were made. We know of only 2 examples. One sold at a German auction in 1976 for $820, the other in late 1984 for $450.)*

BUICK MODEL 1 - Pre-war Japanese folding Ikonta-style camera for 6x6cm on 120 film. "Buick Model 1" on shutter face. This may only be the shutter name, but there is no other name on the camera. Shutter speeds T, B, 25-150. Tritar Anastigmat f3.5 or Kokko Anastigmat f4.5/7.5cm lens. $60-90.

BULL (D.M. Bull, Bullville, N.Y.) Detective - c1892. 4x5" falling-plate magazine camera for 12 plates. Key locks back. Rare. $150-200.

BULLARD CAMERA CO. (Springfield, MA) *Founded about 1895 by Edgar R. Bullard; absorbed into the Seneca Camera Co. about 1902.*

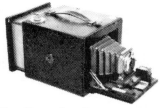

Folding Magazine Camera - c1898. For 18 plates in 4x5" format. First models (rare) were made in Wheeling, West Virginia and were heavier and better made than the later ones made in Springfield, MA. Push-pull action of back advances plates. Front bed hinges down and bellows extend. Unusual, because the majority of the magazine cameras were box cameras, and did not employ folding bed or bellows. $250-300.

Folding plate camera, 4x5" - c1900. Polished mahogany interior. Red bellows. Reversible back. B&L or Rauber & Wollensak lens. Victor shutter. $70-100.

BURKE & JAMES, INC. (Chicago) Cub - c1914. Box cameras. They stand out in a collection of box cameras because they load from the side. Made in 2A, 3, & 3A sizes. $8-12.

Grover - 1940's-1960's. Monorail view cameras in 4x5", 5x7", and 8x10" sizes. Valued as usable equipment rather than collectible, the most important consideration is the shutter and lens, which can vary greatly in value. Without lens or shutter $75-125.

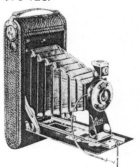

1A Ingento Jr. - c1915. f6.3 lens. $15-20.

3A Ingento Jr. - c1915. Vertical format. Ilex lens. Ingento shutter. $15-25.

3A Folding Ingento, Model 3. - Horizontal format. Ilex lens. Ingento shutter. $15-25.

Korelle - *Marketed by Burke & James, but manufactured by Kochmann. See Kochmann.*

Panoram 120 - c1956-1971. Wide angle camera for 4 exposures 6x18cm (2¼x7") on 120 film. Originally available with Ross f4/5" lens in focusing or fixed focus mount, 1/100 sec single speed shutter. With detachable ground glass back and magazines, we've seen them from $100-550.

PH-6-A - U.S. Signal Corps special wide angle camera for 5x7" filmholders. Wollensak f12.5 Extra Wide Angle lens in Betax No. 2 shutter. $75-100.

Rembrandt Portrait 4x5 - without lens. $150-225.

Rexo cameras:
Box camera - for 6x9cm rollfilm. $5-12.

1A Folding Rexo - c1916-31. For 2½x4¼ on 116 film. Anastigmat lens. $12-18.

1A Rexo Jr. - c1916-24. Folding camera for 2½x4¼ on 116 film. Single Achromatic or RR lens. Ilex shutter. $12-18.

2C Rexo Jr. - c1917-24. Folding camera. $12-18.

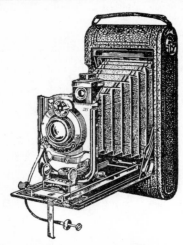

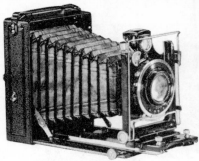

& lens. Identical to Certo Certotrop. $40-65.

Burke & James Folding Rexo

3 Folding Rexo - c1916-31. 3¼x4¼" rollfilm. RR or Anastigmat lens. Ilex shutter. $10-20.

3 Rexo Jr. - c1916-24. 3¼x4¼, single achromatic lens. Ilex shutter. $10-20.

3A Folding Rexo - c1916-24. Postcard-size camera. $15-20.

Vest Pocket Rexo - Wollensak Anastigmat lens in Ultex shutter. $15-20.

Rexoette - c1910. Box camera 6x9cm. $10-20.

Press/View cameras: *Value determined primarily by USABILITY.*
2¼x3¼" & 3¼x4¼" - with lens: $40-60.
4x5" Watson Press - c1940. With f4.7/127mm Kodak Ektar lens: $100-125.
4x5" view - with lens: $150-300.
5x7" view - without lens: $75-150.
8x10" view - Full movements, without lens: $225-450.

Watson-Holmes Fingerprint Camera - 1950's-1960's. A special purpose camera for making 1:1 reproductions of fingerprints or small objects. Front of camera rests on object being photographed and interior bulbs provide illumination. (Military version is called PH-503A/PF). $60-80.

BURLEIGH BROOKS INC. (Englewood, NJ)
Bee Bee - c1938-1941. German folding plate cameras sold in the USA under the "Bee Bee" name (for Burleigh Brooks). Model A for 6.5x9cm, Model B for 9x12cm. Bayonet mount for easy changing of shutter

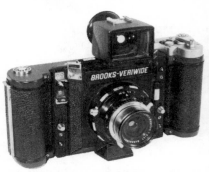

Brooks Veriwide - 1970's. Wide angle camera using the Schneider Super Angulon 47mm lens, f8 or f5.6, on a thin camera body compatible with the Graflex XL system. Price includes any one of the normal backs. f5.6: $600-700. f8: $500-600.

BURR, C.
Stereo camera - Mahogany tailboard camera with square leather bellows, twin brass-barreled Burr lenses and Thornton-Pickard roller blind shutter. $500-750.

Wet plate camera - c1860. Sliding-box style. Polished mahogany with brass barrel lens and brass fittings. Sliding back allows three exposures on a single 3¼x4¼" plate. $2500-3000.

BUSCH, Emil (London, England) *See also Emil Busch Rathenow, below.*
Freewheel, Model B - c1902. Horizontally styled folding rollfilm camera which also allows the use of a ground glass or plate-holders without removing the rollfilm. The name derived from the "freewheeling" advance knob which allowed the film to be rewound onto the supply spool to accommodate the viewing screen or plateholder. Busch f6 lens in Wollensak Regular shutter. One sold at auction in England for $100 in 7/87.

BUSCH, Emil (Rathenow, Germany) *see also Emil Busch London, above.*
Folding Plate Camera - 10x15cm. Double extension bellows. Rapid Aplanat Ser. D f7/170mm. $40-65.

Vier-Sechs - c1920. Strut-folding camera for 4.5x6cm plates. Leather covered wood body. Detectiv-Aplanat f6.8/75mm in Compound 25-100, B,T. Uncommon. $150-175.

BUSCH CAMERA CORP. (Chicago)
Pressman 2¼x3¼ - Miniature press camera. Although sometimes offered at higher prices, there is usually no shortage of good working cameras in the normal range of $60-100.

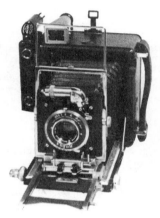

Pressman 4x5 - f4.7 Ektar, Optar, or Raptar lens. Press camera styled like Graphic. $150-250.

Verascope F-40 - c1950's. Stereo camera for 24x30mm pairs of singles. f3.5/40mm Berthiot lens. Guillotine shutter to 250. RF. Made by Richard in France but sold under the Busch name in the U.S.A. Generally considered to be one of the best stereo cameras, and not often found for sale. $350-450.

BUTCHER (W.Butcher & Sons, London)
William Butcher set up in business as a chemist in Blackheath, South London in 1860. However, it was not until c1894 that Butchers began manufacturing photographic goods under the "Primus" trademark. The photographic business was run by Mr. W.F. Butcher and Mr. F.E. Butcher, sons of the founder William Butcher.

The business grew very rapidly so that by February 1902 it moved to Camera House, Farringdon Avenue, London EC. Some cameras and accessories continued to be made at Blackheath and much was bought from contract manufacturers, notably German firms. In fact,

before WWI, the firm was primarily an importer. Before 1909, most of its cameras were made by Hüttig, thereafter by Ica.

The outbreak of war in 1914 caused the cessation of its German supplies and resulted in Butchers pooling manufacturing resources with Houghtons to form the Houghton-Butcher Manufacturing Co. Ltd in 1915. This company made products for both firms which remained separate until their selling operations were finally merged in January 1, 1926 to form Houghton-Butcher (Great Britain) Ltd. Although the Butcher firm had joined forces with George Houghton, and eventually became a part of Ensign Ltd., it still remained a family tradition, and two of Butcher's grandsons were still associated with the Ensign firm in the 1930's. Check Houghton-Butcher for cameras not listed here.

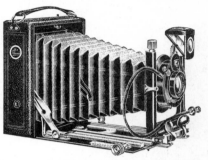

Cameo - A series of folding plate cameras imported from Germany, introduced around the turn of the century and continuing for many years in all sorts of variations. In the common sizes with normal lens and shutter: $40-65.

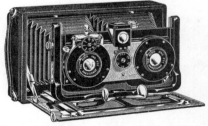

Cameo Stereo - c1906-15. Folding bed style stereo camera for 9x18cm plates. Black covered wood body. Made for Butcher by Hüttig, then Ica. The No. 0 and No. 1 models are simpler, with T,B,I shutter. The No. 2 features rack focusing, DEB, rising front, and shutter speeds to 1/100. Aldis, Beck, or Cooke lens. $125-250.

Carbine cameras - A series of German-made folding cameras primarily for rollfilm, but most models have a removable panel in the back which allows the use of plates as well. Quite a variety of models with

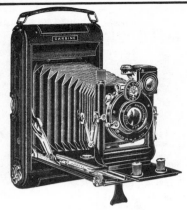

Butcher Carbine No. 5

various lenses and shutters. The models with better lenses and shutters obviously bring the better prices. $30-50.

Clincher - c1913-19. Falling-plate box cameras in several sizes. Wood body with Morocco leatherette covering. T&I shutter. No. 1 takes 6 plates, 2¼x3¼". No. 2 takes 6 plates, 3¼x4¼". No. 3 takes 12 plates, 3¼x4¼". No. 4 takes 6 plates 9x12cm. $20-35.

Dandycam Automatic Camera - c1913-1915. Box camera for ferrotype buttons. Daylight-loading magazine holds 12 plates of 1" (25mm) diameter. Wooden body with Morocco leatherette covering. $350-400.

Little Nipper - c1900. Butcher's name for the Hüttig Gnom. Simple magazine box cameras for glass plates. One model for 4.5x6cm plates, and the larger model for 6.5x9cm plates. Add-on finder is similar to that of the original Brownie camera of the same era. $40-60.

Maxim No. 1 - c1903. A leather covered wooden box camera for 6x6cm exposures on rollfilm. A rather scarce box camera from the days of the first "Brownie" cameras. $35-50.

Maxim No. 2 - Similar, but for 6x9cm images. $25-45.

Maxim No. 4 - for 8x11cm. $25-45.

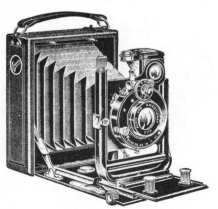

Klimax - 1910's. Folding camera for plates, made by Ica. Aluminum body covered with Morocco leather. In various sizes from ¼ to ½ plate. Model I is single extension, while Model II is double extension. A great variety of shutter and lens combinations were available. $40-50.

Midg - c1902-20. A series of imported drop-plate magazine box cameras in 3¼x4¼" or postcard (3¼x5½") sizes. The No. 0 is the simplest, with built-in shutter and lens. Shutter speed dial is low on the front. The models 1, 2, 3, & 4 have a hinged

front which conceals the better lens and shutter. We have seen these advertised and even sold occasionally at higher prices, but they generally sell with difficulty in the range of $40-50.

Pilot No. 2 - c1904-06. Falling-plate magazine camera for 2½x3½". $25-30.

Popular Pressman - c1913-26. Butcher's entry into the field of reflex cameras was made by Ica in 3¼x4¼" & 3¼x5½" sizes. Focal plane shutter. Generally found with f4.5 lens by Beck, Aldis, Cooke, Dallmeyer, or Ross. $150-200.

Primus No. 1 - c1899. Box camera, 4x5" plates. RR lens in roller-blind shutter. With 3 slides and case: $65-90.

Reflex Carbine - c1925. 6x9cm 120 film SLR. Aldis Uno Anastigmat f7.7/4¼". Two separate releases for T & I. Body of wood covered with black leather. The same basic camera was sold by Houghton as "Ensign Roll Film Reflex". $90-120.

Royal Mail Postage Stamp Camera - c1907-15. Wooden box camera for multiple exposures on a single 3¼x4¼" plate. Two major variations exist. The 3-lens model will take 3 or 6 exposures on a plate by shifting the lensboard. Current value of 3-lens model: $750-1000. The 15-lens model simultaneously exposes 15 stamp-sized images on the plate. The 15-lens models previously sold as high as $1500-2000. Recent auction sales have been $750-1100.

Stereolette - c1910-15. Miniature folding-bed stereo camera from Ica for 45x107mm plates. Zeiss Tessar f6.3 or f4.5 or Aldus Uno Anastigmat in Compound. $250-400.

Watch Pocket Carbine - c1920. Compact folding rollfilm cameras, horizontal or vertical styles, in 6x6cm, 6x9cm, and 6.5x11cm exposure sizes. Leather covered metal body. Made by Ica. Normally with f7.7 Aldis Uno Anast. in Lukos II shutter. $40-65.

Tropical Watch Pocket Carbine - c1923. Like the regular models, but with black unleathered body and Russian leather bellows. $140-175.

Watch Pocket Klimax - c1913-20. Folding bed camera for 1¾x2¼" plates. Same as Ica Victrix. Model I has Aldis Uno Anastigmat f7.7/3" or Triotar f6.3 in Lukos II shutter. Model II has Compound shutter with Aldis Uno, Beck Mutar f4.9, Zeiss Triotar f6.3, or Tessar f4.7. $55-85.

BUTLER (E.T. Butler, England)
Patent Three-Colour Separation
Camera - A mahogany camera for three exposures on separate plates through the use of semi-silvered mirrors. The front and focusing mechanism are very similar to the Butcher Popular Pressman reflex, but with an additional cube on the back. Made in sizes for 2¼x3¼", 3¼x4¼", and 4¼x6½" plates. $2000-3500.

BUTLER BROS. (Chicago)

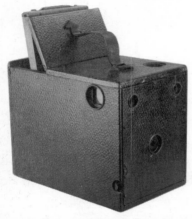

Pennant Camera No. 20 - Box camera for 4x5" plates in standard plateholders which load through a door at the top rear. $25-35.

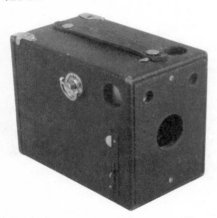

Universal - Wooden box camera with leatherette covering. For 2¼x3¼" exposures on rollfilm. Manufactured for Butler Bros. by Burke & James. Identical to the B&J Rexoette except for the top strap which reads "UNIVERSAL". Uncommon. $5-10.

CADOT (A. Cadot, Paris)
Scenographe Panoramique - Jumelle style 9x18cm plate camera. One lens rotates to center position to change from stereo to panoramic mode. $250-350.

CAILLON (Paris)

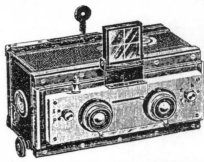

Bioscope - c1915-25. Rigid-bodied jumelle style stereo cameras in 6x13 and 8x16cm sizes. Convertible for use as a panoramic camera. $175-250.

Kaloscope - c1916. Folding bed stereo camera. Leather covered teak body. Lacour-Berthiot f6.8, Hermagis f6.8, or Zeiss Tessar f6.3/112mm lenses. Lensboard can be shifted to use left lens for panoramic pictures. $275-325.

Megascope - c1915. Jumelle style stereo with changing magazine for 12 plates, 6x13cm. Rising/falling front. Folding frame viewfinder. Leather covered metal body. Hermagis f6.3/85mm lenses, guillotine shutter ½-200. $125-200.

Scopea - c1920-25. Jumelle-style stereo camera. Made in 45x107mm and 6x13cm sizes. Various lenses include: Berthiot Olor f6.8/85, or Roussel Stylor f6.3. Three speed shutter, 20-100. $100-150.

CAM-O CORP. (Kansas City, MO)
Ident - 35mm TLR "school camera" for bulk rolls of 46mm film. Wood body. f9.5/114mm. $50-75.

CAMERA - c1930's. Yes, that's the full name of this small Japanese paper "Yen" box camera for single 3x5cm exposures on sheetfilm in paper holders. (See YEN-KAME for description of process.) Ground glass back. Black: $10-15. Colored: $25-35.

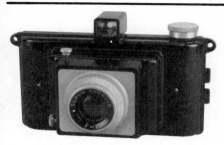

CAMERA (Super Excella) - c1950. Small black bakelite eye-level camera. "Camera" and "Made in Czechoslovakia" molded on front in small type near rivets; easily over-looked. That is the only name on the camera except for the lens which is marked "Super Excella f=6". We're hoping one of our Czech readers will tell us more about this one. $10-20.

CAMERA CORP. OF AMERICA (Chicago)
Original name "Candid Camera Corp. of America" 1938-1945 was shortened to "Camera Corp. of America" in 1945. Ceased operations about 1949 and sold its tools and dies to Ciro Cameras Inc. This is not the same company as the Camera Corp of America (Detroit) which sold the Camcor camera c1956-59, and also not the same as the Camera Corp. of America (Hicksville, NY) also known as Chrislin Photo Industry, which sold the Chrislin Insta Camera c1966-71 (see listing under Chrislin).

Cee-Ay 35 - 1949-50. Wollensak Anastigmat f4.5 in Synchro Alphax 25-150, T,B or Wollensak Anastigmat f3.5 in Synchro Alphax 10-200, T,B. Rarely seen with the Cee-Ay 35 markings. This was the dying effort of the company and it reappeared under the Ciro 35 name. Rare. One reported sale at about $400.

Perfex Cameras (listed chronologically):
Note: Perfex cameras are often found with inoperative or sticky shutters, usually at about half the normal prices listed below.

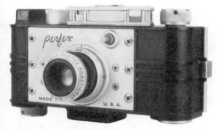

Perfex Speed Candid - 1938-39. Bakelite-bodied 35mm; uncoupled RF. Extinction meter at bottom. Interchangeable f3.5/50 or f2.8 Graf Perfex Anastigmat. Cloth focal

plane shutter 25-500, B. The first American 35mm to use a focal plane shutter. Not seen often. $50-75.

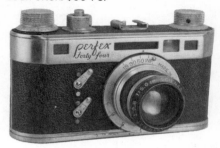

Perfex Forty-Four - 1939-40. Aluminum-bodied 35mm CRF. Interchangeable f3.5 or 2.8/50mm Graf Perfex Anastigmat. Cloth FP shutter 1-1250, B, sync. Extinction meter. $40-60.

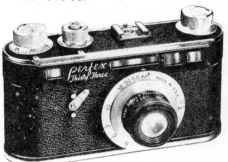

Perfex Thirty-Three - 1940-41. CRF. f3.5 or f2.8/50mm Scienar Anastigmat. FP 25-500, B, sync. Extinction meter. $35-45.

Perfex Fifty-Five - 1940-47. f3.5 or 2.8 Scienar or Wollensak Velostigmat lens. FP shutter, 1-1250, B, sync. CRF. Extinction meter - exposure calculator to 1945; postwar models lack meter. $30-45.

Perfex Twenty-Two - 1942-45. f3.5 Scienar Anastigmat. FP shutter 1-1250, B, sync. CRF. Extinction meter. Black or aluminum body. $40-50.

Perfex DeLuxe - 1947-50. The first of the post-war Perfex models, it introduced the stamped metal body to replace the original die-cast design. Wollensak f2.8 or f2.0 lens. $40-60.

Perfex One-O-One - 1947-50. With Ektar f3.5 or f2.8 lens in Compur Rapid: $40-60. With Wollensak Anast. f4.5/50mm lens in Alphax leaf shutter 25-150, T, B: $30-60.

Perfex One-O-Two - 1948-50. With Ektar f3.5 or f2.8 lens in Compur Rapid: $40-60. With Wollensak f3.5 in Alphax: $35-50.

CAMERA MAN INC. (Chicago)
Champion - Black plastic "minicam" for 16 exp. on 127 film. $8-12.

President - A lofty name for a nicely styled but rather simple black plastic minicam for 3x4cm on 127 film. $10-15.

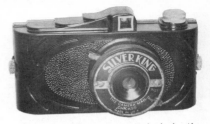

Silver King - An art-deco styled plastic minicam with a metal back. $15-20.

CAMERA OBSCURA - Pre-photographic viewing devices used to view or to trace reflected images. While technically these are not cameras, they did indeed lead to the development of photography in an attempt to fix their image. Original examples which pre-date photography are highly prized, but to a small group of collectors, and they vary widely in price depending on age, style, and condition. $750-3000.

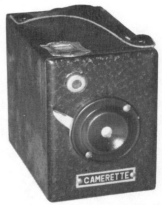

CAMERETTE - Japanese novelty "yen" box camera for single exposures on sheet film in paper holders. $10-15.

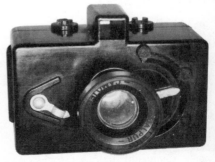

CAMOJECT LTD. (England)
Camoject - Unusual bakelite subminiature

for 14x14mm exposures. $75-100.

CANADIAN CAMERA CO. (Toronto, Canada)
Glencoe No. 4 - 4x5" folding plate camera. Leather covered, red bellows, reversible back. Brass-barrel lens and brass trim. Wollensak shutter. $60-90.

CANDID CAMERA SUPPLY CO.

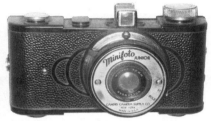

Minifoto Junior - Black plastic minicam for 127 film. Identical to the Falcon Miniature, and actually made by Utility Mfg. Co. for Candid Camera Supply Co. $8-12.

CANON INC. (Tokyo) *Originally established in 1933 as Seiki-Kogaku (Precision Optical Research Laboratory), this firm concentrated on 35mm cameras. (There is also a rare Seiki subminiature for 16mm film which was made by a different company also named Seiki-Kogaku.) The Seiki-Kogaku name was used through the end of WWII. In 1947, the company name was changed to Canon Camera Co., and the Seiki-Kogaku name was dropped. The Canon name was derived from the first 35mm cameras designed by the company in 1933, which were called Kwanon.*

Most of the historical and technical information, photographs, and structuring of this section are the work of Dr. Peter Dechert, who is widely regarded as one of the world's leading collectors and historians in the field of Canon rangefinder cameras. His special interest is now the Seiki-Kogaku cameras and accessories. The price estimates for the early Canon cameras are from Dr. Dechert, since information on the sales of these rare cameras is quite limited. We appreciate his help in this area. Dr. Dechert has graciously volunteered to help other collectors with questions if they will enclose a self-addressed stamped envelope with their queries, or call 5:00-9:00 PM Mountain Time or on weekends. You may contact him at: P.O. Box 636; Santa Fe, NM 87504 USA. Telephone: 505-983-2148. Dr. Dechert is the author of Canon Rangefinder Cameras: 1933-1968, published by Hove Foto Books. It is available in the U.S.A. at $22.95 list.

PRODUCTION QUANTITIES of CANON RANGEFINDER CAMERAS: *Altogether approximately 600,000 Canon Leica-derived RF cameras were made between 1935 and 1968. About half this total was composed of the four*

most common models: IID, IVSB, P, and 7. The following table groups RF Canons according to the number produced.
1-99 - Kwanon, JS, S-I, 1950, IIA, IIAF, IIIA Signal Corps.
100-999 - Hansas, Original, J, NS, J-II, Seiki S-II, IIC.
1000-2999 - S, IV, IID1, IIS, IIF2.
3000-9999 - Canon S-II, IIIA, IVF/IVS, VT-Deluxe, VT-Deluxe-Z, VT-Deluxe-M, VL, VL-2, VI-T.
10000-19999 - IIB, III, IIF, IVSB2, IID2, IIS2, L-1, L-2, L-3, VI-L, 7s.
20000-35000 - IID, IVSB.
90000-95000 - P.
135000-140000 - 7

SERIAL NUMBER RANGES of CANON RANGEFINDER CAMERAS: *Rangefinder Canons after the Hansa/Original and J series were numbered more or less consecutively as they were produced (with many large gaps) and, until #700,001, without regard for model identification. The next table shows the models produced within the several serial number ranges.*
Kwanon, Hansa, Original - No top serial number; use the number on the lens mount.
1000-3000 - J, JS (1938-42)
8000-9000 - J-II (1945-46)
10001-15000 - S, NS, S-I (1938-46)
15001-25000 - Seiki S-II, Canon S-II (1946-49)
25001-50000 - IIB, IV trials (1949-51)
50001-60000 - IIC, III, 1950, IV (1950-51)
60001-100000 - IIA, IIAF, IID, IID1, IIF, III, IIIA, IIIA Signal Corps, IV, IVF, IVS, IVSB (1951-53)
100001-169000 - IID, IID1, IIF, IIS, IVSB, IVSB2 (1953-55). REUSED for 7s and 7sZ (1964-68)
170001-235000 - IID2, IIF2, IIS2, IVSB2 (1955-56)
500001-600000 - VT, VT-Deluxe, VT-Deluxe-Z, VT-Deluxe-M, L-1, L-2, L-3, VL, VL-2 (1956-58)
600001-700000 - VI-L, VI-T (1958-60)
700001-800000 - P (1958-61)
800001-999000 - 7 (1961-64)
Various prototypes and trial models were numbered outside the above ranges.

SEIKI-KOGAKU CANONS - *Canon cameras made between 1933 and 1947 were manufactured by Seiki-Kogaku. Their early lenses, lens mounts, and finder optics were designed and in most cases manufactured by Nippon Kogaku. Serenar lenses made by Seiki-Kogaku were phased in slowly during WWII on Model J and X-Ray Canons, and on other Canons from 1946. Prices on all Canons marked "Seiki-Kogaku" are quite variable, depending on demand, supply, and location worldwide, and are best considered negotiable.*

KWANON SERIES (1934-1935) - These were largely mock-ups and a few working prototypes. The only working Kwanon known today is a very roughly-made Leica II

CANON (cont.)

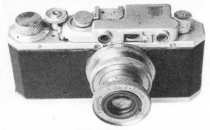

copy repurchased by Canon Japan from a private owner in the 1960's. Canon has made one or more inexact copies of this Kwanon for promotional purposes.

ORIGINAL SERIES (1935-1940) - *The only Canons with the exposure counter on the front face of the body. Speeds 25-500. Nikkor f3.5 lens (early ones have black face without serial number). Pop-up finder. Serial numbers on lens mount and inside of baseplate. Wide variation in details, especially in early production.*

Original Canon - *Most Canon Hansas were sold through Omiya Trading Co. and marked with Omiya's "Hansa" trademark. A smaller number were sold directly and not so marked; for some years collectors used to call the latter the "Original Canon." Both Canon/NK Hansas and Canon Hansas are found without "Hansa" logos, and since they are less common than the "Hansa" marked versions they may bring somewhat increased prices. Hansas and non-Hansas of equal vintage are, however, essentially identical cameras and all varieties were known at the time simply as "the Canon Camera." The type designation "Original Canon" is now outmoded and should not be used except to describe the non-Hansa variation.*

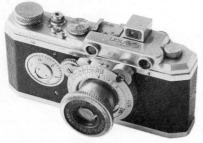

Canon / NK Hansa - 1935-37. Original series features, but occasionally with random parts originally made for use on Kwanon cameras. The earliest Hansa cameras were assembled at Seiki Kogaku Kenkyujo between 10/1935 and 8/1937 under the supervision of Nippon Kogaku managers, and these were marked "Nippon Kogaku Tokyo" next to the camera serial number on the focusing mount. Design elements came from both companies, and

these cameras can be considered forerunners of both "Nikon" and "Canon". Recent prices start at about $3000 and can go much higher for examples with identifiable Kwanon-associated parts.

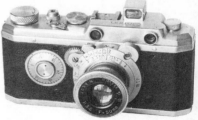

Canon Hansa - 1937-40. In August 1937 Seiki Kogaku Kenkyujo was reorganized and refinanced as Seiki Kogaku K.K.K. Shortly thereafter the "Nippon Kogaku Tokyo" was dropped from the camera body. Although the camera remained essentially the same, it was hereafter primarily a "Canon" product and not directly a "Nikon" predecessor; nor did these later cameras incorporate Kwanon parts. Recent prices from $2250 depending on cosmetic values. Mint examples will bring $5000+.

J SERIES (1939-1946) - *No rangefinder. Viewfinder is built into top housing. "Canon", "Seiki-Kogaku", and serial number on top.*

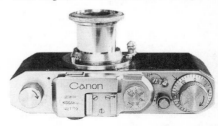

J - 1939-44 Speeds 20-500; no cover patch in slow dial area. Finder housing cut straight from front to back beside a large rewind knob. Nikkor f4.5 or f3.5 in screw mount similar to but not interchangeable with Leica mount. Price negotiable. $4000 and up.

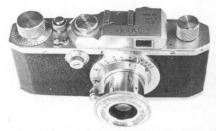

JS - 1941-45. Identical to J except for slow

dial on front face, speeds 1-500. Limited production, most for armed forces. Some were modified after manufacture from model J cameras, either by the factory or elsewhere. Price negotiable. $5000 and up.

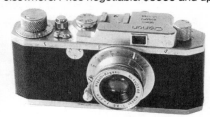

J-II - 1945-46. Like the J, but finder housing nests around smaller rewind knob similar to Leica. No slow speeds. Slow dial area usually covered by metal patch, sometimes by body covering material. Nikkor or Seiki-Kogaku Serenar f3.5 in same mount as J and JS. Price negotiable. $3000+.

S SERIES: *Retained the Hansa pop-up finder until 1946, but moved the frame counter to the top beneath the advance knob, like Leica. Retained the Original Series' bayonet lens mount until 1946.*

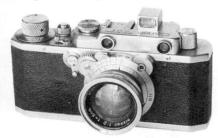

S - 1938-46. Slow dial on front, lever-operated to avoid fouling focusing mount. Considerable detail variation in cameras and lenses, particularly during wartime. Canon records use the designation "S-I" for a small number made after the war, but these were assembled from left-over parts and are hard to distinguish from wartime

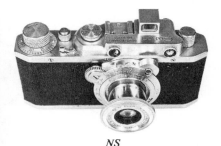

NS

production. A Japanese Navy version, marked entirely in Japanese, was made c.1942. Nikkor f4.5, f3.5, f2.8, and f2 lenses. $2000-2500+.

NS - 1940-42. Like the S, but without slow speeds. Considerable variation in construction, but none with patch over slow dial area. Nikkor f4.5 or f3.5 lens. $2500 and up. *(Illustrated bottom of previous column.)*

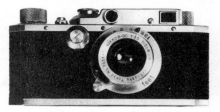

Seiki S-II - 1946-47. "Seiki-Kogaku" on the top plate. Combined single-stage rangefinder-viewfinder. Speeds 1-500. Formed metal body (a few late ones were die-cast). Earliest production retained the J-type lensmount. Slightly later production had a lensmount with sufficient "slop" to accomodate J-lenses or Leica-derived lenses. Final version has Leica thread mount. Nikkor f3.5, Seiki-Kogaku f3.5 and f2 lenses in versions to fit all three mounts. With "Seiki-Kogaku" markings: $300-600. (If not marked "Seiki", see Canon S-II below.)

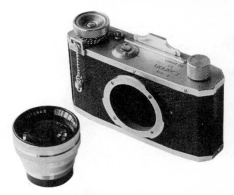

X-RAY CANONS: *Dr. Mitarai, one of the early Canon founders, was especially interested in making cameras to record the images on X-ray screens, and these formed a considerable part of Canon's early production. Three versions of the earliest model were produced, marked as "Seiki" with bird logo, "X-Ray Canon 35", and "Canon CX-35", from about 1939 until 1956, when more elaborate units in 35mm, 60mm, and 70mm were substituted. The three early versions are interesting because they used Nikkor and Seiki-Kogaku Serenar (later Canon Serenar) f2 and f1.5 lenses. Most X-ray cameras were scrapped*

CANON (cont.)

when replaced, and are hard to find. On the other hand, most collectors are not particularly interested in finding them. Prices negotiable. VG, complete with lens and mount: $500+.

CANON CAMERA CO. CANONS:

In September of 1947, the company name was changed from Seiki-Kogaku to Canon Camera Co. At the same time, the lens names were changed from Seiki-Kogaku Serenar to Canon Serenar. In 1952, the Serenar lens name was dropped and they were called simply "Canon" lenses.

CANON II SERIES (1947-1956):

All Canon II cameras have a top speed of 500 and film loading through the baseplate. Nikkor lenses were discontinued in 1948.

Canon S-II - 1947-49. Like the Seiki S-II, but almost all have die-cast bodies, later production with thicker wall than early production. No finder magnification adjustment. Nikkor f3.5, Canon Serenar f3.5 and f2 lenses. $225-325.

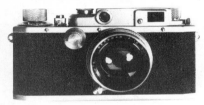

IIB - 1949-52. First 3-way magnification control of combined rangefinder-viewfinder operated by 2-piece lever under rewind knob. Speed dials split at 20. No flash synch rail or original factory synch. Serenar f3.5 & f1.9 collapsible lenses. $160-275.

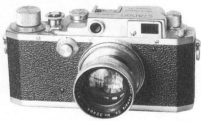

IIC - 1950-51. Like IIB, but speed dials split at 25. Same lenses. $250-350.

IID - 1952-55. Like IIC, but one-piece VF selector lever. No flash synch or film reminder dial. Speed dials split at 25. Canon f3.5, f2.8, f1.8 lenses. $150-275.

IID1 - 1952-54. Like IID, but film speed reminder built into wind knob. $200-325.

IID2 - 1955-56. Like IID1, but speed dials split at 30. Canon f2.8 or f1.8 lenses. $150-275.

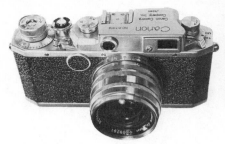

IIA - 1952-53. No slow speeds. Slow dial area covered by metal patch with body covering insert. No synch. Price negotiable, very rare. $1000+

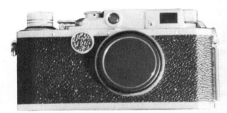

IIAF - 1953. Like IIA, but with flashbulb sync by side rail. Canon f3.5 or f2.8 lenses. Price negotiable, extremely rare.

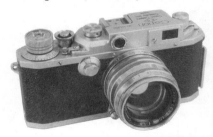

IIF - 1953-55. Fast and slow speed dials split at 25. Side synch rail. No X-synch position on speed dials. Top speed 500. Some examples model-identified on loading diagram. Canon f3.5, f2.8, f1.8 lenses. $140-170.

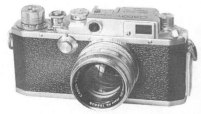

IIF2 - 1955-56. Like IIF, but speed dials split at 30. $150-250.

IIS - 1954-55. Like IIF, but includes X-synch setting on slow dial at 1/15 area. Lock on slow speed dial. Some examples model-identified on loading diagram. $150-250.

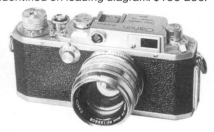

IIS2 - 1955-56. Like IIS, but speed dials split at 30 and X-synch also marked on top dial at 1/45 area. $150-240.

CANON III SERIES: *All Canon III cameras have speeds 1-1000 on two dials, film loading through baseplate, and NO flash synch.*

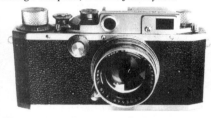

III - 1951-52. Two-piece finder selector lever. No film speed reminder. Canon Serenar f1.9 lens. $125-175.

IIIA - 1951-53. Like III but one-piece finder selector lever, and film speed reminder in wind knob. There are many varieties of III/IIIA hybrids. These are not uncommon and not greatly more valuable than true examples of either type. $100-150.

IIIA Signal Corps - 1953. A small run of very late IIIA cameras marked on the baseplate "U.S. ARMY. SIGNAL CORPS". 50mm, 28mm, 135mm, and 800mm Canon Serenar lenses for these cameras were also so marked. Cameras and lenses were otherwise identical to the standard model, and their current prices depend on demand and supply. $500 and up.

CANON IV SERIES: *All Canon IV cameras have two-dial speeds 1-1000, film loading through baseplate, and side-mounted flash synch rails. (Note: Hybrid variations of models IV through IVSB exist, partly because of running changes during manufacture and partly because of authorized updating. These are not uncommon and are not greatly more valuable than true examples of each type.)*
Canon 1950 - 1950. An early version of Canon IV, marked "Canon Camera Co. Ltd."

and with other cosmetic and mechanical differences. Serenar f1.9, serial numbers between 50000 and 50199. Only 50 were made; most were sold by C. R. Skinner, San Francisco, as model "IIC" (Canon's original short-lived designation) or "IVM" (Skinner's own later designation). Few remain; when found they command $1200 or more.

IV - 1951-52. Two-piece finder magnification lever. No film speed reminder. No X-synch. Serenar f1.9 lens. "Canon Camera Co. Inc." maker's logo. $200-300.

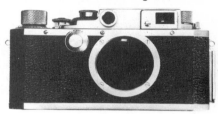

IVF - 1951-52. One-piece finder selector lever. Film speed reminder in wind knob. No X-synch. No lock on slow dial. Built-up interior wall next to film supply chamber. Serenar f1.8 lens. $125-175.

IVS - 1952-53. Like IIF but flat die-cast wall next to film supply chamber. $90-130.

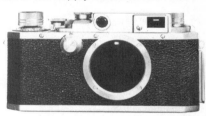

IVSB (IVS2) - 1952-55. X-synch marked on slow dial at 1/15 area. Slow dial locks at 25, at which speed dials are split. Canon f1.8 lens. Model IVSB was known as IVS2 in many countries including USA, but IVSB is proper factory designation. $125-175. *Known sales up to $100 higher in Europe.*

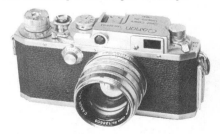

IVSB2 - 1954-56. Like IVSB but speed dials split at 30 and X-synch also marked

on top dial at 1/45 area. $125-175. *Known European sales $100 higher.*

CANON V SERIES: *All Canon V cameras load through a hinged back, have two speed dials split at 30, and wind with a trigger that folds into the baseplate. Normal lenses were 35mm and 50mm in speeds between f2.8 & f1.2.*

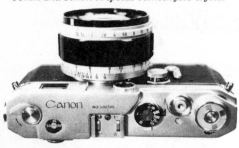

VT - 1956-57. Identified on front of baseplate (a few prototypes marked simply "Model V"). Numerous small manufacturing variations during production. $135-185.

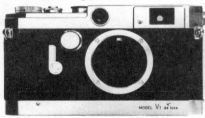

VT-Deluxe - 1957. Identified on front of baseplate. Cloth shutter curtains. No baseplate opening key. Chrome or black enameled bodies. Black: $300-500. Chrome: $125-175.
VT-Deluxe-Z - 1957-58. Like VT-Deluxe but with baseplate opening key. Prices as VT-Deluxe.
VT-Deluxe-M - 1957-58. Marked simply "VT-Deluxe", but with factory-installed metal shutter curtains and silver-coated finder optics. Prices as VT-Deluxe.

CANON L SERIES: *All Canon L cameras have back loading, thumb lever wind on top, two speed dials split at 30. Lenses as on V cameras.*

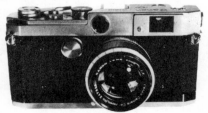

L-1 - 1956-57. Identified on bottom. Cloth

shutter curtains. No self-timer. Some VL prototypes with metal curtains may also be marked "L-1". Black: $400-600. Chrome: $150-200.

L-2 (1956-57), L-3 (1957-58) - Identified on bottom. Common in Japan but scarcer in USA. $150-225.

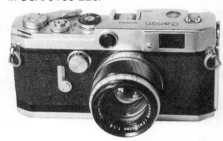

VL - 1958. No model identification on body. Like L-1 but has metal shutter curtains and self-timer. Speeds to 1000. X & FP synch. $225-250.

VL-2 - 1958. No model identification on body. Like VL but has speeds to 500 only. Common in Japan, rare in USA. $175-250.

LATE CANON RF SERIES: *These cameras all have back loading, single speed dial on top with 1-1000 range. Lenses varied, the 50mm f1.4 and f0.95 (on 7 & 7s only) are most desirable.*

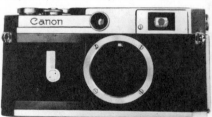

VI-L - 1958-60. No model identification on body. Top lever wind. Single speed dial. Black: $425-550. Chrome: $175-225.

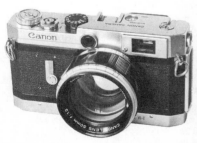

VI-T - 1958-60. Identified on front of baseplate. Last baseplate trigger wind model.

Black: $400-500. Chrome: $175-225. Up to $100 more in Europe.

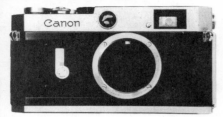

Canon 7

P - 1958-61. Identified on top, this model also exists with special 25th anniversary and Japanese army markings. Numerous running changes during manufacture. Black: $400. Chrome: $150-250. Up to $100 more in Europe. Add $100 for rare 50mm f2.2 lens.

7 - 1961-64. Identified on top. The most common of all RF Canons, and usually overpriced. Reasonable prices: Black: $300-450; with f0.95 add $300-500. Chrome: $110-175; with f0.95 add $300-500. *(Illustrated top of next column.)*

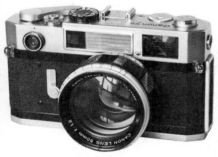

7s - 1964-67. Identified on top, with RF adjustment port in front of shutter speed dial: $250-325. Add $300-500 for f0.95 lens.

7sZ - 1967-68. Also marked "7s" but with RF adjustment port above second "n" in "Canon" logo on top of camera. $250-350. Add $300-500 for f0.95 lens.

BLACK RF CANONS: *The following models are known to exist with black enameled bodies: IVSB (never commercially available), L-1, VT-Deluxe, VT-Deluxe-M, VI-L, VI-T, P, and 7. Produced in relatively small quantities, these black Canons usually command higher prices than the equivalent chrome versions, on the order of two-times with considerable paint wear to 3-times in excellent condition. A black 7s has been reported but not confirmed.*

EARLY CANON SLR CAMERAS: *This list includes all Canon SLR's produced during the period that Leica-mount RF's were still being made. Each model is identified on its body. Some were issued in black as well as chrome.*
Canonflex - 1959-60. Canon's first SLR. Asking prices up to $250. Known sales $100-150.
Canonflex RP - 1960-62. $75-125.
Canonflex R2000 - 1960-62. First 35mm SLR with shutter to 2000. $100-150.
Canonflex RM - 1961-64. Built-in selenium meter. $60-125.
Canonex - 1963-64. First auto-exposure Canon SLR. $80-150.
FX, FP - 1964-66. $75-90.
Pellix - 1965-66. $150-250 in Excellent or better. Very Good: $100-125.
Pellix QL - 1966-70. $100-140.
FT - 1966-72. $75-125.
TL - 1968-72. $60-80.
EX-EE - 1969-73. Interchangeable front elements. $60-75.
F1 - 1971-76. With 50mm f1.4 normal lens: $200-275.
TX - 1975-79. $50-80.

CANONET CAMERAS - A long-lived, very popular series of rangefinder cameras with non-changeable lenses. The first Canonet was introduced in 1960 and the series continues through the current G-III models. Sometimes with f2.8, but more commonly found with f1.7 or f1.9 lenses. $30-50.

DEMI CAMERAS - A series of half-frame cameras initiated in 1963-64 with the Demi and continued as the Demi II (1964-65), Demi S (1964-66), Demi C (1965-66), Demi EE17 (1966-71), Demi EE28 (1967-70), Demi Rapid (1965-66). All have built-in meter. $30-50.

Dial 35 - 1963-67 (Model 2: 1968-71). Half-frame 35mm camera with spring actuated motor drive. Unusual styling with meter grid surrounding the lens and round spring housing extending below the body to serve as a handle. $50-75.

CAPITAL MX-II - c1986. Novelty 35mm from Taiwan, styled with small pseudo-prism. $1-5.

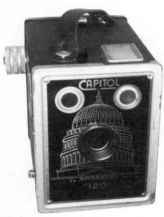

CAPITOL 120 - 2¼x3¼" metal box camera. Body identical to Metropolitan Industries Clix 120, but no B,I. U.S. Capitol dome pictured on front plate. Two versions: Silver faceplate with black letters & design, or the opposite. $15-25.

CAPTA, CAPTA II, SUPER CAPTA - c1940's. Black bakelite cameras for 4.5x6cm on rollfilm. Top styling similar to Kaftax. Super Capta lens. Two speed shutter. $15-20.

CARDINAL CORP. (U.S.A.)

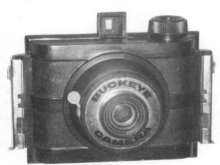

Buckeye, Cardinal, Photo Champ, & Cinex - All are nearly identical small plastic novelty cameras for 16 exp. on 127 film. Similar cameras by other manufacturers include "Halina-Baby", "Can-Tex" etc. $4-6.

CARL ZEISS JENA - *Founded in 1846 and still in operation today as a respected manufacturer of optics. After WWII, some of its personnel moved to nearby Oberkochen in West Germany and started yet another "Zeiss" company, known as Carl Zeiss Oberkochen.*

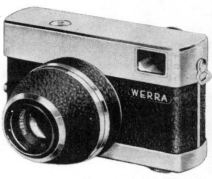

Werra - c1955. Smartly styled 35mm cameras, with streamlined knobless top. Film advanced and shutter cocked by turning ring around lens barrel. Lens shade reverses to encase shutter and lens. Olive green or black ebonite covering. Early models had Compur Rapid, later ones Synchro-Compur, but most had Prestor RVS to 1/750 with rotating blades.
Model I - No meter or rangefinder.
Model II - Bright-frame finder, built-in meter.
Werra III - Coupled rangefinder, no meter, interchangeable lens.
Werra IV - CRF, BIM, interchangeable lens. $25-50 in Germany where common. $50-70 in U.S.A.

CARMEN (France) - c1930's. Small black enameled stamped metal camera for 24x24mm exp. on 35mm wide paper backed rollfilm on special spools. Meniscus lens, simple shutter. Also sold under the name "Pygmee". $75-125.

CARPENTIER, Jules (Paris)

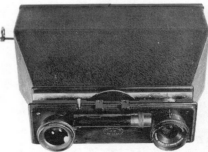

Photo Jumelle - c1890's. Rigid-bodied, binocular styled camera. One lens is for

viewing, the other for taking single exposures. This is not a stereo camera, as many jumelle-styled cameras are. Magazine holds 12 plates. To change plates, a rod extending through the camera's side is pulled out and pushed back in. Various models, 6x9cm and 4.5x6cm sizes. $60-120. (There is also a very rare Stereo version of this camera. Price would be negotiable.)

CECIL CAMERA - Small black plastic camera from Hong Kong for 16 on 127. Similar to the Wales Baby, Empire Baby, and Cardinal cameras. $1-5.

CENTURY CAMERA CO. *Century began operations in 1900, which probably explains the company name well enough. In 1903, George Eastman bought controlling interest. In 1905, Century took control of the Rochester Panoramic Camera Company, which had recently introduced the Cirkut camera. In 1907 it became "Century Camera Div., EKC". Following that, it was in the Folmer-Century Div. of EKC which became Folmer Graflex Corp. in 1926.*

Copying/Enlarging/Reducing Camera - c1900-1910. Professional studio camera for copying photographs. Front & rear bellows. $100-150.

Field cameras - c1900's. Since many of the Century cameras are not fully identified, this listing is provided as a general reference; classified by size, with normal older lens & shutter. (A good usable lens in a synchronized shutter will add to the values given here) *Illus. bottom of previous column.*
4x5 - including models #40, 41, 42, 43, 46. $75-125.
5x7 - including models 15, 47. $60-110.
6½x8½ - $85-125.
8x10 - $125-200.
11x14 - $150-250.

Grand - c1901-08. Folding cameras for plates. Leather covered wood body. Red bellows. 4x5", 5x7" or 6½x8½" size with triple convertible lens: $125-150. With normal lens and shutter: $75-100.

Grand Sr. - c1903-08. Deluxe model plate camera in 5x7" or 6½x8½" size. $100-150.

Long Focus Grand - c1902-05. Similar, but with additional rear track for extra bellows extension. $150-200.

Century Field Camera

Petite - Compact folding-bed camera; no reversible back. The No.2 (illustrated) is the

original design of Petite Century. No.1 is similar but lacks rack & pinion focus. No.3 has swing bed and back. Shutter for No. 1 & 2 is the B&L "No.3 Automatic" with TBI speeds and a lever to open for focusing. $75-125.

Stereo Model 46 - c1900's. 5x7 folding-bed style. "Century Model 46" at base of lens standard. Identifiable as a stereo model by the wide lensboard, even if missing its original stereo shutter. Symmetrical 4x5 lenses in B&L stereo shutter. $325-375.

Studio camera - The large Century studio cameras are often found with stand, lens, vignetter, and other accessories. They haunt the basements and attics of old studios, too large to haul away, and too cumbersome for most of today's studio work. But some collectors with unlimited display space, and some users requiring a large format but only limited movements will pay $250-300 for such an outfit.

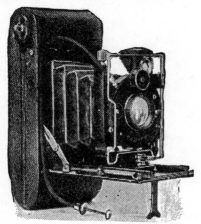

Certonet

CERTO KAMERAWERK
(Dresden, Germany)
Certix - c1930's. 6x9cm folding rollfilm camera. Various shutter/lens combinations cause prices to vary widely. $15-50.

Certo Six - c1950's. 6x6cm folding rollfilm camera for 120 film. Tessar f2.8/80mm lens, Synchro Compur or Prontor SVS shutter. CRF. $85-150.

Certonet - c1926. 6x9cm folding 120 film camera. f4.5/120mm Schneider Radionar. Vario or Pronto shutter, T, B, 25-100. $20-40. *Illustrated bottom of previous column.*

Certonet XV Luxus - c1931. 6x9cm folding rollfilm camera. Brass body covered with brown leather, brown bellows. Radial lever focusing. Compur shutter. Various lenses including Xenar f4.5/105mm. $100-150.

Certo-phot - Rigid bodied simple 120 rollfilm camera, 6x6cm exposures. $12-18.

Certoplat - c1929-31. Folding bed camera for 9x12cm plates. Rack and pinion focus. Rising front. Meyer Plasmat f4 or Schneider Xenar f3.5/150mm. Compur 1-200. $40-60.

Certoruf - c1929. Folding bed camera for 9x12cm plates. Double extension bellows. Ennator or Unofokal f4.5 in Compur. $35-45.

Certoruhm - c1925-30. Folding plate camera, similar in construction to the Certoruf, but with square back that holds plates horizontally or vertically. 9x12cm and 10x15cm sizes. Double extension. $40-60.

Certosport - c1930's. Folding plate cameras. 6.5x9 & 9x12cm sizes. Double extension bellows. Normally with f4.5 Meyer or Schneider lens in Compur or Ibsor shutter. $30-50.

Certotix - c1931. Folding camera for 6x9cm on 120 rollfilm. $15-20.

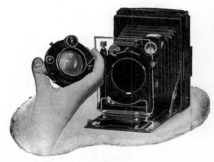

Certotrop - c1929-41. Folding plate cameras, 6.5x9 & 9x12cm sizes. $40-70.

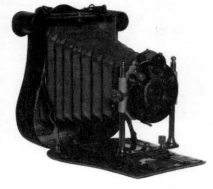

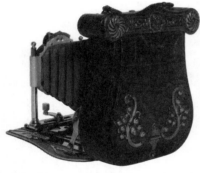

Damen-Kamera - c1900. Lyre-shaped body covered in alligator skin. Looks like a stylish woman's handbag when closed. ¼-plate size. Same camera was sold by Lancaster as the Ladies Gem Camera and by Dr. Adolf Hesekiel & Co. as the Pompadour. Rare, price negotiable. Estimate: $7500-9500.

Dollina - *Folding 35mm cameras made from the 1930's to 1950's. Since the various models are not well identified on the camera body, there has*

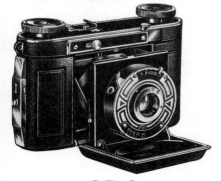

Dollina 0

been a certain amount of confusion among buyers and sellers. Hopefully the distinguishing features and illustrations here will help sellers to correctly identify their cameras.

Dollina "0" - c1937. No rangefinder. Certar f4.5 in Vario or f2.9 in Compur. $40-65. *Illustrated bottom of previous column.*

Dollina I - 1936-39. No rangefinder. All black or with chrome metal parts. Focusing knob on top. Compur 1-300 or Compur Rapid 1-500 shutter. Radionar f2.9, Xenar f2.9 or f3.5, or Tessar f2.8 lens. $35-60.

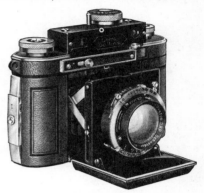

Dollina II - c1936. Rangefinder above body and focus knob above rangefinder. Compur or Compur Rapid shutter. Various lenses including f2 Xenon, f2.8 Tessar and f2.9 Radionar. $30-50.

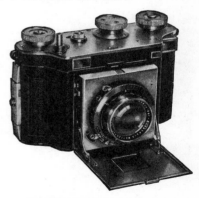

Dollina III - c1938. Separate eyepiece rangefinder incorporated in body. Focus knob on same plane as advance and rewind knobs. $100-175.

Dolly Vest Pocket cameras - c1934-40. *Two major styles were produced concurrently. The "miniature" or 3x4cm model has a straight pop-out front with scissor-struts. The V.P. or 4.5x6cm*

*model is a self-erecting bed type capable of taking
either 4x6.5cm or 3x4cm size on 127 film.*

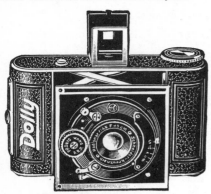

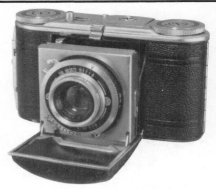

Dolly 3x4 (miniature) - c1932-37.
Compact strut camera for 16 exp. 3x4cm
on 127 film. f2.9, 3.5, or 4.5 lens. Vario,
Pronto, or Compur shutter. Deluxe models
have radial focusing lever and optical
finder. Original prices ranged from $11 to
$70. Currently: $75-125.

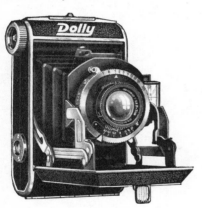

Dolly Vest Pocket - c1936. Also called
Dolly Model A. Self-erecting bed style. 8
or 16 exp. on 127 film. A variation of this
camera, marketed as the "Dolly Model B"
had interchangeable backs for plates or
rollfilm. The same camera, in both rollfilm
& combination models was sold under the
name "Sonny". $40-55.

Doppel Box - c1935. Box camera for 8
exp. 6x9cm or 16 exp. 4.5x6cm on 120 film.
Format changeable by turning a dial. Single
speed shutter, Certomat lens. $25-35.

Durata - c1950's. Horizontal style folding
35. Early model has slim top housing with
folding optical finder, no accessory shoe.
Later model has rigid optical finder

incorporated in taller top housing with
recessed accessory shoe. Trioplan lens in
Cludor shutter. $20-35.

KN35 - c1973. Inexpensive 35mm VF
camera. Non-changeable Kosmar f2.8
lens. $15-20.

Plate camera - 9x12cm. DEB. $35-50.

Super 35 - c1956. Like the Super Dollina
II below, but with Light Value Scale (LVS)
and MXV shutter. $30-60.

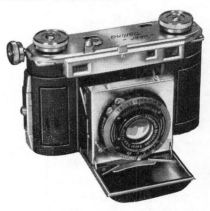

Super Dollina - c1939. Rangefinder
incorporated in body. Focus knob on right
side. Separate eyepiece for rangefinder.
Tall knobs sit above flat top plate. Not
synchronized. Compur Rapid shutter with
f2 Xenon or f2.8 Xenar or Tessar. $50-90.

Super Dollina II - c1951. (Also called
Super Certo II, Certo Super 35, and Certo
35.) Like pre-war Super Dollina, but with
single eyepiece for viewfinder & rangefinder.
Flat knobs recessed into chrome top
housing. Compur Rapid MX sync shutter
with f2.8 or f3.5 coated Tessar or f2
Heligon. $30-60.

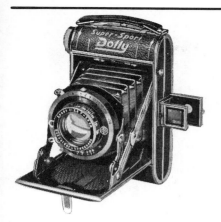

CHADWICK-MILLER
Fun-Face Camera - c1979. Novelty cameras for 126 cassettes. Little boy's or girl's face on front of camera with lens in nose. $10-15.

CHAMPION II - Basic 35mm camera with lever advance and bright-frame finder. Color-Isconar f2.8/45mm in Prontor 125. Made in West Germany. $15-20.

CHAPMAN (J.T. Chapman, Manchester, England)
The British - c1900. ¼-plate magazine camera. Wray Rapid Rectilinear f8 lens, rollerblind shutter. $100-150.

The British - c1903. Folding camera in ¼ and ½-plate sizes. Brass lens, waterhouse stops. Red double extension bellows, brass trim. $150-200.

The British - c1903. Full-plate size. Mahogany body, brass trim. Black tapered double extension bellows. Wray brass f8 lens with iris diaphragm. $175-250.

Supersport Dolly - c1935-41. Folding camera for 12 exp. 6x6cm or 16 exp. 4.5x6cm on 120 film. Available with or without CRF. "Super-Sport Dolly" or "SS Dolly" embossed in leather. After November 1938, an extinction meter was built into the rangefinder housing. Various lenses f2, f2.8, f2.9. Rimset Compur. With Rangefinder: $100-150. Without RF: $50-70.

CHADWICK (W.I. Chadwick, Manchester, England)
Hand Camera - c1891. Black-painted mahogany box camera for single plates. Externals controls. Rack & pinion focusing. Kershaw shutter. Rotating waterhouse stops. $150-225.

Stereo Camera - c1890. ½-plate tailboard stereo. Accepts single or stereo lensboard. Mahogany body, brass trim, rectangular black bellows. Brass barrel Chadwick 5" lenses with rotating waterhouse stops. Thornton-Pickard roller-blind shutter. Other lens variations exist. $475-800.

Millers Patent Detective Camera "The British" - c1900. Black ebonized wood detective box camera for ¼-plates. Falling-plate mechanism. String-cocked rollerblind shutter behind hinged front. Rack focusing. $100-150. *Also available with brown reptile skin covering; no sales data on this finish.*

Stereoscopic Field Camera - ½-plate folding stereo. Dovetailed mahogany construction with brass trim. Twin Wray 5x4 lenses with iris diaphragm. $350-450.

CHARMY - Novelty camera of "Hit" type. $15-25.

CHASE - Novelty camera of "Cardinal" type for 16 exp. on 127 film. Identical to the Wales-Baby and Halina-Baby. Made in Hong Kong. $5-10.

CHASE MAGAZINE CAMERA CO., (Newburyport, Mass. USA)
Chase Magaazine Camera - c1899. For 12 plates 4x5". Plates advanced (dropped)

by turning large key at side. Variable apertures. Shutter speeds I & T. $75-125.

CHICAGO CAMERA CO. (Chicago, Ill.)

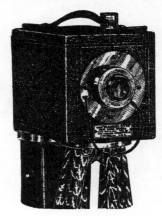

Photake - c1896. A seamless cylindrical camera made to take 5 exposures on 2x2" glass plates. f14/120mm achromat lens, Guillotine shutter. A very unusual camera which originally sold for a mere $2.50. $600-900.

CHICAGO FERROTYPE CO. (Chicago, Ill.) *Founded by Louis & Mandel Mandel, the Chicago Ferrotype Co. was the United States' leading producer of direct positive "street" cameras for tintypes, button tintypes, paper prints, and post cards. See also "PDQ Camera Co."*

Mandel No. 2 Post Card Machine - c1913-30. A direct positive street camera for five styles of photos from postcards to buttons. $75-125.

Mandelette - Direct positive street camera 2½x3½" format. Camera measures 4x4½x6". Sleeve at rear, tank below. Simple shutter and lens. A widely

publicized camera which sold for about $10.00 in 1929. $50-75.

PDQ Street Camera - including models G & H. For direct positive 6x9cm paper prints. $60-90.

YOUR PICTURE
IN ONE MINUTE
FOR **5** CENTS

Wonder Automatic Cannon Photo Button Machine - c1910. An unusual all-metal street camera for taking and developing 1" dia. button photographs. With tank: $600-900. Without tank, deduct $75-100.

CHILD GUIDANCE PRODUCTS INC.
Mick-A-Matic - c1971. Camera shaped like Mickey Mouse's head. Lens in nose. Original model uses the right ear for a shutter release. Later models have a shutter release lever between the eye and ear. Although these cameras took a speculative jump a few years ago, they have settled back to a more normal price range. Actually, they are not hard to find at these prices in the USA, but they command a bit more in Europe where they are not as common.

Original (ear shutter) model: $40-60. Later models: $20-30. *Add 50% if new in box. Prices in Europe 50% higher.*

CHIYODA KOGAKU SEIKO CO. LTD.

Konan-16 Automat - c1950. Precursor of the Minolta-16. Very similar in style, but much heavier. "Made in Occupied Japan". Rokkor f3.5/25mm fixed focus, shutter T,B, 25-200, sync. $75-100.

Minolta - *Although the Minolta cameras were made by Chiyoda, we have listed them under the more widely recognized name- Minolta.*

CHIYODA SHOKAI (Japan)
CHIYODA CAMERA CO. LTD.
REISE CAMERA CO. LTD.
CHIYOTAX CAMERA CO. LTD.

Chiyoca 35 (I) - c1951. Rare Japanese copy of Leica Standard camera, but without rangefinder. Hexar 50mm f3.5 in collapsible mount. FP ½σ-500,B. The "Chiyoca" name was soon dropped because of its similarity to "Chiyoka", a registered trademark of Chiyoda Kogaku Seiko (Minolta), and the new version was called Chiyotax. $600-750 in USA. Higher in Japan.

Chiyoca 35-IF - c1952. Similar to earlier model, but with twin pinhead sync posts. Hexar f3.5/50mm. $600-800.

Chiyoca Model IIF - c1953. Improved version of the IF, with CRF. Lena Kogaku or Reise Kogaku f3.5/50 in collapsible mount. Early version has two pinhead sync posts. Later version has single PC post. $600-800.

Chiyoca Model IIIF - c1954. Like the Chiyoca IIF which it replaced, but with slow speeds. Model number engraved on the top plate. Normal lens is Konishiroku Hexar f3.5/50 in collapsible mount. Later version has "Chiyotax Camera Co. Ltd." on top plate. $800-900.

Chiyoko - 6x6cm TLR with focusing f3.5 Rokkor lens in Seikosha MX shutter. $40-65.

CHRISLIN PHOTO INDUSTRY
(Hicksville, NY) *Also DBA Camera Corporation of America, but not related to the other companies which also used that name.*

Chrislin Insta Camera - c1965-69. Blue plastic box camera for 8 self-developing 60 sec. prints per roll. Eye level viewfinder in handle. This was in direct competition with the Polaroid Swinger camera, and never got off the ground. Unusual and uncommon. $60-100.

CHUO PHOTO SUPPLY (Japan)
Harmony - c1955. Inexpensive eye-level metal box camera for 6x6 on 120. Focusing lens, 3 speed shutter, PC sync. $15-20.

CHURCHIE'S OFFICIAL SPY CAMERA
- Hong Kong novelty 127 rollfilm camera with tiny adhesive label advertising Churchie's. $1-5.

CIA STEREO - c1910. Manufacturer unknown. Stereo box camera for two 6x9cm exposures on 9x12cm plates. Meniscus lens with 3 stops. Individual lenses may be closed off for single exposures. Folding frame finder. Rare. $125-150.

CIMA KG. (Fürth, Germany)
Luxette, Luxette S - c1954. Eye-level camera for 4x4cm on 127 film. Metal body with black crinkle finish. Röschlein Cymat f7.7 in Cylux 25-100 shutter. (Luxette S has Synchro-Cylux shutter.) $20-40.

CINESCOPIE - c1929. Early 35mm for 24mm square exposures on 35mm film in special spools. Made in Brussels, Belgium. Manual film advance without automatic stop or exposure counter. A wire feeler inside is perhaps used to audibly count sprocket holes when advancing film. O.I.P. Labor f3.5/50mm lens in Ibsor shutter, T, B, 1-150. Removable front section allows

shutter and lens to be used with an enlarger. Uncommon. $500-750.

CINEX DELUXE - Unusually styled grey and black plastic "minicam" for 16 exposures on 127 film. Streamlined design. Available with either chrome or black faceplate, for those who may want one of each. $3-7.

CIRO CAMERAS, INC. (Delaware, Ohio)

Ciro 35 - c1949-54. Basically the same camera as the Cee-Ay 35 camera from the Camera Corp. of America. Ciro bought the design and dies and made only minor cosmetic changes. It still did not fare well, and soon was in the hands of Graflex. Graflex sold the Ciro 35, then modified it

to make the Graphic 35. The Ciro 35 is a 35mm RF camera. Three models: R- f4.5, S- 3.5, T- f2.8. Black body less common: $25-40. Chrome: $15-25.

Ciroflex - c1940's. Common 6x6cm TLR, models A through F, all similar, with each new model offering a slight improvement. Models A-D: $20-30. Models E,F (better, less common): $25-35.

CITY SALE & EXCHANGE (London) *Used the trade name "Salex" from an abbreviated form of their name. Never actually made cameras, but sold other makers' cameras under their own name.*

Ancam - c1903-1905. Folding plate magazine camera for 12 ¼-plates or 24 cut films. Simple version has RR f8 lens. Better versions have Ross f5.6/6" lens or Beck Isostigmar f5.8 lens. Leather-covered mahogany body. Shutter 1/15-100. Two waist-level viewfinders for viewing horizontal or vertical photos. $25-45.

Field cameras - Lightweight folding cameras, similar to the Thornton-Pickard models. With normal lens and shutter such as Unicum or Thornton-Pickard. $100-150.

CIVICA INDUSTRIES CORP. (Taipei, Taiwan)

Civica PG-1 - c1985. Cute 110 camera with sliding lens cover. Two bird-like cartoon characters dancing on round lens cover.

Black back with blue or white front. Made in Taiwan. $15-20.

CLARUS CAMERA MFG. CO.
(Minneapolis, Minn.) *Note: The Clarus company never did well, because they could not escape their reputation, although they finally managed to make their camera work.*

MS-35 - 1946-52. Rangefinder 35mm camera. Interchangeable f2.8/50mm Wollensak Velostigmat lens. Focal plane shutter to 1000. At least two versions made. (Shutters tend to be erratic and sluggish, which would decrease the value from the listed price.) $25-45. *These bring a bit more outside the USA, where fortunately they didn't sell when new.*

CLASSIC 35 - *This name has been applied to several entirely different cameras, the earliest of which is a tiny die-cast aluminum camera with black horizontal stripes, made by Craftsmen's Guild. The others were imported to the USA and sold by Peerless Camera Co. of New York. To avoid further confusion, we are listing these full-frame models here.*

Classic 35 - c1956. Made by Altissa-Werk in "USSR occupied" Germany. Same as Altix camera. Trioplan f2.9 coated lens. $25-45.

Classic II - c1957-58. Made in Japan. Original price $18. $30-50.

Classic III - c1959. Made in Japan. Orig. price $18. $30-50.

Classic IV - c1960. Fujita Opt. Ind., Japan. Orig. price of $20 reduced to $14. $30-50.

CLOSE & CONE (Chicago, Boston, NY)

Quad - c1896. The only camera using the new "Quadruple plateholder", an unusual mechanism which turned the four plates into the focal plane. The camera which measured 4⅝x4⅝x6" for 3½x3½ plates was advertised in 1896 as "the largest picture and smallest camera combined ever made", and it cost $5.00 new. $100-125.

CLOSTER (Italy)
IIa - c1950. Bottom loading 35mm VF camera. Mizar f4.5/50mm lens. Closter shutter to 300. $30-40.

C60 - c1960. Simple plastic and aluminum 35mm. Lambron f7/50mm, single-speed shutter. $15-25.

Olympic - c1959. Inexpensive plastic and metal 127 rollfilm camera, 3x4cm. f8/56mm lens. $10-15.

Princess - c1951. 35mm RF. Aires f3.5/50mm lens, Rimset 1-300 shutter. $25-40.

Sport - c1956. Viewfinder 35mm. Closter Anastigmat f8/50mm. Two-speed shutter. $12-20.

Sprint - Inexpensive 35mm with f7/50mm lens in Sincro-Closter shutter to 150. $10-20.

C.M.C. - Japanese novelty camera of "Hit" type. With gold colored metal parts: $35-50. With colored leatherette: $30-40. Chrome with black leatherette: $10-15.

COLIBRI, COLIBRI 2 - c1952-53. Tiny subminiature plastic camera for 13x13mm on special rollfilm. Post-war Germany, U.S. Zone. Uncommon. $125-175.

COLLEGIATE CAMERA NO. 3 - Small Japanese novelty "Yen" box camera for

single paper film holders. $15-20.

COLLINS (C.G.Collins, London)
"The Society" - c1886. Full plate compact mahogany field camera produced under license as an improved version of McKellin's Treble Patent Camera of 1884. $175-225.

COLORFLASH DELUXE CAMERA -
Identical to the Diana DeLuxe. Accessory flash uses AG-1 bulbs. $1-5.

COLUMBIA OPTICAL & CAMERA CO. (London)
Pecto No. 1A - c1902. 4x5 plate camera. Polished mahogany body, red bellows. Shutter built into lensboard. $60-100.

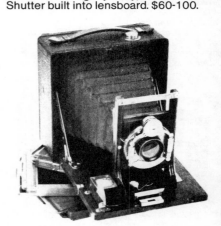

Pecto No. 5 - c1897. Folding bed camera, 9x12cm plates. Leather covered wood body. Double extension bellows. Rising front. B&L RR lens. Unicum shutter. $50-75.

Pecto No. 7 - c1900. 5x7" leather covered hand and stand camera. Double extension red bellows. RR lens, shutter 1-100. $75-125

C.O.M.I.

Luxia, Luxia II - c1949. Small 35mm half-frame cameras. Delmak f2.9/27mm lens, between-the-lens shutter. Chrome trim. Colored: $400-600. Black: $350-400.

COMPAGNIE FRANCAISE DE PHOTOGRAPHIE

Photosphere - c1888. One of the first all-metal cameras. For 9x12cm plates, or could take special roll back for Eastman film. Shutter in the form of a hemisphere. Smaller size for 8x9cm plates: $800-1200. Unusual 13x18cm (5x7") size: $1200-1800. Stereo model (world's sexiest camera, according to an expert on the subject): $4000-6000. Medium sized for 9x12cm plates: $1000-1500.

COMPASS CAMERAS LTD. (London)
Mfd. by Jaeger LeCoultre & Cie., Sentier, Switzerland for Compass Cameras Ltd.

Compass Camera - c1938. The ultimate compact 35mm rangefinder camera system. A finely machined aluminum-bodied camera of unusual design and incorporating many built-in features which include: f3.5/50mm lens, RF, right-angle finder, panoramic & stereo heads, level, extinction meter, filters, ground glass focusing, etc. For 24x36mm exposures on glass plates, or on film with optional roll back. The high prices in the current market are due primarily to collector enthusiasm, not rarity, since they are regularly offered for sale. Complete outfit: $1000-1500. Camera only: $500-700.

Compass Tripod - Rare accessory for the Compass camera. $200-250.

COMPCO Miraflex & Reflex cameras - c1950. Low-cost twin lens box cameras of the 1950's. $5-10.

CONCAVA S.A. (Lugano, Switzerland)

Tessina - c1960 to present. For 14x21mm exp. on 35mm film in special cartridges. The camera, about the size of a package of regular-sized cigarettes, is a side-by-side

twin-lens reflex. One lens reflects upward to the ground glass for viewing. The other lens, a Tessinon f2.8/25mm, reflects the image down to the film which travels across the bottom of the camera. Shutter 2-500. Spring-motor advance for 5-8 frames per winding. Available in chrome, gold, red, black. Gold camera: $300-500. Red: 250-300. Black: $200-250. Chrome camera: $150-200. *Various accessories, including wrist strap, prism finder, meter, watch, etc. add to the value.*

Tessina Accessory Watch - Rectangular watch with Tessina logo on face. Made to fit on top of Tessina camera. Rare. $125-150.

CONLEY CAMERA CO. (Rochester, Minn.) *In addition to the cameras marketed under their own label, Conley also made many cameras for Sears, Roebuck & Co. which were sold under the Seroco label, or with no identifying names on the camera.*

Conley Junior - c1917-22. Folding rollfilm cameras, similar in style to the better known Kodak folding rollfilm cameras. $15-25.

Folding plate camera, 4x5"

Folding plate cameras:
3¼x5½ postcard size - c1900-1910. Vertical folding camera. Fine polished wood

interior. Nickel trim. Double extension red bellows. f8/6½" lens in Wollensak Conley Safety Shutter. $45-75.

4x5 Folding Plate Camera - c1900-10. Black leathered wood body. Polished cherry interior. Red bellows. Usually with Conley Safety Shutter and one of the following lenses: Wollensak Rapid Symmetrical, Rapid Orthographic, Rapid Rectilinear, or occasionally with the Wollensak 6"-10"-14" Triple Convertible (worth more). Normally found in case side by side with holders "cycle" style. The 4x5 is the most commonly found size of the Conley folding models. $60-100. *Illustrated bottom of previous column.*

5x7 Folding Plate Camera - c1908-17. Except for size, similar to the two previous listings. $60-100.

6½x8½ View - c1908-17. Least common size among Conley cameras. $125-175.

8x10 View - c1908-17. Prices vary depending on accessories, particularly lens and shutter, since large format shutters and lenses still have some value as useful equipment. $125-250.

Folding rollfilm camera - c1917. 3¼x5½ "postcard" size, on 122 film. Similar to the Kodak folding rollfilm cameras which are much more common. Vitar Anastigmat f6.3 in B&L Compound shutter. $15-25.

Kewpie box cameras: c1917-22.
No. 2 - For 120 film. Loads from side. Rotating disc stops on front of camera. $12-18.
No. 2A - for 2½x4¼ exposures on 116 film. $12-18.

No. 2C - for 2⅞x4⅞" exposures. $12-18.
No. 3 - 3¼x4¼ exp. $12-18.
No. 3A - 3¼x5½ "postcard" size. $15-20.

Long Focus Revolving Back Conley Model XV - 1909-18. Introduced in 1909, the "Model XV" designation was added in 1910. Self-casing folding view camera with double-extension bellows and rack & pinion focus. Mahogany body covered with bear grain leather. Rapid Orthographic lens in Conley Safety shutter. Made in 5 sizes to 6½x8½". $60-120.

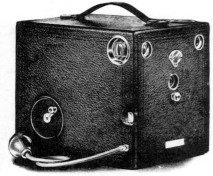

Magazine Camera - c1908-12. Leather covered wooden box camera for 4x5" 12 plates. Plates advanced by crank on right side of camera. $45-60.

Panoramic Camera - c1911-17. Pivoting-lens panoramic camera for 140 degree views, 3½x12". Design based on patents acquired in 1908 from the Multiscope & Film Co. of Burlington, Wisconsin. Four speeds were possible. Without a fan, the equivalent shutter speed was 1/50th of a second. Attaching the smallest of the three fans gave 1/25th; the medium and large fans giving 1/12 and 1/6. Rapid Rectilinear f8 lens with iris diaphragm. Original price of $17.50 in 1911. Current value $300-400.

Shamrock Folding - c1908. Vertical 4x5 folding plate camera with simple metal lens standard. Oxidized and burnished copper shutter with exterior diaphragm. The name is obviously derived from the three diaphragms which form a shamrock shape. Sears, Roebuck used the "Shamrock" name for this camera, which was called "Queen City Folding Camera No. 5" in Conley's catalog. The predecessor of this camera, called "Conley Folding Camera" through 1907, has a diaphragm which even more resembles a shamrock, since it does not have the bright chrome pivot support for the diaphragm in front. Since none of them are identified on the body, just remember that the one which really looks like a shamrock wasn't called by that name. This one was. $30-50.

Snap No. 2 - Strut-type folding camera for 6x9cm on 120 film. Design with cross-swing struts is more typical of Ansco than Conley cameras. $15-25.

Stereo box camera - c1908. For 4¼x6½" plates in plateholders. Simple shutter, I & T. Meniscus lenses. $225-275.

Stereo Magazine camera - c1903. Drop-plate magazine box camera for stereo images on glass plates. $300-400.

Stereoscopic Professional - c1908.

Folding plate camera for stereo images on 5x7" plates. Wollensak Regular double valve stereo shutter. Rise and shift front. (Note: similar models without full movements are of nearly equal value.) $300-350.

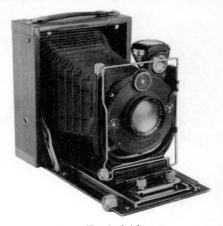

Tropical Adoro

Truphoto No. 2 - Folding camera for 120 rollfilm. One of the most interesting features is the pivoting brilliant viewfinder. Both lenses of the finder are rectangular, each oriented a different direction. Pivoting the finder automatically presents the properly oriented rectangle for composition while the other serves as the finder's objective. Fixed focus Meniscus lens. T & I shutter. Very uncommon. Not listed in any Conley or Sears catalogs. $20-30.

CONTESSA, CONTESSA-NETTEL

(Stuttgart) *Contessa merged with Nettel in 1919. In 1926, a large merger joined Contessa-Nettel with Ernemann, Goerz, and Ica, to form Zeiss-Ikon. The general assumption from the listed dates is that pre-1919 cameras listed here are "Contessa" models. Pre-1919 "Nettel" cameras are listed under Nettel. From 1919-1926, the line includes many models which existed earlier as "Nettel" or "Contessa" cameras, and some of these continued after 1926 as Zeiss-Ikon models. See also Nettel, Zeiss.*

Adoro - c1921. 6.5x9cm and 9x12cm folding plate cameras. Double extension bellows. f4.5 Tessar in Compur. $25-40.

Tropical Adoro - c1921. Like the regular model, but teak wood, brown leather bellows, nickeled trim. $400-475. *Illustrated top of next column.*

Alino - c1913-25. Folding plate camera, 6.5x9cm. Single extension. Tessar f6.3/ 120mm lens in Compur 1-250. $30-40.

Altura - c1921. 3¼x5½". Citonar 165mm lens in dialset Compur shutter. $40-60.

Argus - Monocular styled camera with deceptive angle finder. A continuation of the Nettel Argus, Contessa-Nettel later changed the camera name to Ergo, and the camera continued in production by Zeiss-Ikon under that name. $800-1200.

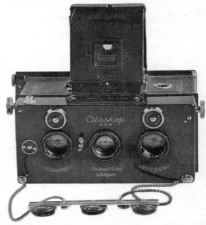

Citoskop Stereo - c1924. 45x107mm.

f4.5/65mm Tessar lenses. Stereo Compur. $200-225.

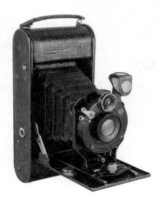

Cocarette - c1920's. Folding bed rollfilm cameras made in 2 sizes, 6x9cm on 120 film & 2½x4¼" on 116 film. Many shutter and lens combinations. $20-30.
Cocarette Luxus - Brown leather and bellows. $75-125.

Deckrullo-Nettel - c1919-26. Folding plate cameras with focal plane shutter. Black leather covered body. Ground glass back. 6.5x9cm with Tessar f4.5/120mm; 9x12cm with Zeiss Tessar f4.5/150mm; 10x15cm with Tessar f4.5/180mm. $100-185.

Deckrullo (Tropical model) - c1919-26. Folding 9x12cm plate camera. Teakwood body partly covered with brown leather. Light brown bellows. f4.5/120mm Tessar. FP shutter to 1/2800 sec. Wide range depending on condition. $300-800.

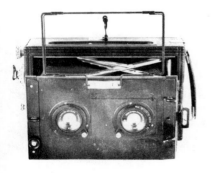

Deckrullo-Nettel Stereo - Focal plane shutter. 6x13cm size with Tessar f4.5/90 lenses or more commonly in 10x15cm size with f4.5 or f6.3/12cm Tessar. $225-275.

Deckrullo Stereo (Tropical) - c1921-25. Folding teakwood-bodied stereo plate cameras. GG back, brown bellows, nickel trim. FP shutter to 2800. 9x12cm size with f2.7/65mm Tessars. 10x15cm size with Double Amatars f6.8 or Tessars f6.3 or f4.5. 10x15cm size takes panoramic exposures with a small eccentric lensboard for one lens (9x12cm could be special ordered with this feature). $850-1200.

Donata - c1920's. Folding plate or pack camera, 6.5x9cm and 9x12cm sizes. f6.3 Tessar or f6.8 Dagor. Compur shutter. GG back. $30-60.

Duchessa - c1913-25. 4.5x6cm folding plate camera. Citonar Anastigmat f6.3/75mm, Compur 1-100. $225-275.

Duchessa Stereo (Focal Plane Type) - c1913-14. Compact strut-folding stereo camera for 45x107mm plates. Focal plane shutter. Various lenses, including Dagor f6.8, Tessar f6.3, f4.5. $250-400.

Duchessa Stereo (Front Shutter Type) - c1913-22. Compact 45x107mm folding stereo camera with lazy-tong struts. Crackle-finish on lensboard. Compound, Compur, or Derval shutter. Various lenses include Teronar, Tessar, Citoplast, Dagor, Tessaplast, Hellaplast. Most common with Tessar f4.5 and Compur 1-250. $250-400.

Duroll - c1913-25. Folding cameras with interchangeable plate or roll backs. 6x9, 9x12, & 9x14cm sizes. $30-60.

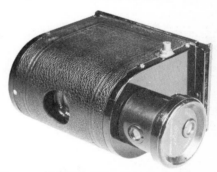

Ergo - c1913-26. Monocular-shaped camera for 4.5x6cm plates. Tessar f4.5, Compur 25-100,B. Right angle finder. $800-1000. *(Earlier model was the Nettel Argus, later model was the Zeiss-Ikon Ergo.)*

Miroflex - 1926. *Originally designed by a Dutch inventor, Brandsma, who sold the rights to Nettel. Nettel brought the camera out just before WWI, but had to cease production. In 1919, Nettel merged with Contessa, and the camera was brought out by CN just a year before the*

merger which formed Zeiss-Ikon. The later Zeiss-Ikon Miroflex is more often found than the Contessa-Nettel model. SLR for 9x12cm plates. Tessar f4.5/150mm lens. FP shutter to 2000. $200-250.

Nettix - c1919-25. 4.5x6cm strut-folding plate camera. Leather covered metal body. Citonar f6.3/75mm lens in Derval 1/25-100 shutter. $150-250.

Onito - c1919-26. 9x12cm. Lenses include: Double Anastigmat Citonar f6.3, Nostar f6.8, or Nettar Anastigmat f4.5/135mm. Derval 25-100; Gauthier or Ibsor 1-100. The 6.5x9cm and 10x15cm sizes sell in the same price range. $25-45.

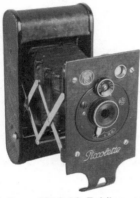

Piccolette - c1919-26. Folding vest pocket camera for 4x6.5cm exp. on 127 film. Among the various lenses and shutters seen are the Tessar f4.5/75mm, Triotar f6.3, or meniscus f11 lens; Dial Compur, Derval, Piccar, or Acro shutter. $70-100.

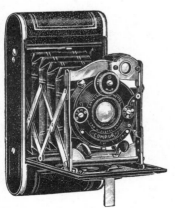

Picolette Luxus - c1924. Brown leather covering and tan bellows. $250-325.

Pixie - c1913. Compact strut camera for 4x6cm on rollfilm. Lazy-tong struts support front with built-in 3-speed shutter. Rare. $200-275.

Recto - c1921. Small lazy-tong strut camera for 4.5x6cm plates. (A low-priced version of the Duchessa.) Acro shutter 25, 50, 75. $100-150.

Sonnar - Folding 9x12cm plate camera, double extension bellows. Contessa-Nettel Sonnar f4.5/135. Compur 1-200. $40-60.

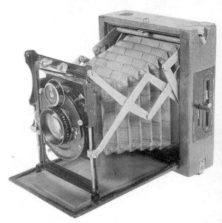

Sonnet - c1920's. (Formerly Nettel). Tropical folding plate cameras, 4.5x6cm and 6.5x9cm sizes with teakwood bodies. f4.5 Zeiss lens. Dial Compur 1-300. Light brown bellows. 4.5x6cm size: $350-500. 6.5x9cm size: $250-300.

Stereax, 45x107mm - c1912-19. Stereo camera with folding bed and struts. Colorplaste 60mm lens. Focal plane shutter 1/5-1/1200. $150-250.

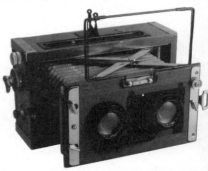

Stereax, 6x13cm - c1919-27. Strut-folding stereo. Leather covered & tropical versions. Tessar f4.5/90mm lens. Focal plane shutter 1-1200. Wire sports finder with expanding

side pieces for panoramic exposures. Tropical: $450-650. Leathered: $150-250.

Steroco - c1921. 45x107mm cheaply made stereo. f6.3 Tessars, Compur. $150-235.

Suevia - c1919-25. Single extension folding plate camera, 6.5x9cm. Leather covered wood body. Nettar f6.3/105mm lens in Derval 1/25-100 shutter. $30-40.

Taxo - c1921. 9x12cm folding plate camera. f8/135 Extra Rapid Aplanat. Duvall shutter to 100. $30-45.

Tessco - c1913-26. Dbl extension folding plate camera, 6.5x9, 9x12, & 10x15cm sizes. GG back. Contessa-Nettel Sonnar f4.5 or Citonar f6.3. Dial Compur 1-200. $35-50.

Tropical plate cameras - c1920s. 6x9cm size. Finely finished wood, reddish-brown bellows, brass trim or combination of brass & nickel trim. Zeiss Tessar f4.5/120. Compur shutter 1-250. General guidelines: Strut-type with focal plane shutter: $400-700. Bed-type with front shutter: $300-400.

CORD (France)
Cord Box 6x9 - c1946. Simple, poorly constructed cardboard box camera. Boyer Meniscus lens. $8-15.

CORFIELD (K.G. Corfield, England)
Formed in 1948, this company is important because it represents a British post-war quality camera manufacturer. The company was taken over by Guinness and ceased camera production in late 1961, and finally closed in 1971.
Corfield 66 - 1961. SLR for 6x6cm on 120 film or cut film backs. FP sh. 1-500. Lumax f3.5/95mm interchangeable lens. Reportedly only 300 made. $100-225.

Periflex - 35mm cameras for 36 exp. 24x36mm. Interchangeable f2.8/50mm Lumax or f1.9 or f2.8/45mm. Focal plane shutter to 1000. Unusual through-the-lens periscope reflex rangefinder which, despite its cumbersome appearance, worked quite well. Most often found in England at indicated prices. Occasionally found at slightly higher prices outside of England.
Periflex (original model) - 1953. Brown

pigskin covering, black anodized top and bottom plates. $400-600.

Periflex (1) (black) - c1954. Like the original, but black leatherette covering. Early production has shutter speeds and name engraved on top plate. Later models have speeds on chrome ring and name on periscope. $150-200. *Illus. previous column.*

Periflex (1) (silver) - c1955. Top & bottom plates finished in anodized silver color to resemble satin chrome. Lumar-X in restyled mount with leatherette grip rings. $70-100.

Periflex 2 - 1958. Simplified version of the Periflex 3. Non-interchangeable finder. Top speed 1/500. Lacks film speed reminder and EV scale. $85-150.

Periflex 3 - 1957. Re-designed taller body incorporates finder and eye-level automatic periscope. FP shutter 1-1000. $150-200.

Periflex 3a - 1959. Improved version of the 3. $150-200.

Periflex 3b - 1961. Recent asking prices $300-350. No confirmed sales in that range.

Periflex Interplan - 1961. No periscope mechanism. Sold as low-priced body with one of three lens mounts: Interplan A = Leica mount; B = Praktica/Pentax; C = Exacta. $100-150.

Periflex Gold Star - c1961. (There is a gold star on the front.) Periscope viewfinder. Interchangeable Lumax f1.9 or f2.8/50mm lens. Focal plane shutter 1-300. $75-150.

CORNU CO. (Paris)
Fama - Small cast-metal 35mm camera with interchangeable shutter and lens mount. Normally found with Flor f2.8/50mm lens. $30-45.

Ontobloc - c1946. 35mm compact camera. Dark grey hammertone painted cast metal body. Based on the Reyna, but with rigid, non-collapsible front. Som Berthiot Flor f3.5/50mm lens in Coronto Paris ½-300 3-blade shutter. Model I has rigid rectangular tube finder cast as part of the body. Models II & III are identified on top of their slightly modernized top housing. $40-60.

Cornu Reyna II

Ontoflex - c1938. TLR for 6x9cm on 120 film. Rotating back for horizontal or vertical format. Model A is for rollfilm only. Model B has interchangeable rollfilm and plate backs. Berthiot f3.5, Tessar f3.5 or f3.8 in Compur. $250-300.

Reyna Cross III - c1944. *Made now by P. Royet at St. Etienne in the "free zone" during the German Occupation.* Black painted cast aluminum bodied 35mm. f3.5 Berthiot or f2.9/45mm Cross. Two blade shutter 25-200, B. $20-30.

Ontoscope - c1934. Rigid-body stereo cameras, made in the popular 45x107mm and 6x13cm sizes in a number of variations: Focusing/non-focusing, Magazine back/plate back, Panoramic/non-panoramic. Inclusion of beautifully constructed Cornu rollfilm back for 127 or 120 film will add to the value.$100-200.

Ontoscope 3D - Stereo camera for 24x30mm frames on 35mm film. Cast metal body, Flor Berthiot f3.5/40mm lenses. Shutter speeds 1-100 set by knob between the lenses. Additional speeds of 200 and 400 by employing a supplementary spring controlled by another knob. Very rustic in comparison with the contemporary Richard Verascope F40, and much more rare. Probably only a few hundred made. $375-500.

Reyna II - c1942. Cast metal 35mm camera. Variations include body finish in black hammertone or brown; Berthiot Flor f3.5/50mm, Boyer Saphir f3.5; Compur Rapid, Vario, Reyna, and Reyna Cross II shutters. Front lens focus. $20-30.
Illustrated top of next column.

Week-End Bob - Cast metal 35mm camera of obvious relation to the Reyna etc., but with attractive grey enameled aluminum body & gold colored knobs. Interchangeable shutter/lens units with Leica thread. Close focusing is allowed by pulling out front tube. Uncommon even in France, where it sells for $60-80.

CORONET CAMERA CO. (Birmingham, England)
Coronet Camera Co. 1926-1946
Coronet Ltd. 1946-1967
Standard Cameras Ltd. c1931-1955
This company was formed c1926 by F.W. Pettifer and manufactured a large number of cheap box and folding cameras until c1967. Many of its cameras were distributed via premium schemes or mail order catalogues. Most of its pre-war box cameras and post-1945 plastic molded cameras appear with different nameplates and lens panel stylings. The company linked up with Tiranty of Paris after WWII to produce cameras and avoid French import restrictions. These cameras usually have "Made in France" and French instructions on controls and include the Rapide, Le Polo, Weekend and Fildia.

Throughout its life the firm produced various Coronet accessories, flash units, closeup filters and viewers and its own Coronet film in 120 and 127 sizes. Close links between Coronet, Standard Cameras Ltd. and Conway cameras exist with molds and body parts being interchanged. Over 50 different Coronets exist.

Ajax - c1935. Box camera for 6x9cm. Blue leather covering. Anastigmat f7.7. Shutter 25-100. $30-40.

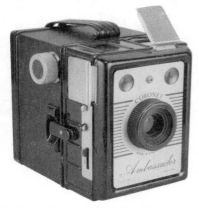

Ambassador - c1955. Metal & bakelite box camera for 6x9cm. Quite attractive with chromed hinged covers over brilliant finders. Two small levers above shutter release engage time exposure and green filter. Fixed focus lens. $10-20.

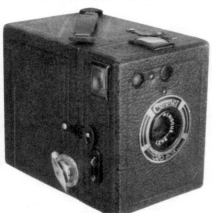

Coronet 020 Box

Box cameras - c1935. Coronet made a great variety of box cameras, most of which are common and not in great demand by collectors. Some were made in France after WWII because of French import restrictions. $5-15.

Cadet - Bakelite body. 2¼x3¼" on 120 rollfilm. $10-15.

Cameo - Bakelite subminiature, 13x18mm on rollfilm. Meniscus, simple shutter. $40-60.

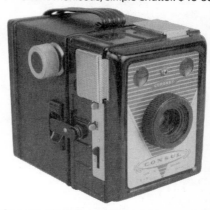

Consul - Bakelite and metal box camera for 6x9cm on 120 film. Red & green enameled metal faceplate. $15-20.

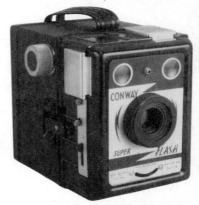

Conway Super Flash - Metal & bakelite box camera for 120 film. Similar to Consul and Ambassador. $15-20.

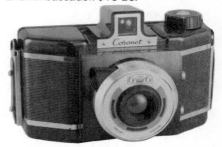

Coronet 66 - Black bakelite eye-level

camera with metal back. Takes 12 exp. on 120 film. Two synch sockets. $10-15.

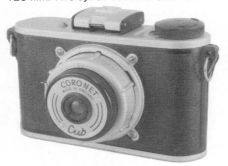

Cub - Plastic bodied camera for 28x40mm on 828 film. Spring-loaded telescoping front. Folding optical finder. Fixed focus; single shutter speed; no flash sync. $12-18.

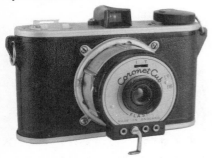

Cub Flash - Similar to the Cub, but with flash sync. Also has T & I shutter, f11 or f16, non-folding optical finder, and hinged front leg. $12-18.

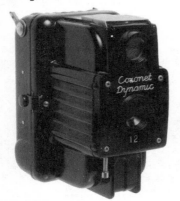

Dynamic 12 - Unusually shaped black bakelite TLR-style box camera for 127 film. $25-35.

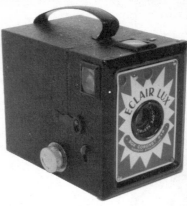

Eclair Lux - c1950's. Metal box camera for 6x9cm on 120 film. Made in France by Tiranty under license from Coronet. Several faceplate variations. $10-15.

Fildia - c1950. Cardboard 6x9cm box camera with hexagonal metal faceplate. Made in France by Tiranty under license from Coronet. $10-15.

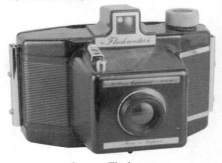

Coronet Flashmaster

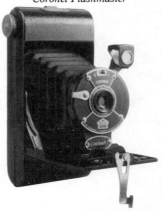

Coronet Folding Rollfilm Camera

Flashmaster - Black bakelite eye-level finder, metal back. Takes 12 exp. on 120 film. Two synch sockets. $10-15. *Illustrated on previous page.*

Folding Rollfilm Camera - Folding 2¼x3¼" cameras. Several variations in body style and lens equipment were sold under this general name in Coronet's catalogs. Normally they have no model identification on the camera itself. Meniscus models are typically not self-erecting. The table stand serves as a front door latch on some. Colored: $20-30. Black: $10-15. *Illustrated bottom of previous page.*

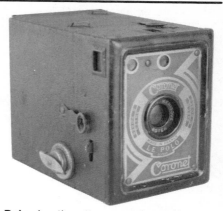

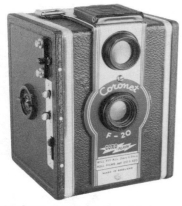

F-20 Coro-Flash - Reflex style box camera for 6x6cm on 620 or 120 film. Fixed focus; T, I shutter. Built-in green filter. $10-15.

Polo - Leatherette-covered metal box camera for 6x9cm on 120 film. Made in France. Boyer Menisque lens, single speed shutter. $8-15.

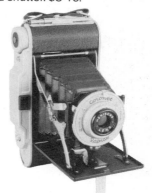

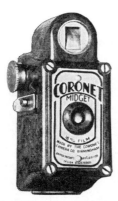

Rapide - Folding 6x9cm rollfilm camera. Body release. Eye-level optical finder. Made in France by Tiranty under license from Coronet. $10-15.

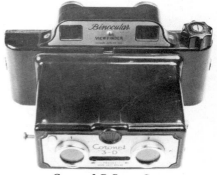

Midget - c1935. A small bakelite 16mm novelty camera. Taylor Hobson Meniscus lens f10. Single speed 1/30. Six exposures per special roll. Original price $2.50. England and USA: Brown, black, or red: $60-90. Green: $65-110. Blue: $150-225. *At auction sales in Germany all colored models tend to sell in the higher price range.*

Coronet 3-D Stereo Camera

Rex - c1950. Cardboard 6x9cm box camera with round metal faceplate. Made in France by Tiranty. Menisque Boyer lens. $8-12.

"3-D" Stereo Camera - c1953. Inexpensive plastic stereo camera for 4 stereo pairs or 8 single exp. 4.5x5cm on 127 film. Single speed shutter, 1/50. Twin f11 meniscus fixed focus lenses. At least four variations exist. $25-35. *Illustrated bottom of previous page.*

Twelve-20 - c1950. Pseudo-TLR metal box camera for 2¼x2¼" on 120 or 620 film. Meniscus lens, single-speed shutter. Built-in color filter. Slight model variations. Colored: $25-35. Black: $10-15.

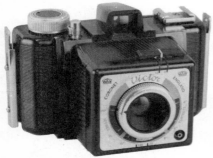

Victor - Black bakelite eye level camera for 4x4cm on 127 film. Focusing f11 lens in synch shutter. $10-15.

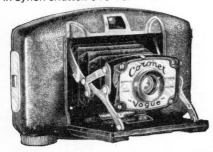

Vogue - c1937. A brown bakelite-bodied folding camera which uses "Vogue 35" film, a spool film similar to Eastman Kodak 828. Fixed focus lens. Simple B&I shutter. $60-80 in U.S.A, only about $25-35 in England.

COSMIC - c1950's-on. Russian 35mm. f4/40mm lens. Shutter 1/5-1/250. $10-20.

COSMO CAMERA CO. (Japan)
Cosmo 35 - c1955. Inexpensive 35mm camera with large shutter lever on front. Identical to Micronta 35 below. S.Cosmo f3.5/45mm lens. $30-50.

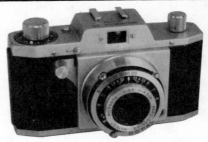

Micronta 35 - c1955. Basic 35mm scale-focus camera. Identical to the Cosmo 35. Micronta f3.5/45mm lens in Copal B,10-200. $30-50.

CRAFTEX PRODUCTS
Hollywood Reflex - c1947. (Including models A-E, Sportsman, Sightseer, etc.) Cast metal twin-lens reflex style cameras. Generally simple construction, although at least one model had externally coupled lenses for true reflex focusing. $15-20.

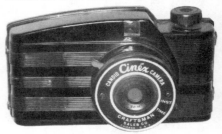

CRAFTSMAN SALES CO.
Cinex Candid Camera - Black plastic "minicam" for 16 exp. on 127. $5-10.

CRAFTSMEN'S GUILD

Classic 35 - c1948. Small streamlined 35mm half-frame camera with die-cast aluminum body. Satin finished with black horizontal stripes or leather covered. Some examples have recessed knobs and buttons. Fixed focus Craftar f4.5/32mm lens. Single speed shutter. $75-100.

CRESTLINE
Empire-Baby - Black plastic novelty camera for 16 exp. on 127. Made in Macao. $5-10.

CROMA COLOR 16 - Japanese subminiature nearly identical to the Mykro Fine Color 16, but in green, red, brown, or black bakelite. (Styled like the Whittaker Pixie cameras.) Often chipped where the front section attaches to the back, and sometimes at the latch cogs. Mint: $100-125. Chipped: $40-60.

CROWN CAMERA - Japanese novelty subminiature of the Hit type. $15-20.

CROWN CAMERA CO. (NY)
Dandy Photo Camera - intro. 1910. Simple paper-covered box camera for 1½" circular plates in paper holders. Meniscus lens, simple shutter. Originally sold in an outfit with developing tank, chemicals, lifting spoon, and illustrated instructions, all in a cardboard carton. Full outfit: $250-300. Camera only: $75-100.

CRUISER CAMERA CO.

Cruiser - Folding camera for 6x9cm exposures on 120 rollfilm. Probably made

by Wirgin. Cast metal body with leatherette covering. Wirgin Edinar f6.3/105mm lens. Vario B, 25, 50, 100. PC sync. $15-20.

CRUVER-PETERS CO. INC. *Later called Palko, Inc.*

Palko camera - c1918-1930's. One of the few folding rollfilm cameras with provision for ground glass focusing without film removal. Based on a 1912 patent of W.A. Peters. Production was apparently started during WWI with the U.S. Government as the primary customer. Adjustable image size of ⅓, ⅔, or full postcard size. B&L Tessar f4.5 lens in Acme to 300. Original price from $70 in 1918 to $122 in the early 1930's, but closed out at $65 with case. Rare. Current value: $600-750.

CRYSTAR - "Hit" type novelty camera for 14x14mm exposures on 17.5mm paper-backed rollfilm. (These bring about twice the listed prices at German auctions.) With colored leatherette: $25-35. With black covering: $8-12.

CRYSTAR OPTICAL CO. (Japan)
Crystar 15 - c1954. Horizontally styled dual-format folding camera for 6x6cm or

4.5x6cm on 120 film. Hinged masks at the film plane. C.Master Anastigmat f3.5/75mm. Crystar Optical Co. B,1-200. $50-75.

Crystar 25 - c1954. Twin-lens reflex, 2¼x2¼". Similar to Crystarflex, but sync on front. C-Master Anastigmat f3.5/80mm. Luzifer or Fujiko shutter, 1-200,B. $45-75.

CRYSTARFLEX - c1953. Medium-priced TLR with externally coupled lenses. Variations include: Magni Anast. f3.5/80mm in Magni synch shutter; C-Master Anast. in Crystar shutter. $25-35.

CURTIS (Thomas S. Curtis Laboratories, Huntington Park, CA)
Curtis Color Master - c1948. 4x5" tri-color camera. Ilex Patagon f4.5/5½" lens, Acme shutter. CRF. $325-375.

Curtis Color Scout - c1941. Tri-color camera, 2½x3". Ektar f4.5/80mm, Compur 1-200 shutter. CRF. $200-325.

CUSSONS & CO. (D.H. CUSSONS & CO., Manufacturers. Southport, England)
Tailboard camera - Brass and mahogany tailboard camera, 4½x7½". $175-250.

CYCLONE - *Western Camera Co. manufactured Cyclone cameras until about 1899, when it was taken over by the Rochester Optical Co., which continued to produce Cyclone models. We have listed Cyclone models under each of these makers.*

DACO DANGELMAIER - see Dacora.

DACORA KAMERAWERK (Reutlingen & Munich) *Originally located in Reutlingen, the company name went through several changes including: Dangelmaier (1952), Daco Dangelmaier (1954), Dacora Kamerawerk (1970), and then Dacora Kamerawerk at Munich (1972-1976). For the sake of unity, we are listing all cameras here regardless of the company name at the time of manufacture.*

Daci, Daci Royal - Metal box camera for 12 exp. 6x6cm on 120 film. Red: $40-48. Grey, or green: $22-35. Black: $10-15.

Daco, Daco II - c1950. Black bakelite box cameras with slightly curved sides and rounded corners. Similar in style to the common metal Daci camera. Daco has f11 lens; Daco II has f8. Uncommon. $40-50.

Dacora I - Folding camera for 12 exp. 6x6cm on 120. Eunar f3.5/75mm. Prontor 1-100. $12-20.

camera with f2.8 lens, 1/300 shutter. (Orig. price $18.) $10-15.

Dacora II - Horizontally styled folding camera for 6x6cm on 120. Ennar f3.5/75 in Pronto, B,25-200. $15-20.

Dacora-Matic 4D - c1961-66. 35mm with coupled meter. Four shutter release buttons for focus zones. Lens rotates to proper focus as release button is pushed. $15-20.

Digna - c1958. Simple camera with tubular telescoping front for 6x6cm on 120. Very common. $5-10.

Dignette - c1957-59. Basic 35mm VF

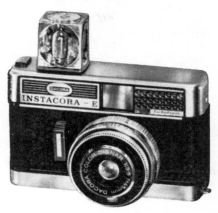

Instacora E - c1966. A high-quality camera for 126 cartridges. Electric eye, 1/30-1/125 speeds, zone focusing f3.5/45mm Color Dignar lens. $15-20.

Royal - c1955. Folding camera for 6x6cm on 120. Uncoupled RF. Ennagon f3.5 or 4.5 lens in Pronto. (Orig. $31-34.) $30-60.

Subita - c1953. Horizontally styled self-erecting folding camera for 6x6cm on 120 film. Subita f6.3/75mm Anastigmat in Singlo 25,75,B shutter. Advertised originally as a low-priced camera at 45 marks. Uncommon. $15-20.

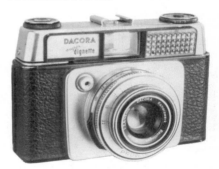

Super Dignette - c1960's. Non-RF 35mm cameras with built-in meter. Cassar, Dignar, or Isconar f2.8/45mm. Pronto LK, Prontor LK, or Vario LK shutter. $10-20.

DAGUERREOTYPE CAMERAS - *The earliest type of camera in existence, many of which were one-up or limited production cameras. Since so few of even the commercially made models have survived time, most Daguerreotype cameras are unique pieces, and price averaging is senseless. However, to keep the novice collector or casual*

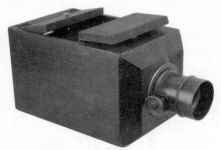

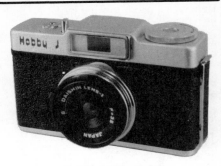

Daishin Hobby Junior

antique dealer from making any big mistakes before consulting with a recognized authority, we will give a few recent figures. Several half-plate American sliding-box-in-box style cameras have been offered for sale at $4000-$5000. A Lerebours type sold at auction for $7100.

DAIDO SEIKI CO. (Japan)
Daido Six Model I - c1953. Horizontally styled folding camera for 6x6cm or 4.5x6cm on 120 film. Side-by-side viewfinder for the two image sizes almost gave the appearance of a rangefinder camera. C.Daido Anastigmat f3.5/75mm in N.K.S. B,1-200. $60-90.

DAIICHI KOGAKU (Japan)
DAI-ICHI OPTICAL WORKS (Japan) *(See Okada Kogaku for the earlier Waltax I camera.)*
Waltax Acme - c1951. Rangefinder camera, similar to the Super Ikonta A. Bio-Kolex f3.5/75mm lens in Dabit-Super shutter, B, 1-500. Rare. $250-400.

Waltax Jr. - c1951. Copy of Ikonta A, for 16 exposures 4.5x6cm on 120 or 620 film. Bio-Kolex f4.5/75mm lens. Okako shutter B, 25-150. USA: $30-45. Germany: $50-75.

Waltax Senior - c1951. Copy of Ikonta A. For 16 exposure, 4.5x6cm, on 120 rollfilm. Bio-Kolex Anastigmat f3.5/75mm lens in Dabit-Super shutter, B, 1-500. $30-50.

Zenobia - c1949. Folding camera for 16 exp. 4.5x6 cm on 120 film. Styled like the early Zeiss Ikonta cameras. f3.5/75mm Hesper Anastigmat. DOC Rapid shutter 1-500, B. (Similar to the Compur Rapid.) $30-45.

Zenobiaflex - c1953. Rollei-style TLR with Neo-Hesper f3.5/75mm in Daiichi Rapid shutter. $40-60.

DAISHIN SEIKI K.K.
Hobby Junior - c1965. 24x36mm on paper-backed "Bolta" size film. Daishin f8/ 35mm lens, single speed shutter. A number have been offered and sold new in box for $15-20. *Illustrated top of next column.*

DAITOH OPTICAL CO. (Tokyo)

Grace - Simple eye-level camera for 120 film. Bakelite & metal body. Folding frame finder. Synchronized. $10-15.

DALE - Japanese novelty subminiature of "Hit" type. $12-18.

DALLMEYER (J. H. Dallmeyer, London)
Founded c1860 by J.H. Dallmeyer. Not actually a camera maker. Most "Dallmeyer" cameras are just cameras retailed by Dallmeyer with their lenses and label applied. This holds true for most of the 19th century wooden cameras and 20th century reflexes. Some cameras were made by other makers for Dallmeyer to sell with their lenses, and we have attemped to identify these where possible.

Correspondent - c1904-14. Leather covered hand camera, 4x5". Double or triple extension bed made it ideal for telephoto work. $150-200.

"Naturalists Hand Camera" - c1894-1904, had a long eyepiece tube extending to the rear. It used a combination of a portrait lens and a negative lens of about half its focus. Probably made by George Hare. No known sales. Estimate: $400-800.

New Naturalists' Hand Camera - c1904-1910. Probably made by Hare. Long extension bellows on front of cubical body allowed use of ordinary lenses in the compact position, or long focus lenses when extended. Short vertical-tube eyepiece views greater portion of the image than previous model. Goerz Anschutz FP sh to 1000. Uncommon. $300-550.

Naturalist's Reflex Camera - c1911-13. Made by Kershaw. Folding hood rather than tube for focusing. Specially designed to carry the Grandac lenses, which "give focal lengths from 10 ins. to 45 ins. at apertures from f/4 upwards." No known sales. Estimate: $250-450.

Press Reflex - c1930's. Ensign 3¼x4¼" Reflex with Dallmeyer lens and name. Focal plane shutter 15-1000. $200-250.

Snapshot Camera - c1929. Made by Houghton-Butcher for Dallmeyer. Folding camera for 6x9cm filmpacks. Cross-swinging strut design. Two-speed shutter built into front. $40-65.

Speed Camera - mid-1920's. Press-type camera made for Dallmeyer by N&G, and equipped with the Dallmeyer "Pentac" f2.9 lens. This fast lens, as well as the ⅛ to 1/1000 FP shutter, account for the camera's name. Small 4.5x6cm size: $150-250. 6.5x9cm or 3¼x4¼": $100-150.

Stereo Wet Plate camera - c1860. Sliding box style. Brass bound corners on finely crafted wood body. Maker's name unspecified, but with brass barrel Dallmeyer lenses (consecutively numbered) with wooden flap shutter. $2500-3200. Other "Dallmeyer" equipped wet-plate stereo cameras of similar type have sold from $1500-3400.

Studio camera - c1900. Mahogany bellows camera with rack focusing, swing/tilt back. Petzval-type Portrait lens, waterhouse stops. $300-400.

Wet Plate Sliding Box Camera - Mid-1860's. $1000-2000.

DAME, STODDARD & KENDALL (Boston)
Hub (Box camera) - Top loading box camera for 4x5 plates. $20-30.

Hub (Folding) - Late 1890's leather covered folding camera for 4x5" plates. Side door at rear for inserting and storage of plateholders. Rotary shutter built into wooden lensboard. Simple lens. $60-90.

DAMOIZEAU (J. Damoizeau, Paris)
Cyclographe à foyer fixe - c1894. An early panoramic camera which revolves on its tripod while the film is transported in the opposite direction past the focal plane slit. Capable of exposures up to 360 degrees (9x80cm). $7500-8500.

DAN CAMERA WORKS (Tokyo) *Later became Yamato Camera Industry (Yamato Koki Kogyo Co. Ltd.) which made the Pax cameras.*
Dan 35 Model I - c1946-48. Compact camera for 15 exposures 24x24mm on 35mm wide paper backed Bolta-sized roll-film. Removable top. Dan Anastigmat f4.5/40mm. Silver-B shutter B, 25-100. $60-100.

Dan 35 Model II - c1948-50. Similar, but with body serial number, automatic frame counter, removable bottom. $60-100.

Dan 35 Model III - c1949. 24x32mm exposures on Bolta-size rollfilm. Dan Anastigmat f3.5/40mm, Silver-B shutter B,25-100. $60-100.

Dan 35 IV - Photavit copy. Rare. $70-100.

Super Dan - A smaller Pax predecessor with Eria Anastigmat. $60-75.

DANCER (J. B. Dancer, Manchester, England)
Stereo Camera - c1856. For stereo pairs on 12 plates 3½x7". A nicely finished wooden stereo camera which set a new record for the highest price paid for an antique camera, $37,500.00 in 1977.

Tailboard view camera - Mahogany ½-plate camera. Ross Rapid Symmetrical lens with wheel stops. Gravity shutter. $100-150.

DANGELMAIER - see Dacora

DARIER (Albert Darier, Geneva, Switzerland)
Escopette - c1888. Invented by Darier, manufactured by E.V. Boissonas (Geneva). Wooden box camera with wooden pistol grip, giving it the general appearance of a pistol. The grip and two small brass front legs serve as a tripod. Brass metal parts. This was one of the first cameras to use the same rollfilm as the #1 Kodak Camera, taking 110 exposures, 68x72mm. Steinheil Periscopic f6/90mm lens. Spherical shutter with trigger release. Speeds variable by adjusting spring tension. Rare. Estimated: $5000+

DARLOT (Paris)

Rapide - c1887. Rigid wooden camera in shape of truncated pyramid. The unusual feature is the external magazine which holds 12 plates, 8x9cm, and which attaches below the camera. Plates slide into the inverted camera by gravity from a slit at the end of one side of the magazine. After exposure, the magazine is inverted and reattached to the camera so the exposed plate is returned to the other side of the magazine. $3500-4500.

DATA CORPORATION (Rockville, Maryland USA)
Aquascan Camera KG-20A - Underwater slit-scan panoramic camera for 35mm film on 100' spools. 50 degree vertical x 120 degree horizontal field of view. Leitz Elcan lens. Pistol grip with trigger-operated magnetic release. Motorized film advance. The ultimate special-purpose camera and a great weekend toy if you outgrow your Calypso and Nikonos. $1500-2500.
Illustrated top of next column.

Data Corp. Aquascan Camera

DAVE - Simple box camera for 6x9cm on 120 film. Meniscus f11/105mm lens. $5-10.

DAVY CROCKETT - Not Herbert-George's box camera, but a black plastic minicam for half-frame 127. Uncommon. $30-45.

DAYDARK SPECIALTY CO. (St. Louis, Missouri)
Photo Postcard Cameras - "Street" cameras for photo postcards or tintypes, complete with developing tank, dark sleeve, RR lens, and Blitzen Daydark shutter. $100-150.

Tintype Camera - small amateur model. Measures 4½x5x7¼. $50-100.

DBGM, DBP, DBPa: *The "DB" stands for "Deutsches Bundesrepublik". The endings of the abbreviations are: "Gebrauchs Muster", "Patent", and "Patent Auslegeschrift", design registration and patent notices which would indicate West German post-war construction.*

DEARDORFF (L.F.) & SONS (Chicago, IL) *Established as camera builders in 1923, the company name goes back to 1893 when Laben F. Deardorff started a camera repair company.*

In 1923 Laben was commissioned by a group of Chicago architects to build 10 cameras to photograph that new Chicago wonder, the skyscraper. Amazingly enough, five of the first 10 cameras built still exist, four of them in daily studio use! To this day, a member of the Deardorff family is involved in the daily production of cameras. These cameras are primarily "user" cameras though there are a few who collect them avidly. There were no serial numbers until 1951.

The condition of these cameras can vary greatly because those sold to studios generally have seen very hard use, while those sold to individual users may have been "babied" and may remain in mint condition even though they are 20-40 years old. L.F. Deardorff is a manufacturing concern that has made MANY one-of-a-kind cameras and accessories through the years. All were well made, but in checking used equipment make sure that all parts are present or it may be useless. On cameras, make sure all racks, rears, wood panels, and especially bellows are in good working order. The bellows are one of the most expensive parts to replace. Be wary of a camera with taped bellows. Tape causes great stress on the camera when closed and this in turn can cause damage to the wood parts.

The "refinished" price reflects a camera that has been PROFESSIONALLY restored by Ken Hough Photographic Repair Service, the only authorized Deardorff service center in the USA. Fully restored cameras include new bellows, wood work and parts where needed, and a duplicate of the factory finish. These cameras may be rated as LN-. All prices were compiled by Ken Hough. He may be reached for any questions regarding the Deardorff camera at 219-464-7526. We are also indebted to Jack Deardorff for the history of the early cameras, and to Merle Deardorff for the history of the Baby Deardorff.

8x10" Cameras The early (pre-1926) cameras are of a light colored, finished mahogany. This wood was taken from the bar tops of Chicago taverns that were closed down during prohibition. Beginning in 1926, the wood was a deep red color.

First series - 1923. Ten cameras. Parquet style bed. Lensboard opening measures 5½x6". Only the first series had this size lensboard. No recent reported sales.

Second series - 1924. 25 cameras. Parquet style bed. Standardized 6x6" wooden lensboard. Aluminum front standard. Current value: Refinished- $1500-2000. Good condition- $400.

Third series - 1924. 25 cameras. Same as the Second series, but all aluminum front standard. Refinished: $1500-2000. Good: $400.

Fourth series - 1925. 75 cameras. Same as the Third Series, above.

Standard V8 -- 8x10"

1936 8x10 with front swing conversion.

- 1926-1937. Wood is deep red in color. Standardized construction with familiar four piece bed, narrow knobs with fine knurling, all brass parts painted with a special gold lacquer. Lensboards have a thinner rabbet on the front. Refinished with front swings: $1650. Refinished: $1200-1400. EX: $900. Good: $350-400.

- 1938-1948. Same as above but brass parts are nickel plated and knobs are wider. Refinished with front swings: $1650-2100. Refinished: $1200-1400. EX: $950. Good: $350-400.

- 1949. Front swings are standard as is the round bed plate. Nickel plated parts. Serial numbers began in 1951 with #100; it was then called the 8x10 View. Refinished: $1650-2200. EX+: $1200-1600. VG: $800. Good: $400.

AN Series - Large group of 8x10" cameras made for the Army and Navy. There are two differences in these cameras from the standard models. 1. A small rectangular plate on the bottom of the bed that gives a government Number and model number. 2. A ⅛" thick rabbet on the front sliding panel. This requires 6x6" Kodak-style lensboards. Prices fall into the same ranges as other 8x10" Deardorff cameras.

5x7" Old Style (OS) V5
- 1929-1937. Basically the same construction as the 8x10" cameras of this time. Red finish on wood. Original square cornered 4½x4½" lensboard, or factory modified 4x4" lensboard. Refinished: $600. VG: $350. Fair: $200. *Illustrated top of next page.*

DEARDORFF (cont.)

1937 5x7 with 4x4" lensboard

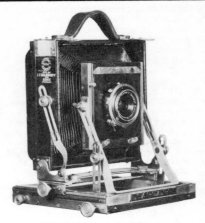

1936 Baby Deardorff Prototype

- 1938-1948. Same construction as the 8x10" cameras of this time. Original round or square cornered 4½x4½" lensboard, or factory modified 4x4" lensboard. Refinished: $650-800. EX: $350-400. VG: $250-350. Good: $150-250. Fair: $100. *Note: This camera may also be seen in a "yellow" colored wood. These were made of Spanish cedar wood because of the wartime shortage of mahogany that was being used in PT boats. Prices may be slightly lower.*

- 1949-present. Redesigned camera body. Front swings, round bed plate, and nickel plated parts are standard. Square cornered 4x4" lensboard. Serial numbers began in 1951 with #100; it was then called the 5x7 View. Refinished: $1000-1400. EX: $900. VG: $450. Good: $350. *Many 5x7 cameras are seen with 4x5 back only.*

4x5" Old Style (OS) V4
- 1929-1937. Same as the 5x7" camera, but with a 4x5" reducing back.

- 1938-1948. Same as the 5x7" camera, but with a 4x5" reducing back.

- 1949-present. Redesigned camera body. Front swings, round bed plate, and nickel plated parts are standard. Square cornered 4x4" lensboard only. Serial numbers began in 1951 with #100. Since that time it has been known as the 4x5 Special. Refinished: $1200-1400. EX: $900. VG: $500. Good: $350.

Baby Deardorff V4 - *Designed by Merle Deardorff, this camera looks like a miniature 4x5" or 5x7" camera. It takes up to a 4x5" back. 3½x3½" lensboard only.*
First style - 1936 only. Wood separator strips on bed between front and rear extension. Twelve prototype cameras were made to test the market. These were recalled for evaluation by Merle Deardorff after about one year. Only eight were returned and these were destroyed when their beds were found inferior. The remaining four examples are all known to exist, one in everyday use. One sold in 1988 in EXC condition for $1900.

Second style - 1940-1945. Extruded extension guides, L-shaped guides on front sliding panel. Refinished: $1400-1600. EX: $1200. VG: $450. Good: $400.

Third style - 1945-49. Same as the Second style, but with U-shaped guides on front sliding panel. Refinished: $1200-1450. EX: $1100. VG: $500. Good: $450.

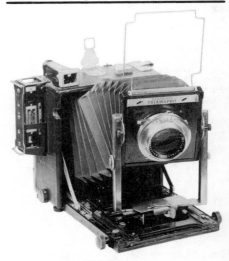

1938 Triamapro

134

Backs available for Baby Deardorff:
- Standard 4x5" still manufactured.
- 3¼x4¼" Graflex style: $60-80
- 2¼x3¼" standard CFH type: $80-100.
- 35mm back. This was a Kodak 35 body that was mounted on a sliding panel with a ground glass focusing screen, similar to a Leica Focoslide, but vertical in normal operation. Only reported sale: $120.

Triamapro - An ultra precise 4x5" Press Style camera, featuring a rotating back, front and rear swings, front rise, and lateral sliding front. May be seen with Hugo Meyer or Kalart rangefinder. Backs seen are standard cutfilm back, either Graflex or Grafloc style. The word Triamapro means TRIple extension, AMAteur, and PROfessional. Usually seen in good to VG condition. EX: $1000-1200. G-VG: $350-500. Note: there were also two 5x7" Triamapro cameras built. No reported sales. *Illustrated bottom of previous page.*

11x14" Cameras:
Early style - Looks like a giant 8x10" view camera. Has no front swings. Many were built for the US Marines for "on the beach" photo reconnaissance. Came with tripods whose legs could be used as bayonets! Refinished: $2500-3000. EX: $2100. VG+: $1200.

Second style - Similar to the Early style, but with front swings. Made in small numbers since 1951. New for $5500. Refinished: $3800-4400. EX+: $3000. EX: $2000.

Commercial Cameras - *8x10" or 11x14" cameras that must be used on 700 lb. Bi-post stands, 8', 10', or 12'. Also known as the "Dog house type". It is almost always found in large studios.*
- 8x10" Until recently, these were seldom found for sale. However, at a large studio auction early in 1989, many were sold in VG condition, with bipost stand for $350-1000. Refinished: $2100. EKC: $1000.

- 11x14" Refinished: $2600. EX: $2000. VG: $1600. Good: $1000. Fair: $400.

- Bi-post stands: $400-1600.

16x20" View - Only two were made. No reported sales.

12x20" View - Special order only. Most recent sales record is from 1983 when one sold, EX+, for $3200.

5x7" Home Portrait - 1940-present. Still in stock, new. EX: $75. Good: $50.

DEBONAIR - Hong Kong 120 rollfilm novelty camera of the Diana type. $1-5.

DEBRIE (Ets. Andre Debrie, Paris)

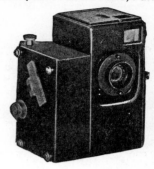

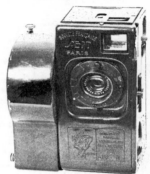

Sept - c1923-27. Spring motor drive camera for still, rapid sequence, or cine. 18x24mm on 5m cartridge of 35mm film. Roussel Stylor f3.5/50mm. First model has square motor housing with single spring. Later, the double-spring model with a round motor housing was added. (Burke & James Inc. of Chicago was selling both models as late as 1940!) Not hard to find. $125-150.

DEFIANCE MFG. CO.
Auto Fixt Focus - c1916-20. Well-made

folding camera with bed and lazy-tong strut construction. Focusing can be done with the camera in the open or closed position. Self-erecting front assumes correct focus when opened. Goerz f4.8 or f6.8 lens in Acme shutter. Uncommon. $25-35.

DEJUR-AMSCO CORP. (New York)

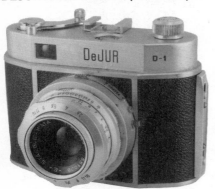

DeJur D-1, D-3 - c1955-57. 35mm VF camera with interchangeable lenses, imported from Germany. Lever film advance cocks shutter. DEP. Staeble-Kata f2.8/45mm normal, f5.6 tele, or f3.5 W.A. lenses. (Orig. price for the 3-lens outfit was under $100.) With normal lens: $15-25. Tele & W.A. lenses each: $15-20.

Dejur Reflex - c1952. TLR. DeJur Chromtar f3.5 lens. Wollensak Synchromatic 10-200 shutter. $30-45.

Dekon SR - c1960. 35mm SLR made by Tokyo Kogaku. Simlar f2.8/50mm lens, Seikosha SLV 1-500 shutter. $75-125.

DELOYE (Paris)
le Prismac - c1905. Built by A. Devaux. Early rollfilm stereo camera. Two 90 degree prisms reflect the image at right angles from the lenses onto the film, allowing for a more compact body than usual. Used Pocket Kodak Camera size #102 rollfilm. Kenngott Anastigmat f8/54mm lenses, 5-speed guillotine shutter. Rare. Estimate: $1500-2500.

DELTAH CORPORATION

Deltah Unifocus - Unusual folding vest-pocket camera for 127 film. All black model, or brown enameled with brown leatherette and black bellows. $15-25.

DELUXE PRODUCTS CO. (Chicago)
Delco 828 - Streamlined bakelite camera for 828 film. Identical to the Argus Minca 28, this camera merely sports the name of its distributor. $20-25.

Remington - Plastic "minicam" for 3x4cm on 127. $5-10.

DELUXE READING CORP. (Topper Toy Div.)

Secret Sam Attache Case - c1960's. Plastic attache case containing a take-apart pistol and a 127 rollfilm camera which can be used with the case closed. $50-90.

Secret Sam's Spy Dictionary - c1966. Novelty which incorporates a camera in a plastic "book" which also shoots plastic bullets. The camera takes 16 exp. on 127 film. $75-95.

DEMARIA (Demaria Freres, Demaria-LaPierre, Paris)

Caleb - c1920's. Folding 9x12cm plate camera. Rectilinaire Hector Extra-Rapide lens. Rack focus. $30-50.

Dehel - Folding 120 rollfilm cameras. f4.5 or f3.5/75mm lens. AGC shutter. $15-25.

Field camera - c1900. 24x30cm. Fine wood body, brass trim, red square double extension bellows. Aluminum and brass Rietzschel Extra Rapid Aplanat f8/480mm lens in Thornton-Pickard shutter. $225-275.

Folding Plate Camera - Strut-type folding camera for 6x9cm plates in single metal holders. Black enamel finish. Demaria Anast. Sigmar f6.3 in Vario 25, 50, 100, T, B. Basic construction is similar to Zion

Pocket Z. Unusual and complicated focusing system with radial lever operated cam sliding a large plate whose two diagonal slots engage pins at either side of the shutter housing. $25-35.

Jumelle Capsa - (Demaria Freres) Stereo camera in 4.5x10.7cm or 6x13cm. All metal body. Guillotine. $175-225.

DEROGY (Paris)
Field camera - c1900. Wood body, brass trim, double extension brown leather bellows. 13x18cm. Brass Derogy Aplanat f8 lens. $225-275.

Single lens stereo camera - Light walnut view camera with sliding front panel and slotted back for single or stereo exposures. Entire bellows rotates to change from horizontal to vertical exposures. Brass trim and brass barrel Derogy lens. $375-425.

Wooden plate camera - c1880. 9x12cm. Derogy Aplanat No. 2 brass barrel lens. Black tapered bellows, polished wood body, brass trim. $175-200.

DESTECH INC. (Toronto, Canada)

Clickit Sports - c1988. Among the hundreds of novelty "Micro-110" types which snap onto a film cartridge, this one stands out by virtue of its sliding lens cover and especially its detachable wrist-strap. New price was about $10.

DETECTIVE CAMERAS - *The earliest "Detective" cameras were simply designed as a box or case. Before long, they were disguised in all shapes and sizes. The original box, case, and satchel cameras are commonly referred to by the name "detective" cameras, while the later disguised/concealed varieties normally are not. Disguised cameras seem to have a special appeal and therefore the prices have remained strong despite the ups and downs of our economy. The magic of the mere name "detective" for an otherwise ordinary-looking box camera has worn thin in the current market and those prices have softened. In any case, they are listed by name of manufacturer.*

DETROLA CORP. (Detroit, Mich. c1939-1940)
All letter models listed below are similar "minicam" type cameras for 3x4cm on 127 film. Except for Model A, all have rectangular aluminum plate in center of front. The "W" in models GW, HW, and KW indicates a Wollensak lens. The plastic used for some of the viewfinders is unstable and shrinks as though melted.

Model A - Basic minicam. Meniscus fixed focus. $10-20.

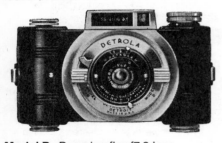

Model B - Duomicroflex f7.9 lens. Extinction meter. $15-20.
Model D - similar, f4.5 lens. $10-20.
Model E - similar, f3.5 lens. $15-20.

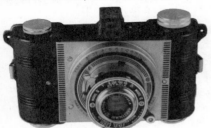

Model G - Ilex or Detrola Anastigmat f4.5. No meter. Viewfinder is made of an unstable plastic which is often shrunken and appears to have been melted. $15-20.
Model GW - Basic model with Wollensak Velostigmat f4.5. $12-18.

Model H - extinction meter. $15-25.
Model HW - similar to GW, but with meter. $15-25.

Model K - Detrola Anastigmat f3.5, extinction meter. $15-20.
Model KW - Wollensak anastigmat f3.5 lens. $15-20.

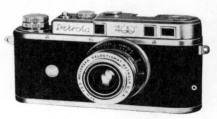

Model 400 - A Leica-inspired CRF 35mm. Interchangeable Wollensak Velostigmat f3.5 or f2.8 lens. FP shutter to 5000. Sync. (Original cost about $70.) $300-400.

DEVIN COLORGRAPH CO. (New York)
(After 1940, Devin-McGraw Colorgraph Co., Burbank California. All rights sold c1950 to Bob Frazer of Altadena, CA.)
Tri-Color Camera - c1939. Makes color separation negatives. Original professional size for 5x7". Apo-Tessar f9/12" lens. Dial Compur shutter. $400-475.
6.5x9cm size - c1938. Goerz Dogmar f4.5/5½" lens. Compound shutter. $450-550.

DEVUS - c1950's on. USSR, 6x6cm TLR. Lomo f4.5/75mm, 1/15-250. Copy of the Voigtländer Brillant, similar to the Lubitel. $30-40.

DEYROLLE (France)

Scenographe (Original model) - c1876. A very early collapsible bellows camera. Wooden body with green silk bellows. Gate-type wooden struts support wooden front with sliding lensboard. Takes single or stereo exposures on 10x15cm plates. Very unusual. Several sales since 1984 with original wooden case, holder, and ground glass for $4000-5000. Later models with cloth bellows have been offered for half that amount.

DIAMANT - c1903. French folding bed camera for 9x12cm plates. Leather covered body. 5-speed guillotine shutter is built into leather-covered lensboard. Mensicus lens. $75-125.

DIAMOND JR. - c1898. Top loading box camera for 3¼x4¼" plates. $50-75.

DIANA - Novelty camera for 4x4cm on 120 film. The same camera exists under many other names with only minor variations in style. (Diana-F is synchronized for flash.) $1-5.

DIANA DELUXE CAMERA - Novelty camera for 120 film. Body release, helical zone focus, hot shoe, imitation meter cell. $1-5.

DIONNE F2 - Hong Kong "Diana" type novelty camera. $1-5.

DIPLOMAT - "Hit" type novelty camera. $10-15.

DORIES - "Diana" type novelty camera. $1-5.

DORYU CAMERA CO.
Doryu 2-16 - c1955. Unusually designed subminiature camera disguised as a pistol. Flash cartridges are shaped like bullets.

10x10mm on 16mm film. $2500-3000.

DOSSERT DETECTIVE CAMERA CO. (NYC)

Detective Camera - c1890. 4x5" box-plate detective camera. Leather covered to look like a satchel. Sliding panel hides lens. Ground glass covered by diamond-shaped panel. Entire top hinges forward to reveal the plate holders for loading or storage. $750-950.

DOVER FILM CORP.
Dover 620 A - c1950. A plastic & chrome camera for 16 exp. 4.5x6cm on 620 film. Somco f9 meniscus, 5 rotary disc stops. Single speed shutter. Built-on flash. $10-15.

DREXEL CAMERA CO. (Le Center, Minnesota) *While we have not yet researched this company, we suspect that its only camera was produced in Chicago, using the same dies as the cameras from the "Camera Man" company.*
Drexel Jr. Miniature - Black plastic minicam for 127 film. Body style identical to the "Champion" and "President" by Camera Man Inc. of Chicago. $5-10.

DREXLER & NAGEL (Stuttgart) *Carl Drexler and Dr. August Nagel formed this firm in 1908. It was renamed Contessa Camerawerke in 1909, so it existed under this name for a very short period of time.*
Contessa - 1908. Folding plate camera 4.5x6cm. Staeble Isoplast f6.8/3". $600-800

DRGM, DRP: *"Deutsches Reichs Gebrauchs Muster", "Deutsches Reichs Patent", design registration and patent notices which would indicate German construction before WWII.*

DRUCKER (Albert Drucker & Co., Chicago)

Ranger - c1940. A stark-looking focal plane camera for 16 exposures on 127 film. Six speeds, 25-200 plus B. Polaris Anastigmat f2.0 or f2.8/50mm lens in collapsible mount with Leica thread. Sold originally by Burke & James for $30 with f2 lens, on a par with the lower-priced 35mm, rollfilm, and plate cameras of the day. Working and with original lens: $150-200. Normally without lens and with inoperative shutter, these are offered for $100-150.

DRUOPTA (Prague, Czechoslovakia) Druoflex I - c1950's. 6x6cm bakelite TLR. Druoptar f6.3/75mm, Chrontax 1/10-200. Copy of Voigtländer Brillant. $35-45.

Stereo camera for 45x107mm - c1910. RR lenses. $200-250.

Vega II - c1949-51. Basic 35mm camera without rangefinder. Non-interchangeable Druoptar f4.5/50mm in Etaxa 10-200,B,T. Collapsible front. $35-50.

Vega III - c1957. Like Vega II, but with Druoptar f3.5 lens in synchronized Chrontax. Accessory shoe on top. $35-50.

DUBRONI (Maison Dubroni, Paris) *The name Dubroni is an anagram formed with the letters of the name of the inventor, Jules Bourdin. Although anagrams and acronyms have always had a certain appeal to writers, and inventors, the story in this case is quite interesting. It seems that young Jules, who was about twenty-two years old when he invented his camera, was strongly influenced by his father. The father, protective of the good reputation of his name, didn't want it mixed up with this new-fangled invention.*

Dubroni camera - c1860's. Wooden box camera with porcelain interior (earliest models had amber glass bottle interiors and no wooden sides on the body) for in-camera processing. Five models were made, the smallest taking photos 5x5cm. Previously sold easily at $3000-3500. One very complete outfit with case, pipettes, bottles, tripod, and instructions, brought just over $6000 in 1986. An "exposed bottle" model recently sold at auction for $4600. Recent sales for the wooden-sided camera alone have been in the $1350-1600 range.

Wet-plate Tailboard camera, 9x12cm - c1870. Wood body with brass trim. Rectangular brown bellows. Dubroni brass lens with rack focusing and waterhouse stops. $600-800.

DUCATI (Societa Scientifica Radio Brevetti Ducati - Milan, Italy)

Ducati - c1950. *Several sources erroneously date this to 1938, but we find no evidence that the company existed before WWII.* For 15 exp. 18x24mm on 35mm film in special cassettes. Better models have interchangeable lenses. Normally with f3.5 or 2.8 Vitor, or f3.5 Ducati Etar lens, 35mm focal length. FP shutter to 500. Two major variations are rangefinder and non-RF models. $300-350.

DUCHESS - c1887. British ½-plate field camera. Mahogany body, brass trim, maroon bellows. RR brass barrel lens. $150-200.

DUERDEN, T. (Leeds, England)
Field camera - Brass-bound mahogany field camera, 6½x8½". Aldis Anastigmat brass-bound f7.7/11" lens. $150-190.

DUFA (Czechoslovakia)
Pionyr - Red-brown bakelite eye-level camera for 6x6 or 4.5x6cm on 120 film. Helical telescoping front. Similar in styling to the Photax cameras. Meniscus lens, T&M shutter. $15-20.

DUO FLASH - Inexpensive American plastic pseudo-TLR. $5-10.

DURST S.A. *Most photographers know Durst for their enlargers. However, at one time they made some solid, well-constructed, innovative cameras.*

Automatica - 1956-63. For 36 exp. 24x36mm on standard 35mm cartridge film. Meter coupled to shutter by pneumatic cylinder. Schneider Durst Radionar f2.8/45mm. Prontor 1-300, B, & Auto. $100-125.

Duca - 1946-50. Vertically styled 35mm camera for 12 exp. 24x36mm on Agfa Karat Rapid cassettes. Ducan f11/50mm. T & I shutter. Zone focus. Rapid wind. Aluminum body. Made in black, brown, blue, red, & white with matching colored pouch. $65-85.

Durst 66 - 1950-54. Compact camera for 12 exp. 6x6cm on 120 film. Light grey

hammertone painted aluminum body with partial red or black leather covering. Durst Color Duplor f2.2/80mm lens. Shutter ½-200, B, sync. $40-60.

Gil - c1938-42. Box camera for 6x9cm on rollfilm. Black metal body with imitation leather covering. Functions labeled in language of destination country, either German, Italian, Swedish or English. Approximately 50,000 made. This was the first camera made by Durst. Uncommon. $35-50.

EARL PRODUCTS CO.

Scenex - c1940. Small plastic novelty camera for 3x4cm exposures. Similar to the Cub. $8-12.

EARTH K.K. (Japan)
Guzzi - c1938. Cast metal subminiature. Eye-level frame finder. Fixed-focus lens; B,I shutter. $100-150.

EASTERN SPECIALTY MFG. CO. (Boston, MA)
Springfield Union Camera - c1899. Premium box camera for 3½" square plates. Four plates could be mounted on the sides of a cube, and each exposed, in turn, by rotating the cube inside the camera. An unusual design from a technical standpoint, and visually appealing with the

boldly lettered exterior. $350-450.

EASTMAN DRY PLATE & FILM CO. EASTMAN KODAK CO.

After designing the Eastman-Cossitt detective camera which was not marketed, the first camera produced by the Eastman Dry Plate & Film Co. was called "The Kodak", and successive models were numbered in sequence. These numbers each introduced a specific new image size and continued to represent that size on many cameras made by Kodak and other manufacturers. The first seven cameras listed here are the earliest Kodak cameras, and the remainder of the listings under Eastman Kodak Co. are in alphabetical order by series name and number. Some of the Eastman models listed are continuations of lines of cameras from other companies which were taken over by Eastman. Earlier models of many of these cameras may be found under the name of the original manufacturer.

For more detailed information on Kodak cameras including production dates, original prices, identification features, and photographs of each model, see "Collectors Guide to Kodak Cameras" by Jim and Joan McKeown available at camera stores, bookstores, or by mail from Centennial Photo, Rt. 3, Grantsburg, WI 54840, USA.

The Kodak Camera (original model) - ca. June 1888 through 1889. Made by Frank Brownell for the Eastman Dry Plate & Film Co. Factory loaded with 100 exposures 2½" diameter. Cylindrical shutter, string set. Rapid Rectilinear lens f9/57mm. This was the first camera to use rollfilm, and is a highly prized collectors' item. Having slumped in price for several years, these have regained ground and now sell

for $2200-3500 in the USA; about $750 higher in Europe.

No. 1 Kodak Camera - 1889-95. Similar to the original model, but sector shutter rather than cylindrical. Factory loaded for 100 exp. 2½" dia. RR f9/57mm. $600-750.

No. 2 Kodak Camera - Oct. 1889-1897.

Also similar and still quite rare, but more common than the previous models. Factory loaded for 60 exp. 3½" dia. $300-475.

No. 3 Kodak Camera - Jan. 1890-1897. A string-set box camera, factory loaded for either 60 or 100 exp. 3¼x4¼. Bausch & Lomb Universal lens, sector shutter. One fine example with rare original carton sold for nearly $800 in England. Normally: $325-400.

No. 3 Kodak Jr. Camera - Jan. 1890-97. A relatively scarce member of the early Kodak family. Factory loaded with 60 exp. 3¼x4¼ on rollfilm. Could also be used with accessory plate back. B&L Universal lens, sector shutter. Overall size: 4¼x5½x9". $285-450.

No. 4 Kodak Camera - Jan. 1890-1897. String-set box camera, factory loaded for 48 exp. 4x5", but with capacity for 100 exp. for prolific photographers. B&L Universal lens. Sector shutter. $250-300.

Auto Colorsnap 35

Model C, issued to commemorate the 50th anniversary of Eastman Kodak Co. Approximately 550,000 were given away to children 12 years old in 1930. Covered with a tan colored reptile-grained paper covering with a gold-colored foil seal on the upper rear corner of the right side. (On a worn example, the gold coloring of the foil seal may have worn off and left it looking silver.) Like New w/Box: $50-75. Mint, but without box: $35-50. VG to Excellent: $20-30.

AUTO COLORSNAP 35 - 1962-64. Kodak Ltd. Black & grey plastic 35mm with BIM for automatic exposure. $10-15. *Illustrated top of previous column.*

AUTOGRAPHIC KODAK CAMERAS *The Autographic feature was introduced by Kodak in late 1914, and was available on several lines of cameras. Listed here are those cameras without any key word in their name except Autographic or Kodak.*
No. 1A - 1914-24. 2½x4¼" exp. on A116 film. Black leather and bellows. $10-15.

No. 4 Kodak Jr. Camera - Jan 1890-97. Similar to No. 3 Kodak Jr. Camera, but for 4x5". Factory loaded for 48 exp. on rollfilm. B&L Universal lens, sector shutter. Can also be fitted for glass plates. $350-400.

No. 3 - 1914-26. 3¼x4¼" on A118 film. $15-20.
No. 3A - 1914-34. 3¼x5½" (postcard size) on A122 film. This is the most common size of the Autographic Kodak Cameras. $15-25.

No. 4 - This is actually a No. 4 Folding Pocket Kodak Camera with a retrofit back, available in 1915. A No. 4 Autographic Kodak Camera was never made. *See No. 4 Folding Pocket Kodak Camera.*

No. 4A - This too is not an Autographic Kodak Camera, but simply a 1915 retrofit back on a No. 4A Folding Kodak Camera. *See No. 4A Folding Kodak Camera.*

ANNIVERSARY KODAK CAMERA - A special edition of No. 2 Hawk-Eye Camera

AUTOGRAPHIC KODAK JUNIOR CAMERAS

No. 2C - 1923-28. CRF. $30-50.
No. 3 - 1914-24. No CRF. 3¼x4¼" on A118. Uncommon size, fairly rare. $35-55.

No. 1 - 1914-27. 2¼x3¼" on 120 film. EUR: $20-30. USA: $15-20.
No. 1A - 1914-27. 2½x4¼" exp. on A116 film. Common. EUR: $15-25. USA: $12-20.
No. 2C - 1916-27. 2⅞x4⅞". A very common size in this line. $15-20.
No. 3A - 1918-27. 3¼x5½" on A122. $10-15.

AUTOGRAPHIC KODAK SPECIAL CAMERA

No. 3A - 3¼x5½" on 122. 1914-16 without CRF: $30-40. 1917-33 with CRF, including the common Model B: $40-60.

No. 3A Signal Corps Model K-3 -
A specially finished version of the 3A Autographic Kodak Special Camera with coupled rangefinder. Body covered with smooth brown leather with tan bellows. Gunmetal grey fittings. B&L Tessar f6.3 in Optimo shutter. Name plate on bed says "Signal Corps, U.S. Army K-3" and serial number. One hundred of these cameras were made in 1916. Rare. $500-850

AUTOMATIC 35 CAMERAS *An improved version of the Signet 35 Camera design. Built-in meter automatically sets the diaphragm when the shutter release is pressed.*

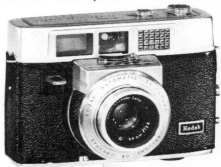

No. 1 - 1915-26. No CRF. $35-65.
No. 1A - 2½x4¼". 1914-16 without CRF: $30-50. 1917-26 with CRF: $35-65.

Automatic 35 Camera - 1959-64. Flash sync. posts on side of body. $15-25.

Automatic 35B Camera - 1961. $15-25.

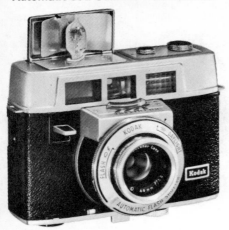

Automatic 35F Camera - 1962-66. Built-in flash on top for AG-1 bulbs. $15-25.
Automatic 35R4 Camera - 1965-69. Built-in flashcube socket on top. $15-25.

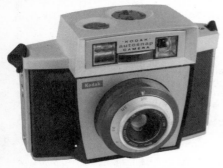

AUTOSNAP - 1962-64. Kodak Ltd. Grey plastic eye-level camera for 4x4cm on 127 film. Automatic exposure. $5-10.

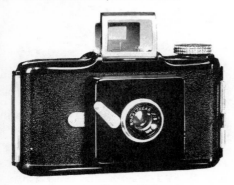

Bantam f8

BANTAM CAMERAS - *For 28x40mm exp. on 828 rollfilm.*

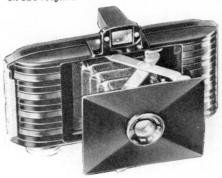

original, f6.3 - 1935-38. Rigid finder. f6.3 lens. $20-30.

f12.5 - 1935-38. Original body style, but with a folding frame finder. Doublet f12.5 lens. $10-15.

f8 - 1938-42. Rectangular telescoping front rather than bellows. Kodalinear f8/40mm. Often with original box for $25-35. Camera only: $15-20. *Illus. bottom of previous column.*

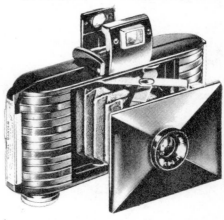

f6.3 - 1938-47. Kodak Anastigmat f6.3/ 53mm. Collapsible bellows. Like original model, but has folding optical finder. $15-25.

f5.6 - 1938-41. Kodak Anastigmat f5.6/ 50mm. Collapsible bellows. $20-25.

f4.5 - 1938-48. Kodak Anastigmat Special f4.5/47mm. Bantam shutter 20-200. Bellows. The most commonly found Bantam. With box: $20-30. Camera only: $15-20. *Illustrated top of next column.*
--Military model - Signal Corps, U.S. Army PH502/PF, Ord. No. 19851. $150-200.

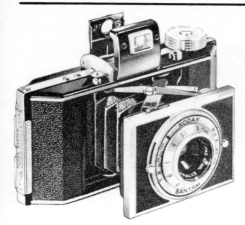

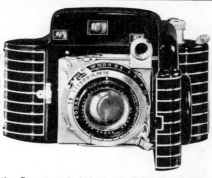

the Supermatic (1941-48). CRF 3' to infinity. With Supermatic: $175-225. With Compur Rapid: $150-200. *About 50% higher in Europe.*

Bantam f4.5

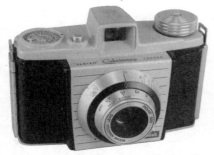

Bantam Colorsnap - Made in London by Kodak Ltd. Kodak Anaston lens, single speed shutter. $10-15.

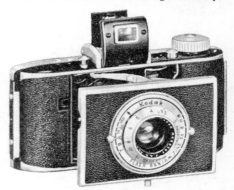

Flash Bantam Camera

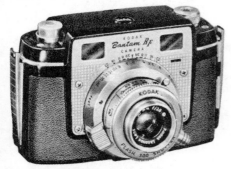

Bantam RF Camera - 1953-57. Non-interchangeable f3.9/50mm Kodak Ektanon Anastigmat. Shutter 25-300. Coupled rangefinder 3' to infinity. $10-20.

Bantam Special Camera - A masterpiece of art-deco styling. Quality construction. f2 Kodak Anastigmat Ektar. Compur Rapid shutter (1936-40) is more common than

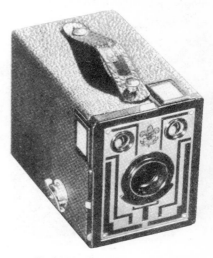

Six-20 Boy Scout Brownie Camera

147

Flash Bantam Camera - Early model (1947-48) has Kodak Anastigmat Special f4.5/48mm. Shutter 25-200. $25-35. Later, 1948-53, with Kodak Anastar f4.5/48mm is more common. $20-30. *Illus. on previous page.*

BOY SCOUT BROWNIE CAMERA
SIX-20 BOY SCOUT BROWNIE CAMERA
- Simple box cameras. Special metal faceplate with Boy Scout emblem. Made in 1932 for 120 film; in 1933-34 for 620 film. Rare 120 model: $150-200. More common in 620 size: $75-125. *Illus. on previous page.*

BOY SCOUT KODAK CAMERA - 1929-1933. For 4.5x6cm on 127 rollfilm. This is a vest-pocket camera in olive drab color with official Boy Scout emblem engraved on the bed. With original green bellows and matching case. $150-175.
With replacement black bellows: $50-75.

No. 0 Brownie

BROWNIE CAMERAS

(Original) - Introduced in February, 1900, and taking a new size film, No. 117 for 2¼x2¼" exposures. The back of the camera fit like the cover of a shoe-box. Constructed of cardboard, and measuring 3x3x5" overall, this camera stayed in production only four months before the back was re-designed. A rare box camera. With accessory waist-level finder. $475-550.

The Brownie Camera (1900 type) - This is a hybrid that falls between the original Brownie and the No.1 Brownie. It has the improved back of the No.1, but the name printed inside the camera's back is still "The Brownie Camera". $60-80.

Brownie Camera (1980 type) - We

include this only because it has the same name as the original Brownie which is much more valuable. This is a small plastic eye-level camera for 110 cartridges. Made by Kodak Limited, and really just a renamed version of the Pocket A1 camera. $1-5.

No. 0 - A small (4x3¼x6cm) box camera of the mid-teens for 127 film. Slightly larger than the earlier "Pocket Kodak" of 1895. Cute, but not scarce. $15-20. *Illustrated on previous page.*

No. 1 - In May or June of 1900, this improved version of the original Brownie Camera was introduced, and became the first commercially successful Brownie camera. Although not rare, it is historically interesting. $40-50. With accessory finder, winding key and orig. box. $75-100. *The earliest examples of this camera were marked "The Brownie Camera". When additional sizes were introduced, the designation was changed to "No. 1". The early type is listed above as "The Brownie Camera (1900 Type)".*

No. 2 - 1901-33. Cardboard box camera for 6 exposures 2¼x3¼" on 120 film, which was introduced for this camera. Meniscus lens, rotary shutter. An early variation had smooth finish and the same rear clamp as the No. 1. This variation has an estimated value of $20-25. Most have grained pattern cloth covering. Later models made of aluminum and came in colors, some of which were also made in London. Black: $3-8. Colored: $20-25. *(Colored models bring $25-50 in Europe.)*

No. 2, silver - 1935. Special edition of the No. 2 Brownie box camera in silver finish with black trim. Made for the British Silver Jubilee. Asking prices up to $85 in England. No confirmed sales.

No. 2A - 1907-33. Box camera for 2½x4¼" on 116 film. Early models have cardboard bodies; later ones aluminum. Black: $3-8.

Later colored models: $20-25 in USA, up to $45 EUR.

No. 2C - 1917-34. Box camera for 2⅞x4⅞" on 130 film. $3-8.

No. 3 - 1908-34. Box camera for 3¼x4¼" on 124 film. $3-8.

Brownie 44A - 1959-66. Made by Kodak Ltd. Plastic eye-level box camera for 4x4cm on 127 film. Dakon lens, single speed shutter. Soft plastic front cover hinged to bottom. $8-12.

Brownie 44B - 1961-63. Similar to 44A, but without the hinged plastic cover. $5-10.

Brownie 127 Camera - 1953-59. Bakelite

149

body with rounded ends, as if slightly inflated. Made in England. Several variations of faceplate style: plain, horizontally striped, diagonally checkered. $8-12.

Brownie 127 (1965 type) - 1965-67. Only the name is directly related to the earlier model. Body style completely changed. Shutter release is white square on front next to viewfinder. $5-10.

Brownie Auto 27 Camera - 1963-64. Electric-eye version of Brownie Super 27. $8-12.

Baby Brownie Camera - 1934-41. Bakelite box camera for 4x6.5cm exp. on 127 film. Folding frame finder. $8-12.

Baby Brownie (Kodak Ltd.) - The British-made version of the Baby Brownie. Like the USA model, but with a "brief time plunger" above the lens. Uncommon in the U.S. $20-35.

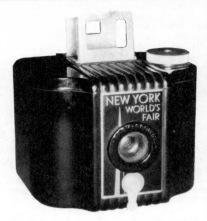

Baby Brownie, New York World's Fair Model - 1939. A special version of the Baby Brownie was made in 1939-1940 for the World's Fair, with a special New York World's Fair faceplate. $150-200.

Baby Brownie Special - 1939-54. Bakelite box camera for 4x6.5cm exp. on 127 film. Rigid optical finder. $5-10.

Beau Brownie Camera - 1930-33. *A simple No. 2 or No. 2A Brownie (box) camera, but in classy two-tone color combinations of blue, green, black, tan, or rose.* Either size in rose: $60-100.

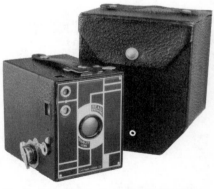

No.2 - Color other than rose: $30-55.
No. 2A - Color other than rose: $30-60. *Generally the same price range applies in Europe, although a few examples at auction have reached $125-165 with case.*

Brownie Bull's-Eye Camera - 1954-60. Vertically styled bakelite camera with metal faceplate and focusing Twindar lens. For 2¼x3¼" on 620 film. (See also "Six-20 Bull's-Eye Brownie Camera"

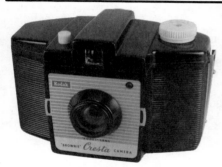

Brownie Cresta

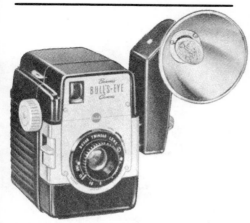

below.) Black: $10-15. Gold: $15-20.

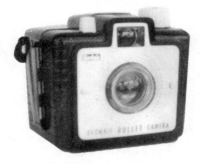

Brownie Bullet Camera - 1957-64. A premium version of the Brownie Holiday Camera. 4.5x6cm on 127 film. $5-10.

Brownie Bullet II Camera - 1961-68. Similar to the Brownie Starlet camera (USA type). Not like the Brownie Bullet Camera! 4.5x6cm exp. on 127 film. $4-8.

Brownie Chiquita Camera - Same as the Brownie Bullet Camera, except for the

faceplate and original box which are in Spanish. With original box: $10-20. Camera only: $5-10.

Brownie Cresta - c1955-58. Black plastic eye-level box camera for 2¼x2¼" on 120. Made by Kodak Ltd. London. Kodet lens. Styled after the popular Brownie 127, but larger and not quite as streamlined. $10-12. *Illustrated top of previous column.*

Brownie Cresta II - c1956-59. Slightly revised Cresta, with flash synchronized through mount rather than PC post. $10-15.

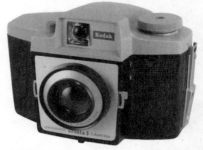

Brownie Cresta III - c1960-65. Restyled with black plastic body and nicely sculpted grey plastic top housing. Synchronized through flash mounting screw. $10-15.

Brownie Fiesta Camera - 1962-66; Fiesta R4- 1966-69. $1-5.

Brownie Flash Camera - Black bakelite box camera identical to the Brownie Hawkeye Flash Model. Made in France for the French market. "Brownie Flash Camera Made in France" on front plate. $10-20. *Illustrated top of next page.*

Brownie Flash II - 1956-59. Kodak Ltd, London. Metal box camera. Fixed focus f14 lens with built-in close-up lens, no filter. $8-12.

Brownie Flash Camera, made in France

Brownie Flash III - 1957-60. Kodak Ltd, London. Metal box with black leatherette covering. Built-in close-up lens and yellow filter. $10-15. *Illustrated in previous column.*

Brownie Flash IV - 1957-59. Same as Brownie Flash III, but with tan covering and brass metal parts. With matching canvas case: $20-25. Camera only: $15-20. *Illustrated in previous column.*

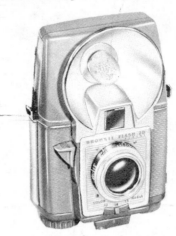

Brownie Flash 20 Camera - 1959-62. Styled like the Brownie Starflash Camera, but larger size for 620 film. $6-12.

Brownie Flash Six-20 Camera - Post-war name for Six-20 Flash Brownie Camera. Trapezoidal metal body. With flash: $5-10.

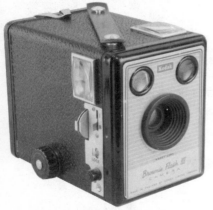

Brownie Flash III

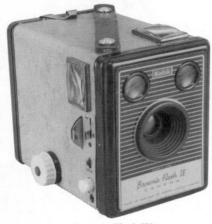

Brownie Flash IV

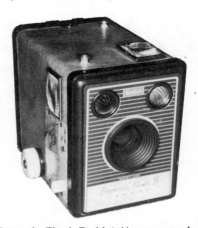

Brownie Flash B - Metal box camera from Kodak Ltd. in London. Shutter B, 40, 80. Brown and beige color. $10-20. Add $5-10 for original canvas case.

Brownie Flashmite 20 Camera - 1960-1965. 2¼x2¼" on 620 film. Less common than the Brownie Starmite, a smaller, 127 film version of this camera. $6-12.

FOLDING BROWNIE CAMERAS
Identifiable by their square-cornered bodies and horizontal format. The No. 3 and No. 3A are at least ten times more commonly found for sale than the No. 2, although prices are much the same. These cameras sell in Europe for about double the USA price.

No. 2 - 1904-07. Maroon bellows, wooden lens standard. 2¼x3¼" on 120 film. $25-45.

No. 3 - 1905-15. 3¼x4¼" on 124 film. $25-35.

No. 3A - 1909-15. 3¼x5½" "postcard" size. The most common size. $25-35.

FOLDING AUTOGRAPHIC BROWNIE CAMERAS *These are a continuation of the Folding Brownie Camera series, but with the addition of the "Autographic" feature. Some of the earlier examples still have the square corners of the earlier style. About 1916, when the 3A size was introduced, they were all given the new rounded corners. To the prices below add 25% for square corners or for RR lens. Add 50% for both. European prices about double the USA price.*

No. 2 - 1915-26. 2¼x3¼" on 120 film. Very common. $8-16.

No. 2A - 1915-26. 2½x4¼". By far the

most common size of this line. $8-16.
No. 2C - 1916-26. 2⅞x4⅞" exp. $15-22.
No. 3A - 1916-26. 3¼x5½". $10-20.

**FOLDING POCKET BROWNIE
CAMERAS** *Horizontal style folding rollfilm
cameras. Square-cornered bodies. Early models
with red bellows bring higher prices. All are
worth 50-100% more in Europe.*

No. 2 - 1907-15. 2¼x3¼". A continuation
of the No. 2 Folding Brownie, but with
metal not wooden lensboard. Red bellows:
$20-40. Black bellows: $15-20.
No. 2A - 1910-15. 2½x4¼" on 116 film.
Red bellows: $30-50. Black bellows:
$15-25.

FOLDING BROWNIE SIX-20 (model I) -
1937-40. Vertically styled folding camera
made by Kodak Ltd., London for 2¼x3¼"
photos on 620. Meniscus lens, B&I shutter.
Folding open frame finder. $10-15.

- (Model 2) - Production resumed in 1948
with a folding optical finder, and also a
more sophisticated model which bore the
name "Six-20 Folding Brownie". $15-20.

Brownie Hawkeye Camera - 1949-51.
Molded plastic box camera for 2¼x2¼" exp.

on 620 film. No flash sync. $10-12.

Brownie Hawkeye Camera Flash Model
- 1950-61. Similar to the above listing, but
with flash sync. $3-6. *See "Brownie Flash
Camera" above for the French version of this
camera.*

Brownie Holiday Camera - 1953-57;
Flash model, 1954-62. 4x6.5cm exp. on
127 film. EUR: $10-15. USA: $3-7.
Illustrated on next page.

Brownie Junior 620 Camera - 1934-36.
Metal box camera. Made by Kodak A.G.
Dr. Nagel-Werk and not imported to the
U.S.A. $8-13.

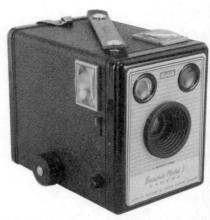

Brownie Model I - 1957-59. Kodak Ltd.,
London. Metal box camera for 6x9cm. A
simple model in the series with the
Brownie Flash II, III, IV. No close-up lens
nor filter. $12-18.

Brownie Pliant Six-20 - c1939. Folding rollfilm camera for 620 film. Very similar to the Kodak Junior Six-20 Series II. Simple lens, Kodo I+T shutter. $25-35. *Illustrated in previous column.*

Popular Brownie Camera - 1937-40. Made by Kodak Ltd., London. Box camera for 6x9cm on 620 film. $10-15. *Illustrated in previous column.*

Portrait Brownie Camera, No. 2 - 1929-1935. Kodak Ltd. 6x9cm on 120 film. $10-20.

Brownie Reflex Camera - 1940-41. Pseudo-TLR for 1⅝x1⅝" exp. on 127 film. No flash sync. EUR: $15-25. USA: $7-12.

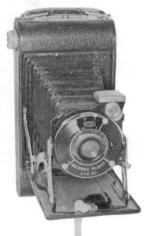

Brownie Holiday, Flash model

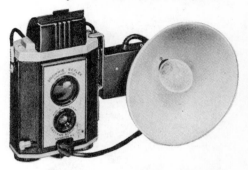

Brownie Reflex Camera Synchro Model - 1941-52. Like the above listing, but has flash sync. EUR: $15-25. USA: $3-8.

Brownie Reflex 20 Camera - 1959-66. Reflex style like the Brownie Starflex Camera, but larger for 620 film. EUR: $10-15. USA: $5-10.

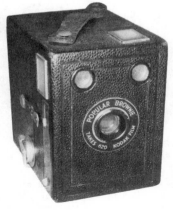

Brownie Pliant Six-20

Six-16 or Six-20 Brownie Cameras - 1933-41. Cardboard box cameras with metal art-deco front. EUR: $10-20. USA: $3-8.

Popular Brownie Camera

Six-20 Brownie B - 1937-41. Kodak Ltd, London. Simple box camera with art-deco faceplate. 2¼x3¼" on 620 film. $15-25.

Brownie Six-20 Camera Models C,D,E

Brownie Six-20 Camera Models C,D,E - 1946-57. Kodak Ltd., London. Metal box cameras for 2¼x3¼" exp. on 620 film. Each was available with two different faceplate styles, the change occuring in 1953. Model C had no flash contacts. Model D had flash contacts on the second version. Model E had flash contacts on both versions. $10-15. *Illustrated in previous column.*

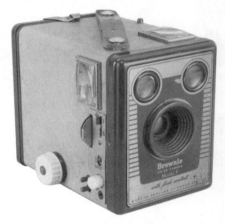

Brownie Six-20 Camera Model F - 1955-57. Sporty version of the Model E. Tan covering & brass trim. $20-25.

Six-16 or Six-20 Brownie Junior Cameras - 1934-42. Box cameras with art-deco front. $5-10.

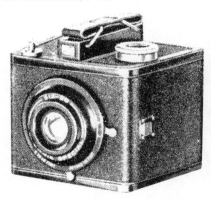

Six-16 or Six-20 Brownie Special Cameras - 1938-42. Trapezoid-shaped box. EUR: $10-15. USA: $5-10.

Six-20 Bull's-Eye Brownie Camera - 1938-41. Black bakelite trapezoidal body with eye-level finder above top. Braided strap on side. For 2¼x3¼" exp. on 620

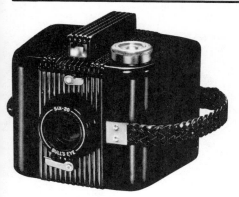

film. Uncommon. $10-20.

Six-20 Flash Brownie Camera, Brownie Flash Six-20 Camera - 1940-1954. Metal trapezoidal box camera, sold under both names. 2¼x3¼" exp. on 620 film. $3-7.

Six-20 Folding Brownie (model 2) - 1948-54. Kodak Ltd, London. A post-war improved version of the "Folding Brownie Six-20". Vertically styled folding camera for 2¼x3¼" on 620. Anaston f6.3/100mm in Dakon T,B,25,50 synched shutter. $15-20. *Illustrated in next column.*

Six-20 Folding Brownie (model 2)

Brownie Starflex Camera

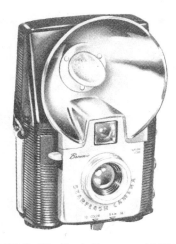

Brownie Starflash Camera - 1957-65. Blue, red, or white: 10-15. Black: $3-7. *In addition to these colors, models "Made in Australia" include a two-tone black and grey.*

Brownie Starflex Camera - 1957-64. 4x4cm on 127 film. $3-7. *Illustrated in next column.*

Brownie Starlet Camera (USA) - 1957-62. 4x4cm on 127. The identical camera was also made in France with French markings. $3-8.

Brownie Starlet Camera (Kodak Ltd.) - 1956. 4x6.5cm on 127. An identical camera is also made in Australia and is so marked. $5-10.

Brownie Starluxe - French-made version of the Brownie Starmite. $8-12.
Brownie Starluxe II - French-made version of Brownie Starmite II. $8-12.

Brownie Starmatic Camera - 1959-61; Starmatic II, 1961-63. 4x4cm on 127 film.

Built-in automatic meter. One of the better and less common of the "Star" series. $9-15.

Brownie Starmeter Camera - 1960-65. Uncoupled selenium meter. $15-20.

Brownie Starmite Camera - 1960-63; Starmite II, 1962-67. $3-7.

No. 2 Stereo Brownie Camera - 1905-1910. Similar to Blair Stereo Weno Camera. For 3¼x2½" exposure pairs on rollfilm. Red bellows. Stereo Brownie Cameras are much less common than comparable Stereo Hawk-Eye Cameras. $300-400.

Brownie Super 27 - 1961-65. $5-10.

Brownie Vecta

Target Brownie Six-16 and Six-20 Brownie Target Six-16 and Six-20 Cameras - Metal and leatherette box cameras. Intro. 1941. Name changed from Target Brownie to Brownie Target in 1946. Six-16 discontinued in 1951; Six-20 in 1952. EUR: $10-15. USA: $3-10.

Brownie Twin 20 Camera - 1959-64. Waist level and eye-level finders. Unusual. $3-8.

Brownie Vecta - 1963-66. Kodak Ltd. London. Vertically styled grey plastic 127 camera of unusual design. Long shutter release bar at bottom front. $10-15. *Illustrated top of next column.*

BUCKEYE CAMERA - c1899. Eastman Kodak Co. purchased American Camera Mfg. Co., which originated this model. The Eastman camera is nearly identical to the earlier version. A folding bed camera of all wooden construction, covered with leather. Lens standard of polished wood conceals the shutter behind a plain front. An uncommon rollfilm model. $75-125.

BULL'S-EYE CAMERAS *After Kodak took over the Boston Camera Manufacturing Co., it continued Boston's line of cameras under the Kodak name. (See also Boston Bull's-Eye.) Bull's-Eye cameras are often stamped with their year model as were other early Kodak cameras. Leather exterior conceals a beautifully polished wooden interior.*
No. 2 - 1896-1913. Leather covered wood box which loads from the top. 3½x3½" exposures on 101 rollfilm or double plateholders. Rotary disc shutter. Rotating disc stops. EUR: $50-75. USA: $30-45. *Illustrated top of next page.*

No. 3 - 1908-13. This model loads from the side. 3¼x4¼" on No. 124 film. Less common than the No. 2 and No. 4. $30-40.

No. 4 - 1896-1904. Nine models. Side-loading 4x5" box for 103 rollfilm. Internal bellows focus by means of an outside lever. $40-55.

No. 2 Bull's-Eye Camera

BULL'S-EYE SPECIAL CAMERAS
Similar to the Bull's-Eye box cameras above, but with higher quality RR lens in Eastman Triple Action Shutter. 1898-1904.
No. 2 - 3½x3½" exp. on 101 rollfilm. EUR: $75-100. USA: $50-75.
No. 4 - 4x5" on 103 rollfilm. $60-80.
Illustrated bottom of previous column.

BULLET CAMERAS
No. 2 Bullet Camera - 1895-96, improved model 1896-1900, double plateholder option 1900-1902. Box camera for 3½x3½" exposures on glass plates or on rollfilm which was first introduced in 1895 for this camera and later numbered 101. Measures 4½x4½x6". Some models named by year and marked on the camera. $30-50.

No. 4 Bullet Camera - 1896-1900. For 4x5" exposures on No. 103 rollfilm (introduced for this camera) or could be used with a single plateholder which stores in the rear of the camera. A large leather covered box. $50-75.

No. 2 Folding Bull's-Eye Camera - 1899-1901. For 3½x3½" exposures. Scarce. $100-125.

No. 4 Bull's-Eye Special Camera

Bullet Camera (plastic) - 1936-42. A cheap & simple torpedo-shaped camera

with fixed focus lens mounted in a spiral-threaded telescoping mount. Common, inexpensive, yet novel. $8-12.

Bullet Camera, New York World's Fair Model - 1939-40. A special World's Fair version of the Bullet camera, marked "New York World's Fair" on a metal faceplate. In colorful original box: $150-175. Camera only: $80-100.

BULLET SPECIAL CAMERAS *Similar to the No. 2 and No. 4 Bullet Cameras above, but with a higher quality RR lens in Eastman Triple Action Shutter. 1898-1904.*

No. 2 - $50-80. **No. 4 -** $100-150.

CAMP FIRE GIRLS KODAK - 1931-34. A brown folding vest-pocket camera with Camp Fire Girls emblem on the front door and "Camp Fire Girl's Kodak" on the shutter face. This is a very rare camera, unlike the less rare Girl Scout or common Boy Scout models. With matching case: $250-350.

CARTRIDGE KODAK CAMERAS *Made to take "cartridge" film, as rollfilm was called in the early years.*
No. 3 - 1900-1907. For 4¼x3¼" exp. on

No. 119 rollfilm (introduced for this camera). This is the smallest of the series. Various shutters and lenses. $75-100.

No. 4 - 1897-1907. For 5x4" exp. on 104 rollfilm (introduced for this camera). This is the first of the series. Leather covered wood body, polished wood interior. Red bellows. Various shutters/lens combinations. (Orig. price was $25.) EUR: $100-125. USA: $60-80.

No. 5 - 1898-1900 with wooden lensboard and bed; 1900-1907 with metal lensboard. For 7x5" exp. on No. 115 rollfilm or on plates. (No. 115 rollfilm, introduced for this camera, was 7" wide to provide the 7x5" vertical format.) Red bellows. Various shutters/lens combinations. $70-90.

CENTURY OF PROGRESS, WORLD'S FAIR SOUVENIR - Made for the 1933 World's Fair. Box camera for 2¼x3¼" exp. on 120 film. $125-175.

CHEVRON CAMERA - 1953-56. For 2¼x2¼" on 620 film. Kodak Ektar f3.5/

78mm lens. Synchro-Rapid 800. $175-250.

CIRKUT CAMERAS, CIRKUT OUTFITS

Manufactured by the Rochester Panoramic Camera Co. 1904-05; Century Camera Co. 1905-07, Century Camera Division of Eastman Kodak Co. 1907-1915; Folmer & Schwing Div. of EKC 1915-17; F&S Dept. of EKC 1917-26; Folmer Graflex 1925-45; Graflex, Inc. (sales only) 1945-49. For obvious reasons of continuity, we are listing all Cirkut equipment under the Eastman Kodak heading rather than split it among all these various companies.

Basically, a Cirkut OUTFIT is a revolving-back cycle view camera with an accessory Cirkut back, tripod, and gears. A Cirkut CAMERA is designed exclusively for Cirkut photos and cannot be used as a view camera. Both types take panoramic pictures by revolving the entire camera on a geared tripod head while the film moves past a narrow slit at the focal plane and is taken up on a drum. These cameras are numbered according to film width, the common sizes being 5, 6, 8, and 10 inches.

NOTE - All prices listed here are for complete outfits with tripod and gears.

No. 5 Cirkut Camera - 1915-1923. With Turner Reich 6¼, 11, 14" Triple Convertible lens. $500-650.

No. 6 Cirkut Camera - 1932-49. With 7, 10, 15½" Triple Convertible. $800-1000.

No. 6 Cirkut Outfit - 1907-25. (5x7 RB Cycle Graphic). With Series II Centar lens: $450-700. With Graphic Rapid Rectilinear convertible 5x7 lens: $500-750.

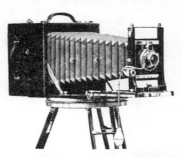

No. 8 Cirkut Outfit - 1907-26. Based on 6½x8½ RB Cycle Graphic. Uses 6" or 8" film. With 10½, 18, 24" Triple Convertible lens: $700-900.

No. 10 Cirkut Camera - 1904-41. Uses 10", 8", or 6" film. This is the most desirable as a usable camera. Before 1932, used 10½, 18, 24" Triple Convertible. From 1932-41, used 10, 15½, 20" lens. With either Triple Convertible lens: $2500-3500. *A revived interest in using Cirkut cameras has made demand exceed supply in this size, which is most popular for use.*

No. 16 Cirkut Camera - 1905-24. Takes 16", 12", 10", or 8" film. Quite rare. Limited production. $5000-6000.

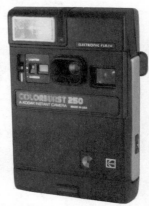

COLORBURST - A series of cameras for instant pictures. Models include: 50, 100, 150, 200, 250, 300, 350. Little collector interest except for a few diehard Kodak nuts, and there are more than enough Colorbursts to go around. More advanced models (250, 300, 350): $5-10. Simple models: $1-5. *Note: Kodak's settlement with owners of instant cameras resulted in many*

instant cameras with nameplates removed. These have virtually no collector value, and are easily found.

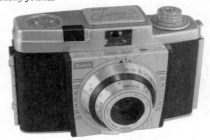

COLORSNAP 35 - 1959-64. Basic 35mm camera based on the earlier Bantam Colorsnap. Plastic and metal construction. Scale-focus Kodak Anaston f3.9 lens. Single speed shutter. Double exposure prevention. $15-20.

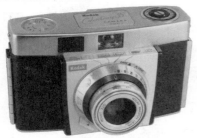

COLORSNAP 35 MODEL 2 - 1964-67. Restyled version of the Colorsnap 35. Cleaner looking top housing with recessed knobs. $15-20.

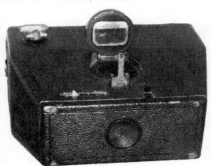

NO. 1 CONE POCKET KODAK - c1898. A very unusual early Kodak camera which is essentially a non-folding box camera version of the Folding Pocket Kodak camera. Early records indicate that 1000 were shipped to London, from where they were apparently shipped to France. Since 1981 at least two examples have surfaced. Price negotiable. Rare.

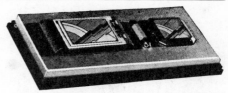

COQUETTE CAMERA - 1930-31. A boxed Kodak Petite Camera in blue with matching lipstick holder and compact. Art-deco "lightning" design. $500-750.

DAYLIGHT KODAK CAMERAS
The Daylight Kodak Cameras are the first of the Kodak string-set cameras not requiring darkroom loading. All are rollfilm box cameras with Achromatic lens and sector shutter. Made from 1891 to 1895, each took 24 exposures on daylight-loading rollfilm.
"A" - 2¾x3¼". (Orig. cost- $8.50) $1000-1300.

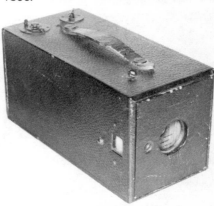

"B" - 3½x4". (Orig. cost- $15.00) $450-600.

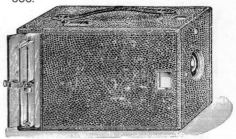

"C" Special Glass Plate Kodak Camera

"C" - 4x5". (Orig. cost- $25.00) $400-500. (Also available in a plate version called "C" Special Glass Plate Kodak Camera.)

DUAFLEX CAMERAS - Models I-IV, 1947-1960. Cheap TLR's for 2¼x2¼" on 620

film. Focusing: $7-14. Fixed focus: $3-8.

DUEX CAMERA - 1940-42. 4.5x6cm on 620 film. Helical telescoping front. Doublet lens. $10-15.

DUO SIX-20 CAMERA - 1934-37. Folding camera for 16 exposures 4.5x6cm on 620 film. Made in Germany. f3.5/70mm Kodak Anast. or Zeiss Tessar lens. Compur or

Compur Rapid shutter. $35-50.

DUO SIX-20 SERIES II CAMERA (without RF) - 1937-39. Folding optical finder on top. No rangefinder. $35-60.

DUO SIX-20 SERIES II CAMERA w/RANGEFINDER - 1939-40. Rangefinder incorporated in top housing. Kodak Anastigmat f3.5/75mm lens. Compur Rapid shutter. Uncommon. $225-275.

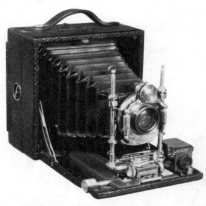

EASTMAN PLATE CAMERA, Nos. 3, 4, and 5 - c1903. No. 3 in 3¼x4¼", No. 4 in 4x5", and No. 5 in 5x7". Folding bed cycle style plate cameras with swing back more typical of some of the Rochester Optical Co. earlier models. Double extension bellows. RR lens. Kodak shutter. $75-125.

KODAK EKTRA - 1941-48. 35mm RF camera. Interchangeable lenses & magazine backs. Focal plane shutter to 1000. A precision camera which originally sold for $300 with the f1.9/50mm lens. Current value with f1.9/50mm: $350-550.

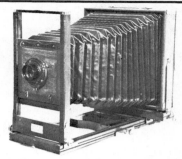

6½x8½", and 8x10" sizes. With original lens and shutter: $100-150.

Ektra accessories:
- 35mm f3.3: $90-125.
- 50mm f1.9: $60-75.
- 50mm f3.5 (scarce): $100-150.
- 90mm f3.5: $75-125.
- 135mm f3.8: $90-125.
- 153mm f4.5: $750-1000.
- Magazine back: $100-135.
- Ground glass back: $150-175.

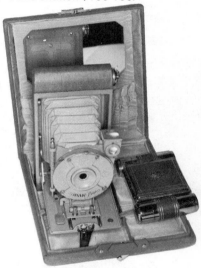

KODAK EKTRA II - Yes, there is an Ektra II. Apparently made as an experimental model, c1944. We know of one extant example (Ser. #7021), which also had a spring-motor auto advance back. Price information not available.

KODAK ENSEMBLE - 1929-33. A Kodak Petite Camera with lipstick, compact, and mirror in a suede case. Available in beige, green, and old rose. $350-450.

KODAK EKTRA 1, 2, 200, 250 CAMERAS - 1978-. Simple 110 pocket cameras for 13x17mm exposures. $1-5.

EMPIRE STATE CAMERAS - c1893-1914. View cameras, usually found in 5x7",

No. 4 Eureka Camera

EUREKA CAMERAS *1898-99. Box cameras for glass plates in standard double holders which insert through side door. Storage space for additional holders. Achromatic lens, rotary shutter.*
No. 2 - 3½x3½" exp. on plates or on No. 106 Cartridge film in rollholder. $60-80.

No. 2, Jr. - same size, but cheaper model for plates only. $50-75.

No. 4 - Made in 1899 only. For 4x5" exposures on No. 109 Cartridge film in rollholder. $50-75. *Illustrated in previous page.*

THE FALCON CAMERA - 1897-98. Style similar to the Pocket Kodak Camera, but larger. 2x2½" exposures on special rollfilm. $60-80.

Kodak Fiesta Instant Camera

NO. 2 FALCON CAMERA - 1897-99. Box camera for 3½x3½" exposures on No. 101 rollfilm. Knob on front of camera to cock shutter. Leather covered wood. $50-70.

FISHER-PRICE CAMERA - c1984. Pocket 110 cartridge camera with cushioned ends. Made by Kodak for Fisher-Price. New, in box: $20-30.

NO. 2 FALCON IMPROVED MODEL - 1899. The improved model can be recognized by its removable sides and back, like the more common Flexo which replaced it late in 1899. Identified inside as "Improved No. 2 Falcon Kodak". $40-60.

FIESTA INSTANT CAMERA - $1-5. *No value without nameplate. See notes under "Instant Cameras". Illustrated top of next column.*

FIFTIETH ANNIVERSARY CAMERA
(see Anniversary Kodak Camera)

FLAT FOLDING KODAK CAMERA - 1894-

1895. Kodak's first folding camera with integral rollfilm back. Marketed only in England. RARE. Very few exist. $800-1200.

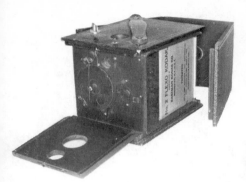

FLEXO KODAK CAMERA, No. 2 - 1899-1913. Box camera for 12 exp. 3½x3½" on No. 101 rollfilm. The most unusual feature is that the sides and back come completely off for loading, and are held together only by the leather covering. It is very similar in outward appearance to the Bull's-Eye series, but was slighty cheaper when new. The same camera was marketed in Europe under the name "Plico". Achromatic lens, rotary shutter. (Orig. cost-$5.00). $25-35.

FLING 35 - Disposable 35mm camera. Bright yellow box with multi-colored K logo on front. We only include a current camera in the guide because disposable cameras tend to disappear quickly and become collectible. New price about $9.

FLUSH BACK KODAK CAMERA, No. 3 - 1908-15. A special version of the No. 3 Folding Pocket Kodak Camera for 3¼x4¼" exposures on 118 film, or for glass plates. B&L RR lens in B&L Auto shutter. Made for the European market and not sold in the U.S.A. $40-60.

FOLDING KODAK CAMERAS *There are two distinct styles of "Folding Kodak" cameras which share little more than a common name.*

The earlier models, numbered 4, 5, and 6 by size, resemble a carrying case when closed, and are easily identifiable by the hinged top door which hangs over the sides like a box cover. The later model can be distinguished by its vertical format and rounded body ends in the more common style. We are listing the early models first followed by the later one.

FOLDING KODAK CAMERAS (early "satchel style") *There are three variations of the No. 4 and No. 5: Sector shutter in 1890-1891; Barker shutter, 1892; and the Improved version with B&L Iris Diaphragm shutter and hinged drop bed, 1893-97.*

No. 4 with early sector shutter

No. 4, No. 4 Improved - 1890-1897. For 48 exp. 4x5" on glass plates or rollfilm in rollholder. $350-450.

No. 5 with Barker shutter

No. 5, No. 5 Improved - 1890-97. Similar

specifications, but for 5x7" film or plates. $450-550.

No. 5 Improved with stereo lensboard - The same camera as the No. 5 Folding Kodak Improved Camera, but with a stereo lensboard and partition for stereo work. RARE. No recent sales.

No. 4A Folding Kodak Camera

FOLDING POCKET KODAK CAMERAS

No. 6 with B&L Iris Diaphragm shutter

No. 6 Improved - 1893-95. Similar, but for 6½x8½". Since the No. 6 was not introduced until 1893, it was only made in the "Improved" version with B&L Iris Diaphragm shutter. This size is even less common than the others. $800-1100.

NO. 4A FOLDING KODAK CAMERA - 1906-15. Vertical folding-bed camera similar to the "Folding Pocket" series. For 6 exp., 4¼x6½" on No. 126 rollfilm. (126 rollfilm, made from 1906-1949, is not to be confused with the more recent 126 cartridges.) Red bellows. $100-175. *Illustrated top of next column.*

Folding Pocket Kodak Cameras:
Original model (left) has 4 round openings on front, lens cone, and no backlatch slide. Second model (right) has only two finder openings, no lens cone and has metal backlatch slide.

The Folding Pocket Kodak Camera - *Renamed No. 1 after 1899. For 2¼x3¼" exp. on No. 105 rollfilm. Leather covered front pulls straight out. Double finders concealed behind leather covered front. Red bellows. The earliest production models (c1897-1898) included a sequence of changes which led to the more*

standard "No. 1". The true "Original" had ALL of these features, and later models had some.
1. Recessed lens opening, a wooden "cone" shape (the shutter is quite different from later versions because of this odd opening.)
2. All brass metal parts are unplated.
3. There are four small openings on the face, two of which are used for finders.
4. No locking clasp for the back.
5. Patent pending.
6. Flat bar provided for horizontal standing, but no vertical stand.

--Original model - all features above: $150-200.
--Transitional models - Brass struts, but not all of the above features: $125-150.
--Nickeled struts - c1898-99: $60-80.

exposures. Recognizable by the domed front door, red bellows, and twin sprung struts for the lensboard. Self-erecting bed. Various models. With twin-finders (made briefly): $40-60. With single, reversible finder: $20-35.

No. 0 - 1902-1906. Similar in style to the original. For 4.5x6cm exposures on No. 121 film which was introduced for this camera. It is the smallest of the series, but by no means the first as some collectors have been misled to believe. $70-90

No. 1, (pull-out front) - 1899-1905. Nickeled struts. Similar to the original model. $45-70.

Twin-finders variation

No. 1, (bed-type) - 1905-15. For 2¼x3¼"

No. 1A, (pull-out front) - 1899-1905. Similar to the original FPK, but for 2½x4¼" exposures. $35-50.

No. 1A, (bed-type) - 1905-15. For 2½x4¼" exposures on 116 rollfilm. Domed front door, twin sprung struts, red bellows. Self-erecting bed. Various models. With twin-finders (made briefly): $45-60. With single, reversible finder: $30-45.

No. 1A Folding Pocket Kodak Camera R.R. Type - 1912-15 and
No. 1A Folding Pocket Kodak Special Camera - 1908-12. Similar to the regular "1A" but with better lenses and shutters. $25-40.

No. 2 - Horizontal style camera for square exposures 3½x3½" on No. 101 rollfilm. Front is not self-erecting. Bed folds down, and front standard pulls out on track. Flat rectangular front door. First model (1899-

1905) has leather covered lensboard with recessed lens and shutter: $50-70. Later models (1905-1915) have wooden standard with exposed shutter and lens: $35-65. *Illustrated top of next column.*

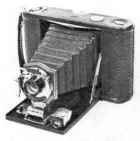

No.,2 Folding Pocket Kodak

Folding Pocket Kodak in Persian Morocco covering and brown silk bellows. Rare. Price negotiable. Estimate: $200-400.

No. 3A - 1903-15. Vertical folding-bed camera for 3¼x5½" exposures on 122 rollfilm (introduced for this camera). Flat, rectangular front door. Red bellows. Polished wood insets on bed. By far the most common model of the FPK series. $30-40.

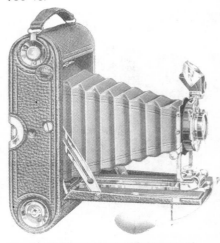

No. 3 - Vertical style folding-bed camera for 3¼x4¼" exposures on 118 rollfilm. Flat rectangular front door. Early models (1900-03) with leather covered lensboard concealing a rotary shutter: $70-100 in EUR, $40-60 in USA. Later models (1904-1915) with exposed lens/shutter: $25-35.

No. 3, Deluxe - 1901-1903. A No. 3

No. 4 - 1907-15. Vertical folding-bed camera for 4x5" exposures on 123 rollfilm. Red bellows, polished wood insets on bed. $50-75.

170

GENESEE OUTFIT - c1886. An early and relatively unknown 5x7" view camera made by Frank Brownell for the Eastman Dry Plate & Film Co. Complete with plate-holders, brass-barrel R.R. lens with waterhouse stops, etc. $200-250.

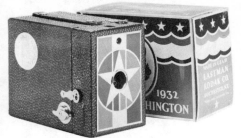

GEORGE WASHINGTON BICENTENNIAL CAMERA - c1932. One of the rarest of Kodak box cameras. This one, like the 50th Anniversary of Kodak camera is based on the No. 2 Rainbow Hawk-Eye Model C, but with special colored covering and a seal on the side. This camera is a very attractive blue, with an art-deco front plate with an enameled red, white, and blue star. Unfortunately, due to the depressed economy in 1932, Kodak decided not to market the camera, and only a few examples are known to exist in museums. It is unlikely that one will ever be offered for sale, but it would probably bring $500-1000 for an opening bid.

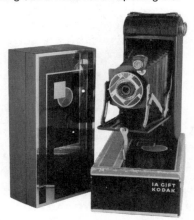

GIFT KODAK CAMERA, No. 1A - 1930-1931. A special rendition of the No. 1A Pocket Kodak Junior Camera. The camera is covered with brown genuine leather, and decorated with an enameled metal inlay on the front door, as well as a matching metal faceplate on the shutter. The case is a cedar box, the top plate of which repeats the art-deco design of the camera. To go

one step further, the gift box is packed in a cardboard box with a matching design. Original price in the 1930 Christmas season was just $15.00. A few years ago these brought a bit more, but enough appeared to fill the demand and reduce the price. Camera with original brown bellows, cedar gift box, instructions and original cardboard box: $400-550. Camera with gift box: $150-225. Camera only: $50-75.

GIRL GUIDE KODAK CAMERA - British version of the Girl Scout Kodak Camera. Blue enameled body with Girl Guide emblem. Blue case. $125-175 in England. Slightly higher in the U.S.A.

GIRL SCOUT KODAK CAMERA - 1929-1934. For 4.5x6cm exposures on 127 film. Bright green color with official GSA emblem engraved on the bed. $75-125.

HANDLE, HANDLE 2 INSTANT CAMERAS - With nameplate: $1-5. *See notes under "Instant Cameras".*

HAPPY TIMES INSTANT CAMERA -

1978. A special two-tone brown premium version of "The Handle" camera with Coca-Cola trademarks. Originally sold for $17.95 with purchase of Coca-Cola products. Current value: $35-45.

HAWKETTE CAMERA, No. 2 - c1930's. British made folding Kodak camera for 2¼x3¼" exposures on 120 rollfilm. Folding style like the Houghton Ensignetté with cross-swinging struts. Body of brown marbled bakelite plastic. These cameras were used as premiums for such diverse products as Cadbury Chocolates and Australian cigarettes. A very attractive camera. Common in England. $35-55.

HAWK-EYE CAMERAS *The Hawk-Eye line originated with the Blair Camera Co. and was continued by Kodak after they absorbed the Blair Co. See also Blair Hawk-Eye.*

Hawk-Eye No.2 - c1913-. Inexpensive cardboard box camera. Meniscus lens; rotary shutter. 2¼x3¼" on 120 film. $5-12.

Hawk-Eye No.2A - c1913-. Black box

camera of cardboard construction. 2½x4¼" on 116 film. $5-12.

Hawkeye Ace, Hawkeye Ace Deluxe - c1938. Small box camera for 4x6.5cm on 127 film. Made in London. Similar to Baby Hawkeye, but with leatherette covering on front. Fixed focus lens, T & I shutter. $20-30.

Baby Hawkeye - c1936. Small box camera for 4x6.5cm on 127 film. Made by Kodak Ltd., London. Fixed focus lens, flip-flop shutter. $25-45.

CARTRIDGE HAWK-EYE CAMERAS (Box cameras)
No. 2 - 1924-34. 2¼x3¼" on 120. Originally all metal, but leatherette covered after 1926. Metal: $8-12. Covered: $4-8. *Illustrated top of next page.*

No. 2A - 1924-34. Originally all metal body. Beginning 1926 with Model B, there is a leatherette covering. 2½x4¼" on 116. Model A (metal): $8-12. Model B: $4-8.

FILM PACK HAWK-EYE CAMERAS *Box*
cameras taking film packs.
No. 2 - 1922-25. 2¼x3¼". All metal
construction. $8-15.
No. 2A - 1923-25. 2½x4¼". $8-15.

**HAWKEYE FLASHFUN, FLASHFUN II
CAMERAS** - $3-6.

FOLDING HAWK-EYE CAMERAS
No. 1A - 1908-15. 2½x4¼". Red bellows.
Various lens and shutter combinations.
With Meniscus or RR lens in Kodak Ball
Bearing or pneumatic shutter: $15-25.
With Zeiss-Kodak Anastigmat or Tessar IIB
lens in Compound shutter: $25-35.

No. 3 - 1904-15. Models 1-9. 3¼x4¼"
exposures on 118 film. Horizontal format.
$15-25.
No. 3A - 1908-15. Models 1-4. 3¼x5½"
exposures on 122 film. Horizontal. $15-25.
No. 4 - 1904-13. Models 1-4. 4x5"
exposures on 103 rollfilm. $25-30.
Six-16 or Six-20 - 1933-34. $15-25.

**FOLDING HAWK-EYE SPECIAL
CAMERAS** - *All have Kodak Anastigmat f6.3.*
No. 2 - 1928-33. $12-22.
No. 2A - 1928-30. $12-22.
No. 3 - 1929-34. $12-22.
No. 3A - c1929. $15-25.

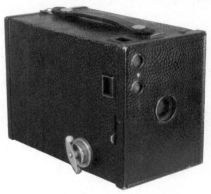

No. 2 Cartridge Hawk-Eye Camera

**FOLDING CARTRIDGE HAWK-EYE
CAMERAS**
No. 2 - 1926-33. 2¼x3¼" on 120 film.
Kodex shutter. Colored models: $15-25.
Black: $6-12.
No. 2A - 1926-34. 2½x4¼" on 116 film.
Single Achromatic or RR lens. $8-15.

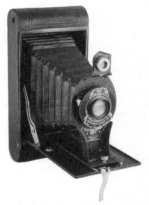

No. 3A - 1926-35. 3¼x5½" on 122 film.
Kodak shutter; RR or Achromatic lens.
$15-20.

**FOLDING FILM PACK HAWK-EYE
CAMERA, No. 2** - 1923. 2¼x3¼"
exposures on film packs. Hawk-Eye shutter.
Meniscus Achromatic lens. $15-20.

HAWKEYE Model BB - Made by Kodak
Ltd. in London. 2¼x3¼" on 120 rollfilm.
Black with bright metal trim. I+T shutter.
$8-12.

PORTRAIT HAWKEYE, No. 2 - 1930.
Kodak Ltd. Box camera for 2¼x3¼" on
120 rollfilm. Built-in close-up lens; I, T
shutter. $8-12.

RAINBOW HAWK-EYE CAMERAS *Box cameras, similar to the Cartridge Hawk-Eye, but in colors: blue, brown, green, maroon, vermillion.*

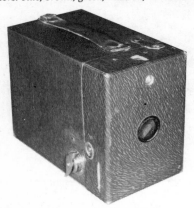

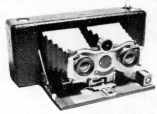

STEREO HAWK-EYE CAMERA - A continuation of the Blair Stereo Hawk-Eye series produced through 1916, and labeled "Blair Division of Eastman Kodak Co." A folding stereo camera taking twin 3½x3½" exposures. Various models, numbered in sequence, offered various lens/shutter combinations. Mahogany interior, brass trim, red bellows. $200-275.

No. 2 - 1929-33. 2¼x3¼" exposures. Colors: EUR: $25-45. USA: $15-20. Black: $4-8.
No. 2A - 1931-32. Same, but in 2½x4¼" size. Colors: EUR: $25-45. USA: $15-20. Black: $4-8.

FOLDING RAINBOW HAWK-EYE CAMERAS *Similar to the Folding Hawk-Eye Cameras, but available in black and colors: blue, brown, green, old rose. (Subtract 35% for black replacement bellows.)*
No. 2 - 1930-34. 2¼x3¼". $25-45.
No. 2A - 1930-33. 2½x4¼". $25-45.

FOLDING RAINBOW HAWK-EYE SPECIAL CAMERAS *1930-33. Available in black and colors: blue, brown, green, maroon.*
Nos. 2, 2A - $50-80.

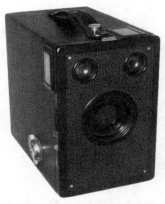

TARGET HAWK-EYE CAMERAS, No. 2, No. 2 Junior, No. 2A, Six-16, and Six-20 - 1932-33. Simple box cameras. No. 2 made in black only; others available in black, blue, and brown. Black: $3-7. Colors: $12-18.

VEST POCKET HAWK-EYE CAMERA - 1927-34. 4.5x6cm exposures. Single or Periscopic lens. $20-30.

VEST POCKET RAINBOW HAWK-EYE CAMERA - 1930-33. Same as V.P. Hawkeye, but in black or colors: blue, green, orchid, and rose. Black: $20-30. Colors, with original colored bellows: $75-95. About 25% higher in Europe. *Illustrated top of next page.*

WENO HAWK-EYE CAMERAS *Box cameras originally made by Blair Camera Co. and continued by Eastman Kodak Co. until 1915. See also Blair Weno Hawk-Eye Camera.*
No. 2 - 3½x3½". $20-30.
No. 4 - 4x5". $20-30.
No. 5 - 3¼x4¼". $20-30.
No. 7 - 3¼x5½". Introduced in 1908 after Blair became a part of EKC. $25-35.

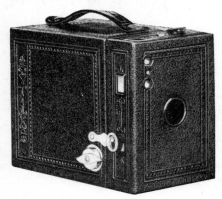

HAWK-EYE SPECIAL CAMERAS - *Deluxe model box cameras with embossed morocco-grain imitation leather.*
No. 2 - 1928-33. $15-20.
No. 2A - 1928-30. $15-20.

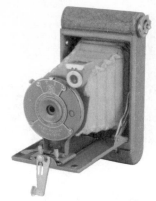

Vest Pocket Rainbow Hawk-eye Camera

INSTAMATIC CAMERAS - Introduced in 1963, using the new 126 cartridge. A variety of models made, most of which are easily found. To give a fairly complete list in a small space, we have grouped them together by features.

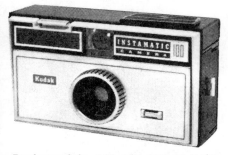

Basic models - 100, 104, 124, 44, X-15, X-15F: $3-6.

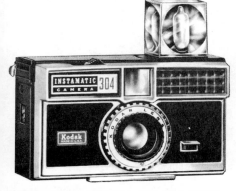

With meter - 300, 304, 134, 314, 333X, X-30, X-35, X-35F: $5-10.

Spring motor models - 150, 154, 174, X-25: $10-20.

Spring Motor & meter - 400, 404, 414, X-45: $15-25.

f2.8 metered models - 324, 500, 700, 704, 714: $20-45.
f2.8, meter, motor, RF - 800, 804, 814, X-90: $20-45.
Instamatic Reflex - 1968-74. SLR for 126 cartridges. Interchangeable lenses. CdS meter. With Xenar f2.8/45mm or Xenon f1.9/50mm lens: $75-125. *Illustrated top of next page.*

Instamatic Reflex

Instamatic S-10 & S-20 - 1967-71/72. Compact models with rectangular pop-out front. Advance knob on end. S-20 has meter. $5-10.

INSTANT CAMERAS - *In October 1985, after nine years of patent litigation with Polaroid, Kodak was banned from making and selling instant cameras and film. The ban took effect in January 1986, at which time Kodak announced a trade-in program. The owners of 16.5 million cameras were given the chance to trade in their cameras for a share of Kodak common stock, a new camera, or $50 worth of Kodak merchandise. The obvious immediate effect on the value of used Kodak instant cameras was that Kodak would pay more for them than most collectors would. By June of 1986, several class action lawsuits had been filed against Kodak by owners of the instant cameras, and the courts brought Kodak's rebate plan to a halt pending the outcome of these suits, which asked, among other things, for a cash rebate option. The final settlement called for the owners to return the camera's nameplate for a refund of cash and credits. This turn-in has been completed, and it appears that of the over 16.5 million Kodak instant cameras once in circulation, certainly there are more than enough examples, complete with their original nameplate, for all of the world's collectors at less than $5 each. A few*

of the top-of-line models, special-purpose types, or commemorative models will attract more collector interest, as they would have done without the legal hoopla. Kodak Instant cameras without nameplates are flooding the market, and have virtually no collector or commercial value.

JIFFY KODAK CAMERAS *Common rollfilm cameras with pop-out front, twin spring struts. The vest pocket model has a Doublet lens, other models have Twindar lens, zone focus. Note: Back latch is often broken which reduces the value by 40-50%. See also "Kodak Enlarger 16mm" for a specialized version of this camera.*

Six-16 - 1933-37. Art-deco enameled front. 2½x4¼" on 616 film. $10-15.

Six-16, Series II - 1937-42. Similar to the Six-16, but with imitation leather front instead of art-deco. Less common. $12-18.

Six-20 - 1933-37. Art-deco front. 2¼x3¼" on 620 rollfilm. $10-15.

Six-20, Series II - 1937-48. Similar to the Six-20, but with imitation leather front. $12-18.

Vest Pocket - 1935-42. 4.5x6cm on 127 rollfilm. Black plastic construction. $12-18.

KODAK A MODELE 11 - Self-erecting folding camera for 6x9cm. Grey plastic top housing with incorporated optical finder. Made in France. $15-20.

KODAK BOX 620 CAMERA - 1936-37. All black metal box camera with leatherette covering. Made by Kodak A.G., Stuttgart. GER: $5-10. USA: $12-18.

KODAK BOX 620C CAMERA - c1939-40. Made by Kodak A.G., Stuttgart. Unlike the Box 620, this camera looks more like the Six-20 Brownie Special. Folding frame finder. Meniscus lens, Kodak Spezial shutter. $50-75.

KODAK ENLARGER 16mm - c1939. Folding camera for enlarging frames of 16mm movie film onto 616 rollfilm. The body is basically that of a Jiffy Kodak Six-16 Model II, with modifications for enlarging. $15-25.

KODAK JUNIOR CAMERAS *Two of Eastman's first cameras bore the name Junior along with their number. They are the No. 3 Kodak Jr., and the No. 4 Kodak Jr. Both are box cameras with string-set shutters, and are listed at the beginning of the Eastman Kodak section.*
The models listed here are folding-bed cameras. Nos. 1 and 1A were introduced in 1914 shortly before the Autographic feature became available. These cameras had a short life-span, with the Autographic Kodak Junior Cameras taking their place. (See Autographic Kodak Junior Cameras.) Kodak Junior I and II are from Kodak Ltd., London, c1950's. They have grey plastic top housing with incorporated optical finder and are identified inside the front of the bed.

No. 1 - 2¼x3¼" on 120 rollfilm. $12-18.
No. 1A - 2½x4¼" on 116 film. $12-18.

Kodak Junior 0 - c1938. Made by Kodak A.G., Stuttgart. Simple 6x9cm folding rollfilm camera. Triskop f11/105mm lens in Kodak Spezial shutter 1/25, B. $30-50.

Kodak Junior I - 1954-59. Kodak Ltd. London. Self-erecting folding camera for 2¼x3¼" on 620. Grey plastic top housing incorporates optical finder. Fixed focus lens in Kodette III shutter. Not synchronized, no body release. $10-15.

Kodak Junior II - 1954-59. Similar to above, but with Anaston f6.3/105 focusing lens in sync'd Dakon II shutter, 50,25,B,T. Body release. $12-15.

Kodak Jr. Six-16 - 1935-37. 2½x4¼" in 616 film. Octagonal shutter face. Self-erecting bed. $15-25.
Kodak Jr. Six-16, Series II - 1937-40. Similar. $12-18.
Kodak Jr. Six-16, Series III - 1938-39. Self-erecting. Streamlined bed supports. $12-18.

Kodak Jr. Six-20 - 1935-37. Octagonal shutter face. Self-erecting bed. $15-20.
Kodak Jr. Six-20, Series II - 1937-40. Similar. $12-18.

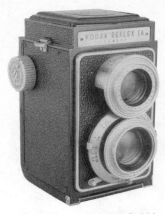

Kodak Jr. Six-20, Series III - 1938-39. Self-erecting. Streamlined bed supports. $12-18.

Kodak Junior 620 - c1936-38. Kodak A.G. $15-20.

KODAK REFLEX CAMERAS - *Twin lens reflex cameras with Kodak f3.5 lens in Flash Kodamatic shutter.*

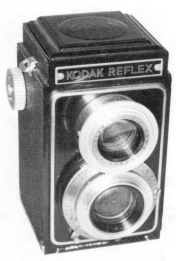

Kodak Reflex (original) - 1946-49. $25-40.
Kodak Reflex IA - Introduced December 1950. Kodak Reflex IA cameras are Kodak Reflex cameras with the original ground

glass replaced by an Ektalite field lens. The conversion kit included the lens and bezel, nameplate, and screws. The original cost of the conversion kit was $10.00. Conversions were made by Kodak and other repair organizations. The number of converted cameras is unknown. Much less common than the Kodak Reflex and Reflex II models. $55-80.

Kodak Reflex II - 1948-54. $25-40.

KODAK SERIES II, SERIES III CAMERAS - *Folding rollfilm cameras from the same era as and similar in appearance to the Pocket Kodak folding cameras.*
No. 1 Kodak Series III Camera - 1926-31. 2¼x3¼" exp. on 120 film. $15-20.
No. 1A Kodak Series III Camera - 1924-31. 2½x4¼" exp. on 116 film. $10-15.
No. 2C Kodak Series III Camera - 1924-32. 2⅞x4⅞" exp. on 130 film. $12-18.

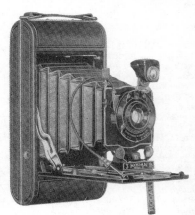

No. 3 Kodak Series III Camera - 1926-33. 3¼x4¼" exp. on 118 film. $20-30.

No. 3A Kodak Series II Camera - 1936-41. 3¼x5½" exp. on 122 film. $35-50.
No. 3A Kodak Series III Camera - 1941-43. 3¼x5½" exp. on 122 film. $25-40.

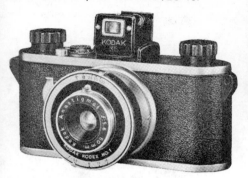

Kodak 66 Model III

KODAK 35 CAMERA - 1938-48. For 24x36mm exposures on 35mm cartridge film. Various lens/shutter combinations. No rangefinder. Very common. $10-20.

KODAK 35 CAMERA (Military Model PH-324) - Olive drab body with black trim. PH-324 printed on back. $75-125.

No. 4 Kodet Camera - 1894-97. For 4x5" plates or rollfilm holder. Leather covered wooden box. Front face hinges down to reveal brass-barrel lens and shutter. Focusing lever at side of camera. Uncommon. $300-450.

KODAK 35 CAMERA, with Rangefinder - 1940-51. f3.5 Kodak Anast. Special or Kodak Anastar lens. Kodamatic or Flash Kodamatic shutter. Very common in USA. EUR: $25-40. USA: $15-25.

KODAK 66 MODEL III - 1958-60. Kodak Ltd, London. Horizontally styled folding bed camera for 6x6cm on 120. Anaston f6.3/75mm in Vario. $20-30. *Illustrated top of next column.*

KODET CAMERAS
No. 3 Folding Kodet Camera - Vertically styled folding bed camera, similar to the No. 4 but slightly smaller. Probably sold only in England. Rare. Estimated value: $400-450.

No. 4 Folding Kodet Camera - 1894-97. Folding-bed camera for 4x5" plates or

special rollholder. Basically cube-shaped when closed. Early model has variable speed shutter built into wooden lens standard. Brass barrel lens, rotating disc stops: $300-450. Later models with B&L or Gundlach external shutters: $250-350.

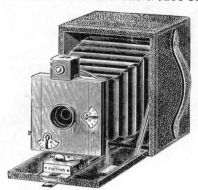

No. 4 Folding Kodet Junior Camera - 1894-97. Rare. Negotiable. Estimate: $300-450.

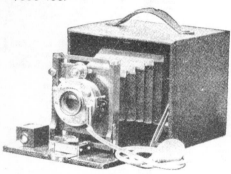

No. 4 Folding Kodet Special Camera - 1895-97. $250-350.

No. 5 Folding Kodet Camera - 1895-97. $250-350.
No. 5 Folding Kodet Special Camera - 1895-97. $250-350.

MATCHBOX CAMERA - 1944-45. Simple metal and plastic camera shaped like a matchbox. Made for the Office of Secret Services. ½x½" exposures on 16mm film. Rare. $1500-2000.

MEDALIST CAMERAS - *2¼x3¼" on 620 film. Kodak Ektar f3.5/100mm. Split image RF.*

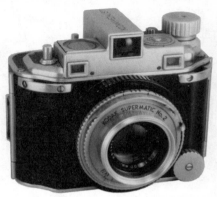

Medalist I - 1941-48. Supermatic shutter to 400, B. No sync. EUR: $125-175. USA: $100-125.

Medalist II - 1946-53. Flash Supermatic shutter. EUR: $125-175. USA: $110-150.

MONITOR CAMERAS - *1939-48. Folding rollfilm cameras, available in two sizes:*
Six-16 - 2½x4¼" on 616 film. f4.5/127mm lens in Kodamatic or Supermatic shutter, 10-400. (This is the less common of the two models.) EUR: $30-45. USA: $20-35.

Six-20 - 2¼x3¼" on 620 film. f4.5 lens. $20-30. *Illustrated top of next page.*

MOTORMATIC 35 CAMERAS - *Similar to the Automatic 35 series, but with motorized film advance. Made in 3 variations:*

Motormatic 35 Camera - 1960-62. Flash sync. posts on end of body. $30-45.

Monitor Six-20

Motormatic 35F Camera - 1962-67. Built-in flash on top for AG-1 bulbs. Flip-up cover on flash socket becomes the flash reflector. $20-40.

Motormatic 35R4 Camera - 1965-69. Built-in flashcube socket on top. $20-40.

NAGEL *Some cameras made by Kodak A.G. in Stuttgart (formerly Dr. August Nagel Werk) are continuations of cameras which were formerly sold under the Nagel brand. These cameras may be found under their model name in both the*

A, B, and C Ordinary Kodak Cameras

181

Eastman and Nagel sections of this guide. (e.g. Pupille, Ranca, Regent, Vollenda.)

ORDINARY KODAK CAMERAS

(Illustrated bottom of previous page.) A series of low-priced wooden Kodak box cameras without leather covering made from 1891-95. They were called "Ordinary" to distinguish them from the Daylight, Folding, Junior and "Regular" Kodaks, as they were called at that time. All have sector shutter, Achromatic lens and take 24 exposures on rollfilm. They differ only in size and price.
"A" - 2¾x3¼". (Original cost $6.00.) $1200-1500.

"B" - 3½x4". (Original cost $10.00.) $800-1000.

"C" - 4x5". (Original cost $15.00.) $700-800. (Also available in the plate version called the "C" Ordinary Glass Plate Kodak Camera.)

PANORAM KODAK CAMERAS *A series of rollfilm panoramic cameras in which the lens pivots and projects the image to the curved focal plane. Although designed basically for wide views, it could also be used vertically.*

No. 1 - April 1900-26. For 2¼x7" exposures on No. 105 rollfilm for an angle of 112 degrees. (Original cost $10.) Model A: $250-325. Models B, C, D: $175-225.

No. 3A - 1926-28. Takes 3¼x10⅜" exposures on 122 rollfilm for an angle of 120 degrees. This is the least common of the series, having been made for only two years. EUR: $300-450. USA: $250-350.

No. 4, (Original Model) - 1899-1900. Has no door to cover the swinging lens. For 3½x12" on No. 103 rollfilm. 142 degree angle. Rapid Rectilinear lens. (Original cost $20.) $175-225.

No. 4, Models B, C, D - 1900-1924. Same as the original model, but with a door over the lens. $125-175.

PEER 100 - c1974. An Instamatic 92 camera whose exterior is designed to look like a package of Peer cigarettes. Used as a sales promotion premium. $275-350.

PETITE CAMERA - 1929-33. Vest Pocket Kodak Model B in colors: blue, green, grey, lavender, and old rose. For 4.5x6cm on 127 film. Meniscus lens, rotary shutter. With original bellows and matching case: $100-125. With black replacement bellows: $50-70. *(See also Kodak Ensemble, Coquette.)*

- "Step Pattern" - Rather than the normal fabric covering on the front door, some of the Petite cameras had an enameled metal front in an art-deco "step" pattern. Currently these bring from $125 for a nice example with replacement black bellows to $200 for an excellent example with original colored bellows, original box, instructions.

PIN-HOLE CAMERA - ca. late 1920's and early 1930's. This is a small kit which consists of 5 cardboard pieces, gummed tape, a pin to make the hole, and instruction booklet. They were given to school children for use as science projects. We have seen a

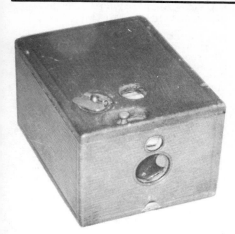

The Pocket Kodak

number of unused kits offered for sale at prices from $195 to $350. Obviously these are no longer for kids to play with. Assembled: $75-100.

PLICO - European name variation of the Flexo. $35-50.

POCKET A-1 CAMERA - c1978-80. Boxy camera for 110 cartridges. Made by Kodak Ltd., London. $1-5.

POCKET B-1 CAMERA - c1979-80. Same as Pocket A-1, but sold for premium use. $1-5.

POCKET INSTAMATIC CAMERAS - Introduced in 1972 for the new 110 cartridge. 13x17mm exposures. Most models are too new to have much collector value, but the better ones still have value as usable cameras. Model 60: $20-35. Model 50: $10-15. Model 40: $10-15. Simpler models: $3-8.

POCKET KODAK CAMERAS *Except for the first camera listed here, the Pocket Kodak cameras are of the common folding rollfilm variety.*

The Pocket Kodak (box types) - 1895-1900. A tiny box camera for 1½x2" exposures on No. 102 rollfilm which was introduced for this camera. An auxiliary plateholder could also be used. Single lens; pebble-grained leather. Earliest 1895 model has a separate shutter board with sector shutter and round viewfinder. Later models have the shutter mounted on the inside of the camera, and it is removed when loading film. Shutter type changed from sector to rotary in 1896. Identified by model year inside bottom. Original 1895 type: $100-125 in USA; $125-175 EUR. Later models: $75-100. *Illustrated top of previous column.*

Pocket Kodak Cameras (folding types) - *All of these incorporate the Autographic feature, but the word Autographic does not form part of the name.*
No. 1 - 1926-31, black; 1929-32, colors. 2¼x3¼" on 120 film. Colors (blue, brown, green or grey): $20-30. Black: $8-13.

No. 1A - 1926-31, black; 1929-32, colors. 2½x4¼" on 116 film. Colors (blue, brown, green, grey): $20-30. Black: $8-15.

No. 2C - 1925-32. 2⅞x4⅞" on 130 film. Black only. $10-20.

No. 3A - 1927-34. 3¼x5½" on 122 film. Black only. $12-20.

POCKET KODAK JUNIOR CAMERAS -
1929-32. Folding bed camera available in black, blue, brown, and green. Meniscus lens in Kodo shutter.

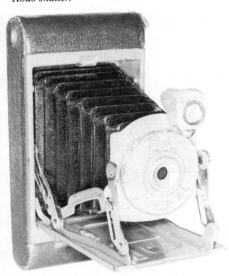

No. 1 - 2¼x3¼" on 120 film. Black: $7-12. Colors: $25-45.

No. 1A - 2½x4¼" on 116 film. Black: $8-13. Colors: $25-45.

POCKET KODAK SERIES II CAMERAS
- Folding bed cameras.

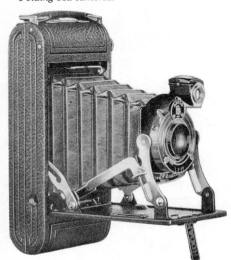

No. 1 - 1922-31. Focusing and fixed-focus models. Black only. $10-15.

No. 1A, (black) - 1923-31. Focusing and fixed-focus models. $10-15.

No. 1A, (colors) - 1928-32. Available in beige, blue, brown, green, and grey. Meniscus Achromatic lens in Kodex shutter. Originally came with matching carrying case. Complete with case & box in EUR: $75-100; USA: $50-75. Camera only: $15-30.

POCKET KODAK SPECIAL CAMERAS
Folding bed cameras in black. Kodak Anastigmat f6.3, f5.6, f4.5 lenses in Kodamatic shutter. (No. 2C not available with f6.3 lens.) Models with f4.5 lens are hard to find and would be worth about 30–40% more. All models less common in Europe where they bring about double the USA price.
No. 1 - 1926-34. 2¼x3¼" on 120 film. $15-25.
No. 1A - 1926-34. 2½x4¼" on 116 film. $15-25.
No. 2C - 1928-33. 2⅞x4⅞" on 130 film. $15-25.

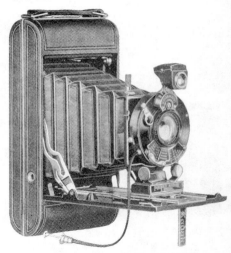

No. 3 - 1926-33. 3¼x4¼" on 118 film. $15-25.

Pony IV

184

PONY CAMERAS
II - 1957-62. For 24x36mm exposures on 35mm film. Non-interchangeable Kodak Anastar f3.9/44mm lens. Bakelite body. EUR: $15-25. USA: $8-15.

IV - 1957-61. Non-interchangeable Kodak Anastar f3.5/44mm lens. 35mm film. $10-15. *Illustrated on previous page.*

135 - 1950-54; Model B, 1953-55; Model C, 1955-58. The first Pony Camera for 35mm film. Non-interchangeable Kodak Anaston f4.5 or f3.5 lens in focusing mount. $8-15.

135 (Made in France) - 1956. 24x36mm on 35mm film. Angenieux f3.5/45mm lens. Shutter 1/25-1/150, B. $15-25.

828 - 1949-59. The first in this series, it took No. 828 film. Easily distinguished from the later 35mm models by the lack of a rewind knob on the top right side next to the shutter release. Common. $8-12.

PREMO CAMERAS *The Premo line was a very popular line of cameras taken over by Kodak from the Rochester Opt. Co. See Rochester for earlier models.*

PREMO BOX FILM CAMERA - 1903-08. For filmpacks. 3¼x4¼" or 4x5" sizes. Achromatic lens, Automatic shutter. $8-15.

No. 2 Cartridge Premo Camera

CARTRIDGE PREMO CAMERAS - *Simple rollfilm box cameras.*

No. 00 - 1916-22. 1¼x1¾". Meniscus

lens. The smallest Kodak box camera.
EUR: $75-125. USA: $50-75.
No. 2 - 1916-23. 2¼x3¼". $10-16.
Illustrated on previous page.
No. 2A - 1916-23. 2½x4¼". $10-16.
No. 2C - 1917-23. 2⅞x4⅞". $10-16.

FILM PREMO CAMERAS - *Wooden-bodied folding bed cameras for filmpacks. Four sizes, 3¼x4¼" through 5x7", usually found in the 3¼x4¼" & 3¼x5½" sizes.*

No. 1 - 1906-16. Simple lens and shutter. $25-35.
No. 3 - 1906-10. Various lens/shutter combinations. $25-45.

FILMPLATE PREMO CAMERA - 1906-1916. Folding camera for plates or filmpacks. 3¼x4¼", 3¼x5½", 4x5" sizes: $40-60. 5x7" size: $50-75.

FILMPLATE PREMO SPECIAL - 1912-1916. This is the same camera as the one above. The Filmplate Premo Camera with the better lens/shutter combinations was called the Filmplate Premo Special after 1912. (Only the version with the Planatograph lens was still called the Filmplate Premo.) $40-75.

PREMO FOLDING CAMERAS - *Folding cameras for plates or filmpacks.*

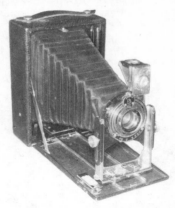

Premo No. 8 - 1913-22. Planatograph lens (or Anastigmat on the 3¼x5½") in Kodak Ball Bearing shutter. 3 sizes: 3¼x5½": $30-40. 4x5": $30-45. 5x7": $40-60.

Premo No. 9 - 1913-23. Various lens/shutter combinations. 3 sizes: 3¼x5½": $25-40. 4x5": $30-45. 5x7": $40-60.

Premo No. 12 - 1916-26. 2¼x3¼" on plates, packs or rollfilm. Various lens/shutter combinations. $25-40.

FOLDING CARTRIDGE PREMO
CAMERAS - *Folding-bed rollfilm cameras.*
Meniscus Achromatic or Rapid Rectilinear lens.
No. 2 - 1916-26. 2¼x3¼" on 120 film.
$10-15.

No. 1 Premo Jr.

POCKET PREMO CAMERAS

No. 2A - 1916-26. 2½x4¼" on 116 film.
$10-15.
No. 2C - 1917-23. 2⅞x4⅞" on 130 film.
Uncommon size. $15-20.
No. 3A - 1917-23. 3¼x5½" on 122 film.
$10-15.

PREMO JUNIOR CAMERAS - *Filmpack*
box cameras. Simple lens and shutter.
Uncommon in Europe, where they bring double
the USA price.
No. 0 - 1911-16. 1¾x2¼". $15-25.
No. 1 - 1908-22. 2¼x3¼". The first model
to be introduced, in 1908 it was called
simply Premo Jr. $12-18. *Illustrated top of*
next column.

Pocket Premo, 2¼x3¼" - 1918-23. Self-
erecting, folding bed camera for filmpacks
only. Mensicus Achromatic lens, Kodak
Ball Bearing shutter. $25-45.

Pocket Premo C - 1904-16. 3¼x4¼" and
3¼x5½" sizes. Uses plates or filmpacks.
Black or red bellows. $25-45.

PONY PREMO CAMERAS - *Folding plate*
cameras. The 4x5" and 5x7" sizes could also
use filmpacks or rollfilm.
Pony Premo No. 1 - 1904-12. 4x5".
Inexpensive lens and shutter. $30-50.

No. 1A - 1909-21. 2½x4¼". $15-25.
No. 3 - 1909-19. 3¼x4¼". $15-25.
No. 4 - 1909-14. 4x5". $20-30.

Pony Premo No. 2 - 1898-1912.
Inexpensive lens/shutters. 3 sizes: 3¼x4¼":
$30-50. 4x5": $35-55. 5x7": $60-90.

187

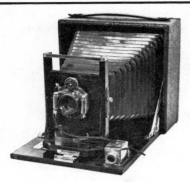

Pony Premo No. 3 - 1898-1912. With inexpensive lens/shutter combinations. 3¼x4¼: $35-45. 4x5": $35-60. 5x7": $75-95.

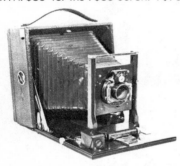

Pony Premo No. 4 - 1898-1912. Various lens/shutter combinations. 4x5": $35-50. 5x7": $75-125.

Pony Premo No. 6 - 1899-1912. Various lens/shutter combinations. For plates. 4x5": $40-60. 5x7": $75-125. 6½x8½": much less common, $100-150. 8x10": $100-150.

Pony Premo No. 7 - 1902-12. Various lens/shutter combinations. For plates. 4x5": $40-60. 5x7": $75-125. 6½x8½": much less common, $100-150.

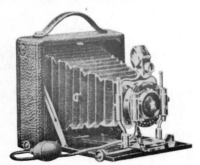

STAR PREMO - 1903-08. Folding bed

camera for 3¼x4¼" exposures on plates or filmpacks. Various lens/shutter combinations. $40-60.

PREMOETTE CAMERAS - *Leather-covered wood-bodied "cycle" style cameras in vertical format. For filmpacks.*

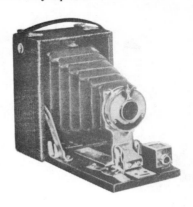

(no number) - 1906-08. 2¼x3¼". Became the No. 1 in 1909 when the No. 1A was introduced. $30-40.

No. 1 - 1906-12. 2¼x3¼". (Models with better lens/shutter combinations were referred to as Premoette Special No. 1 for a few years.) $25-35.

No. 1A - 1909-12. 2½x4¼". (Models with better lens/shutter combinations were referred to as Premoette Special No. 1A for a few years.) $20-35.

No. 1 Premoette Junior Camera

PREMOETTE JUNIOR CAMERAS - *Leather-covered aluminum-bodied folding bed cameras for filmpacks. The bed folds down, but not a full 90 degrees. There is no track on the bed, but the front standard fits into one of several slots at the front of the bed for different focusing positions. These cameras, although not terribly uncommon in the USA, are currently worth about double the US price in Europe.*
(no number) - 1911-12. 2¼x3¼". Became

the No. 1 in 1913 when the No. 1A was introduced. $15-25.
No. 1 - 1913-23. 2¼x3¼". $25-35.
No. 1 Special - 1913-18. Kodak Anastigmat f6.3 lens. $30-35.
No. 1A - 1913-18. 2½x4¼". $30-35.
No. 1A Special - 1913-18. Kodak Anastigmat f6.3 lens. $40-50.

PREMOETTE SENIOR CAMERAS -
1915-23. Folding bed camera for filmpacks. 2½x4¼", 3¼x4¼", and 3¼x5½" sizes. (The only Premoette made in the 3¼x5½" size.) Similar in design to the Premoette Jr. models. Kodak Anastigmat f7.7 or Rapid Rectilinear lens. Kodak Ball Bearing shutter. $20-35.

PREMOETTE SPECIAL CAMERAS -
1909-11. *Versions of the Premoette No. 1 and No. 1A with better lenses and shutters. In 1912, the name "Special" was dropped and these lens/ shutter combinations were options on the Premoette No. 1 & No. 1A.*
No. 1 - 2¼x3¼". $20-35.
No. 1A - 2½x4¼". $20-35.

PREMOGRAPH CAMERAS - *Simple boxy single lens reflex cameras for 3¼x4¼" filmpacks. Not to be confused with the earlier Premo Reflecting Camera, found under the Rochester heading in this book.*
Premograph (original) - 1907-08. Single Achromatic lens. Premograph Reflecting

shutter. $175-225.

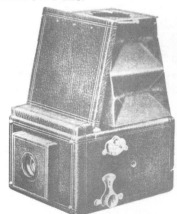

Premograph No. 2 - 1908-09. Better lens. Premograph Reflecting or Compound shutter. $125-175.

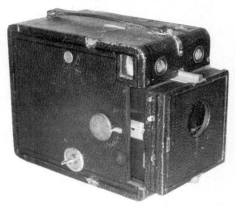

Quick Focus Kodak Camera

189

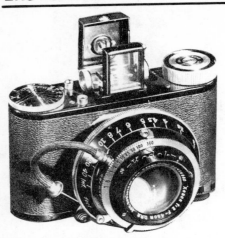

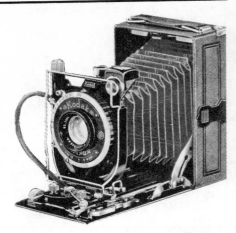

PUPILLE - 1932-35. Made in Stuttgart, Germany by the Nagel Works. For 3x4cm exp. on 127 film. Schneider Xenon f2/45mm. Compur shutter 1-300. $200-250.

QUICK FOCUS KODAK CAMERA, No. 3B - 1906-11. Box camera for 3¼x5½" exposures on No. 125 film. Achromatic lens, rotary shutter. Original cost: $12.00. An unusual focusing box camera. Focus knob (lever on early models) on side of camera is set to proper focal distance. Upon pressing a button, the camera opens (front pops straight out) to proper distance, focused and ready. $125-175. *Illustrated bottom of previous page.*

RADIOGRAPH COPYING CAMERA - Body is identical to the Pony 135, but this apparently was sold in an outfit for specialized use. $15-25.

RANCA CAMERA - 1932-34. Made by Kodak A.G. Similar to the Pupille Camera, but with dial-set Pronto shutter. Nagel Anast. f4.5 lens. 3x4cm exposures on 127 film. $175-250.

RECOMAR CAMERAS - *1932-40. Kodak's entry into the crowd of popular compact folding long-extension precision view cameras. Made in Germany by Kodak A.G.*

Model 18 - 2¼x3¼". Kodak Anastigmat f4.5/105mm in Compur shutter. $50-75.

Model 33 - 3¼x4¼". Similar, but 135mm lens. More common than the smaller model. $45-75.

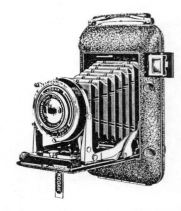

REGENT CAMERA - 1935-39. Made by Kodak A.G. in Stuttgart, Germany. Dual format, 6x9cm or 4.5x6cm on 620 film. Schneider Xenar f3.8 or f4.5, or Zeiss Tessar f4.5 lens. Compur-S or Compur Rapid shutter. Coupled rangefinder incorporated into streamlined leather covered body. Asking prices to $250. Most sales $150-200.

REGENT II CAMERA - 1939. Made by Kodak A.G. in Germany. For 8 exposures 6x9cm on 120 film. Schneider Xenar f3.5 lens. Compur Rapid shutter. Coupled rangefinder in chrome housing on side of camera. Quite rare. $800-1200. *One failed to reach a $1450 reserve at a German auction.*

REGULAR KODAK CAMERAS *"Regular" is the term used in early Kodak advertising to distinguish the No. 2, 3, and 4 "string-set" Kodak cameras from the "Junior", "Folding", "Daylight", and "Ordinary" models. The "Regular Kodak" cameras are listed at the beginning of the Eastman section, where we have called them by their simple original names: No. 2, 3, and 4 Kodak cameras.*

RETINA CAMERAS - *A series of 35mm cameras made in Germany by Kodak A.G.* **Model "I"'s have no rangefinder.**

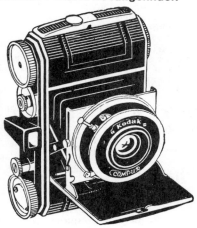

original model, Type 117 - 1934-35. Film advance release wheel next to winding knob. Top film sprocket with short shaft. Rewind release on advance knob. Large diameter advance and rewind knobs. Black finish with nickel trim. Schneider Xenar f3.5/50mm in Compur to 1/300. $100-150.

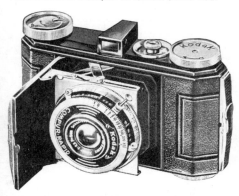

original model, second version- Type 118 - 1935-37. Film advance release lever at rear of top housing. Full length film sprocket shaft with top sprocket only. Rewind release on advance knob.

Schneider Xenar f3.5/80mm in Compur Rapid to 1/500. $75-125.

(I) (Type 119) - 1936-38. Not called "I" until 1937. Recessed exposure counter between advance knob and viewfinder. Rewind release lever to right of film advance release button. Black lacquered metal parts. Lacks accessory shoe. Reduced diameter advance and rewind knobs. Five milled rows on rewind knob. Kodak Ektar or Schneider Xenar f3.5 lens in Compur or Compur Rapid shutter. Not marketed in the USA. $50-75.

(I) (Type 126) - 1936-38. Not called "I" until 1937. Made with black or chrome trim. Accessory shoe (or 2 mounting screws) between finder and rewind knob. Five milled rows on rewind knob. Lenses available were: Kodak Ektar f3.5 (USA market) Schneider Xenar f3.5, Zeiss Tessar f3.5, Rodenstock Ysar and Angenieux Alcor (European market). Compur Rapid shutter. $40-60.

I (Type 141) - 1937-39. Body shutter release inside edge of exposure counter disc. Seven milled rows on rewind knob. Chrome trim. Kodak Anastigmat or Schneider Xenar f3.5. Compur or Compur Rapid shutter. Only the version with the Ektar lens in Compur Rapid shutter was sold in the USA. $30-55.

I (Type 143) - 1939. Like the Type 141, but with black trim. No accessory shoe. Schneider Xenar f3.5 lens in Compur shutter. Not imported into the USA. $45-65.

I (Type 148) - 1939. Taller top housing. Body release next to exposure counter. Cable release socket next to shutter release. Double exposure prevention. Kodak Anastigmat Ektar or Schneider Xenar f3.5 lens. Compur or Compur Rapid shutter. Only the Ektar/Compur Rapid version was sold in the USA. $45-70.

I (Type 149) - 1939. Like Type 148, but black lacquered edges of body. No accessory shoe. Schneider Xenar f3.5 lens in Compur shutter. Not imported into the USA. $70-90.

I (Type 010) - 1946-49. Similar to Type 148. Made from pre-war and wartime parts. USA imports have EK prefix on the serial number in the inside back. f3.5 coated and uncoated Retina Xenar, Kodak Anastigmat Ektar, or Rodenstock Ysar lens. Compur Rapid shutter. Made by Kodak A.G., except for the Kodak Ektar coated lens which was made in the USA. Only the version with Retina Xenar coated lens was sold in the USA. Fairly common. $30-45.

I (Type 013) - 1949-54. Full top housing with integral finder. Knob film advance. Retina Xenar f2.8 or f3.5 in Compur Rapid shutter. Not imported into the USA. $30-50.

Ia (Type 015) - 1951-54. Full top housing with integral finder. Rapid film advance lever on top. Shutter cocking mechanism coupled to film transport. Retina Xenar f3.5 in Compur Rapid shutter, or Retina Xenar f2.8, Rodenstock Heligon f3.5, or Kodak Ektar f3.5 in Synchro-Compur shutter. Not imported into the USA, but is still a very common model. $30-55.

Ib (Type 018) - 1954-58. Rapid film advance lever at bottom. Body corners rounded. Rectangular strap lugs at body ends. Metal shroud covers bellows. Retina Xenar f2.8 lens in Synchro-Compur. Not imported into the USA. $50-75.

IB (Type 019) - 1957-60. Uncoupled selenium meter. Extra front window for bright frame illumination. Retina Xenar f2.8 in Synchro-Compur. Not imported into the USA. $65-100.

IBS (Type 040) - 1962-63. Retina Xenar f2.8 in Compur. Not imported into the USA. $50-80.

IF (Type 046) - 1963-64. Rigid body. Built-in AG-1 flash on top. Recessed rewind knob. Coupled selenium meter. Prontor LK shutter distinguishes this from the IIF. Retina Xenar f2.8 in Prontor 500LK. Not imported into the USA. $60-90.

Model "II"s all have coupled rangefinders.
II (Type 122) - 1936-37. Lever film advance. Coupled rangefinder with separate eyepiece. Two round rangefinder windows. Kodak Anastigmat Ektar f3.5, Schneider Xenon f2.8 or f2.0 lens. Compur Rapid shutter. Not imported into the USA. Scarce. $85-135.

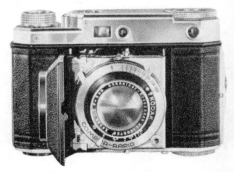

II (Type 142) - 1937-39. Knob film advance. Coupled rangefinder with separate eyepiece. Two round rangefinder windows. Kodak Anastigmat Ektar f3.5, Schneider Xenon f2.8 or f2.0 lens in Compur Rapid. The version with the Ektar lens was not sold in the USA. $30-60.

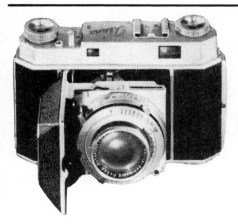

shutter. Compur Rapid shutter also used with the Xenon. Made by Kodak A.G. Only the Xenon/Synchro-Compur version was sold in the USA. $45-60.

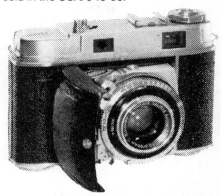

II (Type 011) - 1946-49. Like the IIa, Type 150. No strap lugs. Single eyepiece range/viewfinder. Viewfinder image moves when focusing. No film type indicator on top. Kodak Ektar or Retina f2.0 coated lens, or uncoated Xenon or Heligon lens. Compur Rapid shutter. Only the Xenon version was imported into the USA. $65-85.

II (Type 014) - 1949-50. Single eyepiece range/viewfinder. Film type indicator under rewind knob. Retina Xenon or Heligon lens in Compur Rapid shutter. Not imported into the USA. $60-80.

IIa (Type 150) - 1939. Coupled rangefinder with single eyepiece. Small extensible rewind knob. Strap lugs at body ends. Kodak Ektar f3.5, Schneider Xenon f2.8 or f2.0 lens. Compur Rapid shutter. Not imported into the USA. $45-70.

IIc (Type 020) - 1954-57. Viewfinder windows not equal in size. Bright frame for normal lens only. Film advance lever on bottom of body. No built-in exposure meter. MX sync. Retina Xenon-C or Heligon-C f2.8, Synchro-Compur shutter. Interchangeable front elements change the 50mm normal lens to 35mm wide angle or 80mm tele-photo. Made by Kodak A.G. Only the Xenon-C version was sold in the USA. $75-105.

IIC (Type 029) - 1958. Large finder windows of equal size. Bright frames for 3 lenses. Retina Xenon-C or Heligon-C f2.8 len with interchangeable front elements available. Synchro-Compur shutter. Not imported into the USA. $75-150.

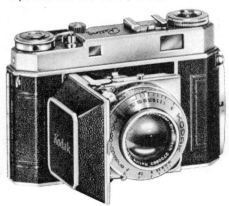

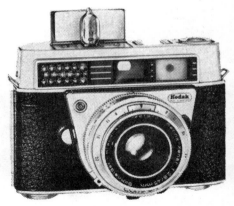

IIa (Type 016) - 1951-54. Rapid rewind lever with built-in exposure counter. Strap lugs on front viewfinder. Retina Xenon or Heligon f2.0 lens in Synchro-Compur

IIF (Type 047) - 1963-64. Rigid body. Built-in AG-1 flash holder. Accessory shoe recessed in top housing. Similar to the IF, but with Synchro-Compur Special shutter. Match-needle visible only in finder. Retina Xenar f2.8 lens. Not common. $75-125.

IIS (Type 024) - 1959-60. Like the IIIS, but without interchangeable lenses. Retina Xenar f2.8 lens in Synchro-Compur shutter. Not imported into the USA. Uncommon. $75-135.

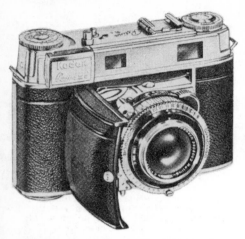

IIIc (Type 021) - 1954-57. Like the IIc, but with coupled selenium meter. Bright frame for normal lens only. Retina Xenon-C or Heligon-C f2.8 lens with interchangeable front elements. Synchro-Compur shutter. Only the Xenon-C version was sold in the USA. Very common. $70-100. *(Although occasionally sold for $100-125 these are very common and nearly always available in the lower price range.)*

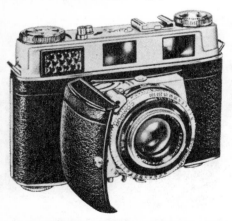

Retina IIIC (Type 028) - 1958-60. Coupled selenium meter. Finder windows of equal size. Bright frames for 3 lenses. Synchro-Compur shutter. Retina Heligon-C or Xenon-C f2.0 lens with interchangeable front elements. Only the version with the

Xenon-C lens was sold in the USA. $175-225. NOTE: During the latter part of the production run, the exposure meter range was extended to ASA 3200, and the 3-section film reminder dial was substituted for the older version which listed individual film types. In the last few years, we have had reports that some of these have been erroneously identified as the IIIC (New Type) of 1977. See the next listing for further identification information.)

Retina IIIC (New Type) - A small quantity of IIIC cameras was assembled in 1977, the 50th anniversary of the Nagel Works, using mainly original parts. One source indicates that 120 were made. During the latter part of the production run of the regular IIIC (Type 028), the ASA range on the exposure meter had been extended from 1300 to 3200, and the film reminder dial was changed from the specific film names to 3-sections for Color outdoors, Color indoors, and B&W. The new type includes these changes, but they are not a sure indication that the camera is one of the new type. The only visible difference which identifies the 1977 cameras is the stamping of the serial number into the leatherette on the camera back. Regular production cameras have been offered at high prices due to confusion about the actual production date. Caution advised. Verified 1977 models: $350-450.

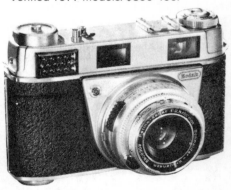

IIIS (Type 027) - 1958-60. The first Retina with a non-folding body. Interchangeable lenses: Retina Xenon or Heligon f1.9, Retina Xenar or Ysarex f2.8. Synchro-Compur shutter. Only the Xenar and Xenon versions were sold in the USA. USA: $75-125. EUR: $65-80.

S1 (Type 060) - 1966-69. Rigid plastic body. Built-in flashcube socket. No meter. Manual exposure with weather symbols. Schneider Reomar f2.8 lens in Kodak 4-speed shutter with B. EUR: $25-45. USA: $30-50. *Illustrated top of next page.*

S2 (Type 061) - 1966-69. Like the S1, but with coupled selenium meter. Schneider Reomar f2.8 lens in Kodak 4-speed shutter with B. Not imported into the USA. EUR: $20-35. USA: $25-45.

RETINA AUTOMATIC CAMERAS
I (Type 038) - 1960-62. Rigid body. Coupled selenium meter. Shutter release on front. Retina Reomar f2.8. Prontormat-S shutter. Not imported into the USA. At European auctions, these bring $25-35.

II (Type 032) - 1960-63. Coupled automatic meter. Shutter release on front. No rangefinder. Retina Xenar f2.8. Compur shutter. Not imported into the USA. In Europe: $25-45.

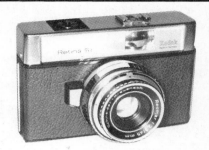

Retina S1

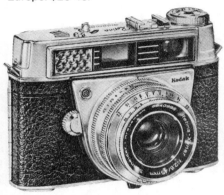

III (Type 039) - 1960-64. Like the Automatic II, but with coupled rangefinder. Retina Xenar f2.8. Compur shutter. $40-60.

RETINA REFLEX CAMERAS

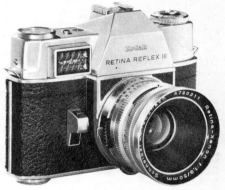

III (Type 041) - 1960-64. Meter needle visible in finder. Shutter release on front. Retina f1.9 Xenon or Heligon, or Retina f2.8 Xenar or Ysarex lens. Synchro-Compur MXV shutter. Made by Kodak A.G. Only the Xenar and Xenon versions were sold in the USA. $50-70. (Add $10-15 for f1.9 lens.)

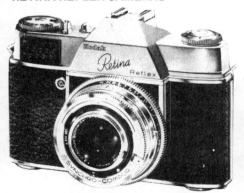

(original model- Type 025) - 1956-58. Single lens reflex. Interchangeable front lens elements. Retina Xenon-C or Heligon-C f2.0 lens. Synchro-Compur MXV shutter. Only the Xenon-C version was sold in the USA. $60-90.

IV (Type 051) - 1964-67. Small window on front of SLR prism to show settings in finder. Folding crank on rewind knob. Hot

shoe. Retina f1.9 Xenon or f2.8 Xenar lens. Synchro-Compur X shutter. $70-90. (Add $15-20 for f1.9 lens.)

S (Type 034) - 1959-60. Coupled meter. Interchangeable Retina lenses: f1.9 Xenon or Heligon, or f2.8 Xenar or Ysarex. Synchro-Compur MXV shutter. Only the versions with the Xenar and Xenon lenses were sold in the USA. $85-110.

RETINETTE CAMERAS
original model- Type 147 - 1939. Folding 35mm camera with self-erecting front. Horizontal style, not like the other folding Retina cameras. Body curved out to a flat bed. Bed hinged at camera bottom. Kodak Anastigmat f6.3/50mm. Kodak 3-speed shutter. Not imported into USA. $200-260.

(Type 012) - 1949-51. Horizontal body style. Bed swings to side. Half top-housing is chromed. Housing ends at viewfinder window. No accessary shoe. Separate cable release socket. Enna Ennatar or Schneider Reomar f4.5 lens in Prontor-S shutter. Not imported into the USA. $75-125.

(Type 017) - Horizontal body style. Bed

swings to side. Full length top housing. Bed is deeper than Type 022. Accessory shoe. Release button threaded for cable release. Schneider Reomar or Xenar f4.5 lens. Prontor SV shutter. Only the Reomar version was sold in the USA. $35-45.

(Type 022) - 1954-58. Non-folding style. Rectangular front plate without the "V" design. Single finder window. Schneider Reomar f3.5 lens. Compur Rapid shutter. Not imported into the USA. $25-35.

I (Type 030) - 1958-60. Non-folding style. A continuation of the Type 022 body style. Rectangular front plate with "V" design. Two windows. Schneider Reomar f3.5 lens in Compur Rapid shutter. Not imported into the USA. $25-45. (This camera was exported to Kodak-Pathe, France as Type 030/7 and to Kodak Ltd., England as Type 030/9.)

Retinette IA (Type 042)

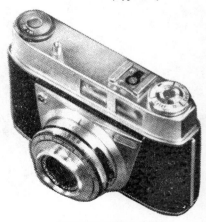

Retinette IA (Type 044)

IA (Type 035) - 1959-60. Non-folding style. "V"-shaped front plate. No zone dots on lens rim. Schneider Reomar f3.5 lens. Pronto or Vero shutter. Not imported into the USA. $25-35. (Type 035/7 was the export version for Kodak-Pathe, France.)

IA (Type 042) - 1960-63. Non-folding style. "V"-shaped front plate. Click stops for zone focus, zones marked by dots on focus ring. Accessory shoe is not a "hot" shoe as on later Type 044. Schneider Reomar f2.8 lens. Pronto shutter. $25-35. *Illustrated on previous page.*

IA (Type 044) - 1963-67. Non-folding style. "V"-shaped front plate. Hot shoe distinguishes this model from the Type 042. Schneider Reomar f2.8 Prontor 250S or 300S shutter. $30-40. *Illustrated on previous page.*

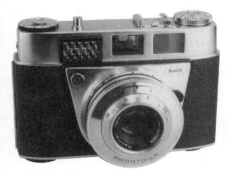

IB (Type 037) - 1959-63. Non-folding style. "V"-shaped front plate. No hot shoe. Built-in meter. Schneider Reomar f2.8 lens. Pronto-LK shutter. Not imported into the USA. $30-45.

IB (Type 045) - 1963-66. Non-folding style. "V"-shaped front plate. Built-in meter. Hot shoe. Schneider Reomar f2.8. Pronto 500-LK shutter. Not imported into the USA. $30-45.

II (Type 160) - 1939. Folding style. Bed swings to the side. Table stand on bed. Deeper bed than on Type 147. Body not curved. Black enameled half-top housing. Ribbed front standard. Kodak Anast. f3.5 or f4.5 lens. Kodak 4-speed or Compur shutter. Not imported into the USA. $45-70.

II (Type 026) - 1958. Non-folding style. A continuation of the Type 022 style. Rectangular front plate with "V" design. Two finder windows. Shutter cross-coupled with diaphragm. Schneider Reomar f2.8. Compur Rapid shutter. Not imported into the USA. Not commonly found in the USA. $35-50.

IIA (Type 036) - 1959-60. Non-folding style. "V"-shaped front plate. Built-in meter. No hot shoe. Schneider Reomar f2.8. Prontormat shutter. Not imported into the USA. $35-50.

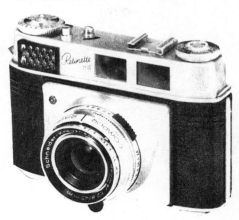

IIB (Type 031) - 1958-59. Non-folding style. Rectangular faceplate with "V" design. No hot shoe. Built-in meter. Schneider Reomar f2.8. Compur Rapid shutter. Not imported into the USA. $35-55.

F (Type 022/7) - 1958. Non-folding style. Same body as Type 022. Made by Kodak A.G. for export to France without lens or shutter. $50-75.

SCREEN FOCUS KODAK CAMERA -
One of the first cameras to provide for the use of ground glass focus on a rollfilm camera. The rollfilm holder hinges up to allow focusing. Similar to Blair's No. 3 Combination Hawk-Eye and the earlier Focusing Weno Hawk-Eye No. 4.

No. 4 - 1904-10. For 4x5" exposures on No. 123 film, which was introduced for this camera. Various lens/shutter combinations. $225-260.

KODAK SENIOR CAMERAS - *1937-39.*
Folding bed rollfilm cameras.

Six-16 - 2½x4¼". $15-25.
Six-20 - 2¼x3¼". $15-25.

Signet 30

Signet 35

SIGNET CAMERAS - *A series of 35mm cameras with coupled rangefinders.*
30 - 1957-59. Kodak Ektanar f2.8/44mm lens. Kodak Synchro 250 shutter 4-250. $18-28. *Illustrated in previous column.*
35 - 1951-58. Kodak Ektar f3.5/44mm. Kodak Synchro 300 shutter. EUR: $20-30. USA: $15-20. *Illustrated in previous column.*

40 - 1956-59. Kodak Ektanon f3.5/46mm lens. Kodak Synchro 400 shutter. EUR: $25-40. USA: $15-20.

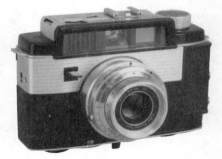

50 - 1957-60. Kodak Ektanar f2.8. Kodak Synchro 250. Built-in meter. $25-40.

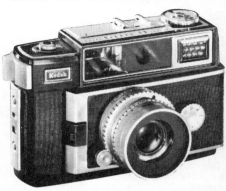

80 - 1958-62. Built-in meter. Interchangeable lens. Behind-the-lens shutter. $40-55.

198

Signal Corps Model KE-7(1) - A version of the Signet 35, made for the U.S. Army Signal Corps. Olive drab color or U.S.A.F. black anodized model. No serial number on the body. $100-125.

SIX-THREE KODAK CAMERAS - *1913-15. A variation of the Folding Pocket Kodak Cameras with f6.3 Cooke Kodak Anastigmat lens in B&L Compound shutter. The camera itself is identified as a Folding Pocket Kodak Camera, but the official name is the Six-Three Kodak Camera.*
No. 1A - 2½x4¼" exp. on 116 film. $20-35.
No. 3 - 3¼x4¼" exp. on 118 film. $15-25.

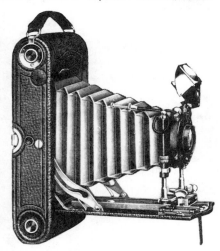

No. 3A - 3¼x5½" exp. on 122 film. $18-25.

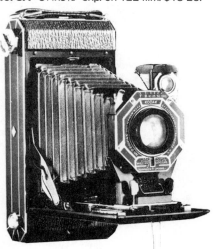

Kodak Six-16 Camera

KODAK SIX-16 and SIX-20 CAMERAS - *1932-34. Folding bed cameras. Enameled art-deco body sides. Available in black or brown. 616 and 620 films were introduced for these cameras.*
Six-16 - 2½x4¼". $15-25. *Illus. other column.*
Six-20 - 2¼x3¼". $15-25.

KODAK SIX-16 and SIX-20 CAMERAS (IMPROVED MODELS) - *Folding bed cameras. Similar to the earlier models, but improved design on the bed-support struts, recognizable by black enameling.*

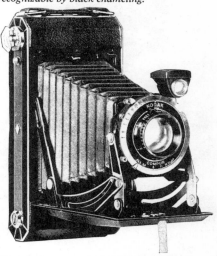

Six-16, Improved - 1934-36. 2½x4¼". $20-30.
Six-20, Improved - 1934-37. 2¼x3¼". $20-30. *Either size with Compur shutter: $30-50.*

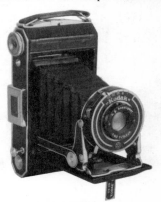

SIX-20 KODAK B - (Kodak Ltd.) 1937-40. Self-erecting 2¼x3¼" folding camera with streamlined art-moderne struts. Folding optical finder. Body release for AGC (Gauthier) T,B,25,50,100 shutter. K.S. Anastigmat f4.5 or f6.3/105mm. $25-35.

Six-16 - 2½x4¼". $15-30.

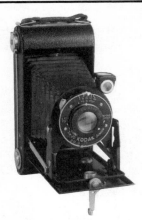

SIX-20 KODAK JUNIOR - (Kodak Ltd.) 1933-40. Various models with Doublet, Twindar, or Kodak Anastigmat lens. $12-18.

SPECIAL KODAK CAMERAS - *Earlier than the Kodak Special Six-16 and Six-20 Cameras listed below. These cameras are similar to the Folding Pocket Kodak cameras but with better lenses in B&L Compound shutters. They were discontinued in 1914 when the Autographic feature was introduced, and this line became Autographic Kodak Special Cameras.*

Six-20 - 2¼x3¼". $15-30.

SPEED KODAK CAMERAS *Folding bed cameras, not at all similar to each other in body style. Focal plane shutter to 1000.*
No. 1A - April 1909-13. 2½x4¼" on 116 rollfilm. Kodak Anast. f6.3, Tessar f6.3 or f4.5, and Cooke f5.6 lens available. Have sold in Europe up to $325. Normal range in USA: $175-225. *Illustrated top of next page.*

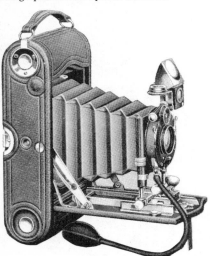

No. 1A - 1912-14. 2½x4¼". $40-60.
No. 3 - 1911-14. 3¼x4¼". $40-60.
No. 3A - 1910-14. 3¼x5½". $40-65.

KODAK SPECIAL SIX-16 and SIX-20 CAMERAS - *1937-39. Folding bed cameras, similar to the Kodak Junior Series III Cameras, but with better lens and shutter.*

No. 4A - 1908-13. 4¼x6½" exp. on 126 rollfilm. (No. 126 rollfilm was made from 1906-1949.) f6.3 Dagor, Tessar, or Kodak Anastigmat or f6.5 Cooke lens. $300-325.

No. 1A Speed Kodak Camera

KODAK SPORT SPECIAL CAMERA OUTFIT - c1987. Specially packaged outfit for the America's Cup races at Freemantle, Australia. Includes Kodak Sport Camera with built-in flash (made in Brazil), wall chart of courses at Freemantle, mini photo album, and a Gold 200 film made in France. Boxing kangaroo adorns the outer box. Original price about $55.

KODAK STARTECH CAMERA - c1959. Special purpose camera for close-up medical and dental photography. Body style

similar to the Brownie Starflash. 1⅝x1⅝" exp. on 127 film. Full kit with flash shield, 2 close-up lenses, original box: $30-45. Camera only: $10-20.

STEREO KODAK CAMERAS *See also Brownie Stereo and Hawk-Eye Stereo in this Eastman section.*

Stereo Kodak Model 1 Camera - 1917-1925. Folding camera for 3⅛x3³⁄₁₆" pairs on No. 101 rollfilm. Kodak Anast. f7.7/5¼" lens. Earliest version has Stereo Automatic shutter, later with Stereo Ball Bearing shutter. EUR: $275-400. USA: $175-275.

No. 2 Stereo Kodak Camera - 1901-05. Kodak's only stereo box camera. 3½x6" stereo exposures on No. 101 rollfilm. Rapid Rectilinear f14/125mm lens. $300-500.

Kodak Stereo Camera (35mm) - 1954-1959. For pairs of 24x24mm exposures on standard 35mm cartridge film. Kodak

Anaston f3.5/35mm lenses. Kodak Flash 200 shutter 25-200. Common and easy to find for $90-125 in USA, or about 30% higher in Europe.

Kodak Stereo Viewers:
Model I - Single lenses. $30-40.
Model II - Doublet lenses. AC/DC model: $75-85. DC only: $60-70.

STERLING II - c1955-60. Folding camera made by Kodak Ltd. in London. Anaston f4.5/105mm lens in Pronto 25-200 shutter. $10-20. *Illustrated top of next column.*

Kodak Sterling II Camera

SUPER KODAK SIX-20 - 1938-44. First camera with coupled electric-eye for automatic exposure setting. 2¼x3¼" exposures on 620 film. Kodak Anastigmat Special f3.5 lens. Built-in 8 speed shutter. $800-1200.

**KODAK TELE-EKTRA 1 & 2 CAMERAS
KODAK TELE-INSTAMATIC CAMERAS
TRIMLITE INSTAMATIC CAMERAS** - Late 1970's cameras for 13x17mm exposures on 110 cartridge film. Similar to the Pocket Instamatic Cameras. Too new to establish a "collectible" value. Very common. $1-5.

TOURIST CAMERAS

KODAK SUPREMA CAMERA - 1938-39. Made by Kodak AG, Stuttgart. 2¼x2¼" exp. on 620 rollfilm. Schneider Xenar f3.5/80mm in Compur Rapid 1-400. Once considered rare, but quite a few have surfaced since the price jumped to $300-400.

Kodak Tourist Camera - 1948-51. Folding camera for 2¼x3¼" on 620 film. With Kodak Anastar f4.5 in Synchro-Rapid 800 shutter: $40-60. With Kodak Anaston f4.5, f6.3, f8.8 or Kodet f12.5 lenses: $12-20.

Kodak Tourist II Camera - 1951-58. With Kodak Anastar f4.5 in Synchro-Rapid 800 shutter: $30-50. Low priced models: $8-15.

"Vanity Kodak Model B" on shutter face. $350-400.

VEST POCKET KODAK CAMERAS - *Folding cameras for 4.5x6cm exposures on 127 rollfilm. Early versions have trellis struts, later models with folding bed.*

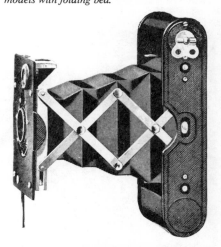

VANITY KODAK CAMERA - 1928-33. A Vest Pocket Kodak Series III Camera in color: blue, brown, green, grey, and red, with matching colored bellows. 4.5x6cm exposures on 127 rollfilm. Camera only: $50-80. With matching satin-lined case: $100-175. Less common in Europe where they bring 50-60% more. *The original colored bellows were fragile and many were replaced with more durable black bellows, which reduce the collector value of the camera by 30-50%.*

VANITY KODAK ENSEMBLE - 1928-29. A Vest Pocket Kodak Model B Camera in color: beige, green and grey. With lipstick, compact, mirror, and change pocket.

Vest Pocket Kodak Camera - 1912-14. Trellis struts. No bed. Meniscus Achromatic lens is most common. f6.9 is uncommon, but the least common is Kodak Anastigmat f8 lens introduced in the Fall of 1913 with the Gift Case. Kodak Ball Bearing shutter. EUR: $50-100. USA: $30-45.

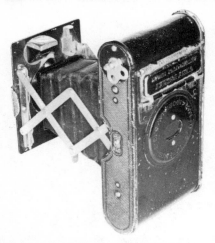

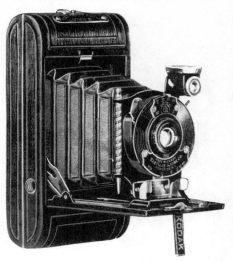

Vest Pocket Autographic Kodak Camera - 1915-26. Trellis struts. No bed. Similar to the Vest Pocket Kodak Camera, but with the Autographic feature. Meniscus Achromatic, Rapid Rectilinear or Kodak Anastigmat f7.7 fixed focus lens. Kodak Ball Bearing shutter. Common. $20-30. *About 50% higher in Europe.*

Vest Pocket Autographic Kodak Special Camera - 1915-26. Like the regular model, but with Persian morocco covering and various focusing and fixed focus lenses. $25-40.

Vest Pocket Kodak Series III Camera - 1926-33. Folding bed camera with autographic feature. Diomatic or Kodex shutter. f6.3 or f5.6 Kodak Anastigmat lens, or f7.9 Kodar. $20-35. *Colored models: see Vanity Kodak Camera, above.*

Vest Pocket Kodak Special Camera (early type) - 1912-14. Trellis struts. No bed. Like the V.P.K., but with Zeiss Kodak Anastigmat f6.9 lens. $40-60.

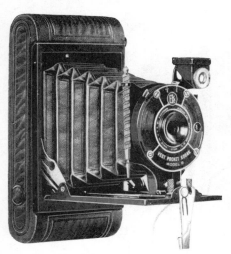

Vest Pocket Kodak Model B Camera - 1925-34. Folding bed camera (with autographic feature until about 1930). Rotary V.P. shutter. $20-40.

Vest Pocket Kodak Special Camera (later type) - 1926-35. Folding bed camera with autographic feature. Same as the Series III, but better lens: f5.6 or f4.5 Kodak Anastigmat. $40-60.

Six-16 - 1940-48. 2½x4¼", 616 film. $10-15.

VIEW CAMERAS - *Because of the many uses of view cameras, there are really no standard lens/shutter combinations, and because they are as much a part of the general used camera market as they are "collectible", they are listed here as good second-hand cameras. A modern usable lens and shutter has more value than the camera body itself. Prices given here are for cameras in Very Good condition, no lens.*
5x7" - $80-150.
6½x8½" - $50-100.
8x10" - Have increased in value in recent years. The very common model 2D is inexpensive when compared with current model 8x10 cameras, and for many purposes will perform as well. $175-200.

VIGILANT CAMERAS - *Folding rollfilm cameras with folding optical finders and body release. Lenses available were Kodak Anastigmat f8.8, f6.3, f4.5, and Kodak Anastigmat Special f4.5 lens.*
Six-16 - 1939-48. 2½x4¼", 616 film. $15-25.

Six-20 - 1939-49. 2¼x3¼", 620 film. $12-20.

VIGILANT JUNIOR CAMERAS - *Folding bed rollfilm cameras with non-optical folding frame finder. No body release. Kodet or Bimat lens.*

Six-20 - 1940-49. 2¼x3¼", 620 film. $10-15.

VOLLENDA CAMERAS - *Mfd by Kodak A.G, formerly Nagel-Werk, in Stuttgart, Germany. See also NAGEL-WERK for earlier models.*

- 3x4cm size - 1932-37. Folding bed camera with self-erecting strut-supported lensboard. Radionar f3.5 or f4.5. $35-60.
- 620 - Two different cameras: vertical style for 6x9cm, 1934-39; and horizontal style for 6x6cm, 1940-41. $18-33.

Vollenda Junior 616 - 1934-37. Vertical style. 6.5x11cm. $20-35.
Vollenda Junior 620 - 1933-37. Vertical style. 6x9cm. $20-35.

KODAK WINNER POCKET CAMERA - 1979-. Premium version of the Trimlite Instamatic 18 Camera. 13x17mm exp. on 110 cartridge film. $5-10. *Illus. on next page.*

Kodak Winner Pocket Camera

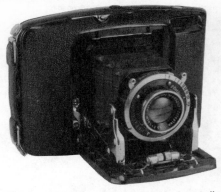

WINNER CAMERA, 1988 OLYMPICS - c1988. Red plastic pocket 110 camera with special emblem above finder: "Kodak, Official Sponsor of the 1988 Olympic Games". $5-10.

Ebner, 4.5x6cm - c1934-35. Horizontally styled version of the streamlined brown bakelite camera. Meyer Görlitz Trioplan f4.5/7.5cm, Compur T,B, 1-300. Front-element focus. Unusual parallelogram folding frame finder. $125-175.

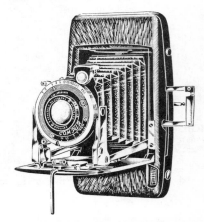

WORLD'S FAIR FLASH CAMERA - 1964-65. Sold only at the 1964 New York World's Fair. 1⅝x1⅝". (The original box, shaped like the pentagonal Kodak pavillion, doubles the value of this camera.) Camera only: $8-12.

ZENITH KODAK CAMERAS - 1898-99. Rare box cameras made in two sizes: No. 3 for 3¼x4¼" and No. 4 for 4x5" plates. Except for the name, they are identical to the Eureka cameras of the same period. They accept standard plate-holders through a side-opening door, and allow room for storage of extra holders. Made in England. Not found often. $100-150.

Ebner, 6x9cm - c1934-35. Folding camera for 8 exp. on 120 film. Streamlined bakelite body. Tessar f4.5/105mm, Radionar f4.5, or Xenar f4.5 lens. Rim-set Compur 1-250. Very similar to Pontiac, Gallus, and Nagel Regent cameras of the same age. $100-150

ECLAIR - c1900. 13x18cm wooden field camera, brass trim, tapered green bellows with black corners. Euryscop Extra Rapide Series III brass barrel lens. $125-175.

ECLIPSE 120 - Metal box camera for 2¼x2¼" on 120 rollfilm. Sync. $5-10.

EDBAR INTERNATIONAL CORP. (Peekskill, NY)
V.P. Twin - c1939. Small plastic novelty camera for 3x4cm on 127 film. Made in

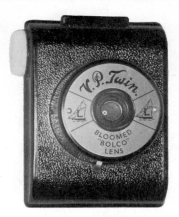

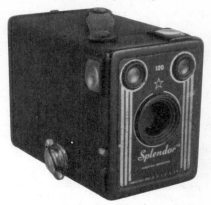

England for Edbar. Most common in black, but also available in green, red, and walnut. Some have metal faceplate, others are all plastic. Colors: $5-15. Black: $5-10.

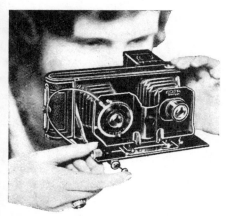

EDER PATENT CAMERA - c1933. Unusual German horizontal twin-lens (non-reflex) camera for plates or rollfilm in sizes 4.5x6cm, 6x6cm, and 6x9cm. Resembles a folding-bed stereo camera, but one lens makes the exposure while the other is simply a viewing lens. Tessar or Xenar f4.5 taking lens, Edar Anastigmat f4.5 viewing lens. Compur shutter to 300. Rare. One mint example with case sold at a German auction in 10/88 for $2700.

EFBE - "FB" for F. Brinkert. Experimental subminiature taking 6 exposures on a 47mm film disc. Enna f2.8/20mm lens, 25-100,B shutter. The lens is the same as the Goldeck 16, possibly from surplus stock. The bodies are handmade, machined from aluminum. These have sold for about $100 in Germany and double that in the USA.

Splendor 120 - Metal 6x9cm box camera with black crinkle finish. $15-25.

EHIRA K.S.K. (Ehira Camera Works, Japan)
Astoria Super-6 IIIB - c1950. 6x6cm on 120 rollfilm. Super Ikonta B copy. Lausar f3.5/85. Shutter 1-400,B. CRF. $150-175.

Ehira-Six - c1948-55. Copy of the Zeiss Super Ikonta B, complete with rotating wedge rangefinder. Tomioka f3.5/85mm lens in Ehira Rapid B,1-400. $75-125.

Weha Chrome Six (also Ehira Chrome Six) - c1937. A modified version of the Ehira Six design, using a telescoping tube front rather than the bed and bellows design. It retains the Ikonta-type rangefinder. $150-200.

Weha Light - Double extension folding plate camera, 6x9cm. f4.5/105mm. $30-50.

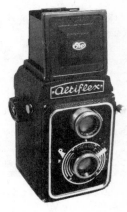

Eho-Altissa Altiflex

EHO-ALTISSA (Dresden) *Founded by Emil Hofert as Eho Kamerafabrik (c1933?). The first Altiflex cameras were introduced c1937, named for Berthold Altmann. The company name changed to Amca-Camera-Werk in 1940, and after the war became VEB Altissa-Camera-Werk.*
Altiflex - c1937-49. 6x6cm TLR for 120 films. f4.5/75mm Ludwig Victar, f4.5 or 3.5 Rodenstock Trinar, or f2.8 Laack Pololyt lenses. Prontor or Compur shutter. $30-45. *Illustrated bottom of previous page.*

Altiscop - c1937-42. Stereo camera for six pairs of 6x6cm exposures on 120 rollfilm. Ludwig Victar f4.5/75mm lenses. Vario-type shutter 25,50,100,B,T. Original price in 1942: $60. Current value: $75-95.

Altissa - c1938. Pseudo-TLR box camera, 12 exposures on 120 film. The finder on this model is like many of the cheap TLR cameras - just an oversized brilliant finder not coupled to focusing mechanism. Hinged viewing hood. Rodenstock Periscop f6. Simple shutter. Black hammertone finish. $15-25.

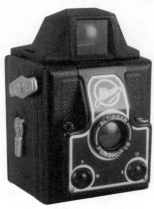

Shroud for eye-level optical finder is shaped like a pentaprism housing, which lends a bit of class to an otherwise ordinary camera. Although not seen often in USA, these are quite common in Germany. $9-15.

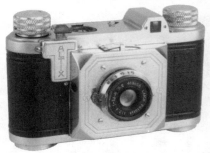

Altix (pre-war) - c1939. Scale-focus 35mm. Shutter is enclosed behind square chromed front housing with beveled corners. "ALTIX" on T-shaped cover for shutter linkage. Takes 24x24mm frames. $25-45.

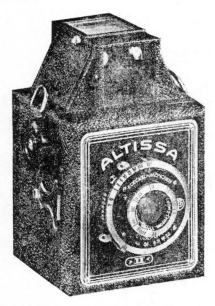

Altissa II - c1938. Similar to the Altissa described above, but with unusual view-finder which can be changed from eye-level to waist-level viewing. Trinar Anastigmat f3.5/75mm in Compur 1-30. Originally sold for $25 but closed out in 1939 by Central Camera Co. for $14.75. Uncommon. $35-50.

Altissa (prism-shaped top) - c1950's. Made by VEB Altissa-Camera-Werk. Basic metal box camera with leatherette covering.

Altix, I,II,IV - c1955. Low-priced 35mm

Eiko Can Cameras

Super Altissa - c1938. Leather-covered box camera for 6x6cm on rollfilm. Victar f4.5/75mm; 1/25-100 shutter. Rare. $50-75.

EIKO CO. LTD (Taiwan)
Can Cameras - c1977-83. Modeled after the original 250ml Coke Can Camera from Japan, these cameras are all shaped like a 250ml beverage can, but with different product labels. While we can't document the origin of each label, we assume that most are from Eiko: Budweiser, Coca-Cola, Mickey Mouse, Pepsi-Cola, 7-up, Snoopy, Panda, Formel-I, Aerogard, Gent Coffee. $15-35. *Illustrated top of previous column.*

camera. Body release, viewfinder, advance & rewind knobs all above the top plate. Meritar or Trioplan f2.9 lens. Synchronized. (Original price $20). $15-30.

Altix-N - c1959. Improved version of Altix, with top housing incorporating viewfinder. Interchangeable Trioplan f2.9/50mm lens. Lever film advance. Accessory shoe. $15-30.

Altix NB - c1960. Similar to N, but with built-in meter. $20-25.

Eho box, 3x4cm - c1932. For 16 exposures on 127 film. (Nicknamed "Baby Box" in this small size, although we have no evidence that it was ever called by that name except by collectors.) f11/50mm Duplar lens. Simple shutter, B & I. Metal body. Rarest of the Eho boxes. $50-75.

Eho box, 4.5x6cm - For 16 exposures on 120 film. $25-40.

Eho box, 6x9cm - c1930's. Rodenstock Periscop or Duplar f11 lens. Simple box shutter. With green leather covering: $35-50. Black: $15-20.

Eho Stereo Box camera - c1930's. For 5 stereo pairs 6x13cm or 10 single 6x6cm exp. on 120. B,I shutter. Duplar f11/80mm lens. $70-95.

Juwel - Box camera for 6x6cm on 120. Eye-level finder in roof-shaped housing on top of body. Appears to be simply a name variation of the eye-level Altissa "Brillant" camera. $20-30.

Mantel-Box 2 - c1930's. Small metal box camera with leatherette covering. Takes 4.5x6cm exposures. Duplar f11 lens. "Mantel-Box 2" on front under lens. Rare. $75-100.

Popular - c1987. Round camera styled like a car tire and wheel. Taiwanese copy of the Potenza camera from Japan. Some versions say "EIKO POPULAR", others only "POPULAR". $15-30.

E.L.C. (Paris)
l'As - c1912. Folding 4.5x6cm plate camera with cross-swinging struts. Rotary disk stops in front of simple shutter. The name means "Ace". $150-200.

ELECTRONIC - Japanese subminiature of the Hit type. $10-15.

ELGIN LABORATORIES
Elgin - Unusual eye-level camera for 828

Empire

film. Stainless steel body with leatherette covering. $35-45.

Elgin Miniature - Plastic minicam for 3x4cm on 127 film. $5-10.

ELITE - Japanese novelty subminiature of Hit type. $8-12.

ELLISON KAMRA COMPANY (Los Angeles, CA) *Michael Ellison and Edward S. McAuliffe filed for a patent in 1926 for a novel two-blade shutter, which was used in the Ellison Kamra and later in the similar, but smaller and more common QRS Kamra.*
Ellison Kamra - c1928. A long brick-shaped black bakelite camera for bulk loads of 35mm film in special cassettes. Similar in styling to the later QRS Kamra, but with a hinged bakelite door which covers the simple fixed-focus lens. The film crank, which also serves as a shutter release, is usually not broken on the Ellison model although rarely found intact on the later QRS model. $100-125.

ELMO CO. LTD. *Originally founded by Mr. H. Sakaki in 1921 as Sakaki Shokai Co. Although more widely recognized for their movie equipment, they made several still cameras as well.*
Elmoflex - Twin lens reflex cameras, made in several variations from the first model of 1938 through the last one introduced in 1955. f3.5/75mm lens. 6x6cm on 120 rollfilm. $40-60.

ELOP KAMERAWERK (Glücksburg & Flensburg, Germany) *Brief history taken from names used in advertising:*
1948: ELOP = Elektro-Optik GmbH, Glücksburg.
1950: ELOP = Vereinigte Electro-Optische Werke, Flensburg-Mürwik.
1952: UCA = Uca Werkstätten für Feinmechanik und Optik GmbH, Flensburg.
ELOP made Elca, Elca II, & Uniflex cameras.

UCA made the Ucaflex (=Uniflex) and Ucanett (=Elca with some changes).
Elca, Elca II - c1948-51. 35mm camera with Elocar f4.5/35mm lens. Elca has single speed shutter, while Elca II has Prontor S or Vario. Takes 50 exp. 24x24mm on standard 35mm cassette. Black painted and nickeled metal body. Model I: $60-80. Model II, less common: $75-100.

EMERALD - Box camera. $10-15.

EMMERLING & RICHTER (Berlin)
Field camera - 13x18cm plates. Wooden body, nickel trim. Without lens: $75-125.

EMPIRE - Japanese "yen" box camera for "No Need Darkroom" film in paper holders. See complete explanation under "YEN-KAME". $10-20. *Illus. top of previous column.*

EMPIRE 120 - All metal box camera for 6x9cm. $4-8.

EMPIRE SCOUT - Inexpensive eye-level camera from Hong Kong for 6x6cm on 120 film. Simple focusing lens; three stops. B & I shutter. $1-5.

EMSON - Japanese novelty camera of Hit type. 14x14mm exposures on 16mm paper backed rollfilm. $10-15.

ENCORE CAMERA CO. (Hollywood, CA)
Encore De Luxe Camera - c1940's-1950's. An inexpensive cardboard novelty camera. Factory loaded. User returns complete camera & film to factory with $1.00 for processing. (Vaguely reminiscent of the "You push the button..." idea which made Eastman rich and famous, but the audience didn't want an Encore.) $15-20. *Illustrated on next page.*

Hollywood Camera - Another novelty mail-in camera, sometimes used as an advertising premium. $15-25.

Encore De Luxe Camera

L'Epatant

ENJALBERT (E. Enjalbert, Paris)

Colis Postal - c1886. An unusual detective camera consisting of the Alpinist folding camera tied with a cord. The package even included a mailing label to complete the disguise. Extremely rare. No known sales. Estimated value: $5000+.

Photo Revolver de Poche - c1883. Highly unusual camera which very closely resembles a pistol. The cylinder contained a magazine mechanism for 10 plates, each 16x16mm. This camera is extremely rare and highly desirable. It is certainly a "world class" collectible, and price would be negotiable. Estimate: $10,000-20,000.

Touriste - c1882. Bed & bellows style camera with unusual magazine back. Eight plates are contained in a light-proof magazine, each supported in a wooden frame. Eight corresponding slots in the rear of the camera accept the ground glass accessory to focus for the chosen plate

position. With the focusing glass removed, the magazine is inserted fully into the back, and the selected plate frame is secured to the opposite side of the back with a small screw. When the magazine is withdrawn again from the center position, the chosen plate remains in the pre-focused position. An ingenious but cumbersome system. Fine wood body, brass trim and handle, tapered red bellows. Steinheil Gruppen-Antiplanet 48, spring shutter. Rare. One example with 6 of 8 plates failed to reach its reserve of $3850 at a German auction in 10/88.

ENSIGN LTD. *Successor company to Houghton-Butcher. For sake of continuity, we have listed all Ensign cameras under the Houghton heading.*

ENTERPRISE CAMERA & OPTICAL CO.
Little Wonder - c1900. Not related to the 1930's metal Little Wonder camera. Miniature box camera for 2x2" plates. Made of two cardboard boxes sliding into one another. Almost identical to the Yale and Zar cameras. $60-90.

Little Wonder (Compliments the Boston) - ca. late 1890's. A rare variation of the Little Wonder camera, this special promotional edition was gold-stamped on the back: "Compliments The Boston, St. Paul Minn." Takes 5x5cm plates, and came originally with chemistry and paper for making prints. $75-125.

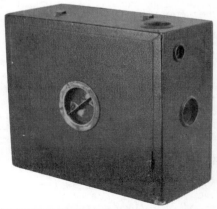

ENTERPRISE REPEATING CAMERA - c1900. A very unusual box camera which employs a rotating drum to hold and

position five glass plates, 6.5cm square. There were several other cameras which used the same system, but apparently none ever gained much support, since any camera using this method for changing plates is quite rare. Similar in function, though not in appearance are the Photo-Quint, the Mephisto and a rare Ernemann Bob, all from about 1899-1900. $175-225.

L'EPATANT - c1905. Small cardboard box camera for 4.5cm square plates, individually loaded in darkroom. Made in France. $60-80. *Illustrated on previous page.*

E.R.A.C. SELLING CO. LTD. (London)

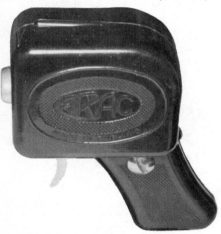

Erac Mercury I Pistol Camera - c1938. An unusual disguised subminiature. The outer bakelite shell is shaped like a pistol, complete with trigger. Inside is a small cast metal "Merlin" camera that is coupled to the trigger, which takes the picture and winds the film. Meniscus f16 lens in single speed shutter. While the camera only bears the ERAC name, the original box calls it the "ERAC MERCURY I SUPERCAMERA". $150-250.

ERKO FOTOWERKE (Freital, Germany)
Erko - 9x12cm folding plate camera. Wood body covered with black leather. Erko Spezial Anastigmat f8 or Erko Fixar f6.8/135mm lens. Ibso shutter, T, B, 1-150. $50-75.

ERNEMANN (Heinrich Ernemann Werke Aktien Gesellschaft, Dresden, Germany) *Founded 1889 by Heinrich Ernemann. Became Heinrich Ernemann AG in 1898. Purchased the Herbst & Firl Co. of Görlitz in 1900. Merged with Contessa-Nettel, Goerz, and Ica to form Zeiss-Ikon in 1926. Some Ernemann cameras continued under the Zeiss-Ikon name.*

Bob Cameras (c1910-1920's) *Early English-language advertisements called these cameras "Ernemann's Roll Film Cameras" before the name "Bob" was used as the camera name. Originally, "Bob" was the name of a shutter. All are folding bed style rollfilm cameras with rounded body ends. Frequently the model name is on the bed or near the handle. The model number indicates the level of specification, not size. Most were available in various sizes. Not all sizes are necessarily listed here for each model.*

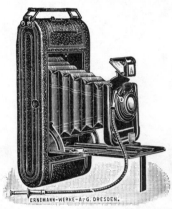

Bob 00 - c1924-25. For 6x9cm on 120 film, or single metal plateholders. Aplanat or Anastigmat f6.8 lens. $20-35.

Bob 0 - c1913. Folding cameras for plates or rollfilm. Ernemann Rapid Detective or Detective Aplanat lens in Auto shutter. Small 4.5x6cm size: $75-110. 9x12cm size: $30-45.

Bob I - c1913. Folding rollfilm or plate camera. 4.5x6cm, 9x12cm (¼-plate) or postcard sizes. Single extension, rack & pinion focus. Aplanat f6.8 or Double Anastigmat f6 lens. Bob, Automatic, or Auto Sector shutters. One with brown

leather covering and red bellows sold for $200. Small 4.5x6cm size: $75-125. 9x12cm size: $30-45.

Bob IV

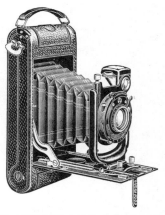

Bob II - c1913. 10x15cm, 8x10.5cm or postcard size. Very similar to the Bob I, but with double extension bellows, focus scales for complete lens or rear element only. 10x15cm: $60-80. Others: $45-65.

Bob III (horizontal style) - c1906. Early, horizontal folding bed camera for 10x15cm on rollfilm, or 9x12cm plates. Leather covered wood body. Wine red double extension bellows. Detective Aplanat f6.8 or Roja Busch Aplanat f8 in Bob shutter. Two variations of this camera sold at auction in 1985-86 for $185-200.

Bob III (vertical style) - c1926. 6x9cm folding bed rollfilm camera. Aluminum body. Rigid U-shaped front. Chronos shutter. $20-30.

Bob IV - c1926. Similar to Bob III, but with radial focusing and rising front. $25-35. *Illustrated top of next column.*

Bob V - c1924-26. 4x6.5cm, 6x6cm, 6x9cm, 6.5x11cm, 7.25x12.5cm, and 8x10.5cm sizes. Radial lever focusing. 4x6.5cm: $75-125. Larger sizes: $30-45.

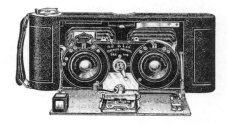

Bob V (stereo) - c1911. Folding bed stereo camera for 45x107mm on No. 0 rollfilm. $175-250.

Bob X - 45x107mm stereo version. $175-250.

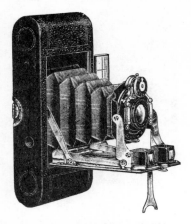

Erni (left) and Ernette (right)

Bob XV - c1911-14. Folding rollfilm cameras in 4x6.5cm, 6x9cm, and 8x10.5cm sizes. The larger model also takes 9x12cm plates. Earlier models had twin reflex finders on bed, later with single folding reflex finder attached to lensboard and bed. $30-45.

Bob XV Stereo - c1913-14. Stereo model for 45x107mm on rollfilm. Folding bed style with self-erecting front. $175-250.

Combined ¼-plate, Postcard, Stereo, Plate & Rollfilm Camera - c1907. That is actually the name it was called in the British Journal Almanac advertisment for 1907. Horizontally styled folding bed camera for 3¼x4¼" rollfilm or 3½x5½" plates. Probably a predecessor of the Stereo Bob. Shifting front allows use of both lenses for stereo or one lens for single photos. Triple extension with rack focusing. $225-300.

Double Shutter Camera - see Heag VI Zwei-Verschluss-Camera.

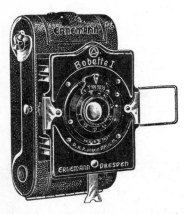

Bobette I - c1925. Folding camera for 22x33mm format on 35mm paper-backed rollfilm. This is a strut folding type without bed. Ernoplast f4.5 lens. $125-175.

Bobette II - Similar to Bobette I, but with folding bed construction and radial lever focusing. Ernoplast f4.5, Ernon f3.5, or Ernostar f2 lens in Chronos shutter. With Ernostar (The first miniature camera with f2 lens): $300-500. With Ernoplast or Ernon: $100-150.

Ermanox - 4.5x6cm rigid-bodied model, c1924-25. (After the 1926 merger, the Ermanox continued as a Zeiss-Ikon model

with Zeiss-Ikon identification on the finder hood.) Originally introduced as the "Ernox". Metal body covered with black leather. Focal plane shutter, 20-1000. Ernostar f2/100mm (rarer and earlier) or f1.8/85mm lens. $900-1800.

Ermanox (collapsible bellows model) - c1925-26. Strut-folding "klapp" camera.

6.5x9cm size - Ernostar f1.8 lens. $600-1000.
9x12cm size - Ernostar f1.8/165mm lens. FP shutter 1/15-1/1500. Rare. Only one confirmed sale in October 1984 at about $3000.

Ermanox Reflex - c1926. SLR for 4.5x6cm plates. Ernostar f1.8/105mm lens in helical focusing mount. $600-1000. (One passed at auction in late 1985 with high bid of $550 against a $1000 reserve.)

Ernette, Erni - c1924. Simple filmpack box cameras. Ernette also uses plates. Folding frame finder. Achromatic lens. T&I shutter. Rare in any size. 4.5x6cm: $175. 6.5x9cm or 9x12cm: $175. Stereo 45x107mm: $175-225. *Illustrated on previous page.*

Ernoflex Folding Reflex: *Originally called "Folding Reflex" and later "Ernoflex Folding Reflex" in English-language catalogs and ads. Called Klapp-Reflex in German. Five basic types: Original type, Model I (single extension), Model II (triple extension), Miniature Ernoflex, and Stereo Ernoflex. (The latter two are listed under "Miniature" and "Stereo".)*

(Ernoflex) Folding Reflex (original type) - c1914. Folding SLR with drop bed and rack focus. Made in 9x12cm/¼-plate size only. Single or double extension models. Ernemann f6.8 or Zeiss Tessar f4.5 lens. $400-550.

Ernoflex Folding Reflex Model I - c1924-26. Unlike the original version, this model has no bed, but scissor-struts to support the front, and helical focus mount for the lens. Single extension only. 4.5x6cm, 6.5x9cm, 3¼x4¼", or 9x12cm sizes. Ernotar f4.5, Ernon f3.5, or Zeiss Tessar f4.5. $200-325.

Ernoflex Folding Reflex Model II - c1924-26. Triple extension. An intermediate front is supported by trellis struts and moves to infinity position upon opening the camera. For additional extension, a front

Ernemann Film U

bed with a double extension rack extends beyond the intermediate front. This allows for extreme close-ups with the normal lens, or long focal length lenses may be used for telephoto work. Quarter plate or 9x12cm size. $300-425.

Film K - c1917-24. Leather covered wood box camera. Meniscus f12.5 in T&I shutter.
6x6cm size - $75-100.
6x9cm size - Most common size.$35-55.

trim, colored bellows. With contemporary lens: $350-550.

Heag *An acronym for Heinrich Ernemann Aktien Gesellschaft. Used mainly to identify a series of folding bed plate cameras. English-language advertising did not always use the name "Heag", but usually the model number was used.*

6.5x11cm and 7.25x12.5cm - $35-60.

Film U - c1925. Box camera for 6x9cm on rollfilm. More compact than the 6x9cm Film K, because it has a collapsing front. Folding frame finder. Doublet lens in automatic shutter. Rare. $50-75. *Illustrated top of next column.*

Folding Reflex: *see Ernoflex Folding Reflex.*

Globus - c1900. 13x18cm folding camera. Double extension bellows. Focal plane shutter. Polished wood body with brass

Heag 00

Heag 0 - c1918. 6.5x9cm and 9x12cm plate cameras. Single extension. $30-50.

Heag 00 - c1914. A cheap single-extension model in 6.5x9cm and ¼-plate sizes. T,B,I shutter. $30-45. *Illustrated previous page.*

extension, rack focusing. Ernemann Aplanat or Anastigmat f6.8. One recent auction sale at $650.

Heag I - c1914. Folding-bed camera in 6.5x9cm, ¼-plate, postcard, or ½-plate sizes. Single extension. Black imitation leathered body. Detective Aplanat f6.8. Ernemann Automat shutter. $25-40.

Heag I Stereo - c1904. Folding bed stereo camera for 9x12cm plates. Leather covered wood body. Red tapered double-extension bellows. Detective Aplanat f6.8 lenses. Ernemann Automat ½-100 sh. $225-275

Heag V - intro. 1924. A single extension camera like the Heag III, but with radial lever focus, micrometer rising front. Small 4.5x6cm: $125-175. Larger sizes: $35-50.

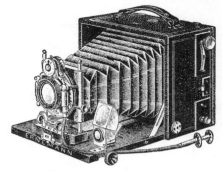

Heag II - c1911-26. Similar to Heag I, but with rack focusing, genuine rather than imitation leather. 6.5x9cm, ¼-plate, postcard, and ½-plate sizes. Model I (single extension) and Model II (double extension). Aplanat f6.8 lens. $40-50.

Heag III - c1926. All metal body. U-shaped front standard. Single extension. 6.5x9cm or 9x12cm sizes. $25-40.

Heag IV (stereo) - c1907. Folding bed camera for stereo photos on plates. Double

Heag VI (Zwei-Verschluss-Camera) - c1907. Leather covered folding bed plate camera in 3¼x4¼" or 3½x5½" size. Focal plane shutter to 2000. Inter-lens shutter T, B, 1-100. Double extension, rack focusing. English ads often call it "Double Shutter Camera" and German ads call it "Zwei-Verschluss-Camera" with neither mentioning the "Heag" name. Ernemann

catalogs use the Heag VI name and "Zwei-Verschluss-Camera" as a sub-heading. $150-250. (See "Tropical" for teak version of this camera).

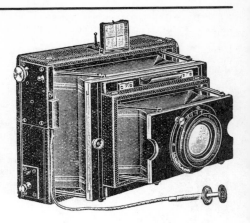

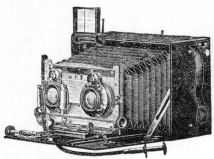

Heag VI Stereo (Zwei-Verschluss-Camera) - c1907. This is a stereo version of the "Double Shutter Camera Model VI", available in postcard or ½-plate sizes. Focal plane and front shutters. English-language advertising called it "Combined Postcard and Stereo, Model VI". $300-400.

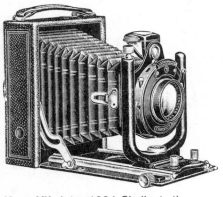

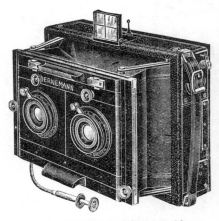

Heag IX Universal Camera with single and stereo lensboards

Heag VII - intro. 1924. Similar to the Heag V, but also includes double extension with rack focusing. 6.5x9cm, or 9x12cm sizes. Vilar f6.8, Ernotar f4.5, or Tessar f4.5. Chronos shutter. $35-50.

Heag IX Universal Camera - c1904-07. An interesting design for a dual-purpose strut camera. The basic design is for a stereo lensboard. To use for single photos, a separate lensboard with its own bellows & struts allows the extra extension needed for the longer focus of the single lens. In English-language ads, this was called "Combined Stereo and Half-Plate Focal-Plane Camera". With stereo or extensible lensboard: $150-225. With both lensboards: $300-400. *Note: Ernemann made similar extension fronts for use on standard cameras for telephoto or closeup work.*

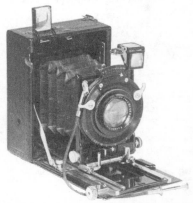

Heag XI - c1913-26. Leathered wood body and aluminum bed. DEB. R&P focus. Rise,

fall, cross front. Swing back. Focusing scales for complete lens or rear element. Anastigmat f6.8 or f6, Aplanat f6.8. ½-plate or postcard sizes. $35-60. (See "Tropical Heag XI" for teakwood model).

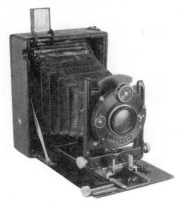

Heag XII - c1906-13. ¼-plate or ½-plate sizes. Compact folding type. Red bellows. Bob shutter with aluminum housing. $35-50.

Heag XII Model III (stereo) - c1925. Folding bed stereo/panorama camera for 9x18cm plates. Double extension, rack focusing. Micrometer rise, fall, cross front. $175-225.

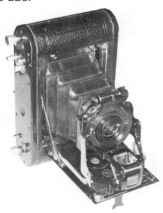

Heag XIV - c1910. *Folding two-shutter cameras: pneumatic front shutter; FP 50-2500.*
4.5x6 cm. - Ernemann Doppel Anastigmat f6/80mm. Front shutter 1-100. $100-150.
9x12cm - Ernon f6.8/120mm. $75-125.

Heag XV, 4.5x6cm - c1911-14. Vertical format self-erecting folding plate camera, 4.5x6cm "vest pocket" size. Early variations have two rigid reflex finders on the front of the bed. Later models have a single folding finder. Both of these types exist in focusing

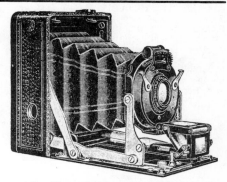

and fixed focus versions. Ernemann Double Anastigmat f6.8/80mm in Automat shutter 1-100. Despite one auction sale at $200, normal range is $75-100.

Heag XV, 6.5x9cm - c1912. Rarer in this size than 4.5x6cm, but also in less demand. Like the 4.5x6cm model with reversible folding finder. Radial lever focusing. Ernemann Detective Aplanat #00 f6.8 lens. Automat shutter 1-100. $60-70.

Heag XV, 6x13cm - c1912-14. Stereo version of 6.5x9cm Heag XV. $200-250.

Heag XVI - c1913. Folding camera with detachable rollfilm back for use with 9x12cm plates. Ernemann Detectiv Aplanat f6.8. $100-150.

Heag (tropical model) - listed with "Tropical" cameras, later in this heading.

"Klapp" cameras - *The word "klapp" indicates a folding camera, and came to be used primarily for folding cameras of the strut type. In the case of Ernemann, it was used for their strut-folding plate cameras with focal plane shutters. In English language advertising, these were usually called "Focal Plane Cameras". These were also available in tropical models.*

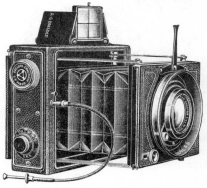

Klapp - c1905-26. Strut-folding focal plane

cameras in 6.5x9cm, 3¼x4¼" or 9x12cm, 3½x5½" or 10x15cm, 4x5", and 12x16.5cm. Early models had single-pleat bellows, unprotected Newton VF, more complex shutter controls on two metal side plates. Later models had normal pleated bellows, Newton VF with clamshell cover, two round shutter knobs on side. Ernostar f2.7, Ernotar f4.5, Tessar f4.5, or Ernon f3.5. $100-200.

Ernemann Reflex

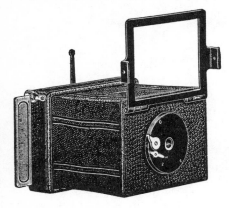

Liliput - c1914-26. Economy model 4.5x6cm or 6.5x9cm folding bellows vest pocket camera. Fixed-focus achromatic lens and T, I shutter. Folding frame finder. 4.5x6cm: $65-110. 6.5x9cm: $45-65.

Liliput Stereo - c1919-25. 45x107mm stereo version of the compact folding Liliput. Meniscus lens, Guillotine shutter. $125-200.

Miniature Ernoflex 4.5x6cm (formerly **"Folding Reflex"**) or **Miniature Klapp-Reflex -** c1925. Strut-type folding reflex for 4.5x6cm plates. Ernon f3.5/75 or Tessar f4.5/80mm lens. Focal plane shutter to 1000. One of the smallest folding SLR cameras ever made. $600-1000.

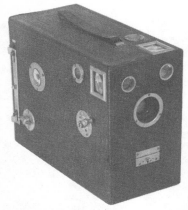

Magazine Box - Drop-plate box camera for twelve 3¼x4¼" plates. $150-175.

Mignon-Kamera - c1912-19. 4.5x6cm compact folding camera, cross-swing struts. Usually with Detectiv Aplanat f6.8. Z,M shutter. $50-125.

Miniature Klapp (4.5x6cm) - c1925. Body like the later "Klapp" style above, but also

with front bed/door. Ernostar f2.7/75mm, Tessar f3.5, Ernotar f4.5, or Ernon f3.5. Focal plane shutter to 1000. $200-300.

Reflex - c1909. Non-folding SLR with tall focus hood and flap over lens. Reversing back. FP shutter to 1/2500, T. Removable lensboard with rise and fall. Double extension, rack & pinion focus. 6.5x9cm, 3¼x4¼", 4¼x6½" sizes. Ernemann f6.8 Double Anastigmat or Zeiss Tessar f4.5. $150-200. *Illustrated on previous page.*

Rolf I - c1924-25. Folding vest pocket camera for 127 film. Leatherette covered body. Rapid Rectilinear f12/75mm lens. T,B,I shutter. $30-40.

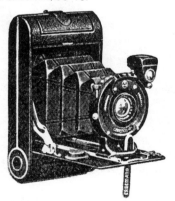

Rolf II - c1926. Similar to Rolf I, but with genuine leather covering. Ernemann Double Anastigmat f6.8 or Ernoplast f4.5 lens. Chronos precision shutter. $35-50.

Simplex Ernoflex - c1926. Simple box-form SLR. No bellows. Helical focusing lens mount. FP shutter with 16 speeds 1/20-1000 sec. Cover for folding hood has front

hinge on some models and rear hinge on others. 4.5x6cm size: $400-600. 6.5x9cm or 9x12cm size: $175-250.

Stereo Bob - see Bob above.

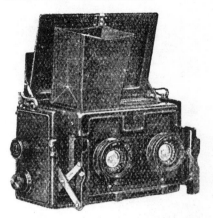

Stereo Ernoflex - c1926. 45x107mm stereo version of Miniature Ernoflex. Scissor-struts support lensboard. Full width top door, but focus hood on one side only. FP shutter 1/10-1000. Ernotar f4.5, Ernon f3.5, or Tessar f4.5 lenses. $900-1200.

Stereo Reflex - c1913. Rigid body jumelle form stereo camera with reflex viewing. Full width viewing hood. FP to 2500, T. Ernemann Anastigmat f6 or f6.8, Zeiss Tessar f6.3 or f4.5, or Goerz Dagor f6.8 lenses. $300-500.

Stereo Simplex - c1920. Non-collapsing, "jumelle" style stereo camera, 45x107mm plates. This is not a reflex model, but has only a wire frame finder. Ernemann Doppel f11/60. Guillotine shutter, TBI. $100-175.

Stereo Simplex Ernoflex - c1926. Simple reflex stereo box camera. No bellows. Ground glass focus on both sides, but reflex focus on one side only. Ernon f3.5/75mm lenses in externally coupled helical mounts. FP shutter 25-1000. $600-800. *Illustrated top of next page.*

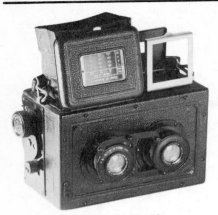

Stereo Simplex Ernoflex

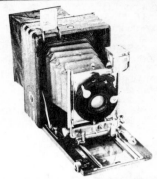

Tropical Heag XI - c1920-30. (Zeiss-Ikon after 1926.) Vertically styled 9x12cm folding-bed camera. (NOT focal plane type.) Teak body, brown double extension bellows, brass fittings. Ernemann Vilar f6.8/135mm, Ernar f6.8, Ernoplast f4.5, or Ernotar f4.5 lens in Chronos B shutter to 100 or Chronos C shutter 1-300. $550-800.

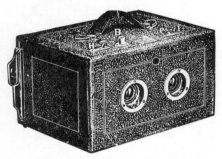

Stereoscop-Camera - c1901. Stereo box camera, 9x18cm stereo pairs. Fixed focus meniscus lenses. B&I shutter. $200-300.

Tropical cameras - *All tropical cameras, including Ernemann, are relatively uncommon. Prices increased rapidly a few years ago, and are now holding steady. There is quite a difference in price between the focal plane shutter models and inter-lens shutter types.*

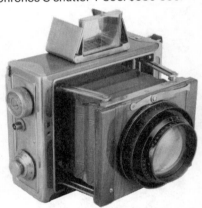

Tropical Klapp - Strut-folding focal plane camera. Same features as normal "Klapp" camera, but polished teak body with lacquered brass trim. $800-1100.

Unette - c1924-29. Miniature box camera for 22x33mm exposures on rollfilm. Overall size: 3x3½x2¼". Two speed (T&I) shutter. f12.5 meniscus lens. Revolving stops. $100-150.

Universal - c1900. 13x18cm double extension folding plate camera. Polished wood body, brass trim. Goerz Double Anastigmat f4.6 brass-barreled lens. Focal plane shutter. $350-550.

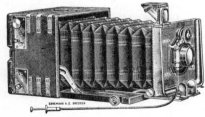

Tropical Heag VI (Zwei-Verschluss-Camera) - c1914. Horizontally styled ¼-plate folding bed camera. Teak with brass fittings. Triple extension, removable lensboard. FP shutter to 1/2500. Front shutter T,B,½-100. Ernemann Anastigmat f6 or Zeiss Tessar. $800-1000.

Velo Klapp - c1901-14. A focal plane camera originally introduced c1901 with top speed of 1/1000; by 1904 speeds to 1/2000; and by 1914 to 1/2500. Aplanat

Eta Etareta

f6.8 lens. The Velo Klapp continued for a time as a lower-priced alternative after the introduction of the more expensive Ernemann Klapp. $100-150.

Zwei-Verschluss-Camera - see Heag VI.

ESPIONAGE CAMERA (FRENCH) - WWII vintage subminiature for 45 exp. 8x11mm. Metal FP shutter to 250. An uncommon camera, usually found without the lens: $400-450. With lens (rare): $600-700.

ESSEM - 5x7 folding camera. RR lens in B&L shutter. Mahogany interior, red bellows. $70-100.

ESSEX - Plastic minicam, styled like Falcon Minicam Jr., Metro-Cam, Regal Miniature, etc. $3-7.

ESTES INDUSTRIES (Penrose, Colorado)

Astrocam 110 - c1979. Small 110 camera designed to be launched via rocket to take aerial photos. Shoots one photo per flight.

The 1/500 second shutter is activated at ejection just prior to parachute deployment. With companion Delta II rocket in original box: $25-40.

ETA (Prague, Czechoslovakia)
Etareta - c1950-55. Non-rangefinder 35mm camera. Etar II f3.5/50mm in Etaxa 10-200,B,T. Collapsible front. $25-35. *Illustrated top of previous column.*

ETAH - British mahogany field camera for 4¼x6½" plates. Brass trim. $175-225.

ETTELSON CORP. (Chicago)

Mickey Mouse Camera - A black bakelite box camera with red trim. Has Mickey Mouse nameplates on the front, rear, and on the advance knob. This is an uncommon camera, especially if found in its original box. Complete with original box: $100-125. Camera only: $50-75.

EULITZ (Dr. Eulitz, Harzburg)

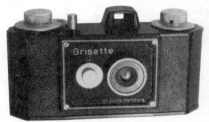

Grisette - c1955. Bakelite camera for 35mm film. 45mm achromat lens. Simple shutter. $40-65.

EUMIG (Austria)
Eumigetta (I) - Cast aluminum eye-level camera for 6x6cm on 120 rollfilm. Model 1 is not identified as Eumigetta or Model 1 on the body. Diamond-shaped Eumig nameplate on top. Square viewfinder above

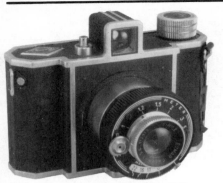

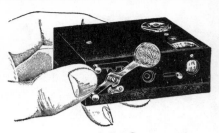

Expo Police Camera

top plate (not in streamlined housing as model 2). Eumar f5.6/80mm lens. $20-30.

EVES (Edward Eves Ltd., Leamington Spa, England)

Blockmaster One-Shot - c1954. Color separation camera utilising beam-splitting mirrors to make 3 filtered exposures on 4x5 plates. Schneider Xenar f4.5/210mm lens in Compound shutter. $750-925.

EXCO - simple box-type stereo camera, also useable for single exposures. Double anastigmat lenses. $100-125.

EXPO CAMERA CO. (New York)

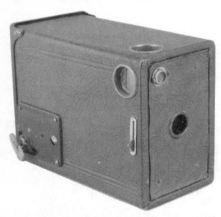

Easy-Load - c1926. Small box camera for 1⅝x2½" exposures on rollfilm in special cartridges, called Expo "Easy-Load" film. Meniscus lens, rotary sector shutter. Red, brown, or green: $50-80. Black: $35-55.

Police Camera - c1911-24. A tiny all-metal box camera for 12 exposures on special cassettes. Fixed focus achromatic lens, 2 apertures. Cloth focal plane shutter, T & I. $200-275. *Illustrated top of next column.*

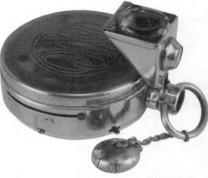

Watch Camera - Introduced c1905, produced for about 30 years. Disguised as a railroad pocket watch. Takes picture through the "winding stem", while the "winding knob" serves as a lens cap. Special cartridges. This is an interesting camera, but actually quite common since it was marketed for so long. Several variations exist. Black or blue enameled versions, rare: $550-700. Chrome camera only, complete with lens cap: $100-150. With reflex finder and original box: $150-205. Add $35 for cartridge.

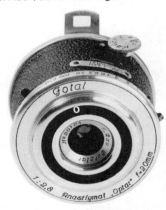

Fabrik Fotografische Fotal

FABRIK FOTOGRAFISCHE APPARATE (Lübeck, Germany)

Fotal - c1950. Round subminiature for 8x12mm exposures on Special-Rollfilm. Optar Anastigmat f2.8/20mm lens. Prontor II 1/250 shutter. One with brown leather sold at auction for only $425. With blue or green leather covering: $1000-1400. *Illustrated bottom of previous page.*

FAISSAT (J. Faissat, Limoges)

Field camera, 9x12cm - c1895-1900. Tailboard-style with single-extension by rack and pinion. Fine wood body with brass trim. Brass barrel lens for waterhouse stops. $135-170.

FALCON CAMERA CO. (Chicago) *The history of the Falcon Camera Company is somewhat unclear. The Falcon line was begun by the Utility Manufacturing Co. of New York about 1934. One source indicates that Utility, which also made Spartus cameras, was sold to the Spartus Corp. in 1940, the new firm taking its name from the Spartus cameras. (The Utility name continued to be used at least as late as 1942, however, on price lists for Falcon cameras.) While the ownership may have belonged to Spartus, the Falcon Camera Co. name was used in advertising in 1946, as was the Spencer Co. name. In fact, we have a camera with the Falcon Camera Co. name, but its instruction book bears the Spencer Co. name. Both of these companies operated out of a building at 711-715 W. Lake St. in Chicago, which is also the address of the Spartus Camera Co., Herold Mfg. Co., and Galter Products. If this is not confusing enough, we should add that the founder of the original Utility Manufacturing Co., Mr. Charles Fischberg, was later prominent in the Herbert-George, Birdseye, and Imperial companies. See also Utility Mfg. Co. for Falcon cameras.*

Falcon Miniature - c1947. Bakelite minicam for 3x4cm on 127 rollfilm. $5-10.

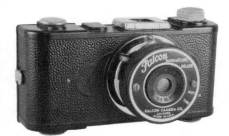

Falcon Miniature Deluxe - c1947. Brown marbelized bakelite minicam for 3x4cm on 127 film. Folding eye-level finder. $5-10.

Falcon Minicam Senior - Another 35mm style camera for 3x4cm on 127 film. Cast aluminum: $15-20. Bakelite: $5-10.

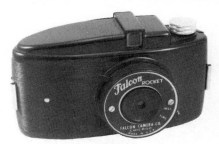

Falcon Rocket - Minicam for 3x4cm on 127 rollfilm. $5-10.

FALLOWFIELD (Jonathan Fallowfield Ltd., London)

Facile - c1890. Mahogany box detective magazine camera. A grooved box carries the fresh plates over a slot where they drop into a second grooved box behind the lens. A milled knob simultaneously moves the top box forward and the lower box backward so that each successive plate drops into the plane of focus in front of the previous one. An uncommon camera, which was designed to be concealed as a package wrapped in paper. Several of the early mahogany models have sold at Christie's: $350-600. Later black painted model: $250-450.

Miall Hand Camera - c1893. A very unusual and rare detective camera disguised as a gladstone bag. In addition to its unusual shape, it boasted the ability to be reloaded, 12 plates at a time, in broad daylight. Original advertising states that this camera was made only to order, which helps account for its rarity. Price negotiable. Estimate: $8000-10,000. *Illustrated next page.*

Peritus No. 1 - Mahogany field camera for 10x12" plates. Ross-Goerz Patent Double Anastigmat f7.7/14". $200-300.

Miall Hand Camera

Popular Ferrotype Camera - c1911. Vertically styled wooden tintype camera. Lens is high and offset to the right. Sliding back at top of camera includes ground glass at far right. Curved nickeled pull at bottom of sliding back allows plates to drop into tank. Design is based on the earlier "Quta" camera whose top section was hinged. Probably made by Quta and distributed by Fallowfield in England. Gennert sold the Quta in U.S.A. $700-800.

Prismotype - c1923. Direct positive street camera for 2½x3½" cards. Unusual design with reflecting turret eliminates the lateral reversal common to most direct positive cameras. $700-1000.

Tailboard cameras - Various sizes, ½-plate to 10x12". Dovetailed mahogany construction with square bellows. Rising and sliding front. Rack focus. With brass barrel lens: $150-250.

Wet-plate 9-lens camera - c1870. Mahogany sliding-box camera with carte de visite sliding back. Lens panel contains 9 lenses. Front flap shutter. Rack and pinion focus. $2500-3000.

FALZ & WERNER (Leipzig, Germany) Field camera - c1900. Small 9x12cm field camera with brass trim and green bellows. $75-125.

FAMA - German single extension folding plate camera, 9x12 size. Verax f8/135 or Sytar f6.3/135 in Vario shutter. $25-35.

FAP (Société FAP, Suresnes, France) *FAP = Fabrique d'Appareils Photographiques.*

Norca A - c1938. France's first competitor in the popular 35mm market. Although its leather covered black plastic body and spring-loaded telescoping front closely resemble the Argus A, its current value in the collector market would shock Oscar Barnack. Boyer Saphir f3.5/50 in Norca T,B, 25-300. Not generally available except in France where they easily bring $125.

Norca B - c1945. Modified front tube is no longer spring loaded. Berthiot, Boyer, or FAP f3.5 lens in Atos, Compur, or Norca shutter. $50-75.

Rower - c1936. Small black plastic camera for 32x40mm on special rollfilm. Appearance is nearly identical to the Universal Univex A of 1933. Common in France where they sell for $25-30.

FED (Dzerzhinsky Commune, Kharkov, Ukraine) *Russian Leica copies. Space does not permit a complete history here, and we certainly could not compete with the excellent history of the Dzerzhinsky Commune presented by Óscar Fricke in the quarterly "History of Photography" April 1979.*

Fed - *The Fed was the earliest successful Leica copy, and the only one achieving any measure of success before WWII. Early models are more*

difficult to identify because they are not numbered until the Fed-2 of 1955. However, the engraving on the top and the serial numbers are helpful in identifying and dating the early models.

Engraving Styles of Fed-1: *Since we lack facilities for typesetting Cyrillic letters, we are simplifying the characteristics and printing the Roman characters which most nearly resemble the correct Cyrillic letters. The top line in all cases is the word FED (ФЭД). The longest line, usually last or next to last, reads "F.E.Dzerzhinskogo" (Ф.Э.Дзержинского).*

Fed-1 Types:
Type 1 - 1934-35. Ser.#31-6000. Second line begins with "Tpy..."; Line 3 = "ИМ."
Type 2 - 1935-39. Ser.#6000-95000. Line 2 = "Tpy..."; Line 3 = "HKBD-YCCP".
Type 3 - 1939-41. Ser.#95000-175000. Line 2 = "HKBD-CCCP"; Line 3 = "Хар...".
Type 4 - c1946-48. Ser.#175000-200000. Line 2 = " завод "; Line 3 = "ИМ."
Type 5 - c1948-53. Ser.#200000-400000. The FED name is now in script. Line 2 = " завод "; Line 3 = "ИМ."
Type 6 - c1953-55. Ser.#400000-700000. Only the FED name in script, without further lines of type.

Fed-1 - c1934-55. Copy of Leica II(D). Usually with FED f3.5/50mm lens (coated after 1952). Production increased annually except during WWII, so naturally the earlier ones are less common and more valuable to a serious collector. Earliest models, without accessory shoe: $500-800. Other prewar models: $100-150. Postwar models: $45-75.

Fed-C - 1938-41. Like the Fed-1, but shutter to 1/1000 and with f2 lens as standard. $75-125.

Fed 2 - c1955-1970s. Removable back, combined VF/RF. From 1956 with self-timer, sync. Originally with Fed f3.5/50mm. From 1957 with Industar-26M. From 1964 with Industar-61. $35-60.*

Fed 3 - c1962-80. Slow speeds, shorter RF base than Fed-2. From 1964 with lever film advance. Industar-26M superseded in 1964 by Industar-61. $30-55.*

Fed 4 - c1964-70s. Built-in meter. Industar-61 lens. $30-50.*
Note: The Fed 2, 3, and 4 are common in Europe, but not in the U.S.A., so they sell for 50% above these figures in the U.S. Fed-3 and 4 were also sold as "Revue"-3 & 4 by Foto-Quelle.

FEDERAL MFG. & ENGINEERING CO. (Brooklyn, NY)
Fed-Flash - c1948. Low priced camera for 8 exp. 4x6.5cm on 127 film. Original prices: Camera $9.95, Case $3.95, Flash $4.51. Finally closed out in 1956 at $4.95

for the complete outfit. Current value: $5-10.

FEINAK-WERKE (Munich)
Folding plate camera - Horizontal format, 10x15cm. Leather covered metal body. Double extension bellows. Schneider Xenar f4.5/165mm. Dial Compur to 150. $75-100.

FEINMECHANISCHE WERKSTÄTTEN (Karl Foitzik, Trier, Germany)

Foinix - c1951-55. 6x6cm folding camera, horizontal style like Ikonta B. Steinar f3.5/75mm coated lens. Singlo, Vario, Pronto, Prontor, or Synchro-Compur. Rangefinder model: $30-60. Regular models: $20-40.

Foinix 35mm - c1955. 35mm viewfinder camera. Foinar f2.8 or f3.5/45mm. Vario or Pronto shutter. Rapid wind lever. $25-35.

Unca - c1953. Similar to Foinix, also for 6x6cm. f3.5 lens. Prontor-S shutter. $20-40.

FEINOPTISCHES WERK (Görlitz, Germany) *The names of camera manufacturers and sales co-operatives in post-war East Germany went through many changes as the companies organized into VEB's (Volkseigener Betrieb =*

People-owned factory). The VEB's in turn were organized in common interest associations called Interest Verband (IV) or Verband Volkseigener Betriebe (VVB). In this atmosphere of change, we see the names "Optisch-Feinmechanischen Werke & Görlitzer Kamerawerke", "Optik Feinoptisches Werk Meyer, Görlitz VEB", "Optik Primar Kamera Werke Görlitz VEB", and "Optik VVB Feinoptisches Werk Görlitz". These names are all essentially the same company, formerly Meyer-Görlitz which also incorporated Bentzin.

Astraflex-II - c1952. 6x6cm SLR. Astraflex was the U.S.A. name given to the camera by Sterling-Howard Corp., while the Primar Reflex II camera was distributed exclusively in the U.S.A. by Ercona Camera Corp. The two cameras are nearly identical, and prone to shutter problems. Tessar f3.5/105mm coated lens. Focal plane shutter, T, B, to 1000. Excellent working condition: $150-200. With shutter problems: $75-100.

FEINWERK TECHNIK GmbH (Lahr, Germany)

Mec-16 - ca. late 1950's. Subminiature for 10x14mm exposures on 16mm film in cassettes. f2.8 lens. Shutter to 1000. Gold-colored body is most common, but also seen in silver-color or all black. Like new, in original presentation case: black: $150-200; silver: $60-100; gold: $50-65. Gold camera only: $30-50.

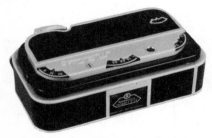

Mec 16 (new style) - An unusual variation of the Mec 16, this model has body styling similar to the Mec 16SB, with aluminum-colored metal and black leatherette. With case, chain: $75-100. Camera only: $50-75.

Mec-16 SB - c1960. Similar but with built-in coupled Gossen meter and Rodenstock Heligon f2 lens. The first camera with through-the-lens metering. Mint condition with presentation case: $125-150. Camera only: $50-75.

FERRANIA (Milan, Italy) *Manufacturer of cameras and film. Currently owned by the 3M company.*

Box camera - c1935. Bakelite box camera, 6x9cm. Simple lens and shutter. $30-35.

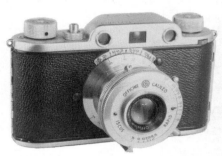

Condor I, Ic - c1950. 35mm rangefinder cameras with front leaf shutter. Some models have "Ferrania" on the top, while others do not. The shutter face bears the name of "Officine Galileo" in either case, and the camera is variously attributed to both companies. This camera is often described as a Leica copy by vendors with imagination. $50-100.

Condor Junior - c1950. Similar to normal Condor, but without rangefinder. Galileo Eliog focusing f3.5/50mm lens. Iscus Rapid shutter 1-500. $50-70.

Elioflex - c1950-53. Inexpensive TLR. Focusing Galileo Monog f8 in B,25-200 shutter. Non-focusing reflex finder. $30-50.

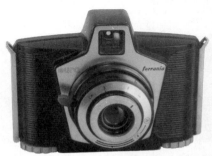

Eura - c1959. Plastic and aluminum eye-level box camera for 6x6cm. Focusing lens; T,I shutter. $5-10.

Euralux 44 - c1961. Smaller version of the Eura, made for 4x4cm on 127 film. Built-in

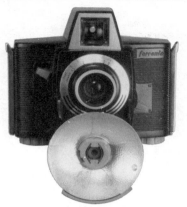

Zeta Duplex - c1940-45.
Zeta Duplex 2 - c1946. Metal box camera for 6x9cm or 4.5x6cm on 120 film. Achromat f11 lens. P,I shutter. Olive or grey: $15-25. Black: $10-15.

FERRO (Buttrio-Udine, Italy)

flash with fan reflector on bottom of camera. Interesting as a collectible, but the low flash angle was obviously not designed for the most flattering portraits. $12-18.

Ibis - c1950. Small cast aluminum camera for 4x6cm on rollfilm. $20-25.

Ibis 6/6 - c1955. Cast aluminum body. Gray or black imitation leather. $20-25.

Lince 2 - c1962. Inexpensive metal 35mm. Cassar f2.8/45 in Vero sh. $20-25.

Lince Rapid - c1965. Inexpensive 35mm camera for rapid cassettes. Dignar Anastigmat in 3-speed shutter. $12-18.

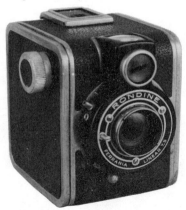

Rondine - c1948. Small all metal box camera for 4x6.5cm exposures on 127 film. Measures 3½x3½2½". Focusing Meniscus f8.8/75mm Linear lens. Simple shutter with flash sync. Available in black, brown, tan, green, blue, & red. Fairly common. $25-40.

Tanit - c1955. Small eye-level camera for 3x4cm on 127 film. $20-30.

G.F. 81 Ring Camera - 1981. Subminature camera built into a large gold finger ring. Takes special discs of film, 25mm diameter. Variable speed guillotine shutter. Removable reflex finder doubles as screwdriver to set the controls. Originally packed in a cylindrical wooden case. Limited production. $800-1000.

G.F. 82 - c1982-83. Similar to the G.F. 81, but with fixed viewfinder. $575-800.

FETTER (France)
Photo-Eclair - c1886. A French version of the concealed vest camera, designed by J.F. Fetter and manufactured by Dubroni in Paris. Similar to the Gray and Stirn Vest camera in outward appearance. Several variations exist, the major difference being that early models had the lens toward the top; while later models c1892 were inverted so that a waist-level finder could be used above the lens. Takes five photos 38x38mm, changed by rotating the back. $1500-2000.

FETZINGER (Vienna, Austria)
Field camera - c1900. Mahogany body, brass trim, 18x24cm. Double extension tapered green bellows with brown corners. Busch Portrait Aplanat f6/280mm lens. $125-175.

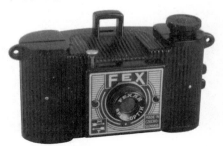

FEX (Czechoslovakia) - Small black

bakelite camera for 4x6.5cm on 127 film. Nearly identical to the French version listed below, but "MADE IN CZECHOSLOVAKIA" plainly printed on the faceplate. $35-50.

FEX/INDO (France) *Originally the company name was FEX, then both names were used concurrently before the Fex name was dropped from use. A prolific manufacturer of inexpensive plastic cameras, many of rather interesting design.*

Delta - Black bakelite eye-level camera, similar to Ultra-Fex. Meniscus lens. $10-15.

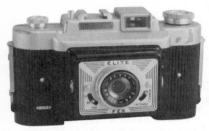

Elite-Fex - c1965. Dual format plastic eye-level camera for 6x9 or 6x6cm on 620 film. This was the top of the 6x9cm line from Fex. Rectangular extensible front. Extinction meter. Three-speed shutter, 2-stop lens. Silver & black plastic body. $10-15.

Fex - c1944. Simple black bakelite camera for 4x6.5cm on 127 film. Lens is identified as Fexar Spec.-Optik. "Optik" is a curious spelling for a French camera, so I was not surprised to find a nearly identical Fex camera whose nameplate states "Made in Czechoslovakia". The Czech version has an M,T shutter and a simple plastic frame finder while the French model has an I,P shutter and an optical finder. By 1945, the name was changed to Superfex and the lens was no longer identified on the camera. Uncommon. $35-50.

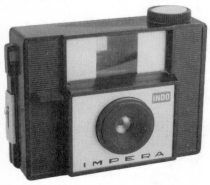

Impera - c1969. Simple black plastic eye-level camera for 4x4cm on 127 film. $3-6.

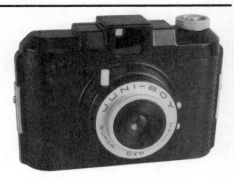

Juni-Boy 6x6 - Simple black plastic eye-level camera. $8-12.

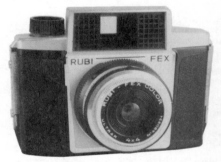

Rubi-Fex 4x4 - c1965. Inexpensive plastic camera for 127 film. $5-10.

Sport-Fex - c1966. Similar to the Elite and Ultra, but the least featured of the series. Simple snapshot model without shutter or lens adjustments. 6x9cm on 620 film. $10-15.

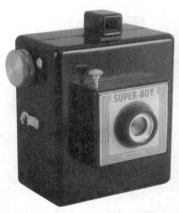

Super-Boy - Simple plastic camera for 3x4cm on 127 film. Also sold under the name "Champion". $8-12.

Superfex - c1945-55. Bakelite camera, 4x6.5cm exposures on 127 rollfilm. I & P shutter, unidentified lens. Based on the "Fex" camera, but with optical finder, metal advance knob, metal latches for back. Much more common than the earlier Fex. $15-25.

Superior - c1940's Black bakelite, 4.5x6cm, similar to Superfex. Fexar Super lens. T,M shutter. $15-25.

Ultra-Fex - c1966. Black plastic eye-level camera for 6x9cm on 120 rollfilm. Features rank it below the Elite-Fex and above the Sport-Fex. Lacks extinction meter and dual format of Elite, but has 3-speed shutter, 25-100. Extensible front, Fexar lens. $10-15.

Ultra-Reflex (f4.5) - The "Ultra Reflex" model name does not appear on this camera as it does on the meniscus model. The basic body is similar, but the large

Atos B,25-300 shutter and f4.5 Fexar lens give it a much more serious appearance. $20-30.

Ultra-Reflex (meniscus) - c1952. Twin-lens plastic box camera for 6x6cm. Fexar meniscus lens. $8-12.

Uni-Fex - c1949. Black plastic eye-level box camera for 6x9cm on 120 film. Rectangular telescoping front. T,I shutter. $8-12.

FIAMMA (Florence, Italy)
Fiamma Box - c1925. Small metal box camera for 3x4cm on 127 film. Black crackle-finish paint. Mensicus lens, T&I shutter. $15-25.

FILMA (Milano, Italy)

Filma 4.5x6cm

Box cameras - c1936. 4.5x6cm and 6x9cm sizes. Front corners are rounded. Achromat lens, guillotine shutter. $20-28.

FINETTA WERK (P. Saraber, Goslar)
Ditto 99 - c1950. same as Finetta 99 below.

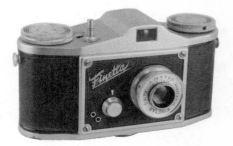

Finetta - c1950. Basic 35mm camera without rangefinder or motor drive. Finetar f2.8/45mm interchangeable lens. Originally $30. Currently: $23-35.

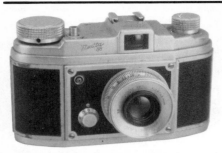

Finetta 88 - Basic knob-wind 35mm viewfinder camera. Interchangeable bayonet-mount lenses. Behind-lens two-blade leaf shutter, B,25-250. $25-35.

Finetta 99 - c1950. Spring motor camera. 36 exposures 24x36mm on 35mm film. Interchangeable Finetar f2.8/45mm lens. Focal-plane shutter 25-1000. Light grey. Excellent working condition: $115-180. Common with defective shutter or advance: $65-85.

Finetta Super - Finetar f2.8/45mm. Central shutter 25-100. $35-60.

Finette - f5.6/43mm Achromat Finar. Simple shutter, TBI. Aluminum body. $15-25.

FIPS MICROPHOT - Tiny black plastic subminiature for 13x13mm on special rollfilm. Made in Western Germany. $75-100.

FIRST CAMERA WORKS (Japan) *First Camera Works was a tradename used by Kuribayashi. See Kuribayashi for listings of "First" brand cameras.*

FISCHER (C.F.G. Fischer, Berlin) Nikette - c1932. Black bakelite-bodied folding camera with pop-out strut-supported front. Luxar f3.5 lens. $75-125.

Nikette II - c1932. Similar, but Maxar f3.5/50mm lens; black or colored body. $75-125.

FIVE STAR CAMERA CO.

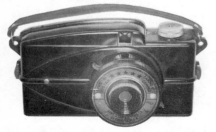

Five Star Candid Camera - Plastic novelty minicam for 3x4cm on 127 film. $5-10.

FLASH CAMERA CO.
Candid Flash Camera - 3x4cm. $5-10.

FLASHLINE - Plastic & metal eye-level box camera from Japan, 6x6cm on 120 film. Fixed focus. Two speeds marked with weather symbols, plus B. PC sync post on front. $3-7.

FLEKTAR - c1955. 6x6cm TLR made in East Germany. Row Pololyt f3.5/75mm lens. $30-50.

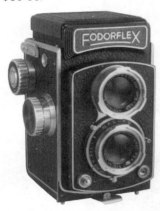

FODORFLEX - c1955. Japanese TLR, probably made by Sanwa Photographic Supply, as it is similar to their "Mananflex". Horinon Anastigmat f3.5/7.5cm in NKS-FB shutter B,1-300. $40-60.

FOLMER & SCHWING
Folmer & Schwing (NYC), 1887.
Folmer & Schwing Mfg. Co. (NYC), 1890.
Folmer & Schwing Mfg. Co. of New York, 1903.
Folmer & Schwing Co., Rochester (EKC), 1905.
Folmer & Schwing Div. of EKC, 1907.
Folmer & Schwing Dept. of EKC, 1917.
Folmer-Graflex Corp., 1926.
Graflex, Inc., 1945.
Because of the many organizational changes in this company which are outlined above, and in order to keep the continuous lines of cameras together, we have chosen to list their cameras as follows regardless of age of camera or official company name at time of manufacture:
Cirkut Cameras- see Eastman Kodak Co.
Graflex, Graphic Cameras- see Graflex

Banquet cameras - c1915-29. Banquet cameras are essentially view cameras with wide proportions for panoramic photographs. They were originally used to photograph entire rooms of people at banquets, and required a wide angle lens with extreme coverage. Surprisingly, these cameras are still used for the same purposes today, and maintain their value as usable equipment based on the prices of current cameras. In any case, the lens

with the camera is an important consideration in determining the value. At least one filmholder should be included in the prices listed here. The film holders would be expensive if purchased separately. Common sizes are 7x17" and 12x20". With an appropriate wide angle lens: $350-650. Without a lens, they bring $250-450.

Finger Print Camera - c1917-29. Portable fingerprint camera. Contains four battery operated lights. Leather covered. Kodak f6.3 lens. $50-75.

Sky Scraper Camera - c1904-15. A special purpose view camera incorporating an extra high rising lensboard and a back with extreme tilt to correct for architectural distortion. It was the perfect solution to the problem of taking photographs of the skyscrapers of the early 1900's. With lens & shutter: $350-500. Without lens: $200-300.

FOSTER INSTRUMENTS PTY. LTD. (Australia)

Swiftshot "Made in Australia" - c1950.

This is the same basic camera as the Model A below, but without a model number. Instead, the faceplate is marked "Made in Australia" below the Swiftshot name. It appears that the "Made in Australia" version was originally made by Swains Industries, and then by Foster. $10-15.

Swiftshot Model A - c1950. Metal box camera for 6x9cm exposures on either 620 or 120 rollfilm. Color and texture variations of the covering include: snakeskin pattern in green & brown or tan & brown; lightly pebbled surface in olive green, maroon flocked covering, etc. Vertically striped faceplate in green, brown, or red to complement the covering. $10-15.

FOTAX MINI, FOTAX MINI IIa - c1948. Sweden. Bakelite camera for 25x25mm on special 35mm rollfilm. f8/35 lens. $45-65.

FOTET CAMERA CO. (London)
Fotet - c1932. Vest-pocket camera with strut-supported front. Takes 16 exposures 3x4cm on 127 film. Meyer Trioplan f3.5 or f4.5 lens. Vario, Pronto, Ibsor, or Compur shutter. Identical to the Korelle 3x4cm strut-folding type. $50-75.

FOTH (C. F. Foth & Co., Berlin)
Derby (original) - 1930-31. The only Derby for 24x36mm on 127 rollfilm. Identified by its small image size. Originally with folding Newton finder, later with an optical telescopic viewfinder. Foth Anastigmat f3.5/50, FP 1/25-1/500. Very rare. $75-125. *Illustrated next page*

Derby (I) - c1931-36. 3x4cm on 127 rollfilm. Optical telescopic viewfinder. Foth Anastigmat f3.5 or f2.5/50mm, FP shutter 1/25-1/500. No self-timer. Black or brown leather covering. This model was referred to as Derby until the improved version with a self-timer was introduced. It then was called the Derby I and the self-timer

Foth Derby (original)

116 or 120 rollfilm. Foth Anastigmat lens. Waist level & eye level finders. $20-25.
-- Deluxe version - Alligator skin covering and black or colored bellows. $75-100.

Foth-Flex - c1934. TLR for 6x6cm on 120. Foth Anastigmat f3.5/75mm. Cloth focal plane shutter 25-500, B. $65-90. *Illustrated next page.*

version was called the Derby II. Not often seen. $35-50. (With Elmar lens add $150.)

Derby II - c1934-42. 3x4cm on 127 rollfilm. Optical telescopic viewfinder. Foth Anastigmat f3.5 or f2.5/50mm, FP 1/25-500, ST. Black or brown leather covering. There were also two rangefinder additions to this camera that were not made by Foth. The first, made in France c1937-40, had a black and chrome rangefinder that was added on to the top of the camera body. The rangefinder remains stationary on the body when the struts extend the front. A focusing knob coupled to the RF was added to the front plate. The second, c1940-42 US-made chrome RF was mounted above the front plate, not to the top of the body. When the struts are extended, the RF also moves forward. A vertical bar connects the helical lens mount to the RF. This CRF could be added to any Derby II, by returning it to the US distributor. Advertisements in the U.S. referred to the Derby II without the added CRF as the "Standard" model or "Model I", and called the Derby II with the US added CRF simply Derby II or Derby Model II. With French CRF: $150-175. With US CRF: $125-165. Without CRF, EUR: $45-70; USA: $40-50.

Folding rollfilm cameras - c1933. For

Foth-Flex II - c1935. Similar, but shutter has slow speeds to 2 sec. Focusing lever replaces knob focusing c1938. $80-120.

FOTO-FLEX CORP. (Chicago)
Foto-Flex - Twin-lens box camera, unusual design. The small viewing and taking lenses are both within the round front disc which resembles a normal lens. (Design is similar to the 35mm Agfa Flexilette.) Takes 4x4cm on 127 film. One model has a cast metal body. Another has a plastic body with a cast metal faceplate. Interior of body is marked "Hadds Mfg. Co." Apparently Hadds manufactured the body or the entire camera for the Foto-Flex Corp. $8-12.

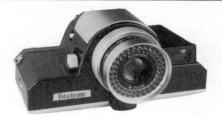

Foth-Flex

FOTO-QUELLE (Nürnberg, Germany)
Founded in 1957, Foto Quelle steadily grew to become the world's largest photographic retailer. Their "Revue" brand is known worldwide, made up of cameras produced by major manufacturers for sale under the "Revue" name.

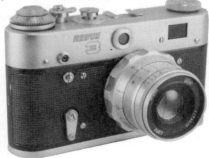

Revue 3 - c1970. Same as Fed 3, but made for Foto-Quelle. "Revue 3" printed on front of top housing. $25-50. Common in Germany for under $35.

Revue 16 KB - c1960's. Name variation of the Minolta 16 MG subminature. Rokkor f2.8/20mm lens. Programmed shutter 30-250. With case, chain, flash, & filters: $20-40.

Revue Mini-Star - c1965-70. Name variant of the Yashica Atoron, a subminiature for 8x11mm on Minox film. $30-40.

FOTOCHROME, INC. (U.S.A.)
Fotochrome Camera - c1965. "Unusual" is a kind description for this machine, designed by the film company to use a special direct-positive film loaded in special

cartridges. The camel-humped body houses a mirror which reflects the 5.5x8cm image down to the bottom where the "color picture roll" passed by on its way from one cartridge to another. Single speed shutter coupled to the selenium meter. Made by Petri Camera in Japan. Often seen new in box for $45-60. Camera only: $20-30.

FOTOFEX-KAMERAS (Fritz Kaftanski, Berlin)

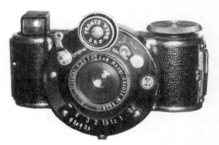

Minifex - c1932. Unusual looking subminiature for 36 exposures 13x18mm on 16mm film. Large Compur, Pronto, or Vario dwarfs the tiny body. $500-750.

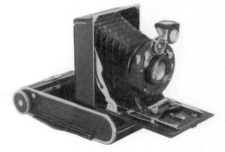

Visor-Fex - c1933. Unusual folding rollfilm camera for 6x9cm or 4.5x6cm on rollfilm. Also accepts single plateholders while the rollfilm is still loaded in the camera. The rollfilm back has a darkslide, and the back hinges down to allow use of ground glass or plateholder. Catalog advertising claimed erroneously that this was the first and only camera in the world to allow ground glass focusing between rollfilm exposures while

film was loaded. There were several such cameras early in the century, and the Palko camera was around in the years immediately before the Visor-Fex. However it is the smallest such camera, and quite rare. Two known sales were in the $75 range, but in both cases the sellers were unaware of the true value. $300-400.

FOTOKOR - c1930. Russian folding plate camera. Gomz f4.5/135mm lens in 25-100, K,D shutter. $30-60.

FOTOTECNICA (Turin, Italy)
Bakina Rakina - c1946. Inexpensive camera for 3x4cm on 127 film. Clippertar f9 lens; B&I shutter. $15-20.

Bandi - c1946. Box camera covered in brown leather, with blue front. 6x6cm on 120 rollfilm. Aplanat 75mm lens, shutter 25-100. $30-45.

Eaglet - c1950s. Side-loading metal box camera for 6x9cm on 120. Pivoting reflex finder. $8-12.

Filmor - c1950. Metal box cameras for 6x6cm or 6x9cm exposures. Achromat lenses, guillotine shutter. $15-25.

Rayelle - c1954. Side-loading metal box camera, 6x9cm on 120. Like the Eaglet, but with tubular eye-level finder. $8-12.

Rayflex - c1946. Simple 6x9cm box camera. Duotar Optik f9 lens, guillotine shutter. $12-18.

Tennar Junior

Tennar, Tennar Junior - c1954. Folding cameras for 6x9cm, 620 film. $12-18.

FR CORP. (Fink-Roselieve Corp., NY)
FR Auto-Eye II - c1961. German-made 35mm with built-in meter. Schneider Radionar f2.8/45mm; Prontormat. $15-25.

FRANCAIS (E. Francais, Paris)
Cosmopolite - c1892. Early twin-lens reflex camera, box-shaped when closed. Side hinged front door conceals brass barrel lenses. $500-600.

Kinegraphe - c1886. Very early twin-lens reflex. Polished wood body, exterior brass barrel lens with waterhouse stops. Sold in England by London Stereoscopic Co. as "Artist's Hand Camera". $850-1200.

Photo-Magazin - c1895. Magazine camera for 6.5x9cm plates. String-set shutter. Leather changing bag. $400-475.

FRANCYA - 14x14mm Japanese subminature of the "Hit" type. $10-15.

FRANKA-WERK (Beyreuth, Germany)
Franka cameras were sold in the U.S.A. by Montgomery Ward Co.
Bonafix - c1950. Folding rollfilm camera, 6x9cm. Similar to the Rolfix. Radionar f4.5/105mm; Vario 1/25-100. $15-25.

Frankarette - c1958. 35mm CRF. Isconar f2.8/45mm in Prontor SVS 1-300. $40-60.

Rolfix - ca. WWII, pre- and post. A dual-format folding camera for 120 film. Some take 8 or 12 exposures per roll, others take 8 or 16 exposures. Post-war models made in U.S. occupied zone from pre- and post-war parts. $15-30. *Illustrated next page.*

Rolfix II - c1951-57. Folding rollfilm camera, similar to the Rolfix, but better lens and shutter. Trinar f3.5/105mm lens. Early ones have Compur-Rapid shutter 1-400, folding viewfinder. Later ones with Synchro-Compur 1-500, non-folding viewfinder built into chrome housing. $40-60.

Rolfix Jr. - c1951-55. Folding camera for 8 exposures 6x9cm or 12 exposures 6x6cm on 120 rollfilm. Frankar f4.5/105 in Vario 25,50,200,B. Standard model has folding

Franka Rolfix

Heidoscop - Three-lens stereo camera for stereo pairs on plates or cut film, in two sizes: 45x107mm and 6x13cm. Named for the designer, Reinhold Heidecke, these were the first cameras made by Franke & Heidecke. Both models have Stereo Compound shutters.

direct eye-level finder. Deluxe model has non-folding optical finder in small add-on top housing. $10-20.

Solid Record - c1950. Similar to the Solida. $15-25.

Solida - Pre- and post-war folding cameras for 12 exposures, 6x6cm on 120 film.
Solida I - f6.3/75mm. $15-25.
Solida II - Anastigmat f3.5 in Vario shutter. $25-45.
Solida III - Radionar f2.9/80mm in Prontor SVS. $30-50.

Solida Jr. - c1954. Horizontal folding 120 rollfilm camera, 6x6cm. f6.3/75mm lens. Shutter B,25,75. $10-15.

FRANKA PHOTOGRAPHIC CORP.
(Taipei, Taiwan) *Not related to Franka-Werk of Germany. Named for founder Frank Lin, this is a marketing company for the Civica Industries Corp. factory. They produce a full line of inexpensive cameras for premium use. In addition to their standard brand names of Civica, Franka, and Konex, which include traditional 35mm and 110 types, they have produced countless cameras with special logos for advertising campaigns. These, of course, are of the greatest interest to collectors, so we are listing only the custom models.*
Kentucky Fried Chicken - Body style like Civica PG-1. White front with red vertical stripes. Col.Sanders face logo on sliding lens cover. $10-15.

St. Louis Steamers - Civica PG-1 style. Yellow front with Steamers logo. Soccer ball on sliding lens cover. $10-15.

NBA 76ers - Civica PG-1 style. White front with NBA logo. Basketball and 76ers logo on sliding lens cover. $10-15.

45x107mm size - 1921-41. Carl Zeiss Jena Tessar f4.5/55mm lenses. $275-350.
6x13cm size - 1925-41. Carl Zeiss Jena Tessar f4.5/75mm lenses. $350-500. (Add $100-150 for 120 rollback.)

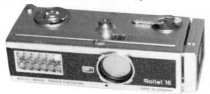

Rollei-16 - 1963-67. (#2,700,000-2,727,999). Subminiature for 12x17mm exposures on 16mm film. Tessar f2.8/25mm. Outfit with case, flash, filter: $75-125. Camera only: $40-60.

Rollei-16S - 1966-72. (#2,728,000-2,747,882). Subminiature. Cream snake: $150-200. Black snake: $100-150. Green: $100-150. Red: $100-150. Black: $40-60.

Rollei 35 - 1967-75. (#3,000,000-on). Tessar f3.5/40mm. Model from Germany: $125-175. From Singapore: $65-85. In gold: $400-500.

Rollei 35B - 1969-78. (#3,600,000-on). Zeiss Triotar f3.5/40mm. $50-75.

Rollei 35C - intro. 1969. ($3,600,000-on). $65-90.

Rollei 35LED - 1978-80. $50-85.

Rollei 35S - intro. 1974. In gold, as new in box: $700-900. In silver, as new in box: $400-650. Black, as new: $250-350. Chrome, like new: $200-275.

Rollei 35T - 1976-80. Black or chrome. $125-200.

Rollei A26 - c1973-78. Self-casing pocket-sized camera for 126 cartridges. Sonnar f3.5/40mm. Programmed shutter 30-250. With case and flash: $40-50. Camera only: $25-30.

Rolleicord - A series of 6x6cm TLR cameras.

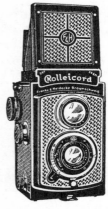

I (nickel-plated) - 1933-36. Art-deco, nickel-plated exterior. Zeiss Triotar f4.5/75mm lens. Compur shutter 1-300, B, T. $100-200.

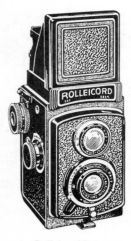

Rolleicord Ia

I (leather covered) - 1934-36. Black leather-covered exterior. Zeiss Triotar f3.8 lens. Compur 1-300, B,T. No sync. $50-70 in USA. (Nearly double that in Germany.)

Ia - 1936-47. Zeiss Triotar f4.5/75mm lens. No bayonet mounts on viewing or taking lenses. Rim-set compur shutter 1-300, B,T. No sync. Most have a frame finder in the focusing hood. $50-85. *Illustrated bottom of previous column.*

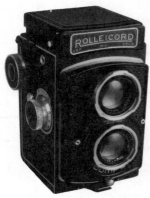

II - 1936-50. (#612,000-1,135,999). f3.5/75mm Zeiss Triotar or Schneider Xenar. Compur shutter 1-300, B,T or Compur Rapid 1-500,B; no sync. Originally without bayonet mounts, but bayonet added to the taking lens and then the viewing lens during the course of production. Version with bayonets on both the taking and viewing lenses sometimes referred to as the IIa. $45-85.

III - 1950-53. (#1,137,000-1,344,050). f3.5/75mm Zeiss Triotar or Schneider Xenar lens. Compur-Rapid shutter 1-500, B. X sync. $60-95.

IV - 1953-54. (#1,344,051-1,390,999). Schneider Xenar or Zeiss Triotar f3.5/75mm lens. Synchro-Compur 1-500, B. MX sync. Double exposure prevention. $80-110.

V - 1954-57. (#1,500,000-1,583,999). Schneider Xenar f3.5/75mm lens. Synchro-Compur shutter, 1-500, self-timer. MXV sync, LVS scale. Double exposure prevention. Large focusing knob with film speed indicator on right side. $75-125.

Va - 1957-61. (#1,584,000-1,943,999). Schneider Xenar f3.5 lens. Synchro-Compur 1-500, B. Large focusing knob on left side. Non-removable focusing hood. $100-125.

Vb - 1962-70. (#2,600,000-on). Schneider Xenar f3.5 lens. Synchro-Compur 1-500 shutter. Large focusing knob on left side. Removable focusing hood. $125-165.

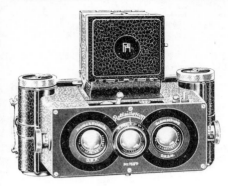

Rolleidoscop - 1926-41. The rollfilm version of the Heidoscop stereo camera. Actually, some of the very earliest production models of the Rolleidoscop still bore the name Heidoscop. Like the Heidoscop, this is a three-lens reflex. The center lens, for reflex viewing, is a triplet f4.2. Stereo Compound shutter 1-300.
45x107mm - Tessar f4.5/55mm lenses. Much less common than the 6x13cm size. $900-1400.
6x13cm - Tessar f4.5/75mm lenses. Stereo Compound 1-300. For B11 or 117 rollfilm. Many converted for 120 rollfilm by users. $900-1400.

Rolleiflex - 6x6 TLR cameras. For 6x6cm exposures on 120 film.

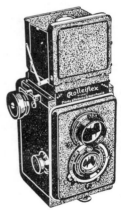

I (original model) - 1929-32. (#?-199,999). The "little sister" of the already well-known Heidoscop and Rolleidoscop. Readily identified by the Rim-set Compur shutter, 1-300, B & T, and the film advance system, which, on this early model was not automatic; hence, no exposure counter. With Zeiss Tessar f4.5/75mm, or more often, f3.8/75mm lens. This first model was

made to take 6 exposures on No. 117 film, but some were converted to the standard 12 exposures on 120 film. Film winding knob, not lever. The earliest version of this model had no distance scale on the focus knob, and the back is not hinged, but fits into a groove. The second version has focus scale and hinge. $100-125.

Rolleiflex Automat models:

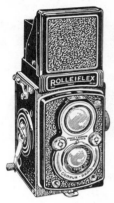

Automat (1937) - 1937-39. (#563,516-805,000). Zeiss Tessar f3.5/75mm lens. Bayonet mount for accessories on taking lens only. Compur-Rapid shutter 1-500, B, T, and self-timer. Automatic film feed. No ruby window. Knurled wheels for setting lens stops and shutter speeds. No sportsfinder. $80-120.

Automat (1939) - 1939-49. (#805,000-1,099,999). Tessar or Xenar f3.5 lens. Like the 1937 model, but bayonet mounts on both the taking and the viewing lenses. $80-120. (About 50% higher in Germany.)

Automat (X-sync.) - 1949-51. (Called the Automat II in Germany.) (#1,100,000-1,168,000). Tessar or Xenar f3.5/75mm lens. Synchro-Compur shutter, 1-500, B. Self-timer. X-sync. Sportsfinder. $125-175.

Automat (MX-sync.) - 1951-54. (#1,200,000-1,427,999). Tessar or Xenar f3.5/75mm lens. Synchro-Compur 1-500, B. Self-timer. Lever for selecting M or X type sync. Very common. $100-130.

Automat (MX-EVS) - 1954-56. (#1,428,000-1,739,911). Tessar or Xenar f3.5/75mm lens. Synchro-Compur shutter, 1-500, B. Self-timer. MX sync and LVS scale on shutter. $80-125.

Rolleiflex 2.8A - 1950-51. (Also known as Automat 2.8A.) (#1,101,000-1,204,000). Zeiss Tessar f2.8/80mm lens. Synchro-Compur shutter, with X or MX sync. Self-timer. Sportsfinder. $80-100.

Rolleiflex Old Standard

Rolleiflex 2.8B - 1952-53. (Also known as Automat 2.8B.) (#1,204,000-1,260,000). Zeiss Biometar f2.8/80mm lens. MX sync. $100-125.

Rolleiflex 2.8C - 1953-55. (Also called Automat 2.8C.) (#1,260,350-1,475,405). f2.8/80mm Schneider Xenotar or Zeiss Planar lens. Synchro-Compur shutter with MX sync. No LVS scale. $150-175. (Higher in Germany.)

Rolleiflex 2.8D - 1955-56. (#1,600,000-1,620,999). f2.8/80mm Schneider Xenotar or Zeiss Planar lens. Synchro-Compur shutter with MX sync and LVS scale. $175-225 in USA. (About 30% higher in Europe.)

Rolleiflex E - 1956-59. Dual-range, non-coupled exposure meter. (Original distributor's advertising referred to this camera as the model "G" when sold without the meter.) MX sync. Two variations:
2.8E - (#1,621,000-1,665,999). f2.8/80mm Zeiss Planar or Schneider Xenotar. $200-250. (Higher in Germany.)
3.5E - (#1,740,000-1,787,999 and 1,850,000-1,869,999). f3.5/75mm Zeiss Planar or Schneider Xenotar. $225-300. (Higher in Germany.)

Rolleiflex E2 - No exposure meter. Flat, removable focusing hood. Two variations:
2.8E2 - 1959-60. (#2,350,000-2,356,999). f2.8/80mm Xenotar. $350-450.
3.5E2 - 1959-62. (#1,870,000-1,872,010 and 2,480,000-2,482,999). f3.5/75mm Xenotar or Planar. $250-325.

Rolleiflex E3 - 1962-65. No exposure meter. Removable focusing hood. Planar or Xenotar lens. Two variations:
2.8E3 - (#2,360,000-2,362,024). f2.8/80mm lens. $250-300.
3.5E3 - (#2,380,000-2,385,034). f3.5/75mm lens. $200-250.

Rolleiflex F2.8 Aurum - 1983. Gold-plated commemorative model with alligator leather covering. Approximately 450 made. Schneider Xenotar f2.8/80mm. As new with original teak box, strap, etc.: $1200-1800.

Rolleiflex SL26 - 1968-73. Sophisticated SLR for 126 cartridge film. Interchangeable Tessar f2.8/40mm lens. TTL metering. EUR: $75-100. USA: $95-125.

Rolleiflex Standard models:
Old Standard - 1932-38. (#200,000-567,550). Zeiss Tessar f4.5, f3.8, or f3.5/75mm lens. Compur 1-300, B,T or Compur-Rapid 1-500, B shutter. Lens mount accepts push-on accessories; no bayonet. Single lever below lens for tensioning and releasing the shutter. Lever-crank film advance. Exposure counter. $65-95.
Illustrated top of previous column.

New Standard - 1939-41. (#805,000-927,999). Zeiss Tessar f3.5/75mm lens. Compur-Rapid, 1-500, B (no T or self-timer). Bayonet mount on viewing and taking lenses. Lens stops and shutter speeds set by levers. $65-100.

Studio - 1932-34. 9x9cm or 6x9cm. The only Rolleiflex in the 9x9cm size, this is the rarest of the Rolleiflexes. Prototypes only or possibly very limited quantities. Zeiss Tessar f4.5/105mm lens in Compur S shutter 1-1/250, T, B. Price negotiable. No known sales.

Rolleiflex T - 1958-75. (#2,100,000- on). Zeiss Tessar f3.5/75mm lens. Shutter with X or MX sync. Provision for built-in dual-range exposure meter. Available in black or grey. Grey: $200-250. Black, with meter: $225-300. Without meter: $135-160. (Higher in Germany.)

Tele Rolleiflex - intro. 1959. Zeiss Sonnar f4/135mm lens. Removable focusing hood. Later models allow use of 120 or 220 film. $600-850.

Wide-Angle Rolleiflex (Rolleiwide) - 1961-67. Distagon f4/55mm lens. Less than 4000 produced. $1500-1800.

Rolleiflex 4x4 Cameras: *For 4x4cm exposures on 127 film. Some variations called "Baby Rolleiflex", or "Rolleiflex Sport".*
Original - 1931-38. (#135,000-523,000). Zeiss Tessar f3.5 or f2.8/60mm lens.

Frati 120

Compur shutter 1-300, B,T or Compur-Rapid 1-500, B,T. Earliest models (1931-33) have rim-set shutter. Later versions (1933-38) have levers for setting the lens stops and shutter speeds. Lens mount accepts push-on accessories (no bayonets). Widely ranging prices. $125-225.

Sports Rolleiflex - 1938-41. (#622,000-733,000). Zeiss Tessar f2.8/60mm lens. Compur-Rapid, 1-500, B,T. Bayonet mount on taking lens; some also have a bayonet mount on the finder lens. $275-425.

Grey Baby - 1957-59. (#2,000,000- on). Grey body. Xenar f3.5 lens. MXV shutter with LVS scale and self-timer. Double bayonet. Common. $125-200.

Post-War Black Baby - 1963-68. (#2,060,000-?). Black body. Zeiss Tessar or Schneider Xenar f3.5/60mm. Synchro-Compur MXV 1-1/500, B. Rare. $300-450.

Rolleimagic - 6x6cm TLRs with automatic exposure control. Xenar f3.5/75mm lens. **(I)** - 1960-63. (#2,500,000-2,534,999). USA, England: $85-140. (50% more in Germany.) **II** - 1962-67. (#2,535,000-2,547,597). Manual override on the exposure control. USA, England: $125-175. (50% higher in Germany.)

FRATI 120 - Basic box camera for 6x9cm on 120 film. Made in Argentina. Cardboard body with metal front and back. "FRATI" is embossed on the front. This camera may also exist with the name KOLUX. $20-25. *Illustrated top of next column.*

FRELECA MAGIC F - Inexpensive plastic 127 camera, made in Hong Kong. $4-8.

FRENNET (J. Frennet, Brussels) Stereoscopic Reflex - c1910. Large SLR for stereo exposures on 6x13cm or 7x15cm glass plates. $350-500.

FT-2 - c1955. Russian panoramic camera, 12 exposures 24x110mm on 35mm film. Industar f5/50mm lens. Shutter 100-400. $250-300.

FUJI - Japanese novelty "Hit" type subminiature. Black leatherette, gold colored metal parts. Top has stamped outline of Mount Fuji. Quite uncommon. $40-60.

FUJI KOGAKU SEIKI *Made cameras primarily before WWII, but the subminiature Comex was a post-war model.*

FUJI (cont.) - FUJITA

Baby Balnet - 1940's. Japanese copy of Zeiss Baby Ikonta, 3x4cm on 127 rollfilm. Balnet shutter. Nomular Anastigmat f2.9/50mm lens. Two styles: Early version has folding viewfinder and black trim. Later version, c1947, has rigid optical viewfinder, chrome trim, and accessory shoe. $75-125.

Baby Lyra - c1941. Folding camera for 3x4cm on 127 film. Terionar f3.5/50mm in Picco 25-100 shutter. Rare. $125-175.

Comex - Novelty subminiature for 14x14mm on rollfilm. Marked "Made in Occupied Japan". $175-225.

Lyra 4.5x6cm (Semi-Lyra) - c1936-40. Compact folding camera for 16 exposures 4.5x6cm on 120 rollfilm. Similar to Zeiss Ikonta A. Terionar f3.5/75mm anastigmat. Fujiko or Noblo shutter. Folding viewfinder. (Later c1952 version has optical rigid viewfinder.) $30-45.

Lyra Six, Lyra Six III - c1939. Horizontally styled folding cameras for 6x6cm on 120. Similar to Zeiss Ikonta B. Less common than the "semi" model. Terionar f3.5/75mm lens, Fujiko shutter. $30-50.

Lyraflex, Lyraflex J - c1941. 6x6cm TLR. Terionar f3.5/75mm lens, Fujiko shutter. An uncommon "Rollei copy". $65-110.

Lyrax - c1939. Telescoping front camera for 4.5x6cm on 120. Uncoupled rangefinder. Terionar f3.5/75mm in Fujiko shutter. $100-150.

FUJI PHOTO FILM CO. *Founded about 1934, the Fuji Photo Film Co. made film before WWII, but didn't begin camera production until after the war. The Fuji Photo Film Company is the manufacturer of Fujica cameras, many of which are still in use today. We are only listing a few of the more collectible models in this collectors guide.*
Fotojack - Disposable camera. Earlier and less common than the bright green "Quicksnap" which is currently sold

throughout the world. $15-20.

Fujica Drive - Half-frame 35mm with spring motor drive. Fujinon f2.8/28mm in Seikosha-L shutter. Auto exposure. $30-50.

Fujica Mini - c1964. Very small half-frame camera for 35mm film in special cartridges. Fujinar-K Anastigmat f2.8/25mm fixed focus lens. Shutter coupled to meter. $75-125.

Fujicaflex - c1954. Twin lens reflex for 6x6cm on 120. Fujinar f2.8/83mm. Seikosha-Rapid B,1-400. $150-200.

Fujipet, Fujipet EE - c1959. Simple eye-level cameras for 6x6cm on 120 film. The EE model has a built-in meter and is somewhat similar in styling to the Revere Eyematic EE127. Meniscus lens, I,B shutter. $15-20.

Pet 35 - Inexpensive lightweight 35mm. Fujinar f3.5/4.5cm focusing lens. Copal shutter, B, 25, 50, 100, 200. $15-25.

FUJIMOTO MFG. CO. (Japan)
Semi-Prince, Semi-Prince II - c1935-36. Copies of the Zeiss Ikonta A, 4.5x6cm. Schneider 4.5/75mm. Various shutters. $50-75.

FUJITA OPT. IND. LTD. (Japan)
Classic 35 IV - c1960. Inexpensive 35mm camera imported to the USA by Peerless Camera Co., NY as one of a series of "Classic" cameras. f3.5/45mm. Fujita shutter B,25-300. $30-50.

Fujita 66SL - c1958. Similar to the 66ST, but slow speeds to 1/5 sec. Block lettering on nameplate. $75-125.

Fujita 66SQ - c1960. Improved model of the 66SL with quick-return mirror. Fujita f2.8/80mm lens. $75-125.

Fujita 66ST - c1956. SLR for 6x6cm on 120 film. Interchangeable F.C. Fujita f3.5/80mm. Focal plane shutter B,25-500. Script lettering on nameplate. $75-125.

FUTURA KAMERA WERK A.G., Fritz Kuhnert (Freiburg)
Futura (Futura Standard) - c1951-55. Compact 35mm CRF. Compur-Rapid 1-400, B,T. Interchangeable Elor f2.8, Evar f2.0 or Frilon f1.5/50mm lens. With f1.5: $150-225. With f2: $100-150. With f2.8: $60-100.

Futura-P - c1953-55. Similar to the Futura, but Futar f3.5/45mm or Xenar f2.8/45mm lens. Prontor-SV 1-300. $50-60.

Futura-S - c1950's. A very well constructed 35mm CRF camera. Interchangeable Kuhnert Frilon f1.5/50mm normal lens. Compur Rapid 1-400,B. With normal, wide angle, tele lenses and auxiliary finder: $150-225. With normal lens: $50-75.

GAERTIG & THIEMANN (Görlitz)
Ideal Model VI - c1906-09. Triple extension field camera. Brass trim, brass Steinheil lens with Waterhouse stops. Brown tapered bellows. $150-200.

GAICA SEMI - c1940. Folding rollfilm camera for 4.5x6cm on 120. Gaica K.O.L. f4.5/75mm in RKK 1/175 shutter. $55-75.

GAKKEN CO. (Tokyo) - *The Gakken Co. publishes magazines for science students in Japan. In 1974, they began to give simple cameras to students to teach the principles of photography.*

The kits include a simple plastic camera which usually requires some assembly. At the back of the camera is a removable plastic focusing screen and filmholder, which are standard in size from year to year, though the outer bodies of the cameras show many interesting variations. Along with the camera comes sensitized paper, developer, and fixer.

Antique Tripod Cameras - 1986, 1987. There are two versions of the antique view camera, the 1986 model being the more realistic with its pleated plastic bellows. The 1987 version has striped paper decals to represent the bellows. The cameras are otherwise similar. $15-25. *Illustrated bottom of previous column.*

Book Camera - 1984. Black plastic body shaped like book. Red decal for spine and front clearly identify it as a book. The spirit of Krügener's Taschenbuch is alive and well. $15-25.

Gakken Antique Tripod Cameras

Eye Camera - 1985. The similarities between the eye and camera become obvious in this novel camera, whose lenscap is a stylized iris. $15-25.

Robot Camera - 1984. Miniature cousin of R2-D2. $15-25.

Soccer Ball Camera - 1983, 1986. Although similar in size, the two versions of the soccer ball are quite different. In 1983, the shape is a polyhedron, while the 1986 model is a sphere. The earlier model with its flat hexagonal sides is a much better candidate for the self-sticking white decals. The illustrated model is the 1986 version, which proves that a flat decal will wrinkle on a curved surface. Some Gakken cameras apparently teach more than photography. $15-25.

GALILEO OPTICAL (Milan, Italy)
Associated with Ferrania, also of Milan.
Condor I - c1947. 35mm rangefinder camera, similar in style to Leica, but with front shutter. Eliog f3.5/50mm in Iscus Rapid shutter B,1-500. CRF with separate eyepiece. Collapsible front. $60-100.

Gami 16 - c1955's. Subminiature for exposures 12x17mm on 16mm film in cassettes. f1.9/25mm lens. Shutter 2-1000.

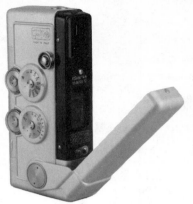

Coupled meter, parallax correction, spring-motor wind for up to 3 rapid-fire shots. Original cost $350. These are not rare, yet are occasionally advertised at higher prices. Normal range: $250-275. Complete outfit with all accessories: f4/4x telephoto, flash, filter, 45 degree viewer, wrist strap, etc. sells for 2 to 3 times the cost of the camera & case only.

GALLUS (Usines Gallus, Courbevoie, France)

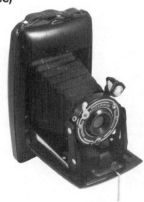

Bakelite - A streamlined folding camera made of bakelite plastic. Design based on the Ebner camera from Germany. Takes 6x9cm exposures on 120 film. Achromat f11 lens. P & I shutter. $30-50.

Derby - c1939-41. Folding strut camera for 3x4cm on 127 film. Som Berthiot Flor or Saphir f3.5 lens. Focal plane shutter. A French-made version of the Foth Derby. $40-60.

Derby-Lux - c1945? All polished aluminum camera for 3x4cm on 127 film. This was

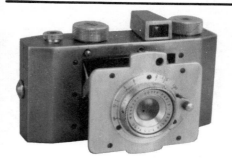

Stereo camera - c1920's. Rigid "jumelle" style all metal camera for stereo exposures in the two popular formats: 6x13cm or the smaller 45x107mm. Simple lenses, I&B shutter or more expensive versions with nickel-plated aluminum bodies, 1/300 jewelled shutters, and Goerz, Krauss, or Zeiss lenses. $75-125.

GALTER PRODUCTS (Chicago) *Founded in 1950 by Jack Galter, former president of Spartus Camera Co., and apparently in business for only a few years. Spartus Camera Co., meanwhile, became Herold Mfg. Co. at about the same time, having been bought by Harold Rubin, former Sales Manager for Spartus.*

the first postwar reincarnation of the Foth Derby, and was renamed "Derlux" before long. It can be identified by the name on the back plate. Strut-supported front. Boyer Saphir f3.5 lens. FP shutter B,25-500. $100-150.

Derlux - c1947-52. Folding camera for 3x4cm on 127 rollfilm. Polished aluminum body. Very similar to the Foth Derby. Early examples are identified as "Derby Lux" on the back, see above. Gallus Gallix f3.5/50mm. FP shutter 25-500. $75-125.

Hopalong Cassidy Camera - c1950. Plastic box camera for 8 exposures 6x9cm on 120 rollfilm. Meniscus lens and simple shutter. The front plate depicts the famous cowboy and his horse. These are synchronized and non-sync models. The original flash unit with Hoppy and his horse pictured on the reflector is quite rare. Camera and flash have sold for $100-150. Camera only, with or without synch: $20-30.

Folding rollfilm camera - c1920. Rising front with micrometer screw, 6.5x11cm. Gallus Anastigmat f6.3/120 in Ibsor. $20-35.

Majestic, Pickwik, Regal - Plastic "minicam" type cameras for 3x4cm on 127 film. $5-10.

Sunbeam 120 - Black bakelite box

Gamma Pajta's

camera without flash sync. Body style identical to the Hopalong Cassidy camera. $5-10.

GAMMA (subminiature) - Novelty subminiature from "Occupied Japan". Shutter release on top of body. Angel f4.5 lens with rotating disc stops. $125-150.

GAMMA (Societa Gamma, Rome)

Gamma (35mm) - c1947-50. Leica-inspired 35mm cameras. Model I c1947 has bayonet-mount lens, FP shutter with

speeds B,20-1000 on one dial. Model III c1949 has screw-mount lens, and shutter speeds 1-1000. Gamma, Angenieux, or Koristka Victor f3.5 lens. Rare. Estimate: $400-525.

GAMMA WORKS (Budapest Hungary)
Duflex - c1947. 24x32mm. First 35mm SLR to have a metal focal plane shutter, instant return mirror and internally actuated automatic diaphragm. Extremely rare. $1000-1500.

Pajta's - c1960. Heavy black bakelite eye-level camera for 6x6 on 120. Achromat f8; T&M shutter. $30-40. *Illustrated top of previous column.*

GANDOLFI (London) *The history of the Gandolfi family in the camera business is already a legend, and 1985 marked the hundredth anniversary of the founding of the business by Louis Gandolfi. It has remained a family business since that time, with sons Thomas, Frederic and Arthur working with their father and eventually taking the reins after his death in 1932. The company has always specialized in hand-made wooden cameras, some of which were custom-built to the specifications of clients. It would be difficult to give specific prices to such a wide range of individually crafted cameras. In the 1950's and 1960's, Gandolfi offered the cheapest large format cameras on the English market; thus there are many common Gandolfi cameras which sell in England at about $100. At the same time, the user market places a higher value on 4x5 and 8x10 format cameras especially with Graflok backs, and we have a number of recorded sales in the range of $175-450 and some up to $1000. This is understandable in view of the recent prices for new Gandolfi cameras of $1600 for 4x5 and $2250 for 8x10. Obviously, since the cameras were made for 100 years in a traditional style, they are still as much in demand for use as for collections. Some examples of recent sales are:*
Field camera - c1890's. Mahogany tailboard camera with brass trim and appropriate lens. $8x10": $500-1000. 6½x8½": $250-400. 4¼x6½": $500-700.

Tropical camera - Teak tailboard camera for ½-plates. Brass fittings. Almost identical to the Universal Stereo, below, but nameplate bears only the manufacturer's name and no camera name. Brass lens in Thornton-Pickard roller-blind. $800-1000.

Universal - 4x5" hand and stand camera. Leather covered body, brass trim. Meyer Trioplan f4.5/135mm lens. $400-550.

Universal Stereo - c1899. Folding tailboard stereo camera for 12x16.5cm plates. Black square bellows. Brass trim. Brass f8 Thornton-Pickard Crown lenses in Thornton-Pickard roller-blind shutter. $400-600.

GARLAND - (London, England)
Wet Plate camera - c1865. 8x10". Ross lens. $1300-1800.

GATLING 72 - c1963. Half-frame 35mm, house-brand name for the Ricoh Auto Half. Ricoh f2.8/25mm lens. BIM. $55-85.

GAUMONT (L. Gaumont & Cie., Paris)

Block-Notes - Compact folding plate cameras.
4.5x6cm - c1904-24. f6.8 Tessar, Darlot or Hermagis Anastigmat lens. $90-160.
6.5x9cm - c1909-24. f6.3 Tessar lens. Less common than the smaller model. $100-150.

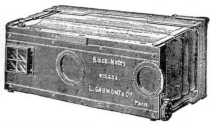

Block-Notes Stereo - Compact folding cameras like the other Block-Notes models, but for stereo formats: 6x13cm and 45x107mm. f6.3 lenses. Variable speed guillotine shutter. For single plateholders or magazines. $200-250.

Bramham - 35mm stereo camera. Finetar f4/43mm lenses. $250-350.

Folding Spido - c1925. Strut-folding press camera, nickel body. 12-plate magazine for 9x12cm plates. Zeiss Tessar lens, FP shutter to 2000. $125-175.

Reporter - c1924. Heavy metal strut-folding camera for 9x12cm single plates or magazine. Flor f3.5/135mm lens. FP 1/25-1000 shutter. $200-300.

Spido - c1898. 6x9cm or 9x12cm magazine camera in tapered front "jumelle" shape. Leather covered. Berthiot, Protar, or Dagor lens, pneumatic shutter. $125-175.

Stereo Spido Ordinaire - c1906-31. Black leather covered jumelle style stereo cameras for 6x13cm or 8.5x17cm stereo plates. Krauss Zeiss Protar f12.5/183mm or Tessar f6.3. Six speed Decaux Stereo Pneumatic shutter. $150-240.

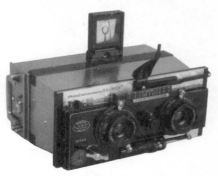

Stereo Spido Metallique - c1920's. Panoramic version with 120 rollback: $250-400. Regular 6x13cm size without rollback: $150-300.

Stereo cameras - Misc. or unnamed models, 6x13cm. f6.3/85mm lenses; guillotine shutter. $200-300.

G.E.C.

Transistomatic Radio Camera - c1964. Combination of a G.E. Transistor radio and Kodak Instamatic 100 camera. $75-150.

GENERAL PRODUCTS CO. (Chicago)
Candex Jr. - Black plastic minicam for 127 half-frames. $5-10.

Clix Miniature Camera - Brown marbelized plastic minicam for 3x4cm on 127 film. $5-10.

GENIE CAMERA CO. (Philadelphia, PA)
Genie - c1892. Focusing magazine-box camera for 3¼x4" plates. Push-pull action changes plates and actuates exposure counter on brass magazine. String-set shutter. $400-550.

GENNERT (G. Gennert, NYC)

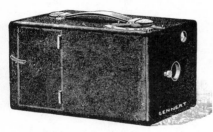

Montauk - c1890. Detective style camera for plateholders which load from the side. Shutter-tensioning knob on the front next to the lens opening. Internal bellows focusing via radial focus lever on top of camera. $100-125.

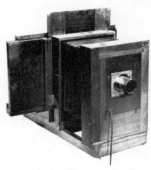

Gennert Penny Picture

Stereoscopic Montauk - c1898. Like the 5x7" Folding Montauk, but with Stereo lensboard. $250-350.

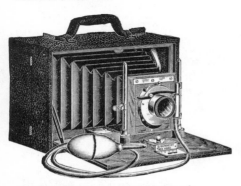

Folding Montauk, Golf Montauk, Montauk III - c1898. Folding plate cameras, 4x5" or 5x7". Leather covered wood bodies. "Cycle" style. Wollensak Rapid Symmetrical, Ross Patent, or Rapid Rectilinear lens. $60-100.

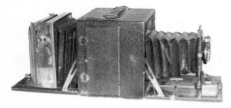

Long Focus Montauk - c1898. Like the Folding Montauk, but also has rear bellows extension. $70-120.

Montauk rollfilm camera - c1914. $20-30.

"Penny Picture" camera - c1890. A 5x7" studio camera with sliding back and masks to produce multiple small images on a single plate. $250-300.*Illustrated top of next column.*

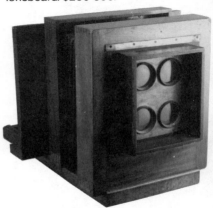

Wet-Plate Camera, 4-lens - Fixed tailboard bellows-style camera with 4-tube lensboard. Side-hinged ground glass screen. Drip trough below ground glass. Wooden septum fastens inside 7x7" opening to allow 4 photos on 5x7" plate. $800-1000.

GENOS K.G. (Nurnberg. Germany)
Flash Box - Bakelite pseudo-TLR. $10-20.

Genos - c1949. Small black bakelite eye-level camera for 25x25mm on 35mm wide rollfilm. f8 lens, Z&M shutter. $30-45.

Genos Fix - c1951-56. Two-tone 4.5x6cm bakelite rollfilm box camera, similar in style to the better known Bilora Boy. $30-35.

Genos Rapid - c1950. Plastic reflex camera, 12 exp. 6x6cm on 120 film. $10-20.

Genos Special - c1953. Black bakelite box camera for 6x6cm, similar to Genos Rapid. Achromat f8, simple shutter. $15-25.

Special Fix - c1950. Black bakelite eye-level box camera for 4.5x6cm on 127. "Special" on metal nameplate above lens. "Fix" molded into body below lens. $15-25.

GERSCHEL (Paris)

le Mosaic - c1906. An unusual camera designed to take 12 exposures, 4x4cm each, on a single 13x18cm plate. The camera is approximately the size and shape of a cigar box standing on end. A removable partition divides the camera interior into twelve chambers. The lens and shutter move horizontally and vertically on two tambours (like a roll-top desk) to allow for twelve separate exposures. The sliding front has index marks to indicate the proper lens position for each exposure. There is also a second set of index marks for making nine exposures per plate with a different interior partition. Oddly, it comes with a Rapid Rectilinear lens fitted in either a Wollensak or Bausch & Lomb shutter. $1800-2000.

GEVAERT *Founded in 1890 by Lieven Gevaert to manufacture calcium paper. Merged with Agfa in 1964. Although a leader in photographic materials, the company was never a major producer of cameras.*

Gevabox: *c1950. Box cameras in several variations for 120 film:*
Gevabox 6x6 - c1950. Black bakelite camera with white trim. Looks like an overgrown "Ansco Panda", and nearly identical to the Adox 66. $20-30.

Gevabox 6x9 (eye level) - c1955-56. Metal box camera with eye-level finder above body. Shutter 1/50 and 1/100. $8-15.

Gevabox 6x9 (waist level) - c1951. Waist level brilliant finder. B,M shutter. $15-20.

Gevabox Special - c1951. Streamlined box camera 6x9cm on for 120 rollfilm. f11 lens, shutter 50,100,B. $15-20.

Ofo - Bakelite camera with helical telescoping front. Similar to the Photax camera from France. Both cameras are designed by Kaftanski, whose creations were manufactured in Germany, France, and Italy. This one, however, is made by "SIAF Industria Argentina". Black or brown. $30-50.

GEYMET & ALKER (Paris)
Jumelle de Nicour - c1867. An early binocular-styled camera for 50 exposures

on 1¼x1¼" plates. A large cylindrical magazine contained the 50 plates, which were loaded and unloaded from the camera for each exposure by gravity. (Rather like a modern slide tray.) Rare. Estimate: $7500+.

GIBSON (C.P. Gibson, Hull, England)
Stereo camera - Mahogany tailboard camera with brass trim, brass bound Clement and Gilmer lenses. 4¼x6½" plates. Square red bellows. $600-650.

GILLES-FALLER (Paris)
Studio camera - c1900. 18x24cm. Hermagis Delor f4.5/270mm lens with iris diaphragm. Finely finished light colored wood. $250-350.

GINREI KOKI (Japan)
Vesta - c1949. Novelty subminiature from "Occupied Japan". Two models: one has eye-level finder, the other has both eye and waist level finders. $50-75.

Vester-Six - c1940. Horizontally styled camera for 6x6cm on 120 film. Nearly

identical to the Clover Six B. Venner Anastigmat f3.5/75 in Vester 3 shutter T,B,1-200. $60-80.

GIRARD (J. Girard & Cie., Paris)

Le Reve - c1908. Folding 9x12cm camera. Special detachable rollfilm back has darkslide so that it can be removed and replaced by a ground glass screen or a plateholder. Beckers f6.3 or Roussel Anastigmat f6.8/135mm lens in Unicum shutter. Red bellows. $125-175.

GLOBAL - Japanese 16mm "Hit" type novelty camera. $10-15.

GLOSSICK MFG. CO. (East Peoria, Illinois)

Direct Positive Street Camera - A leather-covered wooden camera with a rear sleeve for manipulating the 6x9cm sheets of direct positive paper. Suitcase styling is typical of street cameras, but tapered in toward the top. $75-125.

GLUNZ (G. Glunz & Sohn Kamerawerk, Hannover) *The company was originally founded in 1889, according to their catalog*

claims. *The name Glunz & Bülter was used from about 1894-1904, at which time G. Glunz & Sohn split away, leaving Bülter & Stammer. G. Glunz & Sohn remained in business until sometime in the 1930's. (The latest catalog we have on file is 1932.)*
Folding plate camera, 6.5x9cm - c1920's. Double extension bellows. Tessar f4.5/120mm. Compur 1-250. $40-60.

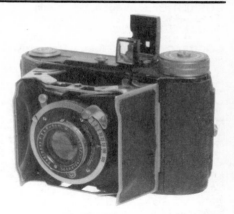

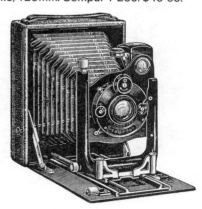

Folding plate camera, 9x12cm - c1920's. Wood body, leather covered. Double extension bellows. Dial Compur shutter. Goerz Tenastigmat f6.8, or Zeiss Tessar f4.5 lens. $40-60.

Folding plate camera, 13x18cm - c1905. Horizontally styled folding camera. Leather covered wood body. Triple extension bellows. Hemi-Anastigmat Series B f7.2 lens. Unicum double pneumatic shutter. $85-105.

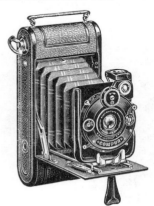

Folding rollfilm models - f6.3 Tessar. Compur shutter. $25-35.

Ingo - c1932. Compact horizontally styled camera for 3x4cm on 127 film. Interesting "barn-door" front which provides solid support for the extended front. (This same system proved to be much more popular on the 1950's Voigtländer Vitessas.) The Ingo was also sold by Rodenstock as the Rodinett, recognizable by its Rodenstock Ysar lens. The Ingo has the Glunz name on the advance knob. With Makro Plasmat lens in helical mount, an astute collector would pay $50-75 extra. With normal Trinar, Trioplan, or Radionar lens in Compur: $150-225.

GNCO - Japanese novelty subminiature of the "Hit" type. $10-15.

GNOFLEX - c1956. Japanese Rolleicord copy. Horinor f3.5/75mm lens. NKS shutter B,1-300. $40-60.

GNOME PHOTOGRAPHIC PRODUCTS, LTD. (England)

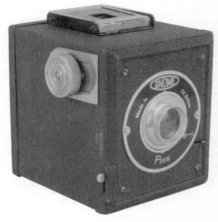

Pixie - Metal box camera for 6x6cm on 620 film. Black crinkle-finish enamel. $10-15.

**GOEKER (Copenhagen, Denmark)
Field camera** - 18x24cm. Carl Zeiss
Series II f8/140mm lens. $125-150.

GOERZ (C. P. Goerz, Berlin, Germany)
*Started in a two-room shop in 1886 as a mail-
order firm selling mathematical drawing tools to
schools. In 1888 Goerz acquired a mechanical
workshop and started making amateur cameras.
Lensmaking began in late 1888 or early 1889
and became the main business. Became a major
manufacturer with over 3,000 employees within the
lifetime of the founder. In 1926, three years after
the death of Carl Paul Goerz, the company merged
with Contessa-Nettel, Ernemann, and Ica to form
Zeiss-Ikon. Some Goerz models were continued
under the Zeiss name. In 1905, Mr. Goerz
organized C.P. Goerz American Optical Co. to
supply the steady demand for his products in the
United States. This company is still in business,
at the leading edge of space-age technology.*

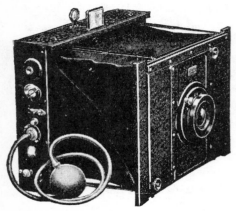

Ango - Strut-type folding camera with
focal plane shutter, introduced in 1896 as
the Anschütz camera. The ANGO name, a
contraction of ANschütz and GOerz, was
apparently adopted in 1905 after the
introduction of the new self-capping shutter.
This name was phased in slowly, however,
and does not appear in any catalogs we
have seen until after 1908. As for the
camera itself, the new self-capping shutter
shows up in 1906 catalogs. The Newton
finder has the rear sight changed from a
peep hole to a lens in 1907. By 1911, the
new model with both shutter and finder
improvements is called the Ango, while the
earlier style is still being sold as the
Anschütz, Model I. The same evolving
design was produced for at least 30 years.
Goerz Dagor f6.8, Dogmar f3.5, Syntor
f6.8, Double Anastigmat f4.6, or Celor f4.8
are among the lenses you could expect to
find. $80-120.

Ango Stereo - Same as Anschütz stereo.

Anschütz (box form) - c1892. (Note: An
earlier version, c1890, existed, but there
are currently no known examples, nor even
any illustration.) Dovetailed walnut box
camera for 9x12cm plates. Cloth focal plane
shutter. Goerz Extra-Rapid Lynkeioscop
lens. Folding sportsfinder. Uncommon.
$1200-1500.

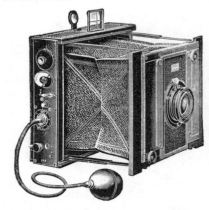

Anschütz (strut-type) - Introduced in
1896 and quite common with the press
during the early part of the century. A
bedless "strut" type folding camera, using
a focal plane shutter based on the design
of Ottomar Anschütz. The name was
gradually changed to the contracted form
"ANGO" between 1905-1910. Most often
found in the 6x9cm, 9x12cm, and 4x5"
sizes. $75-130.

Anschütz Deluxe - Similar, but green
leather panels and bellows. $250-400.

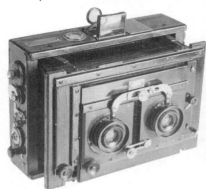

Anschütz Stereo - c1896-1921. Began life
as Anschütz, but was re-named "ANGO".
A focal plane strut-folding bedless stereo
camera for paired exposures on 8x17cm,
9x14cm or 9x18cm plates. Panoramic views
are also possible by sliding one lens board

to the center position. With Goerz Dagor Double Anastigmat or Goerz Wide-Angle Aplanat lenses. A relatively uncommon camera. $175-275.

Box Tengor - c1925. Made in two sizes for 6x9cm or 6.5x11cm exposures on rollfilm. Goerz Frontar f11 lens. 6.5x11cm: $40-60. 6x9cm: $25-35.

Folding Reflex - 1910-11. A compact folding single lens reflex camera for 4x5" plates. Designed to operate as an efficient full-size SLR, but be as portable as an ordinary press camera when folded. Made for only a short period due to patent problems. $225-275.

Folding rollfilm cameras - for 120 or 116 rollfilms. Various models with Goerz lens and Goerz or Compur shutter. $25-35.

Photo-Stereo-Binocle - c1899. An unusual disguised detective binocular camera in the form of the common field glasses of the era. In addition to its use as a single-shot camera on 45x50mm plates, it could use plates in pairs for stereo shots, or could be used without plates as

a field glass. f6.8/75mm Dagor lenses. $1500-2000.

Roll Tengor - c1925. Vertical folding rollfilm cameras. Cheaper lenses than the Roll Tenax.
4x6.5 cm - Vest Pocket size, 127 film. Goerz Frontar f9/45mm lens. Shutter 25-100, T,B. $35-50.
6x9cm - Tenaxiar f6.8/100mm in Goerz 25-100 shutter. $20-30.
6.5x11cm - Tenaxiar f6.8/125mm in Goerz 25-100 shutter. $20-30.

Tenax: listed by film type. Plate cameras followed by rollfilm cameras.

Vest Pocket Tenax (plate type) - c1909. Strut-type folding camera, 4.5x6cm plates. A smaller version of the "Coat Pocket Tenax". Goerz Double Anastigmat Celor f4.5/75mm, or f6.8 Dagor or Syntor lens. Compound, Compur, or guillotine shutter. $100-175.

Coat Pocket Tenax - c1912-25. 6.5x9cm on plates or film packs. Strut-type camera like the Vest Pocket Tenax. Goerz Dagor

f6.8/90mm or Dogmar f4.5/100mm lens. Compound shutter 1-250, T, B. $50-80.

Tenax Folding Plate cameras, bed type (Tenax, Manufoc Tenax, Taro Tenax, etc.) - Plate cameras c1915-1920. Folding bed type in common square-cornered plate camera style. Double extension bellows. Ground glass back.
9x12cm size - Goerz Dogmar f4.5/ 150mm. Dial Compur 1-150. $40-60.
9x12cm, Tropical - c1923. Teakwood with brass fittings. Brown or red leather bellows. Dogmar f4.5 or Xenar f3.5/135mm in dial Compur. $250-450.
9x14cm size - Goerz Dogmar f4.5/ 165mm. $60-90.
10x15cm - Goerz Dagor f6.8/168mm, or Tenastigmat f6.3. Compound or Compur shutter. $35-50.

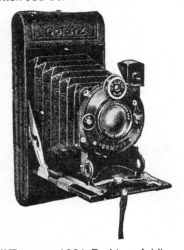

Roll Tenax - c1921. Bed-type folding rollfilm models.
4x6.5cm - Vest pocket size for 127 film. Similar to the folding vest pocket cameras of Kodak & Ansco. f6.3/75mm Dogmar in Compur shutter to 300. $50-75.

6x9cm - Tenastigmat f6.3/100mm in Compur shutter 1-250. $20-40.
6.5x11cm - Goerz Dogmar f5/125mm in Compur. $20-40.
8x10.5cm - Tenastigmat f6.8/125. $25-45.
8x14cm - Postcard (3¼x5½") size. Dogmar f4.8/165mm or Dagor f6.8 in Compur. $40-70.

Roll Tenax Luxus - c1925-26. Metal parts are gold-plated. Wine red leather covering and bellows. (Also made in blue/ green version.) Dogmar f4.5/75mm. Compur 1-300. Rare. Only known recent sale at auction in mid-1985 for about $800.

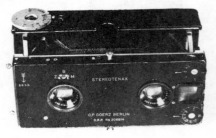

Stereo Tenax - c1912-25. Strut-type folding stereo camera for 45x107mm plates or packs. Goerz 60mm Dagor f6.8, Syntor f6.3, or f4.5 Dogmar or Celor. Stereo Compur or Compound shutter. $150-225.

Tengor - see Box Tengor, Roll Tengor

GOERZ (Optische Anstalt C.P. Goerz, Vienna) *This is a different company from C.P. Goerz, Berlin which existed from 1886-1926.*

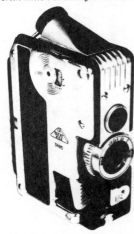

Minicord - c1951. Subminiature TLR for 10x10mm exp. on 16mm film in special cartridges. f2/25mm Goerz Helgor lens. Metal FP shutter 10-400, sync. $225-350.

Minicord III - c1958. Brown leather covered. $225-350.

GOLDAMMER (Gerhard Goldammer, Frankfurt)
Golda - c1949. 35mm, uncoupled RF. Trinar f3.5/45mm in Prontor II or Radionar f2.9/50mm in Prontor-S. $50-70.

Goldeck - c1960. Rigid-bodied 120 rollfilm camera, telescoping lensmount. 6x6cm. Steiner f3.5/75; Vario 1/25-200,B. $20-35.

Goldeck 16 - c1959. Subminiature for 10x14mm exposures on 16mm film. Interchangeable "C" mount f2.8/20mm Enna-Color Ennit lens. Behind the lens shutter. Several models exist. Standard model has fixed focus lens in Vario shutter. Model IB is similar, but with focusing mount. The Super Model has a 9-speed Prontor shutter and front cell focusing. All have rapid wind lever, bright frame finder. While classified as a subminiature because of its small film, the camera is about the same size as a compact 35mm camera. With normal and telephoto lenses: $75-110. With normal lens only: $60-90.

Goldix - c1950's. Unusual brick-shaped camera for 4x4cm on 127 film. Eye-level viewfinder is built into the far side of the body. Goldeck f7.7/60mm. Singlo-2 shutter 30-100. $20-25.

GuGo - c1950. Low priced 6x6cm camera with telescoping front. Similar to the Welta Perle Jr. 120. Kessar f4.5/75mm in Vario 25-200. $15-20.

GOLDMANN (R. A. Goldmann, Vienna)
Amateur Field Camera, 9x12cm - c1895-1900. Wood body with brass trim, tapered bellows. Goerz Doppel Anastigmat f4.6/150mm. $125-150.

Field camera, 13x18cm - c1900. Reversible back, Aplanat lens, mahogany body with brass trim. $125-150.

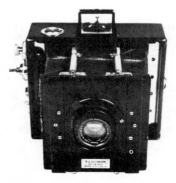

Press camera - c1900. Bedless strut-

folding 9x12cm plate camera. Zeiss Tessar f6.3/135. Focal plane shutter T, B, ½-90. Black wood body, leather bellows, nickel trim & struts. $150-175.

Universal Stereo Camera, 9x18cm - c1906. Strut-type focal plane stereo camera. Ebonized wood body. Tessar f6.3/136mm lens. Rare. $750-900.

GOLDSTEIN (France)
Goldy - c1947. Box camera of heavy cardboard with colored covering. Takes 6x9cm on 120 film. Built-in yellow filter. Made in black, blue, white, red, green, and maroon. Also available under such diverse names as Spring, Superas, Week-End, and Racing. Colors: $15-25. Black: $5-10.

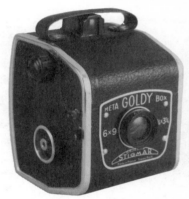

Goldy Metabox - Vertically styled aluminum box camera with tapered front. Rigid Galilean finder on top under strap. Takes 120 or 620 film. Double exposure prevention. $15-20.

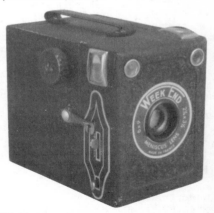

Week End - Stamped aluminum 6x9cm box camera with black crinkle finish. $15-25.

GOLTZ

GOLTZ & BREUTMANN (Berlin and Dresden)
Started in Berlin and later moved to Dresden. Began the manufacture of reflex cameras and strut cameras in 1898 and probably made more than anyone else in the world except Graflex. The company name was changed from "Goltz & Breutmann Fabrik Photogr. Apparate" to "Mentor-Kamera-Fabrik". Later model Mentor cameras were made by Rudolph Grosser, Pillnitz. All Mentor cameras are listed here, including those manufactured by Mentor-Kamera-Fabrik, or Rudolph Grosser.

Klein-Mentor - c1913-35. A small SLR for 6x9cm and 6.5x9cm formats. Fold-up viewing hood. Measures 3½x4x4¾" when closed. This camera is a smaller version of the Mentor Reflex. Triotar f6.3/135mm in Compur 1-250. $125-175.

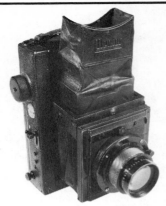

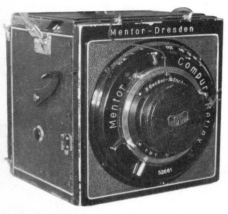

Mentor Compur Reflex - c1928. SLR box for 6.5x9cm plates. Also made in less common 9x9cm size. Zeiss Tessar f4.5/ 105 or f2.7/120mm lens. Compur shutter 1-250. Reflex viewing, ground glass at rear, and adjustable wire frame finder. Black metal body, partly leather covered. $95-175.

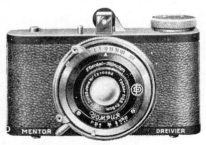

Mentor Dreivier - c1930. An eye-level camera for 16 exposures 3x4cm on 127 film. Styled much like a 35mm camera. Tessar f3.5/50mm lens in Compur shutter 1-300. Rare. $500-750.

Mentor Folding Reflex (Klappreflex) - c1913-1930. Compact folding SLR in four different styles. The only common style folds up tall and thin and was made in a wide range of sizes, including 6x9cm, 9x12cm and 4x5". Zeiss Tessar lenses, usually f2.7 or f4.5. Focal plane shutter to 1000. $150-200.

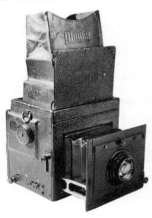

Mentor Reflex - c1898-1960's. Basically a cube when closed. Fold-up viewing hood, bellows focus, focal plane shutter. Various styles with or without bellows or R.B. in three common sizes: 6.5x9cm, 9x12cm, and 10x15cm. For plates or packs. Most common lenses are f4.5 Tessar, Heliar, and Xenar. $150-225.

Mentor Sport Reflex, 9x12cm - c1936. Box-form SLR without bellows. This is the only post-1905 Mentor Reflex without bellows. Tessar f4.5/135mm lens. FP 1/8-1300. Rare. $175-200.

Mentor Stereo Reflex - c1913-25. Bellows focusing focal plane box reflex for stereo pairs in the two common European

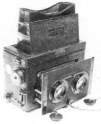

stereo sizes: 45x107mm, with Tessar f4.5/75mm lenses, and 6x13cm with Tessar f4.5/90mm lenses. Both sizes have focal plane shutter 15-1000. $300-450.

Mentor II - c1907. A strut-folding 9x12cm plate camera (NOT a reflex). Triplan f6/125mm or Tessar f4.5/120mm lens. FP shutter. Wood body covered with black leather. Ground glass back. $100-150.

Black bakelite 6x6cm reflex style camera. 620 rollfilm. It is an export model of the Palma Brillant Model 2 which used 120 film. $8-12.

G.P.M. (Giuseppi Pozzoli, Milano, Italy) Fotonesa - c1945. Black bakelite subminiature, 20x20mm exposures. Frontar Periscop f8. I,T sh. Uncommon. $125-175.

GRAEFE & BARDORF (Berlin)

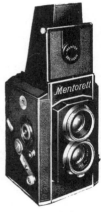

Mentorett - c1936. TLR for 12 exposures 6x6cm on 120 film. Mentor f3.5/75mm. Variable speed focal plane shutter, 1/15-1/600 sec. Film transport, shutter setting and release are all controlled by a single lever. Automatic exposure counter. This is a rare camera, which shows up about once a year at auction in Germany, where it sells in the range of $435-800.

GOMZ (USSR)
Sport (Cnopm) - c1935. 35mm SLR. Industar f3.5/50mm lens, shutter 1/25-500. 50 exposures 24x36mm in special 35mm cassettes. $800-1000.

GOODWIN FILM & CAMERA CO. *Named for the Rev. Hannibal Goodwin, the inventor of flexible film, but taken over by Ansco. See Ansco for the listing of "Goodwin" cameras.*

GOYO CO. (Japan)
Rosko Brilliant 620, Model 2 - c1955.

Clarissa, Tropical - 4.5x6cm plate camera. Light colored wood body with red bellows. Brass struts and lens barrel. Some have wooden front standard, others have brass front. Focal plane shutter 1/20-1000. Meyer Görlitz Trioplan f3/75mm. $1200-1800.

GRAFLEX, INC. *(Also including Folmer & Schwing and Folmer Graflex products from 1887-1973 except Cirkut cameras which are listed under Eastman.)*
Founded in 1887 as a partnership between Wm. F. Folmer & Wm. E. Schwing and incorporated in 1890 as the Folmer & Schwing Manufacturing Co., it began camera manufacturing in 1897. It incorporated in 1903 as the Folmer & Schwing Manufacturing Co. of New York. George Eastman purchased the company in 1905, moving it to

Rochester NY where it was called the Folmer & Schwing Co., Rochester. The company dissolved in 1907, becoming first the Folmer & Schwing Division of Eastman Kodak and then in 1917 the Folmer & Schwing Department of Eastman Kodak Co. The new Folmer-Graflex Corporation took over the reins in 1926, changing its name to Graflex Inc. in 1945. Graflex was a division of General Precision Equipment Corp. from 1956 until 1968 when it became a division of Singer Corporation. In 1973, Graflex dissolved and Singer Educational Systems was formed, the latter being bought by Telex Communications in 1982.

BRIEF EXPLANATION OF SERIAL NUMBERS ON GRAFLEX CAMERAS

The numbers on the attached chart have been taken directly from the original company serial number book. The first existing page of that book starts somewhere in the year 1915. From observations of actual cameras made previous to 1915 it would be safe to assume that the serial numbers run sequentially at least back to 1905. Because of the purchase of Folmer & Schwing in 1905 by Eastman Kodak, it is not known at this time whether the serial numbering was changed because of that purchase. Furthermore, it must be kept in mind that Folmer & Schwing did not actually start manufacturing their own cameras until 1897. Before that year, the cameras that they offered under their own name were manufactured by someone else. The question is; was the serial numbering started before 1897, or only after the company began its own manufacturing? Also, whenever the serial numbering started did it begin with number 1?

The attached chart only takes the serial numbers through the end of 1947. After that year, a great deal of confusion begins, and it would take more room than the Price Guide allows to explain it all. Basically, after 1947 different camera models were assigned different serial number blocks, and the blocks do not run sequentially. In addition, several numbers were repeated within the same camera model line. The serial number list will be printed in its entirety and the confusion minimized in the forthcoming book on the history of Graflex by Roger M. Adams.

The accompanying chart should also be used only as an approximation, as it reflects only the dates that the serial numbers were entered in the book. The cameras were actually made sometime during the following 8-12 months. It should NOT be used to figure the total amount of cameras that were manufactured as some cameras were scrapped and others were never made, even though the serial numbers had already been assigned. The serial number book was never changed to show any of these variations. Actual production figures may never have existed, and if they did, have not been located as of this date.

Serial Numbers	Dates
Folmer & Schwing Division/Department	
47,000- 87,976	1915-12/5/18
87,977-113,431	12/5/18-1920
113,432-122,949	1921-1922
122,950-147,606	1923-1925
Folmer-Graflex Corporation	
147,607-159,488	1926-1927
159,489-175,520	1928-1930
175,521-183,297	1931-1933
183,298-229,310	1934-1937
229,311-249,179	1938-1939
249,180-351,511	1940-6/15/45
Graflex, Inc.	
351,512-457,139	7/30/45-1947

A great deal of information in this section was used with the kind permission of Mr. Richard Paine, from his 1981 book "A Review of Graflex" published by Alpha Publishing Co., Houston, Texas. Collectors wishing more detailed information on Graflex cameras should consult this book.

We would also like to thank Roger Adams for reviewing this section and adding notes and corrections where necessary. Mr. Adams is currently working on a book on Graflex cameras, and he invites readers who are interested in Graflex to contact him at 675 Fairview Dr., #246-249, Carson City, NV 89701, (702)-882-5777. He is interested in everything related to the Graflex companies, including apparatus, literature, advertising, documents, records, employee papers, awards, banners, etc. He will be happy to field questions on any areas of collecting, and would like to make contact with anyone who has Graflex lore to share, especially former employees.

NOTE: To keep major lines together, we have divided this section into three parts, each in alphabetic order:
1. Graflex Single Lens Reflex Cameras.
2. Graphic cameras, including press and small format types.
3. Other cameras made by Graflex Inc.

GRAFLEX SLR CAMERAS: *All models have focal plane shutters to 1000, unless otherwise noted.*

Graflex (original) - c1902-05. (Earliest patent granted 11/5/01.) Boxy SLR with fold-up viewing hood. Stationary back. Top-hinged door covers the interchangeable lens. Focal plane shutter to 1200. Shutter controls on one piece plate. Normal lenses f4.5 to f6.8. Rare, negotiable. Estimates: 4x5" and 5x7": $250-500. 8x10": Find one first, then ask the price!

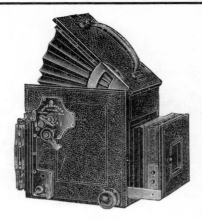

Graflex 1A - 1909-25. 2½x4¼" on 116 rollfilm. B&L Tessar f4.5 or f6.3, Zeiss Kodak Anastigmat f6.3, or Cooke f5.6 lens. Early cameras have an "accordian" style hood with struts for support. Later ones have the more typical folding hood. Autographic feature available 1915-on. $85-110.

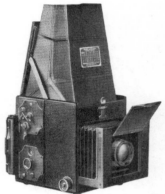

Auto Graflex, early and later versions

at back. Bulge at rear for reverse-wind curtain. Extensible front. Same body later used in the 2¼x3¼" series B. $90-125.

Graflex 3A - 1907-26. 3¼x5½" "postcard" size, 122 film. Minor body changes, such as the addition of the autographic feature in 1915. Various lenses, f4.5 to f6.8. $75-125.

Auto Graflex - 1906/07-1923. (Patented 2/5/07.) Stationary Graflex back. Extensible front with lens door hinged at top. Normal lenses f4.5 to f6.8. Design changes include: Pleated hood with front hinge, 1907-c.1910. Folding hood with front hinge c.1911-15. Folding hood with rear hinge 1916-23. 3¼x4¼": $60-90. 4x5": $75-125. 5x7": $150-200. *Add $50 for early model with pleated hood. Illustrated top of next column.*

Auto Graflex Junior 2¼x3¼" - 1914-24. Stationary Graflex back. Top door hinges

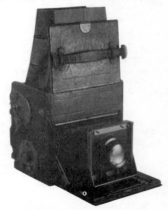

Compact Graflex - Stationary Graflex

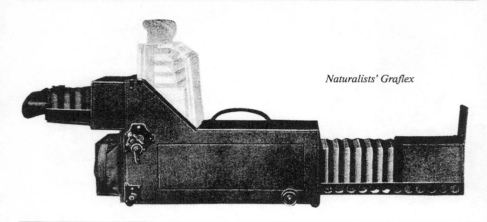

Naturalists' Graflex

back. Top door hinged at front. Front bed.
Double curtain to cap shutter.
3¼x5½" - 1915-24. $125-175.
5x7" - 1916-25. $200-250.

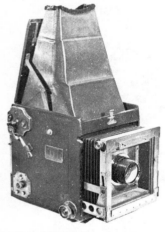

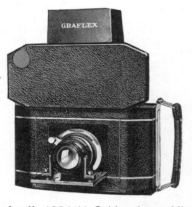

Home Portrait Graflex - 1912-42. 5x7".
Revolving back. Focal plane shutter ½-500.
Was also available as the "Special Press
Model" with a high speed shutter to 1000.
The focal plane shutter could be set to
pass one, two, or more of the aperture
slits for a single exposure, thus allowing a
very broad range of "slow" speeds. Normal
lenses f4.5 to f6.3. This camera was used
as the basis for "Big Bertha". $250-300.

National Graflex - SLR for 2¼x2½" on
120 rollfilm. Focal plane shutter to 500, B.
B&L Tessar f3.5/75mm. Two models:
Series I - 1933-35. Non-interchangeable
lens. Mirror set lever at operator's right of
hood. $125-200.

Series II - 1934-41. Cable release. Mirror
set lever at operator's left of hood. Ruby
window cover. With normal f3.5/75mm
lens: $100-160. (With additional B&L f6.3/
140mm telephoto add $75-100.)

Naturalists' Graflex - 1907-21. One of
the rarest of the Graflex cameras, it has a
long body and bellows to accomodate
lenses up to 26" focal length. 1907 model
has a stationary viewing hood, set to the
rear. After that, viewing hood could be
positioned to view from top or back. $2000-
2500. *Illustrated top of this page.*

Press Graflex - 1907-23. 5x7" SLR.
Stationary detachable spring back. Focal
plane shutter 1/5-1500. Extensible front.
No bed. Normal lenses f4.5 to f6.8. $250-
350. *Illustrated next page.*

Reversible Back Graflex - c1902-05.
Very similar to the original Graflex camera,
but reversible back. 4x5" and 5x7" sizes.

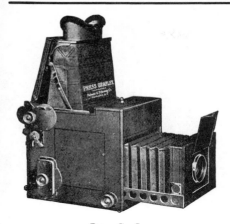

Press Graflex

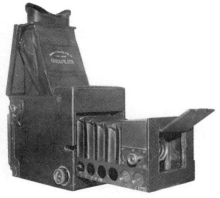

Focal plane shutter to 1200. Knob on the frcnt standard to raise or lower the lensboard. $250-500.

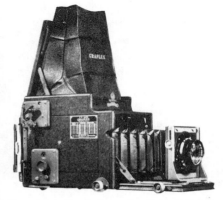

Revolving Back Auto Graflex - Normal lenses f4.5 to f6.8.

3¼x4¼" - 1909-41. Style of 1909-16 has front door which forms bed, unlike earlier 4x5" model; front hinged top lid, 3x3" lensboard. Style of c1917-41 has unique top-front curve, rear hinged top lid, and 3¼x3¼" lensboard. $100-150.
4x5" - 1906-41. Early models (1906-08) are styled like the original Graflex. Extensible front racks out on two rails; front flap covers lens. Later styles as with 3¼x4¼" size above, but with 3.75x3.75" lensboard. $125-175.

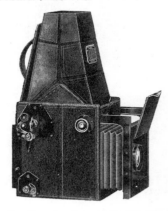

R.B. Graflex Junior - 1915-23. 2¼x3¼". Revolving back. Fixed lenses, normally f4.5 to f6.3. Lensboard suspended from focusing rails. Similar body style later used for the R.B. Series B. Rare. $110-175.

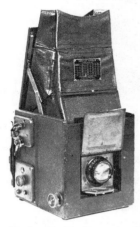

Graflex Series B - Stationary back. Kodak Anastigmat f4.5 lens. Small front door opens allowing lens and small bellows to extend.
2¼x3¼" - 1925-26 only. Rare. $150-255.
3¼x4¼" - 1923-37. $60-90.
4x5" - 1923-37. $75-125.
5x7" - 1925-42. $150-200.

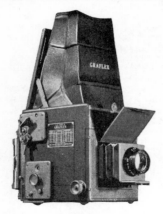

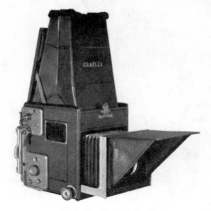

R.B. Graflex Series D

R.B. Graflex Series B - Revolving back. Kodak Anastigmat f4.5 lens.
2¼x3¼" - 1923-51. Same body style as earlier RB Graflex Junior. Small front door opens allowing lens and small bellows to extend. $100-150.
3¼x4¼" - 1923-42. Same body style as RB Tele Graflex. $75-125.
4x5" - 1923-42. Same body style as RB Tele Graflex. $75-125.

R.B. Super D Graflex - Revolving back SLR. Flash synch on focal plane shutter. Automatic stop-down diaphragm. Minor variations made during its life.
3¼x4¼" - 1941-63. Normal lenses: Kodak Anastigmat f4.5, Kodak Ektar f4.5 and f5.6. $150-225.
4x5" - 1948-58. f5.6/190mm Kodak Ektar or Graflex Optar. $275-350.

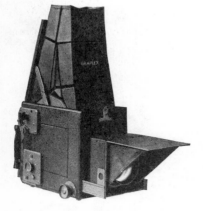

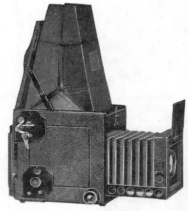

R.B. Graflex Series C - 1926-35. 3¼x4¼" only. Revolving back. Fixed Cooke Anastigmat f2.5/6½" lens. Extensible front with hood over the lens. Rare. $125-175.

R.B. Graflex Series D - Same body as the earlier RB Tele Graflex and RB Series B. Interchangeable lensboards. Extensible front with hood over the lens. Grey-painted hardware. Later 4x5" models have black hardware and chrome trim.
3¼x4¼" - 1928-41. $60-110.
4x5" - 1928-47. $125-175.
Illustrated top of next column.

R.B. Tele Graflex - 1915-23. Revolving back. Designed with a long bellows to allow the use of lenses of various focal lengths. Same body used for RB Graflex Series B beginning in 1923. 3¼x4¼": $75-125. 4x5": 110-140.

Stereo Graflex - 1904-05. 5x7" stereo SLR. Stationary back. Similar to style to the original Graflex, but wider to allow for stereo exposures. Two magnifiers in the hood. Quite rare. $2000-2500. *Illustrated top of next page.*

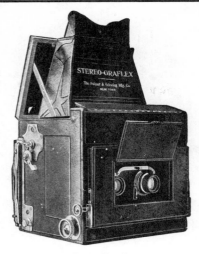

Stereo Graflex

No. 0 Graphic - 1909-23. 1⅝x2½" on rollfilm. Focal plane shutter to 500. Fixed-focus Zeiss Kodak Anastigmat f6.3 lens. $175-235.

Stereo Auto Graflex - 1906-23. 5x7" stereo SLR with only minor improvements having been made on the Stereo Graflex. Stereo prisms in the viewing hood resulted in one STEREO image on the ground glass. That has to be the ultimate composing aid for stereo photographers. Rising front. Very rare. $1500-2000.

Tourist Graflex - c1902-05. Stationary back. Extensible front. Sliding-door covers interchangeable lens. Shutter controls on one piece plate. 4x5" and 5x7" sizes. Very rare. Estimate: $300-600.

GRAPHIC CAMERAS:
Graphic camera - c1904. Simple plate cameras with single extension red bellows. No back movements. 4x5", 5x7", 8x10". $125-150.

Century Graphic - 1949-70. 2¼x3¼" press camera. Basic features of the Pacemaker Crown Graphic, but no body release, Graflock back only, and has a plastic body. Black or grey body with black or red bellows. With Ektar f4.5: $150-200. With Xenotar f2.8: $200-250.

Combat Graphic - c1942. 4x5" military camera made for the armed forces in WWII. Rigid all wood body, without bellows. Olive drab color. No tension knob on shutter. Sold as a civilian model "Graphic 45" in 1945. $175-275. *Illustrated top of next page. Note: the name "Combat Graphic" has been applied by collectors to other military models of conventional cameras, but we have listed those by their proper designation after the corresponding civilian models. See Anniversary Speed Graphic for KE-12(1), and Super Speed Graphic for KE-12(2). The 70mm model KE-4(1) is with the miscellaneous models at the end of the Graflex Inc. section.*

Crown Graphic Special - c1958-73. Same as the 4x5" Pacemaker Crown Graphic, but sold with a Schneider Xenar f4.5/135mm lens. Rangefinder/viewfinder mounted on top. Synchro-Compur 1-500,B. $200-250.

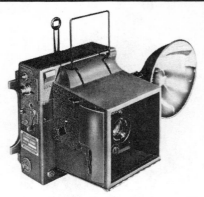

Combat Graphic

Deceptive Angle Graphic - c1904. Box camera for 3¼x4¼" exposures using double plate holders, magazine plate holder or cartridge rollholder. The 1904 Graflex catalog calls it "in every sense of the word a detective camera, being thoroughly disguised to resemble a stereo camera and so arranged as to photograph subjects at right angles to its apparent line of vision." Quite rare. Estimate: $2000-3000.

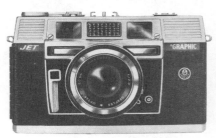

Graphic 35 Jet - c1961. An unusual design, incorporating an auto advance mechanism powered by CO_2 cartridges. Made by Kowa. Quite prone to problems with both the shutter and the CO_2 advance system. Completely operational, with original case, box, and a few spare cartridges: $200-250. As normally found with the CO_2 system inoperative: $75-125. With shutter also bad: $40-60. *Note: Because of the problems with the CO_2 advance mechanism, a completely manual model was also made.*

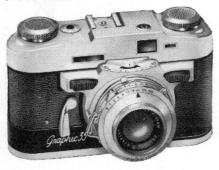

Graphic 35 - c1955-58. 35mm camera designed and built in the U.S.A. by Graflex. Lens and shutter made in Germany and imported by Graflex for use on this camera. Graflar f3.5 or 2.8/50mm lens in helical mount with unique push-button focus. Prontor 1-300. Coupled split-image rangefinder. $25-40.

Graphic 35 Electric - c1959. 35mm camera with electric motor built into the takeup spool. Made by Iloca in Germany. Ysarex f2.8 or Quinon f1.9 in Synchro Compur shutter. Interchangeable front lens element. Coupled meter. In excellent working condition: $100-135. Often found with inoperative motor: $30-50.

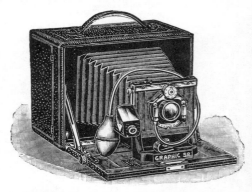

Graphic Sr. - c1904. Very similar to the Graphic camera of the same era, but with

swing back. Red bellows. Polished brass trim. 4x5" or 5x7". $75-150.

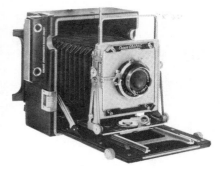

Pacemaker Crown Graphic - Front shutter only. No focal plane shutter. Built-in body release with cable running along bellows. Metal lensboard. Hinged-type adjustable infinity stops on bed. Wide range of current prices.
2¼x3¼" - 1947-58. $100-155.
3¼x4¼" - 1947-62. $75-125.
4x5" - 1947-73. (Top mounted Graphic rangefinder with interchangeable cams added in 1955.) $150-250.

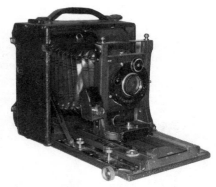

Reversible Back Cycle Graphic - c1900-06. "Cycle" style cameras with reversible back. Black leather, rising front, triple-extension red bellows. Interchangeable lensboards.
3¼x4¼" & 4x5" sizes - $100-125.
5x7" & 6½x8½" sizes - $125-175.

Reversible Back Cycle Graphic Special - 1904-06. Similar to the original R.B. Cycle Graphic, but sturdier design. Double-swing back. Rising/falling, shifting front. Drop-bed. Front and back focusing. Black leather, triple extension black bellows. Grey-oxidized brass trim. An accessory focal plane shutter was available. 5x7" and 6½x8½" sizes. Quite rare. $150-200.

Revolving Back Cycle Graphic - 1907-1922. Very similar to the Reversible Back Cycle Graphic (above), but has revolving back, no back focus or rear movements. Accessory FP shutter available. 4x5": $75-125. 5x7", 6½x8½", 8x10": $200-250.

SPEED GRAPHIC CAMERAS *Many modifications and improvements were made in these cameras during their exceptionally long life-span (1912-68), so they are usually sub-divided for identification purposes into the following periods: Early (or top handle), Pre-anniversary, Anniversary, and Pacemaker. All models have focal plane shutters. The Speed Graphics are listed here in essentially chronological order.*

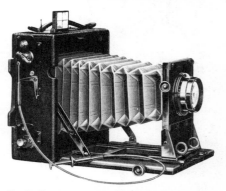

Early Speed Graphics - Top handle. Barrel lenses. Tapered bellows, almost double extension. Rising front. Folding optical finder with cross-hairs. Single focus knob on wooden bed.
3¼x4¼" - 1915-25. $70-120.
3¼x5½" - 1912-25. $110-160.
4x5" - 1912-27. (More compact Special Speed Graphic introduced 1924.) $75-125.
5x7" - 1912-24. $140-190.

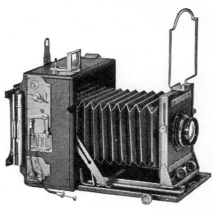

Pre-anniversary Speed Graphic - Side

265

handle. Larger, straight bellows to accomodate a larger lens standard and lensboard. Wooden bed with single focus knob. Grey trim. Early versions with folding optical finder, later with tubular finder. Hinged (not telescoping) sportsfinder.
3¼x4¼" - 1935-39. $60-100.
4x5" - 1928-39. $85-135.
5x7" - c1932-41. $150-200.

Miniature Speed Graphic - 1938-47. 2¼x3¼". Could almost be classified as an Anniversary model with its two focus knobs on the metal bed and chrome trim, but other features from the pre-anniversary years remain. The bed does not drop; the front does not shift. The sportsfinder is hinged, not telescoping. Earliest models with folding optical, later with tubular finder. $90-150.

Pacemaker Speed Graphic - Metal lensboard. Two focus knobs on the metal drop-bed. Built-in body release with cable running along the bellows. Single control on focal plane shutter. Hinged adjustable infinity stops on bed. Telescoping sports-finder. Tubular viewfinder. Chrome trim. Prices vary widely. Most fall into the ranges listed, and there is no shortage of these cameras, but some vendors consistently advertise at higher prices.
2¼x3¼" - 1947-58. $150-175.
3¼x4¼" - 1947-63. $100-150.
4x5" - 1947-68. (Top mounted Graphic rangefinder with interchangeable cams added in 1955.) $150-250.
Military model KE-12(1) - 4x5". Optar f4.5/127mm. Olive drab leather & enamel: $150-250. Full set KS-4A(1), with flash unit, film holders, tripod, etc. in Halliburton case. $225-350.

Anniversary Speed Graphic - 1940-47. Metal drop-bed with two focus knobs. Rising/shifting lens standard. Wooden lensboard. Telescoping sportsfinder. No body release for front shutter. All black (wartime models) or chrome trim. 3¼x4¼": $70-100. 4x5": $95-150.

Stereoscopic Graphic - c1902-21. Solidly built 5x7" stereo camera. Rising front. Drop bed. Black bellows. Grey metal parts. Focal plane shutter. Very rare. $1200-1500.

Stereo Graphic (35mm) - ca. mid-1950's for stereo pairs on 35mm film. Graflar f4/

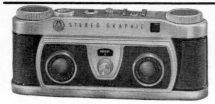

35mm lenses, shutter 1/50,B. $50-75.

Super Graphic - 1958-73. 4x5". All-metal press style camera. Built-in coupled rangefinder. Focusing scale for lenses from 90 to 380mm. Normal lenses include: Kodak Ektar f4.7/127, Schneider Xenar or Graflex Optar f4.7/135mm. Rise, swing, shift, tilt front movements. Revolving back. Electric shutter release. $250-400.

Super Speed Graphic - 1959-70. 4x5". Same as the Super Graphic (above), but with Graflex-1000 front shutter. No focal plane shutter. $250-350.
Military KE-12(2) - with tripod, flash, etc. & olive drab Halliburton case: $250-350.

Graphic View II

Graphic View - 1941-48. 4x5" monorail view camera. Without lens: $135-165.

Graphic View II - 1949-67. Improved version of the Graphic View. Has center axis tilts, not available on Graphic View I, and longer bellows. Without lens: $175-225. *Illustrated bottom of previous column.*

MISCELLANEOUS CAMERAS FROM GRAFLEX INC.:

Century 35 - c1961. 35mm camera made by Kowa in Japan. Several models including A, N, NE. Prominar f3.5, 2.8, or 2.0 lens. Similar to the Kallo 35. $20-40.

Century Universal - c1929-36. Triple extension view camera with reversible back, full front movements. 8x10". $75-100.

Ciro 35 - c1950. 35mm RF, formerly sold by Ciro Cameras Inc. f4.5, 3.5, or 2.8 lens. Alphax or Rapax shutter. $20-35.

Crown View - 1939-42. Wooden 4x5" view camera. 4x4" lensboards interchangeable with 4x4" Speed Graphic. Rare. $185-250.

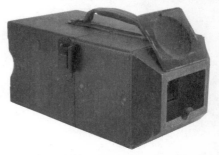

Finger-Print Camera - 2¼x3¼". A special-purpose camera for photographing fingerprints or making 1:1 copies of other photos or documents. Pre-focused lens is recessed to the proper focal distance inside a flat-black rigid shroud. To make an exposure, camera front opening is placed directly on the surface to be photographed. Four battery-operated flashlight bulbs provide the illumination. (Two similar cameras called the Inspectograph (see listing below) and Factograph were also

made. The Factograph used special positive paper film on a roll. Later models of the Factograph became very specialized using bulk loads of film, motorized advance, and special lighting and bore no resemblance to the earlier models.) $75-110.

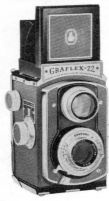

Graflex 22 - TLR for 6x6cm on 120 film. Optar or Graftar f3.5/88mm. Century Synchromatic or Graphex shutter. Fairly common. $30-45.

Inspectograph Camera - Identical to the Fingerprint camera, but wired for 110V AC current instead of built-in batteries. Only about 500 made. $75-110.

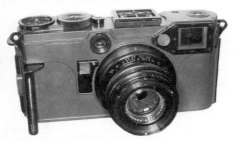

KE-4(1) 70mm Combat Camera - c1953. Civilian black or Signal Corps Model in olive drab. For 5.5x7cm exposures on 70mm film. Designed by the late Hubert Nerwin, formerly of Zeiss Ikon, the camera resembles an overgrown Contax and is nicknamed "Gulliver's Contax". A few years ago, these were scarce and highly sought. Then Uncle Sam started disposing of them, and now they are very easy to find. Consequently, prices have dropped and they are harder to sell. Many are still advertised at higher prices, but one major dealer reported advertising an outfit with two lenses, flash, and case for 7 months at $495 before it finally sold. The f4.5/2½" Ektar wide angle is the least common lens. Camera set KS6-(1) with normal, tele, and

W.A. lenses, case: $750-1000 in USA. Often found with f2.8/4" and f4/8" Ektar lenses, flash, and Halliburton case: $500-600 asking prices. Camera with normal lens only: $300-400. Mint examples have sold in Europe for 2-3 times the USA prices.

Norita - c1969-73. Eye-level SLR for 6x6cm on 120 or 220 film. Three models: Deluxe, Professional (with front shutter), and Super Wide. Made by Norita Kogaku K.K. in Tokyo, imported by Graflex. Originally imported as the Warner. Noritar f2/80mm lens in interchangeable breech-lock mount. Focal plane shutter 1-500. $300-350.

Photorecord - Developed around 1934, introduced to the open market in 1936. Made through the 1950's in many different forms and models, including civilian and military versions. Special purpose camera for microfilming, personnel identification, and copy work. All versions were designed around the same basic heavy cast metal camera and film magazine unit, and were offered as complete outfits including lights, stands, copy or I.D. apparatus. Designed for use with 100 ft. rolls of 35mm film, they were capable of 800 "double frame" or 1600 "single frame" exposures. Also capable of single exposures using Graflex plate or film holders. Camera with film magazine: $75-125.

GRAY (Robert D. Gray, NYC)
Vest Camera - c1885. All metal disc-shaped camera designed to be worn under a vest. Forerunner of the more common Stirn Vest Camera. Manufactured for Gray by the Western Electric Co. Takes 6 round exposures on an octagonal glass plate. $1000-1500.

View camera - c1880. 8x10". Periscope No. 4 lens, rotary disc stops. $175-200.

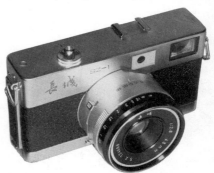

GREAT WALL SZ-1 - c1976. People's Republic of China 35mm spring-motor camera. CRF. f2.8/45mm coated lens, rotating 1/30-1/300 shutter. Leather covered aluminum body. $50-60.

GREEN CAMERA WORKS (Japan)

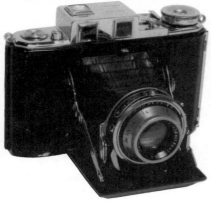

Green 6x6 - c1950. Horizontally styled folding camera for 6x6cm on 120. Waist-level and eye-level finders. Green Anastigmat f3.5/75mm in Pisco 1-250,B,T shutter. $100-150.

GRIFFIN (John J. Griffin & Sons, Ltd., London)

Pocket Cyko Cameras - c1902. Folding cameras of unusual book form, designed by Magnus Niell, the Swedish designer who is also responsible for the popular Expo and Ticka designs. Also sold on the continent under the name "Lopa". Several sizes and styles, including the No. 1 for 6.5x9cm plates, and the No. 2 with magazine back for 8x10.5cm plates. No. 2: $500-750. No. 1: $400-600.

GRIFFITHS (Walter M. Griffiths & Co., Birmingham, England)
Guinea Detective Camera - c1895. Leather covered cardboard camera in the shape of a carrying case. The top hinges to one side to change plateholders, and the front conceals a guillotine shutter. $175-225.

GROSSER (Rudolph Grosser, Pillnitz)
Manufacturer of Mentor cameras during the 1950's. However, all Mentor Cameras are listed in this edition under Goltz & Breutmann.

GRUNDMANN
Leipzig Detective Camera - All wood box detective camera for 9x12cm plates. String-set shutter. $800-850.

Stereo camera - Mahogany with brass trim, brass bound Rapid Symmetrical lenses. 4¼x6½" plates. $225-250.

GUÉRIN (E. Guérin & Cie., Paris)
Guérin also worked with Lucien Leroy. We have a 1916-1917 catalog from Lucien Leroy which is overstamped with the name "L. Leroy & E. Guérin".
Le Furet - c1923. Small, early 35mm camera for 25 exposures 24x36mm using special cassettes. This is the smallest of the pre-Leica 35mm cameras. $800-1000.

Minimus Leroy - c1924. Rigid body 6x13cm stereo jumelle. $175-225.

GUILFORD - Polished walnut 5x7" English view camera with brass fittings. Brass-barreled Ross Extra Rapid lens. $150-175.

GUILLEMINOT (Guilleminot Roux & Cie., Paris)
Guilleminot Detective Camera - c1900. Polished walnut detective camera for 9x12cm plates. Brass knobs rack front panel forward and concealed viewfinders are exposed. Brass carrying handle and fittings. Aplanat f9/150mm lens. Eight speed rotary sector shutter. $800-900.

GUNDLACH OPTICAL CO., GUNDLACH MANHATTAN OPTICAL CO.
(Rochester, N.Y.) *Originally founded by Ernst Gundlach for the production of optical goods, but for most of the company's history it was operated by H.H.Turner, J.C.Reich, & J.Zellweger. Gundlach Optical Co. acquired the Milburn Korona Company in 1896, which added a line of cameras to their line of lenses. Shortly thereafter, they joined with Manhattan Optical to become one of the leading sellers of dry-plate cameras well into the 1900's. The company was taken over by John E. Seebold in 1928 and the name changed to "Seebold Invisible Camera Company."*

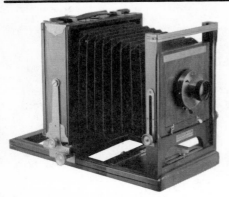

Criterion View - c1909-1930's. Traditionally styled wooden view, virtually unchanged in appearance from its 1909 Gundlach catalog listing to the mid-1930s catalogs of Burke & James. Made in 5x7", 6½x8½", and 8x10" sizes. Current value is still as a good used view camera, depending on size and condition. $75-150.

Korona cameras - classified here by size: **Korona 3¼x4¼, 3¼x5½" -** Folding plate, including "Petit" models. Cherry wood body, leather covered. Red bellows. $30-60.

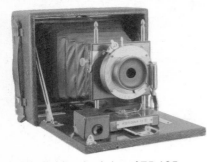

--4x5" - Folding bed view. $75-125.
--5x7" - as above two listings. $75-135.

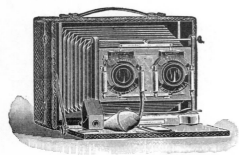

--5x7" Stereo - Folding plate camera for

stereo exposures on standard 5x7" plates. Leather covered wood body, polished wood interior. Simple stereo shutter. $300-360.

Korona 6½x8½" view - $100-150.
Korona 8x10" view - $200-250.

Korona 7x17, 8x20, and 12x20" Panoramic View - usually called "Banquet" cameras. With holder, without lens: $200-300. Add for lens, depending on type. A good working outfit with several holders and a good lens & shutter will bring $350-650.

Long Focus Korona - $140-190.

Milburn Korona - c1895. Beautiful mahogany folding plate camera made for the Milburn Korona Co. Single extension red bellows. Brass trim, brass f8 lens. Pneumatic shutter. One fine example sold for $500 at a German auction in 9/87.

HACHIYO KOGAKU KOGYO (Suwa, Japan)
Alpenflex - c1952-54. A series of TLR cameras. Alpo f3.5/75mm lens in Orient II or III shutter. $50-75.

Supre-Macy - c1952. TLR made for Macy's of New York. Similar to Alpenflex IS. Alpo f3.5/75 in Orient II shutter B,1-200. $50-75.

HACOFLEX - 1950s. Japanese Rolleiflex copy with Tri-Lausar f3.5/80mm lens, shutter 1-300. $40-60.

HADDS MFG. CO. - see Foto-Flex Corp.

HADSON - Japanese novelty subminiature of Hit type. $10-20.

HAGI MFG. (Japan)
Clover - c1939. Folding camera for 4.5x6cm on 120 film. Venner f4.5/75mm Anastigmat in Vester shutter, T,B,1-200. $50-75.

Clover Six - c1940. Folding camera for 6x6cm on 120 film. G.R.C. Venner f4.5/80 in Oriental shutter T,B,1-200. $50-75.

HAKING (W. Haking, Hong Kong) *While Haking produces many cameras, most are not yet of collectible age. We are listing a few of the "novelty" types.*

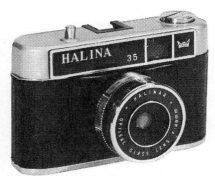

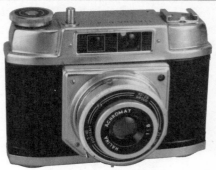

Halina 6-4 - Simple stamped-metal eye-level camera for 120 film. Its interesting feature is the dual format capability. Two finders: one for 4x4, the other for 6x6cm. The camera takes 120 film, with no apparent way to take a smaller spool. Two red windows on the back are marked for the two formats, apparently allowing either 12 or 16 exposures on 120 film. $10-15.

Halina A1 - c1952. TLR, 6x6cm. Halina f3.5/80mm taking lens externally coupled to viewing lens. Shutter 25-100. $35-50.

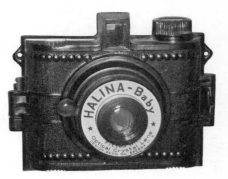

Halina 35 - c1982. Inexpensive plastic 35mm camera. Although a recent model, this is definitely a novelty camera. The same camera, of very inexpensive construction, appears under various names, often as a low-cost premium. $10-15.

Halina-Baby - Plastic novelty camera from Macau. $1-5.

Halina-Prefect Senior - Fixed focus TLR-style camera, 6x6cm. Stamped metal body with leatherette covering. Double meniscus f8 lens, B&I shutter. $10-15. *Illustrated top of next page.*

Halina Viceroy - Twin-lens box camera similar to the Halina-Prefect Senior. $10-15.

Kinoflex Deluxe - c1960. TLR style box camera, similar to the Halina-Prefect Senior. $10-15.

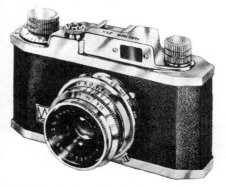

Halina 35X - c1959. Inexpensive but heavy 35mm camera with cast metal body. $8-12.

Roy Box - c1960's. For 4x4cm. Halimar 47mm lens. Single speed shutter. Built-in flash. $1-5.

Halina-Prefect Senior

Sunscope - Twin-lens reflex-style box camera, similar to the other Halina TLR cameras. $10-15.

Votar Flex - c1958. TLR style, also similar to the Halina-Prefect Senior. $10-15.

Hall Pocket Camera

Wales Reflex - TLR style camera similar to Halina-Prefect Senior (above). $10-15.

HALL CAMERA CO. (Brooklyn, NY)

Mirror Reflex Camera - c1910. 4x5" Graflex-style SLR. f4.5/180mm. $100-150.

Pocket Camera - c1913. Small focal plane strut camera. Goerz Celor f3.5. $600-700. *Illustrated previous column.*

HALMA-FLEX - 6x6cm TLR. Halmar Anastigmat f3.5/80mm. $12-18.

HAMAPHOT KG (Monheim, Germany)

Blitz-Hexi - Black bakelite eye-level camera with helical telescoping front. USA: $12-18. EUR: $5-10.

Hexi-Lux - Bakelite camera with telescoping front, similar to the Blitz-Hexi. USA: $12-18. EUR: $5-10.

Modell P56L - c1952. Bakelite camera with telescoping front. Takes 6x6cm on 120. Available in black or dark green. USA: $12-18. EUR: $5-10.

Hamilton Super-Flex

Modell P56M Exportmodell - Dark green bakelite camera with helical telescoping front. Gold-colored metal trim. USA: $12-18. EUR: $5-10.

Modell P66 - c1950. Bakelite eye-level camera for 6x6cm on 120 rollfilm. Achromat f7.7/80mm. B,25,50,100. USA: $12-18. EUR: $5-10.

Moni - Another name variation of the basic

Hamaphot camera. This one has T&M shutter in addition to the two diaphragm settings. $12-18.

HAMCO - Japanese 14x14mm novelty camera of Hit type. $10-15.

HAMILTON SUPER-FLEX - c1947. Bakelite novelty TLR for 16 exposures on 127 film. Similar to Metro-Flex, etc. $5-10. *Illustrated in previous column.*

HANAU (Eugene Hanau, Paris)

le Marsouin - c1900. Rigid aluminum body stereo camera for 18 plates in magazine back. No. 1 size for 45x107mm plates; No. 2 size for 6x13cm plates. Tessar or Balbreck lenses. Guillotine shutter. $175-225.

Passe-Partout - c1890. Unusual wooden detective camera with conical brass front. Several size and style variations. One version uses a double 6x13cm plateholder for two exposures per side, making a 6cm round exposure at each position. Another makes 6x13cm exposures on 13x18cm plates. Yet another makes single 8x8cm photos on 8x8cm plates. Quite rare. Its sales history shows cameras offered for sale in early 1982 at $6500, in October of 1984 for $2775, and in late 1986 for $2800. Confirmed 1988 sale at $2250.

HANEEL TRI-VISION CO. (Alhambra CA)
Tri-Vision Stereo - c1953. Plastic and aluminum stereo camera for 28x30mm

pairs on 828 rollfilm. f8 meniscus lenses with 3 stops. At auction in Germany, these have sold for up to $150 in red and $95 in black. However, they are not uncommon in the USA. Often found in the USA in excellent condition with original box, stereo viewer, etc. for $35-50. Camera only $20-35 in USA.

HANIMEX
Holiday, Holiday II - c1960's. 35mm cameras with CRF. S-Kominar f3.5/45 in Copal. $10-20.

HANNA-BARBERA
Fred Flintstone, Huckelberry Hound, Yogi Bear (127 types) - Novelty cameras for 127 film, each featuring the image of a cartoon character printed on the side. Imitation light meter surrounds the lens. $5-10.

Fred Flintstone, Yogi Bear (126 types) - Similar small cameras, but for 126 cartridge film. On these, the front of the camera is in the shape of the character's head, with the lens in the mouth. $10-15 in USA. Double that in Germany.

HANSEN (J.P. Hansen, Copenhagen)
Norka - c1920's. Studio view camera for 2,3,4, or 6 portraits on one 12x16cm plate. Cooke Aviar Anastigmat f4.5/152mm or Corygon Anastigmat f3.5/105mm lens. With large Norca studio stand: $1000-1300.

HAPPY - Japanese Hit-type novelty camera. $10-15.

HARBOE, A. O. (Altona, Germany)

Wood box camera - c1870. For glass plates. Simple cameras of this type were made in various sizes by various makers in Germany and Denmark during the 1870-1890 period. Although it pre-dated the "Kodak", it was made for the ordinary person to use. Brass barrel lens, simple shutter, ground glass back. Only one sale on record, in late 1976 at $600.

HARE (George Hare, London)
Stereo Wet-plate - c1860. For 3¼x6¾" wet collodion plates. Mahogany body with twin red bellows. Matching brass lenses with waterhouse stops. With ground glass back and wet-plate holder: $1500-2500.

Stereo Wet-plate camera - c1865. For stereo views on 5x8" wet plates. Polished mahogany body with brass fittings. Petzval lenses with waterhouse stops and flap shutter. $2000-3000.

Tailboard Camera - Half-plate, full-plate, and 10x12" sizes. Mahogany construction. Rack focus. Dallmeyer Rapid Landscape lens. $100-250.

Tourist camera - c1865. Half-plate. Fallowfield Rapid Doublet lens with iris diaphragm. Changing box. $350-600.

HARTEX - Japanese subminiature of the Hit type. $10-15.

HARUKAWA (Japan)

Septon Pen Camera - c1953. A rare subminiature of unusual design. Camera is combined with an oversized mechanical pencil. There are two major variations.
Deluxe Model - Has serial number on metal lens rim. Guillotine shutter. Variable f-stops controlled by knob under viewfinder. Back fastens with sliding latch.
Simple Model - Even more rare than the deluxe model. No serial number. No metal lens rims. Sector shutter. No f-stops. Back fastens with two thumb-screws.

Several years ago, a few new "Deluxe" models were discovered, complete with original box and instructions. These quickly sold for approximately $1250 each, and several recent transactions support that price. Used models, without the box and instructions have sold in the range of $500-800.

Septon Penletto - c1953. A name variant of the Septon. Features are like the simpler version, except for the conical lens mount with narrow front. $600-900.

HASSELBLAD (Victor Hasselblad Aktiebolag, Goteborg, Sweden) *The Hasselblad family was in the marketing business for 100 years before Victor Hasselblad established a new company to manufacture cameras. The original Hasselblad company was founded by Fritz Victor Hasselblad in 1841 as F.W. Hasselblad & Co. The company opened a photo department in 1887. Due to expansion in that department, a separate company, "Hasselblads Fotografiska Aktiebolag", was founded in 1908 and became the Kodak general agent in Sweden. Although the early companies sold cameras made by other manufacturers, the real beginning was when "Victor Hasselblad Aktiebolag" was established in 1941 to manufacture aerial cameras for the Royal Swedish Air Force, as well as ground reconnaissance cameras. Dr. Victor Hasselblad retained his staff after the war and began the final designing of the Hasselblad 1600F, which was introduced in 1948. To ascertain the year of production, the two letters before the serial number indicate the year, with the code "VH PICTURES" representing the digits "12 34567890".*

stamped in gold "Hasselblad Svenska Express". $650-750.

Aerial Camera HK7 - c1941-45. Hand-held aerial camera for 50 exposures on 70mm film. Tele-Megor f5.5/250mm. Shutter 1/150-400. $800-1200.

1600F - 1948-52. The world's first 6x6cm SLR with interchangeable film magazines. It is most easily distinguished by its focal plane shutter to 1/1600. Originally supplied with Kodak Ektar f2.8/80mm lens and magazine back for $548. Accessory lenses included 135mm f3.5 Ektar and 250mm f4 Zeiss Opton Sonnar. The shutter was not of the quality we have since grown to expect from Hasselblad, and often this model is seen for sale with an inoperative shutter for less. The prices given here are for cameras in VG-E condition, operational, with back and original lens: $450-650.

Svenska Express - c1900. Falling plate magazine camera. Probably made by Murer for Hasselblad. Leather covered. Back

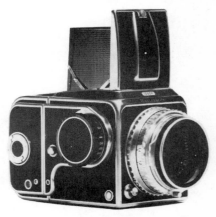

1000F - 1952-57. The second Hasselblad model, and still with a focal plane shutter,

but with the top speed reduced to 1/1000 sec. This attempted to eliminate the accuracy and operational problems of the older shutter. Sold for $400 when new. Replaced the 1600F, but while supplies lasted, the 1600F continued to sell at $500. Despite improvements, these still are often found with inoperative shutters, for less than the prices quoted here. With back, normal lens: EUR: $500-600. USA: $375-475.

Super Wide Angle - 1954-59. Also called SW and SWA. Can be easily distinguished from the normal models, since it has a short, non-reflex body. "Super Wide Angle" is inscribed on the top edge of the front. The early SWA can be distinguished from the later SWC in several ways. The most obvious is that it has a knob for film advance rather than a crank, and shutter cocking is a separate function. The shutter release is on the lower right corner of the front, while the SWC has a top release button. Zeiss Biogon f4.5/38mm lens in MX Compur to 500. The value of this camera is not as a collectible, but as a usable camera. With finder and magazine back: $750-1000.

500C - 1957-70. Historically, the 500C broke with tradition for medium format SLR's by adopting the innovative Compur front shutter with full aperture viewing and automatic diaphragm, a system first seen on the Contaflex. From a practical standpoint, however, its value is primarily as a very usable piece of equipment, despite the advanced age of some of the earlier ones. Collectors want cosmetically clean cameras, but generally users will outbid collectors for a clean 500C. Because of the wide range of lenses and accessories, it would not be practical to go into detail here, but as an example, you might pick up a nice 500C with back, finder, and f2.8/80mm Planar in the range of $650-850.

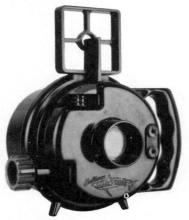

Healthways Mako Shark

HEALTHWAYS
Mako Shark - c1957. Cylindrical plastic underwater camera. The entire working mechanism including shutter, lens, and film transport are identical to the Brownie Hawkeye Flash Model. Synchronized and non-sync models. $35-50. *Illustrated bottom of previous column.*

HEILAND PHOTO PRODUCTS (Div. of Minneapolis-Honeywell, Denver, Colorado)
Premiere - c1957-59. 35mm non-RF camera made in Germany. Steinheil Cassar f2.8/45mm in Pronto to 200. $20-30.

HELIN-NOBLE INC. (Union Lake, Michigan)
Noble 126 - Miniature gold & black "snap-on" camera for 126 cartridges, with matching flash. Winding knob pivots for compactness. Advertised as the world's smallest 126 cartridge camera. With tele and W.A. lenses in original plastic box: $50-75.

HELM TOY CORP. (New York City)
Bugs Bunny - c1978. Plastic camera with figure of Bugs Bunny. "Eh-Doc, Smile!". EUR: up to $40. USA: $20-30.

Mickey Mouse - c1979. Blue plastic camera with white molded front. Mickey Mouse riding astraddle a toy train. EUR: $20-30. USA: $15-25.

Mickey Mouse Head (110 film) - c1985. Cheaply constructed camera in shape of Mickey Mouse head with red bow tie. Round camera mechanism for 110 film is based on the Potenza design. $10-15.

Punky Brewster - c1984. Red plastic 110 pocket camera. Added-on front with hinged top cover. Decals applied to the front, top, and carrying case. Retail price about $6. *Illustrated top of next page.*

Helm Punky Brewster

Snoopy-Matic - A modern detective camera. The camera is shaped like a dog house, with Snoopy relaxing on the roof. The chimney accepts magicubes. This camera is less common than the others from Helm, and is a more interesting design. $60-100.

HENDREN ENTERPRISE

Octopus "The Weekender" - c1983. Named for its multiple functions, this device houses an AM-FM transistor radio, alarm clock with stopwatch functions, flashlight, storage compartment, and a 110 camera with electronic flash. It sold new for $70-80. This high price, coupled with quality problems, kept it from making great waves in the marketplace. Less than 5000 made. The manufacturer was still attempting to liquidate in 1989 for $80 each in a "collector's packet" with the product history signed by the inventor. The few used examples which appear for sale are priced as low as $12.

HENNING (Richard Henning, Frankfurt /M, Germany) *Presumably the trade name Rhaco stands for Richard Henning And Co.*
Rhaco Folding Plate Camera - c1930. 6.5x9cm. Ennatar Anastigmat f4.5/105mm. Ibsor 1-125 shutter. Radial lever focusing. $20-30.

Rhaco Monopol - c1933. 9x12cm folding plate camera. Radionar f6.3/135mm in Ibso 1-100. Radial lever focusing. $20-30.

HENSOLDT (Dr. Hans Hensoldt, Wetzlar) *The Henso cameras were actually made by I.S.O. in Milan, but sold with the Hensoldt, Wetzlar label for the Italian market.*

Henso Reporter - c1953. 35mm RF camera produced by ISO in Italy. Dr. Hans Hensoldt Iriar f2.8/5cm or Arion f1.9/50mm lens. FP 1-1000. Folding rapid advance lever in base. $900-1350 in Germany.

Henso Standard - Similar, but knob wind rather than lever. $650-900.

HERBERT GEORGE CO. (Chicago)
Founded by Herbert Weil and George Israel c1945. Bought out in 1961 and name changed to "Imperial Camera Corp."
Davy Crockett - Black plastic box camera for 6x6cm. Metal faceplate illustrates Davy Crockett and rifles. $20-35.

Donald Duck Camera - c1946. Plastic 127 rollfilm camera for 1⅝x1⅝" exposures. Figures of the Disney ducks (Donald, Huey, Louie, and Dewey) in relief on the back. Meniscus lens, simple shutter. This was the first camera design patented by George L. Israel. The earliest models, ca. Sept 1946 were olive-drab color and without external metal back latches. This version brings about $10 more than the later ones. The body was soon changed to black plastic, and by November 1946, external back latches had been added. This is the most common version. With original cardboard carton: $35-50. Camera only: $20-30.

Flick-N-Flash - Twin lens box camera. $3-6.

Happi-Time - Plastic camera for 127. Essentially the same design as the Donald Duck camera, but without the bas-relief back. $5-10.

Herco Imperial 620 Snap Shot - Cheap plastic box camera. $1-5.

Savoy

Imperial Reflex - ca. mid-1950's plastic 6x6cm TLR for 620 film. Simple lens and shutter. $1-5.

Imperial Satellite 127, Imperial Satellite Flash - $1-5.

Insta-Flash - Twin lens box camera. $1-5.

Roy Rogers & Trigger - Black plastic box camera for 620 film. Aluminum faceplate pictures Roy Rogers on Trigger. $15-20.

Savoy, Savoy Mark II, etc. - Common plastic box cameras. $1-3. *Illustrated top of previous column.*

Herco-flex 6-20 - Plastic twin-lens style. 2¼x2¼" on 620 rollfilm. $3-6.

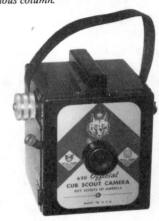

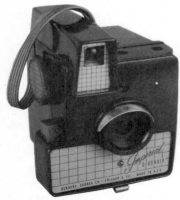

Imperial Debonair - Bakelite box camera with interesting styling. Normally found in black color. $3-6.

Imperial Mark XII Flash - Plastic box camera, in colors. $3-6.

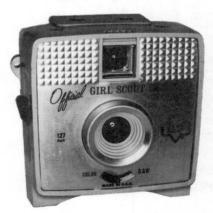

Camera Official "Scout" cameras - Boy Scout, Brownie Scout, Cub Scout, Girl Scout. In black or in official scout colors. These cameras were based on many different "civilian" models, so quite a number of variations exist. Camera only: $5-10. In original box with flash unit: $15-25.

Stylex - An unusual design for the Herbert-George company. Plastic body with rectangular telescoping front. 6x9cm on 620 film. $5-10.

HERBST & FIRL (Görlitz, Germany)
Field camera - c1900. 13x18cm tailboard camera. Mahogany body, nickel trim, green tapered bellows with brown corners. f8 Universal Aplanat Extra Rapid. $250-375.

HERLANGO AG (Vienna) *An amalgamation of Hrdliczka, Langer & Co., and Goldman. An importer, mainly of German cameras.*
Folding camera - For 7x8.5cm plates or rollfilm back. Tessar f4.5/105mm. Compur shutter 1-250. $30-40.

Folding Plate Camera, 10x15cm - Folding bed camera for 10x15cm plates. Double extension bellows. $25-35.

HERMAGIS (J. Fleury Hermagis, Paris)
Field Camera 13x18cm - Polished walnut camera with brass handle and inlaid brass fittings. Rotating maroon bellows for vertical or horizontal use. Thornton-Pickard roller-blind shutter. Hermagis naturellement, Aplanastigmat f6.8/210mm lens. $175-250.

Micromegas - c1875. An unusual wooden box camera with hinged edges, designed to

fold flat when the lensboard and viewing screen are removed. Nickel-plated lens with small slot for waterhouse stop in the focusing helix. $3500-4500.

Velocigraphe - c1892. Detective style drop-plate magazine camera for 12 plates 9x12cm in metal sheaths. Polished wooden body built into a heavy leather covering which appears to be a case. Front and back flaps expose working parts. $750-1000.

Velocigraphe Stereo - c1895-97. Polished walnut magazine box camera for six 8x17cm plates. Matching, individually focusing Hermagis lenses in bright nickel-plated barrels. Shutter tensioning and plate changing mechanisms are coupled. And you thought the first idiot-proof cameras were made of plastic! $1200-1500.

HEROLD MFG. CO. (Chicago) *The Herold name was first used in 1951 when Harold Rubin, former Sales Manager for Spartus Camera Co., purchased the Spartus company and renamed it. This was about the same time that Jack Galter, former President of Spartus, had formed Galter Products. Herold Mfg. continued to produce Spartus cameras, changing its name to Herold Products Co. Inc. in 1956, and to "Spartus Corporation" about 1960. Check under the "Spartus" heading for related cameras.*

Acro-Flash - Black bakelite minicam for 127 film. Twin sync posts above the lens barrel. One of the few minicams with flash sync. $5-10.

Da-Brite - Brown bakelite minicam for 3x4cm on 127 film. $5-10.

Flash-Master - Synchronized minicam like the Acro-Flash. 3x4cm on 127 film. $5-10.

Herold 40 - Black bakelite minicam for 3x4cm on 127 film. $5-10.

Photo-Master - Economy model plastic minicam. "Photo Master" molded into the plastic shutter face rather than using a metal faceplate. $3-7.

Spartacord - c1958. Inexpensive 6x6cm TLR, but with focusing lenses. Nicely finished with brown covering and accessories. $12-18.

Spartus 35 - Low cost brown bakelite 35mm camera with grey plastic top. $10-15.

Spartus 35F, Spartus 35F Model 400 - Variations of the Spartus 35. EUR: $15-25. USA: $12-18.

Spartus 120 Flash Camera - c1953. Brown bakelite box camera with eye level finder on side. $5-10.

Spartus Co-Flash - c1962. Small bakelite box camera with built-in flash reflector beside the lens. 4x4cm on 127. $8-12.

Sunbeam 120 - Bakelite box camera, either brown or black. Synchronized. Several variations. $5-10.

Sunbeam 127 - Two types: Plastic box camera for 12 square pictures 4x4cm on 127 film. Styled like the more common Spartus Vanguard. $3-5. Streamlined brown bakelite minicam for 16 exposures 3x4cm on 127 film. $5-10.

Sunbeam Six-Twenty - Plastic TLR style box camera. Several variations. $3-7.

HERZOG (August Herzog, New York) Herzog Amateur Camera - c1877. Very simple 2x2½" plate camera made of wood and cardboard. Dry plate slides into the back which is mounted on a baseboard. Pyramidal front holds brass lens that slides in and out for focusing. Rare. We have seen only one offered for sale in mid-1983 for $3500 in the original box with accessories.

HESEKIEL (Dr. Adolf Hesekiel & Co., Berlin)
Pompadour - Same as Certo Damen-Kamera; also sold by Lancaster as Ladies' Gem Camera. See Certo Damen-Kamera.

Spiegel Reflex - c1893. Beautiful tropical box-form SLR for 9x12cm plates. Front extends for focusing. Square brown bellows, nickel trim. Brass barrel lens, FP shutter. $2000-2500.

HESS & SATTLER (Wiesbaden, Germany)
Field Camera, 9x12cm - c1895-1900.

Tailboard style. Fine wood with brass trim. Tapered wine-red bellows. Hess & Sattler Universal Aplanat Extra Rapid lens with waterhouse stops. $125-175.

HESS-IVES CORP. (Philadelphia, PA)

Hicro Color Camera - c1915. Box-shaped camera for color photos 3¼x4¼" by the separation process via multiple exposures with filters. Meniscus lens. Wollensak Ultro shutter. (Made for Hess-Ives under contract by Hawk-Eye Division of E.K.C.) $100-200.

HETHERINGTON & HIBBEN (Indianapolis)

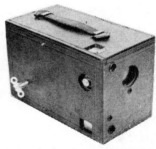

Hetherington Magazine Camera - c1892. Magazine camera for 4x5" plates. More than one model of similar camera. The No.1 measures 11⅜x6x7" and holds 12 plates; another model measures 6x6½x9" and holds 6 plates. Dark brown or black leather covered. Plate advancing, aperture setting, & shutter tensioning are all controlled by the same key in different keyholes. This camera was once marketed by Montgomery Ward & Co. $450-550.

HG TOYS INC. (Long Island, New York) HG TOYS LTD. (Hong Kong) Masters of the Universe He-Man 110 Camera - c1985. Green plastic camera shaped like "Castle Grayskull". Made in China under license from Mattel. $8-10. *Illustrated top of next page.*

HG Masters of the Universe

Princess of Power She-Ra 110 Camera - c1985. Pink plastic camera shaped like "Crystal Castle". Made in China under license from Mattel Toys. $8-10.

HI-FLASH - Novelty camera of Diana type. Synchronized. $1-5.

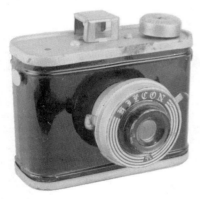

HILCON - Inexpensive metal eye-level camera for 4x5cm exposures on 120 film. Similar to the General, Rocket, and Palmer cameras from the Rocket Camera Co., but with a slightly longer body. $5-10.

HILGER (Adam Hilger, Ltd., London) Three-Colour Camera - Color separation camera with 2 small semi-silvered mirrors behind the lens. $700-1000.

HILL (G. Hill & Son, Brimingham, England)
Field camera - c1888. Mahogany body, brass trim and brass lens. 4¼x6½" plates. $150-175.

HIRONDELLE La Parisienne - c1885. Simple folding plate camera, 9x12cm. Name means "The Swallow". Fine wood body, brass trim, tapered bellows. Brass-bound lens with built-in spring shutter. Wooden lensboard. $300-400.

HIT TYPE CAMERAS - *There are many small cameras which were made in post-WWII Japan. One class of these subminiatures is commonly called "Hit-types" because the Hit name (from Tougodo) was one of the first and most popular names found on this type of camera. Despite their overall similarity, there are many subtle differences in construction from one camera to the next, and there is a seemingly endless number of names which graced the fronts, tops, and cases. There may never be a complete list, but this is probably the most complete one to date. If you know of others not on this list, please write to the authors. This list is intended to include only the inexpensive, lightweight "Hit" type cameras. Heavier models, such as the Corona, Mighty, Mycro, Rocket, Tacker, Tone, Vesta, Vestkam, etc. are not included on this list.*

Prices for most of the Hit types are usually about $10-15 in the USA where they are fairly common. The more recent and common ones (Arrow, CMC, Colly, etc.) are the lowest priced, often $5-10. Uncommon names will sell for $15-20 each, because most Hit collectors will pay a bit more to add a new name to their collection. Gold metal and colored leatherette each add another $10-15 to the price. Prices in Europe are about double the USA prices. **Name variations** - AHI, Amerex (Occupied Japan), Arcoflex, Arrow, Astra, Astropic, Atomy, Babymax, Barco, Beica, Bell 14, Betsons, Bluestar, Charmy, Click, CMA, CMC (in chrome or gold with a variety of colored coverings), Colly, Crown, Crystar, Dale, Diplomat, Electronic, Elite, Emson, Enn Ess, Francya, Fuji, Global, Globe, GNCO, Hadson, Hamco, Happy, Hartex, Hit (Occupied Japan, chrome, gold models), Homer, Homer 16 (rectangular body), Homer No. 1 (gray rectangular body), I.G.B., Jay Dee, Kassin, Kent, Lenz, Lloyd's, Lucky, Madison, Marvel, Midge, Midget, Mighty Midget, Minetta, Mini Camera (Hong Kong), Miracle, Mity, Mykro Fine, Old Mexico, Pacific, Pamex, Peace, PFCA, Prince, Q.P, Real, Regent, Rocket (heavier Rocket also exists, but labeled "Rocket Camera Co."), Satellite, Shalco, Shayo, Sil-Bear, Sing 88, Siraton, Speedex, Spesco, Sputnik, Star-Lite, Stellar, Sterling, Swallow, Tee Mee, Toyoca (note: heavier "Toyoca 16" also exists), Traveler, Vesta (this is a heavier type, but not by much!), Walklenz.

PLEASE SEND ANY ADDITIONS AND CORRECTIONS TO: Jim McKeown; Centennial Photo; Box 1125; Grantsburg, WI 54840 USA. Please send your name and address if you wish to be on our "Hit list" and to cooperate in the research and enjoyment of these little cameras.

HOBBIES Ltd. (England)

Field camera - Mahogany body, brass trim. 4¼x6½" plates. Busch 5" brass bound lens in roller-blind shutter. $90-130.

HOEI INDUSTRIAL CO. (Japan)

Hoei Ebony 35 De-Luxe

Anny-44 - c1960. Inexpensive metal eye-level box camera for 4x4cm on 127 film. Designed to look like a 35mm camera. f8 fixed focus lens, single speed shutter. $10-15.

Hoei Ebony Deluxe IIS

HOFERT (Emil Hofert, EHO Kamera Fabrik, Dresden, Germany) see EHO-ALTISSA.

Ebony 35 - c1957. Bakelite camera for 25x37mm exposures on 828 rollfilm. f11 meniscus lens. Simple B & I shutter. $15-20.

Ebony 35 De-Luxe - c1955. Like Ebony 35, but metal trim on front and finder. f8 lens. $15-20. *Illustrated next column.*

Ebony Deluxe IIS - c1957. Metal front and top housing. PC sync accessory shoe. f8/50mm lens. $15-20. *Illustrated next column.*

HOLLYCAM SPECIAL - Unusual small wooden camera for 127 film. Some parts have a definite appearance of factory production, but the wooden body and acrylic viewfinder give the appearance of something assembled from a kit. We have been unable to find any documentation on this camera, and solicit help from our readers. The few known examples have sold in the range of $80-100.

HOMER - Hit-type novelty subminature. $10-15.

HOMER 16 - c1960. Japanese novelty camera for 14x14mm exposures on 16mm film. Meniscus lens, simple shutter. Hit-type camera, but with rectangular top housing and thumb-wheel advance. (Similar to Bell 14 and Homer No. 1.) Chrome top body with black covering. "Homer 16" on viewfinder glass and shutter face. EUR: $30-40. USA: $15-20.

HOMER NO. 1: see Kambayashi & Co., Ltd.

HONEYWELL
Electric Eye 35R - c1962. 35mm RF camera made by Mamiya with Honeywell name. Meter for auto diaphragm surrounds lens. $15-25.

HORIZONT - c1968. Russian 35mm panoramic camera with f2.8 pivoting lens for 120 degrees. $300-500.

HORNE & THORNTHWAITE (Newgate, G.B.)
Collapsible camera - 1850s. Unusual folding camera: sides collapse when front and back are removed, making it a relatively small item to carry. Mahogany with brass fittings, brass bound lens in rising/shifting lens panel. Two sold in England in 1988 for $4000 and $12,000.

Powell's Stereoscopic Camera - Patented in 1858 by T.H. Powell, the camera had a sliding back for two successive exposures on the same plate. The single lens camera could be positioned for the second exposure by sliding it along the tracks on the carrying case and its hinged lid. We have no recent sales recorded, but at least 2 examples sold in 1974 in the $3500-4000 range.

Wet-plate camera - c1860. Sliding box style for 12x16.5cm plates. $1000-1500.

Wet-plate triple-lens stereo - c1865. Unusual stereo with 3 brass bound lenses mounted on a single lens panel. Center lens takes waterhouse stops. Position of sliding shutter determines if single or stereo exposure will be made. Mahogany body, brass trim. $2500-3500.

HORSMAN (E. I. Horsman Co., N.Y.C.)
In addition to cameras, the Horsman company sold lawn tennis equipment and bicycles.

No. 2 Eclipse - c1888-1900. Polished cherry camera for 3¼x4¼" plates. Leatherette bellows. Originally advertised in 1888 "with tripod and complete chemical outfit" for $5. In 1897, Sears Roebuck still sold the outfit for just $4.50. Current value $150-225.

No. 3 Eclipse - c1890's. Folding bed, collapsible bellows, polished cherry-wood view camera for 4½x6½" plates. Styled like the more common Scovill Waterbury camera. Brass barreled meniscus lens. Rubber-band powered shutter. $175-225.

Eclipse - c1895. An unusual box-plate camera for single exposures 4x5". Black papered wood body. Primitive meniscus lens. Wooden lens cap. $200-225.

HOUAY

Anny-35 - c1964. Inexpensive 35mm novelty camera. Looks convincing from a distance, but is only a box camera. $10-15.
Perhaps Houay and Hoei are variations in the English translation of the same manufacturer. Anny-35 has "Houay" stamped into the top. Anny-44 has "Hoei Industrial Co." on the lens rim. They are quite similar in construction.

HOUGHTON

HOUGHTON (London, England)

Houghtons dates back to 1834 when George Houghton joined Antoine Claudet as a glass seller. After the announcement of the Daguerreotype process in 1839, Claudet and Houghton secured the patent rights to the process in England and began selling Daguerreotype requisites. On Claudet's death in 1867 the firm became George Houghton and Son, George Houghton and Sons in 1892, and Houghtons Ltd. in 1904. The firm produced a vast range of cameras and accessories, notably after 1904 when it absorbed a number of smaller camera makers. From 1895 Houghtons was also responsible for producing the Sanderson camera. From 1900 until around 1909, a large number of Houghton's cameras were German imports, primarily Krügener.

The firm came together for manufacturing purposes with W. Butcher in 1915 and the two finally merged on January 1, 1926 as Houghton-Butcher (Great Britain) Ltd. Houghton-Butcher manufactured products and a selling arm, Ensign Ltd, was set-up in 1930. On the night of September 24-25, 1940 enemy action completely destroyed Ensign's premises at 88/89 High Holborn. Johnson and Sons, manufacturing chemists, took over Ensign forming Houghtons (Holborn) Ltd and sold apparatus including that manufactured by Johnsons. The "Ensign" name was retained by H-B which in 1945 joined forces with the long established Elliott and Sons to form Barnet-Ensign. Barnet Ensign Ross followed in 1948 and Ross-Ensign in 1954. George Houghton's sons and grandsons had continued in the business throughout all the mergers until the firm finally disappeared about 1961. Throughout its history the firm produced cameras and accessories notably after 1926 for the mass-amateur market. During the inter-war period it was the largest producer of photographic equipment and was the most important in Britain.

the prices listed here for black ones. Box models: $8-12. Folding models: $10-15. (Including Ensign Pocket Models I & II.)

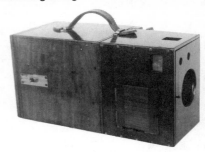

"Automatic" Magazine Camera - c1891 An unusual wooden magazine camera for 12 quarter plates. An internal scoop, operated by a large external handle, shovels the plate into taking position with the help of gravity. (The camera must be rotated to drop the plate). Brass barreled f8 lens with external focusing lever. Behind the lens roller-blind shutter with external string setting. $900-1200.

Autorange 16-20 Ensign - c1953. Copy of Super Ikonta A, taking 16 4.5x6cm exp. on 120 or 620 rollfilm. CRF. Ross Xpres f3.5/75mm, Epsilon 1-400,B,T. $125-175.

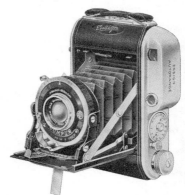

Autorange 220 Ensign - 1938-40. Folding camera offering a choice of 12 or 16 exposures on 120 film. f4.5 Ensar or Tessar in Prontor or Compur. Focus by radial lever on bed. $50-75.

Coronet - Brass and mahogany field camera, 4¼x6½". Brass-bound lens, roller-blind shutter. $150-175.

Empress - c1912-23. Mahogany field camera with extensive tilting movements. Made in ¼, ½, and full-plate sizes. Brass barrel lens, roller-blind shutter. $175-250.

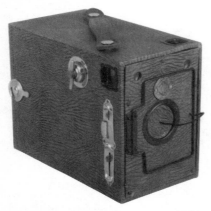

All Distance Ensign Cameras - c1930. An euphemistic term for "fixed focus", this name was applied to box and folding model cameras for 2¼x3¼" (6x9cm) on rollfilm. Note: Colored models bring about twice

Ensign Autospeed - c1933. 6x6cm format 120 rollfilm camera with FP 15-500. Film advance cocks the shutter. Aldis f4.5/4" lens. $175-325.

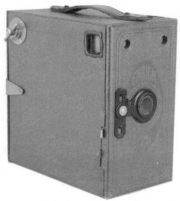

Ensign box cameras - Including E20, E29, 2¼A, 2¼B, Duo, etc. Black: $5-10. Colored: $15-30.

Ensign Cadet - c1927-31. Simple box camera with leather-grained covering. Folding frame finder on side. Everset I+T shutter, achromatic lens. $15-25.

Ensign Cameo - c1927-38. Folding plate camera. Leather-covered wood body with metal front. Made in 2½x3½", 3¼x4¼", and postcard sizes. Aldis Uno Anastigmat f7.7 or Zeiss Tessar lens. $40-60.

Ensign Carbine - 1920's-1930's. A series of folding cameras originated by Butcher and continued after the merger. Primarily for rollfilm, but most models have a removable panel in the back which allows use with plates as well. Many models in a wide range of prices. $20-50.

Ensign Commando

Ensign Carbine (Tropical models) - c1927-36. Nos. 4, 6, 7, 12. Bronzed brass body, tan bellows. Tessar f4.5 lens in Compur shutter. $80-145.

Ensign Commando - c1945. Folding rollfilm camera for 6x6cm or 4.5x6 cm. Built-in masks at the film plane and in the viewfinder. Rangefinder coupled to the moving film plane. Ensar f3.5/75mm lens in Epsilon 1-300 shutter. $75-125. *Illustrated bottom of previous column.*

Ensign Cupid - Introduced 1922. Simple metal-bodied camera for 4x6cm exposures on 120 film. The design is based on a 1921 prototype for a stereo camera which was never produced. Mensicus achromatic f11 lens. Available in black, blue, grey, and perhaps other colors. $45-75.

Ensign Double-8 - c1930-40. Strut-folding camera for 3x4cm on 120. f4.5 Ensar Anastigmat lens in 25-100 shutter. $40-65.

Folding Ensign 2¼B - 1910's-20's. Folding-bed rollfilm camera. Wooden body

with leatherette covering. Rear door slides out to load film. Several body and feature variations over the years. $10-20.

Ensign Ful-Vue - c1940. Box camera with large brilliant finder. Several major styles. Rectangular box-shaped model c1941 is less common than the oddly shaped black or colored post-war model. Blue: $40-65. Red: $35-55. Grey: $25-40. Black: $15-25.

Ensign Ful-Vue Super - Black cast metal body. Similar to Ful-Vue, but with hinged finder hood. Achromat f11 lens. Two-speed shutter. One unusual example marked "Made in India" brought $45 at a 1986 auction, but normal models sell for $15-25.

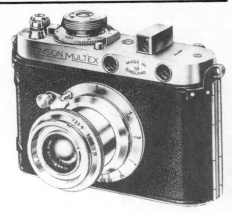

Ensign Multex

Ensign Greyhound - Folding bed 6x9cm rollfilm camera. Metal body with grey crackle finish. $15-20.

Junior Box Ensign - c1932. Simple box camera, identified as "J B Ensign" on the front. 6x9cm. Two-speed shutter. $12-18.

Ensign Mascot A3, D3 - c1910. Drop-plate magazine box cameras for 3¼x4¼" plates. $35-50.

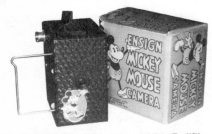

Ensign Mickey Mouse - c1935. Rollfilm box camera, 6 exposures 1⅝x1¼". Mickey Mouse decal on front. Originally available alone or in the "Mickey Mouse Photo Outfit" complete with darkroom equipment and chemicals. Camera only: $60-90.

Ensign Midget - 1934-40. Compact folding cameras for 3.5x4.5cm exposures on E-10 film.
Model 22 - Meniscus lens, T,I shutter. Uncommon. $45-65.
Model 33 - Meniscus lens. Shutter 25-100. Most common model. $45-60.

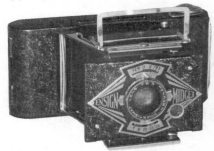

Model 55 - Ensar Anastigmat f6.3. Shutter 25-100. Most complex model. $40-55.

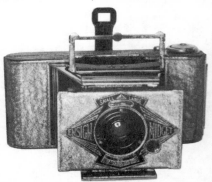

Silver Jubilee models - 1935. Specially finished in silver ripple enamel to

commemorate the silver jubilee of the King and Queen. Model S/33 has fixed focus lens; Model S/55 has Ensar f6.3 Anastigmat. These are the rarest of the Ensign Midgets. $60-80.

Ensign Multex - c1936-47. Small rangefinder camera for 14 exposures on 127. Coupled rangefinder in top housing with viewfinder above. FP shutter T, 1-1000. Ross Xpres f3.5 or f2.9 lens. $150-250. *Illustrated top of previous page.*

6x9cm on 120 or 620 film. $15-25.

Pocket Ensign 2-1/4B - Strut-type folding camera for 120 rollfilm. T & I shutter, 3 stops. $12-18.

Ensign Pocket E-20 - Self-erecting camera for 6x9cm on 120 rollfilm. Fixed focus lens, T & I shutter. $10-15.

Ensign Pressman Reflex - Continuation of the imported Ica Reflex, previously imported by Butcher. $75-100.

Ensign Ranger, Ranger II, Ranger Special - c1953. Folding cameras for

Ensign Reflex, Deluxe Reflex, Popular Reflex, Special Reflex - c1915-30. Unlike the imported "Pressman" reflex, these are English-made SLR cameras. 2½x3½" and 3¼x4¼" sizes. Focal plane shutter to 1000. Various lenses. $65-115.

Ensign Roll Film Reflex - c1920's. For 6x9cm exposures on 120 film. Several models. The same basic camera was sold by Butcher as the Reflex Carbine. $75-125. *Illustrated top of next page.*

Ensign Roll Film Reflex, Tropical - c1925. Teak with brass trim. Aldis Uno or Dallmeyer Anastigmat lens. Focal plane shutter 25-500. $400-475.

Ensign Selfix 16-20 - c1950's. For 16 exposures 4.5x6cm on 120 film. (This style of camera was often called a "semi" at that

Ensign Roll Film Reflex

No. 0 Klito

time, because it took half-frames on 120.) f4.5/75 Ensar or f3.8 Ross Xpress. $50-75.

Ensign Selfix 12-20, 20, 220, 320, 820 - c1950's. Folding rollfilm cameras for 6x6cm or 6x9cm. Various inexpensive lenses and shutters. $25-45.

Ensign Selfix 420 - Self-erecting camera for 8 exposures 6x9cm or 12 exposures 6x6cm on 120 film. Folding direct frame finder and small pivoting brilliant finder. Ensar Anastigmat f4.5/105mm lens in Epsilon 1-150,B,T. $20-35.

Ensign Special Reflex, Tropical - c1930's. 6.5x9cm SLR. Teak body, brassbound. Brown Russian leather bellows. FP shutter 15-1000. $300-500.

Ensign Speed Film Reflex - Called "Focal Plane Rollfilm Reflex" for a time. Box-form SLR with tall folding hood. Similar to the "Roll Film Reflex" but with focal plane shutter, 25-500,T. For 6x9cm on 120 film. Ensar f4.5 Anastigmat is standard lens, but others were available. $75-125.

Ensign Speed Film Reflex, Tropical - c1925. 6x9cm SLR. Teak body, brassbound. Aldis Anastigmat f7.7/108mm. FP shutter 25-500. $400-450.

Ensign Super Speed Cameo - A special model of the Cameo. Cast metal body with leather-lined panels at the sides and top. Two variations: Brown crystalline enamel with bronze fittings and brown bellows. Black model has chrome plated fittings. Dallmeyer Dalmac f3.5 lens in Compur shutter. Brown: $75-100. Black: $30-40.

Vest Pocket Ensign - c1926-30. Body design is the same as the Ensignette, but takes 1⅝x2½" exposures on 127 rollfilm. Enameled aluminum body. Achromatic f11 lens, 3 speed shutter. $40-60.

Ensignette - c1909-30. Folding rollfilm camera of the bedless strut type. Similar to the Vest Pocket Kodak camera but has extensions on both ends of the front panel which serve as table stands. Made in three sizes: No. 1 for 1½x2¼", No. 2 for 2x3", and Junior No. 2 for 2¼x3¼". Early No. 1 is brass. Later No. 1 and No. 2 are all-aluminum. Junior No. 2 is wood with metal back. Simple lens and shutter. $40-55.

Anastigmat Ensignette, Ensignette Deluxe - Versions of the No. 1 and No. 2

with focusing Anastigmat lenses such as Tessar f6.8 or Cooke f5.8 and better shutters. $75-150.

Holborn - c1900-05. Magazine box cameras, most common in ¼-plate size. Leather covered exterior, polished wood interior. $100-150.

Holborn Postage Stamp Camera - c1901. 9-lens copy camera. Makes 9 simultaneous stamp-sized copies of a photograph on a quarter plate. $300-500.

Klito, No. 0 - c1905. Magazine box camera, falling plate type, 3¼x4¼" size. Rapid Rectilinear lens. Rotating shutter. $30-45. *Illustrated previous page.*

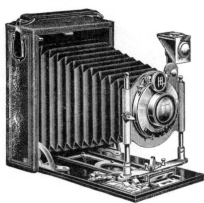

No. 00 Folding Klito

Folding Klito - 1900's-20's. For 3¼x4¼" sheet films. Several variations include pre-1910 versions made by Krügener and later ones (beginning c1912?) made in London. $40-50.

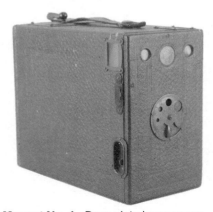

Mascot No. 1 - Drop-plate box camera

for 6.5x9cm plates. Fixed focus f11 lens with 4 stops on external rotating disc. T&I shutter. Identified on strap. $25-35.

Royal Mail Stereolette - Polished wood stereo box camera for 45x107mm plates. Guillotine shutter. Small reflex finder. $600-750.

Sanderson cameras *Even though later manufactured by Houghton, all Sanderson cameras are listed under Sanderson.*

Studio camera - c1914. Mahogany and brass tailboard camera, 12x15". Brass Dallmeyer 5" lens. $350-400.

Superbe Victo - c1912-14. Like the Triple Victo, but with extra rack and pinion to move the back forward when using short focal-length lenses. $150-225.

Ticka - c1905-14. Pocket-watch styled camera manufactured under license from the Expo Camera Co. of New York, and identical to the Expo Watch Camera. For 25 exposures 16x22mm on special cassette film. Fixed focus f16/30mm meniscus lens. I & T shutter. Silver plated: $1000-1300. Standard chrome: $125-175.

Ticka, Focal plane model - With focusing

lens. Rare. (Exposed works make it easy to identify.) $1000-1500.

Ticka, Watch-Face model - c1912. Hands on the face show the viewing angle. An uncommon model, and difficult to establish a price. Two sold at auctions several years ago for $70 and $460. Dealers have offered them for sale at prices from $1500-2000. Recent confirmed auction sales in the same range.

Ticka Enlarger - Enlarges the 16x22mm Ticka negative to 6x9cm. Meniscus lens. $50-100.

Triple Victo - c1900's. ½-plate triple extension field camera. Mahogany body, brass trim. Taylor Hobson Cooke brass-bound lens. Thornton-Pickard roller-blind shutter. Front movements. $175-250.

Tudor - c1906. Folding bed camera for ¼-plates. Combined rising and swing front. Rack focus. Aldis Anastigmat or other lens in Unicum or Automat shutter. $60-80.

Victo - c1900. Full or ½-plate triple extension field cameras. Polished wood, black bellows. RR or Bush lens. Thornton-Pickard roller-blind or Automat pneumatic shutter. $125-200.

HOWE (J.M. Howe, San Francisco)
Pinhole camera - Compact folded

disposable paper camera with self-contained single dry plate and instructions for developing. Few have survived. Estimate: $150-200.

HUNTER (R. F. Hunter, Ltd. London)
Gilbert - Steel box camera with brown lizard skin covering. $30-50.

Hunter 35 - Viewfinder 35. Made in Germany. Same as the Steinette. $15-20.

Purma Plus - c1951. A re-styled version of Purma Special. Metal body. 32x32mm on 127 rollfilm. Purma Anastigmat f6.3/55. Metal FP shutter to 500, speeds are gravity controlled. $30-45.

Purma Special - c1930's. Bakelite & metal camera for 16 exposures 32x32mm (1¼" sq.) on 127 film. Three speed metal focal plane shutter. Speeds controlled by gravity. Fixed focus f6.3/2¼" Beck Anastigmat (plastic) lens. One of the first cameras to use a plastic lens. $30-45.

HURLBUT MFG. CO. (Belvidere, Ill.)

Velox Magazine Camera - c1890. An unusual magazine-plate detective camera. Plates are dropped into the plane of focus and returned to storage by turning the camera over. Focusing lever and plate changing lever are hidden in a recessed bottom. $550-750.

HUTH BROS. (Dresden, Germany)
Field camera - c1895-1905. Wooden 13x18cm tailboard camera, nickel trim, green tapered bellows with black corners. Huth Universal Rapid Aplanat f8 in roller-blind shutter. $160-230.

HÜTTIG (R. Hüttig, A.G., Dresden, R. Hüttig & Son, Dresden) *Founded 1862. Claimed to be the oldest and largest camera works in Europe, just prior to its 1909 merger with Krügener, Wünsche, & Carl Zeiss Palmosbau to form Ica AG, which later merged to form Zeiss-Ikon in 1926.*
Atom - c1908. Continued as an Ica model after 1909 merger. 4.5x6cm plate camera. f8/90mm lens. Compound shutter 1-250. Two versions, vertical and horizontal, as with the later and more common Ica models. $150-250.

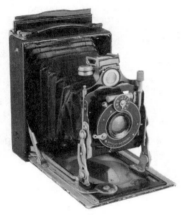

Cupido - Self-erecting 9x12cm plate camera with radial focusing. Rising front with micrometer screw. Extra Rapid Aplanat Baldour f8/125mm in Hüttig shutter, B, T, 1-100. $30-40.

Fichtner's Excelsior Detective - c1892. Polished wood body with built-in 12-plate magazine, 9x12cm. Goerz Lynkeioskop 125mm lens. 3-speed rotating shutter. 2 reflex viewfinders. $750-1200.

Folding plate camera - c1906. 9x12cm plates. Black leathered wood body, aluminum bed. Red double extension bellows. Pneumatic shutter. $50-75.

Gnom - c1900-1907. Falling-plate magazine box camera. Holds up to 6 plates 4.5x6cm. Meniscus lens. Rotary shutter. $125-200.

Helios - c1907. Strut-type folding plate camera, 9x12cm. 185mm Anastigmat lens. Focal plane shutter 6-1000. $75-125.

Ideal, 9x12cm - c1908. Folding-bed plate camera. Hüttig Extra Rapid Aplanat Helios f8. Automat shutter, 25-100, B, T. Aluminum standard and bed. Red bellows. $35-50.

Ideal, 9x18cm - c1907. Helios f8/125mm. Sector shutter 1-250. $75-125.

Ideal Stereo - c1908. 6x13cm plates. Extra Rapid Aplanat Helios f8/105mm. Hüttig Stereo Automat shutter 1-100, T,B. $130-170.

Juwel - c1905. Folding plate, 13x18cm. Leather covered wood body, nickel trim, double extension red bellows. Extra Rapid Anastigmat f8/130mm; Lloyd double pneumatic 1-100,B,T shutter. $200-300.

Lloyd, 9x12cm - c1905. Folding camera for 3¼x4¼" rollfilm or 9x12cm plates. Goerz Dagor f6.8/135mm lens. Compound shutter 1-250. Double extension red bellows. $50-90.

Lloyd, 13x18cm - c1905. Unusual in this large size. Double extension red bellows. Extra Rapid Aplanat f8 lens in Double pneumatic shutter. One example with focal plane and front shutters sold for about $200. Another with front shutter only brought $160.

Magazine cameras - c1900. 6.5x9cm and 9x12cm drop-plate type box cameras, leather covered, including varied Monopol models. Focusing Aplanat lens and simple shutter. $50-60. (Polished wood models without leather covering $250-500.)

Merkur - c1906. 9x12cm magazine box camera, holding 12 plates. Black leather covered wood body. Achromat f11 lens, Z+M shutter. $50-70.

Nelson - c1907. Double extension folding plate camera, 9x12cm. Huttig Aplanat f8/125mm lens; Hüttig pneumatic shutter 1-100,B,T. $30-45.

Record Stereo Camera - 9x12cm plates. Hugo Meyer Aristostigmat f6.8/120mm lenses. Focal plane shutter. $250-350.

Stereo Detective - c1900. Polished wood box camera for 9x18cm plates. Nickel trim. M&Z shutter. $400-500.

Stereolette - c1909. Small folding stereo camera for 45x107mm plates. Helios f8/65mm lens. I,B,T, shutter. $150-250.

Toska - c1907. Folding bed plate camera, 9x12cm. Leather covered mahogany body. Double extension aluminum bed. Rack focus. Universal Rapid Aplanat f7/130mm. $30-45.

Tropical plate camera - 6x9cm. Fine wood body with brass trim and bed. Double extension brown bellows. Steinheil Triplan f4.5/135mm lens in Compound shutter 1-150. $450-600.

HYATT (H.A. Hyatt, St. Louis, MO)

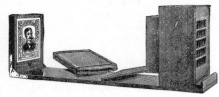

Patent Stamp Camera - c1887. 16-lens copy camera for making 16 stamp-size photos on a 4x5" plate. $500-750.

ICA A.G. (Dresden) *Formed in 1909 as a merger of Hüttig, Krügener, Wünsche, and the Carl Zeiss Palmos factory. Zulauf of Switzerland, maker of Polyscop and Bébé, joined Ica in 1911. Ica became a part of Zeiss-Ikon in 1926, along with Contessa-Nettel, Ernemann and Goerz. Some models were continued under the Zeiss name. See also Zeiss-Ikon.*

Atom - c1909-25. Small folding camera for 4.5x6cm plates, formerly made by Hüttig. In two distinctly different models, both in appearance and current value:

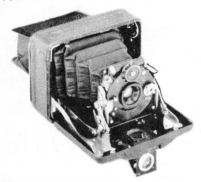

Horizontal-format Atom (Model B) - Folding bed type with self-erecting front. Generally with f4.5/65mm Tessar or f6.8 Hekla. Compound shutter, 1-300. Unusual location of reflex brilliant finder. Viewing lens on front center of bed, but mirror and objective lens extend below the bed. $200-250.

Vertical-format Atom - (Including Models A, 50, 51.) In the more traditional folding bed style. Reflex finder is still on the front of the bed, but remains above the bed. $100-150. *Illustrated top of next column.*

Aviso - c1914-25. 4.5x6cm magazine box camera. Simple lens and shutter $70-90.

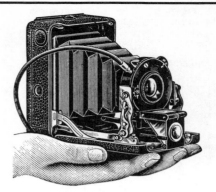

Vertical format Atom

Bébé - c1911-25. Bedless strut-type folding plate camera, formerly made by Zulauf. Bébé 40 for 4.5x6cm, Bébé 41 for 6.5x9cm. Earlier models with Compound shutter. Typically with Tessar f4.5 lens in dial-set Compur shutter which is built into the flat front of the camera. $100-145.

Briefmarken Camera - c1910. Polished mahogany camera with brass trim. Takes 15 stamp-sized photos on a 9x12cm plate. Rare. Only one recorded sale, at an auction in October 1986 for $3800.

Corrida - c1910. Folding 9x12cm plate camera. Helios f8/130mm in Automat shutter. $25-35.

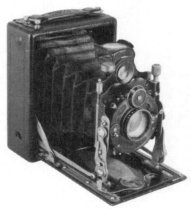

Cupido 75 - Self-erecting camera for 6.5x9cm plates. Tessar f4.5/12cm in Dial Compur. Radial focus. Rising front with micrometer screw. Pivoting collapsible brilliant finder. "Cupido 75" on strap. $40-60.

Cupido 77, Cupido 80 - c1914. Folding bed camera for 9x12cm plates or rollfilm back. Tessar f4.5/12cm lens. Compur dial-

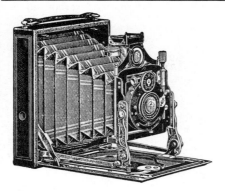

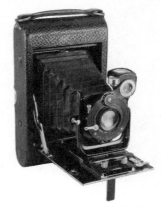

set shutter. $30-40.

Delta - c1912. Folding 9x12cm plate camera. Double extension bellows. Hekla f6.8/135mm in Compound shutter. $35-45.

Elegant - c1910-25. Tailboard field camera, 13x18cm. Highly polished mahogany, nickel trim, double extension square black bellows. $100-150.

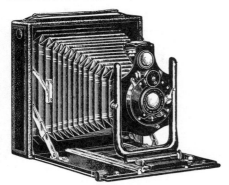

Favorit - c1925. Folding-bed plate cameras. Square black double extension leather bellows.
-Model 265 - 9x12cm. $30-50.
-335 - 10x15cm. $45-65.
-425 - 13x18cm (5x7") plates. f6.3/210mm Tessar. Compur dial-set 1-150. An uncommon size. $100-200.

Favorit Tropical - Polished teakwood body. Folding 9x12cm plate or filmpack camera. Tessar f4.5 lens in Compur shutter. $400-550.

Folding plate cameras - misc. models in 6x9 & 9x12cm sizes. $25-35.

Halloh 505, 506, 510, 511 - c1914-26. Folding rollfilm cameras (also for plate backs) in the 8x10.5cm (3¼x4¼") size.

Tessar f4.5/12cm or Litonar f6.8/135mm. Dial Compur shutter 1-250, B,T. $25-35.

Hekla - c1912-14. Double extension folding plate camera, 9x12cm. Hekla Anastigmat f6.8/135mm; Automat shutter. $25-35.

Icar 180 - c1913-26. Folding bed plate camera for 9x12cm. Ica Dominar f4.5/135. Compur dial-set shutter 1-200, T,B. $30-40.

Icarette I

Icarette - 1920's. Folding bed rollfilm cameras for 120 film. Two basic styles: the horizontally styled body for 6x6cm exposures such as the Icarette A and I, and the vertical body style for 6x9cm such as the Icarette C, D, and L. Prices average the same for either style. $30-45. Asking prices with Tessar lens are about $50-75 higher. *Vertical body style illustrated top of next page.*

Icarette 501, 502, 503 - c1919. 6.5x11cm image on rollfilm. Hekla f6.8/12cm or Tessar f4.5/12cm in Compur, or Novar f6.8/135mm in Derval shutter. $30-40.

293

Icarette C

Ideal - c1920's. Folding-bed vertical style plate cameras. Double extension bellows. (See also Zeiss for the continuation of this line of cameras.) In three sizes:
6.5x9cm - (Model 111) Hekla f6.8/90mm, Tessar f6.3/90mm, or Litonar f4.5/105. Compur shutter 1-150. $40-60.
9x12cm - (Including models 245, 246.) Tessar f4.5/150mm in Compur. $30-50.
10x15cm - (Model 325) Tessar f4.5/165mm in Compur. $75-100.
13x18cm (5x7") - (Model 385) Tessar f4.5/210mm in dial Compur shutter. This larger size is much less common than the others. $90-125.

Ingo 395 - c1914-25. Folding camera for 13x18cm plates. Horizontal style. Novar Anastigmat f6.8/180mm. Ica Automat shutter. $60-80.

Juwel (Universal Juwel) - c1909-1925. (Also continued as a Zeiss model after 1926.) A drop-bed folding 9x12cm plate camera of standard style, but with square format bellows and rotating back. It also incorporates triple extension bellows, wide angle position, and all normal movements. $200-275.

Lloyd - c1910. Folding camera for exposures 8x10.5cm on rollfilm or 9x12cm on plates. Dominar f4.5/135mm. Compur 1-200. $35-45.

Lloyd-Cupido 560 - c1922-25. Horizontally styled self-erecting rollfilm camera for 8.3x10.8cm. Hekla f6.8/100mm in Compound. Helical focus. Rare. $75-125.

Lloyd Stereo - c1910. Folding stereo or panoramic camera for plates or rollfilm. 8x14cm or 9x18cm sizes. A lever on the top moves the cloth roller septum in back for panoramic exposures. f6.3 Tessars or Double Anastigmat Maximar f6.8 lenses in Stereo Compound 1-100 or Compur 1-150 shutter. $200-250.

Lola 135, 136 - c1912-14. Folding bed, single extension camera for 9x12cm plates. Similar to the Sirene. Wood body with leatherette covering. Periskop Alpha f11, Ica Automatic shutter. $30-40.

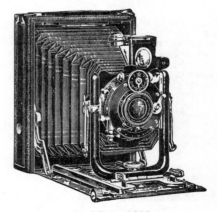

Ica Minimal 235

Maximar - c1914-26. Folding bed double extension precision plate camera. Although the Zeiss-Ikon Maximar is much more common, it originated as an Ica model. 9x12cm size with f4.5/135 Novar, f6.8/135 Hekla, f4.5/135 Litonar, in Compound or Compur shutter. $40-50.

Minimal 235 - c1912. 9x12cm folding bed double extension sheetfilm camera. f6.8/135 Hekla, or f6.8/120 Goerz Dagor lens. Ica Automat or Compound shutter. Leather covered wood body. $35-45. *Illustrated bottom of previous page.*

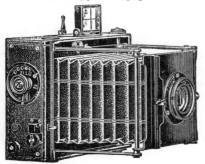

Minimum Palmos - 1909-1920's. Formerly made by Carl Zeiss Palmos Camerabau. Compact vertical format folding bed plate camera with focal plane shutter, T,B, 50-1000. The 4.5x6cm size (not introduced until 1925) is Ica's smallest focal plane camera. Zeiss Tessar f2.7 or f4.5 lens. 4.5x6cm: $300-500. 6.5x9cm: $175-250. 9x12cm: $125-175. 10x15cm: $175-225.

Nelson 225 - c1915. Folding bed double extension plate camera, 9x12cm. Tessar f4.5/150. Dial Compur T,B, 1-150. $35-45.

Nero - c1905. Magazine box camera for

9x12cm plates. Guillotine shutter, T & I. $40-60.

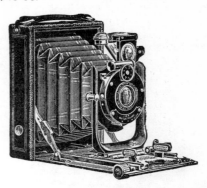

Niklas 109 - c1920's. Folding bed plate cameras in 6.5x9 and 9x12cm sizes. f4.5 Litonar or Tessar lens in Compur shutter. $30-40.

Nixe - 1909-1920's. Folding bed cameras, formerly made by Wünsche. Model numbers include 555, 595. 9x12cm: $40-60. 9x14cm plates or 122 rollfilm. $40-70.

Orix 209 - c1924-25. Double extension folding 9x12cm plate camera. Double Anastigmat Litonar f4.5/135mm. Compur 1-200. $25-35.

Palmos Klapp-Stereo - c1911-26. Folding bed stereo camera for 9x12cm plates, originally from Zeiss Palmos Werk c1905. Aluminum body and bed, covered with leather. Focal plane shutter. Zeiss Tessar f6.3 or f4.5/9cm lenses. Some Zeiss and Ica models have the Dr. W.Scheffer inter-lens adjusting system. The two lenses are drawn closer together by stylus-type rods running in converging tracks on the camera bed. This allows for close-up work with

automatic adjustment. This rare accessory dates from c1908-14. With close focus system: $450-550. Normal models: $300-475.

Periscop - 9x12cm plate camera. Alpha lens. $30-40.

Plaskop - c1925. Rigid-bodied stereo camera for plates or packfilm. Ica Novar Anastigmat lens in guillotine shutter, T & I. Black leather covered wood body with black painted metal parts. Reflex & wire frame finders. 6x13cm: $100-150. 45x107mm: $80-120.

Polyscop (rigid body) - c1911-25. Formerly made by Zulauf. Rigid-bodied stereo camera. Some models had plate backs; some had magazine backs. Could also be used as a panoramic camera by using one lens in the center position and removing the septum. Tessar f4.5 or 6.3 lenses. 6x13cm: $125-190. 45x107mm: $150-195. *Illustrated next column.*

Polyscop (strut-folding model) - For 45x107mm plates. Less common than the rigid models. $175-225.

Reflex 748, 750, 756, 756/1 - c1910-25. Large-format SLR's, such as the Artists Reflex for 6x9cm, 8.5x11cm, or 9x12cm

Ica Polyskop, rigid body

plates. The name Tudor Reflex was sometimes used for models of slightly lower specification. Tessar f4.5 or Maximar f6.8 lens. Focal plane shutter to 1000. $125-175.

Folding Reflex - c1924. Very compact SLR which folds to about one-third the size of the box model. f4.5 Tessar or Dominar. $175-225.

Reporter (Record) - c1912. Strut-folding 9x12cm plate camera. Tessar f4.5/150mm. FP shutter to 1000. $100-150.

Sirene - c1914-26. Folding plate cameras, 6x9 or 9x12cm sizes. Economy models with f11 Periskop or f6.8 Eurynar lens. Ibso shutter. (Most common is Model 135 for 9x12cm.) $25-35.

Stereo Ideal (Type 650) - c1914-26. Folding stereo camera for 9x18cm plates. Twin f6.3 Tessar lenses. Compound shutter to 150. Twin black bellows. $200-275.

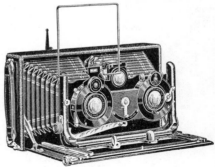

Stereo Ideal (651) - c1910. Folding bed stereo camera for 6x13cm plates. 90mm lenses (f4.5 or 6.3 Tessar or f6.8 Double Anastigmat) in Stereo Compound shutter. Magazine back. $175-275.

Stereo Minimum Palmos (693) - c1924-1926. Strut-folding stereo camera for 6x13cm plates or filmpack. Aluminum body with leather covering and leather bellows.

Folding frame finder. Externally coupled focusing Tessar f4.5 or Triotar f3.5 lenses. Focal plane shutter 1/30 to 1000. $300-450.

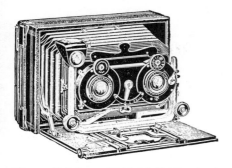

Stereo Reicka - c1910-14. Folding bed stereo camera for 10x15cm plates. Various lenses in Stereo Compound shutter. $200-300.

Stereo Toska (680) - c1912. Folding-bed stereo for 10x15cm plates. f6.8/135mm Hekla. Compound shutter to 100. $150-200.

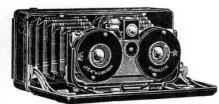

Stereolette 610, 611 - c1912-26. Compact folding-bed stereo camera for 45x107mm plates. Variety of available lens/shutter combinations. Model 610 has rack focus. Model 611 has radial lever. Wide range of sales from $150-350.

Stereolette Cupido (620) - c1912. Folding 45x107mm stereo. Hekla f6.8 or Tessar f4.5 lenses. Stereo Compound or Compur shutter. $175-225.

Stereofix - c1919. Simple rigid-body jumelle-style stereo camera for 45x107mm plates. Novar Anastigmat f6.8 in Ica Automatic shutter, T,B, 25-100. $150-175.

Teddy - c1914-22. 9x12cm folding plate camera. f8/130mm Extra Rapid Aplanat Helios or f6.8/135 Double Anastigmat Heklar. Automat shutter. $25-40.

Toska, 9x12cm - c1914-26. Folding plate camera. Zeiss Double Amatar f6.8/135 or f8/130 Rapid Aplanat Helios. Ica Automat or Compound shutter. $25-40.

Toska 330, 10x15cm - Horizontally-styled double extension plate camera. Extra wide lens standard allows use as a stereo camera with optional stereo lensboard. Zeiss Doppel-Protar Series VII f7/145mm in Compur 1-200. $75-100.

Trilby 18 - c1912. Magazine box camera for 6 plates 9x12cm or 12 exposures on sheet film. Automatic exposure counter. Ica Achromat lens. Guillotine shutter, T & I. $100-150.

Triplex - c1912-14. Leather-covered folding plate camera, 13x18cm. Triple extension, black, bellows. Nickel trim. Dagor f6.8/180mm lens in Compound shutter. $250-275.

Trix - c1915. Cut film camera. 9x12cm: $35-45. 10x15cm: $40-60.

Trona - c1912-26. 6x9cm or 9x12cm double extension plate/rollfilm cameras. f4.5 Tessar. Compur shutter. $40-60.

Tropica 285 - c1912-26. Tropical model folding-bed 9x12cm plate camera. Square back style. Double extension bellows, finely finished wood body with nickel plated brass trim. $350-500.

Tudor Reflex - c1919-26. 9x12 SLRs, basically the same as the Ica Reflex, but the Tudor name was used in advertising those of slightly lower specification. Dominar f4.5/105mm or Tessar 150mm lens. FP shutter. $100-175.

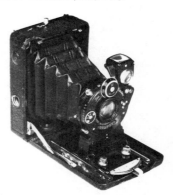

Victrix - c1912-25. Folding bed camera for 4.5x6cm plates. Ica Dominar f4.5/75mm or Hekla f6.8/75mm. Automat or Compur shutter. Focus by radial lever on bed. $100-140.

Volta 125, 146 - c1914. Folding-bed 9x12cm plate camera. Novar Anastigmat f6.8/105mm. Shutter 25-100, T,B. $30-40. *Illustrated top of next page.*

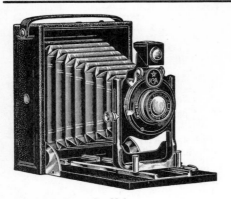

Ica Volta

ICO S.C. (Belgium)
Liberty-620 - c1950. Metal box camera for 6x9cm on 620 rollfilm. Simple f11 lens, 2-speed shutter. Folding frame finder on top. Rare. One recorded auction sale at $95.

IDAM (Société d'Appareils Mécaniques IDAM, Colombes, France)
Belco - Cast metal camera for 36x36mm exposures on 127 rollfilm. Similar to the Clic camera, but with extinction meter incorporated in finder housing. Since the camera is not adjustable, the meter serves only to let the user know if it is practical to take a picture. The same camera was also sold with the name Roc. $40-50.

Clic - c1953. Cast metal camera for 3x3cm on special film similar to Kodak 828. Single speed shutter. Bilux f8 lens. $40-50.

Roc - See Belco, above.

IDEAL TOY CORP. (Hollis, NY)

Kookie Kamera - c1968. Certainly in the running for the most unusual camera design of all time, from the plumbing pipes to the soup can. It looks like a modern junk sculpture, but takes 1¾x1¾" photos on direct positive paper for in-camera processing. With colorful original box, instructions, disguises etc.: $85-125. Camera only: $60-90.

I.G.B. Camera - Japanese novelty subminiature of the Hit type. $15-20.

IHAGEE KAMERAWERK (Steenbergen & Co., Dresden, Germany) *The name derives from the German pronunciation of the initials "IHG" from the full company name "Industrie und Handels Gesellschaft" which means Industry and Trading Company. Ihagee was the largest independent camera maker in Germany. The larger firms, Voigtländer, Zeiss Ikon, and Agfa were owned by other firms (Scheering, Carl Zeiss Jena, & IG Farben.)*

Duplex cameras - *Ihagee used the name "Duplex" for double-extension cameras. One of the Duplex models also had two shutters, and is listed under "Zweiverschluss".*

Duplex (vertical format) - c1920's-1940's. Folding bed plate camera with double extension bellows. 6.5x9cm or 9x12cm. Steinheil f3.5 or 4.5 lens, Compur shutter. $40-50.

Elbaflex VX1000 - 35mm SLR. Same as Exakta VX1000. FP shutter 12-1000. Body with waist-level finder: $70-85.

Exa - c1950's. 35mm focal plane SLR. Models I, Ia, II, IIa, IIb. Normal lenses: Meritar f2.8 or Domiplan f2.9. $25-45.

Exakta (original) - 1933. The first small focal plane SLR. For 8 exposures, 4x6.5cm, on 127 rollflm. f3.5 Exaktar or Tessar. Focal plane shutter 25-1000. Black finish. No slow speeds or synch. (Called model A only after the introduction of model B in 1934. Synch was added to

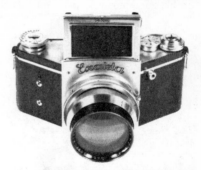

all models in 1935.) $150-200.

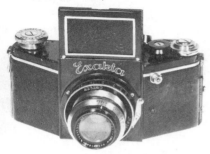

Night Exakta - c1936. Similar to the model B, but with special fast lenses. It was available only in all-black until 1937, when chrome became an option. Biotar f2.0/80, Xenon, or f1.9 Primoplan lens. $300-375. *The easiest way to make a quick identification is that the serial number is on the viewing hood and not on the lens flange.*

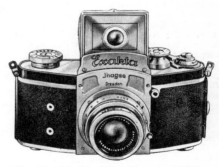

Exakta B - c1935. Similar to the original model (A) above, but with slow speeds. Main body still black leather covered, but some models have chrome finish on metal parts. Focal plane shutter 25-1000, and slow speeds to 12 sec. Self-timer. f2.8 or f3.5 Tessar or Xenar normal lens. Early models have knob wind, later ones have lever. $125-175.

Exakta C - c1935. Much less common than the A & B. Accepts plate back adapter with ground glass for using plates or cut film. $150-200.

Kine Exakta I (original type) - 1936. Identifiable by the round magnifier in the non-removable hood. Similar in appearance to the larger "VP" model from which it was derived. Focal Plane shutter 12 sec. -1000. Bayonet mount interchangeable lenses include Exaktar f3.5/50, Primotar f3.5/50, Tessar f3.5/50, Tessar f2.8/50, Primoplan f1.9/50, and Biotar f2/58mm. One of the first 35mm SLR's; the Russian "Sport" camera having taken that honor in 1935.

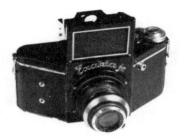

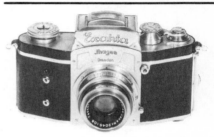

Exakta Jr. - c1936. Similar to the model A, but speeds only 25-500. "Exakta Jr" on the front. Non-interchangeable lens. No self-timer. $100-150.

Kine Exakta I, rectangular magnifier

IHAGEE (cont.)

Historically important and rare. A few sold at auction for $1000. Normal range: $500-800.

Kine Exakta I (rectangular magnifier) - c1937-46. Like the original type, but with a rectangular focusing magnifier. No cover on the magnifier. Non-removable finder. $90-150. *Illustrated bottom of previous page.*

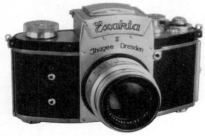

Exakta II - c1949-50. 35mm SLR. Hinged protective door on rectangular focus magnifier. Interchangeable bayonet-mount lenses: f2.8 or 3.5/50mm Tessar, f2.8/50 Westar, f2/50 Schneider Xenon. $60-100.

Exakta V (Varex) - c1950. First 35mm with interchangeable finder. Normal lenses as listed above with Exakta II. $65-90.

Exakta VX (Varex VX) - 1951, model changes in 1953 & 1956. Same normal lenses as Exakta II. Very common. With normal lens: $60-90. Body only: $40-55.

Exakta VX IIA (Varex IIA) - 1957, model changes in 1958 & 1961. Also very common. With normal lens and prism finder in Excellent condition: $60-100. Body only: $40-60.

Exakta VX IIB (Varex IIB) - c1960's. Similar to the VX IIA with minor cosmetic changes. With normal lens: $50-90.

Exakta VX 1000 - c1967. Newly designed camera with instant return mirror. With normal lens: $80-110.

Exakta 66 - Single lens reflex for 12 exposures 6x6cm on 120 rollfilm. f2.8 Tessar or Xenar. Two distinct body styles:

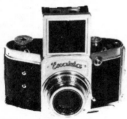

-Pre-war model - c1938. Horizontal body

style and film transport (like an overgrown Exakta A, B or C). Focal plane shutter, 12 sec to 1/1000. $575-775.

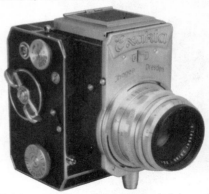

-Post-war style - c1954. Vertical style. Features interchangeable lenses from 56mm to 400mm, interchangeable backs for rapid film change. M-X sync. shutter 12 sec. - 1/1000 sec. With f2.8/80mm preset Zeiss Tessar normal lens: $550-750.

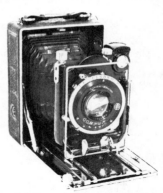

Ihagee folding plate cameras - Made in a large range of sizes from before WWI until WWII. Most commonly found are: 6x9cm size with f4.5/105mm Tessar in Compur shutter or 9x12cm size with similar equipment: $35-50.

Ihagee folding rollfilm cameras - 1920's-1930's. Large range of sizes. Typical example with f4.5 anastigmat lens in Compur or Prontor shutter: $30-50.

Newgold - c1927. Tropical folding plate camera. 6.5x9cm or 9x12cm sizes. Polished teak, brass fittings. Brown leather bellows. U-shaped gilt brass front standard with rise/fall/shift. Tessar f5.6 lens in gilt Compur shutter. $700-850.

Parvola - c1930's. Also called Klein-Ultrix.

For 127 rollfilm, plates or packs. Helical telescoping front. Three models: 3x4cm, 4x6.5cm, and twin or two-format model for both sizes. 3x4cm: $75-95. 4x6.5: $50-75.

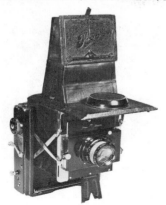

Patent Klapp Reflex - c1920's. Compact folding SLR for 6.5x9 or 9x12cm. Focal plane shutter to 1000. f4.5 Dogmar, Tessar or Xenar. $225-375.

Photoklapp Derby - c1924-34. Single extension folding bed 9x12cm plate camera. Luxar f7.7/135mm in Vario 25-100. $25-35.

Photoknips - pre-1924. Compact 4.5x6cm plate cameras. Front supported by cross-swinging struts. Wire frame finder. Achromatic lens. Front wheel with 3 stops. Shutter ¼-100,Z. Uncommon. $175-200.

Plan-Paff - 1921-c1930. Box style SLR for 6.5x9cm plates. Trioplan f6.3/105mm lens. Z,M shutter. Also available in 4.5x6cm size which brings a bit more. $90-140.

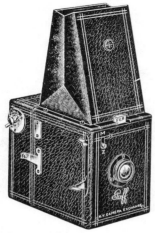

Roll-Paff-Reflex - intro. 1921. SLR box

camera for 6x6cm on 120 film. Simple meniscus Achromatic or Meyer Trioplan f6.8/90mm lens. Z,M shutter. $75-100.

Stereo camera - Folding bed style for 6x13cm plates. Meyer Trioplan f6.3/80mm lens. Stereo Prontor shutter. $175-250.

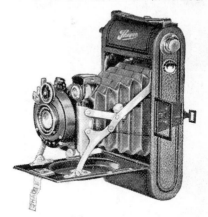

Ultrix (Auto, Simplex) - c1930. Folding bed rollfilm camera. Small size for 4x6.5cm on 127: $65-100. Larger size for 6x9cm on 120: $25-50.

Ultrix (Cameo, Weeny) - c1931. Models with telescoping screw-out lens mount like the Parvola, above. $50-75.

Ultrix Stereo - c1925-37. 7x13cm folding bed stereo rollfilm camera. Leather covered. Brass and nickeled parts. Black enamelled baseboard. Doppel-Anastigmat f4.5/80mm. Compur shutter 1-300. $175-250.

Victor - c1924-35. Double extension folding plate camera, 9x12cm. Xenar f4.5/ 105mm lens, Compur shutter. $30-40.

Zweiverschluss Duplex - c1920's. Folding bed plate camera. Square body with DEB. Focal plane shutter in addition to the front inter-lens shutter. 6.5x9cm and 9x12cm sizes. $100-150.

IKKO SHA CO. LTD. (Japan)
Start 35 - c1950. A simple bakelite eye-level camera for 24x24mm on 35mm wide Bolta-size rollfilm. "Start 35" molded into top. Top removes to load film. Fixed focus f8, B,I shutter. Original box says "Start Junior Pen Camera" and instructions call it "Start Junior Camera". This model is much less common than the later ones. $40-75. *Illustrated top of next page.*

Start 35 K - Similar, but with hinged back. $25-40. *Illustrated top of next page.*

Ikko Sha Start 35

Ikko Sha Start 35 K

Start 35 K-II - c1958. A deluxe version with metal top housing and front trim plate. PC sync post on front. "Start 35 K-II" on top. An attractive camera. $35-50.

ILFORD LTD. (England)
Advocate - c1953. Cast metal 35mm. Ivory enameled finish. Early model had Dallmeyer Anastigmat f4.5 and later one had Dallmeyer f3.5/35mm. A few had Wray f3.5. Shutter 25-200. $75-110.

Craftsman - Bakelite reflex box camera with focusing lens. Large brilliant

finder. $25-35.
Envoy - c1953. Bakelite 120 rollfilm camera, 6x9cm. Optimax lens, single speed shutter. Optical eye-level viewfinder molded into top. $10-15.

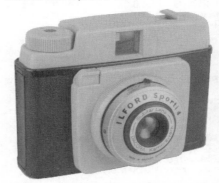

Sporti 4 - An inexpensive plastic eye-level camera for 127 film. Styled like a 35mm camera. Black & tan body with brass-colored trim. Made by Dacora for Ilford. $12-18.

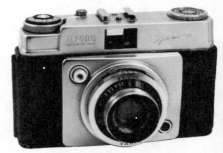

Sportsman - c1967. Viewfinder 35mm. Made for Ilford by Dacora. Like the Super Dignette. Dignar f2.8/45mm. Pronto LK 15-500 shutter. $10-20.

Sportsmaster - c1960. Made by Dacora for Ilford, similar to the Dacora-Matic 4D. Simple rigid 35mm with BIM. Dacora Dignar f2.8, Prontor-Lux 1/30-500. Four shutter release buttons on front used to select four different focusing ranges. $25-40.

Sprite - 4x4cm gray plastic eye-level box camera. Made by Agilux (Colt 44). $5-10.

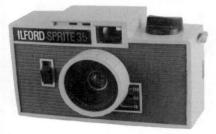

Sprite 35 - Inexpensive grey plastic 35mm. Fixed focus f8 lens, with f11 and f16 stops. Single speed shutter. Lever advance. DEP. Identical to Agilux Agiflash 35. $10-15.

Witness - c1951. 35mm CRF. Originally with 2.9/50mm Daron, later with Dallmeyer Super-Six f1.9/2" lens in interrupted screw-thread mount. FP shutter 1-1000. It is rumored that less than 500 were made. Uncommon. $600-800. *Several incomplete or broken examples have sold at auction in England between $225 and $325.*

IMPERIAL CAMERA CORP. (Chicago)

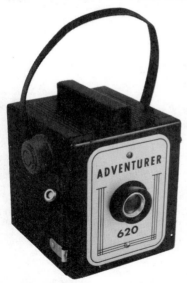

Plastic 6x6cm cameras - c1956. Such

as: Adventurer, Mark XII Flash, Reflex, Savoy, Six-twenty, Six-Twenty Reflex. Colored: $10-15. Black: $3-6.

Plastic 4x4cm cameras - c1964. Such as: Cinex, Cubex IV, Delta, Deltex, Lark, Mark 27, Matey 127 Flash, Mercury Satellite 127, Nor-Flash 127, Roy, Satellite II. Colored: $10-15. Black: $3-6.

Deluxe Six-Twenty Twin Lens Reflex - Inexpensive plastic TLR box camera. $3-6.

Special models - Scout cameras, Rambler Flash Camera (AMC preminum), etc. $10-18.

IMPERIAL CAMERA & MFG. CO.
(LaCrosse, WI)

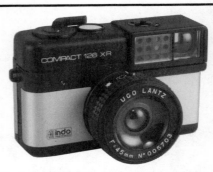

Compact 126 XR - One of the few 126 cameras to break away from the boxy design of the orignial Kodak "Instamatic" cameras. For those who collect 126, this is worth looking for. Rarely found outside of France. $10-15.

Magazine camera - c1902. Falling-plate magazine box camera for twelve 4x5" plates. $30-50.

IMPULSE LTD. (Maryland Heights, MO. USA)

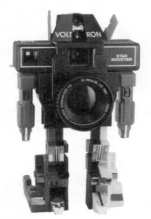

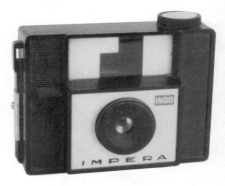

Impera 4x4 - c1969. Black plastic eye-level box camera for 127 film. $1-5.

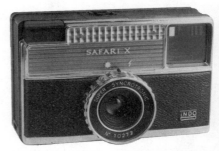

Voltron Starshooter 110 - c1985. A working 110 camera forms part of the body of the Voltron robot. The robot itself converts to the shape of a 35mm camera, with the taking lens of the real 110 camera appearing to be the viewfinder of the dummy 35mm camera. Made in Macau. Retail $25.

INDO (Lyon & Paris, France) *The name is an abbreviation of Industrie Optique, and the camera line is a continuation of the cameras from Fex. Most cameras with the Indo name are low-priced models, often used as premiums and found frequently with promotional messages printed on them.*

Safari X - c1978. Designed by the French Underground to compete with the Leica Safari. Please don't quote me on this. It is a secret. Actually, Indo had an earlier Safari camera for 127 film in 1969 which pre-dates the Leica Safari model. Could it have been the Ur-Safari? Is your editor going crazy? This is a basic camera for 126 cartridges and X cubes. $1-5.

INDRA CAMERA (Frankfurt, Germany)

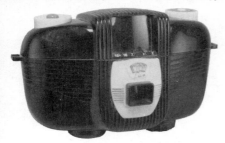

Indra-Lux - c1949. Streamlined black plastic camera for 4x4cm on 127 film. Fixed focus f7.7/60mm lens. Z&M shutter. Very Rare. Indra Camera was in business only a few months. Until now, no major reference book even had a photograph of this camera, but only the line drawings used in early advertising. $125-160.

INETTE - Folding 6x9cm rollfilm camera, made in Germany. Inetta f6.3/85mm in Embezit shutter. $15-20.

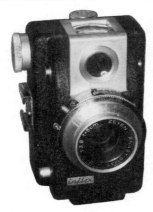

INFLEX - c1950. Unusual German cast-metal camera for 4x4cm on 127 film. Reflex styling, but viewer is a simple brilliant finder. Zeyer Anastigmat f3.8/50mm in Vario shutter. Rare. $150-175.

INGERSOLL (Robert Ingersoll Brothers, New York City)
Shure-Shot - Tiny all-wood box plate camera for single exposures on glass plates. Simple rotary shutter. 2½x2½" size: $150-225. 3¾x3¾" size, less common: $200-300. *Note: This is not to be confused with the later model "Shur-Shot" box cameras by Agfa and Ansco for rollfilms.*

INTERNATIONAL METAL & FERROTYPE CO. (Chicago, Ill)
Diamond Gun Ferrotype - Large nickel

cannon-shaped street camera. $800-1200.

IRWIN (U.S.A.)

Cheap 3x4cm cameras - c1940's. Such as: Dual Reflex, Irwin Reflex, Irwin Kandor, Kandor Komet. Metal sardine-can shaped novelty cameras. $15-20.

ISE (Germany)
Edelweiss Deluxe - Folding camera for 6.5x9cm plates. Brown leather, tan double extension bellows. Tessar f4.5/120mm lens in Compur. $75-100.

ISGOTOWLENO: *Translates as "Made in the U.S.S.R."*

ISING
Isoflex I - c1952. Heavy cast metal reflex box, 6x6cm. Focusing lens. Large brilliant finder. Same as Pucky I. $10-20.

Puck - c1948. Telescoping 3x4cm rollfilm camera. Cassar f2.8/50mm in Prontor II. $20-35.

Pucky - c1949-50. Twin-lens box camera. Bakelite body. Large brilliant finder. M&Z shutter. $20-30.

Pucky I, Ia, II - c1950-54. Like Pucky but with cast aluminum body. Model I is found with or without hinged finder hood. Models Ia & II have hood. $20-35.

ISO (Milan, Italy)

Bilux - c1950. 35mm, coupled rangefinder. Essentially the same camera as the Iso and Henso Reporter cameras. Lever advance in baseplate. Interchangeable Iriar f3.5/50mm lens. Focal plane shutter 1-1000. $800-1200.

Duplex 120, Super Duplex 120 - c1950. Stereo camera for 24 pairs of 24x24mm exposures on 120 film. The 24x24 format was the common format for 35mm stereo, but putting the images side-by-side on 120 film advanced vertically was a novel idea. $250-350.

Standard - c1953. Rangefinder 35mm. Iadar f3.5/50mm. FP shutter 20-1000. Quite similar to the Hensoldt "Standard", a knob-advance version of the more interesting Henso Reporter. $650-900.

ISOPLAST GmbH (Germany)

Filius-Kamera - c1954. Black plastic novelty camera for 32x40mm on 828 film. $20-30.

IVES (F.E. Ives, Philadelphia, Penn.)

Kromskop Triple Camera - c1899. First American camera making tri-color separation negatives in a single exposure. Three plates exposed simultaneously through 3 colored filters, by the use of prisms. Plates were arranged vertically in the camera body. Rare. Price negotiable. Estimate: $3000-5000 or more.

JAK-PAK

Kiddie Camera - Novelty camera for 126 cartridges. A boy's or girl's face covers the camera front. $5-10.

JAPY & CIE. (France)

le Pascal - c1898. Box camera with spring-motor transport. 12 exposures, 40x55mm on rollfilm. Meniscus lens, 3 stops. 2-speed shutter, B. Leather covered wood and metal body with brass trim. The first motorized rollfilm camera. $250-350.

JAY DEE - "Hit" type Japanese novelty subminiature. $10-15.

JEANNERET & CIE. (Paris)

Monobloc - c1915-25. Stereo camera for 6x13cm plates. f4.5 Boyer Sapphir or f6.3 Roussel Stylor 85mm lenses. Built-in magazine. Pneumatic shutter. Metal body, partly leather covered. $150-200.

JEM (J. E. Mergott Co., Newark, N.J.)

Jem Jr. 120 - c1940's. All metal box camera. Simple lens and shutter. $5-10.

Jem Jr. 120, Girl Scout - All metal, green-enameled box camera. The Girl Scout emblem is below the lens. $12-20.

JEWELL 16 - Plastic camera for half-frame exposures on 127 rollfilm. $5-10.

JIPPO - Simple kit for building a camera which attaches to 126 cartridge. Sold with the Finnish children's newspaper "Jippo" in May, 1978. Unassembled, with original magazine: $15-20.

JOHNSON (Emil Johnson, Germany)

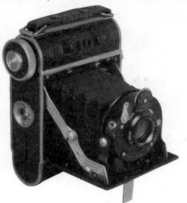

Ejot - c1933. Folding camera for 4.5x6cm on 120. Made by Balda for Emil Johnson. Same as the Baldax 4.5x6. "Ejot" embossed on front leather. Ejotar Anastigmat f4.5/75mm lens in Vario shutter. $35-45.

JONTE (F. Jonte, Paris, France)
Field camera - c1895-1900. 5x7" mahogany camera with brass binding. Rotating bellows for vertical or horizontal use. $150-250.

JCS-PE GmbH (Hamburg & Munich)
The company name comes from one of the owners, JOSef PEter Welker, a banker. The other owners were photographer Koppmann and engineer Gauderer.

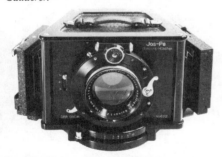

Tri-Color Camera - c1925. All-metal camera for single-shot 3-color separation negatives. Coupled focusing via bellows to each plate magazine. Scarce.
4.5x6cm size - Quinar f2.5/105mm lens. Compound shutter. $1300-2000.
9x12cm size - Cassar f3/180mm in Compound 1-50 shutter. $1000-1500.

JOTA BOX - c1949. 6x9cm German metal box camera. Simple lens & shutter. $30-45.

JOUGLA (J. Jougla, Paris, France)
Sinnox - c1901-06. Magazine-box camera

with tapered body. Magazine holds 6 plates, 9x12cm. Rapid Rectilinear lens in Wollensak pneumatic shutter. $150-175.

JOUX (L. Joux & Cie. Paris, France)
Alethoscope - 1905. All-metal stereo plate camera. Rectilinear Balbreck lenses. 5-speed guillotine shutter. Newton finder. 45x107mm or 6x13cm sizes. $150-200.

Ortho Jumelle Duplex - c1895. Rigid-bodied "jumelle" style camera. Magazine holds 6.5x9cm plates. f8/110 Zeiss Krauss Anastigmat. Five speed guillotine shutter. An uncommon camera. $150-200.

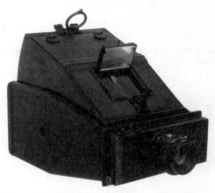

Steno-Jumelle - c1895. Rigid, tapered body, magazine camera for 18- 6.5x9cm or 12- 9x12cm plates. The magazine is built into the camera body, and is loaded through a panel on top. Raising the hinged top when the lens is pointed upward moves the push-pull plate-changing mechanism. $150-225.

Steno-Jumelle Stereo - c1898. Similar design to the Steno-Jumelle, but with 2 lenses for 8x16cm stereo exposures. 12-plate magazine. $300-375.

JUHASZ INC. (Los Angeles)

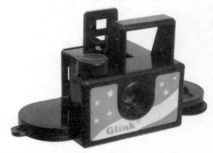

Glink - Unusually designed snap-on camera for 110 cartridge, made in Taiwan for Juhasz. Red, white, & blue front label in American flag motif. $1-5.

JULIA - c1900-05. Horizontally styled folding bed rollfilm camera for 9x9cm. Leather covered wood body. Shutter built into wooden lensboard. $175-225.

JUMEAU & JANNIN (France)
Le Cristallos - c1890. Folding bed camera for darkroom-loaded rollfilm, 6x9cm or 9x12cm. Black leather has gold outlines. Lens has external wheel stops. $200-250.

JUMELLE *The French word for "twins", also meaning binoculars. Commonly used to describe stereo cameras of the European rigid-body style, as well as other "binocular-styled" cameras where one of the two lenses is a viewing lens and the other takes single exposures. See French manufacturers such as: Bellieni, Carpentier, Gaumont, Joux, Richard.*

JUNKA-WERKE (Zirndorf b/Nürnberg, Germany)

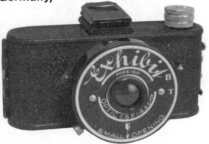

Exhibit - An uncommon export version of the Junka, with English language markings. $60-90.

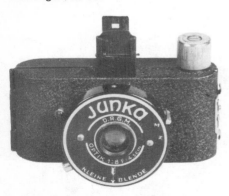

Junka - c1938. 3x4cm exposures on special paper-backed rollfilm. Achromat f8/45mm lens in single speed shutter. $35-60. *The same basic camera was sold by Adox after WWII and was named Juka.*

JURNICK (Max Jurnick, Jersey City, New Jersey)
Ford's Tom Thumb Camera - c1889.

Similar body style to the Photosphere camera. All metal. Camera is concealed in a wooden carrying case for "detective" exposures. Later models are called the Tom Thumb camera, dropping Ford's name from the camera name. With original wooden case: $2500-3500.

JUSTEN PRODUCTS
Justen - Plastic novelty camera of the "Diana" type. $1-5.

KAFTANSKI (Fritz Kaftanski)

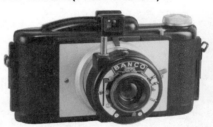

Banco Perfect - Plastic bodied rollfilm camera with telescoping front. 2¼x3¼" exposures. Focusing lens, built-in yellow filter. $10-15.

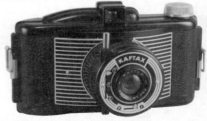

Kaftax - Similar in design to the Banco Perfect, but simpler. Rigid body with non-collapsing front. Fixed focus lens. $10-15.

KALART CO. (New York City)

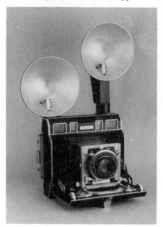

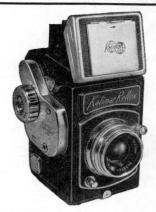

Fujita 66. With normal lens: $60-90.

Kalart Press camera - 1948-53. 3¼x4¼". Dual rangefinder windows to allow for use with either eye. f4.5/127mm Wollensak Raptar in Rapax 1-400 shutter. Dual shutter release triggers controlled by Electric Brain. $140-160.

KALIMAR (Japan)
Kali-flex - c1966. Simple, plastic, TLR-style camera. Kalimar f8 to f22 lens. Between-the-lens shutter. 6x6cm exposures on 120 film. $8-12.

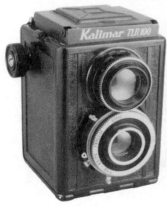

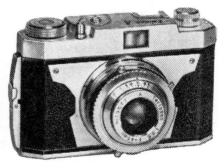

TLR 100 - Black plastic TLR from Russia. Copy of Voigtländer Brillant body, but viewing lens is externally coupled to the taking lens. Lomo T-22 f4.5/75mm. Shutter B, 15-250. Also sold as Lubitel 2. $10-15.

Kalimar A - c1955. 35mm non-rangefinder camera. f3.5/45 Terionon lens. Between-the-lens synchro shutter to 200. $20-35.

Kalimar 44 (Colt 44) - c1960. Made for Kalimar by Hoei Industrial Co. Both names, "Colt 44" and "Kalimar 44" appear on the camera. 4x4cm on 127 rollfilm. Kaligar f8/60mm lens. Single speed shutter. $10-20.

Kalimar Reflex - c1956-62. Made for Kalimar by Fujita Optical Ind. SLR. Inter-changeable Kaligar f3.5/80mm lens, focuses to 3½". FP shutter 1-500, B, X sync. Instant return mirror. Export version of the

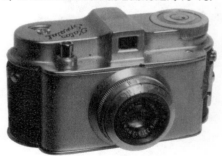

Kalos Spezial

KALOS CAMERABAU GMBH (Karlsruhe, Germany)
Kalos - c1950. Subminiature for 30

exposures, 9x12mm on unperforated 16mm film. Eye-level optical finder. Mikro-Anastigmat f4.5/20mm lens. Shutter B,30, 50,100. Uncommon. $175-225.

Kalos Spezial - Improved version of the Kalos, with more streamlined appearance. Staeble-Werk Kata f2.8/25mm lens. $175-225. *Illustrated bottom of previous page.*

KAMBAYASHI & CO. LTD. (Japan)

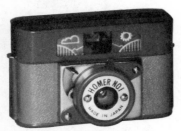

Homer No. 1 - c1960. Novelty subminiature. Construction similar to "Hit" type cameras, but style is different. Gray metal exterior. Black plastic interior. 14x14mm exposures on 16mm rollfilm. Meniscus lens. Single speed sh. $40-65.

KAMERA & APPARATEBAU (Vienna, Austria)
Sport-Box 2, Sport-Box 3 - c1950. Black bakelite eye-level box cameras. Folding frame finder. f8/50mm, M,T shutter. $25-35.

KAMERAWERKE THARANDT (Germany)
Vitaflex - c1949. TLR-style, 6x6cm on 120 film. f4.5 lens. $30-55.

KAMERETTE No. 1, No. 2 - Small Japanese "Yen" box camera with ground glass back. Uses sheet film in paper holders. $10-15.

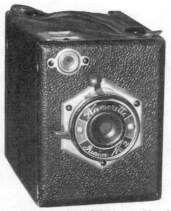

KAMERETTE JUNIOR No. 1, No. 2,

No. 4 - c1930. Japanese "Yen" box camera for 1¼x2" cut film. $15-20.

KAMERETTE SPECIAL - Japanese folding "Yen" camera for single sheet films in paper holders. Wood body, ground glass back. $20-25.

KASHIWA (Japan)
Motoca - c1949. 35mm Leica copy. Lunar Anastigmat f3/45mm in interchangeable mount, but Kashiwa made no other lenses to fit this camera. 25-300,B sh. $300-500.

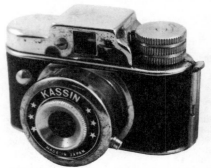

KASSIN - Japanese novelty subminiature of the Hit type. $15-20.

KEITH CAMERA CO.

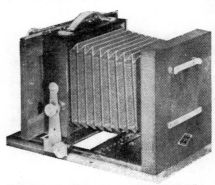

Keith Portrait Camera - c1947. 5x7" wooden studio camera. Silver hammertone finish. 17" bellows extension. Swing back. $150-200.

KEMPER (Alfred C. Kemper, Chicago)
Kombi - intro. 1892. The mini-marvel of the decade. A 4 oz. seamless metal miniature box camera with oxidized silver finish. Made to take 25 exposures 1⅛" square (or round) on rollfilm, then double as a transparency viewer. (From whence the name "Kombi".) Sold for $3.00 new, and Kemper's ads proclaimed "50,000 sold in one year".

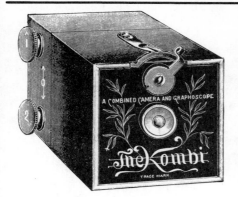

Although not rare, they are a prized collector's item. $150-175. (Add $25 for original box, often found with the camera.) Occasional auction sales in Germany for double the USA price.

KENFLEX - Japanese 6x6cm TLR. First Anastigmat f3.5/80mm lens. $35-55.

KENNEDY INDUSTRIES (London, England)
K.I. Monobar - c1950. 35mm monorail camera, with full movements. 24x36mm exposures on cut film. $700-900.

KENNGOTT (W. Kengott, Stuttgart)
6x9cm plate camera - c1920's. Folding-bed style. Double extension bellows. f4.8/105mm Leitmeyr Sytar lens in Ibsor 1-125 shutter. $30-40.

9x12cm plate camera - c1930. Double extension folding bed camera. f4.5/150mm Dialytar in Compur. $25-35.

10x15cm plate camera - Leather covered wood body. Revolving back. Triple extension bellows. Kengott (Paris) Double Anastigmat f6.8/180mm lens in Koilos shutter 1-300. $50-75.

10x15cm plate camera, Tropical model - Lemonwood body. Gold-plated brass trim. Light brown leather bellows. Steinheil Unifocal f4.5/150 lens in Kengott Koilos 1-100, T, B shutter. $500-750.

Matador - c1930. 6.5x9cm folding plate camera. Self-erecting front. Spezial Aplanat f8/105mm in Vario. Very rare. $50-75.

Phoenix - c1924. Tropical camera with gold-plated metal parts. Brown bellows. Sizes: 6x9cm, 9x12cm, or 9x14cm. Most common in 9x12cm size with Tessar f4.5/135mm in dial Compur. $300-600.

Supra No. 2 - c1930. Double extension folding camera for 6.5x9cm plates. Xenar f4.5/105mm in Compur 1-250. $20-35.

KENT - Japanese novelty camera of the "Hit" type. 14x14mm. $10-15.

KERN (Aarau, Switzerland)
Bijou - c1925. Aluminum-bodied hand and stand camera. Inlaid leather panels on sides. Rounded corners. Kern Anastigmat f4.5 lens in Compur 1-200 shutter. 6.5x9 or 9x12cm size. $300-400.

Stereo Kern SS - 1930-35. Early 35mm stereo camera, 20x20mm exposures. Kern Anastigmat f3.5/35mm lenses, with 64mm inter-lens separation (larger than the Homeos). All controls are located on the top of the camera. Leica-style viewfinder. $800-1000. (A complete outfit with camera, case, transposing table viewer, etc. could nearly double this price.)

KERSHAW (A. Kershaw and Sons Ltd.)
Abram Kershaw established his firm in 1888 and by 1898 was making camera parts for trade manufacturers. During the early 1900's the photographic side expanded. Field cameras, studio cameras and tripods were being made. From 1905 the Kershaw Company started in earnest to produce the Soho Reflex which was based on Cecil Kershaw's patent of 1904. These were being made for Marion and Co., London Stereoscopic Co., Ross, Beck, & Fallowfield who sold them under their own names. Kershaw also produced cameras for other manufacturers.

Kershaw joined APM in 1921 and Soho Ltd. in 1929 where it was the dominant partner. In both companies Kershaw produced most of the cameras and equipment marketed under the APeM and Soho names. At the same time Kershaw pursued its own projects, notably cine equipment through its associated company of Kalee Ltd. The firm produced a range of cameras until the 1950's when production ceased because the Rank Organisation, which had acquired Kershaw in 1947, wished to direct production to other products.

Most of the Kershaw cameras were named after birds because company directors were avid bird-watchers.
Curlew I,II,III - c1948. Self-erecting folding camera for 6x9cm on 120 film. Sturdy construction but poor sales. Production is estimated at less than 300 for all models combined. $80-100.

Kershaw 450 - Self-erecting folding camera for 6x6 on 120. British Etar Anastigmat f4.5 scale-focusing lens in

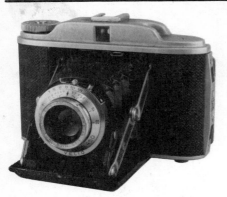

German Velio shutter. $15-20.

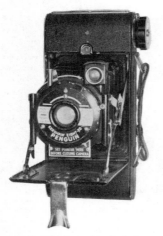

Eight-20 Penguin - c1953. 6x9cm rollfilm camera. $10-15.

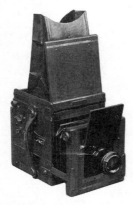

Kershaw Patent Reflex - c1920. Graflex-

style single lens reflex. Revolving back. 6x9cm exposures. $100-150.

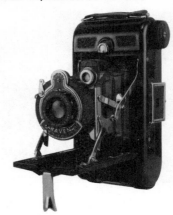

Raven - Folding rollfilm camera with nearly black bakelite body. Leather design molded into the front and back. Kershaw Anastigmat f4.5/4" lens. Waist-level reflex and folding frame finders. $20-25.

KEYS STEREO PRODUCTS (U.S.A.)

Trivision Camera - c1950's. For 6 stereo pairs or 12 single shots on 828 film. Fixed focus f8 lenses. Single speed shutter. Similar to Haneel Tri-Vision, but large black decal covers aluminum back. $20-35.

KEYSTONE (Berkey Keystone, Division of Berkey Photo, Inc.) *There are many Keystone cameras, most of which were low-priced amateur models, including cartridge-loading and instant types. Even the ones with built-in electronic flash have not reached a point where they have significant collector value, so we will wait a bit longer before including them in this guide.*
Wizard XF1000 - c1978. Rigid-bodied instant camera for Polaroid SX-70 film. f8.8/ 115mm lens. Electronic shutter. Production of this camera resulted in a legal confrontation between Keystone & Polaroid. $10-15.

KEYSTONE FERROTYPE CAMERA CO. (Philadelphia, PA)
Street camera - Suitcase style direct-positive street camera with ceramic tank

Clown Camera

inside. Various masks allow for taking different sized pictures. $125-175.

KIDDIE CAMERA (Made in Taiwan) *A series of cameras, all employing a basically round body similar to that originated by the Potenza tire camera from Japan. Although the basic structure is copied, there is plenty of imagination on the exterior design, and some even include electronic music boxes which play when the shutter is released. The lens is hidden under the nose which doubles as a lenscap. Practicality is not the main concern. Most children would either lose the lenscap or forget to remove it. Nevertheless, it is a cute series of novelty cameras. "Kiddie Camera" is the brand name used on the packaging of most that we have seen.*

Bear Camera - Camera shaped like a bear's head. Made in Taiwan. Uses 110 film. Removable nose is lens cap. Several variations of color and equipment. Colors include "Brown Bear" with brown face and yellow nose and ears; "Panda" in black and white; Tan with panda markings; Orange with white nose and red eyes, etc. Some have hot shoe; others have plugged top. $25-40.

Clown Camera - The same round camera with the facade of a clown's head. The lens is still under the removable nose, but the clown's hat is the shutter release. Some have plugged top, others have electronic music box which plays "Home Sweet Home". $25-40. *Illustrated top of next column.*

Dog Camera - Basically round camera with facade of Dog's head. Head is brown with orange around mouth; nose and tongue are red. $25-40.

Santa Claus - The same round camera, but this time with the visage of the famous man from the North Pole. Molded in white plastic, with red hat and lips. $25-40.

KIGAWA OPTICAL (Japan) *Before about 1940, the company was called Optochrome Co.*
Tsubasa Baby Chrome - c1937. Bakelite bodied eye-level camera for 16 exposures, 3x4cm on 127. Optical eye-level finder. New Gold f6.3/50mm in New Gold shutter B,25-100. $50-75.

Tsubasa Chrome - c1937. Dual format eye-level camera for 4x6.5cm or 3x4cm on 127 film. Lucomar f6.3/75mm in Wing Anchor shutter T,B,25-150. Spring-loaded telescoping front. $40-60.

Tsubasa Semi - c1952. Vertical folding bed camera, 4.5x6cm on 120. Bessel f3.5/75mm lens. KKK shutter 10-200,B. $30-50.

Tsubasa Super Semi - c1938. Horizontal folding bed camera, 4.5x6cm on 120. Lucomar Anastigmat f4.5/75mm. New Gold shutter 25-150, T,B. $40-60.

Tsubasaflex Junior - c1951. Inexpensive 6x6cm TLR. Lenses externally gear-coupled. Lause Anastigmat f3.5/80mm. Shutter 10-200,B. $50-75.

KIKO 6 - Japanese 120 rollfilm camera. $20-40.

KIKO-DO CO. (Japan)
Superflex Baby - c1938. The first 4x4cm SLR from Japan. 127 film. Design similar to Karmaflex. Super Anastigmat f4.5/70mm; behind the lens shutter B,25-100. $150-250

KILFITT *(Heinz Kilfitt, Munich, Germany; Heinz Kilfitt Kamerabau, Vaduz, Liechtenstein; Metz Apparatebau, Nürnberg, Germany)*
Mecaflex - c1953. A well-made 35mm SLR in an odd 24x24mm format for 50

313

exposures on regular 35mm cartridge film. Interchangeable bayonet mount lenses, f3.5 or 2.8/40mm Kilar. Prontor-Reflex behind-the-lens shutter. Entire top cover of camera hinges forward to reveal the waist-level reflex finder, rapid-wind lever, exposure counter, etc. When closed, the matte-chromed cast metal body with its grey leatherette covering looks somewhat like a sleek, knobless Exakta. Not too many were made, and it was never officially imported into the United States. $250-375.

KIMURA OPTICAL WORKS
Alfax Model I - c1940. Japanese camera for 4x6.5cm on 127 film. Recta Anastigmat f3.5/60mm in New Alfa shutter. Waist-level and eye-level finders. $50-75.

KINDER CO. (S. Milwaukee, Wisconsin)

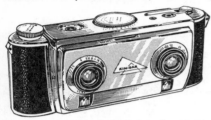

Kin-Dar Stereo camera - c1954. Stereo camera for 5-perforation format on 35mm film in standard cartridges. Steinheil Cassar f3.5/35mm lenses. Five speed shutter, 1/10-1/200, B. Advancing the film cocks the shutter, but the shutter can also be cocked manually. Viewfinder and rangefinder combined in single eyepiece, located near the bottom of the camera. Designed by Seton Rochwite, whose first major success was the Stereo Realist Camera. Original price in 1954 was $99.50. $50-90.

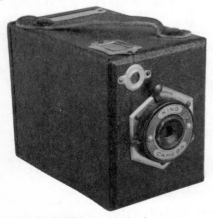

KING CAMERA - c1930's. Japanese miniature cardboard "Yen" box camera for single sheet film in paper holder. Single speed shutter with separate cocking lever. Ground glass back. This is one of the better quality "Yen" cameras. $15-25.

KING KG (Bad Liebenzell, Germany)
Dominant - Postwar German 35mm. Cassar f2.8/45mm in Prontor 500LK shutter. $10-20.

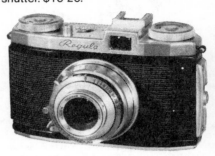

Regula - 35mm cameras, introduced in 1951. Various models: IA through IF, IP, IPa; IIIa, b, bk, c, d; Cita III, IIId; Gypsy; KG, PD, RM, etc. f2.8 Cassar, Gotar, Ennit, or Tessar lens. $20-35.

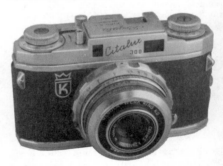

Regula Citalux 300 - Luxus version of the Regula Cita with red leather and gold trim. CRF. Cassar S f2.8/45mm. $200-250.

KING SALES CO. (Chicago, Illinois)
Cinex Candid camera - Bakelite minicam for half-frame 127. Identical to the Rolls Camera Mfg. Co.'s Rolls camera. $5-10.

KING'S CAMERA - Plastic novelty camera for half-127. Made in Hong Kong. $3-6.

KINGSTON - c1960. Small novelty TLR from Hong Kong. Takes 4x4cm on 127 film. Plasicon f8/65mm lens. $5-10.

KINN (France)
Kinaflex - c1951. Twin lens reflex made by ATOMS. Berhtiot Flor f3.5/75mm taking lens is externally coupled to the viewing lens. Atos-2 shutter. $40-65.

Kinax (I) - c1949. Folding camera, 8 exposures on 120 film. This model does not have parallax corrected finder. Berthiot f4.5/105mm lens. Colored: $30-45. Black: $15-25.

Kinax II - c1950. Folding camera for 120 rollfilm, 6x9cm. Parallax correction in viewfinder. Variations include: black or gray leather with black or gray bellows, red metal with red leather bellows. f4.5/105 Som Berthiot or Major Kinn lens in Kinax shutter. Red or grey: $30-45. Black: $15-25.

Kinax Alsace - c1952. Folding rollfilm camera for 6x9cm on 620 film. Berthiot f6.3/100mm lens. Kinax shutter 25-100. Burgundy: $30-45. Black: $15-25.

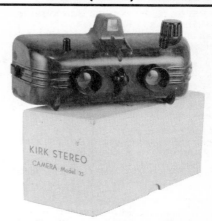

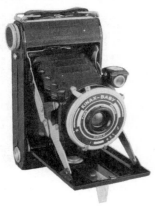

KIRK Stereo camera, Model 33 - Brown bakelite body. Same body style as Haneel Tri-Vision. Takes six stereo pairs, 26x28mm on 828 film. Three variations: 1. Has aperture numbers 1,2,3 on front but no name on back. 2. Has "Kirk Stereo" on back, but no aperture numbers on front. 3. Has neither name nor numbers. $50-75.

KIYABASHI KOGAKU (Japan)

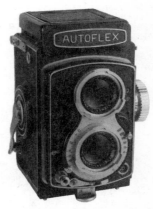

Kinax Baby - c1950. Low-priced version of the Kinax with Meniscus lens. 6x9cm on 120 film. $20-30.

Kinax Junior - c1950. One of the better-equipped of the Kinax series. Kior Anastigmat f6.3/100mm in 25-150 shutter. $20-30.

Autoflex - c1957. 6x6cm TLR for 120 film. f3.5 Tri-Lausar lens. $50-75.

K.K. - *Found after the name of many Japanese camera companies, the initials K.K. stand for "Kabushiki Kaisha" meaning "Joint Stock Co."*

KLAPP - *Included in the name of many German cameras, it simply means "folding". Look for another key reference word in the name of the camera.*

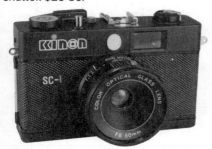

KINON SC-1 - c1986. Novelty 35mm camera from Taiwan, styled like rangefinder type. $1-5.

KINUSA K-77 - c1986. Novelty 35mm from Taiwan, with small pseudo prism. $1-5.

KLEER-VU FEATHER-WEIGHT - Plastic novelty camera made in Hong Kong. Half-frame on 127. $1-5.

KLEFFEL (L. G. Kleffel & Sohn, Berlin)
Field camera - c1890. 13x18cm
horizontal format. Brown square-cornered
bellows. Wood body with brass trim. Brass
barrel lens. $150-200.

KLOPCIC (Louis Klopcic, Paris)
Klopcic - Strut-folding focal plane camera,
10x15cm size. Similar to the Deckrullo-
Nettel. Berthiot Series I f4.5/165mm lens.
Focal plane shutter 1-2000. $150-170.

Klopcic "Reporter" - Introduced c1903,
though all known illustrations and cameras
are later models. Strut-folding camera for
9x12cm plates or magazine back. Flor
Berthiot f4.5 or Tessar f3.5/135mm lens.
FP ½-1200 or later ½-2000. $150-200.

KNIGHT & SONS (London)
Knights No. 3 Sliding-box camera -
c1853. From the transition period between
Daguerreotypes and wet plates, which first
were used about 1851. Sliding box-in-box
style camera of dovetailed mahogany.
Rising front. Two positions for plateholder.
Brass landscape lens with waterhouse
stops. Full-plate size: $900-1200.

KOCH (Paris, France)
Stereo wet-plate camera - c1860.
Wooden stereo box camera for 9x21cm
wet-plates. Jamin f11/125mm lenses
mounted on a tamboured panel for
adjustment of lens separation. Rare.
$3000-4000.

**KOCHMANN (Franz Kochmann,
Dresden)**

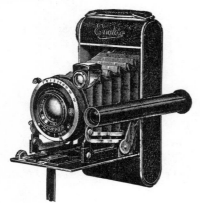

Enolde - c1931. 6x9cm self-erecting
rollfilm camera with an unusual detachable
telescope-viewer which mounts on the side.
The front of the telescopic finder attaches
to the lens standard while the rear portion
is fixed to the camera body. It serves for
focusing and as a viewfinder, especially for
close-ups. Rack & pinion focusing to 3 feet.

Enolde Anastigmat f4.5 in 3-speed shutter
or Zeiss Tessar f4.5 in Compur. $200-250.

Enolde I,II,III - c1930. Folding bed
cameras for 6.5x9cm plates. Models I and
II are single extension; Model III has
double extension. Model I has a small
reflex brilliant finder; Model II has reflex
and wire frame finders. $20-40.

Korelle cameras - *There are several basic
types of Korelle cameras which appear regularly
on today's market. The most common of these
by far is the reflex. All types, even if not identified
by model name or number on the camera, are
easily distinguished by size and style. For this
reason, we have listed the Korelle cameras here
in order of increasing size.*

18x24mm (Korelle K) - c1933. Compact
35mm half-frame camera in vertical format.
Thermoplastic body is neither folding nor
collapsing type. Shutter/lens assembly is
a fixed part of the body. Front lens focusing.
Trioplan f2.8/35mm in Compur 1-300
shutter. Reddish brown: $500-750. Black:
$250-350.

**3x4cm (style similar to the model K, or
like a Wirgin Gewirette)** - c1932. For 16
exposures on 127 film. This model has
telescoping front like the Gewirette.
Schneider Radionar f2.9/50mm. Compur
1-300, T, B. Asking prices in England: $75-
90. Sales in USA and Germany: $40-65.

3x4cm (strut-folding type) - For 16
exposures on 127 film. E. Ludwig Vidar
f4.5/50mm lens in Vario or Compur
shutter. $50-75.

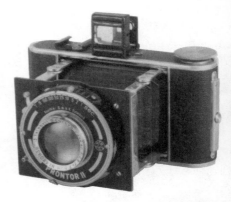

4x6.5cm (strut-folding convertible type) -
c1930. For 8 exposures on 127 film.
However, the film guide roller and mask
slide out to allow insertion of a plateholder,
film pack adapter, or cutfilm holder. This
model was called the "3-in-1" by Burke &
James, the U.S. distributor. Schneider

Radionar f3.5/75mm or Xenar f2.8/75mm. Compur or Compur Rapid. Appears basically the same as the Korelle "P" below, but rounded ends added to the length of the body to house the film rolls. These two cameras were contemporary and sold for the same price when new. A good quality camera and clever design which has gone unnoticed by many collectors. Despite the fact that the less sophisticated model P has been selling for much more, this unsung convertible model has been bringing only $40-70 in Germany and $65-95 in USA.

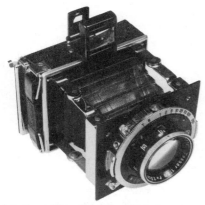

4.5x6cm (Korelle P) - c1933. Strut-folding type for plates only. Shorter than the above convertible model and with square ends. A fine quality vest-pocket plate camera. Tessar f2.8/75mm or f2.9 Xenar. Compur shutter 1-250. Leather covered metal body. Uncommon. $250-400.

6x6cm (strut-folding rollfilm type) - c1937. Hinged lens shade/cover. Various lenses f4.5 to f2.8. Prontor I,II; Compur, Compur Rapid; Ibsor shutters. $50-75.

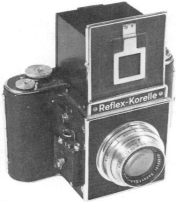

Reflex-Korelle - Introduced 1935, after

the Noviflex, neither of which is the first 6x6cm SLR. Single lens reflex for 12 exposures on 120 film. The first model is identifiable by the focal plane shutter 1/10 to 1/1000. Later models had 1/25 to 1/500. A more expensive model had slow speeds to 2 seconds. The 1/1000 top speed returned again on the chrome III camera. *A camera of similar appearance was made by WEFO of Dresden after WWII and called "Meister Korelle" (Master Reflex in the USA).* $75-125.

KOGAKU - *Japanese for "Optical". This term is found in the name of many Japanese firms, usually preceded by the key name of the manufacturer. (However, if you are reading the name from a lens, it may only be the maker of the lens and not the camera.)*

KÖHNLEIN (Konrad Köhnlein, Nürnberg, Germany)
Wiko Standard - c1936. Bakelite subminiature for 13x17mm on special 16mm rollfilm. Laack Poloyt f4.5/30mm. Focal plane shutter 20-200. $125-150.

KOJIMA OPTICAL SEIKI CO. (Japan)

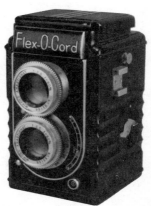

Flex-O-Cord - c1954-55. Heavy bakelite TLR with externally gear-coupled lenses. Film transport section pulls out like a drawer from the right side of the camera. Appears identical to the Mikono Flex P except for the nameplate. It was also advertised as "Flex-O-Cord II", but we can find no evidence of a second model. Mikono f3.5/80mm Anastigmat in MRS shutter. $50-75.

Mikono-Flex P - c1952. Heavy bakelite TLR, identical to Flex-O-Cord. $50-75.

KOLAR (V. Kolar, Modrany & Prague, Czechoslovakia)
Box Kolex - c1932. Brown leathered metal box camera for 4.5x6cm plates. Rekolar f6.3/75mm lens in Pronto or Vario. Rare. $150-200.

Kola - c1936. Unusual box-shaped camera for various formats on either of two film types: Takes 24x36mm exp. on 35mm film, or 4x4cm or 3x4cm exposures on 127 film with different masks. Zeiss f2.8/60mm Tessar or f2.9/50 Xenar. Compur shutter. Early model has folding optical finder; later model has tubular finder. $200-250.

Kola (folding rollfilm) - c1934. Folding body, 16 exposures 4.5x6cm on 120 rollfilm. Rekolat f6.3/75mm in Vario 25-100. $40-50.

Kola Diar - c1933. "Diary" camera for children and beginners. Small camera for twelve 32x32mm exposures on special rollfilm. Folding direct frame finder. Simple construction with fixed focus f11/50mm Achromat. Two stops. Siko shutter for instant or time. $200-300.

Kolar - c1930s. Bakelite body, similar to Photax but brown and chrome, 6.5x7.5cm. Rekolar f6.3/75mm lens in Vario. $45-70.

Kolarex - c1932. Similar to the Kolex, but for 127 film. Rare. $100-125.

Kolex - c1932. Small vertically styled self-erecting camera for 4.5x6cm plates. Rekolar f4.5/75mm in Vario or Pronto. Also seen with Trioplan f3.5/75mm in Compur. Rare. $125-165.

KOMLOSY - Metal-bodied 70mm camera.

Rapid advance. $75-125.

KONISHIROKU KOGAKU (Japan)

Konishiroku and its predecessors have been involved in the photographic business since 1873 when Konishi-ya sold photographic and lithographic materials.
1873- Konishi-ya
1876- Konishi Honten
1902- Rokuoh-sha factory founded.
1921- Reorganized as corporation "Konishiroku Honten".
1936- Incorporated as a limited company "Kabushiki Kaisha Konishiroku" (Konishiroku Co. Ltd.).
1943- Name changed to "Konishiroku Shashin Kogyo Kabushiki Kaisha" (Konishiroku Photo Industry Co. Ltd.).
1944- Merger with Showa Photo Industries Co. Ltd.

Baby Pearl - c1934. Self-erecting folding camera for 16 exposures on 127 rollfilm. f4.5/50mm Hexar or Optar lens. Rox shutter B,25-100. $100-150.

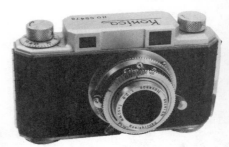

Konica - c1948-54. 35mm RF. Hexar or Hexanon f2.8 or 3.5 lens in Konirapid or Konirapid-S 1-500 shutter. Earliest models were made in Occupied Japan, and were not synched. No double exposure prevention. $50-75.

Konica II - 1951-58. 35mm RF. Hexanon f2.8/50mm lens in Konirapid-MFX 1-500

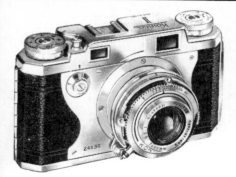

Konica III

Seikosha SLV 1-500 shutter. $100-150.

shutter. Double exposure prevention. $40-50.

Konica III - 1956-59. 35mm RF. Hexanon f2/48mm lens in Konirapid-MFX 1-500 shutter. $40-60. *Illustrated top of next column.*

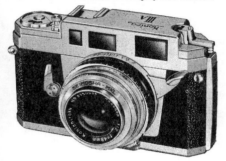

Konica Autoreflex - c1967. Japan's first 35mm SLR with focal plane shutter to feature automatic exposure control. Full or half-frame. (Also marketed as the Autorex.) $125-175.

Konica F - c1960. Konishiroku's first 35mm SLR. Coupled selenium meter. Shutter to 1/2000. Scarce in the U.S.A. $400-600.

Konica IIIA - 1958-61. Similar to the Konica III, but large center viewfinder window and larger rangefinder windows. Hexanon f2/48mm lens. $40-55.

Konica FS - c1961-64. 35mm SLR. Interchangeable Hexanon f1.4/50mm lens. FP shutter 1-1000,B. $60-80.

Konilette - c1953. Bakelite folding bed camera; 24x36mm exposure on 35mm film in special cassettes. Konitar f4.5/50mm in Copal 1/25-200,B shutter. $40-60.

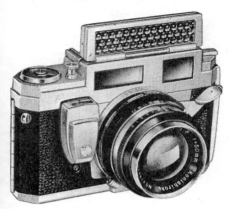

Konica IIIM - 1959-60. 35mm RF for full or half frame exposures. BIM (usually not working). Hexanon f1.8/50mm lens in

Konilette 35 - c1959. 35mm viewfinder

camera. Konitor f3.5/45mm lens. Shutter to 1/200, B, sync. $40-60.

Pearl (Showa 8), Pearl No. 2 - c1923-31. Folding-bed rollfilm cameras for 6x9cm. First Japanese camera to use 120 rollfilm. Early ones made of wood; c1927 changed to all metal. Shutter 25-100,T,B. $40-60.

Pearl I - c1949-50. Folding camera 4.5x6cm "semi" or half-frames on 120 film. Hexar f4.5/75mm in Durax shutter T,B,1-100. Uncoupled rangefinder. $75-125.

Pearl II - c1952-55. Similar to Pearl I, but with coupled rangefinder and Konirapid-S shutter to 500. "Pearl II" on top housing. $75-125.

Pearl IV - c1958. Folding 120 rollfilm camera, 4.5x6cm. CRF. Elaborate system of projected frames in viewfinder. Hexar f3.5/75mm. Seikosha-MXL, B,1-500. $175-225.

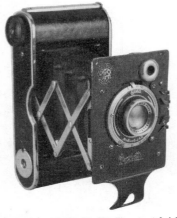

Pearlette - c1925-46. Trellis-strut folding camera for 4x6.5cm exposures. First

Japanese camera to use 127 rollfilm. Various models. Most commonly found with Rokuohsha Optar f6.3/75mm in Echo shutter 25-100. Deluxe models have f4.5 lens, folding optical finder. $60-80.

Rokuoh-Sha Machine-gun Camera Type 89 - World War II vintage training camera for machine gunners. Size, shape, and weight comparable to a machine gun, but holds 35mm film to make moving picture of targeted subject. Camera runs while trigger is squeezed, making 18x24mm images. Hexar f4.5/75mm lens. $300-400.

Sakura (Vest Pocket Camera) - c1931. Not related to the Sakura Seiki Co. which made the Petal camera. Small brown or maroon bakelite camera for ten exposures 4x5cm on 127 film. One of very few cameras to use the 4x5cm format on 127 film. Pull-out front. Rokuoh-Sha fixed focus lens. B,I shutter. $75-125.

Semi-Pearl - c1938-48. Self-erecting folding bed camera for 16 exposures, 4.5x6cm, on 120 film. Hexar f4.5/75mm lens. Shutter to 100. $40-60.

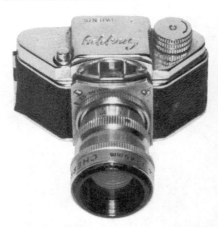

Snappy - c1949. Subminiature camera for 14x14mm exposures. Interchangeable Optar f3.5/25mm lens. Guillotine shutter behind the lens: B, 25, 50, 100. Made in Occupied Japan. With normal lens: $100-150. With f5.6/40mm Cherry Tele lens add: $50-75.

KORSTEN (Paris)
Litote - 1902-04. Rigid-bodied jumelle-style stereo for plates. 4.5x10.7cm or 6x13cm sizes. Aplanat or Krauss lenses. 3-speed guillotine shutter. Newton finder. $50-100.

KOSSATZ (Konstantin Kossatz, Berlin, Germany)
Spiegel-Reflex - c1897-WWI. Large format SLR. Leather covered body with nickel-plated metal parts. 13x18cm exposures on plates. Goerz Dogmar f4.5/240mm. Focal plane shutter. Rare. One nice example with working shutter sold at auction in 1983 for $368. No further sales data.

KOWA OPTICAL (JAPAN)
Kallo - c1955. Rangefinder 35, some models have uncoupled meter. f2.8 or f2 Prominar. Seikosha B,1-500. $20-35.

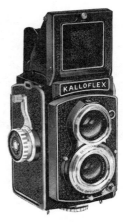

Kalloflex - c1954. 6x6cm TLR, 120 film. Prominar f3.5/75mm lens in Seikosha 1-500 shutter. $70-100.

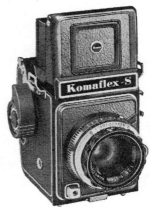

Komaflex-S - c1960. One of the very few

4x4cm SLR's ever made. 127 film. Die-cast body. Gray anodized finish. Gray covering. Kowa Prominar f2.8/65mm. Seikosha SLV between the lens shutter, 1-500, B. $100-130.

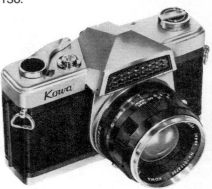

Kowa E - 1962-66. 35mm SLR. Coupled selenium meter. Prominar f2/50mm non-interchangeable lens (with telephoto and wide-angle attachments available). Seikosha SLV shutter, 1-500, B. $30-45.

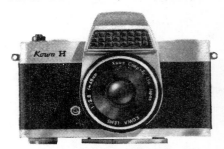

Kowa H - 1963-67. 35mm SLR. Coupled selenium, automatic, shutter preferred. Kowa f2.8/48mm lens in Seikosha 30-300 shutter. $30-45.

Kowa SE - c1964-69. Like the Kowa H, but has round CdS meter above lens instead of selenium meter. $35-50.

Kowa SW - 35mm wide angle camera with fixed Kowa f3.2/28mm lens. Seikosha SLV 1-500,B shutter. $200-275.

Kowaflex E - c1960-63. 35mm SLR with coupled selenium meter. Same as the Kowa E, but has "Kowaflex" name on it. $30-45.

Ramera - intro. 1959. Plastic six-transistor radio with 16mm sub-miniature camera. Also sold under the name Bell Kamra. 10x14mm exposures. Prominar f3.5/23mm. 3-speed shutter, 50-200, B. Available in:

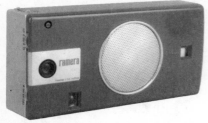

black, blue, red, white. Generally found new in box for $50-100.

Super Lark Zen-99 - c1960. Gray 127 camera with imitation light meter and rangefinder windows. 4x6cm or 4x4cm on 127 rollfilm. Prominar f11/70mm fixed focus. I,T shutter. $10-20.

Zen-99 - Inexpensive eye-level camera for 8 or 12 exposures on 127 film. Dark grey enamel with light grey covering. $10-20.

KOZY CAMERA CO.
Pocket Kozy - c1895. Flat-folding bellows camera. Bellows open like the pages of a book. Early model has a flat front, not rounded as on the later model. 3½x3½" exposures on rollfilm. Meniscus f2.0/5" lens. Single speed shutter, T. Waist-level viewfinder. $1200-1500.

Pocket Kozy, Improved - c1898. Similar to the first model, but front end with lens is rounded, not flat. $600-800.

KRANZ (L.W. Kranz)
Sliding-box Daguerreotype Camera - c1856. Wood body. 9x12cm. $5000+

KRAUSS (E. Krauss, Paris) *See the next listed manufacturer, G.A. Krauss of Berlin, for other Krauss cameras.*
Eka - c1924. For 100 exposures, 30x44mm on 35mm unperforated film. Krauss Zeiss

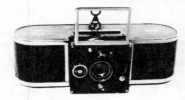

Tessar f3.5/50mm lens in Compur 1-300 shutter. $600-900.

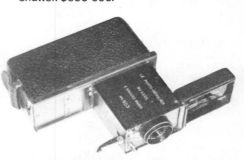

Photo-Revolver - c1920's. For 18x35mm exposures on 48 plates in magazine or special rollfilm back. Krauss Tessar f4/40mm lens. 3-speed shutter, 25-100, T. With rare rollfilm back: $1800-2200. With magazine back: $1400-1600.

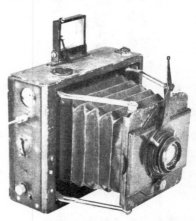

Takyr - c1906. Strut-folding camera for 9x12cm plates. Krauss Zeiss Tessar f6.3/136mm lens. Focal plane shutter. $125-175.

KRAUSS (G. A. Krauss, Stuttgart) *For other Krauss cameras, see the previous listings under E. Krauss, Paris.*

Nanos - c1923. Strut-folding plate camera, 4.5x6cm. Tessar f4.5/75mm lens. $75-125.

Rollette Luxus - c1928. Similar, but with light brown reptile covering and brown bellows. $125-175.

Stereoplast - c1921. All-metal rigid body stereo, similar to the Polyscop. 45x107mm exposures. f4.5/55mm lenses. Stereo-Spezial shutter to 300. Magazine back for glass plates. $200-350.

KREMP (Wetzlar, Germany)

Peggy I - 1931. 35mm strut-folding camera. Tessar f3.5/50mm lens. Compur shutter 1-300. $300-450.

Peggy II - c1934. Basically the same as Peggy I, but with coupled rangefinder. Early model automatically cocked the shutter by pushing in the front and releasing it, but this meant that the camera was stored with the shutter tensioned. Later model (scarcer) had manual cocking lever. Often with Xenon f2 or Tessar f2.8. $300-500.

Kreca - c1930. Unusual 35mm with prismatic telescope for rangefinder. Identical to the Beira II camera from Woldemar Beier, but rarer still. "Kreca" embossed on front leather. "Kremp, Wetzlar" logo embossed on back. Kreca f2.9 lens in rim Compur to 300. $250-350.

KROHNKE (Emil Krohnke, Dresden)
Photo-Oda - c1902. Unusual rectangular metal subminiature for 18x18mm on special rollfilm. Meniscus lens, single speed shutter. Nickel finish with decorative engraving. Produced at the same time as the cane handle camera, the Photo-Oda appears to have been a ladies detective camera. The only known example sold at auction in May 1989 for $9100 with original box and a roll of film.

KRÜGENER (Dr. Rudolf Krügener, Bockheim/Frankfurt, Germany) *Merged in 1909 with Hüttig, Wünsche, and the Carl Zeiss Palmos factory to form Ica AG. Many of Krügener's camera lines continued under the Ica label, and indeed these later "Ica" models are more commonly found. Such names include: Halloh, Plascop, Teddy, Trix, & Trona.*

Delta (rollfilm) - c1900-1903. Horizontally styled folding bed 6x9cm camera with rounded ends. Leather covered wooden body and aluminum bed. Leather-covered wooden lensboard with built-in M,Z shutter and reflex finder. Wine-red bellows. $75-100

Rollette - c1920's. Folding rollfilm cameras, with Krauss Rollar f6.3/90mm lens in Pronto 25-100 shutter. Late models focus by radial lever on bed. $30-40.

Delta (plate & rollfilm) - Horizontally styled rectangular body. Folding bed. Early models c1900 have wooden lensboard with

built-in shutter or external brass "Delta" shutter. Later types c1905 have Unicum shutter and large metal frame finder. Wine red or light brown bellows. 9x9cm and 9x12cm sizes. Early types with built-in shutter or Delta shutter: $200-300. Later types with Unicum shutter: $125-175.

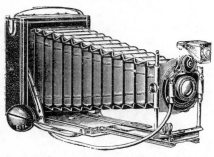

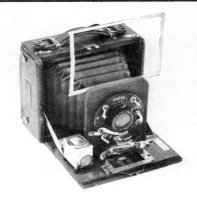

Delta Periskop

Delta (plate camera) - c1905. Vertically styled 9x12cm folding plate camera. Black leather covered wood body. Aluminum standard, nickel trim. f6.8/120mm Dagor or Euryscop Anastigmat lens. Delta shutter 25-100. $50-90.

Delta Detective - c1890. Small polished mahogany box camera. Leather changing bag for 12 plates, 6x8cm. Shutter cocked and released by pulling on 2 strings on top of the camera. $400-600.

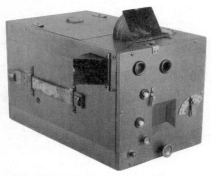

Delta Magazine Camera - c1892. For 12 exposures 9x12cm on plates which are changed by pulling out a rod at the front of the camera. Achromat lens in simple spring shutter. $400-500.

Delta Periskop - c1900. Folding bed camera for 9x12cm plates. Leather covered wood body. Red bellows. Krügener Rapid Delta Periscop f12 lens in delta shutter 25-100. $75-100. *Illustrated top of next column.*

Delta Stereo - c1898. Folding bed stereo camera for 9x18cm exposures on plates

or rollfilm. Earliest models with wooden lensboard, later made of metal. Periplanat or Extra-Rapid Aplanat lenses. Red bellows. Polished wood interior. $175-275.

Delta-Teddy - c1898. Folding camera for 9x12cm plates. Delta Achromat lens, 3-speed shutter with revolving diaphragm mounted in front of the lens. $100-150.

Electus - c1889. Non-focusing TLR-style magazine box camera. Similar to the Simplex Magazine camera, but only holds 18 plates. Steinheil lens. Single speed shutter. $800-1200.

Jumelle-style magazine camera - For 18 plates 6x10.7cm. Brass-barrel Periscop lens, leather covered wood body. Built-in changing magazine. $175-250.

Million - c1903. Leather covered stereo. Looks like a box camera, but has a short bellows extension. Red bellows. 9x18cm on rollfilm, single or stereo exposures. Periskop lenses. Guillotine shutter. $150-225.

Minimum Delta - c1909. Double extension folding plate camera with very thin body. 9x12cm. Pneumatic shutter, 1/25-100. $60-90.

Normal Simplex - c1892. Polished mahogany magazine camera for 12 plates, 9x12cm. Small box with waist-level view-finder retracts into the top of the camera body when not in use. Antiplanat lens, 3 diaphragm stops. $1200-1600.

Plaskop - c1907. Compact strut-folding camera for 45x107mm stereo plates. Unusual hinged frame finder incorporates lenscaps. Metal body available with or without leather covering. Various lenses. Four speeds plus time. Rare. $250-350. *Illustrated top of next page.*

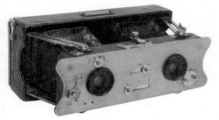

Plastoscop - c1907. Strut-folding stereo camera for 45x107mm plates. $125-175.

Krügener Plaskop

K.S.K.
Corona - Subminiature made in Occupied Japan. 14x14mm exposures. Rim-set leaf shutter, iris diaphragm. Red leather covering with gold-colored metal parts. $200-250.

KUGLER (Earl Kugler, U.S.A.)
Close Focus Camera - Unusual vertically styled polished wood folding bed camera for 2½x4¼" exposures on rollfilm. Rack and pinion focusing to 12". Symmetrical 4x5 lens in Unicum shutter. Rigid wood handle on top. $150-200.

KUEHN (Berlin, Germany)
Lomara - c1921. Large SLR for plates. Focal plane shutter. $150-200.

KUH (Czechoslovakia)
Companion Reflex - c1939. TLR. Trioplan f2.8/75mm, Compur 1-250 shutter. $45-65.

KULLENBERG, O. (Essen, Germany)
Field camera - 5x7". Vertical format field camera with red tapered bellows, brass-barreled Universal Aplanat f8 lens with iris diaphragm. Rouleau shutter. $175-225.

Simplex Magazine - c1889. Non-focusing TLR-style with changing mechanism for 24 plates, 6x8cm. Polished mahogany. Steinheil or Periscop f10/100mm lens. Single speed sector shutter. $1200-1400.

KUNIK, Walter KG. (Frankfurt)

Foto-Füller (Luxus) - c1956. The German version of the French Stylophot, designed by Fritz Kaftanski. This luxus version has a crudely applied covering of imitation snakeskin. Hardly in competition with the Luxus Leica, but still not often found. $200-250.

Taschenbuch-Camera - c1889-1892. Leather covered, disguised as a book. Achromatic f12/65mm lens is in the "spine" of the book. Guillotine shutter, T, I. Shutter is cocked and released by pulling on 2 strings. Internal magazine holds 24 plates for 40x40mm exposures. $2500-3000.

Mickey Mouse Camera - c1958. Subminiature, like the Ompex, but with the Mickey Mouse name on the faceplate. 14x14mm exposures on 16mm Tuxi film. Red hammertone body. Meniscus lens, single speed shutter. $75-100. *Illustrated top of next page.*

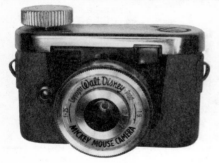

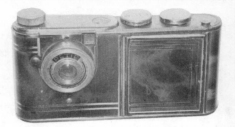

Mickey Mouse Camera

Petie Vanity - c1956. Petie camera housed in a make-up compact. Front door opens to reveal mirror and powder. One top knob contains a lipstick, another provides storage for an extra roll of film. Art deco enameled finish in black, red, green, or blue. $450-750.

Ompex 16 - c1960. Subminiature similar to the Tuxi. Black or red body. Meniscus lens, single speed shutter. Red: $50-75. Black: $40-50.

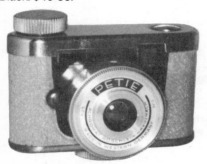

Petie with gold trim

Petie - c1958. Subminiature for 16 exposures 14x14mm on 16mm film. Meniscus f11/25mm lens in simple shutter. Gray crinkle finish enamel with gold-colored trim: $40-60. Black with silver parts: $25-45.

Petitax - c1962. Novelty camera for 14x14mm exposures on rollfilm. f11/25mm lens. Simple shutter. $30-45.

Petietux, gold - c1957. Similar to the Petitax. 14x14mm. Achromat f9/25mm lens. BIM. $70-110.

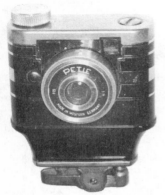

Petie Lighter - c1956. Petie in a special housing incorporating a cigarette lighter. Art deco enamel or leather covered. $450-500.

Tuxi - c1960. For 14x14mm on 16mm film.

Achromat Röschlein f7.7/25mm lens in synched shutter, B, M. $35-55.

Tuximat - c1959. 14x14mm on 16mm film. Meniscus lens f7.7/25mm. Synched shutter. Simple built-in meter. $100-125.

KURBI & NIGGELOH - see Bilora

KURIBAYASHI CAMERA WORKS, PETRI CAMERA CO. (Tokyo)
Kuribayashi Camera Works was established in 1907 as a small workshop producing photographic accessories such as plate holders and wooden tripods. Its first production camera was the Speed Reflex of 1919. Most pre-WWII models were sold under the "First" brand name by Minagawa Shoten, a trading firm. During the Occupation, the name "Petri" was chosen, contracted from "Peter the First". This was hoped to improve acceptance in non-Japanese markets. The company name was changed to Petri Camera Company in 1962. After seventy years, the company went bankrupt in 1977.

None of the pre-WWII models were marketed outside of Japan. Though Kuribayashi was a leading domestic manufacturer, most models were still made in small lots and are now quite rare and highly sought in Japan. During the Occupation, nearly all Japanese cameras, including Petri models, were sold to Allied forces and western markets.

Most of the historical and technical information on Kuribayashi/Petri as well as the photos in this section were provided by Mr. John Baird. His book on the subject is scheduled for publication by Centennial Photo in the near future. John also publishes a newsletter and a series of monographs on collectible Japanese cameras. For further information, write to: Historical Camera Publications; P.O. Box 90, Gleed Station; Yakima, Washington 98904.

Cameras in this section are grouped by type and are listed in chronological order.

PLATE CAMERAS
1919 Speed Reflex - Similar to the English Ensign large format SLR's. Two models in either ¼-plate or 6x9cm formats. German Tessar lens, cloth focal plane shutter to 1/1000. Very rare. $600+

HAND PLATE CAMERAS
Folding hand plate cameras, interchangeable 2¼x3¼" ground glass focusing backs and plate holders. Initially fitted with imported European Vario or Compur shutters and Tessar or Trinar 105mm lenses. By 1934, the majority of the plate models used some of the very first all-Japanese made shutters/lenses, specifically Toko and State (Tokyo Kogaku) 105mm Anastigmat lenses and Vario-inspired Seikosha Magna.

Mikuni - c1926. One of the leading Japanese-made cameras during the late 1920's. Tessar f4.5-6.3/105mm lens, Vario shutter. No known example in any Japanese collection. Value unknown.

First Hand

Kokka Hand

327

KURIBAYASHI (cont.)

First Hand - 1929, new model 1932. The "First" series began this 1929 First Hand. *Illustrated previous page.*
Kokka Hand - 1930, new model 1932. *Illustrated previous page.*
Tokiwa Hand - 1930. *Illustrated next column.*
Romax Hand - 1934. *Illustrated next column.*
All models rare, available only in Japan. Collectors' price $75-300.

First Etui Camera - 1934. Patterned after the KW Patent Etui. Very compact folding camera fitted with Toko Anastigmat 105mm, Magna shutter. $150-275.

PRE-WAR ROLLFILM MODELS
Starting in the early 1930's with the increasing supply of rollfilm in Japan, hand plate models gave way to the compact, easy to use, rollfilm models. These models have self-erecting folding bellows and are fitted with a variety of Japanese made lenses/shutters, dominated for the most part by Toko Anastigmats and Seikosha's copy of either the Vario or rim-set Compur shutter. In fact, the 1936 Semi First sported the first Compur-type Seikosha shutter.

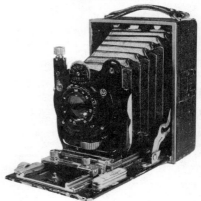

Tokiwa Hand

Romax Hand

variety of Japanese and German shutters. Full frame exposures on 120. $150-250.

Semi First - 1935. 4.5x6cm on 120 rollfilm. No sales data.

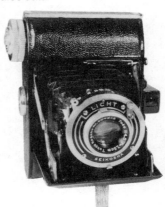

First Roll - 1933. Folding metal body. Radionar, Trinar or Toko (State) 105mm;

Baby Semi First - 1936. 4.5x6cm on 120.

328

No sales data.

First Center - 1936. 6x9cm on 120. No sales data.

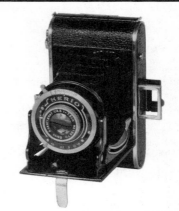

First Speed Pocket

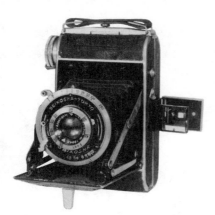

First Six - 1936. The first Japanese-made camera for the 12-on-a-roll format. Toko Anastigmat f3.5/75mm. Seikosha T,B,1-250 shutter. Vertical body. (See Tokiwa Seiki for a later First Six, c1950's.) $60-120.

First Speed Pocket - 1936. The first Japanese camera to take both Vest and Baby formats. 127 film. $50-100. *Illustrated top of next column.*

BB Semi First - 1940. 4.5x6cm on 120 rollfilm. The first camera to be made in Japan with a built-in exposure meter (extinction type). $100-300.

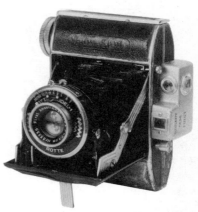

Baby BB Semi First - 1940. 4.5x6cm on 120 rollfilm. No sales.

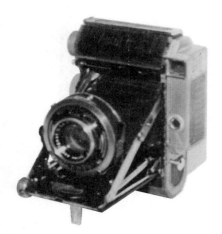

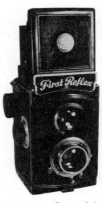

Auto Semi First - 1940. 4.5x6cm on 120 rollfilm. $100-250.

First Reflex - 1937. One of Japan's first 120 twin lens reflex cameras, fitted with

329

First Anastigmat 75mm and First shutter, 1-200. Very rare, with less than five examples known. Few sales. $300+.

POST-WAR ROLLFILM MODELS

After the war, Kuribayashi introduced its own line of shutters and lenses; Carperu leaf shutters in a variety of speeds; Orikon and Orikkor lenses.

Kuri Camera - 1946.
Lo Ruby Camera - 1947. Both models are improved versions of the pre-war Semi First. Made in small quantities mounting First or Kokka 75mm Anastigmats, and First or Wester Compur-type shutters. No sales.

Petri Semi, II, III - 1948. First use of the word "Petri". Fitted with Petri and Orikon 75mm lenses and Petri 1-200 shutter. Built-in uncoupled rangefinder. Majority marked MIOJ on back cover latch. $75-100.

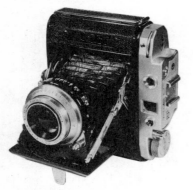

Petri RF - 1952. Compact version of the larger Petri Semi type. Orikon f3.5/75mm and Carperu 1-200 shutter. Uncoupled rangefinder. About $100.

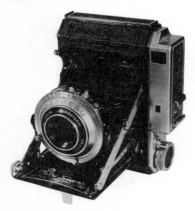

Petri Super - 1955.
Petri Super V - 1956. Last Kuribayashi

rollfilm self-erecting models. Very similar to pre-war Auto Semi First with coupled rangefinder. Tessar-type Orikkor 75mm and Carperu or Seiko Rapid shutter. Uncommon high quality folding camera. $300-400.

Petri RF 120 - 1955. Very similar to the Petri RF, but with coupled rangefinder. Uncommon. Price unknown. No sales.

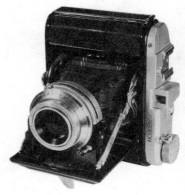

Karoron - 1949.
Karoron S - 1951. Popular models of the more expensive feature-laden Petri Semi. Neither fitted with rangefinders. Orikon 75mm lens; Carperu shutter to 200. $75-95.

Karoron S-II, RF - 1951-52. Same as Petri RF except for nameplate. Orikon f3.5/75, Carperu shutter. Uncommon. $85-110.

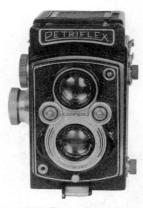

Petriflex - 1953. The only post-war TLR camera to be manufactured by Kuribayashi Camera. Rolleicord-inspired with matched Orikkor f3.5/75mm taking and viewing lenses and Carperu shutter to 200. Rare. $150.

PETRI 35mm CRF MODELS

Kuribayashi's first 35mm rangefinder camera was the 1954 Petri 35.

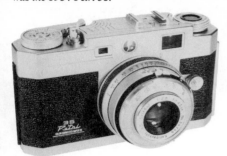

Petri 35 - 1954. Orikkor f3.5 or f2.8/45mm lens, Petri-Carperu shutter, 1/10-200. Uncommon. $35 and up.

Petri 35X, MX - 1955.
Petri Automate - 1956. *Illustrated below.*
Petri 35 2.0 - 1957. *Illustrated below.*
Petri (35) 2.8 - 1958. *Illustrated next column.*
Petri 35 1.9 - 1958. *Illustrated next column.*
These models were based on the original 1954 Petri 35. Fitted with Orikkor 45mm f2.8, 2.0, 1.9 lenses; Copal and Carperu shutters with speeds of either 1/300 or 1/500. All have coupled rangefinders. Common, with prices starting at $10.

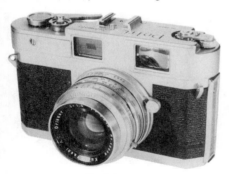

Petri Automate

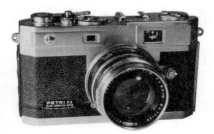

Petri 35 2.0

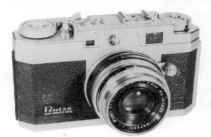

Petri (35) 2.8

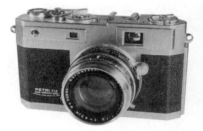

Petri 35 1.9

PETRI COLOR SUPER SERIES

Improved 35mm models with a projected bright line viewfinder with automatic parallax correction. High quality taking lenses.

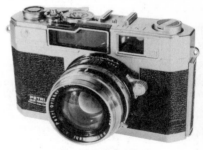

Petri 1.8 Color Super

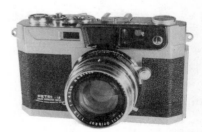

Petri 1.9 Color Super

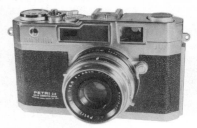

Petri 2.8 Color Super - 1958.
Petri 1.8 Color Super - 1959. *Illustrated on previous page.*
Petri 1.9 Color Super - 1960. *Illustrated on previous page.*
Sold in vast numbers. Common. $10 and up.

Petri Seven S

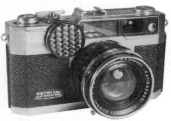

Petri EBn - 1960. Built-in selenium cell exposure meter fitted in Petri Color Super body. Orikkor 45mm f1.9 or 2.8 lens. Copal or Carperu shutter in geometrical progression to 500. $35.

Petri Pro Seven

PETRI SEVEN SERIES
CRF with selenium cell (CdS on Racer) mounted inside of lens ring, called "Circle Eye" by the factory. All have f1.8 or 2.8 Petri lenses (f1.8 only on Petri Pro Seven); shutters to 500. Exposure readout in viewfinder and on the top cover, (Petri Seven is fitted only with finder meter scale).

Petri Prest

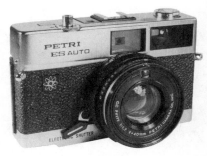

Petri Seven - 1961.
Petri Seven S - 1962. *Illustrated next column.*
Petri Pro Seven - 1963. *Illus. next column.*
Petri Racer - 1966.
Petri Seven S-II - 1977.
Very popular cameras. User prices $5-30.

Petri ES Auto 1.7

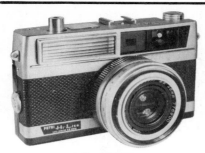

Petri Hi-Lite

OTHER PETRI CRF MODELS
Petri Prest - 1961. *Illustrated previous page.*
Petri Hi-Lite - 1964. *Illustrated above.*
Petri Computor 35 - 1971.
Petri M 35 - 1973.
Petri ES Auto 1.7 - 1974 *Illus. previous page.*
Petri ES Auto 2.8 - 1976.
Petri 35 RE - 1977.
With the exception of the selenium-celled Petri Prest and Hi-Lite, these models contain fully automatic CdS photometers. All have coupled rangefinders with projected bright line frames. Petri lenses in 40 and 45mm focal lengths in a range of apertures to f1.7 using Petri and some Seiko-made shutters. Prices start at $10.

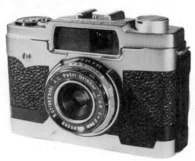

Petri Half

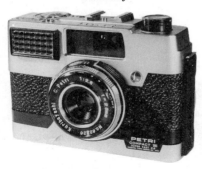

Petri Compact E

PETRI HALF-FRAME MODELS
Kuribayashi was the second Japanese camera maker to produce half-frame models.
Petri Half, Junior, Compact - 1960. *Illustrated previous column.*
Petri Compact E - 1960. *Illustrated previous column.*
Petri Compact 17, Petri Half - 1962. Projected bright line viewfinders. Petri-Orikkor f2.8/28mm lenses. 1960 Petri Half had a rapid advance lever and Carperu shutter to 250. Compact E was the same as Petri Half, but with a built-in uncoupled selenium exposure meter. 1962 half-frame models sported electric eye photometer for fully automatic exposure and revised body design. All still available both for the user and collector. Compact and high quality. Prices start at $35.

PETRI FULL FRAME COMPACT 35mm

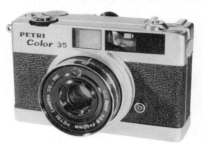

Petri Color 35 - 1968.

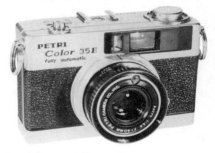

Petri Color 35E - 1970.
Petri Micro Compact - 1976.
Retractable Petri f2.8/40mm patterned after Rollei 35. One of Petri's most successful models, the original 1968 Petri Color 35 had a coupled CdS photometer; shutter speeds to 250. The other two models are very similar but have fully automatic exposure mechanism. $25-45.

PETRI SINGLE-LENS-REFLEX MODELS
Most models supplied with 55mm f2 or f1.4 normal lens in Petri breech mount. All share the same basic body design and front-mounted shutter release. Most models common and still available on the used market.

KURIBAYASHI (cont.)

PETRI PENTA SERIES
Kuribayashi's first modern SLR.
Petri Penta - 1959. *Illustrated below.*
Petri Penta V2, Petri Flex V - 1961.
Petri Penta (Flex) V3 - 1964. *Illus. below.*
Petri Penta (Flex) V6 - 1965. *Illus. below.*
Petri Penta (Flex) V6-II - 1970.
Focal plane shutter ½-500; pre-set screw-mount Petri Orikkor f2.0/50mm lens. Later improvements include automatic lens aperture and introduction of Petri breech lens mount system with the Petri Penta V2 (called Petri Flex series in non-Japanese markets). Clip-on CdS photometer on the Petri Penta V3 and later Petri V6. Japan: $200. USA: $65-85.

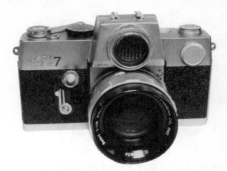

Petri Flex Seven - 1964. External CdS cell. Cloth focal plane shutter of 1-1000. Breech lensmount. Rare and highly sought after by Japanese collectors, with prices starting at $200.

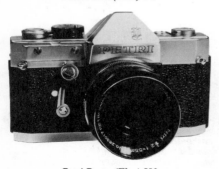

Petri Penta

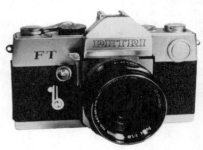

Petri FT

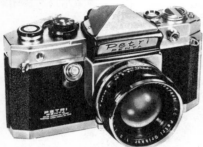

Petri Penta (Flex) V3

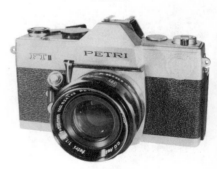

Petri FT-II

Petri FT - 1967. *Illustrated above.*
Petri FT-II - 1970. *Illustrated above.*
Petri FTX - 1974.
Petri FT 1000 - 1976. *Illustrated next page.*
Petri FT 500 - 1976.
Petri MFT 1000 - 1976. Compact model.
Petri Micro MF-1 - 1977. Compact model. *Illustrated next page.*
TTL photometers with stop-down aperture, match-needle meters. Cloth focal plane

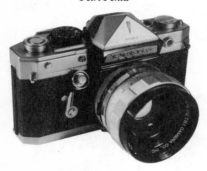

Petri Penta (Flex) V6

shutter of 1-1000 (500 top speed on the FT 500). Breech lens mount used on models FT, and FT-II; universal 42mm screw-type lens mount on all other models. FT 1000 and 500 were also sold under different brand names. User prices from $60-150.

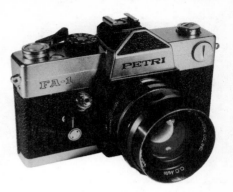

Petri FA-1

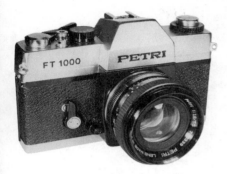

Petri FT 1000

Petri FT EE - 1969.
Petri FTE - 1973. *Illustrated previous column.*
Petri FA-1 - 1975. *Illustrated above.*
All shutter speed priority, fully automatic reflexes. TTL meter sets f stop with full aperture metering. Cloth focal plane shutter in FT EE and FTE similar to Petri Flex V (½-500), and 1-1000 with FA-1. FT EE and FTE nearly alike, except for designation. FA-1 most deluxe, advanced model of its type from Petri Camera. All use standard Petri breech lens mount. $60-150.

RAPID FILM SYSTEM MODELS

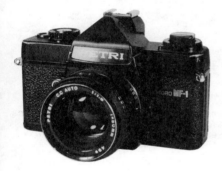

Petri Micro MF-1

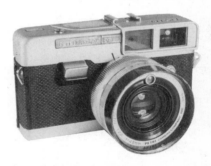

Petri Auto Rapid - 1965.
Petri Instant Back (AKA Anscomatic 726) - 1966. *Illustrated next page.*
Petri Pocket 2 - 1975.
Petri Grip-Pack 110 - 1977.
Petri Push-Pull 110 - 1977.
These feature quick loading film systems: Petri Auto Rapid (Agfa Rapid), Petri Instant Back (Eastman Kodak 126); Petri Pocket 2, Grip Pak, and Push-Pull (Eastman Kodak 110 cartridge load). Leaf shutter and fixed Petri lenses. All common with user prices at $20-30.

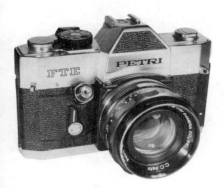

Petri FTE

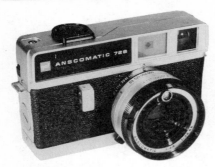

Petri Instant Back (Anscomatic 726)

Fotochrome Camera - 1965. Made by Petri Camera for USA firm of Fotochrome Inc. Using mirror-type image reversing system, special drop-in film packs allowed for direct color prints without negative with factory processing. Unusual plastic body with flip-up reflector for built-in bulb flash. Petri f4.5/105mm lens and Vario-type shutter. Still available new in boxes usually for $20-30; double that in Europe.

K.W. (Kamera Werkstatten, Dresden, Germany) *After WWII, KW eventually became part of the "V.E.B. Pentacon" group which formed in 1964.*
Astra 35F-X - c1953-57. Same as the KW Praktica FX. Three versions: c1953 has 3 front sync contacts; c1955 has 1 sync contact; c1957 has large sync contact. $30-50.

Astraflex 35 - c1955-62. Same as the Contax D. $60-100.

Happy - c1931. Folding 6.5x9cm plate camera. A name variant of the Patent Etui. Black leather covered metal body. Schneider Radionar f6.3/105mm lens in Vario shutter. $50-75.

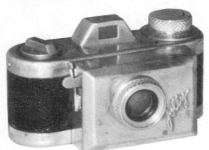

Jolly - c1950. Subminiature for 10x15mm exposures. T & I shutter. Rare. One of the first post-war subminiatures from Germany, and the only one from K.W. $200-250.

Kawee - *Apparently this was the American marketing name for the "Patent Etui", below.*

Patent Etui, 6.5x9cm size - Tessar f4.5/105mm or Radionar f6.3/105mm lens. Focus knob on bed. Vario, Ibsor or Compur shutter. Grey, brown, red, blue, or black leather covering and matching colored bellows. Colored models are uncommon. Red or blue: $200-300. Grey or brown: $150-200. Black, in USA: $50-90; Germany: $30-70.

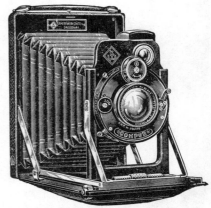

Patent Etui, 9x12cm size - The most common size. f4.5 or f6.3 Rodenstock Eurynar, Schneider Radionar, Isconar, Erkos Fotar, or Zeiss Tessar or Trioplan. Shutter: Ibsor, Vario, or Compur. Made with grey, red, blue, brown or black leather covering and matching colored bellows. Red or blue: $200-300. Grey or brown: $150-200. Black: $30-55.

Pentaflex - Same as Praktica Nova, below.

Pilot 6 - 1936-39. SLR for 12 exposures 6x6cm on 127 rollfilm. Laack Pololyt f3.5/

336

75mm or 80mm, or KW Anastigmat f6.3/ 75mm. Metal guillotine shutter 25-100, later 20-150. Last models c1938-39 have 20-200 shutter and interchangeable lenses. Replaced in 1939 by Pilot Super. $80-110.

Pilot Reflex - 1932-37. TLR for 16 exposures 3x4cm on 127 film. With f2.0 Biotar: $400-500. With Xenar f2.9, f3.5; or Tessar f2.8, f3.5: $200-250.

Praktica - c1952. 35mm SLR. Waist-level viewing. Interchangeable lens: f2.8 or 3.5. Focal plane shutter 2-500, B. $35-50.

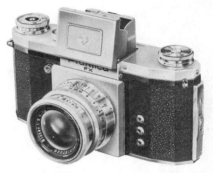

Pilot Super - 1939-41. SLR for 12 exposures 6x6cm on 120 film. Could also take 16 exposures 4.5x6cm with mask. Built on the same chassis as the Pilot 6, but easily distinguished by the addition of a small extinction meter attached to the viewing hood. Interchangeable lens, such as: Ennastar, Pilotar, or Laack, f2.9, 3.5, or 4.5. Shutter 20-200,T,B. $60-90.

Praktica FX - 1952-57. 35mm SLR, waist-level finder. Westanar or Tessar f2.8 or 3.5 lens. Focal plane shutter 2-500. $30-50.

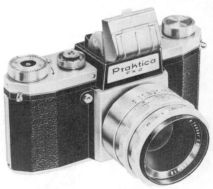

Pocket Dalco - A name variation of the Patent Etui 6x9cm. Tessar f4.5/105mm in Compur. Available in black, and probably the other colors as well. We have sales records of at least one in blue leather covering with blue bellows at $200-250. Black: $40-60.

Praktica FX2 - c1956. Same as FX, but with accessory pentaprism for eye-level viewing. With normal lens and prism finder: $35-50.

Praktica FX3 - c1957. Like FX2, but with internal automatic diaphragm stop-down. $30-50.

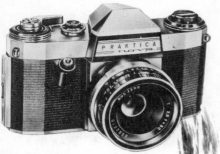

Praktica Nova - c1965. 35mm eye-level SLR. Domiplan f2.8 lens. Focal plane shutter 2-500. $35-55.

Praktica Prisma - c1962. 35mm eye-level SLR. Tessar f2.8 lens. Focal plane shutter 2-500. $40-60.

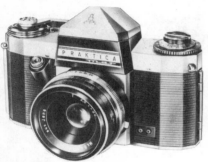

Prakticamat - c1965-69. 35mm SLR. Interchangeable lens, 42mm thread. Cloth FP 1-1000,B. TTL CdS metering. $35-50.

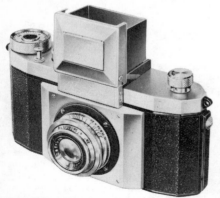

Praktiflex - c1938. Early 35mm SLR, probably the 2nd or 3rd produced. Victor f2.9/50mm, Tessar f3.5 , or Biotar f2.0 lens. Waist-level finder. Focal plane shutter 20-

500. Red or Blue: no sales data. Grey lacquered with brown leather: $100-200. Normal: $50-75.

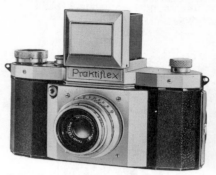

Praktiflex II - c1940. Victor f2.9/50mm lens. $30-50.

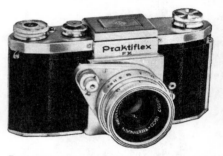

Praktiflex FX - c1955. Same as Praktica FX, possibly given this name by U.S. importers. Tessar f2.8 or Primoplan f1.9 lens. $30-50.

Praktina FX - c1956-66. 35mm SLR. Interchangeable Biotar f2/58mm lens. FP shutter 1-1000, B. Interchangeable penta-prism. Without motor: asking prices in England, $75-100. Numerous sales in Germany and USA: $35-60. *Add $40-60 each for spring motor drive or bulk film back.*

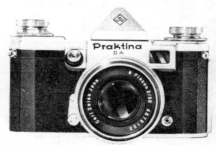

Praktina IIa - c1959-74. 35mm SLR. Usually with Jena Flexon f2/50mm. Focal

plane shutter to 1000. $45-90 in Germany, $80-120 in USA without motor. *Add $40-60 each for spring motor drive or bulk film back.*

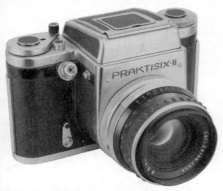

Praktisix, Praktisix II - c1957-62. 6x6cm SLR. (Later models from VEB Pentacon are Pentacon Six and -Six TL still in production; also modified to Exakta 66.) Changeable waist-level or prism finders. Interchangeable bayonet mount Meyer Primotar f3.5/80mm or Tessar. Later models have Biometar. Focal plane shutter 1-1000. USA: $150-200. Germany: $100-150.

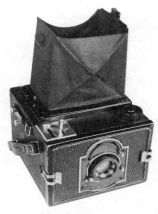

Reflex-Box - c1933. Boxy SLR for 8 horizontal exposures 6x9cm on 120 rollfilm. KW Anastigmat f6.3/105mm, or Steinheil f4.5/105mm. Three speed shutter 25-100, B. Folding top viewing hood. $70-125.

Rival Reflex - c1955. Praktica 35mm SLR body with crude name change for export to the USA. Wetzlar Vastar f2.8/50mm lens. Focal plane shutter, sync. $30-45.

KYOTO SEIKI CO. (Japan)
Lovely - c1948. Rare Japanese subminiature taking 14x14mm exposures

on paper-backed rollfilm. Simple fixed-focus lens, shutter 25-100,B. $500+.

LA CROSSE CAMERA CO. (LaCrosse, Wisc.)

Snapshot - c1898. Miniature cardboard and brass box camera. 28x28mm exposures. (Identical to the Comet Camera made by Aiken-Gleason Co. of LaCrosse.) $250-350.

LA ROSE (Raymond R. La Rose & Sons, Culver City, USA)
Rapitake - c1948. Unusually designed 35mm for 18x24mm exposures. Metal body. Tubular viewfinder. Fixed focus f7.5/35 lens. Single speed shutter. Plunger at back is the shutter release and also advances the film. $200-300.

LAACK (Julius Laack & Sons, Rathenow)
Ferrotype camera - c1895. Metal "cannon" camera for 25mm dia. ferrotypes. f3.5/60mm lens. $700-900.

Merkur - 10x15cm folding plate camera. Polyxentar f6.8/150mm lens in Koilos shutter. $30-50.

Padie - 9x12cm folding plate camera. Laack Pololyt f6.8/135mm. Rulex 1-300 shutter. $25-40.

Tropical camera - Folding plate camera, 9x12cm. Wood exterior, brown bellows.

Laack Pololyt f4.5/135 lens in Ibsor shutter or Laack Dialytar f4.5 in Compur. With gold plated metal parts: $500-600. With brass trim: $200-300.

Wanderer - For 6.5x9cm plates. $25-40.

LABARRE (J.B.R. LaBarre)
Tailboard camera - Wood body with brass trim, brass barrel Rectilineaire Extra Rapid f8 lens. Revolving red bellows. Lenscap acts as shutter. $175-225.

LACHAIZE (Paul Lachaize, Lyon France)

Mecilux - c1955. Unusually styled 35mm amateur camera. Single weather setting adjusts shutter and diaphragm; blocks shutter if flash is needed. Pop-up flash with folding reflector. Star-shaped film advance knob on bottom. Back locks closed until film is rewound. Boyer 45mm/f2.8. Scarce. $175-250.

LACON CAMERA CO., INC. (Shinano Camera Works, Japan)

Lacon C - c1954. 35mm viewfinder camera. S-Lacor f3.5/45mm lens, shutter 25-300,B. $30-50.

LAMPERTI & GARBAGNATI (Milan)
Detective camera - c1890. 9x12cm. Polished wood body. Leather changing sack. $250-350.

Wet-plate camera - c1870. Polished walnut body, square blue bellows. 18x18cm. Tilting back. Brass barrel Darlot Petzval lens, waterhouse stops. $1500-2000.

LANCART (Etablissements Lancart, Paris)

Xyz - c1935. Nickel-plated subminiature. Roussel Xyzor f7/22mm lens. Shutter: 25,B,I. 12x15mm exposures. $500-650.

LANCASTER, (J. Lancaster, Birmingham, England)
Brass Bound Instantograph - c1908. Mahogany view, with brass binding. Lancaster lens and shutter. $175-275.

Gem Apparatus - c1880. 12-lens camera, taking 12 exposures on a 9x12cm ferrotype plate. Polished mahogany body. Front panel is slid sideways to uncover the lenses and back again to end the exposure. $1200-1600.

Instantograph ¼-plate view - c1886-1908. Brass barrel Lancaster f8 or f10 lens in Lancaster rotary shutter. Iris diaphragm. Tapered red bellows. Wood body. Widely ranging auction prices in England: $125-275.

Instantograph ½-plate or full-plate view - c1886-1910. Wood body. Brass-barrel Lancaster lens. $150-250.

International Patent - c1892-1905. Tailboard style mahogany camera with reversible back. Most commonly found in ¼ and ½-plate sizes. Wine-red square bellows. Lancaster brass barrel lens with iris diaphragm. $140-200.

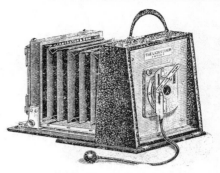

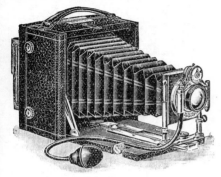

Kamrex - c1900. ¼-plate camera. Red leather bellows. Mahogany with brass trim. R.R. lens. $125-175.

Ladies Cameras: Note there are several cameras with similar names.

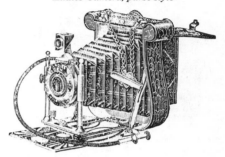

Ladies Camera, purse style

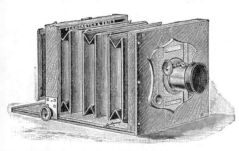

Ladies Camera - c1880's. Folding tailboard style view camera of polished mahogany. Not to be confused with the handbag style "Ladies" cameras. $200-350.

Ladies Camera - c1890's. ½-plate reversible-back camera. Achromatic lens, iris diaphragm. Single speed pneumatic shutter. When closed, the case resembles a ladies' purse with tapered sides. In the early variation, ca. 1894, the front door hinges 270 degrees to lay flat under the body. The rear door forms a tailboard for rearward extension of the back. Later models use the front door for a bed on which to extend the front with tapered bellows. $1000-1500. *Illustrated top of next column.*

Ladies Gem Camera - c1900. Lyre-shaped body covered in alligator skin. Same camera as the Certo "Damen-Kamera". Looks like a stylish woman's handbag when closed. ¼-plate size. Rare. Negotiable. Estimate: $7500-9500.

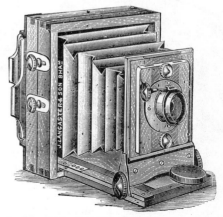

Le Meritoire - c1882. Wooden view. Brass trim. Brown or blue double extension bellows. Lancaster lens. Sizes from ¼-plate to 10x12". $150-220.

Le Merveilleux - c1890's. ¼-plate field

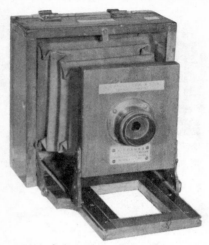

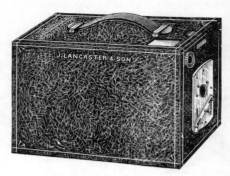

Omnigraph

camera. Aplanat lens. Quite common on auctions in England. $120-170.

Omnigraph - c1891. ¼-plate detective box camera. Achromatic lens. See-Saw shutter. One sold at auction in Germany in 1978 for over $500, but more recently, another went unsold for $275 in the USA in 1987. *Illustrated top of next column.*

Postage Stamp Cameras - c1896. Wood box cameras of various designs, having 4 or 6 lenses, for "gem" exposures. $1500-2500.

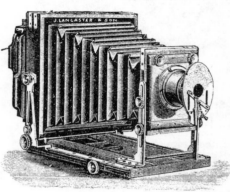

Special Brass Bound Instantograph

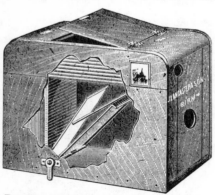

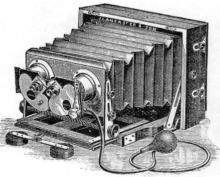

Rover - c1891. Detective box camera, holding 12 plates. Rectilinear lens, See-Saw shutter. $400-600.

Special Brass Bound Instantograph - c1891. Folding tailboard camera, double swing. Brass bound. Red or black square leather bellows. Rectigraph or Lancaster lens. Patent See-Saw shutter. ¼ and ½-plate sizes. $150-250. *Illustrated in next column.*

Stereo Instantograph - c1891. Folding 8x17cm stereo. Red bellows. Rectograph lenses. $350-450.

Watch Camera - c1890's. Camera designed like a pocket watch. Self-erecting design consists of six spring-loaded telescoping tubes. Men's size (1½x2" plates) or Ladies' size (1x1½" plates).

Rare. Price negotiable. Estimate: Men's: $13,000. Ladies': $15,000. Beginning about 1982, reproductions of this rare camera have been offered for sale. $1100-1200.

LAURIE IMPORT LTD. (Hong Kong)

Dick Tracy - c1974. Miniature plastic novelty camera as described below. The camera has no special markings, but the box has the name and picture of Dick Tracy. $8-12.

Miniature Novelty Camera - c1974. Small plastic novelty for 14x14mm exposures on Mycro-size rollfilm. Originally could be obtained for 10 Bazooka gum wrappers. $3-6.

LAVA-SIMPLEX INTERNATIONALE
Simplex Snapper - c1970. Novelty camera for 126 cartridge. The film cartridge becomes the back of the camera. 28x28mm exposures. $5-10.

LAVEC INDUSTRIAL CORP. (Taipei, Taiwan)
Lavec LT-002 - Inexpensive 35mm novelty camera styled like a pentaprism SLR. $1-5.

LAWLEY, Walter (London)
Wet-plate camera - c1860. Bellows-type wet-plate camera for plates up to 13x13cm. Brass Petzval lens, waterhouse stops. $1000-1500.

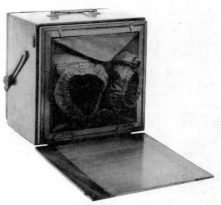

Folding Plate Camera with changing box - Unusual mahogany folding plate camera with integral changing box for 6½x8½" plates. Twin light-tight sleeves at rear. Internal folding light-tight flap. Brass bound lens. $700-750.

LE DOCTE (Armand Le Docte, Brussels, Belgium)
Excell - 1890. Twin-lens reflex style box camera. Teak body, brass fittings. Rapid Rectilinear f8 lenses are on a recessed board, behind the front door. Bag-type plate changer. Magazine holds 20 plates, 8x10.5cm. Mirror system allows for either horizontal or vertical viewing. $900-1200.

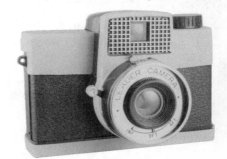

LEADER CAMERA - Beige and black plastic camera of the "Diana" type. Made in Hong Kong. $3-6.

LECHNER
Hand Camera - c1905-07. Folding 9x12cm camera with single-pleat bellows and gate struts. Ebonized wood body with trim. Focal plane shutter. Goerz Doppel Anastigmat Series III f6/120mm. Accessory reflex finder fits in shoe. $150-275.

LEE INDUSTRIES (Chicago, IL)
Leecrest - Bakelite minicam, 3x4cm on 127 rollfilm. $6-10.

LEECH & SCHMIDT
Tailboard camera, 13x18cm - Walnut construction. Bellows and focusing screen revolve as a unit to change orientation. $125-200.

LEHMAN (Gebr. Lehman, Berlin)
Pelar-Camera - c1947. One of the very first post-war cameras made in Germany. General body style resembles Leica A (actually more like Leica B, since it has no FP shutter). Ludwig Pelar f2.9/50mm lens in 25-100 front shutter which resembles Vario or Stelo. Only about 83 were made. Extremely rare. One known auction sale in 1986 for $350.

LEHMANN (A. Lehmann, Berlin)

Ben Akiba - c1903. Cane handle camera. Obviously, a rare camera like this cannot be shackled with an "average" price. Two known sales were for $5,000 and $8,000. *Readers are advised to be aware that increasing numbers of replicas are showing up, sometimes presented as genuine. Informed collectors are very cautious of any Ben Akiba.*

LEIDOLF (Wetzlar)
Leidox, Leidox II - c1951. 4x4cm. Triplet f3.8/50mm lens in Prontor-S shutter to 300. $25-35.

Lordomat, Lordomat C-35, Lordomat SLE, Lordomatic, Lordomatic II - c1954. 35mm cameras with interchangeable Lordonar f2.8/50mm. Prontor-SVS shutter. CRF. Some models have built-in meter. Two-stroke film

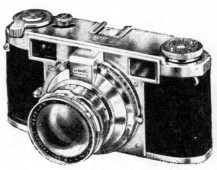

advance. Early models: $40-60. With meter and multi-lens viewfinder: $60-100.

Lordox - c1953. Compact 35mm viewfinder camera. Body release. Lordon f2.8 or 3.8/50mm lens. Pronto shutter, sync. $30-45.

LEITZ (Ernst Leitz GmbH, Wetzlar)
The history of Ernst Leitz in the optical industry began in 1849, only a decade after Daguerre's public announcement of his process. It was not until 75 years later that the first Leica camera was put on the market. If that seems like a long time for research and development it must be pointed out that the Leica was not the raison d'etre of the company. In 1849, Ernst Leitz began working in the small optical shop of C. Kellner at Wetzlar, whose primary business was the manufacturing of microscopes and telescopes. After Kellner's death, Ernst Leitz took over the company in 1869, and the operation continued to grow, becoming one of the world's major manufacturers of microscopes. Oskar Barnack, who worked for Zeiss from 1902-1910, joined the Leitz firm in 1911 and built the first Leica model in 1913. (Some historians speculate that he had proposed a similar camera to his former employer before joining the Leitz firm.) This first prototype had a fixed speed of 1/40 second, the same as movie cameras. Several 35mm still cameras were marketed at about this time by other companies, but without great success. At any rate, the "Leica" was mothballed for 10 years before finally being placed on the market in 1925. The immediate popularity of the camera coupled with continued quality of production and service catapulted the Leitz company into a strong position in the camera industry.

LEICA COLLECTING - Leica collecting is a fascinating field which has attracted collectors of all ages, from those who used the Leica cameras when they were youngsters to those who have just acquired their first camera within the last few years. Hence, there is an international demand worldwide for cameras of all ages, from the first Leica I with fixed lens to the latest limited edition of the Leica M4P.

During the late 1970's, the prices of rare or unusual Leica cameras had increased to such an extent that speculators joined the bandwagon and the ensuing unselective buying sent the prices sky high for even the most mundane items. Fortunately, the speculators have now left the field of collecting and the price structure is now a more adequate reflection of demand.

TWO GOLDEN RULES that apply to Leica Collecting are:
1. That all items in excellent or like-new condition should be acquired.
2. That items of extreme rarity be acquired regardless of condition.
Thus, common items in less than excellent condition should be acquired only for use or for parts. For some of the more specialist items such as the Leica M Anniversary cameras, it is now essential for them to have their certificates, as of late some forgeries have been circulating. On the whole, the price structure has not changed, although rarer items have seen their values increase disproportionately to common ones. The five most desirable Leica cameras are the following: Leica I with Elmax, Leica Compur, Leica 250, Leica 72, and Leica MP. These items will always demand very high prices, and the condition is important but not essential. More important is the authenticity and the originality of these cameras. It is better to have a camera in lesser but all original condition than a like-new specimen that has been renovated at great cost.

Leica cameras - *All models listed are for full-frame (24x36mm) exposures, and all are listed in chronological order by date of introduction. Although we have included a few basic identification features for each camera, these are meant only for quick reference. For more complete descriptions, or history of each model, we would suggest that you refer to a specialty book on Leica cameras. There are a number of good references, among which are: "Leica, The First Fifty Years" by G. Rogliatti, published by Hove Camera Foto Books in England; "Leica Illustrated Guide" by James L. Lager, published by Morgan & Morgan in New York; or "Leica, A History Illustrating Every Model and Accessory" by Paul-Henry van Hasbroeck, published by Sotheby Publications in London.*

SERIAL NUMBERS: *Concurrent camera models shared the same group of serial numbers in most cases. Therefore, where a serial number range is listed for a particular model, it does not belong exclusively to that model.*

This guide presents the basic information to help a novice collector to determine the probable value range of most common Leica cameras. It is not intended to be complete or extensive. That would require much more space than our format will allow. Our intention with this guide is not to give Leica specialists a price list, but rather to report to our more general audience the current price ranges which are being established by those specialists. There are many specialists in Leica cameras. One of them has been especially helpful in reviewing all of the prices in this section. A "blind" survey comparing his separate price estimates with our data proved to be surprisingly close on most items. We should caution, however, that the Leica market fluctuates more than many of the other areas of collecting, and you should consult with several respected authorities before making any major decisions about which you are unsure. Our primary Leica consultant is a well-known dealer in the field who would be happy to help you with questions on important cameras. Of course, he would also be interested in hearing about Leica cameras you have for sale. Contact: Don Chatterton, 1301 Spring St., Seattle, WA 98104 (206-329-6050).

CONDITION OF LEICA CAMERAS:
Leica collectors are generally extremely conscious of condition. The spread of values is quite great as condition changes from VG to EXC to MINT. With the exception of some of the very early and rare Leicas which are collectible regardless of condition, it would be wise to assume that EXCELLENT CONDITION should be considered the MINIMUM condition which collectors seek. Therefore we are using figures in this section of the book only which represent cameras in at least EXCELLENT but not quite MINT condition. Cameras which are truly MINT or NEW would bring higher prices and be easier to sell. Cameras in less than excellent condition are difficult to sell and often must be discounted considerably below these figures. Even the rare models, where less than perfect condition is tolerated, must be complete and in the ORIGINAL state.

For further information, or if in doubt about authenticity of rare models, contact:
Leica Historical Society of America,
7611 Dornoch Lane, Dallas TX 75248.
Phone: 305-477-7300. Memberships $20.00/yr.

Except where noted, prices are given for body only. A separate list of add-on prices for normal lenses is at the end of the Leica section.

Ur-Leica (Original) - Oscar Barnack's original prototype. Based on this design, a number of replicas have been made for historical or display purposes. See next listing.

Ur-Leica (Replica) - Non-functional display model of Oscar Barnack's original 1913 prototype, reproduced by Leitz for museums, etc. Cosmetic condition is the

345

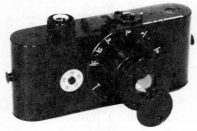

important consideration, since these are inoperative cameras. $500-750.

Leica 0-Series - Preproduction series of 31 cameras, Serial #100-130, hand-made in 1923 & 1924. Since the focal plane shutter was not self-capping on the first seven examples, they required the use of a lens cap which was attached with a cord to a small bracket on the camera body. This feature was retained on the second batch even though they had a self-capping shutter. The viewfinder (either folding or telescope type) is located directly above the lens. Leitz Anastigmat f3.5/50mm lens in collapsing mount. Extremely rare and highly desirable. $15,000-25,000.

Leica I (A) - 1925-30. The first commercially produced Leica model, and the first mass produced high quality 35mm camera. These facts make the Leica I a highly sought camera among not only Leica collectors, but general camera collectors also. Non-interchangeable lenses, all 50mm f3.5 in collapsible mount with helical focus. "Hockey stick" lens lock on the front of the body is the most obvious identification feature. Black enameled body. Body serial numbers listed are approximate and may overlap between the variations. Value depends on lens and serial number.

Anastigmat f3.5/50mm (1925) - The earliest and rarest. Perhaps 100-150 made. (#130-260?) Shutter speed 1/25-1/500. A mint example would sell for over $15,000. Recent sales range of $10,000 - $19,000.

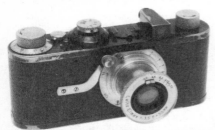

Elmax f3.5/50mm (1925-26) - (#260?-1300?) Originality and completeness of

original fittings is an important consideration with this camera. There are lots of fakes, perhaps as many as the real ones. A major broker offers $7500 for a mint example. Recent recorded sales from $4800-$5100.

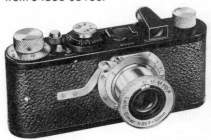

Elmar f3.5/50mm (1926-30) - (#1300?-60000) Priced by Serial #. 4-digit: $400-600. 5-digit: $300-500. Most examples are found in less than excellent condition and would bring $200-300, while a truly mint example could reach $1000. The close focusing model (to 20" rather than 1m) used to add $25-50 to above prices, but that price distinction generally has disappeared.

Hektor f2.5/50mm (1930) - (#40000-60000) Relatively rare, but not as appealing to some collectors as the other early Leicas. In Exc + condition: $1300.

I Luxus - Gold-plated A-Elmar camera with lizard skin covering. Only about 95 were made by the factory, but many imitations abound. Authentic models have serial numbers between 28,692 and 68,834. Only certain numbers within that range are true factory "Luxus" models, and original factory serial number lists are the only safe way to check. Consult with a Leica specialist for exact numbers. If the number turns out to be "correct", then you only need to find out if it is real or a forgery. The forgeries outnumber the authentic models by a wide margin. Only a handful of original authentic specimens have been recorded. Authentic, with verified serial number, not modified: Prices of $15,000 - $25,000 are reported from Japan. Confirmed sales elsewhere have been $8,000 - $12,000. With original crocodile case, add $1000-2000.

Luxus Replica - A gold-plated model which is not factory original. A number of replicas or "counterfeit" Luxus models have been made from other Leica I cameras, and while these resemble the real thing for purposes of display, they are not historically authentic. High quality conversions (some of the best conversions are being imported from Korea), if beautifully Mint condition have sold for $1000-$1800. Many replicas are offered in lesser condition for $1000,

most of which are only worth half that amount. While they serve a good purpose for decoration, they are not necessarily considered to be a good investment item.

Leica I (B) with Rim-set Compur

Leica Mifilmca - c1927. Microscope camera with permanently attached microscope adapter tube with a Mikas beam splitter and an Ibsor shutter. Body design is like the Compur Leica (B) but without a viewfinder or accessory shoe. The design was modified about 1932 to accomodate the standard lens flange fittings. Early Mifilmca camera with fixed tube is quite rare, but not as highly sought as non-technical models, so despite rarity, when encountered they sell for: $2000-3000. The later models with detachable tube might bring $1600-1800.

Leica I (B) - 1926-30. The "Compur" Leica. Approximately 1500 were made in two variations, both with Elmar f3.5/50mm.

the distance from the lens flange to the film plane was not standard. The lens flange is not engraved, but each lens is numbered with the last three digits of the body serial number. With matching engraved Elmar lens: $900-1000 if very clean. A very few (first couple hundred made) had the full serial number on the lens. These bring an extra $100. Most which do not have a swing-down viewfinder mask were fitted with Hektor lenses: $1200-1400. It is difficult to locate an outfit with two lenses, let alone three lenses. With swing-down mask and 35mm, 50mm, and 135mm lenses, all with matching number, full set: $3000-4500.

Standardized lens mount - The lens mount on the body has a small "o" engraved at the top of the body flange. Lenses now standardized and interchangeable from one body to another. With f3.5/50mm. Mint: $600. Excellent: $250-400.

Dial-set Compur - (1926-29) is extraordinarily rare, especially if in excellent condition. About $6000-7000.

Rim-set Compur - (1929-30). Although not as rare as the dial-set version, this is still a highly sought camera. $3500-4500. *Illustrated top of next column.*

Leica I (C) - 1930-31. The first Leica with interchangeable lenses. Two variations:
Non-Standardized lens mount - Lenses were custom fitted to each camera because

Leica II (D) - 1932-48. The first Leica with built-in coupled rangefinder. This is a desirable camera, but only if in exceptional condition.
Black body - Quantity-wise, there are more black ones, but condition is harder to maintain on black. A mint black body of this age is highly unlikely. If exceptionally fine condition: $300-400. Normally: $150-200.

Chrome body - Less common in number than black, but retails for less. $100-150.

Body & lens - Together with a matching lens in the correct serial number range, the set will bring a slight premium. Serial numbers for lenses up through the early post-war models should be approximately 50% above the serial number of the body. This is because about three lenses were made for every two bodies. So a nice clean outfit with a black body and a nickel Elmar lens would bring $300-400. A chrome body and lens in similar condition: $200-250.

Leica Standard (E) - 1932-48. Similar to the standardized "C", but with smaller (12mm dia.) rewind knob, which pulls out to make rewinding easier. A rare camera, especially if found in black and nickel finish, complete with rotating range finder and nice nickel lens. Such a set would be expected to bring $300-500. A similar set in chrome with Elmar lens, excellent condition: $200-300. Black body: $200-300.

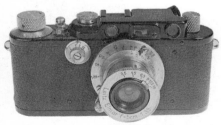

Leica III (F) - 1933-39. The first model with slow-speed dial, carrying strap eyelets, and diopter adjustment on rangefinder eyepiece. Shutter to 500. Black body: $200-300. Chrome body: $150-175. (As with most Leica cameras, one in exceptionally fine condition could bring twice the prices listed, which are for cameras between excellent and mint condition.)

Leica 250 Reporter - 1934-43. The early model (FF) is like Model F, but body ends extended and enlarged to hold 10 meters of 35mm film for 250 exposures. Only about

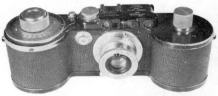

950 were made. Later model (GG) is built on a model G body and has shutter speed to 1000. These were designed for heavy use, and most were used accordingly, so there are not many which are very clean. They are difficult to sell if restored. Very clean, original examples would sell in these ranges: FF, up to $8000; GG, $4000-6000. More commonly found in lesser condition for $2500-3000. Probably the rarest but not the most expensive is the chrome version. A motorized version camera would probably bring twice as much.

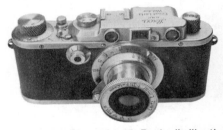

Leica IIIa (G) - 1935-50. Basically like the "F", but with the addition of 1/1000 sec. shutter speed. Chrome only. (There are rumors of a small number of black finished IIIa's, but to date none with any sort of pedigree have appeared.) The IIIa was the most produced of all pre-war Leicas, and therefore is not highly rated as a collectible. However, an early example in near mint condition might prove to be a wise purchase, since they can be bought with Elmar lens for $125-250.

Leica IIIa "Monté en Sarre" - Assembled after WWII (between 1950 and 1955) in the French occupied German state of Saarland, from pre- and post-war parts. Very few were made. The top of the body

is engraved "Monté en Sarre" below the normal "Ernst Leitz, Wetzlar" engraving. Down considerably from earlier sales figures. Realistically: $600-900.

Leica IIIb (G) - 1938-46. Similar to the IIIa, but rangefinder and viewfinder eyepieces are next to each other. Diopter adjustment lever below rewind knob. Hard to find in excellent condition, but worth: $125-225. This was the last pre-war camera produced by Leitz, and the first to have batches allocated to the military.

Leica IIIb Luftwaffen Eigentum - $1000-1200.

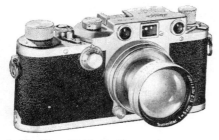

Leica IIIc - 1940-46. Die-cast body is ⅛" longer than earlier models. One-piece top cover with small "platform" for advance-rewind lever. This is a difficult camera to locate in fine condition, due to the poor quality of the chrome during wartime Germany. An exceptionally clean example would be worth $200. Early model with red curtain (one curtain has red side facing forward): $200-250. A regular body, EXC condition: $75-150. Less than EXC: $40-60.

Leica IIIc "K-Model" - The letter K at the end of the serial number and on the front of the shutter curtain stands for "kugellager" (ball-bearing), or perhaps "kaltefest" (cold weather prepared). The ball-bearing shutter was produced during the war years, primarily for the military. Chrome model: $650. Often blue-grey painted. $450-900, depending on condition.

Leica IIIc Luftwaffe & Wehrmacht models - Engraved with "Luftwaffen Eigentum", "W.H.", eagle, or other military designations. Most have "K" shutter. The most interesting military markings are worth more. Grey or chrome body: $500-900. Up to $2500 for truly MINT with lens.

Leica IIId - 1940-42. Similar to IIIc, but with the addition of an internal self-timer. This was the first Leica to include a self-timer. Factory and other conversions exist. Considering this camera's elevated price, it would be wise to verify authenticity before paying the going rate of: $4000-5500.

Leica 72 - 1954-57. Similar to IIIa but for 18x24mm format. Identifiable by exposure counter for 75 exposures, half-frame masks on viewfinder and at film plane. Most were made in Midland, Ontario. A very small quantity was made in Wetzlar, but verify serial number as there have been many fakes of the Wetzlar model. Either type sells for $5000-7000.

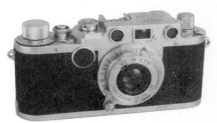

Leica IIc - 1948-51. Like IIIc, but no slow speeds. Top shutter speed 500. Not a hot selling camera. Body only, MINT: $200-250.

Leica Ic - 1949-51. No slow speeds. No built-in finders. Two accessory shoes for mounting separate view and range finders. Difficult to find in truly Mint condition, when it will reach $400. Normal range: $200-300.

Leica IIIf - 1950-56. MX sync. Common in all three variations, so prices are for MINT.

"Black-dial" - shutter speed dial lettered in black, with speeds 30, 40, 60. $120-150.

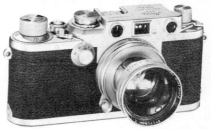

"Red-dial" - shutter speed dial is lettered in red, with speeds 25, 50, 75. $130-180.

349

"Red-dial" with self-timer - $200-275.

Leica IIIf (Swedish Army) - An all black version, made for the Swedish Army, if complete with matching black lens: $4500-6000.

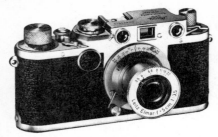

Leica IIf - 1951-56. Like the IIIf, but no slow speeds. Black dial and red dial models. Body only, MINT: $125-175. Excellent: $50-75.

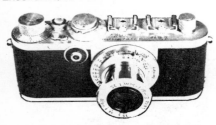

Leica If - 1952-56. No slow speed dial nor finders. Separate finders fit accessory shoes. Flash contact in slow speed dial location. Black dial body is rare, and used to bring much higher prices. Difficult to find in really clean condition, they sell currently for $350-675. Red dial body: $225-300.

Leica If Swedish 3 crown - Chrome body. Actually engraved by Swedish military, not Leitz. Not a legitimate Leica model.

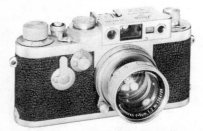

Leica IIIg - 1956-60. Last of the screw-mount Leicas. Bright-line finder and small window next to viewfinder window which provides light for finder illumination. MINT condition could sell in $450-600 range. EXC to EXC+: $325-550. EXC or less sells with difficulty for $200-250.

Leica IIIg, black - Very rare. One major dealer is offering $6000 for mint with 50mm f3.5 lens.

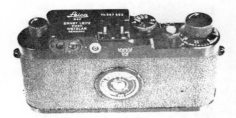

Leica IIIg Swedish Crown Model - 1960. A batch of 125 black-finished cameras for the Swedish Armed Forces were among the very last IIIg cameras produced. On the back side of the camera and on the lens are engraved three crowns (the Swedish coat-of-arms). With lens: $5000-7000.

Leica Ig - 1957-60. Like the IIIg, but no finders or self-timer. Two accessory shoes accept separate range & view finders. Top plate surrounds the rewind knob, covering the lower part when not extended. Only 6,300 were made. Body only. Mint: $750-1000. Excellent: $400-600.

Leica Single-Shot - c1936. Ground glass focus. Single metal film holder. Ibsor shutter. Should be complete with lens, shutter, film holder, and ground glass for $600-700. Add $250 for rare viewfinder.

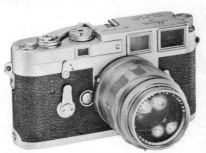

Leica M3 - 1954-66. This is a classic Leica in itself and much sought after, being one of the leading cameras of the 1950's. Fine specimens will reach good prices especially if boxed and in Mint condition. Two variations in film advance:
Single-stroke advance - There is a price differential based on serial number ranges. Prices listed are for body only. MINT to LIKE NEW will bring double the prices listed here for EXCELLENT condition with serials below 1,000,000: $275-325. Serials 1,000,000 to 1,100,000: $350-450. Serials above 1,100,000: $450-600.

Double-stroke advance - Body only, Mint: $400-525. Excellent: $200-300.

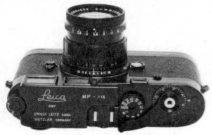

Leica MP, black (above) and chrome (below)

Leica MP - 1956-57. A variation of the M3. Normally identifiable by the MP serial number, but authenticity should be verified as counterfeit examples have reached the market. Chrome: $4000-4500. Black: $5000-5500. *The Leica MP must not be confused with the Leica MP2 which is a motorized Leica M3. This motorized Leica MP2 is extremely rare.*

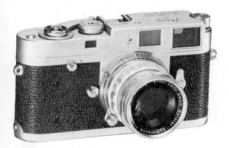

Leica M2, chrome - 1957-67. Like the single-stroke M3, but with external exposure counter. Finder has frame lines for 35, 50, & 90mm lenses. All early models and some later ones were made without self-timer. (Existence of self-timer does not affect price). Prices listed are for body only. A truly MINT example will bring $600-750. Excellent prices follow. Button rewind: $250. Lever rewind, serial under 1,100,000: $325. Serials over 1,100,000: $375.

Leica M2, black - Mint body: $1500-2000. EXC+: $600-1000.
Leica M2, Grey finish - Much rarer than green M3 or M1. $3000-4500.

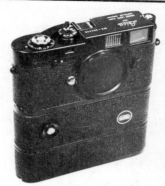

Leica M2 MOT, M2M - Motorized versions. $1500-2000.

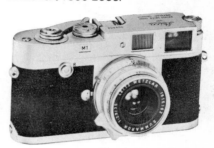

Leica M1 - 1959-64. Simplified camera for scientific use, based on the M2. Lacks rangefinder, but has automatic parallax correcting viewfinder. $350-550.
Leica M1 Military Green - $3000-4000.

Leica MD - 1965-66. Replaced the M1, and further simplified. Based on the M3 body, but has no rangefinder or viewfinder. Allows insertion of identification strips to be printed on film during exposure. MINT: $400-600. EXC+: $375-450.

Leica MDa - 1966-75. Similar to the MD in features, but based on the M4 body (slanted rewind knob). $350-450.

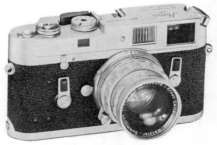

Leica M4 - 1967-73 (plus a later batch in

351

LEITZ (cont.)

1974-75 in black chrome). Similar to M2 and M3, but slanted rewind knob with folding crank. Frames for 35, 50, 90, and 135mm lenses.
Silver Chrome - EXC: $525. Mint to $1000
Black Chrome - Excellent condition. Canadian: $550. Wetzlar: $625. *These can be identified by the wax seal in a small hole at 12 o'clock on the lens mounting flange. New cameras have excised letters: "C" for Canada or "L" for Wetzlar. Factory serviced cameras have incised letters: "Y" for Rockleigh, "51" for Vancouver, "T" for Toronto, "L" for Wetzlar.*

Black Enamel - $1000.
M4 50 Jahre Anniversary Model - Must be NEW in box with warranty cards. These have dropped in price in the last few years. Wetzlar model: $1250. Midland: $1450.

Leica KE-7A - A special rendition of the M4, made for the U.S. Military and using their designation "KE-7A Camera, Still Picture". With Elcan f2/50mm lens. Military version with federal stock number, or "Civilian" model without back engraving: $2500-$3500.

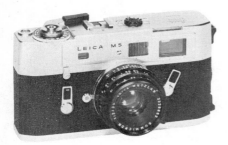

Leica M5, chrome (above) and black (below)

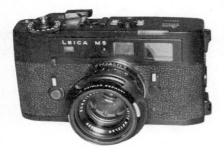

Leica M4M, M4 Mot - Should be complete with electric motors, and MINT condition. $4000-$4500. In Exc+ condition: $1800-2000.

Leica M5 - 1971-85. Rangefinder camera with TTL metering. Black: $700-800, MINT. Chrome: $700-1000 MINT. *If absolutely like new, in box with cards, the silver chrome model will bring more than the anniversary model, because most were used and fewer remain in truly mint condition. On any M-camera, the condition of the strap lugs is often an indicator of the amount a camera has been used. Any scratch can knock the price down by 50%. Illustrated bottom of previous column.*
Fiftieth Anniversary model - Must be NEW. Black chrome: $1200. Silver chrome: $1450.

Leica CL - 1973-75. Designed by Leitz Wetzlar, but made in Japan by Minolta. Body: $200-350.

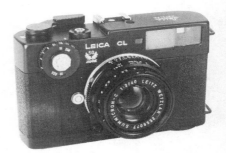

Leica CL 50 Jahre Anniversary model - New in box with cards, up to $1150. Mint: $500-700.

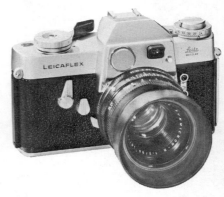

Leicaflex - Original model introduced 1964. A landmark in the development of reflex cameras, due to its very bright prism system. Chrome: up to $500 if MINT;

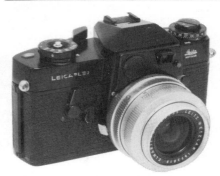

EXC+: $175-200. Black: $500-600 normally, but up to $850 MINT.

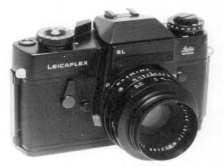

Leicaflex SL, black

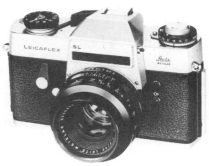

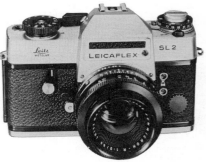

Leicaflex SL - Chrome: $200, up to $500 Mint. Black Enamel: $200 if used, up to $700 MINT. Black Chrome: $300. *Black version illustrated top of next column.*

Leicaflex SL Olympic - NEW in box with cards: $800-900.

Leicaflex SL2 - Important in that it is the last mechanical Leitz reflex camera and sought after by both collectors and users. This accounts for the high prices. Black or Chrome: $750. MINT: $1000-1200.

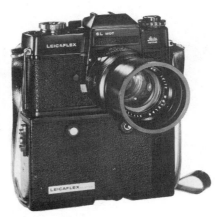

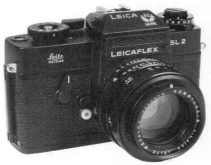

50 Jahre Anniversary Model - Only collectible if NEW. Black: $1500. Chrome: $1650.

Leicaflex SL2 Mot - With motor: $1500-1800.

Leica R3 - Black: $200. Chrome: $400 if MINT. *This camera was produced in Portugal. A small number have German baseplates as though made in Germany and not Portugal. One*

Leicaflex SL Mot - With motor, nice condition: $700-750.

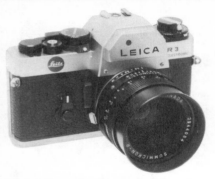

source indicates that this may have been done to avoid problems with customs for Photokina. At any rate, the "German" models in either black or chrome bring about the same price as the normal chrome model or perhaps just slightly more.

Leica R3 Gold - Must be complete with gold Summilux-R f1.4/50mm lens, in original wood case, with box, strap, etc. AS NEW: $3000-3400.

Leica R3 Safari - c1972. About 2500 made. Olive green body. With original box, as new: up to $1000.

Leica R3 Mot - With winder: $400.

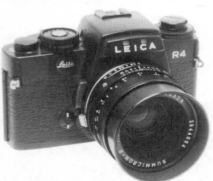

Leica R4 - Although people collect them, these are primarily usable cameras, and an important word of warning comes from one of our consultants. Due to the high cost of repairs, Leitz only repairs the R4 under its "Signature Service" which costs $235. There are four generations of R4 cameras, the first three of which were subject to electronic problems. Try to avoid a used R4 which is out of warranty or with serial number below 1,600,000. Black or Chrome: $300-350.

R4 Mot (incorrectly engraved) - Over 1000 were made, and they are not rare, but they may bring slightly more than the normal ones. Asking prices: $625-850 Mint.

Leica R4S - A limited version of the R4. Same warnings apply, and not much different in price. Many offered for sale at $425 E+ to $500 Mint. ($650 new with warranty.)

LEICA LENSES - The following lens prices are "add-on" values to the body prices listed above. Condition is extremely important in buying a used Leica lens. Because of the age of many screwmount lenses, and the type of balsam glue used to cement the elements together, a large number of these lenses are showing signs of separation, crazing, or cloudiness. They should be carefully checked by shining a flashlight through from the rear of the lens and examining closely. If the lens shows signs of deterioration, forget it. Not only would it be costly to repair, but it would be virtually impossible to match the original optical quality.

In previous editions of this guide we listed only screwmount lenses. Now we have added some bayonet-mount lenses as well. We are using abbreviations "SM" and "BM" to distinguish between them. Prices given are for EXCELLENT condition unless otherwise specified. Often we quote prices for MINT condition, which is the preferred condition for easy saleability. If we quote only a MINT price, deduct AT LEAST 25% to arrive at an estimate for EXC condition.

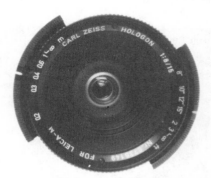

15mm f8 Zeiss Hologon (BM only): $3000-3500, MINT with filter and finder.
21mm f4 Super Angulon (SM): $500-$700 MINT w/finder.
21mm f4 Super Angulon (BM): $400 MINT.
21mm f3.4 Super Angulon (BM): $700 MINT w/finder.
28mm f6.3 Hektor (SM): $100 MINT.
28mm f5.6 Summaron (SM): $400 MINT.
28mm f2.8 Elmarit (BM) Blk, Canada: $350 MINT.

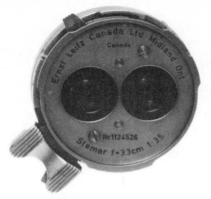

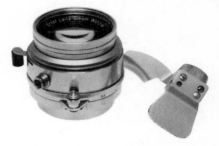

33mm f3.5 Stemar (SM or BM): $1800-2000 with viewfinder and beamsplitter in case. To $2500 MINT.

35mm f3.5 Elmar (SM): $100 MINT.

35mm f3.5 Elmar (SM): $125 MINT with E39 filter. *Note: Latest version is E-39. The 39mm filter screws into the lens flange. Earlier versions used E-36 filters which clamp over the lens with a screw.*

35mm f2.8 Summaron (SM): $800 MINT. *Examine to be sure not taken from M3 "bug eye" model. It will fit on body but will not focus.*

35mm f2.8 Summaron (BM): no eyes: $250-300 MINT. w/eyes: $150-220 MINT.

35mm f2 Summicron (SM): $1000 MINT. *Note: Many fakes converted from lower-valued bayonet-mount lenses.*

35mm f2 Summicron (BM), Blk, Germany: $400-500 MINT.

40mm f2 Summicron for CL: $200 MINT w/hood.

50mm f3.5 Elmar (SM, pre-war uncoated): $40 MINT.

50mm f3.5 Elmar (SM, postwar, black scale, coated): $40 MINT.

50mm f3.5 Elmar (SM, postwar, red scale, coated): $150-200 MINT.

50mm f3.5 Wollensak Velostigmat (SM): $50

50mm f2.8 Elmar (SM): $175 MINT.

50mm f2.8 Elmar (BM): $175 MINT w/hood.

50mm f2.5 Hektor (SM): $100.

50mm f2 Summar (collapsible SM): $10.

50mm f2 Summar (rigid SM): $750-900 MINT.

50mm f2 Summicron (collapsible SM) - Inspect carefully. About 90% have scratches on front element, and they are also subject to haze and crystallization. Unscratched and crystal clear: $125 EXC to $200 MINT.

50mm f2 Summicron (rigid SM): $500-700 MINT.

50mm f2 Summicron (rigid BM): $200 MINT.

50mm f2 Summicron (dual range focus to 18", #2,300,000+): $250-400 MINT.

50mm f2 Summicron (in Compur Shutter, BM only): $2500-3000 with arm.

50mm f2 Summitar (SM): $18.

50mm f1.5 Summarit (SM): $50.

50mm f1.5 Xenon (SM): $50.

50mm f1.4 Summilux (SM, chrome only): $700-900 MINT.

50mm f1.4 Summilux (BM, black): $360-550 MINT.

50mm f1.4 Summilux (BM, chrome): $300 over Ser. #1,840,000; $225 under Ser. #1,840,000 MINT.

50mm f1.2 Noctilux (BM): $1500 MINT.

65mm f3.5 Elmar (Visoflex) with 16464 focusing adapter and special rear cap: $250 black MINT; $175 chrome MINT.

73mm f1.9 Hektor (SM): $125-175.

85mm f1.5 Summarex (SM, black): $650 EXC to $850 MINT.

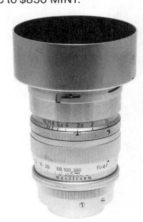

85mm f1.5 Summarex (SM, chrome): $350.

90mm f4.5 Wollensak Velostigmat (SM): $85.

90mm f4 Elmar (SM): $60.

90mm f4 Elmar (Collaps. BM): $225 MINT.

90mm f2.8 Elmarit (SM): Rare. $750 MINT; $400 EXC+.

90mm f2.8 Elmarit (BM) Black: $500 MINT. Chrome: $375 MINT.

90mm f2.2 Thambar (SM, with shade & caps): $800-1000 EXC to $1400 MINT.

90mm f2 Summicron (SM): $500 MINT; $300 EXC+. *With removable shade, complete, Mint, add 50%.*
105mm f6.3 Elmar ("Mountain" Elmar) (SM): $375-475.
125mm f2.5 Hektor (SM): $325 w/hood & caps.
127mm f4.5 Wollensak Velostigmat (SM): $75.
135mm f4.5 Hektor (SM): $60.
135mm f4 Elmar (SM, chrome only): $350 MINT.
135mm f4 Elmar (BM, chrome only): $200 MINT.
180mm f2.8 Elmarit (for Visoflex): $600-800 MINT.
200mm f4.5 Telyt (for Visoflex): $90.
200mm f4 Telyt (for Visoflex): $170.
280mm f4.8 Telyt (for Visoflex): $200. (New in box: $300.)
400mm f5 Telyt (for Visoflex, attached shade): $400.
400mm f5 Telyt (for Visoflex, removable shade): $550.

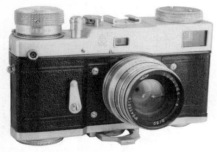

LENINGRAD - late 1950's-mid 1960's. Russian 35mm RF camera with spring-motor drive. Jupiter-8 f2/50mm lens in Leica mount. FP shutter, 1-1000. $200-275.

LENNOR ENGINEERING CO. (Illinois)

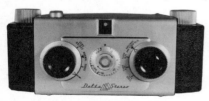

Delta Stereo - c1955. 35mm stereo camera, 23x25mm pairs. Usually blue enamel and leatherette covered, but also found in black plastic with brushed aluminum trim and leatherette covering. La Croix f6.3 lens in guillotine shutter 25-100, B. Scale focus 5,8,10,12' to infinity. Camera and case only: $50-75. With matching viewer. $100-125.

LENZ - "Hit" type novelty camera for 16mm film. $15-20.

LEONAR KAMERAWERK (Hamburg)

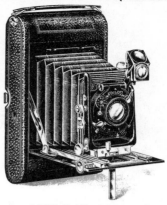

Filmos - c1910. Folding camera for 8x10.5cm on rollfilm or 9x12cm on plates. Leonar Aplanat f8 or Periscop Aplanat f11/130mm. $35-50.

Leonar, 10x15cm - c1910. Similar to the Filmos, but with Leonar Anastigmat f8/140 or f6.8/170 lens. Dial Compur 1-200 shutter. Triple extension. Uncommon in this size. $70-100.

Perkeo Model IV - c1910. Simple folding camera for 9x12 plates or 8x10.5cm filmpacks. Achromat f16, Aplanat f11, of Extra-Rapid Aplanat f8. B&L Auto shutter. $25-35.

LEREBOURS (Paris)
Gaudin Daguerreotype - c1841. Cylindrical all-metal daguerreotype camera. Fixed-focus. Rotating diaphragm. One recorded sale, Oct. 1982: $8350.

LEROY (Lucien LeRoy, Paris)
Minimus - c1924. Rigid body 6x13cm stereo. $175-215.

Stereo Panoramique - 1905-11. Black all-metal camera for 6x13cm plates in stereo or, by rotating one lens to center position,

panoramic views. Krauss Protar f9/82mm or Goerz Doppel Anastigmat f8.5/80mm. Five speed shutter. $175-215.

LESUEUR & DUCOS du HAURON Melanochromoscope - c1900. Color separation camera making three exposures on one plate. Could also be used as a chromsoscope, for viewing the pictures. Despite considerably higher estimates, one failed to attract bids over $1800 at a November 1982 auction, and remained unsold. No recent sales records.

LEULLIER (Louis Leullier, Paris)

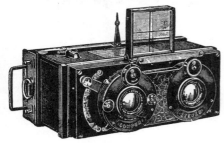

Summum - c1925. Roussel Stylor f4.5/ 75mm lenses. Focusing and fixed-focus models. Stereo shutter 25-100. Rising front. Changing magazine for six 6x13cm stereo plates. $100-150.

Summum Sterechrome - c1940. 24x30mm stereo exposures on 35mm film. Berthiot Flor f3.5/40mm lens. Shutter to 300. $300-400.

LEVI (S.J. Levi, London, England) Leviathan Surprise Detective - c1892. Polished walnut box camera which holds six 3¼x4¼" plates on the three vertical sides of a revolving drum. $800-900.

Minia Camera - ¼-plate. Black leather covered body, maroon leather bellows. Ross/Goerz Patent Doppel-Anastigmat f7.7/ 5". T-P rollerblind shutter. Rack focus. $50-75.

Pullman Detective - c1896. Satchel style detective for 5x7" plates. The bottom becomes the bed of the camera, when the leather case is placed on its back. Single or stereo lensboards were available. Archer & Sons lens. Roller blind shutter. $1200-1800.

LEVY-ROTH (Berlin) Minnigraph - c1915. 18x24mm exposures on 35mm film in special cassettes. The first European still camera to use cine film. Minnigraph Anastigmat f3.5/54mm lens. Single speed flap shutter. $800-1100. *Illustrated top of next column.*

Levy-Roth Minnigraph

L.F.G. Francais

LEWIS (W. & W.H. Lewis, New York) Daguerreotype camera - c1852. Initiated the "Lewis-style" daguerreotype cameras later made by Palmer & Longking. Ground glass focusing. Collapsible bellows. For ½-plates. $6000-6500.

Wet Plate camera - c1862. Large size, for plates up to 12x12". Folding leather bellows. Plates and ground glass load from side. A rare camera. $900-1100.

LEXA MANUFACTURING CO.
(Melbourne, Australia)

L.F.G. Franceville, in plastic

Lexa 20 - c1950. Metal box camera for 6x9cm on 120 film. $10-20.

L.F.G. & CO. (Paris, France)
Francais - c1910. Small metal box camera for two 4x5cm plates which pivot into position for exposure. Meniscus f11/55mm lens in simple shutter. $80-110. *Illustrated on previous page.*

Franceville, in cardboard, back view

Franceville - c1908. Simple black box camera made of plastic or cardboard. Takes 4x4cm exposures on plates. Meniscus lens, guillotine shutter. Plastic version is unidentified. Cardboard type has gold lettering on back. $95-125. *Plastic version illustrated top of next column.*

LIEBE (V. Liebe, Paris)
Monobloc - c1920. For stereo or panoramic views on 6x13cm plates. Tessar f6.3 or Boyer Saphir f4.5/85mm lenses in pneumatic spring shutter. Metal body is partly leather covered. $150-175. *See also Jeanneret Monobloc.*

LIFE-O-RAMA CORP.
Life-O-Rama III - c1953. German 6x6cm on 120 film. f5.6/75 or f3.5 Ennar lens. Vario shutter, sync. $15-20.

LIFE TIME
Life Time 120 Synchro Flash - All metal box camera identical to the Vagabond 120. $3-6.

LIGHT - c1934. Japanese Maximar copy. 6.5x9cm. Heliostar f4.5/105mm lens in Neuheil rim-set 25-150 shutter. $50-75.

LIGHT INDUSTRIAL PROD. (China)

Seagull 4 - c1970's. TLR for 6x6cm on 120

rollfilm. f3.5/75mm lens. 1-300 shutter, X-synch. Collectible because few Chinese cameras are imported to the U.S.A. Asking prices in England $65-80. Selling prices in USA: $35-45.

Seagull No. 203 - 6x6cm folding bed camera. Copy of Zeiss Ikonta IV. 12 or 16 exposures on 120 film. f3.5/75mm lens. $55-80.

LIGHT SUPER - Inexpensive Japanese 127 camera. Uera lens. $40-60.

LIKINGS DELUXE - Inexpensive silver & black plastic camera of the "Diana" type for 55x55mm on 120. $1-5.

LINA, LINA-S - 4x4cm plastic novelty cameras of the "Diana" type. $1-5.

LINDEN (Friedrich Linden, Lüdenscheid, Germany)
Lindar - c1950. Metal box camera, leather covering. 6x6cm on 120. Large waist-level

brilliant finder. Meniscus f9.5/80 lens. T, I shutter. Built-in yellow filter. $25-40.

Lindi - c1950. Metal 6x6cm box camera with large reflex brilliant finder. Black or grey hammertone finish. Meniscus f10.5/80mm lens. A lower priced version of the Lindar. Grey: $35-50. Black: $20-35.

Reporter 66 - c1952. Metal 6x6cm box camera with leather covering. Similar to the Lindar and Lindi. Meniscus f9.5/80mm lens. $20-35.

LINHOF PRÄZISIONS KAMERAWERK (V. Linhof, Munich) *While we are presenting a selection here of cameras which could be considered "collectible", generally the Linhof line tends to be a family of cameras which fall more into the category of usable equipment.*

(early folding cameras) - c1910-1930. (pre-"Technika" models.) Folding plate cameras in standard sizes, 6.5x9cm to 13x18cm. Front and back extensions. Ground glass focus. $75-150.

Multi-Speed Precision Camera - c1925. Folding bed camera for 9x14cm plates. Spring-loaded back accepts single metal holders in front of ground glass. Emil Busch Multi-Speed Leukar f6.8/6½" lens in General T,B, 5-100 shutter. $60-95.

Precision View - c1930. Triple extension hand camera. Rise/cross front. Tessar f4.5/135mm in Compur. $150-250.

Stereo Panorama - c1920. For 6x13cm exposures (stereo or panoramic). Two Rietzschel Sextar f6.8/120mm lenses and one Rietzschel Linar f5.5/150mm lens. Compound shutter. Metal body, leather covered. $250-300.

Technika I - c1930. With Tessar f4.5 in Compound or Compur shutter. 6.5x9cm: $425-525. 9x12cm: $300-500. 5x7": $400-600.

Technika III - 1946-50. Despite the fact that these are old enough to be considered collectible, their primary value lies in their usability. Price dependent on lens and shutter accessories. Commonly found with

f4.5 Xenar. 2¼x3¼" or 4x5": $375-500.
5x7": $400-550.

Lippische Flexo

Technika Press 23 - 1958-63. 6x9cm press camera. Accepts cut film, film packs and rollfilm. Interchangeable lenses. Compur shutter to 400. The high prices are due to usability, not rarity. $350-550.

LIONEL MFG. CO. *(The train people)*
Linex - c1954. Cast metal subminiature for stereo pairs of 16x20mm exposures on rollfilm. f8/30mm lenses. Guillotine shutter, synched. Camera only: $40-60. Viewer only: $20-30. Outfit with case, flash, viewer: $65-90. *About 70-90% higher in Europe.*

LIPPISCHE CAMERAFABRIK (Barntrup)
Flexo - c1950. Twin lens reflex for 6x6cm on 120 film. Helical focus operated by lever below lens. Identical taking and viewing lenses include Ennar f3.5 or f4.5 and Ennagon f3.5. Prontor-S, Pronto-S, Prontor II, or Vario shutter. $40-60. *Illustrated top of next column.*

Flexo Richard - c1953. Unusual name variation of the Flexo. "Flexo Richard" on nameplate at front of finder hood. $60-90.

Flexora - c1953. 6x6cm TLR, Models I, II, IIA, III, IIIA. Ennar f3.5 or 4.5/75mm or Ennagon f3.5/75mm lens. Vario, Pronto-S, or Prontor-SV shutter. $45-70.

Optimet (I) - c1958. TLR for 6x6cm on 120 film, similar to Rollop. Rack and pinion focus with left-hand knob. Ennagon f3.5/75mm lens in Prontor-SVS shutter. $60-80.

Rollop - c1954. TLR for 6x6cm on 120 film. Ennagon f3.5/75mm lens. Prontor-SVS shutter 1-300. $65-85.

Rollop Automatic - c1956. TLR for 6x6cm on 120. Called Automatic because shutter is tensioned by film advance. Ennit f2.8/80mm lens. Prontor SVS 1-300. $70-100.

LITTLE WONDER - c1922. (Not related to the c1900 "Little Wonder" box camera.) All metal camera for 40x64mm on 127 rollfilm. Folding frame finder, external T & I

shutter. Lens housing extends via helix. Meniscus lens. Sold by L. Trapp & Co., London, but may have been made in Germany. $40-60.

LIZARS (J. Lizars, Glasgow)
Challenge - c1905. 3¼x4¼" or 4¼x6½" plates. Leather covered mahogany construction. f6 or f8 Aldis or Beck lens, or f6.8 Goerz. $175-260.

Challenge Dayspool, 3¼x4¼" - c1905. For rollfilm. Leather covered mahogany construction. f6 or f8 Aldis or Beck lens, or f6.8 Goerz. $175-200.

Challenge Dayspool Tropical - Similar to the Dayspool, but with polished Spanish mahogany body, rather than leather covered. Red leather bellows. $450-600.

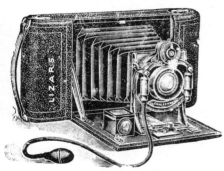

Challenge Dayspool No. 1, 4¼x6½" - c1900. For rollfilm. Leather covered. Red bellows. Beck Symmetrical lens. $175-225.

Challenge Dayspool Stereoscopic Tropical - c1905. Mahogany camera for 2¼x6¾" plates or rollfilm. $650-900.

Challenge Junior Dayspool - c1903-11. Horizontally styled folding-bed rollfilm camera. Identical to the No. 1 Dayspool but with B&L single valve shutter, 25-100. Three sizes: A: 2¼x2¼". B: 2¼x3¼". C: 2½x4¼". "A" size, rare: $225-275. "B" or "C": $175-225.

Challenge Magazine Camera - c1903-1907. Box camera for 12 plates or 24 films, 3¼x4¼". Beck Symmetrical lens. Unicum shutter. $35-60.

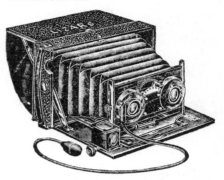

Challenge Stereo Camera, Model B - c1905. 3¼x6¾" plates. B&L RR or Aldis Anastigmat lenses in B&L Stereo shutter. Wooden "Tropical" model, teak with brass trim: $750-900. Leather covered model: $300-450.

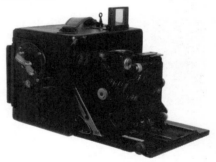

Challenge Stereoscopic Camera, Model 1 B - c1905. Folding bed stereo camera with Goerz-Anschutz FP shutter. Beck lenses. $400-550.

Rambler - c1898. Field camera, 8x10.5cm plates. Mahogany body, brass trim, brass barrel lens. Tapered black bellows. Thornton-Pickard shutter. $250-325.

LLOYD (Andrew J. Lloyd & Co., Boston)
Box camera - 4x5" glass plates. $40-60.

LLOYD (Fred V.A. Lloyd, Liverpool, England)
Field camera - c1910. ½-plate folding camera. $100-150.

LOEBER (Eugene Loeber, Dresden)
Field Camera, 13x18cm - c1895-1900. Tailboard style field camera with fine wood and brass trim. Tapered green bellows with wine red corners. Rodenstock Bistigmat

13x18 brass lens with revolving stops and built-in manually operated shutter blade. $150-200.

Klapp camera - c1915. Strut-folding 9x12cm plate camera. Anastigmat f6.8/135mm lens. $75-125.

Magazine Camera - c1905. Leather covered box camera, holding 12- 9x12cm plates. f8 lens, 3-speed shutter. Rapid wind lever. Two large brilliant finders. $75-125.

LOEBER BROTHERS (New York)
The Loeber Brothers manufactured and imported cameras c1880's-1890's.
Folding bed plate camera - British full-plate camera. Fine polished wood, black bellows, brass trim. Brass-barreled lens with waterhouse stops. $150-200.

LOGIX ENTERPRISES (Montreal, Canada & Plattsburgh, NY)
Kosmos Optics Kit - 35mm SLR with interchangeable lenses in an optical experiment kit. $15-20.

Logikit - Kit of plastic parts to build your own 35mm SLR. $15-20.

LOLLIER (X. Lollier, Paris)

Stereo-Marine-Lollier - c1903. An unusual instrument which combines the features of a stereo camera and binoculars.

Unidentified lenses. Two-speed guillotine shutter. Its general appearance and operation are somewhat similar to the more common Goerz Photo-Stereo-Binocle, but it uses standard 45x107mm stereo plates. Very rare. $3500-4500.

LOMAN & CO. (Amsterdam)
Loman's Reflex - 1890-c1910. Box-style SLR. Polished wood, brass fittings. Loman Aplanat f8/140mm lens. FP shutter 3-200. (The first focal plane shuttered camera to achieve commercial success.) Made in sizes ¼ to ½ plate. $1000-1800.

Loman Reflex - c1906. Leather covered SLR with tall folding viewing hood. Rack focusing front with bellows. Focal plane shutter 1/8-1300. Eurynar Anastigmat f4/135mm. $125-150.

LOMO (Leningrad)
135 BC (VS) - late 1970's - current. Spring-wound 35mm. f2.8 lens, shutter to 250. Common except in USA where Russian cameras have not enjoyed good marketing. $35-50.

LONDON & PARIS OPTIC & CLOCK CO.
Princess May - c1895. Half-plate mahogany and brass field camera. Ross Anastigmat f8/7½" lens. $175-250.

LONDON STEREOSCOPIC & PHOTO
CO. *This company imported and sold under their own name many cameras which were manufactured by leading companies at home and abroad.*

Artist Hand Camera - c1889. Twin lens reflex style box camera. Mahogany body, brass lens. Identical to the Francais Kinegraphe. 9x12cm plates. $900-1400.

Artist Reflex, Tropical - c1910. SLR for ¼-plates. Same as Marion Soho Tropical. Mahogany or teak body, usually green or occasionally red leather hood and bellows. Brass trim. Heliar f4.5/150 lens. FP shutter to 1000. $1600-2300. *Illustrated top of next page.*

style detective camera covered in dark green leather. Camera is in the front half of the box, the 9x12cm plates store in the back half. Side-hinged lid. $600-800.

Field camera - c1885. Mahogany body, brass trim, red double extension bellows. RR f8 lens. Full and ½-plate sizes. $150-250

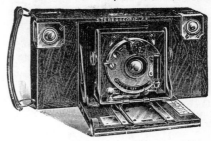

London Stereoscopic Artist Reflex, Tropical

Binocular camera - c1898. Rigid-bodied, jumelle style stereo. Two sizes: 6x9cm 18-plate magazine; 5x7" 12-plate magazine. Krauss-Zeiss Anastigmat f6.3 or f8/110mm lens. Guillotine shutter. $125-200.

King's Own Tropical - c1905. Folding bed camera for 2½x4¼" plates or rollfilm. Teak with brass fittings. Goerz Dagor f6.8/120mm lens in Koilos pneumatic shuter, 1-300. $1000-1400.
--4¼x6½" - Similar to the smaller size, but with Goerz Doppel Anastigmat f9/180mm in B&L shutter. $1000-1400.

Tailboard stereo camera - c1885. 3½x6¼" plate. Swift & Son 4" lenses. Side board panel. Thornton rollerblind shutter. Dark maroon bellows. $450-550.

Carlton - c1895. Box-TLR for 12 plates or 12 films. ¼-plate, 4x5", ½-plate. Euryscope f5.6, Rapid Rectilinear or Ross Goerz Dbl Anastigmat f7.7. Shutter 1-100,T,I. $400-600

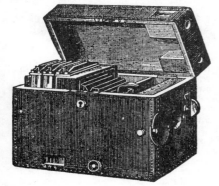

Twin Lens Artist Hand Camera - c1889. Large twin lens reflex. Front door covers the recessed lenses. Leather covered. 9x12cm, 4x5", ½-plate sizes. Magazine holds 24 sheets or 12 plates. $250-400.

Wet plate camera - c1855. 4x5" sliding box style. Light colored wood body (7x7½x6¼" overall) which extends to 10". London Stereoscopic Petzval-type lens in brass barrel. $1800-2000.

Dispatch Detective - c1888. Wooden-box

Box camera, No. 49 - for 122 film. $6-12.

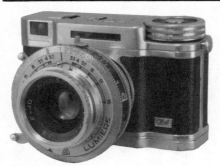

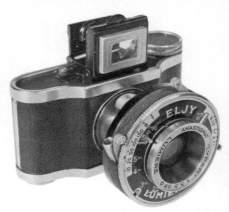

Lumière Eljy Club

LORENZ (Ernst Lorenz, Berlin)
Clarissa - c1929. Small 4.5x6cm strut-type focal plane camera. Polished ebony-wood body with brass trim and brown bellows. Helioplan f4.5 or Trioplan f3/75. Rare. Few sales, wide range of prices: $1400-2700.

LORILLON (E. Lorillon, Paris)
Field camera - c1905. 13x18cm, tailboard style. Wood with brass trim, square red bellows. Taylor, Taylor & Hobson lens in roller-blind shutter. $150-200.

LUBITEL, LUBITEL 2 - c1949-present. 12 exposures, 6x6cm on 120 film. Copies of Voigtländer Brillant. f4.5/75mm T-22 lens. Variable speed shutter, 10-200. $20-30.

LUCKY - Japanese novelty subminiature of the Hit type. $15-20.

LUDIX - c1949. 4.5x6cm on rollfilm. Emylar f4.5/70mm; Pronto 1/25-125 sh. $50-75.

LUMIÈRE & CIE. (Lyon, France)

Eljy, Super Eljy - c1937-48. 24x36mm exposures on special 30mm wide paper-backed rollfilm. Lypar f3.5/50mm lens in Eljy shutter. Fairly common. $50-75.

Eljy Club - c1951. 24x36mm exposures on special 35mm film. Lypar f3.5/40mm. Synchro shutter 1-300. Chrome top housing incorporates optical finder and extinction meter. (Last model is without extinction meter.) $100-125. *Illustrated top of previous column.*

Lumibox - c1934-38. Metal box camera for 6x9cm on 120. Focusing lens. $5-10.

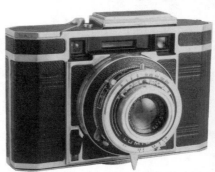

Lumiclub - c1951. Heavy, well-made cast aluminum camera for 120 or 620 film. Originally designed and advertised by Pontiac as the "Versailles" but never produced. Lumière bought the molds from the failing Pontiac company and modified them to make the Lumiclub. Takes 6x6cm or 4.5x6cm with internal mask. Eye-level and waist-level finders, extinction meter, telescoping front, lever advance neatly fitted into body top, DEP, body release. This camera is rare even in France. $150-175.

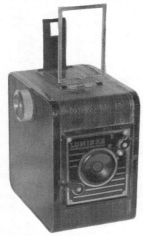

Box camera - Simple lens and shutter, 127 rollfilm. $6-12.

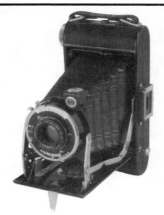

Lumirex - c1946. Self-erecting camera for 6x9 on 620 film. Fidor f6.3 or Spector f4.5/105mm lens. Reflex and frame finders, body release. $12-18.

Lumix F - c1946. Folding 6x9cm rollfilm camera. Same body as Lumirex, but with a simple shutter and meniscus lens. $15-25.

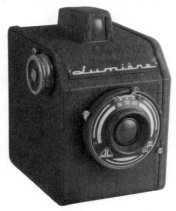

Lux-Box - Metal box camera with brown crinkled paint. Eye-level optical finder. Synchronized shutter, 25,75,B. For Lumière #49 film (same as Kodak 620). $15-20.

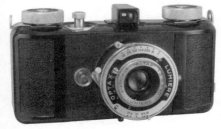

Optax - c1948. Bakelite 35mm. First model

has folding finder like Eljy and collapsible tube front. Second model (1949) has rigid optical finder and non-collapsing front. $75-95.

Scout-Box - c1935. Painted metal box camera. 6x9cm on 120 rollfilm. $10-15.

Sinox - 6x9cm folding rollfilm. Nacor Anastigmat f6.3/105mm lens. Central shutter 25-100. $15-25.

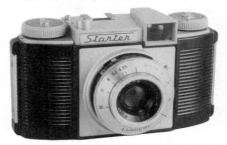

Starter - c1955. Simple black plastic 35mm with grey plastic top housing. Lypar f3.5/45mm. $30-50.

Sterelux - c1920-37. Folding stereo camera for 116 rollfilm, 6x13cm. Spector Anastigmat f4.5/80mm lens. Shutter 1/25-1/100, later models have 1-100. $180-230.

LUMIKA 35 - Japanese 35mm viewfinder camera. Tri-Lausar Anastigmat f3.5/45mm lens in Rektor 1-300 shutter, ST. $45-60.

LUNDELIUS MFG. CO. (Port Jervis, NY) Magazine camera - c1895. For 12 plates in vertical format. Leather covered wood body measures 10x8x4½ overall. $100-150.

LURE CAMERA LTD. (Los Angeles, CA)

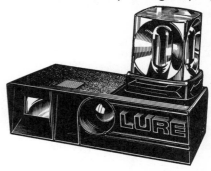

Lure - c1973. Plastic 110 cartridge camera. Camera was sent in for processing of film; pictures and new camera were mailed back. The same camera also appears as "Lure X2" in Hawaii, "Blick" in Italy, "Rank" in England and Europe, and "Love" which is made in Brazil. New: $3-6.

LÜTTKE (Dr. Lüttke & Arndt, Wandsbek, Hamburg, & Berlin, Germany)
Field camera - c1900. 9x12cm tailboard camera. Fine wood, brass trim. Single extension green square bellows, black corners. Periscop f16 lens, Junior shutter. $140-180.

Folding plate camera - 9x12cm, horizontal format. Black leathered wood body. Red-brown bellows. Lüttke Periscop lens, rotary stops. Brass shutter. $50-75.

Folding plate/rollfilm camera - c1900-1902. Unusual folding camera for either rollfilm or 9x12cm plates. Wooden body with nickel trim. Rare. $200-225.

Folding rollfilm camera - 8x10.5cm. Black leathered body with red cloth bellows. Nickel trim. Lüttke Periplanat lens. $40-50.

Linos - c1898. 9x12cm folding plate camera. Walnut body, brass trim. Aplanat f8/165mm. Pneumatic shutter. $275-375.

MACKENSTEIN (H. Mackenstein, Paris)
Field camera - c1900. 13x18cm tailboard style folding view camera. Polished wood with brass trim and brass handle. Tapered wine-red bellows. Carl Zeiss Anastigmat in Mattioli roller-blind shutter. $200-300.

Folding camera - c1890. Hinged mahogany panels with round cutout support front standard, like the Shew Eclipse. Maroon bellows. Brass Aplanat f9/150mm lens. $250-275.

Francia, 9x12cm - c1910. Strut-folding plate camera with focal plane shutter 15-2000. Wine red single pleat bellows. Leather covered wood body. With Dagor f6.8/120mm lens and magazine back: $175-225.

Francia Stereo (folding) - c1906. Strut-folding stereo cameras for 45x107mm or 6x13cm plates. Max Balbreck or Sumo Aplanat lenses, guillotine shutter with variable speeds. Red leather bellows. $175-200.

Francia Stereo (rigid) - c1900-10. Jumelle-style stereo cameras in 6x13cm and 9x18cm sizes. Goerz Dagor or Doppel Anastigmat f6.8 lenses. Guillotine shutter. Large Newton finder. With magazine back: $225-265.

Jumelle Photographique - c1895. Rigid jumelle-style camera for single (non-stereo) exposures. Leather covered wood body. 6.5x9cm and 9x12cm sizes. Goerz Doppel Anastigmat f8 lens. Six-speed guillotine shutter. With magazine back: $150-200.

Photo Livre - c1890. The French edition of the popular Krügener Taschenbuch-Camera. A leather-covered camera disguised as a book. Achromatic f12/65mm lens is in the "spine" of the book. Guillotine shutter. Internal magazine holds 24 plates for 4x4cm exposures. $2300-2700.

Pinhole camera - c1900. Polished walnut ¼-plate tailboard camera. Maroon bellows. 6 "pinhole" openings on the lensboard, take 6 exposures per plate. One offered in Nov. 1982 for $750.

Stereo Jumelle - c1893. For 18 plates 9x18cm in magazine. Goerz Double Anastigmat 110mm lens, variable speed guillotine shutter. $150-175.

MACRIS-BOUCHER (Paris)

Nil Melior Stereo - c1920. A wide-angle stereo camera, based on the theory that short focus wide angle lenses gave more natural stereo vision and allowed 6x13cm exposures in a camera just slightly larger than most 45x107mm stereos. Boyer Sapphir or E. Krauss Tessar f4.5/65mm lens in seven-speed spring shutter. Large newton finder. 12-plate magazine for 6x13cm plates. $100-150.

MACVAN MFG. CO.

Macvan Reflex 5-7 Studio camera - c1948. Large studio-style TLR. Revolving, shifting back. Parallax correction. 5x7"

plates or cut film. Ilex Paragon f4.5/8½" lens in Ilex #4 Universal shutter. Reflex or ground glass viewing. $225-275.

MACY ASSOCIATES

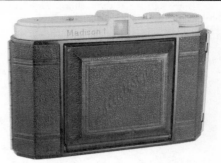

Flash 120 - Metal box camera, 6x9cm. Black crinkle enamel finish. Art-deco faceplate. $10-15.

Macy M-16 - c1930s. Basic black box camera, probably made by Ansco for Macy's. Interesting faceplate with star and radiating lines. $10-15.

Supre-Macy - c1952. Japanese 6x6cm TLR made by Hachiyo Optical Co. for Macy's. Similar to Alpenflex I. Alpo f3.5/ 75mm in Orient II 1-200 shutter. $50-80.

MADER (H. Mader, Isny, Württemberg) Invincibel - c1889. All-metal folding camera for 5x7" plates. The bed folds down; sides fold out. Aplanat f6/180mm lens. Iris diaphragm. $900-1400.

MADISON ! - Folding camera for 6x6cm

on 620 film. f4.5 lens. Shutter to 200. $25-40.

MAGIC INTRODUCTION CO. (N.Y.)

Photoret Watch Camera - c1894. For 6 exposures ½x½" (12x12mm) on round sheet film. Meniscus lens. Rotating shutter. $300-450. (Original box and film tin would add $30-50 each to this price.)

Presto - c1896. All-metal, oval-shaped camera, invented by Herman Casler.

28x28mm exposures on rollfilm or glass plates. Meniscus lens with rotating front stops. Single speed shutter. $450-550. (Original box and plates will add $150-200.)

MAGNACAM CORP. (New Jersey)

Wristamatic Model 30 - c1981. Short-lived plastic wrist camera. 6 circular exposures on 9mm dia. film. Fixed focus. Like new in box: $25-40.

MAL-IT CAMERA MFG. CO. INC. (Dallas, TX)

Mal-It - Factory-loaded disposable cardboard camera, pre-addressed to the processing lab. The original price of the camera included processing and printing of 8 Jumbo pictures. $25-35.

MAMIYA CAMERA CO. (Tokyo)
Auto-Lux 35 - c1965-67. 35mm SLR. Coupled selenium meter above lens. Fixed Mamiya/Sekor f2.8/48mm lens, Copal-X 1-500 shutter. $75-125.

Camex Six - c1950. Horizontally styled folding bed rangefinder camera for 6x6cm on 120. Similar to the Mamiya 6, with movable film plane for focusing. Takatiho Zuiko f3.5/75mm in Seikosha-Rapid 1-500. Unusual. $100-150.

Family - c1962. 35mm SLR. Uncoupled exposure meter with cell on front of prism. Behind-the-lens Copal shutter B,15-250. Interchangeable Sekor f2.8/48. $60-100.

Junior - c1962. 35mm SLR. Coupled match-needle selenium meter located on pentaprism, centered above the lens. Non-interchangeable Mamiya-Sekor f2.8/45mm lens. Leaf shutter 1/15-250. $40-65.

Korvette - c1963. Name variant of the Mamiya Family camera, marketed in England by B.Bennett & Sons Ltd. $60-100.

Magazine 35 - c1957. 35mm RF camera. Non-interchangeable Mamiya/Sekor f2.8/50mm lens. Seikosha-MXL, 1-500,B. Interchangeable film magazines. $75-125.

Mamiya 6 IV

Mamiya 6 - c1946-1950's. Basically a horizontal folding-bed camera for 12 square exposures, 6x6cm, on 120. Some featured the option of 16 vertical exposures, 4.5x6cm, as well. About a dozen models were made. Coupled rangefinder. Unusual feature: Knurled focusing wheel just above the back door of the camera moves the film plane to focus while the lens remains stationary. Prewar models with K.O.L. Special f3.5/75mm lens and NKS 1-200 shutter bring a premium price of $150-250. Later models with Zuiko f3.5/75mm lens in Copal or Seikosha shutter: $60-90.

Mamiya-16 - c1950's. Subminiature for 20

368

exposures 10x14mm on 16mm film. Various models including: Original model, Deluxe (with plain, smooth body), Super (like original but with sliding filter), Automatic (built-in meter). No significant price difference among these models. All are relatively common. $25-50. *Up to 50% higher in Europe.*

Mamiya-16 Police Model - c1949. This was the first Mamiya 16 camera, made in black finish. Has no serial number. Fixed focus lens. Shutter B,25,50,100 only. No built-in filter. Detachable waist-level brilliant finder. $350-400.

Mamiyaflex Automatic-A - c1949. This was the first Japanese TLR with automatic film stop (not requiring use of red window). Zuiko f3.5/75mm in Seikosha-Rapid shutter. The earliest version does not have a sports finder. $100-150.

Mamiyaflex Automatic A-II - c1954. Similar to Automatic A, but bayonet mount on viewing and taking lenses. Zuiko f3.5/75mm; Seikosha-Rapid 1-500,B. $65-95.

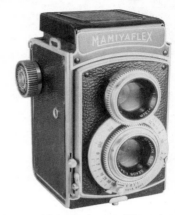

Self-timer. ASA synch post. Film advance cocks shutter. $75-125.

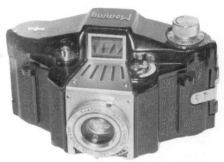

Mammy - c1953. Small bakelite camera for 24x28mm exposures on 828 film. Cute Anastigmat f3.5/45mm lens. Shutter 25-100,B. Unusual design. $60-85.

Mamiyaflex Junior - c1948. Mamiya's first TLR, of relatively simple design especially when compared with the sophisticated models of the next two decades. At least three variations, all with Towa Koki Neocon f3.5/75mm lens in Stamina shutter. The first model has the winding knob low on the right side, while the others place it near the top. First two have speeds to 200, third goes to 300. All have front-element focusing with externally gear-coupled taking and viewing lenses. Uses 120 film for 6x6cm images. First model: $100-150. Later variations: $50-75.

Mamiyaflex II - c1952. TLR for 6x6cm on 120 film. Setagaya Koki Sekor f3.5/7.5cm. Merit B, 1-300. Front element focus; viewing lens externally gear-coupled.

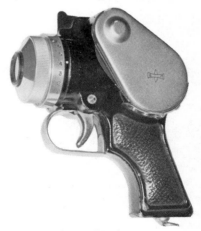

Mamiya Pistol camera

Myrapid - c1967. Automatic half-frame 35mm with meter cell surrounding lens. Tominon f1.7/32mm in Auto Copal 30-800. $15-25.

Pistol camera - c1954. Half-frame 35mm camera, shaped like a pistol. Sekor fixed focus f5.6/45mm lens. Single speed shutter. Only 250 believed to have been made for police training. $1000-1200. *Illustrated on previous page.*

Saturn - c1963. Name variant of the Mamiya Family. Marketed in England by Dixons Photographic Ltd. $60-100.

Super Deluxe - c1964. 35mm CRF camera with built-in CdS meter. Mamiya-Sekor f1.7/48mm lens, Copal-SVE 1-500, B shutter. $25-45.

Mamiya/Sekor (CWP) - c1964-67. 35mm SLR. Body has Mamiya/Sekor nameplate; USA advertising referred to it as the "CWP". Through-the-lens metering; CdS meter window on right side of metal front plate. Mamiya-Sekor f1.7/58mm lens. FP shutter 1-1000,B. $60-100.

Mamiya/Sekor 500 DTL - c1969. 35 SLR with CdS meter. Like the 500 TL but with dual metering system; meter can be set for spot or area metering. Mamiya/Sekor f2/55mm. FP shutter 1-500,B. $40-60.

Mamiya/Sekor 500 TL - c1966. 35 SLR with CdS meter, the first Mamiya with TTL metering. Interchangeable Mamiya/Sekor f2.8/55mm. FP shutter 1-1000,B. $40-60.

Mamiya/Sekor 1000 DTL - c1968. 35 SLR with CdS meter. Similar to the 500 DTL, but FP shutter 1-1000,B. Mamiya/Sekor f1.8/55mm. $40-65.

Mamiya/Sekor 1000 TL - c1966. 35 SLR with CdS meter. Similar to the 500 TL, except FP shutter 1-1000,B. Mamiya/Sekor f1.8/55mm. $40-65.

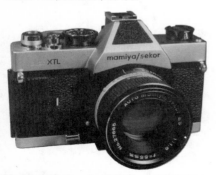

Mamiya/Sekor Auto XTL - c1971. 35mm SLR. Advanced design but limited production due to poor sales. TTL automatic exposure. Auto Mamiya-Sekor f1.8/55mm interchangeable lens. $100-125.

MANHATTAN OPTICAL CO. (New York)
(See also Gundlach-Manhattan)

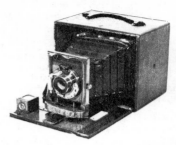

Bo-Peep, Model B, 4x5" - c1898. Folding plate camera. Red bellows, brass shutter. $50-75.

Bo-Peep, Model B, 5x7" - c1898. Double extension bellows. Brass lens with rotating stops. $65-100.

Night Hawk Detective - c1895. For 4x5" plates. Polished oak body, or leather covered. String-set shutter, T & I. Ground glass or scale focus. Rapid Achromatic lens. All wood: $300-350. Leather covered: $200-275.

Wizard Duplex No. 1, No. 2 - c1902. Folding bed rollfilm camera for 3¼x4¼" exposures. Focusing similar to the Screen Focus Kodak: ground glass focusing where back is removed. Dark slide on back prevents exposures of film. $250-300.

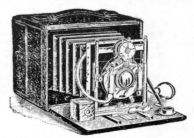

Wizard folding plate cameras:
4x5" - Including Baby, Cycle, Wide Angle,

Senior, Junior, A, and B models. $60-90.
5x7" - Including Cycle, B, and Senior models. $75-100.

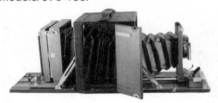

Long-Focus Wizard - 5x7". Includes Cycle and Senior models. Triple extension maroon bellows, RR lens, Unicum shutter. $85-125.

Wizard Special - c1896. Leather covered folding plate camera. 3¼x4¼" or 4x5" size. Nickel trim. Double extension red bellows. Wizard Sr. double pneumatic shutter. EUR: $125-175. USA: $75-100.

MANIGA 13x14mm - Small die-cast metal subminiature, similar to the Aiglon and Bobby. Takes 13x14mm exposures on rollfilm. Oversized round or oval shutter. Uncommon. $125-175.

MANIGA 3x4cm - c1930. Sardine-can shaped metal camera for 3x4cm on 127 rollfilm. Simple lens and Maniga shutter as on the subminiature model. $150-200.

MANIGA MANETTA - c1930. Small metal camera, 3x4cm on rollfilm. Body shaped like sardine can with tubular finder on top. Laack Poloyt f4.5/50mm in Pronto-style Manetta 25-100,B,T. Uncommon. $200-250.

MANSFIELD (A division of Argus, Inc.)

Mansfield Automatic 127 - Horizontally styled black plastic box camera for 4x4cm on 127 film. Styling like the USC Tri-matic, Tower Camflash 127, and Tower Automatic 127. Automatic exposure. Selenium meter controls diaphragm. Single speed shutter. Built-in AG-1 flash beside lens. $5-10.

MANSFIELD HOLIDAY
Skylark - c1962. 35mm camera with coupled meter. Luminor Anastigmat fixed focus lens. Shutter 10-200, X-sync. $15-20.

Skylark V - Postwar 35mm rangefinder camera. Cinenar f1.9/45mm lens. $35-60.

MAR-CREST MFG. CORP.
Mar-Crest - Bakelite novelty camera for half-frame 127. $5-10.

MARION & CO., LTD. (London) *Marion was established in 1850 as an offshoot of the Parisian firm of A. Marion and Cie. and was set up to exploit the carte-de-visite craze. It expanded to deal in photographic materials and as photographic dealers it sold cameras. In 1887 it set up its own plate manufacturing plant at Southgate, North London.*
The Soho range of cameras (named after Marion's Soho Square address) was sold by Marion but most were made by Kershaw of Leeds. This arrangement was formalized in 1921 when the two firms joined with five others to form APM. Marion was also a part of the 1930's regrouping that resulted in the formation of Soho Ltd.

Academy - c1885. TLR-style camera. Eye-level viewfinder. 4 sizes: 1¼x1¼" to 3¼x4¼". Magazine holds 12 plates. Petzval-type lens. Rotary shutter, T,I. Finished wood, brass fittings. Rack and pinion positioning of plates for exposure. In 1887, a mirror was added to the finder of the larger models to make it usable as a waist-level camera. This improved version was called the "New Academy". Estimate: $2000-3000. A nice example of the smallest size, with magazine and viewfinder magnifier all in a fitted plush lined box sold at auction in 11/88 for $6300.

Cambridge - c1901-04. Compact folding field camera. Mahogany with brass trim. Made in ¼, ½, and full-plate sizes. RR lens and rollerblind shutter. $100-150.

Field camera - c1887. Mahogany tailboard camera for full-plates. Square bellows. Marion Rapid Rectilinear lens, metal drop shutter. $325-370.

Krügener's Patent Book Camera - The English edition of the better known Krügener's Taschenbuch Camera. Its cover gives the story, embossed in leather: "Manufactured in Germany for Marion & Co. The Sole Agents." One auction sale, late 1986: $2500.

Metal Miniature - c1884. Tiny, all-metal plate camera. Back moved into focus by a rack-and-pinion. Petzval-type f5.6/55mm. Guillotine shutter. Later versions were more streamlined, with a sliding lens tube for focusing. Made in 5 sizes from 3x3cm to half-plate. Despite higher prices a few years ago, more recent auction sales indicate a range of $1250-1600.

Modern - c1898-1905. Simple folding plate camera. Single extension black bellows. Mahogany body, brass trim. Achromatic or Rapid Rectilinear lens. T+I shutter. $140-180.

Parcel Detective - 1885. A box detective camera, neatly covered with brown linen-lined paper and tied with string to look like an ordinary parcel. Fixed focus lens. It used standard 3¼x4¼" plates which could be loaded into the camera in daylight from flexible India-Rubber plateholders. No known sales. Estimated value: $5000+.

Perfection - c1890. Folding field camera, full plate, 10x12", or 12x15" size. Fine polished wood. Dallmeyer brass barrel f8 RR lens with iris diaphragm. $175-325.

Radial Hand camera - c1890. Mahogany magazine camera for 12 ¼-plates. Plates were held in radial groves to be moved into position for exposure and then moved back again. Guillotine shutter. $700-900.

Soho Reflex - Large-format SLR cameras. Focal plane shutter.
2½x3½" - Tessar f4.5/4". $125-200.
3¼x4¼" - Ross Xpres f3.5/5½". $125-225.
3½x5½" - Ross Xpres f4.5. $125-175.
4¾x6½" - Dagor f6.8/210mm. $75-125.

Soho Stereo Reflex - c1909. Similar to the Soho Reflex, but for stereo exposures. Goerz lenses. FP shutter. 9x14cm plates. $600-800.

Soho Stereo Tropical Reflex - c1909. Similar to the Soho Tropical Reflex, but takes 3½x5½" stereo exposures. Ross Compound Homocentric f6.8/5" lenses. A rare and beautiful camera. One nice example with tropical magazine back sold at auction in England in 11/88 for $8800.

Soho Tropical Reflex - Fine polished teak wood. Red leather bellows and viewing hood. Brass trim. 2½x3½" or 3¼x4¼" size. Dallmeyer f3.5 Dalmac or other popular lenses. (Ross sold the same camera with Ross Xpres f3.5 lens.) Revolving back. A beautiful tropical camera. $1700-2400.

MARK S-2 - c1958-65. 35mm RF, copy of Nikon S-2. Made in Japan. Fixed Tominor f2/50mm, Copal 1-300 shutter. $75-125.

MARKS (Bernard Marks & Co. Ltd., Canada)
Marksman Six-20 - Metal box camera, 6x9cm. $5-10.

MARLOW BROS. (Birmingham, England)
MB, No.4 - c1900. Mahogany field camera, with brass fittings. Various sizes 3¼x4¼" to 10x12". $250-350 with appropriate lens.

MARSHAL OPTICAL WORKS (Japan)
Marshal Press - c1966. Press camera for 6x9cm on 120/220 rollfilm. Designed by Mr. Seichi Mamiya, the founder of the

Mamiya Optical Co. Nikkor-Q f3.5/105mm lens. Converters which screw into the front of the normal lens make it f4.7/135 or f5.6/150. Seiko shutter B, 1-500. While not uncommon in Japan, they are not seen often in Europe or the U.S.A. Therefore, this is one quality camera which will bring as much in the U.S. as it does in Japan. With normal lens only: $500-800. The auxiliary lenses are less common and will bring an additonal $100-150 each.

MARTAIN (H. Martain, Paris)
View Camera - 13x18cm size. Bellows and back swivel for vertical or horizontal format. Sliding lensboard. With Darlot lens: $175-200.

MARUSO TRADING CO. (Japan)
Spy-14 - c1965. Actually, the Spy-14 is not a camera, but rather an outfit which includes a Top II camera with case, film, and developer in an attention-getting display box. Commonly found like new, in original box, for about $40.

Top Camera - c1965. Bakelite Japanese subminiature camera with metal front and back. The entire camera is finished in grey hammertone enamel so it looks like an all-metal camera. Rectangular shape is similar to the Minolta-16, but construction quality is more like the Hit-types. Takes 14x14mm

exposures on standard "Midget" size rollfilm. Meniscus lens, single speed shutter. One version has a reflex finder. USA: $35-50. *A few have sold 50% higher in Europe.*

Top II Camera - c1965. Nearly identical to the Top Camera, above. Some examples have black front and back; others are all grey. $20-25.

MARVEL - Half-127 camera similar to the Detrola. Extinction meter and uncoupled rangefinder in top housing. $15-20.

MARVEL PRODUCTS INC. (Brooklyn, NY)

MarVette - Bakelite minicam for 127 half-frames. Shorter body length than most cameras of this type, because it does not allow for a spare film roll to be stored inside. $15-20.

MARYNEN (Brussels)
Studio camera - c1910-20. Large wooden studio camera, 18x24cm plates. Brass trim, Brass Eurynar f4.5/360mm lens. Square green bellows. One sold at auction in 9/87, with large wooden studio stand, for $950.

MASHPRIBORINTORG (Moscow, USSR) *Not a manufacturer, but an exporting organization. For lack of accurate information on the actual factories, we have chosen to list a number of Russian cameras together here rather than to scatter them throughout the book by their model names.*

Chaika II - c1968. (Cyrillic letters look like YANKA-II.) Half-frame 35mm for 18x24mm

exposures. Interchangeable Industar-69 f2.8/28mm lens. Shutter 30-250. $30-40.

Bera - see Kiev-Vega below.

John Player Special - Spy camera disguised as package of John Player cigarettes. Camera mechanism is Kiev-Vega (copy of Minolta 16). Disguise is a metal duplicate of a cigarette package, and the cigarettes protruding from the top are actually the controls to operate the camera. There is also space for two real cigarettes to complete the illusion of reality. These were not a retail camera, so the limited supply comes from undercover sources. Though sales have reached $2500+, these are generally available $1000-1500.

Kiev-2 - c1947. 35mm CRF camera, copy of Contax II. Jupiter-8 f2/50mm lens. FP shutter ½-1250,B. $50-75.

Kiev-2A - c1950. Same as the Kiev-2 with flash sync added to front. $50-75.

Kiev-3 - c1947. 35mm CRF with meter. Copy of Contax III. Jupiter-8 f2/50mm lens. FP shutter ½-1250,B. $125-175.

Kiev-3A - c1950. Same as the Kiev-3 with flash sync added to front. $75-100.

Kiev-4 - Minor body modifications in the Kiev-3A resulted in the Kiev-4. $45-80.

Kiev-4A - Minor body modifications in the Kiev-2A resulted in the Kiev-4A. $65-100.

"No-Name" Kiev - c1963. Rangefinder camera made for USA market. Does not have the "Kiev" name on the front. Because they closely resemble the Zeiss Contax IIa or IIIa, they are sometimes referred to as "No-Name Contax". $300-450.

Kiev 30 - c1960. Subminiature for 13x17mm exposures on 16mm film. Third in the series, following Kiev-Vega, Kiev-Vega 2. All black body. $30-50.

Kiev-Vega, Kiev-Vega 2 ("Vega" in Cyrillic script resembles "Bera" in Roman script.) - Subminiature for 20 exposures on 16mm. Copies of Minolta-16, but with focusing lenses. Industar f3.5/23mm. Shutter 30-200. $40-60.

Kneb - see Kiev.

Narciss - c1960. Cyrillic-lettered versions look like "Hapyucc". Subminiature SLR for 14x21mm on 16mm unperforated film. White or black leather covering. Industar-60 f2.8/35mm lens. Previously peaked at $750-1000, but now stabilized at $450-550.

Smena - c1952. Cyrillic letters resemble "Cmeha". Black plastic 35mm cameras, models 1 to 8. f4.5/40mm lens. Shutter 10-200, T. $10-20.

Smena Symbol - c1970's. $12-18.

MASON (Bradford, England)
Field camera - Mahogany dbl extension camera which folds very compactly. Brass trim, brass Busch Bis-Telar lens. Roller-blind 1/15-90 shutter. $175-225.

MASON (Perry Mason & Co., Boston)

Argus Repeating Camera - c1890. Metal-bodied camera in leather case giving the appearance of a handbag. Vertical style. 12-plate magazine. 3" dia. image on 3¼x4¼" plates which drop into plane of focus when lenstube assembly is turned. $1500-2000.

Companion - c1886. 4x5" polished mahogany tailboard view. Brass Achromatic lens, rotating disc stops. $100-150.

Harvard camera - c1890. Black all metal, gold pin-striping, 2½x3½" plate. Meniscus lens. A few years ago these sold in the $150 range, but recent trends are $50-60.

Phoenix Dollar Camera - c1890. Black tin inexpensive camera, 4.5x6cm plates. $75-125.

MAWSON (John Mawson, Newcastle, England)
Wet-plate camera - c1860. Sliding-box style. Petzval type lens. $1000-1500.

Wet-plate stereo - c1865. Bellows style for 3¼x6½" stereo exposures on wet-plates. Ross Achromatic lenses. $1000-1500.

MAXIM MF-IX - c1986. Novelty Taiwan 35mm, with a small pseudo-prism. $1-5.

MAY, ROBERTS & CO. (London, England)
Sandringham - c1900. 8x10.5cm field camera. Wood body, brass fittings, black bellows. Wray 5" lens. $125-150.

MAY FAIR - c1930. Metal box camera. T & I shutter. $12-18.

MAYFIELD COBB & Co. (London)
Companion - Mahogany ½-plate field camera. Brass trim, brass Lancaster Portrait lens. Roller-blind shutter. $175-250.

MAZO (E. Mazo, Paris)
Field & Studio camera - c1900. 9x12cm or 13x18cm on plates. Horizontal format. Fine wood body, GG back, double extension bellows. Mazo & Magenta Orthoscope Rapid f8 lens in Thornton-Picard shutter. Wide price range: $150-375.

Stereo camera - Polished mahogany tailboard stereo. Brass-barrel Mazo lenses in Thornton-Pickard shutter. Red leather bellows. $400-600.

McBEAN (Edinburgh)

Stereo Tourist - 9x18cm. Steinheil Antiplanat lens. Thornton-Picard shutter 1-225. $350-450.

McCROSSAN (Glasgow, Scotland)
Wet-plate camera - Sliding-box style. Petzval-type lens. $600-800.

McGHIE and Co. (Glasgow, Scotland)
Detective camera - c1885. Leather covered wooden box contains a bellows camera and enough room to store 6 double plate holders. Brass lens. One failed to reach a reserve of $925 at a German auction in 10/88. Estimate: $600-800.

Field camera - Folding ½-plate camera. Mahogany body, brass trim, brass bound lens. Tapered black bellows. $250-300.

Studio View - c1890. Polished mahogany, folding bed camera. Square bellows. Swing/tilt back. GG back. Pneumatic shutter. Brass barrel lens with rack/pinion focus. $200-250

McKELLEN (S.D. McKellen, England)
Treble Patent Camera - c1884. Full-plate mahogany field camera, named for its three patents: 1. Solid inset tripod head, which never became common but was soon modified by him and others to an open metal turntable. 2. Front folding and support arrangement, still used world wide on some field cameras. 3. Back horizontal swing, with slots on sides at rear. Dallmeyer R.R. lens with waterhouse. $200-250.

MEAGHER (London, England)
Stereo camera - c1870. Polished mahogany tailboard stereo, 9x18cm exposures. Brass-barrel Dallmeyer lenses. $350-500.

Tailboard camera - c1900-05. Dovetailed mahogany. Brass trim. Brass barrel lens with wheel stops. ¼-plate to full plate sizes. $175-350.

Wet-plate bellows camera - c1860. Made in front bed and tailboard styles. Half plate, full plate, or 10x12" size. Polished mahogany, tapered maroon bellows. Ross or Dallmeyer lens. Waterhouse stops. Normal range: $300-500.

Wet-plate sliding-box camera - c1860. Polished mahogany. Sliding box moves by rack and pinion. Made in sizes ¼-plate to 5½x7½" sizes. Petzval-type brass barrel lens. $1300-1800.

MECUM - c1910. Stereo box camera for 9x12cm plates. Leather covered. Ground glass or waist-level viewing. Meniscus lenses. T,B,I shutter. Either lens can be capped for single exposures. $125-175.

MEFAG (Sweden)
Handy Box - Box camera for 6x6cm on rollfilm. Rare. $25-40.

MEGO MATIC - Blue and black plastic camera of the "Diana" type. $1-5.

MEGURO KOGAKU KOGYO CO. LTD. (Japan)

Melcon - c1955. 35mm Leica-copy. FP 1-500,T,B. Collapsible Hexar f3.5/50mm lens. $800-1200.

MENDEL (Georges Mendel, Paris)
Detective camera - For 12 plates 3¼x4¼". RR lens, rotating shutter, iris diaphragm. $125-150.

Triomphant - c1900-05. Magazine box camera for 9x12cm plates. Brown leather covered wood body. Ortho-Symmetrical lens. Extra Rapid shutter. $125-150.

MENDOZA (Marco Mendoza, Paris)
View camera - Mahogany tailboard-style, sizes from ¼-plate to 12x18cm. $70-150.

MENTOR-KAMERA-FABRIK *See Goltz & Breutmann.*

MEOPTA (Prerov, Czechoslovakia)

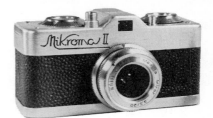

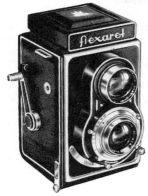

Flexaret - c1953-62. 6x6cm TLR. Models (I), II, III, IV, VI. Mirar or Belar f3.5/80mm in Prontor II shutter. Crank advance on early models, changed to knob advance in Model IV. Model VI with grey leather: $60-80. Earlier models: $40-60.

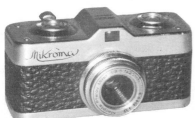

Mikroma - c1949. 16mm subminiature. Mirar f3.5/20mm lens. Three-speed shutter 25-200. Rapid-wind slide. $60-100.

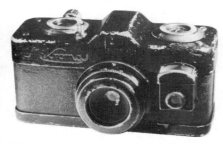

Mikroma, black - c1960. Made for the Czechoslovakian police. Black finish on all metal parts. Besides the normal eye-level finder on top there is a waist-level brilliant finder mounted on the front. $375-450.

Mikroma II - c1964. Similar to Mikroma,

but with 7-speed shutter, ⅕-400. Normally with green leather covering, but occasionally beige. $60-120.

Milono - c1950. Unusual folding-bed camera for 6x6cm on 120 film. Mirar f4.5/80mm in Compur Rapid 1-500. $35-45.

Opema - c1951. Leica copy. Opemar f2 or Belar f2.8 lens. FP shutter 1/25-500. Rare. $65-125.

Stereo Mikroma (I) - c1961. For stereo exposures on 16mm film. Mirar f3.5/25mm lenses. Shutter ⅕-100. Sliding bar cocks shutter. Full outfit: $225-300. Camera only: $160-185.

Stereo Mikroma II - Similar to the Stereo Mikroma, but advancing film automatically cocks shutter. Grey or black leather. $125-175.

Stereo Mikroma Accessories - Cutter: $25-45. Viewer: $20-30.

Stereo 35 - c1960's. 12x13mm stereo exposures on 35mm film. Mirar f3.5/25mm fixed focus in Special shutter 1/60, B. Stereo slides fit into View-Master type reels. Diagonal film path allows 80 stereo pairs to be exposed in two diagonal rows on a single pass of the film. MX sync. Plastic and metal. Camera only: $100-150. Add $50-75 for cutter and viewer.

MERIDIAN INSTRUMENT CORP.
Meridian - c1947. 4x5" press/view. Linhof copy. f4.5/135mm lens. $150-225. *Illustrated top of next page.*

Meridian

MERIT - Plastic Hong Kong novelty camera of the "Diana" type. 4x4cm on 120 film. $1-5.

MERKEL (Ferdinand Merkel, Tharandt, Germany)
Elite - c1924. Double extension camera for 6.5x9cm plates. Anastigmat f6.8/120mm. 1-100 shutter. $35-50.

Metharette - c1931. Folding rollfilm camera for 3x4cm exposures. Trinar f2.9/50mm. Ring Compur. Rare. $75-110.

Minerva - c1925. Tropical style folding bed camera. Mahogany body with brass trim. Brown double extension bellows. Rack focus. 9x12cm size has Meyer Trioplan Methan's Anastigmat, or Steinheil Unofokal f4.5/135mm lens in Compur or Ibsor shutter. 6.5x9cm size has Selar f4.5/105mm lens. $500-700.

Metro Flash No. 1 Deluxe

MERTEN (Gebr. Merten, Gummersbach, Germany)
Merit Box - c1935. Brown marbelized or red and black bakelite box for 4x6.5cm on 127 film. f11/75mm Rodenstock lens. T & I shutter. Colors: $100-150. Black: $50-75.

METASCOFLEX - 6x6cm Rolleicord copy from Japan. Metar f3.5/80mm lens. $60-90.

METRO MFG. CO. (New Jersey)
Metro Flash - Folding rollfilm camera, 6x9cm. $10-18.

Metro Flash No. 1 Deluxe - Self-erecting, rollfilm camera with art-deco covering. 6x9cm. $20-30. *Illustrated bottom of previous column.*

METROPOLITAN INDUSTRIES (Chicago, Ill.)
Clix 120 - All metal box camera, 6x9cm on 120. $3-6.

Clix Deluxe - Black plastic minicam for half-127. $3-7.

Clix Miniature - Black plastic minicam for 828 film. $3-7.

Clix-Master - Black plastic minicam for 127 film. $3-7.

Clix-O-Flex - c1947. Reflex style plastic novelty camera. Half-frame 127. $5-10.

Metro-Cam - Black plastic minicam for 3x4cm on 127 film. $3-7.

Metro-Flex - Plastic, TLR-style novelty camera. Half-frame 127. Several variations in body styling. $5-10.

METROPOLITAN SUPPLY CO. (Chicago, Ill.)

King Camera - Small 2x2x3½" cardboard camera for glass plates. Back fits on like a shoe-box cover, similar to Yale and Zar. Not to be confused with the Japanese King Camera of the WWII era. $75-100.

MEYER (Ferd. Franz Meyer, Blasewitz-Dresden, Germany)

Field Camera (English style) - c1900. Self-casing field camera of the compact "English" folding type. Solid wood front door becomes bed. Front standard hinges forward and lensboard pivots on horizontal axis. Tapered red or green bellows with accented corner reinforcements. Rapid Rectilinear lens in brass barrel. $150-200.

Field Camera (revolving bellows) - c1900-1905. Tailboard style folding camera for 13x18cm plates. Fine wood with brass trim, brass handle. Tapered green bellows with black or red corners. Back and bellows rotate as a unit to change orientation. Rise and cross front. Meyer Lysioskop #2 lens. $125-180.

Field Camera (square bellows) - c1900-1905. Tailboard style 13x18cm view camera with square black bellows. Fine wood with brass trim. Meyer Universal Aplanat f7.8 brass barrel lens. $100-125.

MEYER (Hugo Meyer & Co., Görlitz)

Megor - c1931. Strut-folding 3x4cm rollfilm camera, a Korelle as marketed by Meyer with its lens equipment. Leather covered aluminum body. Trioplan f3.5/50mm lens. Compur 1-300, T,B shutter. $75-100.

Silar - c1930. Folding-bed view camera with generous movements. Triple extension bellows. Made in 4.5x6cm, 6.5x9cm, 9x12cm, 10x15cm, and 13x18cm sizes. These cameras were probably made by Perka, but Meyer fitted them with Plasmat or Aristostigmat lens in Compur. $150-250.

MEYER & KASTE

Field camera - c1900. Fine wood vertical tailboard camera. Green rectangular bellows with black corners. Nickel barrel Universal Aplanat Extra Rapid f8. $125-175.

MF Stereo Camera - 45x107mm plates. f6.8 Luminor lenses. $125-175.

MICRO 110 - c1986. Miniature novelty camera which snaps onto a 110 film cartridge. Same camera also sold as "Mini 110" and "Baby 110". Retail $2-7.

MICRO 110 (Cat & Fish) - c1988. Novelty camera for 110 cartridge. Oversized hinged lens cover shaped like a cat holding a fish. Some have small digital clock in the middle of the fish's back. $10.

MICRO 110 (Cheeseburger) - c1988. Lens cover depicts cheesburger. With or without digital clock. $10.

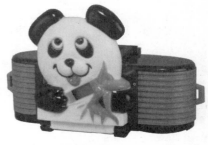

MICRO 110 (Panda) - c1988. Lens cover is Panda eating bamboo shoots. With or without digital clock. $10.

MICRO PRECISION PRODUCTS (England)

Microcord - c1952-59. Rolleicord copy, 6x6cm. Ross Xpres f3.5/75mm lens. Prontor SVS 1-300 shutter. Model I has mirror in finder hood for eye-level viewing. Model II has frame finder in hood. $75-100.

Microflex - c1959. Rolleiflex copy, 6x6cm. Micronar f3.5/77mm lens in Prontor SVS 1-300 shutter. $70-90.

MICRONTAFLEX - Postwar TLR, 6x6cm. Made in Japan. Horinor f3.5/75mm in NKS SC shutter. $75-125.

MIDDLEMISS (W. Middlemiss, Bradford, England)
Middlemiss Patent Camera - c1887. Very compact folding field camera, ¼-plate. Mahogany body, brass trim, brass bound lens. $150-200.

MIDGET - Japanese Hit-type novelty camera. $10-15.

MIGHTY MIDGET - Japanese Hit-type novelty camera. Red leather. $25-35.

MIKUT (Oskar Mikut, Dresden)

Mikut Color Camera - c1937. For 3 color-separation negatives 4x4cm on a single plate 4.5x13cm. Mikutar f3.5/130mm lens. Compur shutter 1-200. $2000-2500.

MILBRO - c1938. Simple Japanese folding bed "Yen" camera for 3x5cm sheet film. Meniscus lens, simple shutter. $15-25.

MILOFLEX - Japanese postwar TLR, 6x6cm. Tri Lausar f3.5/80mm. $75-125.

MIMOSA AG (Dresden)
Mimosa I - c1947. Compact 35mm. Meyer Triplan f2.9/50mm lens. Compur Rapid shutter. Unusual boxy style for 35mm camera. $50-75. *There were isolated earlier sales for higher prices, but recent confirmed sales have all been in the $40-80 range.*

Mimosa II - c1950. Meritar or Trioplan f2.9 lens. Usually with Velax shutter 10-200, but also available with Prontor-S. $45-75. *See note above.*

MINETTA - "Hit" type Japanese 16mm rollfilm novelty camera. A relatively late and common model. $10-20.

MINI-CAMERA - Common Hong Kong "Hit" type camera. Much poorer quality than the earlier Japanese types. $5-10.

MINOLTA (Osaka, Japan) *The Minolta Camera Company was established by Mr. Kazuo Tashima in 1928 under the name of "Nichi-Doku Shashinki Shokai" (Japan-Germany Camera Company). The company's history is more easily followed by breaking it into five distinct periods. The brand names of the cameras made during each period follow in parentheses.*
1928-31 Japan-Germany Camera Company (Nifca cameras)
1931-37 Molta Company (Minolta cameras)
1937-62 Chiyoda Kogaku Seiko (Minolta, Konan, and Sonocon cameras)
1962-82 Minolta Camera Co. Ltd. (Minolta cameras)
1982- Minolta Camera Co. Ltd. (Minolta cameras)
Nifca period - 1928-31. The newly formed company produced cameras which were of the latest designs of their day, using Japanese made bodies and German made lenses and shutters.
NIFCA= (NI)ppon (F)oto (CA)meras.

Molta Period - 1931-37. As the company grew it was reorganized as a joint stock firm under the name of the Molta Company. It was during the early years of this period that the name Minolta was adopted as a trade name on the cameras.
MOLTA= (M)echanismus (O)ptik und (L)insen von (TA)shima.

Chiyoda Period - 1937-62. As expansion and progress continued the company went through another reorganization emerging as Chiyoda Kogaku Seiko, K.K. With this expansion, Chiyoda become the first Japanese camera company to manufacture every part of their own cameras.

Minolta Period - 1962-82. Began with a change of the company name to The Minolta Camera Company, Ltd. Marketing areas were expanded; so were the products that were manufactured. It was during this period that Minolta entered the fields of office copy machines, planeteria, and manufacturing for other companies.

Modern Minolta Period - 1982-. Signified by the new Minolta logo. Minolta has produced in excess of 40 million cameras.

Many arguments exist regarding which of Minolta's many "firsts" was most significant to photography. My nomination is Minolta's founder, the late Mr. Kazuo Tashima, who remained at the head of his company from 1928-82. "The first founder of any camera company to remain its president for 54 years." (His son, Hideo Tashima, became Minolta's president at that time and Kazuo Tashima stepped into the role of "Chairman of the Board" of the Minolta Camera Co.)

Most of the information and photographs in this section have been provided by Jack and Debbie Quigley of Quigley Photographic Services. Both are particularly fond of Minolta equipment, which led them to study Minolta cameras and history. If you have any questions on Minolta, Nifca, or Molta cameras, particularly rare or unusual models, the Quigleys will be happy to help. Contact them in care of Quigley Photographic Services, 1120 NE 155 St., N. Miami Beach, FL 33162. You may also wish to have a free copy of their newsletter. See details in their display ad in the back of this book.

Prices for many rare early cameras are as estimated by the Quigleys in consultation with Minolta collectors worldwide. Many of the early cameras are not often seen for sale, so estimates of experts are our best guide. For the cameras which are common, we used price statistics from our data base.

The cameras in the Minolta section have been arranged in a somewhat unusual manner. Generally we have followed a chronological order, but with second and third generation models

immediately after their predecessor to aid collectors in identification and comparing of features. For the same reason, we have listed all of the twin-lens reflex models together, and likewise the subminiatures. These two groups are toward the end of the Minolta section.

Nifcalette - 1929. Folding camera for 4x6.5cm on 127 film. Hellostar Anastigmat f6.3/75mm. Koilos 25-100,T,B shutter. There were 5 models of Nifcalette A, 4 models of Nifcalette B and 2 models of Nifcalette D. Some have Compur 1-300,T,B shutters with Zeiss Anastigmat lenses. Others had Vario shutters with Wekar lenses. The camera itself was marked Nifca Photo. New price: 39 Yen. Current value: $350+.

Nifca-Klapp - 1930. 6.5x9cm folding plate camera. f6.3/105mm Zeiss Anastigmat or Wekar Anastigmat. Vario 25,50,100,T,B or Compur 25-200 shutter. New price: 39 Yen. Current value: $225+.

Nifca-Sport - 1930. 6.5x9cm folding plate camera. Wekar Anastigmat f4.5/105, Compur 1-200,T,B. There were three models of this camera. Some had Vario

and Koilos shutters; Zeiss Anastigmat lens. New price: 85 Yen. Current value: $225+.

Nifca-Dox - 1930. 6.5x9cm strut folding camera. First Japanese camera with front focusing. Two models were made. One had Nifca Anastigmat f6.8/105mm in Koilos 25-100,T,B. The other had a f6.3/105 lens, details uncertain. New price: 29 Yen. Current value: $500+.

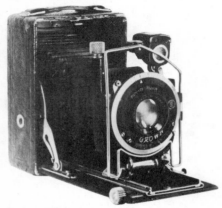

Happy (Molta Co.) - 1931. 6.5x9cm

folding plate camera, similar to the Arcadia. Earliest models were equipped with Zeiss and Wekar Anastigmat f4.5 lenses in a Compur shutter 1-200. Later models had Coronar Anastigmat f4.5/105mm, Crown 5-200,T,B, some with self-timer. New price: 40 Yen to 65 Yen, depending on features. Current value: $300+.

Arcadia (Molta Co.) - 1931. Folding hand camera for 6.5x9cm plates. Metal body. Helostar f4.5/105mm lens. Lidex rim-set shutter 1-200, the first Japanese complex leaf shutter. $300+

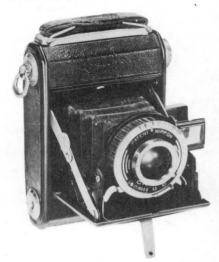

Semi-Minolta I - 1934. Folding camera for 4.5x6cm on 120 rollfilm. Coronar Anastigmat f4.5/75mm in Crown 5-200,T,B shutter. New price: 70 Yen. Current value: $150.

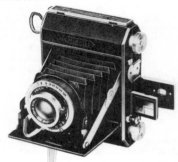

Semi Minolta II - 1937. Folding camera, for 16 exposures, 4.5x6cm on 120 rollfilm. Coronar Anastigmat f3.5/75mm in Crown 5-200,T,B. New price: 120 Yen. Current value: $50-65.

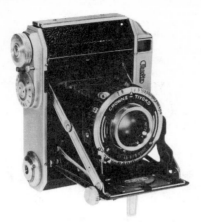

Featured a built-in footage scale. New price: 97 Yen. Current value: $225-250.

Auto Semi Minolta - 1937. Folding camera for 6x4.5cm on 120 rollfilm. Promar Anastigmat f3.5/75mm in Crown II-Tiyoko 1-400,T,B. CRF. Self-stop film counter and advance. The body is almost identical to the Welta Weltur. New price: 248 Yen. Current value: $100-150.

Semi Minolta III - First postwar Minolta camera: IIIA - 1946; IIIB - 1947; IIIC - 1948. Self-erecting folding rollfilm camera, 4.5x6cm. Rokkor f3.5/75mm in Konan-Rapid 1-500,B. $75-125.

Semi-Minolta P - 1951. Last of the semi series, and last folding cameras from Minolta. Eye-level optical finder with parallax correction marks. Chiyoko Promar SII f3.5/75mm in Konan Flicker shutter B, 2-200 w/ ASA sync post. Fairly common. $45-65.

Minolta - 1933. (Note: This was the first use of this brand and model name.) 6.5x9cm strut folding camera. Coronar Anastigmat f4.5/105mm, Crown 1-200,T,B.

Minolta Best (Also called **Vest** and **Marble; Best** is the official name.) - 1934. Collapsing dual format 127 rollfilm camera. Formats 4x6.5cm and 4x3cm obtained by inserting a plate at the film plane. The Minolta name was embossed in the leather. There were three different models. Model I: f8/75mm fixed focus. Model II: f5.6/75mm front element focus. Model III: f4.5/80mm front element focus. All were Coronar Anastigmat lenses in Marble 25-100 shutters. The body and back door were made of a plastic which was not widely known at that time. It was only in the experimental stage in Germany. The telescoping plastic sections were reinforced with bright stainless steel. New prices: Model I- 19.5 Yen; Model II-28.5 Yen; Model III- 37.5 Yen. Current value: $50-75.

Baby Minolta - 1935. Bakelite 127 rollfilm camera; 4x6.5cm or 4x3cm formats were changed by a removable plate at the film plane. Coronar Anastigmat f8/80mm fixed focus, fixed f-stop, pull-out lens in bakelite housing. Japanese-made Vario-type 25-

Auto Minolta

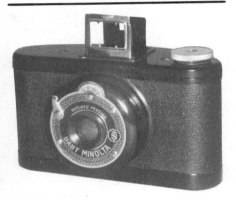

100,T,B shutter. New price: 9.5 Yen. Current value: $60-75.

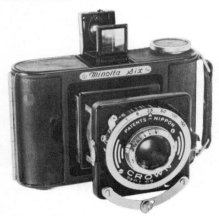

Minolta Six - 1935. Collapsible folding camera for 6x6cm on 120 follfilm. Horizontally styled bakelite body without bed or struts. Front standard pulls out with

telescoping stainless steel snap-lock frames around bellows. Coronar Anastigmat f5.6/80mm. Crown 25-150,T,B. New price: 50 Yen. Current value: $50-90.

Auto Minolta - 1934. 6.5x9cm strut folding plate camera. Actiplan Anastigmat f4.5/105, Crown 1-200,T,B. Top mounted CRF, the first Japanese camera with rangefinder coupled to lens. Footage scale on the face of the camera. New price: 135 Yen. Current value: $175-225. *Illustrated top of previous column.*

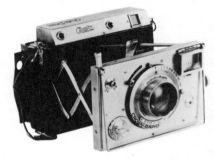

Minolta Autopress - 1937. 6.5x9cm strut folding plate camera, similar in style to the Plaubel Makina. Promar Anastigmat f3.5/105. Crown Rapid 1-400,T,B, synched at all speeds. CRF on the top aligns with a folding optical finder on the camera face. Coupled automatic parallax correction. Footage scale on the face. This camera has commonly been referred to as a Plaubel Makina copy; however, it had features not found in Plaubel Makina until many years later. Complete outfit includes ground glass focusing panel, three single metal plate holders, flashgun, and FPA. New price for body and flashgun: 310 Yen. Current value of complete outfit w/flashgun: $300-400. Camera only: $200-250.

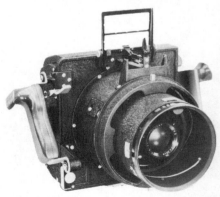

Aerial camera - 1939. 11.5x16cm format.

Designed for military use. Never sold commercially. Unmarked Minolta f4.5/200 lens with f4.5, f5.6 settings. Shutter speeds 200, 300, 400. Current value: $450-500.

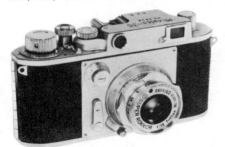

Minolta 35 (first model) - intro. 3/1947. 35mm rangefinder camera, styled like Leica, first for 24x32mm and later 24x36mm on standard 35mm cassettes. Interchangeable (Leica thread) Super Rokkor f2.8/45mm lens. Horizontal cloth focal plane shutter 1-500,T,B, ST. This was Minolta's first 35mm camera. It went through six minor model changes:
- (Type A): 2/48. Serial #0001-4000. Image size of 24x32mm. "Chiyoda Kogaku Osaka" on top. First marketed 2/48.
- (Type B): 8/48. Serials to about 4800. Image size 24x33.5mm, otherwise like Type A.
- (Type C): 2/49. Serial range uncertain. "C.K.S." stamped on top. Image 24x34mm.
- (Type D): 8/49. Begins with serial #9001. Exact physical changes not yet determined, but this is probably the first with front grooved for focusing tab, and with repositioned rewind lever.
- Model E: 2/51. Begins with Serial #10,001. "Model-E" engraved on front. Has strap lugs.
- Model F: 2/52. Begins with serial #20,000. "Model-F" on front.
- None of these were exported, although some were brought back by soldiers. New price: 35,000 Yen. Current values: Early type A: $300+. Later types: $100-200.

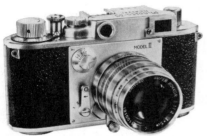

Minolta 35 Model II - 1953. 35mm RF camera for 24x32mm images. Horizontal cloth focal plane shutter, 1-500,T,B, ST. Interchangeable Super Rokkor f2.8/45mm or optional f2.0/50mm lens. New price: 47,200 Yen. Current value: with f2.0, $150-200; with f2.8, $125-175.

Minolta 35 Model IIB - 1958. The first Minolta camera to use the standard 24x36mm image size. Otherwise similar to the 35 Model II. Super Rokkor f1.8/50mm. $250-325.

Minolta Memo - 1949. 35mm viewfinder camera. Rokkor f4.5/50mm lens. Between-the-lens 25-100,B shutter. Helical lever focusing. Rapid advance lever. This was Minolta's low priced 35mm camera of the day. Steel body and basic mechanism, bakelite top and bottom plates. New price: 8,000 Yen. Current value: $95-125.

Minolta A - 1955-57. 24x36mm RF camera. Early models had Optiper MX, Chiyoda Kogaku, and Citizen MV between-the-lens shutters set by wheel on camera top. Non-interchangeable Chiyoko Rokkor f3.5/45mm lens. New price 14,800 Yen. Current value in Europe: $75-100. USA: $40-50.

Minolta A2 - 1955-58. 35mm rangefinder. Non-interchangeable Chiyoko Rokkor f3.5 or f2.8/45mm lens. Between-the-lens shutter set by wheel on camera top. Citizen in 1955-56, Citizen MV and MVL in 1957, and Optiper MXV in 1958. New price: 17,900 Yen with f3.5, 20,100 with f2.8.

Current value in Europe: $60-90. USA: $30-45.

Minolta A3 - 1959. 35mm rangefinder. Non-interchangeable Minolta Rokkor f2.8/45mm lens. Shutter 1-500, B. Europe: $60-90. USA: $30-45.

Minolta A5 - 1960. 35mm rangefinder camera. Rokkor fixed mount lens in Citizen MVL shutter.
- Two Japanese models: f2.8 or f2.0/45mm lens; shutter 1-1000, B. New price: 14,000 and 17,500 Yen. Current value: $60.00.
- U.S.A. model: f2.8/45mm lens, shutter 1-500, B. New price: $69.50. Current value: $15-30.

Minolta Sky - 35mm rangefinder camera designed by Minolta for release in 1957 but was never introduced into the public market-place. About 100 made. Built-in bright-line viewfinder, auto parallax correction. Used interchangeable Minolta M-mount lenses. It could also use Minolta 35 and 35 Model II screw mount lenses

with an M-mount/SM adapter. New price about $325 with Rokkor f1.8/50mm. Current value estimate: $8,000-10,000.

Minolta Super A - 1957. 35mm RF camera. Single stroke lever advance. Seikosha-MX 1-400,B between-the-lens shutter. Most commonly found with Super Rokkor f1.8/50mm lens. (New price: 36,500 Yen.) Other normal lenses were f2.0/50mm (New: 34,500 Yen) and f2.8/50mm (New: 31,300 Yen). Current value of the body with 1 normal lens: $75-125.

Additional Super Rokkor lenses:
- 35mm/f3.5: $50.
Lenses with auxillary finders and case:
- 85mm/f2.8: $75.
- 100mm/f3.8: $75.
- 135mm/f4.5: $75.
- Coupled selenium meter: $20-25. (The meter clipped into the accessory shoe and coupled to the shutter speed control.)

Minolta Autowide - 1958. 35mm RF camera, similar to the Super A, but with Rokkor fixed mount f2.8/35mm lens. Between-the-lens Optiper MVL 1-500,B,ST shutter. Film advance and rewind on the bottom of the camera. CdS match needle metering. New price: 21,000 Yen. Current value: $60-90.

Minolta SR-2 - 1958. 35mm SLR. Quick return mirror, auto diaphragm. Horizontal cloth FP shutter 1-1000, B. Minolta bayonet

styling is more squared in appearance around the top cover edges. Viewfinder eyepiece was squared rather than rounded as on the early SR-1. New accessories, such as a slip on CdS meter, were introduced with this model. $80-100.

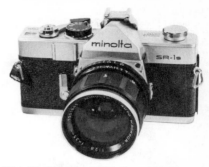

lens mount. Most common lens is the f1.8/ 55mm Minolta Rokkor PF. New: 51,500 Yen with lens. Current value: $90-110.

Minolta SR-1 S - 1964. Same features as the SR-1 of 1964, but top shutter speed now 1000, not 500. $80-100.

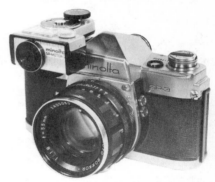

Minolta SR-1, early style - 1959. 35mm SLR. Minolta bayonet lens mount. Most common lens is the Minolta Rokkor PF f2.0/ 55mm. Horizontal cloth focal plane shutter, 1-500, B. There were five variations of the first style SR-1. The first three, 1959-61, did not have the bracket for the coupled meter. The bracket was added in 1962. Other changes include the addition of depth of field preview button. On very early models the "SR-1" was placed to the left of the word Minolta. New price: 36,000 Yen. Current value with lens: $80-100.

Minolta SR-3 - 1960. 35mm SLR. Minolta bayonet lens mount. Most common lens is the Minolta Auto Rokkor PF f1.8/55mm. Horizontal cloth focal plane shutter, 1-1000, B. Detachable coupled CdS exposure meter. New price: 41,500 Yen with lens. Current value: $85-110.

Minolta SR-1, new style - 1964. Same features as the early SR-1 of 1962, but body

Minolta V2 - 1958. 35mm RF camera. Rokkor f2.0/45mm, between-the-lens

Optiper HS (High Speed) 1-2000, B shutter. New price 23,000 Yen. Current value: $85. *Note: Usually found with loose lens and shutter assembly due to the loosening of screws. They should be replaced, not just tightened, to be worth the value shown.*

Minolta V3 - 1960. Like the V2, but with selenium metering. Rokkor f1.8/45mm lens, Optiper HS 1-3000,B shutter. New price: 23,000. Current value: $115. *Note: These also are usually found with a loose lens and shutter assembly. The screws should be replaced, not just tightened, to be worth the value shown. It costs about $40 to have this done professionally.*

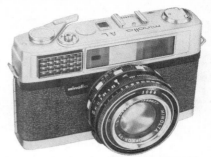

Minolta AL - 1961-65. 35mm rangefinder. Built-in selenium meter. Non-interchangeable f2.0/45mm Rokkor PF lens. Citizen shutter 1-1000, B, MX sync, ST. New price: 19,500 Yen. Current value: $25-40.

Minolta AL-2 - 1963. 35mm rangefinder. Built-in CdS meter. Non-interchangeable Rokkor f1.8/45mm. Shutter 1-500, B. New price: 21,800 Yen. Current value: $40-55.

Minolta AL-S - 1965. 35mm rangefinder with meter. Non-interchangeable Rokkor QF f1.8/40mm. Shutter 1-500, B. Made for the USA market. Current value: $65-75.

Uniomat - 1960. 35mm rangefinder with coupled built-in selenium meter. Minolta Rokkor f2.8 lens. Shutter speeds automatically determined by the light readings. New price: 16,000 Yen. Current value: $45-65.

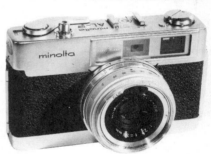

Minolta AL-F - c1968. 35mm RF. Auto CdS controlled, shutter-priority metering. Shutter 30-500. Rokkor f2.7/38mm lens. $50-60.

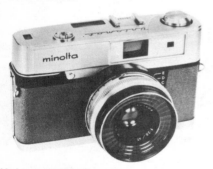

Uniomat III - 1964. 35mm rangefinder. Built-in meter on the lens front. The camera only says "Uniomat" not "Uniomat III". Non-interchangeable Rokkor f2.8/45mm. Shutter automatically controlled by the meter and ASA settings. New price 14,000 Yen. Current value: $45-65.

Variation: Anscoset III - 1964. Identical to the Uniomat III, but says "Anscoset III". Made for export to the USA. New price: $89.95. Current value: $30-45. *Higher in Japan where they are less common.*

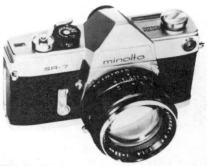

Minolta SR-7, early - 1962. First 35mm

SLR. Built-in CdS meter and scale. Minolta bayonet lens mount. Most common lens is Rokkor PF f1.4/58mm. Horizontal cloth FP shutter, 1-1000, B. ASA dial settings from 6 to 3200. New price: 28,500 Yen. Current value: $70-95. *The dies for this camera were later used in China for the Seagull DF-1 camera.*

Minolta SR-7, new style - 1964. Same features as the early SR-7, but with squared off body styling. $75-100.

Minolta Repo - 1962. Half-frame 35mm rangefinder. Built-in meter automatically sets shutter speeds on Citizen L shutter. MX sync. Fixed Rokkor f2.8/30mm. New price: 10,300 Yen. Current value: $75-100.

Minolta Repo-S - 1964. Half-frame 35mm in black or chrome. Built-in match needle metering. Rokkor PF f1.8/32mm. Shutter ⅛-500, B. New price: 14,500 Yen. Current value: $75-100.

Minolta Hi-Matic - 1962. 35mm RF, built-

in selenium meter. Rokkor PF f2.0/45mm in Citizen to 500, ST, sync. New price: 19,800 Yen. Current value: $45-55.

Variation: Ansco Autoset - 1962. Made by Minolta for Ansco in the USA. Identical to the Hi-Matic but has Rokkor f2.8/45mm lens, and auto metering is slightly different. New price: $90. Current value: $30-45. *Higher in Japan where less common.*

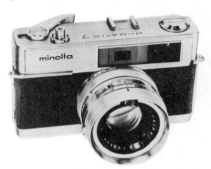

Minolta Hi-Matic 7 - 1963. 35mm with rangefinder and meter. Noninterchangeable Rokkor PF f1.8/45mm. Auto shutter also has manual speeds ¼-500, B. New price: 22,900 Yen. Current value: $60-75.

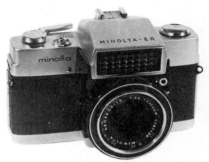

Minolta ER - 1963. 35mm SLR. Fixed mount Rokkor f2.8/45mm lens in 30-500, B shutter. Wide angle and tele auxiliary lens sets available. New price: $119.50. Current value: $100-125.

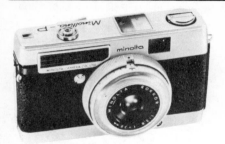

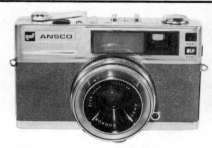

Minoltina-P - 1964. 35mm rangefinder. Match needle metering. Non-interchangeable Rokkor PF f2.8/38mm. Citizen shutter 1/30-250, B, ST, MX sync. New price: 13,700. Current value: $50-65.

$79.95. Current value: $40-50.

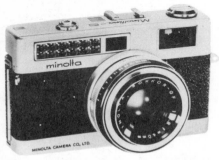

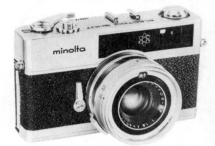

Electro Shot - 1965. Auto 35mm RF with non-interchangeable Rokkor QF f1.8/40. Auto shutter 1/16-1/500. This was the first electronically controlled 35mm lens/shutter camera. New price 22,140 Yen. Current value: $30-40.

Minolta Autopak 500 - c1966. 126 cartridge camera with selenium meter surrounding lens. Rokkor f2.8/38mm zone-focus lens. Programmed EE shutter, 1/40, 1/90. $20-45.

Minoltina-S - 1964. 35mm rangefinder. Built-in meter. Rokkor QF f1.8/40mm lens. Shutter 1-500, B. New price: 20,000 Yen. Current value: $50-65.

Minolta Autopak 700 - c1966. 126 cartridge camera with CdS meter. Rokkor f2.8/38mm, shutter 1/30-250. $30-60.

Minolta Autopak 800 - c1969. 126 cartridge camera with spring-motor drive, CRF, auto exposure. Rokkor f2.8/38mm. Retail price was $80, but sold for $50 when new. $40-75.

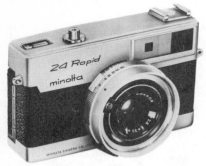

Minolta SRT-101 - c1966. 35mm SLR available in black or chrome versions. Cloth FP shutter 1-1000, B. X-synch at 1/60, and FP bulb synch. Features TTL metering, self-timer, accessory shoe. Most have mirror lock-up. Viewfinder displays shutter speeds with pointer showing selected speed. Match-needle exposure selection. Body: $70-125. Add $30-40 for normal lens.

Minolta 24 Rapid - 24x24mm on 35mm. Rangefinder; built-in CdS meter. Rokkor f2.8/32mm lens. Manual shutter speeds 1/30-250, B. Could also be used on automatic. New price: 15,800 Yen. Current value: $80.

GAF Ansco Autoset CdS - 1964. 35mm rangefinder. Built-in CdS meter. Made for the USA market. Ansco Rokkor f2.8/45mm, shutter 1/30-500 auto, B. New price:

Minolta SRT-100 - c1971. Same as the SRT-101, except top shutter speed is 500, no self-timer, and viewfinder doesn't display the shutter speeds. Body: $75-85.

Minolta SRT Super - Japanese market.
Minolta SRT-102 - USA market.
Minolta SRT-303 - European market.
- c1973. Same as SRT-101, but also has split-image screen, multiple exposure provision, and hot shoe. Body: $100-150.

Minolta SRT-101 B - Japanese market.
Minolta SRT-201 - USA market.
- c1975. Similar to the SRT-101, but FP bulb sync, and most do not have mirror lock-up. Most have split-image screen and hot shoe. Black body: $150-175. Chrome body: $120-140.

Minolta SRT-200 - c1975. Similar to the SRT-100, but shutter to 1000. Some have hot shoe and split image screen. $80-110.

Minolta SR-505 - Japanese market.
Minolta SRT-202 - USA market.
Minolta SRT-303B - European market.
- c1975. Similar to SRT-102, but safe-load signal added and most do not have mirror lock-up. Body: $150-175.

Minolta SRT-MC, SRT-MCII, SRT-SC, SRT-SCII - c1975-80. Camera models that were made under special contract for department stores (Sears, K-Mart, etc.), Oil companies, Credit card companies, etc. Only slight variations from the standard SRT models. Most don't have self-timer. $80-100.

Minolta SR-M - 1970. First 35mm SLR with integrated motor built in the body. Power supply was a grip on the side of the body. Minolta SR/SRT bayonet mount. Most common lens is the Minolta Rokkor MC RF f1.7/55mm. Horizontal cloth focal plane shutter, 1-1000, T,B. Sync at 1/60. There was no meter built into the camera body or provision for adding one. New price: 129,000 with body and grip. Current value: $275-350. *Illustrated top of next column.*

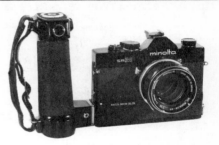

Minolta SR-M

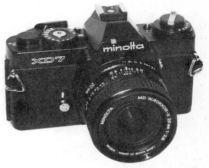

Minolta XD-7, XD-11, XD - 1977. Made in black and chrome, this camera was marketed in Europe as XD-7, in North America as XD-11, and in Japan as XD. This is the world's first multimode exposure 35mm camera. Shutter or aperture priority and metered manual modes. X-sync at 1/100. Mechanical speeds "O", 1/100, B. Minolta bayonet mount for the shutter priority mode MD lens. Vertical traverse metal focal plane shutter with electo-magnetic release. Electronic stepped or stepless speeds 1-1000,B. Black: $200-275. Chrome: $150-200.

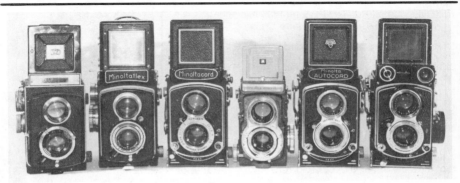

Minoltaflex (1937), Minoltaflex (1950's), Minoltacord,
Minolta Miniflex, Minolta Autocord (non-metered), Minolta Autocord CdS

MINOLTA (cont.)

MINOLTA 6X6cm TWIN LENS REFLEX CAMERAS

There are 24 different models of Minolta 6x6cm TLRs. Any internal or external change is considered to be a new model of that camera. All use either 120 or 220 rollfilm and have f3.5/ 75mm lenses. The shutters are Konan, Citizen, Seikosha and Optiper.

1937 Minoltaflex (I) (two models)
1939 Minolta Automat (two models)
1950-54 Minoltaflex II, IIB, III (three models)
1953-54 Minoltacord (three models)
1955 Minoltacord Automat (one model)
1955 Minolta Autocord L (one model)
(selenium metered)
1955 Minolta Autocord LMX (one model)
(selenium metered)
1955-65 Minolta Autocord (seven models)
(non-metered)
1957 Minolta Autocord RA (one model)
(non-metered)
1965 Minolta Autocord CdS (three models)
(CdS metered)

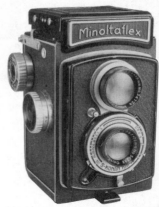

TLR. Rokkor f3.5/75mm lens in S-Konan Rapid 1-500 shutter, B. $60-90.

Minoltacord, Minoltacord Automat - c1955. TLR predecessors of the Minolta Autocord. Rokkor f3.5/75mm lens. Citizen 1-400 shutter. $60-90. *(Illustrated bottom of previous page.)*

Minolta Autocord, Autocord RA - 1955-1965. Non-metered models. Rokkor f3.5/ 75mm lens. Optiper MX 1-500 shutter. $70-95. *(Illustrated bottom of previous page.)*

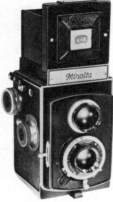

Minoltaflex (I) - 1936. The first Japanese TLR. 6x6cm on 120 rollfilm. Says "Minolta" on front, not "Minoltaflex". Promar Anastigmat f3.5/75mm taking lens, Minolta Anastigmat f3.2/75mm viewing lens. Crown II-Tiyoko 1-300,B. The main body is identical to Rolleicord, top of the hood is identical to Ikoflex. Had a unique side lock and shutter release to avoid double exposure. Also available with Zeiss lenses and Compur shutters. New price: 252 Yen to 305 Yen depending on lens/shutter. Current value: $125-175.

Minolta Automat - 1939. TLR for 6x6cm on 120 rollfilm. Promar f3.5/75mm taking and viewing lenses. Crown 1-300,B. Crank advance like early Rolleiflex. Hood like Ikoflex. New price: 493 Yen. Current value: $150-225.

Minoltaflex II, IIB, III - 1950-54. 6x6cm

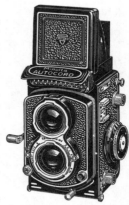

Minolta Autocord L, LMX - Selenium meter. $80-120.

Minolta Autocord CdS I, II, III - CdS meter. $150-175. *(Illustrated bottom of previous page.)*

Minolta Miniflex - 1959. TLR, for 4x4cm on 127 film. Minolta Rokkor f3.5/60mm lens. Optiper or Citizen MVL shutter 1-500, B. Less than 5000 made. New price 12,700 Yen. There were unconfirmed reports that the Miniflex had sold for thousands of

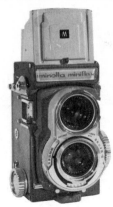

dollars in Japan a few years ago. Recent confirmed sales in the USA/Canada and Europe have been at $450-475.

MINOLTA SUBMINIATURE CAMERAS:
Konan 16 - 1950 (Chiyoda Kogaku). 16mm subminiature, 10x14mm exposures. Chiyoko Rokkor f3.5/25mm lens. 25-200, T,B shutter. Push-pull advance and shutter cocking. New price: 7,750 Yen. Current value: $75-100.

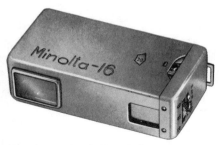

Minolta 16 Model I - 1957-60. Subminiature taking 10x14mm exposures on 16mm film in special cassettes. Rokkor f3.5/25mm lens. Shutter has only three speeds, 25,50,200. No bulb. Push-pull advance. New price: 6,900 Yen. Blue: $100-150. Green: $75-100. Red: $60-90. Gold: $75-100. Black: $35-50. Chrome finish is very common. EUR: $20-35. USA: $15-25.

Minolta 16 Model P - 1960-65. Rokkor f3.5/25mm, shutter 1/100 only, sync. New

price: 4,100 Yen. Very common. EUR: $25-35. USA: $15-25.

Minolta 16 Model II - 1960-66. Identical in appearance to the Model I, but with f2.8 lens and shutter has five speeds 30-500, plus B. New price: 7,300 Yen. Prices for colored models same as the Model I, above. Very common. $20-30.

Sonocon 16mm MB-ZA - 1962. 16mm subminiature, 10x14mm exposures. Black body. Rokkor f2.8/22mm lens, shutter 30-500, B. This is actually a Minolta 16-II combined with a 7 transistor radio. New price: 6,900 Yen. Current value: $100-150.

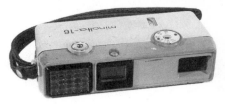

Minolta 16 EE - 1962-64. Rokkor f2.8/25mm; shutter 30-500. Auto exposure using selenium cell. New price: 9,500. Current value: $15-30.

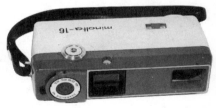

Minolta 16 EE II - 1963-65. Rokkor f2.8/25mm, shutter speeds H (High) and L (Low) (200, 50). Auto exposure CdS meter. New price: 12,400 Yen. Current value: $15-30.

Minolta 16PS - 1964-74. Identical in appearance to the Model P, but shutter 30-100. Originally made only for export to the U.S.A. New price: $26.90. Very common. Usually found like new, with case, box, and instructions for $15-25. Camera with case only: $10-18.

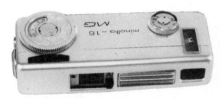

Minolta 16-MG - 1966-71. Rokkor f2.8/20mm, shutter 30-250. Match needle

meter. Very common. Kit with case, chain, and MG flash: $30-40. Camera with case and chain only: $20-25.

Minolta 16 MG-S - 1969-74. 12x17mm. Made in black or silver. Rokkor f2.8/23mm, shutter 30-500. Auto match needle meter. With case, flash, strap, instructions in presentation box: $35-50. Camera and case only: $25-35.

Minolta 16 QT - 1972-74. 12x17mm size. Rokkor f3.5/23mm, shutter 30-250. Auto metering. Black or chrome. Very common. Often found with case, electronic flash, etc. in presentation box. Like new: $35-50. Camera and case only: $25-35.

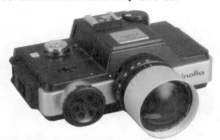

Minolta 110 Zoom SLR - c1976. First 110 film SLR. Fully automatic aperture-priority exposure. EUR: $75-90. USA: $55-80.

Minolta 110 Zoom SLR Mark II - c1979- Restyled totally from the earlier model, the Mark II resembles a small 35mm SLR. Automatic TTL metering. Zoom Rokkor Macro 25-67mm f3.5. $150-175.

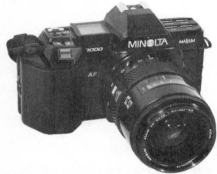

Maxxum - 1985. *Technical details/prices from*

your Minolta dealer. This is new merchandise. We're including it only because of its name. This is a story of the mid-1980's world business atmosphere: International trade agreements, grey-market dealing, import and export restrictions, warranty contracts... all symbols of the times. Separate brand names for different countries led to the name Maxxum for the North American version of the camera called "7000 AF" in Europe and "Alpha 7000" in Japan. In spelling the name Maxxum, the decision was made to use an interlocking double X. That all sounds like a great idea, until giant Exxon sees the advertising. Exxon, of course, has used the interlocking double X in their trademark for some time. Now no one at either Minolta or Exxon is worried that people will put cameras in their gas tank or tigers in their cameras, but from a legal viewpoint, if any infringement on a trademark is allowed, the protected design could soon become generic, unprotectable, and useless as an identifiable symbol for the original product.

So, the innocent new baby, Maxxum, with cameras, lenses, and advertising materials already in distribution, faced a change. Minolta agreed to change the design of the Maxxum logo. Exxon agreed to allow a gradual phasing in of the changes to avoid disrupting Minolta's production schedules. Now that's a reasonable way to conduct business. After all "we all make misteaks."

Will the double-crossed Maxxum be collectible? Of course, if you can afford to buy one and let it sit around. Will it be rare? Probably not. There were many produced and shipped.

MINOX - *Subminature cameras for 8x11mm exposures on 9.5mm film in special cassettes. The original model, designed by Walter Zapp, was made in 1937 in Riga, Latvia.*

Original model - (stainless steel body) - Made in Riga, Latvia by Valsts Electro-Techniska Fabrika. Minostigmat f3.5/15mm lens. Guillotine shutter ½-1000. Historically significant and esthetically pleasing, but not rare. Some sales occur at higher prices,

but these are readily available in the $400-550 range. The original zippered blue, brown, or black case with "Riga" markings will fetch an additional $25.

Minox "Made in USSR" - Stainless steel model made during the short time the Russians held Latvia before the German occupation. (Approximately Spring to Fall, 1940.) $700-850.

Minox II - 1949-51. Made in Wetzlar, Germany. Aluminum body. $60-85.

Minox III - 1951-56. Export model of the Minox A for the USA. $60-80.

Minox III, Gold-plated - With design pattern in metal, gold-plated, in crocodile case with gold chain. $1200-1800.

Minox III-S - c1954-63. Synchronized for flash. Gold, full outfit with gold meter, alligator case, etc.: $2000-2500; camera

only: $1000-1300. Black: $200-400. Chrome: with case and chain: $60-90.

Minox A - c1948. Wetzlar. Complan f3.5. Gold: outfit with gold meter: $2500-3000. Gold camera only: $1500-2000. Chrome: $100-150.

Minox B - c1958-71. Built-in meter. Gold: $1000-1500. Black: $150-200. Chrome: $60-90.

Minox BL - c1971-76. CdS meter. Gold: $600-800. Black: $200-250. Chrome: $100-150.

Minox C - c1969-79. Black: $110-135. Chrome (extremely common): $95-125.

Minox LX Gold - Special commemorative edition to celebrate the 50th anniversary of Minox, 1938-1988. Total production 900, of which 200 for USA. No sales data.

Minox Accessories:
Binocular attachment - $15-25.
Daylight Developing Tank - with thermometer. $25-40.
Flashgun for Model B - with case. $8-12.
Reflex finder for Model B - $10.
Right angle finder for Model B - $10-15.
Tripod adapter - $15-20.

M.I.O.M. (Manufacture d'Isolants et d'Objets Moulés)

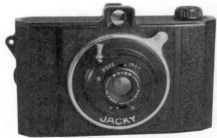

Jacky - c1937-38. Black bakelite eye-level camera based on the design of the Lec Junior, but because if its larger size, it used a helical telescoping front. Uses 120 film for 6x9cm or 4.5x6cm with mask. The same body style was sold under the names Photax, Loisir, MIOM, & Camera 77. $30-40.

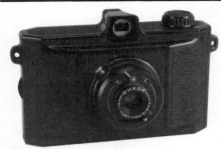

Lec Junior - c1937-38. Rigid, light brown or black bakelite body; "Lec Junior" molded into back. 4x6.5cm exposures on rollfilm. $20-25.

Loisir - c1938. Plastic rollfilm camera for 8 or 16 exposures on 120 film. Radior lens, simple shutter, T & I. $20-25.

Miom - Rigid black bakelite body, like Lec Junior but with octagonal shutter housing. 4x6.5cm on rollfilm. $15-25.

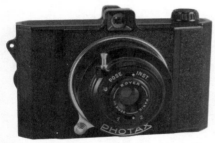

Photax (original) - c1937. Black bakelite body, with rectangular finder tube projecting above body. 6x9cm or 4.5x6cm with mask. Same as Jacky etc. This earliest Photax uses a metal ring with helical thread to extend the front section, while the later Photax Blindé is all plastic. $30-40.

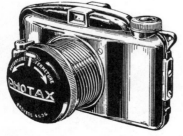

Photax "Blindé" - c1938. Streamlined black bakelite body. Helical telescoping front. 6x9cm on rollfilm. The unique part of this camera is the molded bakelite front

cap which covers the shutter and lens, and is the only place to find the camera's identity. $20-35.

MIRACLE - Japanese novelty subminiature of the Hit type. $10-15.

MIRAGE - Deluxe "Diana" type camera for 6x6cm on 120 film. Built-in AG-1 flash with hinged reflector. Imitation meter cell. $1-5.

MIRANDA CAMERA CO. LTD. (Tokyo, Japan) *The Miranda Camera Company is a descendant of the Orion Camera Company, a photographic services and photographic equipment firm that was formed in Tokyo in 1946 during the American Occupation of Japan. Initially the company manufactured a limited line of products; most of its business was as a service center for professional photographic equipment. Early products included an adapter for Contax and Nikon rangefinder lenses for use on screw-mount Leicas, the Mirax reflex mirror box for use with Leica-thread rangefinder cameras, the Focabell bellows, and the Supreme 105mm f2.8 for use with the Focabell.*

In 1948 investigation and development began for the Phoenix, a revolutionary eye-level SLR with a removable prism. It existed only in the form of a few prototypes of which the production quantity is not known. None of the Phoenix prototypes have been reported, although it is suspected that one or two may exist in Japan. Since the Phoenix name was already in use on a German camera, the name was changed to Miranda before production began. Only photographs remain of the first Japanese eye-level SLR. It had a Zeiss-Tessar in the unique 44mm screw mount used by Miranda.

Introduction of the first production model camera, the Miranda T, began in Japan in 1954. The early bodies were marked "Orion Camera Company" on the front. The pentaprism was engraved "Miranda" and the rear of the body near the serial number was engraved "Miranda T". In 1956, the firm changed its name to Miranda Camera Company and "Miranda" replaced "Orion" on the front of the camera.

In the years following the introduction of the T, a revolutionary camera in Japan, 33 additional SLR models for general use, 4 microscope SLR models and 1 rangefinder model were manufactured. The last model, the Dx3, was a small, lightweight SLR with an electronic shutter and was the only SLR produced by the Miranda Camera Company with a fixed pentaprism. Production ended in 1978 with the bankruptcy of Allied Impex Corporation, an American importing and distribution company that bought the Miranda Camera Company and Soligor Optical Company.

The firm currently using the Miranda name is not associated with the original Japanese company. **Note:** *All early Miranda SLRs have removable backs. This includes all lettered models, Automex, II, III, Sensorex 1.9, early Sensorex 1.8 to Ser. #799,999. Most of the later models (not listed individually in this edition) have hinged backs.*

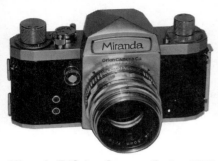

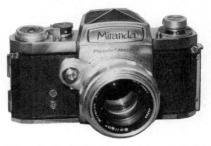

Miranda T (Orion Camera Co.) - c1953-1956. Also referred to as the Miranda Standard. First Miranda-made 35mm SLR, and the first Japanese SLR with a pentaprism (and a removable one at that)! Knob wind. Marked "Orion Camera Company" above lens mount. Removable prism engraved "Miranda". The prism was made without the provision to be leathered. Serial number, on rear of body below film advance knob, prefixed with "Miranda T". Focal plane shutter, 1-500,B, in two ranges. Non-return mirror. Originally sold with Zunow 5cm f1.9 lens, later with Soligor-Miranda 5cm f1.9 lens. All lenses are preset in 44mm screw mount. FP, X synch. Worldwide prices vary considerably. Several known sales at $1300 in Japan, though $750-1000 is more common there. Europe: $500-900. USA: $350-500 to a collector. *A very few were made in black. These are extremely rare. The Pentax Gallery has one.*

Miranda A - 1957. The first lever wind Miranda. Rapid-rewind crank. Focal plane shutter 1-1000,B. Film counter engraved in black with red arrows at 20 and 36. This counter dial is larger than the all black dial of the AII. Camera serial number as on the T. Correct original lens is a Soligor Miranda 5cm f1.9 with a "Y" serial number prefix. The lens is in a polished metal lens barrel. Some lenses are of the preset type; others have an outboard automatic diaphragm button that fits over the shutter button, stopping down as the shutter is tripped. Lenses now in 4-claw breech mount. With lens: $100.

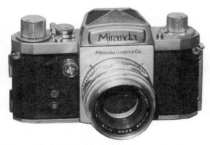

Detail showing differences in film advance dials on Miranda A & AII

Miranda T (Miranda Camera Co.) - 1956. Same as the above except engraved "Miranda Camera Company" above lens mount. Early ones have a prism with or without the indented area for leather. Sold in USA with Soligor Miranda 5cm f1.9 or 5cm f2.8 lens. (Correct optional lens is all bright metal with "MT" serial number prefix.) Also sold in Australia and Japan with Arco 5cm f2.4 or Zunow 5cm f1.9. All lenses in 44mm screw mount. Nice ones could sell for $400-600 in Japan or Europe. They sell at $150 but meet sales resistance at $200 in the USA or Australia.

Miranda AII - 1957. Same as A except smaller film counter dial without red arrows at 20 & 36. Ground glass focusing screen with central microprism spot. $75-100.

Miranda B - 1957. Like AII but first instant-return mirror model. Body serial with "B" prefix. Same lens as the A. About $100.

Miranda C - 1959. Like Miranda B but self-timer added on front of body below rewind knob. Correct lens is 5cm f1.9

397

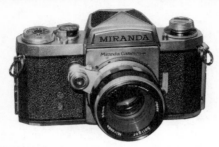

Soligor Miranda in black barrel with bright aperture ring and "K" serial prefix. $75-110.

Miranda ST - 1959. Like T but no model designation, folding rewind crank in rewind knob. Not engraved "ST" on rear. Non-return mirror. Twelve-speed FP shutter 1-500,B,X. Top & front release buttons. $150-160.

Miranda S - 1959. Last of the knobwind bodies. Similar to T except speeds 30-500, B. Serial number is on top of body in front of the advance knob. Engraved "Miranda S Japan" on rear of body below wind knob. Originally advertised with removable waist level finder and Soligor Miranda 5cm f2.8 lens. Correct lens has a six-digit number without letter prefix but with abbreviation "No." before the serial number as in "No.xxxxxx." Sold with Arco 5cm f2.4 lens in markets other than U.S. Normal lenses are preset in screw mount. Pentaprism finder available only as an accessory. $75-125.

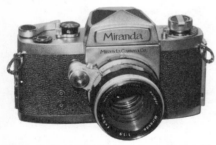

Miranda D - 1960-62. New body style with rounded corners instead of sharp angles. Some marked "Miranda D" on back near rewind; others unmarked. Speeds 1-500,B in two ranges. Speed selector is similar to the model T and ST with a small handle replacing the split shield as on the Miranda A, B & C. Shutter release only on front. Film counter is now on a small dial in front of the film advance lever. Top of advance lever and speed dial covered with black leather (some with black paint). Correct original lens is screw-mount preset Soligor Miranda 5cm f2.8 with "T" prefix. Soligor

Miranda 5cm f1.9 automatic also available in 4-claw breech mount. In markets other than USA, the standard lens was Prominar Miranda 5cm f1.9 with side arm for automatic stopdown. $50-90.

Miranda DR - 1962. Similar to the D except red leather covering the film counter, no letter prefix on body serial number. Interchangeable focusing screens; split-image screen is standard (optional on the D). Standard lens is a Soligor Miranda 5cm f1.9 automatic with sidearm. Miranda 5cm f2.8 preset lens was an option. Correct lens has "K" prefix. $50-75.

During the course of production of the DR, Miranda changed its style of engraving the "Miranda" name on the prism front and on the back of the top housing. All previous models and early DR's have "Miranda" in upper and lower case letters. Late DR's and subsequent models have "MIRANDA" in all caps.

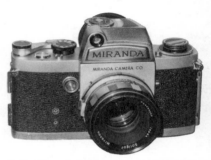

Early Miranda F with optional meter prism. Note preview button opposite front shutter release.

Miranda F - 1963. Speeds 1-1000,B. No model designation on camera. Lens diaphragm coupled internally to body. Early type has stop down lever on side of mirror box. Later ones lack this button and use preview button on lens. Film counter is below top plate and covered by a window. New design of shutter speed dial - all speeds on one dial, no shifting necessary. Early versions have 13-speed FPS 1-1000, B,X on single dial. Later version has top speed of 1/500. The 1/500 sec speed dial of the later could be removed to fit a snap-on meter, thus producing an the equivalent of an Fv. Front & top shutter releases. First Miranda also available in black. Also sold as FM and FT when fitted with optional meter prisms. A really nice black one will approach $100. Chrome: $50-75.

Miranda Fv - 1966. Like F with engraved "Fv" on front below the rewind knob. Serial number moved to a bezel at the rewind crank. Top speed 1/1000. Speed dial removes to attach a snap-on CdS meter,

coupled to shutter speed. Black: $75-100. Chrome: $60-90.

Miranda G - 1965/66. Marked "G" on front. 8 user-interchangeable screens, mirror lockup. 13-speed FPS 1-4000,B,X ST. ASA indicator under rewind knob. Top & front shutter release. Three versions: 1. No meter in prism. 2. Prism with snap-on CdS meter coupled to shutter. 3. Prism with uncoupled meter; made primarily for F, but seen on G. Also sold as GT with a TTL meter prism. Black GT: $100-125. Chrome G: $40-80.

Miranda Automex - 1959. First Miranda with inbuilt coupled meter. ASA to 400. Selenium cells in front of removable prism; coupled with shutter speeds and aperture by an external arm. "Automex" engraved on front. Correct lens has a button at 1 o'clock that switches the diaphragm from manual to auto. Serial number of normal f1.9 lens has "K" prefix. Many cameras are now missing the cover/adapter for the flash/pc socket. Some have motor wind facility. $50-85.

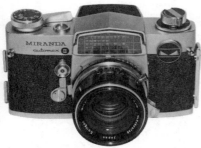

Miranda Automex II - 1963. "Automex II" on front. Meter to ASA 1600. Some with motor drive provision. $50-85.

Miranda Automex III - 1965. "Automex CdS" on front. Selenium cells replaced with a CdS cell where flash connection was on earlier models. Meter fully cross-coupled. Lens has a rectangular stop-down button replacing the round button. No letter prefix on the lens serial number.

- Later models include the Sensorex 1.8, Sensorex 1.9, Sensorex II, Sensomat, Sensomat TM, Sensomat RE, REII, Auto Sensorex EE, Auto Sensorex EE2 and Dx3. Most are available in black.

- Microscope models are engraved Laborec, Laborec II, Laborec III, and Mirax Laborec Electro-D with motor drive.

Sensoret - c1972-75. 35mm CRF camera, Miranda's only non-SLR. Built-in CdS meter. Miranda Soligor f2.8/38mm. Electronic Seiko ESF shutter, 4-1/800 sec. Hot shoe. Normally found with original accessory soft shutter button release and pouch. $15-30.

MISUZU KOGAKU KOGYO CO. LTD.
MISUZU OPTICAL INDUSTRY (Japan)
Alta - c1957. Leica III copy, but with twin PC sync posts on front. FP shutter T,B, 1-500. Interchangeable Altanon f2/50 in rigid mount. Rare. $800-1200.

Bower - Black laboratory camera, similar to the Alta, but no lens or finder. $500-800.

MISUZU TRADING CO. (Japan)
Midget Jilona cameras - *A series of subminiatures, similar in style to the cheap "Hit" cameras, but heavy cast metal construction. Earliest models are from the late 1930's, but post-war models are more common in the U.S.A.*

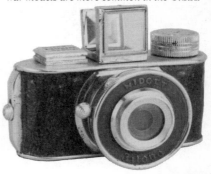

Midget Jilona (I) - c1937. The earliest Midget it is easily identified by the folding finder. It initiated a style which led the way for Mycro and Hit types. Takes 14x14mm exposures on 17.5mm paper-backed rollfilm that eventually became known as "Mycro-size" rollfilm. Uncommon. $100-175.

Midget Jilona Model No. 2 - c1949. Identified on top. Shutter B,I (1/50). $40-60.

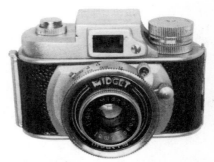

Midget Model III - c1950. "Model III Midget" on top. Body release. Shutter B, 25-100. $50-75.

MITHRA 47 - c1950. Brown plastic box camera for 6x9cm on 120 film. Meniscus; M&Z shutter. Made in Switzerland. $15-25.

MITY - Japanese novelty subminiature of "Hit" type. $10-15.

MIYAGAWA SEISAKUSHO (Tokyo, Japan)

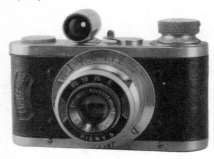

Boltax I, II, III - c1938. Small viewfinder 35mm, 24x24mm on Bolta film. Picner Anastigmat f4.5/40mm, Picny-D 25-100, B shutter. $75-125.

Picny - c1935. Compact camera for 3x4cm exposures on 127 film. Very similar in size and shape to the Gelto-D by Toakoki Seisakusho but rounded ends and better finish almost make it look like a stubby Leica. Even the collapsing lens mount is a direct copy of the Leica styling. Picny Anastigmat f4.5/40mm lens. Picny shutter 1/25-1/100, T,B. $70-90.

MIZUHO KOKI (Japan)
Mizuho-Six - c1952. Folding two-format camera for 120 film, 6x6cm and 4.5x6cm. Militar Speciial f3.5/80mm lens. NKS shutter 1-200,B. $40-55.

MOCKBA - See Moscow

MÖLLER (J. D. Möller, Hamburg, Germany)

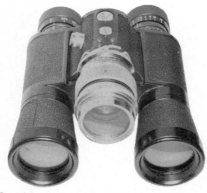

Cambinox - c1956. A combination of high quality 7x35 binoculars and a precision

camera for 10x14mm exposures on 16mm film. Interchangeable f3.5/90mm lenses. Rotary FP shutter 30-800. $600-800.

MOLLIER (Etablissements Mollier, Paris)
Le Cent Vues - c1925-30. An early camera for 100 exposures 18x24mm on 35mm film. Several variations. Early ones have a square cornered, vertically oriented metal body. The metal front has rounded corners. 'Le "Cent Vues"' (100 views) written above the lens. Second model c1926 has leather covered body with rounded ends. Hermagis Anastigmat f3.5/40mm in Compur shutter 1-300. $1100-1600.

MOLTENI (Paris, France)
Detective camera - c1885. Wooden body, 9x12cm plate camera of an unusual design. Front portion of body hinges up 180 degrees to rest on the top of the camera body, becoming the front of the viewfinder. Back of the body lifts up to form the back of the viewfinder. Brass fittings. Brass barrel Molteni Aplanat lens. Brass lens cap acts as the shutter. $1000-1400.

MOM (Magyar Optikai Müvek (Hungarian Optical Works), Budapest)

Fotobox - c1950. Good quality 6x6cm metal box camera. Large built in eye-level finder on top. Achromat f7.7/75mm focusing lens, shutter 1/25-100. $50-65.

Mometta - 35mm. Coupled RF with single eyepiece. Bottom loading. FP shutter, Z, 25-500. Non-interchangeable Ymmar f3.5/50mm. $70-85. *Illustrated top of next page.*

Mometta II - c1953. Rangefinder 35. Ymmar f3.5/50mm lens. FP shutter 1/25-500. $70-100.

Momikon - c1950. Rangefinder 35. Ymmar f3.5/50mm lens. FP shutter 25-500. $80-135.

MOM Mometta

MOMENT (MOMEHM) - Russian copy of Polaroid 95. f6.8/135mm. "BTL" shutter, 10-200, B. Black bellows. Rare. $125-160.

MONARCH MFG. CO. (Chicago) *Also spelled Monarck.*

Plastic novelty cameras - c1939. 127 half frame. Minicam-style, horizontal or reflex-type body. Various names: Churchill, Dasco, Fleetwood, Flash Master, Flex-Master, Kando Reflex, Pickwik, Remington, Royal Reflex. Reflex: $8-12. Horizontal: $4-8.

Monarch 620 - c1939. Simple, cast

aluminum camera for 4.5x6cm on 620 film. Also sold as the Photo-Master Twin 620. $10-15.

MONARCK MFG. CO. (Chicago) *Also spelled Monarch.*
Monarck - Plastic novelty cameras for full or half frames on 828 film. Minicam-style. $4-8.

MONO-WERK (Rudolph Chaste, Magdeburg, Germany)
Mono-Trumpf - c1914. 9x12cm folding bed plate camera. Mono Doppel Anastigmat f6.3/136mm lens. Ibsor shutter. $30-45.

MONROE CAMERA CO. (Rochester, N.Y.) *(Incorporated in 1897, merged in 1899 with several companies to form Rochester Optical & Camera Co.)*

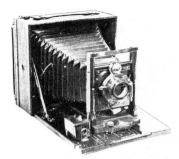

Monroe Model 7 - A 5x7" "cycle" style plate camera. Double extension maroon bellows. RR lens, Gundlach shutter. This camera looks like the Rochester it is about to become. $75-125.

Folding plate cameras (bed types) - "cycle" style folding cameras. 4x5": $50-75. 5x7": $75-100.

Folding plate cameras (strut types) - c1898. They fold to a very compact size, only about 1½" thick including brass double plateholder. Sizes:

Vest Pocket Monroe (left), Pocket Monroe No. 2 (right)

Vest Pocket Monroe - 2x2½". $200-250.
Pocket Monroe No. 2 - The medium-sized version of the compact Monroe cameras, made for 3½x3½" plates. $175-225.

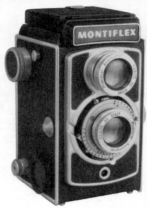

Montanus Montiflex

Pocket Monroe A - 3¼x4¼". The last of the series by Monroe before the merger. $150-200.

MONROE SALES CO.
Color-flex - c1947. Pseudo-TLR aluminum camera. Cream colored enamel and burgundy leatherette covering. $35-50.

MONTANUS CAMERABAU (Solingen, Germany) *About 1953, Potthoff & Co. began using the name "Montanus Camerabau Potthoff & Co." and then simply "Montanus Camerabau" in their advertising. See also "Potthoff & Co." for other cameras from this company.*
Delmonta - c1954-59. 6x6cm TLR. Two Pluscanar f3.5/75mm lenses; Vario or Prontor SVS shutter. Relatively common TLR. $45-70.

Montana - c1956. Basic 35mm camera. Deltanon Anastigmat f3.5/45mm in 50-200 shutter. With imitation reptile covering: $60-90. In normal black: $20-30.

Montiflex - 6x6cm TLR. Pluscanar f3.5/75mm or Steinheil Cassar f2.8/80mm. Prontor-SVS shutter. $50-75. *Illustrated top of next column.*

Rocca Super Reflex - c1955. 6x6cm TLR. Steinheil Cassar f2.8/80mm lens. Prontor 1-300 shutter, MX sync. $60-90.

MONTGOMERY WARD & CO.
Model B - 4x5" folding plate camera. Leather covered wood body. Rapid conv. lens. Wollensak shutter. $40-60. *Note: Most of the cameras sold through Montgomery Ward were not marked with the company name. Sears was one step ahead of Wards in that respect.*

MW - Horizontally styled bakelite folding camera. Similar to Vokar A,B and Voigt Jr. Probably sold by Montgomery Ward, but we can find no catalog references. $20-30.

Thornward Dandy - Detective-type box-plate camera for 4x5" plates. Same camera as the Gem Poco box camera made by Rochester Camera Mfg. Co. $40-60.

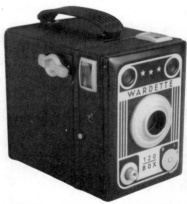

Wardette - Metal box camera made for Wards by Kürbi & Niggeloh (Bilora). $4-8.

Wardflex (metal) - c1955-59. Metal-bodied TLR for 6x6cm on 120 film. Made by Taiyodo for Wards. Telmer f3.5/80mm lens. TKK shutter B,1-200. Rack and pinion focus. $35-50.

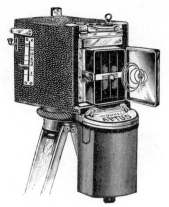

Moore Aptus Ferrotype Camera

Wardflex (plastic) - c1941. Black plastic 6x6cm TLR for 120 film. An Argoflex E with the Wardflex name. Argus Varex f6.3/75mm lens, extrenally gear-coupled to finder lens. Shutter 25-150,T,B. $15-20.

Wardflex II - c1957. This was the best of the Wardflex models. Fresnel field lens for bright focusing. Biokor f3.5 lens in Synchro MX shutter 1-300. Rolleiflex-style double bayonets on both lenses. "Wardflex II" on top of finder hood. $30-50.

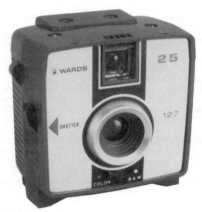

Wards 25 - Grey plastic eye-level camera for 4x4cm on 127 film. Made by Imperial; body identical to Mercury Satellite 127. $1-5.

Wards 35 - c1956. An Adox Polo 1S with the Wards 35 name. Adoxar f3.5/45mm lens. Shutter 1-300. $15-20.

Wards xp400 - Simple 35mm camera with automatic diaphragm. Made in Japan. Meter cell surrounds the lens. $15-25.

MONTI (Charles Monti, France) Monte Carlo, Monte Carlo Special - c1948. Folding rollfilm cameras for 6x9cm on 120 film. f3.5 or 4.5/90mm lens. $20-30.

MOORE & CO. (Liverpool, England) Aptus Ferrotype Camera - 1895-1930's. Black leather covered wood body, for 4.5x6.3cm plates. Meniscus lens. Suction bulb takes unexposed plate and swings it into position for exposures. $150-250. *Illustrated top of previous column.*

MOORSE (H. Moorse, London) Single-lens Stereo - c1865. Unusual stereo camera for 9x18cm exposures on wet-plates. Camera sits in a track on the top of its case. Between the two exposures, the camera is moved along the track to give the proper separation for the stereo exposures. Meniscus lens. $3000-3500.

MORITA TRADING CO. (Japan)

Gem 16, Model II - c1956. Novelty subminiature for 14x14mm on paper-backed rollfilm. Mensicus lens. B,I shutter. $65-85.

Kiku 16, Model II - c1956. Same as Gem 16, Model II, above. $65-85. *Isolated auction sales in Germany for double this range.*

MORLEY (W. Morley, Ltd., London, England) Wet-plate camera, ¼-plate - c1860. Bellows camera. Jamin-Darlot lens, waterhouse stops. $550-650.

Wet-plate camera, full plate - c1860-70. Bellows type camera for 16x18cm wet plates. Fine wood with brass trim. Square red bellows. With original Jamin brass lens: $1000-1500.

Wet-plate stereo camera - c1860. Negretti & Zambra brass-barrel lenses, waterhouse stops. $1800-2200.

MOSCOW (MOSKWA) - c1945-60. Russian copies of the Zeiss Ikonta and Super Ikonta C. Industar f3.5/105 or f4.5/110mm. Moment shutter 1-250. Major model distinctions: 1) Basic model without

Moscow-2

rangefinder. 2) Rangefinder like Super Ikonta C. 3) Like model 1, but accepts sheetfilm. 4) Synchronized version of model 2. 5) Streamlined top housing with integral optical finder. $75-125.

MOUNTFORD (W.S. Mountford Mfg, NY)
Button tintype camera - Leather-covered cannon-style button tintype camera, taking 100 1" dia. tintypes. $800-1200.

MOURFIELD
Direct Positive Camera - Large brown-leathered camera. Prism mounted in front of lens. $120-140.

MOZAR (Dr. Paul Mozer, Düsseldorf, Germany)
Diana - c1950. Bakelite box camera for 6x9cm on 120 film. f11 lens. M&Z shutter. Uncommon. $60-80.

MÜLLER (Conrad A. Müller, Strengenberg, Germany)

Noris - c1930's. Folding camera, 4.5x6cm on 120 film. Cassar f2.9/75mm lens in Compur shutter. $35-50.

MULTI-SPEED SHUTTER CO. (New York, NY)
Simplex - c1914. Early 35mm camera. Film cassettes held 50' of perforated film. Format could be changed from 24x36mm to 18x24mm between exposures by moving a lever. Also made without the 18x24mm capability. B&L Tessar f3.5/50mm lens. Shutter 1-300,T. One recently attracted offers of $6000+.

MULTIPLE TOYMAKERS (N.Y.C.)

Camera Kit, Wonderful Camera - c1973. Small plastic half-frame 127 camera in kit form. Simple assembly of 5 large pieces and a few small ones yields a camera named "Wonderful Camera" with f8 lens in 1/50 sec. shutter. The kit comes bubble packed on a card. Made in Hong Kong. Unassembled: $5-10. Assembled: $1-5.

MULTIPOSE PORTABLE CAMERAS LTD. (France)
Maton - c1930. Brown bakelite box taking 24 exposures, 24x30mm, on positive paper-backed film. Crank advance. Rousell Trylor f4.5/85mm, Gitzo shutter. $250-350.

MULTISCOPE & FILM CO. (Burlington, Wisc.) *The Multiscope & Film Co. manufactured the Al-Vista cameras from 1897 through 1908. At the end of 1908, the company sold all the rights, patents, and equipment for the panoramic cameras to Conley Camera Co. of Rochester, Minnesota.*

Prices quoted are for complete camera, normally with 3 diaphragms, set of 5 fans, and viewer.

Baby Al-Vista (left), and Al-Vista 5D (right)

Al-Vista Panoramic Cameras - patents 1896, 1901, and 1904. Takes panoramic pictures (model no. gives film height in inches) The standard five-format models take pictures in lengths of 4, 6, 8, 10, or 12 inches on rollfilm. The dual-format models take a standard proportion picture or double-width panoramic view.

Baby Al-Vista - c1906-08. For 2¼x6¾" pictures on 120 film. Actually, there are two models. No. 1 was a simple model with 4-position spring tensioning for speed adjustment. It sold originally for $3.50. Baby Al-Vista No. 2, which originally cost $5.00, had an external fan to slow down the swinging shutter. $250-350.

Model 3B - c1900-08. Dual-format model. Picture 3½" high by either 4½ or 9" long. $250-300.

Model 4B - c1900-08. Standard five-format model. Pictures 4" high by 4,6,8,10, or 12" long. $200-250.

Model 4G - c1904. Dual format, 4" high by 5 or 10" long. Takes snapshots only. $225-275.

Model 5B - c1900-08. Standard five-format model. Pictures 5" high by 4,6,8,10, or 12" long. $225-275.

Model 5C - c1900-03. Five panoramic formats on rollfilm or standard photos on glass plates with lens tube locked in center position and rear lens hood detached. A "semi-convertible" model. $250-350.

Model 5D - c1900-08. Like the 5B, but lengths of 6,8,10,12, and 16". $225-275.

Model 5F with folding-bed front (above), and panoramic front (below)

Model 5F - c1900-08. The convertible model. This camera has two fronts which use the same back. One front is the swinging lens panoramic, and the other is a folding-bed front which looks like the typical folding plate cameras of the day. An unusual and rare set. $400-600.

Model 7D - c1901. Dual format, 7" high by 7½ or 15" long. Uncommon. $300-400.

Model 7E - c1901-08. Dual format, 7" high by 10½ or 21" long. Uncommon. $300-400.

Model 7F - c1901-07. Large size convertible model, similar to 5F above. The standard front has extra long bellows for use with convertible lenses, such as the 8½" rectilinear lens originally supplied. Complete: $600-700.

Senior - 1899. Professional model for 8½x26" on 500 inch long rollfilm. Very few made. No known recent sales. Estimate: $1000+.

Note: Other models and variations of Al-Vista cameras generally sell in the $225-275 range. Some of these include: 4, 4A, 4C, 5, and 5A.

MUNDUS (France)
Mundus Color - c1958. Beige vertical camera for 8x14mm exposures on double 8 movie film. Resembles a movie camera. Interchangeable Berthiot f2.8/20mm lens. Shutter 1-300. $175-225.

Mundus Color 60 - c1960-73. Body is more stylized than the original rectangular-shaped Mundus Color. Som-Berthiot f2.8/20mm. $175-225.

Mundus Color 65 - c1974-76. Almost identical to the Mundus Color 60, but lens is f2.8/25mm. $175-225.

MÜNSTER KAMERABAU (Germany)
Phips - 1949. Simple metal box camera for 120 rollfilm, 6x9cm. The parts of the camera came unassembled in a kit. f9 Achromat, I+T shutter. Unassembled, in original box: $250-350. Assembled: $75-95.

MURER & DURONI (Milan, Italy)
Newness Express - c1900. Magazine box cameras for various sized plates: 4.5x6cm, 6x9cm, 7x8cm, 8.5x11cm (3¼x4¼") and 9x12cm. Murer Anastigmat f4.5 or 6.3, focal length depending on size of camera. Focal plane shutter. $30-60.

Folding plate cameras, focal plane models - c1905-30. Strut folding style. In all the sizes listed above. $110-130.

Muro - c1914. Vertical strut-folding 4.5x6cm camera. Suter Anastigmat f5/70mm. FP shutter to 1000. $150-200.

Piccolo - c1900. Rigid bodied rollfilm camera in the truncated pyramid "jumelle" style. Made to take 4x5cm exposures on the same rollfilm as the Pocket Kodak box cameras of 1895-1900 (including the elusive "Cone Pocket Kodak" of nearly identical design). $100-150.

Reflex - mid to late 1920's. SLR for 6.5x9cm plates. Murer Anastigmat f4.5/120mm. Focal plane shutter 15-1000. $100-125.

SL - c1900. Small leather covered wooden 4x5.5cm box camera. Three stops: 10,20, 40. P&L shutter. Two brilliant finders. $75-100.

SL Special - c1910. Strut-folding camera for 45x107mm stereo plates. Murer Rapid Aplanat f8/56mm lenses. Newton finder has lenscaps attached. In retracted position, lenses are protected. $125-150.

Sprite - c1915. Vertical 4.5x6cm strut-folding cameras. Made in 127 rollfilm and plate versions. Rapide Aplanat f8/70mm lens. Shutter 25-100. $65-100.

Stereo - c1920. Folding camera for 45x107mm. Focal plane shutter, 15-1000. Murer Anastigmat f8 or f4.5/60mm. $150-200.

Stereo Box - c1905. Magazine box camera for stereo exposures. 6x13cm or 8x17cm sizes. Rapide Rectilinear f10 lenses. $175-225.

Stereo Reflex - Mid to late 1920's. SLR for 45x107mm plates. F4.5 lenses. $400-450.

UF - c1910. Strut-folding camera for 4.5x6cm filmpacks in special back. Aplanat lens. Between-the-lens shutter 25-100. $75-125.

UP-M - c1924. Strut-folding camera for 4.5x6cm plates. Rapid Aplanat f8/70mm. Between-the-lens shutter. $75-100.

MUSASHINO KOKI
Optika IIa - c1956-60. Essentially a name variant of the Rittreck IIa, but shutter to 400, not 500. With f3.5/105mm Luminor and rollback: $150-250. *Add $50-75 each for extra lenses or rollbacks.*

Rittreck IIa - c1956-60. SLR for 6x9cm on sheetfilm or 120 rollfilm. Historically, this was the first 6x9cm SLR from Japan. Professionally, it was a very competent studio camera. Close focusing bellows. Interchangeable lensboards and backs. FP shutter, T,B,1/20-500. With normal lens and back: $150-250. *Add $50-75 each for extra lenses or rollbacks.*

Museflex

for 6x6cm on 120/220 films. Interchangeable f2/80mm Rittron lens. FP sh. B,1-500. Also sold as Rittreck 6x6, Norita 6x6, Graphic 6x6. $300-350.

MUSE OPTICAL CO. (Tokyo, Japan)
The Muse Optical Co. name was used by Tougodo for various cameras.
Museflex, Model M - c1949. TLR for 3x3cm on paper-backed 35mm rollfilm. f5.6/55mm. Automatic shutter. $50-100. *Illustrated top of previous column.*

MUTSCHLER, ROBERTSON, & CO.
Manufacturer of the "Ray" cameras, which were later sold & labeled under the "Ray Camera Co." name. See Ray.

Rittreck 6x6 - Medium format SLR, 6x6cm on 120/220. Interchangeable Rittron f2/80mm lens. FP sh. B,1-500. Reflex finder or optional pentaprism. Also sold as Warner, Norita, and Graphic 6x6. $300-350.

MYKEY-4 - c1960's? Eye-level camera for 4x4cm on 127 film. Tokinon f3.5/60mm lens in B,25-300 shutter. We assume Japanese manufacture and it has a TSK logo on the accessory shoe. A free cup of coffee for anyone who can give us more details about the manufacturer or date. We have only two recorded sales, at $25 and $125; a rather wide range. It should probably settle in at about $35-60.

MYKRO FINE COLOR 16 - Japanese subminiature for 13mm wide exposures on 16mm film in special cassettes. Body style similar to the Whittaker Pixie. $45-75.

MYSTIC PLATE CAMERA CO. (New York)
Mystic Button Camera - Button tintype camera. Spring loaded tube advances buttons for exposure. One auction sale at Christies for only $75, but normal range is $200-300.

NAGEL (Dr. August Nagel Camerawerk, Stuttgart, Germany)
Formed by Dr. Nagel in 1928, when he left Zeiss Ikon. Sold to Kodak A.G. in 1932.
Anca (10,14,25,28) - 1928-34. Folding plate cameras in 6.5x9cm and 9x12cm sizes. Most commonly found with Nagel Anastigmat f4.5, 6.3, 6.8 lenses in Pronto 25-100 shutter. $80-130.

Warner 6x6 - c1968. Medium format SLR

Fornidar 30 - 1930-31. 9x12cm folding plate camera. Nagel Anastigmat f6.3/135, f4.5, or Laudar f4.5/135mm lens. Compur shutter 1-200. $75-100.

Librette (65,74,75,79) - 1933. 6x9cm folding rollfilm cameras. Most commonly found with Nagel Anastigmat f4.5, f6.3, or f6.8 lens in Pronto 25-100 shutter. Most sales in the $50-90 range.

Pupille - 1931-35. (Also called "Rolloroy" in England). 16 exposures, 3x4cm on 127 film. With Leitz Elmar f3.5/50mm lens: $200-300. Normally equipped with Schneider Xenon f2, Xenar 2.9, or 3.5/50mm in Compur 1-300 shutter. $125-175.

Ranca - 1930-31. 3x4cm on 127 film. Similar to Pupille, but cheaper. Has front-lens focusing. Nagel Anastigmat f4.5/50mm in Pronto or Ibsor 1-150 shutter. $105-190.

Recomar 18 - 1928-32. Folding-bed plate camera, 6x9cm. Compur shutter 1-250. With Leitz Elmar f4.5: $125-175. With normal lens; Nagel Anastigmat, Xenar, Tessar f3.8, 4.5, 6.3/105mm: $50-85.

Recomar 33 - 1928-32. Folding 9x12cm plate camera, double extension bellows. Compur 1-250, T,B. With Leitz Elmar f4.5/135mm: $150-250. With normal f4.5/135mm lens: $50-85.

Vollenda, 3x4cm - 1931-32. Horizontal style folding bed rollfilm camera. Pronto or Compur shutter. With Elmar f3.5/50mm: $150-200. With Tessar f2.8/50mm: $75-125. With Radionar or Xenar f3.5 or 4.5/50mm: $60-90.

Vollenda 70/2 - c1930. Deluxe version of the Vollenda, 6.5x9cm. Has brown leather covering, brown bellows, nickel trim. Xenar f4.5/105mm; Compur shutter. $75-125.

Vollenda, 4x6.5cm, 5x7.5cm, 6x9cm - c1930-32. Folding bed cameras for 127,

129, or 120 film. f4.5 normal lens: $45-65.

NATIONAL (Osaka, Japan)

Radio/Flash CR-1 - c1978. 110 cartridge camera; built-in flash and radio. $75-100.

NATIONAL CAMERA (England)
Folding field camera - c1900-05. ½-plate. Fine mahogany finish. Reversible back, tapered black bellows, Ross Homocentric f6.3/7" lens. Thornton-Pickard roller-blind shutter. $125-200.

NATIONAL CAMERA CO. (N.Y.C.)
Baldwin-Flex - TLR-style minicam for 3x4cm on 127 film. $5-10.

NATIONAL CAMERA CO. (St. Louis, Missouri)

Naco - Horizontal folding rollfilm, 8x14cm. Similar to the #3A Folding Hawk-Eye. Rapid Rectilinear f4 lens. Ilex 25-100 shutter, B,T. $30-50.

NATIONAL INSTRUMENT CORP. (Houston, Texas)

Camflex - 6x6cm aluminum box camera. $15-25.

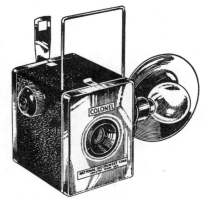

Colonel - c1947. Aluminum 6x6cm box camera. $15-25.

NATIONAL PHOTOCOLOR CORP. (New, York, NY)

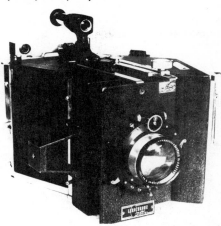

One-Shot Color Camera - c1939. 9x12cm exposures on plates, sheet film or film packs. Goerz Dogmar f4.5/8¼" lens. Compound shutter 1-100, T,B. Single extension bellows. $350-500.
- 5x7" size - c1939. Similar to above, except for size. $350-500.

NATIONAL SILVER CO.
National Miniature - Black plastic minicam for half-frame 127. $5-10.

NAYLOR (T. Naylor, England)
Field camera - Full-plate brass and mahogany field camera. Brass bound lens. $150-200.

NECKA JR. - Box camera. $5-10.

NEFOTAF (Holland)
Neofox II - Box camera, 6x9cm. $25-30.

NEGRA INDUSTRIAL, S.A. (Barcelona, Spain)
Nera 35 - Low cost 35mm. Speed Acrinar lens, two speed shutter. Hot shoe. $10-15.

NEGRETTI & ZAMBRA (London, England)
Cosmos - c1903. Falling plate stereo camera, 45x107mm. Holds 12 plates. Extra Rapid lenses. $450-500.

Field Camera - Mahogany ½-plate camera. Brass-barrel lens with Rollerblind shutter. $100-150.

One-Lens Stereo Camera - c1865-70. Wet-plate sliding-box camera, 8x8cm. For stereo exposures, camera is mounted on top of its stoarge case and moved in its mount between exposures. Negretti & Zambra lens. Rare and desirable. Price negotiable. Estimate: $10,000+.

Stereo Camera - c1862. Mahogany sliding-box wet-plate camera. Brass-barrel Negretti & Zambra lenses. $3000-3500.

NEIDIG (Richard Neidig Kamera-Werk, Plankstadt, Germany)
Perlux - c1950. 35mm camera for 24x24mm exposures. Many shutter and lens combinations, including Kataplast f2.8/45mm in Vario 25-200. $40-60.

NEMROD CO. (Spain) *Named for Nemrod the hunter, King of Babylonia.*

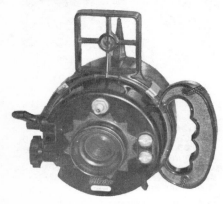

Siluro - c1960-62. Underwater camera molded from "Novodur" plastic. Takes 12 exposures, 6x6cm, on 120 film. Styled like the Healthways Mako-Shark camera, but built for use at depths to 40 meters. Lead weights inside back. Valve on front pressurizes interior. Fixed focus f16 lens, 1-2.5 meters. Single speed shutter 1/55 sec. Battery and capacitor for external flash are contained within the camera body. $40-60.

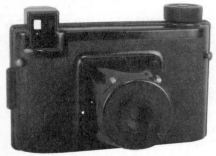

NEO FOT A - Black bakelite 120 rollfilm camera made in Denmark. Unusual body design. $30-40.

NEOCA CO. (Japan)
Neoca 1 S - c1955. 35mm with coupled rangefinder. Neokor f3.5/45mm lens. Ceres shutter 5-300, B. $30-50.

Neoca 2S - c1955. 35mm with coupled rangefinder. Neokor f3.5/45mm lens. Rectus shutter 1-300,B. $35-50.

Robin - Rangefinder 35. Neokar f2.8/45mm lens. Citizen MV shutter to 500. A number of different models, but all in the same price range. $30-45.

NETTEL KAMERAWERK (Sontheim-Heilbronn, Germany)
Formerly Süddeutsches Camerawerk- Körner & Mayer. Later became Contessa-Nettel in 1919 and Zeiss-Ikon in 1926.
Argus - c1911. Monocular-styled camera. Right angle finder in monocular eyepiece. An unusual disguised camera, less common than the later Contessa-Nettel and Zeiss-Ikon "Ergo" models. British catalogs called it the "Intimo". $850-1250.

Deckrullo - c1908-19, then continuing as a "Contessa-Nettel" model. A series of strut-folding focal plane "klapp" cameras for glass plates. Focal plane shutter ½-2800. Typical lenses include Nettel Rapid Aplanat, Nettel Anastigmat, Goerz Dagor & Celor, Zeiss Tessar.
9x12cm size - Zeiss Tessar f6.3/135mm or Dogmar f4.5/150mm. $100-150.
10x15cm size - Tessar f4.5/165mm or 180mm. $125-175.
13x18cm size - Nettel Anastigmat f6.5/18cm. $100-150.
18x24cm size - Xenar f4.5/210mm. FP shutter. $150-200.

Folding plate camera, 9x12cm - Double extension bellows. Tessar f6.3/135mm lens. Dial Compur 1-250. $40-60.

Folding plate camera, 5x7" - Zeiss Anastigmat f8/210mm. $75-125.

Sonnet - c1913. 10x15cm folding plate camera. Single extension. Tessar f6.3/165mm, Compur 1-200. $80-100.

Sonnet, Tropical model - Teakwood with light brown bellows. Compound 1-300 sh.
- **4.5x6cm** - Tessar f4.5/75mm. $400-600.
- **6x9cm** - Tessar f4.5/120mm. $250-400.

Stereo Deckrullo Nettel, Tropical - c1912. Teakwood with brass trim. Tessar f4.5 lenses. Focal plane shutter. Made in 9x14, 10x15, & 9x18cm sizes. $700-900.

Tropical Deckrullo Nettel, 10x15cm - c1910-19. Teakwood camera with nickel struts and trim. Brown bellows. Nettel Anastigmat f4.5/165mm. Focal plane ½-2800. $500-650.

NEUMANN (Felix Neumann, Vienna, Austria)
Field camera - c1900. Wood tailboard camera, brass trim, black tapered double extension bellows. $150-200.

Magazine camera - c1895. Wood box for 12 plates 9x12cm. Leather changing bag, meniscus lens. $175-225.

NEUMANN & HEILEMANN (Japan)
Condor - Folding 120 rollfilm camera, half-frame. $50-75.

NEW HIT - 16mm subminiature made in Occupied Japan. $30-50.

NEW IDEAS MFG. CO. (New York)
Manufacturing branch of Herbert & Huesgen.

Magazine camera - c1898. Polished wood box detective camera. String-set shutter. $250-375.

Tourist Multiple - c1913. One of the earliest cameras to use 35mm motion picture film for still pictures, and the first to be commercially produced. Vertically styled body, leather covered. Tessar f3.5, Goerz Hypar f3.5, or Steinheil Triplar f2.5 lens, guillotine shutter. Film capacity of about 50 feet for 750 exposures 18x24mm. The outbreak of WWI slowed the tourist market for which this camera was intended, and probably only about 1000 were ever made. $1500-2200.

NEW TAIWAN PHOTOGRAPHIC CORP.

Yumeka 35-R5 - c1983. A poor quality transistor radio built into a poor quality 35mm camera. New in box: $20-30.

NEW YORK FERROTYPE CO.
Tintype camera - c1906. Professional model with three-section plateholder for postcards, 1½x2½" tintypes, and "button" tintypes. Two-speed Wollensak shutter. With tank and black sleeve. $150-200.

NEWMAN & GUARDIA, LTD. (London)
Deluxe - c1896. Box-style camera with bellows extension. Zeiss Protar f9/220mm lens. $225-325. *Illustrated top of next page.*

Newman & Guardia Deluxe

Folding Reflex - 1921-1930's. (Available until 1957). SLR for 6.5x9cm plates. Ross Xpress f2.9 or f4.5 lens. Folds to compact size. $150-300.

High Speed Pattern - Variation of the Universal Pattern B with faster Zeiss Tessar f4.5 lens. N&G pneumatic shutter ½-100 and FP shutter ¹⁄₁₀-800. $275-325.

Nydia - c1900. Plate camera with unusual folding design. Tapered bellows detach

from lensboard, which then swings to the end of the body. 9x12cm and 10x13cm sizes. Wray Rapid Rectilinear or Ross f8 or f6.3. Guillotine shutter 2-100. $400-650.

Sibyl Cameras - *Early models with just the "Sibyl" name seem to be pre-1912, when the company began assigning more specific names. Some cameras were made only in certain sizes.*

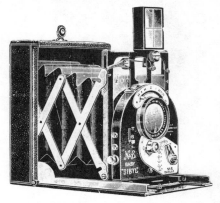

Baby Sibyl (4.5x6cm) - c1912-35. 4.5x6 on plates or filmpacks. Rollfilm model has 1⅝x2⅝" images. Tessar or Ross Xpress f4.5/75mm. N&G shutter 2-200. $275-450.

New Special Sibyl (6.5x9cm) - c1914-1935. For 2½x3½" plates or 2¼x3¼" filmpacks. Rollfilm model gives 2⁵⁄₁₆x3⅝" image. Ross Xpress f4.5/112mm. N&G Special shutter. $175-225.

New Ideal Sibyl (3¼x4¼") - c1913. For 3¼x4¼" plates or filmpacks. Rollfilm model gives 3x4⅝" image. Tessar f4.5/135mm. N&G shutter. $175-225.

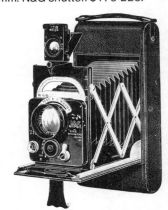

Excelsior (2½x4¼") - c1933. Rollfilm size. Ross Xpres f4.5/136mm lens. N&G patent shutter. $150-200.

Postcard Sibyl - c1912-14. Folding plate camera with bed and trellis struts. Zeiss Tessar f4.5/150mm lens. N&G pneumatic shutter ½-100. $275-325.

Sibyl - c1907-12. Folding-bed rollfilm or plate cameras. Tessar f6.3/120mm, Ross f3.5 or 4.5 lens. N&G Special shutter. 6.5x9cm: $75-125. 3¼x4¼": $100-150.

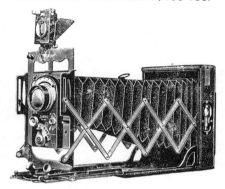

Twin Lens Pattern - c1895. 9x12cm, box-TLR. Viewed through a chimney-like extension in the viewing hood. Also has 2 small waist-level viewfinders, typical of box cameras. Leather-coverd wood body. Rack and pinion focusing. Newman Patent Pneumatic shutter, ½-100. $400-700.

Universal Pattern B, Universal Special Pattern B - c1905-13. Box magazine camera for 3¼x4¼" or 4x5" plates. Internal bellows allow front of box to slide out for copy work or close-ups. Zeiss Anastigmat f12.5 or f6.3 lens. N&G pneumatic shutter 2-100. Available special order with tan leather: $350-400. With normal black leather: $150-250.

Sibyl Deluxe - c1911. 9x12cm. Double extension bellows. Zeiss Protar f6.3/122mm, N&G shutter 2-100. $300-450.

Sibyl Stereo - c1912. 6x13cm plate camera. Trellis struts like other Sibyl cameras. Zeiss Tessar f4.5/120mm lenses. Shutter 2-100. $1000-1400.

Special Stereoscope Rollfilm Sibyl - c1920. Probably the rarest Sibyl. Folding bed camera with rounded body ends. 1¾x4¼" exposures on A116 rollfilm. Ross Xpres f4.5/75mm lenses. N&G shutter ½-100. $1800-2200.

Stereoscopic Pattern - c1896-1911. Variation of the Universal Pattern B for stereo exposures on ½-plates. f6.3 lenses. N&G pneumatic shutter. $775-1175.

NEWTON & CO. (London)
Tailboard camera - c1887. Mahogany and brass field camera with brass bound lens. Made in sizes ½-plate to 10x12". $140-160.

NEWTON PHOTO PRODUCTS (Los Angeles, CA)

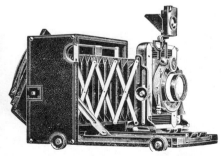

Trellis - c1910's-1930. Folding-bed camera in ¼ and ½-plate sizes, with typical N&G struts. Protar lens, N&G shutter. $250-350.

Newton New Vue - c1947. All-metal bi-rail view. Gray enamel, nickel trim. Rotating back. Rapid front focus, micro focus at rear. With appropriate lens/shutter. $150-250.

NIAGARA CAMERA CO. (Buffalo, NY)

Niagara #2 - Box camera for 3½x3½" plates in double plateholders which load through hinged door on top. Uncommon camera, named for the famous waterfalls. $30-50.

NIC (Barcelona, Spain) *Founded in late 1931 by two brothers, Tomás & Josep Nicolan-Griñó, inventors of a toy projector for animated drawings. For 40 years, they produced a variety of silent and sound projectors and films. Our primary interest here is their unusual still camera.*

Foto Nic - c1935. A relatively complicated, though cheaply constructed camera for positive photos in 5 minutes. Basically a box camera, but with built-in pads for developer and fixer. A brief summary of operation: 1. Load the camera with its special photographic paper. 2. Saturate developer and fixer pads. 3. Expose photo. 4. Turn advance knob until exposed emulsion faces the developer pad. 5. With exterior knob, push developer pad into contact with paper and turn for 1 minute. 6. Advance to fixer position; turn fixer pad against paper for 1 minute. 7. Open top door and remove negative from backing strip. 8. This paper negative is then re-photographed by the same camera, using built-in frame and close-up lens, and developed in the same manner to produce the final print. This camera is rather rare. $150-250.

NICCA CAMERA WORKS (Japan)
Kogaku Seiki Co. 1940-1947
Nippon Camera Works 1948-1948
Nicca Camera Works 1949-1958
see Yashica for post-1958

The Kogaku Seiki Co. produced its first camera, the Nippon, in 1942. In 1948 the first Nicca was produced by Nippon Camera Works. Subsequent Nicca models were manufactured under the Nicca Camera Works name, with such features as flash sync, lever wind, hinged backs and projected frame lines added over the course of the production. Nicca also made cameras for Sears under the "Tower" name. The company was absorbed by Yashica in 1958 and the final two "Nicca" models were the Yashica YE (a Leica IIIc copy) and YF (similar in appearance to Leica M2).

Nippon - 1942-47. Two versions:
1. With rangefinder and slow speed dial.
2. Without rangefinder or slow speed dial. Lenses include K.O.L. Xebec f2/5cm, Nikkor f4/5cm, and Sun Xebec f2/5cm. FP shutter 1-500 or ½₀-500. $2000-3000.

NICCA Features for quick identification: Common features: *To ease identification, we are not repeating the common features, but only those which serve to distinguish one model from another. All of the Nicca models, unless otherwise specified, have cloth focal plane shutter 1-500 with slow speeds 1-20 on front dial. All accept screw-mount lenses in Leica thread which couple to rangefinder. Separate eyepieces are used for RF and VF. Except for the original Nicca (Nippon Camera Works, 1948), all have diopter adjustment on viewfinder eyepiece.*
KNOB WIND models, 1949-57.
Basically similar to the original Nicca, but minor variations on each model.
Nicca Type 3, Nicca IIIA: No sync.
Nicca IIIB, IIIS, 3S, 3F (early): Sync added.
Nicca 4, Nicca 5: Focal plane shutter to 1000, sync.
LEVER WIND models, 1957-58.
Nicca 3F (later type), Nicca 33: Retained the early Leica-style appearance, but a lever advance was added.
Nicca IIIL: A re-styled top housing incorporating a large combined range/viewfinder. Somewhat similar in appearance to Leica M3. The lever advance was built into the top housing, not on the top.

Nicca (Original) - 1948. Essentially identical to the prewar and postwar rangefinder Nippon except for the top plate engraving and Nikkor-QC f3.5/5cm rather

than K.O.L. Xebec lens. Body style similar to the Leica III. Separate RF/VF eyepieces; no diopter adjustment. $1000-1200.

Nicca III (Type-3) - 1949. Features like previous model, but with diopter adjustment. "Nicca Type-3" on top. Original lens is Nikkor-HC f2/5cm. No sync. $150-200.

Nicca IIIA - 1951. The last of the non-sync models. Nikkor-HC 5cm/f2 lens. Also sold as Tower Type-3 (See Sears). $150-200.

Nicca IIIB - 1951. Twin sync posts on front for FP bulbs. Otherwise similar to IIIA. Nikkor-SC f1.5/5cm lens. (Also sold as Sears Tower Type-3). $200-300.

Nicca IIIS - 1952. Sync changed to two PC posts for FP or X sync. Nikkor-QC f3.5/5cm. (Sears sold this camera as Tower Type 3S through 1956 with f2 and f1.4 Nikkor lenses.) $150-200.

Nicca 4 - 1953. Nikkor-SC f1.5/5cm lens. Speeds to 1/1000 sec. $300-400.

Nicca 3-S - 1954. Shutter speeds changed to geometric progression with synch at ½s and top speed of 1/500. Nikkor-QC f3.5/5cm lens. $150-250.

Nicca 3-F - c1956-57. Top housing restyled for cleaner look. Front center portion of extends downward to act as lens escutcheon. Sync post moved to back of top housing below shoe. Nikkor-H f2/5cm lens. Early version has knob wind. Later version has lever wind. $150-250.

Nicca 5 - 1955. Single piece top housing like 3F, but top speed to 1/1000. Sync post on rear of top housing below shoe. Nikkor-H f2/5cm. $300-500.

Snider - c1956. A rare variation of the Nicca 5 named "Snider" was imported and sold in Australia with Schneider Xenon f2/50mm lens. A marketing manager for the importer recalls that about 50-100 were sold. Rare. No sales data.

Nicca 33 - 1957 (continued as Yashica YE after 1958). Single piece top housing no longer extends down toward lens. Hinged back. Nicca f2.8/5cm lens. $250-350.

Nicca IIIL - 1958. Modernized top housing style is somewhat similar to Leica M3. (In 1959, after the Yashica takeover, the IIIL became the Yashica YF, whose top housing which even more closely resembles the Leica M3.) Nikkor-H f2/5cm lens. $150-250.

NICCA L-3 - c1986. Novelty 35mm camera from Taiwan. Not related to the Japanese Nicca cameras. Simple styling without phony prism found on many such cameras. Retail price $8. Now: $1-5.

NICHIRYO TRADING CO. (Japan)

Nicnon Binocular Camera - c1968-78. Binocular camera for half-frame on 35mm. Nicnon f3.5/165mm. 3-speed shutter, 60-250. Viewing is done as with regular binoculars. A beam-splitting device in the right side enables the viewed object to be photographed. The camera body is the Ricoh Auto Half. Motorized film transport. This camera was later distributed by Ricoh under the name "Teleca 35". $250-350.

NICHOLLS (H. Nicholls, Liverpool, England)
Detective camera - Black leather covered wood box taking 3¼x4¼" plates. Rack focusing. Eureka RR lens, iris diaphragm, T-P roller blind shutter. $75-95.

NIELL & SIMONS (Cologne)
Lopa - c1902. Unusual book-form camera, also sold by Griffin as the Pocket Cyko. Versions for single plates or with magazine back. $400-750.

NIHON KOKI CO. (Japan)
Well Standard Model I - c1939. Rollfilm camera with telescoping front. Styled like a 35mm camera. Takes unusual image size of 4x5cm for 10 exposures on 127 film. Eye-level and waist-level finders. Well Anastigmat f4.5/65mm in NKK shutter, T, B, 25-150, or Well Anastigmat f3.5/65mm in Well-Rapid 1-500 shutter. Recorded sales from $80-350.

NIHON PRECISION INDUSTRY
NIHON SEIMITSU KOGYO (Japan)
Zany - c1950. Subminiature for 10x14mm on 16mm film in special cassettes. Fixed-focus Gemmy Anastigmat f4.5/25mm. Internal shutter. Some examples are marked "N.S.K." on top and others are labeled "N.D.K.". A rare subminiature. $200-300.

NIHON SEIKI (Japan)

Nescon 35 - c1956. 35mm viewfinder camera. Similar to the Ranger 35 & Soligor 45. Nescor f3.5/40mm. Shutter 25-200,B. Japan: $50-75. USA: $25-35.

Ranger 35 - c1956. Basic scale-focus 35mm camera. Nescor f3.5/40mm lens. Japan: $50-75. USA: $25-35.

Soligor 45 - c1956. Same as Nescon 35, but with Soligor name and Soligor f4.5/40mm lens. Japan: $50-75. USA: $25-35.

NIKO - Plastic body. 16 exposures, 3x4cm on 127 film. $2-8.

NIKOH CO. LTD. (Japan)
Enica-SX - c1983. Subminiature, 8x11mm on Minox cassette film. Built-in butane lighter. Similar to the Minimax-Lite, but has built-in electronic flash. Tortoise-shell covering; gold edges. Suzunon f3.8/14.3mm fixed focus. Single speed shutter. $60-75.

Minimax-lite - c1981. Subminiature 8x11mm camera with built-in butane lighter. Fixed focus, single speed. $50-60.

Supra Photolite - Identical to the Minimax-lite, but with a different name. $75-100.

NINOKA NK-700 - c1986. Novelty 35mm camera styled like an SLR. Originally offered as a free premium by a travel club, which followed up by offering the companion flash for the inflated price of $21. (Similar camera and flash outfits retail at less than $15.) Collectible value with flash: $5-10. Camera only: $1-5.

NIPPON KOGAKU K.K. (Tokyo)
Nippon Kogaku K.K. was formed in 1917 by the merger of some smaller optical firms. During the pre-war years, they made a large variety of optical goods for both the military and scientific communities. These included binoculars, aerial lenses, microscopes, telescopes, transits, surveying equipment, periscopes, sextants, microtesters and other related equipment. Because of the types of items produced, they were virtually unknown to the general public and to the world outside of Japan. With the advent of WWII, they were chosen to be the primary supplier of optical ordnance for the Japanese military establishment and grew to over twenty factories and 23,000 employees. Most of the optical equipment used by the Japanese Army, Air Force and Navy was produced by Nippon Kogaku. After the end of the war they were reorganized for civilian production only and were reduced to just one factory and 1400 employees. They immediately began to produce some of the fine optical equipment they made before the war for the scientific and industrial fields, but had yet to produce any cameras for general use. Before the war they had begun to make photographic lenses, including those for the famous Hansa Canon, and actually made all of Canon's lenses up to 1947. They also produced their lenses in a Leica-type screw mount as well as the early Canon bayonet. Sometime in 1945 or 1946, they decided that they should get into the camera field in an attempt to expand their product line. Since they were making lenses for 35mm cameras, it was a logical step to make a camera to use these same lenses. By September of 1946, they had completed the design of what was to become their first camera and decided on the name NIKON, from NIppon KOgaku. They studied the strong points of the two leading 35mm cameras of the day, the Contax and Leica, and combined many of the best features of both in the new Nikon design.

The majority of the information and photographs in the Nikon section are the work of Mr. Robert Rotoloni, a prominent collector and avid user of Nikon cameras. His interest in the field led him to write and publish a book entitled "The Nikon -An Illustrated History of the Nikon Rangefinder Series", ©1981. Although his first book is out of print, Mr. Rotoloni has written a new edition entitled "Nikon Rangefinder Camera" published in 1983 by Hove Foto Books in England. In the U.S.A, autographed copies

416

are still available directly from the author at the address below. Since Mr. Rotoloni is also a respected dealer in collectible Nikon cameras, readers are invited to contact him with regard to buying or selling Nikons as well as exchanging information on the subject. Serious Nikon enthusiasts should write to him for full information on *The Nikon Historical Society* and its newsletter. As a courtesy, please include a stamped self-addressed envelope with queries. He may be reached at: PO Box 3213; Munster, IN 46321 USA. Tel. 312-895-5319.

Our second Nikon consultant is Dr. Burton Rubin, a well-known collector of Nikon and 35mm cameras. Dr. Rubin writes a column, "The Collectible 35" for *Shutterbug*. You may write to him at 4580 Broadway, New York, NY 10040. Tel. 212-567-2908.

It is impossible to give any price which will be meaningful throughout the world, so we are continuing with our policy of reporting the USA prices. Nikon Rangefinder cameras generally sell for more in Europe than in the USA primarily because Europe imported far fewer of these cameras before 1959. Most bring 10-20% more in Europe, but rarer items bring 20-25% more. Prices in Japan are 25-40% higher than the USA for common items and nearly double for rare items. Prices are given for cameras in Excellent condition in the USA. They are obviously influenced by the much higher prices in Japan where many active buyers seek mint cameras. We have noted some specific prices from the Japanese market to give some perspective to the listed prices. Where separate prices are given for Mint, these are generally the prices paid by buyers for the Japanese market. Any currency fluctuation could drastically change this frenzied and inflated market.

Nikkorex 35, 35-2 - c1960-62. 35mm SLR with coupled selenium meter on prism front. Non-changeable f2.5/50mm Nikkor. Leaf shutter 1-500,B. $40-60.

Nikkorex Auto 35 - c1964-67. 35mm SLR with coupled selenium meter. Non-changeable f2/48mm Nikkor lens. Leaf shutter 1-500,B. $40-60.

Nikkorex F - c1962-66. 35mm SLR. Body style more closely resembles a Nikon than the other Nikkorex models. Nikon-mount interchangeable f2/50mm Nikkor lens. FP shutter 1-1000,B. $30-50.

Nikkorex Zoom 35 - c1963. The first still camera with a non-interchangeable zoom lens. Zoom Nikkor Auto f3.5/43-86mm. Selenium meter. $125-175.

Nikon I - 1948. Focal plane shutter to 500. Bayonet lens mount which continued to be used for later models. Unusual image

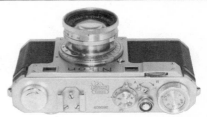

size: 24x32mm. Despite printed information to the contrary, the exposure counter is NOT numbered past 40 in any case. Made for a little over one year, with a total production of about 750. Originally supplied with Nikkor 50mm f3.5 or f2.0 lens. Serial numbers 609-1 to 609-758, with the first 20 or 21 being pre-production prototypes. Rare. Price negotiable. In original condition with no flash synch added, with original leather, working condition, with correct lens: $5,000-$10,000+ (sales in Japan have reportedly reached as high as $12,000). Professional buyers are offering $4500-7000 mint. In lesser condition, with flash added, non-original parts such as knobs, wrong lens or no lens, not working or damaged: $1,000-2,000+.

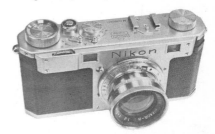

Nikon M - August 1949 - December 1951. Total production of about 3,200 cameras. It is the only Nikon rangefinder camera to be identified on the camera. The letter "M" precedes its serial number on the top plate. Its 24x34mm format is a compromise between the 24x32 of the Nikon I and the standard 24x36mm. An early M with f1.5 lens, MINT, reportedly sold for $3000 in Japan. Current value with normal f2.0 or f1.4 lens: 1949 type (no synch) $1000-1700 MINT. 1950 type (with synch) $500-800. *Note: Late M's with flash sync are considered by the factory to be S's, even though they have the M serial number.*

Nikon S - 1951-54. The first Nikon to be officially imported into the USA. Identical to the later Nikon M with flash sync (which the factory already called "S"). The only difference is that the serial number no longer has the "M" prefix. (#6094100- on.) 24x34mm format. Replaced in December 1954 by the S2. "MIOJ" model $500-1000.

NIPPON KOGAKU (cont.)

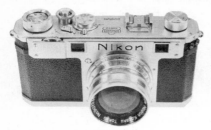

Nikon S

With 8-digit serial number: $300-500. Otherwise, quite common. With f2 or f1.4 lens: MINT: $400. EXC: $150-250.

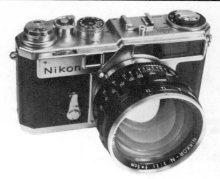

Chrome Nikon SP

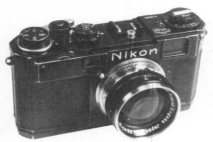

Black Nikon S2

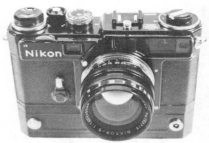

Black Nikon SP, with motor drive

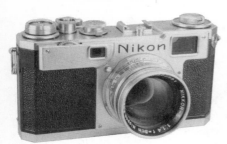

Chrome Nikon S2

Nikon S2 - Dec.1954-early 1958. New features include rapid wind lever, shutter to 1000, crank rewind, and a larger viewfinder window permitting 1:1 viewing. The top plate steps up over the new larger viewfinder, but the accessory shoe remains on the lower level, unlike the later S3. Over 56,000 produced, which is more than any other Nikon rangefinder camera. It was the first to have the 24x36mm format, be available in black, and the first to take a motor drive accessory. Current prices include f2.0 or f1.4 lens. Chrome: $175-250. Chrome with black dials: $200-350. Black: $700-1500. *Note: Chrome model is very common and often seen advertised above and below the normal range.*

Nikon SP - Sept.1957-at least 1964. Most famous and significant Nikon rangefinder camera, again showing innovation in camera design. It offered a removable back which could be replaced with a motor-drive back. Universal finder for six focal length lenses 28-135mm. Approximately 23,000 produced. The popular motor-drive back led the way for Nikon's dominance of motor-driven photography in the following two decades. Easily recognized by the wide viewfinder window which extends over the lens. The "Nikon" logo, no longer fitting above the lens, was moved off center below the shutter release. Prices include f2 or f1.4 lens. Chrome, EXC: $400-550 (double for MINT). Black, EXC: $800-1200 (double for MINT). Add $400-500 for motor drive. *Note: Chrome model is very common and often seen advertised above and below the normal range.*

Nikon S3 - Introduced in 1958, this popular version of the SP could also be motorized. At least 14,000 were made during its production run which continued at least until 1960. Styled similar to the SP, but with a rectangular viewfinder window, and the Nikon logo again centered over the lens. Two major features distinguish it from the earlier S2: The viewfinder window is larger on the S3. The top plate steps up in the center (accessory shoe is on the high

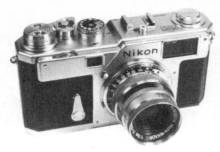

Nikon S3

side). Prices with f2 or f1.4 lens. Black "Olympic" with "Olympic" lens: $800-1500. Black: $600-900 EXC to $1600 MINT. Chrome: $400-750 MINT.

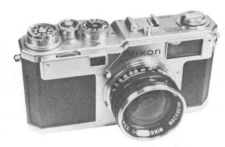

Nikon S4 - Announced in 1959, this simplified version of the S3 was never imported into the USA, so they are seen less frequently in the United States than in Japan. At least 5900 were made, all in chrome finish. With f2 or f1.4 lens: $450-650 EXC to $900 MINT.

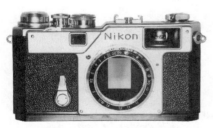

Nikon S3M - 1960. A modified Nikon S3 for half-frames, permitting 72 exposures per load. It was Nikon's first half-frame camera, and was made in black or chrome. Only 195 were reportedly made, although more may exist. Most were motorized. With f2 or f1.4 lens. Chrome or black without motor: $10,000+. With S72 motor: $15,000.

NIKON RANGEFINDER LENSES *All are Nikkor lenses in bayonet mount.*

21mm f4 black only, with finder: $800-1500. Add $50-75 for shade.
25mm f4 chrome, with finder: $450+.
25mm f4 black, with finder: $550+.
28mm f3.5 chrome Type 1 or 2: $200-250.
28mm f3.5 black: $225-300.
35mm f3.5 MIOJ: $150-250.
35mm f3.5 chrome Type 1 or 2: $75-100.
35mm f3.5 black: $100-150.
35mm f3.5 Stereo Nikkor: Outfit with lens, prism attachment, UV filter, shade, and finder in leather case. Very rare. $4000-8000.
35mm f2.5 chrome: $75-125.
35mm f2.5 black Type 1: $150-200.
35mm f2.5 black Type 2 (An f2.5 lens, but in f1.8-type barrel. Not easily found): $300-500.
35mm f1.8 all black: $700-1000.
35mm f1.8 black and chrome: $175-350.
50mm f3.5 Micro Nikkor: $500+.
50mm f3.5 collapsible: Looks very much like the Leitz Elmar, but in Nikon mount. Sold only on Nikon I. $500-800.
50mm f2.0 collapsible: $250-500.
50mm f2.0 chrome: $50-60.
50mm f2.0 black: $60-90.
50mm f2.0 all black: $200-250.
50mm f1.5: $500-600.
50mm f1.4 chrome (MIOJ): $75-125.
50mm f1.4 chrome: $50-90.
50mm f1.4 aluminum: $800-1000.
50mm f1.4 black and chrome: $70-100.
50mm f1.4 all black (early): $400-600.
50mm f1.4 Olympic: $500-800.
50mm f1.1 Internal bayonet: $400-600.
Add $75-100 for matching shade.
50mm f1.1 External bayonet: $400-600.
Add $75-100 for matching shade.
85mm f1.5: $450-750.
85mm f2 chrome MIOJ: $200-400.
85mm f2 chrome: $80-125.
85mm f2 black: $150-300.
105mm f4: $400-800.
105mm f2.5: $150-200.
135mm f4 Short mount for bellows: $200-300.
135mm f4 chrome Ser.#523xx: $500-700.
135mm f4 chrome Ser.#611xx: $500-700.
135mm f4 chrome Ser.#904xx: $300-500.
135mm f3.5 chrome: $70-100.
135mm f3.5 black: $80-125.
180mm f2.5: $350-600.
250mm f4 manual: $250-350.
250mm f4 preset: $200-300.
350mm f4.5 black: $500-900.
500mm f5 black: $1500-2000 with original wooden case.
1000mm f6.3 black: $5000-10,000.
1000mm f6.3 grey: $3500-5000.

NIKON RANGEFINDER ACCESSORIES
Motor Drives:
Black: $400-600. Chrome: $500-750.
Chrome S72 for S3M: $2500-5000.

Finders
21mm optical: $200-300.
25mm optical: $100-200.
28mm optical: $50-100.
35mm mini for S2: $250-400.
35-85-105-135mm chrome optical: $40-50.
Chrome 24X32 Variframe: $600-1000.
Chrome MIOJ Variframe: $150-300.
Chrome Variframe: $75-100.
Black Variframe, with shoe: $250-400.
Black Variframe, no shoe: $300-500.
28mm adapter for black Variframe: $300+
Varifocal Zoom Finder MIOJ: $500+.
Varifocal: $75-150.
28mm adapter for Varifocal: $100-200.
Black bright line finders:
 35, 85, 105, 135mm: $100-200.
 50mm: $300-400.
 stereo: $500+.
Folding Sports finder: $150-250.
Rangefinder Illuminator: $200-275.

Reflex Housings
Type one, copy of Leica PLOOT: $600-
 1500.
Type two, 45 degree: $600-750.
90 Degree finder for type 2: $1200-1600.

Flash Equipment
BCB: $40.
BCB II: $30.
BCB-3: $20.
BC 4, BC 5, BC 6: $10.

Closeup Attachments
For S with f2 or f1.4: $100-150.
For S2, either lens: $125-200.
For SP, either lens: $125-250.

Copy Stands
Model S: $400.
Model SA: $300-350.
Model P: $400.
Model PA: $400.

Special Shades:
21mm: $200.
25mm: $100.
50mm/f1.1: $200.
50mm Micro Collar: $250-300.
85mm/f1.5: $75.
105mm/f4.0: $75.

Miscellaneous:
Bellows attachment: $500-750.
Exposure meter, grey top: $250-300.
Exposure meter, black: $50-150.
Microflex Microscope Units:
 Type one: $500-800.
 Type two: $500-700.
Panorama Head with bubble level: $150.

Nikon F - c1959. First Nikon SLR. FP shutter 1-1000,B. Interchangeable Auto Nikkor lenses. Typical eye-level prism finder. It is hard to believe that this professional workhorse camera is now over 30 years old. Clean: $300-500.

Nikon F Photomic - c1962. The Nikon F with "Photomic" CdS meter prism. Light is read directly by the meter, not through the lens. EUR: $300-450. USA: $200-250.

Nikon F Photomic T - c1965. The Nikon F with "Photomic T" CdS meter prism. The Photomic T has a through-the-lens meter. $125-250.

NIPPON KOSOKUKI SEISAKUSHO (Japan)
Taroflex - c1943. TLR, 6x6cm on 120 rollfilm. Taro Anastigmat f3.5/75mm, NKS 1-200 shutter. $250-400.

NISHIDA KOGAKU (Japan)
Mikado - c1951. Copy of Kodak Duo 620 Series II, 4.5x6cm. Westar Anastigmat f3.5/75mm lens. Northter Model II shutter to 200. $40-60.

Wester Autorol - c1956. Folding bed camera for 6x6cm on 120 film. CRF. Wescon f3.5/75mm in NKK shutter 1-400, B. $35-50.

NITTO SEIKO (Japan)
Elega-35 - c1952. Leica-styled 35mm camera. Eleger or Elega f3.5/45mm screw-mount lens (not interchangeable with the Leica lenses). Rotary shutter 1-200,B. $500-600.

NOMAR No. 1 - Metal box for 127 film. Film spools located behind the plane of focus. Black or green enameled finish. $30-50.

NORISAN APPARATEBAU GmbH (Nürnberg, Germany)
Afex - Small bakelite camera for 25x25mm on standard 828 film. Similar to the Hacon and Nori, but with metal top and bottom plates. $30-40. *Illustrated top of next page.*

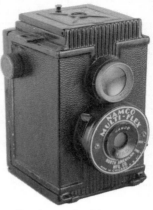

Norisan Afex

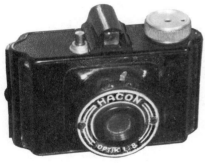

Hacon - c1935. Small bakelite camera for 25x25mm on rollfilm. The same design also appears under the name "Genos", probably after WWII. $30-40.

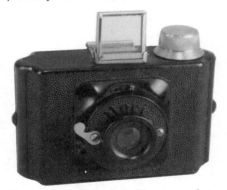

Nori - c1935. Black bakelite camera for 25x25mm exposures on 35mm wide rollfilm. Early version has folding finder. Later version has rigid optical finder. A postwar version was sold under the name "Ernos" by Photoprint A.G. $30-40.

NORTH AMERICAN MFG. CO.
Namco Multi-Flex - c1939. Plastic twin-

lens novelty camera for 16 exposures on 127. Similar to "Clix-O-Flex". $8-12.

NORTHERN PHOTO SUPPLY CO.
Liberty View - c1913. Same camera as the New Improved Seneca View, 8x10". $100-150.

NORTON LABORATORIES *In 1933, Universal Camera Corp. had Norton Labs design a camera. After a falling out between the two companies, Norton continued with the "abandoned" joint project, while Universal set about modifying and producing their own version, the Univex A. See Universal Camera Corp. for related models, including the Norton-Univex.*

Norton - c1934. Cheap black plastic camera for 6 exposures 1⅛x1½" on No. 00 rollfilm on special film spools. The end of the film spool extends outside the camera body and functions as a winding knob. Stamped metal viewfinder on back of body. $20-25.

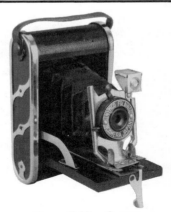

Nymco Folding Camera

421

NOVA - c1938. 3x4cm on 35mm wide rollfilm. Front extends via telescoping boxes. Special Anastigmat f4.5, shutter 25-100. $175-225.

NOVO CAMERA CO.
Novo 35 Super 2.8 - c1950s. 35mm RF. Non-interchangeable Novo Avigon f2.8/45mm. Copal shutter. Lever film advance. $60-75.

NYMCO FOLDING CAMERA - c1938. Low-cost Japanese folding "Yen" camera for 3x5cm cut film in paper holders. Leatherette covered. Simple lens, single-speed shutter. $25-35. *Illustrated bottom of previous page.*

OBERGASSNER (Munich)
Oga - 35mm viewfinder camera. Built-in meter. f2.8/45 lens. $10-20.

Ogamatic - c1960's. 35mm camera with coupled meter. Color Isconar f2.8/45mm in Prontormat shutter. $10-20.

OCEAN OX-2 - c1986. Novelty 35mm from Taiwan, styled with small pseudo-prism. $1-5.

OEHLER (B.J. Oehler, Wetzlar, Germany)

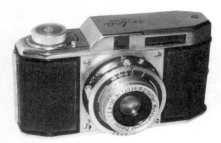

Infra - c1951. Plastic 35mm with metal top and bottom. Extinction meter incorporated in top housing. Punktar f2.8/35mm lens in Prontor 25-200 shutter. 24x24mm. $30-55.

OKADA KOGAKU (abbreviated **OKAKO**)
OKADA OPTICAL WORKS
OKADA OPTICAL INDUSTRIAL CO. LTD. (Tokyo, Japan)
Gemmy - c1950. Pistol-shaped subminiature camera for 10x14mm exposures on 16mm film in special cassettes. Trigger advances film. Fixed focus f4.5/35mm lens. Three-speed shutter. 25,50,100. Current estimate: $600-800.

Kolt - c1950. 13x13mm subminiature from Occupied Japan. Kolt Anastigmat f4.5/25mm. Iris diaphragm. Shutter, B, 25, 50, 100. $150-175.

Waltax (I) - c1940-47. Folding Ikonta-A style camera for 16 exp. on 120 rollfilm. Kolex Anastigmat f3.5/75mm lens in Dabit 1-500 shutter marked OKAKO TOKYO on top. Folding optical finder. Little difference between pre- and postwar models. $50-75. *(See Daiichi Kogaku for other postwar Waltax models.)*

Walz Baby - c1936. Folding strut camera for 16 exp. 3x4cm on 127 film. Similar in style to the Foth Derby, but with front shutter. Walz Anastigmat 50mm/f4.5 in Walz shutter T,B,25-100. Uncommon. $50-100.

OKAM - Czechoslovakia. c1935. Box camera for 4.5x6cm plates. Meyer Helioplan f6/105mm lens in Patent 2 disc shutter 5-1000. Rare. $225-325.

OKAYA OPTICAL WORKS (Japan)
Lord IVB - c1958. 35mm CRF. Highkor f2.8/40mm; Seikosha-MX 1-500,B shutter. $50-75.

OLBIA (Paris)
Clartex 6/6 - Bakelite camera for 6x6cm on 620 film. $20-35.

Olbia BX - Black or maroon bakelite eye-level camera for 6x6cm on 620 film. Identical to the Clartex. Meniscus lens in two-speed shutter. $20-35.

OLYMPIC CAMERA WORKS (Japan)
New Olympic - c1938. Bakelite rollfilm camera for 4x4cm on 127. Ukas f4.5/50mm lens. Shutter 25-150, T,B. $50-75.

Olympic Junior - c1934. Bakelite half-frame 127. Front extends and focuses with bakelite helix. Simple model has folding frame finder; simple lens and shutter like Ruberg cameras. Expensive models have better lens/shutters such as f6.3/50mm helical focus lens in Olympic shutter 25, 50,B. $75-100. *Illustrated top of next page.*

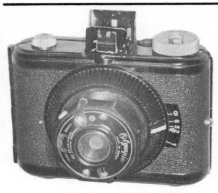

Olympic Junior, simple model

cameras. *Although Olympus has made many cameras which are not far from the mainstream, they have also made several notable products which set them apart as an innovative company. Olympus has often managed to squeeze the full functions of a quality camera into a smaller and lighter body. In addition to their light and compact full-frame models, one can't help but think of the half-frame "Pen" cameras which were so popular in the 1960s and '70s.*

We are listing these cameras basically in a chronological fashion. However, when a particular type of camera is introduced, we have tried to keep its successors with it in order to show the development of the various lines of cameras. We are indebted to Dominique & Jean-Paul Francesch for their research and photographs used in this section. For further reference on Olympus we highly recommend their book "Histoire de L'Appareil Photographique Olympus de 1936 à 1983".

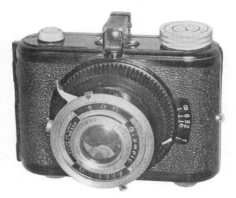

Olympic Junior, expensive model

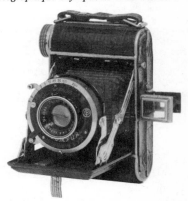

Semi-Olympic - c1937. 4.5x6cm on 120. Bakelite body. Ukas f4.5/75mm lens. Shutter 25-150, T,B. $50-75.

Super-Olympic - c1935. The first Japanese 35mm. Bakelite body. f4.5/50mm lens. Shutter 25-150, T,B. $100-200.

Vest Olympic - c1938. Telescoping metal tube front. Half-frame on 127 rollfilm. Similar to Ruberg Baby Ruby. Ukas f4.5/75mm Anastigmat. Shutter 25-150,T,B. $40-60.

OLYMPUS KOGAKU (Japan)
Olympus was founded on October 12, 1919 as Takachiho Seisakusho with the intention of building the first Japanese microscopes. Its first microscope was marketed in 1920, and since that time, the company has always kept close to medical technology, as evidenced by its 1951 introduction of the world's first gastro camera. The first camera was the 1936 "Semi-Olympus", a bellows-type folding camera. The company name changed in 1942 to "Takachiho Kogaku Kogyo Co., Ltd." and again in 1949 to "Olympus Optical Co., Ltd.", adopting the name of its

Semi-Olympus Model I - 1936. Using a Japanese-made Zuiko f4.5/75mm lens in an imported Compur rimset shutter, this vertically styled folding bellows camera for 16 exposures on 120 film began the long line of Olympus cameras. The second variation (1937) used a Japanese-made Koho shutter to 1/150. Folding optical finder. Rare. $300-450.

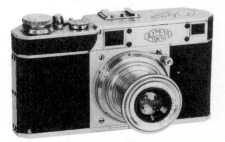

Olympus Standard - 1937. Unusual 127 film rangefinder camera, 4x5cm. Styled like the 35mm rangefinder cameras of the day,

423

with interchangeable lenses. Only 10 examples made. Extremely rare. If you see one for sale, be prepared for a bidding battle with a dozen Samurai warriors.

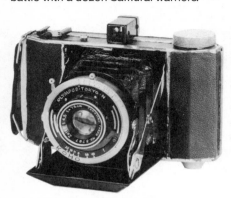

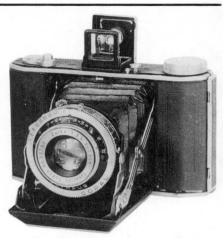

Semi-Olympus Model II - 1938. The first Olympus camera made entirely in Japan. Camera body is now horizontally oriented and has a rigid finder rather than a folding one. Accessory shoe. Body and bellows are large enough to have been made for 6x6cm, but the format remains 4.5x6cm. Zuiko 75mm f4.5 in Koho to 150. $250-375.

Olympus Six (Postwar) - 1946-48. Made from pre-war parts. Identical to the pre-war f3.5 version except that the lens has 4, not 5, elements. It can only be distinguished by removing and examining the front lens. Takachiho's Hatagaya plant which made the Koho shutters had been destroyed in April 1945, so when the existing stock of Koho shutters ran out, the Copal shutter from Copal Koki Co. was used. $60-100.

Olympus Chrome Six - *There are a number of variations of the Chrome Six, none of which are adequately identified on the camera body. In fact, they say "Olympus Six" without the word "chrome". The "Chrome" Six series can be identified by their chrome top plate or top housing, and rigid tube finder rather than folding optical type found on the pre-war design. The bodies are diecast rather than stamped metal. All are dual-format for 6x6cm or 4.5x6cm on 120 film. For quick identification: Chrome Six I, II, III have tubular finder above top plate. I has f3.5 lens; II*

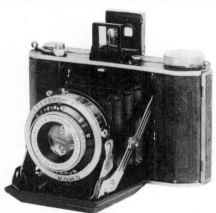

Olympus Six - 1939, 1940. Horizontally styled self-erecting bellows camera for 6x6cm on 120. Although the design reverted to a folding finder and the accessory shoe disappeared, this new model went to the larger square format, and added a body release for the Koho shutter. The 1939 model has the same 4-element lens as the earlier Olympus cameras, while the 1940 model introduced new 5-element Zuiko 75mm f4.5 and f3.5 lenses. (Late wartime lenses designated "S Zuiko" are of this 5-element design). Koho shutter to 200. $150-175.

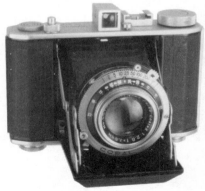

Olympic Chrome Six II

has f2.8; III has flash sync post on shutter, heavy machined accessory shoe. Chrome Six IV, V, RII have finder integrated in top housing.

Chrome Six I - 1948-50. Combines the best features of the Semi-Olympus Model II (rigid tube finder and accessory shoe) and the Olympus Six (f3.5 lens and body release). Copal 1/200 shutter. $75-125.

Chrome Six II - 1948-50. Same as Chrome Six I, but with f2.8 lens. $75-125. *Illustrated bottom of previous page.*

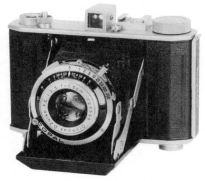

Chrome Six III - 1950-54. Improved version of I/II above. Synchronized shutter; heavy machined accessory shoe; back-tensioned supply spool for better film flatness. With f3.5 lens it is IIIA; with f2.8 it is IIIB. $60-100.

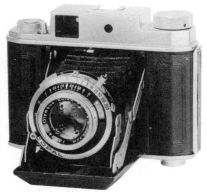

Chrome Six IV - January-November 1954. Built-in uncoupled rangefinder with tiny unadorned circular window in the center of the top housing. Viewfinder is at the right end of the top housing, next to shutter release. Only Olympus Six with both rangefinder and knob advance. The later model RII has lever advance. With f3.5 it is IVA; with f2.8 it is IVB. Uncommon. Made for less than a year. $75-125.

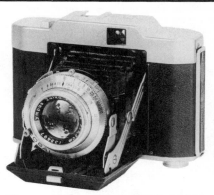

Chrome Six V - January-October 1955. Characteristics: Full top housing but no rangefinder; lever advance, so no knobs on top. With f3.5 = VA; with f2.8 = VB. Although made for a shorter time than the Chrome Six IV, the V was made in larger quantities and is easier to find. $60-100.

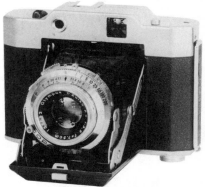

Chrome Six RII - 1955-57. Rangefinder built into top housing. Lever advance. First issued with the same Copal 1/200 shutter used on the other Chrome models. In 1956, this was increased to 1/300. RIIA = f3.5; RIIB = f2.8. $60-100.

Olympus Twin Lens Reflex Cameras - *Although the Rolleiflex had been around since 1929, and Minolta had produced its first TLR in 1937, it wasn't until after WWII that the demand for 6x6 TLR cameras became epidemic. The 1950's saw Rolleicord copies flooding from the land of the rising sun. Olympus had better manufacturing facilities available, since many of the others were assembled in rather spartan little shops. Although the basic design still leans heavily toward Franke & Heidecke, Olympus made a few positive changes. Like Rolleicord, Olympus used a right-hand focus knob, but raising the shutter release to the midpoint of the front allowed focusing with the right hand while the trigger*

finger remained ready to shoot. Some features such as bayonet mounts were intentionally made to match the popular Rollei cameras.

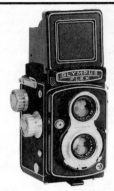

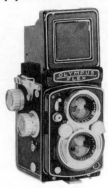

Olympus Flex A3.5II

Olympus Flex B I - 1952. The first TLR from Olympus and the first Japanese TLR with f2.8 viewing and taking lenses. Zuiko 75mm f2.8 taking lens (6 elements in 4 groups) and similar viewing lens (4 elements in 3 groups). Seikosha-Rapid shutter 1-400. $100-150.

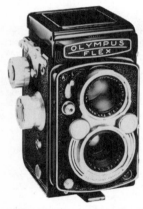

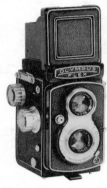

Olympus Flex A3.5 - 11/54-8/56. In addition to simplified setting levers, this first version of the A also eliminated the double bayonets in favor of a simpler threaded mount for lens accessories. D-Zuiko f3.5 in Seikosha-Rapid 1-500. $60-100.

Olympus Flex BII - 1953-55. Similar to the BI, but with Rollei-style focus magnifier, click-stops on shutter & aperture settings. $75-125.

Olympus Flex A - *A lower cost version of the B series, introduced in the wake of poor sales brought about by three major factors: The improved Rolleiflex cameras took a better market share; the American occupation of Japan ended; and the Korean war ended. Since American soldiers had been heavy purchasers of TLR's, their reduced numbers had a parallel effect on sales. The economized A series eliminated the small knurled knobs for shutter and aperture setting and used levers at each side of the shutter housing.*

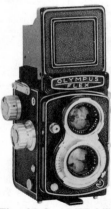

Olympus Flex A2.8 - 11/55-8/56. An

upgraded model, introduced a year after the A3.5. Besides the obvious f2.8 lens, this model also brought back the bayonets, though retaining the levers to set shutter and aperture. On the market for less than a year, it is not too common. $75-125.

Olympus Flex A3.5II - 6/56-9/57. The last Olympus TLR and their last camera for 120 film. Like the earlier A3.5, it had levers for shutter & diaphragm. But it used bayonets for lens accessories, and is the only Olympus TLR with MFX selection lever for flash sync. $60-100. *Illustrated top of previous page.*

OLYMPUS PEN HALF-FRAME CAMERAS

There are 19 models of the compact half-frame Pen cameras, plus four reflex models of the "F" series. The compacts were made for over 20 years, from 1959 into the 1980's. The concept of a camera that could be carried and used as easily as a writing instrument was the inspiration for the name. The instant success of the new half-frame series caused a boom in half-frame cameras in Japan during the 1960's. Although a number of earlier 35mm cameras had used the single- or half-frame format, they had appeared at a time when medium and large formats still held a large market share, and 35mm was still considered "small format". By the late 1950's, the 24x36mm frame was considered more standard than small, and 35mm cameras had gotten larger and heavier. This, plus better available films made a compact half-frame camera more appealing.

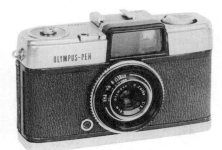

Pen - 10/59-11/64. This first model of the Pen series was not originally manufactured by Olympus. It was produced by a subcontractor, but tested and shipped by Olympus. (Olympus began production in its own Suwa plant in 1960 with the Pen S.) Zuiko 28mm f3.5 lens in Copal X shutter (25 50 100 200 B). $35-55.

Pen S 2.8 - (1960-64)
Pen S 3.5 - (1965-67)
Similar to the original Pen, but Zuiko 30mm f2.8 lens; Copal X shutter with standardized speeds (8 15 30 60 125 250 B). The second model of the Pen S with a 30mm f3.5 lens appeared at the time the original Pen was

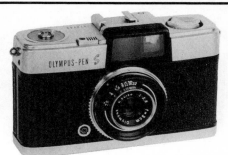

discontinued. It is basically the same except for the shutter speeds. $20-35.

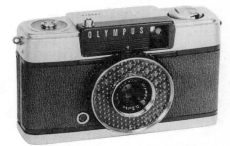

Pen EE - 8/61-5/63. The EE, of course stands for the large Electric Eye which surrounds the fixed-focus 28mm f3.5 lens. Today we would call this a point-and-shoot camera, and for that reason coupled with its original price below $50, it sold in record numbers. Common. $20-35.

Pen EES - 1962-68. Improved version of the EE, with f2.8/30mm zone-focusing lens. Cost $60 new. $30-45.

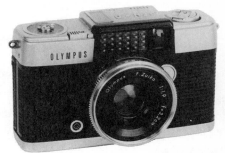

Pen D - 1962-66. Advanced model with fast Zuiko f1.9/32mm. Copal-X shutter 1/8-500,B. Built-in meter with readout on top of camera. Sold for $70 at the time. $40-60.

Pen D2 - 1964-65. Like the Pen D, but with CdS meter instead of selenium type. Was $80 new. $45-65.

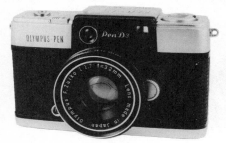

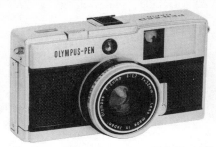

Pen D3 - 1965-69. Took over from the D2 with a slightly faster f1.7 Zuiko lens. $50-70.

Pen Rapid EED - 9/65-5/66. The "Rapid" cassette version which preceded the standard Pen EED. Very Rare. $100-150.

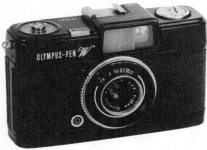

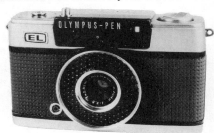

Pen W (Wide) - 1964-65. All black version of the Pen S body, but fitted with a 25mm f2.8 wide angle lens. Although it sold for under $50 when new, it is rather hard to find one these days. We have recorded sales up to $250, but most have been in the range of $60-80.

Pen EE-EL, Pen EES-EL - 1966-68. Same as Pen EE, but with takeup spool slotted in four places and with a tooth at the bottom of each slot to engage the film for faster loading. This change was dubbed "Easy Loading" and there is a small "EL" sticker on the front of the camera (unless it has fallen off.) Prices same as regular models of EE and EES: $20-45.

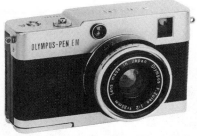

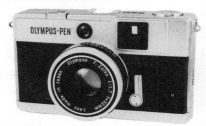

Pen EM - 1965-66. Motorized film advance and rewind. F.Zuiko 35mm f2 lens. Subject to problems with the motor drive. Variation: with flash shoe. $40-60.

Pen Rapid EES - 1965-66. Essentially the same as the regular Pen EES, but rather than standard 35mm cartridges, it was built to accept the Agfa-Rapid cassette which required no rewinding. Unfortunately, the "Rapid" system never gained worldwide popularity, and so the cameras made to use this film didn't break sales records either. $60-80.

Pen EED - 1967-72. Automatic CdS metering with shutter speeds $\frac{1}{15}$-500 and f1.7 lens. Low light warning in viewfinder. Easy load system. $30-55.

Pen EES2 - 1968-71. Automatic exposure controlled by meter cell around lens. Zone focus. D.Zuiko f2.8/30mm lens. $20-35. *Illustrated top of next page.*

Pen EE-2 - 1968-77. Fully automatic regulation of shutter & diaphragm, fixed focus f3.5/28mm lens, and compact size made this a very popular camera to keep in a pocket. $20-30.

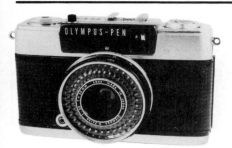

Olympus Pen EES2

Pen EE-3 - 1973-83. Essentially identical to the Pen EE-2. $20-30.

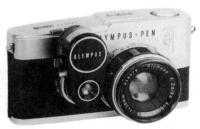

Pen F - c1963-66. The first 35mm half-frame SLR. Porro-prism allows streamlined design without roof prism. New rotary focal plane shutter synched to 1/500. Lever cocks shutter on first stroke, advances film on second. Bayonet-mount normal lenses include Zuiko f1.4/40mm and Zuiko f1.8/38mm. An accessory meter mounted to the shutter speed dial via bayonet. Common. EUR: $90-170. USA: $80-140.

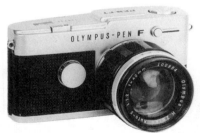

Pen FT - c1966-72. An improved version of the Pen F, incorporating CdS meter, single stroke lever advance, and self-timer. With f1.8/38mm normal lens. Black model: $250-300. Chrome model is very common. EUR: $200-250. USA: $75-150.

Pen FV - 1967-70. A compromise between the F and FT. Single-stroke lever, self-timer, but no built-in meter. Accepts external accessory meter. Less common than the others. $125-175.

PEN F ACCESSORIES
20mm 3.5 G Zuiko Auto W - $130-170.
25mm f2.8 G Zuiko Auto W - $130-150.
25mm f4 E Zuiko Auto W - $80-130.
38mm f1.8 F Zuiko Auto S - $35-55.
38mm f2.8 Compact - $125-200.
38mm f3.5 Macro - $150-225.
40mm f1.4 G Zuiko Auto S - $50-90.
42mm f1.2 H Zuiko Auto S - $80-110.
60mm f1.5 G Zuiko Auto T - $100-150.
70mm f2 F Zuiko Auto T - $100-150.
100mm f3.5 E Zuiko Auto T - $85-125.
150mm f4 E Zuiko Auto T - $75-130.
250mm f5 E Zuiko T - $175-225.
400mm f6.3 E Zuiko T - $500-1000.
800mm f8 Zuiko Mirror T - $400-700.
50-90mm f3.5 Zuiko Auto Zoom - $100-140.
100-200mm f5 Zuiko Zoom - $150-250.
Bellows - $20-35.
CdS Meter for F, FV - $40-60.

OLYMPUS 35 CAMERAS *The first 35mm cameras from Olympus began with a prototype designed by Mr. Eiichi Sakurai in 1947. This prototype is called Olympus 35, and its commercial result is Olympus 35 (I). Since most of the Olympus 35 series cameras are identified on the body simply as "Olympus 35", it is important to consider the features for proper identification.*

Quick Identification Features:
I & III - *External linkages from shutter to body. Right hand side has rectangular housing over body release linkage. Opposite side has a pin through a curved slot in the body. I=24x32mm; III=24x36mm.*
IV - *Front of camera has no external linkages, but top plate still has knobs & finder above it. IVa=Copal; IVb=Seikosha-Rapid.*
V - *Streamlined top housing incorporates finder. Va=f3.5; Vb=f2.8.*
K - *Rangefinder; Copal to 500.*

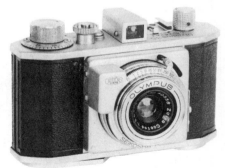

Olympus 35 I - 1948-49. Essentially the same as the 1947 prototype but improved finish. Takes 24x32mm exposures, which led to its demise in favor of the standard 24x36mm. Zuiko f3.5/40mm in Seikosha-Rapid. $50-75.

Olympus 35 II - 1949. Prototypes only. Not released.

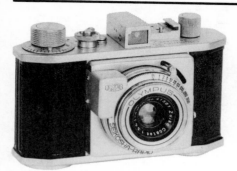

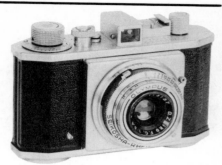

Olympus 35 III - 1949-50. The first 24x36mm from Olympus. Zuiko f3.5/ 40mm in Seikosha-Rapid. In addition to the format, it can be told from model I by a machined rather than stamped metal accessory shoe, and by a round knob instead of a lever to open the back. Made for only a few months, so not commonly found. $40-60.

Olympus 35 IVb - 1954-55. As Model IVa, but with Seikosha-Rapid 1-500. (No longer externally linked as on models I & III). Flash sync is PC type on shutter, not ASA type on body. $30-50.

Olympus 35 Va - 1955. Restyled top housing with incorporated finder. Hinged, not removable, back. Copal 1-300 shutter with self-timer. $20-35.

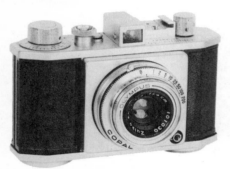

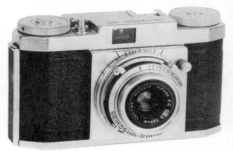

Olympus 35 IV - 1949-53. Copal B, 1-200 inter-lens shutter replaces the behind-lens Seikosha-Rapid of earlier models. ASA flash synch post on front. "Made in Occupied Japan" branded into leather. $30-50.

Olympus 35 Vb - 1955. Same as Va, but with Seikosha-Rapid 1-500. A bit less common. $20-35.

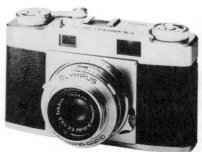

Olympus 35-S, first type

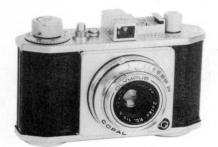

Olympus 35 IVa - 1953-55. As model IV, but shutter to 300 and marked "Made in Japan", not "Occupied Japan". $25-40.

Olympus 35-S - 1955-58. Improved body incorporates RF in top housing; film advance lever also cocks shutter. First type has V-shaped focusing knob, lacks crank on rewind knob, has Seikosha-Rapid shutter with f3.5 or f2.8 lens. Second type, available

in f3.5 or f2.8 (also f1.9 from 1956-57), has round focusing knob, folding rewind crank, and Seikosha MX shutter. $30-50.

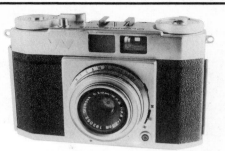

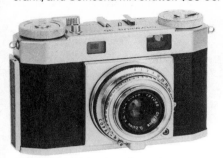

Olympus 35-K - 1957-59. RF 35, styled much like the 35-S series. "Olympus 35" on the top doesn't give much clue to its model, but it can be easily recognized by its focusing ring near the front of the lens, rather than next to the body. The coupling between the lens and the rangefinder is in a small housing below the lens. It sports a Copal 1-500 shutter, whereas earlier cameras marked simply "Olympus 35" had no RF and their Copal shutters went only to 300. $30-50.

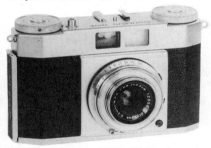

Olympus Wide - 1955-57. Basic scale-focus camera with f3.5/35mm wide-angle lens. $30-50.

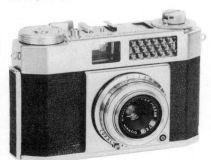

Olympus Wide E - 1957-58. Improved version of the Olympus Wide incorporating selenium meter and lever wind. $40-60.

Olympus Wide II - 1958-61. Like Olympus Wide, but with lever advance, and folding crank on rewind knob. The positions of the finder and bright-frame windows are reversed from the original model. Some have "W" embossed on the front of the top housing; later ones do not. Not exported to Europe, so less common there than in Japan or the USA. $30-50.

Olympus Wide S - 1957-58. Best of the Wide series. Coupled RF; fast f2/35mm lens in Seikosha-Rapid to 1/500. $40-60.

Olympus 35-S II - 1957-59. *Based on the Olympus Wide S body, this series marked "Olympus 35-S" can be distinguished from the earlier 35-S models by the 3 window front.*

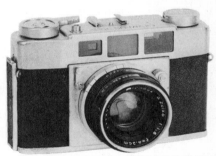

- f1.8 (first version) - 1957-58. Self-timer lever on front below shutter button.

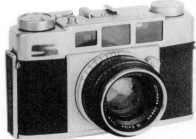

- f1.8 (second version) - 1958. Lacks self-timer; has stylized "S" on front of top housing.

OLYMPUS (cont.)

- **f2.8** - 1957-1959. E.Zuiko f2.8/45mm lens. More common than the other models.
- **f2** - 1958-1959. Despite the 10 month production period, the f2 model is difficult to find.

With the exception of the first f1.8 version, none of these have self-timer, and all share the same basic body. Current values: f2: $40-60. f1.8: $40-60. f2.8: $25-40.

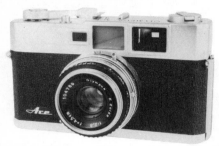

Olympus Ace - 1958-60. The first attempt by Olympus to market an interchangeable lens RF camera. (The 1937 Standard was never marketed.) Bayonet lenses include: E.Zuiko 45mm/f2.8, 35mm/f2.8, & 80mm/f5.6. Less common with all three lenses: $200-250. With normal lens only: $50-75.

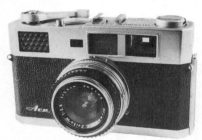

Olympus Ace E - 1958-61. Improved "Ace" with match-needle metering. With 3 lenses: $200-250. With normal lens: $60-85.

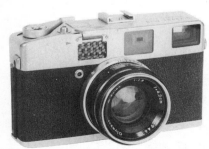

Olympus Auto - 1958-59. Contemporary with the original Ace, the Auto featured metering but fixed 42mm/f1.8 lens. Choice of aperture or shutter priority. $30-55.

Olympus Auto B - 1959-60. Lower-priced version of the Auto, with f2.8 lens and lacking the cover for the meter cell. $30-50.

Olympus Auto Eye - 1960-63. An advanced camera for its day. Automatic shutter-priority metering with diaphragm readout in viewfinder. Flash exposures determined by "Flash-matic" system. D.Zuiko 45mm/f2.8 in Copal SV to 500. $60-90.

Olympus Auto Eye II - 1962-63. Simplified version of Auto Eye, without "Flashmatic" system. D.Zuiko 43mm/f2.5 lens. $60-90.

Olympus-S "Electro Set" - 1962-63. Rangefinder; selenium meter. G.Zuiko 42mm/f1.8 lens. $30-60.

Olympus-S (CdS) - 1963-65. Similar to the previous model, but with round CdS

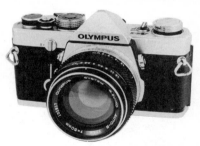

Olympus M-1

meter cell rather than rectangular "beehive" selenium cell. $30-60.

For this edition, we have chosen the arbitrary date of 1965 to cut off our listings of Olympus 35mm RF cameras in order to include some of the earliest Olympus SLRs.

OLYMPUS 35MM SLR CAMERAS

Despite their long history and numerous 35mm cameras, Olympus did not enter the full-frame SLR market until 1971. The Pen F had virtually created the half-frame 35mm SLR market eight years earlier. The first full-frame SLR, the TTL, was a rather ordinary screw-mount camera. The OM-1 which replaced it within two years was truly a masterpiece. In this collectors guide, we are listing only the first two Olympus SLRs. The later ones definitely are more usable than collectible.

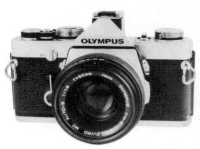

Olympus OM-1 - 1973-74. Weighing in at only 660 grams, accepting a full range of bayonet-mount lenses & interchangeable screens, and introducing a quiet shutter all improved the first impression of the OM-1 as it entered a world of more experienced and reputed cameras. Its lenses are still usable on more current Olympus cameras, and the OM-1 itself is still primarily a usable camera. We include it in the collectors guide only because it ranks a solid position in the design evolution of 35mm SLR cameras. With normal 50mm/f1.8 lens: $75-135.

OMI (Ottico Meccanica Italiana, Rome)

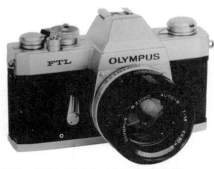

FTL - 1971-72. Interchangeable 42mm screw-mount lenses included: 50mm f1.4 & f1.8 normal lenses plus 28mm/f3.5, 35mm/f2.8, 100mm/f3.5, & 200mm/f4. Other accessories were also available for this short-lived system. With normal lens: $50-75. *Add $20-40 each for extra lenses.*

Olympus M-1 - c1972. 35mm SLR introduced at Photokina in 1972. The original model designation "M-1" (already registered by Leica since 1959) was quickly changed to "OM-1". Very few were marked "M-1". FP shutter 1-1000,B. $200-300. *Illustrated top of next column.*

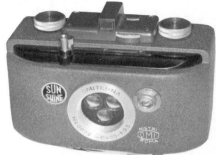

Sunshine - c1947. Small three-color camera/projector. A few years ago, these sold for about $3000, since only a few were known to exist. Since that time, more have

surfaced and we have seen them offered as new, in box, for as low as $500 from 1984 to 1986. Auction sales have been in the $240-500 range.

OMO (U.S.S.R.)

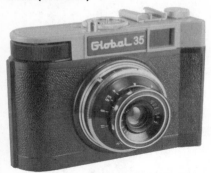

Global 35 - Black bakelite 35mm camera of simple but attractive design. f4/40mm lens; B, 15-250 shutter. Also sold as Smena 6. $15-25.

O.P.L.-FOCA (Optique et Précision de Levallois S.A., France) *This company manufactured precision instruments such as machine guns and marine rangefinders for national defense. In 1938 they decided to make an entirely French precision camera to compete with the German Leica and Contax. The war brought the camera project to a halt because of military priorities. However, during the German occupation, the project was undertaken again and the first Foca cameras were ready in late 1945.*

Foca () (1945 type) -** 1945 only. This is the earliest of the Foca models, and rather rare. However, not all two star models are from 1945. (The common model PF2B of 1947 also has two stars on its nameplate.) The 1945 type has several identifying charactistics:
1. The two stars are printed, not engraved, on the nameplate. 2. Tall shutter knob; stem is as tall as knurled top part. 3. Speeds 20-500, not 25-1000. 4. Leather covering may be brown or black. $150-200.

Foca (*) (1946 type) - 1946 only. Simplified replacement for the (**) of 1945. No rangefinder. Fixed, non-interchangeable lens. That is its easiest recognition point. The lens flange and mounting screws are clearly visible. The single star on the nameplate is printed, not engraved as on the "Standard". This is probably the rarest of the Foca cameras. Foca f3.5/3.5cm lens. Shutter 20-500. $175-225.

Foca () PF2B -** c1947-late 1950s. Similar to the (**) of 1945, but shutter speeds 25-1000. While the very earliest ones still had

no sync, most had two posts for M & X at the left hand side of the top housing. It can also be distinguished from the 1945 version of the (**) by its nameplate on which the stars are engraved rather than printed. $75-100.

Foca PF2B Marine Nationale - A short series of PF2B's were made with the "Marine Nationale" name on the small front nameplate in lieu of the two stars. Some were covered with blue leather and some were black. Relatively rare, none exceeding three digit serial number. $200-250.

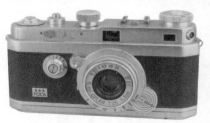

Foca (*) PF3, PF3L -** Easily recognized by the three stars on the front plate, the PF3 is like a PF2 but with a slow speed dial added to the front. PF3L has lever advance rather than knob. $100-150.

Foca Universel, Universel R - c1948. The earlier Foca models had removable lenses, but only the normal lens coupled with the rangefinder. The Universel allowed a full line of bayonet-mount lenses from 28mm to 135mm to couple with the rangefinder. From the exterior, it appears much like the others, though it has no stars on its nameplate. Slow speed dial on front. Earliest models had no sync. Later ones had dual posts. Universel R has lever advance. With normal lens: $75-125. *Add $50-60 for each extra lens.*

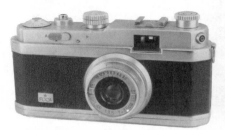

Foca Standard (*) - c1947-1970's. No rangefinder. Replaced the single star model of 1946 (fixed lens). The Standard has interchangeable screw-mount lenses, and has a single engraved (not printed) star on the nameplate. Shutter 25-500. Earliest models not synchronized. Later with dual posts. The most common of the Foca cameras. $80-120.

Foca Marly - Simple plastic camera for 4x4cm on 127 film. Built-in flash. Fixed focus Meniscus lens. Single speed shutter. $10-20.

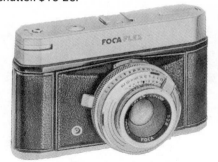

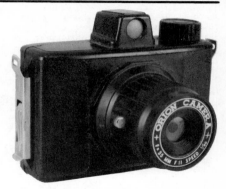

Focaflex - c1960. Unusually styled 35mm SLR. By using a mirror instead of a prism, the top housing does not have the familiar SLR bulge. Styling is very much like the rangefinder cameras of the same era, but without any front windows on the top housing. Oplar Color f2.8/50mm lens; front element focusing; fixed mount. Leaf shutter B, 1-250. $150-200.

Focaflex II - c1962. Upgraded version of the Focaflex. Interchangeable lenses in helical focusing mounts include: Néoplex f2.8/50mm, Retroplex f4/35mm, and Téléoplex f4/90mm. Prontor Reflex shutter. With normal lens: $275-225.

Focaflex Automatic - c1962. Similar to the original Focaflex, but built-in meter automatically controls diaphragm and gives arrow in finder. Oplar-Color f2.8/5cm lens. $75-125.

Focasport - c1955-. Compact 35mm. Many variations: some with meter, some with rangefinder. Later versions have a rectangular shape instead of the normal 35mm appearance. Most commonly found with Neoplar f2.8/45mm lens, Atos-2 1-300 shutter. $30-45.

OPTIKOTECHNA (Prague and Prerov, C.S.S.R.)
Flexette - c1938. TLR for 6x6cm on 120 film. This is the renamed Kamarad II, formerly manufactured by Bradac. Trioplan f2.9/75mm lens in Compur 1-250. $75-125.

Spektareta - c1939. Three-color camera, for 3 simultaneous filtered exposures on 35mm film. Body is styled like a movie camera. Spektar f2.9/70mm. Compur 1-250 shutter. $3000-3500.

ORION CAMERA, MODEL SIMPLICITE - Plastic novelty camera from Hong Kong. 3.5x4cm on 127. $4-8.

ORION CAMERA, No. 142 - Plastic novelty camera from Hong Kong. 3x4cm on 127. $4-8.

ORION WERK (Hannover)
Daphne - Vest pocket rollfilm camera. F. Corygon Anastigmat f6.3/85mm in Pronto. $20-30.

Orion box camera - c1922. Meniscus f17 lens, simple shutter. For 6x9cm glass plates. $50-60.

Rio 44C - c1921-25. Horizontally styled folding bed camera for 9x12cm plates. Typically with Corygon f6.3 in Vario or Helioplan f4.5/135mm in Compur 1-200. Uncommon. $50-75.

Rio folding plate cameras - c1923. 6.5x9, 9x12cm, and 10x15cm sizes. Leather covered wood body with metal bed. f4.5 or f6.3 Meyer Trioplan, Helioplan, or Orion Special Aplanat. Vario or Compur. $40-80.

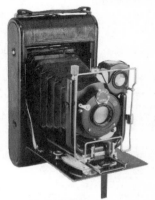

Rio 84E, 8x10.5cm

Rio folding rollfilm cameras - Individual models are difficult to identify, since many variations were produced but not generally marked with model number. Most common in the 6x9cm and 8x10.5cm sizes. $50-90.

435

Tropen Rio 2C, 5C - c1920. Folding-bed 9x12cm plate cameras. Teak and brass. Brown double extension bellows. Model 5C is like 2C but with slightly wider front standard to accomodate faster lenses in larger shutter. Model 2C normally with f6.3 or f6.8 lens. Model 5C typically with Tessar or Xenar f4.5/150mm lens in Compur shutter 1-150. $275-400.

O.T.A.G. (Österreichische Telefon A.G. Vienna, Austria)
Amourette - c1925. Early 35mm for 24x30mm exposures using special double cassettes. Trioplan f6.3 lens. Early model has Compur shutter 25, 50, 100. Later, c1930, with Compur to 300. $175-275.

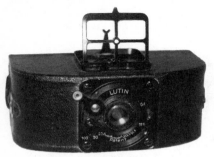

Lutin - Nearly identical to the better known Amourette. $200-325.

OTTEWILL (Thomas Ottewill, London)
Sliding-box camera - c1851. Mahogany wet-plate camera in 9x11" size. Camera is completely collapsible when front and back panels are removed. Ross or Petzval-type lens. $6000-8000.

OWLA KOKI (Japan)
Owla Stereo - c1958. For stereo pairs 24x23mm on 35mm film. Owla f3.5/35mm lenses. Shutter 10-200,B. $150-200.

PACIFIC - Japanese novelty subminiature of the "Hit" type. $10-15.

PACIFIC PRODUCTS LTD. (Hong Kong, Los Angeles, Taipei)
Lynx PPL-500XL - c1986. Inexpensive novelty 35mm camera. $1-5.

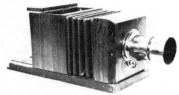

PALMER & LONGKING
Lewis-style Daguerreotype camera - c1855. ½-plate. $5000-7000.

PANAX - Plastic novelty camera of the "Diana" type. $1-5.

PANON CAMERA CO. LTD. (Japan)
Panon Wide Angle Camera - c1952. 140 degree panoramic camera, 2x4½" exp. on 120 rollfilm. Hexar f3.5/50mm or Hexanon f2.8/50mm. Shutter 2, 50, 200. $700-900.

Panophic - c1963. 140 degree panoramic camera. 6.5x12cm exposures on 120 film. f2.8/50mm; shutter ⅛, 60, 250. $950-1400.

Widelux - c1959- current. Panoramic for 24x59mm images on standard 35mm film. Lux f2.8/26mm lens. Also sold under the Kalimar label. Various models, including FV, F6, F6B, F7. The F7 has been in production since about 1975. Main value as usable, not collectible, camera. $400-500.

PAPIGNY (Paris)
Jumelle Stereo - c1890. For 8x8cm plates. Magazine back. Chevalier f6.5/100 lenses. Guillotine shutter. $175-225.

PARIS (Georges Paris) *Cameras used the name GAP, from the manufacturer's initials.*

GAP Box 3x4cm - ca late 1940's. Small

box camera shaped somewhat like the Zeiss Baby Box. Available black painted, black leather covered, or with decorative front panels in gold, blue & gold, or red & gold. $25-40.

GAP Box 6x9cm - c1947. Metal box camera, normally with black leatherette covering but occasionally found with marbled colors. 6x9cm on 120 film. $15-20.

PARK (Henry Park, London)
Tailboard cameras - c1890's. Park sold a variety of field and studio cameras in ½-plate, full plate, and 10x12" sizes. Mahogany construction with brass trim. With comtemporary brass-bound lens, these have recently sold in the range of $160-260.

Twin Lens Reflex - c1890. Large wooden TLR with separate viewing and taking bellows. Rack and pinion focus. Taylor, Taylor & Hobson 5" lenses with wheel stops. $1200-1500.

PARKER PEN CO. (Janesville, Wisc.)

Parker Camera - c1949. Plastic submini-

ature for 8 images, 13x16mm on a 147mm strip of unperforated 16mm film in a special cylindrical cassette. Parker Stellar f4.5/37mm lens in rotary shutter, 30-50. At least 100 cameras were used in a test marketing study by Parker and a Chicago advertising firm. At one time they were presumed to have been destroyed, and only a few examples were known to exist. The collectible value reached a $750-1000 range. Currently these are hard to find and they bring $500-700.

PCA (Photronic Corp. of America)
Prismat V-90 - c1960-63. 35mm SLR made by Mamiya. Bayonet mount Mamiya-Sekor f1.9/48mm lens. Leaf shutter 1-500, B. Coupled match-needle selenium meter on pentaprism front. $60-100.

PDQ CAMERA CO. (Chicago)
PDQ Photo Button Camera - c1930. All-metal button tintype camera. Echo Anastigmat lens. $750-900.

Mandel Automatic PDQ, Models G & H - c1935. Large street camera for 6x9cm exposures rolls of direct positive paper. RR f6/135mm lens. Built-in developing tank with tubes to change solutions. $175-300.

PEACE - c1949. Early "Hit-type" camera with cylindrical finder. Simple fixed-focus lens; B & I shutter. $150-225.

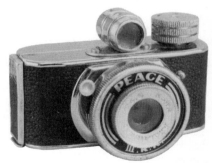

PEACE III - c1950. Similar to the earlier version, but with Kowa f4.5 lens, R.K. shutter, different back latch. $125-175.

PEACE, PEACE BABY FLEX - c1949. Japanese reflex style subminiatures for 12x14mm on rollfilm. Fixed focus lens, B,I shutter. $500-700.

PEARSALL (G. Frank E. Pearsall, Brooklyn, NY)
Compact - c1883. First camera to use the basic folding camera design, used by most American folding plate cameras into the 1920's. Full plate size. Only one known sale, in 1981, for $3200.

PECK (Samuel Peck & Co., New Haven, Conn.)
Ferrotype, 4-tube camera - c1865. Takes ⅑ plate tintypes. $800-1200.

Wet-plate camera - c1859. Full plate size. $900-1200.

PEER 100 - Camera disguised as a package of cigarettes. The camera is a Kodak Instamatic 92 or Instamatic 100 camera within a plastic outer housing which resembles a package of Peer 100 cigarettes. $200-250.

PEERLESS MFG. CO.
Box camera - Early paperboard box camera for single 2½x2½" glass plates. $60-90.

PENROSE (A.W. Penrose & Co. Ltd., England)
Studio camera - c1915. 19x19". $250-350.

PENTACON (VEB Pentacon, Dresden, Germany) *At the end of WWII, as the U.S. troops mooved out of Jena & Dresden and the Russians moved in, many of the Zeiss-Ikon personnel moved out with the American troops and set up a second Zeiss-Ikon operation in the former Contessa factory in Stuttgart, where they continued making rollfilm cameras (Ikonta, etc.) which had always been made there. Some Carl Zeiss Jena staff moved west to Oberkochen. The machinery and dies for the Contax II and III cameras were moved to Russia. Despite these* handicaps, *production started again shortly after the war at Zeiss-Ikon in Dresden. Ercona (continuation of Ikonta), Tenax I, and soon the new Contax S were produced. After much dispute with the West German operation at Stuttgart, the Zeiss Ikon and Contax names were relinquished completely. In 1959, various Dresden and Sachsen firms reorganized as VEB Kamera und Kinowerke Dresden. In 1964, after absorbtion of VEB DEFA, the result was VEB PENTACON. In 1968, the combination of VEB Feinoptisches Werk Görlitz and VEB Pentacon resulted in KOMBINAT VEB PENTACON DRESDEN.*

Astraflex Auto 35 - c1965-71. Same as the Pentacon F. $50-75.

Consul - c1955. Rare name variation of the Pentacon (Contax-D). Identical except for the factory-engraved Consul name. $125-175.

Contax D - c1953. 35mm SLR. Standard PC sync on top. Zeiss Jena Biotar f2, or Hexar or Tessar f2.8. FP shutter to 1000. Four or five variations. Last version has auto diaphragm like Contax F, but is not marked F. Clean and working: $75-125.

Contax E - c1955. Like the Contax D, but with uncoupled selenium meter built onto prism. $100-150.

Contax F - c1957. Same as the Contax D, but with semi-automatic cocking diaphragm. Clean & working: USA: $75-125. GERMANY: $60-80.

What's in a name?
Trademark usage and export/import regulations led to various names being used on the East-German Contax SLR cameras. The Contax S was the earliest model (c1949-51) and does not exist with other name variations, because it was out of production before the trademark and name changes began. It is recognizable by sync. in tripod socket. There are three or four versions. Generally the earliest are finished best.
The following chart compares the original "Contax" model with name variants.

CONTAX Model (VEB Zeiss-Ikon)	FEATURES	NAME VARIATIONS of PENTACON MODELS
Contax S	Sync. in tripod socket	NONE
Contax D	Standard PC sync. on top	Pentacon, Consul, Hexacon*, Astraflex*, "No name"*
Contax E	Meter built onto top of prism	None known.
Contax F	Auto diaphragm	Pentacon F, Ritacon F
Contax FB	Auto diaphragm plus meter	Pentacon FB
Contax FM	Auto diaphragm plus interchangeable finder screen	Pentacon FM
Contax FBM	Auto diaphragm, meter, RF	Pentacon FBM

The model letters are based on the camera's features. F=Automatic Diaphragm, B=Built-in meter, M=Split-image finder screen

*Note: Hexacon and Astraflex are "House brands". The original Pentacon name has been obliterated and the store name riveted or glued on. The "No name" version has the Pentacon Tower emblem, but no camera name engraved.

Contax FB - Zeiss Biotar f2/58mm. Focal plane shutter 1-1000. USA: $90-135. GERMANY: $65-100.

Ercona II

Contax FM - c1957. Zeiss Biotar f2/58mm. Automatic diaphragm. Interchangeable finder screen. $100-150.

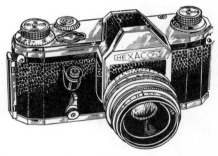

Contax S - 1949-51. First 35mm prism SLR along with Rectaflex: both were exhibited in 1948 and produced from 1949. Contax's patent date is first, however. Identifiable by sync connection in tripod socket. Biotar f2 lens. FP shutter 1-1000, B. Early models have no self-timer. Later models have a self-timer lever below shutter release. Early models are well-finished with typical Zeiss quality. Clean and working: $175-225.

Hexacon - c1954. Same as the Contax D. Clean & working: $75-125.

Orix - c1958. Half-frame (18x24mm) on 35mm film. Precursor of the Penti. $40-65.

Pentacon - c1948-62. Same as the Contax D. 35mm SLR. Tessar f2.8/50mm lens. Focal plane shutter 1-1000. $75-125.

Ercona (I) - c1949-56. Folding bed camera for 6x9 or 6x6cm on 120 rollfilm. Folding optical finder. Lenses include Novar f4.5/11cm, Tessar f3.5/105mm, Novonar f4.5/110mm in Junior, Compur, Prontor S, or Tempor shutter. $20-35.

Ercona II - c1956. Improved model of the Ercona. Restyled top housing incorporates optical finder. Novonar f4.5/110mm or Tessar f3.5/105mm in Junior, Priomat, or Tempor shutter. A mint example with Tessar brought over $100 at auction, but the more normal range is $30-50. *Illustrated top of next column.*

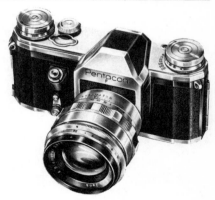

Pentacon F

439

PENTACON (cont.)

Pentacon "No-Name" - Like Pentacon, and has Pentacon tower emblem, but no name engraved. This should not be confused with the so-called "No-Name Contax" or "No-Name Kiev" which is a rangefinder camera. $200-300.

Pentacon F - c1957-60. Meyer Primotar f3.5/50mm or Tessar f2.8/50mm. USA: $60-80. GERMANY: $30-50. *Illustrated bottom of previous page.*

Pentacon FB - c1959. Built-in exposure meter. Tessar f2.8/50 or Steinheil f1.9/55 lens. USA: $75-125. GERMANY: $35-60.

Pentacon FBM - c1957. Built-in exposure meter. F2 or f2.8. USA: $75-125. GERMANY: $40-60.

Pentacon FM - c1957. Built-in exposure meter. Tessar f2.8/50mm lens. USA: $50-100. GERMANY: $30-45.

Pentacon Super - c1966. 35mm SLR with metal FP shutter, 8 sec to 1/2000. Interchangeable finders; TTL meter with open aperture metering. Speeds & f-stop visible in finder. Accessories include motors, bulk back, etc. With Pancolar f1.8/50mm lens: $250-400. Back for 17m cassettes: $80-125.

Penti - c1959. 18x24mm on 35mm film. Gold colored body with enamel in various colors: blue-green, red, cream, etc. Meyer Triplan f3.5/50mm lens. $25-40.

Penti II - c1961-62. Similar to Penti, but with built-in meter and bright-frame finder.

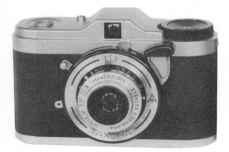

Taxona

Colors include: black & gold, black & silver, or ivory & gold. $25-40.

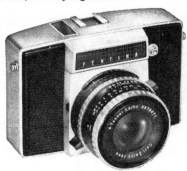

Pentina, Pentina E, Pentina FM - c1960s 35mm leaf-shutter SLR. Tessar f2.8 in breech-lock mount, similar to Praktina mount. Rarely in working order. Repairmen hate them according to one source. Normally $25-40; more if clean & working.

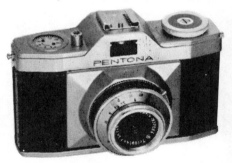

Pentona, Pentona II - Low-priced basic 35mm viewfinder camera. Meyer f3.5/45mm lens. Bright frame finder. USA: $25-35. GERMANY: $15-25.

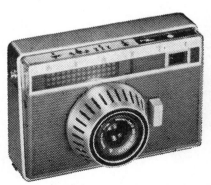

Prakti - c1960. Electric motor drive 35mm camera, but motor drive rarely working. Meyer Domiton lens. $25-50.

Ritacon F - c1961. Very rare name variant of the Pentacon F. $125-175.

Taxona - c1950. For 24x24mm exposures on 35mm film. Novonar or Tessar f3.5 lens. Tempor 1-300 shutter. (This is the DDR successor to the postwar Zeiss Tenax.) $25-50 in Germany. Somewhat higher in U.S.A. *Illustrated bottom of previous page.*

PEPITA - c1930. German telescoping-front camera for 3x4cm images. Rapid Aplanat f7.7/50mm in 25-100 shutter. Uncommon. One example with green leather covering brought $230 at auction in 9/88. More normal price with black leather: $50-75.

PERFECT CAMERA - c1910. Cardboard box camera, 6x9cm single plates. $75-125.

PERKA PRÄZISIONS KAMERAWERK (Munich, Germany)

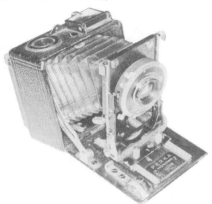

Perka - c1922. Double extension folding-bed plate camera. Back and lens standard tilt for architectural photos. Lenses include: Symmar f5.6/135, Staeble Polyplast-Satz f6/135 and Tessar f4.5/150mm. Compound, Compur, or Compur-Rapid. $150-250.

PERKEN, SON, & RAYMENT (London)

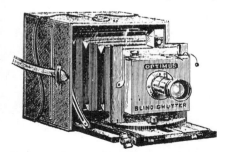

Optimus Camera DeLuxe - c1894. Black leather-covered folding camera ¼-plate.

Opens like an early Folding Kodak. Extra Rapid Euryscope lens. Rack and pinion focus. Roller-blind (Thornton-Pickard) shutter. Iris diaphragm. Estimate: $300-500.

Optimus Detective - c1888. Mahogany bellows camera inside of a black leather covered box, ¼-plate. External controls. RR brass lens, waterhouse stops, rotary shutter. Nearly identical to the Detective Camera of Watson & Sons. Estimate: $500-700.

Optimus Folding camera - c1890. Mahogany with brass trim. Optimus lens. ½-plate. $150-225.

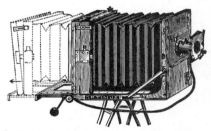

Optimus Long Focus Camera - c1892-1899. Tailboard style field camera. Mahogany body, brass trim. Square red-brown double extension bellows. Rack and pinion focus. $200-275.

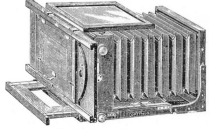

Perken Studio Camera

441

Studio camera - c1890's. Full-plate (6½x8½") size. $200-225. *Illustrated bottom of previous page.*

Tailboard camera - c1886. ¼-, ½-, and full plate sizes. Mahogany body with brass fittings. Ross lens, waterhouse stops. Maroon leather bellows. $150-250.

PFCA - Japanese novelty subminiature camera of the Hit type. Unusual streamlined top housing. Large flat advance knob. $10-15.

PHOBA A.G. (Basel, Switzerland)
Diva - 6x9cm folding-bed plate camera. Titar f4.5/105mm; Compur shutter. $30-45.

PHO-TAK CORP. (Chicago)
Eagle Eye - c1950-54. Metal box camera with eye-level optical finder. Precision 110mm lens. T&I shutter. $3-7.

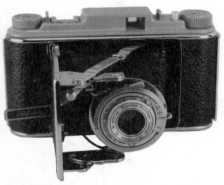

Foldex - c1950's. Folding camera for 620 film. All metal. Octvar or Steinheil lens. $5-10.

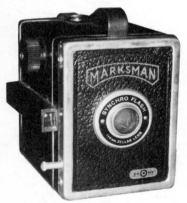

Macy 120, Marksman, Spectator Flash, Trailblazer 120, Traveler 120 - c1950's. Metal box cameras for 6x9cm. EUR: $10-20. USA: $5-10.

Reflex I - c1953. TLR-styled box camera. $8-15.

Scout 120 Flash - Metal box camera made for the Boy Scouts. Similar to the Macy 120. $10-20.

PHOCIRA - Small box camera for 3x4cm on 127 film. Similar to Eho Baby Box. $50-75.

PHOTAVIT-WERK (Nürnberg, Germany)
Originally called Bolta-Werk.
Photavit - c1937. A series of compact 35mm cameras for 24x24mm exposures on standard 35mm film in special cartridges. $70-100. *(Description and photo are under the Bolta heading).*

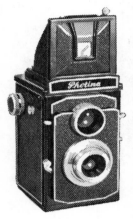

Photina - c1953. 6x6cm TLR. Cassar f3.5/75mm lens in Prontor-SVS shutter. $40-75.

Photina III - c1954. TLR with externally gear-coupled lenses. Westar f3.5/75mm. Prontor SVS shutter. $75-125.

PHOTO-BOX - c1939. French box camera, paper body with black paper covering. $10-20.

PHOTO DEVELOPMENTS LTD. (Birmingham, England)
Envoy Wide Angle - c1950. Wide angle camera for 6x9cm on 620 or 120 rollfilm, or cut film. f6.5/64mm Wide Angle lens. 82 degree angle of view. Agifold 1-150 shutter. $150-225.

PHOTO HALL (Paris)
Perfect Detective - c1910. Leather covered box camera for 9x12cm plates. Extra-Rapid Rectilinear lens. $150-200.

Perfect, folding plate - 9x12cm. Berthiot f4.5/135mm in Gauthier shutter. $30-40.

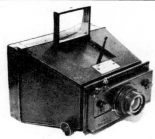

Perfect Jumelle - c1900. Jumelle-style single lens 6.5x9cm plate camera, magazine back. Zeiss Protar f8/110mm. $150-200.

Stereo camera - c1905. Rigid truncated pyramid "jumelle" style camera for 6x13cm plates in single metal holders. Guillotine shutter 10-50. Folding Newton finder. $75-95.

PHOTO-IT MFG. CO. (LaCrosse, WI)

The Photo-It - Round subminiature pinhole camera, 65mm dia. Stamped metal body, Cream enamel with brown lettering. Takes 8 exposures on a 12mm film strip wrapped on an octagonal drum. $1500-2000.

PHOTO MASTER - c1948. Brown or black bakelite or black thermoplastic body. 16 exposures 3x4cm on 127 film. Rollax 50mm lens, single speed rotary shutter. $3-7.

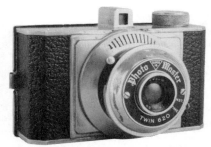

PHOTO MASTER SUPER 16 TWIN 620
- Cast aluminum eye-level camera for 16 exposures 4x5.5cm on 620 film. Styling similar to the aluminum "Rolls" cameras. Fixed focus Rollax 62mm lens. Instant & Time shutter. $10-15.

PHOTO MASTER TWIN 620 - Simple cast-metal camera for 16 shots on 127 film. Identical to the Monarch 620, and probably made in the same factory in Chicago. $10-15.

PHOTO MATERIALS CO. (Rochester, NY)

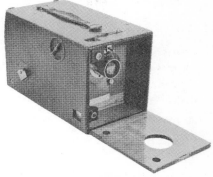

Trokonet - c1893. Leather covered wooden magazine box camera. Holds 35 cutfilms or 12 glass plates, 4x5". Gundlach rectilinear lens, variable speed shutter. Inside the box, the lens is mounted on a lensboard which is focused by rack and pinion. $500-700.

PHOTO-PAC CAMERA MFG. CO., INC. (New York City & Dallas, TX)

Photo-Pac - c1950. Disposable cardboard mail-in camera. We have seen two different body variations under the Photo-Pac name. One had a Dallas address and it had the shutter release near the TOP of the right side. The other type has a N.Y.C. address and has the shutter release on the lower front corner of the right side. The two versions also have their address labels on opposite sides. $20-30.

PHOTO-PORST (Hans Porst, Nürnberg)
Distributor of many brands of cameras, including some made with their own name "Hapo" = HAns POrst.
Hapo 5, 10, 45 - c1930's. 6x9cm folding rollfilm cameras, made by Balda for Porst. Schneider Radionar f4.5/105mm or Trioplan f3.8/105mm lens. Compur or Compur Rapid shutter. $15-25.

Hapo 35 - c1955. Folding 35mm, made by Balda for Porst. Enna Haponar f2.9/ 50mm lens. Prontor-SVS 1-300 shutter. Coupled rangefinder. $15-25.

Hapo 36 - 35mm, non-coupled rangefinder. f2.8 Steinheil in Pronto shutter. $15-25.

Hapo 66, 66E - 6x6cm. Enna Haponar f3.3 or f4.5/75mm lens in Pronto sync. shutter, ½-200. Model 66E has rangefinder. $25-35.

Haponette B - c1960's. 35mm camera. Color Isconar f2.8/45mm in Prontor shutter. $5-10.

Photo Quint, exterior and interior views

PHOTO QUINT - c1911. Simple cardboard camera for 5 plates, 4x5cm. The lens cap serves as shutter, and the plates are moved into position by rotating the bottom. Though barely more than a toy, this camera is unusual and rare. Estimate: $500-800.

PHOTO SEE CORP. (N.Y.C.)
Photo-See - An art-deco box camera and developing tank for photos in 5 minutes. An interesting, simple camera. According to a popular but untrue rumor, the view-finders are on backwards and instructions were never printed. Actually the finders are as designed and instructions exist, though not often found with the cameras. These

are usually found new in the box, with developing tank, and always with traces of rust from storage in a damp area. $30-50.

PHOTOGRAPHIE VULGARISATRICE (Paris, France)
Field camera - c1900. Folding camera made of light wood. Mazo lens. $200-250.

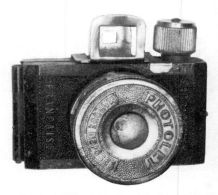

PHOTOLET - c1932. French subminature for 2x2cm on rollfilm. Meniscus f8/31mm. Single speed rotary shutter. Similar to the Ulca. $75-125.

PHOTON 120 CAMERA - Grey & black plastic camera of the "Diana" type. Matching flash for AG-1 bulbs fits in hot shoe. Made in Hong Kong. $1-5.

PHOTOPRINT A.G. (Germany)
Ernos - c1949. Small bakelite camera for 25x25mm exposures on 35mm wide rollfilm. Identical to the pre-war "Nori" from Norisan Apparatebau. $30-45.

PHOTOSCOPIC (Brussels, Belgium) - c1924. Unusually designed early 35mm camera for 50 exposures 24x24mm on 35mm film in special cassettes. O.I.P. Gand Labor f3.5/45mm lens. Pronto or Ibsor shutter. Metal body with black hammertone enamel. Tubular Galilean finder. Only 100 examples were made according to the inventor, Mr. A Van Remoortel, and several

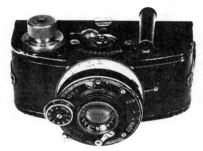

Photoscopic

variations are known, including: 1. Pull-tab film advance like earlier Amourette camera. Full focusing. 2. Full focusing but with knob advance. 3. Fixed focus with knob advance. $500-600.

PIC - c1950. Unusual English disk-shaped plastic camera. 3x4cm exposures on 127 rollfilm. Meniscus lens, rotary sector shutter. $75-125.

PICTURE MASTER - Stamped metal minicam for 16 exposures on 127 film. Not to be confused with the Bell & Howell plastic pocket 110 camera called "Picture Master". Body style identical to Scott-Atwater Photopal. $10-20.

PIERRAT (André Pierrat, France) *During the occupation of France, André Pierrat was secretly working on his copy of the Zeiss Ikonta camera, and it became one of the first quality French-made cameras after the end of WWII.*
Drepy - c1946-50. The Drepy, named from a contraction of the designer's name, was essentially a copy of the Zeiss Ikonta. Takes 8 or 16 exp. on 120 film. The most common model has leatherette covered

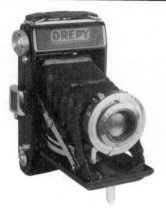

body with black enameled edges. Drestar Anastigmat f4.5/105mm in Drestop shutter B,1-250. $15-25.

PIGGOTT (John Piggott, London, England)
Sliding-box wet-plate camera - c1860. Mahogany body. 8x8". Petzval-type lens. $1200-1800.

PIGNONS AG, (Ballaigues, Switzerland)
Pignons S.A. is a family business, founded in 1918 for making watches and clocks. Because of continual fluctuations in that business, the decision was made in 1933 to move into the photographic market by producing a camera which combined the advantages of reflex viewing and a rangefinder. The first of these prototypes appeared in 1939, and bore the name "Bolca", before the name "Alpa Reflex", which first was shown in 1944 at a public fair in Basel. The company no longer actively produces Alpas.

Editor's note: The information in this section is primarily the work of Jim Stewart, whose particular interests revolve around Alpa, 35mm, and subminiature cameras. In addition to this section, he has made other important contributions to this guide. Contact him at Box 415, Mt. Freedom, NJ 07970. Phone: (201)-361-0114.

Cameras are listed chronologically by year of introduction. Serial number ranges are approximate. Prototypes fall into the 10000 and 25000 range. Discontinuance dates indicate the end of series production. Special orders of later bodies often occurred as long as parts were available. Almost any custom variation could be factory ordered. It is interesting to note that the total production of all Bolca, Bolsey Reflex, and Alpa cameras probably did not equal the production of the Leica A!

Bolca I - 1942-46. (#11000 series). Waist-level SLR, eye-level VF and split-image CRF. Cloth FP shutter 1-1000. Berthiot f2.9/

Bolsey Model A (Bolca I)

50mm in collapsible mount. Samples for Jacques Bolsky in New York marked "Bolsey Model A". All are semi-prototype, especially the "Bolsey A". Bolca I: $1000+. Bolsey A: $1200+.

Bolca (Standard) - 1942-50. (#11000 series). Similar to Bolca I, but without reflex viewing. VF/CRF only. From 1947-50, sold as "Alpa Standard". Very rare. $800-1000. *Total of all "Bolcas" is less than 500.*

Alpa Reflex (I) - c1946-47. (#12000 series). Reflex similar to the "Bolca" but with a modified lens bayonet. Angenieux f2.9/5cm in collapsible mount. RF coupling still at top of mount. Only a few known. $600+.

Alpa Reflex (II) - 1947-52. (#13000-25000). First real production model. Features of Alpa Reflex (I) above, but with

RF coupling moved to bottom of lens mount and other improvements. Full speed range. Also sold as "Bolsey Reflex". With Angenieux f2.9/50mm collapsible: $250-350. With f1.8/50mm rigid lens: $275-450.

Alpa (Standard) - 1947-52. (#13000-25000). Non-reflex type similar to the Alpa Reflex (II). Angenieux f2.9/50mm in collapsible mount. $1000+. (One known with no slow speeds, 25-1000 only: $1500.)

Alpa Prisma Reflex (III) - 1949-52. (#22000-25000). WL reflex hood and finder of the Alpa Reflex were replaced with 45 degree eye-level prism. (One of the earliest prism SLR's). Lenses as "Reflex" above, plus some late models have Xenon f2.0. $300-375. *Note: #28,000 series reserved for prototypes and #29,000 for display dummies. No prices established for these oddities.*

Alpa 4 - 1952-60. (#30001-ca.39000). All new diecast magnesium alloy body. Introduced new bayonet lens mount used for all subsequent models. Integral magnifier hood for non-prismatic reflex viewing. Spektros f3.5/50mm collapsible lens. Rare. $450-550.

Alpa 5 - 1952-60. (#30001-ca.39000). As model 4, but integral 45 degree prism. Old Delft f2.8/50mm, rigid or collapsible mounts. $225-275.

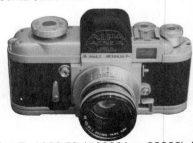

Alpa 7 - 1952-59. (#30001-ca.39000). As model 5, but adds self-timer, superimposed image vertical base RF & multi-focal (35, 50, 135) built-in finder (first time done). Kern Switar f1.8. $250-275.

Alpa 6 - 1955-59. (#30001-ca.39000). As model 5, but adds split-wedge RF on ground glass, plus self-timer. $250-300.

Alpa 8 - 1958-59. (#37201-ca.39000). As model 7, plus prism RF of model 6. First auto lenses. Very short production run. $275-350.

Alpa 7s - 1958-59. (#37201-ca.39000). As model 7, but single frame (18x24mm) format. Rare. $450-500.

Alpa 4b - 1959-65. (#40701-48101). As model 4, but rapid return mirror and added advance lever. Old Delft f2.8/50mm, rigid mount only. $475-600.

Alpa 5b - 1959-65. (#39801-48101). As model 5, but rapid return mirror and added advance lever. Macro Kern Switar (redesigned and black finished) f1.8/50mm (focus to 8"). $225-275.

Alpa 6b - 1959-63. (#39601-48100). As model 6, but rapid return mirror and added advance lever. Macro Kern Switar f1.8/50mm (focus to 8"). $240-275.

Alpa 7b - 1959-65. (#40001-48101). As model 7, but rapid return mirror and added advance lever. Macro Kern Switar f1.8/50mm. $275-325.

Alpa 8b - 1959-65. (#40001-48101). As model 8, but rapid return mirror and added advance lever. Macro Kern Switar f1.8/50mm. Scarce. $325-375.

Alpa 6c - 1960-69. (#42601-46500). Kern 45 degree prism replaced with standard pentaprism. Uncoupled selenium meter added. Macro Kern Switar f1.8/50mm. $245-275.

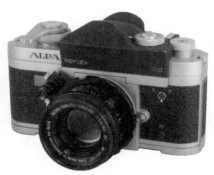

Alpa 9d - 1964-69. (#46501-52000). As model 6c, but top deck match-needle TTL CdS meter. Some gold or black finish with red or green covering. Macro Kern Switar f1.8/50mm. $350-450.

Alpa 9f - 1965-67. (#46201-46500). As model 9d, but without meter. Macro Kern Switar f1.8/50mm. Rare. $450-525.

Alpa 10d - 1968-72. (#52501-56400). New body with cross-coupled "zero center" match needle CdS meter. Normal lens reformulated. Kern Macro Switar f1.9/50mm. Gold or black with colored leather: $375-450. Chrome: $275-325.

Alpa 10p - 1968-72. (#52501-56400). As 10d, but removable prism and revised metering. No sales recorded.

Alpa 10s - 1968-72. (#52501-56400). As 10d, but single frame 18x24mm format, no meter, no self-timer. Very low production. Rare. $450-500.

Alpa 10f - 1972. (#57101-?). As 10d, but no meter. Rare. $400-450.

Alpa 11e - 1970-72. (#57201-58300). As 10d, but lighted over-under exposure arrows, both off at correct exposure. Many all black, some gold or black with red or green covering. Kern Macro Switar f1.9/50mm. Black leather: $350-400. Colored leather: $400-475.

Alpa 11el - 1972-74. (#58301-59500). As 11e, but both arrows lighted on correct exposure. Colored leather: $450-500. Black: $375-450.

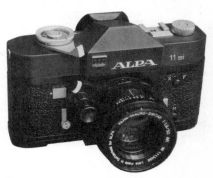

Alpa 11si - 1976-80? (#60001-?). As 11el, but lighted arrows replaced by red, green, yellow diodes. Gold-plated: $2000. Majority of production black with black chrome top deck. $400-500.

Alpa 11fs - 1977-80? (#60001-?). As 11si, but single frame (18x24mm) format. Xenon f1.9/50mm. Rare. $475-575.

Alpa 11r - c1977? (#unknown). Special order single-frame pin-registered filmstrip camera. No further information nor recorded sales.

PIGNONS (cont.) - PLASTICS

Alpa 11s - c1977? (#unknown). As 11el, but no meter. No further information nor recorded sales.

Alpa 11z - c1977-? (#61300-?). Special order single frame model. Similar to 11fs, but no meter, shutter 1/60 only, microprism screen only (no prism). Very rare. $800-950.

PINHOLE CAMERA CO. (Cincinnati, Ohio)
Pinhole camera - Cardboard body. $20-30.

PIONEER - Blue and black plastic camera of the "Diana" type. $1-5.

PIPON (Paris)

Magazine camera - c1900. Leather covered wood box for 9x12cm plates. Aplanoscope f9 lens. $75-100.

Self-Worker - c1895. Jumelle camera for 9x12cm plates. Goerz Double Anastigmat 120mm lens. 6-speed guillotine shutter. $125-200.

PLANOVISTA SEEING CAMERA LTD.
(London) *Imported a camera with their name on it, but it was actually a Bentzin camera. See Bentzin.*

PLASMAT GmbH (Berlin-Halensee, Germany)
Dr. Paul Rudolph is well known not only for his Plasmat lens designs, but also for the first Anastigmat (1891), Planar (1896), Unar (1899), Tessar (1902), Magnar (1909), and the Film Plamos camera (1900).

Roland - 1934-37. Telescoping front camera for 4.5x6cm exposures on 120 rollfilm. Coupled rangefinder. Designed by Dr. Winkler in association with Dr. Paul Rudolph, who designed the various Plasmat lenses. It was highly regarded for its 6-element Plasmat f2.7/70mm lens and sold new for $93-143. Two basic models. First one had built-in optical exposure meter. Second model had no meter, but had automatic exposure counter. Either model was available with normal Compur 1-250 or Compur Rapid to 400. $800-1200.

PLASTICS DEVELOPMENT CORP. (Philadelphia, Penn.)
Snapshooter - c1970. Black plastic slip-on camera for 126 cartridges. $3-7.

Snapshooter Bicentennial 1976 - 1976. Commemorative model for the USA's 200th anniversary. Like new in box: $30-50.

PLAUBEL & CO. (Frankfurt, Germany)
Aerial Camera - c1955. Hand-held aerial camera, grey hammertone body. For 6x9cm on 120 film in interchangeable magazine backs. Reports indicate that 60 were made for the Swedish Army. Focal plane shutter 20-1000. Interchangeable Anticomar f3.5/100mm lens. With universal 100-600mm viewfinder, 2 film magazines, case, and filters. Three were offered for sale a few months apart at German auctions during 1985, with reserve of 2500 DM (approx. $1000-1200 at the time). The first two sold for just over the minimum bid, while the third remained unsold at that price.

Baby Makina - 1912-35. 4.5x6cm. f2.8/75mm Anticomar, Compur sh. $400-650.

Folding-bed plate cameras - 6x9 and 9x12cm sizes. Double extension bed and bellows. Anticomar or Heli-Orthar lens. Ibso or Compur shutter. $30-40.

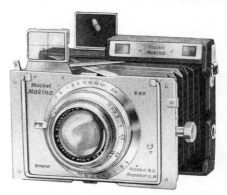

Makina (I) - 1920-33. Compact 6.5x9cm strut-folding sheet film camera. No rangefinder. Anticomar f2.9 lens. Compur shutter. $100-150.

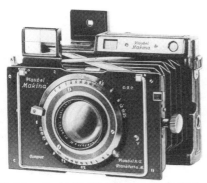

Makina II - 1933-39. Coupled rangefinder. Anticomar f2.9/100mm lens converts to 73mm wide angle or 21cm telephoto by changing lens elements in the Compur shutter. $115-150.

Makina IIS - 1936-49. Interchangeable Anticomar f2.9/50mm. All lens elements in front of the shutter, unlike the Makina II. Shutter 1-200. $150-190.

Makina IIa - 1946-48. Non-changeable, fixed Anticomar f4.2/100mm or Xenar f4.5/105mm lens. Shutter to 1/400. Self-timer. $175-225.

Makina IIb - Like the Makina IIa, but shutter to 200, no self-timer. $100-150.

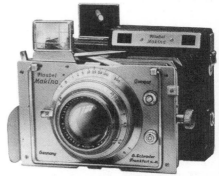

Makina III - 1949-53. 6x9cm strut-folding camera. Anticomar f2.9/100mm lens. Rim-set Compur shutter 1-200. Coupled rangefinder. $150-200.

Makinette - c1931. Strut-folding camera for 3x4cm on 127 rollfilm. Anticomar f2.7 or most often with Supracomar f2/50mm. Compur 1-300. Rare. USA: $750-1000. GERMANY: $500-750. *Illustrated next page.*

Normal Peco - c1926. Folding plate camera, 9x12cm. Leather covered metal body. Double extension rack and pinion. Anticomar f4.5/150mm lens. Compur shutter. One recent auction sale at $110 with tele and WA lenses.

PLAUBEL (cont.) - PLAYTIME

Prazision Peco - c1922-32. Like the Normal Peco, but more solid construction with brass and nickel parts. Anticomar f3.2/135mm lens. Compur shutter. One Mint example brought $350 at auction.

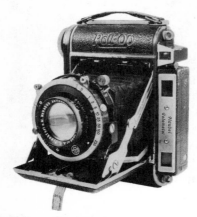

Roll-Op (II) - c1935. Although the camera itself is simply labeled Roll-Op, original brochures called it Roll-Op II. Folding bed rollfilm camera, for 16 exposures 4.5x6cm on 120 film. Anticomar f2.8/75mm lens. Compur Rapid shutter 1-250. Coupled rangefinder. $175-275.

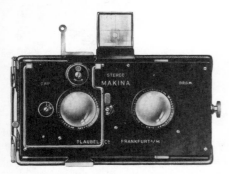

Stereo Makina, 6x13cm - 1926-41. Strut-folding stereo camera. Anticomar f2.9/90mm lenses in stereo Compur shutter 1-100. Black bellows. Black metal body, partly leather covered. $575-900.

Stereo Makina, 45x107mm - 1912-27. Similar, but f6/60mm Orthar or f3.9 Anticomar lens. $500-850.

Veriwide 100 - c1960. Wide angle camera for 6x9cm on 120 film. 100 degree angle of view. Super-Angulon f8/47mm in Synchro Compur 1-500 shutter, B, MXV sync. $450-600. *Illustrated next column.*

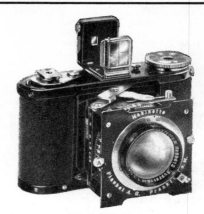

Plaubel Makinette

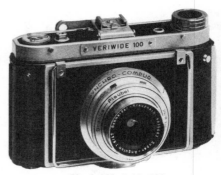

Plaubel Veriwide 100

PLAUL (Carl Plaul, Dresden, Germany) Field camera - c1900-10. Simple wooden 9x12cm field cameras of tailboard style. Square bellows or tapered red bellows. Carl Plaul Prima Aplanat lens in brass barrel for waterhouse stops. $125-160.

PLAVIC - c1920. Leather covered wood body. 6x9cm on rollfilm. Meniscus lens, guillotine shutter. $20-30.

PLAYTIME PRODUCTS INC. (New York, NY)

Cabbage Patch Kids 110 Camera - c1984. Yellow plastic 110 pocket camera, black trim. Green "Cabbage Patch Kids"

decal on front. Uses flip-flash. Made in China. Retail $13.

Go Bots 110 Camera - c1984. Grey plastic 110 camera with black & red trim. Go Bots sticker on front. Same basic camera as Cabbage Patch Kids above. New price: $13.

PLIK - 127 plastic box camera from Brazil. Similar in style to the Bilora Boy. $40-50.

PLUS (Paul Plus Ltd., Newcastle, England)

Plusflex 35 - c1958. 35mm SLR with Exa/Exakta bayonet mount. Made by Tokiwa Seiki Co. for Paul Plus Ltd. Similar to the pentaprism version of the Firstflex 35. Simple mirror shutter, B, 60, 125. Auto Pluscaron 45mm/f2.8 lens. One British dealer asking $345 in late 1988. Previous recorded sales around $50. Our estimate: $75-125.

POCK (Hans Pock, Munich, Germany) Detective camera - c1888. Mahogany detective camera, concealed in a leather satchel. Gravity-operated guillotine shutter, 1-100. Magazine holds 15 plates 6x9cm. Voigtländer Euryskop fixed-focus lens. $2500-3000.

POCKET MAGDA - c1920. Compact French all-metal folding camera in 4.5x6cm and 6.5x9cm sizes. Meniscus lens, simple shutter. 4.5x6cm size: $400-500. 6.5x9cm size: $150-200.

POCKET PLATOS - French 6.5x9cm folding plate camera. Splendor f6.2/90mm lens in Vario shutter. $75-125.

POLAROID (Cambridge, MA) *Polaroid cameras, using the patented process of Dr. Land, were the first commercially successful instant picture cameras which were easy to use, and were not in need of bottles of chemicals, etc. The idea of in-camera development is not new; there are records of ideas for instant cameras from the first year of photography. In 1857, Bolles & Smith of Cooperstown, New York patented the first instant camera which actually went into production. Jules Bourdin of France invented a simple system which was successfully marketed as early as 1864. Many other attempts met with mediocre success, but Polaroid caught on and became a household word. Because of the success*

Polaroid 95

of the company, their cameras generally are quite common, and obviously none are very old. There is more supply than demand for most models in the United States, but some of the early models sell better in Europe. We are listing them in order by number, rather than chronologically. We have not listed cameras introduced after 1965, so this list is by no means a complete history of Polaroid.

80 (Highlander) - 1954-57. The first of the smaller size Polaroid cameras. Grey metal body. 100mm/f8.8 lens. Shutter ¹⁄₂₅-100 sec. Hot shoe. $5-15.

80A (Highlander) - 1957-59. Like the 80, but with the shutter marked in the EV system. (Orig. price: $72.75) $5-15.

80B - 1959-61. Further improvement of the 80A with new cutter bar and film release switch. $5-10.

95 - 1948-53. The first of the Polaroid cameras, which took the market by storm. Heavy cast aluminum body, folding-bed style with brown leatherette covering. f11/135mm lens. Folding optical finder with

sighting post on the shutter housing. Diehard collectors like to distinguish between the early models with the flexible spring sighting post and the later ones with a rigid post. EUR: $45-85. USA: $15-25. *Illustrated previous page.*

95A - 1954-57. Replaced the Model 95. Essentially the same but sighting post was replaced with a wire frame finder, X-sync added, and shutter speeds increased to ¹⁄₁₂-100. f8/130mm lens. EUR: $30-50. USA: $10-20.

95B (Speedliner) - 1957-61. Like the 95A, but the shutter is marked in the EV (Exposure Value) system, rather than the traditional speeds. (Orig. price: $94.50) EUR: $30-50. USA: $10-20.

100 (rollfilm) - 1954-57. (Not to be confused with the 1963 "Automatic 100" for pack film.) Industrial version of the 95A. Better roller bearings and heavy duty shutter. Black covering. $10-20.

100 ("Automatic 100") - 1963-66. An innovative, fully automatic transistorized electronic shutter made the world stand up and take notice once again that the Polaroid Corporation was a leader in photographic technology. In addition to the marvelous new shutter, Polaroid introduced a new type of film in a flat, drop-in pack which simplified loading. Furthermore, the photographs developed outside the camera so that exposures could be made in more rapid succession. Three-element f8.8/114mm lens. Continuously variable speeds from 10 seconds to 1/1200. RF/viewfinder unit hinged for compactness. $10-15.

101, 102, 103, 104, 125, 135 - c1964-1967. Various low-priced pack cameras following after the Automatic 100. $5-10.

110 (Pathfinder) - 1952-57. Coupled rangefinder. Wollensak Raptar f4.5/127mm lens. Shutter 1-1/400 sec. $45-60.

110A (Pathfinder) - c1957-60. Improved version of the 110. Rodenstock Ysarex f4.7/127mm lens in Prontor SVS 1-300 shutter. Special lens cap with f/90 aperture added in 1959 for the new 3000 speed film. Charcoal covering. (Originally $169.50) $40-60.

110B (Pathfinder) - 1960-64. Like the 110A, but with single-window range/viewfinder. $40-70. *These professional models can be converted to pack film. See ad pages.*

120 - 1961-65. Made in Japan by Yashica. Similar to the 110A, but with Yashica f4.7/127mm lens in Seikosha SLV shutter 1-500,B. Self-timer. CRF. Not as common in the U.S.A. as the other models, because it was made for foreign markets. $40-80.

150 - 1957-60. Similar to the 95B with EV system, but also including CRF with focus knob below bed, parallax correction, and hot shoe. Charcoal grey covering. (Originally $110.) $10-20.

160 - 1962-65. Japanese-made version of the 150 for international markets. $10-20.

180 - 1965-69. Professional model pack camera made in Japan. Tominon f4.5/114mm lens in Seiko shutter 1-500 with self-timer. Zeiss-Ikon range/viewfinder. Has retained its value as a usable professional camera. $200-250.

185 - Sold only in Japan. Mamiya Sekor f5.6 lens. CdS meter. Combined electronic and mechanical "trapped-needle" auto exposure with manual override. Reportedly only about 30 made. Rare. $300-400.

190 - European version of the Model 195. Zeiss finder, f3.8 lens. Electronic development timer. $175-225.

195 - Like the Model 180, but Tominon f3.8/114mm lens instead of f4.5. Albada finder like the Model 100. Mechanical wind-up development timer. $175-225.

415 - Variation of the Swinger Model 20. $3-7.

700 - 1955-57. Uncoupled rangefinder version of the 95A. $15-20.

800 - 1957-62. All the features of the 150, but with carefully selected lens, electronically tested shutter, and permanently lubricated roller bearings. (Original price: $135 with flash, bounce bracket and 10 year guarantee.) $10-20.

850 - 1961-63. Similar to the 900 below, but with dual-eyepiece rangefinder & viewfinder. $10-15. *Illustrated top of next column.*

Polaroid 850

900 - 1960-63. The first Polaroid with fully automatic electric-eye controlled shutter. Continuously variable shutter speeds (1/12-600) and apertures (f/8.8-f/82). $10-15.

Big Shot - 1971-73. Unusually designed pack-film camera for close-up portraits at a fixed distance of one meter. Since the lens is fixed focus, the rangefinder functions only to position the operator and subject at the correct distance. Built-in socket and diffuser for X-cubes. EUR: $25-35. USA: $5-15.

J-33 - 1961-63. Newly styled electric-eye camera to replace the "80" series. Still using the 30 series double-roll films for 6x8cm pictures. $5-10.

J-66 - 1961-63. Newly styled electric-eye camera, with simple f/19 lens. Tiny swing-out flash for AG-1 bulbs. $5-10.

Swinger Model 20 - 1965-70. White plastic camera for B&W photos on Type 20 roll film, the first roll film to develop outside the camera. If this is not the most common camera in the world, it certainly must be near the top of the list. Current value $5 per truckload, delivered.

Swinger Sentinel M15 - 1965-70. Variation of the Swinger Model 20. Lacks built-in flash. $3-7.

SX-70 (Deluxe Model) - 1972-77. The original SX-70 camera. Ingeniously designed folding SLR which ushered in a new era of instant photography. The miracle was watching the colored photo slowly appear in broad daylight after being automatically ejected from the camera. The technical and esthetic marvel was the compact machine which fit easily into a coat pocket. The basic folding design was not new. Perhaps one of Polaroid's engineers

had seen the circa 1905 "Excentric" camera of R. Guénault, which is surprisingly similar. But Guénault would never have dreamed of an even more compact camera incorporating SLR focusing to 10½ inches, automatic exposure up to 14 seconds, and motorized print ejection, all powered by a disposable flat battery which came hidden in the film pack. This is a landmark camera, but quite common because it was so popular. EUR: $40-60. USA: $25-40.

POLYFOTO - c1933. Repeating-back camera, taking 48 ½x½" exposures on a 5x7" plate. Plate moves and exposure is made when a handle is cranked. $150-250.

PONTIAC (Paris) *Founded in 1938 by M. Laroche, whose first product was a polarising filter. The first cameras of the firm were the streamlined "Bakelite" models based on the Ebner camera from Germany. During the war, the aluminum-bodied Bloc-Metal cameras were produced in an attempt to improve the quality and durability of both the cameras and the company image. While other materials were in short supply during wartime, aluminum was produced in abundance in France. Its availability and strength led to its choice for the bodies of the Bloc-Metal and Lynx cameras.*

Bakélite - c1938-41. Folding camera for 8 6x9cm exposures on 120 rollfilm. Bakelite body similar in style to its predessors, the Gallus and Ebner cameras. Berthiot f4.5/ 105mm lens. Shutter 25-150. $40-80. *Illustrated below.*

Bloc-Metal 41 - 1941-48. Cast aluminum-alloy body with grained texture and painted finish, due to wartime shortage of leather. Original 1941 model has MFAP shutter to 100. Later versions have Pontiac or Prontor II shutter to 150. Pontiac or Berthiot f4.5 lens. $20-30. *Illustrated below.*

Bloc-Metal 45 - c1946. As the model number indicates, this was to have been a 1945 model, but it did not actually appear until late in 1946. It was more professional than the model 41 in features and appearance. Streamlined die-cast top housing incorporates an optical finder and a rotating depth of field scale. Usually with Flor Berthiot or Trylor Roussel f4.5/105mm in Prontor II with body release. Early examples still have cloth rather than leather bellows. $30-50. *Illustrated below.*

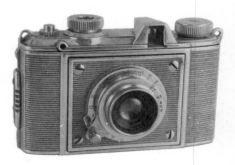

Lynx, Lynx II - c1948. Polished aluminum body. (Model II also exists with black enameled body.) 16 exposures 3x4cm on 127 film. Berthiot Flor f2.8/50mm coated lens in Leica-style collapsible mount. Focal plane shutter. $50-75.

Super Lynx, I, II - c1950's. Made in Paris and Morocco. 35mm body has an aluminum finish, black enamel, or is leather covered. f2.8 or f3.5 Flor lens; Super Lynx II has interchangeable lenses. Rarely seen with the fast f2.0 Sacem Hexar lens. FP shutter. Some dealers really stetch the point by calling this a Leica copy. $200-300.

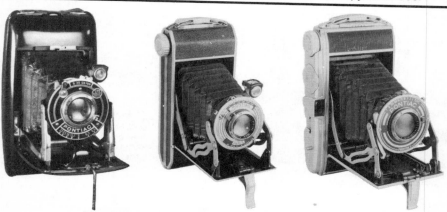

Three Pontiac cameras: Bakélite, Bloc-Metal 41, Bloc-Metal 45

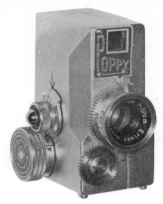

POPPY - Rare Japanese subminiature. Price negotiable. Estimate: $500-750.

POPULAR PHOTOGRAPH CO. (New York)
Nodark Tintype Camera - c1899. All-wood box camera for 2½x3½" ferrotype plates. The camera has a capacity of 36 plate. With tank: $600-900. Less $100 if missing tank.

POPULAR PRESSMAN - see Butcher.

POTENZA CAMERA - c1981. 110-cartridge camera shaped like a tire. Meniscus f11 lens, single speed shutter. New in box: $20-45.

POTTHOFF (Kamerafabrik Potthoff & Co., Solingen, Germany) *See also Montanus Camerabau, the new name of Potthoff & Co. beginning about 1953.*
Plascaflex PS 35 - c1952. TLR for 6x6cm. Plascanar f3.5/75mm in Prontor-S shutter. $40-60.

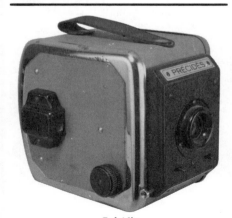

Précidès

POUVA (Karl Pouva, Freital, Germany)
Start - c1952-56. Helical telescoping camera for 6x6cm exposures on 120 rollfilm. Bakelite body and helix. Fixed focus Duplar f8 lens. Z&M shutter. $12-18.

PRÉCIDÈS - Simple French stamped metal box camera with light grey cloth covering. Also sold as "Menetrel". $15-20. *Illustrated bottom of previous column.*

PRECISION CAMERA INC. (Minneapolis, MN)
Andante 100 - Large blue and gray plastic "school" camera. Twin lens reflex style. Uses bulk rolls of 35mm film. $60-90.

PREMIER INSTRUMENT CO. (New York)
Kardon - c1945. 35mm Leica IIIa copy. Made for the Signal Corps, and also for civilians. Ektar f2/47mm lens. Cloth focal plane shutter, 1-1000. Coupled rangefinder.
- Civilian Model - Uses standard Leica-style advance knob and shutter release. No rear nameplate on body. Civilian lens mounts with knurled focusing wheel toward top between slow speed dial and RF window (11 o'clock position viewed from front). $300-500.

Front and back views of Kardon Signal Corps model

- Signal Corps Model - Obvious identification is rear nameplate on body. Military models were also designed to be operated more easily when wearing gloves, with an enlarged cylindrical advance knob, removable tall extension for release button, and with lens focusing wheel near bottom of camera (7 o'clock position) away from the other controls. Body: $175-225. With lens: $250-350.

PRESCOTT - Q.R.S.

PRESCOTT & CO. (Glasgow)
Field camera - Brass and mahogany folding camera for ½-plates. Lens is set in a Challenge pneumatic shutter. $225-275.

PRIMO - c1950's. Basic scale-focus 35mm camera made in the Netherlands. Design is based on the German Steinette. Improvements include lever wind, two small feet on bottom to allow camera to stand on a flat surface, top shutter speed increased to 200. Nedinsco-Venlo f3.5/45mm lens in unidentified shutter 25-200. Black leatherette or grey rubberized covering. $30-50.

PRINCE - c1960's. Rectangular green and black bakelite subminiature from Japan. Uses Mycro-size rollfilm. Fixed focus f10, B,I shutter. Scarce. $200-250.

PRINTEX PRODUCTS (Pasadena, CA)
Printex - c1946. Rigid-bodied, all-metal press camera. Telescoping lens mount rather than the bellows found on the popular Speed Graphics of its day. Made in 2¼x3¼" and 4x5" sizes. Uncommon. $75-125.

PRO CAMERA - Factory loaded disposable camera. 28x31mm on 35mm film. $15-25.

PRONA TROPICAL - c1925. Single extension folding plate camera, 6.5x9cm. Brown leather, black bellows. Prona Anastigmat f6.3/105mm. Vario shutter. One auction sale, mint condition: $100.

PUTNAM (F. Putnam, N.Y.)

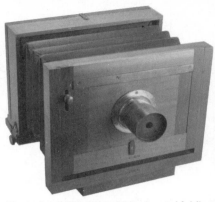

Marvel - c1885-95. 5x8" horizontal folding view camera. Appears to be the same as the Scovill Waterbury View. Scovill Waterbury lens with rotating disc stops. Earlier examples have removable washer-style waterhouse stops. $150-175.

PYNE (Manchester, England)
Stereoscopic Camera - c1860. Tailboard stereo, 8x17cm plates. Ross lenses. One sold at auction in 1979 for $4800. Sorry, but we know of no recent sales.

Q.P. - c1950. Japanese "Hit" type novelty camera; 16mm paper-backed rolls. $15-25.

Q.R.S.-DeVRY CORP. (Chicago)

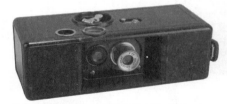

Q.R.S. Kamra - c1928. Brick-shaped brown bakelite body. 40 exposures,

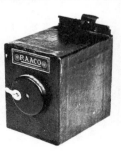

Raaco

456

24x32mm, on 35mm film in special cassettes. Graf Anastigmat f7.7/40mm. Single speed shutter trips by counter-clockwise motion on winding crank. With crank intact: $100-125. As normally found with broken crank: $60-80.

RAACO - Box camera for 4.5x6cm. Cardboard construction. Meniscus lens. Sector shutter. $75-110. *Illustrated bottom of previous page.*

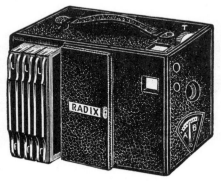

RADIX - c1897. Box camera for 3¼x4¼" glass plates in standard double holders. Hinged door on side of camera to change and store plateholders. $40-60.

RAJAR LTD. *A manufacturer of sensitised photographic materials, it merged with several other photographic companies in 1921 to form APM (Amalgamated Photographic Manufacturers, Ltd). It was one of the companies that split from APM in 1929 to form Apem Ltd.* See APM for more information, including the Rajar No. 6 camera.

RAKSO - c1970's. One of the up and coming collectibles. Special purpose camera for close-up work. Self-erecting, single extension, telescoping front. Built-in 10-90mm zoom. Ball-bearing shutter with body release. Automatic flash. $15-25.

RALEIGH - 4x4cm novelty of the "Diana" type. $1-5.

RANDORFLEX - Small novelty TLR for 4x4cm on 127 film. Same as Bedfordflex, Splendidflex, Stellarflex, Windsorflex, Wonderflex, etc. $5-10.

RANKOLOR LABORATORIES (U.S.A.)
Rank - c1975. Small plastic camera, factory loaded with 110-size film. This is the European name variation for the "Lure" camera. Made in U.S.A. for distribution by Rank Audio Visual of Brentford, England. Camera is returned intact for processing and a new camera is returned with processed prints. $1-5.

RAY CAMERA CO. (Rochester, N.Y.)
Originally established in 1894 as Mutschler, Robertson & Co., the company began making "Ray" cameras in 1895. In 1898 the company moved to a new building and changed its name to "Ray Camera Co." In 1899, it became part of the new "Rochester Optical & Camera Co."
Box camera - For 3½x3½" glass plates. Rear section of top hinges up to insert holders. $30-45.

Pocket Ray - c1904. Folding plate camera, 3¼x4¼". Leather covered wood body, red bellows. Brass RR lens, Ray automatic shutter. $50-75.

Ray No. 1

457

Ray Nos. 1, 4, 6, - c1899. 4x5" wooden folding plate cameras. Red bellows. Black leather covered. $85-130. *Illus. previous page.*

Ray No. 2, No. 7 - c1899. 5x7" folding plate camera, similar to the No. 1. Dark mahogany interior, red bellows. Brass barrel lens, Unicum double pneumatic sh. $60-90.

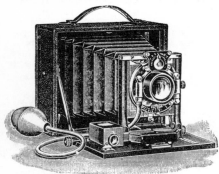

Ray A, Ray C - c1899. Box cameras for 4x5" plates. Wood body covered with black leather. $60-80.

Ray Jr. - c1897. 2½x2½" plates. $40-60.

Telephoto Ray Model C - c1901. Folding bellows camera, 4x5". Wollensak Automatic shutter. $50-80.

REAL CAMERA - Japanese novelty subminiature of the Hit type. $10-15.

RECORD CAMERA - c1890. English mahogany TLR-style box camera. 3¼x4" plates. Fixed focus; T,I shutter. $800-1200.

RECTAFLEX (Rome, Italy)

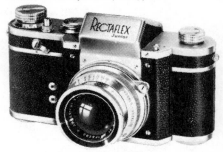

Rectaflex Junior - c1952. 35mm SLR. 25-500 shutter. Angenieux f2.9/50. $100-150.

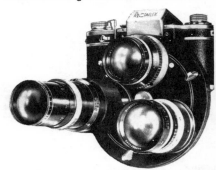

Rectaflex Rotor - c1952. 35mm SLR with 3-lens turret. With normal lens: $600-900. *Wide angle and tele lenses, each $50-75. Add $50-75 for grip. Add $75-150 for gunstock.*

Rectaflex Standard - 1949-56. One of the

first prism SLR's, along with the Contax S. Both cameras were exhibited in 1948 and produced in 1949. The Contax has an earlier patent date. Schneider Xenon f2.0 or f2.8/50mm, Biotar f2/58mm, Angenieux f1.8/50mm, or Macro-Kilar lens. Focal plane shutter 1-1000 (up to 1300 after 1952), sync. These standard (non-rotor) Rectaflex cameras are also designated Rectaflex 1000 and 1300 after their top shutter speed. Model 1000: $175-225. Model 1300: $150-200.

RED FLAG 20 - c1971-76. Chinese copy of Leica M4. Reportedly only 182 made. First two digits of serial number indicate year of production. With Red Flag 20 f1.4/50mm (Summilux copy) lens. Although quite rare, we have seen these offered under $3000 in less than ideal condition. Complete with shade and case have reached $4800 at auction.

REDDING (H.J. Redding & Gyles, London, England)

Focal plane postcard camera - c1912. Vertical folding plate postcard camera. Focal plane shutter. Cooke Anastigmat or Ilex RR lens in plain mount. $140-160.

Redding's Patent Luzo - c1896-99. (Formerly made by Robinson from 1889.) Mahogany detective box camera. Brass fittings. Several sizes, including 2¼x3¼" and 3x4" exposures on Eastman rollfilms. The first English rollfilm camera. f8 lens, sector shutter. $800-1000.

REFLEX 66 - c1955-65. Japanese copy of Reflex Korelle. Anastigmat f3.5/75mm. FP shutter to 1000. $150-200.

REFLEX CAMERA CO. (Newark, NJ & Yonkers, NY) *Founded by J.L.R. Holst. Originally located in Yonkers, NY from about 1897-1909, when they moved to Newark, NJ and took over the Borsum Camera Co., with whom they shared a complex association. The Reflex Camera of c1898-99 was one of the early popular American SLR cameras, although the Monocular Duplex had reached the market about 15 years earlier.*

Junior Reflex - c1911. Simple SLR box camera, 3¼x4¼" plate. Simple lens, 4-speed sector shutter coupled to mirror. $100-125.

Patent Reflex Hand camera - c1902. Early model leather covered 4x5" SLR box camera. Internal bellows focus. Focal plane shutter. Red focusing hood. Fine finished wood interior. Without lens: $200-350.

Reflex camera, 4x5" - c1900's. Slightly later model than the last listing. Tall viewing hood. Internal bellows focus. Euryplan Anastigmat 7" lens. $125-165.

Reflex camera, 5x7" - c1900's. f16/ 210mm Anastigmat lens. $225-325.

REGAL FLASH MASTER - Black bakelite box camera wiht integral flash. Identical to Spartus Press Flash. $5-10.

REGAL MINIATURE - Plastic novelty camera for half-frame 828. $3-7.

REGENT - Japanese Hit-type novelty camera. $10-15.

REICHENBACH, MOREY & WILL CO. (Rochester, N.Y.)

Alta Automatic - c1896. Folding camera for 4x5" plates. Named for self-erecting front, which is not common among cameras of this type. Leather covered mahogany body. Light tan leather bellows. Reversible back. Unidentified lens in R.M.&W. shutter, I&T. The shutter is easily removable from the front board with a simple twist of the locking plate whose milled edge surrounds the shutter. $75-125.

Alta D - c1896. 5x7" folding plate camera. $75-125.

REID & SIGRIST (Leicester, England)

Reid I - 1958-65. 35mm viewfinder camera, copy of the Leica Standard. Cloth focal plane shutter ½₀-1000, B,T. Interchangeable helical focus Taylor Hobson f2/2" lens with Leica screwmount thread,. $250-300.

Reid Ia - 1958-65. Similar to the Reid I, but has a second accessory shoe (like the Leica If) instead of the attached viewfinder. No reported sales.

Reid I, Ia Military - c1958. Identical to the Reid I and Ia, above, but back has British military markings, such as "0553/ 8810" with broad arrow. $300-350.

Reid II - 1958-65. 35mm camera, coupled rangefinder. Similar to the earlier Reid III, but no slow speeds. Focal plane shutter ½₀-1000, B,T. No reported sales.

Reid III - 1947-65. 35mm CRF camera, copy of Leica IIIb. Referred to only as "Reid" until 1958 when the other models were introduced. Top plate says "Reid". Interchangeable Taylor Hobson f2/2" (50mm) lens with helical focusing. Cloth focal plane shutter 1-1000. Originally introduced without sync. B,T sync added in 1953. Prices given are for camera with lens. Body only has half the value. Early versions without sync: $400-450. Synchronized: $250-300.

RELIANCE - 4x4cm "Diana" type novelty camera. $1-5.

REMINGTON MINIATURE CAMERA - Black bakelite minicam for half-frames on 127 film. $3-7.

REPORTER MAX - c1960. Black plastic 6x6cm camera. Single-speed shutter. $10-15.

REVERE
Automatic-1034 - c1969. Inexpensive plastic camera for 126 cartridges. Its only claim to fame is that the plastic body, leatherette covering, and metal trim came in several color combinations. $1-5.

Revere Stereo 33

Eyematic EE 127 - c1958. 127 film. Wollensak f2.8/58mm lens. $20-35.

Stereo 33 - c1953. Amaton, Enna Chromar S, or Wollensak f3.5/35mm. Shutter 2-200, MFX sync. Rangefinder. $100-175.
Illustrated top of next column.

REWO (Delft, Netherlands)
Rewo Louise - Metal box camera with black hammertone finish. Meniscus lens, M&T shutter. $15-20.

REX
Baby Powell - Small rollfilm camera. Copy of Zeiss Baby Ikonta. Hexar f4.5/50mm lens in Konishiroku rimset shutter. $75-125.

REX KAYSON - Japanese 35mm RF camera. f3.5/45mm; Compur 1-300 shutter. Looks like a small Leica M. $30-45.

REX MAGAZINE CAMERA CO. (Chicago)

Rex Magazine Camera - c1899. 4x5" and 3¼x4¼" sizes. Simple lens & shutter. Unusual plate changing mechanism. Plates are moved from rear storage slots to plane of focus by: 1) Select plate number by placing peg in hole. 2) Slide receptacle to rear until stopped by peg. 3) With receptacle in vertical position, invert camera. 4) Slide receptor to focal plane and re-invert camera to normal position. 5) After exposure, return exposed plate to storage by reversing these steps. Holds 12 plates. $175-225.

Rex Magazine Camera - 2x2" format. The baby brother of the above model. $200-250.

REYGONAUD (Paris)
Stand camera - c1870. Jamin Darlot lens. Brass trim. For 8x11cm plates. $400-550.

REYNOLDS & BRANSON
(Leeds, England)
Field camera - c1890. Full or half plate size. Mahogany body. Brass barrel RR lens. $100-150.

RHEINMETALL (VEB Rheinmetall, Sömmerda, East Germany)
Exa System - Similar to the earlier Ihagee Exa, but marked "System Exa, VEB Rheinmetall Sömmerda" on the faceplate. Tessar f2.8/50mm. $85-125.

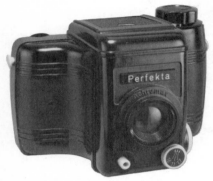

Perfekta - c1955. Black bakelite eye-level box camera for 6x6cm on 120. Large folding frame finder. Rigid rectangular front. Achromat f7.7 lens M,Z shutter. Models with and without sync. $15-20.

Perfekta II - Black bakelite camera with collapsible telescoping front. Optical eye-level finder built into top. Achromat f7.7/ 80mm. B,25,50,100 shutter. $15-20.

RICH-RAY TRADING CO.

Rich-Ray - c1951. Small bakelite camera for 24x24mm exposures on Bolta rollfilm. Nearly identical to Start-35. Marked "Made in Occupied Japan" on the bottom; "Rich-Ray" on top. Simple fixed focus f5.6

lens with lever-operated f8 waterhouse stop. B,I shutter. $25-35.

Richlet 35 - c1954. Rectangular bakelite camera with metal faceplate. Takes 24x36mm on Bolta-size rollfilm. Focusing f5.6 lens. B,25-100 shutter. Stores spare film roll inside. $20-35.

RICHARD (F.M. Richard)
Detective - c1895. Magazine box camera for 13x18cm plates. Rack and pinion focusing. $500-700.

RICHARD (Jules Richard, Paris, France)

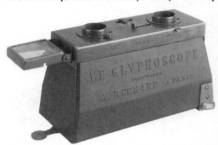

Glyphoscope - c1905. 45x107mm stereo camera of simple construction. Black ebonite plastic or leather covered wood. Meniscus lens, guillotine shutter. $75-125.

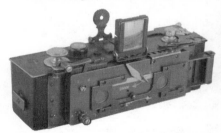

Homeos - c1914. The first stereo for 35mm film. 25 exposures on standard 35mm cine film. Optis or Zeiss Krauss Anastigmat f4.5/28mm. Guillotine shutter. Wide range of sales: $1200-2500. (Add $500-750 for viewer and printer.)

Homeoscope - c1900. Stereo cameras in 6x13 and 9x18cm sizes. $180-240.

Verascope *The Verascope line of stereo cameras bridged from the 1890's to the 1930's, with numerous variations. They were made in 45x107mm, 6x13cm, and 7x13cm sizes, with many shutter and lens combinations. Although definitely collectible, their value is still largely related to their usability.*

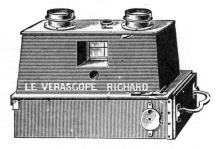

Verascope, simple models - Fixed-focus lenses, single speed shutter. All metal body, made only in 45x107mm size. Basic camera: $65-85. *Add $35-50 for magazine back. Add $100-150 for usable 127 or 120 film rollback, less for early 126 and 116 rollbacks.*

Verascope, better models - With higher quality lenses and shutters. More common than the simple models. Basic camera: $100-150. *Add $35-50 for magazine back. Add $100-150 for usable 120 or 127 film rollback, less for early 126 and 116 rollbacks.*

Verascope F40 - c1950's. Stereo camera for 24x30mm pairs of singles. Berthiot f3.5/40mm lens. Guillotine shutter to 250. RF. Made by Richard in France but sold under the Busch name in the U.S.A. Generally considered to be one of the best stereo cameras, and not often found for sale. With printer and transposing viewer: $600-700. Camera and case: $350-500.

RICHTER (Germany)
Rica-Flex - c1937. TLR, 6x6cm on rollfilm. Pololyt f3.5/75mm in Stelo shutter. $75-125.

RIDDELL (A. Riddell, Glasgow)
Folding plate camera - c1880's. 9x12cm. Built-in roller-blind shutter. $200-250.

RIETZSCHEL (A. Heinrich Rietzschel GmbH Optische Fabrik, Munich, Germany) *Merged with Agfa in 1925, at which time the Rietzschel name was no longer used on cameras and the first Agfa cameras were produced.*
Clack - c1910. Folding bed camera for plates. 9x12cm or 10x15cm sizes. Red bellows, black leathered wood body,

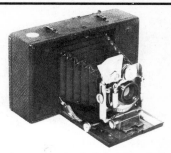

aluminum standard, nickel trim. f6.3 or f8 lens. $75-125.

Clack Luxus - Deluxe version of the Clack folding bed plate cameras. Brown leather, brown double extension bellows. Compur shutter. 6.5x9cm size has Solinar f4.5/120mm lens. 9x12cm has Linear f4.8/135mm lens. $275-350.

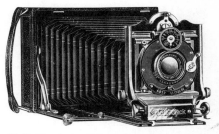

Heli-Clack, horizontal type - c1910. 9x12cm or 10x15cm horizontal format folding plate cameras. Double extension bellows. Double Anastigmat f6.8 or Tri-Linear f4.5 lens in Compound shutter. $75-150.

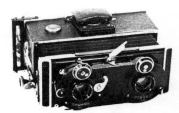

Kosmo-Clack Stereo - c1914. 45x107mm format. Double Anastigmat f6.3, Rietzschel f4.5/60mm or f6.8/65mm lenses in Compur 1-250 shutter. Panoramic photos also possible. $175-225. *A usable rollback would add $100-150 to this price.*

Miniatur-Clack 109 - c1924. Small folding bed camera for 4.5x6cm plates. The first camera produced by Rietzschel in this size. Double extension bellows. Linear f4.5/

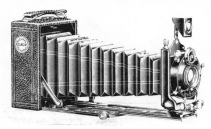

165mm Anastigmat in Compound or Compur shutter. $150-240.

Platten Tip I - c1906-10. Double extension folding plate camera, 9x12cm. f8 Rectigraphique lens in shutter ½25-100. $100-150.

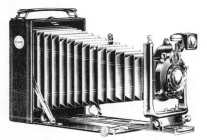

Reform-Clack - c1910-1920's. 6.5x9cm folding plate camera. Dialyt f6.8/105mm in Compound or Dial-set Compur 1-250. Double extension bellows. $35-50.

Taschen Clack 128 - c1920-25. Folding rollfilm camera, 4.5x6cm. Also accepts plates. (Rietzschel did not make very many rollfilm cameras.) Sextar f6.8/90mm in Compur. $60-80.

Universal Heli-Clack - Folding bed camera. Similar to the regular Heli-Clack, but with wide lensboard.

- Type I - Panoramic with single lens. 13x18cm size, with Linear Anastigmat f4.8/210mm lens: $100-125. 8x14cm size: $60-90.

- Type II - Stereo with two lenses in stereo shutter. 13x18cm size with Doppel Apotar f6.3/120mm stereo lenses: $350-450. 8x14cm size: $200-300.

- Type III - 3 lenses in Stereo-Panorama shutter. No sales data.

RIKEN OPTICAL (Japan)
Baby Kinsi - c1941. Strut-folding 127 rollfilm camera, 3x4cm. Kinsi Anastigmat f4.5/5cm in Seikosha Licht sh. $200-300.

Golden Ricoh 16 - c1957. Subminiature for 25 exposures 10x14mm on 16mm film. Interchangeable Ricoh f3.5/25mm fixed focus lens. Sync. shutter 50-200,B. Have sold for up to $325 at German auction. Often found with case and presentation box for $125-150 in USA. Camera and normal lens only: $80-100.

Golden Steky - c1957. Subminiature for 10x14mm on 16mm film. Same as Golden Ricoh 16 except for the name. Shutter 50-

200,B. Stekinar fixed focus f3.5/25mm lens: $120-150 in USA; up to 70% higher in Europe. *Add $50 for f5.6/40mm telephoto.*

Hanken - c1952. Subminiature camera nearly identical to the Steky III, but with additional waist-level viewer. Rare. $250+.

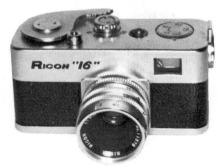

Ricoh 16 - c1958. Subminiature for 10x14mm exposures on 16mm film. Interchangeable Ricoh f2.8/25mm focusing lens. Shutter 50-200,B. Rapid wind. Like the Golden Ricoh 16, but in chrome. Much less common. $125-175.

Ricoh 35 - c1955. 35mm RF. Ricomat f3.5/45mm lens in Riken shutter 10-200,B, or f2.8 in Seikosha-Rapid 1-500,B. $25-35.

Ricoh 35 Flex - c1963-66. 35mm SLR with coupled selenium meter on pentaprism front. Fixed Ricoh f2.8/50mm lens in ½o-300,B front shutter. $40-60.

Ricoh 300 - c1959-60. 35mm RF. Noninterchangeable Rikenon f2.8/45mm lens in Riken leaf shutter ¹⁄₁₀-300. $10-20.

Ricoh 300S - c1962. Similar to the Ricoh 300. Shutter ⅛-300. $15-25.

Ricoh 500 - c1957-61. 35mm CRF. Ricomat f2.8/45mm in Seikosha-MXL shutter 1-500. Lever advance on bottom with pivoting trigger. $20-40.

Ricoh Auto 35 - c1960-65. 35mm. Top half of body is chrome, bottom blue-gray. Automatic electric eye meter cell surrounds lens. Ricoh f4/40mm fixed focus lens, shutter ¹⁄₂₅-170. Lever advance on bottom. $25-35.

Ricoh Auto 35-L - same as Ricohmatic 35 below.

Ricoh Auto 66 - c1960-64. TLR for 6x6cm on 120 rollfilm. Rolleimagic copy. Built-in coupled exposure meter. Ricoh f3.5/80mm lens, Seikosha-L shutter 1-250. $75-125.

Ricoh Auto Half - c1960-63. Spring-wind half-frame 35mm. Built-in selenium meter.

Ricoh f2.8/25mm fixed focus lens in Seikosha shutter 1/30, 1/125. (Also sold in the USA as Ansco Memo II.) $20-35.

Ricoh Auto Shot - c1960-66. Spring-wind 35mm. Built-in coupled selenium meter around lens. Rikenon f2.8/35mm in Copal 1/30, 1/125. Unique lens cover becomes a flash attachment when inserted into accessory shoe. With lenscover: $25-40.

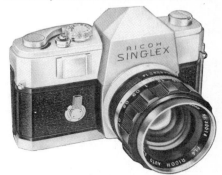

Ricoh Singlex - c1964-66. 35mm SLR. Nikon-bayonet mount Auto Rikenon f1.4/55mm. FP shutter 1-1000,B. Optional CdS meter on right side of front plate. $75-125.

Ricoh Six - c1952. 6x6cm or 4.5x6cm on 120 rollfilm. Orinar f3.5/80mm. Riken shutter 25-100,B. $35-50.

Ricoh Super 44 - c1958. 127 TLR. Riken f3.5/60mm. Citizen-MV 1-400,B. $45-70.

Ricoh Teleca 240 - c1971. Half-frame 35mm camera built into 7x50 binoculars. Rikenon f3.5/165mm lens. Copal 60-250 shutter. Motorized film transport. Same camera/binoculars sold under the Nicnon name. $300-500.

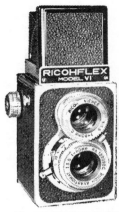

Ricohflex - Models III (1950), IIIB (1951),

IV (1952), VI (1953), VII (1954), VIIS (1955). (Note: There are no models I, II, or V.) 6x6cm TLR. Ricoh Anastigmat f3.5/80mm lens. $25-35.

Ricohflex Dia - c1955. TLR, 6x6cm. Ricoh f3.5/80mm lens, Citizen-MXV shutter 1-400,B. $60-100.

Ricohflex TLS-401 - c1970. 35mm SLR. Pentaprism converts from normal eye-level to reflex viewing by turning small knob on side of prism housing. CdS TTL metering. Auto Rikenon f1.7/50mm. $75-100.

Ricohmatic 35 - c1961-64. Similar to the Ricoh Auto 35, but with coupled RF, faster f2.8/40mm focusing lens, and shutter to 200. $30-40.

Ricohmatic 44 - c1956. Gray TLR, 4x4mm on 127. Built-in meter. Riken f3.5/ 60mm. Shutter 32-170,B. $40-60.

Ricohmatic 225 - c1959-62. TLR, 6x6cm. Built-in direct reading selenium meter. Rikenon f3.5/80mm lens, Seikosha-SLV shutter 1-500,B. Crank film advance. Built-in 35mm adapter. $75-125.

Ricolet - 1954. First Riken 35mm camera. No rangefinder. "RICOLET" on front of cast-metal finder housing. Ricoh f3.5/45mm. Riken 25-50-100, B shutter. $20-40.

Ricolet S - 1955. Similar, but shutter ⅒-200. $20-40.

Roico - c1940-43. Eye-level camera for 4x4cm on 127 film. Telescoping front. Automatic film stop. Roico Anastigmat f3.5/60mm. Early model c1940 has T,B,5-200 shutter. Later, c1943, with R.K.K. T,B, 1-200 shutter. $100-150.

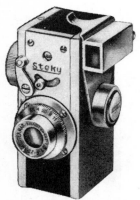

Steky - c1947. Subminiature for 10x14mm on 16mm film. Stekinar Anastigmat f3.5/ 25mm fixed focus lens. Shutter 25, 50, 100. $50-75. *Up to 50% higher in Europe.*

Steky II, III, IIIa, IIIb - c1950-55. Only minor variations in the models. $50-75. 50% higher in Europe. *Add $25 for tele lens.*

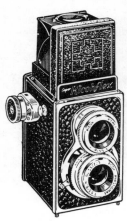

Super Ricohflex - c1955. TLR for 3 different film sizes: 6x6cm on 120, 4x4cm on 127, 24x36mm on 35mm. Ricoh Anastigmat f3.5/80mm. Riken shutter 10-300, B. $25-45.

RILEY RESEARCH (Santa Monica, CA)

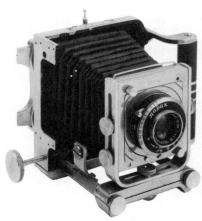

Rilex Press - c1948. 2¼x3¼" all aluminum press & view camera with generous front movements and revolving back. Tessar f4.5 or Wollensak Velostigmat f4.5 lens. $125-175.

RILO - 6x9cm metal box camera, leatherette covering. $10-15. *Illustrated top of next page.*

RIMEI BOX - Box camera for 6x6cm. $30-40.

RIVAL 120 - c1950. Box camera for 6x9cm on 120 rollfilm. Art-deco front plate. $10-15.

RO-TO (Turin, Italy)
Elvo - c1938. Brown bakelite strut-folding camera for 3x4cm on 127 film. Achromatic f8 lens. $40-55.

Nea Fotos - c1948. Bakelite camera for 4x6.5cm on 127 film. Styled like a 35mm camera. Eye-level finder. Focusing f7.7/54mm lens. Shutter: 25-100,B. $15-25.

ROBBIN PRODUCTS (Hollywood, CA)

Rilo

RING CAMERA (Poland) - Unusual "spy" camera disguised as a finger ring of chromed metal. Engraved 'Trioplan 2.8/10' and 'Warsavie'. Sold at auction in July, 1987 for $1,925.

RIVAL - c1953-57. Folding camera made in versions for 620 and 120 rollfilm. 2¼x3¼" or 1⅝x2¼". f4.5 lens, shutter to 200. $8-12.

Robbin Reflex - Simple TLR-style box camera similar to the Herco-Flex 620. Made by Herbert George Co. for Robbin. A common looking camera, but uncommon with this name. Originally with a cheap imitation leather ever-ready case. $5-10.

ROBINSON (J. Robinson & Sons)

RIVAL 35 - c1950. German folding 35mm sold by Peerless Camera Stores in U.S.A. Radionar or Ennagon f3.5/50mm in Prontor S shutter. $20-30.

Luzo - c1889. Mahogany detective box camera. 6x6cm on rollfilm. A model also exists for glass plates. Aplanat f8/75mm. Rotary sector shutter. $800-1000.

ROCAMCO PRODUCTS (Boonton, NJ)
Also known as Rochester Camera Co., New York City. Named for its president, Richmond Rochester.

Rocamco - c1936. Small metal box for 2.5x3cm on special 35mm film. $100-200.

Rocamco No. 3 Daylight Loading Rollfilm Camera - c1938. For 30x32mm on special rollfilm. Small bakelite camera. "A Rochester Product" molded on back. "No. 3 Daylight Loading Rollfilm Camera" designation is on the original box. $25-40.

ROCHE (J. Roche, Villeurbanne, France)
Allox - c1948. Leatherette covered stamped metal eye-level camera for 6x9cm. Cast aluminum top and front. Achromatic f11 lens in simple I&P shutter. Very uncommon, having not sold well even in France. $40-60.

Rox - c1948. Similar to the Allox, but with

Rox.A f8 Aplanat or Trylor f4.5 lens in Gitzo shutter. Uncommon even in France. $65-80.

ROCHECHOUARD (Paris)
Le Multicolore - c1912. Magazine box camera for 9x12cm plates. Color filters could be moved into place, one at-a-time behind the lens for color separation plates. Rapid Rectilinear lens. Guillotine shutter. $800-1200.

ROCHESTER CAMERA MFG. CO.
ROCHESTER CAMERA & SUPPLY CO.
ROCHESTER OPTICAL COMPANY
ROCHESTER OPTICAL & CAMERA CO.
The Rochester OPTICAL Company was established in 1883 when W.F. Carlton took over the business of Wm. H. Walker & Co. The Rochester CAMERA Mfg. Co. was founded in 1891 by H.B. Carlton, brother of W.F. Thus there existed in Rochester, N.Y. two comtemporary companies, with similar names, and owned by brothers. Their major camera lines even had similar names. The Rochester CAMERA Mfg. Co. made POCO cameras, while the original Rochester OPTICAL Company began its PREMO camera line in 1893. To further complicate the name game, the Rochester Camera Mfg. Co. changed its name in 1895 to "Rochester Camera Co.", and in 1897 to "Rochester Camera & Supply Co.". In 1899, the two "Rochester" companies merged with the Monroe Camera Co, the Ray Camera Co. (formerly Mutschler & Robertson Co.), and the Western Camera Mfg. Co. of Chicago (mfr. of Cyclone cameras), to form the new "Rochester Optical and Camera Company". The new company retained the original products: Cyclone, Poco, Premo, and Ray. In 1903, George Eastman purchased the company and shortened the name again to "Rochester Optical Co.". It became "Rochester Optical Division, E.K.C." in 1907 and finally "Rochester Optical Department" in 1917. While the many name changes can seem confusing at first, they do help to date particular examples of cameras:

Rochester Camera Mfg. Co.: 1891-1895
Rochester Camera Co.: 1895-1897
Rochester Camera & Supply Co.: 1897-1899
Rochester Optical Co.: 1883-1899, (& 1903-1907, owned by Eastman)
Rochester Optical & Camera Co.: 1899-1903
Rochester Optical Div., EKC: 1907-1917

ROCHESTER CAMERA MFG. CO.
Favorite - c1890. 5x8" or 8x10". Brass Emile No. 5 lens with waterhouse stops. $150-250.

Folding Rochester - c1892. The first folding plate camera that they made. 4x5" and 5x7" sizes. Made only briefly. Seldom seen. $300-400.

Poco Cameras - Introduced in 1893.
- 4x5" Folding-bed plate cameras -
Models 1-7, A, B, C, including Cycle Pocos.

Pocket Poco

No. 4 Cycle Poco

Leather covered wood body and bed. Nicely finished wood interior. Often with B&L RR lens and Unicum shutter. $60-90.

- 5x7" Folding-bed plate cameras - Models 1-5, including Cycle Pocos. Black leather covered wood body. Polished interior. Red bellows. RR lens. Unicum shutter. $75-125.

- 8x10" Poco - Similar, but larger. Double extension bellows. B&L Symmetrical lens. $90-140.

Gem Poco, box - c1897. 4x5" plate. Sliding lever at left front for focusing. Shutter tensioned by brass knob on face. $40-60.

Gem Poco, folding - c1895. Very compact folding camera for 4x5" plates in standard holders. Red bellows. Polished wood interior. Shutter built into polished wood lensboard. $75-125.

King Poco - c1899. 5x7" folding view, advertised as "Compact, elegant in design, and equipped with every known appliance. Especially adapted for those desiring the most perfect camera made." This was the top of the line. Not seen often. $125-200.

Pocket Poco - 3¼x4¼" folding plate camera. Red bellows, RR lens, single pneumatic shutter. $50-75. *Illustrated top of previous column.*

Pocket Poco A - c1903. Strut-folding plate camera similar in design to the Pocket Monroe A (see Monroe). 3¼x4¼" size. B&L Achromatic lens, Automatic shutter. NOT similar to the Pocket Poco which is a folding bed camera. $100-150.

Stereo Poco - c1898-1903. Folding plate camera, 5x7". Basic body style is similar to the Cycle Poco cameras. Rapid Rectilinear lenses in pneumatic Unique Stereo shutter. $250-300.

Telephoto Poco, Telephoto Cycle Poco:

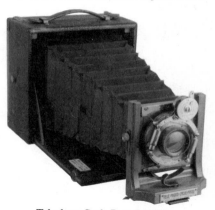

Telephoto Cycle Poco D 4x5"

- 4x5" - c1891. Folding plate camera. Double or triple extension red leather bellows. B&L lens in Auto or Victor shutter. Some have storage in back of camera for extra plateholders. $75-125.

- 5x7", 6½x8½" - c1902. Folding plate cameras. Red leather bellows, double or triple extension. B&L RR lens, Auto shutter. $75-125.

Tuxedo - c1892. Leather covered 4x5" folding plate camera. Black wood interior, black wood front standard. This is an all-black version of the Folding Rochester camera. Brass trim. $225-300.

View - c1899. Tailboard view in sizes 5x7" to 8x10". Maroon bellows, nickel trim. With contemporary brass lens. $175-225.

ROCHESTER OPTICAL CO.

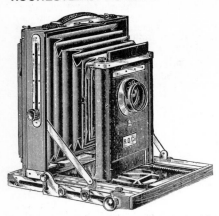

Carlton - c1893-1903. All-wood, double extension view, similar to the Universal. Double swing back. Brass trim. With lens: $150-250.

Cyclone Cameras - (made by Western Camera Mfg. Co. prior to 1899.)

Magazine Cyclone - No. 2, 4, or 5. c1898. For 3¼x4¼ or 4x5" plates. Black leathered wood box. Meniscus lens, sector shutter. $40-60.

Cyclone Junior - c1902. Plate box camera for 3½x3½" glass plates in standard holders. Top door hinges forward to load plateholders. A cheaper alternative to the Cyclone magazine cameras. $30-40.

Cyclone Senior - c1902. Plate box camera, 4x5" for standard plateholders. $25-35.

Cyko Reko - c1900. An export model of the Pony Premo D. Made for Army & Navy

Auxiliary Supply, London. Folding bed camera for 4x5" plates. Meniscus Achromatic lens in Unicum shutter. $60-90.

Empire State View - c1895. Folding field camera. Polished wood. Brass fittings. 5x7" & 6½x8½": $60-100. 8x10": $75-125. 11x14": $60-90.

Folding Pocket Cyko No. 1 - For 3¼x4¼" plates. Aluminum body. Sector shutter. $200-250.

Handy - c1892. 4x5" detective box-plate camera. Internal bellows focus. A simple, less expensive version of the Premier. $100-160.

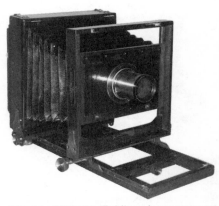

Ideal - c1885-95. Folding view cameras, 4x5" to 8x10" sizes. Cherry wood, brass trim. Ranging in price, depending on size and equipment, from $100-200.

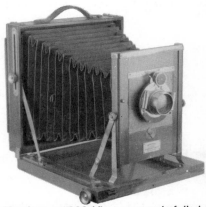

Monitor - c1886. View camera in full plate and 8x10" sizes. Wood body folds in the "English" compact style. $125-175.

- 3¼x4¼" - Pony Premo No. 2, Star Premo, etc. Brass RR lens; Gem shutter. $75-125.

New Model View, New Model Improved View - c1895. Made in all the common sizes from 4x5" to 8x10". $125-200.

Peerless view - c1897. 5x7" plates. Dark mahogany. Brass Wollensak Regular shutter. $125-200.

Premier box camera - c1891. Internal bellows focus with external control knob. Side panel opens to insert plate holders. 4x5 and 5x7" sizes. $100-200.

Pony Premo No. 2

- 4x5" - c1900. Folding plate cameras, ncluding: Pony Premo, Premo Senior, Star Premo, Premo A-E, 2, 4, 7, and 15. Red bellows. EUR: $75-125. USA: $50-90.

- 5x7" - c1900. Folding plate cameras, including: Pony Premo B and E, Pony Premo Sr., No. 4, and No. 6, Premo No. 6, Premo B, and Premo Senior. Red bellows. EUR: $100-150. USA: $75-125.

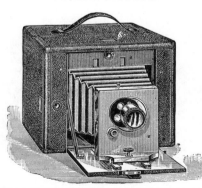

Premier folding camera - c1892. 4x5 or 5x7" size, for plates. Originally with shutter built into wooden lensboard: $300-400. Later w/ B&L pneumatic shutter: $200-250.

Premo Cameras *See also Eastman for their continuation of the Premo line. Prices here are for cameras with normal shutter/lens combinations. (Often B&L lenses, Victor shutter.)*

Premo Folding Film Camera No. 1 - 1904-05. Folding bed camera for filmpacks. Made in 3¼x4¼", 3¼x5½", and 4x5" sizes. Double RR lens, Gem Automatic sh. $60-80.

Premo Folding Film Camera No. 3 - 1905. Folding bed camera for filmpacks. Same as No. 1 in three sizes, but better lens/shutter equipment including: B&L Zeiss Protar, B&L Plastigmat, Goerz Double Anastigmat f6.8, or Planatograph lens in Volute or B&L Automatic shutter. $75-125.

Folding Premo Camera - 1893-94. This is the original folding plate model. Rapid Rectilinear lens, Star shutter. Sizes 4x5", 5x7", and 6½x8½". $100-150.

Pocket Premo - 1903-05. 3¼x4¼" folding bed camera for plates or filmpacks. Various lenses in B&L Automatic or Volute shutter. $35-50.

Pony Premo No. 5 - 1898-1903. Various lens/shutter combinations. For plates. 4x5": $50-75. 5x7": $75-100. 6½x8½", much less common: $80-150.

Long Focus Premo - 1895-1904. Triple extension red bellows. Sizes 4x5, 5x7, 6½x8½". Various lens/shutter combinations. $125-250.

Premo Reflecting Camera - 1905-06. 4x5" single lens reflex camera with front bed and bellows (unlike the later Premograph). Various B&L or Goerz lenses. FP shutter. Reversible back. Tall focusing hood supported by trellis strut. This is a rare model and should not be confused with the less rare Premograph. Price negotiable. Estimate: $600-900.

Premo Sr. Stereo - 1895-1900. 5x7" or full plate. Rapid Rectilinear lens. B&L Stereo pneumatic shutter. Maroon bellows. Folding plate camera, a modification on the Premo Sr. $200-350.

Reversible Back Premo - 1897-1900. 5x7". Looks like a Long Focus Premo, but back shifts from horizontal to vertical. $125-200.

Reko - c1899. Folding camera for 4x5" plates. Leather covered mahogany body with brass trim. Red leather bellows. Special Reko Rectilinear lens in Unicum shutter. Uncommon. $60-90.

Rochester Stereo Camera - c1891. Wooden stereo field camera with folding tailboard. 5x7 or 6½x8½" size. B&L shutter. Red bellows. $250-350.

Snappa - c1902. Unusual ¼-plate folding-bed view with integral magazine back. Holds 12 plates or 24 cut films. Red bellows, nickel & brass fittings. RR lens. Quite rare. We have only one sale on record, in early 1982, at $585.

New Rocket - Early postwar Japanese novelty subminiature, 14x14mm. Some cameras are marked "Rocket Camera Co." below lens, others have "Tokyo Seiki Co. Ltd." A third variation has "New Rocket" on the shutter face and no manufacturer name. All have "New Rocket" on top. Chrome: $140-160. Gold: $175-200.

RODEHÜSER (Dr. Rodehüser, Bergkamen, Westf., Germany)
Panta - c1950. Cast metal body with telescoping front. Two sizes: 5x5.5cm on 120, or 4x6.5cm on 127 rollfilm. Ennar f4.5, or Steiner or Radionar f3.5/75mm lens. Prontor, Prontor S, or Vario shutter. $40-50.

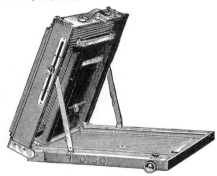

RODENSTOCK (Optische Werke G. Rodenstock, Munich) *Never made cameras, but sold mainly Welta cameras with Rodenstock lenses under their own names.*
Astra - Double extension folding plate camera 6.5x9cm. Eurynar f6.8/90mm in Compound shutter. $35-45.

Universal - intro. 1888. Polished wood view, 5x7" or 6½x8½". Brass trim, brass barrel lens with Waterhouse stops. $125-165.

ROCKET CAMERA CO. LTD. (Japan)

General, Palmer, Rocket Camera - c1955. Simple metal box cameras, 4x5cm on 120 film. Fixed focus, B,I shutter. $5-10.

Citoklapp - c1930. Self-erecting folding rollfilm, 6x9cm. Trinar f4.9/100mm lens in Pronto shutter. $35-50.

Citonette - c1933. Self-erecting folding bed camera for 16 exposures, 4.5x6cm,

on film. Trinar f2.9 or f3.9, Ysar f3.5 or f4.5/ 75mm. Pronto S or Compur S sh. $30-45.

Clarovid, Clarovid II - c1932. Folding-bed dual-format rollfilm cameras for 6x9cm or 4.5x6cm exposures. Rim-set Compur 1-250. Trinar Anastigmat f4.5 or f3.8/ 105mm lens. Coupled rangefinder. The rangefinder is Rodenstock's, but the camera body is from Welta. $95-140.

Folding plate/sheetfilm camera - 9x12 or 6.5x9cm. f2.9, f3.8, or f4.5 Trinar. $30-40.

Folding rollfilm camera - Models for 120 rollfilm, 4.5x6 and 6x6cm, or 116 rollfilm. Rodenstock Trinar f2.9 or Eurynar f4.5 lens. Rim-set Compur 1-250. $30-50. *Illustrated top of next column.*

Perforette Super - c1950. Viewfinder 35mm. Rodenstock Trinar Anastigmat f3.5/ 75mm. Prontor 1-175, B,T. $20-30.

Prontoklapp - c1932. Self-erecting folding bed camera for 6x9cm on 120 film. Trinar Anastigmat f4.5 or f5.8/105mm. Vario, Pronto, or Compur shutter. $25-40.

Robra - c1937. Folding camera, 4.5x6cm on 120. Robra Anastigmat f3.5/75mm. Compur shutter. $45-60.

Rodenstock Folding rollfilm camera

Rodella - c1932. Strut-folding rollfilm camera, 3x4cm. Trinar f4.5 or f2.9/50mm lens in Prontor II or Compur shutter. $60-80.

Rodinett - c1932. Small rollfilm 3x4cm camera with front "barn-door" and strut system to support lens panel. Made by Glunz, using the body of the equally scarce Glunz Ingo, but fitted with a Rodenstock Ysar f3.5/50mm lens. $150-225.

Rofina II - c1932. Strut-folding vest pocket camera for 4x6.5cm on 127 film. Trinar f2.9/75mm in Compur-S. $45-75.

Wedar, Wedar II - c1929. Folding bed plate camera. Model II has rack and pinion focus. Made in 6.5x9cm and 9x12cm sizes. Various lenses and shutters. $25-45.

Ysella - c1932. Strut folding camera with bed. Half-frame 127. Trinar f2.8 or 4.5/ 50mm in Compur shutter. $50-75.

ROGERS JUNIOR - Folding 6x9cm rollfilm camera. Uncommon. $20-25.

ROKUWA CO. (Japan)

Stereo Rocca - c1955. Plastic stereo camera for 23x24mm stereo pairs side-by-side on 120 rollfilm. Film travels vertically through camera. Fixed focus f8 lens, shutter 30,B. $100-135.

ROLAND (Alphonse Roland, Brussels, Belgium)
Folding plate camera - c1895. Leather covered mahogany body, brass trim, brass f11 lens. Takes 9x12cm plates. $200-250.

ROLLO-FREX - c1941. Forget the technical description. The name alone makes it a crassic. Possibly made by Taiko-do Co. Relatively scarce TLR from the immediate pre-war period. Rarity and the unusual name would surely attract a few buyers. No known sales. Estimate: $200+

ROLLS CAMERA MFG. CO. (Chicago)
Beauta Miniature Candid - Bakelite minicam for half-127 film. Originally sold as a punchboard premium. $3-7.

Picta Twin 620 - Cast aluminum camera for 620 film. Front appears to be collapsing type, but is rigid. Rollax 62mm lens in simple shutter. $10-15.

Rolls - c1939. Bakelite novelty camera for half-frame 127. $3-7.

Super Rolls 35mm, f3.5 - Inexpensive cast metal 35mm with body release. Retractable front has helical focusing. Shutter 25-200. Achromatic Rollax f3.5 lens. $15-20.

Super Rolls 35mm, f4.5 - Similar, but

without body release. Anastigmat f4.5 lens. $15-20.

Super Rolls Seven Seven - Heavy cast metal camera for 4x5.5cm on 620 film. T,B,I leaf shutter with body release. Named for its f7.7 Achromatic Rollax lens. Focuses 3' to infinity by manually extending the front to proper footage mark. $10-15.

Rolls Twin 620 - c1939. Cast aluminum box camera for 620 film. $10-15.

RONDO COLORMATIC - c1962. 35mm camera with meter cell surrounding lens. $10-20.

RONDO RONDOMATIC - c1962. Identical to the Colormatic. $10-20.

ROROX - 3x4cm on 127 film. Bottom loading. $30-45.

ROSKO - "Diana" type novelty camera. Imitation meter grid on top housing. $1-5.

ROSS (Thomas Ross & Co.)

Folding Twin Lens Camera - c1895. Boxy twin lens reflex style camera. Front double doors open straight out. Goerz Double Anastigmat f7.7/5" lens. $500-700.

Kinnear's Patent Wet-Plate Landscape Camera - c1860's. Wet plate field camera. Mahogany construction, tapered bellows. Named for the patented bellows design of C.G.H. Kinnear, a Scottish photographer. His tapered bellows folded more compactly than the typical square type of the day. 6x7" or 10x12" size. Brass barrel landscape lens. $500-550.

Portable Divided Camera - c1891. Called "Portable Twin Lens Camera" beginning in 1895. Boxy twin-lens reflex. Front door is hinged at left side and swings 270 degrees to lay flat against the side of the body. Wooden body is covered with hand-sewn black hide. Ross Rapid Symmetrical lens. $450-600.

Reflex - c1912-35. Single lens reflex, similar to the Marions Soho Reflex. 1/4-plate to 5x7" sizes. FP 1/14-800. $100-160.

Stereo camera - c1900. 1/2-plate. Polished mahogany, tapered leather bellows. Ross lenses. Thornton-Pickard shutter. $500-700.

Sutton Panoramic Camera - c1861. This camera, made for Thomas Sutton by Ross, takes curved glass plates in special curved holders. And wet-plates at that! Only about 30 were made. The lens is water-filled and gives an angle of 120 degrees. Three of these cameras sold at auction in 1974 for approximately $24,000 to $27,000. In June 1983 there were two offered for sale at $14,000 and $17,000. Confirmed sales indicate a current value in the $12,000-14,000 range.

Tailboard camera - c1888. Mahogany and brass folding plate camera, brass bound Ross lens. Thornton-Pickard FP shutter. 1/2-plate, to 10x12 sizes. $200-350.

Wet-plate camera (sliding box style) - Recent sales have been in the range of $800-1200.

Wet-plate camera (tailboard style) - c1865. 12x12" mahogany camera, brass fittings, folding tailboard and bellows. Euryscop lens, waterhouse stops. $750-950

476

Wet-plate Stereo (sliding-box style) - Mahogany body. Grubb or Dallmeyer brass bound lenses. $3000-5000.

Wet-plate Stereo (tailboard style) - c1865. Full plate size. Maroon square bellows. Ross Petzval 6" lenses, waterhouse stops. $2500-3500.

ROSS ENSIGN LTD.

Fulvueflex Synchroflash - c1950. Inexpensive plastic reflex-style box camera, 6x6cm on 120 film. Fixed focus Astaross lens, B & I shutter. Twin sockets on left side for flash. $15-25.

Snapper - Self-erecting camera for 6x9 on 620 film. Cast aluminum body with integral eye-level finder. Grey crinkle-finish enamel. $15-25.

ROTH (A. O. Roth, London) *Mainly an importer of Meyer lenses and Mentor cameras.*
Reflex, 4.5x6cm - c1926. SLR. Hugo Meyer Trioplan f6.3/75mm lens in FP shutter 10-1000. $300-350.

Reflex, 8x10.5cm - c1910. SLR. Hugo

Meyer Trioplan f2.8/95mm lens in FP shutter 10-1000. $200-300.

ROTHLAR 4x4 - Bakelite body with stamped aluminum top and bottom. The only identification on the camera is "Made in Germany" stamped on the rear of the top. "Achromat F=6cm" on lens rim. Z & M speeds on middle lens collar. Rear collar has stops: 16, 12.5, 9. Identifying characteristic: the back latch button is unusually located front and center, above and behind lens. If you happen to find one in its original case, the case front says "Rothlar-Optik". $30-40.

ROUCH (W.W. Rouch & Co., London, England)
Eureka - c1888. Polished mahogany detective camera. Magazine for 12 8x8cm or ¼-plate size. Brass barrel Rouch 150mm lens, rollerblind shutter. $300-400.

Excelsior - c1890. Mahogany detective camera, similar to the Eureka, but takes ordinary double slides as well as the Eureka magazine back. ¼-plate size. $350-500.

Patent camera - Mahogany field camera with brass fittings. Earliest versions for 7½x7½" wet-plates. Later, c1892, for dry plates, ½-plate size. Ross Rapid Symmetrical lens with Waterhouse stops. $150-250.

ROUSSEL (H. Roussel, Paris)
Stella Jumelle - c1900. 9x12cm plates. Roussel Anti-Spectroscopique f7.7/130mm

in 7-speed guillotine shutter. Leather covered wood body. $175-225.

ROVER - Hong Kong "Diana" type novelty camera. $1-5.

ROYAL CAMERA CO. (Japan)
Royal 35 - c1960. 35mm RF. Tominor f2.8/50mm non-changeable lens. Copal 1-300 shutter. $75-125.

Royal 35M - c1957. 35mm camera with coupled rangefinder and built-in selenium meter. Tominor f2.8/45mm lens in Copal MXV shutter. $50-75.

ROYAL-HAMILTON INDUSTRIES INC. (New York & Chicago)

Royal #1 - Unusually styled bakelite camera for 2¼x3¼". Obviously related to the many "minicam" types for 3x4cm on 127 and 828 film, this one is overgrown and with protruding snout to hold the normal sized lens and shutter. $15-25.

ROYCE MFG. CO.
Royce Reflex - c1946. Twin lens reflex, cast aluminum body and back. Externally gear-coupled lenses. f4.5/75mm in Alphax shutter 25-150, T,B. $25-35.

ROYER (Fontenay-sous-Bois, France)
Altessa - c1952. Telescoping front camera for 6x9cm or 6x6cm on 120 film. Angenieux interchangeable f3.5/105mm. $50-100.

Royer A - c1949. Self-erecting folding bed camera for 6x9cm on 120 film. Built-in optical finder. Angenieux Type VI f4.5/105mm in Sito 10-200. $15-20.

Savoy II - c1960. 35mm viewfinder camera with rapid wind lever. Berthiot f2.8/50mm lens. $20-30.

Savoyflex - c1959. 35mm SLR. Som Berthiot f2.8/50mm. Prontor Reflex interlens shutter, 1-500. $50-75.

Savoyflex II - Similar but with helical focusing. $50-75.

ROYET (Paul Royet, St. Etienne, France)

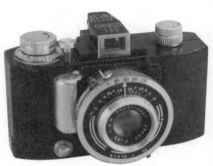

Reyna Cross III - Black painted cast aluminum bodied 35mm. f3.5 Berthiot or f2.9/45mm Cross. Two blade shutter 25-200, B. This camera was essentially a continuation of the Cornu Reyna line, but manufactured away from Paris which was under German occupation. See Cornu for similar models. $20-35.

RUBERG & RENNER
Adickes - c1933. Black bakelite body with helical lens mount. Rodenstock lens, I+T shutter. Similar to the Baby Ruby. Sold in Germany as the Rubette. $40-50.

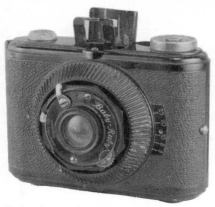

Baby Ruby - Small bakelite camera for 3x4cm exposures. Front extends to focus position via ring and helix. Fixed focus lens with 2 stops, "BIG" and "Small". T & I shutter. $40-50.

Fibituro - c1934. Metal body in red marbelized enamel. Takes 4.5x6cm or 3x4cm on rollfilm. Rodenstock Periscop f11. M&Z shutter. $30-40.

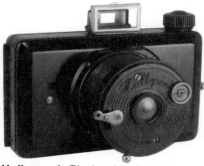

Hollywood - Black painted metal camera with bakelite helical telescoping front. Similar to the other Ruberg cameras, but molded shutter face rather than enameled metal. Takes 40x55mm photos on 127 film. The markings are all in French, including "Fabrique en Allemagne", so it was probably made exclusively for export to France. $20-30.

Nenita - c1950's. Named "little baby", this camera has all of its markings in Spanish. Other than that, it is like the Ruberg Futuro or Fibituro. Red & black marbelized enamel on metal body. Helical extending front. Takes 4x6cm on 127 rollfilm. The rarest of the Ruberg family. If the price scares you, don't worry. You'll probably never see one. $75-100.

Ruberg - c1953. Metal body, 4x6cm on rollfilm. Front section screws out like the Photax. $30-50.

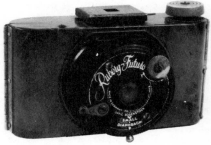

Ruberg Futuro - Metal body, 4.5x6cm on 127 rollfilm. Red or black enameled. Helical lens mount. $30-50.

RUTHINE - 35mm CRF camera. Friedrich Corygon f2.8/45mm lens. Shutter 25-100, B. $15-25.

SAINT-ETIENNE (France)
Universelle - c1908. Vertical folding plate/rollfilm camera, along the lines of the Screen Focus Kodak, but with a removable back. Beckers Anastigmat f6.8/150mm in B&L Unicum shutter. $150-200.

SAKURA SEIKI CO. (Japan)

Petal, round and octagonal models

Petal - c1948. Subminiature camera about the size of a half-dollar. (Approximately 30mm dia.) Takes 6 exposures on circular film. Original price about $10. Two models:
- Octagonal model - This is the later version, but not as common. Made by Sakura and identified on the front as "Sakura Petal". $250-325.
- Round model - The more common early model, made by Petal Kogaku Co. Pre-dates the Sakura octagonal model. $150-175.

SALYUT-S - Russian Hasselblad 500C copy. Interchangeable Industar-24 f2.8/80mm. FP shutter 2-1500, T. $200-250.

SAN GIORGIO (Genova, Italy)
Janua - c1949. 35mm rangefinder Leica copy. Essegi f3.5/50mm. FP shutter 50-1000. Built-in meter. $500-750.

Parva - c1947. Subminiature for 16mm rollfilm. Less than 10 made. No known sales. rare. Estimate: $500+.

SANDERS & CROWHURST (Brighton, England)
Birdland - c1904. ¼-plate SLR. Extensible front. Waist-level focusing hood also allows for eye level focusing. Dagor f6.8 lens. FP shutter to 1000. $200-350.

SANDERSON CAMERA WORKS
(England) *Mr. Frederick H. Sanderson (1856-1929) was a cabinet maker, and a wood and stone carver. In the 1880's, he became interested in photography, particularly architectural work, which required special camera movements. While these movements were available on the cameras of the day, he found their manipulation awkward, so he designed his own camera. In January 1895 he had a patented new design. All Sanderson cameras incorporate his patented lens panel support system. The production models of the camera were built by the Holmes Brothers whose works became known as Sanderson Works. The cameras were marketed by Houghton's, with ads appearing as early as 1896. After the 1904 merger, Holmes Bros became part of Houghton, and thus Houghton became the manufacturer of Sanderson cameras.*

Sanderson Field camera - c1898. Mahogany folding cameras in ½-plate, full plate, and 10x12" sizes. Brass fittings. Double extension, tilt/swing back. Thornton-Pickard roller-blind shutter. $175-275.

Sanderson Regular

Sanderson "Regular", "Deluxe", and "Junior" Hand and Stand cameras - Folding plate cameras with finely polished wood interior. Heavy leather exterior. Generally common, though some models are rare. Made in 3¼x4¼", 4x5", 4¼x6½", and 5x7" sizes. All sell for at least $150-250 in England. Sometimes higher elsewhere.

Sanderson Tropical Hand and Stand cameras - ¼- to ½-plate sizes. Polished teak with brass fittings. We have noted

these sales with the following lenses, which may not have been original equipment. Goerz Dagor f6.8, Aldis f6.3, or Beck f7.7 lens. Compur shutter. $450-800.

SANDS, HUNTER & CO., LTD. (London, England)

Field cameras - c1890. Tailboard or folding bed styles. Half plate to 10x12" sizes. Rectilinear lens. $200-400.

SANEI SANGYO (Japan)

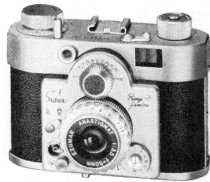

Samoca 35 Super with and without meter

Samoca 35 Super - c1956. "Super Rangefinder" on front. 35mm camera for 36 exposures, 24x36mm on standard

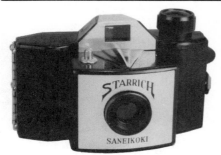

Saneikoki Starrich 35

cartridges. Ezumar f3.5/50mm lens. Shutter 10-200. Coupled rangefinder. Versions with and without built-in selenium meter. $35-45.

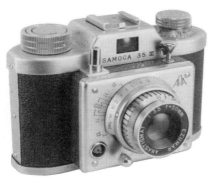

Samoca 35 III

Samoca 35, 35II, 35III - c1950's. Simpler viewfinder models. Ezumar f3.5/50mm. Shutter 25-100 or 1-200. $20-45.

Samoca LE - c1957. 35mm rangefinder camera of conventional design. Built-in selenium meter. Ezumar f2.8/50mm. Shutter 1-300,B. $25-45.

Samoca 35 M-28 - c1960. CRF. Ezumar f3.5/50mm, Samoca Synchro 1-300. $25-40

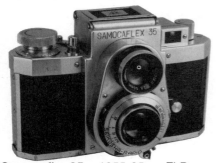

Samocaflex 35 - c1955. 35mm TLR.

Waist-level reflex viewing with split-image focusing. Also has optical eye-level finder. Ezumar f2.8/50mm lenses. Seikosha Rapid 1-500,B. Not common. $200-350.

Samocaflex 35 II - c1956. Same basic features as Samocaflex 35, but Seikosha MX shutter, B,1-500. $200-350.

SANEIKOKI (Japan)
Starrich 35 - Small bakelite camera for 24x36mm exposures on "Bolta" size 35mm paper-backed rollfilm. Similar to the Ebony and Start cameras, but not as common. $35-50. *Illustrated top of previous column.*

SANGER-SHEPHERD (London, England)
Three-color camera - c1907. Takes one exposure on a single plate. Similar in design to the Ives Kromskop. Only one known example. About $2500.

SANRIO CO. LTD. (Japan)

Hello Kitty Camera - c1981. 110 film plastic camera in bright colors. Rotating kitty acts as cover for lens and viewfinder. Built-in electric autowinder and electronic flash. A cute but expensive camera for the child who already has a silver spoon. Retail price near $100.

SANWA CO. LTD., SANWA SHOKAI
(Japan) *Some of the company's Mycro IIIA Cameras were also sold under the name of Mycro Camera Company Ltd.*
Mycro (original model) - 1938. The first pre-war model of the Mycro camera. There is no streamlined top housing as on the later Sanwa Mycro cameras, but rather a square optical finder attached to the top. Next to the finder is a small disc marked "T.A.Co.", but we have not yet discovered the meaning of these initials. This early model is uncommon, and diehard subminiature collectors have been known to pay $100-150.

Mycro - 1940-49. 14x14mm novelty camera. Mycro Una f4.5/20mm. 3-speed shutter. There are a number of variations of the Mycro cameras, most of which sell in the USA for $30-50. Up to 40% higher in Europe. *With colored leatherette add 25%. Illustrated top of next page.*

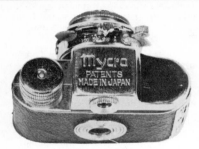

Sanwa Mycro

Mycro IIIA - c1950. Similar to the normal Mycro, but shorter, streamlined viewfinder. Some versions are marked "Mycro Camera Company Ltd."; others are marked "Sanwa Co. Ltd". EUR: $60-100. USA: $50-75.

Suzuki Baby I - c1951. Folding bed camera for 3x4cm on rollfilm. Teriotar f4.5/ 50mm lens in STK shutter. $100-200.

SASSEX - c1951. Simple eye-level camera for 6x6cm on 120 film. Body is shaped like the Reflex Korelle, but this camera is not a reflex. Large eye level folding frame finder. Sas-Siagor f9/80mm lens. T,B,M shutter. Dark brown $60-90. Black: $30-50.

SATELLITE - A later "Hit" type subminiatures of cheaper construction. $10-15.

SAWYERS INC. (Portland, Ore.)
Mark IV (same as Primo Jr.) - c1958. TLR, 4x4cm on 127 film. Topcor f2.8/60mm lens. Seikosha MX shutter 1-500,B. Auto wind. $75-120.

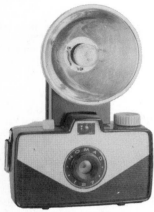

Nomad 127

Nomad 127, Nomad 620 - c1957. Brown bakelite box cameras. 4x6.5cm on 127 and 6x6cm on 620. $5-10.

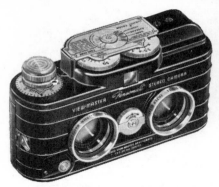

View-Master Personal Stereo - c1952. For making your own view-master slides. Film was wound twice through the camera with lenses raised/lowered for each pass. 69 stereo pairs, 12x13mm. Anastigmat f3.5/25mm lenses. 1/10-100 shutter. Quite common. Brown & beige model: $125-150. Black models with flash: $90-125. Mark film punch: $120-120.

Sawyers Europe: View-master Stereo Color - c1963-71. The European model, made in Germany. Some models are marked "Viewmaster Mark II". For stereo exposures 12x13mm on 35mm film. Diagonal film path allows stereo pairs to be exposed on one pass of the film. Rodenstock Trinar f2.8/20mm lenses and single-speed shutter. EUR: $150-200. USA: $100-125.

View-Master Projectors:
Senior - Metal non-stereo projector with automatic frame centering. Anastigmat f3/ 3" lens. Helical focusing. Uses 75-watt bulb to project a 36" wide image. Built-in screen pointer. $25-45.

Junior - Plastic and metal non-stereo projector. Doublet f3 lens. Uses 30-watt bulb to project a 16" wide image. $8-12.

View-Master Projector - Projects a non-stereo image, 22" wide. $10-20.

Deluxe Projector - Projects a non-stereo image, 50" wide. Focusing f2.8/2¼" lens. $20-30.

Deluxe 300w Projector - Similar to the Deluxe Projector listed above, but is fan-cooled because of the higher wattage bulb. $30-40.

Entertainer - 30w bulb. Projects a non-stereo image. Blue plastic body. Less boxy shape than the Deluxe Projectors. $20-30.

Stereo-Matic 500 - Projects stereo images using a 500 watt bulb. Two models producing 40" wide and 50" wide images. (Special polarized glasses were used to view the image in stereo.) Die-cast aluminum body. Anastigmat f3 lenses, automatic focusing. Fan-cooled. With 2¼" lenses: $250-300. With 3" lenses: $200-250

SCAPEC (France)

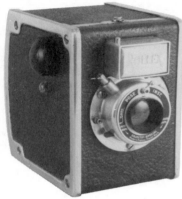

Rollex - Unusual cast aluminum box camera for 6x9cm. Interesting waist-level reflex finder folds into small housing above shutter. Not exactly cute, but very interesting and not common. Not in the same price category as the watch of the same name. $15-25.

S.C.A.T. (Societa Construzioni Articoli Technici, Rome)

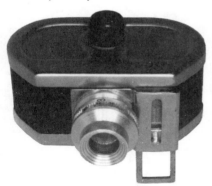

Scat - c1950. Subminiature for 7x10mm exposures on 16mm film in special cassettes. f3.5 lens, single speed revolving shutter. Leather covered metal body. Uncommon. $100-150.

SCHAAP & CO. (Amsterdam)
Van Albada Stereo - c1900. 6x13cm box stereo. FP shutter with variable tension and slit width. Four-element lenses in nickel-plated lens mounts, rotary stops. $600-850.

SCHATZ & SONS (Germany)

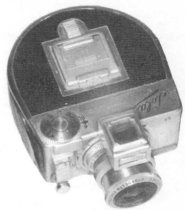

Sola - c1938. Unusually-shaped subminiature, 13x18mm on unperforated film in cassettes. Spring drive, 12 exposures per wind. Interchangeable Schneider Kinoplan f3/25 or Xenon f2/25 lens. Behind-the-lens shutter, 1-500, B. Waist-level or eye-level viewing. $1000-1800.

SCHIANSKY
Universal Studio Camera - c1950. All metal, for 7x9¼" sheet film, with reducing back for 5x7". Zeiss Apo-Tessar f9/450mm. Black bellows extend to 1 meter. Only 12 made. One known sale in 1976 for $500.

SCHMITZ & THIENEMANN (Dresden)
Uniflex Reflex Meteor - c1931. SLR box, 6.5x9cm. Meyer Trioplan f4.5/105mm in self-cocking Pronto 25-100. $150-175.

SCHUNEMAN & EVANS (St. Paul, Minnesota)
Lightning - 4x5" folding plate camera. Red bellows. Black leather exterior; polished mahogany interior. B&L Unicum sh. $50-70.

SCOTT-ATWATER MFG. CO. (Minneapolis, Minn.)

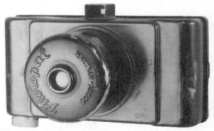

Photopal - Simple, stamped metal novelty

camera, enameled black. 3x3.5cm or 4x6cm sizes. $25-35.

SCOVILL MANUFACTURING CO. (N.Y.)

Brief summary of name changes & dates: Scovill & Adams, 1889; Anthony & Scovill, 1902; Ansco, 1907. (See also Anthony and Ansco.) Scovill produced some excellent cameras, all of which are relatively uncommon today.

Antique Oak Detective - c1890. 4x5" box-plate camera finished in beautiful golden oak. String-set shutter, variable speeds. $500-650.

Book Camera - c1892. Camera disguised as a set of 3 books held with a leather strap. Rare. Estimate: $8000+.

Field/View cameras:
- **4x5"** - Square black box with folding beds on front and rear. Bellows extend both directions. Top and side doors permit loading the plateholders either way into the revolving back when only the front bellows are being used. Nickel plated Waterbury lens. $125-175.
- **8x10"** - ca. early 1880's. Light colored wood body. $125-175.

Irving - c1890. 11x14" compact folding view. RR lens, waterhouse stops. $250-350.

Knack Detective - c1891. The Antique Oak Detective camera with a new name. $500-650.

Mascot - c1890-92. 4x5" format leather covered wood box camera. Similar to the Waterbury detective camera listed below, but with an Eastman Roll Holder. String-set shutter. $350-450.

Scovill Detective - c1886. Leather covered box detective camera for 4x5" plates in standard plateholders. Entire top of camera hinges open to one side to reveal the red leather bellows (and to change plates). The bottom of the camera is recessed, and the controls are located there, out of sight. A very uncommon detective camera. This camera was never shown close-up in original advertising in order to preserve its "concealed aspects". $550-650.

St. Louis - c1888. 8x10" reversible back camera No. 116. With lens: $125-175.

Stereo Solograph - c1899. 4x6½" compact folding stereo camera. Stereo RR lenses, Automatic Stereo shutter. $275-375.

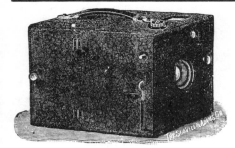

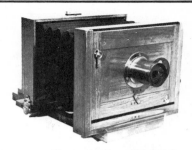

Triad Detective - c1892. Leather covered 4x5" box detective camera for plates, rollfilm, or sheet film. Variable speed string-set shutter. $200-350.

Waterbury Detective Camera, Original model - c1888. Black painted all wood box, or less common leather-covered model. Side door for loading plates. Focused by means of sliding bar extending through the base of the camera. Recessed bottom stores an extra plateholder. 4x5": $350-475. 5x7": $450-650.

Waterbury View, 5x8" or 6½x8½" - c1886-94. Horizontal format. Light wood finish. Brass barrel Waterbury lens. $125-150.

Waterbury View, Stereo - c1885. 5x8". All wood body. Scovill Waterbury lenses. $300-400.

Wet-plate camera - c1860's. 4-tube wet-plate tintype camera for 4 exposures on a 5x7" plate. $1400-1800.

SDELANO: *Identifying mark on some Russian cameras beginning in the late 1950's. It means "Manufactured in the U.S.S.R." This is not a camera model or manufacturer's name.*

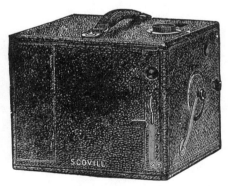

Waterbury Detective, Improved model - c1892. Same as the original model, except focus knob is at top front. $250-375.

SEARS ROEBUCK & CO. (Seroco)
Seroco is an abbreviation for Sears, Roebuck & Co., whose cameras were made by other companies for sale under the Seroco name. The Conley company made many cameras for Sears after the turn of the century, and was purchased by Sears.
Delmar - box camera for plates. Top rear door hinges up to insert plateholders. Storage space for extra plateholders. For 3¼x4¼ or 4x5" plates. $25-35.

Marvel S-16 - c1940. 116 rollfilm box cameras. Art-deco faceplate. $4-8.

Marvel S-20 - c1940. 120 rollfilm box camera made by Ansco for Sears. Art-deco faceplate. $4-8.

Marvel-flex - c1941. 6x6cm TLR. Wollensak Velostigmat f4.5/83mm. Alphax 10-200,T,B shutter. $20-35. *Illustrated top of next page.*

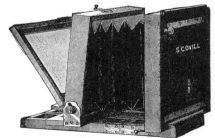

Waterbury View, 4x5" - c1886-94. Folding-bed collapsible bellows view camera. Eurygraph 4x5 RR lens, Prosch Duplex shutter. $135-175.

Perfection - 4x5" plate camera. $35-50.

Marvel-flex

Plate Camera - "Cycle-style" camera for 4x5" plates, styled somewhat like the Pony Premo E. Shutter concealed in wooden lensboard. "Sears Roebuck & Co. Chicago III." at base of lens standard. $75-100.

Seroco 4x5" folding plate camera -

c1901. Black leathered wood body with polished interior. Red bellows. Seroco 4x5 Symmetrical lens and Wollensak shutter are common. $50-75.

Seroco 5x7" folding plate camera - similar to the above except for the size. $75-125.

Seroco 6½x8½" folding plate camera - Red double extension bellows. $75-105.

Seroco Magazine - c1902. 4x5" box camera. Leather covered, nickel trim. 12-plate magazine. $45-60.

Seroco Stereo - 5x7" plates. Leather covered mahogany body with polished interior. Red leather bellows. Wollensak Stereo shutter & lenses. $275-325.

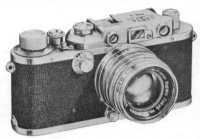

Tower, Type 3 - c1949. Made by Nicca Camera Co. in Occupied Japan, and sold by Sears. Copy of a Leica III. This is the same camera as the Nicca III. Nikkor f2/50mm interchangeable lens. With normal lens: $125-250.

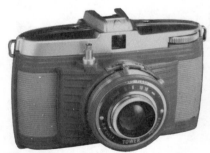

Tower No. 5 - c1958. 4x4cm on 127 rollfilm. Styled like a 35mm. Blue-gray enameled with gray plastic partial covering. Made by Bilora for Sears and similar to the Bilora Bella. $10-15.

Tower 10A - c1960. 35mm RF camera with coupled match-needle selenium meter. Made by Mamiya for Sears. Mamiya-Sekor f2.8/48mm lens in B,1-500 shutter. Original price was $55. Current value: $15-30.

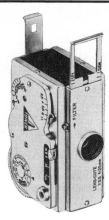

Tower 16 - c1959. A Mamiya-16 Super with the Tower name on it. $35-50.

Tower 18A - c1960. Similar to the Tower 10A, but with faster f1.9 lens. Original price: $75. Current value: $20-35.

Tower 18B - c1962. 35mm camera with coupled rangefinder and built-in meter. Made by Mamiya for Sears. Mamiya-Kominar f2/48mm lens in Copal SVK B, 1-500. $15-25.

Tower 22, Tower 23, Tower 24 - c1954-1959. 35mm SLR cameras made by Asahi Optical Co. in Japan and sold by Sears. Export versions of the Asahiflex IIA and IIB. Takumar f3.5/50mm or f2.4/58mm. FP shutter to 500. $150-275.

Tower 26 - c1958-59. Name variation of Asahi Pentax (original model). Takumar f2.4/55mm lens. $150-200.

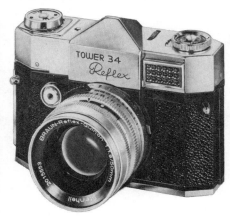

Tower 34

Tower 32A - c1963. 35mm SLR made by Mamiya for Sears. Interchangeable Mamiya/Sekor f1.7/58mm lens. FP shutter 1-1000,B. $100-150.

Tower 33 - c1960. 35mm SLR made by Braun for Sears. Same as the Braun Paxette Reflex. Coupled selenium meter on left side of front plate. Braun-Reflex-Quinon f2.8/50mm lens. Synchro-Compur 1-500, B,ST. $40-70.

Tower 34 - c1960. Like the Tower 33, but with f1.9/50mm lens. $50-75. *Illustrated bottom of previous column.*

Tower 37 - c1961. SLR made by Mamiya for Sears. External linkage stops lens down before exposure, but diaphragm must be manually reopened for viewing. Mirror returns when winding film. $50-75.

Tower 39 Automatic 35 - c1962. Boxy 35mm with built-in flash for AG-1 bulbs. Automatic exposure controlled by selenium meter. Zone focusing Mamiya f3.8. $10-20.

Tower 41 - c1962. Boxy 35mm, similar to Tower 39, but with f2.8 lens, rangefinder, accessosry shoe, and sync post in addition to built-in AG-1 flash. Made by Mamiya. $15-25.

Tower 50 (35mm) - c1954-58. Basic scale-focus 35mm made by Iloca for Sears. Originally sold for just $29.00. Cast metal body. Cassar f2.8/45mm lens in 25-200,B shutter. $10-15.

SEARS (cont.)

Tower 51 (35mm) - c1954-58. Similar to Tower 50, but with CRF. Cassar f2.8/50, Prontor-SVS B,1-300. Made by Iloca. $20-35.

Tower 51 (rollfilm) - c1955. Folding bed 6x9cm camera, identical to the United States Camera Corp. Rollex. $5-10.

Tower 55 - c1959-62. Basic scale-focus 35mm made by Yamato Koki Kogyo. Sold new for $18. Lever advance. Color Luna f3.5/45mm in B,25-300 leaf shutter. $20-35.

Tower 127EF - Horizontally styled camera for 1⅝x1⅝" on 127 film. Electronic flash beside lens. Capacitor and electronics in detachable handle. Early example of a camera with built-in electronic flash. $20-35.

Tower Automatic 127 - c1960. Horizontally styled white plastic body. Flash and meter built-in. 4x4cm on 127. Looks like the United States Camera Corp. Automatic 127. $10-15.

Tower Bonita Model 14 - Metal twin-lens box camera with reptile-grained covering. Made by Bilora for Sears. "Bilora" on strap,

"Bonita" on viewing hood. "Tower Model 14" on front plate. Time & Inst. shutter. Taking lens focuses via lever concealed under finder hood. $20-30.

Tower Camflash 127, Camflash II 127 - Horizontal style 4x4cm, like the United States Camera Corp. Comet 127. Built-in flash. $5-10.

Tower Companion - Plastic 6x6cm box camera, identical to Imperial Debonair. $5-9.

Tower Flash, Flash 120, One-Twenty, One-Twenty Flash - c1950's. 6x9cm box cameras. Leatherette or enamel finish. $3-7.

Tower Hide Away - c1960. Grey and green plastic box camera made by Imperial, same style as the Imperial Mark 27. Built-in flash with retractable cover. $1-5.

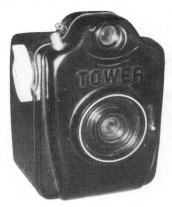

Tower Junior - c1953-56. Small bakelite box camera, eye-level finder. Made by Bilora for Sears and identical to the Bilora Boy. "Tower" on front, "Bilora" on back. $15-25.

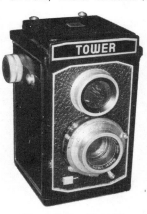

Tower Reflex, Type III

488

Tower Pixie 127, Pixie II 127 - Gray plastic 4x4cm, 127 camera. $1-5.

Tower Reflex - c1955. 6x6cm TLR. Type II is same as Photina I. Type III *(illustrated bottom of previous page)*is same as Photina II, with Westar Anastigmat f3.5 in Pronto 25-200. $20-40.

Tower Reflex (pseudo-TLR) - c1955. Various styles of 6x6cm pseudo-TLR bakelite box cameras. $10-15.

Tower Skipper - 4x4cm plastic box. Identical to the Mercury Satellite 127. $1-5.

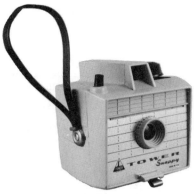

Tower Snappy - Plastic 6x6cm 620 camera, identical to the Herbert-George Savoy. In colors. $5-10.

Tower Stereo - c1955-60. Made in Germany by Iloca for Sears. Same as Iloca Stereo II; also sold by Montgomery Ward as the Photrix Stereo. Isco-Westar f3.5/ 35mm lenses. Prontor-S shutter 1-300. $100-150.

Trumpfreflex - c1940. German-made 6x6cm TLR sold in the U.S. by Sears. Looks very similar to the Balda Reflecta and Welta Reflekta. Parallax correction accomplished by the taking lens tilting up at close focusing distances. Normally found with Trioplan f3.5/75mm lens. Shutter 1-300. $25-45.

SECAM (Paris)
Stylophot cameras - c1950's "pen" style cameras, according to the name, but even if compared to the large deluxe European fountain pens, it ends up looking a bit hefty. The pocket clip is the closest resemblance to a pen. For 18 exposures 10x10mm on 16mm film in special cartridges. Shutter cocking and film advance via pull-push sliding mechanism which pushed film from cartridge to cartridge. Automatic exposure counter. Weight: 3 oz. (85 gr.) *Note: The*

same camera was also sold in Germany as the Foto-Füller, listed in this guide under Kunik.

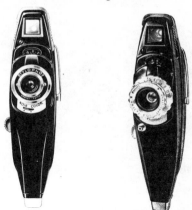

Stylophot "Standard" or "Color" model - The cheaper of the two models, with fixed focus two-element f6.3 coated lens, single speed shutter ($\frac{1}{50}$). Also sold under the name "Private Eye". Original price: $15. Current value: $100-125.

Stylophot "Luxe" or "Deluxe" model - with f3.5/27mm Roussel Anastigmat lens. Iris diaphragm. Focus to 2½ ft. (0.8m). Single speed shutter ($\frac{1}{75}$) synched for flash. Original price: $33. This model is very uncommon. $130-160.

Stereophot - An unique stereo camera consisting of two Stylophot cameras mounted side-by-side on a special plate. Awkward, maybe... but rare. $450-550.

S.E.D.E. (Rome)
Kelvin Maior - c1952-60. Inexpensive cast-metal 35mm camera. Duo-Kelvin Achromat f8/50mm; 3-speed shutter; three stops. $10-15. *Illustrated top of next page.*

S.E.D.E. Kelvin Maior

Kelvin Minor - c1952-60. Similar to the Maior, but with no stops and only 2-speed shutter. $10-15.

SEDIC LTD. (Japan) *A large manufacturer of cameras, many of which are sold under the house names of other companies. Most are too new to be collectible, except for some of the novelty shapes, such as binoculars, beverage cans, etc. which we have generally listed under the distributors names.*

SEE - Another name variant of the "Diana" type for 120 film. $1-5.

SEEMAN (H. Seeman)
Stereo camera - Black wooden strut-folding camera, nickel-plated fittings. Goerz Dagor 120mm lenses. $300-450.

SEETORETTE - c1938. Simple German folding rollfilm camera. Radionar f4.5/105mm, Prontor II shutter. $20-35.

SEIKI KOGAKU CO. *(Seiki Kogaku means "Precision Optical" and this name was used on more than one occasion by unrelated companies. This company is not related to the Seiki Kogaku which made the early Canon cameras.)*
Seiki - c1950. Oval-shaped 16mm subminiature. Seek Anastigmat f3.5/25mm. B, 25, 50, 100 shutter. $500-700.
Illustrated top of next column.

Seiki

SEISCHAB (Otto Seischab, Nürnberg, Germany)
Esco - c1922. 400 exposure half-frame 35mm. Similar in style to the Leica Reporter. Steinheil Cassar f3.5/35mm. Dial-set Compur 1-300. Rare. One recorded sale at $2000. Another failed to reach a reserve of about $5800 at a 1986 auction. One sold at auction in 7/88 for $2800 with case.

S.E.M. (Société des Établissements Modernes; Aurec, France) *In 1942-45, during the German occupation of Paris, the Reyna Cross 35mm cameras were made in St. Étienne under license from Cornu. Once the war was over, the St. Étienne firm broke the ties with Cornu and re-established itself in the neighboring town of Aurec under the S.E.M. name. The Reyna-Cross camera design, with some improvements, soon appeared as the Sem-Kim, and S.E.M. went on to design and build a number of medium and small-format cameras up through the early 1970's.*
Babysem (first type) - c1949. 35mm, grey-enameled. Same body as Sem-Kim, but no body release or double exposure prevention. Cross f2.9/45, or Berthiot f3.5 or f2.8 lens. Orec shutter 25-200. $20-35.

Babysem (new type) - While guarding the

same functional characteristics of the earlier Babysem, the new model was nicely styled in cast aluminum with the rectangular front facade concealing the knobs. Light grey painted with partial leatherette covering in blue or red. $20-40.

Challenger - c1959. Aluminum-colored plastic camera for 16 exposures 4x4cm on 620 film. $15-25.

Colorado - Grey plastic dual-format camera. Takes 16 exposures 4x4cm or 20 exposures 24x35mm on 620 film. $25-35.

Kim - c1947. Simple cast aluminum 35mm camera. Successor of the Reyna-Cross.

Cross Anastigmat f2.9/45mm. Shutter 25-200, later extended to 1-200. $25-35.

Semflex Joie de Vivre 45 - Light-gray plastic covered TLR. Metal faceplate. Berthiot f4.5/80mm lens. $40-60.

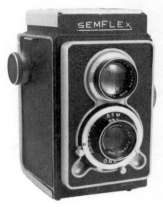

Semflex Standard - c1950. Twin-lens reflex camera for 6x6cm on 120 film. Several model variations. $30-50.

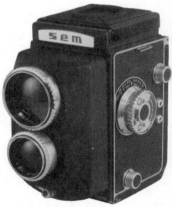

Semflex Studio Standard - c1951-72. 6x6cm TLR with extended front for use with Tele-Berthiot f5.4/150mm lens. Viewing lens is f3.9. Long focusing rack allows close focusing to 1.5m. Two versions: Knob advance or crank advance. Single lever below lens tensions and releases shutter. Synchro Compur shutter after 1972. $200-275.

SEMMENDINGER (A. Semmendinger, Ft. Lee, NJ)
Excelsior - c1870. Wet-plate cameras in sizes 5x5" to 12x12". Large sizes have sliding backs. With lens: $750-1000.

SENECA

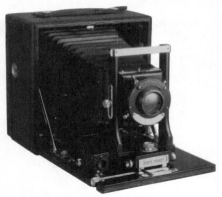

Black Beauty - Folding "cycle style" view camera in 3¼x5½" and 4x5" sizes. $50-75.

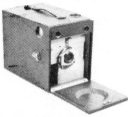

Busy Bee - c1903. 4x5" box-plate camera. Fold-down front reveals a beautiful interior. $45-65.

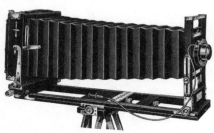

Camera City View - c1907-25. 5x7" to 8x10" view cameras. Seneca Anastigmat lens. Ilex shutter. $100-175.

Chautauqua 4x5" - Folding plate camera. Wollensak lens. Seneca Uno shutter. A very plain all-black camera. $40-80.

Chautauqua 5x7" - All black "ebonized" model: $50-90. With polished wood interior: $100-150.

Chief 1A - c1918. 2½x4¼" on rollfilm. $12-18.

Competitor View - c1907-25. 5x7" or 8x10" folding field camera. Light colored

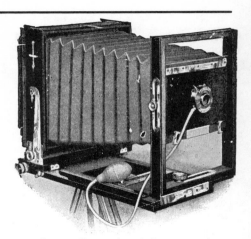

wood or medium colored cherry wood. $100-150.

Competitor View, Stereo - Same as normal 5x7 Competitor, but equipped for stereo. $200-300.

Duo - Not a camera name. This is a shutter with T,B,1,2,5,25,50,100. It was the medium-priced shutter in the Seneca line-up.

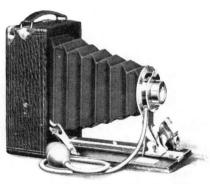

Filmett - 1910-16. 3¼x4¼" folding filmpack camera. Leather covered wood body. Black bellows. Wollensak Achromatic or Rapid Rectilinear; Uno or Duo shutter. $25-35.

Folding plate cameras:
3¼x4¼" - Wollensak f16 lens. Uno shutter. $30-45.
3¼x5½" - Black double-extension bellows and triple convertible lens. $30-45.
4x5" - Black leathered body with nickel trim. Double extension bellows. Seneca Uno or Auto shutter. $50-75.
5x7" - Similar, black or polished wood interior, black leathered wood body. 7" Rogers or Seneca Anastigmat lens in Auto shutter. $50-80.

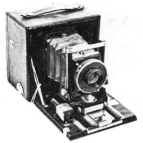

No. 9 Folding Plate Camera - c1907-23. 4x5". Maroon bellows. Velostigmat lens. Compur shutter. $50-75.

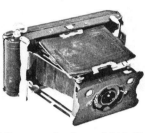

No. 1 Seneca Junior - c1916. 2¼x3¼" exposure folding rollfilm camera. Strut-supported lensboard and hinged front cover. Ilex shutter. $15-20.

Kao - Box cameras for glass plates in standard double holders. Fixed focus. All black. Kao Jr. is for 3½x3½" plates; Kao Sr. is 4x5". $25-40.

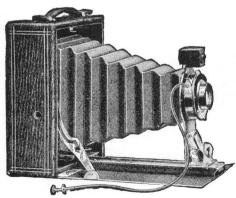

Pocket Seneca No. 3A - c1908. Folding plate camera. Double extension bellows. Rapid convertible lens, Auto shutter 1-100. $20-30.

Pocket Seneca No. 29 - c1905. Simple 4x5" folding plate camera. Seneca Uno shutter. f8 lens. $25-35.

Roll Film Seneca No. 1, No. 1A - c1914-1924. Folding rollfilm camera made in two sizes, 2¼x3¼", 2½x4¼". Simple lens and shutter. $12-18.

Scout cameras: Made in box and folding varieties.

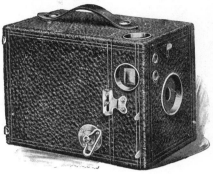

Scout box cameras:
No. 2, 2A, 3, 3A - c1913-25. For rollfilm. $6-12.

Folding Scout cameras:
No. 2A - c1915-25. Wollensak lens, Ultro shutter. $12-18.
No. 2C - c1917-25. $12-18.
No. 3 - c1915-25. Ultro shutter. $12-18.
No. 3A - c1915-25. Seneca Trio shutter. 122 film. $12-18.

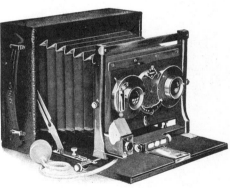

Stereo View - c1910. 5x7" folding-bed collapsible bellows view camera with wide front lensboard. Leather covered wood body. Wollensak lenses. Stereo Uno or Automatic Double Valve Stereo shutter. $275-375.

Trio - Trio is a shutter name, not a camera name.

Uno - Not the name of a camera, but rather the low-priced shutter on Seneca cameras. Provides I,T,B speeds.

Seymore Products Brenda Starr

Vest Pocket - c1916-25. Compact folding camera for 127 film. Seneca Anastigmat f7.7 lens. Shutter 25-100. $25-45.

View Cameras:
5x7" - c1903. Seneca Rapid convertible or Goerz Syntor f6.8 lens. Ilex shutter 1-100. Black double extension bellows. Polished wood body. $85-125.

5x7" Improved - c1905-25. Wollensak Planatic Series III lens. Auto shutter. Black leather bellows. Fine wood body. $85-125.

6½x8½" Improved - c1905-24. Goerz Double Anastigmat f6.8/7" lens in Volute shutter. $80-120.

8x10", 8x10" Improved - c1902-25. With Wollensak Velostigmat Ser. 2, f4.5/12" lens or double anastigmat lens in Optimo or Wollensak Regular shutter. $100-175.

SEVILLE SUPER SW 500 - c1985. Novelty 35mm from Taiwan styled with small pseudo-prism. $1-5.

SEYMORE PRODUCTS CO. (Chicago, IL) *See also alternate spelling "Seymour".*
Brenda Starr Cub Reporter - Bakelite minicam for 16 exposures on 127 film. Enameled 4-color illustrated faceplate. Probably the rarest and most desirable of the "Minicam" type cameras. $30-50.
Illustrated top of next column.

Dick Tracy - Like the Seymour Sales Dick Tracy, but black faceplate. $15-25.

SEYMOUR SALES CO. (Chicago) *See also alternate spelling "Seymore".*
Dick Tracy - Black bakelite minicam for 3x4cm on 127 film. Picture of Dick Tracy and camera name are printed in red on the metal faceplate. $15-25. *See second variation above under "Seymore Products".*

Flash-Master - Inexpensive 3x4cm 127 rollfilm minicam with sync. $3-7.

S.F.O.M. (Société Française d'Optique Méchanique)

Sfomax - c1949. Cast aluminum subminiature with black or grey leatherette covering. Takes 20 exposures 14x23mm on unperforated 16mm film in special cartridges. S'fomar f3.5/30mm lens. Shutter 30-400 (early models 25-400). Split image rangefinder. $400-600.

494

SGDG: *Breveté S.G.D.G. (Sans garantie du gouvernement) indicates French manufacture. According to French patent law, if an article is marked "breveté" (patented) it must also be marked "sans garantie du gouvernement" or S.G.D.G.*

SHACKMAN (D. Shackman and Sons, London, England)
Auto Camera, Mark 3 - c1953. 24x24mm on 35mm film in 250 exposures cassettes. Recording camera designed for scientific work. Motorized advance. Gray painted body. Fixed focus Dallmeyer lens. $50-100.

SHAJA - 9x12cm double extension plate camera. Tessar f4.5/135mm in Compur shutter. $25-35.

SHAKEY'S - Plastic novelty 4x4cm camera of the "Diana" type. Made in Hong Kong. $1-5.

SHALCO - 14x14mm Japanese Hit-type novelty camera. $15-20.

SHANGHAI - c1950's. Chinese copy of Leica IIIf. Collapsible f3.5/50mm lens. JAPAN: $600-800. USA: $500-600.

SHANSHUI B - Chinese plastic 120 camera. $25-30.

SHAW (H.E. Shaw & Co.)

Oxford Minicam - Black plastic half-127, made by Utility Mfg. Co. for Shaw Co. $3-7.

SHAW-HARRISON
Sabre 620 - c1962. Plastic 6x6cm box camera. Various colors. $4-8.

Valiant 620 - Colored plastic 6x6cm box camera. Identical to the Sabre 620. $4-8.

SHAYO - Japanese novelty subminiature of the Hit type. $15-20.

SHEW (J. F. Shew & Co., London)
Day-Xit - c1910 variation of the Xit. Meniscus lens, synchro shutter. Black leathered wood body. $125-175.

Eclipse - c1890. Mahogany with dark brown bellows. Darlot RR lens in inter-lens shutter named "Shew's Eclipse Central Shutter". 3¼x4¼", 4x5", 4¼x6½", or 5x7" sizes: $160-280.

Focal Plane Eclipse - Similar to Eclipse, but with focal plane shutter. $175-225.

Guinea Xit - c1906. Mahogany gate-strut folding camera. Red bellows. 8x10.5cm on plates or cut film. Achromatic 5½" lens. Central rotary shutter. $150-225.

Stereo Field Camera - c1900. 5x7". Mahogany body with brass trim. Front bed supported by wooden wing brace at side. Double extension tapered wine-red bellows. Rack and pinion focus. Tessar f6.3/120mm lenses in double pneumatic shutter. Unusual style and rare. $800-1100.

Tailboard camera - c1900-05. 13x18cm folding plate camera. Mahogany body with brass trim, brass Beck Symmetrical f8 lens. Iris diaphragm. Red square leather bellows. $175-225.

Xit, Aluminum Xit - c1900. Similar to the Eclipse with aluminum and mahogany body. ¼ and ½-plate sizes: $160-260.

Xit Stereoscopic - Folding gate-strut stereo camera. $600-800.

SHIMURA KOKI (Japan)

Mascot - c1950. Vertical subminiature for 14x14mm on paper-backed "Midget" rollfilm. Mascot f4.5/25mm. Shutter 25-100, B. $250-400.

SHINANO CAMERA CO. LTD., SHINANO OPTICAL WORKS (Japan)

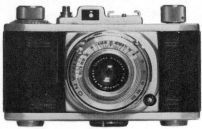

Pigeon - c1952. Viewfinder 35mm. Tomioka Tri-Lausar f3.5/45mm. Synchro shutter 1-200. Advance knob. $30-50.

Pigeon III - c1952. Viewfinder 35mm. Tomioka Tri-Lausar f3.5/45mm. NKS or TSK shutter 1-200. Lever wind. $30-50.

SHINCHO SEIKI CO. LTD. (Japan)

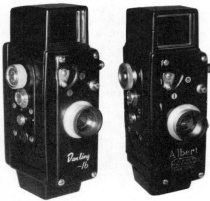

Albert - A name variation of the Darling-16. "Albert Fifth Avenue New York" on metal faceplate. $250-325.

Darling-16 - c1957. Vertically styled subminiature accepts 16mm cassettes for 10x12mm exposures. Bakelite body with metal front and back. $250-325.

SHINSEI OPTICAL WORKS (Japan)
Monte 35 - c1953. Inexpensive Japanese 35mm camera. Monte Anastigmat f3.5/50mm in Heilemann, SSS or SKK shutter. $20-35. *Illustrated top of next column.*

SHOEI MFG. CO. (Japan)
Ruvinal II, III - c1951. 6x6cm folding

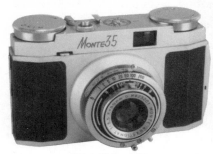

Shinsei Monte 35

cameras taking 120 or 620 rollfilm. Pentagon f3.5/80mm or Seriter f3.5/75mm lens. Shutter 1-200. $20-40.

SHOWA KOGAKU (Japan)

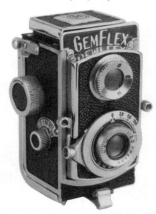

Gemflex - c1949. Subminiature TLR for 14x14mm on standard "Midget" paper-backed rollfilm. Gem f3.5/25mm, shutter 25-100. Early models: Back plate has serial number and "Made in Occupied Japan"; finder hood opens for eye level viewing. Later models: No serial number; not marked Occupied Japan; no eye-level viewing provision. $300-375.

Leotax Cameras. Prices include normal lens.

Leotax Model I - 1940 Leica copy. Uncoupled rangefinder, no accessory shoe. Only one known. Impossible to price.

Leotax Special, Special A - Wartime camera. Viewfinder window to left of RF windows. No slow speeds, coupled RF. $1000-1250.

Leotax Special B - Wartime camera. Viewfinder window to left of RF windows. Slow speeds. $1000-1250.

Leotax Special DII - 1947. Viewfinder window between RF windows. No slow speeds. $400-700.

Leotax DII MIOJ - $250-350.

Leotax Special DIII - 1947. Viewfinder window between RF windows. Slow speeds. $400-700.

Leotax DIII MIOJ - $250-350.

Leotax DIV - 1950. Rangefinder magnification 1.5X, no sync. $250-300.

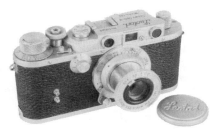

Leotax S - 1952. RF magnification 1.5X; synch posts on front; slow speed dial; no self timer. Front viewfinder bezel has round corner at upper right. $175-250.

Leotax F - 1954. Fast speed dial now 25-1000. Slow speed dial, self-timer. $125-250.

Leotax T - 1955. Top speed 1/500. Slow speed dial, self-timer. $150-200.

Leotax K - 1955. Top speed 1/500, self-timer. No slow speeds. $150-200.

Leotax TV - 1957. Slow speeds, self timer. $250-300.

Leotax FV - 1958. Lever wind, self timer, slow speeds to 1000. $250-300.

Leotax T2 - 1958. Slowest speed on fast speed dial now 1/30. Slow speed dial, no self-timer. $250-300.

Leotax K3 - 1958. Slow speeds limited to 1/8 & 1/15. No self timer. $250-300.

Leotax TV2 (Merit) - 1958. Lever wind, self timer, slow speeds to 500. $350-450.

Leotax T2L (Elite) - 1959. Lever wind, no self timer. Slow speeds to 500. $350-450.

Leotax G - 1961. Shutter 1-1000. Small dial. $300-400.

Semi-Leotax - c1940's. Folding camera for 4.5x6cm exposures on 120 film. f3.5/75mm lens. 1-200 shutter. $60-90.

SIAF (Argentina & Chile)

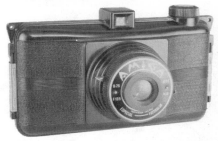

Amiga - Black plastic eye-level camera made in Chile. Streamlined design like many Kaftanski cameras. Dual format, 6x9cm or 4.5x6cm with metal insert, on 120 film. f7.5/135mm lens. Instant & Pose speeds. $20-35.

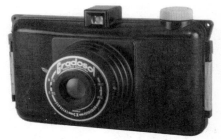

Gradosol - Identical to the Amiga above, but made in Argentina. $20-35.

SIDA GmbH (Berlin-Charlottenburg)

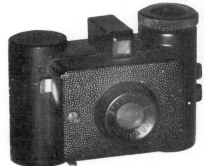

Sida - c1936. Small eye-level camera, 24x24mm exposures. Variations include early black cast metal body, later version made in France with black plastic body, and Italian version in red marbelized plastic. $20-40.

Sida Extra - c1938. Small eye-level camera making 24x24mm exposures. Dark brown/black plastic body. Similar to the

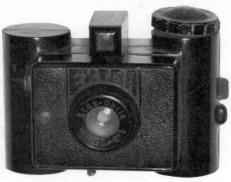

Sida, but the name "Extra" is molded into the body above the lens. $45-85.

Sida Standard - c1938. Black cast-metal miniature for 25x25mm exposures. Several variations include shutter release on bottom. $25-45.

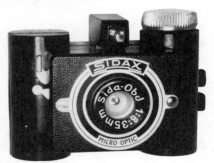

Sidax - c1948. Small black bakelite camera similar to the Sida and Extra. Made in Paris by Kafta. Fritz Kaftanski, the designer of Sida in Berlin, had moved to Lyon France during the war and then to Paris, where he reincarnated the Sida. Uses Lumiere #1 rollfilm for 25x25mm exposures. $40-60.

SIGRISTE (J.G. Sigriste, Paris)
Sigriste - c1900. Jumelle-style camera 6.5x9cm or 9x12cm sizes. Zeiss Tessar f4.5. Special Focal Plane shutter 40-2500. (This shutter had speeds to 1/10,000 on some cameras.) Rare. $3000-4000.

Sigriste Stereo - Rare stereo version of the above. One was offered for sale in late 1984 at $5000, which seemed like a realistic figure at the time. No recent data.

SIL-BEAR - "Hit" type camera. $10-15.

SIMCO BOX - 6x6cm reflex style box camera made in Germany. Stamped metal with black crinkle-enamel. $10-20.

SIMDA (Le Perreux, France)

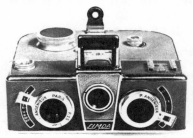

Panorascope - c1955. Wide angle stereo camera for 16mm film. Some have "Panorascope" on front, some just say "Simda". Leather covered metal body. Early version has fixed focus Roussel lenses, black covering. Later version with Angenieux f3.5/25mm lenses and grey covering. Stereo shutter 1-250, sync. Less than 2500 were made. $500-650.

SIMMON BROTHERS, INC. (N.Y.)

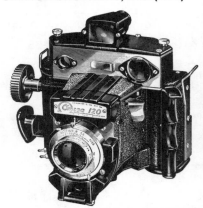

Omega 120 - c1954. A professional rollfilm press camera for 9 exposures 2¼x2¾" on 120 film. Omicron f3.5/90mm lens. Sync shutter 1-400. Coupled rangefinder. $125-195.

Signal Corps Combat Camera - Cast magnesium camera with olive drab finish for 2¼x3¼" filmpacks only. Wollensak Velostigmat f4.5/101mm in Rapax shutter. $150-200.

SIMONS (Wolfgang Simons & Co., Bern, Switzerland)
Sico - c1923. Dark brown wooden body with brass trim. Takes 25 exposures 30x40mm on unperforated 35mm paper-backed rollfilm. Dagor f6.8 Double Anastigmat or Sico f3.5/60mm Rüdersdorf Anastigmat lens in focusing

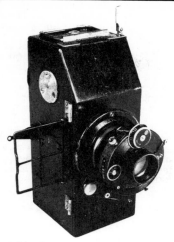

mount. Iris diaphragm to f22. Dial Compur shutter 1-300. $1000-1400.

SIMPRO CORP. of AMERICA
Simpro-X - Novelty camera front for 126 cartridges. Film cartridge forms the back of the camera. $1-5.

SIMPRO INTERNATIONAL LTD.
Slip-on - 126 film cartridge forms the back of the camera body. $1-3.

SINCLAIR (James A. Sinclair & Co., Ltd., London)
Traveller Roll-Film Camera - c1910. Horizontally styled box camera for 3¼x4¼" on #118 rollfilm. Goerz Dagor f6.8 lens in B&L Automat shutter, concealed behind the hinged front panel with sliding lens cover. Unusual. $175-200.

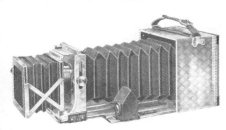

Traveller Una - c1927. Similar to the Una, but made of Duralumin, a special metal, almost as light as aluminum, but stronger. 6x9cm. Ross Combinable Lens in N.S. Perfect shutter. $2500-3500.

Tropical Una - 1910's-1920's. Similar to the Una, but teak or polished mahogany with brass fittings. 6x9cm to ½-plate sizes. $750-1100.

Tropical Una Deluxe - Similar to the Tropical Una, but triple extension. $800-1200.

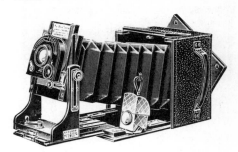

Una - c1895. Folding plate camera, 6x9cm to 5x7" sizes. Heavy wood construction. Goerz f6.8 Double Anastigmat lens. Revolving back. $300-500.

Una Deluxe - c1908. Same as the Una, but hand-stitched leather exterior. Available in brown with mahogany interior or black with black interior. No. 1 was double extension, No. 2 was triple extension. $650-850.

SING 88, 388, 838 - 14x14mm novelty subminiatures, later rectangular versions of the "Hit" types. Made in Hong Kong. $15-25.

SIRATON - Japanese novelty subminiature of the "Hit" type. $15-25.

SIRCHIE FINGER PRINT LABORATORIES INC. (Raleigh, NC)

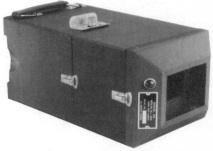

Finger Print Camera - All-metal close-up camera with built-in lights. Various models for 2¼x3¼" filmholders, filmpacks, or for 3¼x4¼" Polaroid pack film. Raptar f6.3 lens. Alphax 25-150 shutter. 6x9cm or 8x10.5cm size. $45-85.

SIRIO (Florence, Italy)
Elettra I - c1950. Viewfinder 35mm. Fixed Semitelar f8/50mm. Shutter 25-200. $125-175.

Elettra II - c1950. Viewfinder 35mm. Scupltor f5.6/40mm. Shutter 25-200. $125-175.

SITACON CO. LTD. (Taiwan)
Sitacon ST-3 - c1982. Inexpensive 35mm novelty camera. Identical to the Windsor WX-3. Original price: $8-12. Collectible value: $1-5.

S.J.C. & CO. (England)
Camelot - c1900. Small wooden field camera, 8x10.5cm. Mahogany body, brass trim, brass Landscape lens. Black, double extension, square leather bellows. $150-200.

SKAIFE (Thomas Skaife, London, England)
Pistolgraph - c1858. Brass miniature camera for 28mm dia. exposures on wet-plates. Dallmeyer Petzval-type f2.2/40mm, waterhouse stops. Double-flap shutter. One known sale at auction in August 1977 for $15,000.

SKYFLEX - c1955. Japanese twin lens reflex for 6x6cm on 120 film. Tri Lausar f3.5/80mm in B,1-300 shutter. Manufacturer unknown, but body style is very similar to Toyocaflex IB. $75-125.

SKYVIEW CAMERA CO. (Cleveland, OH)
Skyview Aerial Camera Model K - c1939. Small hand-held aerial camera for 2¼x3¼" filmpacks. One-piece cast aluminum body with integral finder. Hinged aluminum back. Wollensak Aerialstigmat f4.5/5" lens. $75-125.

SMEDLEY & CO. (Blackburn, England)
Up-to-Date - c1901. Brass and mahogany 10x12" field camera. Folds very compactly. Rising/falling front; double swing, reversing back. Rapid Rectilinear brass-bound lens. $250-325.

SMITH (Gosport, England)
Detective camera - Polished mahogany magazine box camera for 12 plates 3¼x4¼" distributed by Smith. Built-in leather changing bag. Brass trim. Two waist level viewfinders with brass covers. Guillotine shutter. $400-600.

SMITH (James H. Smith, Chicago, IL)
Known mainly for the manufacture of professional equipment.
Multiplying Camera - c1870's. 4¾x6½" plate can be moved hoizontally and vertically to take 2 to 32 exposures on it. Polished mahogany body; sliding back. Brass trim. Bellows focus. Portrait lens, pneumatic flap shutter. $500-750.

SNAP 16 - Black and gold cardboard box camera for 3x4cm on 127 film. $15-25.

SNAPPY - Plastic camera of the Diana type. $1-5.

SNK CAMERA WORKS (Japan)
Folding rollfilm camera - Folding bed camera. Waist level and eye level finders. Erinar Anastigmat f3.5/75mm. $75-125.

Sun B - Small, "heavy hit" subminiature. Styled in the general pattern of the Hit cameras, but heavier like Vesta. Made in Occupied Japan. $60-80.

SÖNNECKEN & CO. (Munich)
Field Camera - 5x7". Mahogany body. Univ. Aplanat Extra Rapid lens with iris diaphragm. $75-125.

Folding camera - 6x9cm. Double extension. Steinheil Unofocal f5.4/105mm lens. $20-30.

SOHO LTD. (London) *Soho was the result of the split of APM in 1928 and consisted of the equipment manufacturers of APM. Kershaw of Leeds took the dominant role. Eventually Soho became absorbed by Kershaw into Kershaw-Soho (Sales) Ltd. During the 1930's the firm produced a number of plastic-bodied cameras of good quality which are very collectable.*
Soho Altrex - c1932. 6x9cm folding bed rollfilm camera. Leather covered body. Kershaw Anastigmat lens, 7-speed shutter. $15-25. *Illustrated top of next page.*

Soho Altrex

bakelite camera for 6x9cm on 120 film. Cross-swinging metal struts support bakelite front. Wine-red bellows. Fixed focus lens, T & I shutter. An attractive camera. $25-40.

Soho Myna Model SK12 - Metal folding-bed rollfilm camera with self-erecting front. 6x9cm on 120. $12-20.

Soho Cadet - c1930. Reddish-brown bakelite 6x9cm folding bed rollfilm camera. Meniscus lens. 2-speed shutter. $25-35.

Soho Pilot - c1933. Black bakelite folding rollfilm camera for 6x9cm on 120 film. Octagonal bakelite shutter face. Intricate basket-weave pattern molded into front & back. Angular art-deco body styling. Fixed focus lens, T & I shutter. $20-35.

Soho Precision - Well-made self-casing triple extension camera with full range of movements. Takes 2½x3½" plates. A copy of Linhof, and a fine professional view camera in its day, though it does not take modern film holders. Although generally selling for considerably less, a very nice complete outfit in case sold at a British auction in 1986 for $670.

Soho Model B - Reddish-brown folding

Soho Vest Pocket

Soho Press camera - c1931-34. Leather-covered strut-folding for 2¼x3¼" plates. Focal plane shutter, ⅟₁₆-800. Soho Anastigmat f4.5/4¾" lens. $75-125.

Soho Vest Pocket - c1930. Strut-folding camera for 4x6.5cm on 127 film. Leather covered. Single Achromatic lens, 3-speed shutter. $20-30. *Illus. bottom of previous page.*

SOKOL AUTOMAT - c1970's. Russian 35mm with Industar 70 f2.8/50mm lens in 30-500 shutter. Rapid wind lever. $15-25.

SOLAR MATES

In-B-Teens - c1988. Fashion coordinated sunglasses and Mini-mate 110 camera. Another version also has binoculars. About $5.

Sunpet 826 - c1986. Simple plastic camera for 126 cartridges. Nothing exciting about it except that it comes with a matching pair of sunglasses. Available in red, blue, or yellow. Retail about $4.

SOLIGOR *Soligor was a trade name used by Allied Impex Corp. for cameras imported from various manufacturers.*
Soligor 35 - c1955. 35mm SLR made by Tokiwa Seiki. Waist-level finder. Built-in meter. Interchangeable Soligor f3.5/50mm lens. Leaf shutter 1-200, B. Same camera

as the earlier Firstflex 35, but sold originally with a different lens. Scarce. One reported sale over $400. Earlier sales around $100.

Soligor 45 - c1955. Viewfinder 35mm made by Nihon Seiki Co. Nearly identical to the Nescon 35. Soligor f4.5/40mm. Shutter 25-100. $60-100.

Soligor 66 - c1957. 6x6cm SLR. FP shutter 25-500, T,B. Interchangeable Soligor f3.5/80mm. $60-100.

Soligor Reflex, Reflex II, Semi-Auto - c1952. 6x6cm TLR for 120 film. Made in Japan. Soligor f3.5/80mm, Rektor rim-set shutter. $75-125.

SOMNER (Bernard Somner, Dresden, Germany)
Somner Modell R.I - c1927. Strut-folding press camera, 6.5x9cm plates. Black lacquered metal body. FP shutter to 1000. Anticomar f2.9/100mm. $150-200.

SONORA INDUSTRIAL S.A. (Manaus, Brasil)

Love - c1975-present. A disposable camera which comes pre-loaded with 16mm wide film for 20 exposures. After exposure, the entire camera is returned for processing, and a new camera is returned with the finished prints. Two-element f11/28mm lens. Film advanced by rotating magicube socket. Over 5 million had been sold in Brazil by 1984. Similar to "Lure" from USA. New price about $5.00

SOUTHERN (E.J. Southern Ind., New York City)

Mykro-Fine - Japanese subminiature of the Hit type. This one actually has the U.S. distributor's name on the shutter faceplate. $15-20.

SPARTUS CORP. (Chicago, Ill.) *Began as Utility Mfg. Co. in New York about 1934, which sold out to the Spartus Corp. of Chicago in the 1940's. During the 1940's, several names were used including Falcon Camera Co., Spencer Co., and Spartus Corp., all of which were probably the same company. In 1951, the firm was purchased by its Sales Manager, Harold Rubin, who changed the name to Herold Mfg. Co. Meanwhile, the former President of Spartus, Jack Galter started a new company called "Galter Products" about 1950. See also "HEROLD" for later model Spartus cameras.*

Spartus 35, 35F - c1947-54. Bakelite 35mm. Simple lens and shutter. $10-15.

Spartus box cameras - including Spartus 116, 116/616, 120, 620, Rocket. $5-10.

Cinex - Reflex-style novelty camera for 3x4cm on 127. Bakelite body. Identical to Spartus Reflex. $10-15.

Spartacord - Brown plastic TLR. $10-15.

Spartaflex - c1950. Plastic TLR. $5-10.

Spartus folding cameras - including Spartus 4, Spartus Vest Pocket. $10-20.

Spartus Full-Vue - c1948-60. Reflex-style 120 box camera. $5-10. *Illus. in next column.*

Spartus Junior Model - Bakelite folding vest-pocket camera, 4x6.5cm on 127 film. Like the earlier Utility Falcon Junior Model, but with different back latches. $10-15.

Spartus Press Flash - 1939-50. Bakelite box camera with built-in flash reflector. This camera was advertised in April 1939 under both Spartus Press Flash (Utility Mfg. Co.) and Falcon Press Flash names. As far as we know, it is the first camera to have a built-in flash reflector. It also exists under other names such, as Galter Press Flash and Regal Flash Master. Historically significant and interesting from a design standpoint, yet common. $5-10. *Illustrated in next column.*

Spartus Super R-I - Non-focusing TLR-style finder. $5-10. *Illustrated in next column.*

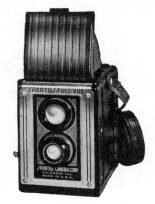

Spartus Full-Vue

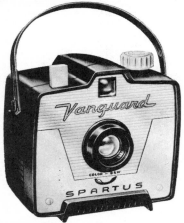

Spartus Vanguard - c1962. 4x4cm plastic box camera. $1-5.

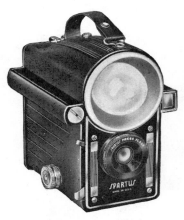

Spartus Press Flash

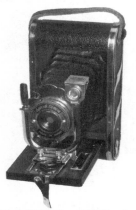

SPECIAL CAMERA - c1930's. Japanese

Spartus Super R-I

504

novelty folding "Yen" camera for sheet film in paper holders. Ground glass back. $15-25.

SPECTRA SUPER II - c1985. Novelty 35mm from Taiwan styled with small pseudo-prism. $1-5.

SPEED-O-MATIC CORP. (Boston, Mass.) Speed-O-Matic - c1948. An instant-picture camera with meniscus lens, single speed shutter, extinction meter. Takes 12 photos 2x3" on direct positive papar in film pack. With developing tank: $20-30. (Clear plastic salesman's "demo" model - $35-50.)

SPEEDEX - 14x14mm "Hit" type Japanese novelty subminiature. $10-15.

SPEICH (Cesare Speich, Genoa, Italy) Stereo Speich - c1953. Unusual stereo reflex camera taking 2 side-by-side 10x12mm exposures on 35mm film. Waist level viewfinder. Rodenstock f2.8/20mm lenses. Shutter 1-250. Only about 20 made. $1000-1500.

SPENCER CO. (Chicago, IL) *The Spencer Co. name is one of many names used by the manufacturers at 711-715 W. Lake Street in Chicago. Among the other names emanating from this building were: Falcon, Galter, Herold, Monarch, Monarck, and Spartus. The Spencer name often appears on the instruction books for cameras which bear one of the other brand names. Some cameras do carry the Spencer brand name, but usually the same camera is also available with one or more of the other brand names.*

Flex-Master - Reflex style minicam for 16 exposures on 127 film. Synchronized and non-sync versions. $5-10.

Full-Vue - 1940s. Black bakelite pseudo-TLR. 6x6cm. $5-10.

Majestic - This black plastic "minicam" would be hard to identify as a Spencer

model without the original instructions. The camera faceplate has no company name, and the box says simply "Candid Type Camera". However, the original instructions bear the imprint of the Spencer Co. Takes 16 exposures on 127 film. $3-7.

SPICER BROS. (London, England) Studio camera - c1888. Studio camera, 6½x8½". Swing back. Rising/falling lens. $15-200.

SPIEGEL
Elf - Metal box camera, 6x9cm on 120. $10-15.

SPIROTECHNIQUE (Levallois-Perret, France)

Calypso - c1960. The first commercially produced camera which was specifically designed for underwater use without any external housing. It takes standard 24x36mm frames on 35mm film, and the overall size is about the same as a normal 35mm camera. Body covering is a grey plastic imitation sealskin. Features interchangeable lenses (Angenieux f2.8/45mm, Flor f3.5/35mm, or Berthiot Angulor f3.3/28mm.) First model of 1960 has guillotine shutter marked 30-1000. Second model of 1961 has guillotine shutter marked 15-500. Nikon bought the design and the Calypso evolved into the successful line of Nikonos cameras. Uncommon. $150-200.

SPITZER (Otto Spitzer, Berlin)
Espi, 4.5x6cm - Compact lazy-tong strut camera for 4.5x6cm plates. Isconar f6.8/90mm lens in Pronto shutter. $100-140.

Espi, 13x18cm - c1910. Folding bed camera for 13x18cm plates. Wood body with leather covering. Wine red double extension bellows. Nickel trim. Dagor f6.8/180mm in Compound ½-250. $60-90.

Princess - c1918. Strut folding camera, 6.5x9cm. Tessar f6.3/120mm lens, Compur shutter. Also sold as Espirette. $60-90.

SPLENDIDFLEX - 4x4cm reflex-style plastic novelty camera. $5-10.

S.P.O. (Société de Photographie et d'Optique, Carpentras, France)

Folding camera - 6x9cm self-errecting rollfilm camera. Anastigmat Sphinx Paris f6.3/105mm. $10-15.

SPORTS ILLUSTRATED - c1985. Inexpensive plastic 35mm given as a premium with magazine subscription. $1-5.

SPUTNIK - Japanese novelty subminiature of the "Hit" type. A rather uncommon name. The few examples we have seen have come from Germany. Normally this type of camera sells for $10-15, but we have several confirmed sales for "Sputnik" in 1986 at $40-50. In at least one case though, the buyer thought he was bidding on the more valuable Sputnik Stereo camera. (See next listing.)

SPUTNIK (CNYTHNK) (U.S.S.R.)

Sputnik Stereo - c1960. Black bakelite three-lens reflex for 6x13cm stereo pairs on 120 film. f4.5/75mm lenses. Shutter 15-125. Ground glass focus. Originally packaged with collapsible viewer and printing frame. $250-375.

SPY CAMERA - Plastic 127 camera, made in Hong Kong. $1-5.

STANDARD CAMERA (Hong Kong) - Small black plastic camera for 3x4cm on rollfilm. Meniscus f11/50mm lens. Simple shutter B,1/50. $1-5.

STANDARD CAMERAS LTD. (Birmingham)

Conway Camera - Box camera for 6x9cm on 120 rollfilm. Several models, including Standard model, Colour Filter Model, Conway Deluxe. $5-15.

Standard Camera No. 2 - Inexpensive cardboard box camera with blue leatherette covering. "No.2 Standard Camera - Made in England" on metal faceplate. We assume

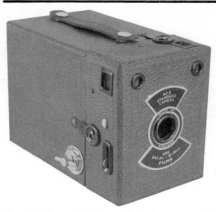

Hand-Camera, 6.5x9cm - c1905-18. Folding strut camera. Black wooden body. Metal knee-struts. Focal plane shutter. Tessar f4.5/120mm lnes. $300-500.

Hand-Camera, 13x18cm - c1895-1905. Strut-folding camera for 13x18cm plates. Unusual design with hinged struts made of wood rather than metal. Fine wood body with nickel trim. Tapered black single pleat bellows. Folding Newton finder. Carl Zeiss Anastigmat f7.7/195mm with iris diaphragm. $750-825.

Stereo Hand-Camera - c1905. Strut-type folding camera for 9x18cm plates. Polished black wooden body. Focal plane shutter. Sliding lens panel has provision for two separate square lensboards, allowing use as a non-stereo camera with two different lenses mounted. $500-700.

that this is made by Standard Cameras, Ltd., but we have no confirming references. Takes 6x9cm on 120 film. I & T shutter. $15-20.

STANDARD PROJECTOR & EQUIPMENT CO.

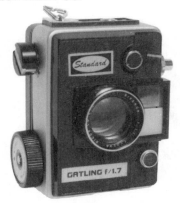

Gatling f1.7 - c1963. Half-frame 35mm with spring motor drive for 12 rapid exposures. Color Rikenon f1.7/35mm lens. Made by Riken. $75-125.

STAR LITE - c1962. Inexpensive reflex-style camera. $5-10.

STAR-LITE - Japanese "Hit" type novelty camera. $10-15.

STARLITE - 1960's. Inexpensive 35mm, 24x36mm. Made by Yamato. Luminar f3.5/45mm. Shutter 25-300,B. $15-25.

STEGEMANN (A. Stegemann, Berlin)
Field camera - 13x18cm. Mahogany body. Single extension square cloth bellows. Normally with Meyer or Goerz lens. $150-200.

STEINECK KAMERAWERK (Tutzing)

Steineck ABC Wristwatch camera - c1949. For 8 exposures on circular film in special magazine. Steinheil f2.5/12.5mm fixed focus lens. Single speed shutter. In original presentation box: $600-800. Camera only: $500-600.

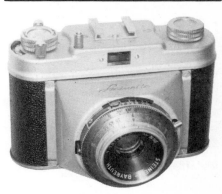

Steiner Steinette

STEINER OPTIK (Bayreuth, Germany)
Hunter 35 - c1950s. Viewfinder 35mm. Steiner f3.5/45mm lens, shutter ½s-100. Hunter 35 was the name used for the Steinette when sold by R.F. Hunter in Britain. $20-35.

Steinette - c1950s. Relatively simple 35mm viewfinder camera. Steiner f3.5/45mm lens in 25-100 shutter. $20-35. *Illustrated bottom of previous page.*

STEINHEIL (Optischen Werke C. A. Steinheil Söhne GmbH, Munich)
Casca I - c1948. Name derived from C.A. Steinheil CAmera. Viewfinder 35. Culminar f2.8/50mm lens in special mount. Focal plane shutter 25-1000. $185-265.

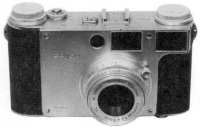

Casca II - c1948. Similar to Casca I, but has coupled rangefinder. Sliding bar on rear selects shutter speeds B,1-1000. Bayonet-mount interchangeable lenses include f4.5/35mm Orthostigmat, f2.8/50, f2.8/85, & f4.5/135mm Culminars. $200-300.

Detective camera - c1895. Magazine camera for 12 plates, 9x12cm or 10x15cm. Wood body with nickel trim. Steinheil or Periskop lens. Rotary or guillotine shutter. $350-650.

Folding plate camera - c1930. Double extension folding bed camera, 9x12cm. Triplar f4.5/135mm in Ibsor. $30-45.

Kleinfilm Kamera - c1930. Small bedless strut-folding camera for 3x4cm on 127 film. Style similar to Welta Gucki. Cassar f2.9/50mm lens in Compur 1-300. $65-80.

Multo Nettel - c1910-12. Folding-bed stereo camera for 3½x5½" (9x14cm) plates. Three convertible lenses on one lensboard allow for stereo or single exposures with a choice of several focal lengths. FP shutter. $375-450.

Stereo Detective - c1893. Wooden body with changing magazine for 8½x17cm plates. Rotating shutter. $850-1150.

Tropical camera - 9x12cm plates. Double extension brown tapered bellows. Fine wood with nickel trim. $400-600.

STELLAR - Japanese novelty subminiature of the Hit type. $10-15.

STELLAR FLASH CAMERA - "Diana" type 4x4cm novelty camera with sync. $1-5.

STELLARFLEX - Twin lens reflex style novelty camera for 4x4cm on 127 film. Identical to the Bedfordflex and a few other names. $5-10.

STEREO CORPORATION (Milwaukee, Wisc.)

Contura - ca. mid-1950's. Stereo camera designed by Seton Rochwite, who also designed the Stereo Realist for the David White Co. It was styled by reknowned product stylist Brooks Stevens, who was also responsible for the Excalibur automobile. It was engineered to be the finest stereo camera ever made. The f2.7/35mm Volar lenses focus to 24 inches with a coupled single-window rangefinder. Probably the first camera to incorporate

"Auto Flash" which adjusted the diaphragm automatically based on the focus distance. The camera reached the production stage just as stereo camera sales plummeted, and a corporate decision was made to abandon the project. Ultimately, 130 cameras were assembled and sold to stockholders for $100 each. The rarity and quality of this camera keep it in demand among collectors. There are usually more offers to buy than to sell in the range of $500-600.

STEREOCRAFTERS (Milwaukee, Wisc.)
Videon - c1950's. Stereo camera for standard 35mm cassettes. Black metal and plastic body. Iles Stereon Anastigmat f3.5/35mm lenses. Sync shutter. $75-100.

Videon II - c1953. Similar to the Videon, but top and faceplate are bright metal. $85-125.

STEREOSCOPIC CO. (England)
Vesca - Tenax style folding camera, 4.5x6cm, made under license by Goerz. Green leather covering, green leather bellows. Goerz Dagor f6.8/75mm lens. $200-300.

Vesca Stereo - Tenax style folding camera, 45x107mm, made under license by Goerz. Green leather covering, green leather bellows. Goerz Celor f4.5/60mm lenses. $350-400.

STERLING - Hit-type camera. $9-15.

STERLING MINIATURE - Black plastic "minicam" for 28x40mm exposures. $3-7.

STERLING CAMERA CORP. (Sterling, Illinois)

2-A Sterling - Basic leatherette-covered cardboard box camera for 2½x4¼" on 116 film. Relatively scarce. $15-20.

STIRN (C. P. Stirn, Stirn & Lyon, N.Y., Rudolph Stirn, Berlin)

Concealed Vest Camera, No. 1 - c1886-1892. Round camera, six inches in diameter, for 6 photos 1¾" diameter on 5" diameter glass plates. Original price, $10.00, and early ads proclaimed, "Over 15,000 sold in first 3 years." Needless to say, many are lost. $650-800. The original wooden box, which also allows the camera to be used on a tripod, doubles the value of the camera.

Concealed Vest Camera, No. 2 - c1888-1890. Similar to the above, but for 4 exposures, 2½" (6.5cm) dia. Camera measures 7" in diameter. $1000-1400.

Magazine camera - c1891. Mahogany box camera for 12 plates 6x8cm. Leather changing bag. Aplanetic lens. Rotating shutter. $500-700.

S.T.M. & CO. (Birmingham, England)
Itakit - c1890. Falling plate magazine camera, 3¼x3¼". Removable magazine. $450-500.

STOCK (John Stock & Co., New York, NY)
Stereo Wet-plate cameras, 5x8" - Very early models of heavier construction: $2000-3000. Later models, more common, lighter construction: $1000-1300.

STÖCKIG (Hugo Stöckig, Dresden)
Union camera - c1907. Folding-bed plate cameras with leather covered wood body and finely polished interior. Wine-red or blue-green single or double extension bellows. 9x12 and 13x18cm sizes. With Meyer Anastigmat f7.2, Detective Aplanat f8, or Union Aplanat f6.8 lens in Union shutter. Made by Ernemann & sold by Stöckig. $100-250.

Union Zwei-Verschluss - c1911. Folding bed camera for 9x12cm plates, made for Stöckig by Ernemann. Leather covered wood body. Double extension wine red bellows. Focal plane shutter ⅟₅₀-2500. Meyer Aristostigmat f6.8/120 in Ernemann ½-100 front shutter. $150-250.

STUDENT CAMERA CO. (New York City)

Student No. 1 - Small wooden box camera for 2⅝x3⅜" on single glass plates held behind two nails on each side of the camera. Interesting diaphragm on the front, but the shutter was the user's fingertip. $75-125.

Student No. 2 - Similar, but for 3¼x4⅝" plates. $75-125.

SUGAYA KOKI, SUGAYA OPTICAL CO., LTD. (Japan)
Hope (Sugaya Model II) - c1950. Subminiature for 14x14mm on 17.5mm rollfilm. Similar to the Myracle with its large "Sugaya Model II" shutter. "HOPE"

embossed in top. Hinged back door. Blue leatherette covering. Uncommon. $60-100.

Myracle, Model II - c1950. Subminiature for 14x14mm on 17.5mm rollfilm. Similar to the Hit-type cameras, but with a better lens and shutter. Hope Anastigmat f4.5. Shutter 25-100, usually with plain faceplate, but also with "Myracle" or "Mycro II" faceplate. Red, blue, or black leather. Some examples marked "Made for Mycro Camera Co. Inc. N.Y." on bottom. Some have hinged back, others load from top. $40-80.

Rubix 16 - c1950's. Subminiature for 50

exposures 10x14mm on 16mm cassette film. Variations with Hope f3.5 or 2.8/25mm lens. Shutter 25-100 or 25-150. $75-140.

SUMIDA OPTICAL WORKS (Japan)
Proud Chrome Six III - c1951. Super Ikonta B copy. 6x6cm or 4.5x6 cm on 120. Coupled rangefinder. Congo f3.5/75mm in Proud Synchront 1-200 shutter, B. $75-100.

Proud Model 50 - c1950. Folding bed camera, 4.5x6cm on 120 rollfilm. Waist-level finder on lens standard. Eye-level finder in top housing. Proud Anastigmat f3.5/75mm in N.K.S shutter 1-200,B. $45-90.

SUMNER (J. Chase Sumner, Foxcroft, Maine)
Stereo rollfilm box camera - Similar to the No. 2 Stereo Kodak box camera. $350-400.

SUNART PHOTO CO. (Rochester, N.Y.)
Sunart folding view - c1898. Various Vici and Vidi models. Black leather covered wood body, polished cherry interior. Double extension bellows. B&L RR lens. Unicum shutter. 5x7": $75-135. 4x5": $65-100.

Sunart Junior - c1896. 3½x3½" and 4x5" plate box cameras, similar in style to the Cyclone Sr. $35-50.

SUNBEAM CAMERA CO.
Sunbeam Minicam - Black bakelite minicam for 16 exposures 3x4cm on 127 film. $4-8.

SUNBEAM SIX TWENTY - Gray plastic twin-lens 6x6cm box camera. Sunbeam label conceals the Spartus name beneath. $8-12.

SUNNY - Small Japanese bakelite camera for 24x24mm exposures on 35mm film. Cartridge-to-cartridge film advance with standard 35mm cartridges elimates the need to rewind. Combination eye-level direct or reflex finder with semi-silvered mirror. $50-75. *Illustrated top of next column.*

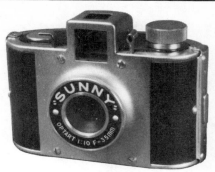

Sunny

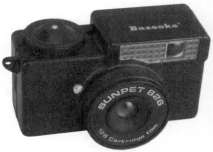

SUNPET 826 BAZOOKA - Specially marked premium version of the inexpensive Sunpet 826 camera. $1-5.

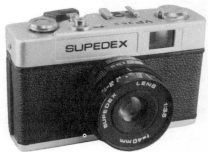

SUPEDEX VP 35 S - Inexpensive 35mm camera from Hong Kong. Simple focusing Supedex f3.5/40mm lens. Three-speed shutter. $3-7.

SUPER CAMERA - c1950. Japanese paper covered wooden "Yen" cameras for sheet film in paper holders. Folding style: $20-30. Box Style: $10-20. *Folding and box versions are illustrated top of next page.*

SUPERIOR FLASH CAMERA 120 - Synchronized metal box camera, 6x9cm. $1-5.

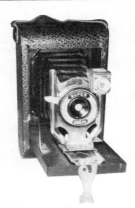

Super Camera, folding style

Super Camera, box style

SURUGA SEIKI CO.
Mihama Six IIIA - c1953. Horizontally styled folding camera for 6x6cm or 4.5x6cm on 120 film. Separate eye-level finders for each size. Mihama or Kepler Anastigmat f3.5 in NKS shutter. $50-75.

SUTER (E. Suter, Basel, Switzerland)

Detective magazine camera - c1890. Early model for 12 plates, 9x12cm. Periskop lens, guillotine shutter. Polished wood with nickel trim. $500-600.

Detective magazine camera - c1893. Later model for 20 exposures on 9x12cm

plates. Suter f8 lens with iris diaphragm, rotating shutter. Leather covered mahogany box with brass trim. $500-650.

Stereo Detective - c1895. Polished wood stereo box camera for 9x18cm plates. Not a magazine camera. $800-1100.

Stereo Detective, Magazine - c1893. Leather covered stereo magazine camera, for 6 plates 9x18cm. The built-in magazine changing-box sits below the camera body and is operated by pulling on a knob. f10/90mm Rectilinear lenses. Coupled rotary sector shutters. $800-1000.

Stereo Muro - c1890's. Press-type body, side struts, 9x18cm plates. f5/85mm Suter lenses. FP shutter 30-1000. $300-400.

SUZUKI OPTICAL CO. (Japan)

Camera-Lite - c1950. Cigarette-lighter spy camera which looks like a Zippo lighter. Very similar to the Echo 8. A supply of Camera-Lites was discovered at a flea market about 1966-67, but released slowly into the collector market. This helped to maintain the same market value for several years at $175-225. Now they are selling for $200-275 and occasionally higher.

Camera-Lite Seastar - Normal Camera-Lite, but with Seastar logo on narrow back edge of body. We don't know the origin or meaning, but one sold at auction in late 1985 for $350.

Echo 8 - 1951-56. Cigarette-lighter camera. Designed to look like a Zippo lighter, it also takes 5x8mm photos with its Echor f3.5/15mm lens on film in special cassettes. There are at least two sizes, the larger measuring 17x47x58mm and the earlier but more common smaller size measuring 15x42x56mm. There were also different film cassettes, either "square" or "rapid" shaped. Also sold under the name Europco-8. $200-300. With presentation box and film slitter add $150.

Press Van - c1953. Japanese 6x6cm strut-folding rangefinder camera. Two variations: One takes an alternate image size of 4.5x6cm on 120, the other 24x36mm on 35mm film. Takumar f3.5/75mm in Seikosha Rapid shutter 1-500,B. $250-350.

SVENSSON (Hugo Svensson, Göteborg)
Hasselblad Svea - c1905. Leather covered falling-plate detective camera, 9x12cm plates. Brass lens. $150-200.

SWALLOW - Hit type novelty subminiature. $10-15.

Tachibana Beby Pilot

SWINDEN and EARP (England)
Magazine camera - c1887. Falling-plate magazine camera. Clement & Gilmer lens, flap and roller blind shutters. $40-60.

TACHIBANA TRADING CO. (Japan)
Beby Pilot - c1940. Bakelite-bodied folding camera for 3x4cm on 127 film. Pirot (sic) Anastigmat f4.5/50mm in "Pilot,O" shutter. $75-100. *Illustrated bottom of previous column.*

TAHBES (Holland)

Populair - c1955. All metal camera with telescoping front. Nickel-plated body with chrome front: $50-60. Leatherette-covered model with black faceplate: $20-40.

TAISEI KOKI (Japan)

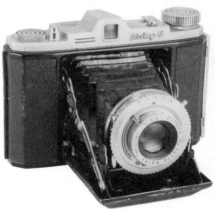

Welmy Six, Welmy Six E - c1951-53. Folding cameras for 6x6cm on 120 film. Terionar f4.5/75mm or f3.5/75mm lens. Shutter 1-200 or 1-300. Eye-level and waist-level finders. $40-60.

Welmy 35 - c1954. A non-rangefinder folding 35mm camera. Terionar f3.5 or f2.8/50mm lens. Welmy shutter 25-150,B. $30-45.

Welmy M-3 - c1956. Rangefinder model. Terionar f3.5/45mm; 5-300 shutter. $30-45.

Welmy Wide - c1958. 35mm viewfinder camera with Taikor f3.5/35mm lens. Shutter 25-200,B. $35-60.

TAIYODO KOKI (T.K.K., Japan)

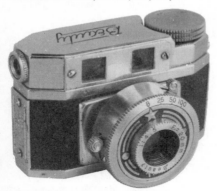

Beauty - c1949, occupied Japan subminiature. Eye-level and deceptive angle finders. f4.5/20mm fixed focus lens. B,25-100 shutter. $50-75.

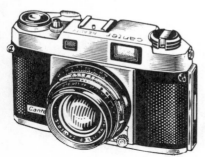

Beauty Canter - c1957. Coupled rangefinder 35mm. Canter f2.8/45mm lens. Copal-MXV 1-500,B. $20-30.

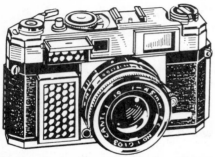

Beauty Super L - c1958. Similar to Super

II, but with built-in meter with booster. Canter-S f1.9/45mm. $25-35.

Beauty 35 Super II - c1958. 35mm CRF. Canter f2/45mm in Copal SV 1-500,B shutter. Lever advance. $20-30.

Beautycord - c1955. 6x6cm TLR for 120 film. Beauty f3.5/80mm in 10-200 shutter. $40-60.

Beautyflex - c1950-55. 6x6cm TLR. Several slight variations, but usually with f3.5/80mm Doimer Anastigmat lens. 1-200 shutter. $35-50.

Epochs - c1948. Heavy cast metal subminiature for 14x14mm on "Midget" size rollfilm. Identical to the Vestkam and Meteor cameras. "Epochs" on top only, not on shutter face. This name is not common. Talent f3.5/20mm. TKK shutter 25,50,B. $125-175.

Meteor - c1949. Same as Epochs, except for name. "Meteor" name on top and shutter face. This name is not common. Vestkam f4.5/25mm lens. TKK shutter 25,50,B. $125-175.

Reflex Beauty - c1954-56. Japanese copy of the Kochmann Reflex Korelle for 6x6cm on 120 film. An early Japanese 6x6cm SLR (first was Shinkoflex of 1940). Canter f3.5/75mm lens. Focal plane shutter to 500.

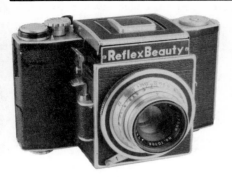

Reflex Beauty II

Model I has chrome nameplate with script lettering. Model II has embossed nameplate and bayonet-mounted lens. $125-250.

Vestkam - c1949. Same as Epochs and Meteor, except for name. This is the most common name. Marked "Made in Occupied Japan". Vestkam f3.5/20mm. TKK shutter 25,50,B. $80-125.

TAIYOKOKI CO., LTD. (Japan)
Viscawide-16 - c1961. Panoramic camera for 10 exposures 10x46mm on specially loaded 16mm film. Lausar f3.5/25mm lens. Shutter 60-300. 120 degree angle of view. $150-250.

TAKAHASHI OPTICAL WORKS
Arsen - c1938-42. Similar to the more common Gelto, but for 12 exp. 4x4cm on 127 film rather than 16 exp. Collapsible front. f3.5 or f4.5/50mm lens in 5-250 shutter. $50-75.

TAKAMINE OPT. (Japan)
Mine Six IIF - c1955. Folding bed rollfilm camera, 6x6cm on 120. CRF. Deep-C Anastigmat f3.5/75mm in Rectus 1-300 shutter or Takumar f3.5 in Copal. $75-150.

Mine Six Super 66 - c1957. Folding bed rollfilm camera, similar to the Super Ikonta IV. 6x6cm or 4.5x6cm on 120. CRF. Built-in selenium meter. Takumar f3.5/75mm in Copal MXV 1-500 shutter. $75-150.

TALBOT (Romain Talbot, Berlin) *Makers of the Errtee cameras. In German, the letters R.T. (for R. Talbot) are pronounced "Err-Tee".*

Errtee folding plate camera - c1930. 9x12cm. Double extension bellows. Dialytar or Laack Pololyt f4.5/135mm lens. Compur shutter 1-200. $30-40.

Errtee folding rollfilm camera, 6x9cm - For 120 rollfilm. Anastigmat Talbotar f4.5/105mm in Vario shutter 25-100. Brown

bellows and brown leather covering: $30-45. Black leathered: $20-30.
- 5x8cm size - Poloyt Anastigmat f6.3/90mm in Vero shutter. Black leather and bellows. $20-35.

Errtee button tintype camera - c1912. A cylindrical "cannon" for 100 button tintypes 25mm diameter. Processing tank hangs below camera and exposed plates drop through chute. Laack f4.5/60mm lens. Single speed shutter. $700-1000.

TALBOT (Walter Talbot, Berlin)

Invisible Camera - c1915-30. Unusual camera shaped like a 7cm wide belt, 34cm long, with a film chamber at each end. The camera is made to be concealed under a vest with the lens protruding from a buttonhole. The versions advertised around 1930 are made for 35mm daylight-loading cartridges, but these ads usually mention that the camera had been in use for "over 15 years", (before there were standard 35mm cartridges.) We suspect that they were not commercially available in the early years. This suspicion is based on the lack of advertising until the late 1920's, and also because of their rarity in the current collector market. Rare. Price negotiable.

TALBOT & EAMER CO. (London)

Talmer - c1890. Magazine box camera with changing bag. 8x10.5cm plates. $300-350.

TANAKA KOGAKU
TANAKA OPTICAL CO., LTD. (Japan)

Tanaka Kogaku had a rather short history starting with the manufacture of Leica copies about 1953 and ending about 1960 just as its designs started to show some originality.

Tanack IIC - 1953-55. Similar to the Leica IIIB, but with hinged back, sync post on front, and with no slow speeds. Location of slow speed dial is capped. Interchangeable Tanar f3.5/50mm lens. Focal plane shutter 1/20-500, B. $300-400.

Tanack IIIF - c1954. Slow speed dial added to front, otherwise like Tanack IIC. Interchangeable Tanar f2.8/50mm lens. FP shutter 1-500, B,T. $250-350.

Tanack IIIS - c1954. Top housing stamped as one piece (as Leica IIIc). Two posts on front for FP & X sync. Otherwise like Tanack IIIF, including slow speeds. Tanar f2.8/50mm. $250-350.

Tanack IIISa - c1955. Like IIIS with single piece top housing, but only one sync post. Tanar f3.5/50mm. Uncommon. $300-400.

Tanack IV-S - c1955. Standard lens was

six-element f2/50mm Tanar with helical focusing. FP shutter 1-500, B,T. The IVS was widely advertised in the USA. Originally it sold for $104. (List price was $169.) By 1960 they were being sold for $65. Current value $250-350.

Tanack SD - 1957. 35mm RF resembling a rangefinder Nikon more than a Leica. Combined range/viewfinder window. Lever advance. Interchangeable screw-mount Tanar f1.5/5cm lens. FP shutter 1-1000, B,T, ST. A nice 3-lens outfit with finder sold quickly at $800. With normal lens: $400-600.

Tanack V3 - c1958. Inspired by the Leica M-series, the V3 sports a re-styled top housing with the sync post at the end below the rewind knob. The lenses use a 3-lug bayonet mount, not compatible with Leica's 4-lug system. This was the only Tanack with bayonet mount. $300-400.

Tanack VP - c1959. The last of the Tanack line has a new top housing with a large window to illuminate the projected frame lines in the finder. Screwmount lenses, with Tanar f1.8/5cm as standard. $250-350.

TARGET (Paris)

New Folding Stereo - Folding bed stereo camera for 9x18cm plates. Leathered wood body with polished wood interior and nickel trim. Stereo shutter built into wooden lensboard. Focusing knob on the front of the bed. $275-325.

TARON CO. (Japan)

Chic - c1961. Vertically styled camera for 18x24mm half-frames on 35mm film. Taronar f2.8/30mm. Taron-LX shutter controlled by selenium meter. $50-75.

Taron 35 - c1955. 35mm CRF. Lausar f2.8/45mm, NKS 1-300,B shutter. $25-35.

Taron Super LM - 35mm CRF. BIM. Taronar f1.9/45mm. $30-45.

TAUBER - c1920's. German 9x12cm folding plate camera. Rapid Aplanat.f8/135mm lens. $25-35.

TAYLOR (A & G Taylor, England)
View camera - Tailboard style ½-plate mahogany view. Clement & Gilmer brass barrel lens, iris diaphragm. $200-250.

TECHNICOLOR CORP.
Techni-Pak 1 - c1960. Plastic 126 factory loaded cartridge camera. Camera must be returned for processing and reloading. $3-7.

TEDDY CAMERA CO. (Newark, NJ)
Teddy Model A - c1924. Stamped metal camera in bright red and gold finish. Takes direct positive prints 2x3½" which develop in tank below camera. Original price just $2.00 in 1924. Current value with tank: $350-500.

TEEMEE - Japanese novelty subminiature of the Hit type. $15-20.

TELLA CAMERA CO. LTD. (London, England)
No. 3 Magazine Camera - c1899. Leather covered box camera for 50 films in a filmpack. Taylor Hobson f6.5, pneumatic shutter. Detachable rise/cross front. $350-500.

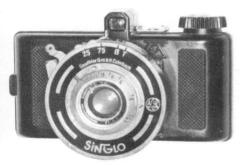

TEX - c1949. German miniature for 3x4cm on unperforated 35mm film in special cartridges. Rectangular telescoping front. Vidar or Helur f4.5/50mm lens, Singlo or Compur shutter. Most common with Helur in Singlo. Cast metal body identical to the Nova camera. $75-100.

THOMAS (W. Thomas, London)
Wet-plate camera - c1870. Folding-bed bellows camera for ½-plates. Brass trim. f11 lens. $800-1200.

THOMPSON (W. J. Thompson Co., NY)
Direct positive street camera - Box-style street tintype camera. Plates, devloping tank, etc. all packed inside the camera's body. $75-125. With tank: $50-60.

THORNTON-PICKARD MFG. CO.
(Altrincham, England) *The company was formed in 1888 when Mr. Edgar Pickard joined the Thornton Manufacturing Co. Its first major product was the T-P roller blind shutter and it soon claimed "the largest sale in the world". T-P undertook a short-lived and relatively unsuccessful scheme to break into the American market in 1894. Camera production concentrated on the Ruby field camera which really took off after 1896 with the introduction of the cheaper version, the Amber. It also produced a range of folding and pocket type cameras, attempting to break into Kodak's market. The firm prospered until 1914 when the war upset production and marketing. Immediately post-war the firm's position seemed hopeful but to consolidate its position T-P was involved with APM in 1921 and Soho Ltd in the 1930's. This did nothing, however, to halt its decline which resulted from a lack of investment. T-P ceased to exist in 1940 although the name was kept alive until at least 1963.*

Aerial Camera, Type C - c1915. Brass reinforced mahogany camera for 4x5" plates in special magazines. Long body accomodates Ross Xpres f4.5/10¼" lens. Focal plane shutter. Detachable cylindrical brass finder. The few known sales have been in the $2600-3200 range.

Amber - c1899-1905. Compact "English style" folding view camera. Sizes from ¼ to full plate. Front door/bed often has turntable for tripod legs. Round opening in bed allows lens and shutter to protrude when camera is folded. $150-250.

Automan (Nimrod Automan, Oxford Automan) - c1904. Hand and stand folding plate camera made in 3¼x4¼" and 4x5" sizes. Polished mahogany interior. Leather covered exterior. Red bellows. Aldis Anastigmat f6 lens. B&L Automat or T-P Panoptic shutter. $150-250.

Thornton-Pickard Duplex Ruby Reflex, Tropical

Mark III Hythe Camera

College - c1912-26. Compact folding double extension field camera. Five sizes from 9x12cm to 18x24cm. Mahogany and brass. Thornton-Pickard Rectoplant lens in rollerblind shutter. $150-250.

Duplex Ruby Reflex - c1920-30. SLR. FP shutter. Aldis Anastigmat f4.5. $100-150.

Duplex Ruby Reflex, Tropical - SLR. 6.5x9cm and ¼-plate sizes. Teak and brass. Double extension orange bellows. Focal plane shutter to 1000. Cooke Anastigmat f6.3 lens. $2000-2500. *Illustrated bottom of previous page.*

Folding plate camera, ½-plate or 5x7" - c1900's. Zeiss Unar f5/210mm lens. Focal plane shutter 15-80. $150-180.

Folding Ruby - c1920's. 3¼x4¼" folding plate camera. Revolving back, fine wood interior, leathered exterior, various correctional movements. Cooke Anastigmat f6.5 lens. $175-250.

Horizontal Reflex - c1923. Large SLR, 3¼x4¼". Entire front extends via rack and pinion. Leather covered wood, black metal parts. Cooke Anastigmat f4.5/5" lens, FP shutter. $100-125.

Imperial Perfecta - c1913. Similar to the Imperial Triple Extension, but only double extension. ½-plate to full-plate sizes. Beck Symmetrical lens. T-P roller-blind shutter. $175-250.

Imperial Pocket - c1916. Folding-bed

plate cameras. Lower priced models have wood body, single extension metal bed. Better models have all metal body, rack focusing. $35-50.

Imperial Stereo - c1910. Folding bed camera, 9x18cm. Accomodates single or stereo lensboards. $250-350.

Imperial Triple Extension - c1904-26. One of the more advanced field cameras with triple extension bellows. ½-plate size. Mahogany with brass trim. Tapered leather bellows. Beck Symmetrical, T-P Rectoplanat lenses. Rollerblind shutter. Common in England in average used condition for $150-250. Fine condition less common and worth an extra $100-200.

Junior Special Ruby Reflex - c1928. Press-type SLR, 6x9cm or 3¼x4¼" sizes on plates. Black leather covering. Dallmeyer Anastigmat f4.5/130mm. FP shutter 10-1000, T. $75-110.

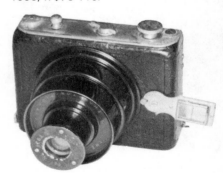

Limit - c1912. Small rigid body camera for 4.5x6cm plates or rollfilm. Cooke f6.3/55mm in telescoping mount. FP shutter 15-100, T. $700-900.

Mark III Hythe Camera - c1915. Rifle-type camera, 4.5x6cm on 120 rollfilm. Used in WWI to train British R.A.F. machine gunners. f8/300mm. Central shutter. $500-650. *Illustrated top of this page.*

Puck Special - 4x5" plate box camera. Focus and shutter adjustable. $50-60.

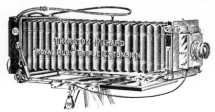

Royal Ruby - c1904-30. Folding plate camera, same as the Ruby, but triple extension model. Nice outfit: $400-500. Camera only: $250-350.

Royalty - Mahogany ½-plate field camera, aluminum trim. Goerz f7.7 lens. $225-275.

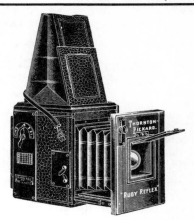

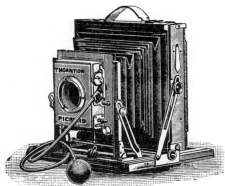

Ruby - c1899-1905. Compact folding field camera. Front door becomes baseboard, with tripod legs fastening to built-in turntable. Ruby R.R. lens. T-P rollerblind shutter. $200-300.

Ruby Reflex - c1928. 4x5" SLR. Ross Homocentric f6.3/6". FP shutter. $150-250.

Ruby Speed Camera - c1925. Small focal plane camera with f2 lens, inspired by the 1924 Ermanox. Even the folding optical finder is the same. Taylor-Hobson Cooke Anastigmat f2/3" in helical focusing mount. Machined cast aluminum body with leather covering. FP shutter T, $\frac{1}{10}$-1000. Only one recorded sale in 1985 for about $2700.

Rubyette Nos. 1, 2, 3 - c1934. 6.5x9cm SLR, plates or rollfilm. Dallmeyer Anastigmat f8, f4.5 or f2.9. FP 10-1000. Nice examples fetch $250-350; average ones $150.

Snappa - c1913. Simple 4.5x6cm plate camera with pull-out box-shaped front, no bellows. Single Achromatic lens with sliding diaphragm. $350-450.

Special Ruby - c1905. Wood field camera with double extension black bellows. Brass trim. Goerz Doppel-Anastigmat f2.5/210mm, T-P roller-blind shutter. $175-225.

Special Ruby Reflex - c1923-38. 2¼x3¼" or 3¼x4¼" sizes. Cooke Anastigmat f4.5 lens. Focal plane shutter. $125-175.

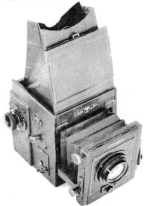

Ruby Deluxe - c1912. Mahogany ¼-plate SLR with brass binding. Goerz Dogmar or Ross Xpres f4.5 lens. Focal plane shutter 10-1000. $150-250.

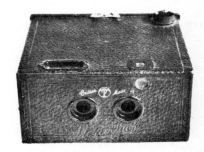

Stereo Puck - c1925. Inexpensive rollfilm

box for 6x8.5cm on 120 film. Meniscus lenses, simple shutter. Black covered wood body. Camera only: $75-100. *With box and viewer, it will bring at least double that price.*

Victory Reflex - c1925. 2¼x3¼" SLR. Dallmeyer or Cooke lens. $75-100.

Weenie - c1913. Simple folding bed plate camera, ½-plate. Fittings are nickel. Single Achromatic lens, T-P Everset T,B,I shutter. $30-40.

THORPE (J. Thorpe, NY)
Four-tube camera - c1862-64. Wet-plate camera with 4 lenses for up to 4 exposures on a 5x7" plate. One on record in 1980 with wet-plate holder and dipping tank for $1250.

THOWE CAMERAWERK (Freital & Berlin)
9x12cm folding plate camera - c1910. Leather covered wood body. Doxanar f6/135mm. Shutter 25-100. $30-45.

Field camera, 9x12cm - Horizontal format. Rear bellows extension. Blue square bellows with black corners. $100-150.

Thowette - c1932. 3x4cm rollfilm camera with telescoping front. Xenar f3.5/50mm in Ring Compur 1-300 shutter. $175-225.

Tropical Plate Camera, 6.5x9cm or 9x12cm - Folding bed camera. Brown double extension bellows. Reptile leather covering. Brown lacquered metal parts. Brass trim. $250-300.

TIEZONETTE - c1932. Strut-folding plate camera, 4.5x6cm. Xenar f3.5/45mm lens in Compur shutter. $125-175.

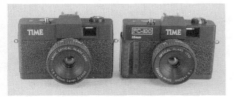

TIME - Minimum-quality 35mm camera from Taiwan. All black plastic with red & white "TIME" on front of top housing. Given free with $20 subscription to TIME magazine in mid-l985. Several variations of body style, probably from different factories. $1-5.

TIME FC-100 - Similar to the above, but with model number and slight variation in body style. Given free during the same promotion, this version of the camera showed up in Australia. $1-5. *Illustrated above with the Time camera.*

TIME-FIELD CO. (Newark, Delaware USA)
Pin-Zip 126 - c1984. Cardboard camera with drilled brass pinhole. Uses 126 cartridge film. An interesting modern pinhole camera, named for the sound made by the light as it enters the pinhole. $5-10.

TIRANTI (Cesare Tiranti, Rome)

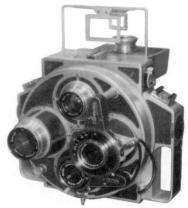

Summa Report - c1954. Unusual press camera with two pairs of lenses mounted on a turret. The normal lens pair was a Schneider Xenar f4.5/105mm in Synchro Compur, and a Galileo Reflar f4 viewing lens. The wide-angle pair was a Schnieder Angulon f6.8/65mm in Synchro Compur, and a Galileo Reflar f3.5 viewing lens. The impressive cast aluminum body took 6x9cm plates, packs, or rollfilm. Only 100 made. Unusual and rarely seen for sale. $4000-5000.

TIRANTY (Paris)
Stereo Pocket - Jumelle type stereo camera for 45x107mm plates. Transpar f4.5/54mm lenses in Jack shutter 25-100, B,T. With magazine back: $150-200.

TISCHLER (Anton Tischler, Munich, Germany)
Colibri - c1893. Small leather covered box camera for 4x4cm plates. Waist-level viewfinder mounted on top of body. Simple lens and shutter. Originally sold with box of plateholders, in a large case. One auction sale in 10/88 for $3200 in mint condition with holders, boxes, etc.

TISDELL & WHITTELSEY (pre-1893)
TISDELL CAMERA & MFG. CO. (post-1893) (New York)
T & W Detective Camera - c1888. Detective box camera for 3¼x4¼" plates. All wood box. Truncated pyramid rather than bellows for focusing. Achromatic

meniscus lens. Rare. One sold a few years ago for $1200, and another for $2800.

Tisdell Hand Camera - c1893. In 1893, the name of the T & W Detective Camera was changed to "Tisdell Hand Camera". Leather covered. Internal bellows focus. $500-750.

TIVOLI - c1895. English ½-plate camera. Mahogany body. Rectilinear lens. $200-275.

TIZER CO. LTD. (Japan)
Can Camera 110 TX Coca-Cola - 1978. Camera the size and color of a Japanese 250ml Coke can. 110 cartridge film. Synched and non-synched versions. Fixed focus. Single speed shutter. $35-65. *See Eiko Co. Ltd. for later can cameras from Hong Kong.*

Orangina Camera - c1977. 110 camera in the shape of a can of orange soda. $25-50.

TOAKOKI SEISAKUSHO (Japan)
Gelto D III - c1938 and 1950. ½-frame 127 film cameras. Pre-war model has black body and Grimmel f4.5/50mm lens in collapsible mount. Post-war model has chrome body

and f3.5 lens. Common features include: eye-level optical finder, shutter T,B,5-250. Prewar: $100-200. Postwar: $70-100.

TOGODO OPTICAL CO. (Japan)
"Togodo" and "Tougodo" are roman spelling variations of the same name. See Tougodo.

TOHOKOKEN CAMERA CO.
Camel Model II - c1953. Inexpensive 35mm camera with styling similar to Canon, but with front shutter and no rangefinder. Even the type style for the name "Camel" is similar to the style used by Canon. Camel f3.5/50mm. Nippol 1-200 shutter. $40-60.

TOKIWA SEIKI CO. (Japan)
Bioflex - c1951. TLR for 6x6cm on 120 film. First Anastigmat f3.5/8cm lens, externally gear-coupled to the viewing lens. B,10-200 shutter. Not to be confused with the cheap plastic Bioflex novelty camera. $40-70.

First Six I, III, V - c1952-54. Horizontal folding cameras for 6x6cm or 4.5x6cm on 120 rollfilm. Separate viewfinder for each image size on Models I, III. Model V has uncoupled rangefinder. Neogonor Tri-Lauser Anastigmat f3.5/80mm. (See First Camera Works for an earlier camera with the same name.) $40-60.

Firstflex - c1951-55. A series of 6x6cm TLR cameras. f3.5/80mm. Some models have shutters to 1/200, others have MSK 1-400 shutter, B. Cheaply made. $25-40.

Firstflex 35 (1955 type) - 35mm SLR with waist-level finder. Removable bayonet-mount f3.5/50mm lens. Behind-the-lens leaf shutter 25-150,B. $100-200.

Firstflex 35 (1958 type) - 35mm SLR with built-in prism. Mirror acts as shutter. Exa/Exakta bayonet mounted Auto Tokinon f2.8/45mm. Also sold under the Plusflex name in England and GM 35 SLR in the USA. $50-80.

TOKIWA (cont.) - TOKYO KOGAKU

Lafayette 35 - c1955. Export version of Firstflex 35. Interchangeable f3.5/50mm Soligor Anastigmat; B,25-100 behind-the-lens leaf shutter. Waist level finder. $90-150.

Windsorflex, 35mm - c1955. Same as the 1955 type Firstflex 35 (waist-level, not eye-level prism). $100-150.

TOKO PHOTO CO. (Japan)

Cyclops - c1950's. 16mm Japanese binocular camera, identical to the Teleca. f4.5/35mm lens. Shutter 25-100. $400-600.

Teleca - c1950. 10x14mm subminiature 16mm telephoto camera built into binoculars. Non-prismatic field glasses have camera mounted on top center. $400-600.

TOKYO KOGAKU (Japan) *Tokyo Kogaku's TLR cameras were sold by three different distributors under different names: "Primoflex" by J.Osawa & Co., "Laurelflex" by K.Hattori & Co., the makers of Seiko shutters, and "Topconflex" for direct sales by Tokyo Kogaku.*
Laurelflex - c1951. 6x6cm TLR. Toko or Simlar f3.5/75mm. Konan Rapid-S or Seikosha Rapid 1-500, B. $40-60.

Minion - c1938. Self-erecting bellows camera for 4x5cm on 127 film. Toko f3.5/60mm. Seikosha Licht 25-100, B,T. Original

1938 model painted black; chrome model introduced in 1939. $65-95.

Minion 35 - c1948. Seikosha Rapid 1-500, B. Toko f3.5/40mm. Models A & B have 24x32mm "Nippon size" format; B has body release. C is standard 24x36mm. $75-125.

Primo Jr., Primo Jr. II - c1958. 4x4cm TLR, 127 film. Sold in the USA by Sawyers. Topcor f2.8/60, Seikosha 1-500,B. $80-120.

Topcoflex Automat - c1957. 6x6cm TLR.

Crank advance. Topcor f3.5/75 in
Seikosha MXL shutter. $60-100.

Topcon 35-L - c1957. 35mm RF. Topcor
f2/44mm in Seikosha-MXL 1-550,B. Auto
parallax-correcting bright-frame finder.
Accessory selenium meter clips in top
shoe; reads directly in EV numbers. With
meter: $50-75. Camera only: $35-60.

Topcon Auto 100 - c1965-73. 35mm
SLR with through-the-lens CdS metering.
This was the first automatic TTL camera.
Interchangeable UV Topcor f2/53mm
lens. Shutter 1/8-500,B. $40-60.

Topcon B - c1959-61. 35mm SLR. Penta-
prism interchangeable with waist-level
finder. Interchangeable Exakta-mount Auto-
Topcor f1.8/58mm lens, externally linked
auto diaphragm. FP 1-1000,B. $100-150.

Topcon C - c1960-63. Like the Topcon B,
but internal automatic diaphragm. $85-125.

Topcon D-1 - c1965-71. 35mm SLR with
through-the-lens CdS metering. RE Auto-
Topcor interchangeable f1.8/58mm lens.
FP 1-1000, B. $75-100.

Topcon R - c1958-60. Same as the
Topcon B. $150-225.

Topcon RE Super - Introduced 1963. The
first SLR with fully coupled through the
lens metering system. (Note that the Mec-
16 SB subminiature already had a coupled
behind the lens metering system in 1960,
but it is not an SLR.) Removable prism. FP
shutter 1-1000,B. With f1.4/58mm lens:
$100-165.

Topcon Super D - c1963-74. 35mm SLR.
Same as the Topcon RE Super. With
interchangeable RE-Auto Topcor f1.8/
58mm lens: $100-150.

Topcon Uni - Same as the Topcon Auto
100. $50-75.

TOKYO KOKEN CO. (Tokyo)
Dolca 35 (Model I) - c1953. Leaf-shutter
35mm camera without rangefinder.

Extensible front with helical housing.
Komeil f3.5/50mm lens in Nipol shutter
B,1-200. ASA sync post. $35-60.

TOKYO KOKI CO. (Japan)

Rubina Sixteen Model II - c1951.
Subminiature for unperforated 16mm film
in special cassettes. Made in Occupied
Japan. Ruby f3.5/25mm lens. Shutter 25-
100,B. $125-150.

TOKYO SEIKI CO. LTD. *See also Rocket
Camera Co.*
Doris - c1952. Folding camera for 4.5x6
cm on 120. "Occupied Japan". Perfa
Anastigmat f3.5/75mm lens, NKS shutter
B,10-200. $20-35.

TOP CAMERA WORKS
Top - c1948. Cast metal subminiature from
Occupied Japan. Eye-level frame finder.
Fixed focus lens. B,I shutter. Same as the
pre-war "Guzzi" camera. Not to be
confused with the boxy rectangular "Top"
subminiatures from Maruso Trading Co.
$100-150.

TOPPER - Cheap plastic box camera for
127 film. Long shutter release plunger on
left side. This is the same camera which is
built into the Secret Sam Attache Camera
and Dictionary. $5-10.

TOREL 110 TALKING CAMERA - c1987. The top section is a micro-110 type camera, and the bottom is a miniature battery-operated phonograph, which says: "Say Cheese! HA HA Ha Ha ha ha..." when rear button is pressed. Camera operates independently, presumably after the recorded voice has put a smile on the subject's face. $20-30.

TOSEI OPTICAL (Japan)
Frank Six - c1951. Folding camera for 6x6cm or 4.5x6cm on 120. f3.5/75mm Anastigmat lens. T.K.S. shutter B,1-200. Optical eye-level viewfinder. $40-65.

TOUGODO OPTICAL (Japan) *Established in 1930 by Masanori Nagatsuka and named for Admiral Tougo of the Japanese Navy.*

Baby-Max - c1951. Novelty subminiature, similar in construction to "Hit" types, but different shape. f11/30mm fixed focus lens. Single-speed shutter. $15-25.

Buena 35-S - c1957. 35mm viewfinder camera. Buena f3.5/45mm lens. Shutter B,25-300. $30-45.

Click - c1951. Subminiature camera of "Hit" type. $15-20.

Colly - c1951. "Hit" type subminiature for 14x14mm exposures. Meniscus f11 lens. $10-15.

Hit - c1950's. Japanese novelty camera for 14x14mm exposures on 16mm paper backed rollfilm. Similar cameras were made under a number of other names, but usually called "Hit type" cameras by collectors. Many of these were probably made by Tougodo, but some came from other mfrs. Gold models: $40-60. "Occupied Japan" model ("Made in Occupied Japan" below lens): $35-50. Normal chrome ones: $10-20.

Hobiflex, Model III - c1952. 6x6cm TLR. Externally gear-coupled lenses. Tri-Lausar or Hobi Anastigmat f3.5/80. Shutter 1-200,B. $20-25.

Hobix - c1951. Compact all-metal camera for 28x28mm on Bolta-size film. Meniscus f8/40 in Complete B, 25,50,100 sh. $30-40.

Hobix Junior - c1955. Inexpensive Bolta-size rollfilm camera for 28x28mm. Fixed focus lens; B,I shutter with PC sync. $20-30.

Kino-44 - c1959. Baby Rollei-style TLR for 4x4cm on 127. Kinokkor f3.5/60mm in Citizen MXV 1-500 shutter. $75-125.

Leader - c1955. Japanese 35mm stereo, also takes single exposures. Looks like the Windsor Stereo. Black bakelite; aluminum trim. Leader Anastigmat f4.5/45mm lenses, 3 speed shutter ½s-100. While users might pay $100-150, a serious collector would pay $300-450 for this rare camera.

Meikai - c1937. Twin lens reflex for 35mm film. In addition to the normal viewfinder for eye-level framing, this uniquely Japanese design incorporates a waist-level reflex finder with true twin-lens focusing. The lenses are located side-by-side, which allowed the overall size to be only barely larger than a standard 35mm rangefinder camera. The first two models used "No Need Darkroom" sheet film in paper holders for daylight developing. (See "Yen-Kame" for description of this process.) The first rollfilm versions c1939 used 16-exposure spools of paper-backed 35mm wide rollfilm for 3x4cm exposures. Meikai f3.5 or f4.5/50mm Anastigmat. Later models had f3.8/50mm Meikai Anastigmat. $300-450.

Meikai EL - c1963. Cheap 35mm viewfinder novelty camera. Imitation exposure meter on front. Fixed focus lens, simple shutter. $10-15.

Meiritto No. 3 - c1940. Small camera taking 28x40mm exposures on special paper-backed daylight-loading film. Waist-level and eye-level finders on top. Fixed focus f6.3 lens, shutter 1/25, 1/100. $150-200.

Meisupi, Meisupi II, Meisupi IV - c1937. Side-by-side twin lens camera for 3x4cm on sheet film. Uncommon. $300-500.

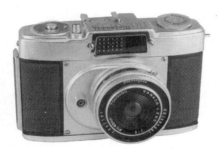

Meisupii Half - c1959. Simple inexpensive 35mm half-frame camera. $15-25.

Metraflex II - TLR for 6x6cm on 120 film. Metar Anastigmat f3.5/80mm. $50-75.

Stereo Hit - c1955. Plastic stereo camera for 127 film. Inexpensive construction. S-Owla f4.5/90mm lens. B,I synch shutter. As a usable camera, it would bring $100-150. Anxious collectors have paid double that amount.

Tougo Camera - 1930. Tougo Camera was the first of the popular Japanese "Yen" cameras, produced by Tougo-do in the Kanda district of Tokyo. The camera itself is of simple construction: a wood body with a paper covering, ground glass back, and simple shutter. The most historically significant feature was the novel film system, which incorporated a 3x4cm sheet of film in a paper holder. The disposable film holder also carried the film through the developing process without the need of a darkroom. The process used a red-colored developer, which effectively filtered daylight into red light. Its simplicity made it very popular, and soon there were many other simple "Yen" cameras on the market. An early example (clearly identified "Tougo Camera" on the shutter face) would easily bring $50+ from a knowledgeable collector, while the later versions usually sell for $10-20.

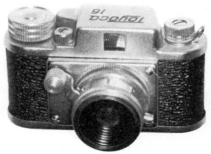

Toyoca 16 - c1955. 14x14mm subminiature, styled like a miniature 35mm. "Toyoca 16" on top. Two models; essentially identical except that the "improved" model has exposure counting numbers on the winding knob. $100-150. *Not to be confused with at least two other styles of "Toyoca" which are cheaper novelty cameras of the "Hit" type.*

Toyoca 35 - c1957. 35mm RF camera. Lausar f2.8 or Owla f3.5/45mm. $30-45.

Toyoca Ace - c1965. 14x14mm subminiature, like the Bell-14. Toyoca Ace 2-speed shutter. EUR: $50-75. USA: $25-40.

Toyocaflex - c1954. 6x6cm Rolleicord copy. Triotar or Tri-Lausar f3.5/80mm. Synchro NKS 25-300 or 1-200 sh. $60-100.

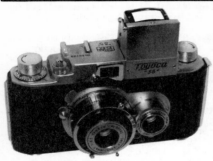

Toyocaflex 35 - c1955. Side-by-side 35mm TLR. Direct and reflex finders. Owla Anastigmat f3.5/45mm viewing and taking lenses. NSK shutter 1-300, B. $150-250.

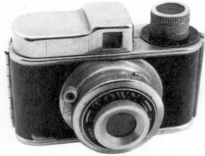

TOWN - An unusual marriage of two Japanese postwar specialties. This camera is styled just like a Hit type, but is much larger, taking 24x24mm exposures on "Bolta-size" rollfilm. "Made in Occupied Japan" on front. Unusual and uncommon. Only one known sale, in 1984 for $100.

TOY'S CLAN

Donald Duck Camera - Plastic camera shaped like Donald Duck's head. The lens is in one eye and the viewfinder in the other. The tongue serves as a shutter release lever. 3x4cm exposures on 127 film. Made in Hong Kong. We saw one at a German auction in the 1970's, but never again until 1984 when a small number, new in boxes, came into circulation and rapidly began selling to avid duck fans for $60-90.

TOYO KOGAKU (TOKO, Japan)

Mighty - c1947. Made in Occupied Japan. Subminiature for 13x13mm exposures on "Midget" size rollfilm. Meniscus lens, single speed shutter. With auxiliary telephoto attachment in case: $75-125. Camera only: $50-75.

Tone - c1948. Subminiature for 14x14mm on "Midget" size rollfilm. Made in Occupied Japan. Eye-level and waist-level finders. f3.5/25mm lens in 3 speed shutter. Germany: $150-200. USA: $75-100.

TOYOCA - Lightweight Japanese novelty camera of the Hit type. $10-20. *Not to be confused with the heavy "Toyoca 16" made by Tougodo.*

TRAID CORPORATION (Encino, CA)

Fotron & Fotron III - 1960's. Grey and black plastic cameras, originally sold by door-to-door salesmen for prices ranging from $150 to $300 and up. The cameras were made to take 10 exposures 1x1" on special cartridges containing 828 film. They featured many high-class advancements such as electric film advance, built-in electronic flash with rechargeable batteries, etc. At the time these cameras were made, these were expensive features. Still, the Fotron camera campaign is considered by some to be the greatest photographic "rip-off" of the century. $25-35.

TRAMBOUZE (Paris)

Tailboard view camera - 13x18cm. Brass barreled f8 lens. $175-225.

TRAVELER - 14x14mm "Hit" type Japanese novelty subminiature. One of the later ones of cheap construction. $10-15.

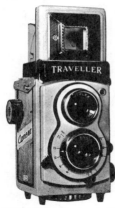

TRAVELLER - Simple plastic Hong Kong 6x6cm TLR-style novelty camera. Shutter 25, 50. $10-15.

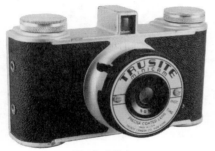

Trusite Minicam

TRIOFLEX - Post-war Japanese TLR. Tri-Lausar f3.5/80mm lens. $60-90.

TROTTER (John Trotter, Glasgow)
Field camera - Mahogany and brass with brass bound lens. ½-plate size. $100-150.

TRU-VIEW - 4x4cm "Diana" type novelty camera. $1-5.

TRUSITE CAMERA CO.

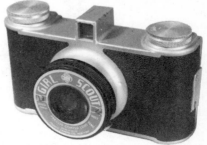

Girl Scout Official Camera - Like the Trusite Minicam, but with Girl Scout faceplate. $25-35.

Trusite Minicam - c1947. Cast metal minicam for 3x4cm on 127 film. $5-10. *Illustrated bottom of previous column.*

T.S.C. TACKER - 14x14mm subminiature from Occupied Japan. f4.5 lens, rotary disc stops. Shutter 25, 50, 100, B. $150-175.

TURILLON (Louis Turillon, Paris)

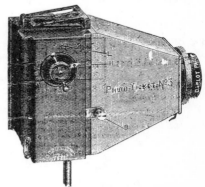

Photo-Ticket - c1905. Aluminum jumelle-style rollfilm camera; No. 2 for 4x5cm, No. 3 for 4.5x6cm. Petzval-type f4.5/95mm. FP shutter. $800-1200.

TURRET CAMERA CO. (Brooklyn, N.Y.)
Panoramic camera - c1905. For 4x10" panoramic views. $800-1000. *Illustrated top of next page.*

527

Turret Panoramic Camera

TYLAR (William T. Tylar, Birmingham, England)

Tit-bit - c1895. Makes 2 exposures on a 6x9cm plate. Lens is mounted on circular plate which is rotated to position it over one side of the plate for the first exposure, then rotated again over the other side to make the second exposure. $250-350.

TYNAR CORP. (Los Angeles, CA)

Tynar - c1950. For 14 exposures, 10x14mm on specially loaded 16mm cassettes. f6.3/45mm lens. Single speed guillotine shutter. Shaped like a small

movie camera (similar to Universal Minute 16). $25-40.

UCA (Uca Werkstätten für Feinmechanik & Optik, Flensburg, Germany) *Brief history taken from names used in advertising:*
1948: ELOP = Elektro-Optik GmbH, Glücksburg
1950: ELOP = Vereinigte Electro-Optische Werke, Flensburg-Mürwik.
1952: UCA = Uca Werkstätten für Feinmechanik und Optik GmbH, Flensburg. ELOP made Elca, Elca II, & Uniflex cameras. UCA made the Ucaflex (= Uniflex) and Ucanett (= Elca with some changes).

Ucaflex - c1950. 35mm SLR of odd design, a copy of the Neucaflex made in Jena. Combines features of SLR and viewfinder. Small mirror and prism move out of the way to allow direct viewing as the shutter is released. Elolux f1.9/50mm lens. Focal plane shutter, 1-1000. Also sold under the name Elcaflex. $300-500.

Ucanett - c1952. 35mm camera for 24x24mm. Ucapan f2.5/40mm in Prontor-S. Successor of Elop Elca II. $125-175.

UCET - Box camera for 6.5x11cm. $10-15.

ULCA CAMERA CORP. (Pittsburgh, PA)

Ulca - c1935. 20x20mm on rollfilm. Cast

zinc body. Meniscus lens, simple shutter. $40-65. *Note: Ulca cameras were also made in England and Germany. The shutter settings are the best indication of country of origin. TMS & STM are German. STI- English. TSL- American. The camera was designed and patented by Otto Henneberger of Nürnberg, Germany.*

UNDERWOOD (E. & T. Underwood; Birmingham, England)

Field cameras - Various models with slight variations in features. Names include: Club, Convention, Exhibition. Sizes: ¼ or ½-plate. Rear extension, square leather bellows. Underwood f11 brass-barrel lens with iris diaphragm. Thornton-Pickard shutter. Swing-out ground glass. $150-225.

Instanto - c1896. Mahogany tailboard camera in ¼, ½, or full-plate size. Underwood landscape lens. $75-125.

Stereograph - c1896. Tailboard style stereo camera. Almost identical to the Instanto, but with stereo lenses. $300-425.

UNGER & HOFFMAN (Dresden)
Verax - Folding plate cameras, in 4.5x6 and 6.5x9cm sizes. Single extension bellows. f3.5 or 4.5 lens. Compound shutter 1-300. Ground glass back. $50-75.

Verax Gloria - c1924. Deluxe version of 4.5x6cm Verax. Brown morocco leather covering with light brown bellows. Dogmar f4.5/75mm in Compur 1-300. $250-350.

Verax Superb - c1930. Folding rollfilm camera, 6x9cm. $20-25.

UNIBOX - c1950. Bakelite box camera made in Sweden. 6x6cm exposures on rollfilm. Large waist-level brilliant finder on top. Meniscus lens, T,M shutter. $75-90.

UNIMARK PHOTO INC.
Unimatic 606 - c1961. Auto diaphragm 35mm made by Leidolf for Unimark. Lordonar f2.8/50mm in Prontor-Matic 30-500. f-stops visible in finder. $15-25. *Illustrated top of next page.*

Unimatic 707 - c1961. Like 606, but also has CRF. $15-25.

UNION OPTICAL CO. (Japan)

Union C-II - c1953. Folding "semi" camera for 4.5x6cm on 120 film. Very similar to the Zenobia and Walcon semi cameras. Coonor Anastigmat f3.5/7.5cm in Copal shutter, B,1-300. $35-60.

UNITED OPTICAL INSTRUMENTS (England)

Merlin - c1936. Cast-metal 20x20mm subminiature. Black, blue, or green crackle-finish enamel. No identification on the camera except small name decal on some examples. $75-125.

UNITED STATES CAM-O CORP.
Cam-O - Oddly shaped wooden TLR "school camera". 250 exposures 4x6.5cm on 70mm film. Wollensak Raptar f4.5/117mm. Alphax shutter. $45-70.

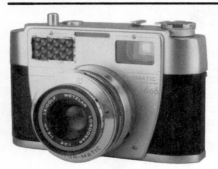

Unimark Unimatic 606

UNITED STATES CAMERA CORP. (Chicago)

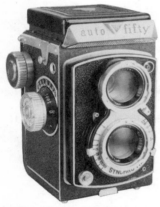

Auto Fifty - TLR for 6x6cm on 120. Biokor f3.5/80mm. Synchro MX 1-300, B. Made in Japan. $35-50.

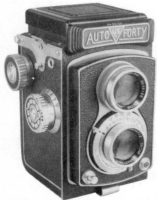

Auto Forty - Good quality TLR, made in Japan. Rack and pinion focus. Tritar Anast.

f3.5/8cm. Synchronized shutter, B, 25-300. Automatic film stop and exposure counter. $35-50.

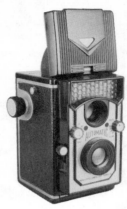

Automatic - c1960. Cast aluminum TLR with black plastic hood and front. Selenium meter cell above viewing lens for automatic exposure. 6x6cm on 620 film. Fixed focus lens. $45-60.

Reflex, Reflex II - c1960's. Inexpensive TLR box cameras. $1-5.

Rollex 20 - c1950. Folding 6x9cm rollfilm camera with self-erecting front. Cheap construction. $5-10.

USC 35 - Viewfinder 35mm. Made in Germany. Built-in extinction meter. Steinheil Cassar f2.8/45mm. Vario 25-200 shutter. $15-25.

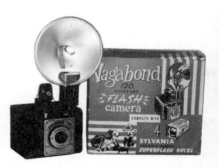

Vagabond 120 Eveready Flash - c1951. Metal box camera for 2¼x3¼" on rollfilm. $3-8.

UNITED STATES PROJECTOR & ELECTRONICS CORP.
Me 35 4-U - c1958. Rangefinder 35mm made by Yamato; identical to the Pax Ruby and Pax Sunscope except for the name.

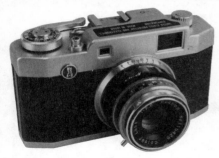

Speaking of names, if prizes were to be awarded for odd names, this would rank high on the list. $30-50.

UNIVERSAL CAMERA CORP. (NYC) *The Universal Camera Corporation was founded on January 26, 1933 in New York by Otto Wolff Githens and Jacob J. Shapiro. Githens, a former New York loan company executive and Shapiro, ex-vice president of an Indianapolis insurance firm formed the company on the assumption that what America needed most was a photographic line that would be affordable to everyone. The company boasted of manufacturing "more cameras per year than any other company in the world". That claim may very well have been true. Their first venture, Univex Model A, at a cost of $.39, sold over 3 million in 3 years. Universal's early success was not solely attributed to the sale of inexpensive cameras; but more so to the sale of the low-cost six exposure rollfilm that was necessary to utilize these cameras. The #00 rollfilm, which was packaged in Belgium on a special patented V-spool, sold for only $.10 in the United States. Twenty-two million rolls were sold by 1938. The special Univex films proved to be one of the major factors responsible for the company's collapse twenty years later.*

Universal became involved with home movies in 1936, when it introduced the model A-8 camera for just under $10 and its companion P-8 projector for less than $15. They used a special Univex Single-8 film, manufactured by Ansco. In the next two years, 250,000 cameras and 175,000 projectors were sold.

During Universal's brief existence, it manufactured almost forty different still and movie cameras and a complete line of photographic accessories. The 1939 New York World's Fair provided Universal with an opportunity to exhibit the newly introduced non-standard 35mm Mercury and the new B-8 and C-8 movie cameras.

Universal verged on bankruptcy in 1940, when all film shipments from Belgium were temporarily suspended because of the war in Europe. Two years later there was still a film shortage, even though Universal was now packaging its film in the United States. The U.S. entry in the war brought Universal a government contract to manufacture binoculars, gunsights, and other optics, and by

1943 Universal had acquired $6,000,000 in sales from the United States government.

After the war, Universal returned to its pre-war line of cameras, some of which were given different names. Having gained experience in optics during the war years, Universal was now able to manufacture most of their own lenses. Universal again met with financial difficulties during the 1948-49 recession. At that time, Universal's prized post-war Mercury II was, for the most part, rejected by the public, mainly because the price had been set at more than triple that of the pre-war Mercury! Two other reasons for the eventual failure of Universal presumably were the $2,000,000 investment into the poorly designed Minute-16 and another investment into a complicated automatic phonograph. Neither of these items proved profitable. Consequently, Universal declared bankruptcy on April 15, 1952.

Universal never gained much respect from the photographic industry, because its business practices were generally believed to be somewhat unethical. Nevertheless, the one thing that Universal will always be remembered for is the originality and ingenuity it displayed in designing some of the most unusual cameras in America.

Our thanks to Cynthia Repinski for her help with the Universal Camera Company in this section and in the movie camera section at the end of the book. Cindy is an active collector of all products of the Universal Camera Co. If you have questions on rare Universal items, you may contact Cindy at P.O. Box 13, Milwaukee, WI 53201.

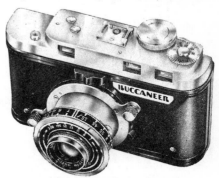

Buccaneer - c1945. Bakelite 35mm camera. CRF. f3.5/50mm Tricor lens. Chronomatic shutter 10-300. Built-in extinction meter, flash sync. $20-25.

Corsair I - c1938. For 24x36mm exposures on Special Univex #200 perforated 35mm film. Univex f4.5/50mm lens in rimset shutter 25-200. $20-25. *Illustrated top of next page.*

Corsair II - c1939. Similar to Corsair I model, but accepts standard 35mm film cartridge. $20-25.

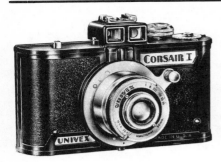

Universal Corsair I

Duovex - c1934. Two Univex A's mounted in a special attachment for stereo work. Manufactured by Pacific Coast Merchandise Co. of Los Angeles and sold as a package with a simple metal viewer and 12 mounting cards. Scarce. With viewer and original box $250-300. Camera only $130-140.

Iris - c1938. Heavy cast-metal camera for 6 exposures 1⅛x1½" on No. 00 Universal film. Vitar f7.9/50mm lens. Ilex shutter. Common. Often with original box for $10-15.

Iris Deluxe - c1938. Similar to the standard Iris, but with leatherette covering and chromium finish. Late models had an adjustable focus lens, focusing to 4'. Flash models were factory mounted with a hot

shoe. Not common. No price difference with or without the flash: $20-28.

Mercury (Model CC) - 1938-42. The first Mercury model. Takes 18x24mm vertical exposures on Universal No. 200 film, a special 35mm wide film. 35mm Wollensak f3.5 Tricor, f2.7 Tricor, and f2.0 Hexar lenses. Rotating focal plane shutter, ½₀-1000. Common in U.S.A. for $20-35. *Up to 50% higher outside the U.S.A.*

Mercury (Model CC-1500) - 1939-40. Similar to the standard model CC but with 1/1500 shutter speed. Same lenses as Model CC. Scarce. $125-175. *Note: This price is for the combination of the rare body and the rare Hexar lens. One without the other would only bring half as much.*

Mercury II (Model CX) - c1945. Similar to Mercury CC, but for 65 exposures on standard 35mm film. 35mm Universal Tricor f3.5, f2.7 or Hexar f2.0 lenses. Rotary shutter 20-1000. Common. $20-35 in USA, 50% higher abroad.

Mercury Accessories:
- **Mercury/Univex Photo Flash Unit -** c1938. Two-piece flash consisting of 4" metal reflector and black bakelite lamp/battery unit. Accepts screw-base flashbulbs. Prewar version used flat 2-cell battery;

postwar version used 2 standard AA batteries. Common. $7-15.

- Mercury Exposure Meter - c1938. Cube-shaped chrome metal extinction meter marked "Univex". Fits Mercury accessory shoe. Not common. $15-20.

- Mercury II Exposure Meter - c1946. Similar to the original Mercury I meter, except unmarked and modified to fit Mercury II (viewing eyepiece lengthened and bottom rear corner cut off). Not common. $20-25.

- Mercury Rapid Winder - c1939. Rapid sequence shots were possible with this device, consisting of metal winder and "pinion" shutter/film wind knob. Camera's regular shutter/film wind knob had to be replaced with pinion knob, without which the winding device was inoperable. Rare. Complete, both pieces: $40-45.

- Mercury Rangefinder - c1939. Super-imposed image type. Partial diecast construction with black enamel finish and chrome hardware. Fits Mercury accessory shoe. Scarce. $35-40.

- Univex Daylight Loading Film Cartridges, M-200 - c1939. Metal film cartridge for bulk 35mm film with "swing-gate" lock. For use in Mercury I & Corsair I cameras. Rare. $7-10.

- Univex Daylight Bulk Film Winder - c1939. Black & red bakelite unit for loading bulk 35mm film into Univex #200 film cartridges. Rare. $65-70.

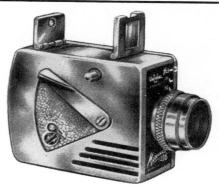

Universal Minute 16

Norton-Univex - c1935. Cheap black plastic camera for 6 exposures on Univex #00 film. Because of the overwhelming success in 1933 of the Univex Model A, the Norton camera, introduced in 1934 by Norton Labs, never gained public interest. The Norton-Univex appeared after Norton Labs sold the remains of their line to Universal. Not common. $15-25.

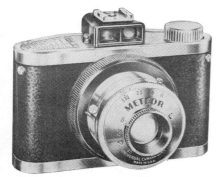

Meteor - c1949. For 6x6cm on 620 rollfilm. Telescoping front. Extinction meter. $5-10.

Minute 16 - c1949. 16mm subminiature which resembles a miniature movie camera. Meniscus f6.3 lens. Guillotine shutter. Very common. With flash and original box: $40-50. Camera only: $15-20. *Illustrated top of next column.*

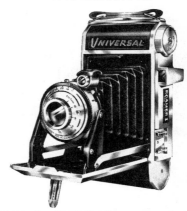

Roamer I - c1948. Folding camera for 8 exposures 2¼x3¼" on 620 film. Coated f11 lens, single speed shutter, sync. $10-15.

Roamer II - c1948. Similar to the Roamer I. f4.5 lens. $10-15.

Roamer 63 - c1948. Folding camera for 120 or 620 film. Universal Anastigmat Synchromatic f6.3/100mm lens. $10-15.

Stere-All - c1954. For pairs of 24x24mm exposures on 35mm film. Tricor f3.5/35mm lenses, single speed shutter. $45-60.

Twinflex - c1939. Plastic TLR for 1⅛x1½" on No. 00 rollfilm. Meniscus lens, simple shutter. $20-25. *Illustrated next column.*

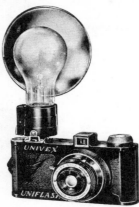

Uniflash - c1940. Cheap plastic camera for #00 film. Vitar f16/60 lens. With original flash & box: $15-20. Camera only: $3-10.

Uniflex, Models I & II - c1948. TLR for 120 or 620 rollfilm. Universal lens, f5.6 or 4.5/75mm. Shutter to 200. $15-25. *Illustrated next column.*

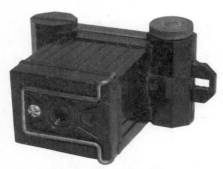

Univex, Model A - c1933. The original small black plastic gem for No. 00 rollfilm. Similar to the Norton, which was originally designed for Universal Camera Corp. Wire frame sportsfinder attached to front of camera, and molded plastic rear sight. Cost $0.39 when new. Several minor variations. $10-15. *50% higher in Europe.*

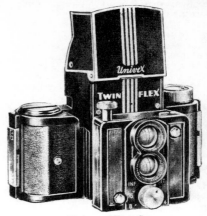

Universal Twinflex

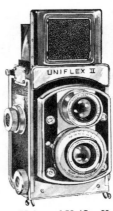

Universal Uniflex II

Univex, Model A, Century of Progress - c1933. Special commemorative model of the simple Model A camera made for the Chicago World's Fair. $50-75.

Univex Model AF-5

Univex AF, AF-2, AF-3, AF-4, AF-5 - c1935-39. A series of compact collapsing

cameras for No. 00 rollfilm. Cast metal body. Various color combinations. $20-30.

Universal Zenith

UNIVERSAL RADIO MFG. CO.
Cameradio - ca. late 1940's. 3x4cm TLR box camera built into a portable tube radio. Like the Tom Thumb listed under Automatic Radio Mfg. Co. $100-125.

URANIA - Wooden rollfilm camera. Roll-holder section detaches to allow the use of plates. Metal fittings are white. B&L lens. $75-125.

UTILITY MFG. CO. (New York & Chicago)
Carlton Reflex - TLR style box camera for 6x6cm. $5-10.

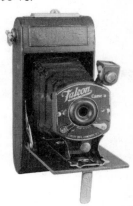

Univex AF, Special models - c1936-38. Special faceplates and colors transformed the normal Univex AF into a promotional or premium camera. These include such models as the G.E. Toppers Club Convention, Official Girl Scout model, or the Hollywood. Rare. $150-200.

Vitar - c1951. Viewfinder 35mm. Extinction meter. Telescoping Anastigmat f3.5/50mm lens. This camera was a promotional item and supposedly never advertised to the public. Not common. $20-25.

Zenith - c1939. Lightweight aluminum body, leatherette covering, chrome finish. Six exposures on Univex #00 film. Univex f4.5/50mm, shutter 25-200. Lens focuses to 3½'. Flash models were factory mounted with a hot shoe. Rare. $75-150. *Illustrated top of next column.*

Falcon - 4x6.5cm folding 127 camera. Cast metal body with black or colored enamel. $10-15.

Falcon Junior - Bakelite folding vest-pocket camera for 4x6.5cm on 127 film. At least two different faceplate styles with different art-deco patterns. Colored models: $10-20. Black: $5-10.

Falcon Junior 16 - Small cardboard box camera for 16 shots on 127 film. Maroon leatherette covering. Red, black, & silver art-deco foil faceplate. Also comes in blue, green, tan, & black versions. Uncommon. $15-25. *Illustrated top of next page.*

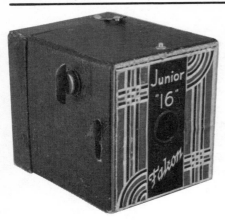

Utility Falcon Junior 16

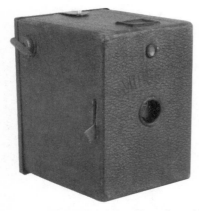

Falcon Midget 16 - Vertical cardboard box camera; enameled metal back. An unusual design keeps the film spools at the back near the film plane, which wastes space and gives a small 3x4cm half-frame image from a box large enough to make full size negatives. Colored: $15-20. Black: $8-12.

Falcon Minette - Black minicam for 3x4cm on 127 rollfilm. $3-7.

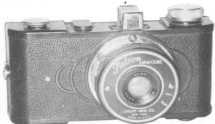

Falcon Miniature - c1938. Minicam for

3x4cm on 127 film. Several different body styles. $5-10.

Falcon Minicam Junior - Black minicam for 3x4cm on 127 rollfilm. Various body styles. $3-7.

Falcon Minicam Senior - c1939. Half-frame (3x4cm) camera for 16 exposures on 127 film. Cast aluminum body with leatherette covering. Minivar 50mm lens. Optical finder is in an elongated top housing, as though styled to look like a rangefinder. Has a body release, which is unusual for this type of camera. The same camera was also sold under the Falcon Camera Co. name in Chicago. $10-15.

Falcon Model Four - c1939-42. 6x9cm self-erecting folding camera. Pre-1940 model has black art-deco shutter face. $10-15.

Falcon Model F - c1938. One of the better models from Utility in 1938, selling for $17.50 with its Wollensak Velostigmat f4.5 lens in Deltax shutter. Eye-level optical finder. Body made of black "Neilite" plastic. Metal helical focusing mount. Takes 16 exposures on 127 film. $12-18.

Falcon Model FE - c1938. Same as Model F, but with extinciton meter in top housing next to viewfinder. $15-20.

Falcon Model G - c1938. Half-frame 127. Wollensak f3.5/50mm. Alphax 25-200 shutter. Telescoping lens mount, helical focusing. $15-20.

Falcon Model GE - c1938. Same as Model G, but with extinction meter. $15-20.

Falcon Model V-16 - Bakelite folding vest-pocket camera identical to the Falcon Junior, but for 16 exposures 3x4cm (½-frame) on 127 film. Colored models: $10-20. Black: $5-10.

Falcon Press Flash - c1939-41. Bakelite 6x9cm box camera, with built-in flash for Edison-base bulbs. Forerunner of Spartus Press Flash. The first camera with built-in flash, introduced in April 1939 under the Falcon Press Flash and Spartus Press Flash name. $5-10.

Falcon Special - c1939. Black bakelite camera for 16 exposures on 127 film. Cast metal back. Extinction meter on top next to viewfinder. Wollensak Velostigmat f4.5 in Alphax Jr. T,B,25-200 shutter. Helical focusing mount. "The Falcon Special" on focusing ring. $15-25.

Falcon-Abbey Electricamera - c1940. Black bakelite box camera, nearly identical to the original Falcon Press Flash, but with additional shutter button on front. Normal shutter lever at side for manual shutter release. Front button is electric release for solenoid which trips shutter and fires flash in synchronization. $10-20.

Falcon-Flex, 3x4cm - TLR-style novelty camera for 127 film. Cast aluminum body. Similar in style to the Clix-O-Flex. EUR: $20-30. USA: $10-15.

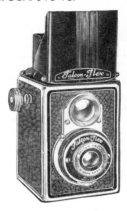

Falcon-Flex, 6x6cm - c1939. Pseudo-TLR box camera. Cast aluminum body. $10-15.

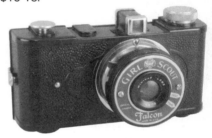

Girl Scout Falcon - Basic black bakelite "minicam" but with a special green-enameled faceplate with Girl Scout logo. $25-35.

"Minicam" types, 3x4cm - c1939. Plastic-bodied cameras for 3x4cm on 127 film. Various body styles, but no practical difference. Names include: Carlton, Falcon Midget, Falcon Minette, Falcon Miniature, Falcon Minicam Junior, Falcon Special, Rex Miniature, Spartus Miniature, etc. Usually with Graf or Minivar 50mm lens. $5-10.

UYEDA CAMERA (Japan)
Vero Four - c1938. Eye-level camera for 4x4cm on 127 film. Verona Anastigmat f3.5/60mm. Rapid Vero shutter T,B,1-500. $100-150.

VAN DYKE BITTERS CAMERA - Box camera for 9x9cm dry plates in double holders. An early example of a camera used as a premium. $100-150.

VAN NECK (London, England)
Press camera - Strut-folding camera in 9x12cm and 4x5" sizes. Ross Xpres f4.5 lens. $70-90.

VANGUARD - Cast metal camera styled like a 35mm, but for 4x4cm on 127. Telescoping front. $10-15.

VANITY FAIR
Character 126 cartridge cameras - "Recent" collectibles. Prices are for NEW condition:

Barbie Cameramatic, Holly Hobbie, Sunny-Bunch, Super Star - $4-8.

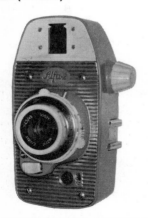

Incredible Hulk, Spider-Man - $10-15.

VARIMEX (Poland)

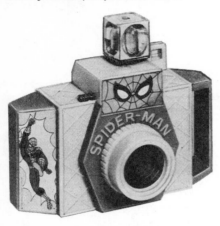

Alfa 2 - c1963. Vertical format 35mm. Aqua or red body, cream colored trim. Emitar f4.5/45mm. Shutter 30-125. Unusual style. $70-100.

VARSITY CAMERA CORP.

Varsity Model V - Streamlined oval bakelite camera for 1⅜x1⅜" exposures on rollfilm. Also called the "Streamline Model V". $10-20.

VAUXHALL - Folding camera for 12 or 16 exposures on 120 film. English importer's name for mainly Beier cameras. Usually with f2.9 lens. Some with CRF: $30-60. Without RF: $25-40.

VEGA S.A. (Geneva, Switzerland)
Telephot Vega - c1902. A compact camera for long focus lenses. The top section of the camera has the lens in front and an internal mirror at the rear. The light path is reflected to the front of the lower section, where it is again reflected to the plate at the rear of the lower section. For compactness, the top section drops into the bottom half, effectively reducing the size of the camera to just over ⅓ of the focal length of the lens. Several variations in size and in method of folding. $2000-3000.

Vega - c1900. Folding book-style camera for plates. The camera opens like a book, the lens being in the "binding" position, and the bellows fanning out like pages. Plate changing mechanism operated by opening and closing the camera. $500-700.

VENA (Amsterdam, Netherlands)

Venaret - c1949. Eye-level box camera for 6x6cm exposures on 120 film. Metal body covered with black or colored leatherette. Nickel trim. f7.7/75mm doublet lens. Simple shutter 25, 50. $15-20.

VICAM PHOTO APPLIANCE CORP. (Philadelphia, PA)

Vicamphoto - A "school camera" for bulk rolls of 35mm unperforated film. Various models. Fixed focus lens. Small compartment on front conceals the string used to measure subject-to-lens distance. $50-75.

VICTORY MFG. CO.
Lone Ranger - Photo-ette novelty camera for 28x40mm on 828 with drawing of Lone Ranger on his horse. Uncommon. $35-50.

VIDMAR CAMERA CO. (New York, NY)
Vidax - c1948. Rollfilm press-type camera for 3 formats on 620 or 120 film: 6x9cm, 6x6cm, 4.5x6cm. Also accepts cut film or filmpacks. Ektar f4.5. Built-in RF. Designed and manufactured by the late Vic Yager, who also designed the Meridian. Only 100 body castings were made. About 50 units were assembled before the announcement of the first Polaroid camera rocked the

industry & dried up investment funds. Total production was 75-85 units. $300-450.

VIENNAPLEX (Austria)
Pack 126 - c1980. Disposable camera for 126 cassette. $5-10.

VIFLEX - c1905. Unusual SLR box camera for 4x5" plates, or sheetfilm. Viewing hood becomes carry case when folded. $175-225

VILIA - c1970's. Simple black plastic 35mm. Nameplate uses Cyrillic and Roman letters so it resembles ВИЛИR-VILIA. Shutter B, 30-250. Triplet 69-3 f4/40mm lens. $8-12.

VILIA-AUTO (ВИЛИR-АВТО) - ca. early 1970's. Russian inexpensive plastic 35mm camera. Like regular Vilia, but automatic exposure controlled by selenium cell around Triplet 69-3 f4/40mm. $10-15.

VINTEN (W. Vinten, Ltd., London)
Aerial reconnaissance camera - For 500 exposures 55mm square on 70mm film. Black laquered body. Anastigmat f2/4" lens. $120-160.

VISTA COLOUR - Black plastic box camera styled like oversized "Bilora Boy" for 6x6cm on 120 film. Made in England. Fixed focus lens; single speed sector shutter. $15-20.

VIVE CAMERA CO. (Chicago)
Folding B.B. - Folding "cycle" style camera for 4x5" plates. $50-70.

M.P.C. (Mechanical Plate Changing) - c1900. Magazine plate box cameras. Side crank advances plates. Two sizes: for 4¼x4¼" or 4x5" plates. Focusing model was called "Vive Focusing Portrait and View Camera". $45-60.

Twin Lens Vive - c1899. For stereo pairs on 3½x6" plates. Similar to the No. 1, but stereo. $400-500.

Vive No. 1 - c1897. The first commercially successful U.S. camera to use the dark-

sleeve to change plates in a camera. Actually, the Blair Tourograph had a sleeve (mitt) in 1879, but there was very limited production. For 12 plates 4¼x4¼". Simple lens and shutter. $60-90.

Vive No. 2 - c1897. An improved model of the Vive No. 1, with a self-capping shutter, and with the viewfinder at the center front. $55-85.

Vive No. 4 - c1897. Like the Vive No.1, but for 4x5" plates. Focusing model. $55-85.

Vive Souvenir Camera - c1895. Small cardboard box camera for single plates, 6x6.5cm. "Vive Souvenir Camera" in gold letters on front. $75-125.

Voigt Junior Model 1

VOIGT - c1947. Horizontal folding camera for 2¼x2¼" on 120 rollfilm. Not made by Voigtländer, but "Voigt" is written on the camera in script deceptively similar to Voigtländer's. Wirgin Anastigmat f4.5/75mm in Gitzo shutter T,B, 25-125. $25-35.

VOIGT JUNIOR MODEL 1 - c1947. Horizontally styled bakelite folding camera for 6x6cm on 120 film. Inexpensively equipped version of the Voigt camera, above. Identical to the Vokar, Model B. Similar cameras also sold under the Wirgin Deluxe and Vokar names. $20-30. *Illustrated bottom of previous page.*

VOIGTLÄNDER & SOHN (Braunschweig) *Please note that the Voigtländer name has never had the letter "h" in it until collectors started spelling it incorrectly.*

- 9x12cm - c1919-34. Skopar f4.5/135mm. Compur or Ibsor shutter. $45-60.

Bergheil - c1914-1920's. Folding plate cameras. These cameras were also called "Tourist" in English language advertising. *Note: Models in colors other than black are listed below under Bergheil Deluxe. Actually, based on our sales data, the 4.5x6cm and 6.5x9cm sizes are no more common in the standard black color than in the deluxe versions, but lack the appeal of the colored leather models.*
- 4.5x6cm - Double extension. Heliar f4.5/80mm lens, Compur 1-300 shutter. Rare in this size. $150-200.

- 6.5x9cm - c1930. Heliar f4.5/105 lens. Compur 1-250. Bayonet system for interchanging of lens/shutter units. $75-125.

Alpin - 1907-28. Folding plate camera for horizontal format 9x12cm plates. Light metal body, painted black. Black tapered triple extension bellows. Voigtländer Collinear f6.8/120mm or Heliar f4.5/135mm lens. Koilos, Compound, or Compur shutter. $150-275.

Alpin Stereo-Panoram - c1914-26. Three-lens stereo version of the Alpin camera in the 10x15cm size. Triple Compound or Compur shutter. $350-500.

Avus, rollfilm models: *Although the plate models are much more common, rollfilm versions also exist.*
- 6x9cm - c1927. Folding bed style camera. Metal body with leather covering. Voigtar f6.3/105mm in Embezet or Skopar f4.5 in Compur. $25-35.
- 6.5x11cm - c1927. Folding bed camera in 1A size, 2½x4¼". Voigtar f6.3/105mm in Embezet or Skopar f4.5 in Compur. $25-35.

Avus, folding plate cameras:
- 6.5x9cm - c1927-36. Skopar f4.5/105mm. Compur 1-250. $45-60.

- 9x12cm - c1925. Double extension. Heliar f3.5 or f4.5/135mm lens. Compound or Compur shutter. $65-125.

- 10x15cm - c1924. 165mm Skopar f4.5 or Collinear f6.3 lens. Compur shutter. $90-130.

VOIGTLÄNDER (cont.)

Bergheil Deluxe - *There are two distinct styles of Bergheil Deluxe. The most deluxe and desirable is the small 4.5x6cm model with BROWN leather and bellows and GOLD metal parts. The larger versions with green Russian leather covering and green bellows are a step up from the normal black models, but are not truly "Luxus" models.*

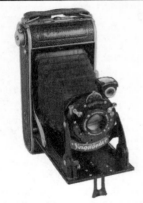

- 4.5x6cm, Deluxe - c1923-27. Brown leather, brown bellows, gold colored metal parts. Heliar f4.5/75mm lens; Compur 1-300 shutter. $450-650.

- 6.5x9cm, Deluxe - c1933. Green leathered body and green bellows. Nickel trim. f3.5 or 4.5/105 Heliar lens. Compur 1-200 shutter. $150-250.

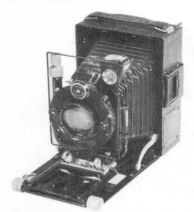

- 9x12cm Deluxe - c1933. Green leather and bellows. $125-175.

Bessa (early models) - c1931-49. Most have waist-level and eye-level viewfinders. Various shutter/lens combinations, such as: Voigtar, Vaskar, and Skopar lenses f3.5 to f7.7. Single, Prontor, or Compur shutters. Better models with f3.5 or f4.5 lens tend to fall in the range of $35-50. Models with f6.3 or f7.7 lens usually sell for $20-35.

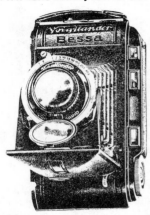

Bessa RF - c1936. CRF. Compur Rapid 1-400. With Heliar f3.5/105mm: $100-120. With Helomar or Skopar f3.5: $80-115.

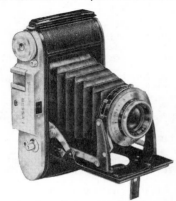

Bessa I - With Skopar or Helomar f3.5/

542

105mm: $50-60. With Vaskar f4.5: $40-50.

Bessa II - c1950. Updated version of the Bessa RF, with housing for coupled rangefinder in chrome instead of black. Compur Rapid or Synchro-Compur 1-400 shutter. With Apo-Lanthar f4.5 (rare): $1500-2000. With Heliar f3.5: $325-425. With Skopar f3.5/105mm: $200-300.

Bessa 46 "Baby Bessa" - c1939. Self-erecting folding camera for 16 exposures 4.5x6cm on 120 rollfilm. Optical finder incorporated in top housing. Trigger release for shutter protrudes from side of front door. Voigtar or Skopar f3.5/75mm lens in Compur shutter 1-300, or Heliar f3.5/75mm in Compur Rapid 1-300. $30-40.

Bessamatic - c1959. 35mm SLR. Built-in meter. Interchangeable lenses. Synchro-Compur shutter. With Zoomar f2.8/36-82mm (world's first SLR Zoom lens): $350-500. With Skopar f2.8/50mm: $60-110.

Bessamatic Deluxe - c1963. Similar, but diaphragm and shutter speed visible in finder. Externally recognizable by the small T-shaped window above the meter cell. With Septon f2 lens: $100-150. With Skopar f2.8: $75-100.

Bessamatic M - c1964. Low-priced version of the Bessamatic without meter. Interchangeable Color Lanthar f2.l8/50 in Synchro-Compur 1-500. $75-100.

Bessamatic CS - 1967-69. SLR with coupled CdS metering. Battery compartment in front of prism, with front door where meter cell was located on previous models. Color-Lanthar f2.8, Color-Skopar f2.8, or Septon f2 in Synchro Compur X. $90-130.

Bessa 66 with folding direct finder (top), and with folding optical finder (below).

Bessa 66 "Baby Bessa" - c1930. Several viewfinder variations: folding frame finder, folding optical finder, optical finder incorporated in top housing. With Skopar f3.5: $35-45. With Voigtar f3.5/75mm or Vaskar f4.5: $25-35.

Bijou - c1908. The first miniature SLR, 4.5x6cm plates. All-metal box body, tapers toward the front. Originally sold only with 100mm Heliar lens. $500-550. *Illustrated top of next page.*

Box - c1950. Metal box camera for 6x9cm on 120. Meniscus f11 lens, 3-speed shutter. $25-35.

Voigtlander Bijou

the Voigtländer factory and they continued to supply replicas through the years. There are thought to be very few of the 1939 replicas. The later authentic Voigtländer replicas are often from the 1950's or later. In 1978, a limited series of 100 replicas was made of the Voigtländer metal camera No. 84. These cameras are serial numbered. Post-1939 authentic replicas generally sell with stand and facsimile instructions for $1500-2500. In recent years some non-authentic replicas have been turned from solid brass by a private vendor. These have little value except for display purposes.

Dynamatic, Dynamatic II - c1961. 35mm with automatic electronic meter. Lanthar or Color-Skopar f2.8/50mm in Prontormat-SV or Prontor-Matic-V shutter. $30-50.

Folding plate cameras (misc. models) - $25-45.

Folding rollfilm camera (misc. models) - 5x8cm, 6x9cm, or 6.5x11cm size. $25-45.

Brillant - c1933. Inexpensive TLR cameras. Among the variations: 1933- metal body with non-focusing finder lens. 1937- plastic body with compartment for extinction meter. 1938- focusing model. Lenses include f3.5/75mm Heliar, f4.5 Skopar, f6.3 or f7.7 Voigtar. Quite common. $20-40.

Daguerreotype "cannon" - 1840. Brass "cannon"-shaped daguerreotype camera: 31cm long, 35cm high. Makes an image 8cm in diameter. This original Voigtländer daguerreotype camera is historically important for its introduction of the fast f3.7 lens. This 4-element lens, mathematically computed by Dr. Joseph Petzval, was 15 times faster than lenses used by Daguerre. Reportedly 600 of these cameras were sold by 1842, but finding one today is highly unlikely. About a dozen are known to exist.

Daguerreotype "cannon" replica - Reproduction of the original 1840 Voigtländer brass Daguerreotype camera. The first replicas were made in 1939 by

Heliar Reflex - c1909. Boxy SLR for 9x12cm plates (and many other sizes), made by Bentzin for Voigtländer. Heliar f4.5/180mm. FP shutter 20-1000. $150-250.

Inos (I) - c1931-32. Dual-format folding bed camera, 6x9cm and 4.5x6cm exposures on 120 film. Wire frame finder indicates both formats. Compur to 250, or Embezet shutter to 100. With Heliar f4.5: $75-125. With Skopar f4.5/105mm: $60-100.

Perkeo E - c1954. Like the Perkeo II, but with rangefinder. Color-Skopar lens in Prontor SVS shutter. $125-150.

Inos II, 6x9cm - c1933-34. Like Inos, but front standard automatically slides forward when bed is dropped. Focusing knob on body can be preset before opening camera. For 6x9cm or 4.5x6cm with reducing masks. Small folding frame finder with hinged mask for half-frames. Skopar f4.5/105mm lens. Compur 1-250 shutter. $75-125.

Inos II, 6.5x11cm - c1933-34. Like the more common 6x9cm size but for 6.5x11cm and 5.5x6.5cm images on 116 film. Uncommon in this size. Heliar f4.5/118mm or Slopar f4.8/118mm lens. $100-150.

Jubilar - c1931. Folding camera for 6x9cm on 120 rollfilm. Voigtar f9 lens. $20-30.

Perkeo, 3x4cm - c1938. Folding camera with self-erecting front. For 16 exposures 3x4cm on 127 film. Camera can be focused before opening via external knob. With Heliar f3.5: $200-250. With Skopar f3.5 or 4.5/55mm: $175-200. *50% higher in Japan.*

Prominent - c1932. Self-erecting folding camera for 6x9cm on 120 film, or 4.5x6cm with reducing masks. Coupled split-image rangefinder. Extinction meter. Heliar f4.5/105mm lens in Compur 1-250. $550-800.

Prominent - c1952-58. 35mm rangefinder camera. Compur-Rapid or Syncho-Compur shutter. Earliest ones have no accessory shoe. Rapid wind lever added in 1956. With f2 Ultron or f1.5 Nokton: $100-175.

Prominent II - c1958-60. Similar but larger bright frame viewfinder for 35, 50, 100, and 150mm lenses. USA: $150-225. *Higher in Japan.*

Stereflektoskop - c1913-1930's. Stereo cameras with plate changing magazine. 45x107mm and 6x13cm sizes. Three Heliar f4.5 lenses in Stereo Compur shutter. (Early version had only two Heliar lenses with a small triplet finder lens above and between the taking lenses.) This is a three-lens reflex, the center lens used for 1:1 reflex viewing. This style was later used in Heidoscop and Rolleidoscop cameras:

Perkeo I - 1952. Folding camera for 6x6cm exposures on 120 film. Prontor shutter. f4.5 Vaskar lens. $35-55.

Perkeo II - c1952. Similar, but with f3.5 Color Skopar in Synchro-Compur. $45-60.

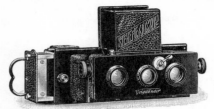

45x107mm size - $250-450.
6x13cm size - $325-550.

Stereophotoskop - c1907-24. Rigid-body 45x107mm stereo camera. Magazine back for 12 plates. Simple reflex bright finder and side Newton finder. Heliars f4.5; sector shutter. $200-275.

Vag - c1920's. Folding plate cameras, 6x9cm and 9x12cm sizes. Voigtar f6.3 or Skopar f4.5 lens in Ibsor or Embezet shutter. $30-45.

Vida - c1911-14. SLR for 9x12cm plates. Revolving back. Rack and pinion front extension. FP shutter 1/12 to 1000. Heliar f4.5/180mm. Uncommon. $350-450.

Superb - c1933. TLR for 120 film, later version has sportsfinder hood. A prism reflects the settings for easy visibility. With Heliar: $200-250. With f3.5/75mm Skopar: $130-180.

Ultramatic - c1963. SLR with selenium meter on front of prism. Color Skopar f2.8/50 in Compur 1-500. Aperture and speed visible in finder. $100-175.

Ultramatic CS - 1965. Similar to the Ultramatic, but CdS meter cells, not selenium. One of the earliest TTL metered SLR's with full information in the finder. Fully automatic aperture control. Color Skopar f2.8 or Septon f2. Behind-the lens Compur shutter. $125-175.

Virtus - c1935. Similar to the Prominent, but smaller, and more common. For 16 exposures on 120 film. Automatically focuses to infinity upon opening. Compur shutter 1-250. With Heliar f3.5/75mm: $275-350. With Skopar f4.5: $250-300.

Vitessa Cameras: *A series of smartly-styled 35mm cameras introduced in 1950. Most are of the folding style with "barn-doors" on front. Named for the rapid winding system operated by a long plunger extending from the top of the camera.*

Vitessa - c1950. Several variations: Originally had smooth top without shoe. Manual parallax correction. Pressure plate

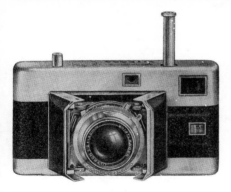

Vitessa L

hinged to body, not back. Ultron f2 lens only. Second variation, still 1950, had the pressure plate on the back door. Third type, 1951, has sync contact on door, accessory shoe top, automatic parallax correction. f2.8 Color Skopar or f2 Ultron lens. Synchro Compur 1-500 shutter. Coupled rangefinder. EUR: $85-150. USA: $75-125.

Vitessa L - c1954. Like Vitessa (1951 type) but with selenium meter. Ultron f2/50mm lens. Coupled rangefinder. $100-150. *Illustrated top of next column.*

Vitessa N - c1951. Same as Vitessa (1951 type), but f3.5 Color Skopar only. $85-135.

Vito - c1939-50. Folding 35mm. Compur 1-300 shutter. Skopar f3.5/50mm lens, yellow hinged filter until 1948. 1949-50, Color-Skopar lens, no attached filter. $25-45.

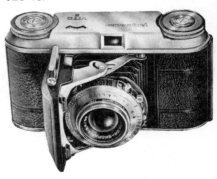

Vito II - c1950. 35mm. Color Skopar f3.5 lens. Prontor or Compur shutter. $30-40.

Vitessa T - c1957. Rigid front without barn doors. Interchangeable Color Skopar f2.8/50mm normal lens. Also accepts bayonet-mounted 35mm f3.4 or 100mm f4.8 lenses. Synchro-Compur 1-500 behind-the-lens shutter. Coupled rangefinder. Common. EUR: $100-175. USA: $75-120.

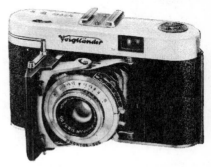

Vito IIa - c1955. Less common that the Vito and Vito II. $35-45.

Vito III - c1950. Folding style with coupled rangefinder. f2 Ultron. Synchro Compur 1-500 shutter. $150-200.

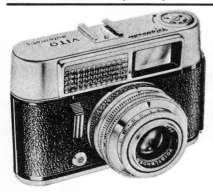

Vito Automatic - c1962. f2.8/50mm Lanthar. Prontor Lux shutter. $20-30.

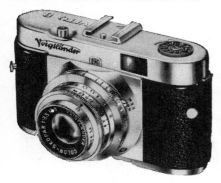

Vito B - c1954. Normally with f3.5 Color Skopar in Pronto or Prontor SVS shutter. Less common with f2.8 Color Skopar in Prontor SVS. $25-35.

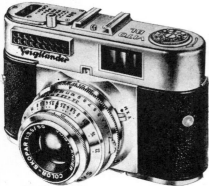

Vito BL - c1957-59. Color-Skopar f2.8/ 50mm. Built-in exposure meter. $25-40.

Vito C - c1961. f2.8/50 Lanthar. Prontor shutter. $20-30.

Vito CD - c1961. Like the C, but with exposure meter. $20-30.

Vito CL - c1962. Like the CD, but meter is coupled. $20-30.

Vito CLR - c1962. Like the CL, but also has CRF. $40-65.

Vitomatic I - intro 1958. 35mm viewfinder camera with coupled selenium meter. Match needle readout on top plate only. Color-Skopar f2.8/50mm lens in Prontor SLK-V 1-300, B. $35-50.

Vitomatic Ia - c1960. Same basic camera as the Vitomatic I, but Prontor SLK-V shutter speed to 500, meter match-needle visible also in finder. $30-40.

Vitomatic Ib - c1965. 35mm viewfinder camera with built-in selenium meter, a re-styled version of the Vitomatic Ia. Meter readout in finder only. Shutter release on front. Color-Skopar f2.8/50mm lens in Prontor 500 SLK-V 1-500, B. $30-45.

Vitomatic II - intro 1958. Similar to the Vitomatic I, but with coupled rangefinder. BIM. Color-Skopar f2.8/50mm lens in Prontor SLK-V 1-300, B. $50-75.

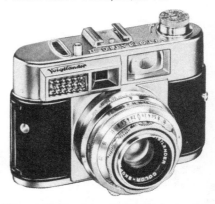

Vitomatic IIa - intro 1959. Similar to the Vitomatic II, but Prontor 500 SLK-V shutter 1-500, B. Semi-automatic exposure. Match-needle in finder. Originally sold with Color-Skopar f2.8/50mm, but later was also available with Ultron f2/50mm lens. With Ultron: $60-85. Common with Skopar: $40-60.

Vitomatic IIb - c1965. Similar to the Ib, but also has coupled rangefinder. $50-75.

Vitomatic IIIb - c1965. Same features as the IIb, but with fast Ultron f2.0/50mm lens. $60-85.

Vokar I

VORMBRUCK CAMERABAU (W. & P. Fertsch, Germany)

Feca (plate camera) - Folding plate camera, made in 6x9cm and 9x12cm sizes. Tessar or Xenar f4.5 lenses. Double extension bellows, GG back. $25-35.

Vitrona - c1964. 35mm with built-in electronic flash. f2.8/50mm Lanthar lens. Prontor shutter 1-250. Never made in any large quantity, because they were novel and expensive. Complete with battery grip: $60-90.

VOJTA (Josef Vojta, Praque)
Magazine Camera - Wooden box camera for 6.5x9cm plates, manually changed through leather sleeve at top rear of camera. Two reflex finders. M&Z shutter. $150-200.

VOKAR CORPORATION (Dexter, Michigan) *Formerly "Electronic Products Mfg. Corp." of Ann Arbor, Michigan.*

Feca (35mm) - c1955. Simple, attractive black bakelite 35mm camera. Meritar f3.5/50mm. Junior 25,50,100,B sh. $50-75.

VOSS (W. Voss, Ulm, Germany)

Vokar, Models A, B - c1940. Bakelite folding camera for 6x6cm on 120. Also sold under the Voigt and Wirgin Deluxe names. $20-30.

Vokar I, II - c1946. 35mm RF cameras. f2.8/50mm Vokar Anastigmat lens in helical mount. Leaf shutter 1-300. $55-85.
Illustrated top of next column.

Diax (I), Ia, Ib, II, IIa, IIb - c1948-1950's. 35mm RF cameras. Xenon f2/45mm lens in Synchro-Compur 1-500 shutter. Coupled

rangefinder on models II, IIa, IIb. Models Ia, Ib, IIa, and IIb have interchangeable lenses. Better models: $45-75. Model (I): $30-50.

Diaxette - c1953. Low-priced viewfinder 35mm based on the early Diax I body. Non-interchangeable Steinheil Cassar f2.8/45mm. Prontor 25-200. $20-30.

VREDEBORCH (Germany)
Adina - c1950. For 6x9cm on rollfilm. $10-15.

Alka Box - c1953. Metal box camera, 6x9cm on 120. $10-15.

Bunny - c1950's. Metal eye-level box for 6x6 on 120. Zone focus. $10-15.

Ecla Box - c1950. Box camera for 6x9cm on rollfilm. $20-35.

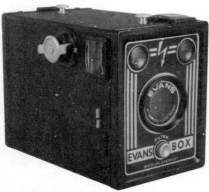

Evans Box - c1950's. Metal box camera, 6x9cm on 120. $10-15.

Felica, Felita - c1954. Metal eye-level box cameras for 6x6cm on 120 film. Meniscus lens, zone focus, simple shutter 25, 50, B. Light gray or black colored. $5-10.

Felicetta - c1965. 35mm with BIM. Nordinar f3.5/45mm in Spezial shutter ⅟₃₀-125. $10-20.

Fodor Box Syncrona - c1950. Box camera for rollfilm. $20-30.

Haaga Syncrona Box - c1955. Basic rectangular box camera, similar to normal Sychrona Box. Meniscus lens, M,B,T shutter. Uncommon name. $15-25.

Ideal - c1950. 6x9cm on rollfilm. $15-20.

Junior - c1954. Same as the Felica, but with the "Junior" name. $5-10.

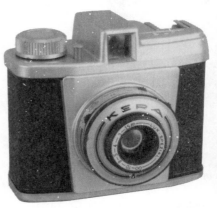

Kera Jr. - Simple plastic & metal eye-level box camera for 6x6cm on 120. Lux Spezial focusing lens. $5-10.

Manex - c1950. 6x9cm on rollfilm. $15-20.

Nordetta 3-D - c1951. Strut-folding stereo, taking two 42x55mm exposures on 127 rollfilm. f4.5/75mm lenses. Guillotine shutter. Cheap construction, but not very common. $120-150.

Nordina - c1953. Telescoping front 6x6cm on rollfilm. Steinar 75mm coated lens. Model I has f4.5, Vario shutter. Model II has f3.5, Vario shutter. Model III has f2.9, Pronto ⅟₂₅-200 shutter. $20-25.

Optomax Syncrona - c1952. Basic metal box camera for 6x9cm, but covered in light grey leather. Meniscus lens. Synchronized M,T shutter. $10-15.

Reporter Junior II - c1950's. Eye-level 6x6 camera like Felica and Felita. Grey or black leather covering. $5-10.

Slomexa - c1950's. Basic metal box camera like Vrede Box. Meniscus f11 lens. $15-25.

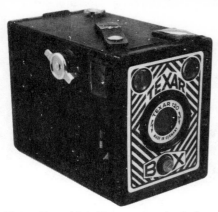

Texar Box - Metal box camera for 6x9cm on 120 film. $10-15.

Union-Box - c1950's. Box camera for 6x6cm. M & Z shutter. Union-Box nameplate below lens. $15-25.

Vrede Box - c1953. Metal box camera with paper covering in various colors. Models include Paloma, Paloma S, Synchrona, etc. With and without PC flash sync. With green or red covering: $35-45. Black: $10-15.

VRSOFOT (Prague, Czechoslovakia) Epifoka - 1947-48. Hand-held aerial camera for 120 rollfilm, designed by the well-known Czech photographer, Mr. Premsyl Koblic. During its two years of production, Mr. Jindrich Svec and his staff of 2 to 4 employees at Vrsofot made less than 1500 cameras total. One model for 6x9cm, another for 6x6cm or 4.5x6cm. Tessar or Dagor lens. Compur or Prontor II shutter. Folding frame finder. Very rare, even in Czechoslovakia. $125-175.

WABASH PHOTO SUPPLY (Terre Haute, IN) Direct positive camera - c1935. Wood body. Ilex Universal f3.5/3" portrait lens. Dimensions 5x8x20". With enlarger and dryer: $150-180.

WAITE (J. Waite, Cheltenham, England) Wet plate Stereo - c1855. Mahogany sliding-box camera for 4x7½" wet plates. Brass trim, brass bound Derogy lenses. Made in London, possibly by Dallmeyer, sold by Waite. One nice outfit in box with chemicals and plates brought $4711 at auction in England.

WALDES & CO. (Dresden) Foto-Fips - c1925. Unusual, low cost folding camera made of light cardboard and paper. Uses single 4x4cm plates. Actually, the camera is built into the bottom half of a small box which also stores the plates, bromo paper, developer and fixer. Boxtop and supplies are all labeled in Czech. Very rare. We have records of only two complete outfits, both of which sold at auction in Germany. One brought $350 in 3/85 and the other sold in 10/88 for $845.

WALDORF CAMERA CO.

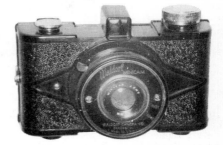

Waldorf Minicam - Black bakelite half-127 camera. Made by Utility Mfg. Co. for Waldorf. $3-7.

WALES-BABY - Plastic half-127 novelty camera. $1-5.

WALKER CO. (Wm H. Walker & Co., Rochester, NY) Walker's Pocket Camera - c1881. Wooden box camera for 2¾x3¼" dry plates. Achromatic lens, guillotine shutter. $2500-3500.

WALKER MANUFACTURING CO. (Palmyra, N.Y.) TakIV - c1892. Cardboard and leatherette construction. Multiple exposures for 4 pictures, each 2½x2½" on dry plates. Rotating shutter and lens assembly. Septums for 4 exp. at rear. $800-1200.

WALKLENZ - Japanese novelty subminiature of the Hit type. $10-15.

WALLACE HEATON LTD. (London)

Zodel was the house name used by Wallace Heaton for cameras that it sold. The majority of these cameras were imported from Germany.

Zodel - c1926. Folding 6.5x9cm plate camera made by Contessa Nettel. Zodellar f4.5/120mm lens in Compur shutter. $30-40.

WALZ CO. (Japan)
Walz Automat - c1959. 4x4cm TLR. Zunow f2.8/60mm. Copal shutter 1-500, B. $100-150.

Walz Envoy 35 - c1959. Rangefinder 35. Kominar f1.9/48mm. Copal SLV shutter, 1-500,B, MFX sync. ST. Single stroke advance. $25-40.

Walz-wide - c1958. 35mm. Walzer f2.8/35mm lens. Copal shutter 1-300,B. $30-40.

Walzflex - c1955. 6x6cm TLR for 120 film. f3.5/75mm Kominar lens in Copal shutter. $50-75.

WANAUS (Josef Wanaus & Co., Vienna)
Full-plate view camera - c1900. Field-type camera for 13x18cm plates. Light colored polished wood, nickel trim. Gustav-Rapp Universal Aplanat lens, waterhouse stops. Geared focus, front and rear. $175-250.

WARWICK (Birmingham, England)

Warwick No. 2 Camera - Basic box camera for 6x9cm on 120 film. Dark brown leatherette covering. $10-15.

WATSON (W. Watson & Sons, London)

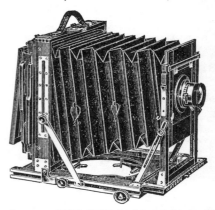

Acme - c1890-1927. Light-weight double extension field camera. Common sizes are full-plate and 8x10". $150-200.

Watson Detective Camera

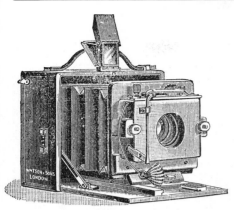

Alpha - c1892. Mahogany hand camera commonly found in 3¼x4¼" and 4x5" sizes. Rising front combined with drop bed permitted the use of wide angle lenses. Rapid Rectilinear lens, T+I front shutter. $400-500.

- Tropical Alpha - c1892. Like the above, but tropical version. Mahogany body has brass reinforcements, maroon bellows. 4x5" size. B&L lens, Unicum shutter. $450-550.

Argus Reflex - c1904. SLR for ¼-plates. Extensible front, short focusing hood. FP ⅕-1000. Holostigmat 6" lens. $70-120.

Detective Camera - intro. 1886. Black leather covered box contains a ¼-plate bellows camera. Box also holds three double plateholders behind the camera, or Eastman's roll-holder also could be used. External controls in bottom of box. Two waistlevel viewfinders in the lid. Rapid Rectilinear lens, adjustable guillotine shutter. Focus by means of a lever in the bottom of the box, from 15' to infinity. $500-800. *Illustrated bottom of previous page.*

Field camera - c1885-90. Tailboard style

in sizes from ½-plate to 8x10". Fine wood body, brass trim. Thornton-Pickard roller blind shutter. Watson f8 brass barrel lens. $150-350.

Gear - c1901. Leather covered box camera with internal bellows for focusing. ¼-plate size. Rapid Rectilinar, shutter ⅟₁₅-75. $35-50.

Magazine box camera - c1900. Falling-plate magazine box cameras, including, "Tornado", "Repeater", etc. For 12 plates, 3¼x4¼". $35-60.

Stereoscopic Binocular Camera - c1901. English imported version of the Bloch Stereo Physiographe. Krauss Tessar lenses. 45x107mm. $1000-1500.

Twin Lens Camera - c1899. An early twin lens style camera for quarter plates. Black leather covered mahogany body. Rapid Rectilinear lens, iris diaphragm. Thornton-Pickard T,I shutter. Reflex viewing. $300-400.

Vanneck - intro. 1890. Plate-changing compartment holds 12 3¼x4¼" plates. Rapid Rectilinear lens. First SLR with instant return spring mirror. Leather covered body. $350-450.

Vril - c1910-13. Strut-folding camera, 3¼x4¼". Black lacquered wood body, nickel and brass trim. Focal plane to 1500. Holostigmat f6.5/4½" lens. $200-300.

WAUCKOSIN (Frankfurt, Germany)
Waranette - c1930. Folding rollfilm cameras in 3 sizes.
- 3x4cm - Strut-folding similar to the Balda Piccochic. Vidar f4.5/50mm in Vario or f2.9/50 in Ring Compur. $60-90.

- 5x8cm - Folding bed. Polluxar f6.3/85mm lens in Vero shutter 25-100. $25-35.

- 6x9cm - Folding bed. Primo Anastigmat f7.7/105mm in Vario. $25-40.

WEBSTER INDUSTRIES INC.
(Webster, NY) *Founded c1947. In 1953 the company name was changed to "Monroe Research", then within a few months to "Zenith Film Corp." Cameras and printed materials are also found using the name "Winpro Camera Co." and sometimes the city is listed as Rochester, of which Webster is a suburb.*
Winpro 35 - 1947-55. Regular or "Synchro Flash" models. Gray or black "Tenite"

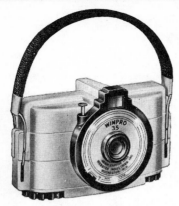

plastic body 35mm. Crystar f8/40mm. Rotary shutter, 50, B. $15-20.

WEDEMEYER (Eric Wedemeyer, N.Y.)

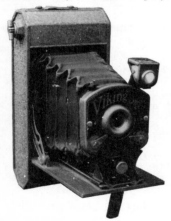

Viking Camera - Folding vest-pocket camera made for Wedemeyer by Utility Mfg. Co. Stamped metal body with brown crinkle-enamel finish. Similar to the Falcon vest camera, but uncommon with this name. $15-25.

Weimet Rocket

WEFO (Dresden)
Meister Korelle (Master Reflex in USA) - A post-war camera of different construction, but similar in appearance to the pre-war Kochman Reflex-Korelle. $50-80.

WEIMET PHOTO PRODUCTS CO.
Rocket - c1947. Inexpensive plastic 3x4cm camera. $3-7. *Illustrated bottom of previous column.*

WELTA KAMERAWERKE (Waurich & Weber, Freital, Germany. Later VEB Welta-Werk, Freital.)

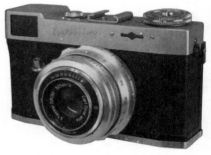

Belmira - c1960. Unusually styled RF 35mm, originally from Belca-Werk. Later version has "Welta" embossed in front leather. VF window at end of top housing. Keyhole-shaped RF window. Rapid wind lever on back. $15-20.

Diana - c1926. 9x12cm folding bed plate camera. Poloyt f4.5/135mm lens in Ibsor shutter. $25-35.

Dubla - c1930. Two-shuttered folding plate cameras. Compur front shutter to 200; rear FP shutter 1/10-1000.
- **9x12cm** - Triple extension. Eurynar, Tessar, or Xenar f4.5 lens. $125-150.
- **10x15cm** - Xenar f4.5/165mm. $125-150.

Garant - c1937. Two-format folding bed rollfilm camera taking 6x9cm or 4.5x6cm exposures. Trinar f3.5 or f3.8, or Trioplan f4.5/105mm lens. Compur shutter to 250. $25-50.

Gucki - c1932. Strut-folding 127 rollfilm camera. 3x4cm and 4x6.5cm sizes. Some models have a folding bed in addition to the struts. Schneider Xenar f2.9 or Radionar f3.5. Compur shutter. $65-80.

Peerflekta (I), II, V - c1956. 6x6cm TLR for 120 film. Pololyt f3.5/75mm lens in Prontor shutter 1-300. $30-50.

Perfekta - c1934. Folding TLR of unusual design for 6x6cm exposures on 120 film.

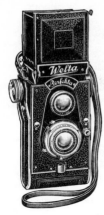

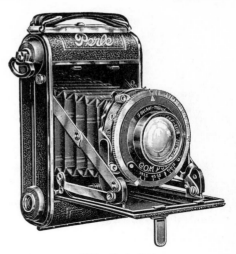

Meyer f3.5, or Xenar or Tessar f3.8/75mm lens. Compur shutter 1-300. $150-200.

Welta Perle, 6x6cm

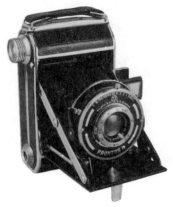

Perle, 4.5x6cm - c1934-39. Self-erecting camera with front lens or helical focusing. Folding Newton finder. Trioplan, Xenar, or Tessar 75mm lens. Compur shutter. $40-70.

Perle, 5x8cm - c1932. Self-erecting camera with radial focusing lever at front of bed. Lever automatically resets to infinity when camera is closed. Brown leather bellows and exterior. Reversible brilliant finder on lens standard, plus folding frame finder on body. Weltar f6.3, or Trinar or Xenar f4.5/90mm. Pronto, Prontor, Ibsor or Compur shutter. $55-90.

Perle, 6x6cm - c1934-38. Similar to the 4.5x6cm except for image size. $40-70. *Illustrated top of next column.*

Perle, 6x9cm - c1932-36. Similar to 5x8cm size, but black leather and bellows. Same lens choices but 10.5cm focal length. $30-50.

Perle, 6.5x11cm - c1932-36. Also similar to the 5x8cm size, but black leather. 12cm lens. $35-60.

Radial - c1930. Folding bed camera, 6x9cm on 120 rollfilm. Xenar f4.5/105mm in Compur 1-300. $30-50.

Reflecta, Reflekta - c1930's-1950's. 6x6cm TLR for 120 film. *Pre-war models c1930-38 seem to spell the name with "c" and postwar models with "k". After the war until about 1952, the manufacturer was Kamerawerk Tharandt in Freital. We also have references to C. Richter, Tharandt as manufacturer. We would appreciate hearing from any reader who can help us with a brief history of the Reflecta and Reflekta cameras. Various lenses and shutters. $35-50.*

Welta Symbol

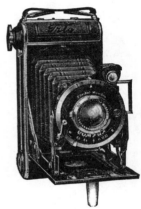

Reflekta II - c1950's. Various f3.5/75mm lenses including: Meritar, Trioplan, Triotar. Junior or Vebur shutter. $25-35.

Reflekta III - c1955. Similar to II. Row Poloyt f3.5/70 mm Prontor SV 1-300. $25-35.

Solida - c1933. Folding 6x9cm rollfilm camera. Coupled rangefinder. Schneider Radionar or Xenar f4.5/105mm. Compur 1-250, T,B. $60-90.

Superfekta - c1932. Folding 6x9cm TLR for 120 film. An unusual design, similar to the Perfekta, above. Pivoting back for taking horizontal pictures. Tessar or Trioplan f3.8/105mm lens. Compur shutter. $200-350.

Symbol - c1937-39. Self-erecting folding rollfilm camera for 6x9cm on 120 film. Beginning in about 1938, a mask was provided to allow half-frame (4.5x6cm) negatives also. This was the budget priced model, with Weltar f6.3/105mm lens in Vario, Prontor, or Prontor II shutter. $15-25. *Illustrated top of next page.*

Trio - c1936. 6x9cm on 120 film. Also allowed 4.5x6cm beginning about 1938. f4.5/105mm lens in rimset Compur shutter. $20-30.

Walta - c1932. 6x9cm folding bed rollfilm camera. Weltar f9, Singlo shutter. $20-35.

Welta, 6x6cm - 120 film. f4.5 Weltar, or f2.8/75 Tessar in Compur shutter. $20-40.

Welta, 6x9cm - Folding plate camera. Orion Rionar, Meyer Trioplan, Tessar, or Xenar f4.5/105mm lens. Ibsor shutter 1-125. $30-50.

Welta, 9x12cm - c1933. Folding plate camera. Rodenstock Eurynar f3.5 or Doppel Anastigmat f4.5/135mm lens. Compur shutter. $35-50.

Welta 35 - c1936. Folding 35mm with optical viewfinder. Similar to Retina cameras of the same time period. Trioplan f2.9/50mm in Ring Compur or Vebur sh. $20-35.

Weltaflex - c1955. TLR for 6x6cm on 120 film. Ludwig Meritar f3.5/75mm lens in Prontor 1-300 shutter or Trioplan f3.5 in Vebur 1-250. $35-60.

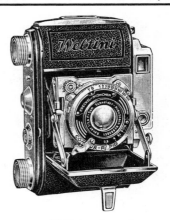

Weltini, early version

f2 or Tessar f2.8 lens in Compur shutter: although we know of a few sales at $125 or more, these are relatively common and usually sell for $35-70.

Weltix - c1939. Folding 35mm. Steinheil Cassar f2.9/50mm lens in Compur shutter. $30-60.

Weltur - c1936-40. Folding rollfilm cameras with coupled rangefinder. Compur 1-250 or Compur Rapid 1-400 shutter. Three sizes:

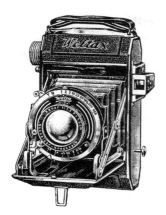

Weltax - c1939. Dual format folding bed camera for 4.5x6cm or 6x6cm images on 120 film. Tessar or Xenar f2.8; Tessar, Meritar, or Trioplan f3.5/75mm lens in Tempor, Junior, Compur, or Prontor shutter. GERMANY: $20-35. *50% higher outside Germany.*

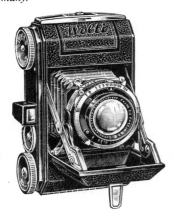

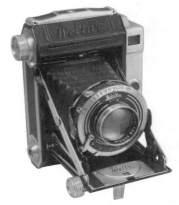

Welti (I), Ic, II - c1935-1950's. Folding 35mm. Vebur, Cludor, or Compur shutter. With Tessar f2.8, f3.5, or Xenar f3.5/50mm: $50-70. With Trioplan f2.9/50mm: $25-35.

Weltini, Weltini II - c1937-41. Folding 35mm with coupled rangefinder. The early version (c1937-38) has a smaller, angular rangefinder housing. On the later version (c1939-41) the rangefinder housing has tapered ends and it covers the full end of the camera body. With Elmar f3.5/50mm in Compur Rapid: $150-250. With Xenon

- **4.5x6cm** - 16 exposures on 120 film. Trioplan f2.9, Xenar f2.8, or Tessar f2.8, f3.5, or f3.8. $75-125.
- **6x6cm** - 12 exposures on 120 film. Tessar or Xenar f2.8/75mm. $75-125.
- **6x9cm** - 8 exposures 6x9cm or 16 exposures 4.5x6cm on 120 film. (Compur on this size is 1-300.) Tessar f4.5 or f2.8/75mm, Xenar f3.8 or f2.8, Cassar or Trioplan f2.9. $75-150.

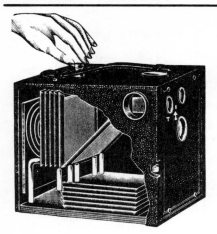

Western Magazine Cyclone No. 2

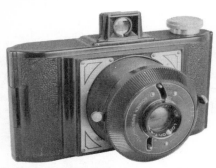

WEMBLEY SPORTS - c1950-56. Black bakelite camera for 6x9cm on 120 film. Helical front with four click-stops for focusing positions. Sportar f11/85mm lens in Rondex Rapid shutter 25,50,100. Made in England, but reminiscent of Kaftanski body designs such as Photax and Fex models. $10-15.

WENK (Gebr. Wenk, Nürnberg, Germany)

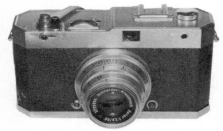

Wenka - Post-war 35mm camera with

interchangeable Leica-thread Xenar f2.8/ 50mm lens. Behind the lens shutter. $150-235.

WESTERN CAMERA MFG. CO.
(Chicago) *The Cyclone cameras listed here were made in 1898, before Western became a part of Rochester Optical & Camera Co. in 1899. See Rochester for later models.*
Cyclone Jr. - 3½x3½" plate box camera. $25-35.

Cyclone Sr. - 4x5" plate box camera. Not a magazine camera. Top rear door to insert plateholders. $30-45.

Magazine Cyclone No. 2 - $30-45.
Illustrated top of previous column.
Magazine Cyclone No. 3 - 4x5". $30-45.

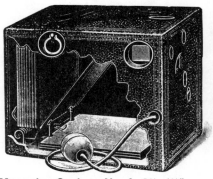

Magazine Cyclone No. 4 - 3¼x4¼". $30-45.
Magazine Cyclone No. 5 - 4x5". $30-45.

Pocket Zar - c1897. Cardboard box camera for 2x2" glass plates. $50-75.

WESTFÄLISCHER KAMERA & APPARATEBAU *This small company existed only a few years.*
Navax - c1950's. Viewfinder 35mm. Röschlein Pointar interchangeable f2.8/ 45mm. FP shutter 5-1000, sync. Very low production. $200-250.

WESTON WX-7 - c1985. Novelty 35mm from Taiwan. This is only one of many cheap cameras disguised to resemble a 35mm

SLR, but of all that we have seen, this one takes the prize as the most convincing look-alike. The size, color, and weight of the camera are frighteningly realistic. Only the small viewfinder window and the lack of serious control knobs expose it for what it is. X-rays of the body reveal carefully designed and placed weights which make the plastic body feel as solid as your favorite $300 SLR! As a photographic instrument, it rates poorly. As a deceptive work of art, it is fantastic. $5-10.

WET PLATE CAMERAS - What is a wet-plate camera worth? Probably between $500 and $5000. A lot depends on the style and age of the camera. Unlike most mass-produced cameras of more recent vintage, wet-plate cameras do not lend themselves to easy averaging of prices because of the wide differences among the few examples sold.

Many wet collodion cameras are listed specifically by manufacturer, and you may wish to look under one of the following: American Optical Co., Atkinson, Bolles & Smith, Burr, Dallmeyer, Dubroni, Fallowfield, Garland, Gennert, Hare, Horne & Thornthwaite, Knight & Sons, Koch, Lamperti & Garbagnati, Lawley, Lewis, London Stereoscopic, Mawson, McCrossan, Meagher, Moorse, Morley, Negretti & Zambra, Ottewill, Peck, Piggott, Ross, Rouch, Scovill, Semmendinger, Stock, Thomas, Thorpe, Waite, Wing, Wood. These 35 makers produced a variety of styles including sliding-box, bellows, stereo, and multiple-lens types. For your convenience, we have analyzed the general price patterns which are summarized below.

Since many cameras from the wet collodion era do not bear a manufacturer's label, they are often sold today under the generic name "Wet plate camera", subdivided by body style and country of origin if known. Prices for unidentified cameras seem to fall into line with similar identified cameras, and with appropriate lens could be generally summarized by type as follows:

- Sliding box style - c1850-1860. $1000-2000. Obvious exceptions to this price range would be the rare Bolles & Smith Patent Camera Box which featured in-camera processing, or the Ottewill design which folds flat for portability.

- Tailboard style - c1860-1870. Most identified cameras fall into the $400-800 range, except stereo and multiple lens types. Unidentified ones have sold at auction for as little as $200-350 without lens.

- Stereo - c1850-1870. Earlier sliding-box types normally range from $2500-$3500. A fine complete boxed outfit with chemicals and accessories occasionally brings an extra $1000. "Tailboard style" bellows types generally sell in the $1000-2000 range.

Notable exceptions: single-lens stereo wet-plate cameras by Moorse or Negretti & Zambra, in which the camera makes its second exposure after being shifted laterally along the top of its carrying case.

- Four lens (sliding box style) - c1860. Not often seen for sale. Range: $2500-4500.

- Four lens (bellows style) - c1860-1870. For 4 simultaneous exposures on a 5x7" plate. These generally bring just slightly less than a stereo camera of the same vintage, averaging $900-1800.

- Specialized wet-plate cameras - *Refer to manufacturers for BERTSCH Chambre Automatique, BOLLES & SMITH Patent Camera Box, BRIOIS Thompson's Revolver, DUBRONI, ROSS Sutton Panoramic, SKAIFE Pistolgraph.*

WHITE (David White Co., Milwaukee, Wisc.)

Realist 35 - c1955. (not stereo) 35mm camera made for David White by Iloca. Identical to Iloca Rapid A. Cassar f3.5 or 2.8 lens. $25-35.

Realist 45 (Model 1045) - 1953-57. Stereo 35 made for White by Iloca. f3.5 Cassar lenses. $80-110.

Stereo Realist - c1950's. 35mm stereo

camera. Movable film plane controlled by focus knob. Model 1042 with f2.8 lenses, case, flash: $200-250. Model 1041 with f3.5 lenses, case, flash: $90-125.

Stereo Realist Custom (Model 1050) - c1960. With matched color corrected, coated "rare earth" f2.8 lenses. Shutter 1-200,T,B. Black coarse-grained kangaroo leather covering. $400-450.

Stereo Realist Macro (Model 1060) - c1971. Probably less than 1000 were produced. Matched f3.5 lenses, focused at 4-5". Sync shutter to 125. Mint outfits have been offered at prices up to $2000. Normal price range for camera only: $1000-1200.

Stereo Realist Viewers:
Model 2061 - Black with red buttons and knobs. Doublet lenses. $50-60.
Model 2062 - Black with green buttons and knobs. AC/DC fittings. Doublet lenses. $90-110.
Model 2063 - Pale green with black front. $25-45.
Model 2064 - Dark brown with white buttons and knobs. Single lens. Uncommon. $50-60.
Model 2065 - Black with green buttons and knobs. DC only. $80-95.
Model 2066 - Black with gold buttons and knobs. For use with views from Macro camera Model 1060. Pairs of doublet lenses. Rare. $150-200.

Whitehouse Prod. Charlie Tuna

WHITEHOUSE PRODUCTS (Brooklyn, N.Y.)
Beacon, Beacon II - c1947-55. Plastic rollfilm camera for 3x4cm on 127 film. Plastic lens, simple spring shutter. Colored models: $10-15. Black: $4-8.

Beacon 225 - c1950-58. Similar to the other Beacons, but 6x6cm on 620. Colored: $10-15. Black: $4-8.

Charlie Tuna - 126 cartridge camera, shaped and colored like Starkist's Charlie Tuna. Truly a novelty camera in "good taste". Sorry, Charlie. $60-85. *Illustrated bottom of previous column. There is a companion radio, somewhat smaller, but also shaped like Charlie Tuna. Beware if your collecting takes such a turn, because you'll also need a Coke can radio to match your Coke can camera... then a Rolls Royce automobile to go with your "Rolls" camera...*

WHITTAKER (Wm. R. Whittaker Co., Ltd., Los Angeles, Calif.)

Micro 16 - c1950's. Subminiature for 16mm film in special cassettes. Cartridge to cartridge feed. Meniscus lens, single speed shutter. Black, blue, or green: $25-40. Chrome: $20-30. *50% higher outside USA.*

Pixie - c1950. Black plastic 16mm subminiature wriststrap camera. $25-40. With flash, wrist strap, etc.: $40-60.

Pixie Custom - Marbelized brown plastic body. Gold-plated metal parts. $150-175.

WHOLESALE PHOTO SUPPLY CO. (Chicago)

Spartus Miniature - Simple bakelite 35mm camera. The same camera and a

synchronized version were also sold as "Spartus 35" by the Spartus Corp. $10-15.

WIDMAR (Robert Widmar, Germany)

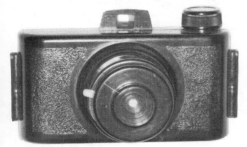

Cowi - Plastic camera for 3x4cm on rollfilm. $20-30.

WILCA KAMERABAU (West Germany)

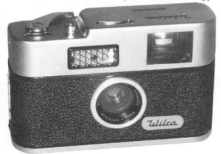

Wilca Automatic - c1963. Subminiature for 24 exposures 10x19mm on 16mm film in special cassettes. Wilcalux Filtra f2/16, Prontor sync shutter. Cpld selenium meter. Rare, reportedly under 100 made. $350-500

WILKIN WELSH CO. (Syracuse, NY)
Folding plate camera - c1900. Folding bed camera, 4x5". Leather covered body, polished wood interior, red bellows. Rauber & Wollensak brass shutter. Rare. $75-125.

WILLIAMSON MANUFACTURING CO. LTD. (London, England)

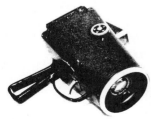

Pistol Aircraft camera - c1930. 6x9cm plate or filmpack camera, with a pistol grip.

Dallmeyer Ross Xpress f4.5/5" lens. Behind the lens louvre shutter 50-200. $300-500.

WINDSOR - 4x4cm "Diana" type novelty camera. $1-5.

WINDSOR WX-3 - Inexpensive plastic 35mm from Taiwan. $3-7.

WINDSOR CAMERA CO. (Japan)
Cameras were probably made by Tougodo or Toyo Kogaku for marketing under the Windsor name.
Windsor 35 - c1953. 35mm RF, made in Japan. Color Sygmar f3.5/50mm lens. Shutter 1-200 or 1-300,B. $20-30.

Windsor Stereo - c1954-60. 35mm black bakelite stereo camera. Windsor f4.5/35 lenses. Windsor 1/25-1/50. $75-100.

WINDSORFLEX - Plastic 4x4cm Hong Kong novelty TLR. Same as the Bedfordflex, Wonderflex, Randorflex, etc. $5-10.

WING (Simon Wing, Charlestown, Mass.)

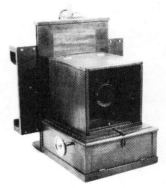

Multiplying View Camera - c1862. For multiple images on a 5x7" collodion plate. Mahogany body, vertical and lateral back movements, shadow box front. About $5000

Multiple-lens camera - c1870. Wet plate studio camera with 4-tube lens set and Wing patented shutter. $1500-1800.

New Gem - c1901. For 15 exposures on

5x7" plates. Sliding front lens panel. $700-900.

WIRECRAFT CO.
Jewel Sixteen - Small 3x4cm plastic novelty camera, similar to Cardinal. $5-10.

WIRGIN (Gebr. Wirgin, Wiesbaden, Germany)
Astraflex 1000 - c1958-71. 35mm waist-level SLR. Similar to the Edixa Reflex, but originally sold with interchangeable f2.8/50mm Tessar or f1.9 Primoplan lens. FP shutter 1-1000. $30-50.

Astraflex 1000 LM - c1959-71. Like the Astraflex 1000, but uncoupled selenium meter on left side. $35-60.

Auta - c1936. Self-erecting folding bed rollfilm camera, 6x9cm. Metal edges are black enameled. Radionar f4.5/105mm, Prontor shutter ½₂₅-150. $20-25.

Baky - c1935. Bakelite folding bed camera for 16 exposures 4.5x6cm on 120 film. Same as Wirginex. See below.

Edina - c1954. Viewfinder 35mm. Edinar f2.8 or f3.5/45mm. Vario 25-200 or Velio 10-200 shutter. $20-35.

Edinex - c1930's-1950's. Compact 35mm camera, almost identical to Adox Adrette. Also sold in the USA under the "Midget Marvel" name although not marked as such. Telescoping front. Film loads from bottom. Late models such as IIIS with CRF: $30-55. Early models, without rangefinder, with f4.5, 3.5, 2.8, or f2 lens. $25-45.

Edinex 120 - c1953. Folding rollfilm camera for 2 formats: 6x9cm, 4.5x6cm. $15-25.

Klein-Edinex (127 film) - c1938. Same camera as the Gewirette. We can find no original advertising with the "Klein Edinex" name, but it has appeared in some collector publications. See Gewirette below.

Edixa - c1955. Viewfinder 35mm. Commonly found with Isconar f2.8/43mm in Prontor SVS shutter. $18-25.

Edixa II - c1956. Similar to the Edixa, but with CRF. $20-30.

Edixa 16, 16M, 16MB, 16S - c1960's. Subminiature cameras for 12x17mm exposures on 16mm film. Schneider Xenar f2.8/25mm lens. $30-50.

Edixa Electronica - c1962. 35mm SLR. Fully automatic with selenium meter. Culminar or Xenar f2.8/50mm lens. Compur sync shutter 1-500. $175-225.

Edixa Flex B - c1959-60. Like the Edixaflex, but with internally coupled diaphragm control for auto lenses. $60-90.

Edixa-Mat B, BL - c1961-67. 35mm SLR with interchangeable waist-level finder and pentaprism. Steinheil f1.9/50mm lens, 42mm thread. Diaphragm coupled internally. FP 1-1000,B. $60-90.

Edixa-Mat C, CL - c1961-67. Like Edixa-Mat B, but uncpld selenium meter. $60-90.

Edixa-Mat D, DL - c1961-67. Like Edixa-Mat B, but Xenar f2.8/50mm lens; shutter 9-1/1000,B. $60-90.

Edixa Prismaflex - c1965-68. 35mm SLR. Fixed pentaprism. Steinheil f2.8/50mm, 42mm thread. FP shutter 1/30-500,B. $50-70.

Edixa Reflex - c1955-60. 35mm waist-level SLR. 42mm screw-mount f2.8 Isconar or Westanar lens. Focal plane shutter 1-1000,B. $40-60.

Edixa Reflex B - c1958-60. Like the Edixa Reflex, but interchangeable pentaprism. FP 1-1000, B. $40-60.

Edixa Reflex C - c1958-60. Like the Edixa Reflex, but uncpld selenium meter. $45-70.

Edixa Reflex D - c1959-60. Like the Edixa Reflex B, but FP shutter 9-1/1000. $40-65.

Edixa Stereo - c1955. 35mm. Steinheil Cassar f3.5/35mm stereo lenses. Vario shutter. $60-90.

Edixa Stereo II, IIa - c1957. Rangefinder 35mm stereo. No meter. Steinheil f3.5. Pronto or Prontor SVS shutter to 200, ST. $60-90.

Edixa Stereo III, IIIa - c1957. 35mm rangefinder stereo camera. Built-in light meter. Prontor SVS shutter. $100-125.

Edixaflex - c1958-60. 35mm SLR. Like the Edixa Reflex, but without slow speeds below 1/25. $40-60.

Gewir - c1936. 6.5x9cm folding bed plate camera. Double extension with rack and pinion focusing. Rise and cross front with micrometer movement. Gewironar f2.9, f3.5; Wirgin Zeranar f3.8; Meyer Trioplan f2.9/105mm lens. Compur shutter. $35-50.

Gewirette - c1937. Eye-level camera for 3x4cm exposures on 127 film. Telescoping front. Film loads from the top. Similar in appearance to the 35mm Edinex, but for 3x4cm exposures on 127 film. Gewironar f4.5, Steinheil Cassar, or Schneider Xenar f2.9/50mm lens. $75-125. *Illustrated top of next column.*

Wirgin Gewirette

Midget Marvel - see Edinex.

Reporter - Similar to Gewirette. Fixanar f2.9/50mm in Compur 1-300. $100-170.

Twin Lens Reflex - c1940. Like the Welta Reflekta, but with Wirgin nameplate. It was also sold as the "Peerflekta" by Peerless Camera Stores, and nearly identical cameras sport the names "Trumpfreflex" and "Vitaflex". Triolar Anastigmat f4.5/75mm in Stelo T,B,100, 50,25 shutter. $35-65.

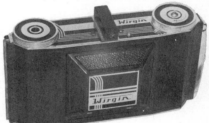

Wirgin Deluxe - Bakelite bodied folding

camera for 6x6cm on 120 film. Similar to Vokar Model B and Voigt Jr. Art-deco metal plates on top, bottom, & front door. $20-30.

Wirgin folding rollfilm camera - 6x9cm on 120 film. Schneider Radionar f4.5, or Gewironar f8.8 or 6.3 lens. $15-25.

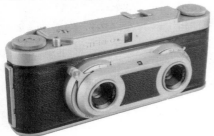

Wirgin Stereo - 35mm stereo camera taking 22x24mm stereo pairs. Steinheil Cassar f3.5/35mm lenses with coupled focusing. Vario B,25,75,200 stereo shutter. Ratcheted lever film advance. $60-110.

Wirgin 6x6cm TLR - c1950. Rodenstock Trinar f2.9/75mm. Built-in extinction meter. $30-50.

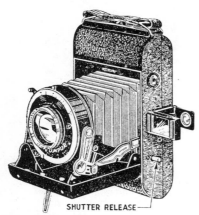

SHUTTER RELEASE

Wirginex (Baky) - c1935. Bakelite self-erecting camera for 16 exposures 4.5x6cm on 120 rollfilm. Black or brown bakelite body. There is no identification on the camera itself, and it was also advertised under the name "Baky" by Wirgin. British importers also advertised it as the Westminster Victoria and Norfolk Miniature. Lenses include: Schneider Radionar, Xenar, or Cassar f2.9 in Compur, Compur Rapid, or Prontor II shutter. Some versions have body release. Lower-priced models have f3.5, f4.5, or f6.3 Anastigmat lens. Recent sales have jumped significantly to $175-225.

WITT (Iloca Werk, Wilhelm Witt, Hamburg, Germany)

Iloca I, Ia, II, IIa - c1950's. Basic 35mm cameras. f2.9 or f3.5/45mm Ilitar lens in Prontor shutter. Models II and IIa with coupled rangefinder. $20-30.

Iloca Quick A - c1954. Viewfinder 35. Ilitar f3.5/45mm. Vario 25-200 shutter, B. $15-20.

Iloca Quick B - c1954. Coupled rangefinder. Ilitar f2.9/45mm in Prontor SV 1-300. $15-20.

Iloca Rapid, Rapid B, Rapid IIL - c1950. Coupled rangefinder, 35mm. Rapid wind. Cassar f2.8/50mm. $20-30.

Iloca Reporter - c1951. Basic 35mm viewfinder camera. Black covering with horizontal white stripes. Prontor-S shutter. Reporter Anastigmat f3.5/45mm. $20-30.

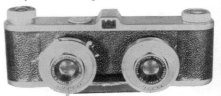

Iloca Stereo, Original Model - c1950. Individually focusing lenses. Apertures and shutters coupled through tube at bottom. Unusual. $125-145.

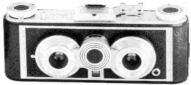

Iloca Stereo, Models I & II - c1950's. 35mm stereo camera for 23x24mm pairs. Ilitar f3.5 lenses, 35mm or 45mm. Prontor-S shutter to 300. Iloca Stereo Model II was also sold by Sears as Tower Stereo and by Montgomery Ward as Photrix Stereo. $60-90.

Iloca Stereo Rapid - c1955. Coupled rangefinder 35mm stereo, 23x24mm pairs. Rapid wind. Prontor SVS 1-300 or Vero 25-200. Rangefinder version of the Realist 45. With Cassarit f2.8: $200-250. With Cassar f3.5: $60-90.

Photrix Quick B - 35mm. Cassar f2.8/50mm, Prontor-SVS to 300. $12-18.

Photrix Stereo - c1950's. 35mm stereo sold by Montgomery Ward in the U.S.A. Basically the same as the Iloca Stereo Model II and Tower Stereo (Sears). $60-90.

WITTIE MFG. & SALES CO.

Wit-eez - Black bakelite minicam, styled like the Rolls. $5-10.

WITTMAN (R. Wittman, Dresden, Germany)
Tailboard camera - c1880. Folding camera for 13x18cm plates. Square bellows. Wittman Universal Aplanat lens, waterhouse stops. $250-350.

WITTNAUER

35mm cameras - c1959. Misc. models including Adventurer, Automaton, Captain, Challenger, Continental, Festival, Legionaire, Scout. RF. Chronex f2.8/45mm lens. $15-25.

Wittnette Deluxe - Inexpensive TLR. $20-30.

WÖHLER (Dr. Wöhler, St Ingbert, Saarland)

Favor - c1949. Basic 35mm camera. Docar

f2.8 or Citar f3.5/45mm lens. Prontor-S or Prontor-SVS shutter. $100-160.

WOLLENSAK OPTICAL CO.

Wollensak Stereo, Model 10 - c1955. 35mm stereo camera. f2.7 lenses; shutter to 300. Similar to the Revere Stereo 33, but faster lenses and shutter, and in black leather, not brown. $200-325.

WONDER CAMERA - Falling-plate magazine box camera for 2½x3½" glass plates. $35-45.

WONDERFLEX - c1965. Hong Kong plastic novelty TLR-style camera, 4x4cm. Same camera sold as Bedfordflex, Splendidflex, etc. $5-10.

WOOD (E.G. Wood, London)
Wet plate sliding box camera - Half-plate mahogany sliding-box camera. Petzval lens with rack focusing and waterhouse stops. $800-1000.

WOOD BROS. (England)
Pansondontropic camera - Wooden field camera, 5x7". Brass trim, brass lens. $175-225.

WRATTEN & WAINWRIGHT (London, England)

Tailboard camera - c1890. Mahogany view camera in 5x8" to 8x10" sizes. Maroon square bellows. Ross Rapid Symmetrical lens. $250-350.

WRAY OPTICAL WORKS (London)
Peckham Wray - 1955-62. 4x5" SLR press camera. Unusual rigid body. Mirror drops down behind the lens, reflecting the image to an eye-level viewfinder on top. A frame

finder is also mounted on top. FP shutter ⅟₁₅-800 and Compur 1-500. Interchange-able Wray Lustrar f4.8/135mm. $140-190.

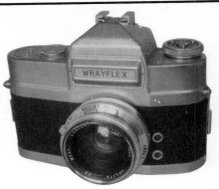

Stereo Graphic - Made under license from Graflex. Same as the Graflex version, but with Wray f4/35mm lenses. Outfit with viewer: $175-215. Camera only: $70-115.

Wrayflex - c1950. The only commercially successful English-made 35mm SLR. Originally designed with a mirror rather than pentaprism. FP shutter ½-1000. Standard lens was Wray f2 or f2.8/50mm. Other interchangeable lenses included 35mm, 90mm, & 135mm Lustrars, and an 8"/f4.5 lens which was produced but not advertised and which is quite rare. Model variations:

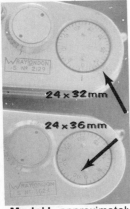

Detail view of the Wrayflex I & Ia. The filmcounter of model I reads past 40. This is the quickest way to distinguish between the two. Serial numbers do not distinguish since they were produced concurrently with a shared serial number range.

-Model I - approximately 750 made. 24x32mm format. Mirror, not prism. $150-200.

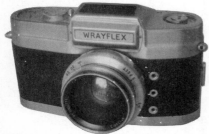

-Model Ia - approx. 1700 made. 24x36mm standard format. Mirror, not prism. $100-150.

-Model II - approx. 300 made. Pentaprism model,24x36mm format. $200-250.

WÜNSCHE (Emil Wünsche, Reick b/Dresden) *Merged in 1909 with Hüttig, Krügener, and the Carl Zeiss Palmos factory to form Ica.*
Afpi - *c1904-09. Folding bed plate cameras for 9x12cm or 10x13cm plates. Many variations were made, and we are listing only a few.*
Afpi (vertical) - $35-60.

Afpi, square - Called "Quadratisch" in original catalogs. Allows horizontal or vertical format. Double extension. Fine wood bed. Black bellows and leather covering. $70-100.

Afpi (with "metal shutter, Model III") - Polished wood lensboard with interesting shutter. Brown leather bellows. $100-150.

Elite - c1900. Stereo magazine camera for 9x18cm. Leather covered wood body. Magazine holds 12 plates. Periscope lenses; M,Z shutter. $350-400.

Favorit - c1900-06. Double extension folding bed plate camera for 9x18cm stereo exposures. Busch Rapid Aplanat f8 lenses in stereo roller-blind shutter. $250-275.

Field cameras - c1900. Wood body. For 3¼x4¼", 5x7", or 10x15" plates. Wünsche Rectilinear Extra Rapid f8 brass barrel lens. $150-210.

Juwel - c1895-1900. 9x12cm falling-plate magazine box camera. f12 lens. Single speed shutter. $50-75.

Knox - c1906. Polished wood folding bed camera for 9x12cm plates. Rotary shutter built on front of wooden lens standard. Tapered single extension blue-green bellows with red corners. $275-325.

Lola - c1905. Strut-folding 9x12cm plate camera. Design of knee-struts is nearly identical to the earliest Folding Pocket

Kodak Camera. Leather covered body. Shutter built into leather covered front. $275-350.

Lola Stereo - c1905. Strut-folding stereo for 9x18cm plates. Leather-covered wood body, nickel trim. Anastigmat f7.7/90mm lenses. $250-350.

Mars 99 - c1895. Leather covered box camera for 9x12cm plates. Aplanat f12/150mm lens; rotating shutter. $250-300.

Mars Detective - c1893. Polished mahogany 12-plate magazine camera. ¼ or ½-plate sizes. Aplanat f8/130mm. Rotary shutter. Plates are moved to and from the plane of focus by sliding a moving sheath above the desired plate, then inverting the camera to drop the plate into the sheath. The sheath is then moved to the plane of focus and when the camera is righted, the plate slides into position for use. $400-500.

Mars Detectiv-Stereoskop - c1897. Wooden magazine plate camera for 8.5x17cm plates. Takes single or stereo exposures. Aplanat lenses. See Mars, above, for description of the plate changing mechanism. The stereo model has the film sheath at the side rather than at the top. Holds 12 plates. Rare. $850-1000.

Postage stamp camera - c1907. 12 lens camera makes twelve 24x30mm exposures on a ½-plate. Wood body with wooden door (flap shutter) covering the lenses. $1500-2000.

Reicka - c1906. Double extension folding plate camera. Leather covered wood body.
- **9x12cm** - Rodenstock Heligonal f5.4/120mm lens, Koilos 1-300 shutter. $40-75.
- **13x18cm** - With Goerz Dagor f6.8/180mm. $125-175.

Sport - c1895. Stereo box camera for 8.5x17cm plates. Polished wood body. Two brass barrel lenses. Stereo sector shutter. Unusual hinged lenscaps. $350-400.

WZFO (Poland)
Druh - Black bakelite eye-level camera with helical front. Bilar f8/65mm lens; B,M shutter. Similar to cameras from Hamaphot. $8-12. *Illustrated bottom of previous column.*

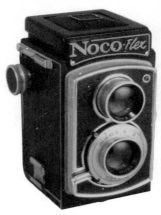

Noco-Flex - TLR with rack & pinion focus. Easily recognized by the handsome cast metal nameplate on the front of the finder hood. $40-60.

YALE CAMERA CO.
Yale Camera - c1910. Small paper box camera for 5x5cm glass plates. Single plates must be darkroom loaded. Similar to the Zar, but with exposed brass shutter pivot. $60-90.

YAMAMOTO CAMERA CO. (Japan)
Semi Kinka - c1938. Self-erecting folding bed camera, 4.5x6cm on 120 rollfilm. Ceronar Anastigmat f4.5/75mm lens in Felix 1/25-150 shutter. $60-90.

YAMATO KOKI KOGYO CO. LTD.
YAMATO CAMERA INDUSTRY CO. LTD. (Tokyo)

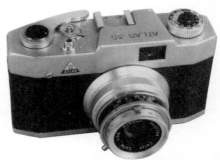

Atlas 35 - c1959-61. Basic scale-focus 35mm camera. Similar to the Pax Ruby but

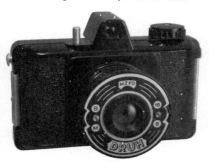

WZFO Druh

without RF. The identical camera was sold by Sears as the Tower 55. Color Luna f3.5/45mm lens. B,25-300 shutter. $20-35.

Alpina M35 - c1957. Same as the Pax M3. $20-30.

Minon Six II - c1950. Folding bed camera for 6x6cm or 4.5x6cm on 120 rollfilm. Uncoupled rangefinder. Minon Anastigmat f3.5/75mm lens; TSK shutter 1-200,B. $50-75.

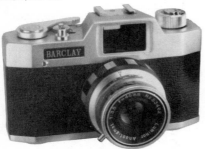

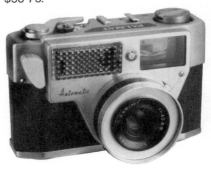

Barclay - Basic scale-focus 35mm. Similar to the Pax Jr. but with direct (plain glass) viewfinder. Luminor Anastigmat f3.5/45mm. Also sold as Starlite. $20-30.

Bonny Six - Zeiss Ikonta B copy. Bonny Anast. f4.5/75mm. $30-50.

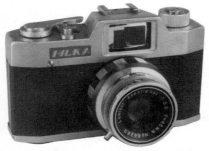

Hilka - Basic scale-focus 35mm with large bright-frame optical viewfinder. Same as Pax Jr. $20-35.

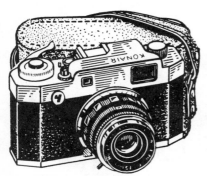

Konair Ruby - c1955. Rangefinder 35, same as Pax Ruby. Konair f3.5/45mm lens in synchro 10-300 shutter. $20-30.

Palmat Automatic - One of Yamato's more sophisticated cameras, this one has automatic exposure controlled by selenium meter. Luminor 40mm lens. $25-45.

Pax (I) - c1952-55. 35mm camera with coupled rangefinder, styled after the Leica, but smaller and with front shutter. Knob advance. Original version has Magino f4.5/40mm lens in Silver-C 1/25-200,B shutter. More commonly seen with Luminor f3.5/45mm in YKK 1/25-150,B shutter. $40-60.

Pax Golden View - Deluxe version of the Pax. All metal parts are gold-colored. Green or red leather covering. $200-300.

Pax Jr. - c1960's. Basic scale-focus 35mm. Large optical finder with bright frame. Also sold as Hilka, Tower 55B, etc. Luminor Anastigmat f3.5/45mm lens. Shutter 1/25-300. $25-45.

Pax M2 - c1956. Similar to the Pax (I), but combined range/viewfinder. Front of top housing now has only one small round window and one rectangular window. Knob advance. Luminor f3.5/45mm, synchro shutter ⅒-300. $40-60.

Pax M3 - c1957. Small 35mm with CRF. Like M2, but restyled full-length top housing. Rectangular rangefinder window, lever wind. Luminor or Lycon f2.8/45mm, synchro shutter ⅒-300. $25-40.

Pax M4 - c1958. Features similar to the Pax M3, but restyled top housing has three rectangular windows on front. Luminor f2.8/45mm, synchro shutter ⅒-300. $35-50.

Pax Ruby - c1958. Color Luna f2.8 or f3.5/45mm, Synchro shutter ⅒-300. Styling similar to M3, but rangefinder window on front is much smaller. The same camera was also sold as Pax Sunscope, Ricsor, Me35 4-u, Konair Ruby, etc. $25-45.

Pax Sunscope - c1958. Export version of the Pax Ruby. Top housing has shallow recess on top with applied nameplate. Colour Luna f3.5/45mm. $20-35.

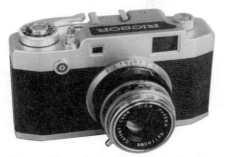

Ricsor - Rangefinder 35, similar to the Pax Ruby. Colour Luna f2.8/45mm. $30-50.

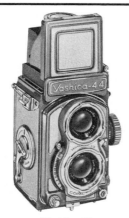

Yashica 44

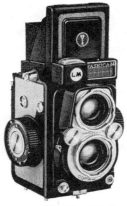

Yashica 44LM

Rippa - c1950. 35mm with direct optical viewfinder. Color-Luna f3.5 lens, ½₂₅-300, B shutter. $25-40.

Rippaflex - c1950s. Rolleiflex copy. Tri-Lausar f3.5/80mm, Rectus shutter. $50-70.

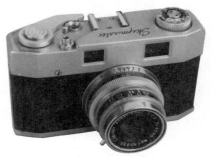

Skymaster - Rangefinder 35. Another name for the Pax M3. Luminor Anastigmat f2.8/45mm. $30-40.

YASHICA (Japan)
Yashica 44 - c1958. TLR for 4x4cm on 127 film. Yashikor f3.5/60mm lens. Copal-SV 1-500,B shutter. Available in black, grey, or brown. $45-90. *Illustrated previous column.*

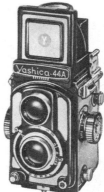

Yashica 44A - c1960. 4x4cm TLR for 127. Yashikor f3.5/60mm. Copal shutter 25-300,B. Available in various colors, including blue, grey, or black enamel with grey leatherette. $45-90.

Yashica 44LM - c1959. Built-in uncoupled meter. Yashinon f3.5/60mm. Copal-SV shutter 1-500,B. Available in black, grey, and brown. $60-100. *Illustrated bottom of previous column.*

Yashica 635 - c1958. TLR for 6x6cm on 120 rollfilm. Yashikor f3.5/80mm; Copal-MXV 1-500,B shutter. $55-80.

Yashica 72E - c1962. Half-frame 35mm. Selenium meter surrounds Yashinon f2.8/28mm lens. $20-30.

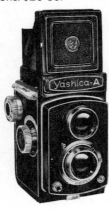

Yashica A - c1959. Inexpensive TLR for 6x6cm on 120. Yashikor f3.5/80mm. Copal 25-300 shutter. $30-45.

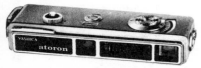

Atoron - c1965. Subminiature for 8x11mm on 9.5mm film (Minox cassettes). Selenium meter. Fixed focus Yashinon f2.8/18mm, shutter 45-250,B. With case, flash, filters, presentation box: $30-40. Camera: $20-30.

Atoron Electro - c1970. Black 8x11mm subminiature. CdS meter. Yashinon DX f2.8/18mm focusing lens. Automatic shutter 8-350. Outfit with presentation box, case, flash, filters: $40-55. Camera only: $20-40. *Illustrated next column.*

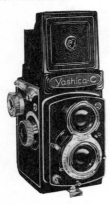

Yashica C - c1958. TLR, 6x6cm on 120.

Yashikor f3.5/80mm. Copal MX 1-300 shutter. $40-55.

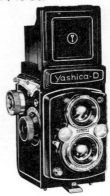

Yashica D - c1958-74. 6x6cm TLR. Yashikor f3.5/80mm in Copal MXV 500 shutter. $35-60.

Yashica EE - c1962. Viewfinder 35mm. Yashinon f1.9/45mm. Copal SVA 1-500, MX sync. Meter cell around lens. $25-35.

Yashica LM - c1957-61. TLR, similar to Yashica C but with built-in meter. $45-70.

Mimy - c1964. Half-frame 35mm with automatic exposure controlled by selenium meter which encircles lens. $30-45.

Penta J - c1962-64. 35mm SLR. Interchangeable Auto Yashinon f2/50mm lens. FP shutter ½-500,B. $40-60.

Pentamatic - c1960-64. Yashica's first 35mm SLR. Interchangeable f1.8/55mm Auto Yashinon lens. FP 1-1000,B. $40-60.

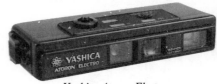

Yashica Atoron Electro

Yashica Y16

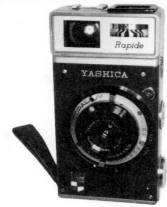

Rapide

Rapide - c1961. Half-frame 35mm. Unusual style: stands vertically like a pocket-sized transistor radio. Built-in meter. Interchangeable Yashinon f2.8/28mm lens in Copal 1-500 shutter. $40-60.

Sequelle - c1962. 35mm half-frame for 18x24mm. Styled like a movie camera. Yashinon f2.8/28mm lens in Seikosha-L shutter 30-250,B. Built-in meter. Battery-powered motor drive. $60-80.

Yashica Y16 - c1959. Subminiature for 10x14mm on 16mm cassette film. f2.8 or 3.5/25mm Yashinon lens. Various color combinations include: aqua & grey, royal blue & grey, maroon & grey, two-tone grey, tangerine & cream. $20-30. *Illustrated previous page.*

Yashica YE - c1959. Rangefinder 35mm, made by the newly acquired Nicca factory. A continuation of the Nicca 33, with similarities to the Leica IIIg and M3 cameras. Interchangeable Yashikor f2.8/50mm. FP shutter ½-500, B,T. Rapid wind lever. $200-300.

Yashica YF - c1959. A continuation of the Nicca camera line, specifically, a Nicca IIIL modification. (Yashica purchased Nicca in 1958.) Styled like Leica M3. Interchangeable Yashinor f1.8/50mm lens. FP shutter 1-1000,B. $200-300.

Yashica YK - c1959. RF 35mm. Single-stroke advance lever. Yashinon f2.8/45mm; between-the-lens 25-300 shutter. $30-45.

Yashica-Mat - c1957. TLR, 6x6cm on 120. Yashinon f3.5/80mm lens, Copal-MXV 1-500,B shutter. $45-65.

YASHINA SEIKI CO. LTD. (Japan)
Pigeonflex - c1953. 6x6cm TLR. Tri-Lausar f3.5/80mm. NKS shutter 1-200, B. $40-60.

YEN-KAME (Yen cameras) *A unique and inexpensive camera type which flourished during the 1930's in Japan, and continued to be popular after WWII. They are occasionally found with "Made in Occupied Japan" markings. The cameras are simple ground-glass backed box or folding cameras which take single sheets of film in paper holders. The negative could be processed in daylight by dipping the entire paper holder into a red-colored developer and then a green-colored fixer. The red coloring in the developer eliminated the need for a darkroom, and the slogan "No Need DarkRoom" is often printed on the camera faces. This slogan is also used to identify the film type. There are many names on the low-priced cameras, and several are listed alphabetically in this guide. We do not have space to give each "brand" a separate listing, but some of the names you might encounter are: Amco, Asahi, Asahigo, Baby, Baby Reflex, Baby Special, Baby Sports, Camera, Camerette, Collegiate, Empire, Highking, Hitgo, Kamerette, Kamerette Junior Nos. 1-4, Kamerette Senior No. 1, Katei, King, King Super, Koseido, Light, Lion, Maruso, Milbro, Million, Nichibei, Nitto Camera, Nymco, Nymco Folding Camera, Pocket, Special Camera, Special King, Super Camera, Tokyo, Tougo Camera, Victory Camera, and Yuuhigo. There are even generic versions with no name at all. To the street vendors and the public, the name was not as important as the low-cost magic of the camera. Generally, box versions sell for $15-20. Folding models: $20-30.*

YUNON YN 500 - c1984. One of the many

inexpensive "Taiwan-35" types. Single speed shutter, hot shoe, 4 stops with weather symbols. The "Yunon" name was used in a promotion by Prestige Travel Club, which had about 5000 surplus cameras in late 1985. $1-5.

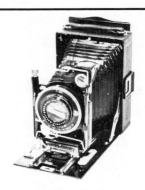

Radionar, f6.8 Jena, f2.9 Zecanar or Xenar. Leather covered wood body. $30-40.

ZARYA (Zapa) - 1960's. Russian 35mm, similar to the Fed 2, but restyled and simplified top housing without RF. Uncommon. Occasionally sells for over $200, but more stable at $100-150.

ZEH (Zeh-Camera-Fabrik, Paul Zeh, Dresden)
Bettax - c1936. Folding 6x6cm rollfilm camera. Radionar f4.5/100mm. Compur shutter. $15-30.

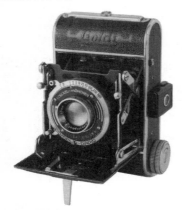

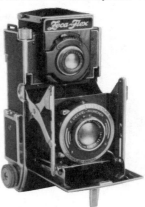

Zeca-Flex - c1937. Folding 6x6cm TLR for 120 film. Schneider Xenar or Zeiss Tessar f3.5/75mm taking lens. Finder lens is "Sucher Anastigmat" f2.9. Compur or Compur Rapid shutter. The folding style 6x6cm reflex never became popular, so this model, along with Perfekta and Superfekta from the neighboring suburb of Freital, was not made in large quantities. $650-800.

Goldi - c1930. Folding-bed camera for 16 exposures 3x4cm on 127 film. f2.9 or 4.5 Zecanar lens. Vario, Prontor, or Compur shutter. $50-75.

Sport - c1933. Folding bed camera for 6.5x9cm plates. Leather covered metal body. Zecanar Anastigmat f6.3/105mm; Pronto 1/25-100. $25-35.

Zeca, 6x9cm - c1940. Folding sheet-film camera. Steinheil f6.8 or Periskop f11 lens. Vario shutter, 25-100. $25-35.

Zeca, 9x12cm - c1937. Folding sheet-film camera. 135mm lenses: f6.3 Schneider

ZEISS (CARL ZEISS JENA; Jena, Germany) *See next manufacturer, ZEISS-IKON for other "Zeiss" cameras. Founded in 1846 in Jena, and still there today, Carl Zeiss Jena has had a prominent place in the world of optics throughout its history. Its early history included microscopes and scientific instruments. The special glass requirements for microscopes led to the foundation of Schott glass works in Jena. When several new glass types were available from Schott, Dr. Paul Rudolph was hired by Carl Zeiss Jena to design photographic lenses with them. His well-known designs include the Zeiss Anastigmat of 1890, Planar of 1896, Unar of 1899, and Tessar of 1902. In 1902, Carl Zeiss took over the Palmos A.G. company*

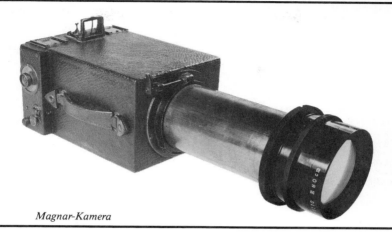

Magnar-Kamera

which had been founded just two years earlier, and thus entered the camera manufacturing business. Carl Zeiss Palmos A.G. was divested to became part of Ica in 1909, while Carl Zeiss Jena continued in its tradition as a prominent lensmaker.

Magnar-Kamera - c1906. Elongated focal plane shuttered box camera with telescoping tube in front. Designed for the Magnar f10/800mm telephoto lens. Newton finder or monocular finder. A very rare camera. We have only one recorded sale, at auction in Germany for DM 3000 (about $1500 at the time). *Illustrated at top of page.*

Stereo Palmos - c1905-11. Folding-bed stereo camera taking 9x12cm plates. Focal plane shutter 25-1000. Zeiss Tessar f6.3/84mm lenses. Rack focusing. $300-500.

Minimum Palmos - c1905. Strut-type focal plane camera in 6.5x9cm and 9x12cm plate sizes. Tessar f6.3 or f4.5 lens. Focal plane shutter ⅟15-1000. $150-200.

Minimum Palmos Stereo - c1907. Strut-folding camera, similar to the Minimum Palmos but for stereo or panoramic exposures on 9x18cm plates. Focal plane shutter 10-1000. With single f6.3/112mm lens for panoramic use: $250-350.

Universal Palmos - c1904-. Folding-bed camera with front shutter only. (An accessory focal plane shutter was available, however.) Rack & pinion focusing. Normally seen with Tessar f6.3/150mm or Double-Protar f7/143mm in Compound shutter. Uncommon. $250-400.

ZEISS IKON

ZEISS IKON A.G. *For pre-1926 "Zeiss" cameras, see the manufacturer "CARL ZEISS JENA" immediately preceding this listing. ZEISS IKON began in late 1926, when some of the major camera manufacturers in Germany, Contessa-Nettel, Ernemann, Goerz, and Ica merged to form Zeiss-Ikon, setting up their headquarters in Dresden. The new firm combined the strengths of the merging companies and continued many of their previous models under the new Zeiss-Ikon logo. In 1946, after WWII, a new Zeiss-Ikon started up in the old Contessa Nettel factory in Stuttgart, West Germany. Camera models were also still being made in the Jena (Carl Zeiss) and Dresden factories. Many consider Zeiss Ikon in Stuttgart to be the manufacturers of the "real" Zeiss Ikon cameras, even though some models from Dresden bore the Zeiss Ikon trademark. (We have listed these models under the manufacturer Pentacon.) Camera production ceased in 1971 with assembly continuing into 1972.*

In a single year Zeiss Ikon offered in their catalog 104 different model names with an average of 3 separate formats and more than 3 lens and shutter combinations per format- 936 choices or "stock" models in that one catalog. The most variations that year were offered in the Deckrullo (later called "Nettel") press camera. One could order it in 4.5x6, 6.5x9, 9x12, 10x15, and 13x18cm formats plus all except the smallest in tropical style with varnished teak and brown leather bellows. With an actual count of 30 different lenses for the 9 types, one had 39 possible choices for this single model! This was in the 1927 catalog before any of the really famous Zeiss Ikon cameras like the Contax, Contarex, Contaflex, Kolibri, and Super Ikontas had been introduced.

From the above you can get some idea of the complexity of identifying and pricing all Zeiss Ikon cameras so please regard this list as covering only the more usual types and/or those of exceptional value. Where the Zeiss Ikon model number is available this number is included in the description to help in identification. Often, these numbers appear on the camera body. Sometimes, especially on U.S.A. models, they are not on the camera itself, but only in the catalog. The number is usually expressed as a fraction- that for a 9x12 Ideal being 250/7 and a 6.5x9cm Ideal being 250/3. Basically, the first half of the number designates the camera model. The second half of the number indicates negative size and is standard from one model to another. The chart below (listed in "Zeiss Historica" Journal Vol. 3 No. 1) gives the size numbers used on Zeiss Ikon still cameras from 1927 to 1960, after which decimal numbers for models were used. (The focal length of the most usual lens for the format is also shown.) A new or improved model usually changes only the last digit of the first number, generally increasing it by one. Hopefully this information will help the user of this guide to locate his Zeiss camera by name, number, illustration, or a combination of the three.

Number	Metric size	F.L.
---	4.5x6cm	75mm
---	22x31mm	45, 50mm
1	45x107mm	twin 65mm
2	6x9cm	105mm
3	6.5x9cm	105mm
4	6x13cm	twin 75mm
5	8.5x11.5cm	135mm
6	8x14cm	150mm
7	9x12cm	135mm
8	9x14cm *(Ica)*	---
9	10x15cm	165mm
10	9x18cm *(Ica)*	---
11	13x18cm	210mm
12	4x6.5cm	75mm
13	13x18cm *(Ica)*	---
14	5x7.5cm	90mm
15	6.5x11cm	120mm
16	6x6cm	80mm
17	8x10.5cm	120mm
18	3x4cm	50mm
20	18x24cm	---
21	24x30cm	---
24	24x36mm	50mm
27	24x24mm	40mm

Zeiss Ikon cameras have attracted a following whose buying habits resemble those of Leica collectors in some respects. This has led to a wider range of prices based on condition. Since most items are not rare, their condition is a very important consideration in establishing prices. The prices here are from our database, showing cameras in condition range 4 to 5. Items in condition range 2-3 would bring a bit more. Range 6 to 9 would not only bring less money, but also be harder to sell.

Editor's note: We are deeply indebted to Mr. Mead Kibbey for the excellent job of researching and assembling this section of the book. Mr. Kibbey is widely respected as one of the world's foremost authorities on Zeiss-Ikon. In addition to his Zeiss collecting, Mead also serves as an officer of the Zeiss Historica Society. See the list of clubs in the back of the book for details of this organization.

Adoro - see Tropen Adoro

Aerial Camera, 13x18cm - c1930. Cast metal aerial camera for hand use. Two hand grips. Folding frame finder. Tessar 250mm/f3.5 lens. Focal plane shutter. $300-350.

Baby-Box Tengor - Baseball sized box camera with name on front or back. 3x4cm on 127 film. Note: On all models except the earliest, the shutter won't work unless wire front sight is lifted.
54/18 - 1931. Frontar f11 lens. Plain leather front. GERMANY: $45-65. *Add $5-10 in USA. Illustrated next page.*
54/18 - 1934-38. Metal front plate with "Baby-Box" under lens. $45-65. *Illustrated next page.*

Baby-Box Tengor 54/18, 1931 version

Baby-Box Tengor 54/18, 1934 version

54/18(E) - 1931-34. Focusing Novar f6.3 lens. Black metal front plate. $50-90.

Baldur Box (51) - 1934-36. Inexpensive black box camera for 16 exposures 4.5x6cm on 120. Frontar f11/90mm. Shutter ⅓₀, T. Rare. $35-50.

Baldur Box 51/2 - 1934-36. For 8 exposures 6x9cm on 120 film. Goerz Frontar 115mm/f11 lens. Shutter ⅓₀, T. $20-35.

Bebe (342) - 4.5x6cm strut camera with unpleated bellows. Front cell focus. 75mm Tessar f4.5 or Triotar f3.5 in dial set Compur (1928): $150-250. Tessar f3.5 in rimset Compur (1930): $200-300.

Bebe (342/3) - 6.5x9cm folding camera. Tessar 105mm/f4.5 or rimset Compur with Tessar f3.5. $125-225.

Bob (510, 510/2) - 1934-41. Inexpensive black folding cameras, 4.5x6 and 6x9cm sizes. Nettar lens. Gauthier shutter 25-75, B, T. $20-45.

Bob IV, V - 1927. (Cameras left over from Ernemann.) Sizes: 4x6.5, 6x6, 6x9, 6.5x11, 7.25x12.5cm. 33 different lens/shutter combinations. 7.25x12.5cm size: $50-90. Other sizes: $25-50.

Bobette I (549) - 1929. Strut folding camera for 22x31mm on rollfilm. With Ernoplast 50mm/f4.5 or Erid 40mm/f8: $200-250. With Frontar f9/50mm: $75-125.

Bobette II (548) - 1929. Folding camera for 22x31mm on rollfilm. Leather covered body. Black bellows. Ernostar 42mm/f2 or Ernon 50mm/f3.5 lens. Shutter ½-100. The first miniature rollfilm camera with f2 lens. $350-550.

Box Tengor 54 - 1934-39. 4.5x6cm (½-frame) on 120 film. Goerz Frontar f11 lens, rotating waterhouse stops, 1 close up lens

controlled from the front of the camera. Single speed shutter. Flash synch. Diamond shaped winding knob. 2 ruby windows. $30-40.

Box Tengor 54/14 - 5x7.5cm on 127 film. Frontar f11. Plain leather front. Winding knob on bottom right side, as viewed by operator. First model (1926-28) has two finder lenses vertical at upper front corner. Quite rare. $100-175. Second model (1928-34) has two finder lenses horizontal across the top of the front. $65-100.

Box Tengor 54/2 - 6x9cm on 120 film. Frontar f11 lens.
- 1926-28. Plain leatherette front. Viewfinder objectives vertical in upper front corner. Winding knob at bottom. $15-30.
- 1928-34. Plain leatherette front. Viewfinder objectives horizontal across front. Winding knob at top. Stops and closeups. $15-30.

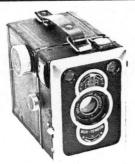

operator's viewpoint). Frontar f9 lens, internal sync. $20-40.

Box Tengor 54/15, 760 - 6.5x11cm (2½x4¼") on 116 rollfilm. Fairly rare in this size. Goerz Frontar lens.

- 1934-38. Extended hexagon front plate around lens with stops and closeup settings around it. Black enamel trim around front edge of camera. Diamond shaped winding knob at top of operator's right side. Asking prices in England up to $60 for mint, where they remain unsold for months. Relatively common in Germany for $15-25 in excellent condition.
- 1938. Same as the previous listing, but release button moved to the top of camera on operator's right. $15-25.

Box Tengor 55/2 - 1939. Same as the 54/2 of 1938, but serrated round winding knob with leatherette center, black front trim, and double exposure interlock on winding knob. $25-45.

Box Tengor 56/2 - 1948-56. Chrome trim. Lever shutter release on lower right side, flash contact on lower left (from

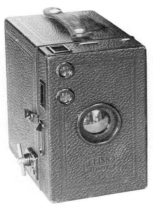

- 1926-28. Ground glass viewfinder windows. Viewfinder objective lenses vertical in upper corner. Winding knob at bottom. $40-60.
- 1928-33. Viewfinder objectives horizontal across top of front. Winding knob at top. Shutter has mirror on front. Close up lenses and diaphragm control on metal strips pulled up on top of camera. $40-60.
- 1933-38. Similar to the 1928-33 model, but metal plate like elongated hexagon on front around lens. Brilliant viewfinders with square lenses. Close up and diaphragm settings on front metal plate around lens. $40-60.

Citoskop (671/1) - A top quality stereo camera for 45x107mm cut film or plates. Sucher Triplett 65mm/f4.5 viewing/focusing lens located between Tessar 65mm/f4.5 taking lenses. "Citoskop" on front of camera. All metal pop-up viewing hood with newton finder lens at front. Fairly rare. $250-350.

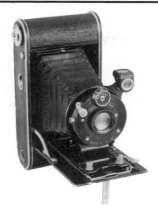

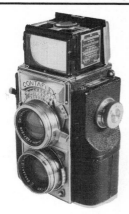

Cocarette, 514/14

Cocarette - 1926-29. Rollfilm is loaded by removing the winder and film track from the side of the camera, somewhat like a Leica (the back does not open). (Also made in a plate back model.) Single extension. Derval, Klio, and Compur dial set shutters. Frontar, Periskop, Novar, Dominar, and Tessar lenses. 64 different lens/shutter combinations. Made in black models. Variations include: #207 (5x7.5cm) an uncommon size; #209 (6x9cm); #514 in 5 sizes. #517, #518: lever focus, vertical lens adjustment, each in 2 sizes. #519: lever focus, no vertical lens adjustment, in 3 sizes. With Tessar lens in dialset Compur: $50-90. With less expensive lens/shutter such as Dominar, Novar or Nettar in Derval or Klio shutter: $35-50. *(In 1930, #517, #518, #519 were made with rimset Compur. Add $5-10 for these rimset models.)*

Cocarette Luxus (521/2, 521/15, 522/17) - 1928. 6x9cm, 6.5x11cm and 8x10.5cm sizes. Brown leather covering, polished metal parts. Double extension. Dial set Compur. Dominar f4.5: $85-130. Tessar f4.5: $150-300.

Colora (10.0641) - 1963-65. An inexpensive 35mm camera. "Colora" on top. Novica 50mm/f2.8 (a fairly unusual lens). Prontor 125 shutter, X sync. $20-30.

Colora F (10.0641) - 1964-65. Similar to the Colora, but AG-1 flash bulb socket under the accessory shoe. Shoe tips back to become the flash reflector and to uncover the socket. Rewind knob has flash calculator in top. $15-25.

Contaflex (860/24) - TLR 35mm camera. 80mm viewing lens. 8 interchangeable taking lenses, 35mm to 135mm. First camera with built-in photoelectric exposure meter. $1000-1850 if excellent to mint.

(Worth much less if meter is broken, shutter jammed, or Albada finder discolored.) In average condition, $400-800.

Contaflex TLR lenses:
- 35mm Orthometar f4.5 or Biogon f2.8: $800-1000.
- 50mm Sonnar f2 or f1.5: $150-300.
- 50mm Tessar f2.8: $150-300.
- 85mm Sonnar f2: $800-1000.
- 85mm Triotar f4: $400-650.
- 135mm Sonnar f4: $600-800.
- 35mm viewfinder: $200-300.

Contaflex I (861/24) - 1953-58. 35mm SLR. Tessar 45mm/f2.8. Synchro-Compur. No exposure meter. Readily available. $60-90.

Contaflex II (862/24) - 1954-58. Like the I, but with built-in exposure meter. Readily available. $45-70.

Contaflex III (863/24) - 1957-59. 35mm SLR. Tessar 50mm/f2.8, interchangeable front element. Knob for film advance and shutter tensioning. No meter. Not as common as Contaflex II. $60-80.

Contaflex IV (864/24) - 1957-59. Like the III, but with built-in exposure meter. Door covers the meter. LVS settings. Readily available. $65-95.

Contaflex Alpha (10.1241) - 1958-59. Same as the Contaflex III, but with the less expensive Pantar 45mm/f2.8 lens. Interchangeable front element for Pantar series lenses. $55-85.

Contaflex Beta (10.1251) - Like the Alpha, but with exposure meter. $60-90.

The Contaflex Rapid, Prima, Supers, and S Automatic all have rapid film advance, accessory shoe on prism housing, and interchangeable magazine backs.

Contaflex Rapid (10.1261) - 1959-61. Tessar 50mm/f2.8, interchangeable front element. Rarely offered for sale. $70-95.

Contaflex Prima (10.1291) - 1959-65. Like the Rapid, but with Pantar 45mm/f2.8. Uncovered match needle exposure meter at operator's right side. Uncommon. $60-90.

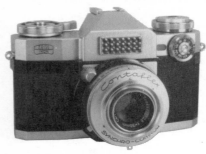

Contaflex Super (10.1262) - 1959-62. Similar to the Rapid, but with coupled exposure meter. Uncovered meter window in front of prism housing. Meter adjustment wheel on front of camera, operator's left. No other Contaflex has this external wheel. Common. Mint examples sometimes bring $100-120, but normal range is $55-80.

Contaflex Super (New Style- 10.1271) - 1962-67. "Zeiss-Ikon" printed on front of larger exposure meter window. No external setting wheel as above. Tessar 50mm/f2.8. Shutter says "Synchro-Compur X" under lens. Exposure meter window on top has two red arrows and no numbers. Inside viewfinder tiny "2x" visible at top of exposure meter slot. No automatic exposure control. Common. $75-150.

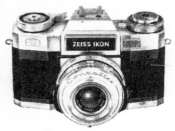

Contaflex Super B (10.1272) - 1963-68. Looks like the new style Super, except has numbers in exposure meter indicator on top and in viewfinder. Shutter says "Synchro-Compur" under lens. Automatic exposure control. $75-135.

Contaflex Super BC (10.1273) - 1967-1970. Similar to above except no external exposure meter window. Internal through-the-lens CdS meter. Battery compartment with square door at 9 o'clock from lens. Black rectangle over the lens, with "Zeiss-Ikon". Less common in black: $250-300. Usually found in chrome: $100-200.

Contaflex S Automatic (10.1273-BL) - 1970-72. "Contaflex S" on front of prism housing. "Automatic" above lens on shutter. Rare in black: $250-300. Chrome: $150-200.

Contaflex 126 (10.1102) - 1970-73. For 28x28mm on 126 cartridge film. "Contaflex 126" on front. Fully automatic exposure control. Interchangeable f2.8/45mm Tessar or Color Pantar normal lens. Not unusual to find an outfit with camera and four lenses; 45mm/f2.8, 32mm/f2.8, 85mm/f2.8, and 135mm/f4 for $200-250. Camera with 45mm/f2.8 lens only, very common: $70-125 in USA, $60-80 in Germany.

Contaflex full frame SLR lenses
- Teleskop 1.7x (fits models I and II only) (11.1203) With bracket: $55-95.
- Steritar A (Stereo prism for above) (20.2004, and 812). $125-175.
- 35mm f4 Pro-Tessar (11.1201, and 1003). 49mm external filters. $30-40.
- 35mm f3.2 Pro-Tessar (11.1201). 60mm external filters. $60-85.
- 85mm f4 Pro-Tessar (11.1202, and 1004). 60mm external filters. $75-135.
- 85mm f3.2 Pro-Tessar (11.1202). 60mm external filters. $75-135.
- 115mm f4 Pro-Tessar (11.1205). 67mm external filters. $80-100.
- Pro-Tessar M-1:1 (11.1204). High resolution close copy lens. $100-145.
- Monocular 8x30B - see Contarex lenses below.

For Contaflex Alpha, Beta, Prima, and Contina III
- 30mm f4 Pantar (11.0601). $30-45.
- 75mm f4 Pantar (11.0601 or 1002). $65-90
- Steritar B (20.2005 or 813) (for Contaflex III through S). $125-175.
- Steritar D (20.2006 or 814). $100-130.

Contaflex 126 lenses
- 25mm f4 Distagon (11.1113). Very rare. No sales records. Estimate: $150.
- 32mm f2.8 Distagon (11.1101). Mint: $20-45.
- 45mm f2.8 Color Pantar (11.1102). $10-15.
- 45mm f2.8 Tessar (11.1103). $10-20.
- 85mm f2.8 Sonnar (11.1104). $45-75.
- 135mm f4 Tele Tessar (11.1105). $25-40.
- 200mm f4 Tele Tessar (11.1112). $100-200.

Contarex Cameras - *All models of this superbly made 35mm camera except the microscope version have the word "Contarex" on front. KEH Camera Brokers, Atlanta assisted in pricing this series.*

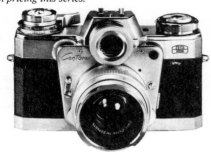

Contarex "Bullseye" (10.2401) - 1960-1967. Large round coupled exposure meter window over lens. Interchangeable Planar 50mm/f2. Later models with data strip slot, mint to $395; normal range $215-300. Early models without data strip slot at rear: $175-275.

Contarex Special (10.2500 body) - 1960-66. No meter. Interchangeable reflex or prism view hood. "Contarex" in script-like letters. Mint to $600. Normal range: $350-500.

Contarex Professional (10.2700 body) - 1967-68. No meter. Only prism viewer. "Professional" on front. Very rare. Less than 1000 made, and almost no mint examples remaining. Absolutely like new: $700-1000. Excellent: $400-550.

Contarex Super (10.2600 body) - 1968-1972. "Super" on front. First model has through-the-lens meter switch on front at 2 o'clock from the lens (opposite from focus wheel). Second model has switch on top under the winding lever. Front switch: $600 MINT, $400 EXC. Top switch: $750 MINT, $500 EXC.

Contarex Electronic (Super Electronic) (10.2800 body) - 1970-72. "Electronic" on front. Chrome or (rarer) black body. Mint: $800-1100. Excellent: $500-750.

Contarex Hologon (10.0659 outfit) - 1970-72. "Hologon" on front. Fixed focus lens 15mm/f8, linear type (not a fisheye). With camera, grip, cable release, special neutral density graduated filter, and case for all: $1200-2000. Camera only: $800-1200.

Contarex Microscope Camera - "Zeiss Ikon" in block letters on top. Interchangeable backs. No lens, viewfinder, or exposure meter. Quite rare. $300-400.

Contarex Lenses - *These lenses, made by Carl Zeiss, Oberkochen between 1959 and 1973 are seldom equalled and never surpassed even with today's technology. Up to 1965, 135mm and shorter lenses have chrome finish, and 180mm and longer have black finish. After 1965, all were black finished.*

- 16mm f2.8 fisheye Distagon (11.2442) 1973. Rare. MINT: to $900. EXC: $500-650.
- 18mm Distagon f4 (11.2418) 1967-73. With adapter ring for B96 filters. MINT: to $750. EXC: $350-500.
- 21mm Biogon f4.5 (11.2402) 1960-63. (For Bullseye only.) $150-200. *Add $200 for finder.*
- 25mm Distagon f2.8 (11.2408) 1963-73. Black: MINT to $600; EXC: $350-450. Chrome: MINT to $500; EXC: $225-325.
- 35mm Distagon f4 Chrome (11.2403) 1960-73. $125-175.
- 35mm Blitz Distagon f4 Black (11.2413) 1966-73. Built-in flash automation. $150-225.
- 35mm f4 PA Curtagon (11.2430) 1973. Made by Schneider, but mounted and sold by Zeiss Ikon, Stuttgart. Automatic stop down. Perspective control by lateral movement of up to 7mm in any of four directions. Rare. $400-600 MINT, with B56 filter ring.
- 35mm f2 Distagon (11.2414) 1965-73. MINT: $450-550. EXC: $225-325.
- 50mm f4 S-Planar (11.2415) 1963-68. For critical close ups to 3". $400-600 MINT.
- 50mm f2.8 Tessar (11.2501). MINT: Black: $200-350. Chrome: $150-250.
- 50mm f2 Planar Chrome (11.2401) 1960-73. $75-125.
- 50mm f2 Blitz Planar Black (11.2412) 1966-73. $100-150.
- 55mm f1.4 Planar (11.2407) 1965-73. Black: MINT to $350; EXC: $200-250. Chrome: $150 EXC to $250 MINT.
- 85mm f2 Sonnar (11.2404) 1960-73. Black: $200 EXC to $350 MINT. Chrome: $175 EXC to $275 MINT.
- 85mm f1.4 Planar 1974. Very rare. Estimate: $650 EXC to $1000 MINT.
- 115mm f3.5 Tessar (11.2417) 1960-73. For use with bellows. Estimate: $400-600. Bellows: $175. Bellows with cable socket: $200.
- 135mm f4 Sonnar (11.2405) 1960-73. Black: $100 EXC to $175 MINT. Chrome: to $150 MINT.
- 135mm f2.8 Olympia-Sonnar (11.2409) 1965-73. MINT: $475. EXC: $250-350.
- 180mm f2.8 Olympia-Sonnar (11.2425) 1967-73. Fairly rare. MINT: $700-900. EXC: $500-650.
- 250mm f4 Sonnar (11.2406) 1960-63. Manual preset ring focus. Two nice examples sold at auction in Germany for $525 and $725 with case, cap, etc. Normal range: $250-350.

- 250mm f4 Olympia-Sonnar (11.2421) 1963-73. Knob focus auto stop-down. $500-600.
- 400mm f5.6 Tele Tessar (11.2434) 1970-1973. Very rare. Estimate: $1000-1500.
- 500mm f4.5 Mirotar (11.2420) Catadioptric. 1963-73. Very rare. $1500-2500.
- 1000mm f5.6 Mirotar (11.2422) Catadioptric. 1964-70. Super rare. $3000-5500.
- 40-120mm f2.8 Vario-Sonnar (11.2423) 1970-73. Rare. MINT w/grip to $2500. EXC: $1500-2000.
- 85-250 f4 Vario-Sonnar (11.2424) 1970-1973. Very rare. $2000-3000.

- Monocular 8x30B with 27mm threaded eyepiece to fit Contaflex SLR or Contarex by use of an adapter. First model (1960) (20.1629) with eyepiece focus and line for 140 feet. $100-200. Second model (1963) with front end focussing and a distance scale. (This second model is the most common type seen.) $150-275. Third model (1969) (11.1206) has porro prism with front end focus. This model is straight and looks like a small refracting telescope. $200-375.
- Adapter to use monocular with 50mm f2 Planar: $40-60.
- Adapter to use monocular with 50mm f1.4 Planar: $75-100.

Contax Series - Introduced in 1932 as a top quality rangefinder 35mm system camera, it was manufactured until 1961 with the exception of the 1944-52 period. Dr. Stanley Bishop assisted in the preparation of this section.

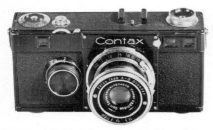

Contax I (540/24) - 1932-36. Identifying features: black enamel finish, square appearance, "Contax" in white on upper front and winding knob on front to operator's right of lens.

Contax I(a) - Serial numbers starting with "AU" or "AV". No low (below 1/25) shutter speeds, no "foot" on tripod socket and often had one or more raised "dimples" over ends of shafts on front of camera. Viewfinder window closer to center of camera than rangefinder window. With contemporary lens: $450-600.

Contax I(b) - Same as the I(a) in appearance except front bezel extends across front to viewing and rangefinder window. $280-380.

Contax I(c) - "Foot" on tripod socket, slow speeds added, guard attached to lens bezel surrounds slow speed setting ring. Like the above models, it has no button to unlock infinity stop when external bayonet lenses are in use. $250-350.

Contax I(d) - Same as the I(c), but button to release infinity lock present at 1 o'clock from lens, and distance scale around base of lens mount now finished in chrome with black numbers rather than in black with white numbers as on earlier models. $260-375.

Contax I(e) - Same as I(d), except viewfinder window moved to outside of rangefinder window, and a shallow vertical groove in front bezel between lens mount containing word "Contax" and focus wheel. $300-420.

Contax I(f) - Same as I(e), but has 4 screws in accessory shoe, and the marker for setting shutter speeds changed from an apparent slotted screw head to a small pointer. $325-525.

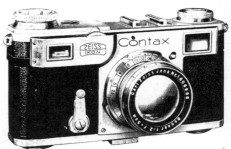

Contax II (543/24) - 1936-42. Identified by satin chrome finish on top and trim. Winding and speed setting on top right (viewed from behind), shutter speeds to 1250, and rangefinder/viewfinder windows combined. A superb rugged camera with no external variations during its production life. It can be differentiated from the postwar Contax II(a) by its larger size, a narrow frame around the small rangefinder window, and the absence of sync connection on upper back. With 50mm Sonnar f2 or Tessar f3.5 or f2.8: $100-175.

Jena Contax (II) - c1947. Very similar to pre-war Contax II. Says "Carl Zeiss Jena" in shoe. Back is made of brass, not aluminum. Black bezel around self-timer. Lettering style is slightly different. Rare. $500-700.

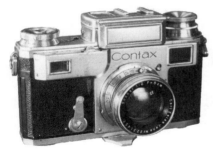

Contax III (544/24) - 1936-42. Same as the Contax II, except had built in, uncoupled exposure meter on top and rewind knob was much higher. $125-200.

Contax, Contax D, and Contax F - Variations of the Contax II and Pentaprism versions which were produced after WWII in East Germany. They tended to be of inferior quality and sell in the range of $50-150. These cameras are covered in more detail under the manufacturer "Pentacon".

Contax II(a) (563/24) - 1950-61. An excellent quality camera produced at Stuttgart and identified by satin chrome top, "Contax" on front, wide frame around right rangefinder window, sync fitting on back near top, and film speed and type indicator on rewind knob.
- First model: all numbers on speed setting dial are black. Sync attachment looks like flat plunger in socket. Requires special attachment to convert mechanical motion to electric contact. (#1361 for bulbs, #1366 for electronic flash.) $145-245.
- Second model: Same, but numbers on speed dial in color (1-1/25 black, 1/50 yellow, 100-1250 red) and regular p.c. flash connector at rear. Many of these are still in use. MINT condition brings $300-400. EXC: $200-275.

Contax IIIa - Same as the IIa, except uncoupled exposure meter on top. First model (black dial): $175-275. Second model (colored dial): $200-300. (Mint condition brings 25-35% more.)

Contax "No-Name" - see Mashpriborintorg "No-Name" Kiev.

Prewar Contax Lenses - *Earliest were black enamel and heavy chrome trim. These are worth from a little to a lot more than the later satin chrome versions. All these lenses plus innumerable Contax accessories are described in "Contax Photography", a Zeiss booklet reprinted in 1981 by David Gorski, 1325 Garfield Ave., Waukesha, WI 53186, and still available from him for $10.95. Even the view finders in the Contax series*

are collected and vary from $20 up to several hundred dollars in value. Serial numbers range from about 1,350,000 to 2,700,000.
- 28mm f8 non-coupled wide angle Tessar: $100-150.
- 35mm f4.5 Orthometar. $175-275.
- 35mm f2.8 Biogon (fits only pre-war Contaxes): $50-85.
- 40mm and 42.5mm f2 Biotar. Black: $500-800. Chrome: $400-700.
- 50mm f3.5 Tessar: $50-75. *Add $10-20 if black front ring (for Contax I).*
- 50mm f2.8 Tessar: $50-75. *Add $10-20 if black front ring (for Contax I).*
- 50mm f2 Sonnar: Rigid mount: $50-80. Collapsible mount: $20-25.
- 50mm f1.5 Sonnar: $25-55. *Add $10 for black.*
- 85mm f4 Triotar: Black: $90-125. Chrome: $50-90.
- 85mm f2 Sonnar: Prewar black: $175-300. Prewar chrome: $75-125.
- 135mm f4 Sonnar: Black: $150-210. Chrome: $70-100.
- 180mm f6.3 Tele Tessar K (direct mount): Black: $400-600. Chrome: $300-500.
- 180mm f2.8 Sonnar ("Olympia Sonnar") In flektoskop (inverted image) with case: $1200-1700. Direct mount: $1200-1600.
- 300mm f8 Teletessar K (direct or Flektoskop mount): $1500-2000.
- 500mm f8 Fern (distance). Rare. Direct mount: $2500-3500. With Flektoskop and case: $2000-2500.

Postwar Contax lenses - *Chrome finish. Fern 500mm, Sonnar f2.8/180mm, and Tessar f3.5/115mm offered in black also.*
- 21mm f4 Biogon (563/013): $100-150. (Add $90 for finder.)
- 25mm f4 Topogon. Rare. $550-800.
- 35mm f3.5 Planar (563/014): $100-140.
- 35mm f2.8 Biometar: $150-225.
- 35mm f2.8 Biogon (563/09): $100-160.
- 50mm f3.5 Tessar (543/00): $60-100.
- 50mm f2 Sonnar (543/59): $35-60.
- 50mm f1.5 Sonnar (543/60): $40-70.
- 75mm f1.5 Biotar. Super rare. $600-1000.
- 85mm f4 Triotar (543/02): $75-125.
- 85mm f2 Sonnar (563/05): $75-125.
- 115mm f3.5 Panflex Tessar (5522/01), for bellows. Rare. $600-750.
- 135mm f4 Sonnar (543/64): $60-90.
- 180mm f2.8 Sonnar, direct or Flektoskop mount. Rare. $1000-1500.
- 300mm f4 Sonnar, direct or Flektoskop. Rare. $2000-2500.
- 500mm f8 Tele-Lens. Flektoskop or Panflex mount and case. (In October 1952, this lens cost $835.) Infrequently offered for sale. Estimate: $2000-2500.

- Stereotar C outfit (810/01, 20.2000). Twin lens assembly, separating prism, special viewfinder, close up lenses, and leather case: $1500-2200.

ZEISS IKON (cont.)

Contessa Series - *Post-war 35mm full frame cameras.*

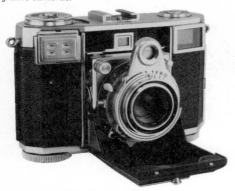

Contessa-35 (533/24), 1950-55 - A fine quality folding 35 with center door somewhat like a Retina. Built-in dual-range, uncoupled exposure meter. "Contessa" in gold on leather door covering, and round rangefinder window directly above lens. Shutter will not fire unless camera has film and it is advanced. Tessar 45mm/f2.8. First version (1950-53), Compur Rapid, X sync. Second version (1953-55), Synchro Compur, MX sync. $110-190.

Contessa-35 (533/24), 1960-61 - Very different from the first 2 versions. Rigid lens mount. Built-in exposure meter. "Contessa" on top. Tessar 50mm/f2.8. Pronto 30-250. $30-50.

Contessa LK (10.0637) - 1963-65. "Contessa LK" on top. Coupled match needle exposure meter. No rangefinder. Tessar 50mm/f2.8 lens, Prontor 500 LK shutter. $30-50.

Contessa LKE (10.0638) - 1963-65. "Contessa LKE" on top. Like the LK, but with coupled rangefinder. $35-60.

Contessa LBE (10.0639) - 1965-67. "Contessa LBE" on top. Like the LKE, but automatic flash control by linkage between distance and aperature setting. $30-50.

Contessa S-310 (10.0351) - 1971. Small very well made rigid mount automatic 35, with manual overide. "S-310" on front. Tessar 40mm/f2.8. Pronto S500 Electronic shutter, exposures to 8 seconds. $50-70.

Contessa S-312 (10.0354) - "S-312" on front. Like the S-310, but with coupled rangefinder. $95-145.

Contessamatic - 1960-61. Same as the "E", but no rangefinder, and Prontor SLK shutter. $30-45.

Contessamatic E - (10.0645) - 1960-63. "Contessa" on top-front of lens mount. No name on top. Tessar 50mm/f2.8. Prontor SLK "Special" shutter, 1-500, MX sync. Coupled rangefinder. Exposure meter. $30-45.

Contessamat - 1964-65. "Contessamat" on top. Fully automatic. Color Pantar 45mm/f2.8. Prontormatic 30-125 shutter. Coupled exposure meter. No rangefinder. $20-35.

Contessamat SE (10.0654) - 1963-65. "Contessamat SE" on top. Like the Contessamat, but with coupled rangefinder, Prontormatic 500 shutter, 30-500. $30-45.

Contessamat STE - 1965. "Contessamat STE" on top. Like the SE, but Tessar 50mm/f2.8 in Prontormatic 500 SL shutter, 1-500. $30-60.

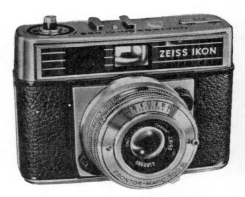

Contessamat SBE (10.0652) - 1963-67. "Contessamat SBE" on top in black. "Flashmatic" in red letters. Like the STE, but covered flash contacts on top. Automatic flash control by linking distance and diaphragm settings. $30-60.

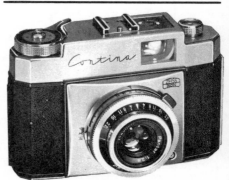

Contina Ia

Contina I (522/24) - 1952-55. 35mm folding camera with center door. "Contina" in gold letters on door. Model number on leather of back by back latch. Novar 45mm/f3.5 in Prontor SV or Tessar 45mm/f2.8 in Synchro Compur. X sync. $20-40.

Contina Ia (526/24) - 1956-58. Rigid mount lens. "Contina" under the lens and on bezel at 1 o'clock from lens. Model number in leather of back next to catch. Novicar 45mm/f2.8 (1956-57) or Pantar 45mm/f2.8 (1958). $20-35. *Illustrated bottom of previous page.*

Contina Ic (10.0603) - 1958-60. Re-styled Contina Ia. Larger top housing, larger viewfinder window. Pantar 45mm/f2.8; Prontor-SVS 1-300 shutter. $25-40.

Contina II (524/24) - 1952-53. Folding 35mm with center door. "Contina" on door. Model number in leather of back near catch. Uncoupled built-in rangefinder. Opton-Tessar 45mm/f2.8 in Synchro Compur MX 1-500 or Novar f3.5 in Prontor SV. $35-60.

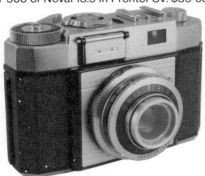

Contina IIa (527/24) - 1956-58. Rigid mount lens. "Contina" on front under lens. Model number on back. Rapid wind lever. Built in uncoupled exposure meter, match needle on top. 45mm Novar f3.5 or Novicar f2.8. Prontor SVS 1-300, MX sync. $25-50.

Contina III (529/24) - 1955-58. A system camera, with the same specifications as Contina IIa, except Pantar 45mm/f2.8 convertible lens. "Contina" on front bezel. Model number on back. Uses all lenses of the Contaflex Alpha series. $30-55.

Contina III Lenses
- 30mm f4 Pantar (1001): $30-45.
- 75mm f4 Pantar (1002): $65-90.
- Steritar D for 3-D pictures (814): $100-130.
- 30mm wide angle finder (422): $25-35.
- Telephoto finder (423): $25-35.
- Telephoto rangefinder (correct field of view for 75mm Pantar) (425): $30-50.
- Universal finder for all items above (426): $60-85.

Contina III Microscope Camera - Body of the Contina III, but modified for use with standard Zeiss Microscope Connecting funnel. No lens. Ibsor B self-cocking shutter, 1-125, X sync. No exposure meter, rangefinder, viewfinder or name, except "Zeiss-Ikon" in middle of back. Usual shutter release button does not release shutter, but must be depressed to advance shutter. Rare. $50-75.

Contina (10.0626) - 1962-65. Rigid mount 35mm. "Contina" on top. Color Pantar 45mm/f2.8. Pronto shutter to 250, X sync, self-timer. $15-25.

Contina L (10.0605) - 1964-65. "Contina L" on top. Like the Contina, but with built-in uncoupled exposure meter. Prontor 250 shutter, 30-250. $15-25.

Contina LK (10.0637) - 1963-65. "Contina LK" on top. Like the "L," but coupled exposure meter. $25-45.

Continette (10.0625) - 1960-61. "Continette" on front beside viewfinder. Rigid mount 35mm, without rangefinder or exposure meter. Pronto shutter 30-250, self-timer. Lucinar 45mm/f2.8. (This lens was not used on any other Zeiss Ikon camera.) $25-45.

Deckrullo, Deckrullo Nettel - 1926-28. Strut-folding cameras. Focal plane shutters to 2800. Formerly made by Contessa-Nettel Camerawerk, now by Contessa-Nettel Division of Zeiss-Ikon, and continuing after 1929 as the "Nettel" camera (870 series). (See Zeiss Nettel.)
- 6.5x9cm (36), 9x12cm (90) - Zeiss Tessar f4.5 or f2.7, or Triotar f3.5. $60-150.
- 10x15cm (120), 13x18cm (165) - Zeiss Tessar f4.5 or Triotar f3.5. $60-150.

Baby Deckrullo (12, 870) - 1926-29. 4.5x6cm plate camera. Strut-folding, with bed. Focal plane shutter to 1200. 80mm Zeiss Tessar f4.5 or f2.7 lens. Camera focus knob on top. $250-375.

Deckrullo Tropical, Deckrullo Nettel Tropical - Same shutter and lens combinations as the Deckrullo. $450-750.

Donata (68/1, 227/3, 227/7) - 1927-31. Inexpensive folding plate camera in 6.5x9cm and 9x12cm sizes. Name usually on or under handle. Preminar, Dominar or Tessar f4.5 lens in Compur shutter. $35-65.

Duchessa (5, 302) - c1926-29. Single extension folding bed camera with trellis side struts. 4.5x6cm plates. Radial lever focusing. Tessar 75mm/f4.5 lens in Compur shutter. $150-175.

Duroll, 9x12cm - c1926-27. Folding bed camera, continued from the Contessa model. Takes 8.2x10.7cm on rollfilm or 9x12cm plates. Dominar or Tessar lens. $50-75.

Elegante (816) - 1927-34. Field camera with rigid front. Square bellows. Wood with brass. $300-400.

Erabox - 1934-38. Inexpensive version of the Box Tengor. "Erabox" around lens. 4.5x6cm or 6x9cm on 120. $20-30.

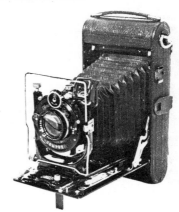

Ergo (301) - 1927-31. Detective camera made to look like a monocular. Shoots at right angles to direction of viewing. "Ergo" in eyepiece area. 4.5x6cm plates. Tessar 55mm/f4.5. Self-cocking shutter. Very rare. $900-1350.

Ermanox (858) - 1927-31. 4.5x6cm plate camera. 85mm Ernostar f1.8 or rare f2 lens. FP shutter 20-1200. Rigid helical focusing. $900-1500.

Ermanox (858/3, 858/7, 858/11) - 1927. Strut-folding, bellows camera. Ernostar f1.8 lens, FP shutter to 1000. 6.5x9cm (858/3) is fairly rare: $500-1000. 9x12cm (858/7) is super rare: $3000-5000. 10x15 and 13x18cm sizes are listed in original catalogs, but are so rare that they are impossible to price.

Ermanox Reflex - 1927-29. Reflex 4.5x6cm plate camera. Ernostar 105mm/f1.8 lens in rigid helical focus mount. FP shutter 20-1200. $1500-2500.

Erni (27, 27/3) - 1927-30. Box plate camera. Celluloid "ground glass". Very rare. Estimate: $150-250.

Favorit (265, 265/7, 265/9, 265/11) - 1927-35. Black bodied plate camera of excellent quality. Name or number usually on handle, number on outside of door near hinge. Interchangeable lenses Tessar or Dominar f4.5 lens. 13x18cm size: Very rare. Estimate: $150-300. Other sizes: $100-180.

Favorit Tropical (266/1, 266/7, 266/9) - 1927-31. Excellent quality teakwood plate camera. Brown leather handle with name and model number. Tessar or Dominar f4.5 in Compur shutter. Price varies, depending on size and condition. $400-700.

Halloh (505/1) - c1927. Single extension folding bed camera, similar to the Icarette series. 8x10.5cm on rollfilm. Tessar f4.5/ 120; Dial set Compur. $60-90.

Hochtourist - c1927-31. Double extension wood view camera; square bellows, brass trim, vertical & horizontal front movements. 5x7", 8x10", and 10x12" sizes. Usually without model name on camera, but with "Zeiss-Ikon" round metal plate. Very rare. No active trading exists. Infrequent sales records indicate a $100-300 range. *See D.B. Tubbs "Zeiss Ikon Cameras 1926-39" for photos.*

Hologon - see Contarex Hologon under this manufacturer.

Icarette - 1927-36. In formats 4x6.5, 6x6, 6x9, 6.5x11, and 8x10.5cm, plus one model which used 6x9cm rollfilm or 6.5x9 plates. Most say "Icarette" on handle or in leather on body. There were over 60 different lens/shutter combinations offered and 4 qualities of bodies, #509, #500, #512, and the fanciest #551/2. There are simply more kinds of Icarettes than most people want to hear about. Interest is still light in this series and the price range is $30-70.

Icarex - 1967-73. *An intermediate priced 35mm system camera. All had cloth focal plane shutter, ½-1000, B, X sync.*

Icarex 35 (10.2200) - Bayonet mount. Interchangeable lenses, viewing screens, and viewfinders. With Ultron f1.8: $125-175. With Color Pantar 50mm/f2.8: $85-110. With Tessar 50mm/f2.8: $90-120. Add $20-40 for black body.

Icarex 35 "TM" - Threaded 42mm lens mount, marked "TM" at 1 o'clock from the lens. With Tessar 50mm/f2.8: $125-175. With Ultron 50mm/f1.8: $135-185.

Icarex 35 CS - Either of the Icarex 35 models becomes an Icarex 35 CS by the addition of a pentaprism viewfinder containing a through-the-lens CdS meter. The finder says "Icarex 35 CS" on its front, and looks like a part of the camera. $75-125.

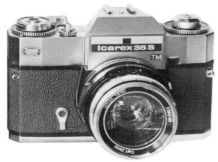

Icarex 35S - intro. 1970. Available in TM (10.3600) and BM (10.3300) models. This camera differs from the Icarex 35 in that the viewfinders and view screens are not interchangeable. The CdS meter is built in and coupled with stop-down metering. Five Zeiss lenses were available for the TM model, 9 for the BM model. Chrome or black versions. Some of the early black models are marked "Pro". With Pantar: $75-110. Tessar f2.8: $80-125. Ultron f1.8: $110-180. For black models, add $20-40.

Icarex Lenses - *All take 50mm bayonet or 56mm screw-over filters and shades.*
Bayonet mount:
- 35mm f3.4 Skoparex (11.2003): $60-90.
- 50mm f2.8 Color Pantar (11.2001): $20-40.
- 50mm f2.8 Tessar (11.2002): $30-50.
- 50mm f1.8 Ultron (11.2014): $75-110
- 90mm f3.4 Dynarex (11.2004): $70-120.
- 135mm f4 Super Dynarex (11.2005): $65-95.
- 200mm f4 Super Dynarex (11.2008): $140-215.
- 400mm f5 Telomar (11.2010). Rare: $275-475.
- 36-82mm 2.8 Zoomar (11.2012): $180-300

Thread mount:
- 25mm f2.8 Distagon (11.3503). Rare: $110-170.
- 35mm f3.4 Skoparex (11.3510): $65-95.
- 50mm f2.8 Tessar (11.35??): $40-60.
- 50mm f1.8 Ultron (11.3502): $80-100.
- 135mm f4 Super Dynarex (11.3511): $70-110.

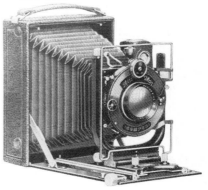

Ideal 9x12cm (250/7)

Ideal - 1927-38. A fine quality double extension folding plate camera usually having the name and model number stamped on the leather body covering under the handle. The 9x12cm size was the most common, followed by the 6.5x9cm. They were offered with Compur shutters, and Dominar, Tessar, or Double Protar lenses, the Tessars being by far the most common. Interchangeable lens and shutter on all but the 6.5x9cm size. All had special "pop-off" backs. 6.5x9 (250/3): $40-70. 9x12 (250/7): $30-50. 10x15 (250/9), rare: $50-95. 13x18 (250/11), very rare: $75-125.

Ikoflex cameras - 1934-60. *Twin lens reflex for 6x6cm format. "Ikoflex" on front.*

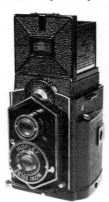

Ikoflex (850/16) - 1934-37. Original

"coffee can" model. All black enamel finish on cast magnesium body. 80mm Novar f4.5 or 6.3 lens. Derval, Klio, or Compur-Rapid shutter. 2 film counters (for 120 and 620 films); lever focus under lens; "Ikoflex" on shutter above lens. Early version has art-deco finder hood, but later hoods are leather covered like other models. Occasionally to $200 but most sales $100-175.

Ikoflex I (850/16) - 1939-51. This is basically the same camera that was earlier called the Ikoflex II (1937-39). Slight changes were made to the body design when production was resumed under the Ikoflex I name. Nameplate is black, with a small chromed area surrounding the name "Ikoflex". Chrome trim. 75mm Tessar or Novar f3.5. Compur, Klio or Prontor-S shutter to 250. Knob focus. $40-75.

Ikoflex Ia (854/16) - 1952-56. "Ikoflex" in chrome against a black background on front of viewfinder. 75mm Novar or Opton Tessar f3.5. Prontor SV to 300. Does not have a folding shutter release. One very nice early example with the old style nameplate brought $160 at auction in Germany in 9/88. Normal range: $75-110.

Ikoflex Ib (856/16) - 1956-58. Improved version of the Ia. 75mm Tessar or Novar f3.5 in 1956/57; Novar only in 1957/58. Prontor SVS shutter. Folding shutter release. Focusing hood opens and closes with single action, magnifiers over diaphragm and shutter speed dials. No exposure meter. $85-125.

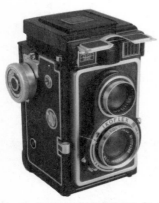

Ikoflex Ic (886/16) - 1956-60. Similar to the Ib, but with built-in exposure meter. Needle visible on ground glass inside hood. A few recent sales of MINT examples over $300. Normal range: $100-175.

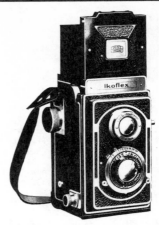

Ikoflex II (851/16) - 1936-39. "Ikoflex" nameplate on front is all chrome. Zeiss Tessar 75mm f3.5 in Compur Rapid 1-500, or Zeiss Triotar 75mm f3.8 in Compur 1-300. Auto film counter. Viewing lens in chromed tube appears to stick out further than on other models. Focus lever in 1937, knob in 1938-39. (This basic model was continued as the Ikoflex I.) $70-120.

Ikoflex II/III (852/16) - 1938-1940's. Entire area of taking and viewing lenses is surrounded by a front housing, with 2 peep windows above the viewing lens. Lens aperture and shutter speed show in the peep windows. Aperture and shutter speed are set by levers under shutter housing. Double exposure prevention. This model was introduced in 1938 as the Ikoflex III, but was renamed "New Style Ikoflex II" in 1939 (when the original Ikoflex II (851/16) was discontinued). Zeiss Tessar 75mm/f3.5 in Compur Rapid 1-500, or Zeiss Triotar 75mm/f3.5 in Compur 1-300. $125-175.

Ikoflex IIa (855/16, early) - 1950-52. Similar to the Ikoflex II, but the front housing surrounds only the taking lens, with the peep windows located on both sides of the viewing lens. Flash sync. Tessar 75mm/ f3.5, Compur Rapid shutter. $75-125.

Ikoflex IIa (855/16, re-styled) - 1953-56. Features similar to earlier IIa, but the peep windows are combined into one window above the viewing lens. Shutter and aperture set by wheels. Body design like the Favorite, but no meter. Tessar 75mm/ f3.5; Synchro-Compur shutter. $75-125.

Ikoflex III (853/16) - 1939-40. Only Ikoflex with huge Albada finder on front of viewing hood (like Contaflex TLR). Crank advances film and winds shutter. Tessar 80mm/f2.8. Compur Rapid 1-400 or 500.

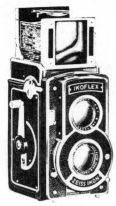

in LIKE NEW condition has brought $950. MINT to $400. EXC condition most common. Range: $200-300.

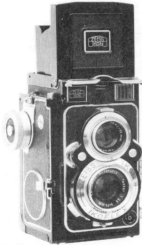

Ikoflex Favorit (887/16) - 1957-60. Last of the Ikoflex line. Tessar 75mm/f3.5. Synchro Compur MXV to 1/500. Built in LVS exposure meter. Cross-coupled shutter and aperture set by wheels. MINT has brought $500-600. EXC+: $200-350. AVERAGE: $150-200.

Ikomatic A (10.0552) - 1964-65. Inexpensive square-looking camera, for 126 cartridge film. Color Citar 45mm/f6.3 lens. Shutter 1/90 for daylight, 1/30 for flash. Built in electric eye exposure control. Hot shoe. "Ikomatic A" on lower front.$10-20.

Ikomatic F (10.0551) - 1964-65. Same general appearance as the "A", but has Frontar zone focus lens. No exposure control. Built-in pop-up reflector for AG-1 bulbs on top of camera. "Ikomatic-F" on lower front. $10-20.

Ikonette (504/12) - 1929-31. Small 127 rollfilm camera. The whole back removes to load the film. Self-cocking shutter. Frontar 80mm/f9. There are at least 2 variations in the body catch mechanism. $35-70.

Ikonette 35 (500/24) - c1958. A unique 35mm camera (for Zeiss) made entirely of grey high impact plastic. Body is curved into a kidney shape. A single lever on the front winds the film, advances the counter, and cocks the shutter on a long stroke. The same lever then releases shutter on a short stroke. Red flag appears in the viewfinder when the shutter is cocked. Two-tone grey and blue plastic case with name on front available (1256/24). $30-60.

Ikonta cameras - *1929-56. Early models also known as Ikomats in the U.S.A. All had front cell focus lenses.*
Ikonta (520/14) - 1931. 5x7.5cm. With Tessar 80mm/f4.5 in Compur shutter: $45-60. With Novar 80mm/f6.3 in Derval: $35-50.

Ikonta (520/18) - 3x4cm rollfilm. Referred to as Baby Ikonta. Tessar 50mm/f3.5 (1936): $200-300. Novar 50mm/f3.5 (1936): $100-150. Novar f6.3, f4.5 or Tessar f4.5 (1932): $75-100.

Ikonta A (520) - 1933-40. 4.5x6cm on 120 film. Compur shutter. With Tessar 80mm/f3.5: $60-90. With Novar f4.5: $35-50.

Ikonta A (521) - c1940's. 4.5x6cm size. With Tessar 75mm/f3.5 in Compur Rapid or Synchro Compur shutter: $75-125. With 75mm Novar f3.5 or f4.5 in Prontor or Compur: $35-50.

Ikonta B (520/16) - 1937-39. For 12 exposures 6x6cm on 120. With Tessar 75mm/f3.5 in Compur Rapid: $80-120. With 75mm Novar f3.5 or f4.5 in Compur or Klio shutter: $40-60.

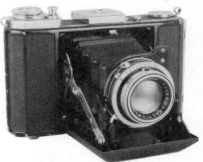

Ikonta B (521/16) - 1948-53. Similar to the 520/16, but with chrome lens mount

and more chrome trim. Rare with Opton Tessar 75mm/f3.5: $100-150. With Novar f3.5: $45-65. With Novar f4.5: $40-50.

Ikonta B (523/16) - 1954-56. Also similar, but with chrome top plate. Opton Tessar or Novar f3.5. Prontor SV or Synchro Compur shutter. Uncommon. $150-200.

Ikonta B (524/16) - 1954-56. Built in uncoupled rangefinder. With Tessar 105mm/f3.5 in Synchro Compur: $100-150. With 105mm Novar f3.5 or f4.5 in Prontor SV shutter: $60-90.

Ikonta C (520/2) - 1930-40. 6x9cm on 120. With 105mm lenses: Tessar f4.5: $50-80. Tessar f3.8 (1936-37 only): $50-80. Novar f6.3: $25-45.

Ikonta C (521/2) - Postwar. With Tessar 105mm/f3.5: $60-80. With Novar f3.5 or f4.5: $35-50.

Ikonta C (523/2) - 1950-56. Heavy chrome trim at top. Uncommon. With 105mm Tessar f3.5, Novar f3.5: $100-150. With Novar f4.5 lens: $75-125.

Ikonta C (524/2) - 1954-56. Like the 523/2 but with built-in uncoupled rangefinder. With Tessar: $125-150. With Novar f4.5 or f3.5: $60-100.

Ikonta D (520/15) - 1931-39. Ikomats seem to be more common in this size than Ikontas. Early versions for 116 film, later for 616 film. With Tessar 120mm/f4.5 in Compur: $60-95. With 120mm Novar f4.5 or f6.3 in Derval shutter: $30-40.

Ikonta 35 (522/24) - 1949-53. Folding 35mm with central door and very rigid front standard. 45mm Novar f3.5, Tessar f2.8, or Xenar f2.8 (1949-51 only). "Ikonta" in leather on back. Later models had accessory shoe. $35-50.

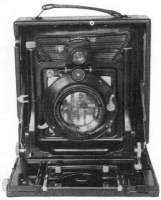

Juwel (275/11) - 1927-39. 13x18cm plate

camera. Lens interchanges with aluminum "board". This model was used extensively by Ansel Adams. With a Triple convertable Protar, this was Zeiss's most expensive camera throughout the prewar years. Quite rare, still usable. With Tessar 210mm/f4.5: $400-650. With Protar: $500-800.

Juwel (275/7) - 1927-38. 9x12cm plate camera. Superb quality, all metal, leather covered with rotating back. Rising/falling, shifting/tilting front. Pop-off backs. Triple extension by means of two rack-and-pinion knobs on folding bed; one moves back and front, one moves lens standard. "Juwel" or "Universal Juwel" on or under the handle. Interchangeable bayonet lenses. Price depends on condition and lens. $350-500.

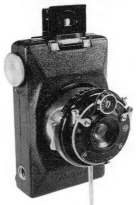

Kolibri (523/18) - 1930-35. A compact 127 rollfilm camera giving 16 exposures 3x4cm. "Kolibri" below lens in leather. Lens extends for picture taking on brightly polished chromed tube. Came with unique shaped case in brown or black. Looking at hinge on right side of open case is a screw in "foot" which is inserted in lens mount for vertical still pictures. Uses 50mm lenses. With Telma shutter- Novar f4.5: $100-175; Novar f3.5, rare: $125-200. With Rimset Compur- Tessar f3.5, most common: $150-250; Tessar f2.8, rare: $250-375; Biotar f2, super rare (also called "Night Kolibri"): $700-1000. Microscope version with no lens or shutter, very rare: $200-300.

Kosmopolit - 1927-34. Wood double extension field camera with brass trim. Reversing back, vertical and horizontal front movements (no swing). Tapered bellows. 5x7" (818, 818/11) or 7x9½" (819, 818/20) size. Very seldom offered. $200-300.

Liliput - 1927-28. Tiny strut folding plate camera. Celluloid "ground glass". Struts are inside the bellows. f12.5 lens. 4.5x6cm (361) or 6.5x9cm (370). $100-150.

Lloyd (510/17) - 1926-31. Black leather covered folding rollfilm camera, can also take 9x12cm cut film. Ground glass focusing by sliding out a back cover plate. "Lloyd" in leather on front. Tessar 120mm/f4.5 in Compur. $35-50.

Maximar A (107/1, 207/3) - 1927-39. 6.5x9cm folding plate camera. Slide in holders. "Maximar" on or below handle in leather. 105mm Tessar or Preminar Anastigmat f4.5 in Compur. $55-80.

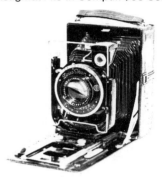

Maximar B (207/1, 207/7) - 1927-39. Similar to the "A", but for 9x12cm. Tessar 135mm/f4.5 in Compur, or 135mm Novar f6.3 or Dominar f4.5 in Klio. $50-75.

Maximar (207/9) - 1927-37. Similar, but 10x15cm. Tessar f4.5/165mm in Compur. Rare. $60-90.

Miroflex A (859/3) - 1927-36. Folding 6.5x9cm SLR plate camera. Exists with Contessa Nettel markings on some parts as it was introduced about the time of the merger. Focal plane shutter 3-2000. Can be used as a press camera by leaving the mirror up, focusing hood folded, and using

Miroflex B (859/7)

the wire finder. "Miroflex" in leather on front. With Tessar 145mm/f2.7, 135mm/f3.5 or Bio Tessar 135mm/f2.8: $275-375. With Tessar 120mm/f4.5: $225-325.

Miroflex B (859/7) - Similar to the "A", but 9x12cm. More common. With 165mm Tessar f3.5, f2.7, or Bio Tessar f2.8: $200-325. With Tessar f4.5: $175-250. *Illustrated bottom of previous column.*

Nettar 515/2

Nettar - Bob (510) was known as the Nettar (510) in England. Inexpensive folding rollfilm cameras. "Nettar" on leather. 1937-41: 4.5x6cm (515), 6x6cm (515/16), & 6x9cm (515/2). 1949-57 (Fancier style with body release and chrome top): 6x6cm (518/16) & 6x9cm (517/2). With Tessar: $30-50. With Novar or Nettar lens: $20-40.

Nettax (538/24) - 1936-38. 35mm. Basic body is the same as the Super Nettel II, but there is no folding bed and bellows. Rotating rangefinder window attached to interchangeable lens. Focal plane shutter to 1000. With Tessar 50mm/f2.8, rare: $650-750 clean & working; $300-450 with inoperable shutter. With Tessar 50mm/f3.5, rarest: add $100. For additional Triotar 105mm/f5.6 lens, add $375-500.

Nettax (513/16) - 1955-57. 6x6cm folding rollfilm camera. Chrome top. Novar 75mm/f4.5, Pronto shutter. Built in uncoupled exposure meter. $60-90.

Nettel - 1929-37 (some sizes discontinued before 1937). "Nettel" below the focal plane shutter winding/setting knob. Black leather covered press camera. 4.5x6cm (870), 6.5x9cm (870/3), 9x12cm (870/7), 10x15cm (870/9), 5x7" (870/11) sizes, with the 9x12cm being the most common. $50-150.

Nettel, Tropen (Tropical) - Focal plane press camera made of polished teak with brown leather bellows. 6.5x9cm (871/3), 9x12cm (871/7), 10x15cm (871/9), 5x7" (871/11) sizes. A very nice clean 10x15cm outfit with three teak plateholders, teak FPA and case reached $1200 at auction in July 1988. A more typical range for camera only: $500-800. *Illustrated top of next column.*

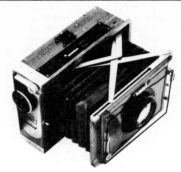

Nettel, Tropen

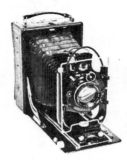

Nixe - 1927-34. High quality double extension folding cameras. "Nixe" on handle or in body leather. Dominar, Tessar, or Double Protar lens. 551/17 for 8x10.5cm rollfilm or 9x12cm cut film; 551/6 for 8x14cm rollfilm or 9x14cm cut film. $50-85.

Orix (308) - 1928-34. Quality double extension folding camera, 10x15cm plates. (Special spring back model also made.) Rack-and-pinion focus. Usually seen with Tessar 150mm/f4.5 lens. $60-100.

Palmos-O - 1927-28. 4.5x6cm plate camera with struts and folding door. Sold in Europe in 1927 only as the "Minimum Palmos". High-speed Tessar f2.7/80mm lens. Focal plane shutter 50-1000. Rare. $350-500.

Perfekt - c1927-31. Double extension, polished mahogany view camera. Tapered bellows. Vertical and horizontal front movements. Sizes 5x7" (834, 834/11, 835, 835/11) and 18x24cm (836, 837, 834/20, 835/20). Usually without model name on camera, but with "Zeiss-Ikon" round metal plate. Very rare. No active trading exists. Infrequent sales records indicate prices in $100-300 range.

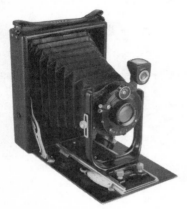

Onito - 1927-29. Inexpensive single extension folding plate cameras. Novar f6.3 lens, lever focus. 6.5x9cm (126/3) or 9x12cm (126/7). $30-35.

Piccolette (545/12) - 1927-30 in Germany, 1927-32 in the U.S.A. Inexpensive all metal strut camera for 4x6.5cm on 127 film. Metal front pulls out for use. "Piccolette" below lens, "Zeiss-Ikon" above. Rare with Tessar 75mm/f4.5 lens: MINT to $300; EXC: $150-250. More common with Achromat f11, Novar f6.3: $60-90.

Piccolette-Luxus (546/12) - 1927-30. Deluxe model with folding bed and lazy tong struts. Brown leather covering and bellows. 75mm Dominar or Tessar f4.5 lens, dial-set Compur shutter. $200-300.

Plaskop - 1927-30. Stereo box cameras.
602/1 - 45x107mm. "Plaskop" under left lens (viewed from front). f12 lenses. No brilliant finder. $100-150.
603/1 - 45x107mm. "Plaskop" in oval on left (viewed from front). Better model than the 602/1, with Novar f6.8/60mm lenses. No brilliant finder. $150-225.
603/4 - 6x13cm. Like the 603/1, but a larger size. Brilliant finder in top center. $175-275.

Polyskop - 1927-30. Precision stereo box cameras. Black leather covering. Septum magazine for 12 plates. Brilliant finder in top center. Tessar f4.5 lenses in Compur dial set stereo shutter. 45x107mm (6C9/1), or 6x13cm (609/4). $200-300.

Simplex (112/7) - 1928-30. Inexpensive folding camera for 9x12cm plates. "Simplex" in leather under handle. "Zeiss Ikon" under lens on front of front standard. Frontar 140mm/f9 or Novar 135mm/f6.3. $35-55.

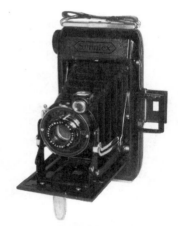

Simplex (511/2) - 6x9cm brown plastic rollfilm camera. "Simplex" on body. Several variations of struts and hardware exist. Nettar 150mm/f6.3 in Telma or Derval shutter. $55-85.

Simplex-Ernoflex - SLR. "Ernemann" on side in 1927-29 version, "Simplex Ernoflex" over lens from 1930-on. Ernoplast f4.5 or f3.5, Ernon f3.5, or Tessar f4.5 lens. Helical focusing. Focal plane shutter 20-1000. 4.5x6cm (853), 6.5x9cm (853/3), or 9x12cm (853/7). Rare. 4.5x6cm size: $400-600. 6.5x9cm or 9x12cm size: $200-300.

Sirene - Inexpensive folding plate camera. "Sirene" under handle. 1927: 6.5x9cm (135/3), 9x12cm (135/7- this number was later used on Volta). 1930-31: 8x10.5cm (135/5) made for the American market. Dominar 135mm/f4.5 lens. Compur shutter. Rare. $45-65.

SL-706 (10.3700) - 1972-73. An improved type of Icarex, with "SL-706" on body at 11 o'clock direction from the lens. Zeiss lenses. Open aperture metering. These cameras were remaindered out by Cambridge Camera at $257, with case, and most are seen in mint condition. With Ultron f1.8: $100-150.

Sonnet - 1927-30. Teakwood folding plate camera. Brown leather covering on door and brown bellows. "Sonnet" inside door at front. Radial lever focusing. Dominar or Tessar f4.5, or Novar f6.3 lens. Originally came with 3 German silver film holders. 4.5x6 (303) or 6.5x9cm (303/3): $350-650.

Stereax, 6x13cm - c1926-28. Strut-folding focal plane stereo camera, a continuation of the Contessa-Nettel Stereax. Left lensboard may be reversed for use as panoramic camera. Tessar 90mm/f4.5 lenses. Focal plane shutter 1/10-1200. Rare with the Zeiss name. One sold at auction in Germany in 3/86 for $750 in nearly mint condition with original box. We have no recent sales on record.

Stereo-Ernoflex (621/1) - 1927-29. Top quality folding stereo. Door on hood extends across entire top of camera. 75mm Ernotar f4.5, Ernon or Tessar f3.5 lenses. Focal plane shutter 20-1000. $1000-1500. *(Illustrated on p.221 under Ernemann.)*

Stereo-Simplex-Ernoflex (615/1) - 1927-30. Medium quality non-folding stereo box camera. "Ernemann" on front between lenses. Viewing hood cover is on half of the camera's top, the other half has a pop-up frame finder. 75mm Ernon f3.5 or Tessar f4.5/75mm or 80mm lenses. Focal plane shutter. $600-800. *(Illustrated on p.222 under Ernemann.)*

Stereo Ideal (651) - 6x13cm folding plate stereo camera, black leather covering. Identified on the handle. 1927 version with dial-set Compur shutters, 1928 version with Compound shutters. Tessar 90mm/f4.5. $200-300.

Stereo Ideal (650) - Similar to the 651, but a larger 9x18cm size for films. 120mm/f4.5 Tessars, Compur shutter. $250-400.

Stereo Nettel - 1927-30. Scissors strut stereo cameras. Black leather covering. Knob focus. Tessar f4.5 lenses. Focal plane

shutter. Wire finder. Removable roller blind inside separates the two images, or allows for full frame use. 6x13cm (613/4): $250-350. 10x15cm (613/9): $200-300.

Stereo Nettel, Tropical - Same as the Stereo Nettel, but in teakwood with brown bellows. 6x13cm (614/4) or 10x15cm (614/9). $400-800.

Stereolette-Cupido (611) - 1927-28. 45x107mm folding plate stereo camera. Black leather covering. "Stereolette" on outside of door, "Stereolette-Cupido" on handle. $175-275.

Steroco (612/1) - 1927-30. 45x107mm plate stereo box camera. Tapered shape. Leather covered. "Steroco" on upper front, "Zeiss-Ikon" below. Tessar 55mm/ f6.3 lenses. Derval or Dial-set Compur shutter. Rare. $175-275.

Suevia - c1926-27. Folding-bed camera for 6.5x9cm plates. Nostar f6.8 or Contessa-Nettel Periskop f11 lens in Derval 25-100 shutter. Uncommon. $40-55.

Super Ikonta Series - *Top quality black leather covered folding rollfilm cameras, with rangefinder of the rotating wedge type gear coupled to front cell focussing lens. The early cheaper lens models were sometimes called "Super Ikomat" before WWII in the U.S.A. Introduced in 1934, they were continued in gradually improving forms until 1959 or 1960. The most recent models with MX sync have increased in value because they have been rediscovered as usable cameras... a lower cost nostalgic alternative to such modern cameras as the new folding Plaubel Makinas.*

Super Ikonta A (531) - 1937-50. Same as the above, but with body release, Albada finder, and double exposure prevention. Usually with 75mm Tessar f3.5 lens. Novar f3.5 lens is rare. Schneider Xenar in 1948. No sync. $140-250.

Super Ikonta A (531) - 1950-56. Chrome top. Normal lens is Tessar 75mm/f3.5. Compur Rapid, X sync, until 1952; then MX sync; & finally Synchro Compur. The latest Synchro Compur model is increasing in demand as a usable camera. Asking prices to $1500 in Tokyo for a mint example. Mint with MX sync will sell for $700 in USA. EXC: $300-400. Compur Rapid model: $200-275.

Super Ikonta B (530/16) - 1935-37. 11 exposures 6x6cm on 120. Some of the earliest say "Super Ikomat" on the door. Separate rangefinder/viewfinder windows. 80mm f2.8 or (rarely) f3.5 Tessar. Compur Rapid to 400. No sync. Lens/shutter housing black enameled. GERMANY: $150-250. USA: $125-200. *In 1936 a model was produced in meters with European tripod socket and "Super Six 530/16" on the back of the camera and front of the ER case. These are rare, but only a modest premium seems obtainable.*

Super Ikonta A (530) - 1934-37. 16 exposures 4.5x6cm on 120 film. Usually seen with Tessar 70mm/f3.5 uncoated lens. No sync. Body release 1935-37. Direct finder (not Albada). $125-200.

Super Ikonta BX (532/16) - 1937-52. Uncoupled exposure meter. 12 exposures 6x6cm on 120. Double exposure and blank exposure prevention. "Super Ikonta- 532/16" in leather on back. Tessar 80mm/f2.8 in Compur Rapid to 400. Exposure meter in DIN or Scheiner before 1948, ASA after 1948. $90-165. *Illustrated in previous column.*

Super Ikonta BX (533/16) - 1952-57. Uncoupled exposure meter in chrome and lower profile than the 1937-52 type. "Super Ikonta 533/16" on back. Synchro Compur MX shutter to 500. Coated Tessar or Opton Tessar lens. $200-325. *Illustrated in previous column.*

Super Ikonta B (532/16) - 1937-56. Single window range/viewfinder. Lens/shutter housing in black enamel through 1948, chrome after 1948. "Super Ikonta 532/16" in back leather. Tessar 80mm/f2.8. Compur Rapid shutter, no sync to 1951. Synchro Compur shutter, MX sync 1951-on. (Some Compur Rapid models c1951 have X sync.) Synchro Compur: $250-300. Compur Rapid: $120-160.

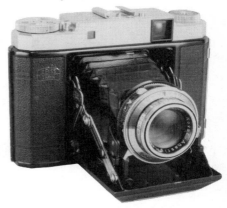

Super Ikonta III (531/16) - 1954-58. A redesigned "B" with no exposure meter. Smaller than the "B". No "front window" at lens for rangefinder. Synchro Compur MX shutter to 500. 75mm Novar or Opton Tessar (until 1956) f3.5. Tessar: $150-250. Novar: $125-150.

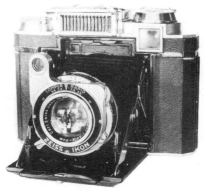

Super Ikonta BX (532/16)

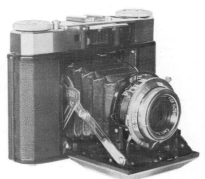

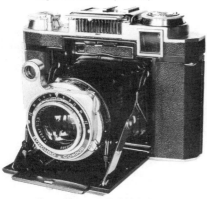

Super Ikonta BX (533/16)

Super Ikonta IV (534/16) - 1956-60. Like the III, but with built in exposure meter using the LVS system (where you lock in a guide number on shutter, after which shutter and diaphragm settings move

together). "534/16" in leather on back by latch. Tessar 75mm/f3.5 only. (During 1983, KEH Camera sold off NEW Super Ikonta IV's for $395.) $165-300.

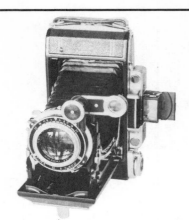

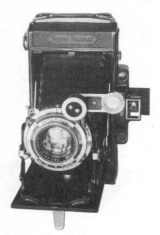

Super Ikomat C (530/2)

Super Ikonta C (530/2) - 1934-36. "Super Ikonta" or "Super Ikomat" in leather on front. "530/2" in back leather by hinge. 6x9cm format. Black enamel finish, nickel plated fittings. No body release. Triotar 120mm/f4.5 in Klio shutter, or 105mm Tessar f4.5 or f3.8 in Compur to 250 or Compur-Rapid to 400. $100-150.

Super Ikonta C (531/2) - 1950-55. "531/2" in leather by back latch. Double exposure and blank exposure prevention. Tessar 105mm/f3.5. (Rare with 106mm Opton Tessar f3.5.) Compur Rapid, X sync, or Synchro Compur, MX sync. This model is both a usable and collectable and many are sold in Japan. MINT with MX sync: $750. EXC+ $300-500.

Super Ikonta D (530/15) - 1934-36. "Super Ikomat" or "Super Ikonta" in front leather. "530/15" in leather by back hinge. Black enamel on rangefinder. 6.5x11cm on 616 film, mask for ½-frame (5.5x6.5cm) and flip-up mask in viewfinder. No body release. 120mm/f4.5 Tessar in Compur to 250, or rare Triotar f4.5 in Klio 5-100. $150-200.

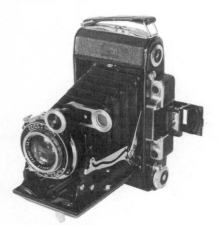

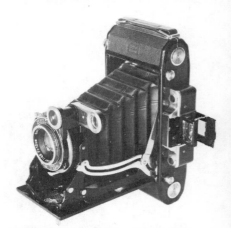

Super Ikonta C (531/2) - 1936-50. Front of rangefinder is chrome. "531/2" in leather by back hinge. Body release, double exposure prevention. Albada finder. 105mm Tessar f3.8 until 1938, Tessar f4.5 or f3.5 after 1938. Compur to 250, or Compur-Rapid to 400. $175-250.

Super Ikonta D (530/15) - 1936-39. "530/15" by back latch. Bright chrome on front of viewfinder. Albada viewfinder with ½-frame marks. Body release. No double exposure prevention. Compur to 250 or Compur Rapid to 400. No sync. $150-200.

Super Nettel (536/24) - 1934-37. 35mm folding bellows camera. Black enamel and leather. "Super Nettel" in leather on door. Focal plane shutter 5-1000. 1934-36, 50mm Tessar f3.5 or f2.8 lens; 1935-37, Triotar f3.5. $250-400.

Super Nettel II (537/24) - 1936-38. Similar to the first model, but with polished chrome door and matte chrome top. Tessar 50mm/f2.8. $400-850.

Symbolica (10.6035) - 1959-62. 35mm viewfinder camera. Coupled match needle exposure meter. "Symbolica" on top. Tessar 50mm/f2.8, front cell focus. $30-60.

Taxo (126/7)

Taxo - Inexpensive folding plate camera,

single extension. "Taxo" on body under handle. Periskop 105mm/f11, Novar 105mm or 135mm f6.3, Frontar, or Dominar lens. Derval shutter. Two variations:
1927-31 - Focus by sliding front standard on track, 6.5x9cm (122/3) or 9x12cm (122/7). $25-40.
1927-30 - Focus by radial lever, 6.5x9cm (126/3) or 9x12cm (126/7). $30-45.

Tenax - 1927. Popular strut-folding plate cameras. "Tenax" or "Taschen Tenax" on front or top. These appear to be clean-up items which were never actually manufactured by or marked "Zeiss Ikon". 4.5x6, 6.5x9, and 45x107mm (stereo) sizes. Various lenses. $80-150.

Tenax I (570/27) - 1930-41. 35mm camera for 50 exposures 24x24mm on a 36 exposure roll. "Tenax" under lens. No rangefinder. Novar 35mm/f3.5 lens. Compur shutter, cocked and film advanced by left-hand lever. $35-60.

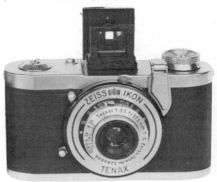

Tenax I (East Germany) - c1948-53. This model was made by the East German "VEB Zeiss Ikon" which later became "VEB Pentacon" after settlement of the trademark disputes. Like the 570/27, but also available with coated Tessar 37.5mm/f3.5 lens. Flash sync contact on top of shutter. "Zeiss Ikon" above lens, "Tenax" below. Early versions,

595

c1948, have Compur shutter. Later with unmarked Tempor shutter. Originally with folding optical finder and folding advance lever. New top housing, c1953, with incorporated optical finder. Advance lever has solid metal knob. Common in Germany. $35-60.

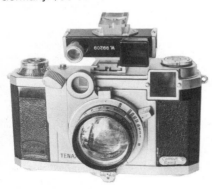

Tenax II with Contameter

Tenax II (580/27) - 1937-41. More expensive and earlier version with coupled rangefinder, interchangeable lenses, and shoe for viewfinders and Contameter (1339). Most often found with Tessar 40mm/f2.8: $250-325. With Sonnar 40mm/f2: $250-350.
Tenax II Accessories:
- 2.7cm Orthometar f4.5 wide angle. $300-500.
- 7.5cm Sonnar f4 telephoto. $300-500.
- Contameter (1339) close-up rangefinder for focusing at 8", 12", and 20". $75-100.

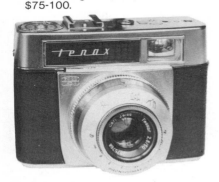

Tenax Automatic (10.0651) - 1960-63. Full frame 35mm. "Tenax" at 11 o'clock from lens on exposure meter window. Automatic exposure control by selenium cell. No rangefinder. Tessar 50mm/f2.8, Prontormat shutter. Front cell focus. $25-45.

Tengoflex (85/16) - 1941-42. Box camera for 6x6cm exposures on 120 film. Large brilliant finder on top, giving the appearance of a twin lens reflex. "Tengoflex" on front. Extremely rare. Several sales 1974-81 in the range of $275-325. One sale at 9/86 auction for $675. A year later, another sold for $190 with some missing leather and a non-original advance knob.

Tessco (76/1) - 1927. Double extension 9x12cm folding plate camera. "Tessco" in leather of handle. Seen with 1 of 5 different lenses, from Periskop f11 to Tessar f4.5. Rare. $50-75.

Toska (400) - c1927. Triple extension, horizontal, folding bed camera for 13x18cm plates. Litonar 180mm/f6.8 in Cronos B shutter. $175-225.

Trona (210 series) - 1927-30. Quality folding plate camera, double extension, screw controlled rise and shift. "Trona" and model number under handle. Dominar or Tessar f4.5 lens. 9x12cm (210/7): $40-60. 6.5x9cm (210/3) or 8.5x11cm (210/5): $50-100. *The 8.5x11cm (210/5) was apparently made for the English and American market for use with 3¼x4¼" film. This size is rare; no recorded sales.*

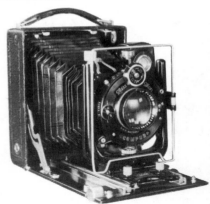

Trona (212/7) - c1928-36. 9x12cm folding plate camera similar to the 210 series. Tessar lens, Compur shutter. $50-70.

Trona (214 series) - 1929-38. A fancier version, with aluminum ground glass back (frequently exchanged for a regular back). Tessar f3.5 lens in Compur shutter (rimset after 1930). "Trona" and model number on body under handle. 6.5x9cm (214/3): $70-125. 9x12cm (214/7): $60-100. (Slightly less for f4.5 models.)

Tropen Adoro - 1927-36. Polished teak, folding plate camera. Brown leather covering on door and back. Brown double extension bellows. "Tropen Adoro" and model number on leather of door. Tessar

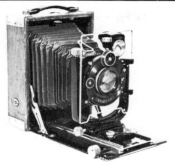

f4.5 lens, Compur shutter. Sizes: 6.5x9cm (230/3), 105 or 120mm lens. 9x12cm (230/7), 135 or 150mm lens. 10x15cm (230/9), 165 or 180mm lens. $350-550.

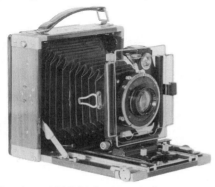

Tropica - 1927-31 (to 1935 in foreign catalogs). A heavy polished teak folding plate camera, the second most expensive camera in 1930 Zeiss line. Strongly reinforced with German silver corners and battens. No leather anywhere on the outside, even the door on the ground glass back is teak. Black bellows. Back rotates ¼ turn. "Zeiss-Ikon" between pull knobs on front stand. 14 different lenses available, all in Compur shutter. Sizes 9x12cm (285/7) and 10x15cm (285/9) are both rare. The 5x7" (285/11) is VERY rare. Sales records are hard to find. Estimate: $800-1200.

Unette (550) - 1927-30. Wood box camera, with leatherette covering. For paper-backed rollfilm, 22x31mm. "Unette" on front in leatherette over lens, "Zeiss-Ikon" over lens, "Ernemann" on side. Metal frame finder at top rear. 40mm/f12.5 lens. Very rare. Only one known sale in 1980 at $225.

Victrix (101) - 1927-31. Small folding plate camera for 4.5x6cm. "Victrix 101" in leather on camera top. "Zeiss Ikon" on lens, door, and between pulls. 75mm Novar f6.3, Dominar f4.5, or Tessar. Compur shutter. $85-150. *Illustrated top of next column.*

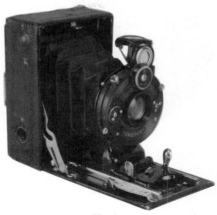

Victrix

Volta - 1927-31. Inexpensive folding plate cameras. Single extension. "Volta" on body under handle, "Zeiss Ikon" on door. Dominar or Tessar lens, Klio or Compur shutter. Radial arm focusing in 6.5x9cm (146/3) or 9x12cm (146/7). Focusing by slide front standard in 6.5x9cm (135/3) or 9x12cm (135/7). (10x15cm and 13x18cm sizes were sold in 1926/27 as clean up of old stock on hand at the time of the union.) Although Voltas are not common, there is little interest in them. $35-55.

ZENIT (Russia)
Photo Sniper - c1968-1980's. Zenit E camera with normal Helios 58mm/f2 and a special Tair-3 300mm/f4.5 lens attached to a gunstock with pistol grip. In fitted metal case: Some dealers ask up to $325 (with ads repeated for months!) but these are common in Europe and regularly sell for $125-175.

Zenit, Zenit 3, Zenit 3M, Zenit B - 1960's-1970's. 35mm SLR cameras. Fixed pentaprism. FP shutter 30-500, B. Including one of the various "normal" lenses. $25-40.

Zenit 80 (Zenith 80) - c1971. Copy of Hasselblad. Industar 80mm/f2.8 lens. FP ½-1000 shutter. With magazine: $150-250.

ZENITH CAMERA CORP.

Comet - c1947. Plastic camera for 4x6cm on 127 film. Vertical style. Telescoping front. $10-15.

Comet Flash - c1948. Plastic camera with aluminum top and bottom. 4x6cm on 127. $10-15.

Sharpshooter - c1948. Black & silver metal box camera. Identical to the J.E. Mergott Co. JEM Jr. $5-10.

Vu-Flash "120" - Hammertone finished 6x9cm box camera. $5-10.

ZENITH EDELWEISS - Folding rollfilm camera for 6x6cm on 620 film. $15-20.

ZENITH FILM CORP.
Winpro 35, Synchro Flash - c1948. Gray plastic 35mm. f7/40mm. $15-25.

ZION (Ed. Zion, Paris)
Pocket Z - c1920's. Folding strut-type camera for 6.5x9cm plates. Rex Luxia or Boyer Sapphir lens. Dial Compur shutter. Leather bellows. Metal body. $75-125.

Pocket Z, stereo - c1928. Strut-folding camera for 6x13cm plates. Zion Anastigmat f6.3/75mm lenses. Gitzo stereo shutter. $150-200.

Simili Jumelle, 6.5x9cm - c1893. Rigid-bodied camera for 6.5x9cm plates in magazine back. Zion Anastigmat lens. Guillotine shutter. Folding Newton finder. $125-175.

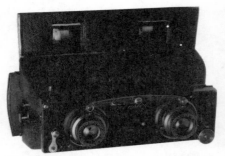

Zionscope - c1900. Stereo camera for 45x107mm plates. Unusual binocular viewfinder and hinged body. $250-350.

ZODIAC - Novelty 4x4cm "Diana" style camera. $1-5.

ZORKI (USSR) *Manufactured by Krasnogorsk Mechanical Works (KMZ) in Krasnogorsk, near Moscow. These are 35mm copies of Leica and other well-known cameras. Zorki cameras, as well as many other Russian cameras, are seen with the name written in Roman letters or in Cyrillic letters.*
Mir - c1959-60. 35mm CRF. Similar to the Zorki 4, but no slow speeds. Uncommon. $45-65.

Zorki - c1948-56. Leica II copy with separate RF/VF windows. 38mm RF base. Removable base. Industar-22 f3.5/50mm. Fairly common in Germany, where they sell for: $40-85.

Zorki 2 - c1952-55. Similar to the Zorki, but with self-timer. $60-90.

Zorki C (S) - c1955-58. Similar to the Leica II, but rangefinder cover is slightly taller and extended, incorporating flash sync. Industar-22 or Industar-50 f3.5/50mm lens. Common in Germany. Clean & working: $40-60. Often with defective shutter for $20-30.

Zorki 2C - c1956-58. Similar to the Zorki C, but with self-timer. Industar-50 f3.5/50mm or Jupiter-8 f2/52mm. $50-80.

Zorki 3 - c1952-55. 35mm with CRF, removable back, like the Kiev cameras. 39mm RF base. Slow speed dial on front. Jupiter-8 f2.0/52mm. $50-75.

Zorki 3C - c1955-56. Similar to the Zorki 3M, but has flash sync. Top cover has been redesigned. $40-60.

Zorki 3M - c1955. Similar to the Zorki 3, but slow speeds appear on the shutter speed dial on top. $40-60.

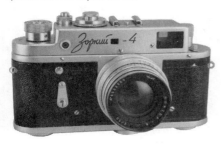

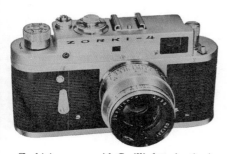

Zorki 4 cameras with Cyrillic lettering (top) and Roman lettering (bottom)

Zorki 4 - c1956-73. Coupled rangefinder. Jupiter-8 f2/50mm or Industar-50 f3.5/50mm. Focal plane shutter 1-1000. Similar to the Zorki 3C, but with self-timer. The most common model. $30-55.

Zorki 4K - c1973-77. Similar to the Zorki 4, but has lever wind and a fixed take-up spool. Jupiter-8 f2/50mm lens. $35-50.

Zorki 5 - c1958-59. 35mm CRF. Industar-50 f3.5/50mm or Jupiter-8 f2/50mm. FP shutter 25-500, sync. Rapid advance lever. Removable base. $40-60.

Zorki 6 - c1960-66. Like the Zorki 5, but with hinged back and self-timer. FP 30-500. $35-50.

Zorki 10 - c1965. Similar to the Ricoh Auto 35. Fixed Industar-63 f2.8/45mm lens, leaf shutter 1/30-500. Automatic exposure. Not like the above Leica screwmount models. $40-65.

Zorki 11 - Similar to the Zorki 10, but no rangefinder. $25-40.

Zorki 12 - Half-frame version of the Zorki 11. Helios-98 f2.8/28mm lens. $30-50.

ZUIHO OPTICAL CO. (Japan)
Honor - c1956-59. Rangefinder 35, Leica copy. Konishiroku Hexar f3.5/50mm, FP shutter 1-500; or Honor f1.9/50mm, FP 1-1000. $400-500.

ZULAUF (G. Zulauf, Zurich) *Original manufacturer of the Bebe and Polyscop cameras which continued successfully as Ica cameras after Zulauf joined the recently formed Ica organization in 1911.*
Bebe - Compact camera for 4.5x6cm plates. Before 1911 it was distributed by Carl Zeiss and Krauss. Logo on camera is G.Z.C. in oval. $150-175.

Polyscop - c1910, then continued as an Ica model. Stereo camera for 45x107mm plates in magazine back. $175-250.

ZUNOW OPTICAL INDUSTRY
Zunow - c1958. First Japanese 35mm SLR with auto diaphragm. Instant return mirror. Interchangeable pentaprism or waist level finders. With Zunow 50mm/f1.8 or 58mm/f1.2 lens in threaded bayonet mount. Rare. At $3000, people would wait in line to buy. $3000-5000 or more.

- 50mm Zunow f1.1 lens - c1953. Most often found in Nikon bayonet mount, but also made in Leica screwmount. Up to $1200 mint in Japan. $400-600 elsewhere.

MOVIE CAMERAS

COLLECTING MOTION PICTURE CAMERAS

Many photographic and persistence of vision developments, over a long period of time, led to the advent of motion pictures. True motion picture cameras, as we know them, did not come into being until the 1890's, and few such cameras were made during that very early period. Some were one-of-a-kind. The very few surviving pre-1900 cameras are in museums and private collections with perhaps a very few in attics, basements or warehouses throughout the world.

From about 1900 on, a variety of motion picture cameras appeared. Some were manufactured for sale to the growing number of motion picture studios and others were made by the studios themselves. A small number were made for amateurs.

The collecting of motion picture cameras from this period on can be a fascinating hobby. The limited number of early cameras available makes collecting challenging. In addition, some of the early cameras do not carry identification because some manufacturers borrowed freely from the designs of others and there were many patent infringment problems. This lack of identification calls for research by the collector to identify some of the cameras.

In the early motion picture days there were many film widths. The 35mm width pioneered by Edison in the U.S.A. and Lumiere in France became the standard for professional motion pictures. Most of the cameras available to collectors are of the 35mm variety and they are found in a wide array of sizes, shapes, and configurations.

It is interesting to note however, that even before 1900 there were 17½mm cameras and projectors for use by amateurs. Several amateur cameras using different 17½ film perforation configurations were made over the years. Cameras using 10, 11, 15, 22, 32, 40, 60, and 70mm film widths were also made. Motion picture cameras were made that used glass plates and circular discs of film for sequential exposures.

In 1912, Pathe of France introduced a 28mm projector and a large library of 28mm feature films for home use. A limited number of 28mm cameras followed. Also in 1912, Edison introduced a 22mm projector (3 rows of pictures per width) and a library of their films, but no 22mm cameras were offered to the public.

Movie cameras did not become available in appreciable numbers until after the introduction of the amateur film formats of 16mm in the U.S.A. and 9½mm in Europe in 1923. Amateur motion pictures then became very popular because the new 16 and 9½mm cameras were easy to use and the new reversal films were economical and had a safety film base.

With the subsequent introduction of 8mm cameras and film in 1932 and Super 8 in 1965 the motion picture camera collector can specialize in many ways, for example: particular format, chronological period, country of origin, manufacturer, or first models, etc. To those just entering the fascinating hobby of motion picture camera collecting: Happy Collecting.

Much of the information in the movie section is due to the efforts of several collectors who specialize in movie equipment. Wes Lambert is a long time collector who specializes in the very early motion picture cameras. He lectures and displays his cameras in museums, cinema schools and camera clubs. He provided most of the information and photographs for the early 35mm cameras and a few of the smaller ones, as well as updated price estimates for these rare early cameras. He will correspond with other movie camera collectors. Contact him at: 1568 Dapple Ave., Camarillo, CA 93010. Tel 805-482-5331.

Cynthia Repinski provided the information on the cameras of the Universal Camera Corp. of New York City. Cindy specializes in both movie and still cameras from Universal. She is an active collector and trader. You may contact her at P.O. Box 13, Milwaukee, WI 53201.

Much of the 8 and 16mm camera information was prepared by Joan McKeown for the 5th edition of this guide. This was greatly expanded in the sixth edition through the courtesy of Mr. Alan Kattelle. He not only expanded the number of cameras and the historical information concerning them, but also initiated an entirely new section on movie projectors. Cine collectors may write to him at 50 Old County Road; Hudson, MA 01749.

Editor's Note on Pricing Trends: While the editors are active collectors of still cameras, we do not collect cine cameras or equipment. However, our pricing research encompasses cine equipment. From the standpoint of statistics, we see trends emerging in the collecting of movie camras which parallel what has already happened with still cameras.

Early hand-cranked cameras are showing continued strength and increasing prices. Middle-priced cameras (most 16mm spring-wind types) are relatively stable. Lower priced, common cameras, particularly 8mm amateur cameras, have weak and unstable prices because supply greatly exceeds demand.

AGFA (Berlin)

Movex 8 - c1937. 8mm movie camera taking a 10m length of single-8 film in Agfa-Kassettes. Black lacquered metal body; rectangular shape. Optical eye-level finder. Spring motor drive, 16 fps. Interchangeable Agfa Kine Anastigmat f2.8/12mm focusing lens. $20-30.

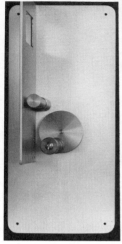

The six most basic motion picture camera movements are illustrated here in chronological order. Almost all motion picture movements are derived from these six. These models were made by Eric Berndt and are now in the Smithsonian Institution.

Top, left to right:
Demeny Beater movement, patented 1893;
Lumiere-Pathe movement, patented 1895;
Geneva Star movement, patented 1896;
Prestwich movement, patented 1899.

Bottom left to right:
Williamson movement, patented 1908;
Chronik movement, patented 1913.

Movex 8L - c1939. 8mm movie camera taking a 10m single-8 Agfa-Kassette. Black lacquered metal body; rectangular shape. Optical eye-level finder. Spring motor drive, 16 fps. Agfa Kine Anastigmat f2.8/12mm fixed focus lens. Coupled meter. $20-30.

Movex 16-12B - c1928. 16mm movie camera taking a 12m Agfa-Kassette. Black leather covered metal body; rectangular shape. Waist-level brilliant finder and eye-level Newton finder. Spring motor drive, 16 fps. Agfa Kine Anastigmat f3.5/20mm focusing lens. $25-35. *Illustrated next page.*

Movex 16-12L - c1931. Like the 16-12B but Agfa Symmetar f1.5/20mm. $25-35.

Movex 30B, 30L - c1932. Takes 16mm in 100' spools. Blue leather covered metal body, oval in shape. Optical eye-level finder. Spring drive. Model 30L has 8-12-16 fps; Model 30B also has 32fps. Interchangeable focusing Kine Anastigmat f2.8/20. $85-100.

Movex 88 - c1957. 8mm movie camera, using double 8 film on 25' spools. Gray crinkle-finished metal body. Optical eye-level finder. Spring motor, 16 fps. Agfa Kine Anastigmat f2.5/11mm lens. Made in focusing and fixed focus versions. $10-15.

Movex 88L - c1958. Similar to the Movex 88, but has built-in coupled meter. Agfa Movexar f1.9/13mm focusing lens. $15-25.

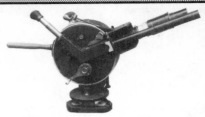

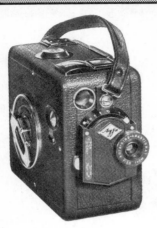

Movex 16-12B

Movex Automatic I - c1958. Double-8 movie camera using 25' spools. Gray leather covered metal body. Optical eye-level finder. Spring motor, 16 fps. Agfa Movestar f1.9/12.5mm focusing lens. Automatic light meter. $10-15.

Movex Automatic II - c1963. Double-8 movie camera taking 25' spools. Two-tone grey hammertone metal body. Optical eye-level finder. Spring motor, 18 fps. Agfa Movestar f1.9/12.5mm focusing lens. Automatic light meter. Features are almost identical to the Movex Automatic I, but the body is re-designed to give it a more modern appearance. $10-15.

Movex Reflex - 1963. 8mm movie camera using spools. Spring motor. Reflex viewing, electric eye visible in viewfinder. Schneider Varigon zoom f1.8/7.5-37.5mm. $20-30.

Movexoom - 1963. Battery-driven 8mm movie camera using spool film. Gray and black enamel body. Reflex viewing. Coupled electric eye. Variogon f1.8/9-30mm manual zoom lens. $20-30.

AKELEY CAMERA, INC. (New York)
Carl Akeley, a famous naturalist, scientist, and inventor, found fault with the best available motion picture cameras for use in photographing wild animals in Africa. He then designed this camera system.
Akeley 35mm Motion Picture Camera - 1914. The Akeley camera features interchangeable taking and viewing lens pairs, and can use very long telephoto lenses. The viewfinder eyepiece optics are articulated. A unique dual gyroscope mechanism built into the tripod head provides a very smooth one hand pan and tilt. The 200 foot film magazines are the

displacement type and include the supply/takeup sprocket for fast reload. The Akeley was affectionately known as the "pancake" and was a favorite of newsreel and sports cameramen for decades. Range: $900-2500. *Camera shown is Serial No. 2.*

ANSCO
Cine Ansco - c1930. The first 16mm amateur movie camera from Ansco. Includes Models A & B. Black or brown leather covered metal body; rectangular in shape. Optical eye-level finder. Spring motor, 8-64 fps. Interchangeable fixed focus Agfa Anastigmat f3.5 lens. $25-40.

Ansco Risdon Model A - c1931. 16mm movie camera manufactured by Risdon Mfg. Co., Naugatuck, Connecticut. Takes 50' spools. Black crinkle-finish lacquered metal body. Optical eye-level finder. Spring motor, 16 fps. B&L Ilex f3.5/1" fixed focus lens. $20-25.

ARGUS
Automatic 8 - 8mm movie camera. Two-tone green lacquered metal body. Battery-operated motor. Cinepar f1.8/13mm lens. Coupled meter. $10-15.

ARNOLD & RICHTER (Munich, Germany)
Kinarri 35 - c1925. This is the first Arri camera. The name was derived from KINe & ARnold & RIchter. The Arri name which became synonymous with professional cinematography actually was used first on a camera designed for amateur use. Drum-shaped aluminum body. Hand-cranked movement for 35mm film on 15m spools. Arrinar f2.7/40mm lens. $1200-1600.

Tropical Kinarri - c1927. 35mm exposures on a 25' film cassette. Body is square with rounded corners indstead of drum-shaped. Black-painted finish. Triotar f3.5/35mm. Hand-crank. Rare. $1400-1800.

ARROW WORKS FOTO NEWS SHA (Japan)
Arrow Cine Camera, Model 50 - c1934. Well-made 16mm spool camera. Spring motor, 3 speeds. Focusing Dallmeyer f1.8. Closely resembles the Victor 16's. $75-125.

ASSOCIATED PHOTO PRODUCTS (NY)
Magazine Pocket - c1951. There is no identification whatsoever on this camera,

but it is otherwise a clone of IPC Simplex Pockette 16mm magazine camera. B&L f3/35mm lens. Telescoping finder. Footage indicator. Gray crinkle finish. $15-30.

BARKER BROS. (LOS ANGELES, CA)

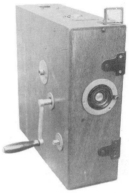

King Barker 35mm Motion Picture Camera - 1917. This camera, known as "The Educator" was manufactured by the Angeles Camera Co. for Barker Bros., a pioneer California furniture Co. It is almost identical to an early English Williamson type camera but "The Educator" can also be used as a projector and a printer. The camera was often used to photograph local events in small towns for projection in the local theater. This camera was also sold under the Omnio Mfg. Co. name. Range: $500-1250.

BAUER
Bauer 88B - c1954. 8mm spool film camera. Hammertone lacquered light blue finish. f1.9 lens. Electric eye/match needle exposure control. Four speeds. $15-25.

Bauer 88L - c1961. 8mm spool film camera. Grey hammertone finish. Bauer Iscovaron Zoom lens f1.8/9-30mm. Spring-wind motor to 64 fps. $15-25.

BEAULIEU
Reflex Control - c1962. Double-8 spring-wind camera. Spool film. Grey body. Reflex viewing. 12-64 fps, 5 speed. Has motor for zoom lens, Schneider Variogon f1.8/8-48mm. $50-75.

BELL AND HOWELL (Chicago, IL, USA)
Bell & Howell Cine Camera #2709 - This excellent studio camera was considered a revolutionary design when introduced in 1912. It features all metal construction with an external dual magazine. A four lens turret is incorporated and preview viewing and focusing can be accomplished through the

taking lens. The most sophisticated feature is the fixed registration pins that engage two film perforations during exposure. This feature and the overall precision of this camera led to its use in studios throughout the world. Although initially a hand crank camera, electric motor drive was soon used. Bell and Howell 2709 cameras are plentiful but are quite expensive for the collector as they are still in use as animation and special effects cameras. Range: $1250-4500.

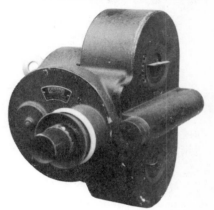

Eyemo 35mm Motion Picture Camera - 1926. The Eyemo camera is the 35mm version of the very successful Filmo 16mm camera introduced 3 years earlier. The Eyemo is a rugged camera that found great use in newsreel photography. Many Eyemo cameras were used by the U.S. Military during World War II. Range: $100-250.

Filmo 70 - *A series of 16mm motion picture cameras introduced in 1923 and lasting until 1979 when Bell & Howell sold the business. The first Filmo camera was introduced shortly after the Cine Kodak and Victor 16mm cameras. The Filmo is an excellent design that had previously appeared briefly as a 17½mm camera. A compact die cast metal body encloses 100' film spools and a heavy spring drive motor. It has a rugged version of the very successful Lumiere/Pathe film transport movement.*
Filmo 70A - 1923. Black crackel finish. Eye-level finder. Spring motor wound by large key on the side. 8-16 fps. Interchangeable Taylor Hobson f3.5/1" fixed focus lens. $20-40.

Filmo 70AC - 1932. Same as the 70A, except with "Morgana System", an early additive color system. Very rare. Price not established.

Filmo 70AD - c1926. Called "Golf Model". Equipped with 110 degree shutter, supposedly to permit better analysis of a golfer's swing. $35-50.

Filmo 121-A - 1934. Bell & Howell's first 16mm magazine cine camera for "Pockette" or "old style" magazines. Brown leatherette & brown lacquered aluminum body. Optical eye-level & waist-level finders. Spring motor 16-24 fps. Interchangeable fixed focus Cooke Anastigmat f2.7/1"lens. $18-24.

Filmo 127-A - 1935. First U.S. made single 8mm movie camera. Called "Filmo Straight Eight". Spring motor 8-32 fps. Interchangeable Mytal Anastigmat f2.5/12.5mm lens. Uncommon. $50-75.

Filmo 141-A, 141-B - 1937. 16mm magazine movie cameras for new Eastman Kodak magazines. Art-deco black enamel metal body. Optical eye-level finder. Spring motor. 141-A has 8-32 fps; 141-B has 16-64 fps. Interchangeable Taylor Hobson f3.5/1" lens. $25-35.

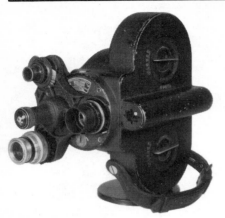

Filmo 70C - 1927. First Filmo with 3-lens turret. $40-60.

Filmo 70D - c1929. Similar to the 70C, but has a more compact turret. 7 speeds, 8-64 fps. $50-75.

Filmo 70DL - c1951. Brown crackle-finish body. 3-lens turret viewfinder brings correct viewfinder lens into use to match the taking lens. Parallax-compensation from 3" to infinity. Super Comat f1.9/1" normal lens. $60-90.

Filmo 70DR, 70HR - 1955. Last of the Filmo 70 cameras. Many professional features such as critical focuser, frame counter. Adapted for external magazines and motor drive. Still in use professionally. $100-200.

Filmo 70G - c1939. Takes slow motion pictures only, operating at 128 fps (eight times the normal speed). Has single interchangeable lens mount instead of 3-lens turret. Taylor-Hobson Kinic f1.5/1" focusing lens. $250-350.

Filmo 70J - 1948. Called the "Specialist". A special professional turret model with shift-over slide base. Very rare. Price not established.

Filmo 70SR - c1963. Features similar to the 70HR, but adapted for slow motion only, operating at 128 fps. $150-200.

Filmo 75 - c1928. 16mm movie camera taking 100' spools. Black, brown, or grey leather covered metal body. Leather is tooled with intricate patterns. Oval shape. Eye-level finder. Spring motor, 16 fps. Interchangeable Taylor Hobson f3.5/20mm fixed focus lens. $50-65.

Filmo 75 A-5 - 1931. Parallax viewfinder. Black pebbled leather. $75-125.

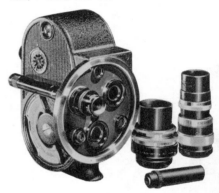

Filmo Aristocrat Turret 8 - c1940. Same as the Filmo Sportster, but with 3-lens turret. $5-10.

Filmo Auto Load - c1940. 16mm magazine movie camera. Brown plastic covered aluminum body. Eye-level finder. Spring motor, 8-32 fps. Interchangeable Lumax f1.9/1" lens. $13-17.

Filmo Auto Load Speedster - c1941. Identical to the Filmo Auto Load, but with speeds of 16-64 fps. $12-18.

Filmo Auto Master - c1941-50. Same as the Filmo Auto Load, but with 3-lens turret. Lens turret also holds the viewfinder objectives, rotating the correct viewfinder into place to match the lens in use. A typical 3-lens set includes Taylor-Hobson f1.5/1", f4.5/4" and f2.7/17mm. $40-60.

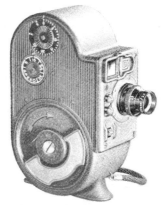

200-T Auto-Load - c1952. Two-lens turret. Sales records to $100 with 3 lenses.

200 TA Auto Master - c1954. 3-lens turret. One sold at auction with 3 lenses for $250.

200EE - c1956. 16mm automatic iris control (battery operated) movie camera, advertised as the first and most famous 16mm EE camera. Also called the world's only 16mm EE movie camera in 1959. Magazine or spool-loading models. Spring motor drive, 16-64 fps. Brushed chrome aluminum body with black leatherette. Optical eye-level finder. Super Comat f1.9/20mm focusing lens. WA and Tele auxiliary lenses available. $25-40.

Filmo Companion - c1941. Double-8 spool load movie camera. Brown leatherette and painted metal body. Eye-level finder. Spring motor, 8-32 fps. Interchangeable Anastigmat f3.5/12.5mm fixed focus lens. $5-10.

Filmo Sportster (Double Run Eight) - c1939-50. Double-8 movie camera. Early models only say "Filmo Double Run Eight". Later models also say "Sportster". Grey body. Similar to the Filmo Companion, but 16-64 fps. $5-10.

Filmo Turret Double Run 8 - c1939. Same as the Filmo Sportster (Double Run Eight), but with 3-lens turret. Matching viewfinder objectives also mount on the turret head. Typical 3-lens set includes f2.5/12.5mm, f2.7/1", f3.5/1.5". $15-30.

Magazine Camera-172 - c1947. 8mm magazine movie camera. Brown leatherette covered metal body. Eye-level finder. Spring motor, 16-64 fps. Interchangeable focusing Comat f1.9, f2.5, f3.5/½" lenses. Available in single lens or 2-lens turret models. $4-8.

Magazine 200 - *16mm magazine movie camera, an updated version of the Filmo Auto Load/ Auto Master series. Chromed metal body with tan leather. Optical eye-level finder. Spring motor, 16-64 fps. Interchangeable Taylor Hobson Cooke f1.9/1" lens. Three versions:*
200 Auto-Load - c1952. Single lens version. $15-25.

220 - c1954. 8mm movie camera referred to in ads as the Wilshire. Gray die-cast aluminum body. Spring motor. Optical eye-level finder. Super Comat f2.5/10mm lens. "Sun Dial" as on the 252. (see below). $5-10.

240A - c1954. 16mm movie camera, with automatic loading feature for 100' rollfilm. Fast crank-winding spring motor, 5 speeds, 8-48 fps. Remaining power indicator and automatic run-down stop. Footage counter. Die-cast aluminum body with black morocco covering and satin chrome finish. Sunomatic f1.9/20mm focusing lens or f2.5/20mm fixed focus lens. $40-70.

240 Electric Eye - 1957. 16mm camera for 100' spools. Accepts single or double perforated films. Spring motor, 5 speeds. Automatic film threading. Remaining power dial and footage counter. Automatic exposure control. Super Comat f1.9/20mm lens. $50-75.

252 - intro. 1954. 8mm movie camera, referred to in ads as the Monterey. Two-tone brown die-cast aluminum body. Optical eye-level finder, marked for telephoto attachment. Spring motor, 16 fps. Super Comat f2.3/10mm fixed focus lens. "Sun Dial" diaphragm setting allows the user to set the dial for the lighting conditions and the diaphragm is set accordingly. Available in single lens or 3-lens turret models. $5-10.
Illustrated top of next page.

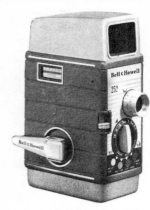

Bell & Howell 252

319 - Double-8mm movie camera. Two-tone brown body. Spring motor, 10-40 fps. Super Comat f1.9/10mm lens. $4-7.

Bell & Howell Projectors
Design 57-A - 1923. First 16mm projector by B&H. 400' capacity; 200w lamp; belt drive to take up and rewind. First model of Design 57 series is distinguished by round base, single condenser slot, fixed resistance. $25-40.

Later models, 57-B, -C, etc. - Have oval base, auxiliary slot for Kodacolor filter, and variable resistor for motor. $10-20.

Design 120-A - 1933. "Filmosound". First B&H 16mm sound-on-film projector. 1600' capacity; 500w lamp; power rewind; built-in amplifier. Estimate: $30-40.

Design 122-A Filmo 8 Projector - 1934. First B&H 8mm projector. 200' capacity; 400w lamp; geared takeup and power rewind. Estimate: $20-30.

BELL MANUFACTURING CO. (Des Plaines, IL)
Bell Motion Picture Camera, Model 10 - c1936. 16mm movie camera taking 50' spools. Black crinkle painted metal body. Oval shape. Small sportsfinder. Spring motor. Fixed focus lens. $20-30.

BLAUPUNKT-WERKE
Blaupunkt E-8 - c1950. Rare 8mm movie camera, taking 10m Agfa-Movex Kassettes. Spring wind by a large lever, 16 fps. Black lacquered crinkle-finish metal body. Direct optical viewfinder. Rodenstock Ronar f1.9/10mm in fixed-focus mount. $150-250.

BOLSEY *See the still camera section for a description of the Bolsey 8 (page 82).*

BRISKIN MFG. CO. (Santa Monica, CA)
Briskin 8 - c1947. Regular 8mm magazine camera. 4-speed spring motor. Telescoping finder. Available in black pebble or brown alligator finish. $20-30.

BRUMBERGER
8mm-E3L, T3L - 8mm movie camera with 3-lens turret. Grey and black body. Brumberger f1.8/13mm normal lens. With normal, tele, and wide angle lenses: $10-20.

BUTCHER AND SONS LTD. (London, England)

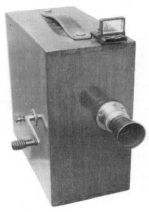

Empire 35mm Motion Picture Camera - c1912. This wood body, hand crank amateur camera is simple and basic in design. It has 100' internal magazines and a fixed focus f6.3/50mm lens. The price was modest and the operation elementary. The English Ensign and Jury cameras are almost identical. Range: $500-1200.

CAMERA CORP. OF AMERICA (Chicago)
Cine Perfex Double Eight - 1947. 8mm magazine camera using 25' Kodak magazines. Footage counter. Spring motor drive, 8-32 fps. 3-lens turret with focusing Velostigmat lenses: f2.5/½", f2.5/1", f3.5/1½". Through-the-body viewfinder has built-in masks for different lenses. Uncommon. $15-20.

CAMERA PROJECTOR LTD. (London, England)
Midas 9½mm Motion Picture Camera/Projector - 1933. The Midas 9½mm camera is unusual in that it is both a camera and a projector. An internal battery pack provided power to drive the camera. As a projector it was hand cranked and illuminiation power was provided by the battery pack. Range: $55-75. *Illustrated top of next page.*

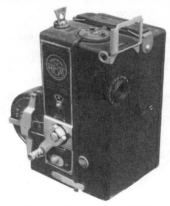

Camera Projector Ltd. Midas

Campbell Cello closed (above) and with back open showing the large internal film magazine (below)

CAMERAS LTD. (Slough, England)

Dekko - c1934. 9.5mm movie camera taking 10m Pathe-size cartridge. Black bakelite art deco body. Optical eye-level body. Spring motor, 16-64 fps. Fixed focus interchangeable Taylor Hobson f2.5/23mm lens. $20-30.

Dekko Model 104 - c1937. Similar to the Dekko, but black lacquered alumnium body. Speeds 8, 16, 64 fps. Viewfinder has parallax compensation. Ross f1.9/1" or Dallmeyer f1.5/1" focusing lens. $25-35.

CAMPBELL (A.S. Campbell Co., Boston, MA)
Cello - c1918. 35mm hand-cranked movie camera. Leather covered wood body. Combination chain and belt drive. Internal wood magazine holds approx. 75' of film. B&L Tessar f3.5 lens. $200-400. *Illustrated top of next column.*

CAMPRO LTD. (Home Cine Cameras, Ltd., London)
Campro - c1927. 35mm movie camera that could also be used as a projector by attaching two special lamp housings. Black metal and wood body is partly leather covered and partly painted. Folding Newton finder. Hand crank, 1 rotation per 8 frames. Uses 100' spool. Dallmeyer focusing f3.5 lens. $250-280.

Campro Cine Camera-Projector - c1935. 9.5mm movie camera, taking 10m Pathe cartridges (later model also used Campro-cassettes). Black crinkle finish metal body. Sportsfinder on top. Spring motor, 16 fps. f3.5 fixed focus lens. Camera could also be used as a projector with an accessory attachment. $35-45.

CANON (Japan)
Canon Eight-T - 1957. 8mm spool film camera with 2-lens turret. Viewfinder for

6.5mm, 13mm, 25mm, and 38mm lenses. Automatic parallax adjustment via cam surface on lens barrel. Ground glass focusing finder. Spring motor. $30-40.

CARENA S.A. (Geneva, Switzerland)
Autocarena - c1962. 8mm spool film. Black leather-covered metal body. Optical eye-level viewfinder. Spring motor is wound by turning the "pistol grip" style handle. 8-32 fps. Steinheil Culminar f1.9/13mm lens. $25-40.

Carena Zoomex - 1962. 8mm spool camera. Electric eye, manual or automatic exposure control. Angenieux f1.8/7.5-35mm zoom lens. Spring motor wound by turning grip. Reflex viewing. $20-30.

CHRONIK BROS. MFG. (New York) *The Chronik Brothers were tool and die makers.*

Chronik Bros. 35mm Motion Picture Camera - 1908. This camera is a typical example of the Chronik Brothers' excellent workmanship and design. The unique film transport is a Chronik patent. The camera features through the lens viewing and convenient control on the lens diaphragm and focusing. Range: $850-1900.

CINCINNATI CLOCK AND INSTRUMENT CO. (Ohio)
Cinklox, Model 3-S - c1937. 16mm spool camera. Spring motor with slow motion, normal and high speed settings. Wollensak f2.5/1" fixed focus lens. (See Paragon for similar camera.) $15-30.

COMPENDICA - c1961. Interesting still/cine camera. Takes 336 photos on a 25' roll of 16mm or double 8mm film. Spring wind, 10 fps. BIM. Optical eye-level viewfinder. Camera converts to a projector. Compendica f2.9/25mm lens. $20-25.

CORONET (Birmingham, England)
Coronet, Models A, B - c1932. 9.5mm movie cameras using 10m Pathe cassettes. Black leather covered metal body. Optical eye-level finder. Spring motor, 16 fps. Coronar Anastigmat f3.9 lens with four stops. $20-30.

DARLING (Alfred Darling, Brighton, England)
Bioscope - c1916. 35mm hand-crank. Rectangular wooden body, wooden 50m spools. Rotary shutter. $600-1000.

DEBRIE (Etablissements Andre Debrie, Paris)

Parvo Interview 35mm Motion Picture Camera - 1908. This wood body, hand crank studio camera has co-axial 400' internal film magazines. It features critical focusing on the film, variable shutter, frame rate indicator, lever control for focus and lens aperture setting, and a precise footage counter. The design and workmanship on this camera are of excellent quality. A metal body model was also made that could use an electric motor drive. Range: $750-1600.

Parvo Model JK - c1925. Precision 35mm hand-cranked cine camera. Heavy aluminum body, black side panels. Features include an automatic diaphragm that adjusts during each exposure to give the best image at any range. $800-1200.

Sept 35mm Motion Picture Camera System - 1922. This precision, compact, short film length 35mm movie camera is extremely versatile. It is a spring motor driven, 250 exposure, pin registered camera system for a: motion picture camera, sequential camera, still camera, and with the addition of a lamphouse, motion picture projector, film strip projector, still enlarger and negative film to positve film cine printer. From these seven functions comes the name "Sept". The Sept design is based on an earlier Italian camera. The camera illustrated at the top of the next page is a 1925 model Sept with a larger spring motor. Range: $100-150. *Illustrated next page.*

DeVry 16mm Deluxe - 1930. Same shape as DeVry Home Movie Camera, but molded bakelite body; 3-lens turret. $100-150.

Debrie Sept

DEJUR-AMSCO CORP. (New York)
Citation - c1950. 8mm spool-film camera. Spring-wind, 12-48 fps. Optical eye-level viewfinder. Interchangeable single-lens mount. Raptar f2.5 or f1.9/13mm lens. Brown lacquered metal body. $15-20.

DeJur-8 - c1948. Small, magazine-load, 8mm cine camera. 16-64 fps. Three-lens turret. Adjustment in optical viewfinder for different lenses. $15-20.

DeJur Electra Power Pan - 1962. 8mm spool. Spring motor. 120 degree panning. Automatic or manual exposure control, backlight control. Viewfinder adjusts to zoom lens. Uncommon. $20-30.

DEVRY CORPORATION (Chicago, IL)
The DeVry Corporation was founded in 1913 by Herman A. DeVry, a former arcade worker and motion picture operator, to manufacture portable projectors "...practical for use by traveling salesmen and by schools." In 1929, the company merged with Q.R.S. Corp., the famed music roll company. The marriage lasted less than three years, but during that time, a number of still picture and motion picture products were produced, variously labeled "QRS" "DeVry" or "QRS-DeVry". In late 1931 or early 1932, the company was re-organized, the music roll business left under new ownership, and H.A. DeVry continued in the motion picture business under the name Herman A DeVry, Inc. Mr. DeVry died in 1941. His sons carried on the business until 1954, when the company was purchased by Bell & Howell.
DeVry, 16mm - c1930. Various models were made with only slight variations. Black or grey cast metal body; large rectangular shape. 100' spools. Folding Newton finder. Spring motor; some models also have a hand crank. Interchangeable Graf f3.5/20mm fixed focus lens. $25-35.

DeVry Standard - 1926. 35mm all-metal newsreel-type cine camera. Rugged design. Nicknamed "The Lunch Box" because of its rectangular shape. 100' film spools. Spring motor. Some DeVry cameras were actually launched in captured German V2 rockets at the White Sands Missile Range after World War II. The DeVry also found use as a rapid sequential still camera in sports work. Range: $85-170.

DeVry Home Movie Camera - 1930. 16mm camera using 100' spools. Die-cast aluminum body. Spring motor. Model 57 has fixed focus f3.5 lens. Models 67 to 97 have focusing f3.5, f2.5, and f1.8 lenses. $30-45.

QRS-DeVry Home Movie Camera - 1929. Bulky all-metal 16mm camera using 100' spools. Spring motor. The first model was a camera only; later models doubled as a projector when mounted on an accessory stand and 3-blade projector shutter was substituted for the camera shutter. Camera only: $15-20. With projector: $25-35.

DeVry Projectors:

Cinetone - c1928. 16mm silent projector;

300w; 400' capacity. Motor drive also drives a 12", 78 rpm turntable mounted on a common base. Record and film had starting marks which were supposed to permit synchronization. Films were supplied by DeVry; records were made by Victor Talking Machine Co. This was one of the early attempts to provide sound with 16mm film. $250.

DeVry Portable Motion Picture Projector - 1928. Suitcase-type 35mm silent projector. Entire mechanism is built into one case. 1000' reels mounted co-axially below lamp and lens head. Motor drive. $35-55.

DeVry Type ESF Projector - 1931. 35mm Sound-on-film portable projector. 500w projector in one case; 4-tube amplifier and speaker in separate case. $100.

DILK
Dilk-Fa - c1950. 16mm movie camera, taking 10m spools. Spring motor, 1, 16-64 fps. 3-lens turret with viewfinder objectives to match each lens. One nice outfit sold at auction with Plasmat f1.5/25mm, Trioplan f2.8/50mm and f2.8/75mm lenses for $345.

DITMAR (Vienna, Austria)

Ditmar, 9.5mm - c1938. 9.5mm movie camera taking 10m Ditmar cassettes. Black leatherette covered metal body. Eye-level finder. Spring wind motor, 16-32 fps. Steinheil Cassar f2.9/20mm fixed focus lens. Built-in light meter. $30-40.

DRALOWID-WERK (Berlin)
Dralowid Reporter 8 - c1953. 8mm spool load movie camera. Green leather covered metal body. Eye-level finder. Spring motor is wound by pulling a cord. Minox Wetzlar Dralonar f2.5/12.5mm fixed focus lens. $45-65.

EASTMAN KODAK CO. (Rochester, NY)
Brownie Movie Camera, first model - 1951. 8mm spool camera with spring motor, open finder, and f2.7/13mm lens. Originaly sold for $47.50. $5-7.

Brownie Movie Cameras - c1951-63. Double-8 spool load movie cameras. Various models with single lens or 3-lens turret. Brown leatherette or brown lacquered bodies. Folding frame or Newton finders. Spring wind motor, 16 fps. Interchangeable fixed focus f1.9 or f2.7 lenses. Turret models also have wide angle and tele lenses. See below for a few individual listings. Generally, turret models: $5-10. Single lens models: $1-5.

Brownie Fun Saver - 1963-68. This was the last Brownie movie camera. Plain black body, no frills. $3-6.

Brownie Turret, Exposure Meter Model - 1958. With Scopesight and 3-lens turret with f1.9 lenses. This was the most expensive Brownie, selling for $99.50. $20-25.

Cine-Kodak - 1923. (Called Model A beginning in 1925 when the Model B was introduced.) This is the first Kodak movie camera. It introduced the new Eastman 16mm safety film for the amatuer. A substantial cost savings was brought about by the small 16mm format and the fact that

the original film was processed by Eastman to a positive rather than a negative, thereby eliminating the extra step to make a positive print. Hand crank, one rotation per 8 frames. All metal black painted body, large boxy square shape. Eye-level finder. Kodak Anastigmat f3.5/25mm focusing lens. $150-225.

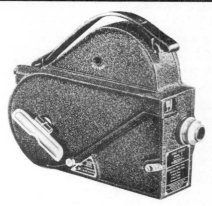

Cine-Kodak with electric motor drive

- **Electric Motor Drive** - Introduced Jan. 1924, for $25. Battery operated drive with built-in waist-level finder. Battery charging kit was available as an extra. Camera with motor drive: $200-250. *Add $100 for the charging kit.*
- **Waist Level Finder** - April 1924. A waist-level finder was added to the camera. Thereafter, the electric motor drive was available without a waist level finder. The camera shown is a 1925 version with the waist-level finder.
- **f1.9/25mm lens** - Feb. 1926. Original price of $200.
- **Slow Motion Attachment** - July 1926. List price was $20.
- **Single Frame Attachment** - Feb. 1927. List price of $20.

Cine-Kodak Model B - 1925-31. 16mm movie camera using 100' spools. Leather covered metal body. Rectangular and not as boxy looking as the Model A. Newton finder and waist level brilliant finder. Kodak Anastigmat 25mm fixed focus lens. Spring motor, 16 fps. First model with f6.5 lens, black leather: $20-30. Later models, 1928-on, f3.5 lens, brown, or grey leather: $10-30.

Cine Kodak Model BB, Model BB Junior - 1929. 16mm movie cameras using 50' spools. Leather covered metal body. Newton finder. Interchangeable Kodak Anastigmat fixed focus f3.5 or focusing f1.9/25mm lens. Spring motor, 8,16 fps. Blue, brown, or grey: $25-35. Black: $15-25.

Cine Kodak Model E - c1937-46. 16mm movie camera taking 100' spools. Black crinkle finish metal body. Advertising for

this peculiar shaped model said it "...safely clears hat brims." Optical eye-level finder. Spring motor, 16-64 fps. Interchangeable Kodak Anastigmat lens: fixed focus f3.5/20mm or focusing f1.9/25mm. $20-35.

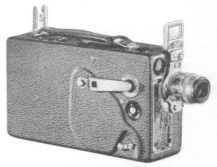

Cine Kodak Model K - 1930-46, making this the longest-lived 16mm model. Takes 100' spools. Leather covered metal body. Folding Newton finder and waist level brilliant finder. Spring motor, 8,16 fps. Interchangeable Kodak Anastigmat f1.9/25mm focusing lens. Blue, brown, or grey: $30-40. Black: $10-20.

Cine-Kodak K-100 - c1955. 16mm cine camera, taking 100' spool film. Spring motor 16-64 fps. Auxiliary external electric motor can also be attached. Single interchangeable lens mount. Ektar f1.9 or f1.4/25mm lens. Optical eye-level viewfinder. This camera filled the gap between the 16mm amateur Cine-Kodak Royal and the professional Cine-Kodak Special II, by providing some professional features such as larger film spool, special-effects features, 5 speeds, and interchangeable lens. $150-200.

Cine Kodak Model M - 1930 (the shortest-lived model). Economy version of the

611

Model K (above). Fixed focus f3.5/20mm. No waist level finder. 16 fps only. $30-40.

Cine Kodak 8 - c1932-47. Leather covered metal body in gray, brown, or black. Newton finder in the handle. Spring motor, 16 fps. Kodak Anastigmat 13mm lens.

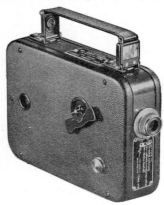

- Model 20 - The first 8mm spool load movie camera using 25' double-8 film. Fixed focus f3.5. $10-15.
- Model 25 - Fixed focus f2.7. $5-10.
- Model 60 - Interchangeable f1.9 focusing lens and machine-turned interior. $15-20.

Cine-Kodak Reliant - c1949. Low-priced alternative to the Cine-Kodak Magazine 8. Uses 8mm spool film instead of film magazine. 16-48 fps. Cine Ektanon f1.9 or f2.7/13mm lens. Spring wind motor. $8-12.

Cine-Kodak Royal - 1950. 16mm magazine camera with spring motor, interchangeable lens. $25-35.

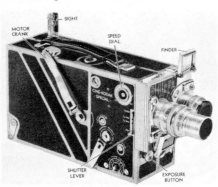

Cine-Kodak Special (1933-47);
Cine-Kodak Special II (1948-61) - 16mm magazine movie cameras. Left side of body is the magazine containing the film spools. The magazine can be removed at any time

and replaced by another. 100' and 200' magazines were available. 2-lens turret has interchangeable focusing Kodak Anastigmat f1.9/25mm and f2.7/15mm lenses. Spring motor 8-64 fps. $170-300.

Magazine Cine Kodak (1936-45);
Cine Kodak Magazine 16 (1945-50) - Body style and features similar to their 8mm counterparts, but for 16mm movies using 50' magazines. $15-25.

Magazine Cine-Kodak Eight Model 90 (1940-46);
Cine-Kodak Magazine 8 (1946-55) - Eastman Kodak's first magazine 8. Similar to the Model 60 (above), but takes a 25' reversing magazine. Optical eye-level finder. 16-64 fps. $5-10.

Kodak Cine Automatic Cameras - 1959-1961. Six versions, all with coupled EE, 8mm spool load, spring motor. Single lens, 3-lens turret, or zoom lenses. Values vary according to lens: $5-40.

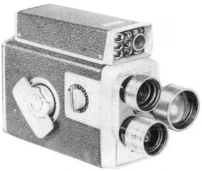

Kodak Cine Scopemeter - c1959. Double-8 spool load movie camera. Built-in meter. Optical eye-level finder in housing with meter. Spring motor, 16 fps. 3-lens turret with Ektanar f1.9 normal, tele, and wide angle lenses. $10-20.

Kodak Electric 8 Automatic - 1962. First 8mm Kodak camera with battery drive and casette loading. Kodak Duex 8 cassette was user-loaded with 25' spool which was flipped over for a second 25' run. One single lens model and two zoom lens models were produced, including the Kodak Electric 8 Zoom Reflex camera which was Kodak's most expensive movie camera, listing at $295. Reflex model, rare: $50-65. Others: $10-15.

Kodak Escort 8 - 1964. Eastman Kodak's last regular 8mm camera. Spool load, spring motor, coupled EE. Fixed focus and zoom f1.6 models. Type A (swing out) filter. $10-15.

Kodak Zoom 8 Reflex - 1960. Two models, with reflex viewing. $20-30.

Eastman Kodak Projectors:

Kodascope - 1923. 16mm motor drive projector; 14v, 56w lamp; 400' reel. First 16mm projector. Earliest model is distinguished by small lamp house, enclosed reels, no carrying handle, no oil tubes. 200w lamp furnished after 1924. $100-150.

Kodascope Model A, Series K - 1926. Similar to above, but with lens and condensers for use with Kodacolor film. $75-100.

Kodascope Model B - 1927. Advanced 16mm projector of unusual design. Folding reel arms at rear of projector with self-threading guides. Forward, reverse and still projection. Power rewind. 400' reels; 200w, 56v lamp; 1" or 2" lens. Black or bronze finish with chrome plated fittings, threading light. Original price, with 2" lens, carrying case, extra lamp, oil can, and splicing kit: $275. Common. $15-30.

Kodascope Model C - 1926. Compact 16mm projector. 400' reels; folding reel arms; 100w lamp. In 1928, the same projector was offered in a carrying case with 5½x7" translucent screen, and 1" lens for rear projection or 2" lens for direct projection. This outfit was called the Business Kodascope. $15-30.

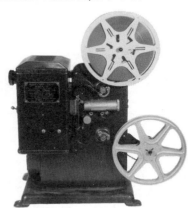

Kodascope Eight Model 20 - 1932. First 8mm projector. 200' reels, belt drive to take-up and rewind. First model furnished with 6v auto headlight bulb, later in same year furnished with 100w, 110v lamp. $10-15.

Library Kodascope - 1929. This is a Model B projector, in bronze, with a walnut case, folding translucent screen for rear projection with 1" lens, or direct projection

with 2" lens. The octagonal shaped case has an ebony inlay and solid bronze octagonal handles, and looks something like a casket. A matching walnut cabinet, 33" high, was available, which had a folding shelf for splicing, turntable top, storage space for the projector, a floor screen and stand, 26 reels of film, splicer, etc. EKC records show that approximately 1500 Library Kodascopes were produced, and less than 500 cabinets. Kodascopes with the cabinet sell for about $750. Projector and case: $125-175.

Sound Kodascope Special - 1937-42. Kodak's first 16mm sound-on-film projector. 2"/f16 lens; 750w lamp; 1600' reels; takeup reel runs at right angle to upper reel. Separate amplifier and speaker case. Very high quality design, priced at $800. Rarest of EKC's projectors; less than 500 made. $300-400.

EDISON (Thomas A. Edison, Inc., Orange, NJ)
Edison Projecting Kinetoscope - c1899. Hand-cranked or motor-driven 35mm projector. Mechanism mounted in 2-piece oak case. Bolt-on 1000' supply reel chamber. No takeup reel; film was caught in cloth bag. Four-slot Geneva intermittent; 2-blade no-fire shutter. Framing by rack & pinion raising entire mechanism. Separate light source. $300-400.

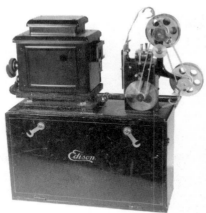

Edison Home Kinetoscope - 1912. Special 22mm hand-cranked projector. This projector was designed by Edison to make home projection safe for the amateur. The film was cellulose acetate based "safety" film supplied by Eastman, and carried three rows of images across the width, each row projected in succession. Cast iron mechanism housing mounted on wood base with sheet metal lamp house, usually with small carbon-arc lamp, although

acetylene lamphouse was available. Projector available with three lens systems, and also could be used to project special Edison glass slides. $475-575.

ELMO CAMERA CO. LTD (Japan)
Distributed by Honeywell Photographic Products in the U.S.A.
Honeywell Elmo Dual-Filmatic and Tri-Filmatic 8mm Zoom - 1966. These battery-powered 8mm cameras were the first to accept all three 8mm formats by means of interchangeable backs. The Dual-Filmatic accepted Super 8 and Single 8; the Tri-Filmatic accepted Super 8, Single 8, and Regular 8. Both cameras featured automatic/manual exposure control and remote control jack. Elmo f1.8/9-36mm lens with power or manual zoom; auxiliary telephoto lens available. Single frame or 18,24 fps, plus reverse (for Single 8 and Regular 8 only). Tri-Filmatic, very few made: $125-150. Dual-Filmatic: $75-125.

EMEL (Etablissement Emel, Paris)
Emel Model CB3 - c1937. Advanced 8mm spool camera featuring 3-lens turret, multi-focal finder with parallax correction, frame counter and film-remaining meter. Spring motor, 5 speeds plus single frame & continuous run. Backwind shaft. $75-100.

ERCSAM (Paris)
Auto Camex - c1960. 8mm spool load movie camera. Reflex viewing. Spring motor, 8-64 fps. Focusing Pan-Cinor zoom lens. $30-50.

Camex Reflex 8 - c1956. First 8mm movie camera with continuous reflex viewing. Double-8 film on 25' spools. Spring motor, 8-32 fps. Interchangeable Som Berthiot f1.9/12.5mm focusing lens. $50-75.

ERNEMANN AG (Dresden, Germany)
Kino I - 1902. Ernemann entered the amateur motion picture field with this very early, center perforation, 17½mm motion picture camera. It has a leather covered wood body. The Kino I is a well built movie camera using a Williamson type film transport with a quality Ernemann lens and a variable shutter. Range: $1000-2000.

Kino II - 1904. This versatile 17½mm, center perforation, amateur camera/printer/projector has features unusual even for professional motion picture cameras of its time. A fast lens was used. The intermittent film transport utilized an eight arm Geneva cross movement. A reciprocating glass platen at the aperture applies pressure during exposure. The Kino II shown has a large co-axial film magazine and a studio type viewfinder that has straight and reflex viewing. Range: $950-1800.
Illustrated top of next column.

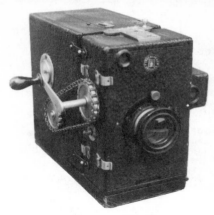
Ernemann Kino II

Kino Model E - 1917. 35mm motion picture camera. This wood body, hand crank studio camera has co-axial 400' internal film magazines. Its appearance and operation are very similar to the 1908 Debrie Parvo camera. Range: $700-1500.

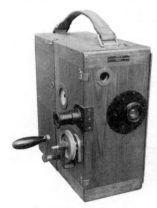

Normal Kino Models A, B, C - 1908-18. The Normal Kino Model A 35mm motion picture camera is a wood-bodied hand cranked field camera. The film magazines are internal, one above the other. Some Kino cameras have Lumiere/Pathe type film transports and some have Williamson type transports. The Model A has a 200' film capacity; the B, 400'; and the C, 100'. $600-1150.

Ernemann Projectors:

Kinopticon - c1919. Hand-cranked 35mm projector, using Demeny "beater" film advance. Two-blade shutter, chain drive. Incandescent lamp house on common

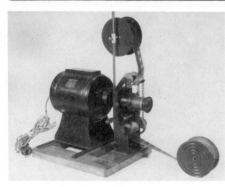

wood base. Lamp house slides over for use as magic lantern for 48mm slides. Film supply reel standard; no takeup reel. $200-250.

ERTEL WERKE (Munich, Germany)

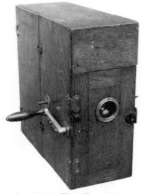

Filmette I - 1920. The Ertel 35mm motion picture camera is a well made, wood body, hand cranked field camera. Brass parts are lacquered black. Folding sportsfinder on side. Ertel Glaukar f3.1/50mm lens. Lens focus and aperture control is accomplished by conveniently placed levers. Range: $550-1200.

Filmette II - c1923. Similar to Filmette I, but folding Newton finder, Ertoplan f3.1/50mm. Polished brass parts. $500-1000.

EUMIG (Vienna, Austria)
Eumig C-3 - c1955. Double-8 movie camera taking 25' spools. Grey or black patterned metal body. Optical eye-level finder. Spring motor, 8-32 fps. f1.9/12.5mm lens. $15-25.

Eumig C-39 - c1938. 9.5mm camera, similar in style to the black C-3. Steinheil Cassar f2.8/18mm lens. $15-25.

Eumig C5 Zoom-Reflex - 1961. 8mm battery-driven spool camera. Eumig f1.8/10-40mm manual zoom, recessed into body of camera. Automatic exposure control, footage counter, outlet for synchronous sound recording with tape recorder. Die cast aluminum body with grey crinkle finish. $20-30.

Eumig C16 - c1956. 16mm movie camera for 100' spools. Lacquered metal body with green leather. Spring motor, 16-64 fps. Semi-automatic coupled meter. Eumigar f1.9/25mm focusing lens. $150-180.

Eumig C16 R - c1957. Same features as the C16, but has WA Eumicronar .5x and Tele-Eumacronar 2x auxiliary lenses on mounts that can be rotated into place over the normal lens. Viewfinder has parallax compensation. $200-300.

Eumig Electric - c1955. Double-8 movie camera taking 25' spools. Green crinkle finish metal body. Eye-level finder. Battery driven motor, 16 fps. Eugon f2.7/12.5mm lens. $5-10.

Eumig Electric R - c1958. Same features as the Electric, but has auziliary WA .5x and Tele 2x lenses on turret mount. $20-40.

Eumig Servomatic - c1958. Double-8 spool-load cine camera. Two-tone grey lacquered metal body. Electric motor takes 4.5v batteries. 16 fps. BIM. Fixed focus Schneider Xenoplan f1.8/13mm. $10-20.

EXCEL PROJECTOR CORP. (Chicago)
Excel 16mm No. 40 - c1938. 16mm camera, 50' spools. Diecast body, brown crinkle finish. Spring motor. Noteworthy for cylindirical shutter, single-claw pull down with register pin amd no feed sprocket. Excel f3.5/28mm lens in non-standard mount. Uncommon. $25-35.

Excel 8mm, No. 38 - Nearly identical to 16mm No. 40, above. Uncommon. $25-35.

FAIRCHILD CAMERA AND INSTRUMENT CORP.
Fairchild Cinephonic Eight - 1960. First 8mm sound-on-film camera, using double-8 pre-striped film with magnetic recording track for direct recording of sound while filming. Built-in transistorized recording amplifier. Camera driven by special nicad rechargeable battery. 3-lens turret. Exposure meter screws onto lens turret for reading. Standard, WA, and Tele lenses available. $75-125.

Fairchild Cinephonic Eight Sound Zoom - 1963. Like the listing above, but with Fairchild f1.8/10-30mm zoom lens, coupled Sekonic Photo-Meter. $75-125.

Fairchild Projectors:
Cinephonic - 1960. 8mm sound-on-film projector, companion to the Fairchild Cinephonic cameras. Magnetic striped film; 400' reels. Projector will play back, overlay, or record. 3/4" f16 lens. Sound level indicator. Separate unit houses speaker, extension cable, microphone, and reel. $35-45.

FRANKLIN PHOTOGRAPHIC INDUSTRIES INC. (Chicago)
Franklin Magazine 8 - 1948. Compact 8mm camera using 25' magazines. Manufactured under EKC's patents. Spring motor, 16-64 fps. Wollensak f2.5/½" lens. A 2-lens turret model was also made. $15-20.

FUJI PHOTO FILM CO., LTD (Japan)
Fujica Single-8 P1 - c1965. Single-8 battery operated camera using special Fuji Single-8 drop-in cartridge. Electric eye, needle visible in finder. $10-20. Later models offered zoom lens, backwinding capability, reflex viewing. $15-25.

GERMAN-AMERICAN CINEMATOGRAPH AND FILM CO.
(New York and Berlin) *Everhard Schneider, the founder of German-American Cinematograph and Film Co. designed and made a series of cine cameras as well as motion picture projectors, printers and film perforators. Edison filed suit against Schneider in 1898 for patent violation. This German-American Co. did not survive World War I.*

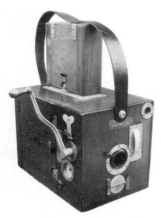

Everhard Schneider 35mm Motion Picture Camera - c1898. This very early motion picture camera was the first of a series of fine equipment. It has an external film supply magazine and an internal take-up magazine. Although some mechanical parts of the camera are castings, several are hand made. Range: $2000-3500.

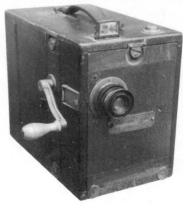

Everhard Schneider 35mm Motion Picture Camera - c1910. This camera is an example of Schneider's less elaborate, wood body, hand crank, field type motion picture camera. 200' co-axial internal magazines are used. Range: $650-1200.

GEYER (Karl Geyer Maschinen und Apparatebau GmbH, Berlin)
Cine-Geyer AK26 - c1925. 16mm amateur cine camera, taking 30m spool film. Black lacquered metal body. Spring motor, 16 fps. Optical eye-level viewfinder as well as waist-level viewfinder. Triotar f2.9/25mm focusing lens. $300-400.

GUSTAV AMIGO (Berlin, Germany)

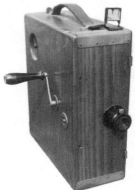

Amigo 35mm Motion Picture Camera - 1920. Though basic in design, the Amigo is a well constructed field camera and is capable of fine work. A Williamson type film transport is used. Range: $500-1125.

HOUGHTON
Ensign Autokinecam - c1930. 16mm movie camera with 100' spool. Spring motor or hand cranked. Single lens. 3 speeds. $30-40.

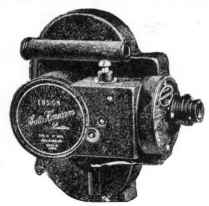

a leather covered metal body. An accessory spring motor drive was also available. It is of quality design and construction. In 1926, the ICA company joined with Contessa-Nettel-Werke, Zeiss, Goerz, and Ernemann to form the Zeiss Ikon Co. Production of the Kinamo continued and more versatile models were produced. Range: $100-200.

IKONOGRAPH CO. OF AMERICA (New York) *Founded about 1905 by Enoch J. Rector, a somewhat notorious film impressario. This company was one of the first to offer a line of projectors designed for the amateur. The films were 17.5mm nitrate stock, center perforated at the frame line, reduction printed from standard 35mm commercial films, and were supplied by the Ikonograph Co. in 40' cans, with titles such as "The Tramp's Bath".*

Ensign Auto-Kinecam 16 Type B - c1935. 16mm movie camera taking 100' spools. Crinkle-finish black metal body. Eye-level finder near the top, Newton finder mounted on the side. Spring motor, 8-32 fps & hand wind. Interchangeable Dallmeyer Anastigmat f2.9/1" focusing lens. $25-50.

Ensign Super-Kinecam - 1931. 16mm movie camera taking 100' spools. Hand crank or spring motor 8-64 fps. 3-lens turret. Quadri-focal finder with auxillary parallax correction. $60-75.

ICA A.G. (Dresden, Germany) **Kinamo 15mm -** c1921. Compact 15mm cine camera, made in 2 sizes for 15m Ica cassettes or 25m cassettes. Hand-crank. Black leather-covered body, folding frame finder. Tessar or Dominar f3.5/40mm focusing lens. $50-75.

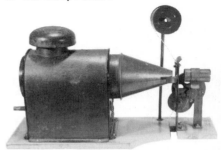

Ikonograph Model B - c1905. 17.5mm hand-cranked projector. Due to its extremely simple mechanism, the projector could be run backward as well as forward, thus bringing a popular Hollywood trick to the home projectionist. Several models were produced with illumination by incandescent or acetylene lamp. $75-200.

Kinamo 35mm Motion Picture Camera - 1924. This compact, hand cranked, amateur camera uses 50' magazines. It has

INDUSTRIAL SYNDICATE OF CINOSCOPE (Italy and Paris, France) **Cinoscope 35mm Motion Picture**

Camera - 1924. This leather covered metal hand crank camera was made in Italy and sold in France. It uses 100' magazines and has Geneva Cross film transport. Kador f3.5/50mm lens. With the addition of a lamphouse and reel arms, the camera can be used as a projector. Range: $500-1000.

INTERNATIONAL PROJECTOR CORP. (NY)

Simplex Pockette - 1931. First U.S. made 16mm magazine camera, used "old style" EKC/IPC magazine. Waist-level finder, sportsfinder on side; optional top-mounted telescope viewfinder with parallax. Spring motor, 12-16 fps. Footage counter. Black or grey aluminum body with embossed art-deco pattern. Non-interchangeable fixed focus f3.5 lens. Later models, c1933, had interchangeable Kodak Anastigmat f3.5/1" focusing lens. $20-35.

IRWIN CORP. (NY)

Irwin Magazine Model 16 - c1930. Among the first U.S.-made 16mm magazine cameras. Takes Irwin 50' magazines. Rectangular metal body. Spring motor, 16 fps. f4.5/1" lens. Hexagonal tube or open top-mounted finder. $15-30.

Irwin Magazine Model 21 - Like the Model 16, but with f4.5 lens, 4 speeds, and through-body finder. $15-25.

Irwin Magazine Model 24 - Like the Model 21, but with f3.5 lens. $15-25.

KBARU (Quartz) 2M - c1960's. Russian double-eight movie camera. Gray enamelled body. Spring wind, 8-32 fps. f1.9/12.5mm lens; coupled meter. With hand grip: $12-18.

KEYSTONE MFG. CO. (Boston) *Founded in 1919 to manufacture toy movie projectors, formerly supplied by European manufacturers.*

Capri Models - c1950's. Models K-25, K-27, K-30. 8mm spool load movie cameras. Grey or brown leather covered body. Single lens and 3-lens turret models. Elgeet f1.9 lens. $5-15.

Keystone A Models - c1930's-1940's. A series of 16mm spool load cameras (models A, A-3, A-7, A-9, A-12). Oval metal bodies are either leather covered or lacquered. In black, brown, or grey. Eye-level finder. Spring motor, 12-64 fps on most models. Some models have an interchangeable lens. $15-40.

Keystone Movie Camera, Model C - c1931. 16mm spool load movie camera. Black crinkle finish metal body. Eye level finder. Hand crank. Oval body like the later "A" models. Ilex f3.5/1" lens. $35-45.

Keystone K-8, K-22 - 1930's-1940's. Like the "A" models, but for 8mm film. $4-9.

Keystone Projectors: *Early projector models were mostly 35mm, hand-cranked, and cheaply made. Only a few representative or unusual models of projectors will be listed.*

Keystone 28mm Moviegraph Projector

Moviegraph - c1919. 35mm hand-cranked projector, early model, marked "Patent Applied For". Toy-like quality. $25-50.

Moviegraph - c1920. Hand-cranked simple projector for 28mm Pathe film. One of very few U.S.-made projectors for Pathe's 28mm film which has three perforations on one side and one perforation on the other. No shutter; no film takeup. $25-35. *Illustrated bottom of previous page.*

Supreme - c1930. Hand-cranked 9.5mm projector for 400' reels or 30' and 60' cassettes. Double sprocket drive; 3-color filter. Only known U.S.-made 9.5mm projector. $40-60.

KLIX MANUFACTURING CO. (Chicago)

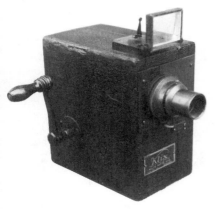

Klix 35mm Motion Picture Camera - 1918. This compact amateur hand crank cine camera has an unusual reciprocating shutter. A Geneva Cross film transport movement is used. A heavy flywheel helps for smooth cranking. This camera has 25' film magazines. A larger Model 2 camera has 100' magazines. Both cameras can be used as projectors with the addition of an adapter kit that includes a lamphouse, reel arms, special shutter, etc. Range: $250-500.

KODEL ELEC. & MFG. CO. (Cincinnati, Ohio)

Kemco Homovie - c1930. Unusual system for 16mm safety film. Unique design to take four frames in each 16mm frame. Film transport moved in boustrophedonic pattern (2 exposures left to right across film, down ½ frame, then right to left, etc.) 100' of film gave the equivalent of 400' in number of exposures. Individual exposures measure 3.65x4.8mm. The spring-motor driven camera was housed in a bakelite case and used an f3.5/15mm lens. The projector was motor-driven, and could project either the Kemco system or regular

full-frame by selecting the proper condenser lens. 250w, 50v lamp. Very rare. No known sales. Estimate: $400-500.

KURIBAYASHI CAMERA WORKS *A little known fact, Kuribayashi Camera produced three different cine models from 1962 through 1966. Apparently few were ever produced, making these models very rare.*
Petri Eight - 1962. Fixed focus Petri f1.8/13mm lens with aperture set by electric eye. Battery powered film transport and shutter (16 fps). Rare. $50.

Petri Power Eight - 1964. Petri Eight with Petri f1.8/9-25mm lens with power zoom control. Rare. Price unknown.

Petri Super Eight - 1966. CdS photometer controlled Petri f1.8/8.5-34mm lens with power zoom feature. Battery powered film transport with 18 or 32 fps setting. Drop-in super eight film loads. Rare. Price unknown.

L.A. MOTION PICTURE CO.

(Los Angeles, CA) *Also known as Angeles Camera Co. Produced original Cine camera designs and also made close copies of the designs of others. During WWI they were able to meet requirements of domestic studios for European type cameras that were not available. They also made cameras that were sold under the brand names of others.*

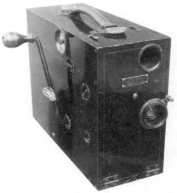

35mm Motion Picture Camera - c1914-23. There is no model name on this well made, metal bodied, hand crank camera. Several features, including 400' internal co-axial magazines. Range: $500-1000.

LEITZ

Leicina 8S - 1960. 8mm spool camera, battery operated. Reflex viewing. Built-in f2/9mm lens with snap-in auxillary f2/9mm wide angle supplementary lens. Automatic exposure control with reading in viewfinder. Film exposed gauge also visible in finder. $80-100.

Leicina 8SV - c1964. Similar to the Leicina 8S, but f1.8/7.5-35mm Zoom lens, 16 and 24 fps. $50-70.

LUBIN (Sigmund Lubin, Philadelphia, PA) *Sigmund "Pop" Lubin, a European immigrant, was quite knowledgeable in optics, chemistry, and mechanics. He was a very early motion picture entrepreneur. He manufactured motion picture equipment for his own studio use. At one time, however, he did offer a camera, projector, and phonograph for use by those starting in the motion picture business, for a modest $150. The buyers later found that the camera and projector used only film supplied and printed by Lubin. Much of his equipment was very similar to that of other manufacturers but his versions were always an improvement. He did hold motion picture equipment patents and was involved with Edison in the Motion Picture Patent Company, a trust formed to control the motion picture industry.*

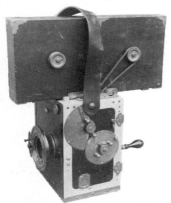

Lubin 35mm Studio Motion Picture Camera - 1908. This was the workhorse of the Lubin studios. It is very similar to the Pathe studio camera but has heavier gearing, a metal body, and a speed governor. Range: $1800-4500.

MAGGARD-BRADLEY INC. (Morehead, KY)
Cosmograph Model 16-R - c1925. 35mm "suitcase" projector of unusual design. Cast aluminum projector mechanism is seated on top of wood carrying case; film is threaded from supply and take-up reels in staggered array below. Lamp house and condenser swing back for lantern slide projection with auxiliary lens. Electric motor drive. $40-60.

MANSFIELD INDUSTRIES, INC. (Chicago)
Mansfield Model 160 - c1954. 16mm spool-film cine camera taking 50' or 100' rolls. Grey crinkle-finish metal body. Spring-wind. f1.9 or f2.5/1" lens. Optical eye-level viewfinder. $25-45.

MARLO - c1930. No maker's name on this 16mm 100' spool camera, but it is identical in almost every detail to the DeVry 16mm cameras, and has a DeVry patent number inside. Spring motor. Graf f5.6/29mm lens. Black crinkle finish. Brass nameplate says "Marlo". $65-75.

MEOPTA
Admira A8F - Similar to the A8G, below, but with BIM. $10-15.

Admira A8G - c1964. Slim, tapered 8mm camera with spring wind motor, 16 fps. Mirar f2.8/12.5mm fixed focus lens. Light and dark grey lacquered metal body. $5-10.

MILLER CINE CO. (England)
Miller Cine Model CA - c1953. 8mm spool load movie camera. Brown leather covered metal body. Eye-level finder. Spring motor, 8-64 fps. Interchangeable fixed focus Anastigmat f2.5/12.5 lens. $5-10.

MITCHELL CAMERA CORPORATION (Glendale, CA)
Mitchell - 1920. The Mitchell studio camera was a major milestone in motion picture camera design when introduced in 1920. It is somewhat similar in appearance to the earlier Bell & Howell 2709 studio camera, but has a simpler through-the-taking-lens previewing system. The Mitchell registration pins are reciprocal and hold the film perforations precisely during exposure. A wide range of accessories are available. The low operational noise level of the Mitchell compared to the Bell and Howell, soon had it replacing the Bell and Howell after the advent of sound movies. The Mitchell soon became the most popular studio camera. It is still in use to this day and its current high price is indicative of its usability. Range: $2500-8500.

MOVETTE CAMERA CORP. (Rochester, NY.) *Reorganized as Movette, Inc. after 1918.*

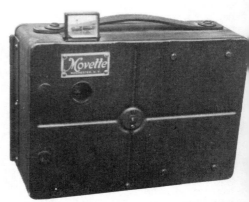

Movette 17½mm - 1917. This amateur

hand cranked camera uses 17½mm film that has two round perforations on each side of the picture frame. The shutter has a fixed opening and the lens has a fixed aperture and focus. The camera used a simple type film magazine. The processed positive print on safety film was returned from Eastman on a similar magazine for use in the companion projector. A library of feature films was offered. This home motion picture system featured simplicity. Camera only: $300-400. Projector: $100-150.

MOVIEMATIC CAMERA CORP. (NY)

Moviematic - 1935. Inexpensively made all-metal rectangular 16mm magazine cameras. Spring motor. Side mounted open finder. Moviematic furnished films in special magazines holding approximately 11' of film: M40 for snapshots; M50 for movie (flip) books; M60 for projection. "Mercury" model with rounded ends: $20-30. Models with bright nickel, copper-plated, or cross-hatched pattern faceplates: $5-15.

MOY (Ernest F.) LTD. (London)

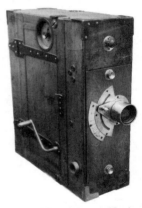

Moy and Bastie's 35mm Motion Picture Camera - 1909. This wood body camera used internal 400' magazines, one above the other. The Moy uses a variable shutter and a unique film transport movement called a drunken screw. Critical focusing is accomplished by viewing the image through the film. A variant of this model has the lens mounted on what would normally be the side and has dual shutters so it can be used as a projector head. Range: $650-1850.

NEWMAN & SINCLAIR (London)

Auto Kine Camera, Model E - c1946. 35mm spring driven movie camera, 10-32 fps. Holds spools up to 200'. Polished, patterned Duralumin body. Eye-level finder. Ross Xpres f3.5 lens. $175-250.

NIPPON KOGAKU (Japan)

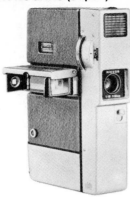

Nikkorex 8, 8F - c1962. Slim 8mm spool load movie cameras. Chrome with brown leatherette covering. Battery operated motor, 16 fps. Nikkor f1.8/10mm fixed focus lens. Electric eye CdS exposure meter. The model 8 has a folding optical eye-level finder. Model 8F has a thru-the-lens reflex finder. $10-20.

Nikkorex Zoom-8 - 1963. Battery operated 8mm spool camera. Manual zoom Nikkor f1.8/8-32mm lens. Automatic/manual exposure control with visible needle. Split-image rangefinder focusing, reflex viewing. Film counter. Battery test. $15-25.

NIZO (Niezoldi & Kramer GmbH, Nizo-Braun AG, Munich)

Cine Nizo 8E Models A, B, C - c1930's. 8mm spool load movie cameras. Spring motor, 6-64 fps. Rectangular metal bodies, black leather covered. Interchangeable Voigtländer Skopar f2.7/12.5mm focusing lens. In addition to the optical eye-level finder found on the Model A, Models B and C have a waist level finder. $60-100.

Cine Nizo 9-½ Model A - c1925. Boxy 9.5mm cine camera using Pathe cassettes. Black leather covered metal body. Eye-level finder. Spring motor, 16 fps, and hand crank. Meyer Trioplan f3.5/77mm fixed focus lens. "N.K.M" manufacturers plate on front. $60-90.

Cine Nizo 9-½ Model F - c1925. Boxy 9.5mm cine camera using Pathe cassettes. Black leather covered metal body. Folding Newton finder. Spring motor, 16-32 fps. Steinheil Cassar f2.8/20mm fixed focus lens. $60-90.

Cine Nizo 9-½ Model M - c1933. 9.5mm cine camera taking 15' Nizo cassettes. Like the Cine Nize 16L, except for size. 8-24 fps. $60-100.

Cine Nizo 16B - c1927. Like the Cine Nizo 9-½ Model A, but for 16mm film. $70-100.

Cine Nizo 16L - c1930's. 16mm movie cameras taking 50' spools. Black crackle finish metal body. Optical eye-level finder. Spring motor, early version 8-24 fps, later one for 8-64 fps. Interchangeable Meyer f1.5/20mm focusing lens. $70-100.

Exposomat 8R - c1955. 8mm movie camera taking a 25' Rapid cassette. Grey crinkle finish metal body. Eye-level finder. Built-in meter. Spring motor, 16-24 fps. Fixed focus Ronar f1.9/12.5mm. $10-20.

Exposomat 8T - c1958. Almost identical to the Exposomat 8R, but for spool film instead of Rapid cassettes. Steinheil Culminon f1.9/13mm fixed focus. $10-20.

Heliomatic 8 Focovario - c1961. 8mm spool-loading cine camera Grey lacquered metal body. Schneider Variogon 8-48mm/f1.8 or Angenieux 9-36mm/f1.4 Zoom lens. Coupled exposure meter. Spring wind 8-48 fps. Eye-level reflex focusing. $75-125.

Heliomatic 8 S2R - c1951. 8mm spool load cine camera. Grey crinkle finish metal body. Coupled meter. Spring motor, 8-64 fps. Rodenstock Heligon f1.5/12.5 and Euron f2.8/37.5mm focusing lenses. $45-65

PAILLARD A.G. (Geneva, Switzerland)

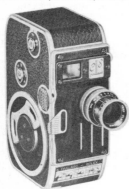

Bolex C8

B8, C8, L8, L8V - A series of double 8mm cameras, with only minor differences in body design or features. Spring motor. Black leather covered metal body. f1.9 to f2.8 lenses available. All sell in the range of $15-25.
L8 (1942) - single interchangeable lens; 16 fps.
L8V (1946) - single interchangeable lens; 12,16,32 fps.
B8 (1953) - 2-lens turret; 8-64 fps.
C8 (1954) - single interchangeable lens; 8-64 fps.

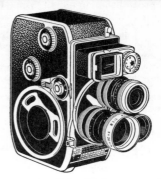

Bolex D8-L

B8L, C8SL, D8L - c1958. Like the B8, and C8 models above, but with built-in light meter. B8L and D8L are 2-lens and 3-lens turret models, 12-64 fps. C8SL has a single lens and 18 fps. D8L: $50-75. B8L: $50-65. C8SL: $20-30.

H8 - intro. 1936. Same body style as H16, but for 8mm movies. Heavier construction than the later L8, B8, and C8 models. Black leather covered metal body. Optical eye-level finder. Spring motor, 8-64 fps. Interchangeable focusing lenses on 3-lens turret. Meyer Kino Plasmat f1.5/12.5mm, Meyer Trioplan f2.8/36mm and f2.8/20mm. With 3 lenses: $100-140.

H-8 Supreme - Same as H-16 Supreme, but for 8mm film. $90-130.

H-16 - intro. 1935. 16mm movie camera for 100' spools. Automatic film threading. Black leather covered metal body. Optical eye-level finder. Spring motor, 8-64 fps. Interchangeable lenses mounted on 3-lens turret. Meyer Trioplan f2.8/75mm, Meyer Plasmat f1.5/6mm & f1.5/25mm. $150-200.

H-16 Deluxe - c1950. An updated version with "Octameter" viewfinder showing field

of view for eight lenses 16mm to 6". Eye-level focus through all lenses. $150-200.

H-16 Leader - c1950. Similar to the Standard F-16 (above), but with thru-the-lens waist level reflex viewing. Achromatic eyepiece. $100-135.

H-16 Reflex - c1950. Similar to the Standard H-16 (above), but with an eye-level reflex thru-the-lens viewfinder. $250-400.

H-16 Supreme - c1954. Has built-in turret lever to facilitate the rotation of the lens turret. $135-175.

Bolex Projectors:
Bolex Cinema G816 - c1939. Electric-drive 16mm projector which can convert to either 8mm or 9.5mm with accessory kits of suitable spindles, sprockets, and guide rollers. 50mm/f1.6 lens; 750w lamp. Uncommon. $100-150.

PARAGON CAMERA CO. (Fond du Lac, WISCONSIN)
Paragon Model 33 - 1933. 16mm spool load, with through-body finder. Wollensak f3.5 lens. Spring motor, single speed (3-speed model made in 1938). Footage counter. Almost identical to Cinklox, possibly a predessor to it. $40-50.

PATHE FRERES, PATHE S.A., (Paris, France) *A major European motion picture company, they introduced the 28mm movie format, and reduced a large 35mm feature movie library to 28mm safety film to increase their home movie business. The 28mm format provided a modest savings in film size, cost, and more importantly, the use of fire resistant film in the home. 28mm projectors were made by Pathe of France and subsequently by Hall Projector and Victor Animatograph of the USA. A few 28mm cameras were made so that the amateur could make his own 28mm movies for the home use.*

Motocamera - c1928. 9.5mm movie camera taking 10m Pathe cassettes. Spring motor, 16 fps. Leather covered metal body. Eye-level finder built into the camera body instead of the folding frame finder found on the earlier Pathe Baby. Krauss Trinar f3.5/20mm fixed focus lens. $25-35.

Motocamera Luxe - c1932. Similar, but with 3 speeds and Zeiss or Krauss f2.9 or f2.7 lens. $40-65.

Motocamera 16 - c1933. 16mm movie camera using cassettes. Black leather covered metal body. Spring motor, 16 fps. Krauss Trinar f3/25mm lens. This 16mm model is not nearly as common as the 9.5mm model listed above. $80-120.

Pathe, 35mm - 1905. Motion picture studio camera. This leather covered wood body hand crank camera uses external 400' magazines mounted on top. The film transport mechanism is based on the movement used in the pioneer Lumiere Cinematograph camera and is still used in the modern Bell & Howell Filmo and Eyemo cameras. In the years just before WWI the Pathe was used on more movies throughout the world than any other camera. It is difficult to find a pristine Pathe as they were heavily used and generally modified to update them. Lubin, Angeles and Wilart made similar cameras in the USA. Range: $1000-2750.

Pathe, 28mm - 1912. This is a scaled down version of their successful 35mm field camera. An economical 28mm version of the English Williamson/Butcher type camera was also offered later by Pathescope of America. Range: $800-1500.

Pathe Baby - 1923-25. 9.5mm hand cranked movie camera, taking 9m Pathe cassettes. One rotation per 8 frames. Extremely compact leather covered metal

it is rewound by hand. Fixed resistor for low-voltage lamp. Unique film-notch system gave automatic delay at title frames for substantial economy in film. Films supplied by Pathe were reductions of commercial films; over 100 titles were available. Die-cast shutter/flywheel is usually deformed and inoperable: $20-30. Working: $30-50.

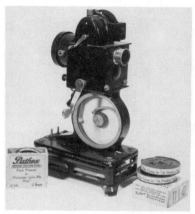

body. Folding sportsfinder. Roussel Kynor f3.5/20mm fixed focus lens. The 9½mm width amatuer film format was introduced in Europe at about the same time 16mm film was introduced in the USA. The 9½mm film perforations are in the center of the film, between frames. The picture format extends to almost the width of the film thereby providing efficient film use. The film has a safety, reversal type base that could be processed by the user. 9½mm movie cameras were popular in Europe and the British empire. $25-40.

Pathe Baby, with motor - c1926-27. Similar to the original model, but body is about twice the width to accomodate the spring motor. 16 fps. Hermagis f3.5/20mm fixed focus lens. $25-45.

Pathe Baby, with Camo motor - Larger motor than the listing above. Marked "Camo" and "Swiss movement Suisse". Kynor f3.5/20mm lens. $75-125.

Pathe Mondial B - c1932. Similar to the Motocamera (above), but slightly smaller body, and black painted instead of leather covered. Trioplan f2.8/20mm lens. $25-35.

Pathe National I - c1930. 9.5mm movie camera taking 9m Type H Pathe cassette. Black painted metal body. Eye-level finder. Spring motor, 16 fps. Krauss Trinar f3.5/20mm fixed focus lens. $20-40.

Pathe National II - c1940's. Improved version of the National I. Grey crinkle finish body. 8-32 fps. Interchangeable Som Berthiot focusing f1.9/20mm lens. $20-45.

Pathe Projectors:

Pathe-Baby - 1922. 9.5mm projector. First model hand-cranked; later, motor drive was available. Cassette loaded with 8.5m of film, caught in glass-front chamber, from which

Pathe Kok Home Cinematograph - 1912. Hand-cranked projector for Pathe's new safety film on cellulose acetate base. Illumination by low voltage lamp, fed from small generator which was driven by the same mechanism that operated the film advance. Films, up to 400', were reduction prints from commercial negatives, supplied by Pathe. The large polychrome rendition of a rooster (Pathe's trademark) on the case cover is one of the attractions of this historic projector. With excellent decal: $125-175.

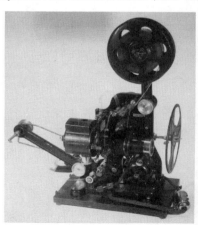

New Premier Pathescope - c1920. Electric drive 28mm projector of rugged construction, manufactured and marketed

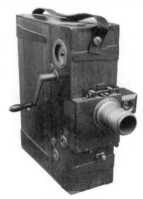

Prestwich 35mm

in the U.S. by Pathescope Co. of America, Inc. Geneva intermittent, large 3-blade shutter in front of lens. $40-60.

Pathe Kid - 1930. Hand-cranked 9.5mm projector, scaled-down version of Pathe Baby. No glass on lower film receptacle. Separate "cage" resistor. Sold by Pathex, Inc. NY. $25-30.

PENTACON (VEB Zeiss Ikon)
AK 8 - c1955. 8mm movie camera using 25' film spools. Metal body with imitation leather covering. Spring motor, 16 fps. Optical eye-level viewfinder. C.Z. Triotar f2.8 lens. $15-22.

POLAROID CORP. (Boston, MA)
Polavision Land Camera - 1977. Battery-driven Super 8 instant movie camera. Special Super 8 film rated ASA 40, in Polaroid cartridge holding approximately 42' (2 minutes, 40 seconds of filming). Polaroid f1.8/12.5-24mm manual zoom lens. Two focus positions: 6'-15', 15'-infinity. Single speed, 18 fps. Reflex viewing. Flag in viewfinder for low light. Warning light for beginning and end or usable film. Battery check light. Film is developed to positive in special developer/player. Plug-in is 110v, 170 watt light available. Camera with player, lights, cords, etc.: $100-125. Camera only: $20-30.

POWER (Nicholas Power Co., NY) *This manufacturer of 35mm theatre projectors appears to have begun operation prior to 1899. The Company was merged with International Projector Corp. about 1920.*
Cameragraph - First models, such as No. 3 were built on a wooden frame, much like Edison 1899 Projecting Kinetoscope. No. 4, c1905, was the first all-metal model. No. 6, c1906, featured the first automatic fire shutter built in the U.S.A. and was the last of the "open mechanism" design.

Complete with lamphouse, lamp, auxiliary lantern slide lens: $350 and up. Projector head only: $75-150.

PRESTWICH MANUFACTURING CO. (London, England)
Prestwich 35mm Motion Picture Camera - 1908. This wood body camera uses internal 400' magazines, one above the other. The patented Prestwich film transport movement is used. The lens is focused by rack and pinion. The lensboard swings out for access to the variable shutter. Critical focusing is accomplished by viewing the image through the film. 200' models were also made. The Pitman and DeFranne cameras, made in the U.S.A. are almost identical to the Prestwich. Range: $750-1750. *Illustrated top of previous column.*

Q.R.S. CO. (Chicago)

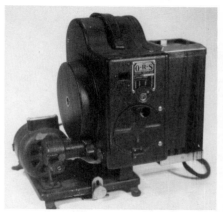

Q.R.S. Projector - c1929. 16mm projector/camera combination consisting of base motor and lamphouse, into which the appropriate Q.R.S. or Q.R.S.-DeVry 16mm camera is fitted. The correct camera is identiifed by: "window" lens on left side where lamp house fits; 3-bladed projector shutter which replaces camera shutter; projection position for aperture blade. Camera and projector base: $30-40.

Q.R.S. Model B - c1930. Inexpensive 16mm projector, some are hand-cranked, others have motor drive. $15-25.

RCA VICTOR CO. INC. (Camden, NJ)
RCA Sound Camera - 1935. World's first 16mm sound-on-film camera. Sound recorded by built-in microphone placed close to operator's mouth when camera was in normal operating position. Sound track was variable area type, recorded by light beam from battery-powered 4-volt auto-headlight type bulb. Eastman 16mm Sound Recording Panchromatic Safety film.

Spring motor driven. 3-lens turret with Universal focus f3.5. Rare. $400+.

REVERE CAMERA CO. (Chicago)

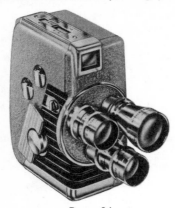

Revere 84

Revere, 8mm - 1940's-1950's. Turret models, including 44, 60, 63, 67, 84, 99: $10-20. Various single lens magazine models, including 40, 61, 70, 77, 88, and Ranger and spool load model 55: $5-15.

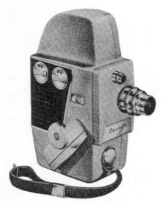

Revere 101, 103 - 1956. 16mm spring motor cameras taking 100' spools. The 101 came with Wollensak f2.5 lens; the 103 with 3-lens turret and one lens. Each lens had objective finders like the Kodak K-100. Listed at roughly half the K-100 price, these cameras typified the aggressive competition Revere offered the "big guys" at this time. $30-50.

Revere Eye-Matic CA-1 to CA-7 - 1958. 8mm automatic exposure control cameras. Spring motor. Spool and magazine load. Various combinations of single-lens and turret styles. CA-7 with Zoom lens: $10-20. Others: $5-10.

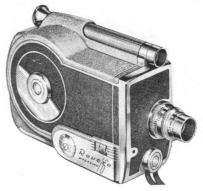

Revere Magazine 16 - c1948. 16mm magazine movie camera. Brushed chrome and grey or brown leather covered metal body. Optical eye-level finder. Spring wind, 12-48 fps. Interchangeable Wollensak Raptar focusing lens. Single-lens models have f1.9/1" lens. Turret models also have f2.7/17mm and f4/3" lenses. $15-35.

Revere Super 8mm - 1939. Despite its name, its not a Super-8 camera at all, but Revere's entry in the brief "craze" for single-8, started in 1936 by Univex, and almost over when this otherwise undistinguished camera came on the market. Single-8 Panchromatic film in 30' spools, made for Revere by Agfa-Ansco. Spring motor. Fixed focus f3.5/½" lens. Rare. $40-60.

RISDON MFG. CO. (Naugatuck, Connecticut)

Risdon Model A - 1931. 16mm spring motor camera using 50' spools. Stamped steel body with black crinkle finish. Simple f3.5 lens, waterhouse stops. Top-mounted telescoping finder. Cameras were later distributed by Agfa-Ansco and the nameplate changed to "Ansco-Risdon". Risdon models: $30-35. Ansco-Risdon models: $20-25.

SANKYO

Sankyo 8-CM - 1963. Compact 8mm spool camera. Pronon f1.8/8.5-26mm zoom lens. Battery drive, 12-24 fps. Folding grip/battery holder. Reflex viewing. Coupled EE for film speeds ASA 10-200. Footage counter. $10-20.

SCHALIE COLLEE (Switzerland)

S.C. Kamera - c1932. Spring wind camera, 16 fps. 16mm on 15m spools. Vertical duraluminum body with rounded ends, polished hammertone finish. Trioplan f2.8/25mm lens. $200-400.

SEKONIC TRADING CO. LTD. (Toyko)
Sekonic Dual Run Simplomat 100 -
1962. 8mm spool load spring motor camera with unique "flip over" film chamber permitting full 50' run without rethreading. Auto exposure control. Footage counter. Zoom f1.8/11.5-32mm lens. Reflex viewing. $25-35.

Sekonic Dualmatic 50 Model 130 - c1963. Economy version of the above. f1.8/13mm fixed lens; non-reflex viewing. $20-25.

SIEMENS & HALSKE AG (Berlin)
Siemens B - c1933. 16mm movie camera taking special 50' Siemens magazines. Black leather covered body. Optical eye-level and waist level finders. Spring motor, 8, 16, 64 fps. Busch Glaukar f2.8/20mm focusing lens. $40-60.

Siemens C - c1934. Similar in style and features to the Siemens B, but with 8, 16, 24, 64 fps and a better lens. Meyer Siemar f1.5/20mm focusing lens. $50-80.

Siemens C II - c1938. Similar to Siemens C, but lens is coupled to the meter. Meyer Optimat f1.5/20 focusing lens. $75-125.

Siemens F - c1936. Similar to Siemens C, but allows for single fram exposures. Interchangeable lens. With Schneider Xenon f1.5/25mm: $60-100. With Meyer-Kino-Plasmat f1.5/25mm: $50-80.

Siemens 8R - c1939. Double-8 spool film cine camera. Black crackle-finish metal body. Spring wind. Rodenstock Sironar f2.2/1cm fixed focus lens. $50-75.

SINEMAT MOTION PICTURE CO. (USA)

Sinemat Duplex 17½mm Motion Picture Camera - c1915. This amateur, hand-cranked, metal body motion picture camera used standard 35mm film that was split lengthwise, providing perforations only on one side. A fixed focus, fixed opening lens

is used. The camera can be opened in such a manner that it can be used as a projector. The single opening shutter is disengaged and a dual opening shutter engaged when used as a projector. Range: $450-950.

SOCIETY OF CINEMA PLATES (Paris, France)

Olikos - 1912. Uses 18- 9.5x9cm glass plates to produce a 90 second movie. The camera, with the addition of a lamphouse is used as a projector. A conventional lens, shutter, and hand crank is used. A unique mechanism takes each plate through a sequence of positions at the focal plane of the camera. Each plate, in turn, is automatically positioned so a series of seven pictures is taken from right to left on the top of the plate. The plate is then immediately moved up and another sequence of seven photographs is taken from left to right and so on for a series of 12 rows of seven or 84 photographs on each plate. Each following plate is automatically positioned and sequenced for a total of a 1512 frame movie. The plate positioning mechanism is precise enough so that the time interval between photographs is acceptably consistent. Few were made. Range: $1500-2500.

SPORT-2 - c1960. Double-8 movie camera. Battery operated motor. T-40 f2.8/10mm lens. $15-20.

STEWART-WARNER (Chicago)
Buddy 8 Model 532-A - 8mm spool camera. Through-body viewfinder, folding sportsfinder on side. $10-15.

Companion 8 Model 532B - intro. 1933. 8mm spool load movie camera. Smaller version of the Hollywood camera listed below. Black lacquered metal body, oval shaped. Spring motor, 12, 16, 48 fps. Interchangeable Wollensak Velostigmat f3.5/12.5mm lens. $5-10.

Deluxe Hollywood Model - 1932. 16mm camera like the 531-B, but with new lens mount for standard C-mount 16mm lenses. Side-mounted telescopic finder. $20-30.

Hollywood (Model 531-B) - c1931. 16mm spool load movie camera. Black lacquered metal body, oval shape. Eye-level finder. Spring motor, 8-64 fps. Stewart Warner f3.5/25mm lens. $15-25.

TECHNICOLOR CORP. (Hollywood, CA)
Technicolor Automatic 8 - c1960. Battery driven 8mm spool camera. Coupled EE. Type A swing-out filter. Footage counter. Technor f1.8/13mm lens. $5-10.

UNIVERSAL CAMERA CO. (Chicago)
Not to be confused with the later "Universal Camera Corporation" of New York City.

Universal 35mm Motion Picture Camera - 1914. This camera, in the classic early English design, has internal 200' film magazines, one above the other. (400' cameras were made for the US Army during World War I.) The film transport mechanism is similar to the early French Lumiere/Pathe movement. The wood body is painted black or khaki and the front and side doors are aluminum with a distinctive engine turned finish. While primarily a field camera, the Universal with added features became a studio camera. Range: $450-850.

UNIVERSAL CAMERA CORPORATION
(New York City) *Not to be confused with the earlier "Universal Camera Co." of Chicago.*
CINE 8 CAMERAS:
A-8 - c1936. Die-cast metal, black finish. Interchangeable f5.6 Ilex Univar. Used Univex 30' patented spools of Single-8 film. Collapsible viewfinder. Common. $10-15.

B-8 - c1939. "True View" model. Die-cast metal, antique bronze finish. Used Univex Single-8 film. Built-on telescopic viewfinder

above the body. Interchangeable f5.6 Ilex Univar or f3.5 Wollensak lenses. $20-25.

C-8 - c1939. "Exposition" or "World's Fair" models. Die-cast metal, antique bronze finish. Interchangeable Ilex Univar f4.5 or f5.6 lenses. Built-in viewfinder. Used Univex Single-8 film. $25-30.

C-8 Turret model - c1939. Same features as the standard C-8, but with 3-lens turret. Sold with f4.5 Ilex Univar or f3.5 Wollensak Univar. Optional Wollensak Univar lenses were: f2.7/½", f1.9/½", f3.5/1" Telephoto, f3.5/1½" Telephoto. Scarce with f3.5, f1.9 and a Telephoto lens: $150-175. Also uncommon with f4.5 or f3.5 only: $45-65.

D-8 - c1941. Dual 8mm "Cinemaster", taking Univex Single-8 or standard Double-8 film. Die-cast metal with green finish. Single speed. Interchangeable f4.5 or f6.3 Ilex Univar. Built-in viewfinder. Scarce. $65-85.

E-8 - c1941. Dual 8mm "Cinemaster" model, taking Univex Single-8 or standard Double-8 film. Die-cast metal, antique bronze finish. Interchangeable Univar f3.5, f2.7, or f2.5 lens. Built-in combination extinction meter and viewfinder. Three speeds. Scarce. $60-80.

F-8 - c1941. Dual 8mm "Cinemaster". Similar to E-8, but with grey satin finish and front and rear chrome plates. $20-25.

G-8 - c1946. Dual 8mm "Cinemaster II" model. Similar to F-8, except for minor improvements in the film transport system. Sold with f3.5 or f2.5 Universal Univar lens. Common. $15-25.

H-8 - early 1950's. "Cinemaster II" model. Identical to G-8, except only standard Double-8 film could be used. This was the last cine camera made by Universal. Scarce. $60-80.

Universal Projectors:

Univex P-8 - c1936. Electric 8mm projector - 100 watts, AC only. Later P-8 models upgraded to 150 watts. Die cast

and pressed steel construction, black enamel finish. 200' reel capacity. Companion projector to Universal's first cine camera, the Univex Model A-8. Common. With carrying case: $35-40. Projector only: $15-20.

Univex P-500 - c1939. Electric 8mm projector - 600 watts, AC/DC. Die cast and pressed steel construction, antique bronze enamel finish. Speed control adjustment, still picture projection, 200' reel capacity. Companion projector to Universal's Exposition & World's Fair cine camera, the Univex Model C-8. Common. With carrying case: $45-50. Projector only: $20-25.

Universal "Cinematic" P-750 - c1947. Electric 8mm projector - 750 watts, AC/DC. Full die cast construction, antique bronze enamel finish. Fully gear-driven, single "clutch" control for forward, reverse and still picture projection, 400' reel capacity. Universal coated lens. Frequent mechanical problems with this model. Scarce. With carrying case: $90-115. Projector only: $65-90.

Universal "Cinematic" P-752 - c1948. Similar to Model P-750, except for modification made to eliminate the gear problems of the earlier Cinematic model. The single "Clutch" control of the earlier model was replaced by two separate controls - one for still picture projection and one for forward/reverse projection. Finished in gray enamel as a companion projector to Universal's Cinemaster II cine camera. Scarce. With carrying case: $75-100. Projector only: $50-75.

Universal PC-500 - c1946. Similar to Model P-500, except for Universal coated lens. Common. With carrying case: $45-50. Projector only: $20-25.

Univex PU-8 - c1937. Similar to Model P-8, except for 200 watt, AC/DC operation with added speed control adjustment. Uncommon. With carrying case, $50-55. Projector only: $30-35.

Universal Tonemaster - c1947. Electric 16mm film/sound projector - 1000 watts, AC/DC. Two-piece aluminium case, 2000' reel capacity. Universal coated lens. Unique "armless" design, reels mount directly on main unit. Scarce. $100-150.

Universal Accessories:
Cine Optical Viewfinder M-27 - c1936. All metal black enamel tubular-shaped viewfinder, used with Univar f5.6, f3.5, or f2.7 lenses. Not common. $10-15.

Cine Optical Viewfinder M-29 - c1937. Similar to M-27 viewfinder, except used with Univar f1.9 or telephoto lenses. Rare. $35-40.

Splicer Kit - c1936. Includes splicer, water and cement bottles, and knife. Common. Complete kit: $8-12.

Standard Titler Outfit - c1936. Includes all metal black enamel collapsible titler, silver pencil and title cards. Common. Complete outfit: $10-15.

Automatic Titler - c1938. All metal black enamel self-standing unit has 36 character openings in three horizontal rows for composing titles. Titler has 36 cog wheels on the back for positioning title characters. RARE. $50-75.

URIU SEIKI (Tokyo)
Cinemax 85E - c1960's. Double-8 movie camera. Spring motor, 12-48 fps. Cinemax Auto Zoom 8.5-42.5mm f1.6 lens. Automatic meter. $3-7.

U.S. CINEMATOGRAPH CO. (Chicago)

35mm Motion Picture Camera - c1916. This wood body, leather covered field camera has 200' co-axial internal magazines. Its film transport movement is

Vicam Baby Standard

somewhat unique. It has a variable shutter and through the film critical focusing. This camera was also sold under the name "Davsco". Range: $350-700.

VICAM PHOTO APPLIANCE CORP. (Philadelphia, PA)
Baby Standard - 1923. 35mm motion picture camera. This wood body, hand cranked camera featured simple design and construction, rather than small film size, to provide economical use for the amateur. A fixed focus lens is used with a two opening waterhouse stop bar. Internal 25' film magazines are used. A removable port in the rear allows the use as a projector. A die cast aluminum body model was also offered. Range: $250-450.
Illustrated bottom of previous page.

VICTOR ANIMATOGRAPH CO.
(Davenport, IA) *Alexander F. Victor's first "motion picture machine" was a spiral disk projector resembling the Urban Spirograph. Patented Nov. 29, 1910; how many of these projectors were actually produced is unknown.*

Victor - 1923. This basic hand crank 16mm camera was produced shortly after the introduction of the Cine Kodak 16mm system. It uses a double push claw for a film transport. The fixed focus lens is fitted with wheel stops. Range: $125-225.

Victor, Models 3, 4, 5 - late 1920's- early 1940's. 16mm movie cameras taking 100' spools. Black or brown crinkle lacquered finish on metal body. Newton finder and reflex critical focus eyepiece. Spring motor, 8-64 fps. Interchangeable lenses. Model 3 for single lens: Wollensak Cine Velostigmat f3.5/1" fixed focus. Models 4 and 5 have a 3-lens turret with focusing lenses: Wollensak f2.7/17mm, Cooke f3.5/2", and f1.9/1". With 3 lenses: $75-110. With single lens: $35-45.

Victor Ultra Cine Camera - 1924. 16mm battery-driven version of the 1923 Victor Cine Camera. Thomas Willard, of Willard Storage Battery Co., is credited with designing this rare modification of the hand-cranked Victor. Re-chargeable battery compartment at rear of camera, powering small electric motor placed in forward bottom part of camera. Less than 100 of these cameras were produced. $500-550.

Victor Projectors:
Victor Animatograph - 1914. 35mm semi-theatre projector, hand-cranked, upright construction. 1000' reel enclosures top and bottom, chain drive to Geneva intermittent. $75-125.

Safety Cinema - 1917. 28mm "safety film", 3 perforations per frame each side. Failed commercially for lack of suitable film. Rare. $125-150.

Home Cinema - 1920. 28mm Pathe safety film, 3 perforations on one side, one on the other. Victor's last attempt to keep 28mm format alive in this country. Rare. $125-150.

Cine Projector - 1923. 16mm EKC direct reversal film. Victor's first projector for the new EKC 16mm film system. Marketed simultaneously with the Victor Cine Camera. Hand-cranked, co-axial 400' reels. 32cp, 12v lamp. $125-150.

Cine Projector Model 3 - c1928. 16mm motor-driven, single sprocket. 400' reels on retractable arms. $25-50.

VITAGRAPH COMPANY OF AMERICA (New York)

Vitagraph - 1915. This wood body, hand crank camera was a ruggedly built in-house design of the Vitagraph Studios. The design is complex and it is a fine looking camera with lots of external brass. It is somewhat unique for this type of camera in that it is

loaded from its right camera side rather than the left. Range: $950-2750

VITALUX CAMERA CO. (Milwaukee, WI) *The Vitalux system was invented in 1918 by a German immigrant to New York City named Herman C. Schlicker. It was manufactured by a company formed by the prominent motion picture executive John R. Freuler.*

The Vitalux Camera - 1922. The camera took a spiral of 1664 images (each slightly larger than present day Super 8) on an endless loop of Eastman Safety negative film 5" wide by 17½" long, loaded in a steel magazine. The camera was die-cast aluminum. Hand-cranked. Goerz Hypar f3.5/20mm lens. Only 2 of these are known to exist. Estimate: $800-1200.

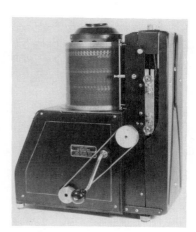

Vitalux Projector - 1922. Companion projector to the Vitalux camera (above). 5"x17½" loop of EKC safety negative film. Hand-cranked, with optional motor drive; 250w lamp, cast-iron frame. Weight of motor, 25lbs. $200.

VITASCOPE CORP. (Providence, RI)
Movie Maker - c1931. 16mm movie camera, taking 50' spools. Hand crank, one rotation per 8 frames. Black crinkle finish metal body. Small waist level finder. Simple lens. $10-20.

WILLIAMSON LTD. (London, England)

Williamson 35mm Motion Picture Camera - 1909. This wood body camera uses internal 400' magazines, one above the other. The patented Williamson film transport movement and a variable shutter are used. Critical focusing is accomplished by viewing the image through the film. 200' models were also made. A 100' basic design camera, similar to Empire was made. Some Williamson cameras are called tropical models and have numerous brass inlays to reduce expansion and shrinkage in the wood body. Range: $650-2750.

WILLIAMSON KINEMATOGAPH CO. (London)
Paragon - c1921. 35mm hand-cranked cine camera taking 400' film magazines. Polished teak body with inlaid brass. Interior lined with sheet aluminum. 3-lens turret with Taylor-Hobson Cooke Anastigmat: 2"/f3.1, 3"/f3.1, 4"/f4.5. $2000-3500.

WITTNAUER CAMERA CO. (NYC)
Automatic Zoom 800 - 1959. 8mm battery drive spool load camera/projector combination like the Cine-Twin. Wittnauer f1.6 zoom lens, front-mounted coupled electric eye. $65-85.

Cine-Simplex - c1958. 8mm battery-drive spool load camera, without the projector conversion that the Cine-Twin has. Made in two models: 4-lens turret with optional screw-in EE exposure meter, or single Elgeet f1.8/13mm Synchronex lens with "wrap-around" electric eye for automatic exposure control. $30-50.

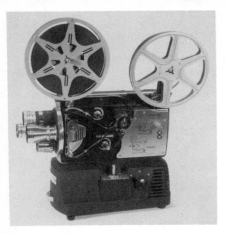

Wittnauer Cine-Twin - 1957. Battery powered 8mm spool load movie camera/ projector. Die cast body. Electric eye exposure meter. 4-lens turret holding standard, WA, and Tele camera lenses plus projector lens. 5-position telescope finder. Camera contains the reel arms and bulb. It is mounted on a base containing the electric motor and blower for projector operation. $50-75. *This is the original model, invented and patented in 1959 by J.W. Oxberry, inventor of the fames Oxberry Animation Stand.*

WOLLENSAK OPTICAL CO. (Chicago)
Model 8 - Grey and black 8mm movie camera. Eye-level finder. Elgeet f1.9/½" focusing lens. $3-7.

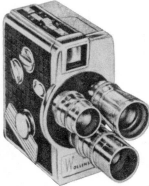

Model 23 - c1956. 8mm magazine camera. 3-lens turret. Eye-level finfer. Spring motor, 5 speeds. Matte aluminum and black. $4-8.

Model 42 - 1957. 8mm spool load with spring motor. f1.9 lens, waterhouse stops, aperture adjustment. $5-15.

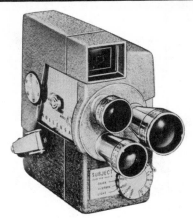

Model 43, 43-D - Like the Model 42, but with 3-lens turret. Model 43-D has 5 speeds. $5-15.

Model 46 - c1958. 8mm spool load movie. Electric eye. 3-lens turret with Raptar f1.8 normal, tele, and wide angle lenses. $5-10.

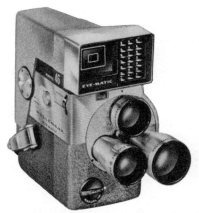

Model 46 Eye-Matic - 1958. 8mm spool load with spring motor. Coupled EE. f-stop visible in viewfinder. Footage counter. Hammertone gray lacquered finish. $5-15.

Model 57 Eye-Matic - 1958. 8mm magazine camera similar to Model 46 Eye-Matic, but with Wollensak f1.8 zoom lens which is powered by camera motor. Also featured "heart-beat" device to assure operator that film was advancing properly, a feature shared by several similar Revere magazine cameras of the period. This camera is marked inside "Made for Wollensak Optical Co. by Revere Camera Co." and probably marks the take-over of Wollensak by Revere. Revere was acquired by 3M Company at about this time. $5-15.

YASHICA (Japan)

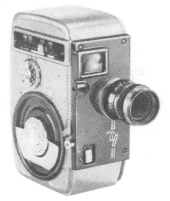

Yashica 8, T-8 - c1959. 8mm spool load movie cameras. Grey and black die-cast aluminum bodies. Spring motor, 16 fps on model 8, 8-64 fps on model T-8. Zoom-type viewfinder for 6.5-38mm lenses. Model 8 has a single interchangeable Yashikor f1.9/13mm lens. T-8 has a 2-lens turret for Yashinon f1.4/13mm normal, 38mm tele, or 6.5mm wide angle lenses. $5-10.

ZEISS
Kinamo N25 - c1927. 35mm using Zeiss film cassettes. Spring wind motor attaches to the side. Black leather covered metal body. Tessar f2.7/40mm lens. Folding wire frame finder on top. $125-175.

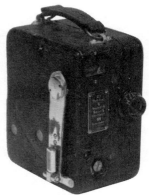

Kinamo S10 - c1928. 16mm taking a 10m special Zeiss magazine. Spring motor, 16 fps. Optical eye-level finder. Black leather covered metal body. Fixed focus f2.7/15mm Zeiss Tessar. Very small body compared to other 16mm cine cameras. $50-75.

Movikon 8 - c1952. 8mm movie camera taking 25' spools. Interesting horizontal body design. Brown or grey crinkle finish

metal body. Eye-level finder. Spring motor. Early version 16 fps; later for 16-48 fps. Focusing Zeiss Movitar f1.9/10mm. $50-70.

Movikon 8 B - c1959. Similar to Movikon 8, but with built-in light meter. Grey crinkle finish body. $50-75.

Movikon 16 - c1936. 16mm spool load movie camera. Black leather covered metal body. Eye-level and waist-level finders, and separate critical focus sight. Spring motor, 12-64 fps. Interchangeable Sonnar f1.4/25mm lens. $175-225.

Movinette 8B - c1959. Similar to Movikon 8 B, but Triotar f2.8/1cm lens, single speed spring motor 16 fps. $45-65.

ZENIT (USSR)
Zenit - c1960's. Spring wind 8mm, 12,64 fps. Built-in meter. Jupiter f1.9 lens. $20-30.

ZIX COMPANY (Detroit, MI)

Zix - 1920. Hand crank 35mm for amateur use. Leather covered wood body. It is unusual in that the shutter is mounted forward of the lens, the lens is mounted midpoint in the camera box and the film plane is at the rear of the camera. The lens is focused by a knob on the side. The film transport is Geneva Cross. The camera can be used as a projector. Range: $350-700.

This section of the book lists items which look like cameras but actually serve a different purpose. Functional cameras are in the main section of this guide. Many of these are recent items. Their "collectible" value is generally not based on rarity or demand, but more realistically is the retail price at which they currently are or recently were available. On these items, we have listed their approximate retail price. Items which have not been available new for some time have prices which reflect the current market value rather than the original price.

They are grouped by function, and the functional types are in alphabetical order:

CATEGIORES
Air Freshener
Albums
Bags (Handbags, Shoulder bags)
Banks
Belt Buckles
Candle
Candy & Gum
Cigarette Lighters
Clocks
Coasters
Compacts & Vanities
Containers
Convertors
Dart & Pellet Shooters
Decanters & Flasks
Dishes & Tableware
Dolls with Cameras
Jewelry
Keychains, Key Ring Fobs
Lights
Masks
Mouse, Worm, & Surprise Cameras
Music Box
Neckties
Ornamental
Pencil Erasers, Sharpeners, Stationery
Phonographs
Planters
Printing Frames
Puzzles & Games
Radios
Rubber Stamps
Salt & Pepper Shakers
Soap
Squirt Cameras
Statuettes & Figurines
Toy Cameras
Toys & Games, unspecified
Vehicles
Viewing Devices

This list is only a sampling of the many camera-like novelites which have been produced. Readers contributions are welcomed to expand this section.

AIR FRESHENER

SOLIDEX INC. (Los Angeles, CA)

Minera Air Freshener - c1984. Room air freshener disguised as a zoom lens. Perfect for the high-tech bathroom, or to keep your camera bags smelling nice. About $5.

ALBUMS

ALBUM - Photo album shaped like 35mm SLR. Holds 24 prints 3¼x5". $4.

ANKER INTERNATIONAL

Ariane and Benjamin Photo Albums

"Ariane" Photo Albums (SLR style) - c1988. Set of 2 albums in a slipcover which resembles a 35mm SLR. The album covers repeat the design of the slipcover, and when in position, the spines form a composite image of the camera top. Each album has 30 double-sided plastic sleeves, 10x15cm. Made in Korea. About $10.

Benjamin Camera - c1988. Set of 4 albums styled like a view camera and labeled "The Benjamin Camera" on the front. The spines of the four albums, when aligned in the slipcase, form a composite image of the side of the view camera. Each album has 20 plastic sleeves for 10x15cm photos. Made in Korea. About $15.

BAGS (HANDBAGS, SHOULDER BAGS)

LEADWORKS

Shoulder Bag - c1985. Rigid plastic carrying bag with shoulder strap. Shaped like a large camera. Lens and back are transparent plastic tinted in magenta or pale green. Retail about $11.

SILVER LENS CAMERA BAG - c1987. Soft plastic bag shaped like 35mm autofocus camera. White or black. $5.

BANKS

EASTMAN KODAK CO.

INSTAMATIC CAMERA BANK - c1967-1970. Given free to customers who purchased two rolls of Kodak color film. Several style variations: front identical to Instamatic 100 Camera (1967-68), or, styled like Instamatic 124 Camera (1968-69). Black plastic body. Printed front behind clear plastic. Kodak logo on front. Molded into the back is "Instant Savings for Instamatic Cameras". Originally purchased by dealers for $5.00 per carton of 25. $1-2.

Kodak Disc Bank - c1983. Black plastic bank shaped like Kodak Disc camera. Aluminum-colored covering. $2-5.

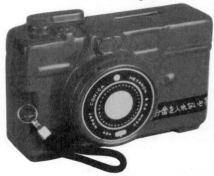

KATO KOGEI Conica - Glazed ceramic coin bank, styled like Konica C35 EF3 camera. Black, red, or white. $15-20.

KODAK BANK - Early cast metal type. Shaped like a Brownie box camera. The door reads "Kodak Bank". This bank was not made by Kodak. Manufacturer unknown. Marked "Patent Pending 1905". It was offered for sale as late as 1914 by Butler Brothers, a toy distributor. $75-100.

PICCOLETTE CAMERA BANK - Ceramic coin bank shaped like Piccolette camera. $10-15. *Illustrated next page.*

POCKET COIN BANK - Black plastic bank shaped like 110 pocket camera. "Pocket Coin Bank" on aluminum-colored top. $1-3.

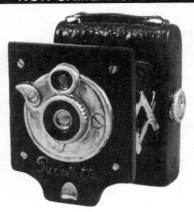

Piccolette Camera Bank

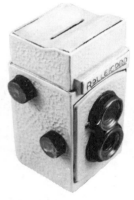

ROLLEICORD - Ceramic bank styled like Rolleicord TLR. White iridescent glaze with gold trim. Clear plastic lenses. $30-50.

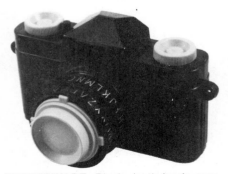

TUPPERWARE - Black plastic bank, grey plastic knobs & lens. Lettered rings around lens set combination "tumblers" to open lens. "Tupper Toys" on front. $3-6.

BELT BUCKLES

LEWIS BUCKLES (Chicago)

Camera Buckles - c1980's. Cast metal belt buckles shaped like cameras or with bas-relief cameras as the major design. Available in various styles for different brands of cameras. About $5.

CANDLE

CAMERA CANDLE - Black wax candle shaped like small 35mm SLR. Aluminum-colored trim. $15-20.

MICKEY MOUSE CANDLE - Hand painted wax candle, 85mm tall, in shape of Mickey Mouse holding a camera. $1-2.

CANDY & GUM

AKUTAGAWA CONFECTIONERY CO. LTD. (Tokyo)
Chocolate Camera - c1981. A well-detailed scaled-down chocolate model of the Canon AE-1 camera. A perfect gift for the man who wants to have his camera and eat it too. Retail price: $3.75

DONRUSS CO. (Memphis, TN)
Hot Flash Chewing Gum - c1984. Red or yellow plastic container shaped like SLR. "Hot Flash" on front of prism. Lens

removes to open. Contains small pellets of chewing gum. Retail: $0.50

CIGARETTE LIGHTERS

AKW (Ankyu Workshop, Tokyo)

Perfect-Lighter - Lighter shaped like 35mm camera. Metal covering with stamped cherry tree design. Tree trunk and branches on back. Some traces of Leica styling include slow speed knob and focus lever. "Perfect" engraved on top, along with model number DI or DII. Actuator button is marked "pushing". "AKW Tokyo" on bottom. Another variation is leatherette covered, and marked "ANKYU WORKSHOP IN TOKYO" on bottom. With tripod: $30-40.

BROWN & BIGELOW (St. Paul, MN)
Kodak Film - Lighter in shape of small red roll of film on a film spool. Pulls apart to reveal "Redilite" lighter. $60-80.

CANON LIGHTER - Lucite butane lighter with Canon Logo. $10-15.

CONT-LITE TABLE LIGHTER - Bakelite-bodied cigarette lighter styled like 35mm camera with cable release and tripod. "CONT-LITE" on back; "Cont-Lite Table Lighter" on original box. $15-25.

CONTINENTAL CAMERA-LIGHTER - Bakelite-bodied lighter, styled like 35mm camera. "CONTINENTAL NEW YORK" around lens. No other identification. "Made in Occupied Japan" molded in bottom. With tripod and cable release: $15-25.

FILM CARTRIDGE LIGHTER - c1988. Gas lighters in the shape of a 35mm film cartridge. Various patterns including Kodak and Fuji films, or decorative designs. $5-10.

K.K.W.
Camera-Lighter - Lighter styled like 35mm camera. Bakelite body with no name on back. Compass built into front. "Made in occupied Japan" on bottom. "K.K.W. CAMERA LIGHTER" on lens rim. With tripod: $15-25.

Photo-Flash Camera-Lighter - Lighter styled like 35mm camera. "Photo-Flash" molded in back of bakelite body. Compass inset in front. "K.K.W. P.P 13449 Japan" on bottom. With tripod: $15-25.

KYOEI TRADING CO. (Tokyo)

Mino Flex Snap Lite - Cigarette lighter styled in the form of a small TLR, 5cm high. Made in Occupied Japan. With tripod and cable release. $30-40.

LUCKY-LITE CAMERA-LIGHTER - Cigarette lighter/telescope shaped like 35mm camera. Bakelite body. "Lucky-Lite" molded in back. Telescope through center

of camera in lens position. Front lens focus. Made in Occupied Japan. $20-30.

LUMIX CAMERA-LIGHTER - Small cigarette lighter styled like Leica IIIc camera. "Winding knob" with numbered skirt functions as shutter release lock. Top housing profile is definitely Leica-styled (unlike other lighters). "Slow speed dial" on front. Viewfinder window and two round rangefinder windows on front. Side by side eyepieces on back. Focus lever on "Excellent Cherry" lens. Metal covering in either cherry blossom or leopard spot pattern. Made in Occupied Japan. $20-35.

MATCH KING - Lighter styled like small Piccolette camera. Top knob unscrews and withdraws attached "match" from the wicking where it has soaked up a small amount of fluid. Match is then struck on the side of the case. Speed dial is marked "Falcon". $20-25.

NIKON F3 TABLE LIGHTER - c1987. Cast metal model of Nikon F3, made to about 85% scale. Butane lighter is in normal position of the shutter release and speed dial on the Nikon F3. Made in Japan. $15.

NST
Phenix camera-lighter (bakelite body) - Lighter styled like 35mm camera. Black bakelite body. "Phenix" molded in back. Compass built into front. Made in Occupied Japan. "NST" on focus ring. With tripod: $15-20.

Phenix camera-lighter (metal covering) - Lighter styled like 35mm camera. Thin metal covering with stamped flower pattern on front. Back engraved with dragon design. Made in Occupied Japan. "NST" on focus scale. $20-25.

MUGETTE CAMERA-LIGHTER - Small black or brown bakelite lighter styled like Piccolette camera. Speed dial is marked "Triumpf". Made in Germany. $20-25.

PEACE-GAS CAMERA-LIGHTER - Gas lighter styled like 35mm camera. "Peace-Gas" molded in back of bakelite body. No compass on front. With tripod and cable release: $15-25.

PENGUIN TRY CAMERA-LIGHTER - c1986. Small rectangular gas lighter with front and back plates printed to resemble a camera. $5.

PERFEOT LIGHTER - Cigarette lighter styled as 35mm camera. "PERFEOT (sic) LIGHTER" on lens rim. No other identification. Thin metal covering stamped with cherry blossom pattern. "Made in Occupied Japan" on back. $20-25.

PHOTOMATIC - Camera-styled lighter on small tripod. "Slow-speed dial" on front. $15-20.

RIVIERA CAMERA-EYE SUPER

LIGHTER BR-C3 - c1987. Gas lighter styled like miniature Konica C35 EF3. Ignites by pressing "electronic flash". $15.

S.M.R. (Japan)

PENTAX ME Cigarette Lighter - Cast metal table model cigarette lighter, styled after the Pentax ME camera. The lighter insert is the refillable gas type. Retail price in 1983 about $35.00.

View Camera Cigarette Lighter - Cast metal table model cigarette lighter, styled after a folding-bed view camera. Refillable gas lighter insert. Current value $10-20.

SUN ARROW (Japan)

KadocK-II Personal Gaslighter - Lighter disguised as a 120 film roll. Styling imitates Kodak packaging. One version even imitates Kodak trade dress in yellow, red and black colors. Another version is in silver and black. $15-30.

WOND-O-LITE - Lighter and cigarette case in shape of TLR. About 50mm square by 92mm high. Fill point is marked "Fluid lens". Back opens to hold cigarettes. $40-50.

CLOCK

COPAL CO. LTD. (Japan)
Asanuma Clock - Brown plastic scale model of a studio camera on a stand. A mechanical digital clock is in the stand below the camera. The lens of the camera is marked "Asanuma & Co. Established in 1871". $30-40. *Illustrated top of next page.*

NIKON CERAMIC CLOCK - Black & white ceramic Nikon with wind-up alarm clock in lens position. $40-60.

Copal Co. Asanuma Clock

COASTERS

GIREY

FRIENDLY HOME PARTIES INC. (Albany, NY)

Camera Coaster Set - Set of six wooden coasters with cork inserts. Storage rack designed like view camera on tripod. Chamfered edges of coasters resemble bellows. About $5.

Kamra-Pak Vanity - Small metal compact shaped like a folding camera. Front door conceals mirror and makeup. Winding knob is a lipstick. Various colored coverings, including colored leatherettes and imitation mother-of-pearl. Metal parts in brass or chrome. Often found with U.S. Navy emblem. Some collectors have expressed the opinion that the resemblance to a

COMPACTS & VANITIES

In addition to the camera-shaped compacts below, there are some real cameras which are built into makeup boxes, compacts, etc. These are listed in the main part of the book, under such diverse names as Ansco Photo Vanity, Vanity Kodak cameras, and Kunik Petie Vanity.

Compact, Change Purse, Cigarette Case - Unidentified manufacturer. Suede covered compact with comb, lipstick, cigarette case and lighter, and change purse. $25-35.

Kamra-Pak Commemoratives

camera is coincidental. The name "Kamra-Pak" used by Girey confirms their intentional design as camera look-alikes. That name is found on the original box, however, and not on the compact itself which has only the Girey name. $15-25.

Kamra-Pak Commemoratives - Special designs of the common compact were made for major events. Examples include the San Francisco Bay 1939 and Century of Progress 1933. $30-50. *Illustrated bottom of previous page.*

Unidentified compact, in brass

Purse, Compact, & Lipstick - Unidentified manufacturer. Suede covered purse with round compact in lens position, lipstick in winding knob position. Top flap opens to small purse. $35-45.

Vanity Case - Shaped somewhat like an early Blair Folding Hawkeye camera. Inside the rectangular front door are found the mirror and makeup items. $50-60.

Unidentified compact - Slightly larger than the common Girey Kamra-Pak. This compact has a door on each side. A mirror and makeup powder are on one side; a manicure set or cigarette case on the other. The winding key conceals the lipstick tube. Available in several finishes, including suede leather and brightly colored leather patterns. Complete: $30-40.

Unidentified compact - Rectangular brass and brass plated steel body with black enamel. Round brass front door in lens position has mirror and opens to powder compartment. Lipstick in film knob. $35-50. *Illustrated top of next column.*

Vanity kits - Several variations of same basic style. Vanity case is shaped like a large folding rollfilm camera in the folded position. The interior houses a makeup set including compact, lipstick, rouge, and comb. Several different exterior coverings, and some have ornamental lens or small mirror in red window position. $50-60.

VENUS-RAY COMPACT - Brass-lacquered chrome compact with horizontal ribs. Shaped like a miniature Ikonta 6x6. Battery-powered lighted mirror in the door of the makeup compartment. The winding knobs

conceal the batteries at the rounded ends of the body. $30-40.

WADSWORTH

Compakit - Camera-shaped vanity case. Round front door has shutter speeds and f-stops. Knobs contain lipstick and cigarette lighter. Bottom opens to cigarette case. Fitted case has opening for "lens". $40-60.

Wadsworth Vanity & Cigarette Case - Styled like a folding rollfilm camera in closed position. Suede covering. $25-40.

CONTAINERS

GIBSON (C.R.) CO. (Norwalk, CT)
Camera Note Box - Cardboard box with note cards and envelopes. Exterior is extremely realistic lithograph of No. 2 Brownie. Design Copyright 1983 by Philip

Sykes. Retail price was $8.50, but it would easily bring double that amount today.

IAN LOGAN LTD. (England)
Foto-File - Cardboard box for storing photographs. Styled to look like an Agfa box camera. $5-10.

JEWELRY CASE - c1930s. Shaped like a folding camera. Green body. Mirror inside. $25-35.

KODAK DISC 4000 Photokina '82 - Shallow covered ceramic dish, shaped and decorated to resemble the Kodak Disc camera. The nameplate is actually the same as used on the real camera. Could be used as a cigarette box, etc. A promotional item from the 1982 Photokina. $15-25.

MYSTERY MUG - c1920's? Leatherette

covered wooden box "camera" is actually a disguised storage box for an enameled metal mug. The mug is shaped like a miniature chamber pot. Perhaps it was designed for use as a cuspidor which could be hidden from view. Rare. Estimate: $75-100.

WELCH (Peter Welch, Yorkshire) Film Cassette Cookie Jar - Oversized film cassette with removable lid. Commissioned by Coverdale & Fletcher Photographers; designed & made by Peter Welch. $25-35.

CONVERTORS

For those who don't understand this modern science-fiction terminology, "convertors" are robot-like people who convert to mechanical objects. Ask your kids.

CAVALIER/Camera A-1 - Toy camera which converts to ray-gun and flashlight. Battery operated light and sound effects. $10-15.

CHIEN HSIN PLASTIC FAC. CO. LTD. (Taiwan)
Camera Pistol 116 - Toy disguised as a camera. Opens to become a cap gun. "Camera Pistol 116" on back. $4-8.

COMWISE INDUSTRY CO. LTD.
Camera Laser Gun 3-in-1 - c1982. This toy is shaped like a camera, but with a

flashlight in the lens position. Converts to a toy laser gun. Retail price about $15.00

DAH YANG TOYS (Taiwan)
Cap gun camera - Toy disguised as a camera. Opens to become a cap gun. $4-8.

GALOOB (Lewis Galoob Toys, Inc., San Francisco)

Beddy-Bye Bear - c1984-85. A small pink and blue plastic charm which converts from a camera to a teddy bear in bed. One of a series of nine "Sweet Secrets" charms. Retail about $4.

LI PING CO. LTD. (Taiwan)
Cambot Wonderful Slide Robot - c1985. Robot converts to camera shape and functions as a viewer for 35mm slides. In

643

the absence of exhaustive research, we can only report that the package illustrates red, blue, and yellow variations. Even more interesting is that the body has holes for a speaker, and "volume" and "tuning" molded near the edge. This indicates that a radio-equipped version may also exist. $12-18.

MARK

MICROX ROBOT-TO-CAMERA - c1984. Three robots combine to make Microx camera. It does not function as a camera, but can be used as a telescope. Retail about $8-10.

SHELCORE INC. (So. Plainfield, NJ)

Change-A-Toy - c1985. A children's toy which converts from a camera to a car with a few simple motions. White, blue, yellow, and red plastic. Retail about $8.

TAIFONG

Mark MA-1 as camera and robot. Film can in upper photo gives a size reference.

MA-1 camera-robot - Small SLR-type camera converts to robot. Copyright 1984 by Select, New York and Mark, Japan. Retail about $2.50.

Snap-Shot Secret Gun CH-337 - Toy disguised as a camera. Opens to become a cap gun. 'Snap Shot' on front. 'Secret Gun' on back. $4-8.

Camera Shooter NIKO Nikosound 112XL - c1983. Toy styled like movie camera. Features include gun, flashlight, telescope 3.5x, laser gun. Provisions for built-in radio, but the only example we have seen did not have one. Retail about $12.

DART & PELLET SHOOTERS

JA-RU
Pellet Shooting Camera - Small camera-shaped pellet shooter. Comes with box of pellets which resembles film box. Retail in 1980: $1.25

KUZUWA TOY

Trick Ompus XA Bickri Camera - Small black or red toy shaped like Olympus XA camera with sliding front door. Shutter release pops open lens, revealing a small funny face picture. Continued pressure ejects the funny face "dart" at the subject. Darts are stored in a film box which imitates Kodak trade dress. Original package also contains sugar coated chewing gum. $15.

LINDSTROM TOOL & TOY CO. INC.
(Bridgeport, Conn.)

Candid Camera Target Shot - Masonite target, 9" square. Blue, aqua, green, yellow, and red sections, with photos of various planes. One plane (in 9:00 position) is inverted. Metal "Candid Camera Gun" camera, spring-loaded to shoot darts. Set with darts and boards: $40-50. Camera only, without darts: $10-15.

DECANTERS & FLASKS

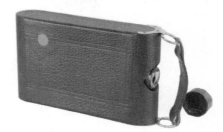

CAMERA-FLASK, Folding Camera style (American) - Several different styles, shaped like a folding rollfilm camera in the closed position. Glass flask bottle inside leatherette covered wood body or leather covered aluminum body. $40-60.

CAMERA-FLASK, Folding Camera style (German) - Very well made, all metal with genuine leather covering. Winding knob conceals set of four nested metal shot glasses. Corner of camera body twists off to pour contents. Beautifully crafted. $100-150.

CANDID SHOT - Ceramic decanter styled like 35mm. Winding knob is cork stopper. Two shot glasses in pouch on strap. $10-20.

MOVIE CAMERA (three-lens) - Nameless ceramic decanter, very similar to the Relco Movie Shot, but with non-removable lenses. $10-20.

MOVIE CAMERA (two-lens) - Ceramic decanter shaped like movie camera. Black glaze with gold trim. Two shot glasses for lenses. $10-20.

Reflex Shot

RELCO (Japan)

Movie Shot - Ceramic decanter shaped like three-lens turret movie camera. The lenses are actually removable and usable as shot glasses. Black glazing with gold trim. $10-20.

REFLEX SHOT - Ceramic decanter shaped like TLR. Black glaze with gold trim. Cork stopper in top. Two shot glasses for lenses. $10-20. *Illustrated next column.*

SWANK
Camera Flask - Plastic flask shaped like 35mm SLR. Winding knobs conceal spout and air vent. Clear slot on back and clear lens are useful to gauge level of contents. Comes with a small plastic funnel. $8-12.

Schnapps-O-Flex - Ceramic decanter shaped like a TLR with a flash attachment on the left side. Black glazed with silver

trim. The flash reflector removes to reveal the pouring spout for your favorite beverage. Complete outfit includes black ceramic shotglass in box resembling Kodak 35mm film box. Outfit: $20-30. Flask w/flash only: $10-15.

UNIVEX MERCURY DECANTER - Ceramic decanter shaped like Univex Mercury camera. Glazed in all black, or black body with white shutter housing, lens, speed knobs, and VF window. $10-20.

DISHES & TABLEWARE

CHAMPAGNE GLASS - From 1911 Shriners convention. Shows man with view camera on a stand and a factory building in Rochester, NY. $75-100.

CHEESE DISH - Ceramic tray with cover

shaped like folding camera. "Say Cheese" printed in bottom of dish. $40-50.

ENESCO IMPORTS CORP.

Ceramic Mug - c1985. Exterior has illustration of 35mm SLR. Black interior has printed slogan, "Photographers do it in the dark". $5.

KODAK MUG "You press the button We do the rest" - Ivory colored coffee mug with brown printing. Drawing of woman photographing young girl with original Kodak Camera. Made in Korea for Kodak Australasia. $10-15.

McDONALDS
Great Muppet Caper drinking glass - c1981. Two different glasses with pictures featuring Gonzo with his camera. One depicts Gonzo in a hot air balloon, the other in a bus. Cost 60 cents new in 1981. Current value $1-3.

NIKON MUG - Plastic cup with the Nikon logo. $9-13.

PHOTOMANIAC MUG - White ceramic

Camera ring

Charms: Happy (left) and JAS 300 (right)

CAMERA-CHARM JAS 300 - "JAS 300" on back. Small plastic charm for charm bracelet. Styled like RF 35mm. $0.25.

CAMERA RING - Cheap soft plastic "camera" with elastic finger band. $1-3.

mug made in China. "Photomaniac" and drawing of camera on one side. $2-5.

WILTON (Columbia, PA)
Kodak 1880-1980 Centennial Plate - Cast metal plate, 10" diameter. "A 100-year start on tomorrow" on rim. Center area has bas-relief scene of woman with the original Kodak Camera, photographing a young girl as a boy watches. Dealers ask up to $50.

DOLLS WITH CAMERAS

KNICKERBOCKER TOY CO.
(Middlesex, NJ)
Snoopy The Astronaut - Snoopy doll with space suit, helmet, and camera. Also includes moon shoes, life support system, vehicle, flag, and Woodstock. $15-20.

MATTEL
Fashion Photo Barbie - Imitation camera for fashion photography, connected to doll by a tube. Turning camera lens causes doll to change positions. Copyright 1977. $15-25.

JEWELRY

AMERICAN GREETINGS CO.
Mr. Weekend Button - c1985. A whimsical decorative button illustrating a man with a camera. About $1.00.

CAMERA CHARM - c1986. Small blue, red, or white plastic charms shaped like 35mm rangefinder or SLR cameras. Usually with small bell and plastic clip attached. Occasionally with name such as "Happy" on front of lens. About 3 for $1. *Illustrated next column.*

CAMERA-CHARM, silver - Small charm that looks like a 35mm camera with flash. $8-13.

CANON AE-1 PROGRAM LAPEL PIN - Small brass lapel pin inlaid with black & white enamel. About $1.

Enlarged to show detail

KODAK AUSTRALASIA LAPEL PIN - Made by Swann & Hudson in Australia, this 15x20mm pin features a yellow kangaroo with red boxing gloves on a green background. $1-5.

"KODAK 25" LAPEL PIN - c1957. Silver lapel pin given to employees with 25 years service with the company. $80.

KRUGENER DELTA-CAR LAPEL PIN DVPCA 10th Anniv. - Tiny replica of the Krugener trademark (Delta camera on wheels with rear cab). Fashioned in sterling

silver for the Delaware Valley Photographic Collectors Assn. in 1984. About $20.

MAGAZINE PENDANT - Reproduction in miniature of 35mm cartridge of Agfa, Fuji, or Kodacolor II film. Only one inch tall. Comes with neck chain and matching box. $2.00

PHOTOGRAPHY STAMP TIETAC - Exact reproduction of the 1978 USA 15 cent photography postage stamp made into a cloisonne tie tac. Retail $5.

YASHICA TIE CLIP - $5.

KEYCHAINS

CAMERA KEYCHAIN - c1986. Small plastic and metal camera with attached keychain. Levers and knobs are movable. Retail $1.50.

CAMERA KEYCHAIN, NIKON F3 - Soft black plastic fob attached to keyring. Line drawing of Nikon F3 printed on one side. Back side used for advertising. $1.

GOLD HORSE (Taiwan)
Enjicolor F-II
Keepcolor II - Key fobs shaped as 35mm cassettes, and with the same paper wrapper as the pencil erasers of the same name. To further confuse the issue, they are

marked "pencil eraser" even though they are key chain fobs. Retail under $1.

KODAK NASCAR AUTO - Double-sided antique brass colored miniature Nascar auto with number 4 and "Kodak Film" on side. Attached to split ring. $2.

MICKEY MOUSE VIDEO PHOTO-GRAPHER - Small rubbery plastic figure of Mickey with video camera, attached to key chain. Made in Hong Kong. $2.

LIGHTS

CAMERA KEYCHAIN FLASHLIGHT - c1986. Small black plastic flashlight shaped like camera. Rear button pushes miniature watch battery against bulb contacts. Keychain attached to strap lug. $1-2.

FLASH-IT CORP. (Miami, Florida)
Switchplate cover (photographer) - Ivory plastic cover for electric light switch. Depicts "flasher" photographer with two cameras around his neck and another on a tripod. His trousers are around his ankles; light switch is in an embarrassing position. $4-6.

Switchplate cover (tourist) - Ivory plastic cover for electric light switch. This one features a tourist photographer with a Hawaiian patterned shirt standing in front of the ocean with a sailboat in the background. He has a camera around his neck, a drink in one hand, and a shopping bag in the other. His trousers are around his ankles, and the light switch is in an obvious position. $4-6.

FOTOX - Reddish-brown bakelite flashlight styled like Piccolette. Unusual bulb with solid glass front in lens position. Made in Saxony. $20-35.

PHOTOGRAPHER LAMP - c1987. Ceramic statuette of a photographer with his view camera. Bare light bulb in lens position. If I were an art critic, I would call it tacky, but if you disagree, you might pay the Champs-Elysées price of $40.

SASPARILLA DECO DESIGNS LTD. (New York, NY)
Camera-lamp - White ceramic night-light designed like 35mm camera. Made in Japan. Copyright 1980. $22-27.

WANG'S ALLIANCE CORP.

Hollywood Studio Lamp - c1988. Small table lamp shaped like a movie camera. About $15.

MASK

SPEARHEAD INDUSTRIES, INC. (Minneapolis) Camera Mask - c1983. Rubber face mask shaped like SLR camera and hands holding it. Retail price about $6.

MOUSE, WORM, & SURPRISE CAMERAS

BICOH 36 - Painted metal "camera" with Kiken Bicoh "lens". Shutter latch releases pink worm. Made in Japan. No. 6817612. $2-3.

COMMONWEALTH PLASTICS CORP.
Jack-in-the Camera Sr. - Small black plastic "camera". When release lever is

pressed, a small smiling face springs through the front of the lens. $1-5.

FRIEND BOY'S CAMERA - Eye-level style Mouse camera. $3-6.

HIT-SIZE - Miniature worm camera about the size of a Hit-type novelty camera. $2-5.

KING FLEX - Minature TLR-style worm camera. $1-5.

PANOMATIC 126 - Mouse camera shaped like 126 cartridge camera. Same old mouse in a new package. $3-6.

PRINCE FLEX - Miniature TLR-style worm camera. $2-5.

SNAKE CAMERA (folding bellows style) - Small cardboard bodied folding camera with bellows. Behind the shutter door lurks a green fabric-covered coiled spring with a snake-like head. Fabulous, fragile, and rare. $40-60. *Illustrated previous column.*

Snake camera

WONDER CAMERA FRIEND - Eye-level style mouse camera. $3-6.

WONDER SPECIAL CAMERA - Eye-level style mouse camera. $3-6.

WONDERFLEX COMET SPECIAL CAMERA - TLR styled mouse camera. Also sold under the name "Wonderflex Wonder Special Camera". Made in Japan. $4-8.

MUSIC BOX

Girl holding camera - Ceramic figurine with music box in base. Girl holding camera. Cat seated on nearby chair. Music box plays "Everything Is Beautiful". 1983 retail: $12.

ILLCO TOY CO. (Illfelder Toy Co., NYC) Cabbage Patch Kids Musical Toy Camera - Copr.1984. A music box shaped like a camera. Available in two styles: lavender body with white trim (plays "Farmer in the Dell") and cream body with lavender trim (plays "Old MacDonald".) About $6.

Mickey Mouse Musical Toy Camera - Music box shaped like a camera. Turning lens winds the mechanism. Pressing the release plays "Rock-a-bye-Baby", and a small Mickey Mouse or Donald Duck head turns around on top. Red camera has

Sankyo Snap-Me-Happy Musical Toy

Mickey head on top, Donald face on lens. Yellow camera has Donald head on top, Mickey face on lens. Retail about $6.

Pound Puppies Musical Toy Camera - c1986. Music box shaped like camera. Tan plastic with red trim. Plays "Turkey in the Straw". Retail $6.

Smurf Musical Toy Camera - Copyright 1982. Blue plastic camera-shaped music box toy. Plays "Rock-a-bye-Baby". Smurf head turns around on top. Retail about $5.

SANKYO SEIKI MFG. CO. LTD. (Tokyo) Snap-Me-Happy Musical Camera Toy - c1976. Music box shaped like camera. Red plastic body with yellow trim. Pressing release button plays "Frere Jacques" and yellow bear's head rotates in flashcube position. Made in Hong Kong for Sankyo. Retail about $11. *Illus. previous column.*

ORNAMENTAL

These are decorative, non-functional items.

CAMERA WITH BIRDIE - Miniature cast metal camera on tripod. Birdie on stick above lensboard. About $5.

CAST METAL TOY SLR - Small cast

metal red-enameled model of SLR. New: $3.

De FOTOGRAF - 8" stained glass oval of Photographer with wooden camera on a tripod. $75-100.

DURHAM INDUSTRIES INC. (New York, NY)
Holly Hobbie Doll House Camera - Small cast metal view camera with tripod. $3-4.

HASSELBLAD CRYSTAL 500C - c1980. Crystal replica of Hasselblad 500C, hand crafted, numbered, & engraved. $150-250.

HASSELBLAD PLUSH TOY - Oversized stuffed Hassie for those of us who can't afford the crystal one. Black velour and gray terry-cloth. $5-10.

LIKA - c1987. Wooden toy camera styled like Leica M-3. Very nicely crafted. "Lika" branded in top. Made in USA. About $35.

LIMOGES MINIATURE CAMERA - Tiny ceramic view camera with cobalt-blue or white glazing. Gold trim and gold tripod. Blue: $17. White: $15.

ROYAL HOLLAND PEWTER

Camera with birdie - Small pewter view camera on tripod with birdie sitting on bellows. $40-60.

SHACKMAN (B.) & CO.
Glass Camera on Tripod - Small novelty glass camera on metal tripod. ©1981. $6.

PENCIL ERASERS, SHARPENERS, STATIONERY ITEMS

BEAU BROWNIE PENCIL SHARPENER
-Small, nicely crafted metal replica of the Beau Brownie with built-in pencil sharpener. Camera body catches the shavings and front removes for emptying. Uncommon. No sales data. Estimate $25+

CIPIERE PAPERWEIGHT - 1988. Small cast metal paperweight comemmorating the 100th year of the Cipiere family's camera shop on the "Boulevard de la Photo" in Paris. Given to selected clients by the owner. $10-15.

Gold Horse Keepcolor II Eraser

HELIX LTD. (England)
Camera pencil box - Molded plastic in grey & black, shaped to resemble a 35mm SLR camera. The shutter release button is actually a yellow pencil eraser; the lens removes for use as a magnifying glass; a 35mm cassette inside the camera removes for use as a pencil sharpener; the camera back contains a school timetable. The inside of the camera is suitable for holding pencils, crayons, etc. Retail price about $6.

DOLPHIN WITH CAMERA - Pencil sharpener built into base of small ceramic figurine of dolphin holding camera. Made in China. $1-2.

EASTMAN KODAK CO.
Kodacolor VR 200 - Pencil sharpener shaped like oversized 35mm cartridge. Made in Hong Kong. $1-2.

GOLD HORSE
Enjicolor F-11 Eraser - Rubber eraser shaped like small 35mm film cartridge. Green and white mimics Fujicolor film. $1-2.

Keepcolor II Eraser - Rubber eraser shaped like small 35mm film cartridge. Black & yellow label for "Keepcolor II" film, "Process C-41", imitates Kodak trade dress. $1-2 *Illustrated top of next column.*

HALL & KEANE DESIGN LTD.
Camera Kit - Consists of a pencil sharpener and eraser. In the same series as the Memo set below. Retail about $1.50.

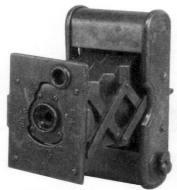

JUGUETES MARTI (Spain)
Pencil Sharpener (VPK style) - Cast metal pencil sharpener shaped like Vest Pocket Autographic Kodak. While the autographic door is historically accurate, the film advance lever added to the back tends to confuse Kodak scholars. $4-8.

MEMO SET - Contains eraser, notebook, pencil sharpener and pencil stylized to relate to photography. Eraser is covered by paper to look like an Instamatic camera; sharpener is shaped and covered to look like two 35mm cassettes and the notebook is called "Photographers Notebook". Retail price about $2.25.

PENCIL ERASER - c1985. Pencil eraser shaped like tiny 35mm SLR. Made of green rubber-like substance. Neck strap at top; hole in bottom to mount on pencil. $1-2.

PENCIL-SHARPENER CAMERA (Hong Kong) - Cast metal pencil sharpener shaped like a view camera. Bellows made of plastic. "Made in Hong Kong" on side of bellows. Retail about $2.

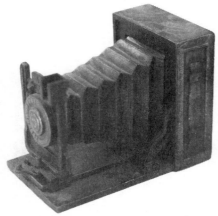

PENCIL-SHARPENER CAMERA (Spain) - Cast metal pencil sharpener shaped like view camera. Bellows are also cast metal (unlike Hong Kong copies). "Made in Spain" and Play/Me trademark. Retail about $3-4.

PENCIL SHARPENER EGFECOLOR 400

- Plastic pencil sharpener shaped like a film can. Red, blue, and yellow label mimics Agfacolor. Retail $1.50.

PENCIL SHARPENER ENJICOLOR F-II - Plastic pencil sharpener shaped like a film can. Red, green, and white label mimics Fujicolor. Retail $1.50.

PENCIL SHARPENER KEEPCOLOR II - Plastic pencil sharpener shaped like a film can. Yellow black label mimics Kodacolor. Retail $1.50.

PENCIL SHARPENER LANTERN PROJECTOR - Heavy metal construction, shaped like an old-fashioned lantern slide projector. $4.

SUNNY MC-8 - c1989. Blue vinyl zippered pencil case. Printed design on front and back resembles 35mm autofocus camera with flash. Contains pencil sharpener, eraser, tablet, ruler, stencils, pens & pencil. About $5.

WONDER FILM RULER - c1984. Flexible 30cm ruler styled like 35mm transparency strip with moving lenticular images. Packed in plastic cannister in yellow film box which mimics Kodak trade dress. $3-5.

PHONOGRAPHS

COLIBRI - Pre-war phonograph made to look like a Zeiss Kinamo movie camera when closed. Made in Belgium. $95.

PETER PAN GRAMOPHONE - Portable hand-cranked 78 rpm phonograph which resembles a box camera when closed. Black leather covered. $125-150.

Heavy cast plaster planter (or pen holder) styled like c1900 view camera. Apparently sold unfinished at craft shops. "Kinwood Camera" appears to be molded into the back, possibly the manufacturer. Nicely finished: $20. Unfinished: $10.

THORENS EXCELDA - A portable hand-cranked 78rpm phonograph which packs neatly into a metal case shaped like a folding rollfilm camera. In black, blue, brown, or green enamel finish. $100-150.

NAPCO PLANTER - Ceramic planter shaped like Mamiya RB-67 camera. Black with silver trim. $8.

PLANTERS

PRINTING FRAME

ELVIN (Japan)

CAMERA PLANTER (35mm SLR) - c1988. Approximately life-sized ceramic planter shaped like 35mm SLR, available in black or red glazed finish. About $7.

Magic Sun Picture Camera - A small cardboard box with a hinged glass back. Printed design resembles either a 35mm or TLR-style camera. Box contains "printing-out" paper for making prints from negatives by two-minute exposure to sunlight. $5-10.

Gakken Taiyou Kankou Kamera

GAKKEN CO. (Tokyo) *The Gakken Co., publishers of science magazines for school children, has produced an interesting variety of cameras*

CAMERA PLANTER (View Camera) -

to teach photography. In addition to the real cameras, they have made a few of what we call the "non-cameras" including this printing frame and an ant farm.

Taiyou Kankou Kamera (Printing Frame Camera) - 1984. Black, red & clear plastic printing frame. Uses printing-out paper with supplied cartoon negatives. $5-9.

PUZZLES & GAMES

EASTMAN KODAK CO.

Dice Cup - Red plastic dice cup with Kodak logo. Five yellow dice with Kodak logo included. $10-15.

Kolorcube - Everybody has heard of Rubik's cube. This is a special version with the Kodak logo on each square of each side. $8-15.

ENSIGN PLAYING CARDS - c1920s. Ensign film logo on box. Cards are printed on the back "Ensign the Good Tempered Film". $10-15.

KONICA PLAYING CARDS - $7

MUPPET PUZZLE "The Photographer" - Plastic puzzle of a wooden view camera with Kermit, Gonzo, & Fozzle. Retail: $5.

PUZZLE CAMERA - Three-dimensional puzzle shaped like small 35mm RF camera. Made in Japan. $1-3.

SNAPSHOT - Jigsaw puzzle of an old photograph. Box resembles a Brownie box camera. Retail about $5.

WARREN COMPANY (Lafayette, Indiana)

Click! Jigsaw Puzzle - c1986. Square jigsaw puzzle, 52x52 cm, with over 550 pieces. Full-color photo of photographic accessories & memorabilia. Retail about $5.

RADIOS

AMICO - Transistor radio shaped like Olympus OM-1 camera. Speaker is in lens mount. $10-15.

DESIGNER RADIO-LIGHT-MIRROR - Transistor radio shaped like 110 pocket camera. Built-in flashlight. Battery door has mirror inside. Also sold under the names "Stewart" and "Diel". $5-10.

EAST ASIA CAMERA-RADIO-FLASHLIGHT - Transistor radio shaped

like 35mm SLR. Flashlight in lens position. Comes with mounting bracket for bicycle. $10-15.

KAMERA - Small transistor radio shaped like a movie camera. Volume and tuning knobs in lens positions. Requires one AA battery. Made in Hong Kong. $10.

KODACOLOR 400 FILM RADIO - Made in Hong Kong. Transistor radio shaped and colored like Kodak film box. Radio box also mimics Kodak film packaging. $15-25.

KODAK INSTANT COLOR FILM PR10 - Transistor radio shaped and colored like a

box of Kodak's now defunct instant film. Operates on one 9v battery. Made in Hong Kong. $10-15.

SHIRASUNA DENKI MFG. CO. LTD.

Silver Pocket Radio - Vacuum tube radio in leather case designed to look like a camera case. Uses one "B" battery and one "A" battery. Small "filter case" on strap contains earphone & antenna wire. $40-50.

STEWART RADIO-LIGHT-MIRROR - Transistor radio shaped like a 110 pocket camera. Built-in flashlight. Battery compartment door has mirror inside. Made in Hong Kong. Also sold under the names "Designer" and "Diel". $5-10.

TOUR PARTNER - Styled like a large camera. Includes radio, lamp, horn and fittings for attaching to bicycle. About $10.

RUBBER STAMPS

BUTTERFLY ORIGINALS LTD. (Cherry Hill, NJ)
Cabbage Patch Kids Figurine Stamper - c1984. Small figurine of Cabbage Patch Doll holding a camera. The base has a rubber stamp (Smile!) and ink pad. Retail $2.50.

KODACLONE SLIDE - A cute rubber-stamp which mimics Kodak's logo on a 35mm slide mount. "Processed by clones" adds an interesting touch. $8-10.
Illustrated top of next page.

658

Kodaclone Slide Stamp

WF Camera-screwdriver-keychain

SALT & PEPPER SHAKERS

Book & Camera - Set includes one small open book and one bellows camera. $9-18.

Movie Camera & Projector - Made of wood. $20-25.

Rollfilm Camera - The "camera" is in two parts. Body is pepper; bellows & front standard is salt. $15-25.

SASPARILLA DECO DESIGNS LTD.
Camera Salt & Pepper - Set of two miniature 35mm-styled ceramic shakers. One is black, the other is white. Retail $6.

SCREWDRIVER

WF
Camera-screwdriver-keychain - Small red plastic "camera" with screwdriver bit in lens position. Interchangeable bits store in body. Keychain attached to strap lug. "WF" molded in back. $5-10. *Illustrated top of next column.*

SOAP

AVON PRODUCTS, INC. (NY, NY)
"Watch the Birdie" Soap - c1962-64. A cake of soap on a rope with a 'birdie' on the lens. "Avon" on back. $30-40 with box.

WOLFF PRODUCTS (Long Island City, NY)

Camera Soap-on-a-rope - A six-ounce bar of soap shaped like a camera. $7-10.

SQUIRT CAMERAS

AMSCAN INC. (Taiwan) *Amscan is a distributor in the U.S. and Canada. Other countries will surely find this toy under another name.*

Squirting Camera - Copy of the well-made Japanese "Flash Shiba" and the poorer "Cohen" from Hong Kong, this brings quality to a new low, while retaining the basic features. See Shiba for further description. Retail: $1.

BATTLESTAR GALACTICA - Small plastic squirt camera with Battlestar Galactica emblem on front. $3.

CHARTERKING LTD.
Wipe-out - c1988. Combination of a Cohen squirt camera packaged with two bottles of disappearing ink. Retail $2.

COHEN - c1986. Black or colored plastic squirt camera from Hong Kong. Copy of the Shiba Aqua Camera. Retail $2.

COMET SPECIAL CAMERA - This small metal TLR looks like a mouse camera but

contains a small bulb of water waiting to be squirted by the long stroke lever on the camera's right side. $5-10.

DE MOULIN BROS. & CO. (Greenville, IL)

TRICK CAMERA
DIRECTIONS
Remove rubber tubing from nozzle of bulb; fill bulb with water and replace tubing.
When candidate is seated to be "photographed" the "photographer" places camera about eight or ten feet from him and takes focus by sighting through peep hole of lense. To make the "exposure" press the bulb.
DeMoulin Bros. & Co.,
Mfrs. of Lodge Supplies, Burlesque and Side Degree Paraphernalia, Uniforms, Banners, Badges, Etc.
Greenville, Illinois.

Trick Camera - c1925. An early wooden box squirt camera. Cubical wooden box, 20cm on a side, with a brass lens tube on the front. Some later models appear to have an aluminum disk with a lens mounted. The squirt tube runs along the bottom of the lens tube and is attached to a rubber hose and bulb outside the rear of the box, which is covered with a black focusing cloth. The rubber bulb is filled with water and then attached to the squirt tube. The

subject is sighted through a tube which runs from the back to the front through the lens tube. The instructions say "To make the 'exposure', press the bulb." $200-400.

DICK TRACY SQUIRT GUN CAMERA - Square plastic squirt camera in Dick Tracy motif. $4.

FOTOMAT
Squirt Camera - Well-made squirt camera shaped and sized like a 126 cartridge camera. Made in Hungary. No relation to the Fotomat film stores in the U.S.A. $5-10.

GREEN PINE WATER CAMERA - c1987. Square black plastic water camera from Hong Kong. Retail $2.

Gucki

GUCKI - c1986. Black plastic squirt camera made in W. Germany. Retail $2. *Illustrated bottom of previous column.*

JA-RU
Trick Squirt Camera No. 803 - Retail $1.

JAK PAK INC. (Milwaukee, Wisconsin)
Squirt Camera X-315 - c1986. Black plastic squirt camera made in Hong Kong. Back of body has "WK Toys" molded in, which is probably the actual manufacturer. Retail about $1.

PHOTO-BIJOU LANCE-EAU - c1930's. Charming little leatherette covered wooden body with imitation lens. Small plastic bulb in rear compartment with tube aimed through the front. No identification on the camera, only on the box. Rare. One verified sale with original box in late 1987 for $100.

PREMIER PLASTICS CO. (Brooklyn, NY)

Squirt Pix - Automatic water shooting camera. With original box: $10-15. Camera only: $3-5.

REDBOX 707 - Small plastic squeeze-type squirt camera. Originally sold in a "Little Kingdom Special Agent" kit which included pistol, handcuffs, badge, and passport. Kit: $10. Squirt camera only: $2.

SAFARI FOTO AQUA (FOTOVISION) - Rigid plastic water camera with rear plunger. "Safari Foto Aqua" is molded on front. Sticker on front with "Fotovision" name could be just one name variation. Assembled from parts of many colors, so many color variations. $2-4.

SHIBA
Aqua Camera Flash Shiba - c1984. Small "camera" which squirts water from the "winding knob". Knob rotates to allow squirting in a different direction. The instructions suggest that after squirting somebody by taking their picture, you give them the chance to do the same to you (but only after you reverse the direction of the knob!) This double-trouble toy comes in black, red, white, silver, or gold. Retail about $3.

"Instamatic" style water camera - No. 314A. Made in Hong Kong. $1-2.

T.H.
Water Camera No. 402 - Black or red plastic water camera. Chrome trim on front. "T.H." trademark and "No. 402" on back. Mushroom top on shutter release. Cloth strap. Retail: under $1.

T.K.

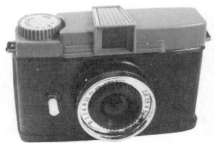

Squirt Camera "Diana Style" No. 686TK - This "camera" looks exactly like the cheap "Diana-type" cameras for 120 rollfilm, but squirts water. Made in Hong Kong. $2.

Water Camera No. 677 - Black plastic squirt camera. Chrome trim on front. "Made in Hong Kong" on back. Thin shutter button. Plastic strap. Retail: under $1.

VOHO

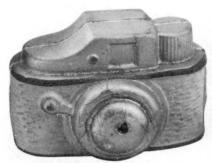

Squirt Camera - Small rubber squirt camera styled like a Hit camera. Cream colored body with aluminum paint on top, front, and "latch". "Made in Occupied Japan" molded into bottom. Also available in a black model. Uncommon. $5-10.

WATER CAMERA - Black plastic squirt camera. White top and bottom. Chrome lens rim. Made in Hong Kong. $1-3.

WATER CAMERA NO. 014 - Simple plastic squeeze-type squirt camera. Made in Hong Kong. Retail $.30.

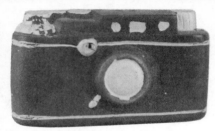

WATER CAMERA, Leica-styled - Black rubber squeeze-type squirt camera made in Occupied Japan. Styling resembles a Leica camera. Squirts from "slow-speed dial". Trimmed with aluminum and gold colored paints. $5-10.

STATUETTES & FIGURINES

ALDON PHOTOGRAPHER - Wooden figurine 30cm (12") tall. Man holds one camera to his face. Two other cameras hang at his sides. Made in China. Retail: $15.

BEAR WITH FLASH CAMERA (tree ornament) - Small hand-painted wooden ornament for Christmas tree or wherever else little bears hang out. $1-3.

BULLY
Tintin Figurine - Created in 1927 by Belgian cartoonist Herge (Georges Remy), this cartoon character has been popular in the French language ever since. Just as Mickey Mouse has a following of collectors, so does Tintin. There are several sizes of figurines of Tintin with his camera and suitcase. Illustrated on the bottom of the previous column is a small one which retails in France for $3.

GIRL WITH CAMERA - Painted ceramic figurine. Girl with view camera. Camera rests on the face of a cat on a chair. Made in Taiwan. $10.

HIPPOPOTAMUS WITH CAMERA - Soft plastic hippo stands 18cm tall. Advertising figure for East German "Pentacon" company. It holds a small "Praktica" camera and a trumpet. $15-25.

Bully Tintin Figurine

Lucy Rigg Teddy Bear Photographers

LEFTON CHINA
Man with camera - Hand painted ceramic figurine. Man with camera on tripod. Powder flash unit in left hand. Box of plates at his feet. Made in Taiwan. Retail: about $30.

LUCY RIGG
Teddy Bear Photographers - c1985. Set of two small figurines, 85mm tall, one a girl & one a boy teddy bear. Each holds a camera. Retail: $5 each. *Illustrated previous page.*

PHOTOGRAPHER TROPHY - Cast metal figure of man holding TLR. About 5" (125mm) tall. Similar trophy features man with Speed Graphic. More recent types have 35mm SLR. $5-10.

ROYAL CROWN (Taiwan)
Boy Holding Camera - Figurine of boy seated on stump holding camera. Retail in 1983: $12.

SCHLEICH
Super Smurf Photographer - Small rubbery Smurf toy. Box camera on tripod. Copyright 1981. Retail. $12.

SHUTTER BUG - Comical furry figure holds a camera. Large eyes, nose, sandaled feet protrude from furry body. "Nikon" SLR camera in left hand. "SHUTTER BUG" placard between feet. $10.

SQUIRREL HOLDING CAMERA - Made in Taiwan. Multicolored ceramic figurine, 4" tall. $15.

STARLUX PHOTOGRAPHER FIGURINE - Tiny plastic figurine, 32mm tall, of man with boxy camera. $3.

These are kid's toys that are made to look like and imitate the functions of real cameras.

20 Craze - Black, pink, & green toy shaped

like a camera. Front pops out when shutter is pressed. Picture of comic character on front. $3-7.

AMBI TOYS

Focus Pocus - c1985. Yellow plastic toy shaped like camera. Front springs open and little man pops out. Retail about $10.

ARCO INDUSTRIES LTD. (New York, NY)
Take-A-Picture - Toy camera styled after Kodak Colorburst 250 camera. Includes 12 pre-printed photos which eject when shutter is depressed. Made in Hong Kong. Copyright 1982. Retail: $3.

BARBIE DOLL CAMERA - Tiny grey plastic "camera" accessory for "Barbie" doll. Under $1.

BLUE BOX TOY (New York, NY)
Click-N-Flick Mini Viewer - c1986. Toy shaped like movie camera. Hand crank flickers shutter for movie effect in viewfinder. Retail about $2. *Illustrated next column.*

Blue Box Click-N-Flick

Turn-N-Click Mini Camera - Childrens toy shaped like 35mm camera. Lens clicks when turned. Pushing the shutter raises "flashcube" with smiling sun. $1-5.

BRIGHT STAR - Black plastic toy camera made in Hong Kong. Shutter button clicks; winding knob turns. No other functions. A 'no frills' toy. $3-7.

665

Mattel Chatter-Pal

FISHER PRICE TOYS

Crazy Camera - c1988. Toy shaped like SLR with electronic flash. Lens rings position special effects and colored filters in viewfinder. Retail $12.

IRWIN

Grand Camera - Black plastic toy camera

which holds a quantity of printed pictures. Sliding a lever on the back ejects pictures one by one. $5-10.

KENNER
Picture-Quick - Toy camera styled like Kodak EK-4 Instant Camera. Knob ejects pre-printed pictures through bottom slot. Dated 1977 on back. $7.

MATTEL CHATTER-PAL - c1980. Pastel-colored plastic camera. Pull string activates photo-related recorded messages. $1-5. *Illustrated top of previous column.*

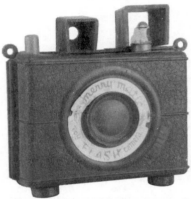

MERRY MATIC FLASH CAMERA - Small black plastic camera-shaped toy. Pressing shutter makes clicking sound and lights flashlight bulb. Operates on one AA battery. $3-7.

SCHAPER MFG. CO. (Minneapolis, MN)

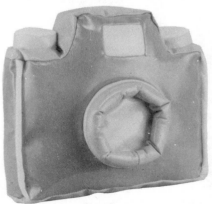

Tendertoys Camera - c1986. Child's stuffed toy shaped like a camera. Red, blue, yellow, and white vinyl fabric covering. Squeaks when squeezed. Retail $8.

SHELCORE INC. (So. Plainfield, NJ)

TOYS & GAMES NOT OTHERWISE SPECIFIED

Clicker Bear - c1985. One of a series of "Squeeze-A-Mals", soft vinyl infant toys. This is a small teddy bear holding a camera. Tan, green, magenta & white. Squeaks when squeezed. Retail about $3.

TOHO

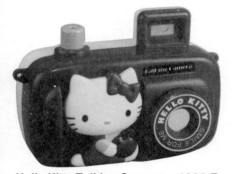

Hello Kitty Talking Camera - c1985. Toy shaped like a large red & white camera with kitty on front. Shutter button activates recordings: "Be Happy Honey", "You look great", "Show me your teeth", "Say cheese", "Don't be shy", "You are the best". $15-20.

TOMY
Ring-a-dingy Camera - Child's toy shaped like a camera. Lens turns with clicking sound. Film advance lever clicks and returns. Shutter button rings bell. © 1982. Other Ring-a-dingy toys are Telephone, Typewriter, and Cash Register. $5.

TOYPOWER MFG. CO. LTD.
Just Like Daddy's Camera - Toy camera with "simulated working flash". Detachable Kaleidoscope and zoom lenses. Copyright 1983. $5.

BEAR WITH FLASH CAMERA - Mechanical bear with camera. Wind-up mechanism raises camera to bear's eye and battery operated flash fires. Made in China. $15-20.

EASTMAN KODAK CO.

Walking film box - Spring-operated mechanism with walking feet is mounted in Kodacolor 400 film box. $3-5.

EFS (Burlingame, CA)
Camp Out - Set of small toy camping items. Includes wrist compass, camera, canteen, flashlight, walkie-talkie, lantern, and radio. $1.50.

GAKKEN CO. (Tokyo)
Ant Farm Camera - 1986. Translucent plastic "camera" is designed to be used

wound musical kaleidoscope shaped like bright yellow camera. Plays the tune "London Bridge". Retail $15.

as an ant farm and also to teach the very basic principles of camera construction. $5-10.

LANCO SCREEN COMPANY

Boo-Boo Bear with camera - c1960's. Small rubber squeeze-toy of seated bear with flash camera. Boo-Boo is the popular sidekick of cartoon character Yogi Bear. Made in Spain. $3-8.

LEGO

Fabuland Patrick Parrot - Toy parrot with flash camera. Also has motorcycle and pipe wrench. Made to interlock with Lego building blocks. Copyright 1982. Retail: $3.

PLAYWELL
Camera Kaleidoscope - c1988. Spring-

PORTRAIT STUDIO - Small cardboard model of an early portrait studio with skylights. Folds flat. $40-60.

TOMY
Roving Eye Camera - A clockwork mechanism allows the camera to walk around; the eye moves around, and the magnifying glass moves up and down. Retail about $3. *Illustrated top of next page.*

668

Tomy Roving Eye Camera

TOTSY MFG. CO. INC.

Flair Doll Camera - Part of a package of 30 doll accessories is a miniscule model of a 35mm SLR with flash. Get out your bifocals to find this one. Retail $1.50.

WINNER TOY (New York, NY)

Jet Setter - Doll-size travel kit. Includes camera, suitcase, purse, passport, money, etc. About $1.

VEHICLES

HOBBYCAR S.A. (Lausanne, Switzerland) *Designer and distributor of a large line of model cars under the "Elicor" label, manufactured in France by L.B.S. of Martignat. Our interest is only in those with photographic theme.*

Ford V8 Camionette 1934, Kodak - Cast metal model of Ford delivery van in Kodak motif. Yellow body, red fenders and running boards. Retail in France: $18.

Ford V8 Delivery Sedan 1932 - Similar to above, but with black plastic representation of soft top, and with rear bumper. Retail $18.

LLEDO

Kodak Van - c1983. Small toy Model T Ford truck with Kodak Film advertising. Cast metal with enameled exterior; plastic trim. Made in England. Part of Lledo's

"Models of Days Gone" series. Retail price around $4, but generally selling now among collectors for $10-15.

PHOTOING ON CAR - c1950's. Battery operated toy automobile, made in China. Horn sounds and headlights flash when it starts. Upon stopping, girl passenger turns with camera and flashbulb lights. New in box, these have sold for as much as $75-100, but they usually bring $30-60, and are not hard to find.

TOYCRAFTER

Wooden Kodak Truck/whistle - c1985. Wooden whistle shaped like a truck. "Products by Kodak" logo on side of truck. $4-6.

WINROSS (Rochester, NY)

Kodak Truck 1880-1980 - Toy truck issued for the Kodak Centennial in 1980. Detachable semi-trailer with operable rear doors. Metal construction, white enameled with yellow trim. Dealers were asking $40-50 for these, but probably not selling many. More recent asking prices have been about $20.

VIEWING DEVICES

CAMERA-CHARM/VIEWER - Small camera has stanhope-size photos inside of Washington D.C. Gold: $35. Silver: $28.

Camera-Viewers: Key chain type (left)
Vepla-Venezia Capri (center)
Small scenic viewer (right)

CAMERA-VIEWER - Small viewer shaped like a camera with 18 views of the Canadian Rockies or some other scenic spot. $2.

CAMERA-VIEWER KEY CHAIN - Small SLR-shaped, with views of New York City, Toronto, other major cities, zoo animals, undressed ladies, etc. Made in Hong Kong. $2. *Illustrated above.*

CHILD GUIDANCE PLAYTHINGS INC.
(Subsid. of Gabriel Industries, Inc., Bronx, NY)

Sesame Street Big Bird's 3-D Camera - Three-dimensional viewer shaped like a camera. 24 different pictures with alphabet letters. Copyright 1978. Retail: $5.

DU ALL PRODUCTS CO. (New York)
Camera Scope - Kaleidoscope shaped like rigid bodied rollfilm camera. Cardboard construction with red

leatherette covering. Uncommon. $90-150.

EAGLE VIEW 88 CAMERA - c1985.
Plastic viewer shaped like 35mm SLR. Shutter button changes 24 transparency views of zoo animals. Several variations of colors, caption language, etc. $3-5.

EPOCH LIGHTED SLIDE VIEWER -
c1950s. Japanese stamped metal slide viewer in shape of camera, complete with neck strap. Leatherette trim panels. $10-15.

FISHER-PRICE TOYS (East Aurora, NY)
Movie Viewer - Hand-cranked toy viewer for 8mm films in special interchangeable cartridges. $1-5.

Picture Story Camera - c1967. Viewer shaped like boxy 35mm camera with flashcube. Shutter button advances 8 transparencies and rotates cube. $3-6. *Illustrated top of next column.*

Fisher-Price Picture Story Camera

Pocket Camera - Viewer shaped like 110 pocket camera with flashcube. Shutter advances 27 photos of zoo animals. $3-6.

HASBRO INDUSTRIES, INC.
(Pawtucket, RI)

Romper Room Snoopy Counting Camera - Camera-shaped child's viewer. Snoopy on front, Woodstock on top. Teaches children to count. 1981 retail: $6.

JA-RU (Jacksonville, Florida)
Home Movie Super-8 Auto-matic - c1984. Toy film viewer shaped like a movie camera. Uses interchangeable film cylinders. New in package: $1-3.

"LEICA" VIEWER - Black and grey plastic viewer shaped like Leica camera. With 18 "Views of beautiful Rhein". "Made in Germany, US-Zone, BPa. DBGM. St. & Co." For the Leica collector who has everything. One sold at 10/86 auction for about $100.

STEVEN MFG CO. (Herman, MO)
Talking Vue Camera - Viewer shaped like a camera. 16 animal cartoon pictures, 6 voice messages. $8.

VEPLA-VENEZIA (Italy)
Camera-Viewer Capri - Detailed SLR-shaped viewer. 14 views of the island of Capri. $3-5. *Illustrated previous page.*

This section on accessories was a new addition to the last Price Guide. It has been expanded and prices have been updated for this edition of the book. We are indebted to Mr. Fred Waterman for his efforts in compiling this listing. The initial compiling of such a list is a time-consuming and frustrating task, since collectors and dealers are not accustomed to using "standardized" names for many of these items. In addition to the organizational problems encountered, Mr. Waterman also had to deal with the widely varying prices which are common in a field without an established pricing guide. Where a single price is given, generally it may be assumed that it is based on a single sale or on a limited number of sales at the same price. Where a range is given, this is the normal range at which we have recorded sales, or offers to buy or sell. In time, this section of the book will take a more firm shape as the accessories market stabilizes and as our base of data expands to allow for better overall tracking of prices in this segment of the market. As with any part of this book, we welcome your comments, criticisms, and suggested additions to make this section better or more useful.

We have divided accessories into the following categories:

ADVERTISING ITEMS
BACK ADAPTERS (Plates, Rollfilm, Filmpacks)
BELLOWS for CLOSE-UP
CLOSE-UP ATTACHMENTS
DARKROOM DEVELOPING EQUIP.:
 DRYING RACKS
 OUTFITS
 SCALES
 TANKS
 THERMOMETERS
 TIMERS
 TRAYS
DARKROOM PRINTING EQUIPMENT:
 ENLARGERS
 MASKS, MOUNTS
 PRINTERS
 RETOUCHING
 MISC.
DARKROOM SAFELIGHTS
EXPOSURE METERS
FINDERS
FLASHES
LENSES without Shutters
LENSES in Shutters
MISCELLANEOUS
MICROSCOPE ADAPTERS
PLATES/ SHEET FILM/ ROLLFILM, ETC.
RANGEFINDERS
SELF-TIMERS
SHUTTERS
STEREO VIEWERS
TRIPODS
WATERHOUSE STOPS

Please note that the intent of this section is not to list the types of accessories in common use among photographers today, but rather to list those accessories whose main attractions are collectibility and historical interest.

ADVERTISING ITEMS

Daguerreian and Ambrotype ads - 7 original newspaper ads. $30.

Daguerreian Broadside - 4¼x7¼", from a catalogue for Whipple's establishment. $40.

Daguerreian Broadside - 12x10" advertising miniatures by E.S. Hayden. $150.

Daguerreian hand bill - $45.

Daguerreian trade tokens - $50-70.

Magazine ads - 1920's and 1930's. $4.

BACK ADAPTERS

- 6x9cm to 120 rollback. $43-50.
- 9x12cm to 120 rollback. $75.

CALUMET C2 120 rollfilm holder - for 4x5" cameras. $90.

EASTMAN KODAK CO.
- 2¼x3¼" film pack adapter. $3.
- 4x5" film pack adapter. $6.
- 5x7" film pack adapter, black and nickel, c1910. $8.
- 3¼x4¼" early wood rollholder with brass fittings. $25-33.
- 4x5" early wood and brass rollholder. Fits No. 4 Folding Kodak. $40-50.
- 4¼x6½" early wood rollholder with brass fittings. $39.
Kodak Reflex to Bantam 828 adapter - $10.
No. 3A Folding Pocket Kodak Combination Back - With ground glass, 6 holders, dark cloth. Rare. $40-50.
No. 3A Folding Pocket Kodak 3¼x5½" Plate Holder - Rare. $5.
No. 4 Cartridge Kodak 4x5" Plate Holder - $5.
Premo Film Pack Adapters - Wooden. 3x4", 4x5": $2-4. 5x7": $3-5.
Recomar 6.5x9cm to Bantam 828 adapter - $15-25.
Recomar 9x12cm to Bantam 828 adapter - Replaces the ground glass back on German 9x12cm plate cameras such as the Recomar or Avus. $20-30.

GRAFLEX
- cut film holder, sizes 2¼x3¼" to 5x7". $3-6.
- film pack adapter, sizes 2¼x3¼" to 4x5". $4-8.
- rollfilm back, 828 Bantam adapter. $20.
Graflex rollfilm holders:
- **No. 22** - For 4x5":$80. For 3¼x4¼": $65.
- **No. 23** - For 5" wide film. $25.

- No. 51 - For 122 film: $15. With 828 Bantam adapter: $20.
- No. 53 - For 5" film. $25.
Graphic RH-20 - rapid wind rollholder. $60.
Adapt-A-Roll 620 - Rollfilm back, 6x9cm on 620, for Miniature Speed Graphic. $35.

IHAGEE KAMERAWERKS Bantam 828 adapter kit - $15.

RADA 120 rollbacks
- for 6x9cm plate cameras. $40-70.
- for 9x12cm plate cameras. $25-35.

ROLLEX
- 6x9cm back - $45
- 116 back. $20.

SUYDAM - 120 rollfilm adapter for 4x5" Graphic backs. $25-35.

TOKYO KOGAKU Topcon 250-exposure back - For Topcon RE Super, Super D, and DM. $75.

ZEISS IKON A.G. Super Ikonta B/BX Bantam adapter - $15-25.

BELLOWS for CLOSE-UP

ACCURA
- close-up bellows for Exakta. $35.
- close-up bellows for Canon. $50.

ASAHI KOGAKU
- single rail bellows, universal screwmount. $15-25.
Bellows II - Universal screw-mount. With slide copier attachment. $40-65.

IHAGEE KAMERAWERK
- Large dual track bellows assembly for Exakta larger focal length lenses. Has external and internal bayonet mounts. $25.

KOPIL - folding single track bellows assembly for Contax, Exakta, Miranda, Praktica: $10-20.

MIRANDA CAMERA CO. LTD.
- dual track bellows. Has internal screw-mount and external bayonet mount. With IB: $20.
Focabell II Deluxe Bellows Outift - Early style dual step assembly with matching slide copier and extension tube attachment set; all in fitted case. $20-35.

NOVOFLEX
- bellows outfit for universal screwmounts. Includes bellows, shade, slide copy attachment. $40-60.
- Exakta dual track bellows assembly. $15.
- Exa Bellows. $40-60.
- Model II bellows. $40-60.

PIESKER - single track folding bellows assembly for Exaktas. $10.

PRINZ - Miranda double track bellows. $15.

TOPCON
- bellows-type microscope attachment for Topcon. $20-30.
Bellows II - Dual rail; includes shade, slide copier, and macro stage which fits on the bellows to hold small objects. $50-75.

ZEISS Contarex bellows - $150-190.

CLOSE-UP ATTACHMENTS

AGFA Agfamatic Pocket Natarix - $5.

ARGUS
Macro Kit - for C, C2, C3. Includes copy stand, extension tubes, two stages with ground glass for focusing, case, ib. $30-50.
Techniscope - Sliding, focusing device for C and C2, with instructions. $25.

BURKE & JAMES Ideal Copy lens No. 2
- slip-on style. $5.

EASTMAN KODAK CO.
Instamatic Reflex Close-Up Set Type N/29.5 - 2 lenses for distances from 12⅝" -35¼". $15-20.
Kodak Stereo Prismatic close-up attachment - Rare. $35.
Kodak Close-Up Stand 1:1 - for Retina I and II. With stage. $60.
Kodak Table Copy Stand - for Retina Reflex. With ball head. $65.
Retina 1:1 tripod copy stand - $15-25.
Retina Close-Up Kit B - $20.
Close Range and View Finder Kit B - for Retina cameras. $30-40.
Retina Close-Up Lenses I, II, III - in leather case. $15-20.
Retina Close-Up Lens Set N - $15-20.
Retina Close-Up Lens N 60/I - $15-20.
Retina Close-Up Lens N 60/II - $15-20.
Retina Close-Up Lens Set Type R /29.5 - 3 lenses, from 6⅞ - 1⅛". $15-20.
Retina Close-up Rangefinder - With two lenses, case, box, instructions. $30-40.

IHAGEE KAMERAWERK Vielzweck Copy Stand Outfit - Dual track, with bellows, slide/copier, etc. $200.

KALIMAR Kali-copier - For pack models series 100 & 200. Metal stand and legs. $5.

MINOX - copy stand. $25-35.

NIPPON KOGAKU K.K. *See Main camera section for a list of Nikon RF accessories.*
Close-up System for Nikon Rangefinder Cameras - includes double rail focobell bellows, reflex housing with angle finder, microscope adapter, and adapters to use the outfit with Miranda and universal screwmount cameras. $200.
Repro-Copy Outfit PFB-2 - Copystand with baseboard & chrome upright and geared head for F, F2, Nikkor mount. $120.

OLYMPUS Pen Up-3 - with copystand. $30.

RIKEN OPTICAL Close-up Adapter +2 - for Ricoh. $10.

TOKYO KOGAKU
Close-up lens #1 - screw-on; 49mm. $10.
Slide copying attachment - Topcon. $35.

VIVITAR Macro Copying outfit - includes stage, slide holder, etc. for Pentax. $15.

ZEISS
Contameter - Close-up rangefinder for Continas, Contessas, and late Tenaxes (28.5mm lens diameter). $60-100.
Ikoprox - 2 close-up lenses for Ikoflex; f.05m and f1m. $45.
Ikoprox #766 - 12" close-up adapter for Ikoflex IA. $30.
Ikoprox 937/05 - f.05 close-up lens. $15.
Proxar 1 or Proxar 2 - $10.

DARKROOM DEVELOPING EQUIPMENT CHEMICALS

ANSCO M-A Developer - tube. $1.00

ARGO - Developing powder in tube. $1.00

BURKE & JAMES
Rexo Metol Quinol Developer - Box of 6 tubes, for paper plates and films. Original price was $0.25. $4.

DEFENDER Sepia Toner - glass tube. $2.

EASTMAN KODAK CO.
- Eastman bottle. $5.
- Eastman brown glass bottle, with complete graphic label. $12.
- Kodak 5 gallon ceramic chemical jug, with trademark on side. $250.
- 8 oz. glass graduate. $10.
Eastman Ammonium Bichromate - in glass bottle marked "EKC". $5.
Eastman Developing Powders - 6 envelopes in a box. $5.
Hydrochinon Developing Powders - for plate and film. Box with 6 packets. $5.
Eastman Kodelun - in 1 oz. brown Kodak-embossed bottle. Has lead-foil Kodak-embossed top. $8.
Eastman MQ Developer - in glass tube. Original price was $0.05. $1.00
Eastman Nepera solution - 4 oz brown Kodak-embossed bottle, lead-foil Kodak-embossed top. In original box. c1910. $10.
Eastman Potassium Ferricyanide - in glass bottle. $4.
Eastman Potassium Meta-Bisulphite - in 1 oz brown Kodak-embossed bottle. Has wax-covered cork. $8.
Eastman Spectal Developing Powders - 4 glass tubes in a box. $7.
Eastman Universal Developing Powders - in 5 glass tubes. $9.
Eastman Intensifier - in glass tube. $2.
Kodak Chromium Intensifier - 6 packs. $5.
Eastman Kodak Pyro - 5 pair. $14.
Kodak Reducer and Stain Remover - in

glass tube marked "EKC". $3.

MINOX Fine Grain Developer - package contains developer in sealed vials. $6.

SENECA M.Q. Developer - glass tube. $1.

TABLOID - developing tablets in glass bottle. $4.

DARKROOM DEVELOPING EQUIPMENT DRYING RACKS

- unidentified 4x5" folding wooden drying rack for glass plates. $5-10.

DARKROOM DEVELOPING EQUIPMENT OUTFITS

AMBRECT Daguerreotype processing apparatus - includes mercury pot, buffing stick, 2 fuming boxes. $500.

ANSCO Developing Outfit - 4x5 contact printer, graduate, clips, therm. developing tank, safelight, trays, chemicals. $15.

BURKE & JAMES Ingento Developing & Printing Outfit No. 1 - c1909. 3 developing trays, 2 tubes of M.Q. developer, 1 printing frame, Rexo/Acid Hypo, 4 oz. graduate, Rexo paper, ruby candle lamp. Original price: $1.00. $20.

EASTMAN KODAK CO.
A-B-C Photo Lab Outfit, Model A - Steel print box, 3 trays, thermometer, graduate, tong, developer, fixer, safelight, ib. $15-25.
A-B-C Darkroom Outfit - 3¼x5½" trays, glass graduate, film clips, print frame, stirring rod, instructions. $20.

DARKROOM DEVELOPING EQUIPMENT SCALES

BAUSCH & LOMB - scales. $50.

EASTMAN KODAK CO. - nickel scale. $38.
Eastman Studio Scale - Black and brass, double pan, wooden base. $60.

OHAUS Dial-o-Gram Touch-n-Weigh - $25.

PELOUZE Mfg Co. Rexo #8 Scale - Avordupois and metric system. $25.

SEEDERER & KOHL BUSCH - Glass enclosed scales with brass interior post. Front & rear panels lift up. Size: 18h x 16w x 9"d. $115.

DARKROOM DEVELOPING EQUIPMENT TANKS

- unidentified brass developing tank for glass plates. Has a dial. $15.
- unidentified nickel-plated daylight developing tank for 120 film. Has orange transparent apron and 2 winding handles. Uncommon. $15-20.

- Wet-plate collodion dipping tank. Heavy glass container in fitted wooden holder with lid and lifter. 12¼x15¾". $200.

AMATO - nickel tank, 45x107mm. $12.

BURKE & JAMES
- glass plate developing tank. Nickel, rectangular box for 4x5" plates, with wire rack, rectangular funnel and hook. $15.
Rexo metal developing tank - $12.

DALLON Cut Film Tanks
- for 4.5x6cm film. $10.
- for 9x12cm film. Nickel-silver. $20.

EASTMAN KODAK CO.
- Kodak stainless steel tank, 4x5". $40.
- nickel tank, 5x7". $12.
Brownie Developing Box - brass. $55.
Developing Tank Model E - c1904. Metal with turning handles and 2 rounded compartments for rollfilm up to 5" wide. $15.

Kodak Film Tank - c1905-37. Consists of a wooden "winding box" in which the film is wound in combination with a light-proof apron onto a reel. The reel is then placed into a nickel-plated cylindrical tank for development. The complete outfit includes the wooden box with two cranks, apron, reel, and tank. Made in sizes for 2½", 3½", 5", and 7" films. $20-40.

Premo Film Pack Tank - $10-20.

ENVOY - 6½ oz bakelite tank. $6.

ESSEX - 35mm daylight-loading tank, built-in thermometer. Frame counter. $10-20.

FR CORP.
Adjustable Developing Tank - for 4x5 or smaller. $20.
Special Adjustable Roll Film Developing Tank Model 2 - c1950. Bakelite, for 35mm to 116 film. Original price: $3.95. $3-5.

GENNERT Auto Tank - c1905. $10.

GOERZ (C.P.) Tenax Developing Tank - Brass with chrome finish. $12.

MINOX Developing Tank - $12. With thermometer: $18-20.

DARKROOM DEVELOPING EQUIPMENT THERMOMETERS

ANSCO - stirring rod/thermometer. $5.

BURKE & JAMES
Ingento #3 Thermometer - metal. $5.
Ingento #4 Thermometer - 5½" long. $7.

EASTMAN KODAK CO.
- 5" thermometer, curved metal with hook at top. In a cardboard box. $5.
- 9" stirring rod/thermometer in wooden tube. $14.

Minox Thermometer - 4" length. In cardboard tube. $6.

DARKROOM DEVELOPING EQUIPMENT TIMERS

BURKE & JAMES
Luxor Photo Timer - c1930s. $8.
Perle Audible Timer - $6.

EASTMAN KODAK - timer, red key wind type. $10.
- **60 minute clock timer** - Round red clock on red metal base. Large minute hand and small second hand. Face swivels on pins on either side. $25.

FR CORP.
Interval Timer - art-deco. $5-10.
Time-O-Lite - M49: $15. P49: $15.

DARKROOM DEVELOPING EQUIPMENT TRAYS

- unidentified amber glass developing tray, 5½x8½". $10.
- enameled trays. Common. $2.
- hard rubber trays. Common. $8.

BURKE & JAMES Ideal Jr. Hypo Fixing Box No. 2A - for 3¼x5½" plates. Original Price: $0.50. $15.

EASTMAN KODAK CO.
Bulls-Eye trays - Set of 3 black, hard rubber trays, 4x6". $10.
Eastman tray siphon - c1934. $7.

NASSBAUM - glass film developing tray. Amber with red on the bottom. $20.

ZEISS IKON A.G. - glass developing tray with "Zeiss Ikon" in the bottom. 5x7". $25.

DARKROOM DEVELOPING EQUIPMENT MISC

Hydrometer - 1930's. For testing specific gravity of solutions. $12.

DARKROOM PRINTING EQUIPMENT ENLARGERS

EASTMAN KODAK
Brownie #2 Enlarging Camera - Black cloth-reinforced cardboard, for 2¼x3¼" to 5x7" negatives. $35.
Direct Positive B&W kit - 1956. $6.
Kodak Enlarging Outfit Camera - Bausch & Lomb RR f4 lens. $80.
No. 1 Kodak Enlarging Camera - 6½x8½". Red bellows. $100.
Home Enlarger - wooden. $30-60.
Kodak Miniature Enlarger - Ektar f4.5/50mm lens. $75.
16mm Enlarger - Body based on Jiffy Kodak Six-16 camera. Enlarges movie frames onto Six-16 rollfilm. $12-18.
Kodak Easel, 11x14" - masking paper board, 2 blade. $35.

ACCESSORIES: DARKROOM - EXPOSURE METERS

DARKROOM PRINTING EQUIPMENT MASKS, MOUNTS

BURKE & JAMES Morrison Vignetter -$6.

EASTMAN KODAK CO. - c1900. Mounts for panoramic photos. $2.50 per dozen.

GENNERT Montauk Post Card Masks - For 3¼x5½" negatives. Original price: $0.15 per dozen. $1.50

MANNING, A.B. (Chicago) Manning's Masks - Package of 10 masks with 2 center pieces for 4x5" printing frames. Original price: $0.25. $1.50

DARKROOM PRINTING EQUIPMENT PRINTERS

- unidentified wooden contact printer for 5x7" prints, with electric light. $35.

EASTMAN KODAK CO. - wooden printing frames: 2¼x3¼, 3¼x4¼, 3½x5½, 4x5". $2-3. **Auto Mask Print Frame** - wooden, 4x5". $12. **Kodak Amateur Printer** - dovetailed oak box, 10x7x8". $15 **Eastman Printer No. 8, Model 2** - A contact printer. $40. **Eastman Printing Frame** - for Stereo Brownie. $75.

DARKROOM PRINTING EQUIPMENT RETOUCHING

- unidentified retouching easel for 8x10" or smaller glass plates. With mirror and swivel reflector in base, sliding hand rest, adjustable hood. $25-35.

ALBERT SPECIALTY CO. Trojan Junior Retouching Set - includes bottles of varnish, pumice, opaque, colored inks, sand paper, brushes, pencils, and pens. $5.

ANTHONY & SCOVILL - retouching easel. Wooden, adjustable ground glass easel with drawer for utensils. $30-50.

BURKE & JAMES
Ingento Retouching Desk No. 2 - Oak with black interior, 16x12". $30-35. **Ingento Retouching Outfit** - $6.

DEVOE & REYNOLDS CO. No. 4 Photo Oil Color Box - 1940's. Wooden box with 10 tubes of colors, 3 bottles of solutions. $5.

EASTMAN KODAK - retouching desk, dark wood. $25-30.

DARKROOM PRINTING EQUIPMENT MISC

BURKE & JAMES Print Burnisher - c1900. $18.

EASTMAN KODAK CO.
- hand print roller, wooden handle. Double

roller: $11. Rollers in 3¾", 7¾", 10": $7-9. **Eastman Print Straightener, Model A** - c1924. $25-35. **Kodak Paper Trimmer** - Wooden, 12x12". $18.

DARKROOM SAFELIGHTS

- unidentified red kerosene safelight. $13.

AETNA No. 4 Kerosene lantern - c1890. With 4x5" glass. $17.

AGFA Safelight - Brown metal box with rounded back. Bulb base sticks out back. Amber glass on front. $2.

BURKE & JAMES
Ingento Darkroom Light - Large black metal kerosene lantern with large red glass front, small round red glass on one side, square white glass on the other (covered by a door). Movable reflector inside. $20. **Ingento #6 Kerosene Safelight** - Red with hinged door. $15. **Ingento #9 Oil Safelight** - $15. **Ingento Ruby Candle Lamp No. 17** - Rectangular red metal box with red glass that pulls out the top when you lift the flap to light the candle. Orig price: $0.40. $9.

EASTMAN KODAK CO.
Brownie Darkroom Lamp A - paper. $5. **Brownie Darkroom Lamp B** - Round plastic cover on a black bakelite base that screws into a socket. 7w bulb. Plastic covers were red, yellow, or green. $3. **Brownie Darkroom Lamp Series 2** - A red Dixie cup-like device with cover on the wide end. 7½w lamp inside. Lamp base protrudes out narrow end. $5. **Brownie Safelight** - c1930's. Green. $9. **Brownie Safelight Lamp Model D** - $7. **Kodak Candle Lamp** - Red canvas on folding wire frame. Metal bottom holds candle; metal top has vent. $10-18. **Kodak Kerosene Lamp** - c1890. 4x5" glass. $20. **Kodak Kerosene Safelight** - Red with top hinged door and red & amber glass. $16.

POCKET TIM - Kerosene Darkroom Lamp. $18.

REX Kerosene Safelight - $13.

ROCHESTER OPTICAL CO. Universal No. 1 Darkroom Kerosene Lamp - $15.

EXPOSURE METERS

A.C.W. ELECTRIC Avo-Smethurst - 1936. Selenium. $20.

AGFA Lucimeter S - $6.

ANSCO Light Meter - Extinction. Circular with square at top. While aimed at the light source, a wheel is turned to match a red dot with the red dot above it. $10.

ARGUS
CM-2 Meter - For C33 or C44R. $15-20.
Model L-3 - Hand-held selenium. $6.
Model L44 - Shoe mount. $6.
Model LC3 - for Match-Matic. $10-15.
Model LS-3 - for C3 Standard. $10-15.

ASAHI KOGAKU - Clip-on CdS meter for very early Pentax models. $50+.

BERTRAM
- 1950's Amateur model. Shaped like a pocket watch. Opening the lid automatically opens the two doors in front of the cell. Scales for still and cine. $10-15.
Chrolon - 1950's. Junior version of the Chronos. $10.
Chronos - late 1940's. $25.
Chronstar - $15-25.
Critic - $5.

BEWI
- Amateur. $10-15.
Automat - $9.
Bewi Jr. - $15-20.
Boy - Selenium. $7.
Electro - 1940 selenium meter with DIN scale & extinction meter in center. $15-25.
Quick - $5.
Standard - $28.
Super L - CdS. $25.
Tele Bewi - Extinction meter in one barrel is attached to a distance meter in a second barrel; turning scales on both barrels. $45.

BOWER - Small gray meter with foot for camera shoe. $8.

BROCKWAY Studio model - $20.

BURGESS BATTERY CO. - 1964. Slide-rule type card with Burgess Photo Flash Guide on one side and Photo Exposure Guide on other. Original cost $.25. Now: $2.

BURROUGHS-WELLCOME *Began making exposure calculator tables in 1903, later incorporating them in the Diary and producing them until the 1970's.*
Photo Exposure Calculator, Handbook, & Diary - Leather folder containing tables and exposure hints, a calculator wheel, info on the company's chemicals, diary pages for recording pictures taken and a pencil.
- 1909: $25.
- 1915: $20.
- 1927: $15.
- 1935: $15.
- 1939: $13.

CALUMET Flashmeter - $18.

CANON auxiliary CdS meter - 1965-67. For models for FP and FT. $15-25.

CAPITAL Model D-1 - $20.

CHARDELLE Meteor MFC-50 - 1940. Pocket flash calculator in shape of a slide rule. $5-8.

CHOU
Promatic 1 - Blue selenium meter. $3.
Promatic Auto-Dial - Hand-held selenium meter with ASA, DIN, and EVS scales. $4.

COMBI Combi-meter - Combination rangefinder and extinction meter, DIN scale. With camera shoe. $10.

CONTAX Helius #1325/3 - Brown bakelite selenium meter. Rare. $125.

CORONET Model B - $7.

DECOUDIN (J. DeCoudin, Paris)
Photometer - c1887. Brass extinction meter. Meter was placed on the ground glass to read the correct setting. $150-200.

DEJUR AMSCO CORP. *All the meters listed below are selenium meters.*
Model 5A - $6.
Model 5B - $8.
Model 6A - c1946-47. $11.
Model 40 - Large metal pre-WWII meter. Weston scale. $8.
Model LM-46A - Made under contract for the U.S. Air Force. USA scale. $17.
Model 50 - c1945. ASA scale. $8-10.
Model SD - $7.
Dual Professional - 1947-53. $7-10.

DIRECTOR PRODUCTS CORP.
Norwood Director - Selenium meters.
- Model B - The top professional meter before the popularity of Luna Pro. $25-45.
- Model C - Precursor to Sekonic L28C2. $18-22.
- Model E - $15.
- M2 - $17.
Norwood Super Director - Selenium. $20.
Norwood Flashrite - Selenium. $12.

DREM
Cinephot - Extinction. $14.
Cinephot Automatic - $10.
Dremophot - Extinction. Telescoping type, black with nickel finish. $13.
Instoscope - Extinction. $7-10.
Justophot - Extinction. Telescoping type, all nickel finish. $10-13.

EASTMAN KODAK Kodalux L - for Retina cameras. $20-25.

EXPOPHOT - $25.

FEDERAL Ideal - 1947. Direct reading selenium meter. $7.

F.R. (NY) EM-1 - 1953. Selenium. $6.

FRANKE & HEIDECKE
Rollei Diaphot - 1932-34. Combination extinction meter/ depth of field previewer, calibrated for 6x6cm models. All black. $38.
Rolleiflex Diaphot - 1934. Iris diaphragm and extinction meter that attaches to the viewing lens of the Old or New Standard Rolleiflexes. $38.

Rolleiphot - Later version of the Diaphot for 4x4cm or 6x6cm cameras. Chrome and black. Rare. $40.

GENERAL ELECTRIC Selenium meters
DW-40 - $5.
DW-47 - 1938. Hexagonal-shaped. $22.
8DW48Y6 - $10.
8DW58Y1 - $10.
8DW58Y4 - measures in foot candles. $13.
8DW58Y4A - $13.
8DW58Y5 - $16.
DW-68 - All-metal version of DW58. $10.
PC-1 Color Control Meter Kit - 1956. With filter kit and case. $30.
PR-1 - 1949. ASA 1000: $13. ASA 1600: $9.
PR-2 - 1953-56. $14.
PR-3 Golden Crown - $22.
PR-3 Mascot - $5.
PR-22 - Clip on Polaroid. $6.
PR-23 - $6.
PR-23A - 1951. Polaroid EVS. $5.
PR-23B - Polaroid. $5.
PR-30 Mascot - $8.
PR-30.35 - $6.
PR Mascot - $12.
Model 213 - foot candle meter. $7.
W 49 - foot candle meter. $8.
Junior Model - $12.

G.M. INSTRUMENTS Selenium meters
Skan - 1946. $5.
Skan B - 1946. $6.
Skan Quick - $5.

GOLD CREST
PR104 - $2.
XL7 - CdS. $18.

GOSSEN
C-Mate - $18.
Dual-Sixon - c1953. Selenium meter with roller-blind. $13.
LunaPro - $60.
Ombrux - c1936. Selenium. $10.
Photoscop - 1936. Selenium. $9.
Pilot, Pilot 2 - Selenium. $15-20.
Retina Meter - Selenium. $13.
Scout - Selenium incident/reflected light meter. $10.
Scout 2 - Selenium. $15.
Sixon - Selenium. $10.
Sixtino - Selenium, ASA 6400. $8.
Sixtomat - CdS meter with white roll-top blind that covered the photo-cell for measuring incident light. $20.
Sixtomat X3 - 1951. Selenium. $12.
Sixtus - in self-contained plastic case. $13.
Super Pilot - CdS. $22.
Trisix - with color temperature scale. $11.

HARVEY Exposure Meter - 1915. Pocket style. Film and plate calculator. $20.

HEYDE Aktina Photo Meter - $28.

HICKOK Photrix SS - 1941. Selenium. $12.

HONEYWELL - Coupled CdS meter for Pentax models H1-H3r. $12.

HORVEX Minilux - 1953. Shoe mount selenium. $7.

HURTER and DRIFFIELD Actinograph - c1890. Slide-rule type calculator. Sold in mahogany case with different slides for time of day, weather conditions, etc. $200.

IDEAL Exposure Scale - 1912-14. Circular slide rule style plate calculator. $15.

IHAGEE
- Combination Prism/direct finder and selenium meter. 1956. $45.
Exakta Lightmeter IIa - Selenium. $50.
Examat Meter Prism - Exakta CdS. $80.

IMPERIAL Extinction meter - $5.

KALIMAR Selenium meters
Model A-1 - $7.
Model B-1 - $7.
Model K-420 - Miniature meter that fits in an accessory shoe. $12.
Sure EX - ASA 25-125. $2.

KINOX Model 3 - Selenium. $3.

KNIGHT meter - $5.

KONICA - Shoe-mount selenium meter for Konica III, IIIa. $8.

LANGE Addiphot - 1932. Pocket extinction meter in slide rule form with varying apertures. $12.50

LAWRENCE Flash Rule - 1946. Slide rule calculator for Wabash flash bulbs. $6.

LEITZ (Ernst Leitz GmbH)
Leica Meter #650 - $40.
Leica Meter M - $50.

LENTAR meter - $4.

LIOS Aktinometer - 1925-28. Telescoping cine meter. $18.

MAXUM INSTRUMENT CO. (N.J.)
Pierce Exposure Meter - Rectangular plastic extinction meter with dials. $9.

METRAWATT Selenium meters
Model M or MC - for Leicas. $18.
Model MR - Early version has extended switch: $35. Later version with recessed switch: $50.
Metraphot - Clip-on. $23.
Metraphot 2 - 1951-53. Leica-mount. $10-15.
Metraphot 3 - Shoe-mount. $10-15.
Polaroid 620 - 1957. $5.
Tempiphot - 1935. $15.

MIMOSA AMERICAN CORP. Extinction meters
Leudi - intro. 1934. American model with no cine scale: $3. European model,

c1940, with cine scale: $3.
Leudi 3 - c1930's. $5.

MINOLTA Selenium meter - $18.
MINOLTA SR meter - $40.

MINOX Meter - $18-25.
MINOX Minosix - $40-60.

MIRANDA
Models F, FV, G - clip-on CdS meters. $13.
Meter Prism - Cell in face. For Models C-F. $15-20.

MONOCADRAN Realt-Deluxe - 1956. Selenium. DIN/SCH. $15.

NIPPON KOGAKU - S series meter. $125.

PHAOSTRON CO. (Alahambra, CA)
Phaostron - pre-WWII. Square, bakelite, battery-operated comparison meter. Knob in center varies brightness of inside bulb to match that of outside light. Both are seen through a little window on top. $13.

PIERCE meter - $8.

RHAMSTINE Electrophot-MSA - 1939. Selenium. 4" square. $40.

RIKEN Ricoh meter - Camera foot mount. $5.

SEARS "Tower" brand meters
- selenium meter, shoe mount, ASA 10-200. $14.
- meter, made in West Germany. $10-15.

SEDIC PR-60 - 1971. CdS. Jeweled movement, shock proof. $5.

SEIKO Sekonic meters
86 - $10.
246 - Foot candle meter. $25.
Auto Leader - $8.
Auto Leader II - $8.
Auto Leader III - $12.
Auto-Lumi - Selenium. $8.
Auto-Lumi 86 - Selenium. $8.
Delux, Model I - $12.
LC-2 - $8.
L6 - 1956. $8.
L8 - 1957. Selenium. Miniature version of the Weston Master V. ASA 1600. $8.
L398 - $30.
L428 - Silicon cell incident or reflected meter. $30.
Leader #32 - $12.
Leader #38 - $11.
Micro - Clip-on CdS meter. $14.
Micro Leader - CdS. $12.

SHOWA-KODEN Sunset Unitic M31 - 1956. Selenium. $8.

SOLIGOR Selector - CdS. $5.
SOLIGOR Selectric - 1964. CdS. $5.

SPECTRA Combi 500 - $25.
SPECTRA Universal - $23.

SYLVANIA Flash-Slide-A-Guide - 1951. Slide rule calculator. Originally: 10¢. $2-4.

UNITTIC meter - $6.

UNIVERSAL Univex extinction meters - Chromed aluminum. For Mercury I: $10. For Mercury II: $7.
Cine - 1938. Telescoping style. $8.

UTILO Instoscop - 1939. $12.

VIVITAR Model 35 - Selenium. $16.
VIVITAR SL - CdS. Reflect/incident. $15.

VOTAR Hyper VII - $4.
VOTAR Hyper VIII - $6.

WALZ Selenium meters.
Coronet B - 1956. Copy of Leica M. $5.
Electric Eye Model P - $6.
M1 - 1955. Cine meter. $3.50
Micro - $4.
Polaroid - 1955. $5.

WATKINS *Bee Meters were patented in 1902, and remained on sale until 1939.*
Bee Actinic Plate - 1905-10. Shape of a pocket watch. Calibrated in HD and US stops. $23.
Bee Colour Plate - Similar, but with a different glass face. $23.
Bee Filmo Cine - Similar, but has scales for cine work. $23.
Bell & Howell Cine Bee (or Filmo) - c1920. For 35mm cine cameras. $20.
Standard - 1890-93. Brass-bound actinometer with chain and timing pendulum. Rare. $75-125.

WELCH Model 3588 - Foot candle meter. $8.

WESTON
Model 560 Master VI - $17.
Model 617 - 1932. First meter in which selenium cell's output alone was used. Streamlined, pocket-type with 2 photocells, one on each side of the meter. $10.
Model 617, Type 2 - 1933. Rectangular with rounded ends, one photocell. $11.
Model 617 Photronic - c1936. Early version of the Cadet. $10.
Model 627, Type 2 Cine - Selenium. $16.
Model 650 - 1935 octagonal version was the first popular model: $15. 1936 rectangular selenium meter: $10.
Model 715 - 1938. Selenium. $13.
Model 717 Master I - c1940. Selenium. First successful meter of the Master series; about twice as thick as later models. $15.
Model 735 Master II - 1946-53. Silver and dark gray selenium meter. $12.
Model 736 Master II Cine - $11.
Model 737 Master III - $18.
Model 744 - $7.50
Model 745 Master IV - Stainless steel case; needle lock. Easy to read. $20-25.
Model 748 Master V - Selenium. $14.
Model 756 Illumination Meter - $18.

Model 819 Cine - 1937. Selenium. $12.
Model 850 - $10.
Model 852 Cadet - Selenium. $10.
Model 853 Direct Reading - Selenium. Direct read F-stop, LV, or Pol. $12-14.
Euro-Master - $23.
Pixie - $13.
Ranger - $15.
Ranger 9 - $40-60
Ranger 9 Model 348 - $50-70.
Universal - $8.

WYNNE
Wynne's Infallible Exposure Meter - 1898-1905. Silver actinic meter shaped like a pocket watch. US stops for plates. $25.
Wynne's Infallible Hunter - Pat. 1914. Extinction meter with hinged cover over face. $23.

YAMATAK Model NE-200 Deluxe - 1971. CdS. $5.

YASHICA Selenium meter - ASA to 800. 1" square. $10.

ZEISS IKON A.G.
Diaphot #1321/7 - c1930. Selenium. $20-30.
Ikophot Model 1940 #1328/1 - $45.
Ikophot Model 1954 #13290 - Selenium. $18.

FINDERS

ALPEX
90mm finder - $15.
Multi-Focal Zoom Finder - Identical to the Tewe and Nikon finders, but with a scale range of 3.5, 5, 7.3, 8.5, 9, 10, 13.5, 15, 18, nd 20cm focal lengths. Parallax base. $45.
135mm Brightline finder - Nikon SP style, parallax base. Black. $13.

ARGUS
Multi-focal or Turret Viewfinder - 30/50/100mm. $20-25.
Variable Power Viewfinder - 30/50/100mm. $20-23.
Viewfinder for 35 and 100mm - fits in shoe. Black plastic. $10-15.
Zoom finder - has flash connection. $20-30.

ASAHI
Pentax Folding Sportsfinder - Fits onto accessory shoe. $20.
Right Angle Finder - $100.

DeMORNAY BUDD Focusing Reflex
Viewfinder Model 288 - 1946. Shoe mount, for Leica and Contax II. 5cm/f3.5 lens and 6x magnifier for gg screen. $40.

EASTMAN KODAK CO.
35/80mm Optical Multifinder - for Retina Models Ib, IIc, IIIc - $25-35.
Right Angle Optical Finders:
- for Kodak Ektra. $40.
- for Retina Reflex. $35-50.

35/80mm Sportsfinder - $15-25.
Retina Sportsfinder 50/80mm - for Retina II, IIa. $15-25.
Retina Folding Sports Finder - for 50mm Retina. $15-20.
Retina Sports Finder, Model C - for all rangefinder and reflex Retinas. $25-30.
Signet 80 Multi-frame finder - $30.

FRANKE & HEIDECKE
Eye-Level Prism Finder - Fits Rolleicords, and Rolleiflex E2 and 3F. $170-215.
Rollei Sports Finder - Hasselblad-style sportsfinder. Fits on the hood of all Rolleicords and Rolleiflex Automats below #1,100,XXX. $15.

GRAFLEX
- flip-up optical viewfinder for early 4x5" Graphic. $18.
Graflex/Norita eye level finder - $50.
Speed/Crown Graphic - Top mount parallax finder, slide on. $10.

HEINEMAN, O.G.
Auxiliary Sportsfinder - Slips over hood of all Rolleiflexes below #1,099,XXX (1937-1946), and non-Rollei cameras. Has parallax correction. $15.
Eye-level prism finder - $155.

IHAGEE KAMERAWERKE
Exa Waist-level finder - Early, original model with non-removable ground glass, magnifier, long sword-like extension. $10.
Exakta Eye-level prism finders:
- Chrome, early style for Exakta. $20.
- With RF grid. $25.
- Later style, for Exakta Varex. $15.

Exakta Waist-level finders
- Original style with non-removable ground glass, flip-out magnifier, and sportsfinder cover. $11.
- Early style with safety foot. $15.
- Later style, chrome. $10.
- Later style with leather top and rangefinder glass. $18.
Magnear finder - $25-30.
Right Angle Magnifying Viewer - with diopter adjustment. $40.

ILOCA Folding Sportsfinder - Chrome, for Pentax. Offset dual shoe; level in the folding joint. $18.

KONISHIROKU Koni-Omegaflex waist level finder - $12.

KOWA 6 waist level finder - $35.

K.W. (KAMERA WERKSTATTEN A.G.)
Praktina waist-level finder - $16.
Praktisix waist-level finder - $20.

MAMIYA TLR waist-level finder - $18.

MINOLTA
35mm Vertical Multi-finder - For RF cameras. $25-35.

135mm tubular finder - chrome. $15-20.

MINOX
Right angle mirror finder - for Model B. $12.
Waist level brilliant finder - chrome. $22.

MIRANDA
Eye-level Prism Finder
- black or chrome, for Models C-G. $13.
- chrome, for Models F, G. $13.
- chrome, for Models T, S, A-D. $13.
Sensorex Eye-level Finder - Black and chrome. With accessory shoe: $10-13. No accessory shoe: $10-12.
Sensorex II Eye-level Finder - Black and chrome, with hot shoe. $10-15.
Waist-level Finder
- for Automex and Sensorex. $8-12.
- for Models S, A-G. $5-10.
- for Models T, S, A-D, black. $5-10.
- for Models T, S, A-D, chrome. $5-10.
VF-1 Finder - Waist level. $15-25.
VF-3 Finder - Early style critical magnifier finder. $15-25.

NIHON SHOKAI Walz Universal Finder - $15-25.

PENTACON frame finder - c1950s. $20.

SANDMAR Zoom-Vue Finder, 35-135mm - For Argus. $22.

TANAKA OPTICAL CO. Tanack finders - 135mm: $15. 35mm: $10.

TEWE Multi-focus Zoom Finders
- original, with 35, 38, 45, 50, 85, 90, 135 range. $50.
- 35-200mm, parallax corrected. $45-60.

TOKYO KOGAKU
- Right angle finder for Topcon. $35.
- Waist-level finder for Topcon, Super D, DM, etc. $20.
Universal Zoom Finder - for Leotax. $35.
Varifocal Zoom Finder - $35.

VOIGTLÄNDER
Kontur 35mm Viewfinder - $5-15.
Right angle finder, #344/45 - $40-55.
Turnit 3 Finder 35/50/100 - Black, for Prominent. $30-35.

WIRGIN Edixamat waist level finder - $8.

WHITTAKER Micro 16 eye level finder - $10-15.

YASHICA Atoron Electro waist level finder - $8.

FLASHES

- Unidentified German Pocket Magnesium Flasholder, c1920's. Hinged case (similar in style to a cigarette case) holds a roll of magnesium ribbon threaded through a flat tube. The tube flips up vertically when the case is opened. Silver finish. $30.

AGFA KAMERAWERKE
Agfalux-C - for cubes. $2.
Agfalux-K - for AG-1. $2.
Magnesium Flash - spring-wind. $25.
Tully-K - for AG-1. $2.

ALPEX Pocket Flash, Type BC - fan, slips on accessory shoe. $3.

ARGUS Flashes
- Argus C. $8.
- Argus C3. $4.
- Argus C4. $5.
- Argus C44. $5.
- Argus F, for hot shoe. $6.
- Argus 75. $4.
Argoflash - $10.
Folding Flash Unit, #760 - for hot shoe. $1-5.
Flash Bracket, #799 - for C4 or 44. $1-5.

BEACON Flash Unit 2 - $1-5.

BOLSEY Flash - for Bolsey or Jubilee. $3-8.
BOLSEY Flashgun #29 - $5-10.

BURKE & JAMES
Ingento Flash Pan No. 1 - 12" metal trough on a metal rod with a wooden handle. Spring-activated pin, released by thumb, strikes paper cap in trough and ignites powder. $22.

CANON
- Bulb flash #B-1, for early RF models. $20.
- Flash for Canon VT. $13.

CIRO Ciro-flex flash kit - $5-10.

EASTMAN KODAK
Brownie Flasholder - for 620 flash. $2.
Brownie Flasholder, Type 2 - $2.
Duaflex Flasholder - $2.
Ektamite flasholder - $5.
Flashgun - for Ektra. $15.
Flasholder Model B - $3.
Flasholder for Kodak Reflex - $10.
Flash sheet holder - $35-40.
Generator Flasholder Type 1, No. 771 - Fires M2 or No. 5 bulb without batteries for cameras with screw-in flasholder fittings. $10.
Generator Flasholder Type 2, No. 772 - Has shoe bracket and cord for most flash synched cameras. $10.
Hawkeye Flashgun - $2.
Kodablitz - Shoe mount, for Retina. Made in Germany. A small plastic box with flip-up lid that becomes the reflector. Takes AG-1 bulbs. $5-10.
Kodak Flash Cartridges - in tin box. $15.
Kodak Handy Reflector, Model C - Cardboard reflectors that unfold and fit (with metal rings) around bulbs in floor lamps. Come 2 in a box. $20.
Kodak Magnesium Ribbon Holder - Metal, teardrop-shaped holder. Roll of magnesium ribbon dispenses out the top. $25-35.

Kodak Standard Flasholder - Uses #5 bulbs. Bakelite handle takes "C" batteries or Kodak BC flashpack. Large plastic reflector with polished chrome finish for #5 bulbs. Mounting bracket for bottom tripod socket; ASA connectors on body and attached cord. $2.

Kodalite Flasholder - for #5 bulbs. $3.

Kodalite IV Flasholder - for #5 and M2 bulbs. $4.

Kodalite Midget Flasholder - For Kodak Stereo. $5.

Kodalite Super M40 - $4.

Pocket Flasholder B-1 - folding unit. $3.

Retina Flasholder - Bracket with midget flash holder. $15.

Rotary Flasholder - Holds 6 bulbs that are manually moved into position. Type 1: $4. Type 2: $5.

Spreader Flash Cartridge Pistol - c1902. Flash cartridge is placed on top of tray. Leather-covered wooden handle is beneath. Has trigger release. $40-45.

EDISON Mazda foil flash lamp - $3.

FEDERAL MFG & ENGINEERING CORP.
Fed-Flash flash unit No. 1-A - $5.

FRANKE & HEIDECKE
Rollei Flash I - Fold-up clamp, cord, and single arm bayonet. $10-15.
Rollei Flash II - dual arm bayonet. $10-20.
Rollei model 16 flash - $10.

GEISS Contact Flash Synchronizer - $13.

GOLD CREST BC7 - tilt, fan flash. $2.

GRAFLEX BC - bulb flash. $2.
GRAFLEX Graflite - with reflector. $5-7.

HONEYWELL Tilt-A-Mite - fan flash. $3.

KAISER Kalux - AG-1 unit. $2.

KALART CO.
BC Flash #411C - for TLR's. $2.
"Safety First" Deluxe Speed Flash - Combination battery case and reflector. Kalabrack extension bracket, test lamp, and passive synchronizer unit for cameras with self-setting auto shutters. $5-10.

KALIMAR Select-O-Flash - Bar holds 1-4 bulbs. $6.

MICROMATIC SPEED FLASH - 1937. Calibrated to adjust the sync to match different cameras. With cable release. $15.

MERCK - 1 oz of magnesium. $15.

MINOLTA Model 16MG flash - $5-10.

MINOX
AG-1 flasholder - for Minox B: $5-10. For Minox C/III: $15.
Cube Flash C4 - for Minox EC. $10-20.
Fan flash Model B - $15.

FC Flash - $15.
FL4 Flash - $4.
TC Flash - $30.

NICHOLS, CHARLES H. Portrait Flash Lamp - Flash powder ignites by blowing the flame from the kerosene lamp through a hole in the metal back plate. It could be raised to 10'. $160.

NIPPON KOGAKU
BC-IV Flash - for S2. $10-15.
BC6 Flash - for Nikon RF's. $10-15.
DC-IV Flash - $25.
M-B C-5 Flash - $10-15.
Model V - $11.

REVERE Model 24 - flash for Revere Stereo 33. $10-15.

RIKEN OPTICAL
Ricoh Fan Flash - $1-5.
Ricohlite V Flash - Holds 5 bulbs. $3-6.

SAWYER Viewmaster Calculator Flash Unit - $20.

SMITH (J.H.) & SONS
Actino Cartridge Holder - 5x8" metal reflector on cardboard handle. The round wooden cartridge sits on a small shelf, with a fuse running through a hole in the back. Original price: $0.50. $20-30.
Actino #12 Flash Cartridges - box of 6. $18.

UNIVERSAL CAMERA CORP.
Mercury Photoflash Unit - With separate calculator wheel, ib, box: $15. Flash only: $8.
Minute 16 Flash Unit - $10-15.
Univex Photoflash Reflector Unit, No. F15. - $8.

VICTOR Flash Powder, Normal Grade - Glass bottle inside cardboard can. $20.

VOIGTLÄNDER
Flash-Case - Front cover of leather case flops down to reveal flash reflector. For Prominent and Vitessa. Takes #5 bulbs. Original price: $30. $10.

WESTPHALEN Little Sunny - Hand-held carbon arc sun gun. $17.

WHITE
Realist BC - $15.
Realist Flash ST52 - $35.
Realist Photoflash Model 1661 - $8.

WHITTAKER Micro 16 flash - $15-20.

WITTNAUER BC Flash - $8.

WOLLENSAK-10 - $19.

YASHICA Autotron Flash - $4.

ZEISS IKON A.G. Ikoblitz Flash - $7.

LENSES (without Shutters)

- ¼-plate unmarked daguerreian lens - $285.
- ½-plate daguerreian lens - "verres combinés". $350-450.
- 310mm unmarked brass barrel lens with geared focusing. Hinged lenscap. $40.
- 8" unmarked in brass barrel with focus knob, slot for waterhouse stops. With set of stops: $75.
- 10" unmarked in brass barrel with focus knob, slot for waterhouse stops. $55.
- 10"/f9 5x8 Premier Rapid Rectilinear. 3" long brass barrel. Waterhouse stops. $50.
- 3½" unmarked stereo lenses with rotating stops. $125.
- 5" Carte-de-Visite 4-lens set. Brass tubes mounted on 5x6¼" brass plate. c1860's. $275.

Patent Globe lens - 1860. $150-300.

ANTHONY (E & HT) & CO.
Single Achromatic 254mm - Brass barrel, rotating diaphragm with 5 stops. $80.
Anthony Achromatic 260mm - Brass barrel, Daguerrotype style, rotating diaphragm with 4 stops. $90.

BAUSCH & LOMB
f18 Zeiss Anastigmat, Series V - $25.
120mm/f20 Zeiss Anastigmat - brass. $36
150mm/f12.5 Zeiss Anastigmat - Brass barrel, rotating diaphragm with 6 stops. $79.
150mm Bausch & Lomb Optical Co. - Brass barrel, geared focusing. $40.
165mm/f8 Planatograph - Brass. $15.
254mm Bausch & Lomb Optical Co. - Brass barrel, geared focusing. $35.
265mm/f20 Zeiss Protar, Series V - 11x14", brass barrel. $50.
355mm Bausch & Lomb Optical Co. - Mfd. for Lubin Mfg. Co. Brass barrel, geared focusing. $20.
375mm/f4.5 Zeiss Protrait Unar No. 9 - Brass barrel, adjustable soft focusing. $100.
5x7"/f4.5 Tessar - Brass barrel. $50.
8x10" Tessar Ic - coated. $95.
8x10 Plastigmat 12" - US 3-128, built-in diaphragm with mounting ring. $100.
8x10"/f18 Protar, Series V - brass barrel, internal diaphragm. $60.
4⅝"/f6.3 Tessar - Black barrel mount, round flange. $20.

BECK (R.J.) Brass barrel lenses
4¼x3¼" Rapid Rectilinear - Waterhouse stops. Leather cap. $75.
254mm/f8 Beck Symmetrical - $50.

BURKE & JAMES 230mm No. 1 Ajax - Brass barrel, geared focusing. $20.

BURKHOLDER, J.H. (Mansfield, Ohio)
8x10 Wide Angle - Waterhouse stops. Mounted on 6x6" board. $35.

CEPHALOSCOPE f8 Portrait lens - Brass with retaining ring. $69.

DALLMEYER, J.H.
455mm 12x10" Rapid Rectilinear - Brass barrel, f8-64. $45.
12x10 London Rapid Rectilinear - pat. 6/30/1868. With mounting ring. $200.
25x21 Rapid Rectilinear - Pat. June 30, 1868. Brass barrel, waterhouse stops. 8" long, 5½" dia. $110.
5" Triple Achromatic - Brass barrel, flange and slot for waterhouse stops. $50.
Daguerreotype lens - 3¼" long, 2¼" dia. Brass barrel, brass sunshade. Sleeve focus, waterhouse stops. $175.

DARLOT OPTICIEN Brass barrel lenses
whole plate daguerreian lens - $350-500.
8½" - front-mounted lens. f-stops on 3 levers. $80.
90mm No. 2 - Built-in 3 lever stops. $95.
200mm - Built-in 3 lever stops. $175.
255mm - Built-in 3 lever stops. $135.
430mm - geared focus. $70.
4 Gem Lenses - Brass tubes, mounted on brass board. No stops. Possibly for CDV wet plate. $550.
Wide Angle - Waterhouse stops. With flange. $50.
3" Wide Angle Landscape - c1870's. 3 lever-activated internal stops. Flared rear element. With flange. $70.

DEKER & Co. (Chicago) Convertible
8x10 Wide Angle Rectilinear - Brass barrel, waterhouse stops. $50.

DEMPSTER, ROBERT (Omaha, NE)
8x10 Improved Hawkeye extreme wide angle - f16-512. $40.

DEROGY OPTN (Paris) Brass bound lens - rack and pinion focusing barrel. $50.

EASTMAN KODAK
7"/f2.5 Aero Ektar - $80.
7½"/f4.5 Anastigmat - in barrel. $30.
8½"/f4.5 Anastigmat - in barrel. $65.
10"/f4.5 Anastigmat - in barrel. Correct size for 5x7" Graflex. With front cap. $105.
12" Portrait - in barrel. $85.
21"/f10 Anastigmat - in barrel. $150.
280mm/f8 Hawkeye Portrait Rapid Rectlinear 8x10 - Brass barrel. $50.
f4 Hawkeye Portrait Series A, No. 3 - Brass barrel, diffusing focus. $150.

ENTERPRISE OPTICAL MFG. CO.
125mm Enterprise - Brass barrel, geared focusing. $20.

FRENCH (Benjamin French & Co., Boston) 6"/f5 - Brass barrel, 2¼" long. Rack and pinion focusing, waterhouse stops. $126.

GOERZ, C.P.
160mm/f4 Rapid Rectilinear - Brass barrel. $40.
500mm/f4.5 Dogmar - coated. On large lensboard. $200.

ACCESSORIES: LENSES without Shutters

Dagor lenses in brass barrel:
60mm/f6.8 - $45
135mm/f6.8 - $50-75.
150mm/f6.8 - $90
10¾"/f6.8 - $220.
12"/f6.8 - $260.

Doppel-Anastigmat brass barrel lenses:
180mm/f6 - c1905. $30.
300mm/f4.6 - c1905. $55.

GRAF-BISHOP
Doublet - soft focus, for view camera.
With flange. $60.
455mm/f8 Anastigmat - brass barrel. $70.

GUNDLACH Brass barrel lenses
5x7" Wide Angle - Rotating diaphragm
with 6 stops. $60.
8x10" Wide Angle - waterhouse stops. $80.
6½x8½" Wide Angle - Early wet-plate lens.
Waterhouse stops. $50.

HARRISON, C.C. *These are American*
Daguerreian lenses, in brass barrels.
- 5½" long, 2½" dia., rack and pinion focus,
waterhouse stops. $150.
- 6" long, 2¾" dia., rack & pinion focus,
waterhouse stops. $275.
7" focal length - Radial drive, slotted for
stops. With shade, no flange. $240.
12" focal length - Radial drive. With
flange: $300.

HOLMES, BOOTH & HAYDEN (N.Y.)
170mm - Brass barrel, geared focus. $60.
Daguerreian lenses in brass barrels:
- 6" focal length, radial drive, shade. $210.
- 7" focal length, rack and pinion focus.
With mounting ring & original board. $275.
- 12" focal length, radial drive, slot for
waterhouse stops. $300.
- 12" focal length, radial drive. c1850's.
Slightly flared front rim and flange. 7½"
long, 4" dia. $300.
- 5¾" long, 2¾" dia. Rack and pinion focus,
waterhouse stops. Leather cap. $275.

KOEHLER 210mm/f16 Commercial
8x10 Wide Angle - Brass barrel, rotating
diaphragm with 5 stops. $60.

LANCASTER Rectigraph - c1905. Brass
bound, iris diaphragm. Size: 2.8x3cm. $40.

LAVERNE (A.) & CO. 200mm/f8
Panorthoscopic Obis - Brass barrel. $22.

LONDON STEREOSCOPIC 125mm/f11
Coy's Wide Angle - Brass barrel, rotating
diaphragm with 5 stops. $65.

MANHATTAN OPTICAL CO. 240mm/f4
Extra Rapid Rectilinear Lens No. 3 -
Brass barrel. $25.

MARION & CO. (London) The Soho
15x12 lens - $60.

MEYER 14½/f4 Double Plasmat - in
barrel. $120.

MORLEY & COOPER Whole plate
Portrait Lens - Brass-bound, rack and
pinion focusing. Waterhouse stops. $51.

MULLETT third series wide angle 8"
lens - with rotating waterhouse stops. $55.

NEHRING (N.Y.) 8x10 Convertible
Rectilinear - Brass barrel, single
waterhouse stop. $45.

OKOLI GESELLSCHAFT 240mm/f4.5
Okolinar Series T - Brass barrel. $75.

PECK Co. 10x12 to 12x14/f8 Rapid
Rectilinear Portrait, Series 770. - $35.

RODENSTOCK
135/f6.8 Eurynar - c1908. Nickel barrel.
In decorative Koilos shutter. $30.
240mm/f6.8 Doppel Anastigmat
Eurynar - Brass barrel. $70.

ROSS (London) Brass barrel lenses
120mm Actinic Doublet - Rotating
diaphragm with 5 stops. $65.
255mm/f5 Unar - Internal diaphram. $60.
5"/f4 Xpres 5x7 Wide Angle - $60.
7"/f7.7 Double Anastigmat - Internal
diaphragm. With flange. $40.
8¼"/f4 Express - $230.
8½"/f4.5 Xpres - $70.
10"/f6.3 Homocentric - With flange. $60.
14"/f8.5 Rapid Symmetrical 9x7 -
Brass barrel, waterhouse stops. 3¼" long,
1⅞" dia. With leather cap. $55.
18"/f5.6 Homocentric - in barrel. $100.

SCHNEIDER-KREUZNACH
90mm/f6.8 Angulon - Brass barrel, on
2⅝" metal board. $35.
180mm/f5.5 Tele-Xenar - For Bertram
Press camera. Very Rare. $130.
210mm/f4.5 Xenar - $50-55.
240mm/f4.5 Xenar - coated. $90-125.

SCIENTIFIC LENS CO.
200mm/f8, 8x10 Wide Angle - Brass
barrel, 5-stop rotating diaphragm. $40-50.
7"/f16, 8x10 Wide Angle - $40.
12"/f8 No. 2 Portrait - Brass barrel. $85.

SCOVILL & ADAMS Morrison 8x10"
Wide Angle - Brass barrel. $75.

SENECA CAMERA CO. 5x7 Rapid
Convertible - $50.

SIMPKINSON & MILLER 355mm/f8
8x10 Premier Rapid Rectilinear - Brass
barrel. $20.

SOMERVILLE (J.C.) (St. Louis) 8x10"/
f8 No. 3A - Brass barrel. $55.

STERLING 200mm/f16, 8x10 Improved
Wide Angle - Brass barrel. $45.

ST. LOUIS PHOTO SUPPLY CO.
335mm Rapid Rectilinear 8x10 Portrait -
Brass barrel. $70.

STEINHEIL
150mm/f12 Orthostigmat - $45.
360mm/f4 Cassar Speed Portrait - $100.

TAYLOR HOBSON
8¼"/f4.5 - black barrel, internal adjustable diaphragm, uncoated. $20.

TAYLOR HOBSON COOKE Brass barrel lenses:
325mm/f4.5 Anastigmat, Series II - $68.
325mm/f5.6 Anastigmat, Series IV - $68.
330/f8 Anastigmat, Series V - $115.
6½"/f6.5 Wide Angle - on lensboard. $49.

TURNER-REICH Lens Set, Series II -
14", 18", 24", 28" lenses that are used in different combinations in one barrel to give 9 different focal lengths. $150-300.

VEGA 3" Stereo Lenses - Adjustable
internal diaphragms; mounting flanges. $250-350.

VOIGTLÄNDER & SOHN Brass barrel lenses
No. 5 - 5½" long, 4¼" dia. Waterhouse stops. $140.
18" Euryscope No. 5 - Slot for waterhouse stops. $85.
Portrait No. 6 - 9" long, 5½" dia. 5 waterhouse stops. $150.
14" lens - 6 aperture discs in holder. $95.
280mm Landschafts No. 4 - Rotating diaphragm with 4 stops. $49.
14" Wet-plate lens - Rack and pinion focus, slot for waterhouse stops. With flange and shade. $120.
18" Wet-plate lens - Slot for waterhouse stops. $220.
Half-plate daguerreian lens - $350-400.

WILLARD & CO. 430mm lens - Brass
barrel, geared focus. $120.

WOLLENSAK OPTICAL
162mm/f4.5 Raptar - in barrel. $45.
5x7" Rapid Convertible - $35.
6½"/f4.5 Velostigmat - in barrel. $35.
6½"/f12.5 8x10 wide angle - barrel. $35.
7"/f4.5 Velostigmat Series II - black. $15.
7½" Velostigmat - in barrel. $30.
8¼"/f4.5 Velostigmat, Series II - $75.
f3.8 Vitax Portrait Lens No. 3 - 11" long, 6" dia. $175.
18"/f4 Diffused Focus Verito - in barrel, on 9x9 board. With Packard shutter. $125.

WRAY (London) 9½" focal length,
8x10 - 3" long. $75.

ZEISS (Carl Zeiss Jena)
180mm/f6.3 Jena Tessar - $20.
180mm/f4.5 Jena Tessar - $40.
210mm/f4.5 Tessar - in barrel, no diaphragm. $30.
360mm/f4.5 Jena Tessar - c1920. $130.
5½" Protar, Series V - 140mm. Brass barrel. $65.

LENSES in Shutters

BAUSCH & LOMB
135mm/f8 Symmetrical - Brass, in double piston shutter. $12.
6½" US4 Rapid Rectilinear - 165mm. Brass barrel, Unicum shutter. $30.
5x7"/f4.5 Tessar Ic - in Ilex Acme shutter. $125.
5x7"/f8 Planatograph - brass and nickel Wollensak Auto 1/100 shutter. $30.
5x7"/f8 Rapid Rectilinear - brass Wollensak Jr. shutter, 2½x3½" board. $30.

CONLEY 250mm/f6.8 Anastigmat - in Conley Auto Shutter. $30.

EASTMAN
127mm/f4.7 Ektar - coated lens, Graflex Supermatic x-sync shutter. $60.
305mm/f4.8 12" Portrait - in #5 Ilex MX Synchro shutter, coated: $285. On 6x6 board, in Universal Synchro Shutter. $255.

GOERZ, C.P.
75mm Hypergon Doppel-Anastigmat Series X, No. 000a - Star-shaped wheel, rotated by air, prevents over-exposure of center of the plate. Scarce. $300-335.

240/f6 Doppel-Anastigmat - c1900. Brass bound. Universal shutter. $55-60.

Dagor lenses:
90mm/f8 W.A. - in Synchro Compur. $225-275.
100mm/f6.8 - in Compound. $125.
111mm/f8 W.A. - in Compur. $450.
125mm/f6.8 - in Compound. $120.
130mm/f6.8 - in Compound. $115.
150mm/f9 W.A. - in Compur. $300.
180mm/f6.8 - in Prontor. $275.
240mm/f6.8 - in Compur. $350-390.
420mm/f7.7 - in Ilex. $400-600.

GUNDLACH
f11 Achromat - Wollensak Jr. brass shutter. $20.
Korona Triple Convertible Anastigmat - 8½"/f6.3, 15"/f11. 18"/f16. Rapax shutter. $125-150.
130mm/f11 - Brass single piston sh. $18.
5x7" Symmetrical - single piston shutter. $15.

ILEX
77mm/f4.5 Paragon - in 00 Acme 1/300 shutter, on 2⅝" square metal board. $25-50.
5½"/f4.5 Paragon - coated, 140mm, in Acme #3 shutter. $60.

MEYER Wide Angle Aristostigmat
120mm/f6.3, 5x7 - Dial Compur sh. $115.
3⅛"/f6.3, 4x5 - 80mm. Compur. $115.

PROSCH MFG. CO.
Stereo Wide Angle lenses - c1880s. Stereo Triplex shutter. $575-600.
125mm - Triplex brass shutter, 5 rotating stops in external shutter mechanism. $105.

ACCESSORIES: LENSES in Shutters - PLATES

290mm - Triplex brass shutter, 5 rotating stops in external shutter mechanism. $125.

SEROCO 5x7 Rapid Rectilinear - in Unicum shutter. $15-25.

SCIENTIFIC LENS CO. 100/f4 Wide Angle Symmetrical No. 2 - Double piston automatic shutter. $10.

ROCHESTER OPTICAL CO.
150mm/f6.8 Victor - Brass, Bausch & Lomb shutter. $15-25.
155mm/f8, 4x5 Rapid Rectilinear - Brass, double piston Unicum shutter. $15-25.

SCHNEIDER-KREUZNACH
80mm/f2.8 Xenotar - MX Compur. $100.
90mm/f6.8 Angulon - uncoated, in unsynched shutter. $75.
120mm/f6.8 Angulon - Compur S, 1/200 shutter. $90.
135mm/f4.7 Xenar - coated, in Compur MX shutter. $115.
150mm/f2.8 Xenotar - coated, in Compur shutter. Leather cap. $300.
150mm/f5.6 Symmar-S - Copal shutter, front cap. $190.

VOIGTLÄNDER
6½"/US 4 Dynar - Early 5-element version of the Heliar. Bionic shutter. $60.
330mm/f7.7, 13" Collinear - Compound-type shutter. $300.

WOLLENSAK
6¼"/f12.5 Wide Angle Series IIIa - in Betax #3 shutter, for 8x10" view. $125-160.
6½"/f6.3 Velostigmat, Series IV - in Betax, X sync. $60.
7"/f6.8 Vinco-Anastigmat - Betax #2 Automatic shutter. $39.
12"/f4.5 Velostigmat - in Studio shutter: $65. Coated, in Betax, X sync. $300.
12"/f4.5 Velostigmat Series II - in "Regular" 2-blade shutter with cocking lever and air retard. $65.
162mm/f4.5 Raptar - coated; Alphax. $95.
210mm/f4.5 Raptar - in Betax, X sync. $150.

ZEISS (Carl Zeiss Jena)
165mm/f6.3 Jena Tessar - Compur. $25.
180mm/f4.5 Jena Tessar - Compur. $40.
180mm/f6.3 Jena Tessar - c1919. In Compur shutter. $40.
300mm/f4.5 Tessar - in Alphax or Betax shutter. $125-175.

MISCELLANEOUS

IRUM Headrest Stand - Stamped 1875. With clamp. $475.

TWEETY BIRD - 1880. Brass bird child's toy. Uses air pressure to sing. $125.

VICTORY Canary Songster - 1920's. Little brass bird. Fill the well with water, blow on the tube, and the bird warbles. $50.

MICROSCOPE ADAPTERS

EASTMAN KODAK CO.
Instamatic Reflex Adapter - $25-30.
Retina Reflex Adapter - $36.
Adapter Kit Model B - for Retina Ib, IIc, IIIc. $30.
Microscope Attachment and Camera Holder Model D - for Retina cameras. $25-30.

IHAGEE
Adapter Type I - $15-20.
Adapter Type II - $20-25.
Exakta microscope attachment - $25.
Long microscope adapter - $30.

KOPIL Exakta-mount microscope adapter - $15.

ZEISS IKON A.G.
#1525/20.1615 - for Contaflex I, II. $10-15.
#1528/20.1620 - for Contaflex Alpha/Beta. $10-15.

PLATES/ SHEET FILM/ ROLLFILM, ETC.

BERNING Robot Film Cassette - $5-10.

CONCAVA Tessina film cassette - $1-5.

CRAMER Lightening Photo Dry Plate - 5x7", expiration date of 1902. Box of 12. $15-25.

EASTMAN KODAK CO.
Dry Plates - Box of 3¼x4¼": $5. 4x5": $6.
Glass Plate Negatives - Box of 6½x8½". $8.
Daylight Film Loader - Bakelite, 35mm. $7.
Verichrome Film Pack - dated 1941, unopened 12 pack. $7.
Verichrome Pan VP130 - unopened. $4

GAMI reloadable film cartridge - $6.

ILFORD Compass Film plates - 35x43mm, for Compass camera. $7.

PHOTAVIT-WERK Photavit Film Cassette - $7.

RIKEN
Golden Ricoh 16mm film - Kodachrome ASA 10, or B&W ASA 100. $8.
Ricoh Film cassette - $7.
Steky 16mm film - Panchromatic, 24 exposure. Expired 2/1950. $3.

SAKURA SEIKI CO. Petal Film Cartridge - Round or octagonal version. $14-20.

UNIVERSAL
Uni-Pan film magazine - for Minute 16. $3.
Univex #100 - Standard 8mm Safety Reversible cine film. Expired 5/1940. $7.

ZEISS Contax reloadable film cassette - pre-1945. $7.50

686

RANGEFINDERS

BALDA
Baldameter - c1930s. $7.
Distanzer - $17.
DEJUR Rangefinder - $10.

DOLLAND Rangefinder - $12.

EASTMAN KODAK
Pocket Rangefinder - Clip-on. $20.
Service Rangefinder - Chrome. $15.
Split-image Rangefinder - Mounts
vertically. $20.

EDSCARP Field Rangefinder - $18.

FRANKE & HEIDECKE Rolleimeter
f2.8 - Prismatic focusing rangefinder for
the f2.8 non-removable hood cameras. $45.

HEYDE
Photo-Telemeter - Pocket split-image
rangefinder. $17.
Pocket Rangefinder. $7.

HUGO MEYER Pocket Rangefinder - $11.

IDEAL Rangefinder Federal - $6-8.

KI SET Rangefinder - Chrome. $8.

KOMBI Combi-Meter - post-WWII.
Combination rangefinder and extinction
meter. $10.

MASTRA Rangefinder - $25.

MEDIS Rangefinder - $12.

PHAOSTRON Superimposed
Rangefinder - $5.

POLLUX Rangefinder - $5.

PRAZIA rangefinder - $15.

PROXIMETER I, II - for Braun. c1950s.
$7.
PROXIMETER II - for Agfa. $4.
PROXIMETER II - for Vito II, Vito BR,
Vitomatic II. $25.

SAYMOUNT Rangefinder - $10.

TELEX Rangefinder - $5-10.

UNITY Rangefinder - Clip-on style. $8.

VOTAR Rangefinder - clip-on with feet.
$7.

WALTZ rangefinder - $2.

WATAMETER II - $12.

WATAMETER Super Rangefinder - $25.

ZEISS IKON A.G.
Rangefinder - Hand-held rangefinder for
early folding camras. $35.
#425 Rangefinder - 75mm. $60.

SELF-TIMERS

AGFA Self-Timer - $3

ALPEX Self-timer - for Leica/Yashica. $4.

CANON Self-timer II - $30.

EASTMAN KODAK CO.
- piston-type. $5-10.
- 1933 self-timer in art-deco box. $10-15.

ELITE Self-timer - $5.

FOCAL Universal - 15 sec. With Polaroid
and Leica adapters. $4.

HAKA
Autoknips I - $5.
Autoknips II - Greater range than the
Autoknips I. $6.

HANSA Self-timer - $6.

KOPIL Self-timer - $6-8.

MINORI Self-timer - $15.

WALZ Self-Timer Assembly - $6.

SHUTTERS

CONLEY 5x5" Packard-type - on
recessed 9x9" board. $12.

GOERZ Stereo Compur - 2 lens flanges.
$60.

GRAFLEX Focal Plane Shutter - For
5x7" camera: $60. For 8x10" camera. $120.

ILEX
00 Acme - 1/300 shutter, chrome. $15.
#3 Ilex - X-sync. Marked for 5"/f4.5 Ilex
Paragon lens. $50.

LANCASTER - Adjustable rubber-band
activated shutter. $20-35.

PACKARD - sync. shutter. $15.

Rollerblind shutter - String set; speeds
1/15 - 1/90 and time. In rectangular
wooden box that fastens on the front of
the lens with a set screw. $35.

STEREO VIEWERS

- c1930's hand-held viewer. Black metal.
$25.
- Portable Combination Graphoscope -
For viewing stereo cards with a pair of
lenses, or cabinet cards with a single lens.
5½x9" wood base. $80.

AMERICAN STEREOSCOPE CO.
The Stereo-Gothard - Hand-held viewer with enclosed area for storing cards. $112.

BAIRD (ANDREW H.) The Lothian Stereoscope - c1875. Brass and wood. Separates into 4 pieces when handle is removed, for easy storage in a box. Adjustable viewing lenses. $250.

BATES (Joseph) (Boston)
Holmes Bates Stereoscope - Pedestal-mounted, Holmes-style viewer. All wood. $85-120.

BECK (R. & J., London) Achromatic Stereoscope - Table-top model with Achromtic lenses. Rack and pinion focus, hinged mirror, swinging card holder. Mahogany case is used as the stand for the viewer. Sold with large foor-standing mahogany table/cabinet: $500-560.

BECKER, ALEXANDER (N.Y.)
Pedestal Stereoscope - c1859. Wood body with internal septum. Dual eyepiece. $250.
Tabletop Stereo Viewer - c1859. Rosewood or walnut. Holds 36 paper or glass views. $400-500.

BREWSTER-Style Stereoscope - c1890's. Tabletop viewer. Light wood. 17" high. Viewing hoods on both sides. $300-330.

BREWSTER-Style Stereoscope - c1890. Wooden viewer on a stand, 15" high. Black laquered base, brass center post. $200-250.

BREWSTER-Style Stereoscope - Smaller, less decorative versions sell from $70-150.

BRUMBERGER Viewer - Ebonite finish. Battery operated. $35.

BUSH Viewer #Y-5081 - Rare. $150.

CUTTS, SUTTON & SON (Sheffield) Achromatic Stereoscope - Rack focusing. $263.

EASTMAN KODAK CO.
Kodaslide I - $45.
Kodaslide II - $85.

FEARN, (Francis H.)
Stereo Graphscope - Huge viewer with inlaid wood designs. Screw focus. $450.

GAUMONT (Paris) Automatic Table Stereoscope - Wide pedestal base. Brown metal body with imitation wood-grain finish. Slide focus. $120.

IVES Stereokromskop Viewer - Wood body. Uses glass color-separation slides to show views in color. In original box, with ib and extra kromograms: $1450.

KAWIN Stereo hand viewer - $35.

KEYSTONE - c1900. Hand-held stereo viewer. Wood with aluminum hood. $35.

MASCHER'S Union Case/Viewer - ¼-plate size with stereo tintypes inside. $400.

MEAGHER (London)
Cabinet Stereoscope - Large wooden cabinet stereoscope. Ornate wood-craved trim around top and eyepieces. Focusing eyepieces. $360.

NEGRETTI & ZAMBRA
Rowsell's Stereographoscope - Burr walnut. With magnifier. $140-190.

NEW YORK STEREOSCOPIC CO.
Brewster viewer - Early. Leather viewer with gold-stamped design. $200.

PLANOX
Stereoscope - French table-top viewer. Large wooden body. Rack and pinion focus; eyepiece adjustment. Internal mechanism for changing slides. $150-200.

PRIMUS
Perfect Stereoscope - Wood viewer with internal septum. Brass fittings. Rack and pinion focus, lens adjustment with swinging mirror. $170-240.

ROWSELL
Parlor Graphoscope - c1875. Folding table model, 23x12" walnut base. $200.

SMITH, BECK and BECK
Achromatic Cabinet Stereoscope - Walnut stereo card cabinet stores cards and the viewer. Viewer fits into mounting plate on top of cabinet. Brass lens panel, rack focusing, tilt adjustment. $200-300.

Mirror Stereoscope - Rack focusing. $65.

UNDERWOOD & UNDERWOOD Sun Sculpture - Holmes-type hand-held viewer. $100-165.

WATSON & SONS (London)
Stereo-graphscope - Mahogany pedestal viewer. Swinging magnifier. $150-170.

WHITING Sculptoscope Stereo Viewer - Coin-operated viewer containing a series of colored lithographs. Large rectangular shape, 13½"x10½"x7". Viewing eyepiece at top front. Label says "Whiting's Travel System. $775.

TRIPODS

EASTMAN KODAK CO.
Bullet, Model H - $10.
Bulls-Eye, Models B and C - Double extension wooden tripod. $10.
Flexo, Model C - $10.
Kodapod - $5.
Metal tripod - #1: $10. #2: $20.

FOLMER GRAFLEX
Crown Tripod #1 - 1920's. Wooden tripod extends to 6'. $18.
Crown Tripod #2 - $30.
Crown Tripod #4 - $40.
Tripod for #10 Cirkut Camera - including turntable head. $150.

FRANKE & HEIDECKE
Rolleifix Quick Release Tripod Adapter - $15-25.

SUNART PHOTO CO. - double extension wooden tripod. $12.

ZEISS 12" tripod - Nickel and black enamel. $24.

WATERHOUSE STOPS

ANTHONY (E. & H.T.) CO.
Brass WH stops
Set of 2 - 2½"-3". $13.
Set of 3 - 2" wide. $18.
Set of 4 - 1⅜"-2¹⁵⁄₁₆". $20.
Set of 5 - 1½"-2⁷⁄₁₆". $25.

INDEX

Asahi Pentax K: 56
Asahi Pentax S: 56
Asahi Pentax Spotmatic: 56
Asahiflex I, Ia, IIB (Asahi): 55
Asahiflex IIA (Asahi): 56
Asahigo (Yen-Kame): 571
Asanuma Clock (Non-Camera): 639
ASANUMA TRADING CO.: 56
Asanuma Kansha-go: 56
Ascot (Anthony): 45
Ascot Cycle No. 1 (Anthony): 46
Ascot Folding Nos. 25,29,30 (Anthony): 46
ASIA AMERICAN INDUSTRIES LTD.: 57
Asia American Orinox Binocular Cam.: 57
Asiana: 57
ASR Fotodisc: 37
ASSOCIATED PHOTO PRODUCTS
 (Movie): 602
Associated Photo Magazine Pocket: 602
ASSOCIATION de TECHNICIENS en
 OPTIQUE et MECANIQUE
 SCIENTIFIQUE (Atoms): 57
Astoria Super-6 IIIB (Ehira): 207
Astra: 57
Astra (Rodenstock): 473
Astra 35F-X (K.W.): 336
Astraflex II (Bentzin Primarflex II): 71
Astraflex-II (Feinoptisches): 228
Astraflex 35 (K.W.): 336
Astraflex 1000 (Wirgin): 562
Astraflex 1000 LM (Wirgin): 562
Astraflex Auto 35 (Pentacon): 438
Astrocam 110 (Estes): 223
Astropic: 57
ATAK: 57
Atak Inka: 57
ATKINSON (J.J.): 57
Atkinson Stereo: 57
Atkinson Tailboard Camera: 57
Atkinson Wet Plate Field Camera: 57
Atlas 35 (Yamato): 567
ATLAS RAND: 57
Atlas Rand Mark IV: 57
Atoflex (Atoms): 57
Atom (Huttig): 291
Atom (Ica): 292
ATOM OPTICAL WORKS: 57
Atom-Six-I (Atom Optical): 57
Atom-Six-II (Atom Optical): 57
ATOMS: 57
Atoms Aiglon: 57
Atoms Aiglon Reflex: 57
Atoms Atoflex: 57
Attache Case Camera 007: 57
Auction: ADV
AURORA PRODUCTS CORP.: 57
Aurora Ready Ranger: 57
AUSTRALASIAN CAMERA
 MANUFACTURERS (ACMA): 18
Australian Dealer: ADV
Auta (Wirgin): 562
Auto Camera, Mark 3 (Shackman): 495
Auto Camex (Ercsam): 614
Auto Colorsnap 35 (EKC): 144
Auto-Eye II (FR): 236
Auto Fifty (United States Camera): 530
Auto Fixt Focus (Defiance): 135

Auto Flash Super 44 (Agilux): 32
Auto Forty (United States Camera): 530
Auto Graflex: 259
Auto Graflex Junior: 259
Auto Kine Camera Model E (Newman): 621
Auto-Lux 35 (Mamiya): 368
Auto Minolta (Minolta): 384
Auto Semi First (Kuribayashi): 329
Auto Semi-Minolta (Minolta): 383
Auto Ultrix (Ihagee): 301
Autocord (Minolta): 392
Autocord CdS I,II,III (Minolta): 392
Autocord L (Minolta): 392
Autocord LMX (Minolta): 392
Autocord RA (Minolta): 392
Autoflex (Kiyabashi): 315
Autographic Kodak (EKC): 144
Autographic Kodak Junior (EKC): 145
Autographic Kodak Special (EKC): 145
Automan (Thornton-Pickard): 517
Automat (Aires): 32
Automat (Minolta): 392
Automat 120: 58
Automatic (United States Camera): 530
Automatic No. 1A (Ansco): 38
Automatic 35 (EKC): 145
Automatic 35B (EKC): 146
Automatic 35F (EKC): 146
Automatic 35R4 (EKC): 146
Automatic 66 (Agfa): 22
Automatic 100 (Polaroid): 452
Automatic-1034 (Revere): 461
Automatic Magazine (Houghton): 284
AUTOMATIC RADIO MFG. CO.: 58
Automatic Radio Tom Thumb Camera
 Radio: 58
Automatic Reflex (Ansco): 39
Automatica (Durst): 141
Automaton (Wittnauer): 565
Automex (Miranda): 397
Automex II (Miranda): 397
Automex III (Miranda): 397
Autopak 500 (Minolta): 390
Autopak 700 (Minolta): 390
Autopak 800 (Minolta): 390
Autopress (Minolta): 384
Autorange 16-20 Ensign (Houghton): 284
Autorange 220 Ensign (Houghton): 284
Autoset (Ansco): 39
Autosnap (EKC): 146
Autospeed (Houghton Ensign): 285
Autowide (Minolta): 386
Autronic I, 35, C3 (Argus): 52
Aviso (Ica): 292
AVON (Non-Camera): 659
Avus (Voigtländer): 541
Azur (Boumsell): 84
B & R MANUFACTURING CO.: 58
B & R Mfg. Photoette #115: 58
B & W MANUFACTURING CO.: 58
B & W Mfg. Press King: 58
B Daylight Kodak (EKC): 163
B Ordinary Kodak (EKC): 182
Babette: 58
Baby (Yen-Kame): 571
Baby Al-Vista (Multiscope): 405
Baby Balnet (Fuji): 242

Baby BB Semi First (Kuribayashi): 329
Baby Bessa (Voigtländer): 543
Baby-Box Tengor (Zeiss): 574-575
Baby Brownie (EKC): 150
Baby Brownie New York World's Fair Model (EKC): 150
Baby Brownie Special (EKC): 150
Baby Camera: 58
Baby Hawk-Eye (EKC): 172
Baby Deardorff: 134
Baby Deckrullo (Zeiss): 583
Baby Finazzi: 59
Baby Flex: 59
Baby Hawk-Eye (Blair): 76
Baby Ikonta (Zeiss): 587
Baby Kinsi (Riken): 464
Baby Lyra (Fuji): 242
Baby Makina (Plaubel): 449
Baby-Max (Tougodo): 524
Baby Minolta (Minolta): 383
Baby Pearl (Konishiroku): 318
Baby Powell (Rex): 461
Baby Reflex (Yen-Kame): 571
Baby Ruby (Ruberg): 479
Baby Semi First (Kuribayashi): 328
Baby Sibyl (Newman & Guardia): 412
Baby Special (Yen-Kame): 571
Baby Sports (Yen-Kame): 571
Baby Standard (Vicam Photo): 630
Baby Wizard (Manhattan): 370
Babysem (S.E.M.): 490
BACO ACCESSORIES: 59
Baco Press Club: 59
BAGS (Non-Camera Handbags): 635
BAIRD: 49-50
Baird Single lens stereo camera: 59
Baird Tropical Field Camera: 59
Bakelite (Gallus): 244
Bakina Rakina (Fototecnica): 236
Baky (Wirgin): 562
Balda AMC 67 Instant Load: 59
Balda Baldafix: 59
Balda Baldak-Box: 59
Balda Baldalette: 59
Balda Baldalux: 59
Balda Baldamatic I,II,III: 59
Balda Baldax: 60
Balda Baldaxette: 60
Balda Baldessa,Ia,Ib: 60
Balda Baldessamat F,RF: 60
Balda Baldi: 60
Balda Baldina: 60
Balda Baldinette: 60
Balda Baldini: 60
Balda Baldix: 60
Balda Baldixette: 60
Balda Doppel-Box: 60
Balda Erkania: 60
Balda Fixfocus: 61
Balda Front-Box: 61
Balda Gloria: 61
Balda Glorina: 61
Balda Hansa 35: 61
Balda Jubilette: 61
Balda Juwella: 61
Balda Mickey Rollbox: 61
Balda Piccochic: 61

Balda Pierrette: 62
Balda Poka: 62
Balda Pontina: 62
Balda Primula: 62
Balda Rigona: 62
Balda Rollbox 120: 62
Balda Springbox: 62
Balda Super Baldax: 62
Balda Super Baldina: 62
Balda Super Baldinette: 62
Balda Super Pontura: 63
BALDA-WERK: 59-63
Baldafix (Balda): 59
Baldak-Box (Balda): 59
Baldalette (Balda): 59
Baldalux (Balda): 59
Baldamatic I,II,III (Balda): 59
Baldax (Balda): 60
Baldaxette (Balda): 60
Baldessa,Ia,Ib (Balda): 60
Baldessamat F,RF (Balda): 60
Baldi (Balda): 60
Baldina (Balda): 60
Baldinette (Balda): 60
Baldini (Balda): 60
Baldix (Balda): 60
Baldixette (Balda): 60
Baldur Box (Zeiss): 575
Baldwinflex (National): 408
BALLIN RABE: 63
Ballin Folding Plate camera: 63
Balnet Baby (Fuji): 242
Ban: 63
Banco Perfect (Kaftanski): 308
Bandi (Fototecnica): 236
Banier: 63
BANKS (Non-Camera): 635
Banner: 63
Banquet Cameras (Folmer & Schwing): 232
Bantam (EKC): 146
Bantam Colorsnap (EKC): 147
Bantam f4.5 (EKC): 146
Bantam f4.5 Military Model (EKC): 146
Bantam f5.6 (EKC): 146
Bantam f6.3 (EKC): 146
Bantam f8 (EKC): 146
Bantam RF (EKC): 147
Bantam Special (EKC): 147
Baoca BC-9: 63
Barbie (Non-Camera): 648
Barbie Cameramatic (Vanity Fair): 538
Barbie Doll Camera (Non-Camera): 665
Barclay (Yamato): 568
Barco: 63
BARKER BROS. (Movie): 603
BARON CAMERA WORKS: 63
Baron Six (Baron): 63
BARTHELEMY: 63
Barthelemy Stereo Magazine Camera: 63
Battlestar Galactica (Non-Camera): 660
BAUCHET: 63
Bauchet Mosquito I,II: 63
BAUDINET INTERNATIONAL: 63
Baudinet Pixie Slip-On: 63
Bauer: 63
BAUER (Movie): 603
Bauer 88B, 88L: 603

BAZIN & LEROY: 63
Bazin & Leroy Le Stereocycle: 63
BB Semi First (Kuribayashi): 329
Beacon, Beacon II (Whitehouse): 560
Beacon 225 (Whitehouse): 560
Bear Camera (Kiddie Camera): 313
BEAR PHOTO CO.: 64
Bear Photo Special: 64
Bear with Flash Camera (Non-Camera): 667
Bear with Flash Camera (tree ornament)
 (Non-Camera): 663
Beau Brownie (EKC): 150
Beau Brownie Pencil Sharpener
 (Non-Camera): 653
BEAULIEU: 603
Beaulieu Reflex Control: 603
Beaurline Imp: 64
BEAURLINE INDUSTRIES INC.: 64
Beaurline Pro: 64
Beauta Miniature Candid (Rolls): 475
Beauty (Taiyodo): 514
Beauty 35 Super II (Taiyodo Koki): 514
Beauty Canter (Taiyodo Koki): 514
Beauty Super L (Taiyodo Koki): 514
Beautycord (Taiyodo Koki): 514
Beautyflex (Taiyodo Koki): 514
Bebe (Ica): 292
Bebe (Zeiss): 575
Bebe (Zulauf): 599
Beby Pilot (Tachibana): 513
BECK: 64
Beck Cornex: 64
Beck Frena: 64
Beck Hill's Cloud Camera: 65
Beck Zambex: 65
Beddy-Bye Bear (Non-Camera): 643
Bedfordflex: 65
Bee Bee (Burleigh Brooks): 90
Beginners Camera (Aivas): 33
Beica: 65
BEIER: 65-66
Beier Beier-Flex: 65
Beier Beiermatic: 65
Beier Beira: 65
Beier Beirax: 65
Beier Beirette: 65
Beier Beirette K,VSN: 65
Beier Edith II: 65
Beier-Flex (Beier): 65
Beier Folding sheet film cameras: 66
Beier Lotte II: 66
Beier Precisa: 66
Beier Rifax: 66
Beier Voran: 66
Beiermatic (Beier): 65
Beira (Beier): 65
Beirax (Beier): 65
Beirette (Beier): 65
Beirette K,VSN (Beier): 65
Belca Belfoca,II: 66
Belca Belmira: 66
Belca Belplasca: 66
Belca Beltica: 67
BELCA-WERK: 66
Belco: 67
Belco (Idam): 298
Belfoca,II (Belca): 66

Bell-14: 67
BELL & HOWELL: 67
BELL & HOWELL (Movie): 603
Bell & Howell 200EE: 605
Bell & Howell 220: 605
Bell & Howell 240 Electric Eye: 605
Bell & Howell 240A: 605
Bell & Howell 252: 605
Bell & Howell 319: 606
Bell & Howell Cine Camera #2709: 603
Bell & Howell Colorist: 67
Bell & Howell Dial 35: 67
Bell & Howell Double Run Eight: 605
Bell & Howell Electric Eye 127: 67
Bell & Howell Eyemo 35mm: 603
Bell & Howell Filmo 70: 603
Bell & Howell Filmo 70A: 603
Bell & Howell Filmo 70AC: 603
Bell & Howell Filmo 70AD: 603
Bell & Howell Filmo 70C: 604
Bell & Howell Filmo 70D: 604
Bell & Howell Filmo 70DL: 604
Bell & Howell Filmo 70DR: 604
Bell & Howell Filmo 70G: 604
Bell & Howell Filmo 70HR: 604
Bell & Howell Filmo 70J: 604
Bell & Howell Filmo 70SR: 604
Bell & Howell Filmo 75: 604
Bell & Howell Filmo 75 A-5: 604
Bell & Howell Filmo-121-A: 604
Bell & Howell Filmo 127-A: 604
Bell & Howell Filmo 141-A, 141-B: 604
Bell & Howell Filmo Aristocrat Turret 8: 604
Bell & Howell Filmo Auto Load: 604
Bell & Howell Filmo Auto Load Speedster:
 605
Bell & Howell Filmo Auto Master: 605
Bell & Howell Filmo Companion: 605
Bell & Howell Filmo Sportster: 605
Bell & Howell Filmo Turret Double Run 8:
 605
Bell & Howell Foton: 67
Bell & Howell Infallible (Electric Eye 127):
 67
Bell & Howell Magazine Camera-172: 605
Bell & Howell Magazine 200: 605
Bell & Howell Projectors 57A,B,C: 606
Bell & Howell Projectors 122-A: 606
Bell & Howell Stereo Colorist: 67
Bell & Howell Stereo Vivid: 67
Bell & Howell TDC Stereo Vivid: 67
Bell & Howell Vivid: 67
BELL CAMERA CO.: 68
BELL INTERNATIONAL: 68
Bell Kamra: 68
BELL MFG. CO. (Movie): 606
Bell Model 10: 606
Bell's Straight-Working Panorama: 68
Bella (Bilora): 74
Bella 35 (Bilora): 74
Bella 44 (Bilora): 74
Bella 46 (Bilora): 74
Bella 66 (Bilora): 74
Bella D (Bilora): 74
Bellaluxa 4/4 (Bilora): 74
Bellcraft Can-Tex: 68
BELLCRAFT CREATIONS: 68

BELLIENI: 68
Bellieni Jumelle: 68
Bellieni Stereo Jumelle: 68
Bellina 127 (Bilora): 74
Bellows replacements: ADV
Belmira (Belca): 66
Belmira (Welta): 554
Belplasca (Belca): 66
BELT BUCKLES (Non-Camera): 636
Beltica (Belca): 67
Ben Akiba (Lehmann): 344
BENCINI: 68-69
Bencini Animatic 600: 69
Bencini Comet: 69
Bencini Comet NK 135: 69
Bencini Cometa: 69
Bencini Eno: 69
Bencini Gabri: 69
Bencini Koroll: 69
Bencini Koroll 24: 69
Bencini Koroll S: 69
Bencini Rolet: 69
BENETFINK: 69
Benetfink Lightning Detective: 69
Benetfink Lightning Hand: 69
Benetfink Speedy Detective: 69
Benjamin Camera Photo Album
 (Non-Camera): 634
BENSON DRY PLATE & CAMERA CO.: 70
Benson Victor: 70
Bentley BX-3: 70
BENTZIN: 70
Bentzin Astraflex II (Primarflex II): 71
Bentzin Folding Focal Plane Camera: 70
Bentzin Plan Primar: 70
Bentzin Planovista: 70
Bentzin Primar: 70
Bentzin Primar Folding Reflex: 70
Bentzin Primar Klapp Reflex: 70
Bentzin Primar Reflex: 70
Bentzin Primarette: 71
Bentzin Primarflex: 71
Bentzin Rechteck Primar: 71
Bentzin Stereo-Fokal Primar: 71
Bentzin Stereo Reflex: 71
Bentzin Stereo Reflex Primar: 71
Bera (Mashpriborintorg Vega): 374
Bergheil (Voigtländer): 541
Bergheil Deluxe (Voigtländer): 542
BERMPOHL & CO. K.G.: 71
Bermpohl Bildmeister Studio Camera: 71
Bermpohl Miethe/Bermpohl: 72
Bermpohl's Naturfarbenkamera: 71
BERNARD PRODUCTS CO.: 72
Bernard Faultless Miniature: 72
BERNER: 72
Berner Field camera: 72
BERNING: 72
Berning Robot I: 72
Berning Robot II: 72
Berning Robot IIa: 72
Berning Robot Junior: 72
Berning Robot Luftwaffe: 72
Berning Robot Recorder 24: 73
Berning Robot Royal: 73
Berning Robot Star, Star II: 73
Berning Robot Star 50: 73

BERTRAM: 73
Bertram-Kamera: 73
BERTSCH: 73
Bertsch Chambre Automatique: 73
Bessa (early models) (Voigtländer): 542
Bessa 46 (Voigtländer): 543
Bessa 66 (Voigtländer): 543
Bessa I (Voigtländer): 542
Bessa II (Voigtländer): 543
Bessa RF (Voigtländer): 542
Bessamatic (Voigtländer): 543
Bessamatic CS (Voigtländer): 543
Bessamatic Deluxe (Voigtländer): 543
Bessamatic M (Voigtländer): 543
Best (Minolta): 383
Besta: 73
Bettax (Zeh): 572
BIAL & FREUND: 73
Bial & Freund Field Camera: 73
Bial & Freund Magazine Camera: 74
Bial & Freund Plate Camera: 73
BIANCHI: 74
Bianchi Tropical Stereo Camera: 74
Bicoh 36 (Non-Camera): 650
Biflex 35: 74
Big Bird 3-D Camera (Non-Camera): 670
Big Shot (Polaroid): 361
Bijou (Kern): 311
Bijou (Voigtländer): 543
Bildmeister Studio camera (Bermpohl): 71
BILLCLIFF: 74
Billcliff Studio Camera: 74
Billette (Agfa): 22
Billy (Agfa): 23
Billy O (Agfa): 23
Billy I, I (Luxus) (Agfa): 23
Billy II (Agfa): 23
Billy III (Agfa): 23
Billy-Clack (Agfa): 23
Billy Compur (Agfa): 23
Billy Optima (Agfa): 23
Billy Record,I,II (Agfa): 24
BILORA: 74
Bilora Bella: 74
Bilora Bella 35: 74
Bilora Bella 44: 74
Bilora Bella 46: 74
Bilora Bella 66: 74
Bilora Bella D: 74
Bilora Bellaluxa 4/4: 74
Bilora Bellina 127: 74
Bilora Blitz Box: 74
Bilora Blitz Boy: 74
Bilora Bonita 66: 74
Bilora Box Camera: 75
Bilora Boy: 75
Bilora Cariphot: 75
Bilora Quelle Box: 75
Bilora Radix: 75
Bilora Stahl Box: 75
Bilora Standard Box: 75
Bilux (Iso): 306
BING: 75
Bing Fita: 75
Binoca Picture Binocular: 75
Binocular camera (Asia American Ind.): 57
Binocular camera (Binoca): 75

Bonita 66 (Bilora): 74
Bonny Six (Yamato): 568
Bonafix (Franka-Werk): 236
Boo-Boo Bear (Non-Camera): 668
Book Camera (Gakken): 243
Book Camera (Scovill): 484
Books on Photographica: ADV
BOOTS: 83
Boots Comet 404-X (Boots): 83
Boots Field Camera (Boots): 83
Boots Special (Boots): 83
BOREUX: 84
Boreux Nanna: 84
BORSUM CAMERA CO.: 84
Borsum 5x7 Reflex: 84
Boston Bull's-Eye: 84
BOSTON CAMERA CO.: 84
BOSTON CAMERA MFG. CO.: 84
Boston Hawk-Eye Detective: 84
Boucher (Macris-Boucher): 366
BOUMSELL: 84
Boumsell Azur: 84
Boumsell Box Metal: 85
Boumsell Longchamp: 85
Boumsell Photo-Magic: 85
BOWER: 85
Bower 35: 85
Bower-X: 85
Box cameras: see Manufacturers' names
Box 24 (Agfa): 24
Box 44 (Agfa): 24
Box Kolex (Kolar): 317
Box Metal (Boumsell): 85
Box Scout No. 2,2A,3,3A (Seneca): 493
Box Special (Agfa): 24
Box Tengor (Goerz): 253
Box Tengor (54) (Zeiss): 575
Box Tengor (54/2) (Zeiss): 576
Box Tengor (54/14) (Zeiss): 576
Box Tengor (54/15) (Zeiss): 576
Box Tengor (55/2) (Zeiss): 576
Box Tengor (56/2) (Zeiss): 576
Boy (Bilora): 75
Boy Holding Camera (Non-Camera): 664
Boy Scout Brownie (EKC): 148
Boy Scout Camera (Herbert George): 278
Boy Scout Kodak (EKC): 148
Boy Scout Memo (Ansco): 42
BRACK & CO.: 85
Brack Field camera: 85
BRADAC: 85
Bradac Kamarad, Kamarad MII: 86
Bramham (Gaumont): 247
Brass Bound Instantograph (Lancaster): 340
BRAUN: 86
Braun Gloria: 86
Braun Gloriette: 86
Braun Imperial 6x6: 86
Braun Imperial Box 6x6, 6x9: 86
Braun Nimco: 86
Braun Norca: 86
Braun Pax: 86
Braun Paxette: 86
Braun Paxette IIM: 86
Braun Paxette Automatic Super III: 87
Braun Paxette Electromatic: 87

Braun Paxette Reflex Automatic: 87
Braun Paxiflash: 87
Braun Paxina: 87
Braun Reporter: 87
Braun Super Colorette: 87
Braun Super Paxette: 87
Braun Super Vier: 87
Brenda Starr (Seymore): 394
Briefmarken Camera (Ica): 292
Bright Star (Non-Camera): 665
Brillant (Voigtländer): 544
Brin's Patent Camera: 87
BRIOIS: 87
Briois Thompson's Revolver Camera: 87
Briskin 8: 606
BRISKIN MFG. CO. (Movie): 606
British (Chapman): 109
BRITISH FERROTYPE CO.: 87
British Ferrotype Telephot Button cam.: 87
Brooklyn Camera: 88
BROOKLYN CAMERA CO.: 88
Brooks Veriwide (Burleigh Brooks): 90
BROWN & BIGELOW (Non-Camera): 637
BROWNELL: 88
Brownell Stereo Camera: 88
Brownie (Original) (EKC): 148
Brownie (1900 type) (EKC): 148
Brownie (1980 type) (EKC): 148
Brownie 44A, 44B (EKC): 149
Brownie 127 (EKC): 149,150
Brownie Auto 27 (EKC): 150
Brownie box cameras (EKC): 148-149
Brownie Bull's-Eye (EKC): 150
Brownie Bullet,II (EKC): 151
Brownie Chiquita (EKC): 151
Brownie Cresta (EKC): 151
Brownie Cresta II,III (EKC): 151
Brownie Fiesta (EKC): 151
Brownie Flash (EKC): 151
Brownie Flash II (EKC): 151
Brownie Flash III (EKC): 152
Brownie Flash IV (EKC): 152
Brownie Flash 20 (EKC): 152
Brownie Flash B (EKC): 152
Brownie Flash Six-20 (EKC): 152
Brownie Flashmite 20 (EKC): 153
Brownie Fun Saver (EKC): 610
Brownie Hawkeye (EKC): 154
Brownie Holiday (EKC): 154
Brownie Junior 620 (EKC): 154
Brownie Model I (EKC): 154
Brownie Movie Camera (EKC): 610
Brownie Plianat Six-20 (EKC): 155
Brownie Portrait (EKC): 155
Brownie Reflex (EKC): 155
Brownie Reflex 20 (EKC): 155
Brownie Scout (Herbert George): 278
Brownie Six-20 (EKC): 156
Brownie Starflash (EKC): 157
Brownie Starflex (EKC): 157
Brownie Starlet (EKC): 157,158
Brownie Starluxe,II (EKC): 158
Brownie Starmatic (EKC): 158
Brownie Starmeter (EKC): 158
Brownie Starmite (EKC): 158
Brownie Super 27 (EKC): 158
Brownie Target Six-16, Six-20 (EKC): 159

Brownie Turret Movie Camera (EKC): 610
Brownie Twin 20 (EKC): 159
Brownie Vecta (EKC): 159
BRÜCKNER : 88
Brückner Field Camera: 88
Brückner Schueler-Apparat: 88
Brückner Union: 88
BRUMBERGER (Movie): 606
Brumberger 8mm-E3L, 8mm-T3L: 606
Brumberger 35: 88
BRUNS: 88
Bruns Detective camera: 88
Buccaneer (Universal): 531
Buckeye (American Camera Mfg.): 35
Buckeye (Anthony): 46
Buckeye (Cardinal): 104
Buckeye (EKC): 159
Buckeye Special (American Camera): 36
Buckles (Non-Camera Belt Buckles): 636
Buddie: 88
Buddy 8 Model 532A (Stewart-Warner): 627
Budweiser (Eiko): 209
Buena 35-S (Tougodo): 524
BUESS: 88
Buess Multiprint: 88
Bugs Bunny (Helm): 276
Buick: 89
BULL: 89
Bull Detective: 89
Bull's-Eye (Boston): 84
Bull's-Eye (EKC): 159
Bull's-Eye Special (EKC): 160
BULLARD CAMERA CO.: 89
Bullard Folding Magazine Camera: 89
Bullard Folding Plate Camera: 89
Bullet (EKC): 160
Bullet (plastic) (EKC): 160
Bullet New York World's Fair (EKC): 161
Bullet Special (EKC): 161
BULLY (Non-Camera): 663
Bunny (Vredeborch): 550
BURKE & JAMES: 89
Burke & James Cub: 89
Burke & James Folding Rexo: 89
Burke & James Grover: 89
Burke & James Ingento: 89
Burke & James No. 1A Folding Rexo: 89
Burke & James No. 1A Ingento Jr.: 89
Burke & James No. 1A Rexo Jr.: 89
Burke & James No. 2C Rexo Jr.: 89
Burke & James No. 3 Folding Rexo: 90
Burke & James No. 3 Rexo Jr.: 90
Burke & James No. 3A Folding Ingento: 89
Burke & James No. 3A Folding Rexo: 90
Burke & James No. 3A Ingento Jr.: 89
Burke & James PH-6-A: 89
Burke & James Panoram 120: 89
Burke & James Press: 90
Burke & James Press/View: 90
Burke & James Rembrandt Portrait: 89
Burke & James Rexo: 89
Burke & James Rexoette: 90
Burke & James Vest Pocket Rexo: 90
Burke & James Watson Press: 90
Burke & James Watson-Holmes Fingerprint Camera: 90

BURLEIGH BROOKS, INC.: 90
Burleigh Brooks Bee Bee: 90
Burleigh Brooks Veriwide: 90
BURR: 90
Burr Stereo camera: 90
Burr Wet plate camera: 90
BUSCH (Emil, London): 90
BUSCH (Emil, Rathenow): 91
BUSCH CAMERA CORP.: 91
Busch Folding plate camera: 91
Busch Freewheel: 90
Busch Pressman: 91
Busch Verascope F-40: 91
Busch Vier-Sechs: 91
Buster Brown (Ansco): 39
Buster Brown Junior (Ansco): 39
Buster Brown Special (Ansco): 39
Busy Bee (Seneca): 492
BUTCHER: 91-93
BUTCHER (Movie): 606
Butcher Cameo: 91
Butcher Cameo Stereo: 91
Butcher Carbine: 91
Butcher Clincher: 92
Butcher Dandy Automatic Camera: 92
Butcher Empire: 606
Butcher Klimax: 92
Butcher Little Nipper: 92
Butcher Maxim No. 1, No. 2, No. 4: 92
Butcher Midg: 92
Butcher Pilot No. 2: 92
Butcher Popular Pressman: 93
Butcher Primus No. 1: 93
Butcher Reflex Carbine: 93
Butcher Royal Mail Postage Stamp Camera: 93
Butcher Stereolette: 93
Butcher Watch Pocket Carbine: 93
Butcher Watch Pocket Klimax: 93
BUTLER: 94
BUTLER BROS.: 94
Butler Bros. Pennant Camera: 94
Butler Bros. Universal: 94
Butler Patent Three-Colour Separation Camera: 94
BUTTERFLY ORIGINALS (Non-Camera): 658
Button tintype camera (Mountford): 404
C Daylight Kodak (EKC): 163
C Ordinary Kodak (EKC): 182
Cabbage Patch Kids 110 Camera (Playtime Products): 450
Cabbage Patch Kids Figurine Stamper (Non-Camera): 658
Cabbage Patch Kids Musical Toy Camera (Non-Camera): 652
Cadet (Agfa): 24
Cadet (Ansco): 39
Cadet (I),II,III (Ansco): 39
Cadet (Coronet): 123
Cadet (Soho): 501
Cadet B-2 Texas Centennial (Agfa): 24
Cadet Flash (Ansco): 39
Cadet Reflex (Ansco): 39
CADOT: 94
Cadot Scenographe Panoramique: 94
Cady (Alsaphot): 33

CAILLON: 94
Caillon Bioscope: 94
Caillon Kaloscope: 94
Caillon Megascope: 94
Caillon Scopea: 94
Caleb (Demaria): 137
Calypso (Spirotechnique): 505
Cam-O (United States Cam-O): 529
CAM-O CORP.: 94
Cam-O Ident: 94
Cambinox (Möller): 400
Cambot Wonderful Slide Robot: 643
Cambridge (Marion): 372
Camel Model II (Tohokoken): 521
Camelot (S.J.C.): 500
Cameo (Butcher): 91
Cameo (Coronet): 123
Cameo (Houghton Ensign): 285
Cameo Stereo (Butcher): 91
Cameo Ultrix (Ihagee): 301
Camera: 94
Camera (Yen-Kame): 571
Camera Buckles (Non-Camera): 636
Camera-Cap Gun (Non-Camera): 643
Camera Charm (Non-Camera): 648
Camera City View (Seneca): 492
Camera Coaster Set (Non-Camera): 640
Camera Collectors Books: ADV
Camera Collectors Fairs: ADV
CAMERA CORP. of AMERICA (Chrislin): 111
CAMERA CORP. of AMERICA (Perfex): 95
CAMERA CORP. of AMERICA (Movie): 606
Camera Corp. Cine Perfex Double-Eight: 606
Camera Corp. Perfex Cee-Ay: 95
Camera Corp. Perfex DeLuxe: 96
Camera Corp. Perfex Fifty-Five: 95
Camera Corp. Perfex Forty-Four: 95
Camera Corp. Perfex One-O-One: 96
Camera Corp. Perfex One-O-Two: 96
Camera Corp. Perfex Speed Candid: 95
Camera Corp. Perfex Thirty-Three: 95
Camera Corp. Perfex Twenty-Two: 95
Camera-Eye Super Lighter BR-C3 (Non-Camera): 639
Camera-Flasks (Non-Camera): 645
Camera Kaleidoscope (Non-Camera): 668
Camera keychain (Non-Camera): 659
Camera Kit, Wonderful Camera (Multiple Toymakers): 404
Camera Kit sharpener (Non-Camera): 654
Camera-Lamp (Non-Camera): 650
Camera Laser Gun 3-in-1 (Non-Camera): 643
Camera-Lighter (Non-Camera): 637
Camera-Lite (Suzuki): 512
Camera-Lite Seastar (Suzuki): 512
CAMERA MAN, INC.: 96
Camera Man Champion: 96
Camera Man President: 96
Camera Man Silver King: 96
Camera Mask (Non-Camera): 650
Camera Note Box (Non-Camera): 642
Camera Obscura: 96
Camera pencil box (Non-Camera): 654
Camera Pistol (Non-Camera): 643

CAMERA PROJECTOR LTD. (Movie): 606
Camera Projector Midas: 606
Camera-Radio-Flashlight (Non-Camera): 657
Camera Repair: ADV
Camera Ring (Non-Camera): 648
Camera-Robot (Non-Camera): 644
Camera Salt & Pepper Shakers (Non-Camera): 659
Camera Scope (Non-Camera): 670
Camera-screwdriver-keychain (Non-Camera): 659
Camera Shooter NIKO Nikosound: 644
CameraShopper Magazine: ADV
Camera Soap-on-a-rope (Non-Camera): 659
Camera (Super Excella): 95
Camera-Viewer (Non-Camera): 670
Camera with Birdie (Non-Camera): 652
Cameradio (Universal Radio): 535
Cameragraph (Power): 625
CAMERAS LTD. (Movie): 607
Cameras Ltd. Dekko: 607
Camerette (Yen-Kame): 96, 571
Cameta: ADV
Camex Reflex 8 (Ercsam): 614
Camex Six (Mamiya): 368
Camflex (National): 409
CAMOJECT: 96
Camp Fire Girl's Kodak (EKC): 161
Camp out (Non-Camera): 667
Campbell, Bob: ADV
CAMPBELL (Movie): 607
Campbell Cello: 607
Campro: 607
Campro Cine Camera-Projector: 607
CAMPRO LTD. (Movie): 607
Camro 28 (Argus): 53
Can Camera 110 TX Coca-Cola (Tizer): 521
Can Cameras (Eiko): 209
Can-Tex (Bellcraft): 68
CANADIAN CAMERA CO.: 97
Canadian Camera Co. Glenco: 97
Candex Jr. (General Products): 247
CANDID CAMERA CORP. OF AMERICA (Camera Corp. of America): 95
CANDID CAMERA SUPPLY CO.: 97
Candid Camera Supply Minifoto Junior: 97
Candid Camera Target Shot: 645
Candid Flash Camera (Flash Camera): 232
Candid Shot (Non-Camera): 645
CANDLE (Non-Camera): 636
CANDY & GUM (Non-Camera): 636
Canon 1950: 100
Canon IIA: 100
Canon IIAF: 100
Canon IIB: 100
Canon IIC: 100
Canon IID: 100
Canon IID1: 100
Canon IID2: 100
Canon IIF: 100
Canon IIF2: 100
Canon III: 101
Canon IIIA: 101
Canon IIIA Signal Corps.: 101
Canon IIS: 101
Canon IIS2: 101

Certoruhm (Certo): 106
Certosport (Certo): 106
Certotix (Certo): 106
Certotrop (Certo): 106
CHADWICK: 109
Chadwick Hand Camera: 109
CHADWICK-MILLER: 109
Chadwick-Miller Fun-Face Camera: 109
Chadwick Stereo Camera: 109
Chaika II (Mashpriborintorg): 373
Challenge (Adams & Co.): 18
Challenge (Lizars): 361
Challenge Dayspool (Lizars): 361
Challenge Dayspool No. 1 (Lizars): 361
Challenge Dayspool Stereoscopic
 Tropical (Lizars): 361
Challenge Dayspool Tropical (Lizars): 361
Challenge Junior Dayspool (Lizars): 361
Challenge Magazine Camera (Lizars): 361
Challenge Stereo (Lizars): 361
Challenger (S.E.M.): 491
Challenger (Wittnauer): 565
Chambre Automatique (Bertsch): 73
Champagne glass (Non-Camera): 647
Champion (Anthony): 46
Champion (Camera Man): 96
Champion II: 109
Change-A-Toy (Non-Camera): 644
CHAPMAN: 109
Chapman The British: 109
Chapman Millers Patent Detective: 109
Chapman Stereoscopic Field camera: 109
Charlie Tuna (Whitehouse): 560
Charm (Non-Camera): 648
Charmy: 109
CHARTERKING (Non-Camera): 660
Chase: 109
Chase Magazine Camera: 109
CHASE MAGAZINE CAMERA CO.: 109
Chatter-Pal (Non-Camera): 666
Chatterton, Leica Specialist: ADV
Chautauqua (Seneca): 492
Cheese dish (Non-Camera): 647
Chevron (EKC): 161
Chic (Taron): 516
CHICAGO CAMERA CO.: 110
Chicago Camera Co. Photake: 110
CHICAGO FERROTYPE CO.: 110
Chicago Ferrotype Mandel: 110
Chicago Ferrotype Mandelette: 110
Chicago Ferrotype PDQ Street camera: 110
Chicago Ferrotype Wonder Automatic
 Cannon: 110
Chief (Agfa): 25
Chief 1A (Seneca): 492
CHIEN HSIN PLASTIC FAC. CO. LTD.
 (Non-Camera): 643
CHILD GUIDANCE PLAYTHINGS INC.
 (Non-Camera): 670
CHILD GUIDANCE PRODUCTS INC.: 110
Child Guidance Mick-A-Matic: 110
CHIYODA KOGAKU SEIKO CO. LTD.: 111
Chiyoda Konan-16: 111
CHIYODA SHOKAI: 111
Chiyoca 35 (Chiyoda): 111
Chiyoca 35-IF (Chiyoda): 111
Chiyoca IIF (Chiyoda): 111

Chiyoca IIIF (Chiyoda): 111
Chiyoko (Chiyoda): 111
CHIYOTAX CAMERA CO.: 111
Chocolate Camera (Non-Camera): 636
Chrislin Insta Camera: 111
CHRISLIN PHOTO INDUSTRY: 111
Christies Camera Auction: ADV
CHRONIK BROS. MFG. (Movie): 608
Chronik 35mm Motion Picture camera: 608
CHUO PHOTO SUPPLY: 111
Chuo Photo Supply Harmony: 111
Churchie's Official Spy Camera: 111
Churchill (Monarch): 401
Cia Stereo: 111
CIGARETTE LIGHTERS (Non-Camera): 637
CIMA: 111
Cima Luxette, Luxette S: 111
CINCINNATI CLOCK & INSTRUMENT
 (Movie): 608
Cincinnati Clock Cinklox Model 3-S: 608
Cine Ansco: 602
Cine Camera #2709 (Bell & Howell): 603
Cine Cameras Wanted: ADV
Cine-Geyer AK26 (Geyer): 616
Cine-Kodak (EKC): 610
Cine Kodak 8 (EKC): 612
Cine-Kodak Magazine 8 (EKC): 612
Cine-Kodak Magazine 16 (EKC): 612
Cine-Kodak Model A (EKC): 610
Cine-Kodak Model B (EKC): 611
Cine Kodak Model BB (EKC): 611
Cine Kodak Model BB Junior (EKC): 611
Cine Kodak Model E (EKC): 611
Cine Kodak Model K (EKC): 611
Cine Kodak Model K-100 (EKC): 611
Cine Kodak Model M (EKC): 611
Cine Kodak Reliant (EKC): 612
Cine Kodak Royal (EKC): 612
Cine-Kodak Special, Special II (EKC): 612
Cine Nizo 8E Model A, B, C (Nizo): 621
Cine Nizo 9-½ Model A, F, M (Nizo): 621
Cine Nizo 16B, 16L (Nizo): 622
Cine Perfex (Camera Corp.): 606
Cinemax 85E (Uriu): 629
Cinephonic Eight (Fairchild): 615
Cinephonic Projector (Fairchild): 616
Cinescopie: 111
Cinetone Projector (DeVry): 609
Cinex (Cardinal): 104
Cinex (Imperial): 303
Cinex (Spartus): 503
Cinex Candid Camera (Craftsman): 126
Cinex Candid Camera (King): 314
Cinex Deluxe: 112
Cinklox Model 3-S (Cincinnati Clock): 608
Cinoscope (Industrial Syndicate): 617
Cipiere Paperweight (Non-Camera): 654
Cirkut Camera (EKC): 162
Cirkut Cameras Wanted: ADV
Cirkut Outfits (EKC): 162
Ciro 35 (Ciro): 112
Ciro 35 (Graflex): 267
CIRO CAMERAS, INC.: 112
Ciroflex: 112
Citation (DeJur-Amsco): 609
Citoklapp (Rodenstock): 473
Citonette (Rodenstock): 473

Companion (Mason): 375
Companion (Mayfield): 376
Companion Reflex (Kuh): 325
Companion 8 (Stewart-Warner): 627
Compass Camera: 115
COMPASS CAMERAS LTD.: 115
Compco Miraflex: 115
Compco Reflex: 115
Compendica: 608
Competitor View (Seneca): 492
Competitor View, Stereo (Seneca): 492
COMWISE INDUSTRY (Non-Camera): 643
CONCAVA S.A.: 115
Concava Tessina: 115
Concealed Vest Camera #1,2 (Stirn): 509
Condor (Neumann): 411
Condor I (Galileo): 244
Condor I,Ic (Ferrania): 228
Condor Junior (Ferrania): 228
Cone Pocket Kodak (EKC): 163
Conica Bank (Non-Camera): 635
CONLEY: 116-118
CONLEY CAMERA CO.: 116-118
Conley Folding plate camera: 116
Conley Folding rollfilm camera: 116
Conley Junior: 116
Conley Kewpie: 116
Conley Long Focus Revolving Back: 117
Conley Magazine Camera: 117
Conley No. 2, No. 2A, No. 2C Kewpie: 116
Conley No. 3, No. 3A Kewpie: 116
Conley Panoramic Camera: 117
Conley Shamrock Folding: 117
Conley Snap No. 2: 117
Conley Stereo box camera: 117
Conley Stereo Magazine camera: 117
Conley Stereoscopic Professional: 117
Conley Truphoto: 118
Conley View: 116
Consul (Coronet): 123
Consul (Pentacon): 438
Cont-Lite Table Lighter (Non-Camera): 637
Contaflex (860/24) (Zeiss): 577
Contaflex TLR lenses (Zeiss): 577
Contaflex I (Zeiss): 577
Contaflex II (Zeiss): 577
Contaflex III (Zeiss): 577
Contaflex IV (Zeiss): 577
Contaflex 126 (Zeiss): 578
Contaflex Alpha (Zeiss): 577
Contaflex Beta (Zeiss): 577
Contaflex Prima (Zeiss): 578
Contaflex Rapid (Zeiss): 578
Contaflex S Automatic (Zeiss): 578
Contaflex SLR lenses (Zeiss): 578
Contaflex Super (Zeiss): 578
Contaflex Super B (Zeiss): 578
Contaflex Super BC (Zeiss): 578
CONTAINERS (Non-Camera): 642
Contarex "Bullseye" (Zeiss): 579
Contarex Electronic (Zeiss): 579
Contarex Hologon (Zeiss): 579
Contarex lenses (Zeiss): 579
Contarex Microscope (Zeiss): 579
Contarex Professional (Zeiss): 579
Contarex Special (Zeiss): 579
Contarex Super (Zeiss): 579

Contax (Zeiss): 580
Contax I (Zeiss): 580
Contax II (Zeiss): 580
Contax IIa (Zeiss): 581
Contax III (Zeiss): 581
Contax IIIa (Zeiss): 581
Contax D (Pentacon): 438
Contax D (Zeiss): 581
Contax E (Pentacon): 438
Contax F (Pentacon): 438
Contax F (Zeiss): 581
Contax FB (Pentacon): 438,439
Contax FM (Pentacon): 438,439
Contax lenses (Zeiss): 581
Contax "No-Name" (Zeiss): 581
Contax S (Pentacon): 438,439
CONTESSA: 118-121
Contessa (Drexler): 139
Contessa-35 (Zeiss): 582
Contessa Adoro: 118
Contessa Alino: 118
Contessa Altura: 118
Contessa Argus: 118
Contessa Citoskop Stereo: 118
Contessa Cocarette: 118
Contessa Deckrullo: 119
Contessa Deckrullo-Nettel: 119
Contessa Deckrullo-Nettel Stereo: 119
Contessa Deckrullo Stereo: 119
Contessa Donata: 119
Contessa Duchessa: 119
Contessa Duchessa Stereo: 119
Contessa Duroll: 119
Contessa Ergo: 119
Contessa LBE (Zeiss): 582
Contessa LK (Zeiss): 582
Contessa LKE (Zeiss): 582
Contessa Miroflex: 119
CONTESSA-NETTEL: 118-121
Contessa Nettix: 120
Contessa Onito: 120
Contessa Piccolette: 120
Contessa Piccolette Luxus: 120
Contessa Pixie: 120
Contessa Recto: 120
Contessa S-310 (Zeiss): 582
Contessa S-312 (Zeiss): 582
Contessa Sonnet: 120
Contessa Stereax: 120
Contessa Steroco: 121
Contessa Suevia: 121
Contessa Taxo: 121
Contessa Tessco: 121
Contessa Tropical Adoro: 118
Contessa Tropical plate cameras: 121
Contessamat (Zeiss): 582
Contessamat SBE (Zeiss): 582
Contessamat SE (Zeiss): 582
Contessamat STE (Zeiss): 582
Contessamatic (Zeiss): 582
Contessamatic E (Zeiss): 582
Contina (Zeiss): 583
Contina I (522/24) (Zeiss): 583
Contina Ia (526/24) (Zeiss): 583
Contina Ic (526/24) (Zeiss): 583
Contina II (Zeiss): 583
Contina IIa (Zeiss): 583

DELTAH CORPORATION: 136
Deltah Unifocus: 136
Deltex (Imperial): 303
De Luxe (Adams & Co.): 18
Deluxe (Newman & Guardia): 411
Deluxe Hollywood (Stewart-Warner): 628
DELUXE PRODUCTS CO.: 136
Deluxe Products Delco 828: 136
Deluxe Products Remington: 136
DELUXE READING CORP.: 136
Deluxe Reading Secret Sam Attache
 Case: 136
Deluxe Reading Secret Sam's Spy
 Dictionary: 137
Deluxe Reflex (Houghton Ensign): 287
Deluxe Six-Twenty Twin Lens Reflex
 (Imperial): 303
DEMARIA: 137
Demaria Caleb: 137
Demaria Dehel: 137
Demaria Field camera: 137
Demaria Folding Plate Camera: 137
Demaria Jumelle Capsa: 137
Demi (Canon): 103
Demon Detective (American Camera): 35
Derby (Foth): 233
Derby (Gallus): 244
Derby-Lux (Gallus): 244
Derlux (Gallus): 245
DEROGY: 137
Derogy Field, plate cameras: 137
Derogy Single lens stereo: 137
Designer Radio-Light-Mirror
 (Non-Camera): 657
DESTECH: 137
Destech Clickit Sports: 137
Detective Camera (Bischoff): 76
Detective Camera (Dossert): 139
Detective Camera (Lamperti): 340
Detective Camera (Smith): 500
Detective Camera (Watson): 553
Detective Cameras: 138
Detrola 400: 138
Detrola A: 138
Detrola B: 138
DETROLA CORP.: 138
Detrola D: 138
Detrola E: 138
Detrola G, GW: 138
Detrola H, HW: 138
Detrola K, KW: 138
DEVIN COLORGRAPH CO.: 138
Devin Tri-Color Camera: 138
DEVRY CORP. (Movie): 609
DeVry 16mm: 609
DeVry 16mm Deluxe: 609
DeVry Cinetone Projector: 609
DeVry Home Movie Camera: 609
DeVry Portable Movie Projector: 610
DeVry QRS-DeVry Home Movie cam.: 609
DeVry Standard: 609
DeVry Type ESF Projector: 610
Devus: 138
DEYROLLE: 138
Deyrolle Scenographe: 138
Dial 35 (Bell & Howell): 67
Dial 35 (Canon): 104

Diamant: 139
Diamond Gun Ferrotype (Int'l Metal): 305
Diamond Jr.: 139
Diana: 139
Diana (Mozar): 404
Diana (Welta): 554
Diana Deluxe: 139
Diana Squirt camera (Non-Camera): 662
Diax (Voss): 549
Diaxette (Voss): 550
Dice Cup (Non-Camera): 657
Dick Tracy (Laurie): 343
Dick Tracy (Seymore): 494
Dick Tracy (Seymour): 494
Dick Tracy Squirt Gun (Non-Camera): 661
Digna (Dacora): 129
Dignette (Dacora): 129
DILK (Movie): 610
Dilk-Fa (Dilk): 610
Dionne F2: 139
Diplomat: 139
Direct Positive Camera (Glossick): 250
Direct Positive Camera (Mourfield): 404
Direct Positive Camera (Thompson): 517
Direct Positive Camera (Wabash): 551
DISHES (Non-Camera): 647
Dispatch Detective (London Stereo.): 363
DITMAR (Movie): 610
Ditmar 9.5mm: 610
Ditto 99 (Finetta): 231
Diva (Phoba): 442
Dog Camera (Kiddie Camera): 313
Dolca 35 (Tokyo Koken): 523
Dollar Box (Ansco): 40
Dollina cameras (Certo): 107
Dolly 3x4 (Certo): 108
De Fotograf (Non-Camera): 653
Dolly Vest-Pocket (Certo): 107, 108
Dolphin with Camera (Non-Camera): 654
Dominant (King): 314
Donald Duck (Toy's Clan): 527
Donald Duck (Herbert George): 277
Donata (Contessa): 119
Donata (Zeiss): 583
DONRUSS CO. (Non-Camera): 636
Doppel-Box (Balda): 60
Doppel Box (Certo): 108
Dories: 139
Doris (Tokyo Seiki): 523
DORYU CAMERA CO.: 139
Doryu 2-16: 139
Dossert Detective Camera: 139
DOSSERT DETECTIVE CAMERA CO.: 139
Double-8 (Houghton Ensign): 285
Double Run Eight (Sportster) (Bell &
 Howell): 605
Double Shutter Camera (Ernemann): 214
DOVER FILM CORP.: 139
Dover 620 A: 139
Dralowid Reporter 8: 610
DRALOWID-WERK (Movie): 610
Drepy (Pierrat): 445
DREXEL CAMERA CO.: 139
Drexel Jr. Miniature: 139
DREXELER & NAGEL: 139
Drexler Contessa: 139
DRGM: 140

Drinking glass (Non-Camera Muppet glass): 647
DRP: 140
DRUCKER: 140
Drucker Ranger: 140
Druh (WZFO): 567
DRUOPTA: 140
Druoflex I (Druopta): 140
Druopta Druoflex I: 140
Druopta Stereo: 140
Druopta Vega II, III: 140
DU ALL (Non-Camera): 670
Duaflex (EKC): 163
Dual Reflex (Irwin): 305
Dubla (Welta): 554
DUBRONI: 140
Dubroni Wet-plate Tailboard camera: 141
Duca (Durst): 141
DUCATI: 141
Duchess: 141
Duchessa (Contessa): 119
Duchessa (Zeiss): 583
Duchessa Stereo (Contessa): 119
Duex (EKC): 164
DUERDEN: 141
Duerden Field camera: 141
DUFA: 141
Dufa Pionyr: 141
Duflex (Gamma): 246
Duo (Seneca shutter): 492
Duo Flash: 141
Duo Six-20 (EKC): 164
Duo Six-20 Series II (EKC): 164
Duovex (Universal): 532
Duplex (Ihagee): 298
Duplex 120 (Iso): 306
Duplex Novelette (Anthony): 47
Duplex Ruby Reflex (Thornton-Pickard): 518
Duplex Ruby Reflex, Tropical (Thornton-Pickard): 518
Durata (Certo): 108
DURHAM INDUSTRIES (Non-Camera): 653
Duroll (Contessa): 119
Duroll (Zeiss): 584
DURST S.A.: 141
Durst 66: 141
Durst Automatica: 141
Durst Duca: 141
Durst Gil: 142
DVPCA Lapel Pin (Non-Camera Krugener Delta-Car): 648
Dynamatic,II (Voigtländer): 544
Dynamic 12 (Coronet): 124
DZERZHINSKY COMMUNE (Fed): 226
Eagle Eye (Pho-Tak): 442
Eagle View 88 Camera (Non-Camera): 671
Eaglet (Fototecnica): 236
EARL PRODUCTS CO.: 142
Earl Scenex: 142
EARTH K.K.: 142
Earth Guzzi: 142
EAST ASIA (Non-Camera): 657
EASTERN SPECIALTY MFG. CO.: 142
Eastern Specialty Springfield Union: 142
EASTMAN DRY PLATE & FILM CO.: 142
EASTMAN KODAK CO.: 142-206, Movie: 610, Non-Camera: 635,657,667

EKC A Daylight Kodak: 163
EKC A Ordinary Kodak: 182
EKC Anniversary Kodak: 144
EKC Auto Colorsnap 35: 144
EKC Autographic Kodak: 144
EKC Autographic Kodak Junior: 145
EKC Autographic Kodak Special: 145
EKC Automatic 35: 145
EKC Automatic 35B: 146
EKC Automatic 35F: 146
EKC Automatic 35R4: 146
EKC Autosnap: 146
EKC B Daylight Kodak: 163
EKC B Ordinary Kodak: 182
EKC Baby Brownie: 150
EKC Baby Brownie New York World's Fair Model: 150
EKC Baby Brownie Special: 150
EKC Baby Hawk-Eye: 172
EKC Bantam: 146
EKC Bantam Colorsnap: 147
EKC Bantam f4.5: 146
EKC Bantam f4.5 Military Model: 146
EKC Bantam f5.6: 146
EKC Bantam f6.3: 146
EKC Bantam f8: 146
EKC Bantam RF: 147
EKC Bantam Special: 147
EKC Beau Brownie: 150
EKC Boy Scout Brownie: 148
EKC Boy Scout Kodak: 148
EKC Brownie: 148
EKC Brownie (Original): 148
EKC Brownie (1900 type): 148
EKC Brownie (1980 type): 148
EKC Brownie 44A, 44B: 149
EKC Brownie 127: 149,150
EKC Brownie Auto 27: 150
EKC Brownie Bull's-Eye: 150
EKC Brownie Bullet,II: 151
EKC Brownie Chiquita: 151
EKC Brownie Cresta,II,III: 151
EKC Brownie Fiesta: 151
EKC Brownie Flash: 151
EKC Brownie Flash II: 151
EKC Brownie Flash III: 152
EKC Brownie Flash IV: 152
EKC Brownie Flash 20: 152
EKC Brownie Flash B: 152
EKC Brownie Flash Six-20: 152
EKC Brownie Flashmite 20: 153
EKC Brownie Fun Saver: 610
EKC Brownie Hawkeye: 154
EKC Brownie Holiday: 154
EKC Brownie Junior 620: 154
EKC Brownie Model I: 154
EKC Brownie Pliant Six-20: 155
EKC Brownie Movie Camera: 610
EKC Brownie Portrait: 155
EKC Brownie Reflex: 155
EKC Brownie Reflex 20: 155
EKC Brownie Six-20: 156
EKC Brownie Starflash: 157
EKC Brownie Starflex: 157
EKC Brownie Starlet: 157, 158
EKC Brownie Starluxe,II: 158
EKC Brownie Starmatic: 158

EKC Brownie Starmeter: 158
EKC Brownie Starmite: 158
EKC Brownie Super 27: 158
EKC Brownie Target Six-16, Six-20: 159
EKC Brownie Turret Movie Camera: 610
EKC Brownie Twin 20: 159
EKC Brownie Vecta: 159
EKC Buckeye: 159
EKC Bull's-Eye: 159
EKC Bull's-Eye Special: 160
EKC Bullet: 160
EKC Bullet New York World's Fair: 161
EKC Bullet Special: 161
EKC C Daylight Kodak: 163
EKC C Ordinary Kodak: 182
EKC Camp Fire Girl's Kodak: 161
EKC Cartridge Hawk-Eye: 172
EKC Cartridge Kodak: 161
EKC Cartridge Premo: 185
EKC Century of Progress: 161
EKC Chevron: 161
EKC Cine-Kodak: 610
EKC Cine Kodak 8: 612
EKC Cine-Kodak Magazine 8: 612
EKC Cine-Kodak Magazine 16: 612
EKC Cine-Kodak Model A: 610
EKC Cine-Kodak Model B: 611
EKC Cine Kodak Model BB: 611
EKC Cine Kodak Model BB Junior: 611
EKC Cine Kodak Model E: 611
EKC Cine Kodak Model K: 611
EKC Cine Kodak Model K-100: 611
EKC Cine Kodak Model M: 611
EKC Cine Kodak Reliant: 612
EKC Cine Kodak Royal: 612
EKC Cine-Kodak Special, Special II: 612
EKC Cirkut Cameras, Outfits: 162
EKC Coke Happy Times: 171
EKC Colorburst: 162
EKC Colorsnap 35: 163
EKC Cone Pocket Kodak: 163
EKC Coquette: 163
EKC Daylight Kodak: 163
EKC Duaflex: 163
EKC Duex: 164
EKC Duo Six-20: 164
EKC Duo Six-20 Series II: 164
EKC Eastman Plate Camera: 164
EKC Ektra: 164
EKC Ektra 1: 165
EKC Ektra 2: 165
EKC Ektra II: 165
EKC Ektra 200: 165
EKC Ektra 250: 165
EKC Empire State: 165
EKC Eureka: 166
EKC Falcon: 166
EKC Fiesta Instant Camera: 166
EKC Fiftieth Anniversay (Anniversary
 Kodak Camera): 144
EKC Film Pack Hawk-Eye: 173
EKC Film Premo: 132
EKC Filmplate Premo: 186
EKC Filmplate Premo Special: 186
EKC Fisher Price Camera: 166
EKC Flash Bantam: 148
EKC Flat Folding Kodak: 166

EKC Flexo Kodak: 167
EKC Fling 35: 167
EKC Flush Back Kodak: 167
EKC Folding Autographic Brownie: 153
EKC Folding Brownie: 153
EKC Folding Brownie Six-20: 154
EKC Folding Cartridge Hawk-Eye: 173
EKC Folding Cartridge Premo: 187
EKC Folding Film Pack Hawk-Eye: 173
EKC Folding Hawk-Eye: 173
EKC Folding Hawk-Eye Special: 173
EKC Folding Kodak: 167
EKC Folding Pocket Brownie: 154
EKC Folding Pocket Kodak: 168-170
EKC Folding Rainbow Hawk-Eye: 174
EKC Folding Rainbow Hawk-Eye Special:
 174
EKC Genesee Outfit: 171
EKC George Washington Bicentennial
 Camera: 171
EKC Gift Kodak: 171
EKC Girl Guide Kodak: 171
EKC Girl Scout Kodak: 171
EKC Handle, Handle 2: 171
EKC Happy Times Instant Camera: 171
EKC Hawk-Eye: 172
EKC Hawk-Eye Nos. 2, 2A: 172
EKC Hawkeye Ace: 172
EKC Hawkeye Ace Deluxe: 172
EKC Hawk-Eye Baby: 172
EKC Hawk-Eye Flashfun, II: 173
EKC Hawkeye Model BB: 173
EKC Hawk-Eye Special: 174
EKC Hawkette: 172
EKC Instamatic: 175-176
EKC Instamatic Reflex: 175
EKC Instamatic S-10, S-20: 176
EKC Instant Cameras: 176
EKC Jiffy Kodak: 176
EKC Jiffy Kodak Six-16, Six-20: 176
EKC Jiffy Kodak Vest Pocket: 177
EKC Kodak (original): 142
EKC Kodak 35: 179
EKC Kodak 35 (Military PH-324): 179
EKC Kodak 35 w/ Rangefinder: 179
EKC Kodak 66 Model III: 179
EKC Kodak A Modele 11: 177
EKC Kodak Box 620, 620C: 177
EKC Kodak Enlarger 16mm: 177
EKC Kodak Cine Automatic: 612
EKC Kodak Cine Scopemeter: 612
EKC Kodak Ektra: 164
EKC Kodak Ektra 1: 165
EKC Kodak Ektra 2: 165
EKC Kodak Ektra II: 165
EKC Kodak Ektra 200: 165
EKC Kodak Ektra 250: 165
EKC Kodak Electric 8 Automatic: 612
EKC Kodak Ensemble: 165
EKC Kodak Escort 8: 612
EKC Kodak Junior,I,II: 177
EKC Kodak Junior Six-16: 177
EKC Kodak Junior Six-16 Series II: 177
EKC Kodak Junior Six-16 Series III: 178
EKC Kodak Junior Six-20: 177, 178
EKC Kodak Junior Six-20 Series II: 177
EKC Kodak Junior Six-20 Series III: 178

EKC Kodak Medalist, II: 180
EKC Kodak Monitor Six-16, Six-20: 180
EKC Kodak Recomar 18, 33: 190
EKC Kodak Reflex, IA, II: 178
EKC Kodak Senior Six-16, Six-20: 198
EKC Kodak Series II: 178
EKC Kodak Series III: 178
EKC Kodak Six-16, Six-20: 199
EKC Kodak Special Six-16, Six-20: 200
EKC Kodak Sport Special: 201
EKC Kodak Startech: 201
EKC Kodak Stereo (35mm): 201
EKC Kodak Suprema: 202
EKC Kodak Tele-Ektra: 202
EKC Kodak Tele-Instamatic: 202
EKC Kodak Tourist, II: 202
EKC Kodak Trimlite Instamatic: 202
EKC Kodak Winner: 205
EKC Kodak Winner, 1988 Olympics: 206
EKC Kodak Zoom 8 Reflex: 613
EKC Kodascope, A,B,C: 613
EKC Kodascope Eight: 613
EKC Kodet: 179
EKC Library Kodascope: 613
EKC Magazine Cine-Kodak: 612
EKC Magazine Cine-Kodak Eight: 612
EKC Matchbox: 180
EKC Medalist, II: 180
EKC Monitor Six-16, Six-20: 180
EKC Motormatic 35: 180-181
EKC Motormatic 35F: 181
EKC Motormatic 35R4: 181
EKC Nagel: 181
EKC New York World's Fair Baby
 Brownie: 150
EKC New York World's Fair Bullet: 161
EKC No. 0 Brownie: 149
EKC No. 0 Folding Pocket Kodak: 169
EKC No. 0 Premo Junior: 187
EKC No. 00 Cartridge Premo: 185
EKC No. 1 Autographic Kodak Junior: 145
EKC No. 1 Autographic Kodak Special: 145
EKC No. 1 Brownie: 149
EKC No. 1 Cone Pocket Kodak: 163
EKC No. 1 Film Premo: 186
EKC No. 1 Folding Pocket Kodak: 169
EKC No. 1 Kodak: 143
EKC No. 1 Kodak Junior: 177
EKC No. 1 Kodak Series III: 178
EKC No. 1 Panoram Kodak: 182
EKC No. 1 Pocket Kodak: 183
EKC No. 1 Pocket Kodak Junior: 184
EKC No. 1 Pocket Kodak Series II: 184
EKC No. 1 Pocket Kodak Special: 184
EKC No. 1 Premo Junior: 187
EKC No. 1 Premoette: 188
EKC No. 1 Premoette Junior: 189
EKC No. 1 Premoette Junior Special: 189
EKC No. 1 Premoette Special: 189
EKC No. 1A Autographic Kodak: 144
EKC No. 1A Autographic Kodak Junior: 145
EKC No. 1A Autographic Kodak Special:
 145
EKC No. 1A Folding Hawk-Eye: 173
EKC No. 1A Folding Pocket Kodak: 169
EKC No. 1A Folding Pocket Kodak Special:
 169

EKC No. 1A Gift Kodak: 171
EKC No. 1A Kodak Junior: 177
EKC No. 1A Kodak Series III: 178
EKC No. 1A Pocket Kodak: 183
EKC No. 1A Pocket Kodak Junior: 184
EKC No. 1A Pocket Kodak Series II: 184
EKC No. 1A Pocket Kodak Special: 184
EKC No. 1A Premo Junior: 187
EKC No. 1A Premoette: 188
EKC No. 1A Premoette Junior: 189
EKC No. 1A Premoette Junior Special: 189
EKC No. 1A Premoette Special: 189
EKC No. 1A Special Kodak: 200
EKC No. 1A Speed Kodak: 200
EKC No. 2 Brownie: 149
EKC No. 2 Bull's-Eye: 159
EKC No. 2 Bull's-Eye Special: 160
EKC No. 2 Bullet: 160
EKC No. 2 Bullet Special: 161
EKC No. 2 Cartridge Hawk-Eye: 172
EKC No. 2 Cartridge Premo: 186
EKC No. 2 Eureka: 166
EKC No. 2 Eureka Jr.: 166
EKC No. 2 Falcon: 166
EKC No. 2 Falcon Improved Model: 166
EKC No. 2 Film Pack Hawk-Eye: 173
EKC No. 2 Flexo Kodak: 167
EKC No. 2 Folding Autographic Brownie:
 153
EKC No. 2 Folding Brownie: 153
EKC No. 2 Folding Bull's-Eye: 160
EKC No. 2 Folding Cartridge Hawk-Eye:
 173
EKC No. 2 Folding Cartridge Premo: 187
EKC No. 2 Folding Film Pack Hawk-Eye:
 173
EKC No. 2 Folding Hawk-Eye Special: 173
EKC No. 2 Folding Pocket Brownie: 154
EKC No. 2 Folding Pocket Kodak: 169
EKC No. 2 Folding Rainbow Hawk-Eye: 174
EKC No. 2 Folding Rainbow Hawk-Eye
 Special: 174
EKC No. 2 Hawk-Eye: 172
EKC No. 2 Hawk-Eye Special: 174
EKC No. 2 Hawkette: 172
EKC No. 2 Kodak: 143
EKC No. 2 Rainbow Hawk-Eye: 174
EKC No. 2 Stereo Brownie: 158
EKC No. 2 Stereo Kodak: 201
EKC No. 2 Target Hawk-Eye: 174
EKC No. 2 Target Hawk-Eye Junior: 174
EKC No. 2 Weno Hawk-Eye: 174
EKC No. 2A Brownie: 149
EKC No. 2A Cartridge Hawk-Eye: 172
EKC No. 2A Cartridge Premo: 186
EKC No. 2A Film Pack Hawk-Eye: 173
EKC No. 2A Folding Autographic Brownie:
 153
EKC No. 2A Folding Cartridge Hawk-Eye:
 173
EKC No. 2A Folding Cartridge Premo: 187
EKC No. 2A Folding Hawk-Eye Special: 173
EKC No. 2A Folding Pocket Brownie: 154
EKC No. 2A Folding Rainbow Hawk-Eye:
 174
EKC No. 2A Folding Rainbow Hawk-Eye
 Special: 174

713

Eclipse (Horsman): 283
Eclipse (Shew): 495
Eclipse 120: 206
EDBAR INTERNATIONAL CORP.: 206
Edbar V.P. Twin: 206
Edelweiss (Zenith): 598
Edelweiss Deluxe (Ise): 305
Eder-Patent Camera: 207
Edina (Wirgin): 562
Edinex, Edinex 120 (Wirgin): 562
EDISON (Movie): 613
Edison Home Kinetoscope: 613
Edison Kinetoscope: 613
Edison Projecting Kinetoscope: 613
Edith II (Beier): 65
Edixa, Edixa II (Wirgin): 562
Edixa 16 (Wirgin): 562
Edixa 16M (Wirgin): 562
Edixa 16MB (Wirgin): 562
Edixa 16S (Wirgin): 562
Edixa Electronica (Wirgin): 562
Edixa Flex B (Wirgin): 562
Edixa-Mat B, BL (Wirgin): 562
Edixa-Mat C, CL (Wirgin): 563
Edixa-Mat D, DL (Wirgin): 563
Edixa Prismaflex (Wirgin): 563
Edixa Reflex, B, C, D (Wirgin): 563
Edixa Stereo (Wirgin): 563
Edixa Stereo II, IIa (Wirgin): 563
Edixa Stereo III, IIIa (Wirgin): 563
Edixaflex (Wirgin): 563
Efbe: 207
E.F.I.C.A. S.R.L.: 207
E.F.I.C.A. S.R.L. Splendor 120: 207
EFS Camp out (Non-Camera): 667
Egfecolor 400 pencil sharpener
 (Non-Camera): 655
Ehira Astoria Super-6 IIIB: 207
EHIRA CAMERA WORKS: 207
Ehira Chrome Six: 207
EHIRA K.S.K.: 207
Ehira-Six: 207
Ehira Weha Chrome Six: 207
Ehira Weha Light: 207
EHO-ALTISSA: 208
Eho-Altissa Altiflex: 208
Eho-Altissa Altiscop: 208
Eho-Altissa Altissa: 208
Eho-Altissa Altissa II: 208
Eho-Altissa Altix (pre-war): 208
Eho-Altissa Altix I, II, IV: 208
Eho-Altissa Altix-N: 209
Eho-Altissa Altix NB: 209
Eho-Altissa Eho Baby Box: 209
Eho-Altissa Eho Box: 209
Eho-Altissa Eho Stereo Box: 209
Eho-Altissa Juwel: 209
Eho-Altissa Mantel-Box 2: 209
Eho-Altissa Super Altissa: 209
Eho Baby Box (Eho-Altissa): 209
Eho Box (Eho-Altissa): 209
EHO KAMERAFABRIK (Eho-Altissa): 208
Eho Stereo Box (Eho-Altissa): 209
Eight-20 Penguin (Kershaw): 312
Eiko Aerogard: 209
Eiko Budweiser: 209
Eiko Can Cameras: 209

EIKO CO. LTD.: 209
Eiko Coca-Cola: 209
Eiko Formel-I: 209
Eiko Gent Coffee: 209
Eiko Mickey Mouse: 209
Eiko Panda: 209
Eiko Pepsi-Cola: 209
Eiko Popular: 209
Eiko 7-up: 209
Eiko Snoopy: 209
Ejot (Johnson): 307
Eka (Krauss): 322
Ektra (EKC): 164
Ektra 1 (EKC): 165
Ektra 2 (EKC): 165
Ektra II (EKC): 165
Ektra 200 (EKC): 165
Ektra 250 (EKC): 165
Elbaflex VX1000 (Ihagee): 298
E.L.C.: 209
E.L.C. l'As: 209
Elca, Elca II (Elop): 210
Electric Eye 127 (Bell & Howell): 67
Electro Shot (Minolta): 390
Electronic: 209
Electus (Krugener): 324
Elega-35 (Nitto): 420
Elegant (Ica): 293
Elegante (Zeiss): 584
Elettra I (Sirio): 499
Elettra II (Sirio): 500
Elf (Spiegel): 505
Elgin: 209
ELGIN LABORATORIES: 209
Elgin Miniature: 210
Elioflex (Ferrania): 228
Elite: 210
Elite (Merkel): 378
Elite (Wünsche): 566
Elite-Fex (Fex): 230
Eljy (Lumière): 364
Eljy Club (Lumière): 364
Ellison Kamra: 210
ELLISON KAMRA COMPANY: 210
ELMO CAMERA CO. (Movie): 614
ELMO CO. LTD: 210
Elmo Honeywell Dual-Filmatic: 614
Elmo Honeywell Tri-Filmatic: 614
Elmoflex (Elmo): 210
Elop Elca, Elca II: 210
ELOP KAMERAWERK: 210
ELVIN (Non-Camera): 656
Elvo (Ro-To): 467
EMEL (Movie): 614
Emel CB3: 614
Emerald: 210
EMMERLING & RICHTER: 210
Emmerling & Richter Field Camera: 210
Empire: 210
Empire (Butcher): 606
Empire (Yen-Kame): 571
Empire 120: 210
Empire-Baby: 210
Empire-Baby (Crestline): 127
Empire Scout: 210
Empire State (EKC): 165
Empire State (Rochester Optical): 470

Falcon-Flex (Utility): 537
Falcon Junior (Utility): 535
Falcon Junior 16 (Utility): 535
Falcon Midget (Utility): 537
Falcon Midget 16 (Utility): 536
Falcon Minette (Utility): 536
Falcon Miniature: 225
Falcon Miniature (Utility): 536
Falcon Miniature Deluxe: 225
Falcon Minicam Junior (Utility): 536
Falcon Minicam Senior: 225
Falcon Minicam Senior (Utility): 536
Falcon Model Four (Utility): 536
Falcon Model F,FE (Utility): 536
Falcon Model G,GE (Utility): 536-537
Falcon Model V-16 (Utility): 537
Falcon Press Flash (Utility): 537
Falcon Rocket: 225
Falcon Special (Utility): 537
FALLOWFIELD: 225
Fallowfield Facile: 225
Fallowfield Miall Hand Camera: 225
Fallowfield Peritus No. 1: 225
Fallowfield Popular Ferrotype: 226
Fallowfield Prismotype: 226
Fallowfield Tailboard camera: 226
Fallowfield Wet-plate 9-lens camera: 226
FALZ & WERNER: 226
Falz Field camera: 226
Fama: 226
Fama (Cornu): 121
Family (Mamiya): 368
FAP: 226
FAP Norca A: 226
FAP Norca B: 226
FAP Rower: 226
Fashion Photo Barbie: 648
Faultless Miniature (Bernard): 72
Favor (Wöhler): 565
Favorit (Ica): 293
Favorit (Wünsche): 566
Favorit (Zeiss): 584
Favorit Tropical (Ica): 293
Favorit Tropical (Zeiss): 584
Favorite (Rochester Camera): 468
Feca (Vormbruck): 549
Feca (35mm) (Vormbruck): 549
FED: 226
Fed-1: 227
Fed 2: 227
Fed 3: 227
Fed 4: 227
Fed-C: 227
Fed-Flash (Federal): 227
FEDERAL MFG. & ENGINEERING CO.: 227
FEINAK-WERKE: 227
Feinak-Werke Folding plate camera: 227
Feinmechanische Foinix: 227
Feinmechanische Unca: 227
FEINMECHANISCHE WERKSTÄTTEN: 227
Feinoptisches Astraflex-II: 228
FEINÖPTISCHES WERK: 227
Feinwerk Mec-16, Mec-16 SB: 228
FEINWERK TECHNIK GmbH: 228
Felica (Vredeborch): 550
Felicetta (Vredeborch): 550
Felita (Vredeborch): 550

FERRANIA: 228
Ferrania Box camera: 228
Ferrania Condor I,Ic: 228
Ferrania Condor Junior: 228
Ferrania Elioflex: 228
Ferrania Eura: 228
Ferrania Euralux 44: 228
Ferrania Ibis, Ibis 6/6: 229
Ferrania Lince 2: 229
Ferrania Lince Rapid: 229
Ferrania Rondine: 229
Ferrania Tanit: 229
Ferrania Zeta Duplex: 229
Ferrania Zeta Duplex 2: 229
FERRO: 229
Ferro Ring Camera: 229
Ferrotype (Laack): 339
Ferrotype (Peck): 438
Festival (Wittnauer): 565
FETTER: 229
Fetter Photo-Eclair: 229
FETZINGER: 229
Fetzinger Field camera: 229
Fex (Czechoslovakia): 229
FEX: 230
FEX/INDO: 230
Fex 4x6.5cm: 230
Fex Delta: 230
Fex Elite-Fex: 230
Fex Impera: 230
Fex Juni-Boy 6x6: 230
Fex Rubi-Fex 4x4: 230
Fex Sport-Fex: 230
Fex Super-Boy: 230
Fex Superfex: 231
Fex Superior: 231
Fex Ultra-Fex: 231
Fex Ultra-Reflex: 231
Fex Uni-Fex: 231
FIAMMA: 231
Fiamma Box: 231
Fibituro (Ruberg): 479
Fichtner's Excelsior Detective (Huttig): 291
Fiesta Instant Camera (EKC): 166
Fiftieth Anniversay (EKC Anniversary
 Kodak Camera): 144
FIGURINES (Non-Camera): 663
Fildia (Coronet): 124
Filius-Kamera (Isoplast): 306
Film Cartridge Lighter (Non-Camera): 637
Film Cassette Cookie Jar (Non-Camera):
 643
Film K (Ernemann): 216
Film Pack Hawk-Eye (EKC): 173
Film Premo (EKC): 186
Film U (Ernemann): 216
FILMA: 231
Filma Box cameras: 231
Filmet (Seneca): 492
Filmette, II (Ertel): 615
Filmo 70 (Bell & Howell): 603
Filmo 70A (Bell & Howell): 603
Filmo 70AC (Bell & Howell): 603
Filmo 70AD (Bell & Howell): 603
Filmo 70C (Bell & Howell): 604
Filmo 70D (Bell & Howell): 604
Filmo 70DL (Bell & Howell): 604

Filmo 70DR (Bell & Howell): 604
Filmo 70G (Bell & Howell): 604
Filmo 70HR (Bell & Howell): 604
Filmo 70SR (Bell & Howell): 604
Filmo 70J (Bell & Howell): 604
Filmo 75 (Bell & Howell): 604
Filmo 75 A-5 (Bell & Howell): 604
Filmo-121-A (Bell & Howell): 604
Filmo 127-A (Bell & Howell): 604
Filmo 141-A (Bell & Howell): 604
Filmo 141-B (Bell & Howell): 604
Filmo Aristocrat Turret 8 (B & H): 604
Filmo Auto Load (Bell & Howell): 604
Filmo Auto Load Speedster (B & H): 605
Filmo Auto Master (Bell & Howell): 605
Filmo Companion (Bell & Howell): 605
Filmo Sportster (Bell & Howell): 605
Filmo Turret Double Run 8 (B & H): 605
Filmor (Fototecnica): 236
Filmos (Leonar): 356
Filmplate Premo (EKC): 186
Filmplate Premo Special (EKC): 186
Finetta: 231
Finetta 88: 232
Finetta 99: 232
Finetta Ditto 99: 231
Finetta Finette: 232
Finetta Super: 232
FINETTA WERK: 231
Finette (Finetta): 232
Finger Print Camera (Folmer & Schwing): 233
Finger Print Camera (Graflex): 267
Finger Print Camera (Sirchie): 499
Fips Microphot: 232
FIRST CAMERA WORKS: 232
First Center (Kuribayashi): 329
First Etui (Kuribayashi): 328
First Hand (Kuribayashi): 328
First Reflex (Kuribayashi): 329
First Roll (Kuribayashi): 328
First Six (Kuribayashi): 329
First Six I, III, V (Tokiwa): 521
First Speed Pocket (Kuribayashi): 329
Firstflex (Tokiwa): 521
Firstflex 35 (Tokiwa): 521
FISCHER: 232
Fischer Nikette,II: 232
Fisher Price Camera (EKC): 166
FISHER-PRICE TOYS (Non-Camera): 666,671
Fita (Bing): 75
FIVE STAR CAMERA CO.: 232
Five Star Candid Camera: 232
Fixfocus (Balda): 61
Flair Doll Camera (Non-Camera): 669
Flammang's Patent Revolving Back
 Camera (American Optical): 36
Flash Bantam (EKC): 148
Flash Box (Genos): 248
FLASH CAMERA CO.: 232
Flash Camera Co. Candid Flash: 232
Flash Champion (Ansco): 40
Flash Clipper (Ansco): 40
FLASH-IT CORP. (Non-Camera): 649
Flash-Master (Herold): 279
Flash Master (Monarch): 401

Flash-Master (Seymour): 494
Flash Shiba (Non-Camera): 662
Flashline: 232
Flashmaster (Coronet): 125
FLASKS (Non-Camera): 645
Flat Folding Kodak (EKC): 166
Fleetwood (Monarch): 401
Flektar: 232
Flex-Master (Monarch): 401
Flex-Master (Spencer): 505
Flexaret (Meopta): 377
Flexette (Optikotechna): 435
Flexilette (Agfa): 25
Flexo (Lippische): 360
Flexo Kodak (EKC): 167
Flexo Richard (Lippische): 360
Flex-O-Cord (Kojima): 317
Flexora (Lippische): 360
Flick-N-Flash (Herbert George): 277
Fling 35 (EKC): 167
Flush Back Kodak (EKC): 167
Foca (O.P.L.): 434
Foca (*) (1946 type) (O.P.L.): 434
Foca (**) (1945 type) (O.P.L.): 434
Foca (**) PF2B (O.P.L.): 434
Foca (***) PF3 (O.P.L.): 434
Foca (***) PF3L (O.P.L.): 434
Foca Marly (O.P.L.): 434
Foca PF2B Marine Nationale (O.P.L.): 434
Foca Standard (*) (O.P.L.): 434
Foca Universel (O.P.L.): 434
Focaflex (O.P.L.): 435
Focaflex II (O.P.L.): 435
Focaflex Automatic (O.P.L.): 435
Focal Plane Eclipse (Shew): 495
Focal Plane Vesta (Adams): 19
Focasport (O.P.L.): 435
Focus Pocus (Non-Camera): 665
Focusing Weno Hawk-Eye (Blair): 77
Fodor Box Syncrona (Vredeborch): 550
Fodorflex: 232
Foinix (Feinmechanische): 227
Foinix 35mm (Feinmechanische): 227
FOITZIK (FEINMECHANISCHE): 227
Foldex (Pho-Tak): 442
Folding '95 Hawkeye (Blair): 77
Folding Ansco: 40-41
Folding Autographic Brownie (EKC): 153
Folding B.B. (Vive): 540
Folding Brownie (EKC): 153
Folding Brownie Six-20 (EKC): 154
Folding Buckeye (American Camera): 35
Folding Buster Brown (Ansco): 39
Folding Cartridge Hawk-Eye (EKC): 173
Folding Cartridge Premo (EKC): 187
Folding Ensign 2¼B (Houghton): 285
Folding Film Pack Hawk-Eye (EKC): 173
Folding Hawk-Eye (Blair): 77
Folding Hawk-Eye (EKC): 173
Folding Hawk-Eye Special (EKC): 173
Folding Klito (Houghton): 289
Folding Kodak (EKC): 167
Folding Montauk (Gennert): 248
Folding Pocket Ansco: 40-41
Folding Pocket Brownie (EKC): 154
Folding Pocket Cyko No. 1 (Rochester
 Optical): 470

INDEX

Gundlach Korona Stereo: 270
Gundlach Korona View: 270
Gundlach Long Focus Korona: 270
GUNDLACH MANHATTAN OPTICAL: 269
Gundlach Milburn Korona: 270
GUNDLACH OPTICAL CO.: 269
GÜRIN: 269
Gürin Le Furet: 269
Gürin Minimus Leroy: 269
GUSTAV AMIGO (Movie): 616
Gustav Amigo: 616
GUTHE & THORSCH (see KW): 336
Guzzi (Earth): 142
Haaga Syncrona Box (Vredeborch): 550
Hachiyo Alpenflex: 270
HACHIYO KOGAKU KOGYO: 270
Hachiyo Supre-Macy: 270
Hacoflex: 271
Hacon (Norisan): 421
HADDS MFG. CO. (FOTO-FLEX): 234
Hadson: 271
Hagi Clover, Clover Six: 271
HAGI MFG.: 271
HAKING: 271
Haking Halina 6-4: 271
Haking Halina 35: 271
Haking Halina 35X: 271
Haking Halina A-1: 271
Haking Halina-Baby: 271
Haking Halina-Prefect Senior: 271
Haking Halina Viceroy: 271
Haking Kinoflex Deluxe: 271
Haking Roy Box: 271
Haking Sunscope: 272
Haking Votar Flex: 272
Haking Wales Reflex: 272
Halina 6-4 (Haking): 271
Halina 35 (Haking): 271
Halina 35X (Haking): 271
Halina A-1 (Haking): 271
Halina-Baby (Haking): 271
Halina-Prefect Senior (Haking): 271
Halina Viceroy (Haking): 271
HALL & KEANE DESIGN (Non-Camera): 654
HALL CAMERA CO.: 272
Hall Mirror Reflex Camera: 272
Hall Pocket Camera: 272
Halloh (Ica): 293
Halloh (Zeiss): 584
Halma-Flex: 272
Hamaphot Blitz-Hexi: 272
Hamaphot Hexi-Lux: 272
HAMAPHOT KG: 272
Hamaphot Modell P56L, P56M: 273
Hamaphot Modell P66: 273
Hamaphot Moni: 273
Hamco: 273
Hamilton Super-Flex: 273
HANAU: 273
Hanau le Marsouin: 273
Hanau Passe-Partout: 273
Hand Camera (Chadwick): 109
HANDBAGS (Non-Camera): 635
Handle, Handle 2 (EKC): 171
Handy (Rochester Optical): 470
Handy Box (Mefag): 376

HANEEL TRI-VISION CO.: 273
Haneel Tri-Vision Stereo: 273
HANIMEX: 274
Hanimex Holiday, Holiday II: 274
Hanken (Riken): 465
HANNA-BARBERA: 274
Hanna-Barbera Fred Flintstone: 274
Hanna-Barbera Huckelberry Hound: 274
Hanna-Barbera Yogi Bear: 274
Hansa (Canon): 98
Hansa 35 (Balda): 61
HANSEN: 274
Hansen Norka: 274
Hapo (Photo-Porst): 444
Haponette B (Photo-Porst): 444
Happi-Time (Herbert George): 277
Happy: 274
Happy (K.W.): 336
Happy (Minolta): 382
Happy Times Instant Camera (EKC): 171
HARBOE: 274
Harboe Wood box camera: 274
HARE: 274
Hare Stereo wet-plate camera: 274
Hare Tailboard camera: 274
Hare Tourist camera: 274
Harmony (Chuo Photo Supply): 111
Hartex: 274
HARUKAWA: 274
Harukawa Septon Pen Camera: 274
Harukawa Septon Penletto: 275
Harvard camera (Mason): 375
HASBRO INDUSTRIES (Non-Camera): 671
HASSELBLAD: 275
Hasselblad 500C: 276
Hasselblad 1000F: 275
Hasselblad 1600F: 275
Hasselblad Aerial Camera HK7: 275
Hasselblad Crystal 500C (Non-Camera): 653
Hasselblad for sale: ADV
Hasselblad Plush Toy (Non-Camera): 653
Hasselblad Super Wide Angle: 276
Hasselblad Svea (Svensson): 513
Hasselblad Svenska Express: 275
Hasselblad Wanted: ADV
Hat Detective Camera (Adams & Co.): 19
Hawk-Eye (Blair): 77
Hawk-Eye (EKC): 172
Hawk-Eye Nos. 2, 2A (EKC): 172
Hawkeye Ace (EKC): 172
Hawkeye Ace Deluxe (EKC): 172
Hawk-Eye Box (Blair): 78
Hawk-Eye Detective (Blair): 77
Hawk-Eye Detective (Boston): 84
Hawk-Eye Flashfun, II (EKC): 173
Hawk-Eye Junior (Blair): 78
Hawkeye Model BB (EKC): 173
Hawk-Eye Special (EKC): 174
Hawkette (EKC): 172
Heag (Ernemann): 216
Heag (tropical) (Ernemann): 222
Heag 0, 00 (Ernemann): 217
Heag I (Ernemann): 217
Heag I Stereo (Ernemann): 217
Heag II (Ernemann): 217
Heag III (Ernemann): 217

Hobix, Hobix Junior (Tougodo): 524
Hochtourist (Zeiss): 584
Hoei Anny-44: 282
Hoei Ebony 35: 282
Hoei Ebony 35 De-Luxe: 282
Hoei Ebony Deluxe IIS: 282
HOEI INDUSTRIAL CO.: 282
HOFERT: 282
Holborn (Houghton): 289
Holborn Postage Stamp Camera
 (Houghton): 289
Holiday, Holiday II (Hanimex): 274
Holly Hobbie (Vanity Fair): 538
Holly Hobbie Doll House Camera
 (Non-Camera): 653
Hollycam Special: 282
Hollywood (Ruberg): 479
Hollywood (Universal Univex AF): 535
Hollywood Camera (Encore): 210
Hollywood 531-B (Stewart-Warner): 628
Hollywood Reflex (Craftex): 126
Hollywood Studio Lamp (Non-Camera): 650
Hologon (Zeiss Contarex Hologon): 579
HOME CINE CAMERAS (CAMPRO): 607
Home Kinetoscope (Edison): 613
Home Movie Super-8 Auto-matic viewer
 (Non-Camera): 671
Home Portrait (Deardorff): 135
Home Portrait Graflex: 260
Homeos (Richard): 462
Homeoscope (Richard): 463
Homer: 282
Homer 16: 283
Homer No. 1 (Kambayashi): 310
HONEYWELL: 283
Honeywell Dual-Filmatic (Elmo): 614
Honeywell Electric Eye 35R: 283
Honeywell Tri-Filmatic (Elmo): 614
Honor (Zuiho): 599
Hopalong Cassidy Camera (Galter): 245
Hope (Sugaya Model II): 510
Horizont: 283
Horizontal Reflex (Thornton-Pickard): 518
HORNE & THORNTHWAITE: 283
Horne & Thornthwaite Collapsible: 283
Horne & Thornthwaite Powell's
 Stereoscopic Camera: 283
Horne & Thornthwaite Wet-plate: 283
HORSMAN: 283
Horsman Eclipse: 283
Hot Flash chewing gum (Non-Camera): 636
Houay Anny 35: 283
HOUGHTON: 284-290
HOUGHTON (Movie): 616
Houghton All Distance Ensigns: 284
Houghton Automatic Magazine: 284
Houghton Autospeed (Ensign): 285
Houghton Autorange 16-20 Ensign: 284
Houghton Autorange 220 Ensign: 284
Houghton Cameo (Ensign): 285
Houghton Carbine (Ensign): 285
Houghton Carbine, Tropical (Ensign): 285
Houghton Commando (Ensign): 285
Houghton Coronet: 284
Houghton Cupid (Ensign): 285

Houghton Deluxe Reflex (Ensign): 287
Houghton Double-8 (Ensign): 285
Houghton Empress: 284
Houghton Ensign Autokinecam: 616
Houghton Ensign Auto-Kinecam 16: 617
Houghton Ensign Autospeed: 285
Houghton Ensign box cameras: 285
Houghton Ensign Cadet: 285
Houghton Ensign Cameo: 285
Houghton Ensign Carbine: 285
Houghton Ensign Carbine, Tropical: 285
Houghton Ensign Commando: 285
Houghton Ensign Cupid: 285
Houghton Ensign Deluxe Reflex: 287
Houghton Ensign Double-8: 285
Houghton Ensign Ful-Vue: 286
Houghton Ensign Ful-Vue Super: 286
Houghton Ensign Greyhound: 286
Houghton Ensign Junior Box: 286
Houghton Ensign Mascot: 286
Houghton Ensign Mickey Mouse: 286
Houghton Ensign Midget: 286
Houghton Ensign Multex: 287
Houghton Ensign Pocket: 287
Houghton Ensign Pressman Reflex: 287
Houghton Ensign Popular Reflex: 287
Houghton Ensign Ranger, Ranger II: 287
Houghton Ensign Ranger Special: 287
Houghton Ensign Reflex: 287
Houghton Ensign Roll Film Reflex: 287
Houghton Ensign Roll Film Reflex,
 Tropical: 287
Houghton Ensign Selfix 16-20: 287
Houghton Ensign Selfix 12-20, 20, 220,
 320, 420, 820: 288
Houghton Ensign Special Reflex: 287
Houghton Ensign Special Reflex, Tropical:
 288
Houghton Ensign Speed Film Reflex: 288
Houghton Ensign Speed Film Reflex,
 Tropical: 288
Houghton Ensign Super-Kinecam: 617
Houghton Ensign Super Speed Cameo:
 288
Houghton Ensignette: 288
Houghton Ensignette Deluxe: 288
Houghton Folding Ensign 2¼B: 285
Houghton Folding Klito: 289
Houghton Ful-Vue (Ensign): 286
Houghton Ful-Vue Super (Ensign): 286
Houghton Holborn: 289
Houghton Holborn Postage Stamp: 289
Houghton Junior Box Ensign: 286
Houghton Klito No. 0: 289
Houghton Mascot: 289
Houghton Mascot (Ensign): 286
Houghton Mickey Mouse (Ensign): 286
Houghton Midget (Ensign): 286
Houghton Multex (Ensign): 287
Houghton No. 00 Folding Klito: 289
Houghton Pocket Ensign: 287
Houghton Popular Reflex (Ensign): 287
Houghton Pressman Reflex (Ensign): 287
Houghton Ranger, Ranger II (Ensign): 287
Houghton Ranger Special (Ensign): 287
Houghton Reflex (Ensign): 287
Houghton Roll Film Reflex (Ensign): 287

JOUX: 307
Joux Alethoscope: 307
Joux Ortho Jumelle Duplex: 307
Joux Steno-Jumelle: 307
Joux Steno-Jumelle Stereo: 307
Jubilar (Voigtländer): 545
Jubilee (Bolsey): 82
Jubilette (Balda): 61
JUGUETES MARTI (Non-Camera): 654
JUHASZ: 307
Juhasz Glink: 307
Juka (Adox): 21
Julia: 308
JUMEAU & JANNIN: 308
Jumeau & Jannin Le Cristallos: 308
Jumelle: 308
Jumelle (Bellieni): 68
Jumelle Capsa (Demaria): 137
Jumelle Photographique (Mackenstein): 366
Jumelle Stereo (Papigny): 436
Jumelle-style magazine camera (Krugener): 324
Juni-Boy 6x6 (Fex): 230
Junior (Mamiya): 368
Junior (Vredeborch): 550
Junior Box Ensign (Houghton): 286
Junior Reflex (Reflex Camera Co.): 459
Junior Special Ruby Reflex (Thornton-Pickard): 518
Juniorette No. 1 (Ansco): 41
Junka: 308
Junka Exhibit: 308
JUNKA-WERKE: 308
JURNICK: 308
Jurnick Ford's Tom Thumb Camera: 308
Just Like Daddy's Camera (Non-Camera): 667
JUSTEN PRODUCTS: 308
Justen: 308
Juwel (Eho-Altissa): 209
Juwel (Huttig): 291
Juwel (Ica): 294
Juwel (Wünsche): 566
Juwel (Zeiss): 588
Juwella (Balda): 61
KadocK-II Personal Gaslighter (Non-Camera): 639
KAFTANSKI: 308
Kaftanski Banco Perfect: 308
Kaftax (Kaftanski): 308
KALART CO.: 309
Kalart Press camera: 309
Kaleidoscopes for sale: ADV
Kali-flex (Kalimar): 309
KALIMAR: 309
Kalimar 44: 309
Kalimar A: 309
Kalimar Colt 44: 309
Kalimar Kali-flex: 309
Kalimar Reflex: 309
Kalimar TLR 100: 309
Kallo (Kowa): 321
Kalloflex (Kowa): 321
Kalos: 309
KALOS CAMERABAU: 309
Kalos Spezial: 310

Kaloscope (Caillon): 94
Kamarad, Kamarad MII (Bradac): 86
Kamaret (Blair): 78
KAMBAYASHI & CO. LTD.: 310
Kambayashi Homer No. 1: 310
KAMERA & APPARATEBAU: 310
Kamera & Apparatebau Sport-Box 2,3: 310
Kamera radio (Non-Camera): 658
KAMERA WERKSTATTEN A.G. (K.W.): 336
KAMERAWERKE: 310
Kamerawerke Vitaflex: 310
Kamerette (Yen-Kame): 571
Kamerette Junior (Yen-Kame): 571
Kamerette Junior Nos. 1, 2, 4: 310
Kamerette Nos. 1, 2: 310
Kamerette Senior (Yen-Kame): 571
Kamerette Special: 310
Kamra-Pak Commemoratives (Non-Camera): 641
Kamra-Pak Vanity (Non-Camera): 640
Kamrex (Lancaster): 341
Kando Reflex (Monarch): 401
Kandor, Kandor Komet (Irwin): 305
Kansha-go (Asanuma): 56
Kao Jr.,Sr. (Seneca): 493
Karat (Agfa): 26-27
Kardon (Premier): 455
Karl Arnold: 54
Karma (Arnold): 54
Karma-Flex 4x4 Models I, 2 (Arnold): 54
Karma-Flex 6x6 (Arnold): 54
Karomat (Agfa): 27
Karomat (Ansco): 41
Karoron (Kuribayashi): 330
Karoron RF (Kuribayashi): 330
Karoron S, S-II (Kuribayashi): 330
KASHIWA: 310
Kashiwa Motoca: 310
Kassin: 310
Katei (Yen-Kame): 571
KATO KOGEI (Non-Camera): 635
Kattelle, Cine Collector: ADV
Kauffer Photo-Sac a Main (Alibert): 33
Kawee (K.W.): 336
Kbaru 2M: 618
KE-4(1) 70mm Combat (Graflex): 268
Keepcolor I (Non-Camera): 649
Keepcolor II Eraser (Non-Camera): 654
Keepcolor II pencil sharpener (Non-Camera): 655
K.E.H. Camera Brokers: ADV
KEITH CAMERA CO.: 310
Keith Portrait Camera: 310
Kelvin Maior (S.E.D.E.): 489
Kelvin Minor (S.E.D.E.): 490
Kemco Homovie (Kodel): 619
KEMPER: 310
Kemper Kombi: 310
Kenflex: 311
KENNEDY INDUSTRIES: 311
Kennedy K.I. Monobar: 311
KENNER (Non-Camera): 666
KENNGOTT: 311
Kenngott Matador: 311
Kenngott Phoenix: 311
Kenngott Plate cameras: 311
Kenngott Supra No. 2: 311

Kent: 311
Kentucky Fried Chicken (Franka): 237
Kera Jr. (Vredeborch): 550
KERN: 311
Kern Bijou: 311
Kern Stereo Kern SS: 311
KERSHAW: 311
Kershaw 450: 311
Kershaw Curlew I,II,III: 311
Kershaw Eight-20 Penguin: 312
Kershaw Patent Reflex: 312
Kershaw Raven: 312
Kessler Collection: ADV
Kewpie (Conley): 116
Keychain (Non-Camera): 659
Keychain Flashlight: 649
KEYCHAINS (Non-Camera): 649
KEYS STEREO PRODUCTS: 312
Keys Trivision Camera: 312
KEYSTONE: 312
Keystone A models: 618
Keystone Capri: 618
KEYSTONE FERROTYPE CAMERA: 312
Keystone K-8, K-22: 618
KEYSTONE MFG. CO. (Movie): 618
Keystone Model C: 618
Keystone Moviegraph: 619
Keystone Street camera: 312
Keystone Supreme: 619
Keystone Wizard XF1000: 312
K.I. Monobar (Kennedy): 311
Kiddie Camera: 313
Kiddie Camera (Ansco): 42
Kiddie Camera (Jak-Pak): 306
Kiev (Mashpriborintorg): 374
Kiev-2, 2A (Mashpriborintorg): 374
Kiev-3, 3A (Mashpriborintorg): 374
Kiev-4, 4A (Mashpriborintorg): 374
Kiev 30 (Mashpriborintorg): 374
Kiev-Vega (Mashpriborintorg): 374
Kiev-Vega 2 (Mashpriborintorg): 374
KIGAWA OPTICAL: 313
Kigawa Tsubasa Baby Chrome: 313
Kigawa Tsubasa Chrome: 313
Kigawa Tsubasa Semi: 313
Kigawa Tsubasa Super Semi Chrome: 313
Kigawa Tsubasaflex Junior: 313
Kiko 6: 313
KIKO-DO CO.: 313
Kiko-Do Superflex Baby: 313
Kiku 16 Model II (Morita): 403
KILFITT: 313
Kilfitt Mecaflex: 313
Kim (S.E.M.): 491
KIMURA: 314
Kimura Alfax: 314
Kin-Dar Stereo (Kinder): 314
Kinaflex (Kinn): 314
Kinamo (Ica): 617
Kinamo N25 (Zeiss): 633
Kinamo S10 (Zeiss): 633
Kinarri 35 (Arnold & Richter): 602
Kinax, Kinax II (Kinn): 315
Kinax Alsace (Kinn): 315
Kinax Baby (Kinn): 315
Kinax Junior (Kinn): 315
KINDER: 314

Kinder Kin-Dar Stereo: 314
Kine Exakta I (Ihagee): 299
Kinegraphe (Francais): 236
Kinetoscope (Edison): 613
KING: 314
King (Yen-Kame): 571
King Barker (Barker): 603
King Camera: 314
King Camera (Metropolitan): 379
King Cinex Candid Camera: 314
King Dominant: 314
King Flex (Non-Camera): 651
King Poco (Rochester Camera): 469
King Regula: 314
King Regula Citalux 300: 314
KING SALES CO.: 314
King Super (Yen-Kame): 571
King's Camera: 314
King's Own Tropical (London Stereo.): 363
Kingston: 314
KINN: 314
Kinn Kinaflex: 314
Kinn Kinax: 315
Kinn Kinax II: 315
Kinn Kinax Alsace: 315
Kinn Kinax Baby: 315
Kinn Kinax Junior: 315
Kinnear's Patent Wet-Plate Landscape
 Camera (Ross): 476
Kino I, II (Ernemann): 614
Kino-44 (Tougodo): 524
Kino Model E (Ernemann): 614
Kinoflex Deluxe (Haking): 271
Kinon SC-1: 315
Kinusa K-77: 315
Kirk Stereo camera: 315
Kiyabashi Autoflex: 315
KIYABASHI KOGAKU: 315
K.K.W. (Non-Camera): 637
Klapp: 315
Klapp (Ernemann): 219
Klapp (tropical) (Ernemann): 222
Kleer-Vu Feather-Weight: 315
KLEFFEL: 316
Kleffel Field camera: 316
Klein-Edinex (Wirgin): 562
Klein-Mentor (Goltz & Breutmann): 256
Klein-Ultrix (Ihagee Parvola): 300
Klimax (Butcher): 92
Klito No. 0 (Houghton): 289
KLIX MFG. CO. (Movie): 619
Klix: 619
Klondike (Anthony): 47
KLOPCIC: 316
Klopcic: 316
Klopcic Reporter: 316
KN35 (Certo): 108
Knack Detective (Scovill): 484
KNICKERBOCKER TOY CO.
 (Non-Camera): 648
KNIGHT & SONS: 316
Knight Sliding-box camera: 315
Knox (Wünsche): 566
KOCH: 316
Koch Stereo wet-plate camera: 316
KOCHMANN: 316
Kochmann Enolde, I,II,III: 316

Kochmann Korelle: 316
Kochmann Korelle K: 316
Kochmann Korelle P: 317
Kochmann Reflex-Korelle: 317
Kodaclone Slide (Non-Camera): 658
Kodacolor 400 Film Radio (Non-Camera): 658
Kodacolor VR 200 sharpener (Non-Camera): 654
Kodak (original) (EKC): 142
Kodak 25 Lapel Pin (Non-Camera): 648
Kodak 35 (EKC): 179
Kodak 35 (Military PH-324) (EKC): 179
Kodak 35 w/ Rangefinder (EKC): 179
Kodak 66 Model III (EKC): 179
Kodak 1880-1980 Centennial Plate (Non-Camera): 648
Kodak A Modele 11 (EKC): 177
Kodak Australasia Lapel Pin (Non-Camera): 648
Kodak Bank (Non-Camera): 635
Kodak Box 620, 620C (EKC): 177
Kodak Enlarger 16mm (EKC): 177
Kodak Cameras guidebook: ADV
Kodak Cameras Wanted: ADV
Kodak Cine Automatic (EKC): 612
Kodak Cine Scopemeter (EKC): 612
Kodak Dice Cup (Non-Camera): 657
Kodak Disc 4000 Photokina (Non-Camera): 642
Kodak Disc Bank (Non-Camera): 635
Kodak Ektra (EKC): 164
Kodak Ektra 1 (EKC): 165
Kodak Ektra 2 (EKC): 165
Kodak Ektra II (EKC): 165
Kodak Ektra 200 (EKC): 165
Kodak Ektra 250 (EKC): 165
Kodak Electric 8 Automatic (EKC): 612
Kodak Ensemble (EKC): 165
Kodak Escort 8 (EKC): 612
Kodak Film-Lighter (Non-Camera): 637
Kodak Instant Color Film PR10 Radio (Non-Camera): 658
Kodak Junior (EKC): 177
Kodak Junior I (EKC): 177
Kodak Junior II (EKC): 177
Kodak Junior Six-16 (EKC): 177
Kodak Junior Six-16 Series II (EKC): 177
Kodak Junior Six-16 Series III (EKC): 178
Kodak Junior Six-20 (EKC): 177
Kodak Junior Six-20 Series II (EKC): 177
Kodak Junior Six-20 Series III (EKC): 178
Kodak Kolorcube (Non-Camera): 657
Kodak Medalist, II (EKC): 180
Kodak Monitor Six-16, Six-20 (EKC): 180
Kodak Mug (Non-Camera): 647
Kodak Nascar Auto (Non-Camera): 649
Kodak Recomar 18, 33 (EKC): 190
Kodak Reflex (EKC): 178
Kodak Reflex IA (EKC): 178
Kodak Reflex II (EKC): 178
Kodak Senior Six-16, Six-20 (EKC): 198
Kodak Series II (EKC): 178
Kodak Series III (EKC): 178
Kodak Six-16 (EKC): 199
Kodak Six-20 (EKC): 199
Kodak Special Six-16, Six-20 (EKC): 200

Kodak Sport Special (EKC): 201
Kodak Startech (EKC): 201
Kodak Stereo (35mm) (EKC): 201
Kodak Suprema (EKC): 202
Kodak Tele-Ektra (EKC): 202
Kodak Tele-Instamatic (EKC): 202
Kodak Tourist, II (EKC): 202
Kodak Trimlite Instamatic (EKC): 202
Kodak Truck 1880-1980 (Non-Camera): 670
Kodak Truck/Whistle (Non-Camera): 670
Kodak Van (Non-Camera): 669
Kodak Winner (EKC): 205
Kodak Winner, 1988 Olympics (EKC): 206
Kodak Zoom 8 Reflex (EKC): 613
Kodascope Eight (EKC): 613
Kodascope, A,B,C (EKC): 613
KODEL ELEC. & MFG. CO. (Movie): 619
Kodel Kemco Homovie: 619
Kodet (EKC): 179
KOGAKU: 317
KOGAKU SEIKI (NICCA): 414
KÖHNLEIN: 317
Köhnlein Wiko Standard: 317
Koinor 4x4 (A.D.Y.C.): 21
KOJIMA: 317
Kojima Flex-O-Cord: 317
Kojima Mikono-Flex P: 317
Kokka Hand (Kuribayashi): 328
Kola (Kolar): 318
Kola Diar (Kolar): 318
KOLAR: 317
Kolar Box Kolex: 317
Kolar Kola: 318
Kolar Kola Diar: 318
Kolar Kolarex: 318
Kolar Kolex: 318
Kolarex (Kolar): 318
Kolex (Kolar): 318
Kolibri (Zeiss): 588
Kolorcube (Non-Camera): 657
Kolt (Okada): 422
Komaflex-S (Kowa): 321
Kombi (Kemper): 310
Komlosy: 318
Konair Ruby (Yamato): 568
Konan 16 (Chiyoda): 111
Konan 16 (Minolta): 393
Konica (Konishiroku): 318
Konica II (Konishiroku): 318
Konica III (Konishiroku): 319
Konica IIIA (Konishiroku): 319
Konica IIIM (Konishiroku): 319
Konica Autoreflex (Konishiroku): 319
Konica F (Konishiroku): 319
Konica FS (Konishiroku): 319
Konica Playing Cards (Non-Camera): 657
Konilette (Konishiroku): 319
Konilette 35 (Konishiroku): 319
Konishiroku Baby Pearl): 318
KONISHIROKU KOGAKU: 318
Konishiroku Konica: 318
Konishiroku Konica II: 318
Konishiroku Konica III: 319
Konishiroku Konica IIIA: 319
Konishiroku Konica IIIM: 319
Konishiroku Konica Autoreflex: 319

Kuribayashi Petri 35 1.9: 331
Kuribayashi Petri 35 2.0: 331
Kuribayashi Petri 35 2.8: 331
Kuribayashi Petri 35 RE: 333
Kuribayashi Petri 35X, MX: 331
Kuribayashi Petri Auto Rapid: 335
Kuribayashi Petri Automate: 331
Kuribayashi Petri Color 35, 35E: 333
Kuribayashi Petri Compact: 333
Kuribayashi Petri Compact 17: 333
Kuribayashi Petri Compact E: 333
Kuribayashi Petri Computor 35: 333
Kuribayashi Petri EBn: 332
Kuribayashi Petri Eight: 619
Kuribayashi Petri ES Auto 1.7: 333
Kuribayashi Petri ES Auto 2.8: 333
Kuribayashi Petri FA-1: 335
Kuribayashi Petri Flex: 330,334
Kuribayashi Petri Flex Seven: 334
Kuribayashi Petri Flex V: 334
Kuribayashi Petri Fotochrome: 336
Kuribayashi Petri FT: 334
Kuribayashi Petri FT-II: 334
Kuribayashi Petri FT 500: 334
Kuribayashi Petri FT 1000: 334
Kuribayashi Petri FT EE: 335
Kuribayashi Petri FTE: 335
Kuribayashi Petri FTX: 334
Kuribayashi Petri Grip-Pac 110: 335
Kuribayashi Petri Half: 333
Kuribayashi Petri Hi-Lite: 333
Kuribayashi Petri Instant Back: 335
Kuribayashi Petri Junior: 333
Kuribayashi Petri M 35: 333
Kuribayashi Petri MFT 1000: 334
Kuribayashi Petri Micro Compact: 333
Kuribayashi Petri Micro MF-1: 334
Kuribayashi Petri Penta: 334
Kuribayashi Petri Penta V2: 334
Kuribayashi Petri Penta V3: 334
Kuribayashi Petri Penta V6, V6-II: 334
Kuribayashi Petri Pocket 2: 335
Kuribayashi Petri Power Eight: 619
Kuribayashi Petri Prest: 333
Kuribayashi Petri Pro Seven: 332
Kuribayashi Petri Push-Pull 110: 335
Kuribayashi Petri Racer: 332
Kuribayashi Petri RF, RF 120: 330
Kuribayashi Petri Semi: 330
Kuribayashi Petri Seven: 332
Kuribayashi Petri Seven S: 332
Kuribayashi Petri Seven S-II: 332
Kuribayashi Petri Super: 330
Kuribayashi Petri Super Eight: 619
Kuribayashi Petri Super V: 330
Kuribayashi Petriflex: 330,334
Kuribayashi Plate cameras: 327-328
Kuribayashi Romax Hand: 328
Kuribayashi Semi First: 328
Kuribayashi Speed Reflex: 327
Kuribayashi Tokiwa Hand: 328
KÜRBI & NIGGELOH (Bilora): 74
KUZUWA TOY (Non-Camera): 645
K.W.: 336-338
K.W. Astra 35F-X: 336
K.W. Astraflex 35: 336
K.W. Happy: 336

K.W. Jolly: 336
K.W. Kawee: 336
K.W. Patent Etui: 336
K.W. Patent Etui Luxus: 336
K.W. Pentaflex: 336
K.W. Pilot 6: 336
K.W. Pilot Reflex: 337
K.W. Pilot Super: 337
K.W. Pocket Dalco: 337
K.W. Praktica: 337
K.W. Praktica FX: 337
K.W. Praktica FX2: 337
K.W. Praktica FX3: 337
K.W. Praktica Nova: 338
K.W. Praktica Prisma: 338
K.W. Prakticamat: 338
K.W. Praktiflex: 338
K.W. Praktiflex II: 338
K.W. Praktiflex FX: 338
K.W. Praktina IIa: 338
K.W. Praktina FX: 338
K.W. Praktisix, II: 339
K.W. Reflex-Box: 339
K.W. Rival Reflex: 339
Kwanon (Canon): 97
KYOEI TRADING CO. (Non-Camera): 637
Kyoto Lovely: 339
KYOTO SEIKI CO.: 339
L'As (E.L.C.): 209
L.A. 35mm Movie camera: 619
L.A. MOTION PICTURE CO. (Movie): 619
La Belle Pal (Bolsey): 82
LA CROSSE CAMERA CO.: 339
La Crosse Snapshot: 339
LA ROSE: 339
La Rose Rapitake: 339
LAACK: 339
Laack Ferrotype camera: 339
Laack Merkur: 339
Laack Padie: 339
Laack Tropical camera: 339
Laack Wanderer: 340
LABARRE: 340
LaBarre Tailboard camera: 340
LACHAIZE: 340
Lachaize Mecilux: 340
Lacon C: 340
LACON CAMERA CO. INC.: 340
Ladies Cameras (Lancaster): 341
Ladies Gem Camera (Lancaster): 341
Lady Carefree (Argus): 53
Lafayette 35 (Tokiwa): 522
Lambert, Cine Collector: ADV
Lamp (Non-Camera): 650
LAMPERTI & GARBAGNATI: 340
Lamperti & Garbagnati Detective: 340
Lamperti & Garbagnati Wet-plate: 340
LANCART: 340
Lancart Xyz: 340
LANCASTER: 340-342
Lancaster Brass Bound Instantograph: 340
Lancaster Gem Apparatus: 340
Lancaster Instantograph: 340-341
Lancaster International Patent: 341
Lancaster Kamrex: 341
Lancaster Ladies Cameras: 341
Lancaster Ladies Gem Camera: 341

Lancaster Meritoire: 341
Lancaster Merveilleux: 341
Lancaster Omnigraph: 342
Lancaster Postage Stamp Cameras: 342
Lancaster Rover: 342
Lancaster Special Brass Bound
 Instantograph: 342
Lancaster Stereo Instantograph: 342
Lancaster Watch Camera: 342
Lancer, Lancer LG (Ansco): 42
LANCO SCREEN CO. (Non-Camera): 668
Lantern slide projector pencil sharpener
 (Non-Camera): 655
Lapel pin (Non-Camera): 648
Lark (Imperial): 303
Laurelflex (Tokyo Kogaku): 522
Laurie Dick Tracy: 343
LAURIE IMPORT LTD.: 343
Laurie Miniature Novelty Camera: 343
LAVA-SIMPLEX INTERNATIONALE: 343
Lava-Simplex Simplex Snapper: 343
LAVEC INDUSTRIAL CORP.: 343
Lavec LT-002: 343
LAWLEY: 343
Lawley Folding Plate Camera: 343
Lawley Wet-plate camera: 343
Le Cent Vues (Mollier): 400
Le COULTRE & CIE. (Compass): 115
Le Cristallos (Jumeau & Jannin): 308
LE DOCTE: 343
Le Docte Excell: 343
Le Furet (Gürin): 269
le Marsouin (Hanau): 273
Le Multicolore (Rochechouard): 468
le Pascal (Japy): 306
Le Prismac (Deloye): 136
Le Reve (Girard): 250
Le Stereocycle (Bazin & Leroy): 63
Leader: 343
Leader (Tougodo): 524
LEADWORKS (Non-Camera): 635
Lec Junior (M.I.O.M.): 396
LECHNER: 344
Lechner Hand camera: 344
LEE INDUSTRIES: 344
Lee Industries Leecrest: 344
LEECH & SCHMIDT: 344
Leech & Schmidt Tailboard: 344
Leecrest (Lee Industries): 344
LEFTON CHINA (Non-Camera): 664
Legionaire (Wittnauer): 565
LEGO (Non-Camera): 668
LEHMAN: 344
Lehman Pelar-Camera: 344
LEHMANN: 344
Lehmann Ben Akiba: 344
Leica I (A) (Leitz): 346
Leica I (B) (Leitz): 347
Leica I (C) (Leitz): 347
Leica I Luxus (Leitz): 346
Leica I Luxus Replica (Leitz): 346
Leica Ic (Leitz): 349
Leica If, Swedish 3 Crown: 350
Leica If (Leitz): 350
Leica Ig (Leitz): 350
Leica II (D) (Leitz): 347
Leica IIc (Leitz): 349

Leica IIf (Leitz): 350
Leica III (F) (Leitz): 348
Leica IIIa (G) (Leitz): 348
Leica IIIa "Monte en Sarre": 348
Leica IIIb (G) (Leitz): 349
Leica IIIb Luftwaffen Eigentum (Leitz): 349
Leica IIIc (Leitz): 349
Leica IIIc "K-Model" (Leitz): 349
Leica IIIc Luftwaffe (Leitz): 349
Leica IIIc Wehrmacht (Leitz): 349
Leica IIId (Leitz): 349
Leica IIIf (Leitz): 349
Leica IIIf Swedish Army (Leitz): 350
Leica IIIg (Leitz): 350
Leica IIIg Swedish Crown Model: 350
Leica 72 (Leitz): 349
Leica 250 Reporter (FF) (Leitz): 348
Leica 250 Reporter (GG) (Leitz): 348
Leica CL (Leitz): 352
Leica CL 50 Jahre (Leitz): 352
Leica for sale: ADV
Leica Historical Society of America: ADV
Leica KE-7A (Leitz): 352
Leica lenses (Leitz): 354-356
Leica M1 (Leitz): 351
Leica M2 (Leitz): 351
Leica M2 MOT, M2M (Leitz): 351
Leica M3 (Leitz): 350
Leica M4 (Leitz): 351
Leica M4 50 Jahre (Leitz): 352
Leica M4M, M4 MOT (Leitz): 352
Leica M5 (Leitz): 352
Leica MD (Leitz): 351
Leica MDa (Leitz): 351
Leica Mifilmca: 347
Leica MP (Leitz): 351
Leica O-Series: 346
Leica R3 (Leitz): 353-354
Leica R3 MOT (Leitz): 354
Leica R4, R4 MOT (Leitz): 354
Leica R4S (Leitz): 354
Leica Single-Shot (Leitz): 350
Leica Standard (E) (Leitz): 348
Leica-style water camera (Non-Camera):
 663
Leica viewer (Non-Camera): 671
Leica Wanted: ADV
Leicaflex (Leitz): 352
Leicaflex SL, SL MOT (Leitz): 353
Leicaflex SL Olympic (Leitz): 353
Leicaflex SL2, SL2 MOT (Leitz): 353
Leicaflex SL2 50 Jahre (Leitz): 353
Leicina 8S, 8SV (Leitz): 620
LEIDOLF: 344
Leidolf Leidox, II: 344
Leidolf Lordomat: 344
Leidolf Lordomat C-35: 344
Leidolf Lordomat SLE: 344
Leidolf Lordomatic, II: 344
Leidolf Lordox: 344
Leidox, Leidox II (Leidolf): 344
Leipzig Detective (Grundmann): 269
LEITZ: 344-356
LEITZ (Movie): 619
Leitz Leica I (A): 346
Leitz Leica I (B): 347
Leitz Leica I (C): 347

Mamiyaflex Automatic-A (Mamiya): 369
Mamiyaflex Automatic A II (Mamiya): 369
Mamiyaflex II (Mamiya): 369
Mamiyaflex Junior (Mamiya): 369
Mammy (Mamiya): 369
Man with camera (Non-Camera): 664
Mandel (Chicago Ferrotype Co.): 110
Mandel Automatic PDQ (PDQ): 437
Mandelette (Chicago Ferrotype Co.): 110
Manex (Vredeborch): 550
MANHATTAN OPTICAL CO.: 370
Manhattan Baby Wizard: 370
Manhattan Bo-Peep: 370
Manhattan Cycle Wizard: 370
Manhattan Long-Focus Wizard: 370
Manhattan Night Hawk Detective: 370
Manhattan Wide Angle Wizard: 370
Manhattan Wizard Duplex Nos.1, 2: 370
Manhattan Wizard Junior: 371
Manhattan Wizard Senior: 371
Manhattan Wizard Special: 371
Maniga: 371
Maniga Manetta: 371
MANSFIELD: 371
Mansfield Automatic 127: 371
MANSFIELD HOLIDAY: 371
Mansfield Skylark, Skylark V: 371
MANSFIELD IND. (Movie): 620
Mansfield Model 160: 620
Mantel-Box 2 (Eho-Altissa): 209
MANUFACTURE d'ISOLANTS et d'OJECTS
 MOULES (M.I.O.M.): 395
Manufoc Tenax (Goerz): 254
MAR-CREST MFG. CORP.: 371
Mar-Crest: 371
Marble (Minolta): 383
MARION & CO., LTD.: 371
Marion Academy: 371
Marion Cambridge: 372
Marion Field camera: 372
Marion Krügener's Patent Book Camera:
 372
Marion Metal Miniature: 372
Marion Modern: 372
Marion Parcel Detective: 372
Marion Perfection: 372
Marion Radial Hand camera: 372
Marion Soho Reflex: 372
Marion Soho Stereo Reflex: 372
Marion Soho Stereo Tropical Reflex: 372
Marion Soho Tropical Reflex: 372
MARK (Non-Camera): 644
Mark III Hythe Gun Camera (Thornton-
 Pickard): 518
Mark IV (Atlas Rand): 57
Mark IV (Sawyers): 482
Mark XII Flash (Imperial): 303
Mark 27 (Imperial): 303
Mark S-2: 372
Markfinder (Argus 21): 51
MARKS: 372
Marks Marksman Six-20: 372
Marksman (Pho-Tak): 442
Marksman Six-20 (Marks): 372
Marlo (Movie): 620
MARLOW BROS.: 372
Marlow MB, No. 4: 372

Mars 99 (Wünsche): 567
Mars Detective (Wünsche): 567
Mars Detectiv-Stereoskop (Wünsche): 567
MARSHAL OPTICAL WORKS: 372
Marshal Press: 372
Marsouin (Hanau): 273
MARTAIN: 373
Martain View Camera: 373
Maruso (Yen-Kame): 571
Maruso Spy-14: 373
Maruso Top, Top II Camera: 373
MARUSO TRADING CO.: 373
Marvel: 373
Marvel (Putnam): 456
Marvel MarVette: 373
MARVEL PRODUCTS: 373
Marvel S-16, S-20 (Sears): 485
Marvel-flex (Sears): 485
MarVette (Marvel): 373
MARYNEN: 373
Marynen Studio camera: 373
Mascot (Houghton): 289
Mascot (Houghton Ensign): 286
Mascot (Scovill): 484
Mascot (Shimura): 496
MASHPRIBORINTORG: 373-375
Mashpriborintorg Bera: 374
Mashpriborintorg Chaika II: 373
Mashpriborintorg John Player Special: 374
Mashpriborintorg Kiev: 374
Mashpriborintorg Kiev-2: 374
Mashpriborintorg Kiev-2A: 374
Mashpriborintorg Kiev-3: 374
Mashpriborintorg Kiev-3A: 374
Mashpriborintorg Kiev-4: 374
Mashpriborintorg Kiev-4A: 374
Mashpriborintorg Kiev 30: 374
Mashpriborintorg Kiev-Vega: 374
Mashpriborintorg Kiev-Vega 2: 374
Mashpriborintorg Narciss: 375
Mashpriborintorg "No-Name" Kiev: 374
Mashpriborintorg Smena: 375
Mashpriborintorg Smena Symbol: 375
Mashpriborintorg Yanka II: 373
MASKS (Non-Camera): 650
MASON: 375
Mason Argus Repeating Camera: 375
Mason Companion: 375
Mason Field camera: 375
Mason Harvard camera: 375
Mason Phoenix Dollar Camera: 375
Master Reflex (WEFO): 554
Masters of the Universe (HG Toys): 280
Matador (Kenngott): 311
Match King (Non-Camera): 638
Matchbox (EKC): 180
Matey 127 Flash (Imperial): 303
Maton (Multipose): 404
MATTEL (Non-Camera): 648,666
MAWSON: 375
Mawson Wet-plate camera: 375
Mawson Wet-plate stereo camera: 375
Maxim MF-IX: 375
Maxim No. 1, No. 2, No. 4 (Butcher): 92
Maximar (Ica): 295
Maximar (Zeiss): 589
Maximar A, B (Zeiss): 589

739

Maxxum (Minolta): 394
MAY, ROBERTS & CO.: 375
May, Roberts & Co. Sandringham: 375
May Fair: 375
MAYFIELD COBB & CO.: 376
Mayfield Companion: 376
MAZO: 376
Mazo Field & Studio camera: 376
Mazo Stereo camera: 376
MB, No. 4 (Marlow): 372
McBEAN: 376
McBean Stereo Tourist: 376
McCROSSAN: 376
McCrossan Wet-plate camera: 376
McGHIE & CO.: 376
McGhie Detective camera: 376
McGhie Field camera: 376
McGhie Studio View: 376
McDonalds (Non-Camera): 647
McKELLEN: 376
McKellen Treble Patent Camera: 376
Me 35 4-U (United States Projector & Electronics Corp.): 530
MEAGHER: 376
Meagher Stereo Camera: 376
Meagher Tailboard camera: 376
Meagher Wet-plate cameras: 376
Mec-16, Mec-16 SB (Feinwerk): 228
Mecaflex (Kilfitt): 313
Mecilux (Lachaize): 340
Mecum: 376
Medalist, II (EKC): 180
MEFAG: 376
Mefag Handy Box: 376
Megascope (Caillon): 94
Mego Matic: 376
Megor (Meyer): 379
MEGURO KOGAKU KOGYO CO.: 376
Meguro Melcon: 376
Meikai (Tougodo): 524
Meikai EL (Tougodo): 525
Meiritto No. 3 (Tougodo): 525
Meister Korelle (WEFO): 554
Meisupi (Tougodo): 525
Meisupi, II, IV (Tougodo): 525
Meisupii Half (Tougodo): 525
Melanochromoscope (Lesueur): 357
Melcon (Meguro): 376
Memar (Ansco): 42
Memo (Agfa): 27
Memo (Ansco): 42
Memo (Minolta): 385
Memo II (Ansco): 43
Memo Automatic (Ansco): 42
Memo Set (Non-Camera): 654
Memory Kit (Ansco): 43
MENDEL: 376
Mendel Detective camera: 376
Mendel Triomphant: 376
MENDOZA: 376
Mendoza View camera: 376
MENTOR: 377
Mentor II (Goltz & Breutmann): 256
Mentor Compur Reflex (Goltz & B.): 256
Mentor Dreivier (Goltz & Breutmann): 256
Mentor Folding Reflex (Goltz & B.): 256
MENTOR KAMERAWERKE (Goltz): 256

Mentor Klappreflex (Goltz & B.): 256
Mentor Reflex (Goltz & Breutmann): 256
Mentor Sport Reflex (Goltz & B.): 256
Mentor Stereo Reflex (Goltz & B.): 256
Mentorett (Goltz & Breutmann): 257
MEOPTA: 377
MEOPTA (Movie): 620
Meopta Admira A8F, A8G: 620
Meopta Flexaret: 377
Meopta Mikroma, Mikroma II: 377
Meopta Milono: 377
Meopta Opema: 377
Meopta Stereo 35: 377
Meopta Stereo Mikroma (I), II: 377
Mercury (Universal): 532
Mercury II (Universal): 532
Mercury Satellite 127 (Imperial): 303
MERGOTT (Jem): 306
Meridan: 377
MERIDIAN INSTRUMENT CORP.: 377
Merit: 378
Merit Box (Merten): 378
Meritoire (Lancaster): 341
MERKEL: 378
Merkel Elite: 378
Merkel Metharette: 378
Merkel Minerva: 378
Merkur (Huttig): 291
Merkur (Laack): 339
Merlin (United Optical): 529
Merry Matic Flash Camera (Non-Camera): 666
MERTEN: 378
Merten Merit Box: 378
Merveilleux (Lancaster): 341
Metal Miniature (Marion): 372
Metascoflex: 378
Meteor (Taiyodo Koki): 514
Meteor (Universal): 533
Metharette (Merkel): 378
Metraflex II (Tougodo): 525
Metro-Cam (Metropolitan): 378
Metro Flash: 378
Metro Flash No. 1 Deluxe: 378
Metro-Flex (Metropolitan): 378
METRO MFG. CO.: 378
Metropolitan Clix 120: 378
Metropolitan Clix Deluxe: 378
Metropolitan Clix-Master: 378
Metropolitan Clix Miniature: 378
Metropolitan Clix-O-Flex: 378
METROPOLITAN INDUSTRIES: 378
Metropolitan King Camera: 379
Metropolitan Metro-Cam: 378
Metropolitan Metro-Flex: 378
METROPOLITAN SUPPLY CO.: 379
MEYER (Ferd. Franz): 379
MEYER (Hugo): 379
Meyer Field Camera: 379
Meyer Megor: 379
Meyer Silar: 379
MEYER & KASTE: 379
Meyer & Kaste Field camera: 379
Meyer & Kaste MF Stereo Camera: 379
MF Stereo Camera (Meyer & Kaste): 379
Miall Hand Camera (Fallowfield): 225
Mick-A-Matic (Child Guidance): 110

Mickey Mouse (Eiko): 209
Mickey Mouse (Ettelson): 223
Mickey Mouse (Helm): 276
Mickey Mouse (Houghton Ensign): 286
Mickey Mouse (Kunik): 325
Mickey Mouse Candle (Non-Camera): 636
Mickey Mouse Head (Helm): 276
Mickey Mouse Musical Toy Camera
 (Non-Camera): 652
Mickey Mouse Video Photographer
 (Non-Camera): 649
Mickey Rollbox (Balda): 61
Micro 16 (Whittaker): 560
Micro 110 cameras: 379
Micro Microcord: 380
Micro Microflex: 380
MICRO PRECISION PRODUCTS: 380
Microcord (Micro): 380
Microflex (Micro): 380
Microntaflex: 380
Micromegas (Hermagis): 279
Micronta 35 (Cosmo): 126
Microx Robot-to-Camera (Non-Camera): 644
Midas (Camera Projector): 606
MIDDLEMISS: 380
Middlemiss Patent Camera: 380
Midg (Butcher): 92
Midget: 380
Midget (Coronet): 125
Midget (Houghton Ensign): 286
Midget Jilona (Misuzu): 399
Midget Jilona Model III (Misuzu): 399
Midget Jilona No. 2 (Misuzu): 399
Midget Marvel (Wirgin): 563
Miethe/Bermpohl (Bermpohl): 72
Mighty (Toyo Kogaku): 527
Mighty Midget: 380
Mignon-Kamera (Ernemann): 220
Mihama Six IIIA (Suruga): 512
Mikado (Nishida): 420
Mikono-Flex P (Kojima): 317
Mikroma, Mikroma II (Meopta): 377
Mikuni (Kuribayashi): 327
MIKUT: 380
Mikut Color Camera: 380
Milbro (Yen-Kame): 380, 571
Milburn Korona (Gundlach): 270
Military Model Bantam f4.5 (EKC): 146
MILLER CINE CO. (Movie): 620
Miller Cine Model CA: 620
Millers Patent Detective (Chapman): 109
Million (Krugener): 324
Million (Yen-Kame): 465
Miloflex: 380
Milono (Meopta): 377
MIMOSA: 380
Mimosa I, II: 380
Mimy (Yashica): 570
Minca 28 (Argus): 54
Mine Six IIF (Takamine): 515
Mine Six Super 66 (Takamine): 515
Minerva (Merkel): 378
Minetta: 380
Minex (Adams & Co.): 19
Minex Tropical (Adams & Co.): 19
Minex Tropical Stereoscopic Reflex
 (Adams & Co.): 19

Mini-Camera: 380
Minia Camera (Levi): 357
Miniatur-Clack (Rietzschel): 463
Miniature Ernoflex (Ernemann): 220
Miniature Klapp (Ernemann): 220
Miniature Speed Graphic (Graflex): 266
Minicord (Goerz): 254
Minicord III (Goerz): 255
Minifex (Fotofex): 235
Miniflex (Minolta): 392
Minifoto Junior (Candid Camera Supply): 97
Minimal (Ica): 295
Minimax-Lite (Nikoh): 416
Minimum Delta (Krugener): 324
Minimum Palmos (Ica): 295
Minimum Palmos (Zeiss): 573
Minimum Palmos Stereo (Zeiss): 573
Minimus (Leroy): 356
Minimus Leroy (Gürin): 269
Minion (Tokyo Kogaku): 522
Minion 35 (Tokyo Kogaku): 522
Minnigraph (Levy-Roth): 357
Mino Flex Snap Lite (Non-Camera): 637
MINOLTA: 380-394
Minolta: 383
Minolta 16: 393
Minolta 16 Model I: 393
Minolta 16-EE-II: 393
Minolta 16-EE: 393
Minolta 16-II: 393
Minolta 16-MG-S: 394
Minolta 16-MG: 393
Minolta 16-P: 393
Minolta 16-PS: 393
Minolta 16-QT: 394
Minolta 24 Rapid: 390
Minolta 35, Model I: 385
Minolta 35, Model II: 385
Minolta 35, Model IIB: 385
Minolta 35, Model E: 385
Minolta 35, Model F: 385
Minolta 110 Zoom SLR: 394
Minolta 110 Zoom SLR Mark II: 394
Minolta A: 385
Minolta A2: 385
Minolta A3: 386
Minolta A5: 386
Minolta Aerial camera: 384
Minolta AL: 388
Minolta AL-2: 388
Minolta AL-F: 388
Minolta AL-S: 388
Minolta Ansco Autoset: 389
Minolta Anscoset III: 388
Minolta Arcadia: 382
Minolta Auto Minolta: 384
Minolta Auto Semi-Minolta: 383
Minolta Autocord: 392
Minolta Autocord CdS I,II,III: 392
Minolta Autocord L, LMX: 392
Minolta Autocord RA: 392
Minolta Automat: 392
Minolta Autopak 500: 390
Minolta Autopak 700: 390
Minolta Autopak 800: 390
Minolta Autopress: 384
Minolta Autowide: 386

Minolta Baby Minolta: 383
Minolta Best: 383
Minolta Electro Shot: 390
Minolta ER: 389
Minolta GAF Ansco Autoset CdS: 390
Minolta Happy: 382
Minolta Hi-Matic: 389
Minolta Hi-Matic 7: 389
Minolta Konan 16: 393
Minolta Marble: 383
Minolta Maxxum: 394
Minolta Memo: 385
Minolta Miniflex: 392
Minolta Minoltacord: 392
Minolta Minoltacord Automat: 392
Minolta Minoltaflex (I): 392
Minolta Minoltaflex II: 392
Minolta Minoltaflex IIB: 392
Minolta Minoltaflex III: 392
Minolta Minoltina P: 390
Minolta Minoltina-S: 390
Minolta Nifca-Dox: 382
Minolta Nifca-Klapp: 381
Minolta Nifca-Sport: 381
Minolta Nifcalette: 381
Minolta Repo: 389
Minolta Repo-S: 389
Minolta Sales & Service: ADV
Minolta SR-1: 387
Minolta SR-1S: 387
Minolta SR-2: 386
Minolta SR-3: 387
Minolta SR-505: 391
Minolta SR-7: 388-389
Minolta SR-M: 391
Minolta SRT-100: 390
Minolta SRT-101: 390
Minolta SRT-101B: 391
Minolta SRT-102: 391
Minolta SRT-200: 391
Minolta SRT-201: 391
Minolta SRT-202: 391
Minolta SRT-303: 391
Minolta SRT-303B: 391
Minolta SRT-MC: 391
Minolta SRT-MCII: 391
Minolta SRT-SC: 391
Minolta SRT-SCII: 391
Minolta SRT Super: 391
Minolta Semi-Minolta I, II, III: 382
Minolta Semi-Minolta P: 383
Minolta Six: 384
Minolta Sky: 386
Minolta Sonocon 16mm MB-ZA: 393
Minolta Super A: 386
Minolta Uniomat: 388
Minolta Uniomat III: 388
Minolta Vest: 383
Minolta V2: 387
Minolta V3: 388
Minolta Wanted: ADV
Minolta XD: 391
Minolta XD-7: 391
Minolta XD-11: 391
Minoltacord (Minolta): 393
Minoltacord Automat (Minolta): 392
Minoltaflex (I) (Minolta): 392

Minoltaflex II (Minolta): 392
Minoltaflex IIB (Minolta): 392
Minoltaflex III (Minolta): 392
Minoltina P (Minolta): 390
Minoltina-S (Minolta): 390
Minon Six II (Yamato): 568
MINOX: 394
Minox, original: 394
Minox A: 395
Minox B: 395
Minox BL: 395
Minox C: 395
Minox LX Gold-plated: 395
Minox II: 395
Minox III: 395
Minox III, Gold-plated: 395
Minox III-S: 395
Minox "Made in USSR": 395
Minute 16 (Universal): 533
M.I.O.M. Jacky: 395
M.I.O.M. Lec Junior: 396
M.I.O.M. Loisir: 396
M.I.O.M. Miom: 396
M.I.O.M. Photax "Blindé": 396
M.I.O.M. Photax (original): 396
Mir (Zorki): 598
Miracle: 396
Miraflex (Compco): 115
Mirage: 396
Miranda A: 397
Miranda AII: 397
Miranda Automex: 397
Miranda Automex II: 397
Miranda Automex III: 397
Miranda B: 397
Miranda C: 397
MIRANDA CAMERA CO. LTD.: 396-399
Miranda D: 398
Miranda DR: 398
Miranda F: 398
Miranda Fv: 398
Miranda G: 399
Miranda S: 398
Miranda Sensoret: 397
Miranda ST: 398
Miranda Standard (T): 397
Miranda T: 397
Miroflex (Contessa): 119
Miroflex A (Zeiss): 589
Miroflex B (Zeiss): 589
Mirror Reflex Camera (Hall): 272
MISUZU TRADING CO.: 399
Misuzu Midget Jilona: 399
Misuzu Midget Jilona Model III: 399
Misuzu Midget Jilona No. 2: 399
MITCHELL CAMERA CORP. (Movie): 620
Mitchell: 620
Mithra 47: 399
Mity: 400
MIYAGAWA SEISAKUSHO: 400
Miyagawa Boltax I,II,III: 400
Miyagawa Picny: 400
MIZUHO KOKI: 400
Mizuho-Six: 400
Modern (Marion): 372
MÖLLER: 400
Möller Cambinox: 400

INDEX

Nil Melior Stereo (Macris-Boucher): 366
Nimco (Braun): 86
Ninoka: 416
Nippon (Nicca): 414
NIPPON CAMERA WORKS (NICCA): 414
NIPPON KOGAKU (Movie): 621
NIPPON KOGAKU K.K.: 416-420
NIPPON KOSOKUKI SEISAKUSHO: 420
Nippon Nikkorex 8, 8F: 621
Nippon Nikkorex 35: 417
Nippon Nikkorex 35-2: 417
Nippon Nikkorex Auto 35: 417
Nippon Nikkorex F: 417
Nippon Nikkorex Zoom 8: 621
Nippon Nikkorex Zoom 35: 417
Nippon Taroflex: 420
NISHIDA KOGAKU: 420
Nishida Mikado: 420
Nishida Wester Autorol: 420
Nitor (Agfa): 27
NITTO SEIKO: 420
Nitto Elega-35: 420
Nixe (Ica): 295
Nixe (Zeiss): 590
NIZO (Movie): 621
Nizo Exposomat 8R, 8T: 622
Nizo Heliomatic 8 S2R, Focovario: 622
No Name Contax (Zeiss): 581
No-Name Kiev (Mashpriborintorg): 374
No Need Dark Room (Yen-Kame): 571
No. 0 Brownie (EKC): 149
No. 0 Buster Brown (Ansco): 39
No. 0 Buster Brown Special (Ansco): 39
No. 0 Folding Pocket Kodak (EKC): 169
No. 0 Graphic (Graflex): 263
No. 0 Premo Junior (EKC): 187
No. 00 Cartridge Premo (EKC): 185
No. 00 Folding Klito (Houghton): 289
No. 1 Ansco Junior: 41
No. 1 Autographic Kodak Junior (EKC): 145
No. 1 Autographic Kodak Special (EKC): 145
No. 1 Brownie (EKC): 149
No. 1 Cone Pocket Kodak (EKC): 163
No. 1 Film Premo (EKC): 186
No. 1 Folding Ansco: 40
No. 1 Folding Buster Brown (Ansco): 39
No. 1 Folding Pocket Kodak (EKC): 169
No. 1 Goodwin Jr. (Ansco): 41
No. 1 Kodak (EKC): 143
No. 1 Kodak Junior (EKC): 177
No. 1 Kodak Series III (EKC): 178
No. 1 Panoram Kodak (EKC): 182
No. 1 Pocket Kodak (EKC): 183
No. 1 Pocket Kodak Junior (EKC): 184
No. 1 Pocket Kodak Series II (EKC): 184
No. 1 Pocket Kodak Special (EKC): 184
No. 1 Premo Junior (EKC): 187
No. 1 Premoette (EKC): 188
No. 1 Premoette Junior (EKC): 189
No. 1 Premoette Junior Special (EKC): 189
No. 1 Premoette Special (EKC): 189
No. 1 Seneca Junior (Seneca): 493
No. 1 Special Folding Ansco: 40
No. 1 Speedex (Agfa): 29
No. 1 Student: 510
No. 1 Tourist Buckeye (American Camera Mfg.): 36

No. 1A Ansco Junior: 41
No. 1A Autographic Kodak (EKC): 144
No. 1A Autographic Kodak Junior (EKC): 145
No. 1A Autographic Kodak Special (EKC): 145
No. 1A Folding Ansco: 40
No. 1A Folding Goodwin (Ansco): 41
No. 1A Folding Hawk-Eye (EKC): 173
No. 1A Folding Pocket Kodak (EKC): 169
No. 1A Folding Pocket Kodak Special (EKC): 169
No. 1A Folding Rexo (Burke & James): 89
No. 1A Gift Kodak (EKC): 171
No. 1A Ingento Jr. (Burke & James): 89
No. 1A Kodak Junior (EKC): 177
No. 1A Kodak Series III (EKC): 178
No. 1A Pocket Kodak (EKC): 183
No. 1A Pocket Kodak Junior (EKC): 184
No. 1A Pocket Kodak Series II (EKC): 184
No. 1A Pocket Kodak Special (EKC): 184
No. 1A Premo Junior (EKC): 187
No. 1A Premoette (EKC): 188
No. 1A Premoette Junior (EKC): 189
No. 1A Premoette Junior Special (EKC): 189
No. 1A Premoette Special (EKC): 189
No. 1A Rexo Jr. (Burke & James): 89
No. 1A Special Kodak (EKC): 200
No. 1A Speed Kodak (EKC): 200
No. 2 Agfa-Ansco Box (Agfa): 22
No. 2 Brownie (EKC): 149
No. 2 Buckeye (American Camera): 35
No. 2 Bull's-Eye (EKC): 159
No. 2 Bull's-Eye Special (EKC): 160
No. 2 Bullet (EKC): 160
No. 2 Bullet Special (EKC): 161
No. 2 Buster Brown (Ansco): 39
No. 2 Buster Brown Special (Ansco): 39
No. 2 Cartridge Hawk-Eye (EKC): 172
No. 2 Cartridge Premo (EKC): 186
No. 2 Eclipse (Horsman): 283
No. 2 Eureka (EKC): 166
No. 2 Eureka Jr. (EKC): 166
No. 2 Falcon (EKC): 166
No. 2 Falcon Improved Model (EKC): 166
No. 2 Film Pack Hawk-Eye (EKC): 173
No. 2 Flexo Kodak (EKC): 167
No. 2 Folding Autographic Brownie (EKC): 153
No. 2 Folding Brownie (EKC): 153
No. 2 Folding Bull's-Eye (EKC): 160
No. 2 Folding Cartridge Hawk-Eye (EKC): 173
No. 2 Folding Cartridge Premo (EKC): 187
No. 2 Folding Buster Brown (Ansco): 39
No. 2 Folding Film Pack Hawk-Eye (EKC): 173
No. 2 Folding Hawk-Eye Special (EKC): 173
No. 2 Folding Pocket Brownie (EKC): 154
No. 2 Folding Pocket Kodak (EKC): 169
No. 2 Folding Rainbow Hawk-Eye (EKC): 174
No. 2 Folding Rainbow Hawk-Eye Special (EKC): 174
No. 2 Goodwin (Ansco): 41

No. 2 Hawkette (EKC): 172
No. 2 Hawk-Eye (EKC): 172
No. 2 Hawk-Eye Special (EKC): 174
No. 2 Kewpie (Conley): 116
No. 2 Kodak (EKC): 143
No. 2 Rainbow Hawk-Eye (EKC): 174
No. 2 Speedex (Agfa): 29
No. 2 Stereo Brownie (EKC): 158
No. 2 Stereo Kodak (EKC): 201
No. 2 Student: 510
No. 2 Target Hawk-Eye (EKC): 174
No. 2 Target Hawk-Eye Junior (EKC): 174
No. 2 Weno Hawk-Eye (Blair): 79
No. 2 Weno Hawk-Eye (EKC): 174
No. 2A Agfa-Ansco Box (Agfa): 22
No. 2A Brownie (EKC): 149
No. 2A Buster Brown (Ansco): 39
No. 2A Buster Brown Special (Ansco): 39
No. 2A Cartridge Hawk-Eye (EKC): 172
No. 2A Cartridge Premo (EKC): 186
No. 2A Film Pack Hawk-Eye (EKC): 173
No. 2A Folding Autographic Brownie
 (EKC): 153
No. 2A Folding Buster Brown (Ansco): 39
No. 2A Folding Cartridge Hawk-Eye
 (EKC): 173
No. 2A Folding Cartridge Premo (EKC): 187
No. 2A Folding Hawk-Eye Special (EKC):
 173
No. 2A Folding Pocket Brownie (EKC): 154
No. 2A Folding Rainbow Hawk-Eye (EKC):
 174
No. 2A Folding Rainbow Hawk-Eye
 Special (EKC): 174
No. 2A Folding Scout (Seneca): 493
No. 2A Goodwin (Ansco): 41
No. 2A Hawk-Eye (EKC): 172
No. 2A Hawk-Eye Special (EKC): 174
No. 2A Kewpie (Conley): 116
No. 2A Rainbow Hawk-Eye (EKC): 174
No. 2A Target Hawk-Eye (EKC): 174
No. 2C Ansco Junior: 41
No. 2C Autographic Kodak Junior (EKC):
 145
No. 2C Autographic Kodak Special (EKC):
 145
No. 2C Brownie (EKC): 149
No. 2C Buster Brown (Ansco): 39
No. 2C Cartridge Premo (EKC): 186
No. 2C Folding Autographic Brownie
 (EKC): 154
No. 2C Folding Cartridge Premo (EKC): 187
No. 2C Folding Scout (Seneca): 493
No. 2C Kewpie (Conley): 116
No. 2C Kodak Series III (EKC): 178
No. 2C Pocket Kodak (EKC): 183
No. 2C Pocket Kodak Special (EKC): 184
No. 2C Rexo Jr. (Burke & James): 89
No. 3 Ansco Junior: 41
No. 3 Autographic Kodak (EKC): 144
No. 3 Autographic Kodak Special (EKC): 145
No. 3 Brownie (EKC): 149
No. 3 Buckeye (American Camera): 35
No. 3 Bull's-Eye (EKC): 159
No. 3 Buster Brown (Ansco): 39
No. 3 Cartridge Kodak (EKC): 161
No. 3 Combination Hawk-Eye (Blair): 76

No. 3 Eclipse (Horsman): 283
No. 3 Film Premo (EKC): 186
No. 3 Flush Back Kodak (EKC): 167
No. 3 Folding Ansco: 40
No. 3 Folding Brownie (EKC): 153
No. 3 Folding Buster Brown (Ansco): 39
No. 3 Folding Hawk-Eye (Blair): 77
No. 3 Folding Hawk-Eye (EKC): 173
No. 3 Folding Hawk-Eye Special (EKC): 173
No. 3 Folding Kodet (EKC): 179
No. 3 Folding Pocket Kodak (EKC): 170
No. 3 Folding Pocket Kodak, Deluxe
 (EKC): 170
No. 3 Folding Rexo (Burke & James): 90
No. 3 Folding Scout (Seneca): 493
No. 3 Goodwin (Ansco): 41
No. 3 Kewpie (Conley): 116
No. 3 Kodak (EKC): 143
No. 3 Kodak Jr. (EKC): 143
No. 3 Kodak Series III (EKC): 178
No. 3 Pocket Kodak Special (EKC): 184
No. 3 Premo Junior (EKC): 187
No. 3 Rexo Jr. (Burke & James): 90
No. 3 Special Kodak (EKC): 200
No. 3 Weno Hawk-Eye (Blair): 79
No. 3 Zenith Kodak (EKC): 206
No. 3A Ansco Junior: 41
No. 3A Autographic Kodak (EKC): 144
No. 3A Autographic Kodak Junior (EKC):
 145
No. 3A Autographic Kodak Special (EKC):
 145
No. 3A Buster Brown (Ansco): 39
No. 3A Folding Ansco: 40
No. 3A Folding Autographic Brownie
 (EKC): 154
No. 3A Folding Brownie (EKC): 153
No. 3A Folding Buster Brown (Ansco): 39
No. 3A Folding Cartridge Hawk-Eye
 (EKC): 173
No. 3A Folding Cartridge Premo (EKC): 187
No. 3A Folding Hawk-Eye (EKC): 173
No. 3A Folding Hawk-Eye Special (EKC):
 173
No. 3A Folding Ingento (Burke & James): 89
No. 3A Folding Pocket Kodak (EKC): 170
No. 3A Folding Rexo (Burke & James): 90
No. 3A Folding Scout (Seneca): 493
No. 3A Ingento Jr. (Burke & James): 89
No. 3A Kewpie (Conley): 116
No. 3A Kodak Series II (EKC): 179
No. 3A Kodak Series III (EKC): 179
No. 3A Panoram Kodak (EKC): 182
No. 3A Pocket Kodak (EKC): 183
No. 3A Signal Corps Model K-3 (EKC): 145
No. 3A Special Kodak (EKC): 200
No. 3B Quick Focus Kodak (EKC): 190
No. 4 Autographic Kodak (EKC): 144
No. 4 Bull's-Eye (EKC): 159
No. 4 Bull's-Eye Special (EKC): 160
No. 4 Bullet (EKC): 160
No. 4 Bullet Special (EKC): 161
No. 4 Cartridge Kodak (EKC): 161
No. 4 Eureka (EKC): 166
No. 4 Folding Ansco: 41
No. 4 Folding Hawk-Eye (Blair): 77
No. 4 Folding Hawk-Eye (EKC): 173

Perken Studio camera: 442
Perken Tailboard camera: 442
Perkeo (Leonar): 356
Perkeo (Voigtländer): 545
Perkeo I, II (Voigtländer): 545
Perkeo E (Voigtländer): 545
Perle (Welta): 555
Perlux (Neidig): 410
Pet 35 (Fuji): 242
Petal (Sakura): 479
Peter Pan Gramophone (Non-Camera): 655
Petie (Kunik): 326
Petie Lighter (Kunik): 326
Petie Vanity (Kunik): 326
Petietux (Kunik): 326
Petitax (Kunik): 326
Petite (Century): 105
Petite (EKC): 182
Petite Kamarette (Blair): 78
Petri 1.8 Color Super (Kuribayashi): 332
Petri 1.9 Color Super (Kuribayashi): 332
Petri 2.8 Color Super (Kuribayashi): 332
Petri 35 (Kuribayashi): 331
Petri 35 1.9 (Kuribayashi): 331
Petri 35 2.0 (Kuribayashi): 331
Petri 35 2.8 (Kuribayashi): 331
Petri 35 RE (Kuribayashi): 333
Petri 35X, MX (Kuribayashi): 331
Petri Auto Rapid (Kuribayashi): 335
Petri Automate (Kuribayashi): 331
PETRI CAMERA CO. (KURIBAYASHI): 327
Petri Color 35 (Kuribayashi): 333
Petri Color 35E (Kuribayashi): 333
Petri Compact (Kuribayashi): 333
Petri Compact 17 (Kuribayashi): 333
Petri Compact E (Kuribayashi): 333
Petri Computor 35 (Kuribayashi): 333
Petri EBn (Kuribayashi): 332
Petri Eight (Kuribayashi): 619
Petri ES Auto 1.7 (Kuribayashi): 333
Petri ES Auto 2.8 (Kuribayashi): 333
Petri FA-1 (Kuribayashi): 335
Petri Flex (Kuribayashi): 330,334
Petri Flex Seven (Kuribayashi): 334
Petri Flex V (Kuribayashi): 334
Petri Fotochrome (Kuribayashi): 336
Petri FT (Kuribayashi): 334
Petri FT-II (Kuribayashi): 334
Petri FT 500 (Kuribayashi): 334
Petri FT 1000 (Kuribayashi): 334
Petri FT EE (Kuribayashi): 335
Petri FTE (Kuribayashi): 335
Petri FTX (Kuribayashi): 334
Petri Grip-Pac 110 (Kuribayashi): 335
Petri Half (Kuribayashi): 333
Petri Hi-Lite (Kuribayashi): 333
Petri Instant Back (Kuribayashi): 335
Petri Junior (Kuribayashi): 333
Petri M 35 (Kuribayashi): 333
Petri MFT 1000 (Kuribayashi): 334
Petri Micro Compact (Kuribayashi): 333
Petri Micro MF-1 (Kuribayashi): 334
Petri Penta (Kuribayashi): 334
Petri Penta V2 (Kuribayashi): 334
Petri Penta V3 (Kuribayashi): 334
Petri Penta V6 (Kuribayashi): 334
Petri Penta V6-II (Kuribayashi): 334

Petri Pocket 2 (Kuribayashi): 335
Petri Power Eight (Kuribayashi): 619
Petri Prest (Kuribayashi): 333
Petri Pro Seven (Kuribayashi): 332
Petri Push-Pull 110 (Kuribayashi): 335
Petri Racer (Kuribayashi): 332
Petri RF, RF 120 (Kuribayashi): 330
Petri Semi (Kuribayashi): 330
Petri Seven (Kuribayashi): 332
Petri Seven S (Kuribayashi): 332
Petri Seven S-II (Kuribayashi): 332
Petri Super (Kuribayashi): 330
Petri Super Eight (Kuribayashi): 619
Petri Super V (Kuribayashi): 330
Petriflex (Kuribayashi): 330,334
PFCA: 442
PH-6-A (Burke & James): 89
Phenix Camera-Lighter (Non-Camera): 638
Phips (Münster): 406
PHO-TAK CORP.: 442
Pho-Tak Eagle Eye: 442
Pho-Tak Foldex: 442
Pho-Tak Macy 120: 442
Pho-Tak Marksman: 442
Pho-Tak Reflex I: 442
Pho-Tak Scout 120 Flash: 442
Pho-Tak Spectator Flash: 442
Pho-Tak Trailblazer 120: 442
Pho-Tak Traveler 120: 442
PHOBA A.G.: 442
Phoba Diva: 442
Phocira: 442
Phoenix (Kenngott): 311
Phoenix Dollar Camera (Mason): 375
PHONOGRAPHS (Non-Camera): 655
Photake (Chicago Camera Co.): 110
Photantiques: ADV
Photavit: 442
Photavit (Bolta): 83
Photavit Photina, III: 442
PHOTAVIT-WERK: 442
PHOTAVIT-WERK (Bolta): 83
Photax (original) (M.I.O.M.): 396
Photax "Blindé" (M.I.O.M.): 396
Photina, III (Photavit): 442
Photo-Bijou Lance-Eau (Non-Camera): 661
Photo-Binocle-Stereo (Goerz): 253
Photo Binocular 110 (American Rand): 37
Photo-Bouquin Stereoscopique (Bloch): 79
Photo-Box: 442
Photo Button Camera (PDQ): 437
Photo-Champ (Cardinal): 104
Photo-Craft (Altheimer & Baer): 34
Photo Cravate (Bloch): 79
PHOTO DEVELOPMENTS LTD.: 442
Photo Developments Envoy: 442
Photo-Eclair (Fetter): 229
Photo-Flash Camera-Lighter
 (Non-Camera): 637
PHOTO HALL: 442
Photo Hall Perfect, folding: 442
Photo Hall Perfect Detective: 442
Photo Hall Perfect Jumelle: 352
Photo Hall Stereo camera: 443
Photo-it: 443
PHOTO-IT MFG. CO.: 443
Photo Jumelle (Carpentier): 104

Plan Primar (Bentzin): 70
Planovista (Bentzin): 70
PLANOVISTA SEEING CAMERA LTD.: 448
PLANTERS (Non-Camera): 656
Plascaflex PS35 (Potthoff): 455
Plaskop (Ica): 296
Plaskop (Krugener): 324
Plaskop (Zeiss): 591
PLASMAT GmbH: 448
Plasmat Roland: 448
PLASTICS DEVELOPMENT CORP.: 448
Plastics Development Snapshooter: 448
Plastoscop (Krugener): 325
Plate (Non-Camera Kodak plate): 648
Platten Tip I (Rietzschel): 464
PLAUBEL & CO.: 449
Plaubel Aerial Camera: 449
Plaubel Baby Makina: 449
Plaubel Folding-bed plate cameras: 449
Plaubel Makina: 449
Plaubel Makina II: 449
Plaubel Makina IIa: 449
Plaubel Makina IIb: 449
Plaubel Makina IIS: 449
Plaubel Makina III: 449
Plaubel Makinette: 449
Plaubel Normal Peco: 449
Plaubel Prazision Peco: 450
Plaubel Roll-Op (II): 450
Plaubel Stereo Makina: 450
Plaubel Veriwide 100: 450
PLAUL: 450
Plaul Field Camera: 450
Plavic: 450
PLAYTIME PRODUCTS: 450
Playtime Prod. Cabbage Patch Kids: 450
Playtime Prod. Go Bots: 451
PLAYWELL (Non-Camera): 668
Plenax (Agfa): 28
Plico (EKC): 183
Plik: 451
PLUS: 451
Plusflex 35 (Plus): 451
POCK: 451
Pock Detective camera: 451
Pocket (Yen-Kame): 571
Pocket A-1 (EKC): 183
Pocket B-1 (EKC): 183
Pocket Camera (Hall): 272
Pocket Camera-Viewer (Non-Camera):
 671
Pocket Coin Bank (Non-Camera): 635
Pocket Cyko Cameras (Griffin): 269
Pocket Dalco (K.W.): 337
Pocket Ensign (Houghton): 287
Pocket Instamatic (EKC): 183
Pocket Kodak (EKC): 183
Pocket Kodak Junior (EKC): 184
Pocket Kodak Series II (EKC): 184
Pocket Kodak Special (EKC): 184
Pocket Kozy (Kozy): 322
Pocket Magda: 451
Pocket Monroe: 401
Pocket Monroe A: 401-402
Pocket Monroe No. 2: 401
Pocket Platos: 451
Pocket Ray: 457

Pocket Poco (Rochester Camera): 469
Pocket Poco A (Rochester Camera): 469
Pocket Premo (EKC): 187
Pocket Premo (Rochester Optical): 472
Pocket Premo C (EKC): 187
Pocket Seneca Cameras (Seneca): 493
Pocket Z (Zion): 598
Pocket Z Stereo (Zion): 598
Pocket Zar (Western): 558
Poco (American Camera Mfg.): 36
Poco (Rochester Camera): 468
Poka (Balda): 62
POLAROID: 451-453
POLAROID LAND CAMERA (Movie): 625
Polaroid 80 (Highlander): 452
Polaroid 80A (Highlander): 452
Polaroid 80B: 452
Polaroid 95: 452
Polaroid 95A: 452
Polaroid 95B (Speedliner): 452
Polaroid 100 (Automatic 100): 452
Polaroid 100 (rollfilm): 452
Polaroid 101, 102, 103, 104: 452
Polaroid 110 (Pathfinder): 452
Polaroid 110A (Pathfinder): 453
Polaroid 110B (Pathfinder): 453
Polaroid 120: 453
Polaroid 125: 453
Polaroid 135: 453
Polaroid 150: 453
Polaroid 160: 453
Polaroid 180: 453
Polaroid 185: 453
Polaroid 190: 453
Polaroid 195: 453
Polaroid 415: 453
Polaroid 700: 453
Polaroid 800: 453
Polaroid 850: 453
Polaroid 900: 453
Polaroid Big Shot: 361
Polaroid J-33: 453
Polaroid J-66: 453
Polaroid Polavision: 625
Polaroid Swinger Model 20: 453
Polaroid Swinger Sentinel M15: 453
Polaroid SX-70: 453
Polaroid wanted: ADV
Polavision (Polaroid): 625
Police Camera (Expo): 224
Polo (Coronet): 125
Polomat (Adox): 21
Polyfoto: 454
Polyscop (Ica): 296
Polyscop (Zulauf): 599
Polyskop (Zeiss): 591
Pompadour (Hesekiel): 280
PONTIAC: 454
Pontiac Bakelite: 454
Pontiac Bloc-Metal 41,45: 454
Pontiac Lynx, Lynx II: 454
Pontiac Super Lynx I, II: 454
Pontina (Balda): 62
Pony II (EKC): 185
Pony IV (EKC): 185
Pony 135 (EKC): 185
Pony 828 (EKC): 185

Reinke/International/Fotodealer: ADV
Reko (Rochester Optical): 472
Reliance: 461
RELCO (Non-Camera): 646
Rembrandt Portrait (Burke & James): 89
Remington (Deluxe Products): 136
Remington (Monarch): 401
Remington Miniature: 461
Rentals: ADV
Repairs: ADV
Repo (Minolta): 389
Repo-S (Minolta): 389
Reporter (Braun): 87
Reporter (Gaumont): 247
Reporter (Ica): 296
Reporter (Wirgin): 563
Reporter 66 (Linden): 359
Reporter Junior II (Vredeborch): 550
Reporter Max: 461
Restoration: ADV
Retina (EKC): 191-196
Retina (117) (EKC): 191
Retina (118) (EKC): 191
Retina I (010) (EKC): 192
Retina I (013) (EKC): 192
Retina I (119) (EKC): 191
Retina I (126) (EKC): 191
Retina I (141) (EKC): 191
Retina I (143) (EKC): 191
Retina I (148) (EKC): 192
Retina I (149) (EKC): 192
Retina Ia (015) (EKC): 192
Retina Ib (018) (EKC): 192
Retina IB (019) (EKC): 192
Retina IBS (040) (EKC): 192
Retina IF (046) (EKC): 192
Retina II (011) (EKC): 193
Retina II (014) (EKC): 193
Retina II (122) (EKC): 192
Retina II (142) (EKC): 192
Retina IIa (016) (EKC): 193
Retina IIa (150) (EKC): 193
Retina IIc (020) (EKC): 193
Retina IIC (029) (EKC): 193
Retina IIF (047) (EKC): 193
Retina IIS (024) (EKC): 194
Retina IIIc (021) (EKC): 194
Retina IIIC (028) (EKC): 194
Retina IIIC (New Type) (EKC): 194
Retina IIIS (027) (EKC): 194
Retina Automatic I (038) (EKC): 195
Retina Automatic II (032) (EKC): 195
Retina Automatic III (039) (EKC): 195
Retina Reflex (025) (EKC): 195
Retina Reflex III (041) (EKC): 195
Retina Reflex IV (051) (EKC): 195
Retina Reflex S (034) (EKC): 196
Retina S1 (060) (EKC): 194
Retina S2 (061) (EKC): 195
Retinette (EKC): 196
Retinette (012) (EKC): 196
Retinette (017) (EKC): 196
Retinette (022) (EKC): 196
Retinette (147) (EKC): 196
Retinette I (030) (EKC): 196
Retinette IA (035) (EKC): 197
Retinette IA (042) (EKC): 197

Retinette IA (044) (EKC): 197
Retinette IB (037) (EKC): 197
Retinette IB (045) (EKC): 197
Retinette II (026) (EKC): 197
Retinette II (160) (EKC): 197
Retinette IIA (036) (EKC): 197
Retinette IIB (031) (EKC): 197
Retinette F (022/7) (EKC): 197
Reve (Girard): 250
REVERE: 461
Revere 8mm models: 626
Revere 101: 626
Revere 103: 626
Revere Automatic-1034: 461
REVERE CAMERA CO. (Movie): 626
Revere Eye-Matic CA-1 to CA-7: 626
Revere Eyematic EE 127: 461
Revere Magazine 16: 626
Revere Stereo 33: 461
Revere Super 8mm: 626
Reversible Back Camera (Blair): 78
Reversible Back Cycle Graphic (Graflex):
 265
Reversible Back Cycle Graphic Special
 (Graflex): 265
Reversible Back Graflex: 260
Reversible Back Premo (Rochester
 Optical): 472
Revolving Back Auto Graflex: 261
Revolving Back Cycle Graphic (Graflex):
 265
Revue 3 (Foto-Quelle): 235
Revue 16 KB (Foto-Quelle): 235
Revue Mini-Star (Foto-Quelle): 235
REWO: 461
Rewo Louise: 461
REX: 461
Rex (Coronet): 126
Rex Baby Powell: 461
Rex Kayson: 461
REX MAGAZINE CAMERA CO.: 461
Rex Magazine Camera: 461
Rex Miniature (Utility): 537
Rexo (Burke & James): 89
Rexoette (Burke & James): 90
REYGONAUD: 461
Reygonaud Stand camera: 461
Reyna II (Cornu): 122
Reyna Cross III (Cornu): 122
Reyna Cross III (Royet): 478
REYNOLDS & BRANSON: 462
Reynolds Field camera: 462
Rhaco (Hendren): 277
Rhaco Monopol (Hendren): 277
RHEINMETALL: 462
Rheinmetall Exa System: 462
Rheinmetall Perfekta, II: 462
Rica-Flex (Richter): 463
Rich-Ray: 462
Rich-Ray Richlet 35: 462
RICH-RAY TRADING CO.: 462
RICHARD (F.M.): 462
RICHARD (Jules): 462
Richard Detective: 462
Richard Glyphoscope: 462
Richard Homeos: 462
Richard Homeoscope: 463

Rolleiflex 2.8C (Franke & Heidecke): 240
Rolleiflex 2.8D (Franke & Heidecke): 240
Rolleiflex 4x4 Baby (Franke & Heidecke):
 (original): 240
 Grey Baby: 241
 Post-war Black Baby: 241
Rolleiflex Automats (Franke & Heidecke):
 (1937): 239
 (1939): 239
 (MX-EVS): 239
 (MX-sync): 239
 (X-sync): 239
Rolleiflex E (Franke & Heidecke): 240
Rolleiflex E2 (Franke & Heidecke): 240
Rolleiflex E3 (Franke & Heidecke): 240
Rolleiflex F2.8 Aurum (F & H): 240
Rolleiflex New Standard (F & H): 240
Rolleiflex Old Standard (F & H): 240
Rolleiflex SL26 (Franke & Heidecke): 18
Rolleiflex Studio (Franke & Heidecke): 240
Rolleiflex T (Franke & Heidecke): 240
Rolleiflex Tele (Franke & Heidecke): 240
Rolleiflex Wide-Angle (F & H): 240
Rolleimagic (Franke & Heidecke): 241
Rolleimagic II (Franke & Heidecke): 241
Rollette (Krauss): 323
Rollette Luxus (Krauss): 323
Rollex (SCAPEC): 483
Rollex 20 (United States Camera): 530
Rollfilm Vesta (Adams): 19
Rollo-Frex: 475
Rollop (Lippische): 360
Rollop Automatic (Lippische): 360
Rolls: 475
Rolls Beauta Miniature Candid: 475
ROLLS CAMERA MFG. CO.: 475
Rolls Picta Twin 620: 475
Rolls Super Rolls: 475
Rolls Twin 620: 476
Romax Hand (Kuribayashi): 328
Romney, Ed: ADV
Romper Room Snoopy Counting Camera
 (Non-Camera): 671
Rondine (Ferrania): 229
Rondo Colormatic: 476
Rondo Rondomatic: 476
Rorox: 476
Rosko: 476
Rosko Brillant 620, Model 2 (Goyo): 257
ROSS: 476
ROSS ENSIGN: 477
Ross Ensign Fulvueflex: 477
Ross Folding Twin Lens Camera: 476
Ross Kinnear's Patent Wet-Plate
 Landscape Camera: 476
Ross Portable Divided Camera: 476
Ross Reflex: 476
Ross Snapper: 477
Ross Stereo Camera: 476
Ross Sutton Panoramic Camera: 476
Ross Tailboard Camera: 476
Ross Wet-plate camera: 476
Ross Wet-plate Stereo camera: 477
ROTH: 477
Roth Reflex: 477
Rothlar 4x4: 477
ROUCH: 477

Rouch Eureka: 477
Rouch Excelsior: 477
Rouch Patent camera: 477
ROUSSEL: 477
Roussel Stella Jumelle: 477
Rover: 478
Rover (Lancaster): 342
Roving Eye Camera (Non-Camera): 669
Rower (FAP): 226
Rox (Roche): 468
Roy (Imperial): 303
Roy Box (Haking): 271
Roy Rogers & Trigger (Herbert George):
 278
Royal (Adams & Co.): 19
Royal (Dacora): 129
Royal #1 (Royal-Hamilton): 478
Royal 35 (Royal): 478
Royal 35M (Royal): 478
ROYAL CAMERA CO.: 478
ROYAL CROWN (Non-Camera): 664
ROYAL-HAMILTON IND.: 478
Royal-Hamilton Royal #1: 478
ROYAL HOLLAND PEWTER
 (Non-Camera): 653
Royal Mail Postage Stamp Camera
 (Butcher): 93
Royal Mail Stereolette (Houghton): 289
Royal Reflex (Monarch): 401
Royal Ruby (Thornton-Pickard): 519
Royalty (Thornton-Pickard): 519
ROYCE MFG. CO.: 478
Royce Reflex: 478
ROYER: 478
Royer A: 478
Royer Altessa: 478
Royer Savoy II: 478
Royer Savoyflex, II: 478
ROYET: 478
Royet Reyna Cross III: 478
RUBBER STAMPS (Non-Camera): 658
Ruberg: 479
RUBERG & RENNER: 478
Ruberg Adickes: 478
Ruberg Baby Ruby: 479
Ruberg Fibituro: 479
Ruberg Futuro: 479
Ruberg Hollywood: 479
Ruberg Nenita: 479
Rubi-Fex 4x4 (Fex): 230
Rubin, RF cameras: ADV
Rubina Sixteen Model II (Tokyo Koki): 523
Rubix 16 (Sugaya): 510
Ruby (Thornton-Pickard): 519
Ruby Baby (Ruberg): 479
Ruby Deluxe (Thornton-Pickard): 519
Ruby Reflex (Thornton-Pickard): 519
Ruby Speed Camera (Thornton-P.): 519
Rubyette Nos. 1, 2, 3 (Thornton-P.): 519
Ruthine: 479
Ruvinal II,III (Shoei): 496
Sabre 620 (Shaw-Harrison): 495
Safari Foto Aqua (Non-Camera): 662
Safari X (Indo): 304
SAINT-ETIENNE: 479
Saint-Etienne Universelle: 479
SAKAKI SHOKAI CO. (Elmo): 210

Taiyodo Koki Epochs: 514
Taiyodo Koki Meteor: 514
Taiyodo Koki Reflex Beauty: 514
Taiyodo Koki Vestkam: 515
TAIYOKOKI CO. LTD.: 515
Taiyokoki Viscawide-16: 515
Taiyou Kankou Kamera (Printing Frame
 Camera) (Non-Camera): 657
Takahashi Arsen: 515
TAKAHASHI OPTICAL WORKS: 515
TAKAMINE OPT.: 515
Takamine Mine Six IIF: 515
Takamine Mine Six Super 66: 515
Take-A-Picture (Non-Camera): 665
TakIV (Walker): 551
Takyr (Krauss): 323
TALBOT (Romain): 515
TALBOT (Walter): 515
TALBOT & EAMER CO.: 516
Talbot & Eamer Talmer: 516
Talbot Errtee button tintype camera: 515
Talbot Errtee folding plate camera: 515
Talbot Errtee folding rollfilm camera: 515
Talbot Invisible Camera: 515
Talking Vue Camera (Non-Camera): 671
Talmer (Talbot & Eamer): 516
Tamarkin, Leica cameras: ADV
Tanack, Type IV-S (Tanaka): 516
Tanack IIC (Tanaka): 516
Tanack IIIF (Tanaka): 516
Tanack IIIS (Tanaka): 516
Tanack IIISa (Tanaka): 516
Tanack SD (Tanaka): 516
Tanack V3 (Tanaka): 516
Tanack VP (Tanaka): 516
TANAKA KOGAKU: 516
TANAKA OPTICAL CO. LTD.: 516
Tanaka Tanack, Type IV-S: 516
Tanaka Tanack IIC: 516
Tanaka Tanack IIIF: 516
Tanaka Tanack IIIS: 516
Tanaka Tanack IIISa: 516
Tanaka Tanack SD: 516
Tanaka Tanack V3: 516
Tanaka Tanack VP: 516
Tanit (Ferrania): 229
TARGET: 516
Target Brownie Six-16 (EKC): 159
Target Brownie Six-20 (EKC): 159
Target Hawk-Eye (EKC): 174
Target New Folding Stereo: 516
Taro Tenax (Goerz): 254
Taroflex (Nippon): 420
TARON CO.: 516
Taron 35: 516
Taron Chic: 516
Taron Super LM: 516
Taschen Clack 128 (Rietzschel): 464
Taschenbuch-Camera (Krugener): 325
Tauber: 516
Taxo (Contessa): 121
Taxo (Zeiss): 595
Taxona (Pentacon): 441
TAYLOR: 517
Taylor View camera: 517
TDC Stereo Vivid (Bell & Howell): 67
Techni-Pak 1 (Technicolor): 517

TECHNICOLOR CORP.: 517
TECHNICOLOR CORP. (Movie): 628
Technicolor Automatic 8: 628
Technicolor Techni-Pak 1: 517
Technika I, III (Linhof): 359
Technika Press 23 (Linhof): 360
Teddy (Ica): 297
Teddy Bear Photographer (Non-Camera):
 664
TEDDY CAMERA CO.: 517
Teddy Model A: 517
Teemee: 517
Tele-Ektra 1, 2 (EKC): 202
Tele-Instamatic (EKC): 202
Tele Rolleiflex (Franke & Heidecke): 240
Teleca (Toyo Photo): 522
Telephot Button Camera (British
 Ferrotype Co.): 87
Telephot Ray Model C: 458
Telephot Vega (Vega): 538
Telephoto Cycle Poco (Rochester
 Camera): 469
Telephoto Poco (Rochester Camera): 469
TELLA CAMERA CO. LTD.: 517
Tella No. 3 Magazine Camera: 517
Tenax (Goerz): 253
Tenax (Zeiss): 595
Tenax I (Zeiss): 595
Tenax II (Zeiss): 596
Tenax II accessories (Zeiss): 596
Tenax Automatic (Zeiss): 596
Tendertoys Camera (Non-Camera): 666
Tengoflex (Zeiss): 596
Tengor (Goerz Box Tengor): 253
Tennar (Fototecnica): 236
Tennar Junior (Fototecnica): 236
Tessco (Contessa): 121
Tessco (Zeiss): 596
Tessina (Concava): 115
Tex: 517
Texar Box (Vredeborch): 551
T.H. Water Camera (Non-Camera): 662
THOMAS: 517
Thomas Wet-plate camera: 517
THOMPSON: 517
Thompson Direct positive camera: 517
Thompson's Revolver Camera (Briois): 87
Thorens Excelda (Non-Camera): 656
THORNTON-PICKARD: 413-415
Thornton-Pickard Aerial Camera: 517
Thornton-Pickard Amber: 517
Thornton-Pickard Automan: 517
Thornton-Pickard College: 518
Thornton-Pickard Duplex Ruby Reflex: 518
Thornton-Pickard Duplex Ruby Reflex,
 Tropical: 518
Thornton-Pickard Folding plate camera: 518
Thornton-Pickard Folding Ruby: 518
Thornton-Pickard Horizontal Reflex: 518
Thornton-Pickard Imperial Perfecta: 518
Thornton-Pickard Imperial Pocket: 518
Thornton-Pickard Imperial Stereo: 518
Thornton-Pickard Imperial Triple
 Extension: 518
Thornton-Pickard Junior Special Ruby
 Reflex: 518
Thornton-Pickard Limit: 518

Thornton-Pickard Mark III Hythe Gun Camera: 518
Thornton-Pickard Puck Special: 518
Thornton-Pickard Royal Ruby: 519
Thornton-Pickard Royalty: 519
Thornton-Pickard Ruby: 519
Thornton-Pickard Ruby Deluxe: 519
Thornton-Pickard Ruby Reflex: 519
Thornton-Pickard Ruby Speed Camera: 519
Thornton-Pickard Rubyette Nos. 1, 2, 3: 519
Thornton-Pickard Snappa: 519
Thornton-Pickard Special Ruby: 519
Thornton-Pickard Special Ruby Reflex: 519
Thornton-Pickard Stereo Puck: 519
Thornton-Pickard Victory Reflex: 520
Thornton-Pickard Weenie: 520
Thornwood Dandy (Montgomery Ward): 402
THORPE: 520
Thorpe Four-tube camera: 520
THOWE CAMERAWERK: 520
Thowe Field camera: 520
Thowe folding plate camera: 520
Thowe Thowette: 520
Thowe Tropical plate camera: 520
Thowette (Thowe): 520
Three-color camera (Sanger): 481
Three-Colour Camera (Hilger): 281
Three-D Stereo Camera (Coronet): 126
Ticka (Houghton): 289
Ticka Enlarger (Houghton): 290
Ticka, Focal plane model (Houghton): 289
Ticka, Watch-Face (Houghton): 290
Tiezonette: 520
Tilley Buys Cameras: ADV
Time: 520
Time FC-100: 520
TIME FIELD CO.: 520
Time Field Pin-Zip 126: 520
Tintin Figurine (Non-Camera): 663
Tintype Camera (Daydark): 132
Tintype Camera (New York Ferrotype): 411
TIRANTI: 520
Tiranti Summa Report: 520
TIRANTY: 520
Tiranty Stereo Pocket: 520
TISCHLER: 520
Tischler Colibri: 520
TISDELL & WHITTELSEY: 520
TISDELL CAMERA & MFG. CO.: 520
Tisdell Hand Camera: 521
Tisdell T & W Detective Camera: 520
Titan (Ansco): 44
Tit-bit (Tylar): 528
Tivoli: 521
TIZER CO. LTD.: 521
Tizer Can Camera 110 TX Coca-Cola: 521
Tizer Orangina Camera: 521
T.K. Water Camera (Non-Camera): 662
T.K.K. (Taiyodo Koki): 514
TOAKOKI SEISAKUSHO: 521
Toakoki Gelto D III: 521
TOGODO OPTICAL CO.: 521
TOHO (Non-Camera): 667
TOHOKOKEN CAMERA: 521
Tohokoken Camel Model II: 521
Tokiwa Bioflex: 521
Tokiwa First Six I, III, V: 521

Tokiwa Firstflex: 521
Tokiwa Firstflex 35: 521
Tokiwa Hand (Kuribayashi): 328
Tokiwa Lafayette 35: 522
TOKIWA SEIKI: 521
Tokiwa Windsorflex: 522
TOKO PHOTO: 522
Toko Photo Cyclops: 522
Toko Photo Teleca: 522
Tokyo (Yen-Kame): 571
TOKYO KOGAKU: 522
Tokyo Kogaku Laurelflex: 522
Tokyo Kogaku Minion: 522
Tokyo Kogaku Minion 35: 522
Tokyo Kogaku Primo Jr., Jr. II: 522
Tokyo Kogaku Topcoflex Automat: 522
Tokyo Kogaku Topcon 35-L: 523
Tokyo Kogaku Topcon RE Super: 523
Tokyo Kogaku Topcon Auto 100: 523
Tokyo Kogaku Topcon B: 523
Tokyo Kogaku Topcon C: 523
Tokyo Kogaku Topcon D-1: 523
Tokyo Kogaku Topcon R: 523
Tokyo Kogaku Topcon Super D: 523
Tokyo Kogaku Topcon Uni: 523
TOKYO KOKEN CO.: 523
Tokyo Koken Dolca 35: 523
TOKYO KOKI CO.: 523
Tokyo Koki Rubina Sixteen Model II: 523
TOKYO SEIKI CO. LTD.: 523
Tokyo Seiki Doris: 523
Tom Thumb Camera Radio (Automatic Radio): 58
TOMY (Non-Camera): 667,669
Tone (Toyo Kogaku): 527
Top (Top Camera Works): 523
Top Camera (Maruso): 373
TOP CAMERA WORKS: 523
Top Camera Works Top: 523
Top II Camera (Maruso): 373
Topcoflex Automat (Tokyo Kogaku): 522
Topcon 35-L (Tokyo Kogaku): 523
Topcon RE Super (Tokyo Kogaku): 523
Topcon Auto 100 (Tokyo Kogaku): 523
Topcon B (Tokyo Kogaku): 523
Topcon C (Tokyo Kogaku): 523
Topcon D-1 (Tokyo Kogaku): 523
Topcon R (Tokyo Kogaku): 523
Topcon Super D (Tokyo Kogaku): 523
Topcon Uni (Tokyo Kogaku): 523
Topper: 523
Torel 110 Talking Camera: 524
TOSEI OPTICAL: 524
Tosei Optical Frank Six: 524
Toska (Huttig): 291
Toska (Ica): 297
Toska (Zeiss): 596
TOTSY MFG. CO. (Non-Camera): 669
Tougo (Tougodo): 525
Tougo Camera (Yen-Kame): 571
TOUGODO: 418-420
Tougodo Baby-Max: 524
Tougodo Buena 35-S: 524
Tougodo Click: 524
Tougodo Colly: 524
Tougodo Hit: 524
Tougodo Hobiflex: 524

Tougodo Hobix: 524
Tougodo Hobix Junior: 524
Tougodo Kino-44: 524
Tougodo Leader: 524
Tougodo Meikai: 524
Tougodo Meikai EL: 525
Tougodo Meiritto No. 3: 525
Tougodo Meisupi: 525
Tougodo Meisupi II, IV: 525
Tougodo Meisupii Half: 525
Tougodo Metraflex II: 525
Tougodo Stereo Hit: 525
Tougodo Tougo: 525
Tougodo Toyoca 16: 525
Tougodo Toyoca 35: 525
Tougodo Toyoca Ace: 525
Tougodo Toyocaflex: 525
Tougodo Toyocaflex 35: 526
Tour Partner (Non-Camera): 658
Tourist (EKC): 202
Tourist (Hare): 274
Tourist II (EKC): 203
Tourist Buckeye (American Camera): 36
Tourist Graflex: 263
Tourist Hawk-Eye (Blair): 79
Tourist Hawk-Eye Special (Blair): 79
Tourist Multiple (New Ideas): 411
Touriste (Enjalbert): 211
Tower 16 (Sears): 487
Tower 18A (Sears): 487
Tower 18B (Sears): 487
Tower 22 (Asahi Asahiflex IIA): 56
Tower 22 (Sears): 487
Tower 23 (Sears): 487
Tower 24 (Sears): 487
Tower 26 (Sears): 487
Tower 32A (Sears): 487
Tower 33 (Sears): 487
Tower 34 (Sears): 487
Tower 37 (Sears): 487
Tower 41 (Sears): 487
Tower 50 (Sears): 487
Tower 51 (Sears): 488
Tower 55 (Sears): 488
Tower 127 EF (Sears): 488
Tower Automatic 127 (Sears): 488
Tower Bonita (Sears): 488
Tower Camflash 127 (Sears): 488
Tower Camflash II 127 (Sears): 488
Tower Companion (Sears): 488
Tower Flash (Sears): 488
Tower Flash 120 (Sears): 488
Tower Hide Away (Sears): 488
Tower Junior (Sears): 488
Tower No. 5 (Sears): 486
Tower 10A (Sears): 486
Tower One-Twenty (Sears): 488
Tower One-Twenty Flash (Sears): 488
Tower Pixie 127 (Sears): 489
Tower Pixie II 127 (Sears): 489
Tower Reflex (Sears): 489
Tower Reflex Type (Sears): 489
Tower Skipper (Sears): 489
Tower Snappy (Sears): 489
Tower Stereo (Sears): 489
Tower Type 3 (Sears): 388
Town: 527

TOY CAMERAS (Non-Camera): 664
TOY'S CLAN: 527
Toy's Clan Donald Duck: 527
TOYCRAFTER (Non-Camera): 670
TOYO KOGAKU: 527
Toyo Kogaku Mighty: 527
Toyo Kogaku Tone: 527
Toyoca: 527
Toyoca 16 (Tougodo): 525
Toyoca 35 (Tougodo): 525
Toyoca Ace (Tougodo): 525
Toyocaflex (Tougodo): 525
Toyocaflex 35 (Tougodo): 526
TOYPOWER MFG. CO. LTD.
 (Non-Camera): 667
TOYS & GAMES, UNSPECIFIED
 (Non-Camera): 667
Trade-in Service: ADV
TRAID CORPORATION: 527
Traid Fotron: 527
Traid Fotron III: 527
Trailblazer 120 (Pho-Tak): 442
TRAMBOUZE: 527
Trambouze Tailboard view camera: 527
Transistomatic Radio Camera (Gec): 247
Traveler: 527
Traveler 120 (Pho-Tak): 442
Traveller: 527
Traveller Roll-Film Camera (Sinclair): 499
Traveller Una (Sinclair): 499
Treble Patent Camera (McKellen): 376
Trellis (Newman & Guardia): 413
Tri-Color Camera (Devin): 138
Tri-Color Camera (Jos-Pe): 307
Tri-Vision Stereo (Haneel): 273
Triad Detective (Scovill): 485
Triamapro (Deardorff): 135
Trick Ompus XA Bickri Camera
 (Non-Camera): 645
Trick Squirt Camera (Non-Camera): 661
Trilby (Ica): 297
Trimlite Instamatic (EKC): 202
Trio (Seneca shutter): 493
Trio (Welta): 556
Trioflex: 527
Triomphant (Mendel): 376
Triple Victo (Houghton): 290
Triplex (Ica): 297
Trivision Camera (Keys): 312
Trix (Ica): 297
Trokonet (Photo Materials): 443
Trolita (Agfa): 30
Trolix (Agfa): 30
Trona (Ica): 297
Trona (Zeiss): 596
Tropen Adoro (Zeiss): 596
Tropen Rio 2C, 5C (Orion): 436
Tropica (Ica): 297
Tropica (Zeiss): 597
Tropical Adoro (Contessa): 118
Tropical camera (Laack): 339
Tropical Deckrullo Nettel (Nettel): 411
Tropical Field Camera (Baird): 59
Tropical Heag VI (Ernemann): 222
Tropical Heag XI (Ernemann): 222
Tropical Kinarri (Arnold & Richter): 602
Tropical Klapp (Ernemann): 222

Tropical plate camera (Huttig): 292
Tropical plate cameras (Contessa): 121
Tropical Una (Sinclair): 499
Tropical Una Deluxe (Sinclair): 499
Tropical Watch Pocket Carbine (Butcher): 93
Tropical Zwei-Verschluss-Camera Model VI
(Ernemann): 222
TROTTER: 527
Trotter Field camera: 527
Tru-View: 527
Trumpfreflex (Sears): 489
Truphoto (Conley): 118
TRUSITE CAMERA CO.: 527
Trusite Girl Scout Official Camera: 527
Trusite Minicam: 527
T.S.C. Tacker: 527
Tsubasa Baby Chrome (Kigawa): 313
Tsubasa Chrome (Kigawa): 313
Tsubasa Semi (Kigawa): 313
Tsubasa Super Semi Chrome (Kigawa): 313
Tsubasaflex Junior (Kigawa): 313
Tudor (Houghton): 290
Tudor Reflex (Ica): 297
Tupperware Bank (Non-Camera): 636
TURILLON: 527
Turillon Photo-Ticket: 527
Turn-N-Click Mini Camera (Non-Camera):
665
TURRET CAMERA CO.: 527
Turret Panoramic camera: 527
Tuxedo (Rochester Camera): 469
Tuxi (Kunik): 326
Tuximat (Kunik): 327
Twin Lens Artist Hand Camera (London
Stereoscopic): 363
Twin Lens Camera (Watson): 553
Twin Lens Reflex (Newman & Guardia): 413
Twin Lens Reflex (Wirgin): 563
Twin Lens Vive: 540
Twinflex (Universal): 534
Two-shuttered Duplex (Ihagee): 301
TYLAR: 528
Tylar Tit-bit: 528
Tynar: 528
TYNAR CORP.: 528
UCA: 528
Uca Ucaflex: 528
Uca Ucanett: 528
Ucaflex (Uca): 528
Ucanett (Uca): 528
Ucet: 528
Ulca: 528
ULCA CAMERA CORP.: 528
Ultra-Fex (Fex): 231
Ultra-Reflex (Fex): 231
Ultrix (Ihagee): 301
Ultrix Stereo (Ihagee): 301
Ultramatic (Voigtländer): 546
Ultramatic CS (Voigtländer): 546
Una, Una Deluxe (Sinclair): 499
Unca (Feinmechanische): 227
UNDERWOOD: 529
Underwood Field camera: 529
Underwood Instanto: 529
Underwood Stereograph: 529
Unette (Ernemann): 222
Unette (Zeiss): 597

UNGER & HOFFMAN: 529
Unger & Hoffman Verax: 529
Unger & Hoffman Verax Gloria: 529
Unger & Hoffman Verax Superb: 529
Uni-Fex (Fex): 231
Unibox: 529
UNIMARK PHOTO: 529
Unimark Unimatic 606: 529
Unimark Unimatic 707: 529
Unimatic 606 (Unimark): 529
Unimatic 707 (Unimark): 529
Uniflash (Universal): 534
Uniflex I, II (Universal): 534
Uniflex Reflex Meteor (Schmitz &
Thienemann): 483
Uniomat (Minolta): 388
Uniomat III (Minolta): 388
Union (Brückner): 88
Union (Stöckig): 510
Union-Box (Vredeborch): 551
Union C-II: 529
Union Cases guidebook: ADV
UNION OPTICAL CO.: 529
Union Zwei-verschluss (Stöckig): 510
UNITED OPTICAL INSTRUMENTS: 529
United Optical Merlin: 529
United States Cam-O: 529
UNITED STATES CAM-O CORP.: 529
UNITED STATES CAMERA CORP.: 530
United States Camera Auto Fifty: 530
United States Camera Auto Forty: 530
United States Camera Automatic: 530
United States Camera Reflex: 530
United States Camera Reflex II: 530
United States Camera Rollex 20: 530
United States Camera USC 35: 530
United States Camera Vagabond: 530
UNITED STATES PROJECTOR &
ELECTRONICS CORP.: 530
United States Projector Me 35 4-U: 530
Universal (Butler Bros.): 94
Universal (Ernemann): 222
Universal (Gandolfi): 246
Universal (Rochester Optical): 473
Universal 35mm Movie camera: 628
Universal A-8: 628
Universal B-8: 628
Universal Buccaneer: 531
Universal C-8: 628
Universal C-8 Turret model: 628
UNIVERSAL CAMERA CO. (Movie): 628
UNIVERSAL CAMERA CORP.: 531-535
UNIVERSAL CAMERA CORP. (Movie): 628
Universal Cine Accessories: 629
Universal Cinematic P-750: 629
Universal Cinematic P-752: 629
Universal Corsair I, II: 531
Universal D-8: 628
Universal Duovex: 532
Universal E-8: 628
Universal F-8: 628
Universal G-8: 628
Universal G.E. Toppers Club (Univex AF):
535
Universal H-8: 628
Universal Heli-Clack Type I, II (Rietzschel):
464

Velocigraphe (Hermagis): 279
Velocigraphe Stereo (Hermagis): 279
Velox Magazine Camera (Hurlbut): 290
VENA: 539
Vena Venaret: 539
Venaret (Vena): 539
Ventura 66, 69 (Agfa): 31
Ventura 66, 69 Deluxe (Agfa): 31
Venus-Ray Compact (Non-Camera): 641
VEPLA-VENEZIA (Non-Camera): 671
Verascope (Richard): 463
Verascope F40 (Busch): 91
Verascope F40 (Richard): 463
Verax (Unger & Hoffman): 529
Verax Gloria (Unger & Hoffman): 529
Verax Superb (Unger & Hoffman): 529
Veriwide 100 (Plaubel): 450
Vero Four (Uyeda): 537
Verto (Adams): 19
Vesca (Stereoscopic): 509
Vesca Stereo (Stereoscopic): 509
Vest (Minolta): 383
Vest Camera (Gray): 268
Vest Olympic (Olympic): 423
Vest Pocket Ansco Junior: 45
Vest Pocket Ansco Model A: 45
Vest Pocket Ansco No. 0: 44
Vest Pocket Ansco No. 1: 44
Vest Pocket Ansco No. 2: 45
Vest Pocket Autographic Kodak (EKC): 204
Vest Pocket Autographic Kodak Special (EKC): 204
Vest Pocket Ensign (Houghton): 288
Vest Pocket Hawk-Eye (EKC): 174
Vest Pocket Kodak (EKC): 203
Vest Pocket Kodak Model B (EKC): 204
Vest Pocket Kodak Series III (EKC): 204
Vest Pocket Kodak Special (EKC): 204
Vest Pocket Monroe: 401
Vest Pocket Rainbow Hawk-Eye (EKC): 174
Vest Pocket Readyset (Ansco): 45
Vest Pocket Rexo (Burke & James): 90
Vest Pocket Roll Tenax (Goerz): 254
Vest Pocket Speedex (Ansco): 45
Vest Pocket Tenax (Goerz): 253
Vesta (Adams): 19
Vesta (Ginrei): 250
Vester-Six (Ginrei): 250
Vestkam (Taiyodo Koki): 515
VICAM PHOTO: 539
VICAM PHOTO (Movie): 630
Vicam Photo Baby Standard: 630
Vicamphoto (Vicam Photo): 539
Viceroy (Aires): 33
Victo (Houghton): 290
Victor: 630
Victor (Anthony): 49
Victor (Benson): 70
Victor (Coronet): 126
Victor (Ihagee): 301
VICTOR ANIMATOGRAPH CO. (Movie): 630
Victor Animatograph Projector: 509
Victor Cine Projector: 630
Victor Home Cinema Projector: 630
Victor Model 3, 4, 5: 630
Victor Safety Cinema Projector: 630
Victor Ultra Cine: 630

Victory Camera (Yen-Kame): 462
Victory Lone Ranger: 539
VICTORY MFG. CO.: 539
Victory Reflex (Thornton-Pickard): 520
Victrix (Ica): 297
Victrix (Zeiss): 597
Vida (Voigtländer): 546
Vidax (Vidmar): 539
Videon (Stereocrafters): 509
Videon II (Stereocrafters): 509
Videx (Adams & Co.): 19
VIDMAR CAMERA CO.: 539
Vidmar Vidax: 539
VIENNAPLEX: 539
Viennaplex Pack 126: 539
Vier-Sechs (Busch): 91
View (Agfa): 31
View (Ansco): 45
View (Anthony): 49
View (Blair): 79
View (EKC): 205
View (Rochester Optical): 473
View Camera Cigarette Lighter (Non-Camera): 639
View-Master Mark II Stereo (Sawyers): 482
View-Master Projectors (Sawyers): 482
View-Master Personal Stereo (Sawyers): 482
View-Master Stereo Color (Sawyers): 482
VIEWING DEVICES (Non-Camera): 670
Viflex: 539
Vigilant Junior Six-16 (EKC): 205
Vigilant Junior Six-20 (EKC): 205
Vigilant Six-16 (EKC): 205
Vigilant Six-20 (EKC): 205
Viking (Agfa): 31
Viking (Ansco): 45
Viking (Wedemeyer): 554
Viking Readyset (Ansco): 45
Vilia: 539
Vilia-Auto (BNANR-ABTO): 539
Vintage Cameras Ltd.: ADV
VINTEN: 540
Vinten Aerial reconnaissance camera: 540
Virtus (Voigtländer): 546
Viscawide-16 (Taiyokoki): 515
Viscount (Aires): 33
Visor-Fex (Fotofex): 235
Vista Colour: 540
Vitaflex (Kamerawerke): 310
Vitagraph: 630
VITAGRAPH CO. OF AMERICA (Movie): 630
VITALUX CAMERA CO. (Movie): 631
Vitalux Camera: 631
Vitalux Projector: 631
Vitar (Universal): 535
VITASCOPE CORP. (Movie): 631
Vitascope Movie Maker: 631
Vitessa (Voigtländer): 546
Vitessa L (Voigtländer): 547
Vitessa N (Voigtländer): 547
Vitessa T (Voigtländer): 547
Vito (Voigtländer): 547
Vito II (Voigtländer): 547
Vito IIa (Voigtländer): 547
Vito III (Voigtländer): 547
Vito Automatic (Voigtländer): 548

Vredeborch Kera Jr.: 550
Vredeborch Manex: 550
Vredeborch Nordetta 3-D: 550
Vredeborch Nordina: 550
Vredeborch Optomax Syncrona: 550
Vredeborch Reporter Junior II: 550
Vredeborch Slomexa: 550
Vredeborch Texar Box: 551
Vredeborch Union-Box: 551
Vredeborch Vrede Box: 551
Vril (Watson): 553
VRSOFOT: 551
Vrsofot Epifoka: 551
Vu-Flash 120 (Zenith): 598
Wabash Direct positive camera: 551
WABASH PHOTO SUPPLY: 551
WADSWORTH (Non-Camera): 642
WAITE: 551
Waite Wet-plate Stereo: 551
WALDES & CO.: 551
Waldes Foto-Fips: 551
WALDORF CAMERA CO.: 551
Waldorf Minicam: 551
Wales-Baby: 551
Wales Reflex (Haking): 272
WALKER CO.: 551
WALKER MANUFACTURING CO.: 551
Walker TakIV: 551
Walker's Pocket Camera: 551
Walking Film Box (Non-Camera): 667
Walklenz: 551
WALLACE HEATON LTD.: 552
Wallace Zodel: 552
Walta (Welta): 556
Waltax (Okada): 422
Waltax Acme (Daiichi): 130
Waltax Jr. (Daiichi): 130
Waltax Senior (Daiichi): 130
Walz Automat: 552
Walz Baby (Okada): 422
WALZ CO.: 552
Walz Envoy 35: 552
Walz Walz-wide: 552
Walz Walzflex: 552
Walz-wide (Walz): 552
Walzflex (Walz): 552
WANAUS: 552
Wanaus View: 552
Wanderer (Laack): 340
WANG'S ALLIANCE CORP.
 (Non-Camera): 650
Waranette (Wauckosin): 553
Wardette (Montgomery Ward): 402
Wardflex (Montgomery Ward): 402-403
Wardflex II (Montgomery Ward): 403
Wards 25 (Montgomery Ward): 403
Wards 35 (Montgomery Ward): 403
Wards xp400 (Montgomery Ward): 403
Warner 6x6 (Musashino): 407
WARREN CO. (Non-Camera): 657
WARWICK: 552
Warwick No. 2 Camera: 552
Watch Camera (Expo): 224
Watch Camera (Lancaster): 342
Watch Pocket Carbine (Butcher): 93
Watch Pocket Klimax (Butcher): 93
"Watch the Birdie" Soap (Non-Camera): 659

WATER CAMERAS (Non-Camera): 660
Waterbury Detective Camera (Scovill): 485
Waterbury View (Scovill): 485
Waterbury View Stereo (Scovill): 485
WATSON: 552
Watson Acme: 552
Watson Alpha: 553
Watson Argus Reflex: 553
Watson Detective: 553
Watson Field camera: 553
Watson Gear: 553
Watson-Holmes Fingerprint Camera
 (Burke & James): 90
Watson Magazine box camera: 553
Watson Press (Burke & James): 90
Watson Stereoscopic Binocular Camera:
 553
Watson Twin Lens Camera: 553
Watson Vanneck: 553
Watson Vril: 553
WAUCKOSIN: 553
Wauckosin Waranette: 553
W.D. Service, Inc.: ADV
WEBSTER INDUSTRIES INC.: 553
Webster Winpro 35: 553
Wedar,II (Rodenstock): 474
WEDEMEYER: 554
Wedemeyer Viking: 554
Week End (Goldstein): 255
Week-End Bob (Cornu): 122
Weenie (Thornton-Pickard): 520
Weeny Ultrix (Ihagee): 301
WEFO: 554
WEFO Master Reflex: 554
WEFO Meister Korelle: 554
Wega II, IIa (Afiom): 21
Weha Chrome Six (Ehira): 207
Weha Light (Ehira): 207
WEIMET PHOTO PRODUCTS CO.: 554
Weimet Rocket: 554
Weiner, Alan: ADV
WELCH (Non-Camera): 643
Well Standard (Nihon): 415
Welmy 35 (Taisei Koki): 513
Welmy M-3 (Taisei Koki): 514
Welmy Six, Welmy Six E (Taisei Koki): 513
Welmy Wide (Taisei Koki): 514
Welta: 556
Welta 35: 556
Welta Belmira: 554
Welta Diana: 554
Welta Dubla: 554
Welta Garant: 554
Welta Gucki: 554
WELTA KAMERAWERKE: 554-557
Welta Luxus: 554
Welta Peerflekta: 554
Welta Perfekta: 554
Welta Perle: 555
Welta Radial: 555
Welta Reflecta: 555
Welta Reflekta: 555
Welta Reflekta II, III: 556
Welta Solida: 556
Welta Superfekta: 556
Welta Symbol: 556
Welta Trio: 556

Wirgin Edixa 16: 562
Wirgin Edixa 16M: 562
Wirgin Edixa 16MB: 562
Wirgin Edixa 16S: 562
Wirgin Edixa Electronica: 562
Wirgin Edixa Flex B: 562
Wirgin Edixa-Mat B, BL: 562
Wirgin Edixa-Mat C, CL: 563
Wirgin Edixa-Mat D, DL: 563
Wirgin Edixa Prismaflex: 563
Wirgin Edixa Reflex: 563
Wirgin Edixa Reflex B: 563
Wirgin Edixa Reflex C: 563
Wirgin Edixa Reflex D: 563
Wirgin Edixa Stereo: 563
Wirgin Edixa Stereo II, IIa: 563
Wirgin Edixa Stereo III, IIIa: 563
Wirgin Edixaflex: 563
Wirgin folding rollfilm camera: 564
Wirgin Gewir: 563
Wirgin Gewirette: 563
Wirgin Klein-Edinex: 562
Wirgin Midget Marvel: 563
Wirgin Reporter: 563
Wirgin Stereo: 564
Wirgin TLR: 564
Wirgin Twin Lens Reflex: 563
Wirgin Wirginex: 564
Wirginex (Wirgin): 564
Wit-eez (Wittie): 565
Witness (Ilford): 303
WITT: 564
Witt Iloca I, Ia: 564
Witt Iloca II, IIa: 564
Witt Iloca Quick A, B: 564
Witt Iloca Rapid: 564
Witt Iloca Reporter: 564
Witt Iloca Stereo (original): 564
Witt Iloca Stereo I, II: 564
Witt Iloca Stereo Rapid: 564
Witt Photrix Quick B: 564
Witt Photrix Stereo: 564
WITTIE MFG. & SALES CO.: 565
Wittie Wit-eez: 565
WITTMAN: 565
Wittman Tailboard camera: 565
WITTNAUER: 565
Wittnauer Adventurer: 565
Wittnauer Automatic Zoom 800: 631
Wittnauer Automaton: 565
WITTNAUER CAMERA CO. (Movie): 631
Wittnauer Captain: 565
Wittnauer Challenger: 565
Wittnauer Cine-Simplex: 631
Wittnauer Cine-Twin: 632
Wittnauer Continental: 565
Wittnauer Festival: 565
Wittnauer Legionaire: 565
Wittnauer Scout: 565
Wittnauer Wittnette Deluxe: 565
Wittnette Deluxe (Wittnauer): 565
Wizard Duplex No. 1, No. 2 (Manhattan): 370
Wizard folding plate cameras (Manhattan): 370
Wizard Junior (Manhattan): 371
Wizard Senior (Manhattan): 371

Wizard Special (Manhattan): 371
Wizard XF1000 (Keystone): 312
WÖHLER: 565
Wöhler Favor: 565
WOLFF PRODUCTS (Non-Camera): 659
Wollensak Model 8: 632
Wollensak Model 23: 632
Wollensak Model 42: 632
Wollensak Model 43,43-D: 632
Wollensak Model 46: 632
Wollensak Model 46 Eye-Matic: 632
Wollensak Model 57 Eye-Matic: 632
WOLLENSAK OPTICAL CO.: 565
WOLLENSAK OPTICAL CO. (Movie): 632
Wollensak Stereo: 565
Wond-O-Lite (Non-Camera): 639
Wonder Automatic Cannon (Chicago Ferrotype Co.): 110
Wonder camera: 565
Wonder Camera Friend (Non-Camera): 651
Wonder Film Ruler (Non-Camera): 655
Wonder Special Camera (Non-Camera): 651
Wonderflex: 565
Wonderflex Comet Special Camera (Non-Camera): 652
WOOD: 565
WOOD BROS.: 565
Wood Cameras Wanted: ADV
Wood Pansondontropic Camera: 565
Wood Wet plate camera: 565
World Cameras: ADV
World's Fair Flash (EKC): 206
WORM CAMERAS (Non-Camera): 650
W.P.C.A.: ADV
WRATTEN & WAINWRIGHT: 565
Wratten & Wainwright Tailboard camera: 565
WRAY OPTICAL WORKS: 565
Wray Peckham Wray: 565
Wray Stereo Graphic: 566
Wray Wrayflex: 566
Wrayflex (Wray): 566
Wristamatic (Magnacam): 368
WÜNSCHE: 566
Wünsche Afpi: 566
Wünsche Elite: 566
Wünsche Favorit: 566
Wünsche Field cameras: 566
Wünsche Juwel: 566
Wünsche Knox: 566
Wünsche Lola: 566
Wünsche Lola Stereo: 567
Wünsche Mars 99: 567
Wünsche Mars Detective: 567
Wünsche Mars Detectiv-Stereoskop: 567
Wünsche Postage stamp camera: 567
Wünsche Reicka: 567
Wünsche Sport: 567
WZFO: 567
WZFO Druh: 567
WZFO Noco-Flex: 567
X-Ray Canon: 99
Xit (Shew): 495
Xit Stereoscopic (Shew): 495
Xyz (Lancart): 340

Yale camera: 567
YALE CAMERA CO.: 567
Yale No. 1, No. 2 (Adams & Co.): 19
Yale Stereo Detective No. 5 (Adams): 20
YAMAMOTO CAMERA CO.: 567
Yamamoto Semi Kinka: 567
Yamato Alpina M35: 567
Yamato Atlas 35: 567
Yamato Barclay: 568
Yamato Bonny Six: 568
YAMATO CAMERA INDUSTRY: 567
Yamato Hilka: 568
YAMATO KOKI KOGKO CO. LTD.: 567
Yamato Konair Ruby: 568
Yamato Minon Six II: 568
Yamato Palmat Automatic: 568
Yamato Pax: 568
Yamato Pax Golden View: 568
Yamato Pax Jr.: 568
Yamato Pax M3: 568
Yamato Pax M4: 568
Yamato Pax Ruby: 568
Yamato Pax Sunscope: 569
Yamato Ricsor: 569
Yamato Rippa: 569
Yamato Rippaflex: 569
Yamato Skymaster: 569
Yanka II (Mashpriborintorg): 373
YASHICA: 569-571
YASHICA (Movie): 633
Yashica 8: 633
Yashica 44: 569
Yashica 44A: 569
Yashica 44LM: 569
Yashica 72E: 570
Yashica 635: 569
Yashica A: 570
Yashica Atoron: 570
Yashica Atoron Electro: 570
Yashica C: 570
Yashica D: 570
Yashica EE: 570
Yashica LM: 570
Yashica Mimy: 570
Yashica Penta J: 570
Yashica Pentamatic: 570
Yashica Rapide: 571
Yashica Sequelle: 571
Yashica T-8: 633
Yashica Y16: 571
Yashica YE: 571
Yashica YF: 571
Yashica YK: 571
Yashica Yashica-Mat: 571
Yashina Pigeonflex: 571
YASHINA SEIKI CO. LTD.: 571
Yen-Kame: 571
Yogi Bear (Hanna-Barbera): 274
Ysella (Rodenstock): 474
Yumeka 35-R5 (New Taiwan): 411
Yunon YN 500: 571
Yuuhigo (Yen-Kame): 571
Zambex (Beck): 65
Zany (Nihon): 415
Zapa: 572
Zar (Western Pocket Zar): 558
Zarya (Zapa): 572

Zeca (Zeh): 572
Zeca-Flex (Zeh): 572
ZEH: 572
Zeh Bettax: 572
Zeh Goldi: 572
Zeh Sport: 572
Zeh Zeca: 572
Zeh Zeca-Flex: 572
ZEISS (Carl Zeiss JENA): 572
ZEISS IKON A.G.: 574-597
ZEISS (Movie): 633
Zeiss Adoro (Tropen Adoro): 596
Zeiss Aerial Camera: 574
Zeiss Baby-Box Tengor: 574-575
Zeiss Baby Deckrullo: 583
Zeiss Baby Ikonta: 587
Zeiss Baldur Box: 575
Zeiss Bebe: 575
Zeiss Bob: 575
Zeiss Bob IV, V: 575
Zeiss Bobette I: 575
Zeiss Bobette II: 575
Zeiss Box Tengor (54): 575
Zeiss Box Tengor (54/2): 576
Zeiss Box Tengor (54/14): 576
Zeiss Box Tengor (54/15): 576
Zeiss Box Tengor (55/2): 576
Zeiss Box Tengor (56/2): 576
Zeiss Citoskop: 576
Zeiss Cocarette: 577
Zeiss Cocarette Luxus: 577
Zeiss Colora: 577
Zeiss Colora F: 577
Zeiss Contaflex (860/24): 577
Zeiss Contaflex I: 577
Zeiss Contaflex II: 577
Zeiss Contaflex III: 577
Zeiss Contaflex IV: 577
Zeiss Contaflex 126: 578
Zeiss Contaflex Alpha: 577
Zeiss Contaflex Beta: 577
Zeiss Contaflex Prima: 578
Zeiss Contaflex Rapid: 578
Zeiss Contaflex S Automatic: 578
Zeiss Contaflex SLR lenses: 578
Zeiss Contaflex Super: 578
Zeiss Contaflex Super B: 578
Zeiss Contaflex Super BC: 578
Zeiss Contaflex TLR lenses: 577
Zeiss Contarex "Bullseye": 579
Zeiss Contarex Electronic: 579
Zeiss Contarex Hologon: 579
Zeiss Contarex lenses: 579
Zeiss Contarex Microscope: 579
Zeiss Contarex Professional: 579
Zeiss Contarex Special: 579
Zeiss Contarex Super: 579
Zeiss Contax: 580
Zeiss Contax I: 580
Zeiss Contax I(a): 580
Zeiss Contax I(b): 580
Zeiss Contax I(c): 580
Zeiss Contax I(d): 580
Zeiss Contax I(e): 580
Zeiss Contax I(f): 580
Zeiss Contax II: 580
Zeiss Contax IIa: 581

Zeiss Contax III: 581
Zeiss Contax IIIa: 581
Zeiss Contax D: 581
Zeiss Contax F: 581
Zeiss Contax "No-Name": 581
Zeiss Contax lenses: 581
Zeiss Contessa-35: 582
Zeiss Contessa LBE: 582
Zeiss Contessa LK: 582
Zeiss Contessa LKE: 582
Zeiss Contessa S-310: 582
Zeiss Contessa S-312: 582
Zeiss Contessamat: 582
Zeiss Contessamat SBE: 582
Zeiss Contessamat SE: 582
Zeiss Contessamat STE: 582
Zeiss Contessamatic: 582
Zeiss Contessamatic E: 582
Zeiss Contina: 583
Zeiss Contina I (522/24): 583
Zeiss Contina Ia (526/24): 583
Zeiss Contina Ic (526/24): 583
Zeiss Contina II: 583
Zeiss Contina IIa: 583
Zeiss Contina III: 583
Zeiss Contina III lenses: 583
Zeiss Contina III Microscope: 583
Zeiss Contina L: 583
Zeiss Contina LK: 583
Zeiss Continette: 583
Zeiss Deckrullo: 583
Zeiss Deckrullo Nettel: 583
Zeiss Deckrullo Nettel Tropical: 583
Zeiss Deckrullo Tropical: 583
Zeiss Donata: 583
Zeiss Duchessa: 583
Zeiss Duroll: 584
Zeiss Elegante: 584
Zeiss Erabox: 584
Zeiss Ergo: 584
Zeiss Ermanox: 584
Zeiss Ermanox Reflex: 584
Zeiss Erni: 584
Zeiss Favorit: 584
Zeiss Favorit Tropical: 584
Zeiss Halloh: 584
Zeiss Hochtourist: 584
Zeiss Hologon (Contarex Hologon): 579
Zeiss Icarette: 584
Zeiss Icarex: 585
Zeiss Icarex 35: 585
Zeiss Icarex 35 CS: 585
Zeiss Icarex 35S: 585
Zeiss Icarex 35 "TM": 585
Zeiss Icarex lenses: 585
Zeiss Ideal: 585
Zeiss Ikoflex: 585
Zeiss Ikoflex I: 586
Zeiss Ikoflex Ia: 586
Zeiss Ikoflex Ib: 586
Zeiss Ikoflex Ic: 586
Zeiss Ikoflex II: 586
Zeiss Ikoflex II/III: 586
Zeiss Ikoflex IIa: 586
Zeiss Ikoflex III: 586
Zeiss Ikoflex Favorit: 587
Zeiss Ikomat (see Ikonta): 587

Zeiss Ikomatic A: 587
Zeiss Ikomatic F: 587
Zeiss Ikonette: 587
Zeiss Ikonette 35: 587
Zeiss Ikonta: 587
Zeiss Ikonta 35: 588
Zeiss Ikonta A: 587
Zeiss Ikonta B: 587-588
Zeiss Ikonta C: 588
Zeiss Ikonta D: 588
Zeiss Jena Contax II: 580
Zeiss Juwel: 588
Zeiss Kinamo N25: 633
Zeiss Kinamo S10: 633
Zeiss Kolibri: 588
Zeiss Kosmopolit: 588
Zeiss Liliput: 588
Zeiss Lloyd: 589
Zeiss Magnar-Kamera: 573
Zeiss Maixmar: 589
Zeiss Maximar A: 589
Zeiss Maximar B: 589
Zeiss Minimum Palmos: 573
Zeiss Minimum Palmos Stereo: 573
Zeiss Miroflex A: 589
Zeiss Miroflex B: 589
Zeiss Movikon 8: 633
Zeiss Movikon 8 B: 633
Zeiss Movikon 16: 633
Zeiss Movinette 8B: 633
Zeiss Nettar: 589
Zeiss Nettax (513/16): 589
Zeiss Nettax (538/24): 589
Zeiss Nettel: 590
Zeiss Nettel, Tropen: 590
Zeiss Nixe: 590
Zeiss No Name Contax: 581
Zeiss Onito: 590
Zeiss Orix: 590
Zeiss Palmos-O: 590
Zeiss Perfekt: 590
Zeiss Piccolette: 590
Zeiss Piccolette-Luxus: 591
Zeiss Plaskop: 591
Zeiss Polyskop: 591
Zeiss Wanted: ADV
Zeiss Simplex (112/7): 591
Zeiss Simplex (511/2): 591
Zeiss Simplex-Ernoflex: 591
Zeiss Sirene: 591
Zeiss SL-706: 591
Zeiss Sonnet: 591
Zeiss Stereax: 591
Zeiss Stereo-Ernoflex: 591
Zeiss Stereo Ideal: 591
Zeiss Stereo Nettel: 591
Zeiss Stereo Nettel, Tropical: 592
Zeiss Stereo Palmos: 573
Zeiss Stereo-Simplex-Ernoflex: 591
Zeiss Stereolette-Cupido: 592
Zeiss Steroco: 592
Zeiss Suevia: 592
Zeiss Super Ikomat: 592
Zeiss Super Ikonta A: 592
Zeiss Super Ikonta B: 592-593
Zeiss Super Ikonta BX: 593
Zeiss Super Ikonta C: 594

Dating cameras by shutter type is a rather unreliable guide to dating, since shutters and lenses are easily interchanged, and photographers over the years have often made these changes. However, if the shutter has been determined to be original equipment, then the following dates serve the purpose of estimating a date AFTER WHICH the camera would have been made. Shutters are listed by manufacturer, either in alphabetical order by shutter name, or chronologically.

We are indebted to Dr. Rudolf Kingslake for the research on these shutters, particularly the Bausch & Lomb, Kodak, and Wollensak brands.

BAUSCH & LOMB (Rochester, NY)
Bausch & Lomb began as an optical company, at first making eyeglass lenses, then in 1883 adding photographic lenses. In 1888 they made their first shutters, and continued making shutters until 1935.

Iris Diaphragm Shutter - 1890-1904. Shutter blades act as diaphragm. *(Illustrated in previous column.)*

"Star" - 1893. Has rotating disc with waterhouse stops. Pneumatic release cylinder added in 1894. *(Illustrated in previous column.)*

Bausch & Lomb Iris Diaphragm shutter

Victor (Unicum with air retard cylinder) - 1894-1897. Iris diaphragm.

Bausch & Lomb "Star" shutter

Unicum - 1897-past 1907. Iris diaphragm.

Vici - c1892.

Argos - Patented 1900.

Bausch & Lomb Auto

Victor (1901 type) - 1901. Flat top with speed dial on it.

Volute - Patented 1902, continued until 1935.

AUTOMATIC SHUTTERS

All B&L Shutters made after 1901, except for the Volute, were of the automatic type which did not require cocking.

Auto - Patented Dec. 1900. Speed lever on bottom. Inverted a couple years later so speed dial was on top. *(Illustrated in previous column.)*

Gem - c1902 (Patented Feb. 1901). First model had TBI lever on left (viewed from front) and air retard cylinder on right. In 1903, the mechanism was reversed, so the positions of the TBI lever and air cylinder were also reversed. This was called the "Simplex". *(Illustrated in previous column.)*

Simplex - c1903. See "Gem" above. *(Illustrated in previous column.)*

Automat (1901 type) - Introduced late 1901, but not patented until December 1904. Speed control lever in a curved slot just below the lens.

Automat (1906 type) - c1906-1913. This popular style has a circular control lever at the top.

Bausch & Lomb Gem (above)
Bausch & Lomb Simplex (below)

FPK Automatic - 1903-1913. Made for the Eastman Kodak Co. for use on the Folding Pocket Kodak cameras.

Automatic (1910) - Three distinct types.

- IBT. Two-blade shutter

- 1-100, BT controlled by lever at top

- Same speeds as previous shutter: 1, 2,

5, 25, 50, 100, BT but this version is controlled by dial at top.

Compound - c1907 or 1908 on. Made under license from Deckel. *See Deckel Compound shutter.*

- c1907-1910. Speed dial has flat face with markings on face.

- c1910. Speed dial is conic section with markings on the edge.

- c1914. Pneumatic piston replaced by cable release.

B&L STEREO SHUTTERS

Iris Diaphragm Stereo - Intro. 1893. Two air cylinders between lenses.

Automat Stereo (slot below lens) - Intro. 1901.

Simplex Stereo - Intro. 1902. Air valve and TBI lever on left face of shutter (viewed from front.)

Automat Stereo (top dial) - Intro. 1904.

Single Valve Stereo - 1907.

Stereo Compound - 1911

DECKEL (Friedrich Deckel, Munich)
Bruns & Deckel founded 1903. F. Deckel firm established 1905. Following are major shutter types with approximate dates of introduction.

Compound - Introduced c1903.

Compur (Dial-set) - Introduced 1912.

Compur (Rim-set) - Introduced c1930.

Synchro Compur - c1951.

GAUTHIER (Alfred Gauthier, Calmbach)

Koilos (original with leather brake) - c1904.

Koilos (air piston) - c1906.

Ibso - c1908.

Ibsor - c1926. Gear control.

Prontor S - c1948.

Prontor SV - c1950. Full synchronization.

Prontor SKL - 1957. Meter-coupled

Prontormat-S - Fully automatic meter-controlled.

KODAK SHUTTERS - *This list includes only those shutters made by Kodak. They are listed in alphabeticl order by shutter name.*
Automatic - 1904-17. 5-speed, bulb release.

Automatic Flash - 1960-. Single-speed. For Automatic and Motormatic Cameras.

Kodak Ball Bearing shutter

Ball Bearing Shutters: *3-speed shutter illustrated bottom of previous page.*
- #0 - 1914-26. 2-speed. For Vest Pocket cameras.
- #1 - 1909-24. 3-speed. Bulb or cable release.
- #2 - 1909-33. 3-speed. Bulb or cable release.
- Stereo Ball Bearing - 1919-24. 3-speed. Similar to the #2.

Brownie Automatic - 1904-15. Single-speed.

Brownie Automatic Stereo - 1905-15. Single-speed. For bulb operation.

Dak - 1940-1948. Single-speed.

Dakar #1 - 1935-36. 4-speed.

Dakon - 2-speed version 1940-48. 3-speed version 1946-48. *(Illustrated next page.)*

Diodak - 4-speed.
- #1 - 1932-35.
- #2 - 1932-33.
- #2A - 1936-41.

Diomatic top dial shutters - 4-speed.
- #0 - 1924-35.
- #1 - 1924-33.

Diomatic ring set shutters - These are similar to the Kodamatic #1 and #2 shutters.
- #1 - 3-speed version 1940-48. 4-speed version 1938-48.
- #2 - 1938-39. 4-speed.

Eastman Automatic - 1898-1906. Single-speed.

Flash 200 - 1949-59. 4-speed.

Flash 200 Stereo - 1954-59. 4-speed.

Flash 250 - 1957-61. 4-speed.

Flash 300 - 1953-58. 4-speed.

Flash Dakon - 1947-48. 3-speed

Flash Diomatic - 1946-52. 3 and 4-speed versions.

Flash Kodamatic - 1946-53. 5-speed version. 1946-54. 7-speed version for the Kodak Reflex Camera.

EKC Dakon shutter

Flash Kodon - 1948-58. Single-speed, TBI. This is the "Dak" shutter with flash sync.

Flash Supermatic #1 - 1946-48. 9-speed.

Flash Supermatic #2 - 1946-52. 9-speed.

Hawk-Eye - 1923. Single-speed. A simplified Ball Bearing #0, T and I only.

Kodal #0 - 1932. Single-speed. Octagonal. T & I only.

Kodal #1 - 1932-40. Single-speed. Octagonal, B & I only.

Kodamatic (old style) - 1921-34. 7-speed. Small version was called the #1 or #1A. Large version was called #2 or #3A.

Kodamatic (ring set) #1 - 1937-48. 5-speed.

Kodamatic (ring set) #2 - 1937-47. 5-speed.

Kodex #0 - 1924-34. 2-speed.

Kodex #1 - Old style 1925-33; 2-speed. New style 1935-45; 3-speed.

Kodo #0 - 1929-40. Single-speed.

Kodo #1 - 1929-40. Single-speed.

Kodon #0 - 1932-40. 3-speed. Octagonal.

Kodon #1 - 1932-40. 3-speed. Octagonal.

Supermatic #0 - 1941-48. 9-speed. For the Bantam Special.

Supermatic #1 - 1939-48. 9-speed.

Supermatic #2 - 1939-47. 9-speed.

Supermatic #3 - 8-speed.

Supermatic X - 8-speed. Same as the #3 but with X sync.

Synchro 80 - 1959-. 2-speed. For the Automatic 35 Camera.

Synchro 250 - 1957-60. 7-speed. For the Signet 30 and 50 Cameras.

Synchro 300 - 1951-58. 4-speed. For the Signet 35 Camera.

Ballard Unique - 1901?. Single-speed, T,B.

Synchro 400 - 1956-59. 7-speed. For the Signet 40 Camera.

Synchro-Rapid 800 - 1949-56. 10-speed.

Triple Action - 1897-03. 3-speed. Made in small and large versions.

WOLLENSAK SHUTTERS

Actus - 1912-14. 3-speed, T,B.

Alphax - 1946-56. 5-speed, T,B.

Autex - 1908-13. 6-speed, T,B.

Auto A - 1913-18. 6-speed, T,B.

Auto B - 1918-22. 7-speed, T,B.

Automatic A - 1901-02. 8-speed, T,B.

Automatic B - 1902-08. 6-speed, T,B.

Automatic s.v. - 1900-02. 3-speed, T,B.

Conley Safety - 1911?. 6-speed, T,B.

Deltax - 1922-42. 3-speed, T,B.

Gammax - 1922-42. 4-speed, T,B.

Graphex - 1946?. 9-speed, T,B.

Betax - 1922-48. 6-speed, T,B.

Junior - 1901-11. Single-speed, T,B.

Optimo #0 - 1916-22. 7-speed, T,B.

Optimo (Velosto) - 1909-30. 8-speed, T,B.

Rapax - 1946-56. 9-speed, T,B.

Regno A - 1908-11. 6-speed, T,B.

Regno B - 1911-18. 6-speed, T,B.

(Original) - 1900-01. 8-speed, T,B.

Regular A - 1901-02. 8-speed, T,B.

Regular B - 1902-08. 6-speed, T,B.

Studio - 1906-40.

TIB - 1911-14. Single-speed, T,B.

Ultro A - 1914-19. Single-speed, T,B.

Ultro B - 1919-22. Single-speed, T,B.

Victo A - 1914-18. 4-speed, T,B.

Victo B - 1918-22. 4-speed, T,B.

Victus - 1908-12. 3-speed, T,B.

Winner A - 1901-02. 4-speed, T,B.

Winner B - 1902-08. 3-speed, T,B.

Senior - 1903-07. Single-speed, T,B.

Skyshade - 1906-13. 6-speed, T,B.

METRIC/ENGLISH EQUIVALENTS of camera image sizes

The sizes in this table are not always exact measurements, but are the equivalents used in popular parlance among collectors.

METRIC	ENGLISH	COMMENTS
5x8mm		Echo 8
8x11mm		Minox
10x14mm		many 16mm subminiatures
13x17mm		110 cassette
14x14mm		many 16mm subminiatures
16x22mm	⅝x⅞"	Expo watch camera
18x24mm	¾x15/16"	single frame 35mm
18x28mm	¾x1⅛"	Expo police camera
2x3cm	¾x1⅛"	
22x31mm	¾x1¼"	
22x33mm	⅞x1¼"	
22x35mm	⅞x1⅜"	
24x24mm	1x1"	35mm square format
24x30mm	15/16x1-3/16"	many 35mm stereo cameras
24x36mm	1x1⅜"	35mm standard format
25mm dia.	1" round	
28x28mm	1⅛x1⅛"	126 cassette
28x40mm	1⅛x1½"	828 full frame, 8 exp.
3x4cm	1-3/16x1½"	127 half frame, 16 exp.
32x45mm	1¼x1¾"	Cartridge Premo #00
35x45mm	1⅜x1¾"	
4x4cm	1⅝x1⅝"	127 square format, 12 exp.
4x5cm	1½x2"	
4x6cm	1½x2¼"	
4x6.5cm	1⅝x2½"	127 full frame, 8 exp.
4.5x6cm	1¾x2¼"	120/620 half frame, 16 exp.
4.5x6cm	1¾x2-5/16"	popular plate size
4.5x6cm	1¾x2⅜"	Premo Jr. #0
4.5x6.5cm	1¾x2½"	
4.5x10.7cm	1¾x4¼"	popular stereo plate size
5x5cm	2x2"	
5x6.5cm	2x2½"	
5x7.5cm	2x3"	Houghton Ensignette #2
5x8cm	2x3⅛"	
5.5x6.5cm	2-1/16x2½"	116/616 half frame, 16 exp.
6x6cm	2¼x2¼"	120/620 square format, 12 exp.
6x6.5cm	2¼x2½"	National Graflex, 10 exp on 120
6x7cm	2¼x2¾"	1/9 plate, "Ideal format": 10 exp. on 120 or 21 exp. on 220
6x8.5cm	2¼x3¼"	
6x9cm	2¼x3¼", 2¼x3½"	120/620 full frame, 8 exp.
6x13cm	2¼x5⅛"	common stereo plate size
6x17cm	2¼x6¾"	Baby Al Vista
6x18cm	2¼x7"	panoramic
6.5x6.5cm	2½x2½"	
6.5x7.5cm	2½x3"	
6.5x9cm	2½x3½"	common plate size
6.5x11cm	2½x4¼"	1A or 116/616 full frame
7x8.4cm	2¾x3¼"	1/6 plate, or "A" Daylight or Ordinary Kodak
71x93mm	2¾x3⅝"	Kodak instant film (68x91mm actual)
7.25x12.5cm	2⅞x4⅞"	2C or 130 film
7.5x10cm	3x4"	
8x8cm	3⅛x3-3/16"	each image of stereo pair
8x10.5cm	3¼x4¼"	¼ plate (popular approximation), lantern slide
8x14cm	3¼x5½"	3A or 122 film, postcard size

METRIC	ENGLISH	COMMENTS
8x16cm	3⅛x6¼"	stereo pair
8x26cm	3¼x10⅜	panoram
8x46cm	3¼x18"	panoram
8.2x10.7cm	3¼x4¼"	8x10.5cm approximation is usually used
8.5x14.5cm	3⅜x5¾"	stereo format
9x9cm	3½x3½"	
9x10cm	3½x4"	"B" Daylight or Ordinary Kodak
9x12cm	3½x4¾"	popular European plate size
9x13cm	3½x5"	
9x14cm	3½x5½"	
9x15cm	3½x6"	stereo format
9x16cm	3½x6¼"	stereo format
9x18cm	3½x7"	stereo format
9x23cm	3½x9"	Al Vista 3B
9x30cm	3½x12"	#4 Panoram Kodak
9.5x12cm	3¾x4¾"	
10x13cm	4x5"	common plate and film size
10x15cm	4x6"	sometimes used as 4x5" metric equivalent
10x25cm	4x10"	
10x30cm	4x12"	
11x11cm	4¼x4¼"	
11x16.5cm	4¼x6½"	half plate
11.5x14cm	4½x5½"	
11.5x21.5cm	4½x8½"	Stock stereo wet-plate
12x16.5cm	4¾x6½"	
12x17cm	4¾x6¾"	
13x18cm	5x7"	popular plate and film size
13x19cm	5x7½"	
13x20cm	5x8"	popular size before 1900
13x30cm	5x12"	
14x16.5cm	5½x6½"	⅔ plate
16.5x21.5cm	6½x8½"	full plate
18x24cm	7x9½"	
18x25cm	7x10"	
18x28cm	7x11"	
18x43cm	7x17"	"banquet" cameras
19x24cm	7½x9½"	
20x25cm	8x10"	
20x50cm	8x20"	"banquet" cameras
	8½x13"	double whole plate
24x30cm	9½x12"	
25x30cm	10x12"	
28x35.5cm	11x14"	large studio size
	13½x16½"	mammoth plate

KODAK & ANSCO FILM NUMBERS AND IMAGE SIZES

KODAK	ANSCO	INCHES	METRIC
101	8A	3½x3½	9x9cm
103	10A	4x5	10x13cm
105	5A	2¼x3¼	6x9cm
116	6A,6B	2½x4¼	6.5x11cm
117	3A	2¼x2¼	6x6cm
118	7A	3¼x4¼	8x10.5cm
120	4A	2¼x3¼	6x9cm
122	18A	3¼x5½	8x14cm
124	7C	3¼x4¼	8x10.5cm
125	18C	3¼x5½	8x14cm
127	2C	1⅝x2½	4x6.5cm
130	26A	2⅞x4⅞	7.25x12.5cm

COLLECTORS' ORGANIZATIONS

This list was prepared by the Western Photographic Collectors' Assn. and updated by Centennial Photo Service. If your organization is not included in this listing, please contact either the WPCA or Centennial Photo.

	DUES Single Family International Corre- sponding n=non-profit	SHOW DATES	MEMBERSHIP	MEET- INGS Monthly Bi-mon. Annual	PUBLICA- TIONS Newsletter Journal: Annual Semi-ann'l Quarterly
ALL JAPAN CLASSIC CAMERA CLUB c/o Monarch Mansion Kohrakuen Room 802 No. 24-11, 2-chome Kasuga, Bunkyo-ku Tokyo 112, JAPAN 03-815-6677	3000 yen	none	417	B	Q
AMERICAN PHOTOGRAPHIC HISTORICAL SOCIETY P.O. Box 1775 Grand Central Station New York, NY 10163	$22.50 n	May Nov	600	M	N
AMERICAN SOCIETY OF CAMERA COLLECTORS, Inc. 4918 Alcove Ave. North Hollywood, CA 91607 (818) 769-6160	$20.00 n	March Sept	283	M	N
ATLANTA PHOTOGRAPHIC COLLECTORS CLUB P.O. Box 98291 Atlanta, GA 30345	$10.00	Nov	30		
BAY AREA PHOTOGRAPHICA ASSN (BAPA) 2538 34th Ave. San Francisco, CA 94116 (415) 664-6498	$8.00 n	none	32	B	
CALGARY PHOTOGRAPHIC HISTORICAL SOCIETY P.O. Box 3184, Stn B Calgary, Alberta CANADA T2M 4L7	$20.00 I (CDN)	Oct- Nov	40	M	N
C.A.M.E.R.A. (Camera and Memorabilia Enthusiasts Regional Association) c/o William J. Tangredi, Sec'y PO Box 11172 Loudonville, NY 12211	$12.00 n	March Nov	18	M	
CHICAGO PHOTOGRAPHIC COLLECTORS SOCIETY P.O. Box 375 Winnetka, IL 60093 (708) 223-4348	$20.00 n	March Sept	145	M	N
CLUB DAGUERRE-DARRAH 2562 Victoria Wichita, KS 67216 (316) 265-0393	$12.00	Feb	18	M	N
CLUB NIEPCE LUMIERE 35 rue de la Mare a l'Ane F93100 Montreuil FRANCE	325 FF n	Oct	200	M	Q
DELAWARE VALLEY PHOTOGRAPHIC COLLECTORS ASSN P.O. Box 74 Delanco, NJ 08075	$15.00 n	Feb June Aug Nov	90	M	N

	DUES Single Family International Corre- sponding n=non-profit	SHOW DATES	MEMBERSHIP	MEET- INGS Monthly Bi-mon. Annual	PUBLICA- TIONS Newsletter Journal: Annual Semi-ann'l Quarterly
DUTCH SOCIETY OF FOTOGRAFICA COLLECTORS P.O. Box 4262 2003 EG HAARLEM NETHERLANDS	$25.00 I	March Nov	1100		Q (Dutch & English)
EXAKTA CLUB COLLECTORS CIRCLE 6 Maxwell Road Sholing, Southampton, England S02 8EU 0703 435-960	£5	May	70	B	N
IHAGEE HISTORIKER GESELLSCHAFT c/o H.D. Ruys **(IHG)** Tesselschadelaan 20 NL-1217 LH Hilversum, NETHERLANDS	--	none	--		
INTERNATIONAL KODAK HISTORICAL SOCIETY P.O. Box 21 Flourtown, PA 19031	$20.00	none	105		J
INTERNATIONAL PHOTOGRAPHIC HISTORICAL ORGANIZATION P.O. Box 16074 **(InPHO)** San Francisco, CA 94116 (415) 681-4356	none	none	300		N
LEICA HISTORICA e.V. p.a. Klaus Grothe Bahnhofstr. 55 D-3252 Bad Muender WEST GERMANY	DM50 n	Spring Fall	400		Q
LEICA HISTORICAL SOCIETY c/o G.F. Jones 23 Salisbury Grove Wylde Green, Sutton, Coldfield West Midlands ENGLAND B72 1XY 021 384-7100	£12 £14 I	March July Oct	300	B	Q
LEICA HISTORICAL SOC. of AMERICA 7611 Dornoch Lane Dallas, TX 75248 (214) 387-5708	$28.00 $37.00 I n	Oct	1025	A	N Q
MICHIGAN PHOTOGRAPHIC HISTORICAL SOCIETY Box 12278 Birmingham, MI 48012-2278 (313) 582-1656	$10.00 n	Nov	90	B	N S
MIDWEST PHOTOGRAPHIC HISTORICAL SOCIETY 19 Hazelnut Ct. Florissant, MO 63033 (314) 921-3076	$10.00 F n	April Oct	65	M	N
THE MOVIE MACHINE SOCIETY 50 Old County Rd Hudson, MA 01749 (508) 562-9184	$15.00	none	90		N

	DUES Single Family International Corre- sponding n=non-profit	SHOW DATES	MEMBERSHIP	MEET- INGS Monthly Bi-mon. Annual	PUBLICA- TIONS Newsletter Journal: Annual Semi-ann'l Quarterly
NATIONAL STEREOSCOPIC ASSN Box 14801 Columbus, OH 43214 (614) 263-4296	$22.00 $30, 1stCl	July- Aug	2400		J
NIKON HISTORICAL SOCIETY c/o Robert Rotoloni P.O Box 3213 Munster, IN 46321 USA (312) 895-5319	$20.00	varies	175		Q
OHIO CAMERA COLLECTORS SOCIETY P.O. Box 282 Columbus, OH 43216 (614) 885-3224	$10.00	May	100	M	N
PENNSYLVANIA PHOTOGRAPHIC HISTORICAL SOC., Inc. P.O. Box 862 Beaver Falls, PA 15010-0862 (412) 843-5688	$15.00 S $20.00 F n	Aug Oct	55	B	N
PHOTOGRAPHIC COLLECTORS CLUB of GREAT BRITAIN P.O. Box 127A Surbiton, Surrey, ENGLAND KT6 7EE 01 393-9070	£15 £18 EUR £25 USA + £3 joining fee	May	850	M	Q +postal auctions
PHOTOGRAPHIC COLLECTORS of HOUSTON P.O. Box 70226 Houston, TX 77270 (713) 868-9606	$20.00	March Sept	75	M	N
PHOTOGRAPHIC COLLECTORS of TUCSON P.O. Box 18646 Tucson, AZ 85731 (602) 721-0478	none	March Nov			
THE PHOTOGRAPHIC HISTORICAL SOCIETY P.O. Box 39563 Rochester, NY 14604	$15.00 n	Oct (tri- ennial)	100	M	N
THE PHOTOGRAPHIC HISTORICAL SOCIETY of CANADA	$20.00 n	May Oct	250		J
PHOTOGRAPHIC HISTORICAL SOCIETY of METROPOLITIAN TORONTO P.O. Box 115, Postal Stn "S" Toronto, Ont, CANADA M5M 4L6 (416) 221-8888 or 483-4185	$ 8.00 n	Fall Wint	150	M	N
PHOTOGRAPHIC HISTORICAL SOCIETY of NEW ENGLAND, Inc. P.O. Box 189 Boston, MA 02165 (617) 731-6603	$18.00 S $24.00 F $35.00 I n	April Oct	400	M	N Q

	DUES Single Family International Corre- sponding *n=non-profit*	SHOW DATES	MEMBERSHIP	MEET- INGS Monthly Bi-mon. Annual	PUBLICA- TIONS Newsletter Journal: Annual Semi-ann'l Quarterly
THE PHOTOGRAPHIC HISTORICAL SOCIETY of the WESTERN RESERVE P.O. Box 21174 South Euclid, OH 44121 (216) 382-6727	$12.00 *n*	July -Aug	65	M	N
PHOTOGRAPHICA - A.S.B.L. Chaussée de la Hulpe 382 1170 Brussels BELGIUM 02-673.84.90	1200 (BFRS) *n*	May			J
PUGET SOUND PHOTOGRAPHIC COLLECTORS SOCIETY 10421 Delwood Dr. S.W. Tacoma, WA 98498 (206) 582-4878	$10.00 *n*	April	115	M	N
STEREO-CLUB FRANÇAIS 45, Rue Jouffroy 75017 Paris FRANCE 47-63-31-82	280 FF *n*	March June Oct	700	M	
TRI-STATE PHOTOGRAPHIC COLLECTORS SOCIETY 8910 Cherry Blue Ash, OH 45242 (513) 891-5266	$5.00 *n*	none	12	M	
WESTERN CANADA PHOTOGRAPHIC HISTORICAL ASSN Box 33742 Vancouver, B.C. CANADA V6J 4L6 (604) 254-6778	$15.00 S $20.00 F $10.00 C	none	45	M	N
WESTERN PHOTOGRAPHIC COLLECTOR ASSN　(WPCA) P.O. Box 4294 Whittier, CA 90607 (213) 693-8421	$25.00 S $20.00 C $30.00 I *n*	May Nov	400	M	Q
ZEISS HISTORICA SOCIETY P.O. Box 631 Clifton, NJ 07012 (201) 472-1318	$20.00 $25.00 I	none	175	A	J

DATING CAMERAS BY UNITED STATES PATENT NUMBERS

Patent dates can often be helpful in dating cameras, shutters or other accessories. One must be careful, however, not to conclude that the item was manufactured in the year the patent was issued. This is usually not the case. The patent date serves to indicate the year *after* which the item was made. Often the patents had been issued for five years or more before an item was produced bearing the patent number. Many products continued to carry the patent numbers for many years after the patent was issued. Thus a camera manufactured in 1930 could have a 1905 patent date.

The first numbered patents were issued in 1836, just before the advent of photography. Originally the law required that the patent date (but not the number) be put on the product. The present requirement to place the patent number on the item or its container began on April 1, 1927. Many earlier products, however, bore the patent number even though it was not required by law.

The following table lists the first patent number for the indicated year.

YEAR	NUMBER	YEAR	NUMBER	YEAR	NUMBER
1836	1	1887	355,291	1938	2,104,004
1837	110	1888	375,720	1939	2,142,080
1838	546	1889	395,305	1940	2,185,170
1839	1,061	1890	418,665	1941	2,227,418
1840	1,465	1891	443,987	1942	2,268,540
1841	1,923	1892	466,315	1943	2,307,007
1842	2,413	1893	488,976	1944	2,338,081
1843	2,901	1894	511,744	1945	2,366,154
1844	3,395	1895	531,619	1946	2,391,856
1845	3,873	1896	552,502	1947	2,413,675
1846	4,348	1897	574,369	1948	2,433,824
1847	4,914	1898	596,467	1949	2,457,797
1848	5,409	1899	616,871	1950	2,492,941
1849	5,993	1900	640,167	1951	2,536,016
1850	6,891	1901	664,827	1952	2,580,379
1851	7,865	1902	690,385	1953	2,624,046
1852	8,622	1903	717,521	1954	2,664,562
1853	9,512	1904	748,567	1955	2,698,434
1854	10,358	1905	778,834	1956	2,728,913
1855	12,117	1906	808,618	1957	2,775,762
1856	14,009	1907	839,799	1958	2,818,567
1857	16,324	1908	875,679	1959	2,866,973
1858	19,010	1909	908,436	1960	2,919,443
1859	22,477	1910	945,010	1961	2,966,681
1860	26,642	1911	980,178	1962	3,015,103
1861	31,005	1912	1,013,095	1963	3,070,801
1862	34,045	1913	1,049,326	1964	3,116,487
1863	37,266	1914	1,083,267	1965	3,163,865
1864	41,047	1915	1,123,212	1966	3,226,729
1865	45,085	1916	1,166,419	1967	3,295,143
1866	51,784	1917	1,210,389	1968	3,360,800
1867	60,658	1918	1,251,458	1969	3,419,907
1868	72,959	1919	1,290,027	1970	3,487,470
1869	85,503	1920	1,326,899	1971	3,551,909
1870	98,460	1921	1,364,063	1972	3,631,539
1871	110,617	1922	1,401,948	1973	3,707,729
1872	122,304	1923	1,440,362	1974	3,781,914
1873	134,504	1924	1,478,996	1975	3,858,241
1874	146,120	1925	1,521,590	1976	3,930,271
1875	158,350	1926	1,568,040	1977	4,000,520
1876	171,641	1927	1,612,790	1978	4,065,812
1877	158,813	1928	1,654,521	1979	4,131,952
1878	198,733	1929	1,696,897	1980	4,180,167
1879	211,078	1930	1,742,181	1981	4,242,757
1880	223,211	1931	1,787,424	1982	4,308,622
1881	236,137	1932	1,839,190	1983	4,366,579
1882	251,685	1933	1,892,663	1984	4,423,523
1883	269,820	1934	1,941,449	1985	4,490,855
1884	291,016	1935	1,985,878	1986	4,562,596
1885	310,163	1936	2,026,516	1987	4,645,548
1886	333,494	1937	2,066,309	1988	4,716,594

UNION CASES - A Collector's Guide to the Art of America's First Plastics
Clifford & Michele Krainik with Carl Walvoord
Voted "Best Book of the Year" in 1988 by the American Photographic Historical Society.
This is a superbly researched and produced book that belongs in the library of all photo
historians and collectors. Early 19th century photographs, particularly daguerreotypes
and ambrotypes were fragile images, usually placed in protective wood and leather cases. In
1853, a method was devised for mass producing cases out of plastic. Referred to as
Union Cases, they were manufactured in the U.S. from the early 1850's through the late
1860's, many of the designs based on works of art. This history of a unique industry shows in
actual size every known case design - 773 examples. A supplemental price guide is provided.
240 pp. 10½ x 12 inches. 825 illus. Hardbound. $85.00 ISBN 0-931838-12-6

COLLECTORS GUIDE TO ROLLEI CAMERAS by Arthur Evans
A complete, illustrated guide to all Rollei cameras from 1921 to 1986. This book includes
descriptions of all models of Heidoscop, Rolleidoscop, Rolleiflex, Rolleicord, 35mm and
6x6cm SLRs, subminis, and compact 35s.
272pp. 5½x8½". 134 B&W photographs. $22.95. ISBN 0-931838-06-1

COLLECTORS GUIDE TO KODAK CAMERAS
Millions of Americans own antique Kodak cameras, and this is the first comprehensive
guide which describes and illustrates most of these family heirlooms. Large, clear photos
and easy to use index make it an ideal guide for the novice or expert alike. Identification
features have been included for each camera model as well as technical specifications
and original prices. Virtually all Kodak and Brownie cameras are listed along with the
shutter and lens variations and the years of production for each variation.
176 pages, 5½x8½ inches. $16.95. ISBN 0-931838-02-9

*Add $3.00 for postage for a single title, $4.00 for any multiple-book order. We will ship by 4th Class Book
Rate in the USA and by Surface Mail to foreign countries. If other method of shipping is requested, please
include sufficient payment. Foreign orders, please pay in U.S. Dollars, preferably in currency to avoid
excessive bank charges. We accept VISA and MasterCard. Include card number, expiration date, and
name of cardholder.*

Centennial Photo ● Rt. 3 Box 1125 ● Grantsburg, WI 54840 USA

KODAK CAMERAS - The First Hundred Years by Brian Coe
No collector of Kodak cameras should be without this book. Over 600 models of Kodak and Brownie cameras are assembled in chapters by camera type. In addition to many large illustrations of the cameras, variations of construction are detailed and illustrated. Covers cameras from the U.S.A., Britain, Germany, France and several other countries. 8 x 10¼ inches, 298 pages, hardbound. $55.00

POCKET PRICE GUIDE: 7,000 Cameras in your pocket!
The abridged McKeown guide is handy for use at camera shows, flea markets, auctions, etc. Entries include Manufacturer, Camera name, price, and page reference to the main guide for further information. The pocket edition does not include historical and technical information or photos like the main guide... just thousands of names and prices in a handy size. AVAILABLE ONLY BY MAIL from CENTENNIAL PHOTO for $12.95 postpaid.

ORION CAMERA BLUE BOOK: Essential for pricing <u>usable</u> equipment.
Over 15,500 products: Cameras, Backs, Lenses, Meters, Electronic Flashes, Projectors, Enlargers, Tripods, Lighting equipment . . . just to name a few categories.
- **There has never been such a comprehensive listing of usable equipment.**
- Information includes NEW LIST, RETAIL USED, & WHOLESALE used prices.

A perfect supplement to our "Antique & Classic" guide. **This large format 8½ x 11 inch, 320 page book is absolutely packed with information.** Published annually in December. The 1990 edition will be available 12/89; the 1991 edition in 12/90.
LET'S MAKE A DEAL:
If you promise to quit asking me to put the latest electronic marvels in my book of antique cameras, I'll give you a 10% discount on the book that has the modern cameras you're looking for. The 1990 edition sells for $119.50. You can buy it from Centennial Photo for just $107.55. And we'll keep our special price of $107.55 for the 1991 edition as well.

MY FIRST CAMERA BOOK - (Includes free camera)
Start your children in photography with this delightful new instructional book. All the basics of good photography are explained by Bialosky Bear in this 64 page book. Includes a reusable red 'Bialosky Cub Photographer" camera. A great gift item for children and camera collectors. $8.95 each. Quantity discounts available for 10 or more.
ORDERING INFORMATION ON PREVIOUS PAGE (p. 799).

BURTON TILLEY BUYS CAMERAS!

**TOLL FREE
1-800-525-0359
PLEASE CALL**

We Will Buy The Following Cameras in Ex+ or Better Condition at Prevailing Prices.

JAPANESE CAMERAS
Acro 35 w/top viewer
Hansa Canon
Canon S or S-2 any cond.
Canon J or J2, any cond.
Canon Seiki Serenar Lenses
Canon VI or VIT w/Lens
Honor w/lens (Leica copy)
Nikon I Serial #609-1 to 609-759, any cond.
Nikon M Serial #M609-759 to M609-2000, any cond., no sync.
Nikon M Serial #M6092000 to M6094000, any cond. (factory sync) WL
Nikon 50mm lens only, for above, says "Tokyo" not "Japan", some are rare.
Nikon S2, S2 Black, w/lens. Exc+
Nikon S3 w/lens. like new
Nikon S3 Black, w/lens. Exc+
Nikon S4, SP w/lens. Mint
Nikon SP Black, w/lens. Exc++
Nikon S-3M Half frame
Nippon Kogaku "Tokyo" lenses
Nikon 21mm or 25mm lens w/finder for RF
Nikon 50/3.5 Macro, or 50/1.1 SM or BM for RF
Nikon RF any camera accessories
Nippon Camera (Leica copy)
Nippon Camera collapsible fixed lens, any cond.
Look, Leica copy
Peerless, Leica copy

EUROPEAN EQUIPMENT
Alpa-Reflex I, ca. 1947
Bertram (3 lens set) Mint
Casca (no rangefinder) or Casca II (w/RF)
Exakta 6x6 Pre or Post War
Gami (complete)
Kardon Military or Civilian
Leica copies
Minox B new type, Mint
Minx III or IIIS
Pilot TLR
Plaubel Makinette
Cart Bentzin Primarette
Roland
Rolleiflex 4x4 black or grey
Grey Rollei T
Rollei 2.8F or 3.5F, newest, truly Mint, 120/220 Planar
Rolleiwide w/case. Mint
Sept. Exc+
Sybil Baby and all other sizes
Vollenda w/Elmar lens. Exc++

LEICAS
Leitz plastic stereoviewer
Leica IIIc Wartime. Must be Exc+

Leica IIIf RD ST. Must be Mint
Leica Ig. Must be Exc+
Leica M2. Must be Mint
Leica M3 under SR #700200, any cond.
Leica M3 above #1,100,000. Mint
Leica M5 chrome, 3 lug. Mint
Leica Brightline finders 21, 28, 35
Leitz 15 Hologon w/finder
Leitz 28/5.6 Summaron or 28/6.3 Hektor
Leitz 33/2.5 Stemar Stereo. Set.
Leitz 35/2 Summicron. Germany or no eyes-SM
Leitz 50/2 Summicron Rigid, BM
Leitz 50/3.5 Red Dial, Elmar, SM
Leitz 90/2.8 Elmarit or 90/4 Elmarit
Leitz 90/4 Elmar collapsible or SM
Leitz 125/2.5 Hektor w/hood & caps
Leitz 135 Elmar
Leica All Viewfinders, many types
Other cameras - Please CALL

VOIGTLANDER
Bessas, many types, I, II, II Apo-Lanthar
Prominent II
Superb, Heliar or Skopar lens, like new

ZEISS
Contaflex Twin lens truly Mint
35/2.8 Biogon for above w/finder
Contarex Professional, Special, or SE Electronic Exc++
Contarex Super, new type
Contarex 16mm or 18/4 Distagon, black
Contarex 25/2.8 or 35/2 Distagon, black
Contarex 35/4 Curtagon, PA
Contarex 85/1.4 black
Contarex 180/2.8, black RARE
250/4 Sonnar w/knob focus black
Contarex 1000mm or 500mm Mirotar, Valuable
Contarex Vario Sonnar S. Valuable
Contax D, Contax F, Contax S
Contax IIa full sync Exc++, 50/1.5 "Carl Zeiss" lens
Contax IIIa full sync Exc+, 50/1.5
Contax 21mm lens w/finder
Contax 25mm Topogon
Contax 28mm Black Tessar
Contax 35mm Orthometer or Biometer
Contax 35mm Biogon (post war) or Planar
Contax 40mm or 75mm Biotar. Rare
Contax Long Lenses and Contax Reflex Housings
Icarex
Hologon w/grip filter
Baby Ikonta w/Tessar
Super Ikonta A or C w/MX Tessar
Zeiss plastic stereoviewer for Stereotar C

Burton Tilley's World Cameras

**1705 14th Street, Suite 222, Boulder, CO 80302
TOLL FREE 1-800-525-0359 or (303) 443-3097**

804

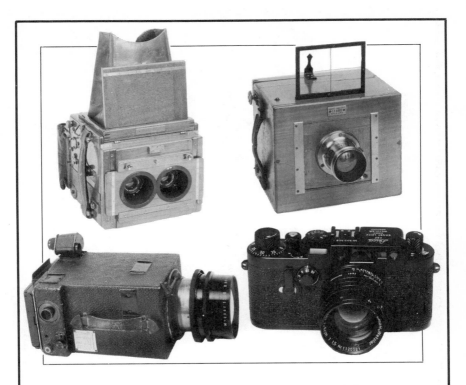

Cameras and Photographic Equipment

Christie's South Kensington commenced auctions of cameras in 1971 and have established an enviable reputation on behalf of both buyers and sellers.

We hold regular auctions of rare, fine and collectible cameras, optical toys, magic lanterns, photographic books and related material . A special auction of Leica equipment is held each July.

For further information about buying or selling at auction or for illustrated sale catalogues contact Michael Pritchard, Christie's South Kensington, 85 Old Brompton Road, London SW7 3LD. Tel: 441/581-7611. Telex: 922061. Fax: 441/584-0431.

CHRISTIE'S
SOUTH KENSINGTON

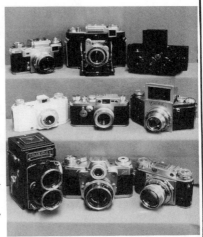

814

Fine Antique Cameras
Photographic Images

Fig. 7.

We buy collections and fine individual items.

Allen & Hilary Weiner • 80 Central Park West • N.Y.C. 10023

(212) 787 · 8357

Dealers by appointment.

49 West 23rd Street 2nd Floor
New York, NY 10010

(212) 935-USED
(800) 243-USED
FAX (212) 691-3718

Dear Reader and Collector;

In our "Used & Collectable" Camera Division, we have a fine selection of used and rare photographica pieces. Whether, it be Leica, Canon or Nikon range-finders, Zeiss, Kodak, Exakta, Contaflex, Minox, Rolleiflex, Medium format, Large Format, and many more.

We now have computerized our entire operation where we can place you on our mailing list. By telling us what items you are collecting or are interested in, we will send you our bi-monthly print-out of what we have available of your favorite collectibles.

We also have a Trade-in Department where we will purchase anything from one piece to an entire Collection or Estate. To make it more convenient for you when selling a Collection or an Estate, we can either come to your place, or we will pay for your travel expenses to our place.

Whether you are Buying or Selling, you can feel confident that you will be treated with fairness and courtesy.

FOTO-CELL
Trade and Used Dept.

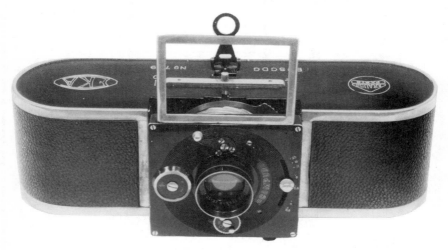